# THE
# ENLIGHTENMENT

# THE

# ENLIGHTENMENT

═══

*The Pursuit of Happiness,*
1680-1790

═══

RITCHIE

ROBERTSON

HARPER

*An Imprint of* HarperCollins*Publishers*

HarperCollins books may be purchased for educational, business, or sales promotional use. For information, please email the Special Markets Department at SPsales@harpercollins.com.

Originally published in Great Britain in 2020 by Allen Lane.

FIRST U.S. EDITION

Library of Congress Cataloging-in-Publication Data has been applied for.

ISBN 978-0-06-241065-8

21 22 23 24 25  LSC  10 9 8 7 6 5 4 3 2 1

*To Katharine*

# Contents

# List of Illustrations

# Preface

Historians often claim that the period they are studying or writing about is important for the present, but it is undeniable that the Enlightenment has a particularly urgent message for our time. Opponents of tyranny, injustice and superstition often appeal to 'the values of the Enlightenment'. With the definite article, 'the Enlightenment' refers to a historical period, which for the purposes of this book runs from about 1680 to about 1790. Within this, the Enlightenment stands for the endeavours of thinkers, writers and practical administrators in many countries to increase the well-being of humanity, and to do so by the process called (without the article) 'enlightenment'. For them, to enlighten humanity is to clear away the false beliefs which have blinded people to their own interests; to oppose the power of institutions, especially the organized Churches, which have encouraged such blindness; to arrive at a true understanding of human nature, and of the political and economic societies in which people live; to increase people's well-being and happiness; and to do so by close attention to empirical facts and the use of reason. The conviction animating these endeavours is that the world need not be a vale of tears; the earth is the destined home of humanity, and a place where happiness is attainable.

Recently, the case for the Enlightenment has been put with particular eloquence by the psychologist Steven Pinker and the philosopher Susan Neiman. 'The era', according to Pinker, 'was a cornucopia of ideas, some of them contradictory, but four themes tie them together: reason, science, humanism, and progress.'[1] Neiman's summary of Enlightenment values has a somewhat different emphasis. Alongside freedom and autonomy, she singles out 'happiness, reason, reverence and hope' as 'values cherished by every thinker who was central to the Enlightenment'.[2] By including 'reverence', perhaps surprisingly, Neiman means that the believers in a rational religion, who formed much of the Enlightenment mainstream, meant to substitute for the questionable God presented by the Churches a conception of divinity that measured up to humanity's moral intuitions.

There is, however, another view of the Enlightenment, which was acknowledged, even when being dismissed, by another defender of the

Enlightenment, the late historian Eric Hobsbawm, in a lecture he delivered
in 1992:

> I believe that one of the few things that stands between us and an acceler-
> ated descent into darkness is the set of values inherited from the
> eighteenth-century Enlightenment. This is not a fashionable view at this
> moment, when the Enlightenment can be dismissed as anything from super-
> ficial and intellectually naïve to a conspiracy of dead white men in periwigs
> to provide the intellectual foundation for Western imperialism. It may or
> may not be all that, but it is also the only foundation for all the aspirations
> to build societies fit for *all* human beings to live in anywhere on this Earth,
> and for the assertion and defence of their human rights as persons.[3]

The 'dead white men in periwigs' have been accused of holding, and
imposing on others, a blinkered, rationalistic view of the world; of using
science and technology to confirm humanity's domination of nature, ulti-
mately for the benefit of industrial capitalism; of reducing human beings
to interchangeable, manipulable units, and classifying them in schemes
that reinforced race- and gender-based hierarchies; and of subjecting the
non-European world to an imperialism justified by Western claims to
possess universal values.[4]

The grain of truth in some of these charges has been hugely exaggerated
by two factors. The first is simply insufficient knowledge of what was
really said, written and done in the Enlightenment. The second is a fault
to which even defenders of the Enlightenment are sometimes prone: what
historians call 'presentism' – that is, a tendency to see the past only from
a present-day perspective, and to ignore or underestimate its difference
from the present. Pinker's term 'humanism', for example, could mislead
incautious readers. Nowadays it serves well to define a secular morality,
based not on supposedly divine commandments but on the sympathies
which, as Enlighteners increasingly realized, bound human beings together
in a community that transcended national frontiers. Yet the word 'human-
ism' was not used in this sense until the mid-nineteenth century.

In this book, I have tried to remain aware of the continuities between
the present and the past, but to avoid projecting present-day concerns onto
a period separated from us by several centuries. The proponents of the
Enlightenment, whom I shall henceforth call 'Enlighteners', inhabited a
very different world from ours and had very different assumptions. In the
opinion of most Enlighteners, God had planned the universe in accordance
with laws (which had recently been discovered by Isaac Newton), and had
then left it to run its orderly course. Only a small minority thought there
was no God, and they took care not to advertise their scepticism. Even the

boldest thinkers estimated the age of the earth at no more than a hundred thousand years. Species were thought to be constant: God would not have created beings only to let them become extinct. In the political world, the default mode of government, despite its acknowledged shortcomings, was monarchy. Republics were rare. Direct democracy, as known mainly from the history of ancient Rome and Athens, was distrusted, because experience showed that power usually fell into the hands of demagogues and this led to anarchy, followed by tyranny. Only representative democracy could work, as in the fledgling United States and – to a still very limited extent – in Britain. Women could have no part in politics, though this assumption was rendered dubious by the conspicuous success of women in governing the empires of Austria and Russia. We should not expect to find in the Enlightenment, therefore, some early version of the liberal values of the present day; but we can certainly find there the seedbed in which many of these values germinated.

I have tried to present a rounded picture of the Enlightenment, and, in doing so, to challenge some of the current notions about it. In particular, the cliché of 'the age of reason' needs to be questioned. Yes, Enlighteners did indeed advocate and exemplify the use of reason, as opposed to blind trust in authority. The claims made by authorities, notably the Churches, needed to be challenged: philosophically, by disclosing the often glaring flaws in their arguments, and historically, by asking what foundation there was for the assertions made in the Scriptures and in subsequent theological writings. Moreover, reason had many obvious practical applications. In education, in criminal law and in farming, for instance, there were many methods inherited from earlier generations which, on examination, showed themselves to be unsuitable for their alleged purposes. So there is a lot in this book about practical enlightenment: about the concrete proposals by Enlighteners, including enlightened monarchs, for making the world better and people happier. Whether by freeing people from false beliefs or by increasing their material well-being, the pursuit of happiness, long before Thomas Jefferson used the phrase in drafting the American Declaration of Independence, was the overriding purpose of enlightened thought and activity. Accordingly, although 'reason' is an important concept throughout this book, its governing idea is the pursuit of happiness.

It should not be thought that in setting up reason against traditional authority, the Enlightenment, as some of its critics have argued, was in danger of creating another authority just as tyrannical as its predecessors. The process of enlightenment consists not in teaching people what to think, but in teaching them *how* to think. Immanuel Kant's famous formulation, published in 1784, cannot be repeated too often: the

watchword of enlightenment is 'Have the courage to use your *own* intellect!'

Nor should reason be identified with logic and calculation. The philosophers of the seventeenth century regarded geometrical reason, where each statement follows ineluctably from the foregoing, as the model of rational thought. In the Enlightenment itself, 'reason' is much more often synonymous with 'good sense' or 'common sense'. Common sense can be a force for change: one can look at a time-honoured practice, such as hereditary monarchy or capital punishment, and ask for evidence that it really achieves what it is conventionally supposed to.

What the slogan 'the age of reason' obscures, however, is that the Enlightenment was also the age of feeling, sympathy and sensibility. Well before the Enlightenment, legal theorists in particular had asked about the sources of social solidarity that bound people together into a community. Enlighteners argued that fellow feeling, mutual sympathy, was at the heart of human nature and of people's coexistence in society. Society was not an aggregation of isolated individuals, but a body of people interconnected by the exchange of emotions. Human interconnectedness, an innate love of dealing with one another and exchanging goods, was the impulse that Adam Smith identified as the basis of commercial society. It was no accident that Smith wrote first a treatise on emotions and later a treatise on economics. *The Wealth of Nations* (1776) presupposed the earlier *Theory of Moral Sentiments* (1759). The Enlightenment actively promoted what Pinker calls 'the humanitarian revolution'.[5]

The term 'age of reason' also implies a false opposition between reason and religion. Certainly the Enlightenment strongly opposed the ill-founded historical and philosophical claims made by the Churches, and the moral tyranny for which these claims provided a pretext. They equally opposed the prevalence of superstition among uneducated people. But enlightenment also occurred *within* the Churches. It was widely thought possible to have a rational religion that at least played down the supernatural element in Christianity and transferred the emphasis to the moral and ethical content of religious teaching.

In this book I try to present the Enlightenment not only as an intellectual movement but also as a sea change in sensibility, in which people became more attuned to other people's feelings and more concerned for what we would call humane or humanitarian values. For this purpose, I draw extensively on literature, especially narrative fiction. It is surprising how little use most studies of the Enlightenment make of literature. Yet it is in literature, and in the recorded response to literary texts, that we can find evidence for major shifts in collective feeling. Above all, the great, emotionally

compelling novels of the mid-eighteenth century, by Richardson, Rousseau and Goethe, provided their readers with an education in empathy that flowed over into increased sympathy with oppressed members of society.

Another preconception associates the Enlightenment first and foremost with Paris. One thinks readily of Voltaire, the most brilliant and versatile writer of the age, and of the great collective project, the *Encyclopédie*, directed with superhuman dedication by Diderot. Without doubt, Paris carried a greater weight in the history of the Enlightenment than any other city, but it is now recognized that the Enlightenment was truly international. Enlightened activity can be found from Philadelphia to St Petersburg. In particular, the importance of Germany, including the 'classical age' of Goethe and Schiller, and of Scotland, the home of David Hume and Adam Smith, is increasingly being acknowledged.

It has therefore been argued that we should think, not of '*the* Enlightenment', but of a large number of distinct national Enlightenments. It is absolutely right that the study of the Enlightenment needs to be sensitive to local differences. In France, the bearers of the Enlightenment were predominantly the self-styled *philosophes* of Paris; in Germany, they were often the administrators who did their best to reform the many German states. But this distinction is not hard and fast. In France, Anne-Robert-Jacques Turgot was an enthusiastic Enlightener and an administrator; in Germany, Kant was a philosopher (though, as a professor, he was also a state official). In any case, the concept of different national Enlightenments takes for granted that there was an overall Enlightenment of which they formed different facets.

A stronger scepticism would object to the term 'the Enlightenment' on the grounds that it was not used at the time. By that argument, however, most historical period terms would have to be discarded. Medieval people did not say, or know, that they were living in the Middle Ages. Those who lived through the religious upheavals of the sixteenth century could not suspect that their time would eventually be labelled the Reformation. However, people in the eighteenth century knew that something momentous was happening, and they actually called it the spread of enlightenment, reason, philosophy, *lumières*, or *Aufklärung*. They looked back in horror to the religious wars of the sixteenth and seventeenth centuries and saw that advances in philosophy, including 'natural philosophy' (what we would now call science), had begun to diffuse tolerance and reason more widely – though still not widely enough.

'Natural philosophy' had proved its worth in the Scientific Revolution of the seventeenth century. It provided the Enlightenment with a model of reliable knowledge. Scientific knowledge was trustworthy because it was based on empirical study of the world. But because it could so often be corrected

by more accurate observations, its authority was always provisional, never absolute – in contrast to the authority still claimed by the Churches. An interest in science, especially the physical sciences, was widespread in the Enlightenment. Philosophers extended their scientific approach to what David Hume called 'the science of man', and to society through the study of law, political systems and what came to be called 'political economy'.

Although it is justified to speak of 'the Enlightenment', one should not therefore assume that the Enlightenment was a homogeneous movement, or that all Enlighteners thought the same. General statements beginning 'The Enlightenment' are unavoidable – there are plenty in this book – but they should always be treated with caution. Many Enlighteners opposed capital punishment as being inhumane and ineffectual, but some justified it because it acknowledged the status of the individual as a moral being who was responsible for his offences and must be prepared to atone for them. The concept of human rights may well be thought one of the most valuable of the Enlightenment's legacies, but some Enlighteners questioned the very notion. The Enlightenment is sometimes dismissed out of hand by the argument that its proponents had a starry-eyed conception of progress and imagined that a perfect society was just around the corner. A few people did think this way, and their illusions will be described in the following chapters, but most Enlighteners were realistic enough to see that progress was neither inevitable nor irreversible, and that all societies were liable eventually to decline and decay. Not for nothing is the Enlightenment's greatest work of history Edward Gibbon's *Decline and Fall of the Roman Empire* (1776–89).

Many misunderstandings of the Enlightenment arise from the abuse of hindsight. At the end of the period stands the French Revolution. It is easy, but wrong, to interpret the Enlightenment as a prelude to the Revolution, and to imagine groups of radical philosophers plotting to overthrow the established order. In fact, the Enlighteners who wanted major social changes expected those changes to be made from above, not from below. They were impressed by the sweeping reforms that enlightened rulers had introduced in Prussia, Russia, Austria and many smaller states. By the 1780s it was becoming increasingly apparent that France was unlikely to bring in economic reforms or curtail the damaging privileges enjoyed by the nobility. But, as with the fall of Communism in 1989–90, nobody expected the French Revolution until it happened. It was a new event, significantly different from the American Revolution often considered its predecessor and catalyst. Those who welcomed its initial bold reforms did not perceive the unstoppable dynamic that would lead to the Reign of Terror and eventually – as critics of 'democracy' had always warned – to the

arrival of a dictator, in this case Napoleon. Another abuse of hindsight consists in projecting the imperialism of the nineteenth century back onto the eighteenth. Enlighteners were intensely interested in the world outside Europe. That world was explored for practical purposes, above all for trade, though also to support geopolitical rivalries among the European powers. If, as was generally believed, there was a large southern continent, then it mattered very much which European power would be the first to discover and lay claim to it. By the eighteenth century the commercial exploitation of non-European territories was in full swing. But the depredations of the English, French and Dutch East India Companies were constantly attacked by Enlighteners, above all in that great but nowadays too little read work the *Histoire des deux Indes* (*History of the East and West Indies*), on which the abbé Raynal collaborated with Diderot and others. In order to convey the complexity of Enlightenment cosmopolitanism, I have avoided the words 'Eurocentric' and 'Orientalist'. Both words were useful in the past, but they have by now declined, at worst into mere boo-words, at best into crudely moralistic labels for cultural relations.

There are many studies of the Enlightenment which can claim classic status, beginning with the book on the philosophy of the Enlightenment written by the German-Jewish philosopher Ernst Cassirer on the eve of the Nazi catastrophe. With the partial exception of Cassirer, I have kept these books at arm's length. This is a study of the Enlightenment, not of books about the Enlightenment. Anyone who wants a judicious overview of Enlightenment research can find it in the opening chapter of *The Case for the Enlightenment* (2005) by John Robertson (no relation). I have presented my own view of the Enlightenment, so much so that some of its prominent advocates, as well as its detractors, if they bother to read that far, will probably be annoyed. I refer constantly to primary texts to allow the writers of the Enlightenment to speak for themselves. I offer thumbnail summaries of some of the key works of the Enlightenment, and I sometimes argue with their authors. Anyone who thinks it pointless to argue with dead authors should remember that their ideas are still alive. Although as a scholar I am committed to a historical understanding of literature and philosophy, I am also conscious that historicism can be a dead hand laid on the past, denying it the power to interfere with our thinking and disturb our complacencies. Part of my purpose is to depict the Enlightenment as a set of ideas that are still vital, and a set of controversies that are still unresolved, at the present day.

In undertaking to write a book on the Enlightenment I have ventured far outside my comfort zone. I am therefore deeply grateful to the

Enlightenment scholars who have read and commented on all or some of this book. Catriona Seth, Joachim Whaley, David Wootton and Brian Young read and commented valuably on an earlier version of the entire text; Laurence Brockliss, Kevin Hilliard and Dorinda Outram read substantial portions. I thank Diarmaid MacCulloch and Faramerz Dabhoiwala for advising me on publishing, and most especially my agent, Catherine Clarke of Felicity Bryan Associates, for negotiating on my behalf. I am grateful above all to my editor, Stuart Proffitt, who invited me to undertake this work, and whose meticulous reading and re-reading very much benefited the book; and also to my wife, Katharine Nicholas, whose shrewd advice induced me to remodel, and considerably improve, several chapters. Needless to say, responsibility for the opinions expressed, and for any remaining factual errors, is entirely mine.

I have also benefited greatly from my involvement with the Besterman Centre for the Enlightenment at Oxford, from the unrivalled knowledge of Voltaire which its director, Nicholas Cronk, shared with me, and from attending its weekly Enlightenment workshops, organized by Kelsey Rubin-Detlev and more recently by Avi Lifschitz. I owe warm thanks to Martin van Gelderen for generously inviting me to spend a year as a senior research fellow at the Lichtenberg-Kolleg in Göttingen, and to his invariably helpful colleagues Dominik Hünniger and Kora Baumbach. While in Göttingen I benefited not only from access to superb libraries but also from many conversations with László Kontler, Anthony La Vopa, Dorinda Outram and Mara van der Lugt. I am grateful to David Wootton for allowing me to read his book *Power, Pleasure, and Profit: Insatiable Appetites from Machiavelli to Madison* (2018) before its publication. Looking further back, I owe thanks, as often before, to the late Edward Timms, with whom, as long ago as 1991, I co-edited a volume on *The Austrian Enlightenment and its Aftermath*. I owe more diverse debts to Audrey Borowski, Peter Ghosh, Martin Gierl, Andrew Kahn, Paschalis Kitromilides, Laura Anna Macor, Karen O'Brien, Jim Reed, John Robertson, Kelsey Rubin-Detlev and David Womersley. The many pleasures of studying the Enlightenment include the licence to trespass across disciplinary boundaries and to establish intellectual and personal friendships with fellow-scholars from many areas. But the greatest motive for studying this subject is the awareness that the Enlightenment, though distant in time, remains vitally important. In an age that seems dominated by 'fake news', widespread credulity, xenophobia and unscrupulous demagogues, it matters more intensely than ever to hold on to reliable knowledge, to be aware of our common humanity, and to pursue the possibility of human happiness.

# Note on Translations

Translations are my own unless otherwise stated. Quotations are normally given in English only, except for passages of poetry. There I have given the original followed usually by a plain prose translation.

# I

# Happiness, Reason and Passion

The Enlightenment declared the conviction that the goal of life was happiness, and that if this goal could be attained at all, it was to be found in the here and now, despite the manifold imperfections of earthly life. As early as 1671, the philosopher Gottfried Wilhelm Leibniz defined wisdom as 'the science of happiness'.[1] John Locke wrote in 1677: 'The businesse of man [is] to be happy in this world by enjoyment of the things of nature subservient to life health ease and pleasure and by the comfortable hopes of another life.'[2] Locke publicly reaffirmed the priority of happiness in his *Essay concerning Human Understanding* (1690), one of the Enlightenment's foundational texts: 'I lay it for a certain ground, that every intelligent being really seeks happiness, which consists in the enjoyment of pleasure, without any considerable mixture of uneasiness.'[3] Alexander Pope, in the *Essay on Man* (1733–4), famously apostrophized 'happiness! our being's end and aim'.[4] The 'pursuit of happiness' was, equally famously, among the basic human rights formulated by Thomas Jefferson in the preamble to the American Declaration of Independence in 1776. But this pursuit was not confined to Western Europe and North America. Far away, in what is now Romania, Iosipos Moisiodax, head of the Princely Academy at Jassy (now Iași), defied the Orthodox Church by issuing a similar message in his *Apology* (1780): 'Sound Philosophy ... is a comprehensive theory, which investigates the nature of things always with an eye to their end, so that it preserves, it promotes the true happiness that mankind, as mankind, can enjoy upon the earth.'[5]

'Happiness' and its equivalents – *bonheur, félicité, felicità, Glück, Glückseligkeit, lycksalighet* – epitomize what one leading contemporary historian of the Enlightenment has called 'the commitment to understanding, and hence to advancing, the causes and conditions of human betterment in this world', which gave the Enlightenment its intellectual coherence.[6] It was this aim that underlay the attention that Enlighteners gave to society, to the study of forms of government, to political economy, and to history,

# AN
# E S S A Y

CONCERNING

## Humane Understanding.

In Four B O O K S.

*Quam bellum est velle confiteri potius nescire quod nescias, quam ista effutientem nauseare, atque ipsum sibi displicere !* Cic. de Natur. Deor. *l.* 1.

*L O N D O N:*

Printed by *Eliz. Holt,* for **Thomas Basset,** at the *George* in *Fleetstreet,* near St. *Dunstan's* Church. MDCXC.

The original title-page of Locke's *Essay concerning Human Understanding.* Despite bearing the date 1690, the book was actually published in 1689. The Latin quotation runs: 'How fine to be willing to admit that one does not know what one does not know, instead of spewing out such nonsense and disgusting oneself!' (Cicero, *On the Nature of the Gods*).

which was often understood as a narrative of development from the barbarism and anarchy of the early Middle Ages to the relative liberty and prosperity of modern commercial society. It helped to motivate not only the pursuit of scientific knowledge but also such practical endeavours as the improvement of farming techniques, the attempt to make punishment more humane and at the same time more effective, and the search for methods of education that would bring out pupils' individuality and equip them to understand the world around them. The textual counterpart of these endeavours was the *Encyclopédie*, the compendium of knowledge, including crafts and techniques, compiled with enormous effort and against frequent official opposition by Denis Diderot and his collaborators. And the campaigns waged by some Enlighteners against the Churches – as well as the campaigns often undertaken within the Churches by believers who wanted to reconcile the doctrines of Christianity with the demands of common sense – were intended to demolish the falsehoods that kept people in unhappy intellectual immaturity and social subjection. A dimly imagined happiness might exist beyond the grave, but the prospect could not compensate for the shortcomings of this life. If happiness was possible – and that was far from certain – Enlighteners wanted to attain it before death. To them, happiness was not, as it often is in present-day discussions, simply a subjective state, such as might be induced by chemicals; it meant attaining the preconditions for personal happiness, including domestic affection, material sufficiency and a suitable degree of freedom.[7]

Such a conviction was far from self-evident. It meant overcoming centuries of Christian teaching that represented this world as a mere vale of tears in which we had to earn the true happiness that could only be found in heaven. St Augustine, the theologian who more than any other shaped the character of medieval (and subsequent) Christianity, declared that, even for the righteous, true happiness was unattainable in our present life.[8] The medieval pope Innocent III, in his much-read treatise on the wretchedness of life, observed: 'We be all borne yelling and crying, to the end we may express our myserie'; after which things would only get worse, especially as, for most people, misery on earth was a mere prelude to much greater suffering in hell.[9] The Enlightenment was only possible once such assumptions had been discarded. Hence, we must consider it not only as a philosophical movement aiming ultimately to increase earthly happiness, but also as part of a tectonic shift in outlook, a far-reaching change in mentality.

The belief that the purpose of human life is the attainment of happiness is called 'eudaemonism'. But eudaemonism leaves open the question of what happiness is, and whether it is attainable at all. These were central

questions for the Enlightenment, both in theory and (as we shall see in Chapter 8) in practice.

## IS HAPPINESS POSSIBLE?

On the possibility of happiness, the classical and Christian traditions disagreed. Many classical philosophers, and many of their Enlightenment successors, were eudaemonists: they assumed that happiness was the final end of human life.[10] Horace's poem beginning 'Beatus ille' attributes happiness to a simple and independent farmer; in a seventeenth-century translation:

> Happy the Man whom bounteous Gods allow
> With his own hands Paternal Grounds to plough![11]

Jesus, however, presented his hearers with the paradox that to be happy you had to be poor in this life, because then you would be amply recompensed in a future life: the Vulgate, using the same word as Horace, has him say 'beati pauperes quia vestrum est regnum Dei' (Luke 6:20), tendentiously translated in the Authorized Version not as 'Happy are the poor' but as 'Blessed be ye poor: for yours is the kingdom of God.'

In the ancient world, earthly happiness was thought to be attainable, and not just for the farmers nostalgically celebrated by Horace and Virgil. It might consist in the exercise of virtue, or in sensual pleasure. The philosopher Epicurus (341–270 BCE) taught people to abandon unnecessary fears: of the gods, who had no concern with humanity, and of death, which led merely to non-existence. Freed from these fears, the individual should not expect 'supreme' felicity, but could aim for 'subalterne or graduall' felicity,

> a certain state, in which a man may be as Happy as the Frailty of his Nature will permit; or such, in which he may enjoy very much of necessary Goods, and suffer very little of Evils: and consequently, wherein He may spend his daies pleasantly, calmly, and permanently, so far forth as the Condition of his Country, Society, Course of life, Constitution, Age, and other Circumstances shall give leave.[12]

Freed from these fears, the individual could cultivate happiness, or at least minimize pain, by friendship, healthy living and moderate pleasures.

Insofar as Epicurus was known during the Middle Ages, he was thought to be an immoral sensualist. Dante placed him and his followers in the sixth circle of hell for claiming that the soul dies with the body. A better

understanding of Epicurean philosophy gradually followed the rediscovery of his follower Lucretius, whose poem *De rerum natura* (*On the Nature of the Universe*, first century BCE) was unearthed in 1418 by the humanist Poggio Bracciolini. Early modern admirers of Epicurus had to express themselves cautiously, however, since he was in bad odour as an atheist and (unjustly) for supposedly advocating sensual self-indulgence (as Ben Jonson's Sir Epicure Mammon does in *The Alchemist*).[13]

However, Enlighteners were also sharply aware of the difficulties – illness, bereavement, misfortunes of all kinds – that frustrated the individual's desire for happiness. So they seldom ventured to aspire beyond the modest and prudent ambitions formulated by Epicurus. 'Enquiries after Happiness, and Rules for attaining it,' said Joseph Addison, 'are not so necessary and useful to Mankind as the Arts of Consolation, and supporting one's self under Affliction. The utmost we can hope for in this world is Contentment; if we aim at any thing higher, we shall meet with nothing but Grief and Disappointments.'[14] David Hume advocated an even lower-key Epicureanism: 'in general, no course of life has such safety (for happiness is not to be dreamed of) as the temperate and moderate, which maintains, as far as possible, a mediocrity, and a kind of insensibility, in every thing.'[15]

Despite such caution, most Enlighteners agreed not only that happiness was desirable, but that its attainment was provided for in the scheme of things. Even some pious Christians believed that God wanted people to be happy. 'The production of Happiness seems to be the only motive that could induce infinite Goodness to exert infinite Power to create all things; for, to say truth, Happiness is the only thing of real value in existence,' opined the conservative politician Soame Jenyns in 1757.[16] Other thinkers, more remote from Christianity, ascribed the same intention to nature, as the philosopher and administrator Anne-Robert-Jacques Turgot did when addressing the Sorbonne in 1750: 'Nature has given all humanity the right to be happy: needs, passions, and a reason which is combined with these different principles in a thousand ways, are the forces she has given it to attain this goal.'[17]

Was happiness solely the concern of the individual, to be attained in isolation? One could certainly satisfy one's sensual desires, as the materialist Julien Offray de La Mettrie notoriously advocated. A much-bruited but apocryphal story had him meet an appropriate death in 1751 by keeling over at a Berlin dinner-table after gorging on truffles.[18] Or one might do the opposite: the physician George Cheyne, who ascribed depression, along with a wide range of illnesses, to over-indulgence in eating and drinking, in 1733 recommended temperance and virtue as the sure route to happiness: 'for Virtue and Happiness are literally and really Causes and

Effects'.[19] Or one might conclude, with the scientist Émilie du Châtelet, that one should satisfy one's passions so far as feasible – the most reward-ing passion being that of study. Du Châtelet also recommends avoiding gloomy thoughts and cultivating pleasant illusions; the greatest pleasures come from love, although (or because) it includes illusion.[20] Her essay on happiness makes sad reading, for it was written at some time in the late 1740s during the breakdown of her long relationship with Voltaire, and is really an analysis of her own unhappiness.[21]

Acknowledging that individual happiness was hard to attain, the Enlightenment explored the concept of 'public happiness'. The welfare, and hence the happiness, of the population could and should be the object of government. Princes therefore should not resemble Louis XIV, who had come close to beggaring France through such magnificent but exceptionally costly projects as Versailles and through expensive and destructive wars. An influential critique of such policies (published without the author's consent) was *Les Aventures de Télémaque* (*The Adventures of Telemachus*, 1699), by François de Salignac de la Mothe-Fénelon, archbishop of Cam-brai. In what was to become one of the most popular novels of the following century, the son of Ulysses learns the art of government by touring various countries around the Mediterranean. In the most famous episode, his tutor Mentor, who is the goddess Athena in disguise, undertakes to reform the kingdom of Salente, whose shortcomings recall those of France, in order to render its population happy: 'Happy are these men, without ambition, distrust or deceit, provided the gods bestow upon them a virtuous king!'[22]

A good king, whose first and all-absorbing concern was the happiness of his people, became the ideal of enlightened absolutism. There were classical models among the good Roman emperors, such as Alexander Severus, who, according to Edward Gibbon, combined wisdom with power so that 'the people, sensible of the public felicity, repaid their bene-factor with love and gratitude'.[23] Frederick the Great, king of Prussia from 1740 to 1786, said of princes that their 'only function must be to work for the happiness of mankind'.[24] Enlightened philosophers and administra-tors in the German lands shared this ideal. So the young French revolutionary Louis-Antoine de Saint-Just was mistaken when in 1794, introducing a measure that would confiscate the goods of 'enemies of the revolution' and transfer them to the poor, he boasted: 'Happiness is a new idea in Europe.'[25] On the contrary, it had long been a commonplace.

But how was public happiness related to private happiness? Christian Wolff, the most influential philosopher of the early German Enlighten-ment, affirmed that public happiness, which it was the state's duty to promote, would ensure the private happiness of every individual.[26] In the

dialogues on Freemasonry by Gotthold Ephraim Lessing, *Ernst und Falk* (1778), the speaker who is closest to being the author's mouthpiece argues the opposite way, starting from the individual and asserting that public happiness is simply the happiness of every individual: 'The happiness of the state is the total of the individual happinesses (*Glückseligkeiten*) of all its members. There is no other.'[27] The administrator Johann Heinrich Gottlob von Justi argued that the two were so closely related as to be inseparable. Happiness was always social, since it required the satisfying feeling of performing one's duty towards one's fellow-humans. By working on one's own happiness, one was also advancing that of others. 'Anyone who wishes truly to further the happiness of humanity must undoubtedly set to work to further his own happiness. So he must first have overcome his own passions.'[28]

With these ideals, it was tempting to seek a formula for happiness. Jeremy Bentham's quantitative principle, 'the greatest happiness of the greatest number', later dubbed the 'felicific calculus', has a long prehistory in the Enlightenment.[29] Its first occurrence is in 1725 in the work of the Glasgow-based philosopher Francis Hutcheson: '*that Action is best*, which accomplishes the *greatest Happiness* for the *greatest Numbers*'.[30] Hutcheson and his successors, evidently impressed by the mathematical achievements of Isaac Newton in the *Principia* (1687), often try to quantify the search for happiness in mathematical terms. Thus Hutcheson offers his readers an extremely forbidding mathematical equation, in which B stands for Benevolence, A for Ability, S for Self-love, I for Interest, and M for 'the Moment of Good':

> the entire Spring of good Actions is not always *Benevolence alone*; or of Evil, *Malice alone*; (nay, sedate Malice is rarely found) but in most Actions we must look upon *Self-love* as another Force, sometimes conspiring with *Benevolence*, and assisting it, when we are excited by Views of *private Interest*, as well as *publick Good*; and sometimes opposing *Benevolence*, when the good Action is any way *difficult* or *painful* in the Performance, or *detrimental* in its Consequences to the *Agent*. In the former Case, $M = B + S \times A = BA + SA$; and therefore $BA = M - S = M - I$, and $B = \dfrac{M - I}{A}$. In the latter Case, $M = B - S \times A = BA - SA$; therefore $BA = M + SA = M + I$ and $B = \dfrac{M + I}{A}$.[31]

François-Jean de Chastellux provided a simpler formula in *De la félicité publique* (*On Public Happiness*, 1770). Individual happiness cannot be measured, but the preconditions for happiness, that is, the *félicité publique*, can. Happiness is what remains of (a) after subtracting (b) and (c), where (a) is the amount of work a man can do without becoming

miserable, (b) is the amount of work he must do to secure basic necessities, and (c) is the amount of work demanded of him by his rulers. Happiness is secured by the relation among these three elements.[32]

At the other extreme from these enthusiastic planners, some other Enlightenment figures were thoroughly sceptical in evaluating the possibility of happiness. Pietro Verri, a leading Enlightener in Milan, argued that happiness was not something positive, but consisted only in the cessation or diminution of pain. A simple calculation shows that pain predominates in life: 'The sum total of painful sensations must in every man be greater than the sum total of pleasurable sensations.'[33] Unhappiness, according to Verri, consists in the excess of our desires over our power to fulfil them. The answer is not to suppress our desires, as a Christian ascetic would recommend, for that leads to a condition of vegetation rather than life, but rather the prudent management of our desires, for example by eliminating whatever in them is chimerical. It is not reasonable to pursue wealth, for example, without forming a clear idea of one's object and the disadvantages, such as continual worry, that attend it. Reason must be deployed not to reduce compassion and affection, but to direct them effectively, and to avoid throwing oneself away on unworthy objects of love.[34] Moreover, the progress of enlightenment and reason equip humanity better every day to recognize error, to perceive the world as it is, and thus to advance on the road to happiness (or at least to less unhappiness).[35]

Immanuel Kant, in his home city of Königsberg, which he never left, had read Verri, but was even more sceptical about the possibility of happiness. Writing on moral philosophy in the *Grundlegung zur Metaphysik der Sitten* (*Groundwork of the Metaphysics of Morals*, 1785), Kant argues that if nature had designed us principally to be happy, we would have been endowed with a sure instinct, like animals, not equipped with such an uncertain guide as reason. Happiness is a gift of fortune, like health and power, but not an unqualified good, because it can be abused. A rational and impartial onlooker would surely think that happiness was misplaced if it were enjoyed by a wicked person. The only unqualified good is the good will that recognizes and performs our moral duty towards other people. Admittedly, it is part of our duty to seek our own happiness, because if we are unhappy, worried and frustrated we will be tempted to violate the demands of morality. But our duty is more important than our happiness and may well require us to sacrifice some of our happiness for it. Duty is motivated not by the desire for happiness, but by obedience to the moral law. We have to obey the maxim that Kant calls the categorical imperative: '*I ought never to act except in such a way that I could also*

*will that my maxim should become a universal law'.*[36] The moral law constitutes 'the idea of another and far worthier purpose of one's existence, to which therefore, and not to happiness, reason is properly destined, and to which, as supreme condition, the private purpose of the human being must for the most part defer'.[37]

In saying this, Kant seems to strike a blow at the whole tradition of Enlightenment philosophy, from Leibniz on, that maintained that the exercise of reason could lead to happiness. However, Kant is not *against* happiness. He admits that we are naturally inclined to search for happiness, but he argues that nature has destined us never to find it. We will always be somewhat discontented, and that very discontent is good for us by spurring on our energies and our creativity. Just as there can be no final and perfected state of public happiness, so there can be no final and perfect individual happiness.[38]

Kant's philosophy is frequently claimed as the culmination of the Enlightenment. Often, however, as here, Kant intervenes in an Enlightenment debate in order to question its assumptions and take the argument off in a new direction. Kant's arguments lead out of the Enlightenment's comfortable harmony between God, nature and humanity and into a severe, unforgiving landscape that would later be dominated by the Victorian sense of duty. It was in this spirit that George Eliot (herself steeped in German thought), walking with F. W. H. Myers in the Fellows' Garden at Trinity College, Cambridge,

> stirred somewhat beyond her wont, and taking as her text the three words which have been used so often as the inspiring trumpet-calls of men, – the words, *God, Immortality, Duty,* – pronounced, with terrible earnestness, how inconceivable was the *first*, how unbelievable the *second*, and yet how peremptory and absolute the *third*.[39]

## FREEDOM FROM FEAR

If the Enlightenment had a collective mission, part of it was 'the slow vanquishing of fear'.[40] Early modern people had a great deal to be afraid of. Some of the evils they feared were imaginary, but many were all too real. In an age when medical treatment largely stagnated, illness was almost universal.[41] Smallpox left many permanently disfigured. Beggars, despite laws against vagrancy, displayed their disabilities in public: 'Persons of delicate fibres and a weak constitution of body', claimed Adam Smith in 1759, 'complain, that in looking on the sores and ulcers which are exposed

by beggars in the streets, they are apt to feel an itching or uneasy sensation in the correspondent part of their own bodies.'[42]

Most people's diet was poor in fruit and vegetables, so that scorbutic diseases were common. When staying in the south of France in 1764, Tobias Smollett, a doctor, found himself suffering from scurvy, which he attributed to a salty coastal atmosphere.[43] The poor in England had a monotonous diet in which bread and cheese predominated; in France, the diet of 95 per cent of the poor was cereal.[44] Poor people got little protein and were permanently undernourished. Those who could afford it ate a protein-rich, meat-heavy diet, as we see from the huge meals lovingly recorded in Parson Woodforde's diary. Such unhealthy diets promoted dropsy, gout and 'the stone', the formation of agonizing blockages in the urinary tract. For all, but especially for the poor, infancy was a particularly dangerous time. It is estimated that in England a third of children, and in France half, died before the age of five. Average life expectancy in eighteenth-century England was 37; in France before 1750, life expectancy among those who survived infancy was 40.25 years for men, and 41.2 years for women.[45]

Illness, if not fatal, had to be lived with. Operations were a form of torture that people usually preferred to avoid. Few people, remarks Pietro Verri, can stand being present when the lithotomist 'cuts open a living man to extract the stone'.[46] In 1811 Frances Burney (by then married to Alexandre d'Arblay, and living in Paris) was diagnosed with breast cancer and consented to a mastectomy. Her breast was cut open by surgeons, of course without anaesthetic (other than some wine which may have contained laudanum), and the cancerous tumour removed. Her letter to her sister, written nine months after the event, records it in unsparing detail: 'I began a scream, that lasted unintermittingly during the whole time of the incision – and I almost wonder that it rings not in my Ears still! so excruciating was the agony.'[47]

Epidemics, famine and war were less frequent than in the past, but still recurrent dangers. Bubonic plague had largely vanished; the last great outbreak in Western Europe was in Marseilles and its environs in 1720, which carried off some 120,000 victims. In 1696–7, famine killed a quarter of the population of Finland, some 100,000 people.[48] Elsewhere, though famines became rare, bad harvests awakened cultural memories of near-starvation. In 1774, a disastrous harvest, combined with the deregulation of the grain trade, provoked the widespread riots known as the 'Flour War' in France; further harvest failures in the 1780s led to murderous attacks on grain stores.[49] Tuscany and some other parts of Italy experienced a famine in 1764–5 that deeply shocked contemporaries.

War was a normal implement of political policy and often decided succession disputes, notably the Wars of the Spanish Succession (1701–14) and the Austrian Succession (1740–48). Armies marched through farmland, destroying crops, and in occupied areas soldiers routinely burned, killed, raped and plundered, reducing the surviving population to beggary.[50] Such devastation might be the work of undisciplined soldiers, especially the 'light troops', such as Russian Cossacks and Austrian Croats, that accompanied regular armies and were especially feared for their love of torturing and mutilating their captives. It was also sometimes practised as a deliberate policy of terror, as when French troops destroyed all the towns in the Rhenish Palatinate in 1689, or when British and Austrian troops ravaged Bavaria in 1704.

Enlightenment historians pointed out that modern warfare was, nevertheless, far less savage than in the ancient world, where people fought desperately to avoid massacre or enslavement. In a sermon of 1755, the eminent cleric and historian William Robertson noted 'the little ferocity and bloodshed which accompany modern victories', ascribing it to the spirit of Christianity.[51] Certainly some attempts were made to limit attacks on civilians, as during the duke of Marlborough's campaign in the Netherlands in 1705–11. Some wars did approach the model of the 'cabinet war', fought on limited territory by disciplined troops who were supplied by commissariat organizations instead of living off the land. Even so, the lives and property of civilians were readily sacrificed to the necessities of war. Hume asks rhetorically: 'What governor of a town makes any scruple of burning the suburbs, when they facilitate the approaches of the enemy? Or what general abstains from plundering a neutral country, when the necessities of war require it, and he cannot otherwise subsist his army?'[52]

For civilians in wartime, the fall from prosperity to misery could be almost instantaneous. During the Great Northern War (1700–1721), Swedish forces, in revenge for earlier devastation, approached the Danish-owned town of Altona on the night of 9 January 1713, ordered the inhabitants to leave the town immediately, and burned it to ashes. The refugees, having reached the gates of nearby Hamburg, were denied admittance because its citizens were afraid of infectious diseases, so most of the homeless died in front of the walls of Hamburg.[53] And people's terror was sustained not only by war, but also by rumours of war. In a largely illiterate society, news was transmitted by rumour, with the inevitable exaggeration and deficient sense of what was probable.[54]

Even normal life became frightening as soon as the sun set. In contrast to the light pollution that nowadays lightens the darkness around every town or village, moonless or overcast nights were truly dark. Admittedly,

human beings have reasonably good night vision, and lanterns and torches were often available to help nocturnal travellers.[55] Nevertheless, night-time provoked both superstitious fear of spirits and realistic fear of lurking criminals.

There was not much that Enlighteners could do about these evils, though, as we shall see in Chapter 8, enlightened administrators tried hard to make everyday life more secure. Adam Smith argued that people had the best chance of happiness in a commercial society. Not only did free economic activity lead eventually to the diffusion of prosperity across the population, but it required order and security provided by the government:

> Commerce and manufactures can seldom flourish long in any state which does not enjoy a regular administration of justice, in which the people do not feel themselves secure in the possession of their property, in which the faith of contracts is not supported by law, and in which the authority of the state is not supposed to be regularly employed in enforcing the payment of debts from all those who are able to pay. Commerce and manufactures, in short, can seldom flourish in any state in which there is not a certain degree of confidence in the justice of government.[56]

In the meantime, Enlighteners tried to free people from the additional burden of imaginary terrors. Chief among these were the terrors of religion. The poet Louis Racine, a Jansenist, believing in Original Sin and predestination like his father the dramatist, imagined Paradise as a hierarchy of fear:

> L'ordre régnoit alors, tout était dans son lieu:
> L'animal craignoit l'homme, et l'homme craignoit Dieu.[57]

[At that time order reigned, everything was in its proper place: animals were afraid of man, and man was afraid of God.]

Exactly, retorted the Enlightenment: religion was about fear. '[I]t must be acknowledg'd,' says a persuasive speaker in Hume's *Dialogues Concerning Natural Religion*, 'that, as Terror is the primary Principle of Religion, it is the Passion, which always predominates in it, and admits but of short intervals of Pleasure.'[58] A God who inspired fear rather than love could hardly be the perfectly good being that Christianity claimed. '[T]o fear God any otherwise than as a consequence of some justly blameable and imputable act is to fear a devilish nature, not a divine one', argued the diplomat and philosopher Lord Shaftesbury in 1699.[59]

Enlighteners targeted also the everyday anxieties induced by superstition. An early issue of the *Spectator* in 1711 deplores the fears aroused by

spilling salt or laying one's knife and fork across each other. 'As if the natural Calamities of Life were not sufficient for it, we turn the most indifferent Circumstances into Misfortunes, and suffer as much from trifling Accidents, as from real Evils . . . A Screech-Owl at Midnight has alarm'd a family, more than a Band of Robbers.'[60] These campaigns gradually achieved so much success that Samuel Johnson could write in 1770:

> One of the chief advantages derived by the present generation from the improvement and diffusion of philosophy, is deliverance from unnecessary terrours, and exemption from false alarms. The unusual appearances, whether regular or accidental, which once spread consternation over ages of ignorance, are now the recreations of inquisitive security. The sun is no more lamented when it is eclipsed, than when it sets; and meteors play their coruscations without prognostick or prediction.[61]

Thunder and lightning were particularly alarming. Readers of the Bible remembered that God had spoken to Moses in thunder on Mount Sinai. When, in 1505, the young Martin Luther was caught in a thunderstorm in the open air, he vowed to become a monk, and kept his vow despite his father's disapproval.[62] In 1641 the fourteen-year-old Robert Boyle was terrified by a thunderstorm in Switzerland, first into thinking that the world was about to end, then into resolving to lead a fully Christian life.[63] Even without fearing divine wrath, people were generally afraid of thunder: when Jean-François Marmontel stayed with his lover Marie de Navarre at her country house around 1745, she so much feared thunder that on a stormy day she would have her meals in the wine-cellar, amid fifty thousand bottles of champagne.[64] Later in the century, however, the devout came to regard thunder with awe rather than terror, while for others thunder became a source of the aesthetic thrill labelled 'sublime'.[65]

Lightning strikes were interpreted as signs of God's wrath, even though they tended especially to hit church spires. When St Michael's Church in Hamburg was struck by lightning in 1750, an extraordinary day of fasting and prayer was ordained for the entire city. A great symbolic moment for the Enlightenment, and for its project of freeing humanity from needless terrors, occurred in 1752 in Philadelphia. During a thunderstorm, Benjamin Franklin flew a kite with a pointed wire at the end and succeeded in drawing electric sparks from a cloud. He thus proved that lightning was an electrical phenomenon and made possible the invention of the lightning-rod, which, mounted on a high building, diverted the lightning and drew it harmlessly to the ground by means of a wire. Humanity no longer needed to fear fire from heaven. In 1690 the conservative-minded diplomat Sir William Temple could still call thunder and lightning 'that great

Artillery of God Almighty'.[66] Now, instead of signs of divine anger, they were natural phenomena that could be mastered. When another Hamburg church spire was struck by lightning in 1767, a local scientist, J. A. H. Reimarus, who had studied in London and Edinburgh, explained its natural causes in a paper read to the Hamburg Patriotic Society, and advocated lightning-rods as protection.[67] Kant, whose early publications were on natural science, called Franklin 'the Prometheus of modern times', recalling the mythical giant who defied the Greek gods by stealing fire from heaven and giving it to the human race.[68]

Gradually a change of outlook was occurring. Extraordinary events need not be signs from God; they might just be natural phenomena, which could be understood and brought under some measure of human control.

## THE WITCH CRAZE AND ITS END

The Enlightenment was not only a conscious undertaking by philosophers to improve the quality of human life. It was also part of an enormous change in mentality: an uneven but decisive transformation of people's understanding of the world and of their basic assumptions. This can be illustrated by examining the most dramatic manifestation of fear in pre-Enlightenment Europe: the great witch craze that, beginning in the late Middle Ages, raged with renewed fury from about 1560 to the mid- to late seventeenth century, and claimed some fifty thousand victims. This phenomenon fascinates and puzzles historians, who still dispute how it began and why it ended.[69]

Nothing could more illustrate the dominion of fear over pre-Enlightenment minds than the witch craze, and nothing could be more antithetical to the Enlightenment. We cannot, however, give the Enlightenment credit for defeating witch-beliefs, for by the late seventeenth century, when the Enlightenment was just gathering pace, the belief in witchcraft was already in steep decline. The nineteenth-century Irish historian and rationalist William Lecky pointed out that the growth of scepticism about witchcraft 'was mainly silent, unargumentative, and insensible; that men came gradually to disbelieve in witchcraft, because they came gradually to look on it as absurd'.[70] The Enlightenment did not cause the diminution of witch-beliefs; rather, that diminution was among the preconditions which enabled the Enlightenment to emerge.

The conviction that some humans can injure or destroy people, livestock and crops by spells, the evil eye or the assistance of supernatural beings is found in most cultures and was endemic in European popular belief. Fear

of witchcraft reached a new and extraordinary intensity in the early modern period. Witchcraft persecutions were sometimes initiated by people who attributed their misfortunes to malevolent neighbours, sometimes by zealous rulers or magistrates. Lawyers investigating such charges thought they were beginning to uncover a huge network of evildoers directed by the Devil himself. Confessions extracted by torture revealed that the witches' activities were a parody of Christian ritual.[71] They were magically transported – monthly, weekly, or several times a week – to large gatherings called sabbats, where they celebrated a Black Mass, worshipped the Devil, kissed his anus, feasted at his expense, and copulated with him. The sabbat was central to the investigation, because the accused, under pressure to reveal who else had attended, came up with names of neighbours who were, in turn, arrested and interrogated, thereby proving to the inquisitors the horrifying extent of the witch conspiracy.[72] As for the mental state of the accused, deranged by arrest, confinement, crippling tortures and sleep deprivation (the *tormentum insomniae*), there are twentieth-century analogies in the victims of Stalin's purges, who, under similar pressure, came out with whatever nonsense their interrogators wanted to hear.[73] In both cases, the absurd testimonies are attributable not only to torture and mental derangement, but to a kind of complicity: victims persuade themselves that they actually are guilty, and confess to whatever their interrogators want in order to attain a kind of purification.[74]

Historians have wondered why learned inquisitors were so keen not just to accept, but to elaborate hugely, the fantasies of the uneducated. Part of the puzzle is that over the preceding centuries educated elites had become more, not less, willing to believe in witchcraft. In the so-called Dark Ages, many claims about witchcraft were treated officially with scepticism. In the later Middle Ages, however, the Church exerted its authority against heretics, declaring them to be in league with the Devil.[75] The image of the heretic became conflated with that of the witch. Anxiety about witches was increased by the religious divisions that split Christendom soon afterwards. All sides in the Reformation found convenient scapegoats in witches and Jews.

The myth of the witches' sabbat was a new element. It is now agreed to be a construction by the inquisitors, incorporating bits of popular superstition and enlarged into a coherent fantasy by the inversion of Christian imagery. More than a popular belief, it was a delusion of the learned. The demonologists, who produced shelves of erudite treatises around 1600, have been claimed as the leading intellectuals of their day, and even as reputable scientists.[76] Armed with an unfalsifiable theory, the licence to confirm it by torture, and a conviction that they were Christendom's

last defence against the power of Satan, these intellectuals had, in reality, the destructive effect that their fantasy ascribed to witches.

The demonologists were responding to an extraordinary situation, though not the one they imagined. From about 1560 onwards, Europe was in the grip not of Satan and his minions, but of the Little Ice Age.[77] Wet springs, cold summers, frequent hailstorms, crop failure and food shortages became the norm. Glaciers advanced down Alpine valleys. Lake Constance froze over in 1563 and again in 1672–3. Baffled and terrified by what they saw as unnatural weather, people sought an explanation and a scapegoat in the supposed maleficent practices of witches. It has been shown that phases of particularly bad weather coincided with collective panics leading to persecutions.[78] Thus the first great witch-hunt in south-western Germany, in the town of Wiesensteig, began when the local ruler had some women arrested on suspicion of causing a violent hailstorm, which severely damaged crops, in August 1562. By December, sixty-one supposed witches had been executed.[79] Such extensive destruction, it was thought, could not be the work of a single person but pointed to a conspiracy, which must be uncovered by whatever means.

Eventually the witch craze petered out. The last major episode in Europe was the Swedish persecution of 1668–75, though the Salem witch-trials in remote New England followed in 1692. Isolated cases continued. The last person sentenced to death for witchcraft in England was Jane Wenham in 1712: she was found guilty by a jury, despite the scepticism of the judge, but reprieved after a neighbour appealed to Queen Anne.[80] A decade later, an insane old woman from the parish of Loth, in the extreme north of Scotland, was burned at the stake for bewitching pigs and poultry; she was further accused of transforming her daughter into a pony, having her shod by the Devil, and riding about on her.[81] In the German-speaking world, well over a hundred people were executed for alleged witchcraft during the eighteenth century. The last, at Glarus in Switzerland in 1782, was Anna Göldi, a domestic servant who was accused of causing her employer's eight-year-old daughter to vomit pins. Her employer, a town councillor, who led the prosecution, was rumoured to have been sexually involved with her. The author of the only contemporary account of the case seems aware of the anachronistic and implausible nature of the charge. Writing in a defensive tone, he professes an enlightened scepticism about witchcraft but claims that his scepticism was overcome by the irrefutable empirical evidence (an enlightened criterion of knowledge) presented at the trial.[82] One suspects that this was an officially commissioned apologia for Göldi's torture and execution.

When witchcraft accusations were no longer taken seriously by the legal authorities, the people often took the law into their own hands. In 1751,

at Tring in Hertfordshire, an old couple, reduced to beggary, were seized by the mob and thrown into a horse-pond, where the woman drowned.[83] Similar cases are recorded from nineteenth-century France. In 1839, in Valensole (Basses-Alpes, now Alpes-de-Haute-Provence), a farmer killed an elderly woman who he thought had caused the death of numerous sheep and pigs; the neighbours agreed with his suspicions of her.[84]

The riddle for historians is how and why educated elites ceased to believe in witchcraft. For example: in 1652 a woman was condemned and burned in Geneva for witchcraft. Less than forty years later, a judge examining her trial records had not the slightest doubt 'that her whole crime was to be very credulous and extraordinarily timid'.[85] There was a two-stage process. In the first stage, the educated stopped supporting witch-trials, while still admitting the possibility of witchcraft. In the second, even the possibility of witchcraft came to seem ridiculous.

The first stage is relatively easy to explain. One could admit that witchcraft was possible and yet doubt whether it was remotely as common as the inquisitors maintained. The Bible said: 'Thou shalt not suffer a witch to live' (Exod. 22:18), so there must be witches, but perhaps not many.[86] The mass executions and the accompanying terror and social disruption could only be justified by cast-iron proofs, whereas the inquisitors relied on fantastic stories obtained by torture. The decline in witch-belief accompanied an increased concern to examine evidence scrupulously as a means of establishing truth.[87] Admittedly, the demonologists claimed to have empirical evidence in the confessions of suspects; the uniformity of these confessions seemed to confirm that witchcraft was widespread, though really it only demonstrated the imaginative poverty of the obsessed inquisitors. But for those not obsessed, it was not good enough to condemn someone to death for her answers to leading questions given in unbearable pain, nor for the alleged discovery on her body of extra teats at which she suckled her familiars. The Jesuit Friedrich Spee argued in *Cautio criminalis* (*Precautions for Prosecutors*, 1631) that torture was not only cruel but also counterproductive: there might be some real witches, but innumerable innocent people were convicted too, especially as the inquisitors thought that those who obstinately refused to confess under torture were just as guilty as those who confessed. The jurist Christian Thomasius, who enjoyed defying convention both in philosophy and in academic dress, thought that Spee, though too prudent to say so openly, had effectively undermined belief in witchcraft.[88] Thomasius himself argued in *De crimine magiae* (*On the Crime of Magic*, 1701) that the Devil, though real, had no material existence, and therefore pacts and orgies with the Devil were impossible, a mere amalgam of pagan and popish fantasies.

Why was it, he wondered, that people were eager to believe fantastic tales about the Devil, yet would dismiss as an 'enthusiast' anyone who ascribed material events to good angels?[89] 'What judge, I ask, would be so absurd and stupid as to lend credence to a thousand old women if they claimed to have been in heaven, danced with St Peter, or slept with his hound?'[90]

The courts eventually heeded these doubts. 'Evidence' that had convinced the witch-finder Matthew Hopkins in the 1640s no longer satisfied English judges and juries later in the century.[91] In Germany at the same period, accusations of witchcraft were commonly dismissed as unfounded slander, and were even made a punishable crime.[92] In France, an edict of 1682 forbade prosecutions for witchcraft; anyone who tried to practise black magic could still be tried, but for obscenity or sacrilege.[93] Witchcraft played only a marginal role in the 'affair of the poisons', a panic concerning a supposed conspiracy against the life of Louis XIV. Although between 1675 and 1682 no fewer than 218 people were arrested and 36 executed for involvement in this conspiracy, only 2 were accused of witchcraft.[94] Yet when the witch craze was at its height, demonologists had claimed that witches, being enemies of God, must be particularly hostile to kings, as the Lord's Anointed; hence James VI of Scotland, himself a learned demonologist, thought that the storms that assailed his ship as he was returning to Scotland from Denmark with his bride in 1590 must have been raised by witches, and witch-trials were held in Edinburgh and Copenhagen.[95] Times had changed: the records of Scottish kirk sessions and criminal courts reveal that 'throughout the initial decades of the eighteenth century, the courts heard more cases of bestiality than they did of witchcraft'.[96]

How are we to explain the second stage – the increasing reluctance of educated people to believe in witchcraft, and, indeed, in the magical universe in which witches had a place?[97] Historians used to point to the rise of the 'new philosophy'.[98] In René Descartes' model of the universe, initially adopted in England by the Royal Society, all physical processes, albeit under God's management, could be explained as matter in motion, with no magical or occult forces. Nowadays such an explanation for the decline of witchcraft belief is doubted as being too 'intellectualist'.[99] There is certainly no simple relationship between the rise of science and the decline of magic. At the very least, it must have taken a long time for modern philosophy to be absorbed to any significant degree by a wider educated public. Moreover, the Royal Society as a body paid scarcely any attention to witchcraft or other alleged supernatural phenomena, implying thereby that such matters were unworthy of serious attention.[100]

Those who reject the 'intellectualist' conception routinely note that one could be committed to the new scientific methods and still believe in

witchcraft. The example usually given is that of Joseph Glanvill, a Fellow of the Royal Society, who firmly believed in witchcraft and thought it should be subjected to empirical investigation – not to disprove it, but to find out how it worked.[101] Glanvill, however, is not an ideal witness for the coexistence of scientific and witchcraft beliefs. In his posthumously published treatise *Saducismus Triumphatus* (1681), in which he denounces sceptics by associating them with the Sadducees of the New Testament who denied the immortality of the soul, he shows himself decidedly credulous. His arguments for the reality of witchcraft boil down to three: 1) we know so little about the supernatural that anything is possible, including the transformation of witches, with the Devil's help, into cats and hares; 2) the testimony for witchcraft is so strong that it cannot be doubted; 3) disbelief in witches implies disbelief in God.[102] Moreover, Glanvill presents these arguments as answers to frequently asked questions. His interlocutors object, for example, that the actions ascribed to witches are '*ridiculous* and *impossible* in the nature of things', and must be 'but an *illusion* of *crasie imagination*'.[103] Glanvill denounces such sceptics as 'a sort of *Infidels*, though they are not ordinary among the *meer vulgar*, yet are they numerous in a little higher rank of *understandings*'.[104] He gives the impression of trying to hold back a rising tide of scepticism, and of being unable to afford the slightest concession to the 'Infidels' whose conception of 'the nature of things' differs so markedly from his.

Scepticism may in fact have been much commoner than the written evidence suggests. In the late sixteenth century, Michel de Montaigne, arguing that one should be cautious about all testimony, says: 'how much more natural that our mind should be enraptured from its setting by the whirlwind of our own deranged spirit than that, by a spirit from beyond, one of us humans, in flesh and blood, should be sent flying on a broomstick up the flue of his chimney'.[105] His English contemporary Reginald Scot, in a comprehensive demolition of witchcraft beliefs, maintains that so-called witches are either victims of injustice, or else confidence tricksters. Scot is particularly instructive when criticizing the lax standards of evidence required in witch-trials and the psychological tricks and physical tortures used by interrogators (gruesomely reminiscent of modern secret-police methods), which he sums up as 'parciall and horrible dealings, being so apparentlie impious, and full of tyrannie'.[106]

In mid-seventeenth-century England, and even later, it was imprudent to declare openly one's scepticism about witchcraft and magic. One risked being associated with the dangerous radical Thomas Hobbes, who in *Leviathan* (1651) put forward a materialism that explicitly denied the reality of supernatural phenomena, or with the freethinkers who

challenged magical beliefs in the early eighteenth century.[107] Arthur Wilson, a spectator at the trial of twenty-five witches at Chelmsford in 1646, 'could find nothing in the Evidence that did sway me to thinke them other then poore, mallenchollie Envious, mischievous, ill disposed, ill dieted, atrabilious Constitutions' with over-active 'fancies working by grosse fumes & vapors', but he wisely kept his diagnosis to himself.[108] Besides, it was intellectually over-bold to assert flatly that *all* such phenomena were illusory. Hence Robert Boyle, one of the leading figures of the Scientific Revolution, affirmed in his correspondence with Glanvill that a few accusations of witchcraft might be true, and also took an open-minded interest in evidence for alchemy and for the 'second sight' recorded in the Highlands.[109] As late as 1711, Addison says cautiously: 'I believe in general that there is, and has been such a thing as Witchcraft; but at the same time can give no Credit to any Particular Instance of it.' In the same essay he warns readers of the *Spectator* against the absurdity and inhumanity of imputing witchcraft to harmless old women such as his fictional figure Moll White.[110] In his *Political History of the Devil* (1726), written in an ironic tone that implies scepticism without declaring it, Defoe ridicules the idea that witches can command the Devil by spells, and that their crimes can be exposed by throwing them into a pond. He says these beliefs are 'too simple to be believ'd, [yet] so universally receiv'd for Truth, that there is no resisting them without being thought atheistical'.[111]

The definitive treatise against witchcraft, published by Francis Hutchinson in 1718, shares Addison's caution.[112] Hutchinson concedes the reality of spirits, on the grounds that it would be 'Irrational to imagine, that we poor Worms of the Earth should be the Head of the Creation'.[113] But he points out that the Bible's testimony to good and evil spirits bears no resemblance to the tales told about dealings between witches and the Devil, and maintains that such stories 'if not altogether, yet for the greatest Part, . . . are made by the Imaginations of Men'.[114] The disordered imaginations are those not only of the victims, but also of the persecutors. Hutchinson is scathing about the judicial methods of inquisitors and the confused evidence of their victims: 'The gross Part of our Stories of the Devil, are grounded upon the Confessions of Brainsick People, after Superstition or ill Usage had made them Mad.'[115] Thus he identifies much witchcraft testimony as the product of the superstition of inquisitors, who torture victims into madness and thus obtain whatever confessions they want.

The accumulated evidence may suggest not that people *became* sceptical about witchcraft, but that an already widespread, though inadmissible, scepticism could eventually be uttered. Caveats like Addison's, admitting the possibility of witchcraft, do not imply any firm or ardent belief, but are

merely a formal acknowledgement. Even during the great persecutions, how many people really credited the fantasies of the inquisitors? There may have been many people like Arthur Wilson who did not even commit their scepticism to paper. Similarly, in 1930s Russia, how many really believed that the Old Bolsheviks were directing a vast conspiracy against Stalin?

## REASON

The Enlightenment criticized both popular belief and religious and political authority by means of reason. The familiar term 'the age of reason', implying that humanity can henceforth be guided by reason instead of blind faith, goes back to the Enlightenment itself. Turgot in 1750 called the preceding hundred years 'the century of reason' because of its scientific achievements.[116] Thomas Paine in 1794 gave the title *The Age of Reason* to his unsparing critique of theology.

The meanings attached to 'reason', however, were diverse. Support for the primacy of reason was often found in the ancient philosophy of Stoicism. The Stoics flourished in Athens from about the third century BCE, and versions of their philosophy were transmitted to posterity by the Latin writers Cicero and Seneca. According to Stoicism, man's reason enabled him to lead a virtuous life by discerning the rational order of the universe. All events happened by necessity and must be accepted without complaint. One cannot control external events, but one can control one's own emotions, and one should discipline them or even suppress them by cultivating *apatheia* or insensibility.

This philosophy had a particular appeal during an era of rebellions and wars, when disruption was exacerbated (as we have seen) by the Little Ice Age. It also suited the age of absolute government. It suggested that the ideal prince should be rational, like the divine power whose earthly representative he was, and should demand strict obedience from his subjects. It provided a positive ethos for a public servant by emphasizing steadfastness, self-control and rigorous performance of duty.[117] This was the message of *De constantia* (*On Steadfastness*, 1584), the best-selling treatise by the Dutch philosopher Justus Lipsius. Lipsius did his best to create a Christian Stoicism, interpreting the recognition of divine power as submission to God's providence. Emotion is not to be suppressed altogether, but firmly subordinated to reason, which inculcates the great virtue of steadfastness: 'being regulated by the rule of right Reason is the very root whereupon is settled the high and mighty body of that fair oak Constancy'.[118] The steadfast man will show mercy to others, but will not waste

time on pity, either for himself or them. Here the difficulty of joining Christianity and Stoicism is already apparent.

Stoicism, says the historian Ernst Cassirer, with its demand that reason should overcome emotion, 'not only dominates the philosophy of the seventeenth century, but it permeates the intellectual life of the age in general'.[119] It is prominent in seventeenth-century drama. Shakespeare's Horatio, a man who is 'not passion's slave' and 'more an antique Roman than a Dane', is a successful Stoic. Julius Caesar, Othello and Coriolanus are unsuccessful ones. George Chapman's Bussy D'Ambois dies a Stoic death: 'The equall thought I beare of life and death / Shall make me faint on no side; I am up. / Here, like a Roman statue, I will stand / Till death hath made me marble.'[120] Plays featuring martyrs, such as Pierre Corneille's *Polyeucte* (1642) and Daniel Casper von Lohenstein's *Epicharis* (1665), invite us not to pity the martyr but to admire his or her fortitude. However, literature puts philosophies to a practical test by asking how they play out in real life. Shakespeare's Coriolanus, having resolved not to 'obey instinct, but stand / As if a man were author of himself / And knew no other kin', collapses in tears when confronted by his mother.[121] Even successful Stoic heroes often show an off-putting theatricality. Instead of quietly being stoical by themselves, they insist on displaying their fortitude to an audience.[122]

As Shakespeare's heroes show, Stoicism was a difficult philosophy to live by. It was vigorously opposed by Christian thinkers who took their stand on Augustine's doctrine of Original Sin. Since Adam's fall, man could not be master of himself. He was a weak and sinful creature whose will was constantly assailed and usually defeated by his passions. Not his own feeble efforts, but only divine grace, could lead him to virtue and ultimate salvation.[123] Even without the aid of theology, it was repeatedly pointed out during the eighteenth century that Stoicism was false to the facts of experience. Samuel Johnson in *Rasselas* (1759) presents a philosopher whose principles of fortitude are overturned by grief at the death of his daughter.[124] Henry Fielding introduces into *Tom Jones* (1749) a Stoic philosopher called Square, who is always talking about the eternal fitness of things and the insignificance of pain: 'In pronouncing these [sentiments] he was one Day so eager, that he unfortunately bit his Tongue; and in such a Manner, that it not only put an End to his Discourse, but created much Emotion in him, and caused him to mutter an Oath or two.'[125]

Neo-Stoic thought was developed by the Dutch-Jewish philosopher Baruch Spinoza, who, because of his supposed atheism, was excommunicated in 1656 by the Jewish community of Amsterdam and forbidden by the Dutch authorities to publish his works. In Spinoza's philosophy, freedom

from the bondage of the emotions can only be attained by reason. Reason admits us to the knowledge of God, which Spinoza also describes as the intellectual love of God. We already exist within God, for God is immanent in Nature, that is, in the universe. The universe, being divine, is therefore perfect, and our task is to align ourselves with that perfection, not by suppressing our emotions as the Stoics advocated, but by bringing them under proper control. 'In life,' writes Spinoza, 'it is especially useful to perfect, as far as we can, our intellect, or reason. In this one thing consists man's highest happiness, or blessedness. Indeed blessedness is nothing but that satisfaction of mind which stems from the intuitive knowledge of God.'[126] This attractive philosophy won Spinoza many admirers, especially when people knew of his difficult life: having been expelled from Amsterdam's Jewish community he lived alone, earned his living by polishing lenses, and devoted himself to philosophy and (as we shall see in a later chapter) to highly original studies of the Bible. He was often seen as a saintly figure in his dedication to thought unruffled by passions.[127]

How much influence Spinoza's practice of reason had on the Enlightenment is disputed. His equation of God with nature, commonly misinterpreted as pantheism, was sometimes mocked. In his *Historical and Critical Dictionary* (1696), Pierre Bayle condemns Spinoza's identification of God with nature as atheism and assails it with a whole series of arguments. For example: if God is everything, he must have mutually contradictory qualities at the same time, and perform logical impossibilities. One should not say 'the Germans have killed ten thousand Turks' but 'God modified into Germans has killed God modified into ten thousand Turks'.[128] Many others understood Spinoza as a materialist who anticipated the radical view of such French Enlighteners as Baron d'Holbach and La Mettrie, that the world was a system of mechanical necessity. Yet that would be incompatible with Spinoza's claim that we are free to use our reason and divert our energies from worldly passions to the love of God.[129] Much of Spinoza's alleged influence therefore rests on misunderstandings of his work. Attempts to trace his impact often, in fact, focus on 'Spinozism', a loose complex of ideas including atheism, materialism and monism, which, when Spinoza's work was known more by reputation than at first hand, was readily foisted onto Spinoza himself.[130]

Reason was accorded similar primacy in the intellectual method to which Descartes, and other pre-Enlightenment philosophers of the seventeenth century, were committed. They hoped to attain knowledge of the world that was absolutely certain. Their model was the logical certainty provided by mathematics. Knowledge should start from a principle that was known intuitively and was beyond doubt. From that principle, a chain

of rigorous arguments should be constructed, as in geometry. Each proposition could be deduced from the one before it, demonstrated to be true, and give rise to another proposition which could be demonstrated in its turn. Thus the certainty of the initial principle would be transmitted all the way down the chain of reasoning and result in a system of knowledge that was free from doubt. Even when mathematical certainty was unobtainable, as in the study of nature, the precision of mathematics might supply a model of clarity. The tireless popularizer of natural science Bernard le Bovier de Fontenelle explained in 1709 how the spirit of geometry can be applied to many other subjects: 'A work on ethics, politics, criticism, or even eloquence, other things being equal, is merely so much more beautiful and perfect if it is written in the geometric spirit.'[131]

In early modern politics, too, reason was assigned a special role. Political thinkers developed the concept of rational calculation known as reason of state (*Staatsräson, Staatskunst, raison d'état, ragione di stato*). This concept is particularly associated with Machiavelli, although he does not use the term. Like the later 'reason of state' theorists, Machiavelli is concerned first and foremost with the effectiveness of politics. In *The Prince* (1532), he advises on how a prince may best gain and secure power; in the *Discourses* (1531), he discusses how a republic may best flourish. Moral considerations are ignored. The question whether it is better for a prince to be loved or feared by his subjects, for example, is treated as a purely pragmatic one.[132] Later in the sixteenth century, however, the methods that Machiavelli recommended to his Prince came to be described as the principles of government suitable for absolutism. The expedients that Machiavelli had recommended for an unstable situation were now adopted as the inevitable art and craft of government. The term 'reason of state' came into common use, denoting a conception of government as a self-contained and autonomous technique, an art of management, which could be studied and perfected.[133]

The idea was most influentially formulated by the Catholic priest and diplomat Giovanni Botero in his treatise *Della ragion di stato* (*On Reason of State*, 1589).[134] Botero describes a prince's virtues as justice, liberality, valour and prudence. Under the heading of prudence he gives a series of maxims that sound pragmatic and Machiavellian. The first is: 'Let it be taken for a settled matter that in the deliberations of princes interest overcomes every other consideration, and so the prince ought not to trust any friendship nor relationship nor alliance nor any other bond with negotiating partners that is not based on interest.'[135] He advises the prince on how to preserve his reputation: thus, if the prince is weak, he must take care to hide his weakness. Dealing with heretics and infidels, the prince

should be absolutely ruthless. The worst heretics are, in Botero's view, the Calvinists – he was writing when the Netherlands were in rebellion against Spain. By infidels he means the Ottoman Empire. He thinks the means used by heretics and infidels ought, when effective, to be adopted and used against them. For example, one should stir up factions and dissensions in enemy countries; Botero says: 'the pretended queen of England used this method – which we [i.e. his fellow-Catholics] should use with enemies of the faith – with the Catholic King in Flanders and with the Most Christian King in France'.[136] Here, as in the many subsequent writers on reason of state, the ends justify the means. Its advocates insisted that rational calculation, far from being immoral, was itself a moral action in order to secure the well-being of the state. Rather than mere deceit, the statecraft of a politic king consisted in astute political judgement, in knowing how to adjust his behaviour to circumstances.[137]

Thinkers of the Enlightenment, however, rejected such principles. David Hume suggests that one should not equate all politics with 'reason of state'. Thus the earl of Bristol, negotiating between James I and Philip III of Spain over the marriage between James's heir and the Spanish infanta, may have relied on humane as well as strictly political considerations:

> Perhaps, too, like a wise man, he considered that reasons of state, which are supposed solely to influence the councils of monarchs, are not always the motives which there predominate; that the milder views of gratitude, honour, friendship, generosity, are frequently able, through princes as well as private persons, to counterbalance these selfish considerations.[138]

Gibbon gives a disapproving account of the Roman emperor Septimius Severus, whose deceitful acts 'cannot be justified by the most ample privileges of state reason'.[139] Kant is most forthright in rejecting 'the serpentine coils of an immoral doctrine of prudence'.[140] He distinguishes sharply between the political moralist, who relies solely on experience and never rises to the level of principle, and the moral politician, who is aware not only of what people do now but of what they may do in the future when their potential is more fully realized. While the short-sighted political moralist decides on his purpose and then finds the most effective means, the moral politician will choose his means in the light of the principle 'do as you would be done by' or the categorical imperative, here formulated as: 'Act in such a way that you can wish your maxim to become a universal law (irrespective of what the end in view may be).'[141] Here as elsewhere, Enlightenment reason was not a matter of unfeeling, amoral means–ends calculation; that was appropriate, rather, to the age of rationalism and absolutism from which the Enlightenment had moved on.

Around the turn of the seventeenth and eighteenth centuries, philosophy made a sharp change of direction, which is fundamental to the Enlightenment. Rationalism began giving way to empiricism; the authority of Descartes yielded, though slowly and unevenly, to that of John Locke. Locke's *Essay concerning Human Understanding* (1689) was the authoritative statement of empiricism. Locke compared the infant's mind to a *tabula rasa*, a blank slate, or 'white paper', and argued that all ideas came from experience.[142] The mind perceives, not external objects directly, but ideas proceeding from those objects, which depend on the mind for their existence. Ideas may be simple or complex. They may concern primary or secondary qualities. Primary qualities, such as size, actually exist in external objects; secondary qualities, such as smell, texture, or colour, result from the relations between the object and the observer's sensory apparatus. This distinction saved Locke from the suspicion of scepticism or idealism. In his philosophy there really is an external world, even though we cannot know it directly. Reason enables us to distinguish true from false perceptions.

Locke's empiricism had major consequences for the study of the world around us.[143] Aristotle had maintained that scientific investigation aimed at knowledge of the essential natures of things, and that such knowledge must be necessarily true. Descartes agreed, maintaining that our clear and distinct ideas about the world must be true because they are guaranteed by a benevolent God who would not deceive us. For Locke, however, knowledge comes only from experience, and our experience can never disclose to us the inner essences of things. We can know only the surface of the world, not its hidden depths. And what we know is not even the phenomena of the world, but the ideas which these phenomena produce in our minds; and not even the ideas, but the relations among these ideas. 'Knowledge then seems to me to be nothing but the perception of the connexion and agreement, or disagreement and repugnancy of any of our ideas.'[144] While it would be absurd to doubt the reality of the external world, it would be mistaken to claim that we can have any certain knowledge of it. The study of the external world can never claim certainty, only a degree (often a very high degree) of probability.

Thus empiricism directed attention away from abstract principles to the data of experience. Hence, while the philosophers of the pre-Enlightenment period favoured the geometric method, reasoning deductively from first principles, their successors worked by induction, first observing particular details and arriving eventually at general truths. In the mid-eighteenth century, the Enlightener Jean Le Rond d'Alembert called the former method the *esprit de système*, implying the love of system for its own sake; in its place he aimed to substitute an *esprit*

*systématique*, which is controlled by experience. The *esprit de système* favours closed, rigid systems, whereas the *esprit systématique* accepts the authority of empirical phenomena and comes to conclusions that are provisional and can be modified in the light of further findings.[145] The *esprit systématique* was embodied in the Enlightenment's great intellectual and practical enterprise, the *Encyclopédie*, which d'Alembert helped to compile, and which undertakes to present, within a single system, the principles on which all arts and sciences are based, as well as the relevant factual details. To do this, as d'Alembert explained in his 'Preliminary Discourse', it was necessary to go back to the origins of all our ideas, not in abstract reflection but in sensation. The Encyclopedists began by examining 'the genealogy and the filiations of our knowledge, the causes that must have given them birth, and the characters that distinguish them; in a word, to ascend to the origin and the generation of our ideas'.[146]

Enlightened thinkers, especially in France, also spoke of the 'philosophical spirit' that distinguished their century. Thus the abbé Dubos in 1733 speaks of 'this superiority of reason, which we call philosophical spirit'.[147] Diderot says in 1749: 'we live in a century in which the philosophical spirit has rid us of a great number of prejudices'.[148] The expression 'philosophical spirit', however, is not itself a philosophical term; it is used in a variety of different ways, and is perhaps best understood as a slogan around which Enlighteners could rally.[149] It was in a similarly broad sense that Joseph Addison used the word 'philosophy' when he defined the purpose of his new daily paper, the *Spectator*: 'I shall be ambitious to have it said of me, that I have brought Philosophy out of Closets and Libraries, Schools and Colleges, to dwell in Clubs and Assemblies, at Tea-Tables and in Coffee-Houses.'[150]

'Philosophy' and 'philosopher' are key words to define the activity and the character of the Enlightenment intellectual. Since the philosopher deals with a wide range of subjects, beyond the bounds of academic philosophy, it is convenient to use the word *philosophe* so as to reduce the academic associations of the English word. The *philosophe* does not claim that philosophy, or the exercise of reason, can solve every problem or provide a complete understanding of life. Rather, the ambitions of the *philosophe* are strikingly modest. Believing, with Locke, that all our knowledge comes ultimately from the senses, and is thus empirical, not metaphysical, in origin, the *philosophes* do not profess to know what lies behind empirical phenomena.[151] They do not inquire into the ultimate nature of things. Voltaire, who promoted Locke's philosophy in France, agreed with him in placing religious belief outside the scope of human knowledge. *Philosophes* associate philosophy especially with 'natural

philosophy', or, as we would now say, natural science. Natural philosophy has criteria for determining truth which owe nothing to religion; it interprets experience with the help of reason, and hence becomes the model for all knowledge. It can even provide a model for the conduct of one's life. In the *Encyclopédie* article 'Philosophe', Diderot says that the *philosophe*, unlike the bulk of humanity, reflects on the causes of things, reasons before he acts, and is thus capable of furthering his own and others' happiness by avoiding disagreeable sensations and obtaining congenial experiences. The *philosophe* is not a solitary sage but a sociable being, who wishes to help others. Thus he places himself under the guidance of reason as the Christian submits to the guidance of divine grace: 'Reason is for the *philosophe* what grace is for the Christian. Grace tells the Christian how to act; reason guides the *philosophe*.'[152]

The turn from rationalism to empiricism means that when Enlighteners speak of reason, they rarely mean logical or mathematical reasoning. They use phrases such as 'right reason', 'good sense' (*le bon sens*), 'common sense', 'sound reason', 'sound philosophy' (*la saine philosophie, die gesunde Vernunft*). This 'reason' is not a specialized faculty, requiring logical or mathematical training. In the words of Cicero, one of the classical authorities to whom the Enlightenment most often appealed, it is common to all humanity:

> True law is right reason, consonant with nature, spread through all people. It is constant and eternal; it summons to duty by its orders, it deters from crime by its prohibitions . . . There will not be one law at Rome and another at Athens, one now and another later; but all nations at all times will be bound by this one eternal and unchangeable law.[153]

Thus when Enlighteners advocate reason, they usually mean the use of this 'right reason' and good sense to arrive at truth by means of debate. They urge people to be rational, but, still more, to be reasonable. Enlightened reason, typically, is a faculty that is exercised not in solitude, but in dialogue with others. The *philosophe*, according to Diderot, 'combines a spirit of reflection and judgement with manners and qualities that are sociable'.[154] The others in dialogue may be the physical people with whom one conducts an argument, or the opinions stored in books; in either case, conversation and reading are essential additions to the intellectual material that the individual can draw on. Reason is shown not only in calculation, but also in judgement: in judging whether a narrative is plausible, an argument convincing, or a course of action likely to succeed. Judgement is exercised above all in social life. In this sense, although few people can be philosophers, philosophy, or sound judgement, may spread throughout

society.[155] Hume expresses this aspiration in An *Enquiry concerning Human Understanding* (1748), where he hopes that

> though a philosopher may live remote from business, the genius of philosophy, if carefully cultivated by several, must gradually diffuse itself through the whole society, and bestow a similar correctness on every art and calling. The politician will acquire greater foresight and subtilty, in the subdividing and balancing of power; the lawyer more method and finer principles in his reasonings; and the general more regularity in his discipline, and more caution in his plans and operations.[156]

Very often these terms are used in an oppositional sense. Writers appeal to the evident facts of experience, or to the dictates of unprejudiced reason, in order to oppose the claims of political or religious authorities. In a treatise subtitled *An Appeal to the Consciences and Common Sense of the Christian Laity*, the Anglican bishop Benjamin Hoadly in 1716 defended the rights of the individual conscience against the authority of the Church of England's clergy. Hume, summoning 'good sense' to oppose prejudice, equates it with 'reason'.[157] In France, the freethinking Baron d'Holbach disseminated his views under the title *Good Sense, or Natural Ideas opposed to Supernatural Ideas* (1772).[158] And in America, Thomas Paine prompted the War of Independence with his inflammatory pamphlet *Common Sense* (1776), attacking the unreasonable and tyrannical measures of the British government.

The role of reason was the repeated theme of a debate on the meaning of enlightenment that was conducted in Berlin in the 1780s.[159] It was this debate that produced Kant's famous essay, 'Beantwortung der Frage: Was ist Aufklärung?' ('An Answer to the Question: What is Enlightenment?') The essay is usually, and justifiably, taken as a definitive formulation of enlightenment, summing up a century of philosophical discussion.[160] But it also points beyond the Enlightenment in new directions.

Kant's essay appeared in the *Berlinische Monatsschrift* (*Berlin Monthly*), a major journal of Enlightenment thinking, in December 1784, prompted by an earlier contribution to the same journal. The suggestion had been made that marriage need not be a religious ceremony, only a civil one. The clergyman Johann Friedrich Zöllner complained that such proposals threatened to 'shake the first principles of morality, degrade the value of religion, and to confuse people's heads and hearts under the name of *enlightenment*'. He added in a footnote: '*What is enlightenment?* This question, which is almost as important as "What is truth?", needs to be answered before one sets about enlightening! And I have never yet found an answer!'[161] The journal received two essays in reply. One was by the

Berlin Jewish philosopher Moses Mendelssohn, who distinguished between intellectual enlightenment (*Aufklärung*) and broader social refinement (*Kultur*), and pointed out that the two could easily get out of sync: thus the French had more *Kultur*, the English more *Aufklärung*, while the ancient Greeks had excelled in both.[162] The other reply was sent by Kant from Königsberg on the distant Baltic coast.

Kant begins with a firm definition of enlightenment that can hardly be quoted too often:

> *Enlightenment is man's emergence from his self-incurred immaturity.*
> *Immaturity* is the inability to use one's own understanding without the
> guidance of another. This immaturity is *self-incurred* if its cause is not lack
> of understanding, but lack of resolution and courage to use it without the
> guidance of another. The motto of enlightenment is therefore: *Sapere aude!*
> Have courage to use your *own* understanding![163]

Most people, Kant continues, are too lazy to think for themselves. They allow guardians of various kinds to think for them, and the guardians are only too happy to take control and reduce their charges to a position like that of domestic animals, or small children who cannot walk without leading strings.[164]

The metaphor of 'immaturity' (*Unmündigkeit*) deserves a closer look. If you are *unmündig*, you have not yet come of age, and are not yet considered legally as a responsible adult. Until you are *mündig*, you must obey a guardian (*Vormund*). Since everyone attains maturity by the passage of time, Kant's metaphor implies that humanity as a whole must likewise become mature in the course of history. Enlightenment, or learning to think for oneself, is thus a process guaranteed by nature.

In the word *Vormund*, the syllable *mund* is derived from an archaic word meaning 'protection', but it happens also to be the modern German word for 'mouth', so one can, if one wants, read into Kant's wording the implication that immature people are forbidden to speak and must rely on guardians to speak on their behalf. Such an implication is appropriate, for in Kant's essay thinking for oneself leads to speaking for oneself. Kant is concerned with how the mature individual takes part in the wider conversation of a community.

Kant conceived enlightenment as involving reasoned criticism of the social order. But his essay also shows the narrow limits within which, even under the enlightened monarch Frederick the Great, such criticism could be expressed. In Frederick's Prussia, which is the immediate and unavoidable context of Kant's essay, that conversation is subject to various restrictions. There are figures in authority who tell one not to argue (Kant

puts into their mouths the disparaging term *räsonnieren*). Thus a soldier must not argue back when an officer gives him orders, and a layman should not argue about theology with a clergyman, who knows better and whose superior knowledge is attested by his office. The clergyman himself, as a public servant, is obliged to teach the official doctrines of the Church. This is what Kant, a little confusingly, calls 'the private use of reason': the restrictions on intellectual expression imposed by professional responsibilities. However, the clergyman can also exercise 'the public use of reason'. As a learned man, he can publish articles querying this or that dogma of his Church. Similarly, as a private citizen I must pay my taxes, but as a member of the public I can argue in the press about the state's fiscal policy. This has been called Kant's ' "two hats" doctrine': with my private hat on I must serve the state, but with my public hat on I can argue for the improvement of its institutions.[165] In this way, Kant hopes, enlightened discussion can gradually modify and liberalize the state.

Kant admits that the process of enlightenment still has a long way to go. 'If it is now asked whether we at present live in an *enlightened* age, the answer is: No, but we do live in an age of *enlightenment*.'[166] An age of enlightenment is one in which people are free to think as their intellect guides them. No body, even the Church, can permanently restrict freedom of thought by prescribing what people must believe, now and for ever. The attempt to forbid the progress of enlightenment 'would be a crime against human nature, whose original destiny lies precisely in such progress'.[167]

By this insistence on freedom, Kant gives a new and important twist to the debate on enlightenment. He is not interested only in *what* people think, but also, and rather more, in *how* they think. Enlightenment is not a set of ideas but an intellectual practice for exploring the unknown.

The thinking that Kant advocates is not some rarefied intellectual activity available only to a few. In his initial injunction, he urges people to use their 'understanding' (*Verstand*); in the body of the essay he uses the word 'reason' (*Vernunft*) and advocates the use of one's own reason. In the technical language of philosophy, 'understanding' is the faculty that processes the empirical information delivered by the senses and needs to be assisted by 'reason' as the supreme faculty of abstract thinking.[168] Writing for a wider audience, however, Kant does not observe this technical distinction, but uses 'understanding' and 'reason' interchangeably in his plea for critical and independent thinking.

# THE PASSIONS

A perennial problem in moral philosophy and psychology has been what relation should be desired between reason and the passions. The violence of the passions can all too easily overwhelm the sovereignty of reason. An ancient allegory in Plato's *Phaedrus* represents reason, or the rational part of the soul, driving a chariot pulled by two horses. One of the horses is noble and obedient, the other is restive and troublesome. The noble horse stands for such praiseworthy passions as righteous indignation, but the other embodies unruly passions, desires and lusts. The charioteer has the difficult task of keeping both horses under control, pursuing the right course and heading towards the goal of wisdom.[169] Reason aims at an understanding of the cosmic order. If one has such understanding, one will know how to tame the ignoble horse and to use the noble horse for good and wise purposes. Aristotle similarly maintains that the passions can be subjected to rational control: to 'being infused with, and thus docile to, rational insight into what is appropriate'.[170]

This classical contrast between reason and passion often implied a further contrast between the mind and the body. In the much-quoted Priests' Chorus from Fulke Greville's drama *Mustapha* (1609), reason and passion are placed in tragic opposition:

> Oh wearisome Condition of Humanity!
> Borne under one Law, to another bound:
> Vainely begot, and yet forbidden vanity,
> Created sicke, commanded to be sound:
> What meaneth Nature by these diverse Lawes?
> Passion and Reason, self-division cause . . .[171]

Although the priests are supposed to be Muslims, the antithesis they formulate sharply recalls the conflict expressed by St Paul between the law of God, which he affirms intellectually, and another law located in his body: 'For I delight in the law of God after the inward man: But I see another law in my members, warring against the law of my mind, and bringing me into captivity to the law of sin which is in my members' (Romans 7:22–3).

As we approach the Enlightenment, however, the antithesis becomes less sharp, and the passions receive more positive treatment. Descartes discussed the passions in a late essay, *Les Passions de l'âme* (*The Passions of the Soul*, 1649). The soul here is the agent of thoughts. Being immaterial, it is distinct from the body, but the part of the body with which it interacts most closely is the pineal gland, situated in the brain. Through this gland,

the brain can be affected by animal spirits, i.e. very subtle parts of the blood composed of tiny and fast-moving bodies. Thoughts may be active, when they are willed by the soul, or passive; among the latter are perceptions of external objects and physical sensations, and perceptions taking place within the soul. These last are 'perceptions, or sensations, or emotions of the soul that we refer particularly to the soul itself, and that are caused, sustained, and fortified by some movement of the [animal] spirits'.[172]

Passions of the soul are potentially valuable. Unlike the Stoics, Descartes thinks they should not be suppressed, but put to good use. Thus, while I know rationally that I should run away from an angry bull, the passion of fear enables me to run all the faster. In another situation, the passion of courage may animate me to resist a danger. Whether fear or courage predominates in a given situation depends on the disposition of my brain. However, this too is to some extent under my control. A strong soul will form 'firm and definite judgements concerning the difference between good and evil, according to which it has resolved to conduct the actions of its life'.[173] Strength of soul can be cultivated and become habitual. The strong soul, however, does not overcome a passion such as fear by a mere act of will; rather, it summons up examples and reflections that promote the countervailing passion of courage. Thus it is important not to overcome the passions, but to manage them. Descartes concludes that the passions 'are all good of their nature', and that we are to avoid only 'their misuse or their excess'.[174] In the very last section he goes even further, affirming that since 'it is the passions alone that make for all that is good or bad in this life', 'the greatest benefit of wisdom is that it teaches us to master the passions so thoroughly and to handle them so skilfully that the evils they cause are perfectly bearable, and can even, all of them, be a source of joy'.[175]

In the philosophy of Shaftesbury, at the turn of the eighteenth century, the 'affections or passions' are all-important.[176] We are connected with other people, he says, by 'natural affection, parental kindness, zeal for posterity, concern for the propagation and nurture of the young, love of fellowship and company, compassion, mutual succour and the rest of this kind', which serve the good of the species as a whole.[177] Equally natural to us is the sense of right and wrong. Virtue consists in the right direction and degree of the affections, 'a certain just disposition or proportionable affection of a rational creature towards the moral objects of right and wrong'.[178] The role of reason is 'to secure a right application of the affections'.[179] Thus it enables us to avoid such aberrations as selfishness, cruelty, idolatry, or the attribution to one's gods of evil demands, or the excess of an essentially good impulse, as when religious devotion turns into

# CHARACTERISTICKS

OF

## Men, Manners, Opinions, Times.

### In THREE VOLUMES.

By the Right Honourable
*ANTHONY*, Earl of SHAFTESBURY.

*Vid.*  *Inf.*

*Vol. III.*  *Sim: Gribelin Sculps:*  *P. 195, 199.*

## M. DCC. XIV.

The second edition of Shaftesbury's *Characteristicks*. The corrections were made just before the author's death in 1713. The medallion alludes to two passages from Graeco-Roman philosophy quoted in Shaftesbury's text. The Greek words from Marcus Aurelius within the medallion mean 'all is opinion'. The ray of light striking the bowl of water illustrates a passage from Epictetus: 'As is the water dish, so is the soul; as is the ray which falls on the water, so are the appearances. When then the water is moved the ray too seems to be moved, yet is not. And when, accordingly, a man is giddy, it is not the arts and the virtues which are thrown into confusion, but the spirit to which they belong; and when he is recovered so are they.'

fanaticism. For Shaftesbury, the passions are now the locus of the moral life. Reason simply formulates the goals to which our affections instinctively draw us, and corrects us when our affections risk getting out of hand.

A similarly modest role is assigned to reason in Pope's *Essay on Man* (1733–4). Humanity is actually animated by the passions, which are different modes of self-love, and may be either good or bad, depending on their purpose. Reason restrains self-love and weighs up the different goals it might seek.

> Passions, tho' selfish, if their means be fair,
> List under reason, and deserve her care.[180]

Even when the mind is dominated by a ruling passion, reason can 'rectify, not overthrow, / And treat this passion more as friend than foe'.[181] Without passion, reason would be helpless. Reason provides the sailor with a chart to show where he is going, but passion moves the ship:

> On life's vast ocean diversely we sail,
> Reason the card, but Passion is the gale.[182]

It is a short step, and a short interval of time, from Pope's presentation of reason as merely a guide to passions, to Hume's reversal of their usual roles in his *Treatise of Human Nature* (1739–40). Hume opposes the common tendency, both in philosophy and in ordinary discourse, to contrast reason with passion and to maintain that rational beings should obey the dictates of reason and keep their passions firmly in check. This, according to Hume, is a fallacy pervading most of moral philosophy, both ancient and modern. As a rejoinder, Hume undertakes to show, '*first*, that reason alone can never be a motive to any action of the will; and *secondly*, that it can never oppose passion in the direction of the will'.[183] Reason can direct our judgement, by telling us what causes will produce desirable or undesirable effects, but what makes us perform or avoid any action is the prospect of pleasure or pain to be derived from it; and though reason can tell us what may happen, it cannot directly *make* us do anything. We do things because we want to, and it is our passions, not our reason, that make us want to. Indecision is not a conflict between passion and reason, but a conflict between two opposing desires. Therefore it is passion, not reason, that motivates our actions. 'Reason is, and ought only to be the slave of the passions.'[184]

This claim, one might rejoin, is so striking because Hume is stretching the meaning of the word 'passions'. Although it suggests primarily violent passions such as greed, ambition or lust, Hume is extending it to include even the mildest form of desire. On his showing, it is passion, not reason, that makes one go about one's daily business, but 'passion' would seem

an absurdly grandiose word for such mild and ordinary motivations. Even allowing for dramatic overstatement, however, Hume has sharply adjusted the familiar understanding of human nature. His originality can be appreciated by a comparison with a passage from Kant's essay 'Versuch über die Krankheiten des Kopfes' ('Essay on the Maladies of the Head', 1764), written before he had read Hume. Kant acknowledges that the will is motivated by passions, that the intellect serves to identify goals and helps towards their attainment, and that passions can easily get out of hand. Somebody who fails to control his passions is a fool (*Tor*), whether besotted by love or carried away by milder obsessions with building, collecting pictures, or acquiring books. A wise man is free from passions, though Kant admits that, as the passions are so all-pervasive, we may have to search for this wise man in the moon.[185] Kant deplores the power of the passions, which Hume provocatively celebrates.

As yet few people agreed with the primacy Hume gave to the passions. The article 'Passions' in the *Encyclopédie* acknowledges that the passions are essential to human life: 'It is the passions that set everything in motion, that bring the picture of this universe to life, and, so to speak, give the life and soul to its various parts.'[186] The author nevertheless deplores the propensity of the passions to escape from control and the difficulty that reason experiences in maintaining a balance among them. The article ends by adopting Pope's image of a sea voyage in which passion too often blows the ship off course:

> Sad picture of the state to which man is reduced by his passions! surrounded by reefs, driven by a thousand contrary winds, could he ever reach the port? Yes, he can; for him there is a reason that moderates the passions, a light that shines on him, rules that guide him, a vigilance that sustains him, a prudence of which he is capable.[187]

This, however, was already a backward-looking view. The Enlightenment, the so-called 'age of reason', would increasingly rely on the guidance of the emotions. Reason untempered by feeling was felt to be inadequate, even dangerous. 'Virtue born of reason alone,' said Pietro Verri, 'makes us just, faithful, discreet and circumspect; but that which springs from sentiment makes us generous, affectionate, benevolent; the first tends to remove evil from our actions, the second urges us with positive actions towards the good.'[188] By 1795 Friedrich Schiller could condemn an enlightenment that applied only to the intellect without also educating the emotions: 'That enlightenment of the mind, which is the not altogether groundless boast of our refined classes, has had on the whole so little of an ennobling influence on feeling and character that it has tended rather to bolster our

depravity by providing it with the support of precepts.'[189] Accordingly, by the late eighteenth century the Enlightenment was increasingly dominated by emotion rather than reason, in ways to be explored in detail in the chapters that follow. The concept of sympathy, as the glue holding society together, would be explored by philosophers from Shaftesbury to Adam Smith. Sensibility, an emotional participation in other people's experiences, would be promoted by the great novels of the mid-century – Richardson's *Clarissa*, Rousseau's *La Nouvelle Héloïse*, Goethe's *Werther* – and helped to motivate such social reforms as the campaign against slavery. The indulgence of individual appetites, which powered a commercial economy but was often stigmatized as wanton 'luxury', would become a central theme in debates about society. And in aesthetics, the concept of the sublime, in which emotion and reason were imagined as interacting, would be a central topic from Burke's *A Philosophical Enquiry into the Origin of our Ideas of the Sublime and Beautiful* (1757) to Kant's *Critique of Judgement* (1790).

## INTERPRETING THE ENLIGHTENMENT

How, in the early twenty-first century, should we define and interpret the Enlightenment? The best starting-point remains the definition of the Enlightenment, already quoted, as a coherent intellectual movement united by a 'commitment to understanding, and hence to advancing, the causes and conditions of human betterment in this world'.[190] This formulation, however, needs some qualifications. Yes, the Enlightenment was a conscious and deliberate attempt by thinkers better to understand humanity – and the world in which humans live – in order to promote happiness. Philosophers, whom we might today describe rather as intellectuals, sought to influence public opinion through a rapidly growing network of communications and, sometimes, by persuading the more open-minded kings and emperors of the time to introduce enlightened reforms. Here their efforts interacted with the work of administrators, especially in France and the German states, who were seeking to improve people's living conditions and public order. Alongside the intellectuals, therefore, we must give credit to the university-trained administrators, bearing in mind that the two categories often overlapped.

Besides the agency of philosophers and administrators, however, I have tried in what follows to take account of larger, impalpable shifts in outlook, for which I have already used the term 'mentality' as a useful shorthand.[191] An essential precondition for the Enlightenment was the Protestant Reformation, which changed the way people understood

reality. It helped to weaken belief in the supernatural, whether in the magic offered by the Church (e.g. the alleged transformation of bread and wine into the body and blood of Christ) or in the natural world. It contributed to what the sociologist Max Weber would much later call the 'disenchantment of the world'. And it undermined the Church's authority: instead of a single Church, there were now Churches with diverse attitudes to authority, and theology became a subject about which laymen too could argue.[192]

By weakening the repressive authority of the Churches, the Reformation made possible another essential precondition of the Enlightenment: the investigation of the natural world known, however controversially, as the Scientific Revolution. The natural world no longer appeared as a complex of occult forces and symbolic meanings, but as a field available for scientific investigation. When in 1682 Pierre Bayle mocked the idea that comets were portents of disaster, he was expressing what was already the standard view held by educated people; although the comet of 1680 caused some popular alarm, comment on it in the press was generally light in tone.[193] The mathematical calculations of the movement of comets published by Edmond Halley in 1705 did not dispel superstition; superstition was already on the wane.[194] Similarly, belief in witchcraft was already disappearing before Enlighteners – excepting a few isolated voices at earlier periods – debunked its absurdity.

The Enlightenment is therefore presented here in two interconnected ways: both as a deliberate undertaking and as the continuation of a shift in mentality; indeed, it could be summed up as the interaction between the two. Treatises and campaigns against superstition reinforced a tendency that was already under way, and that tendency in turn made intellectual arguments seem even more persuasive. Thanks to the growth of the print media, illustrated by 'moral weeklies' written by Joseph Addison, Richard Steele and their many imitators, debates among philosophers were transmitted in accessible form to a wide public. Accordingly, I have at many points drawn on life-writings and travel literature to present aspects of people's experience during the eighteenth century.

In doing so, I have taken a particular interest in records of emotional experience. The Enlightenment, as I have been arguing, is not adequately described as 'the age of reason'. The rationalism of the seventeenth century, represented by Descartes, gave way gradually to the empiricism of Locke and to the emphasis on emotion ('affections') found in the influential writings of Shaftesbury. As the eighteenth century wore on, emotion, sensibility and desire became increasingly prominent in philosophy, in social life and in literature. For this reason, unlike most other books on the Enlightenment, this one not only includes a chapter on aesthetic theory

but refers frequently to literature, and to records of the reception of literary works, as evidence of shifts in outlook, or of what Raymond Williams called 'structures of feeling'.[195]

Any study of the Enlightenment has to answer some basic questions: not only *what* the Enlightenment was, as in the previous paragraphs, but also *when, where* and *how many*. I have chosen to begin with the 1680s, the decade that saw the publication of Bayle's *Letter on the Comet* and Isaac Newton's *Principia* (1687), as well as the 'Glorious Revolution' in Britain which asserted the sovereignty of Parliament. Ending in 1790 acknowledges that the French Revolution was a historical turning-point, whether or not it is interpreted as the outcome of Enlightenment endeavours; it also leaves us on the threshold of Romanticism, a diverse and fuzzy movement in which we find attempts to restore a magical conception of the universe, and a new enthusiasm for the Middle Ages, which Enlighteners considered a benighted and semi-barbarous period.

Where was the Enlightenment? Its location is not solely a geographical matter. There is 'a certain degree of nationalist pride still linger[ing] around the issue of who "owns" the Enlightenment'.[196] Robert Darnton wrote in 1997 that the Enlightenment was 'a movement, a cause, a campaign to change minds and reform institutions . . . which can be located in time and pinned down in space: Paris in the early eighteenth century.'[197] Later in his essay, he qualified this by mentioning many other centres of the Enlightenment, from Edinburgh to Philadelphia. Similarly, a classic study of the Enlightenment by Peter Gay puts the emphasis on France.[198] This is unavoidable: if any single figure was identified with the Enlightenment, then and now, it was Voltaire; if any single enterprise typified the Enlightenment, it was the *Encyclopédie*, directed by Diderot and d'Alembert; and the Paris *philosophes* were highly visible and controversial figures. Jonathan Israel, who traces the Enlightenment back to impulses from the late-seventeenth-century Netherlands, and whose massive studies extend from Peru at one extreme to Greece and Russia at the other, nevertheless gives prolonged and detailed attention to France.[199] Israel, like Margaret Jacob earlier, also makes an impassioned case for the crucial importance of the Netherlands as the seedbed of Spinozism, the centre of relatively free publishing, and a place of refuge for Huguenots and freethinkers exiled from France.[200]

What about the British Isles? In the eighteenth century, England was often thought to be the heartland of the Enlightenment thanks to the achievements of Bacon, Newton and Locke. The Russian traveller Nikolai Karamzin wrote, on arriving in London in 1790: 'I am engaged in philosophising: sorry. Such is the action of the English climate. Here is the birthplace of Newton, Locke and Hobbes!'[201] Whether one can properly speak of an

English Enlightenment is disputed.[202] John Pocock has argued that England had an 'Arminian Enlightenment', i.e. dedicated to religious toleration; but his two main exhibits – the sceptical historian Gibbon and the Anglican bishop William Warburton, whose eccentric ideas about interpreting the Old Testament were mocked by many, including Gibbon – hardly strengthen his case.[203] In contrast to France, Scotland or Naples, there was no cohesive group of *philosophes* or self-aware proponents of Enlightenment. Enlightened thinking in England was widespread, but diffuse.[204] And even the term 'the Scottish Enlightenment', first used in 1900, became widely current only in the 1960s, though a 'Scottish school of philosophy' was influentially identified by one of its members, Dugald Stewart, at the beginning of the nineteenth century and was generally recognized thereafter.[205]

Germany has traditionally been the stepchild of Enlightenment studies. That is in part due to conventions of German historiography. For a long time, histories of German culture treated the Enlightenment as a foreign body. They identified it with rationalism and French influence, limited it to a few decades in the early and mid-eighteenth century, and recorded with relief the advent of the *Sturm und Drang* movement in the 1770s. With Johann Gottfried Herder, the young Johann Wolfgang Goethe and others, a movement praised for its irrationalism got under way, anticipating the Romanticism that past generations saw as the quintessential expression of the German spirit. This dated narrative is clearly rooted in nineteenth-century nationalism.[206] Recently, however, it has been powerfully argued that not only Lessing and Kant, but Goethe, Schiller and Herder should be understood as carrying on the aims and values of the Enlightenment.[207] They therefore play a prominent part in this book, though (with a few exceptions) I have confined myself to their works published before 1790.[208]

Given that the Enlightenment can be found in so many different countries, it has often been asked whether we can really call it a single phenomenon. Pocock is perhaps the best-known critic of a single conception of 'the Enlightenment', arguing that 'it occurred in too many forms to be comprised within a single definition and history, and that we do better to think of a family of Enlightenments, displaying both family resemblances and family quarrels'.[209] Here Pocock seems to be using Wittgenstein's concept of 'family resemblances' as a way of capturing similarities among diverse phenomena, but the concept has been criticized as woolly.[210] One can identify diversity within the Enlightenment without dissolving the concept; and by retaining the concept of 'Enlightenment', even without the definite article, as Pocock does, one acknowledges that such diversity is spanned by an overarching unity. An important study of the Enlightenment

in various nations did not go so far as to talk of different Enlightenments.[211] I much prefer Israel's argument that to talk even of different national Enlightenments is 'decidedly the wrong framework for so international and pan-European a phenomenon'.[212] And, of course, the Enlightenment was not only pan-European but also American, extending not only to the northern part of the continent but also, despite the power of the Church, to Spanish America.[213]

A final problem in discussing the Enlightenment is that, more than most historical movements, it demands a double optic. As part of the past, removed from us by several centuries, it needs to be studied with the distance and the objectivity proper to the historian. But the detachment of the historian can often seem to lay a dead hand on the past, putting people and conflicts that were once alive into a historical deep freeze. That would be particularly unfortunate in dealing with a movement that still speaks urgently to the present. We often hear and read impassioned pleas to uphold Enlightenment values in the face of tyranny and superstition. Some distinguished historians and philosophers have issued such appeals with compelling arguments and persuasive eloquence.[214] In invoking 'Enlightenment values', however, one can fall into the trap that historians deplore as 'presentism': distorting the past by interpreting it too much in the light of the present. When Jonathan Israel opens his monumental series of volumes on the Enlightenment by telling us that it replaced outdated values, 'intellectually and to a degree in practice', with 'the principles of universality, equality and democracy', his interpretation is unmistakably influenced by hindsight.[215] There are many pressing present-day issues, such as the current troubles of democracy, about which the Enlightenment has little guidance to offer. The greatest crisis of the present and imminent future, the devastation of the environment by man-made climate change, is one of which only the very faintest premonitions can be found in the Enlightenment.

Nevertheless, it would be hard not to find the Enlightenment inspiring, insofar as it involved the advance of reason, good sense and empirical inquiry against superstition, blind prejudice and the authority arrogated by political and ecclesiastical bodies. The Enlightenment's search for the betterment of human life, for the increase of happiness, required a more accurate understanding of the world. Cassirer speaks of 'the almost unlimited power which scientific knowledge gains over all the thought of the Enlightenment'.[216] That understanding of the physical and natural worlds was transformed by the Scientific Revolution, which provided the Enlightenment with a model of knowledge and impelled it to extend its inquiries to what Hume called 'the science of man' and to the study of society. But the precondition for these, the Scientific Revolution, first claims our attention.

# 2

# The Scientific Revolution

In medieval and Renaissance Europe, 'natural philosophy', or the study of the natural world, was based on the canonical texts by Aristotle and commentaries on them.[1] Aristotle thought knowledge should be deductive: it should proceed from first principles to the study of phenomena, instead of starting with the phenomena and inferring general principles from them. Among Aristotle's principles was teleology. Animate and inanimate beings seek to attain a goal. The goal of an acorn is to become an oak tree. Phenomena behave in accordance with their intrinsic character: thus, stones fall downwards because it is in the nature of stones to do so – that's what stones do. By the seventeenth century some people perceived that such arguments were vacuous. Hence in 1673 Molière ridiculed doctors for maintaining that opium induces sleep because of its 'dormitive' (i.e. sleep-inducing) properties.[2] The empirical study of nature had to contend with the seemingly unchallengeable authority of Aristotle, which continued to dominate university curricula throughout Europe until the mid-eighteenth century: when Adam Smith arrived at Oxford from the more progressive University of Glasgow in 1740, he was annoyed to find that Oxford was still teaching Aristotle's 'exploded system'.[3]

There was a long-standing view, first found in the twelfth-century poet Alan of Lille, that God had revealed himself to humanity not only in the Bible but also in the natural world, which was a book displaying God's wisdom and goodness.[4] But just as the Bible communicated on several levels, and required learned and patient exegesis, so the book of nature was likewise difficult to read. Natural phenomena were also symbolic: thus the pelican, which was said to feed its young with blood from its own breast, symbolized the self-sacrifice of Christ for humanity. The entire natural world, the macrocosm, was linked to man, the microcosm, by a vast network of correspondences. As George Herbert affirmed in his collection *The Temple* (1633):

> Man is all symmetrie,
> Full of proportions, one limbe to another,
> And all to all the world besides:
> Each part may call the furthest, brother:
> For head with foot hath private amitie,
> And both with moons and tides.[5]

The sixteenth century, however, already saw the advent of literal-mindedness. Interpreters of the Bible, including many Catholics as well as Protestants, showed less interest in the supposed allegorical dimensions of the biblical text and attached ever more importance to its literal meaning.[6] Martin Luther insisted on the primacy of the literal sense as 'the highest, best, strongest'.[7] In the seventeenth century, students of the natural world increasingly concentrated on the actual properties of its denizens that were available for empirical inspection. Natural phenomena, animals and plants, were not symbols with hidden religious meanings. For an increasing number of people, comets were not portents of disaster, and thunder was not the voice of God. Natural phenomena were of interest because of the ways in which they originated, functioned and interacted, as the scientific observer described them.

But this did not mean that nature ceased to be divine. The world was a wonderful, coherent, interlocking system, and in its harmony, perceptible to anyone but explained by the scientist, it manifested the wisdom and benevolence of its Creator. It was described as an 'economy', meaning 'an intricate system of interrelated, functional parts'.[8] The great eighteenth-century botanist Carl von Linné (better known as Linnaeus) popularized the phrase 'the economy of nature' to describe the interrelatedness of natural phenomena, which, he was convinced, had been designed by God: 'By the Œconomy of Nature we understand the all-wise disposition of the Creator in relation to natural things, by which they are fitted to produce general ends, and reciprocal uses.'[9] Linnaeus elsewhere described the natural world as like a well-organized social hierarchy, but only as a metaphorical comparison. In the vegetable kingdom, for example, mosses corresponded to 'the poor laborious *peasants*', grasses to the '*Yeomanry*', herbs to the gentry, while trees were the nobility among plants because 'they are deeply rooted, elevate their heads above their fellow-citizens, and protect them from storms, heat and cold'.[10]

The study of nature presupposed a major shift in mentality. Curiosity had to become respectable, even admirable. The Churches had long condemned curiosity as an attempt to pry into the secrets of God; St Augustine repeatedly speaks of it as 'sacrilegious'.[11] In his *Confessions* he condemns

a friend who was curious about gladiatorial shows, and who contemplated marriage simply out of curiosity about sex.[12] He himself, echoing the New Testament's condemnation of 'the lust of the eyes' (1 John 2:16), deplores this desire as the soul's 'vain and curious desire, veiled under the title of knowledge and learning, not of delighting in the flesh, but of making experiments through the flesh'.[13] The late-medieval theologian Jean Gerson wrote a treatise, *Contra vanam curiositatem* (*Against Vain Curiosity*), warning against the desire to penetrate into the secrets of nature.[14] Such an attitude is echoed in *Paradise Lost*, when Milton makes the Archangel Raphael rebuke Adam for being interested in astronomy: 'Dream not of other worlds'.[15] Even in the eighteenth century, the Northamptonshire poet Mary Leapor wondered about the moon –

> Who that beholds the full-orb'd Moon arise,
> That chearful Empress of the nightly Skies;
> Who wou'd not ask (cou'd learned Sages tell)
> What kind of People on her Surface dwell?[16]

– but restrained her curiosity by reflecting that God might not have intended us to know such things.

## BACON OR DESCARTES?

Francis Bacon, in his manifesto for empirical research, *The Advancement of Learning* (1605), replied firmly to those biblical authorities, Solomon and St Paul, who had condemned learning as unprofitable and as conducing to vanity. Provided it did not serve conceit or ostentation, Bacon argued, learning would enable us to appreciate the wisdom of God, as revealed both in the Bible and in the creation:

> let no man, upon a weak conceit of sobriety or an ill-applied moderation, think or maintain that a man can search too far or be too well studied in the book of God's word or in the book of God's works; divinity or philosophy; but rather let men endeavour an endless progress or proficience in both.[17]

Curiosity led many people into a fascination with freaks of nature ('monsters') and the exotic artefacts that were collected in cabinets of curiosities or *Wunderkammern*. Writing in a more serious spirit, the authors of the *Encyclopédie* gave little attention to wonders, supplying only a short and dismissive article on the marvellous ('Merveilleux').[18]

Natural philosophy was considered intellectually superior to natural history. The former inquired into the causes of things and drew on

mathematics to place its findings on a quantitative basis. The latter accu-
mulated observations of the natural world, and arranged them in
taxonomic systems, but it had no higher intellectual ambitions.[19] Some-
times it was mocked for triviality. The 'virtuoso', who might be an inquirer
into natural history, was a standard object of satire. In Thomas Shadwell's
play The Virtuoso (1676), one of Sir Nicholas Gimcrack's irritated nieces
calls him 'A Sot, that has spent 2000 l. in Microscopes, to find out the
Nature of Eels in Vinegar, Mites in Cheese, and the Blue of Plums, which
he has subtilly found out to be living Creatures.'[20] Nevertheless, the col-
lections made by natural historians eventually formed the basis of today's
museums, and the classification and cataloguing of specimens was not an
antiquarian exercise but an essential intellectual undertaking. The Irish-
man Sir Hans Sloane, whose accumulation of dried plants, manuscripts,
books, coins and medals, bequeathed to the nation, formed the core of
the British Museum (established by an Act of Parliament in 1753), declared
that 'the collection and accurate arrangement of these curiosities consti-
tuted my major contribution to the advancement of science'.[21]

How should the scientist, or the 'natural philosopher', set about
studying the world? Francis Bacon's programme for science, which
would exercise a decisive influence down to our own day, was set out
in The Advancement of Learning. Bacon was aware that the world had
been changed by three inventions: the compass, which made possible
the discovery of America and the sea route to Asia; the printing-press,
which permitted mass communication; and gunpowder, which sus-
tained the power of absolute monarchs. The intellectual sciences needed
to advance similarly. Bacon therefore rejected the empty abstractions
of scholastics who immersed themselves in Aristotle and ignored the
world around them:

> For the wit and mind of man, if it work upon matter, which is the contem-
> plation of the creatures of God, worketh according to the stuff and is limited
> thereby; but if it work upon itself, as the spider worketh his web, then it is
> endless, and brings forth indeed cobwebs of learning, admirable for the
> fineness of thread and work, but of no substance or profit.[22]

He also rejected the search for occult knowledge, undertaken by some
Renaissance thinkers who placed their faith in magic. Instead, the natural
philosopher should undertake the empirical study of the world around
him. Mere empiricism, however – the accumulation of data – was as bad
as desk-bound reasoning. There should be a marriage between experience
and theory. Investigations along these lines should be conducted by
research communities, like the one Bacon imagined in his fantasy The

*New Atlantis* (1627), and rest on the authority of shared public knowledge, not on the personal authority of a magus.

Bacon's dismissal of Aristotelian abstractions was supported by such hands-on experimenters as Robert Boyle. Boyle complained that scholastic philosophers following Aristotle tried to explain phenomena by appealing to certain real entities or qualities that were separate from the phenomena and existed in some realm beyond observation. Thus, if asked why snow dazzles the eyes, they would reply that snow had a '*Quality* of Whiteness' that dazzled the eyes by its very nature.[23] This was as vacuous as the 'dormitive' quality mocked a few years later by Molière.

The new philosophers accepted the demystified picture of the universe. Early in the seventeenth century, the conception of nature as an animated play of interconnected forces came under attack from what was called 'the mechanical philosophy'.[24] The Catholic priest and mathematician Marin Mersenne objected that conceiving the universe as animate tended to draw God into the universe and present a kind of pantheism. Ironically, it was in order to preserve the distinctness of the supernatural that Mersenne proposed a version of the mechanical philosophy, in which nature consisted in inert matter, and the supernatural force was needed to account for all activity.[25] In 1649, in another version of the mechanical philosophy, Pierre Gassendi revived the classical theory of Epicurus that matter consisted of atoms, and argued that atomism, despite its origins in pre-Christian philosophy, was perfectly compatible with Catholicism.[26] Such caution was necessary because mechanism was also upheld by Thomas Hobbes, who was generally considered to be an atheist and therefore beyond the moral pale.

The version of the mechanical philosophy that achieved most impact was that of Descartes. Although he is chiefly remembered now as a philosopher, Descartes' philosophy was intended to support his science, by providing a basis in absolutely certain knowledge. If I examine my ideas rigorously and winnow out all those that might be false, I am left with a small number of clear and distinct ideas, including the idea of God. Since God is completely good, it is impossible that he should deceive me by making me believe ideas that are in fact false. This small stock of ideas, including the abstract concepts of shape, motion and extension (the property of occupying space), therefore provides the basis for knowledge, and Descartes implies that the knowledge of the world deduced from these basic ideas can be arranged in a quasi-logical sequence, like the propositions of geometry. The knowledge thus obtained, however, does not resemble our everyday empirical knowledge of material objects. It is knowledge of 'things as they really are – knowing them as God knows them'.[27]

The sensory qualities we perceive simply correspond to the effect of bodies on our nerves. 'The nature of body consists not in weight, hardness, colour and the like, but simply in extension.'[28]

All matter is extension. There can therefore be no empty space, no vacuum. The whole of space is filled up by tiny bodies or particles, an idea Descartes developed under the influence of his friend the Dutch mathematician Isaac Beeckman.[29] This corpuscular theory marks a rejection of Aristotle's assumption that matter consists of four basic elements: earth, air, water and fire. Beeckman and Descartes suppose instead that the world consists of homogeneous particles, and the differences among phenomena can be explained by the particles' movement. This presents another problem, however, for if the world is completely filled by particles, it might follow that the movement of one particle communicates itself to all other particles, so that every part of the world is in constant motion. To avoid this consequence (and the perpetual sea-sickness it would imply), Descartes supposes that matter moves in circles, which he calls vortices (*tourbillons*). A fish that swishes its tail in a deep pool displaces the water around it, but does not move all the water in the pool.[30] Similarly, any motion displaces matter, which goes round in a circle and finally fills up the space from which it started. This provides an explanation for the orbits of the planets round the sun.

The problem Descartes never solved, and that would puzzle scientists and philosophers throughout the eighteenth century, was how extension was connected with the other side of reality, namely thought. What connected *res extensa* with *res cogitans*, matter with thought, the body with the soul? Descartes speculated that the two were somehow connected by 'animal spirits', which enter the brain through the pineal gland, located in the back of the neck.[31] This fanciful physiology did not carry much conviction, and Descartes' physics would eventually be overthrown by Newton, yet for many Enlightenment thinkers Descartes remained an exemplary figure. His project of returning to first principles made him an inspiring advocate of reason, and his insistence on clear and distinct ideas made him an enemy of obfuscation.[32]

The Cartesian separation of thought from extension had consequences for the understanding of the spiritual world. In his four-volume treatise *De betoverde weereld* (*The World Bewitched*, 1691–3), Balthasar Bekker argued that the Cartesian separation of body from spirit was presupposed in the Bible: 'Nature teaches that spirit and body are of such distinct natures that they cannot have the slightest connection: Scripture says more or less the same, but not so clearly, because it takes the distinction for granted and leaves sound reason to work it out.'[33] Hence the Devil, being

a spirit, could not assume material form. If he exercised any influence, it was on people's minds, but tales of meeting with him, signing pacts with him, or copulating with him were among the relics of pagan belief, which found a congenial home in Catholicism. Bekker, a Dutch pastor, affirmed his belief in good and bad spirits.[34] His main concern was to provide a critical interpretation of the Bible that took its text literally while minimizing its supernatural content.[35] He argued that when the Bible referred to angels or devils, the best translation would be 'messenger' or 'enemy', and that its supernatural language was only a poetic embellishment. His book was translated into German (three times) and French, but only the first volume appeared in English. On the Continent, it gave rise to a furore that has been described as 'assuredly the biggest intellectual controversy of Early Enlightenment Europe'.[36] Conservative theologians complained that by questioning the reality of Satanic power, Bekker proved that Cartesianism must ultimately destroy Christian belief; others accused Bekker of undermining theology and making it subordinate to philosophy.

The mechanical philosophy was a powerful instrument for describing those aspects of nature that could be quantified. By comparing the universe to a clock, it offered a clear and intelligible model, free from mystery and obscurity. Thus, in Fontenelle's *Entretiens sur la pluralité des mondes* (*Conversations on the Plurality of Worlds*, 1686), in which a philosopher gives an intelligent and receptive noblewoman chatty lessons in Cartesian astronomy, his pupil is pleased by the analogy:

> By what you say, said *Madame la Marquiese*, Philosophy is become very Mechanical. So very Mechanical, said I, that I am afraid men will quickly be ashamed of it; for some would have the Universe no other thing in Great, than a Watch is in Little; and that all things in it are ordered by Regular Motion, which depends upon the just and equal disposal of its Parts: Confess the Truth, Madam, have not you had heretofore a more sublime *Idea* of the Universe, and have not you honoured it with a better Opinion than it deserved? I have known several esteem it less since they believed they knew it better; and for my part, said she, I esteem it more since I knew it is so like a Watch: And 'tis most surprising to me, that the course and order of Nature, how ever admirable it appears to be, moves upon Principles and Things that are so very easie and simple.[37]

Although Descartes expressed admiration for Bacon, the empirical research advocated by Bacon was not compatible with the intellectual method to which Descartes, and other pre-Enlightenment philosophers of the seventeenth century, were committed.[38] While Cartesian rationalism cleared away much philosophical lumber, it made little direct contribution

to the positive understanding of the natural world. Descartes' vortices, for example, were a theoretical construct that could not survive critical examination. Descartes is notorious also for his attempt to apply the mechanical philosophy to animals: he thought it at least probable that they were machine-like, their movements being automatic actions and reactions (like the involuntary contraction of a muscle).[39] Some of his followers went further, asserting that the howling of a beaten dog was a mere reflex by an automaton incapable of pain. This was a convenient doctrine for the hard-hearted, but could scarcely convince anyone with much experience of animals. It was duly mocked by Voltaire: 'he claims that animals are pure machines, which look for food without having an appetite, which always have organs of feeling in order never to experience the slightest sensation . . .'[40] Eventually, the shortcomings of the mechanical philosophy in explaining organic life would lead to its replacement by theories based on sensibility, which will be examined in Chapter 6.[41]

The empirical study of the world was the motor of the Scientific Revolution, which one historian of science has called 'the most profound revolution achieved or suffered by the human mind' since Greek antiquity.[42] The high points of this revolution include Nicolaus Copernicus' publication of the heliocentric system in 1543; Galileo's astronomical observations made from 1609 onwards with the help of the telescope; William Harvey's demonstration of the circulation of the blood in 1628; Christiaan Huygens' discoveries in mechanics, including the theory of the pendulum (1656); Antonie van Leeuwenhoek's observation of animalculae with the microscope, made known in 1676; and Newton's law of universal gravitation, presented in his *Principia mathematica* (1687). Not all of them relied on experiment: mathematics and associated studies, for example, remained based on calculation, as in classical times.[43] Others, however, were transformed by the invention of instruments such as the telescope, the microscope, the barometer and the air-pump. Experimentation was known in the period before Bacon, but experiments were often simply thought-experiments, never conducted in practice, or else they were intended only to confirm what had already been established theoretically. The great innovation was to conduct real, physical experiments without knowing in advance what the outcome would be.[44]

How to date the Scientific Revolution is controversial. Rather than starting with Copernicus, as is customary, its most recent historian proposes dating it from 1572, when the Danish astronomer Tycho Brahe observed a new star, a supernova, in the constellation Cassiopeia. This observation fatally undermined the hitherto dominant authority of Aristotle. Within Aristotelian science, the appearance of a new star was

impossible, for the heavens, unlike the impermanent sublunary world, were supposed to be unchanging.[45] Now one of Aristotle's basic tenets was proved wrong by experience.

Contemporaries did not talk about the 'Scientific Revolution', a phrase first used only in 1915.[46] The word 'revolution' still normally meant a cyclical movement, not a major and irreversible change. But they had no doubt that something big was happening. The achievements of recent science were a major theme in the long-running debate known as the 'Querelle des Anciens et des Modernes' ('Quarrel of the Ancients and the Moderns').[47] Though it had antecedents in seventeenth-century Italy, the debate was really launched by Charles Perrault on 27 January 1687, when he read his poem *Le Siècle de Louis le Grand* (*The Century of Louis the Great*) to the French Academy. Here, and in the dialogues entitled *Parallèle des anciens et des modernes*, Perrault pointed out that the ancients knew neither Christianity, modern science, nor polished taste. The science of Aristotle had been completely superseded by the invention of the telescope and the microscope and by the discovery of the circulation of the blood. Homer, despite his greatness, made his heroes often brutal, undignified and vulgar. Fontenelle weighed in with the claim that the best tragedies of Sophocles and Euripides were inferior to those of the brothers Corneille. The superiority of the ancients was upheld in France by the theologian Bossuet and in England by Sir William Temple and his sometime secretary Jonathan Swift, who imagined writers slugging it out in *The Battle of the Books* (1704). But the moderns acquired a powerful defender in Voltaire, for whom the age of Louis XIV was an unsurpassable pinnacle of cultural achievement. In his view, Locke was a better philosopher than Plato, St Peter's a more beautiful building than the Capitol.[48]

Progress was easier to demonstrate in the sciences than in the arts. Fontenelle, who in 1697 was appointed Perpetual Secretary of the Paris Académie des Sciences, argued in his contribution to the debate that in poetry the summit of achievement could be reached fairly quickly, whereas sciences such as physics, medicine and mathematics required the coalescence of an immense number of different views and an extreme precision in reasoning. It was inevitable, therefore, that the scientific attainments of the present should far surpass those of the past, and that our own posterity – who, Fontenelle remarked in passing, might by that time be Americans – would look back condescendingly at us. 'Nothing', he concluded, 'hinders the progress of things, nothing sets such bounds to the intellect, so much as the excessive admiration for the ancients.'[49]

Weighing up the achievements of the 'ancients' and the 'moderns' in 1694, William Wotton devotes most of his attention to 'natural philosophy' (what

we would now call the sciences). He describes the modern inventions that have made new knowledge possible, especially the telescope and the microscope, but also the thermometer, the 'baroscope' (barometer), the air-pump and the pendulum clock. He notes that the ancients made little use of mathematics and that they often relied on authority instead of experience. By contrast, the work of 'the new Philosophers, as they are commonly called' is based on four principles.[50] First, all terms used must be intelligible, with no appeal to 'occult forces' and the like. Second – a key idea of the Scientific Revolution and of the Enlightenment – nothing is accepted merely on authority, but 'Matter of Fact is the only Thing appealed to'.[51] Third, the understanding of nature must be based on mathematics. And fourth, general conclusions can only be based on a large number of experiments or observations. 'So that the Inferences that are made from any Enquiries into Natural Things, though perhaps set down in general Terms, yet are (as it were by Consent) received with this Tacit Reserve, *As far as the Experiments or Observations already made, will warrant.*'[52] The last point is especially important. Not only must science be clear, factual, quantifiable and empirical, but it cannot aspire to absolute certainty. Although some early modern thinkers hoped to extend the certainty of geometrical demonstration to the natural world, such hopes are chimerical. Wotton was right: scientific knowledge, even if so well established that we cannot imagine it being overturned, is in principle always provisional and capable of being corrected.[53]

To write like this, Wotton had to use the intellectual and linguistic toolkit that made the Scientific Revolution possible. It was necessary to question the authority of Aristotle and other ancient natural philosophers, to show that the world contained things they had not known about, and to do so with concepts that had not previously been available. There had to be a concept of discovery, an acceptance that many things were unknown but real and waiting to be found. Columbus discovered America; Galileo discovered the moons of Jupiter. There had to be a concept and practice of experimentation. The discoveries made experimentally had to be recognizable as facts – truths known by experience – which helped to reveal that nature operated by regular laws. Miracles, as violations of the laws of nature, became increasingly hard to believe in. Isaac Newton wrote in 1703: 'Natural Philosophy consists in discovering the frame and operations of Nature, and reducing them, as far as may be, to general Rules or Laws, – establishing these rules by observations and experiments, and thence deducing the causes and effects of things.'[54]

Bacon's programme for collective research was put into practice by the English Royal Society, founded in 1660 and given a royal charter in 1662.

# THE
# HISTORY
OF THE
# Royal-Society
OF
# LONDON,
For the Improving of
## NATURAL KNOWLEDGE.

BY
## THO. SPRAT.

LONDON,
Printed by *T. R.* for *J. Martyn* at the *Bell* without
*Temple-bar*, and *J. Allestry* at the *Rose* and *Crown* in
*Duck-lane*, Printers to the *Royal Society*.
MDCLXVII.

The title-page of Sprat's *History* (1667). Despite its title, the book is less a history of the Society, founded only in 1660, than a manifesto for its scientific mission.

Its principles were set out in Thomas Sprat's *History of the Royal-Society* (1667). Largely written in 1664, soon after the Society's foundation, Sprat's book is less a history than a manifesto, formulating ideals that would be widely shared in the Enlightenment.

The Society is devoted to the study of nature. It is in no way hostile to religion: some early natural philosophers, such as Edmond Halley, were privately sceptical, but most sought evidence for God's wisdom in the order and regularity that their investigations revealed in nature. But it strictly avoids religious matters: 'they meddle no otherwise with *Divine things*, than onely as the *Power*, and *Wisdom*, and *Goodness* of the *Creator*, is display'd in the admirable order, and workman-ship of the Creatures'.[55] It rejects the opposite extremes of atheism and fanaticism ('dogmatism'); the latter painfully recalls the sectarian conflicts of the Civil War and Interregnum. Sprat advocates 'the calmness, and unpassionate evenness of the true Philosophical Spirit'.[56]

As Sprat describes it, the Society is to be a laboratory, not a school; to centre not on the relation of teacher and pupil, but on 'a free Philosophical Consultation'.[57] Experiments are performed in public and discussed in detail in order to be clear about 'the matter of *Fact*': what actually happened in the experiment, what effect it produced, and from what possible causes.[58] The Society has no particular interest in the natural wonders that 'virtuosi' assembled in their cabinets of curiosities. Its members 'regard the *least*, and the *plainest* things, and those that may appear at *first* the most *inconsiderable*; as well as the *greatest Curiosities*'.[59] The language they use is to be free from rhetorical embellishment or obscurity: 'a close, naked, natural way of speaking; positive expressions; clear senses; a native easiness: bringing all things as near the Mathematical plainness, as they can: and preferring the language of Artizans, Countrymen, and Merchants, before that, of Wits, or Scholars.'[60] The Society is international, linked with the Académie des Sciences in Paris, the Accademia del Cimento in Florence, and scholars such as the Dutch mathematician Huygens.

The Society held formal meetings, conducted by the chairman with his mallet, and carefully recorded.[61] Their commonest venue was Gresham College, near Holborn.[62] Eminent scientists in Britain and abroad were invited to join. In practice, of course, only those resident in London attended frequently. Meetings were often followed by dinner-parties or coffee-house gatherings (rather as one might now go to the pub after a seminar), so that it has somewhat unfairly been compared to a gentlemen's club. It was dedicated to corporate experimentation, before both scientific and lay witnesses. Its members hoped also to develop it into a research institute, but they failed to obtain an endowment beyond a gift of property worth £1,300 from

Charles II, and the Society was sustained largely by its members' subscriptions. Only the secretary, and a curator responsible for experiments, received salaries. Members pursued research at their own expense, paying for their own instruments. They were predominantly from the professional and landed classes. Sprat, anxious to demonstrate the Society's inclusiveness, stresses that, at the king's request, it has elected the demographer John Graunt, although 'he was a Shop-keeper of *London*'.[63] But only 6 per cent of the Society's members between 1660 and 1685 were merchants or tradesmen; the largest single group consisted of doctors and professional scholars (31 per cent), followed by aristocrats and landowners (30 per cent).[64]

In order to communicate with the wider scholarly world, the Society published a journal, the *Philosophical Transactions*, which still exists. Directed by the Society's secretary, the German-born Henry Oldenburg, the *Transactions* soon became 'the leading European scientific periodical', although, in contrast to contemporary learned journals such as the Leipzig *Acta Eruditorum*, its contents were almost always in English, not Latin.[65] The observations it recorded sometimes recall the tradition of 'wonders': the very first issue contains a report communicated by Robert Boyle, 'An Account of a very odd Monstrous Calf'; the calf was born with a threefold tongue, no joints in its hind legs, and a large stone between its fore and hind legs. Boyle's sober description is clearly not intended to arouse wonder but to provide material for the understanding of anatomical processes.[66] There is occasional credulity. Some reports from the Hebrides by Sir Robert Moray, alongside a fascinating description of life on 'Hirta' (St Kilda), include an account of the tiny creature inside a barnacle; having observed it through a microscope, Moray concluded that it was a minuscule goose, and thus found confirmation for the medieval tradition that barnacle geese grow from barnacles.[67] This shows that the Scientific Revolution was a long and gradual process, in which traces of the past could survive for a long time.

The concepts of the Scientific Revolution and of scientific progress, crucial for the Enlightenment, have been challenged in recent decades. Steven Shapin points out that the Scientific Revolution was not a 'singular and discrete event'; the term was not used by contemporaries, nor was 'science'; their activities were highly diverse, and in some cases continuous with medieval investigations of nature (one might instance the barnacles).[68] That seems obvious. We also find the far stronger claim, not merely that the activities of scientists can be studied sociologically (which, again, is obvious), but that the social milieu of science affects, perhaps determines, the substantive character of scientists' findings. Scientific research is what Ludwig Wittgenstein called a 'form of life' and a 'language game',

conducted by a specific community.[69] Scientific truth is the result that satisfies that community by matching the rules of its game. The Royal Society, for example, was an 'experimental community' playing by the rules of the 'experimental game'.[70] It was not the strength of empirical evidence, but the manipulation of power relations, that decided which findings were valid. Scientific research is 'a contest among alternative forms of life and their characteristic forms of intellectual product [which] depends upon the political success of the various candidates in insinuating themselves into the activities of other institutions and other interest groups.'[71]

This is not scepticism but relativism. Scepticism does not deny that truth is discoverable, but looks critically and cautiously at claims to have discovered it. A justified scepticism would point out that science is often wrong. After all, science proceeds through controversies, in which one side must be wrong by definition. But mistaken ideas often have a long life before being refuted. Throughout the Enlightenment period it was believed that when something burns, it emits an element called phlogiston; this belief was refuted by the chemist Antoine-Laurent de Lavoisier only in 1777 (though, unknown to the Western European public, the Russian scientist Mikhail Lomonosov had already disproved it in 1756).[72] Strong relativism, on the other hand, implies that science is never wrong, because any theory accepted by scientists counts as valid science. So it is difficult to see how one can accept relativism and yet acknowledge that science is 'certainly the most reliable body of natural knowledge we have got'.[73]

The concept of scientific progress has similarly been challenged. It is certainly naïve to think that scientific research consists in piling up facts until a complete and accurate picture of the universe will be attained. More plausibly, scientific knowledge goes through periodical massive adjustments induced by new discoveries. So it can be argued that the Scientific Revolution of the seventeenth century not only happened but was one of many scientific revolutions. More recent ones are associated with such names as Darwin, Einstein, and Crick and Watson. According to Thomas Kuhn, in a classic book, a scientific revolution obliges scientists to adopt a different worldview, so that after it they are 'responding to a different world'; a few pages later Kuhn magnifies his claim by saying that, after Copernicus, 'astronomers lived in a different world'.[74] Research within one world makes progress towards solving specific problems, but Kuhn is reluctant to admit that there is progress across revolutions, because that raises the question of the goal of scientific progress, and Kuhn rejects the idea 'that there is some one, full, objective, true account of nature and that the proper measure of scientific achievement is the extent to which it brings us closer to that ultimate goal'.[75]

Yet it is counterintuitive to claim that as science changes, it gives us not a better understanding of the world, but an understanding of 'a different world'. Present-day astronomers know much more about the universe than Ptolemy did, but it would be absurd to say they are studying a different universe. As one of Kuhn's commentators points out, many scientific insights have survived from earlier periods and are unlikely ever to be discarded. Scientists are not likely to disprove Harvey's discovery of the circulation of the blood, or Thomson's discovery of the electron.[76] Scientific knowledge is bound up with discovery – with finding out aspects of reality that are not 'constructed' or 'produced', but were always there waiting to be found, like America and the Andromeda Nebula.

## NEWTON AND NEWTONIANISM

Isaac Newton, one of the Enlightenment's great icons, was a dedicated proponent of experimental science. His brilliance was recognized early. He was appointed Lucasian Professor of Mathematics at Cambridge in 1669, when he was twenty-seven. He was slow to publish: of his two most famous works, the *Principia* (in full, *Philosophiæ naturalis principia mathematica* or *Mathematical Principles of Natural Philosophy*) appeared only in 1687, the *Opticks* in 1704. Even as an undergraduate, however, he was already getting to grips with Descartes: in notes headed 'Quaestiones', he imagined how Descartes' assertions might be tested experimentally.[77] In his early optical research, he conducted dangerous experiments on himself by staring at the sun for a long time to find how his vision of colours was affected, and poking a bodkin into the recess behind his eye to observe the circles that then appeared.[78] In his *Opticks* Newton formulated the experimental method by saying that natural philosophy should begin with analysis: 'This Analysis consists in making Experiments and Observations, and in drawing general Conclusions from them by Induction, and admitting of no Objections against the Conclusions, but such as are taken from Experiments, or other certain Truths. For Hypotheses are not to be regarded in experimental Philosophy.'[79] In the second edition of the *Principia* (1713) he made the much-quoted claim: 'Hypotheses non fingo', 'I do not feign hypotheses', meaning that he did not suppose, or hypothesize, imaginary entities in order to explain natural phenomena.[80] An example of such imaginary entities would be Descartes' vortices. Another would be the epicycles (smaller circles moving within larger ones) that the Ptolemaic system of astronomy hypothesized to explain the variations of the speed and direction of the heavenly bodies.

# PHILOSOPHIÆ
## NATURALIS
# PRINCIPIA
## MATHEMATICA

Autore *I*S. *NEWTON*, *Trin. Coll. Cantab. Soc.* Mathefeos
Profeffore *Lucafiano*, & Societatis Regalis Sodali.

## IMPRIMATUR·
S. P E P Y S, *Reg. Soc.* P R Æ S E S.

*Julii* 5. 1686;

## L O N D I N I,
Juffu *Societatis Regiæ* ac Typis *Jofephi Streater*. Proftant Vena-
les apud *Sam. Smith* ad infignia Principis *Walliæ* in Cœmiterio
D. *Pauli*, aliofq; nonnullos Bibliopolas. *Anno* MDCLXXXVII.

The title-page of Newton's *Principia* (1687), mentioning that its publication
was authorized by Samuel Pepys, who was President of the Royal Society from
1 December 1684 to 30 November 1686.

Newton of course built on the discoveries of his predecessors. Earlier in the century, Galileo had proved experimentally that all bodies fall at the same speed, irrespective of their mass, and thus worked out laws of terrestrial motion, while Johannes Kepler had explained planetary motion by showing that the planets moved not in circles but in elliptical orbits. No room was left for Descartes' vortices, nor for his principle, inherited from antiquity, that 'nature abhors a vacuum'. Newton was able to describe mathematically how bodies are able to move in empty space and affect one another at a distance, by demonstrating the existence of universal gravitation, whereby every particle of matter is attracted to every other by quantifiable forces. This single and elegant principle explained such diverse phenomena as the motion of the planets and the ebb and flow of the tides. His originality rested on 'a clearly thought out procedure for combining mathematical methods with the results of experiment and observation'.[81]

Unlike the universe conceived by the theories of mechanical philosophy, Newton's universe was not wholly self-regulating. It had room for God. Opposing Descartes' view that the world was completely filled with matter, Newton argued that it contained much empty space that was a suitable dwelling-place for God.[82] As Voltaire said in a popular exposition of the *Principia*, a Frenchman who travels to London 'had left the World a *plenum*, and he now finds it a *vacuum*'.[83] God was, moreover, needed to correct various 'inequalities' in planetary motion, which, if not attended to, would eventually cause the universe to run down.[84] Newton's antagonist Leibniz took particular exception to this idea that the universe was so ill-constructed that God had periodically to crank it up.[85] Moreover, when hard bodies collided, some motion was always lost, requiring God's intervention: 'Motion is more apt to be lost than got, and is always upon the Decay.'[86] Newton also puzzled some readers by refusing to explain what gravitation was in itself. To him, it was a force whose effects were clearly visible and calculable: any attempt to go further and probe its intrinsic nature would have looked like a regression to the Renaissance search for occult knowledge.

Newton's followers saw him as a devout Christian. After his death, however, it emerged that throughout his life he had carefully concealed his heterodoxy. He disbelieved in the doctrine of the Trinity. Although he accepted Christ as the Son of God, he thought the Son far from equal with the Father. By extensive studies in Church history, he had established to his own satisfaction that the doctrine of the Trinity had been imposed on the Council of Nicaea (325 CE) by the artful prelate Athanasius, who had also encouraged the pernicious growth of monasticism. Newton had also

invested a great deal of time and money in alchemy. Books on alchemy formed one-tenth of his library, and his alchemical manuscripts have been estimated to contain at least a million words.[87] Even more voluminous are his researches on ancient chronology, in which he tried to reconcile the timescale given in the Old Testament with the chronologies offered by ancient non-Christian writers.[88] And he devoted much energy to proving that modern science had been known to the ancients, that Plato and Pythagoras understood universal gravitation, that the Egyptian 'god' Thoth had really been a human teacher who knew that the earth went round the sun, and that the early chapters of Genesis (at that time ascribed to Moses) contained a scientific account of the creation of the world, which Moses had expressed in figurative language for the benefit of his naïve audience.[89] How could the greatest mathematician of all time, living on the threshold of the Enlightenment, have wasted his energy on such eccentric and futile researches?

It used to be thought that Newton likewise saw alchemy as the operation of the divine spirit within the material universe, though the prevailing view now is that Newton took a more sober view of alchemy.[90] Despite its association with charlatans, there might be something in it (as Robert Boyle also thought); it might provide insight into natural processes other than the mechanical combination of chemical elements. Alchemists sought to transmute base metal into gold. Transmutation was already familiar from the vegetable kingdom, where a tiny seed could grow and change into a tree. Metals were thought to 'grow' in the earth. Perhaps they could be induced to follow a similar transmutative process, whereby they might grow into gold? Perhaps an indwelling spirit could be harnessed for this purpose?[91] Such speculations were mistaken, but that does not make them absurd.

In his interpretation of Church history, Newton shared – in an extreme degree – the anti-Catholicism that was standard in Britain in his day. It was exacerbated, as we shall see in the next chapter, by the schemes of James II to restore Catholicism in Britain, which led to James's expulsion the year after the *Principia* was published. But Newton's animus was supported by his research into the text of the Bible, which enabled him, for example, to show that the verses alleged to confirm the doctrine of the Trinity were absent from early manuscripts. His interpretations of Scripture were based not on inspiration but on a strict method. He wrote:

> Too much liberty in this kind savours of a luxuriant ungovernable fansy [*sic*] & borders on enthusiasm . . . He that without better grounds then his private opinion or the opinion of any human authority whatsoever shall

turn scripture from the plain meaning to an Allegory or to any other less
naturall sense declares thereby that he reposes more trust in his own imagi-
nations or in that human authority then in the Scripture.[92]

Biblical chronology was a reputable and important study. In the next cen-
tury, the Encyclopedist d'Alembert would call it one of the twin supports
of history, the other being geography; it would be the hobby of the young
Edward Gibbon; and Goethe would call chronology 'the most difficult of
all subjects'.[93] Newton sought to make it rigorous by using astronomy to
supplement and correct written texts, as biblical scholars now use archae-
ology. His revised chronology centred on the correct dating of the voyage
of the Argonauts. Chiron the Centaur, the teacher of Jason, the expedi-
tion's leader, had created a sphere on which the then visible constellations
were drawn. Newton worked out where Chiron had placed the equinoxes
on the sphere, compared it with the value for the annual precession of the
equinoxes given in the *Principia*, and thus dated the expedition to 937–6
BCE.[94] As for the interpretation of biblical prophecy, the restoration of the
scientific learning of the ancients and the reconciliation of the Old Testa-
ment with classical mythology, these may sound like Mr Casaubon's 'Key
to all Mythologies' in *Middlemarch*, but they were serious studies with
well-established traditions (as was Casaubon's), including the long-
standing view, still common in the nineteenth century, that the ancients
had a wisdom, or *prisca sapientia*, which had been obscured but could be
recovered.[95] It may now look quaint to accept the literal truth of the Old
Testament and Greek mythology; but their authority was still firmly
enthroned, and it would have been eccentric not to accept them.

Very few of Newton's contemporaries knew about his work on alchemy,
chronology and prophecy. His study of chronology was published only
after his death. The alchemical writings were neglected until the twentieth
century. Newton's contemporary fame rested securely on the *Principia*,
and to a lesser extent on the *Opticks*. The few who were qualified to assess
the *Principia*, which appeared initially in a print run of at most 400 cop-
ies, immediately recognized a masterpiece that explained the dynamics of
the physical universe on the basis of a small number of mathematical laws
of motion. Newton's fellow-member of the Royal Society, Edmond Halley,
wrote an anonymous review of the *Principia* in its *Transactions*: 'This
incomparable Author . . . has at once shewn what are the Principles of
Natural Philosophy, and so far derived from them their consequences, that
he seems to have exhausted his Argument, and left little to be done by
those that shall succeed him.'[96]

On the Continent the *Principia* received a more cautious reception.

Many readers struggled with the transition from the difficult but compelling mathematics of Books I and II to the account of universal gravitation in Book III. How could theoretical mathematics explain physical events? What *was* gravitation? What caused it?[97]

The eventual acceptance of Newtonianism in France was in part due to the brief popular account given by Voltaire in his *Lettres philosophiques* (1734).[98] That Voltaire's book was promptly banned by the *parlement* of Paris only added to its appeal. For the learned world, the crucial step was taken by the mathematician Pierre Louis Maupertuis, who in his book *Discours sur les différentes figures des astres* (*Discourse on the Various Shapes of the Heavenly Bodies*, 1732) showed that the Cartesian picture of the universe required continual untidy adjustments, whereas Newton's universal gravitation offered, by contrast, a simple and elegant quantitative principle. 'Framed this way, Newton became the real avatar of Cartesian clear and distinct reasoning while the Cartesians were shown to be lost in a haze of mechanist confusion.'[99]

The spread of Newtonianism across Europe was far from a smooth triumphal progress. In France, academics not only found the *Principia* a severe challenge to their mathematics, but were reluctant to accept that parts of the universe could be empty even of the subtle matter postulated by Descartes.[100] In Germany Newtonianism encountered an obstacle in the philosophical school associated with Leibniz and Christian Wolff, though the fate of Wolffianism was sealed when the anti-Wolffian mathematician Leonhard Euler joined the Berlin Royal Academy in 1741 and when Maupertuis became the Academy's president in 1746.[101] The progress of Newtonianism in Italy was hampered by the disapproval of the Church, which a few decades earlier had silenced Galileo and in 1663 placed some of Descartes' writings on the Index of Prohibited Books. The Jesuit physicist Ruggiero Boscovich, an enthusiast for Newton's ideas and a friend of the enlightened Pope Benedict XIV, found that anyone who departed from the conventional Aristotelian account of nature was liable to be branded a heretic.[102] In parts of Italy, however, there was more intellectual freedom. Thus Laura Bassi, the second Italian woman to receive a university degree, lectured on Newtonianism at the University of Bologna from the 1730s to the 1770s.[103] The Greek cleric Nikephoros Theotokis published a book on Newton's physics at Leipzig in 1766-7, though he expressed himself cautiously for fear of conflict with the Orthodox Church, which still maintained that the sun went round the earth.[104]

The *Principia* inspired more than philosophers. Practically minded readers found in it much experimentally based information concerning

the motions of bodies and fluids that was valuable for engineers, and in due course made possible the profession of civil (as distinct from military) engineering.[105] More generally, Newton's picture of a divinely regulated order was recognized as a model not only for God's creation but for earthly monarchies. It applied particularly pleasingly to the limited monarchy consolidated in Britain after the Glorious Revolution of 1688.[106] The Huguenot émigré John Theophilus Desaguliers, whom Newton helped to become the Royal Society's experimental demonstrator in 1714, drew the analogy in *The Newtonian System of the World, the best Model of Government: An Allegorical Poem* (1728):

> That *Sol* self-pois'd in *Æther* does reside,
> And thence exerts his Virtue far and wide;
> Like Ministers attending e'ery Glance,
> Six Worlds sweep round his Throne in Mystick Dance,
> He turns their Motion from its devious Course,
> And bends their Orbits by Attractive Force,
> His Pow'r, coerc'd by Laws, still leaves them free,
> Directs but not Destroys, their Liberty.[107]

International trade was also imagined as a Newtonian balance of forces, composed of regularity and attraction.[108] More broadly still, Newtonian cosmology provided a model for concepts like the 'balance of trade' and the 'balance of power'. It is present even in the American Declaration of Independence, with its opening appeal to 'the Laws of Nature and of Nature's God'.[109] On all these grounds, Newton has been called the '"prime mover" of all Enlightenment thought'.[110]

Newton's example had further momentous consequences. He confined himself to the observation and description of phenomena, without forming hypotheses about their ultimate causes. He showed that the force of gravity operated throughout the physical world, but he did not try to say what gravitation *was*. In a draft of the 'General Scholium' in the *Principia*, composed around 1712, Newton wrote: 'We do not know the substances of things. We have no idea of them. We gather only their properties from the phenomena, and from the properties [we infer] what substances may be.'[111] Natural philosophy thus separated itself from all approaches to reality that sought to ground knowledge in some underlying absolute truth. It differed from the theologians and metaphysicians, like Pascal and Leibniz, who thought there was an 'ultimate fact of the matter' to be discovered by religious or philosophical reflection.[112] It differed also from the eighteenth-century thinkers such as d'Holbach and La Mettrie whose materialism was really just as dogmatic as the theology they opposed.[113] And although

Newton's *Principia* contained the most advanced mathematics of his day, he did not assume, as Descartes had done, that mathematical axioms were the ultimate starting-point for the understanding of reality.

Newton's methodological modesty converged with that of the Dutch scientists of his time, notably Christiaan Huygens and Willem 'sGravesande, who likewise concentrated on exact observation and experimental research. Huygens in his *Traité de la lumière* (*Treatise on Light*, 1690)

> emphasizes that one cannot attain the same clarity in physics as is possible in mathematical demonstrations and inferences, and that there can be no intuitive certainty of the fundamental truths of physics. Physics requires simply a 'moral certainty,' which, however, can be raised to such a high degree of probability that for all practical purposes it is as good as a rigorous proof.[114]

On the other hand, the investigation of nature requires certain basic assumptions. We have to assume as an axiom that nature is uniform. But can that axiom itself be proved? 'sGravesande replies that 'this is not a strictly logical, but a pragmatic axiom; its validity does not lie in the necessity of thought, but in that of action'.[115] It is a working assumption.

The claims of natural philosophy are thus relatively modest. Philosophers do not profess to reveal the ultimate nature of things. They willingly leave such inquiries to the theologians. But, within the domain of natural philosophy, there are agreed criteria of truth – not absolute truth, but truth good enough for all practical purposes – which are much firmer than any criteria theologians can find. Hence d'Alembert, in the 'Preliminary Discourse' to the *Encyclopédie*, prudently admits the need for revealed religion but strictly limits its domain to 'some truths to believe and a number of precepts to practise'.[116] Disputes about matters of fact can eventually be resolved through experiment, whereas disputes about theology drag on for centuries and are generally settled by dogmatic authority and/or *force majeure* – or forgotten when everybody has lost interest.

Precisely because its claims were modest, but feasible, natural science became the model for all knowledge. Cassirer quotes d'Alembert on the impact of scientific advances: 'from the earth to Saturn, from the history of the heavens to that of insects, natural philosophy has been revolutionized; and nearly all other fields of knowledge have assumed new forms'.[117] Natural philosophy – science – was not yet considered distinct from other fields.[118] When Diderot demands that philosophy should be intelligible to the people, his examples of unnecessary obscurity include Newton's *Principia*.[119] Thinkers informed themselves about natural science. Voltaire's exposition of Newton is the cardinal example, but he also twice submitted

scientific papers to learned academies. Having attended lectures on physics given by 'sGravesande in Leiden and studied chemistry, he sent the Académie des Sciences in 1737 an essay on the nature of fire, which the Académie published, though without awarding it a prize.[120] In 1746 he sent the Florentine Accademia della Crusca a paper on the prehistory of the earth's surface, for which the Accademia elected him a member.[121] Diderot wrote on many scientific subjects, including the laws of matter and motion;[122] the young Montesquieu dissected plants and animals in order to learn about their physiology;[123] Rousseau studied chemistry, and wrote on astronomy and cosmography.[124] Samuel Johnson performed chemical experiments as a hobby: Boswell, visiting his library, 'observed an apparatus for chymical experiments, of which Johnson was all his life very fond'.[125] Adam Smith wrote an essay on astronomy;[126] and Kant was the author of a serious and original, though little-noticed, study of astronomy and cosmology.[127]

Natural philosophers ranged widely in their interests. The great Russian scientist Lomonosov, having gained a broad introduction to the natural sciences at the famous school of mines at Freiberg in Germany, conducted pioneering experiments in physics and chemistry, drew up a catalogue of minerals, and studied the geological strata of the earth and the formation of icebergs. As an astronomer, he observed the transit of Venus across the sun in 1761 from his observatory in St Petersburg and was the first to discover that Venus had an atmosphere. He also wrote poetry, a grammar of the Russian language and a history of Russia.[128] A more famous polymath, Goethe, who wrote in almost every literary genre and devoted much of his life to studying geology, mineralogy, anatomy and the processes of organic development in plants and animals, is thus a characteristic, though still remarkable, product of the Enlightenment.

However, to speak of physics and chemistry in the Enlightenment risks anachronism, since, though the terms were much used, their respective areas within natural philosophy were still in the process of being demarcated. Chemistry (or 'chymistry') had been a recognized subject since the end of the sixteenth century, but was poised uneasily between natural philosophy and natural history.[129] 'Physics' often referred to 'the entire study of causes in nature'.[130] Some of the territory of physics was occupied by mechanics, i.e. the mathematical study of the motion and equilibrium of bodies and the action of forces, which built on Newton's discoveries. A very short and selective sketch of the progress of the physical sciences in the Enlightenment will, nevertheless, recall some of their achievements and indicate how the experimental method changed people's understanding of the world they lived in.

## EXPERIMENTAL PHILOSOPHY

An educated man in the year 1700 still took for granted that the world consisted of the four basic elements described by Aristotle: earth, water, fire and air. (He might have known that Aristotle added a fifth, ether, which was supposed to fill the sky above the clouds.) He thought that most work had to be done by the muscle power of human beings, horses or oxen. Although he was familiar with watermills, he did not imagine that energy on a large scale could be generated by harnessing water, let alone steam or electricity (though the first steam engine would soon be invented by Thomas Newcomen, in 1712). He would not have used the word 'energy', which acquired the sense of 'quantifiable physical force' only in the nineteenth century. While he might not accept the biblical account of the creation of the world, he thought it unlikely that the earth was more than about ten thousand years old. And he took for granted that animal species had always existed in their present form. The idea that species might become extinct would, if it had occurred to him, have seemed absurd: why would God have created them only to let them vanish? Similarly, he thought it more likely than not that the other planets were inhabited, because God would hardly have created them to leave them unpopulated.

Experimental methods would change this picture of the world. The 'experimental philosophy', however, did not just mean conducting experiments in a laboratory or elsewhere and trying to verify one's findings by repeating the experiment. Experiments often required complex and expensive machinery. Repeating experiments was correspondingly difficult. Many branches of science, such as astronomy or geology, do not lend themselves to experimentation. 'Experimental' meant, much more broadly, the reliance not on authorities, but on careful observations, which in most cases could in principle, and often in practice, be verified by repetition.

Chemistry lent itself to experimental methods in the narrow sense. In the early eighteenth century, chemistry was widely seen as a branch of medicine. Many of its leading figures, such as Herman Boerhaave in the Netherlands, Georg Ernst Stahl in Germany, and William Cullen and Joseph Black in Scotland, were trained as physicians, and the subject flourished at universities with important medical schools, such as Leiden and Edinburgh.[131] The mechanical philosophy, being primarily concerned with quantitative measurements, treated the qualities of substances as secondary. Experimental methods made it possible to develop the science of chemistry and free it from its dependence on medicine, its subjection to the mechanical philosophy and its origins in alchemy. Previous inquirers into the

composition of matter had wanted to transmute metals by altering the proportions among their constituent parts, thereby producing gold from base metal, or discovering a universal solvent or 'alkahest' that could dissolve any substance into its constituents. Robert Boyle, author of *The Sceptical Chymist* (1661), still had great respect for alchemy, and hoped himself to find the philosopher's stone.[132] He also hoped, by putting his research on a firmly experimental basis, to confirm the claims of the mechanical philosophy that physical events could be explained in terms of matter in motion.

Early chemistry was hampered by lack of instruments. Boyle and his assistant, Robert Hooke, developed the air-pump, a globe from which air could be gradually removed, so as to observe the effects of its loss on objects inside the globe.[133] With this expensive and delicate instrument, Boyle performed some forty-three experiments, showing that air could expand, exert pressure and possess elasticity. Another important technical advance was the invention by Daniel Gabriel Fahrenheit in 1714 of the mercury thermometer, along with the temperature scale that bears his name. This enabled researchers to make precise use of heat in experiments, as well as opening up the whole subject of heat to systematic investigation.[134]

Many experimenters focused on the study of air: a sub-field called 'pneumatic chemistry'. At the beginning of the eighteenth century it was still assumed that air was a simple element, as Aristotle had taught. The Flemish chemist Jan Baptist van Helmont had noticed around 1640 that when he burned charcoal in a closed container, something escaped, leaving an unexpectedly small quantity of ash. He called this invisible substance a 'gas' (his Dutch pronunciation of the Greek *chaos*, meaning empty space). Eighteenth-century experimenters became interested in 'fixed air', air that, when trapped within a substance, lost its elasticity. Stephen Hales, an English clergyman and enthusiastic Newtonian, investigated 'fixed air' in order to substantiate Newton's argument that air contained both attractive and repulsive particles.[135] The Scottish chemist Joseph Black performed a series of experiments on heated limestone and magnesium carbonate, measuring the 'fixed air' that was gained or lost, and identified this air as something distinct from the ordinary air through which it was dispersed: it could not be breathed and it did not support combustion. He had thus discovered carbon dioxide and proved that air is a compound, not a simple substance.[136]

Subsequent researchers discovered yet more airs. Black's student Daniel Rutherford discovered nitrogen in 1772. In 1766 Henry Cavendish, a scrupulous experimenter who was often overlooked because he seldom published his researches, identified what he called 'inflammable air' and we call hydrogen.[137] The English Dissenter and polymath Joseph Priestley,

having already been awarded the Royal Society's Copley Medal for the discoveries recorded in his paper 'Observations on different kinds of air', announced in 1775 his discovery of oxygen, though he did not know that it had already been recognized by the Swedish chemist Carl Scheele.[138] And in 1778 the electrical researcher Alessandro Volta, applying an electric spark to the atmosphere near Lake Maggiore in northern Italy, found what he called 'inflammable air native to the marshes', now known as methane. It became clear 'that "air" was not a single element but a physical state that many chemical substances could assume and that atmospheric air was a mixture of several different chemicals in that same "vaporous", "gaseous" or "aeriform" state'.[139]

Black's work on carbon dioxide, and Priestley's identification of new 'airs', provided a starting-point for Antoine-Laurent Lavoisier, often called the founder of modern chemistry. He analysed the composition of carbon dioxide and refined the understanding of oxygen as 'breathable air'. To explain the nature of gases, he put forward a new theory of combustion, showing that combustion, the production of fire and light, required the combustible body to be surrounded by oxygen. By showing that the burning object absorbs the air in which combustion takes place, and that its increase in weight corresponds to the weight of the air it has absorbed, he put paid to the long-standing idea that when an object burns it releases phlogiston (though, as we have seen, this conclusion had already been reached by Lomonosov in 1756).[140] Lavoisier was also the first person to realize that water, previously thought to be an irreducible element, is a compound substance formed from hydrogen and oxygen, just as carbon dioxide is formed from a combination of carbon and oxygen. In *Traité élémentaire de chimie* (*Elementary Treatise on Chemistry*, 1789) he published a list of chemical elements, divided into gases, metals, non-metals and earths, which laid the foundations of chemistry as a scientific discipline. Sending a copy of his book to Benjamin Franklin in 1790, Lavoisier wrote that he had avoided theory, 'in order to follow as much as possible the torch of observation and experiment'.[141]

Research on gases had highly visible effects, notably the invention of the hydrogen balloon. The first manned flight with a balloon filled by hydrogen was made by its designer, the chemist Jacques Charles, who had studied the work of Black and Cavendish, and his assistant, Nicolas-Louis Robert. They started from the Tuileries gardens in Paris and landed two hours later 22 miles (36 km) away, having reached a height of 1,800 feet. The hot-air balloon, pioneered at the same time by the Montgolfier brothers, was based on the tendency of air to rise when heated. Both alternatives were immediately discussed at the Académie des Sciences,

with Lavoisier prominent in the debate: he favoured the hydrogen method despite its greater expense.

The advance of chemistry not only illustrates the success of the experimental method. It also shows the emancipation of a discipline, both from its more primitive predecessors and from some of its own working assumptions. Lavoisier finally separated chemistry from alchemy. By showing that water was not a simple element, he disposed of the classical theory of four elements. And by showing that combustion required oxygen, he gave the venerable but increasingly threadbare phlogiston theory an empirical refutation. In the course of its development, chemistry also separated itself from the mechanical philosophy. The mechanical philosophy 'gave no advantage for explaining chemical properties such as acidity, alkalinity, metallicity, salinity, and the chemical operations of combustion, fermentation, and distillation'.[142] Black's teacher, William Cullen, pointed out to his students that mechanics could account only for the quantitative aspects of their subject. Chemistry, however, was principally concerned with qualitative matters, such as the changes that occur when water boils or freezes.[143] From being a helpful working model, the mechanical philosophy now became irrelevant to some areas of research and could be quietly discarded.

Physics traditionally meant the study of the entire physical world. Thanks to the mathematical advances of Newton and Leibniz, it came to focus on those aspects that could be studied quantitatively and moved into some areas formerly considered part of mathematics, such as mechanics and optics. Mathematics, previously a predominantly practical subject particularly required for military engineering, expanded as a field of study and was pursued by figures of international repute, such as the Encyclopedist d'Alembert and the Swiss Leonhard Euler, who spent most of his career in St Petersburg and Berlin and contributed to almost every branch of mathematics and mechanics. Mechanics was virtually a branch of mathematics with next to no experimental basis.[144] By 1800 physics was confined to the study of the inorganic world, using experimental and quantitative methods and assisted by instruments such as the air-pump and the thermometer.[145]

Just as the mechanical philosophy was not disproved by a frontal attack, but quietly sidelined, so some concepts in physics were allowed to fade away when they were no longer empirically useful. This applies to the concept of 'subtle fluids', which was introduced into physics around 1740. It was intended to resolve something Newton had left unclear: whether gravitation and similar forces acted at a distance (which to many seemed counterintuitive) or were transmitted through some intervening medium. Such a medium might be ether, a term used by Aristotle to denote

the upper atmosphere above the clouds, and now adopted to describe an imperceptible medium supposed to fill the spaces between particles of air. It seemed necessary to hypothesize such a medium to explain not only gravitational pull but also magnetism and the transmission of heat and light. If subtle fluids varied in density, it would be possible to weigh them and thus quantify these phenomena. Eventually, however, the hypothesis of subtle fluids turned out to be unhelpful and dispensable:

> Just as Newton discovered that he could describe the phenomena of gravi-
> tation mathematically without supposing any ether, so did the physicists of
> the late eighteenth century discover that they could quantify physical
> concepts such as temperature, specific heat, charge, and capacitance with-
> out assigning any specific subtle fluid to them.[146]

A particular source of fascination throughout the century, to scientists and the lay public alike, was electricity. Electrical experiments were performed for the Royal Society over many years. In 1729 the dyer and amateur physicist Stephen Gray discovered that certain materials, such as a brass wire, transmitted electricity, while others, such as a silk thread, did not. He had thus stumbled upon conductivity: all material bodies are either conductors or non-conductors. Gray was elected to the Royal Society in 1732, and was awarded its first Copley Medal for scientific achievement in 1731. On the Continent, it was discovered – accidentally – that it was possible to store electricity in an insulated glass container known as the Leyden jar. Pieter van Musschenbroek electrified water by the then-standard method of placing a jar on an insulating stand and running a wire from the prime conductor so as to fill the water with electricity. One then puts a finger on the prime conductor, whereupon a spark comes from the water. A visitor to Musschenbroek's laboratory incautiously took the water-filled jar in his hand and received a small electric shock. Musschenbroek repeated the experiment and found that if he used a globe instead of a jar, the shock was much greater: 'my right hand', he reported, 'was struck with such force that my whole body quivered just like someone hit by lightning'.[147] Thereby Musschenbroek had invented the condenser. Benjamin Franklin discovered the concept of the electric charge, which could be either positive or negative. By his experiment of flying a kite in a thunderstorm, he showed that lightning was electrical. He stood on an insulator and kept dry under a roof. Georg Wilhelm Richmann, who tried to repeat the experiment at St Petersburg a year later, omitted these precautions, caught a thunderbolt and was electrocuted.[148]

Electricity lent itself to spectacular demonstrations, often involving human beings. Gray suspended an eight-year-old boy by insulated cords

about two feet above the floor and applied a charged glass tube to his bare feet, whereupon the boy, being charged, attracted pieces of brass leaf from 10 inches away.[149] Later demonstrators showed the 'electric kiss': a woman was placed on an insulator and an unwary spectator was invited to kiss her, whereupon a spark issued from her lips and gave him a shock. Another popular trick was 'beatification': a person standing on an insulator, preferably in a dark room, held a wire attached to a prime conductor, so that fire seemed to spring from ears, fingertips and hair.[150] To show how far electricity could be transmitted, people might be asked to stand in a line holding hands; the free hands at either end were connected to a Leyden jar, whereupon all received shocks. In 1746 Jean-Antoine Nollet, who in 1762 became director of the Paris Académie des Sciences, gathered about two hundred monks into a circle about a mile in circumference, with pieces of iron wire connecting them. He then discharged a battery of Leyden jars through the human chain and observed that each man reacted at substantially the same time to the electric shock, showing that the speed of electricity's propagation was very high. He also shocked 180 gendarmes in the presence of the king.[151] Nollet was no mere showman, but an eminent scientist; after he had established his reputation with his six-volume *Leçons de physique expérimentale* (*Lectures on Experimental Physics*, 1743–8), Louis XV acknowledged his redefinition of the subject by creating for him a new university chair in experimental physics.[152]

Thanks to such performances, electricity was long considered a spectacular but relatively unimportant branch of scientific investigation. When Alessandro Volta displayed his condensers to the academies of Paris and London in 1782–3, he was thought more a performer than a serious researcher.[153] Near the end of the century, however, Volta, by then professor of experimental physics at the University of Pavia, invented the electric battery. Luigi Galvani, an anatomist at the University of Bologna, examined why a frog's legs twitched after its death, and attributed the twitching to electricity stored in the frog's muscles. Volta argued that the electricity was not internal to the frog but must come from outside. In 1799 he invented the Voltaic pile, a pile of silver and zinc discs, alternating and separated by cardboard discs soaked in brine. When the top and bottom of the pile were connected by a wire, the result was a steady flow of electric current. Henceforth electric current could be stored and turned on or off as needed (whereas the Leyden jar discharged its contents all at once).[154] This and his earlier inventions caused Volta to be called the Newton of electricity. Nobody, of course, could possibly foresee that the electric battery would become a mainstay of industrial civilization.

## THE HEAVENS AND THE EARTH

Astronomy and geology presented distinctive challenges to proponents of the new methods of inquiry. Their subject matter – the expanse of the heavens, the recesses of the earth – were in obvious ways inaccessible. In addition, both proved increasingly hard to reconcile with the biblical narrative of the six days of creation and the Flood that supposedly engulfed the earth, destroying all animate life except for Noah's family and the pairs of animals sheltered in the Ark.

Since astronomy depends on combining calculation with observation, it demanded well-equipped observatories and instruments of the utmost possible precision. The Paris Académie des Sciences founded in 1667 an observatory at Faubourg Saint-Jacques, to the south of Paris, and invited foreign astronomers to study there. For forty-five years it was directed by Giovanni Domenico Cassini, who observed four new satellites of Saturn, the cleavage between its rings, the red spot on Jupiter and the white spots at the poles of Mars. In Britain, the Greenwich Observatory and the office of Astronomer Royal were founded in 1675. The first Astronomer Royal, John Flamsteed, managed to compile a catalogue of some three thousand stars, all visible from Greenwich. His successor, Edmond Halley, among many other achievements, established the periodicity of comets. Having observed the comet of 1682, Halley noticed resemblances to reports of comets from 1531 and 1607; his theory, that they were the same comet, returning at intervals of approximately seventy-five years, was confirmed after his death when the comet, henceforth called Halley's Comet, reappeared in 1759.

The telescope, invented in the Netherlands in 1608 and used by Galileo for his discovery of the moons of Jupiter, was continually refined throughout the eighteenth century. Telescope technology reached its peak with William Herschel, a native of Hanover (then in personal union with the British crown) who settled in England, practised astronomy as an amateur, and in 1781 discovered a new planet. He wanted to call it the Georgian star after his royal patron, but continental astronomers insisted that it should, like the other planets, have a mythological name, and called it Uranus (after the father of Saturn). Herschel's largest telescope, completed in 1789, had a mirror 49.5 inches in diameter and a tube 40 feet long; Herschel designed and built it with the aid of a royal grant of £4,000 and an army of skilled workmen. With it he promptly discovered two hitherto unknown moons of Saturn. His sister Caroline assisted him in his work and made her own independent discoveries, including a new star and eight comets.

Astronomers were concerned with the earth as well as the heavens. Their

observations could have important implications for navigation, and therefore attracted support from governments. When Newtonianism was introduced into France, one of the points of conflict with the reigning Cartesian orthodoxy was the shape of the earth. Descartes had argued that the earth must be elongated at the poles, and measurements made by Cassini seemed to confirm this view. Newton, however, had argued that the rotation of the earth on its axis should make it bulge at the equator and be flattened at the poles. Measurements made in 1672 near the equator had found that pendulums of the same length swung more slowly near the equator than in France; Newton explained that points on the equator were further from the centre of the earth and therefore the force of gravitation was weaker. To settle this dispute, measurements must be made at the equator and the poles. Two kinds of measurements were possible. One could compare the speed with which pendulum clocks moved at different latitudes. Or one could measure lengths on the ground and correlate them with astronomical observations: the lengths were determined with the help of triangulation, in which the length of a single side of a triangle enables the other lengths to be calculated – but the vertices must be at prominent points, preferably mountain-tops.[155]

The French crown financed two expeditions. One, the French Geodesic Mission, went in 1735 under the leadership of Charles-Marie de La Condamine to South America. Access to Spanish territorial possessions required official permission, so this could claim to be the first international scientific expedition. Condamine's account of his travels, drawn from the journal he kept assiduously, records endless hardships.[156] Some were natural, such as earthquakes, volcanic eruptions, hurricanes and floods, in which important papers were soaked. Others were man-made: the observation points that the academicians erected were blown down by storms or damaged by thievish natives; workmen were negligent; communications with Europe were slow; when the travellers ran out of money, Condamine went from Quito to Lima to use some bills of exchange, only to be accused on his return of transporting contraband. Having again run short of money, Condamine made his return journey by crossing the Andes and sailing down the Amazon, reaching the Atlantic in 1743 and Paris only in 1745.

Meanwhile Maupertuis, the chief advocate of Newtonianism in France, set off in 1736 with his associate Alexis Clairaut and several astronomers for Lapland. Their base was Torneå (now Tornio) at the head of the Gulf of Bothnia. To find an elevation high enough for triangulation, they had to place their instruments on mountains, which they reached by struggling through trackless forests and swamps.[157] Their observations proved that the earth was an oblate spheroid, and, moreover, that aspects of Newton's theories could be confirmed experimentally. However, this

conclusion found general acceptance only after a long and bitter dispute with Cassini, who was unwilling to accept that his calculations could be empirically corrected.

Scientists were prepared to devote years of their lives, and encounter innumerable discomforts and dangers, in order to make discoveries. More such challenges were issued in the 1760s, when there were opportunities for observing the transits of Venus across the sun's disc in 1761 and 1769. These transits occur in pairs, eight years apart, followed by intervals of over a century. The previous transit had been in 1639, and the next would not occur until 1874. By measuring the transit with the utmost attainable precision, it would be possible to establish the distance between the earth and the sun, and, by treating this measure as the basic astronomical unit, to work out the exact dimensions of the solar system.[158] It was necessary to make the observations from numerous different points across the globe, because calculations had to allow for the rotation of the earth; because the duration of the transit would differ when seen from different points; and because some attempts at observation were sure to be frustrated by cloud cover. The observations made in 1761 were inconclusive, so the 1769 transit was awaited with intense excitement. Many nations sponsored far-flung expeditions staffed by scientists. Spain, which normally denied foreigners access to its American possessions, was persuaded to allow a French astronomer to observe the transit from the tip of the Baja California peninsula. Catherine the Great ordered the Imperial Russian Academy to make observations from points in Siberia, the Urals and the Arctic, and German and Swiss astronomers were invited to help. King Christian VII of Denmark and Norway invited the Jesuit astronomer Maximilian Hell to travel from Vienna and make observations from Vardö in the extreme north of Norway.[159] And the British crown helped to finance the Royal Society's expedition, led by Captain James Cook, to the newly discovered island of Tahiti. (The government was further motivated by hopes for new commercial opportunities and, above all, for the discovery of the great southern continent which, it was still thought, must exist as a counter-weight to the Eurasian land-mass, and which it would be important to colonize before another European power – notably the Spanish with their base in South America – reached it.[160]) Altogether, some 150 observations of the transit were made, from California and Tahiti to Manila and Yakutsk, and though they did not reach an altogether conclusive result, they greatly reduced the range of probable measurements.

These journeys could be extremely arduous, and success was far from guaranteed. Cook and his companions were away for three years. Guil-laume Le Gentil spent eleven years travelling in Asia; when he tried to

observe the transit from the French fort of Pondicherry, a cloud suddenly blocked his view at the crucial moment.[161] Hell was almost shipwrecked off the Norwegian coast. Very often the astronomers had to build their own observatories. However, they acquired new knowledge in many fields besides astronomy. The Cook expedition included the naturalists Joseph Banks and Daniel Solander (the latter a pupil of Linnaeus), who were to investigate the natural history of these unknown lands. Hell and his assistant whiled away the Arctic winter by studying the languages of the Lapps and Finns, discovering that they resembled Hungarian and thus belonged to what later philologists would call the Finno-Ugric language group. Le Gentil made a study of ancient Hindu astronomy by examining the calculations, carved on stones that he believed to be older than the Flood, made by the Brahmins so that (in his opinion) they could overawe the people by predicting eclipses of the sun and moon.[162]

The study of the earth was, if anything, more difficult than the study of the heavens. The orthodox assumption was that the history of the earth was reliably recounted in the Book of Genesis. The best attempt at a more precise chronology was considered to be that presented by James Ussher, archbishop of Armagh, in his *Annales Veteris Testamenti* (*Annals of the Old Testament*, 1650), which gained added authority when Ussher's dates were included among the notes to a new edition of the King James Bible in the 1650s. This was a work of historical scholarship, comparing and trying to reconcile information about datable events, including astronomical events such as the appearance of comets, in Latin, Greek and Hebrew sources. Ussher dated the Creation to the eve of 23 October 4004 before the Christian era.[163] It was assumed that human life must be as old as the earth, not only because Genesis tells of the creation of Adam and Eve, but also because it would have seemed pointless for God to create the earth without humans to inhabit it.

Biblical chronology faced two difficulties. One was that other cultures offered alternative – and sometimes much longer – chronologies: those of Egypt, Babylon and China. The other was the existence of fossils. Were they inorganic rock formations that happened to resemble organic objects? Or were they organic in origin? But if so, how did they come to be found on hillsides?

To answer these questions, the new science of stratigraphy, the study and relative dating of rock layers, came hesitantly into being. Its seventeenth-century progenitor, Niels Stensen, known as Nicolas Steno, examined fossils found in the stratified rocks of Tuscany, and argued that fossils were the remains of living beings trapped and petrified within layers of rock that had been deposited as sediment on the ocean floor.[164] Their

presence on hillsides he attributed to some kind of subterranean upheaval. Steno's theory was developed by John Woodward, who in his *Essay toward a Natural History of the Earth* (1695) argued that fossiliferous strata dated from the Flood, and the fossils they contained were living beings from the period before the Flood. The earth had been churned up and arranged in various strata.[165] Thus it became possible to understand strata as sequential deposits.

Leibniz developed this idea in *Protogaea* (written in 1694, published posthumously in 1749), which was intended as part of the history of the Guelf dynasty, including his employers, the dukes of Brunswick-Lüneburg, which he was commissioned to write in 1685.[166] He maintained that the earth had originally been an incandescent mass, the surface of which had cooled and solidified, leaving the crust on which we live around a global core of fire, which is manifested occasionally in volcanic eruptions. The fire pushed humidity into the air, which condensed and filled the larger cavities on the earth's surface with seas and lakes. The seas were afterwards reduced by evaporation, at which point a sequence of strata containing fossils was laid down. Leibniz intended his explanation to be compatible with Genesis: 'the separation of light from darkness indicates the fusion caused by fire; and the separation of wet from dry signifies the effects of inundations'.[167]

It hardly seemed possible, however, that such processes had occurred within a period of a few thousand years. In the first volume of his *Histoire naturelle* (*Natural History*, 1749) Georges-Louis Leclerc, Comte de Buffon, accepted the conventional chronology, arguing that existing physical processes sufficed to explain all the geographical changes indicated by the position of fossils on land.[168] Later, however, in *Les Époques de la nature* (*Epochs of Nature*, 1778), Buffon accepted the speculations by Leibniz and others that the earth had been originally hot and had cooled down. Buffon tried to put Leibniz's speculation about the earth's central fire on an experimental footing. He experimented with heating and cooling iron balls in a cellar remote from solar heat. From their rate of cooling, he extrapolated the length of time the earth would have taken to cool from incandescence, and calculated that the earth had taken 74,832 years to reach the temperature of the present, though he also admitted that a million or more years might have been required.[169] To make his theory compatible with the seven days of creation in Genesis, Buffon interpreted the 'days' of Genesis as seven epochs, or long periods of time.[170] The seventh epoch, the world as it is now, followed six epochs of gradual creation, which lay outside biblical chronology, so that the historical chronology of biblical events need not be questioned.

The *philosophes* were mixed in their responses to these arguments. Voltaire did not like the idea that the world might have undergone great

changes. In the paper he sent to the Accademia della Crusca in 1746, he challenged the view that changes of the earth's surface could be inferred from fossils. There was no good reason, he asserted, to suppose 'that the ocean ever covered the habitable earth for a long time, and that human beings once lived where today there are porpoises and whales'.[171] Nor need one imagine that seashells had been carried up into mountains by violent upheavals; he suggested instead that ammonites or serpent stones were really petrified snakes, and that small shells found in the mountains of France and Italy had been dropped by pilgrims and Crusaders.[172] He also affirmed that all species had remained the same. (After all, if, as Voltaire seems to have believed, the world had been wisely constructed by a God who subsequently left it alone, why and how could it have been drastically changed?) Diderot was more open-minded. Since individuals passed through a cycle of growth, decay and death, why should not entire species do the same? But if species were not constant, and had not, as the Bible assured us, been created in their present form, could there be any natural science? Could philosophy say anything valid about a natural world that was in continual flux?[173]

Most thinkers in the late eighteenth century were prepared to accept that the earth might be far older than biblical chronology suggested, though Buffon's 75,000 years remained the upper limit that could easily be imagined. They found it difficult to accept that species might become extinct. Neither the divine economy nor that of nature could permit such waste. Hence Thomas Jefferson thought that since mammoth bones had been found in America, mammoths must still exist in unexplored regions to the north: 'Such is the œconomy of nature, that no instance can be produced of her having permitted any one race of her animals to become extinct; of her having formed any link in her great work so weak as to be broken.'[174]

The Enlightenment view of a stable earth created as a home for human-ity received its death blow from the zoologist Georges Cuvier. His starting-point was the evidence that species had become extinct. In a paper of 1796, 'On the species of living and fossil elephants', Cuvier compared the skeletal anatomy of different specimens and demonstrated that the Indian and African elephants were distinct species and that both were different from the fossil elephant or 'mammoth' found in Siberia.[175] He pointed out that the fossilized bones of existing species were found mainly in recent rocks, while deeper strata contained the bones of creatures now extinct. Besides, the more ancient deposits were askew and fractured, thus bearing witness to some elemental violence which had hurled them there. In his best-known work, he summed up his argument that the earth had undergone a series of violent upheavals involving floods:

Hence life on this earth has often been disturbed by appalling events. Innumerable living beings have fallen victim to these catastrophes; some, inhabitants of dry land, have been swallowed up by deluges; others who peopled the bosom of the waters have been left high and dry by sudden elevations of the sea floor; even their races have vanished for ever, leaving nothing in the world but some remnants which the naturalist can barely recognize.[176]

The theory of geological catastrophes had yet further implications. Not only did such events have to be imagined in a vast, barely conceivable time-scale. An earth subject to such convulsions could hardly have been designed as a home for humanity. It was a shifting, unstable surface on which human beings lodged insecurely. The replacement of biblical chronology, however modified, with 'deep time' was a shock every bit as great as that delivered, later in the nineteenth century, by Darwin's theory of evolution. Revolutions in the deep history of the earth could easily seem analogous to political revolutions. The new era inaugurated by the French Revolution was stamped by the memory of both natural and human violence.

## SCIENCE AND
## THE ENLIGHTENMENT PUBLIC

In the Enlightenment, however, these alarming consequences were not yet apparent. Science was a subject of widespread fascination. Far from being the preserve of a few researchers or research institutions, it was highly visible, and attracted a wide public.

Scholarly academies, first of all, were public institutions. Some, like the Royal Society, were founded by private individuals. The earliest such academy, the Accademia del Cimento in Florence, was founded in 1657 by a group of natural philosophers who sought to carry on Galileo's experimental and mathematical approach to science.[177] They were supported by Prince Leopoldo of Tuscany, who provided them with quarters in the Pitti Palace, obtained sinecures for them and paid for their instruments, but always insisted that he attended their meetings as an academician, not a prince. Although the Accademia aspired to the certain knowledge guaranteed by geometry, its members recognized that geometry soon had to give way to the inductive and experimental reasoning proclaimed in their motto, *provando e riprovando* ('testing and retesting'). The Accademia broke up around 1667. The Swedish Academy of Sciences, founded in 1739, was an institution, like the Royal Society, financed by

its members. At its first meeting the founders, who included Linnaeus as its first president, resolved that the proceedings should be published as a quarterly journal written not in Latin but in Swedish, so as to be accessible to the people.[178] In order to ensure some international recognition, however, a version was also produced in German.

Elsewhere, however, academies were part of the royal bureaucracy. Thus the French Académie des Sciences was founded in 1666 by Louis XIV's finance minister Colbert to promote the study of natural philosophy and its practical applications. Although the crown paid for salaries and instruments, most members, unless they had a private income, needed to supplement their salaries by teaching in a state military or technical school, advising on the mint or the mines, or writing for encyclopaedias.[179] Dedicated to collective research and unprejudiced inquiry, the Académie excluded Cartesians and Jesuits because these had ideological commitments that prevented them from being open-minded. The French Academy in turn provided a model for the Berlin Academy, founded by the king of Prussia in 1700, but it was underfunded and relatively obscure until Frederick the Great reformed it in 1746. It consisted of four classes: experimental philosophy, mathematics, speculative philosophy and literature. State-sponsored academies could afford to recruit scientists of international repute. Thus, Frederick tempted Maupertuis from Paris as president. Peter the Great of Russia, shortly before his death in 1725, set up the Academy of Sciences of St Petersburg.[180] He failed to secure the philosopher Christian Wolff (generally recognized as the intellectual heir of Leibniz) as its head, but did manage to recruit the great Swiss mathematician Leonhard Euler, until Frederick lured him to Berlin with a better offer in 1741.[181]

Academies were devoted to research, not teaching. It was considered that they should complement universities by doing original research, whereas universities concentrated on transmitting what was already known.[182] However, academies communicated with the public in numerous ways. They announced prizes for the best essay on some philosophical question. Thus Voltaire, as we have seen, entered the competition announced by the Académie des Sciences for the best essay on the nature of fire. Academies tried to publish their proceedings, though often long after the original papers had been presented. The delay between presentation and publication averaged eighteen months for the *Transactions* of the Royal Society, two years for the *Mémoires* of the Berlin Academy, three and a half for those of the Paris Academy, and five years for the St Petersburg proceedings.[183] However, the result was a proliferation of academic papers, which made it harder to keep up with research.

The Paris Academy began reaching out to a wider public after 1697,

when it acquired as its secretary Fontenelle, author of the famous and much-read work of popular astronomy *Conversations on the Plurality of Worlds* (1686). In 1699 Fontenelle started a publishing programme and a series of public meetings, which linked the Academy to the salon culture in which he moved.[184] On his retirement after forty-four years in post, he recalled that when he became secretary, the then minister, the abbé Bignon, 'wanted to see the taste for science spread in society' instead of using, as in ancient Egypt, 'a certain sacred language which was understood by its priests alone'.[185] The allusion to Egypt is significant, for it implies that those who wish to confine science to specialists resemble priests who want to keep their mysteries hidden from an awestruck public, and thus recalls the polemics against 'priestcraft' that Fontenelle had conducted in his *Histoire des Oracles* (*History of Oracles*, 1687). After Fontenelle died, at the age of one hundred, he received this tribute: 'It was reserved to Fontenelle to generalize the work of Bacon and Descartes, to ... make reason a common thing, to introduce and establish it in all *genres* and in all minds.'[186]

An important way of popularizing science was to conduct experiments before an audience. The Royal Society often held experiments in venues accessible to an audience who paid to view them. These experimental demonstrations and lectures were a recognized and well-attended form of public entertainment. They were intended not just to gratify a taste for novelty, but to spread the principles of Newtonianism and to convey the rudiments of natural philosophy. They were often held in coffee-houses, which provided a venue and a ready-made interested public. Members of the Society frequented coffee-houses such as the Grecian Coffee House in Devereux Court in the Strand, and Child's in St Paul's Churchyard.[187] William Whiston, Newton's successor as Lucasian Professor of Mathematics at Cambridge, having been dismissed for his disbelief in the Trinity, became a lecturer in London, expounding Newtonianism to audiences which included Alexander Pope.[188] Before the eclipse of the sun on 11 May 1724, Whiston lectured on the solar system at two coffee-houses, and on the day itself he explained the event with the help of an orrery to an audience who paid half a guinea to hear him.[189] Thus he contributed to the banishment of superstitious fear and its replacement by scientific understanding.

Public lectures also had practical implications. Those by the Newtonian mathematician John Harris, advertised in 1705 as dealing with 'the principles of true Mechanick Philosophy', were aimed particularly at investors in shipping and hence focused on the problems of navigation.[190] A popular subject was the search for a means of determining longitude at sea, which was solved only by John Harrison's invention of the marine chronometer,

recognized in 1773.[191] Experimental lectures were held also in the provinces: at fashionable resorts such as Bath and Scarborough, and in places such as Spalding and Newcastle that had societies devoted to the increase of scientific knowledge, and whose members included local businessmen and mine-owners.[192]

The Newtonian John Desaguliers, elected to the Royal Society in 1714, was particularly effective in mediating between scientists and the lay public. Members of the Society even complained that he held so many experimental demonstrations in public lectures that he gave too few for the Society.[193] As a missionary for Newtonianism, Desaguliers spread the gospel to the Continent. In March 1715 he performed experiments for members of the Dutch embassy, including Willem 'sGravesande, who, after being appointed professor of natural philosophy at Leiden in 1717, 'effectively translated the *Principia* into experimental terms', demonstrating Newton's theories of gravitation, optics and associated topics to the public.[194] Desaguliers also lectured to ambassadors from Spain, Sicily, Venice and Russia, and toured the Netherlands twice in the 1730s.

Experimental demonstrations were popular also in France. Pierre Polinière, a leading advocate of experimental methods, demonstrated the principles of physics around 1700 to students at the University of Paris, and increasingly also to the general public. In 1722 he performed experiments in the presence of the young King Louis XV. Voltaire complained in 1735 that the Parisian fashion for 'philosophy' threatened to destroy interest in poetry: 'everyone wants to be a geometer or a physicist'; if a Frenchman of Louis XIV's time could find himself in Paris now, 'he would think that the Germans had conquered the country'.[195]

The danger with public experiments was that their complicated and perplexing machinery and their spectacular results could look suspiciously like the tricks of travelling mountebanks, sword-swallowers and the like. Enlightened scientists therefore were anxious to avoid any appearance of charlatanry and to demystify science as much as possible. Musschenbroek warned that some experimenters got carried away into thinking they saw such curiosities as microscopic beings with human features.[196] Nollet advised that as soon as an experiment was over, the experimenter should explain to the audience how the effect had been achieved: 'our first concern must be to teach, to enlighten (*éclairer*), not to cause surprise or puzzlement'.[197]

Those with no opportunity to see science being demonstrated could read about it. The Enlightenment saw a large number of publications in popular science. The monthly *Gentleman's Magazine*, founded by Edward Cave in 1731 to supply miscellaneous information, devoted almost a fifth of its

articles to scientific subjects, including many reports taken from the proceedings of the Royal Academies of France, Sweden and Russia. In 1749 alone, readers could find out about marine life, electricity, the anemometer (an improved barometer which also chimed like a watch), a new water-bellows invented in Sweden, a recent eclipse of the sun observed from the north of Scotland, and the physical geography of Siberia and South America. These short essays were quite demanding to read, since the technical detail supplied made no concessions to those ignorant of mathematics. The reports on astronomical phenomena often consisted simply of observations in numerical form. Mathematics was so popular with readers that Cave established another journal entirely devoted to it, entitled *Miscellanea Curiosa Mathematica*, which ran from 1745 to 1753.[198]

Many scientific publications were aimed at female readers. This market – intelligent, underemployed women eager for intellectual stimulus – was first identified by Fontenelle with his *Conversations*, in which an astronomer chats with a marquise about the Cartesian model of the universe. Fontenelle was looking especially for readers who would make an interest in science fashionable.[199] He succeeded. A later popularizer, the Venetian nobleman Francesco Algarotti, prefaced his *Il newtonianismo per le dame* (*Newtonianism for Ladies*, 1737) with a tribute addressed to Fontenelle: 'Your *Plurality of Worlds* first softened the savage Nature of Philosophy, and called it from the solitary Closets and Libraries of the Learned, to introduce it into the Circles and Toilets of Ladies.'[200] Fontenelle's *Conversations* provided a model, for example, for John Harris's *Astronomical Dialogues between a Gentleman and a Lady* (1719), presented in what Harris calls a 'pleasing and agreeable' style, illustrated with plates showing commercially available objects, such as terrestrial and celestial globes and the orrery, and containing instructions for their use.[201] Maupertuis followed the example of Fontenelle by publishing, after a comet appeared in March 1742, a popular exposition of astronomy, addressed to a fictional female reader.[202] Voltaire made a serious study of Newton, helped by his companion Émilie du Châtelet, who translated the *Principia* into French. Having given a brief sketch of Newtonianism in his *Lettres philosophiques* (1734), Voltaire offered a fuller account in his *Élémens de la philosophie de Newton* (*Elements of Newton's Philosophy*, 1738), which gained him membership of the Royal Society. Women could also be instructed through periodicals. An annual mathematical magazine for women, the *Ladies' Diary*, was founded in 1704 by the Coventry schoolmaster John Tipper and ran until 1840. Besides articles on cookery, diet and childcare, it reported on scientific discoveries, such as the astronomical observations made by Edmond Halley.[203]

Science could also be communicated to children. Followers of Locke were aware that knowledge comes through the senses, and that practical examples were the best way of teaching. Nollet, as private tutor to the dauphin, knew that abstract principles could best be conveyed with the help of 'interesting experiments'.[204] William Hooper's *Rational Recreations* (1774) offered four volumes of curious tricks that could be performed with simple, home-made optical, electrical and pneumatic apparatus – enough to entertain children on many wet afternoons and instruct them in basic scientific principles (though some, especially those involving fireworks, look distinctly dangerous).[205] Children could thus apply the knowledge pleasantly imparted in John Newbery's *Newtonian System of Philosophy* (1761), in which a philosopher called Tom Telescope lectures to children on the principles of matter and motion (illustrated by whipping a top), the solar system, the air, physical geography, the animal, vegetable and mineral kingdoms, and the five human senses and the understanding. An up-to-date scientific comprehension of the world is combined with undogmatic piety and illustrated with drawings and diagrams. The children are allowed to look through a telescope at the 'fixed stars', and learn that each star is in all likelihood a sun, surrounded by planets which are populated by living beings, 'all intended to magnify the Almighty Architect'.[206] Tom Telescope is a good Enlightener who finds physical science compatible with the basic principles of Christianity.

## THE HARMONY OF SCIENCE AND RELIGION

The pursuit of scientific knowledge thus corresponded to the Enlightenment goal of improving the human condition. 'There is no subject so worthy of a rational creature,' says Tom Telescope, 'except that of promoting the happiness of Mankind.'[207] Enlighteners asserted that science, by enabling us to understand our surroundings better, increased our happiness by allowing us to feel at home in the world. Lessing, in a philosophical poem of 1748, made this claim with particular reference to astronomy:

> Der Himmel Kenner sein, bekannt mit Mond und Sternen,
> Ihr Gleis, Zeit, Größ und Licht, durch glücklichs Raten, lernen:
> Nicht fremd sein auf der Welt, daß man die Wohnung kennt,
> Des Herrn sich mancher Tor, ohn ihre Einsicht, nennt.[208]

[To know the heavens, to be familiar with moon and stars, to learn their paths, times, size and light, by lucky guesses; not to be a stranger in the

world, and to know the dwelling of which many a fool calls himself the master without understanding it.]

Some forty years later, in his dialogue *Gott: Einige Gespräche* (*God: Some Conversations*, 1787), Herder gives the more authoritative speaker, Theophron, an eloquent defence of science. Science increases our happiness by revealing the regular laws by which nature operates. 'Senseless fear' of cosmic catastrophes vanishes once astronomers' calculations have assured us that the danger of a comet striking the earth is infinitesimally small. Rational calculation inspires 'clear and joyful confidence' in God's goodness and wisdom. Even occasional irregularities in the motion of the heavenly bodies should not worry us:

> A clearer view of the matter suffices to banish groundless terror, since it has been discovered that even these irregularities balance each other out. Beneficent, beautiful necessity, under whose universal sceptre we live! It is the child of supreme wisdom, the twin sister of everlasting power, the mother of all goodness, happiness, security and order.[209]

For the Enlightenment, scientific knowledge was the enemy of superstition, but not of religion: only of the false beliefs that often flourished under the aegis of religion. It would be a mistake to project back onto the eighteenth century the conflict between science and religion that was waged in the nineteenth. The bitterness of that conflict is apparent from the much-read work, *A History of the Warfare of Science with Theology in Christendom* (1896), by Andrew Dickson White, the first president of Cornell University, who encountered fierce opposition in trying to establish a secular university that was not linked to any religious denomination. But it resulted from a hardening of religious attitudes in the early nineteenth century. Evangelical Protestantism, especially in Britain and America, tried to ignore or deny advances in the historical study of the Bible by insisting on the Bible's literal truth.[210] A reinvigorated Roman Catholic Church reasserted the authority of the papacy. In 1864 Pius IX issued the *Syllabus of Errors*, which condemned rationalism, socialism, religious freedom and any separation of Church and state; the last of its eighty propositions denied that 'the Roman Pontiff can and should reconcile himself with progress, liberalism, and recent civilisation'.[211] Both camps were hostile to science. 'Between 1750 and 1870 – from the publication of the *Encyclopédie* to the early work of Nietzsche and of Darwin's *Descent of man* – the relationship of science and religion in the western world passed from fruitful co-operation and modest tensions to harsh public conflict.'[212]

White's antithesis between science and religion has to be modified with respect to the Enlightenment. Certainly, many people still regarded the world as the arena of God's activity. To others, it was becoming no less obvious that the natural world was governed by intelligible laws, with God still present but only in the remote background. In the 1790s the satirist Georg Christoph Lichtenberg captured the clash of outlooks in his well-known aphorism: 'That sermons are preached in churches doesn't mean the churches don't need lightning-conductors.'[213] A professor of physics at Göttingen, Lichtenberg followed the development of the lightning-rod with keen interest and in 1794 installed one on his house, describing it as a 'fear-conductor'.[214] Its presence freed him not only from danger but also from worry.

If we are tempted to see the lightning-rod as symbolizing the triumph of science over religion, we shall be brought up short by the fact that many of its scientific advocates were priests. The Catholic priest Prokop Diviš, living near Znaim in what is now the Czech Republic, appears to have invented the lightning-rod independently of Franklin; he installed one on his vicarage in 1755.[215] The first lightning-rod in Austria was put up in 1778 by Father Dominikus Beck, a professor at the Benedictine university of Salzburg, who also wrote several books explaining electricity to the general public.[216] Enlightened Catholics like Diviš and Beck did not rule out God's occasional intervention in the world, but they thought that most of the time the world proceeded according to regular and intelligible laws that God had laid down at its creation. No contradiction was felt between religious belief and the scientific investigation of the natural world.

Initially at least, Enlightenment thinkers were not concerned to attack religion, but to find ways in which practitioners of different religions could exercise tolerance towards one another's beliefs. The religious wars of the sixteenth and seventeenth centuries were as painfully vivid in collective memory as the First and Second World Wars are today. The next challenge was to reconcile the claims of religion with recent advances in philosophy and science, by promoting enlightenment within the Churches. That meant transferring the emphasis from dogmatic and rationally untenable theological assertions to moral teaching and pastoral care. Finally, even the modified claims of theology had to come under scrutiny. Their intellectual and historical basis proved vulnerable to sustained rational inquiry. Some Enlighteners, like Voltaire, rejected theism in favour of deism, the belief in a benevolent God who had created the universe and thereafter left it alone. Others, though not many, turned to outright atheism, or to new forms of heterodox belief. These developments will be the subject of the next three chapters.

# 3
# Toleration

People in the late seventeenth century were still aware of the religious wars that had raged during the previous hundred years in France, England, Ireland and Germany. The French Wars of Religion, in which Catholics and Huguenots (Calvinists) fought each other intermittently from 1562 to 1598, were remembered as a period of desolation. The Thirty Years War in Germany (1618–48) killed a third of the population. Although during the English Civil War both sides tried to observe the laws of war, atrocities nevertheless occurred, especially towards prisoners who had surrendered, while towards the Irish restraint was considered unnecessary.[1] Such events were not only recorded in books, pamphlets and songs, but in images, such as Frans Hogenberg's pictorial histories of persecution of Protestants in France and the Netherlands and Jacques Callot's etchings *Les Grands Misères de la guerre* (*The Miseries of War*, 1633). One must consider also the effect of innumerable tales of individual suffering passed down through families.[2]

Some particularly notorious atrocities were preserved in collective memory by their names or nicknames. The murderous rampage by Spanish troops in occupied Antwerp in November 1576 was remembered as the 'Spanish Fury'.[3] The massacre of French Protestants over three days in August 1572 gained the label 'St Bartholomew's Night'. The horrors of the Thirty Years War were epitomized in the siege and sack of Magdeburg in 1631. Oliver Cromwell's campaign in Ireland was summed up by the name Drogheda, the town where the entire civilian population was massacred in 1649.

The numbers of victims in these events are staggering; the imagined numbers still more so. Modern historians agree that in the St Bartholomew massacre some 2,000 Huguenots were killed in Paris and another 3,000 in the provinces.[4] At Magdeburg, where 1,700 out of 1,900 houses were destroyed by fire, some 20,000 civilians and defenders fell victim to the fires or to the uncontrollable enemy soldiers.[5] In many cases the number

of victims was swollen by rumour and terror. Contemporaries claimed that as many as 18,000 people were slaughtered in Antwerp, though the death toll may have been in the hundreds. Cromwell's brutality was seen in part as retaliation for the Irish uprising against Protestants in 1641, which found perhaps 2,000 victims, though horrified contemporaries spoke of far greater numbers.[6] In his *History of England* David Hume notes that the victims were sometimes estimated at 150,000 or 200,000, though he himself thinks 40,000 a more plausible (though still possibly exaggerated) figure.[7] Friedrich Schiller in his *Geschichte des Dreißigjährigen Krieges* (*History of the Thirty Years War*, 1791–3) cites an estimate of 30,000 killed at Magdeburg, and calls the city's fate 'a massacre for which history has no language and poetry no pencil'.[8] For collective memory the imagined number of victims and the overall impression of horror are more important than the real number as estimated by modern demographers.

All these conflicts – Catholic Spain against the newly Protestant Netherlands, Protestant England against Catholic Ireland, Catholics versus Huguenots in France, Protestant armies afflicting Catholic populations (and vice versa) in Germany – were religious in origin. By the onset of the Enlightenment, therefore, it was increasingly felt that ways must be found for adherents of different religions to live together, if not harmoniously, then at least without open conflict. Hence a major theme of the early Enlightenment, in particular, is the search for toleration. It must be remembered, though, that institutional toleration was often a by-product of political settlements with other aims; and that, even when toleration was established between large religious groups, smaller groups were often still subject to discrimination and even persecution.

The Dutch invasion of England, which brought about the Glorious Revolution of 1688 by replacing James II with William III, previously stadholder of the Dutch Republic, is traditionally seen as a milestone in the history of religious freedom. Yet the English dignitaries who invited William to invade their country, and the exiles who accompanied his fleet, had been alarmed by James's Declaration of Indulgence, issued in April 1687, which extended toleration to Catholics and suspended the penal laws which had hitherto prevented Dissenters, Quakers and other non-members of the Church of England from openly practising their religion. Hence the unpopular James has been described as 'the most religiously tolerant English monarch since the Reformation'.[9] And the Toleration Act of 1689, while benefiting most Dissenters, would make it illegal for Catholics to practise their religion. So, although the returning exiles included such a prominent advocate of toleration as the Scottish clergyman Gilbert

Burnet, William's personal chaplain, their understanding of toleration was evidently different from what we might nowadays expect.

Religious freedom is generally agreed to be one of the great achievements of the Enlightenment. In present-day Western societies, members of different Churches no longer fight each other. But this is a precarious achievement (as the history of Northern Ireland in the late twentieth century reminds us), and it could easily be lost. Elsewhere in the world, radical believers like those of Islamic State treat people of different faiths as savagely as French Catholics and Protestants treated one another around 1570. So, it is important to look squarely at the complex history of toleration.

## AGAINST TOLERATION

In the nineteenth century, it seemed natural for the rationalist historian William Lecky to tell the story of toleration as the triumph of reason over prejudice and superstition. Lecky acknowledged, however, that this story could be told in two ways:

> In order to understand the history of religious liberty, there are two distinct series of facts to be considered. There is a succession of intellectual changes which destroy the conceptions on which persecution rests, and a succession of political events which are in part the consequence of those changes.[10]

Hence it is tempting to recount this history with an emphasis on ideas. We can identify a series of thinkers, from Erasmus to Voltaire, who advocated toleration on principle. But we might question Lecky's emphasis on these thinkers by arguing that progress towards toleration resulted from a number of pragmatic political actions that were based not on principle, but on the immediate need to resolve conflicts. Where Lecky assigned the motive force to ideas, we might place the emphasis on politics. This is not to belittle Erasmus and his successors, or to dismiss them as voices crying in the wilderness. But it would be difficult to show that their arguments led directly to tolerationist legislation. John Locke's *Letter concerning Toleration*, sometimes supposed to have helped to prompt the Glorious Revolution, was published only after William's invasion, in April 1689. Rather than accept Lecky's claim for the primacy of ideas, therefore, we may suggest that the famous texts on toleration which will receive attention later in this chapter accompanied and strengthened developments that were already, albeit unsteadily, under way.

The concept of toleration, in both theory and practice, has limitations. Toleration is something granted reluctantly. What is tolerated is also

disapproved of. Thus in the Middle Ages prostitution was tolerated, even institutionalized, but not condoned.[11] When Henri IV of France proclaimed the Edict of Nantes in 1598, granting limited freedom of worship to Protestants while keeping Catholicism as France's official religion, this measure was first and foremost a bold exercise in peace-making, not a homage to the abstract virtue of liberty of conscience. It embodied an acceptance that since the Protestants were not going to convert or go away, France would have somehow to live with them. Pragmatism alone, however, is not a strong or lasting foundation for toleration. Pragmatic or – as they were called in the sixteenth and seventeenth centuries – *politique* arguments for toleration were double-edged, for 'religious minorities who lost the capacity to defend themselves by force of arms became in such *politique* accounts legitimately subject to intolerance, since it was their very capacity to disrupt the state which underpinned the case for their toleration'.[12] For toleration to be sustained, principled arguments are necessary too.

Through many centuries, intolerance seemed a virtue. Commenting on the parable in which a wealthy man, whose guests have declined his invitation to a feast, orders his servants to collect people from the highways and byways and 'compel them to come in' (Luke 14:23), St Augustine declared that Christian rulers and magistrates should not persuade, but compel heretics to join the congregation of the faithful. 'Let us come in, they say, of our own good will. This is not the Lord's order, "Compel them," saith he, "to come in." Let compulsion be found outside, the will will arise within.'[13] Once heretics were safely within the Church, they would stop kicking and screaming and appreciate their good fortune. If people were in danger of damnation, it was a Christian duty to rescue them from the terrible consequences of error. To the officials of the Inquisition, eternal punishment was real, and in extreme cases they felt it their painful duty to inflict brief sufferings on the obdurate in order to save them from an eternity of torture.[14]

Persecution from such charitable motives seemed a just and beneficent measure, quite different from the persecution that Christians had suffered from the pagan authorities. It was no kindness to indulge people in error that would lead to damnation. To force them into the true faith was real charity, and, since they would soon come to accept it voluntarily, this method could not really be called compulsion. Besides, it was not sufficient to hold one's beliefs sincerely; they had also to be true beliefs, and in a Christian society truth was readily accessible. Those who denied it must be lazy and perverse, and since they were not suffering 'for righteousness' sake' (Matt. 5:10), they were not really being persecuted and could not claim the moral dignity of martyrs.

Once the Reformation had introduced irreconcilable divisions into the Church, it was widely thought that the answer was not toleration of different views, but intolerance. Social cohesion required that all the inhabitants of a given country should follow the same religion. The turbulent history of the Reformation showed that the coexistence of different religious groups posed a serious threat to civil order. The unity of any Church was already fragile enough: further fragmentation must be avoided at all costs. The heresiographer Thomas Edwards, who composed a description of the sects that arose during the English Civil War, expressed a widespread opinion when he wrote: 'The punishment of Schism is Separation from the Church, is Separation from God, Heresie, Blasphemy, Atheisme, uncleannesse, unrighteousnes.'[15] Edward Stillingfleet, dean of St Paul's, preached in 1680 against 'the Mischief of Separation'. Following St Paul's injunction that all Christians should 'walk by the same rule' (Phil. 3:16), he pointed out that schism in the Church was sinful, immoral and dangerous. It encouraged people to take pride in their differences: withdrawing 'into separate Congregations' could 'tempt some to spiritual Pride and scorn and contempt of others, as of a more *carnal* and *worldly* Church [than] themselves'.[16] Worst of all, by dividing Protestants it risked giving power to their common adversary, the Roman Catholic Church. Hence: 'An *universal Toleration* is that *Trojan Horse*, which brings in our *Enemies* without being seen, and which after a long Siege they hope to bring in at last under the pretence of setting our Gates wide enough open, to let in all our Friends.'[17]

Toleration was also considered wrong in principle, as it implied indifference to divine truth and disregard for ecclesiastical authority. To Edwards, sectarians who demanded toleration were merely seeking liberty to indulge their mistaken opinions by bringing forth 'the monster of Toleration conceived in the wombe of the Sectaries long ago'.[18] Cromwell, taking a broad-minded as well as pragmatic view, repeatedly urged his Presbyterian supporters to extend toleration to their Independent allies: 'He that ventures his life for the liberty of his country, I wish he trust God for the liberty of his conscience, and you for the liberty he fights for.' But the clergy gave him a dusty answer: ' "To let men serve God according to the persuasion of their own consciences," wrote one Presbyterian divine, "was to cast out one devil that seven worse might enter." '[19] In any case, even Cromwell, although he wanted unity among Christians, drew the line at such grave heresies as the denial of the Trinity.[20]

To reach a frame of mind in which apparent error could be tolerated, it was necessary for religion to lose some of the overwhelming, dramatic importance that it had in the Reformation period. For many centuries, differences in religious opinion were seen not just as matters of life and

death, but as eternal in their consequences. The coexistence of Catholic and Protestant practices in the same state seemed no more possible than, during the Cold War of the later twentieth century, a compromise between Communism and capitalism. A member of the contrary faith often seemed as much a public enemy as a Communist in the USA in the 1950s, or a sympathizer with liberalism in the Soviet Union. 'The Continent was confronted with two forms of Christianity – two exclusive religions – each claiming to embody the absolute truth, each asserting itself to be essential to salvation, each regarding the other as a diabolical perversion and a menace to human society.'[21] And when Protestantism fragmented into sects, the sects regarded one another with the bitter antipathy that Freud calls the 'narcissism of minor differences'.[22]

Theologically based intolerance, however, was very gradually undermined by the visible existence of alternative religions. When different religions managed to coexist peacefully for a long period, the visibility of other religions tended to weaken one's conviction of the unique excellence of one's own. The Reformation brought into existence a de facto pluralism, and the legal recognition of dissidents promoted 'at least a measure of grudging acceptance that they were a permanent, if regrettable, presence'.[23] Pluralism on the ground, the coexistence in practice of diverse religious groups, especially if none of them is overwhelmingly large or powerful, is the best way of undercutting belief in the singular salvific power of any one of them. The arrogance that Byron ironically attributes to Anglicans around 1820 –

> I know that all save England's church have shamm'd,
> And that the other twice two hundred churches
> And synagogues have made a *damn'd* bad purchase[24]

– cannot be sustained in a pluralist society. Moreover, pluralism protects believers against the frequent tendency of religious bodies to harden into dogmatic intolerance: one can leave one's church and join, or even found, another.[25]

In a little-noticed passage late in *The Wealth of Nations*, Adam Smith advocates in effect a free market in religions. Instead of a large church, which is a monopoly like the commercial monopolies Smith criticizes elsewhere, there should be 'a great multitude of religious sects'.

> The interested and active zeal of religious teachers can be dangerous and troublesome only where there is, either but one sect tolerated in the society, or where the whole of a large society is divided into two or three great sects; the teachers of each acting by concert, and under a regular discipline and subordination. But that zeal must be altogether innocent where the society

is divided into two or three hundred, or perhaps into as many thousand small sects, of which no one could be considerable enough to disturb the publick tranquillity.

The teachers would learn 'candour and moderation', would have to respect the other sects, and the concessions they would have to make 'might in time probably reduce the doctrine of the greater part of them to that pure and rational religion, free from every mixture of absurdity, imposture, or fanaticism, such as wise men have in all ages of the world wished to see established'.[26] There could hardly be a better formulation of the religious ideal to which most Enlighteners, except the most radical, subscribed.

## PERSECUTION IN FRANCE

In France, as elsewhere, some measure of toleration was introduced piece-meal as a matter of political expediency. Henri IV's Edict of Nantes was the greatest landmark.[27] The Edict allowed complete freedom of conscience (article 6) but said nothing about beliefs: it was focused on the coexist-ence of different religious groups. It did not proclaim universal tolerance. France remained a Catholic country. Catholics were allowed freedom of worship everywhere, Huguenots only in those areas that they already con-trolled. Huguenots were obliged to observe Catholic holidays, obey Catholic laws regarding marriage and contracts, and submit every book they printed to censorship. Fair legal treatment of Protestants was ensured by the bi-partisan chambers (*chambres mi-parties*) provided for in every *parlement*. Henry shared the pragmatic outlook of the statesmen known as *politiques*, such as the Huguenot leader Philippe Duplessis-Mornay. The *politiques* were not advocates of toleration, but included moderate Catholics who accepted, reluctantly, the need to grant the Huguenots rights for the sake of national concord.[28] Duplessis-Mornay, speaking of the Netherlands, stressed the need for 'not interfering with each other's freedom of conscience and religious practice in all these lands, since we all wish to live here in liberty'.[29] Cardinal Richelieu, who became first minister under Louis XIII in 1628, was *poli-tique* in his government of France. He wanted to destroy Protestant military power within France – hence his siege of the Huguenot stronghold of La Rochelle in 1627–8 – but he chose many advisers and agents from the Hugue-not party. He refused to suppress Protestantism, saying: 'the conversion of the Reformed is a work we must await from Heaven.'[30]

Ordinary relations between Catholics and Protestants gave many grounds for mutual hatred. Protestants were better educated, most homes possessing

a Bible, and tended to look down on Catholics. 'Catholics, encouraged by their clergy, envied and hated Protestant arrogance, the pride which caused them to keep their hats on when processions passed, and to refuse to kneel in church, pray for the intercession of saints, or go on pilgrimages and keep fasts.'[31] Moreover, Huguenots were rarely trusted. Their opponents felt that if they acted differently and worshipped differently, they might also think differently on political as well as religious matters and give their first loyalty to Protestant states, rather than to France.

During the later seventeenth century the protections given to Protestants by the Edict of Nantes were gradually eroded. In 1662 Protestant burials were forbidden during daylight hours. In 1669 the bi-partisan tribunals in the *parlements* of Toulouse and Grenoble, set up by the Edict, were abolished. In 1680 all marriages between Protestants and Catholics were declared invalid; all conversions from Catholicism to Protestantism were forbidden; Protestant women were forbidden to become midwives. Between 1679 and 1683 Protestants were excluded from nearly all legal professions, and in 1685 from the practice of medicine. In 1681 Louis XIV authorized the use of *dragonnades*: soldiers, previously billeted on tax-evaders as a punishment, were now quartered on Protestants, sometimes fifteen or more soldiers to a single household. The presence of such soldiers, who were officially encouraged to be licentious and destructive, was enough to force many insincere conversions. What *dragonnades* meant emerges from the atrocity stories recounted by the Huguenot leader Pierre Jurieu: here is one, by no means the worst:

> An Eye-Witness hath written to me, that in a Village of *Poictou*, called Gods Town *Dannai*, an honest Man called M. *Palmenteir*, after having suffered all the first violence of the Dragoons, to wit Blasphemies, Threatnings, Plundering of all his Goods and other things of like nature, not yielding as you shall understand, and in conclusion dyed amidst the torments.[32]

Encouraged apparently by the archbishop of Bordeaux, who entered Palmenteir's house for reasons not explained, the soldiers pulled the old man, who was crippled with arthritis, out of his bed:

> They dragged him to the floor, they applied an Iron Plate red hot to the bottom of his Feet, and to his Hands. In this torment he uttered dreadful cries; the Archbishop in the Chamber above laughed at it and diverted himself with it. The Wife of the said *Palmenteir* came to the succour of her Husband, they knocked her down with blows of their Daggers, and the butt end of their Pistols: she fell into a Swoon. In this estate they bathed her with two or three Buckets of Water.[33]

The archbishop persuaded Palmenteir to promise to take Catholic instruction; as the latter could not write with his burned, arthritic hands, the archbishop signed for him, but Palmenteir died within a few days.

Huguenots were forbidden to escape this oppression by emigration; the many who defied this ban had their goods confiscated. Several Protestant places of worship (*temples*) were demolished on some pretext every week. These measures produced many conversions, but the number of converts was exaggerated by Louis XIV's ministers, so that he believed that the revocation of the Edict of Nantes was a formality that would affect hardly anyone.[34] The revocation was enacted by the Edict of Fontainebleau in October 1685. The public exercise of the Reformed religion was banned. Children of Protestants had to be brought up Catholics. Pastors had to convert within two weeks or emigrate. Anyone else who tried to emigrate would be punished: men by service in the galleys, women by the confiscation of all their worldly goods. Nevertheless, some 200,000 Huguenots did manage to emigrate, depriving France of an economic, social and intellectual elite. The great majority of the emigrants moved to sympathetic Protestant countries – some 100,000 to the Dutch Republic, the rest to Britain and Brandenburg-Prussia.[35] Worries about their loyalty proved self-fulfilling: the Camisards, Protestant peasants of the Cévennes, enraged by a campaign to convert them by force, rose in revolt and, by guerrilla tactics, held the royal troops at bay for two years (1702–4) until the leaders surrendered and emigrated.

The Huguenots who fled France were the original refugees. The word *refugié*, applied to them, had been anglicized as 'refugee' by 1695. Their settlements abroad were called Refuges. Those who remained in France often underwent a nominal conversion to Catholicism but continued to practise their own religion secretly, as converted Jews were said to have done in Spain. They survived more readily in the rural south than in the more urban north, but their position was always uncertain, dependent on the willingness of local priests and magistrates to turn a blind eye. Their situation was modified by a half-hearted Edict of Toleration, issued by Louis XVI in 1787, which allowed Protestants to marry and to own and inherit property, but still denied them their own worship and debarred them from public office.

Jews had been expelled from France in 1394, but by the early eighteenth century there were substantial communities of Sephardic Jews from Portugal in south-west France, and of Ashkenazi Jews around Metz in the east.[36] They received de facto toleration, being allowed to maintain synagogues, largely because of their commercial and financial usefulness to the state. All these restrictions on Protestants and Jews were finally swept

away by the Declaration of the Rights of Man and the Citizen, whose tenth article stated: 'No one should be disturbed for his opinions, even in religion, provided that their manifestation does not trouble public order as established by law.'[37]

## TOLERATION IN THE DUTCH REPUBLIC

The seven provinces established in 1581 as the United Provinces of the Dutch Republic were widely seen as pioneers of toleration. Although the Calvinism of the Dutch Reformed Church was made the established religion of the Republic in 1583, other religions were allowed to coexist. Visitors to the Republic sampled the services on offer in various churches, meeting-houses and synagogues with curiosity, often with disapproval. One who did approve of Dutch toleration was Sir William Temple, English ambassador at The Hague from 1668 to 1670, who published in 1673 an account of the United Provinces in which he praised the tolerance practised there:

> Since this Establishment [of the Reformed Church], as well as before, the great care of this State has ever been, To favour no particular or curious Inquisition into the Faith or Religious Principles of any peaceable man, who came to live under the protection of their Laws, And to suffer no Violence or Oppression upon any Mans Conscience, Opinions broke not out into Expressions or Actions of ill-consequence to the State.[38]

A slender majority of the population were Calvinists. Catholics suffered many restrictions. They were not allowed to hold public office or to build their own churches, but, as Temple noted, their worship was connived at in return for payment, and could be held in buildings that were not recognizable as churches.[39] This system of connivance, or turning a blind eye, was actually advantageous to minorities, because it saved them from the government monitoring to which the Dutch Reformed Church was subject. Nevertheless, what the government regarded as connivance felt to Catholics like persecution: it was a very limited liberty that allowed them to attend Mass only in private houses and usually under cover of darkness. Even so, missionary activity by Catholic priests, working closely with laypeople, brought about so many conversions that by 1656 the Catholic proportion of the adult population had increased in some provinces to a third.[40] The United Provinces offered a home, admittedly with varying restrictions, to so many religious groups that it seemed to Temple like a museum of forgotten sects: 'almost all Sects that are known among

Christians, have their publique Meeting-places; and some, whose names are almost worn out in all other parts as the Brownists, Familists, and others.'[41]

The Brownists were an English Puritan group originally led by Robert Browne (d. 1633). Their name is held up to scorn by the right-thinking Sir Andrew Aguecheek in Shakespeare's *Twelfth Night*: 'I had as lief be a Brownist as a politician' (III.ii.35). Differing from the doctrines of the Church of England, and unwilling to attempt reformation from within like the Puritans, they separated from the Church and settled in the Netherlands. Together with some later separatists, they formed the majority of the Pilgrim Fathers who sailed to New England on the *Mayflower* in 1620. Whether Temple could have encountered Familists, however, is very uncertain. The Familists, or Family of Love, were a group founded in the 1540s by a mystically inclined Dutch merchant, Hendrik Niclaes, who told his followers – who included the painter Pieter Breughel the Younger – that they were filled with the divine spirit. They had probably ceased to exist as a sect on the Continent by 1610, though they lingered longer in Britain: the diarist John Evelyn writes in 1687 that a petition had been presented to James II by 'some of the Family of Love', 'a sort of refined Quakers', numbering about sixty and living mainly in the Isle of Ely.[42]

Temple notes that the Arminians are prominent, belonging especially to the educated classes, though not numerous. They were followers of Jacobus Arminius (Harmenszoon, 1560–1609), a professor at Leiden, who differed from orthodox Calvinism by pointing out that its belief that all men's lives and fates were predestined by God implied that God was responsible for evil. Instead, Arminians argued that salvation was accessible to all believers with the help of divine grace; God had not predetermined who should be saved, but only knew in advance who, by their free actions, would attain salvation. This position, put forward in the Remonstrance of 1610, was condemned as heretical by the Synod of Dort (1618–19). Despite attempts to eradicate them, Arminians, also known as Remonstrants, were too numerous, and from the mid-1630s they were organized into 'colleges' or congregations. Like the Quakers, they had no ministers; members of the congregation spoke as the spirit moved them.

Of the Anabaptists, Temple remarks that they are 'very numerous, but in the lower ranks of people, Mechanicks and Sea-men, and abound chiefly in North-Holland'.[43] Anabaptists rejected infant baptism, arguing that people should only be baptized when they were old enough to understand the ceremony. The Anabaptists fell into discredit after they took over the city of Münster in 1534 and introduced not only adult baptism but community of goods. While the city was under siege from troops led by its deposed

bishop, it came under the charismatic authority of Jan Beukels ('John of Leiden'), the self-proclaimed messianic king of the world, who legalized polygamy and took sixteen wives. The city fell in June 1535, and its leaders were tortured to death.[44] Anabaptists tried later in the 1530s to seize Amsterdam, and suffered severe persecution. However, from the 1570s the Dutch authorities distinguished between the few seditious Anabaptists and the majority of peaceful ones, and tolerated the latter. The peaceful Anabaptists were usually called Mennonites, after Menno Simon, who left the Catholic Church in 1536 and, chastened by the Münster episode, rapidly became a leader of non-violent Anabaptists. Mennonites were tolerated because they were loyal and industrious citizens who strengthened the economy. However, although they benefited from toleration, they were less than tolerant among themselves. By 1600 they were divided into six mutually hostile denominations, and the attempts at reconciliation that were made throughout the seventeenth century never entirely succeeded.[45]

Even the tolerant Dutch, however, drew the line at Socinianism. The Socinians, named after Fausto Sozzini ('Socinus'), maintained that humanity had no innate knowledge of God but could recognize God through the use of reason. Against such doctrines as Original Sin, Sozzini argued that man had the capacity and the responsibility to choose, and to act rightly; only an action resulting from free choice could be called virtuous. He accepted the authority of the Scriptures, but found nothing in them to suggest that Christ was divine. Rather than atoning for our sins in some incomprehensible fashion, Christ was a teacher. It was therefore impossible to believe in a Trinity of which Christ was the second person.[46] Sozzini's reasoning touched Christianity on a weak spot, for the doctrine of the Trinity is indeed poorly attested in the Bible. The only Bible verse that could be construed as giving any support for this doctrine was 1 John 5:7, which reads in the Authorized Version: 'For there are three that bear record in heaven, the Father, the Word, and the Holy Ghost: and these three are one.' The final phrase, known as 'the Johannine comma' (where 'comma' means 'short clause'), is absent from many manuscripts, as Erasmus showed in his critical edition of the Greek New Testament (1516).[47]

Denial of the Trinity was generally considered an intolerable heresy. The Spaniard Michael Servetus, who was friendly with early Reformation theologians, went beyond them in discarding the doctrine of the Trinity. Having escaped from the Inquisition to Calvinist Geneva, he was arrested in 1553 on the orders of John Calvin, put on trial and, having refused to recant his beliefs, burned alive. This notorious event showed that Protestants could be as repressive as the Catholic Church whose authority they had thrown off. The last person in England to be burned alive for heresy,

an ale-house keeper from Burton-on-Trent named Edward Wightman, argued against the Trinity and unwisely sent his arguments to King James. He was condemned in December 1611 for upholding a whole raft of heresies he had probably never heard of.[48]

In 1648 denial of the Trinity was made a capital crime in England. Yet it persuaded many people, whether in its Socinian form or as the Arianism which maintained that Christ was divine but not coequal with God.[49] Milton (who betrayingly refers to Christ in *Paradise Lost* as 'one greater man'), Newton and Locke all disbelieved in the Trinity.[50] Newton's successor as Lucasian Professor of Mathematics at Cambridge, William Whiston, imprudently published his anti-Trinitarian views and was dismissed from his chair and expelled from the university.[51] In the Dutch Republic Socinians were allowed to settle but not to set up their own congregations, nor to print their works.[52] One of their number, Adriaan Koerbagh, denied not only the Trinity but the doctrines of the Incarnation, the Resurrection, the immortality of the soul and much else. Having made his dangerous opinions accessible by publishing them in Dutch, and revealing his authorship, he was sentenced to ten years' imprisonment, was tortured and died in prison in 1669.[53]

In the Netherlands, Jews were tolerated.[54] Until the early seventeenth century they were mostly Sephardic Jews from Spain and Portugal, expelled at the end of the fifteenth century, but in the later seventeenth century there followed many Ashkenazi Jews fleeing from persecution in Germany and Poland. It was, however, not until 1639 that a public synagogue was permitted in Amsterdam; public expression of religious life, such as wedding processions, was restricted by the Jewish community itself in order not to attract unwelcome attention. In 1657, nevertheless, the States General declared that Jews 'are truly subjects of the state and as a consequence they are guaranteed enjoyment of the same rights and advantages . . . secured and obtained for the inhabitants of this state'.[55]

Early in the history of the Republic toleration was severely restricted, but matters changed in the 1630s. By then, the Remonstrance of 1610 had split the established Church. The conservative side maintained the *politique* case that freedom of conscience did not entitle people to divide the Church by preaching, teaching, or publishing their beliefs. The legal theorist Hugo Grotius agreed that the established Church was essential to keep society stable, but thought that Dissenters and Jews should be tolerated, provided they remained as inconspicuous as possible. At the liberal extreme, the Remonstrant theologian Simon Episcopius argued on both pragmatic and principled grounds that all Churches should be allowed freedom of practice. Pragmatically, such freedom would defuse the dangerous frustration

that must build up among those whose beliefs were denied expression, and with Catholics, who were suspected of allegiance to foreign powers, it would encourage them to be loyal citizens. In principle, the suppression of inquiry into Scripture, or the attempt to force belief, denied the fact that every individual has equal access to divine truth. The Church should exercise discipline, but by persuasion, not coercion.[56]

While these debates no doubt modified public attitudes, a decisive influence was exercised by the tolerant policy practised by most stadholders from William the Silent (d. 1584) to William III, prince of Orange (later king of Great Britain).[57] William III came to power as stadholder at the time when the Republic had been disastrously defeated by France. Ironically, French occupation imposed thorough-going toleration for the first time, not only for Catholics and Calvinists, but for Lutherans, Remonstrants and Mennonites. After the French withdrew there was an anti-Catholic backlash, heightened soon afterwards by horror at the persecution of Calvinists in France. William resisted pressure from hard-line Calvinists and intervened to prevent anti-Catholic measures, both because he personally favoured toleration and because he needed to unite both Catholics and Protestants in an international coalition against the threatening and aggressive power of France under Louis XIV.[58] He also protected the refugee Gilbert Burnet, who was indicted *in absentia* for treason in Scotland and was technically an outlaw; William refused to extradite him. Burnet was allowed to become a naturalized Dutch citizen so that he could be tried only in a Dutch court, and, as he was in danger of assassination, William provided him with a bodyguard.[59] Burnet records part of a long conversation with William: 'When he found I was in my opinion for toleration, he said, that was all he would ever desire to bring us to, for quieting our contentions at home.'[60]

By the end of the seventeenth century, toleration existed in the United Provinces, but it was still controversial and was only grudgingly accepted by the bulk of the population. It had eloquent advocates, among them Gerard Noodt, who argued that on issues of conscience one was answerable only to God, not to any earthly authority; Philipp van Limborch, who continued the mission of Episcopius by publishing his works that had remained in manuscript (and whose *Theologia Christiana* was translated into English by William Jones, chaplain to Burnet, by now bishop of Salisbury); and Jean Le Clerc, the latter two both friends of John Locke. But they were an unrepresentative minority. The tolerance of the Dutch Republic around 1700 has been described as 'ambivalent semi-tolerance . . . a partial toleration seething with tension, theological and political'.[61] As often, toleration was led by an enlightened minority.

## BRITAIN: 'A PERSECUTING SOCIETY'

In the late seventeenth century intolerance was more powerful than ever. 'Restoration England', it has been said, 'was a persecuting society.'[62] The Test Acts of 1673 and 1678 (in England) and 1681 (in Scotland) debarred anyone except communicating members of the Established Church from holding public office (including commissions in the army) or sitting in Parliament. Dissenters suffered severe harassment. They were often robbed of their possessions and of the tools they needed for their trade and hence their livelihood, as when a blacksmith lost his anvil and shovel.[63] The Conventicle Act of 1664, renewed in severer terms in 1670, compelled people who met in groups of five or more for illegal worship – disparagingly called 'conventicles' – to pay five pounds or suffer three months' imprisonment. Such meetings, often held in barns, woods, caves and 'among the rocks', were thought to be hotbeds of sedition.[64] The Quaker Ann Docwra complained in 1687:

all these aforesaid Statutes were severely prosecuted against Dissenters, so that a very great number of innocent people that would not turn Hypocrits and conform to them, contrary to their judgments, were exposed to cruel sufferings by a long grinding Persecution that have continued many years.[65]

The Conventicle Act passed by the Scottish Parliament in 1670 was even harsher, prescribing fines for Presbyterians who attended illegal religious meetings and the death penalty for anyone who preached at them; in 1685 a further Act made it a capital crime to preach at a conventicle held in a house or even attend one held out of doors. Covenanters (that is Presbyterians loyal to the Covenant made in 1638 to defend their religion) were actively persecuted. Driven to desperation, they twice rose in rebellion, in 1666 and 1679, and produced in effect terrorists whose activities provided further grounds for official repression.

The year 1685 saw the accession of England's first Catholic monarch for over a century. Despite his religion, James II was welcomed by his subjects. He initially reassured them by saying in his address to his Privy Council (which was published and read aloud in every town and village) that 'I shall make it my endeavour to preserve this government both in church and state as it is now by law established.'[66] Yet it is difficult to forget how Macaulay's *History of England* (1849–55) portrays James as a tyrant, plotting to impose Catholicism on his country with the aid of Irish troops, lurking in his palace and panicking, like Macbeth, as he feels his nemesis approaching in the person of William of Orange.

In reaction to Macaulay's dramatic picture, some historians have argued that James was sincerely devoted to toleration.[67] After all, both Gilbert Burnet and the prominent Quaker William Penn report him saying that he was opposed to religious persecution.[68] In April 1687 James issued his Declaration of Indulgence, allowing all subjects to exercise their religion freely without fear of penal laws. In composing it, he had the help of Penn, who wanted the next Parliament to give religious freedom a statutory form by issuing what he called a 'Magna Charta of Religion'.[69] Penn, who became one of James's closest advisers, sought to gain support for the Declaration by touring the country and making speeches in its defence, often to large audiences – 3,000 in Bristol and 'above a thousand people' at Chester.[70] These figures suggest that there was widespread sympathy with James's policy of toleration, on both principled and pragmatic grounds. Repeal would free people from having to become either criminals or hypocrites. Objections to suspending the Test Acts were often dismissed as mere legalism: 'the Penal Statutes made against Dissenters upon the account of Religion', wrote Ann Docwra, 'are but superficial Laws made for the present imaginaries of State'.[71] Many merchants and manufacturers supported repeal on the grounds that the penal laws damaged trade by imprisoning useful workers and craftsmen and reducing people's spending power.

On the other hand, James did a great deal to make his subjects distrust his long-term intentions. His army, which comprised 8,565 troops when he ascended the throne, had been increased by November 1688 to some 40,000 troops, lodged in garrisons at strategic points around the country. Clearly such a standing army could be used to impose unpopular policies by force. Moreover, he promoted Catholics to commands in the army, dispensing them from the Test Act; by October 1688 some 11 per cent of army officers were Catholics, although Catholics formed less than 2 per cent of the English population.[72] He transferred power from the Privy Council to a cabinet council composed entirely of Catholics. He suspended Parliament in November 1685 and dissolved it in July 1687. He encouraged Catholic missionary campaigns and the foundation of Catholic schools and colleges. He surrounded himself with Jesuits, the most prominent being Father Edward Petre, who came from an old English Catholic aristocratic family and had lived many years in France.[73] James's Catholic supporters held that the king's authority was absolute, and neither active nor passive resistance could be justified under any circumstances. It has recently been argued that James intended to set up a modernizing state, dominated by Catholics and ultimately with a single religion, modelled on Louis XIV's France.[74] To this end, James intended to pack Parliament with obedient MPs who would accept his authority unquestioningly. His

Catholic policy also aroused fears of subservience to France, the dominant power in Europe and feared for its aggressive foreign policy.

Moreover, James had to contend with a fear of Catholicism that was deeply rooted in popular memory. The burning of Protestants in London under Mary Tudor was recounted in John Foxe's *Book of Martyrs*, a book that, thanks partly to its memorable woodcut illustrations, still shaped popular religious consciousness in the seventeenth century.[75] The discovery of the Gunpowder Plot to blow up the Houses of Parliament in 1605 was, and still is, commemorated every year on 5 November. Catholics were blamed for the Great Fire of London in 1666. The monument erected on the site ascribed the fire to the 'treachery and malice of the Popish Faction'.[76] The Test Act of 1673 prohibited all Catholics other than the monarch from holding any civil or military office. In 1678, Catholics were forbidden to sit in Parliament. In the supposed 'Popish Plot', Catholics were alleged to have plotted to assassinate Charles II in order to place his brother James on the throne; besides several Catholic laymen, twenty-four Jesuit priests died, by execution or as a result of their sufferings, six secular priests were executed and three more died in prison. Anti-Catholicism would remain a potent force in English society for many years. It served as 'a powerful cement' uniting the English, Welsh and Scots in a shared identity as Britons.[77] Strengthened by the Jacobite risings of 1715 and 1745, it found violent expression in the Gordon Riots of 1780, which began as a popular protest against the very limited Catholic Relief Act.[78] Only in 1829 were British Catholics allowed to vote and relieved from their civil disabilities.

Anti-Catholic suspicions in the 1680s were heightened by the conduct of some Catholic rulers on the Continent. Louis XIV's persecution of Huguenots caused alarm across the Channel. Many thousands of Huguenot refugees arrived in Britain in the 1680s. They gathered especially in Canterbury and London, their main centre in London being the now-vanished French church in Threadneedle Street.[79] Although they were often unpopular with the English, who considered them an economic threat, their presence made people sharply aware of the reality of Catholic persecution abroad and the possibility of its being repeated in Britain. People were also alarmed by the invasion of Piedmont in 1686 by Vittorio Amedeo, the duke of Savoy (James II's nephew by marriage, and a client of Louis XIV) and his maltreatment of the Waldensian population. The Waldensians were a sect originating in the twelfth century who separated from the Catholic Church, abandoned such practices as praying for the dead and venerating saints, appointed their own ministers, and refused to take oaths or to wage war. They had already suffered severely in the 1650s, when Milton commemorated their persecution in his sonnet beginning 'Avenge O Lord thy

slaughtered saints'.[80] In the 1680s the duke's forces massacred some ten thousand Waldensians and sold the survivors into slavery.[81] James approved of Louis XIV's policy towards the Huguenots, though he may have pre-ferred not to think about the barbarity with which it was enforced, or have discounted such reports as propaganda. The French ambassador Barillon reported that James was 'overjoyed' at Louis' suppression of heresy in France. He had an account of the Huguenots' sufferings publicly burned as a libel.[82] Far-sighted people, moreover, could foresee that James might be only the first of many Catholic monarchs. As James had no son (as yet), and as his daughter Mary, married to William of Orange, was childless, he could reasonably expect her accession to provide only an interlude before the suc-cession passed via Charles I's granddaughter Anna Maria, who was married to the persecuting duke of Savoy.[83]

Matters came to a head in 1688. In April, James issued a revised version of the Declaration of Indulgence and required bishops to instruct clergy-men to read it in churches on two successive Sundays. Since it would have implied that the clergy consented to the Declaration's provisions, this demand prompted resistance. Archbishop Sancroft of Canterbury and six other bishops petitioned the king, asking not to have to make their clergy read it. Another prominent clergyman, Dr William Sherlock, argued on the bishops' behalf that the Declaration contravened the constitution of the Church of England by teaching 'an unlimited and universal Toler-ation'.[84] In an episode memorably narrated by Macaulay, the seven bishops were taken by river to the Tower, and put on trial for conspiring to dimin-ish royal authority. The jury found them not guilty. Londoners celebrated the verdict by holding public bonfires, many of them – with intimidatory intent – outside the houses of well-known Catholic citizens. According to Macaulay, however, 'defeat and mortification had only hardened the King's heart' – a clear allusion to the Book of Exodus, where Pharaoh shows intransigence towards the Hebrews because God has 'hardened' his heart (Exod. 9:35).[85]

The prospect of a continuing Catholic monarchy came much closer when James's son was born on 10 June 1688. People were only too ready to believe paranoid rumours claiming that the infant was not really the son of Mary of Modena but had been smuggled into her chamber by means of a warming-pan. The heir's birth prompted seven dignitaries, on the day of the bishops' acquittal, to write to William of Orange, asking him to intervene on behalf of the great majority of the population who were dis-satisfied with James's rule. William, for his part, fearing that the aggressive foreign policy of Louis XIV would lead to a French invasion of his domains, needed Britain to commit itself to a defensive alliance with the

Dutch Republic against France, and he could not afford to let Britain become a Catholic power. A vast fleet of 53 warships, with 10 fireships and some 400 transport ships, landed at Torbay on 5 November 1688, helped by the so-called 'Protestant wind', which changed just in time to prevent James's fleet from pursuing them. William and his army, numbering some 15,000 men, entered London in triumph on 18 December. James fled, but was found at Faversham in Kent and returned to London; then, asked by William to avoid disorder by leaving London, he went on 19 December to Rochester and thence slipped away to France on the 23rd. Dutch troops guarded Whitehall, St James's Palace and Somerset House until spring 1690. So when William and Mary were invited by Parliament in early 1689 jointly to ascend the throne, they assumed the rule of a country that their troops were already occupying – a fact which has fallen victim to British historical amnesia.[86]

William III was a reserved character whose personal religious beliefs are opaque.[87] His dislike of theological controversy, and his willingness to work with Catholic army officers and Jewish financiers, illustrate his tolerant disposition. His conduct as a statesman is best regarded as pragmatic and *politique*. Before the invasion of England he dismissed his Catholic staff, perhaps as part of 'an emphatic Protestant pose' designed to ingratiate himself with his future subjects.[88]

The Dutch invasion was soon followed by the Toleration Act of 1689, the name of which, says Macaulay, 'is still pronounced with respect by many who will perhaps learn with surprise and disappointment the real nature of the law which they have been accustomed to hold in honour'.[89] The Act established only limited toleration. It allowed freedom of worship to Nonconformists, including Baptists and Quakers, but offered nothing to Catholics. Nonconformists were allowed to hold their own services in licensed meeting-houses, with the doors open as a safeguard against their plotting sedition. Quakers were obliged to sign three documents, promising loyalty to the government, rejecting the doctrine of transubstantiation, and affirming belief in the Trinity – further evidence of the horror in which Socinianism, or scepticism about the Trinity, was generally held. Non-Anglicans were still obliged to pay tithes to the Established Church. The Test Acts remained in force, excluding Catholics and Nonconformists from public office.[90]

However, William established what contemporaries called a 'Toleration', that is, an atmosphere of toleration that went beyond the provisions of the Act. In practice, Catholics benefited from a milder regime. Bishop Burnet wrote: 'the Papists have enjoyed the real effects of the Toleration though they were not comprehended within the statute that enacted it.'[91]

Ireland benefited less. James, having fled from England to France, went to Ireland in order to rally support for his cause. But after much bloodshed the Jacobites were defeated, first at the Battle of the Boyne in 1690, and then at the less celebrated but more decisive Battle of Aughrim a year later. In the Treaty of Limerick, Irish requests for complete liberty of worship were firmly rejected, and the Catholics were given the right to practise their religion only 'as they did enjoy in the reign of king Charles the second', that is, unofficial toleration based on non-enforcement of the penal laws.[92] Catholics were restricted in their rights to education, land-ownership, inheritance, and ownership of weapons and horses. Catholic bishops and priests were expelled from Ireland in 1697; processions, clas-sified as 'riots', were declared illegal in 1704.[93]

Atheism, real or alleged, remained beyond the pale. On 8 January 1697 Thomas Aikenhead, a twenty-year-old student at Edinburgh University, was hanged for blasphemy. Fellow-students testified that he had repeatedly denied the divinity of Christ, dismissed Jesus and Moses as magicians, called the Apostles 'a company of silly witless fisher-men', and asserted that the Pentateuch had been written not by Moses, as in the orthodox view, but many centuries later in Babylon by Ezra the Scribe – a suggestion that Hobbes had put forward in *Leviathan*.[94] Worst of all, he claimed that 'God, the world, and nature are but one thing, and that the world was from eternity'.[95] Before his death, Aikenhead wrote an autobiographical state-ment, saying that he had always sought truth and could not find convincing proof of Christianity, but many reasons to the contrary. Unable to believe in divine punishment, nor in the Trinity, he adopted a deism based on nat-ural law. Before being hanged at the Gallowlee, midway between Edinburgh and Leith, he declared that he now accepted all traditional Christian beliefs and requested the onlookers' prayers. 'The preachers who were the boy's murderers', writes Macaulay, 'crowded round him at the gallows, and, while he was struggling in the last agony, insulted Heaven with prayers more blasphemous than anything that he had ever uttered.'[96]

The Glorious Revolution has an important but ambiguous and even paradoxical place in the history of toleration. Its immediate effect on toleration was limited. In being motivated by opposition to Catholicism, it may even be called intolerant. On the other hand, Catholicism itself was perceived, with good reason, as intolerant. Moreover, religious and political motives were intertwined. In coming to the defence of the Protestant cause, William of Orange wished to protect himself and others against the threat of an invasion by France. Religion at this time was a political issue, and toleration a fortunate by-product of political struggles.[97]

## TOLERATION IN THE
## HOLY ROMAN EMPIRE

In the Holy Roman Empire, toleration was approached primarily as a legal issue.[98] The religious wars in the wake of Luther's Reformation had been settled by the Peace of Augsburg (1555), which followed the essentially intolerant principle of *cuius regio eius religio*: the religion of each state should be that of its ruler; subjects unwilling to conform were entitled to emigrate. Imperial Cities containing both Lutherans and Catholics could be bi-confessional.[99] This settlement was inherently unstable, because it could not foresee or provide for the rapid spread of Calvinism from Geneva to France and the Netherlands. The Treaty of Westphalia, which in 1648 brought to an end the appallingly destructive Thirty Years War, recognized all three of the major Christian confessions – Catholic, Lutheran and Calvinist – and provided for parity among them within impartial institutions.

Although it prioritized the unity of the Empire over the claims of religious groups, the Treaty was not flawless. It did not provide for smaller Protestant sects, still less for Jews, who were not seen as a religious group. It could not resolve in advance the difficulties that arose when a Protestant ruler converted to Catholicism, as Augustus the Strong of Saxony did in 1697, or when, thanks to complicated dynastic connections, a Catholic became ruler of a Protestant territory, as happened in Württemberg in 1733. Nor could it exclude oppression. The expulsion of Jews from Vienna in 1670 belonged to a long tradition in which rulers disposed of their Jewish subjects. In 1732, some 20,000 Protestants from Salzburg (an independent prince-bishopric) were expelled – an oppressive act with disturbing legal implications, because it showed how easily the subjects' right to emigrate could be transformed into a compulsion to emigrate.

Since each of the three hundred or so principalities composing the Empire was ideally supposed to be homogeneous, everyday life developed in distinctively Catholic or Protestant ways.[100] Protestants prided themselves on their work ethic and mocked the number of Church holidays in Catholic territories. Christian names often identified their bearers' religion: Protestant boys would be called Johann, Jakob, Georg, or (under Pietist influence) Fürchtegott ('fear God') or Gotthelf ('God's help'); Catholic boys might be Joseph, Peter, Franz, Anton, Xaver, Aloys, or Ignaz, and might have Maria as a middle name (as with the composer Carl Maria von Weber).[101] The distinctiveness of confessional cultures worked against social integration. Mixed marriages, never numerous, seem to have declined

over the eighteenth century.[102] The Berlin Enlightener Friedrich Nicolai, who made a tour of south Germany and Austria in 1781, was amazed by the visibility of religion: the large numbers of priests and friars in the streets of Vienna, the saints' images attached to houses, the constant ringing of church bells, the popular religious literature on sale, and the processions on religious feast-days.

> When a Protestant sees such things, he thinks he is in a wholly new world. From his youth he has been firmly convinced that the service of God consists in spirit and truth; and here he finds ceremonies and tawdry finery, sanctification through works, and priestcraft, being presented as God's service.[103]

For many years the most striking example of toleration within the Empire was Prussia, where it came into force piecemeal and for pragmatic reasons, but nonetheless effectively. By the Edict of Potsdam (1685) Elector Frederick William admitted Calvinist refugees from France into Prussia. He had previously, in 1668, forced the three cities of Königsberg to allow Calvinists to acquire property and become citizens. He was not equally sympathetic to all minorities: thus Catholic worship was tolerated in ducal Prussia and the Hohenzollern territories of the Rhineland, where it was protected by treaties, but not in the core territories of Brandenburg and Eastern Pomerania.[104] But, unlike most rulers, Frederick William tolerated Baptists, Socinians and Jews. His successors continued his policy of pragmatic toleration, welcoming Protestants expelled from Salzburg who helped to populate the underexploited territories not only of Prussia itself but of the eastern territory of Prussian Lithuania.

The most famous exponent of toleration was Frederick the Great, sceptic, Francophile and patron of Voltaire, who welcomed useful citizens of every Christian denomination, including Catholics; he helped the latter to build St Hedwig's Cathedral in Berlin, consecrated in 1773. Frederick regarded all religious beliefs with impartial contempt. In his history of his dynasty he described Pietists, Zinzendorfians or Moravian Brethren, and 'Quackers' as 'sects that are each more ridiculous than the other', adding:

> All these sects live here in peace and contribute equally to the happiness of the State. There is no religion that differs much from others on the subject of morality; so they can all be equal in the eyes of the government, which consequently leaves everyone at liberty to go to heaven by whatever path he pleases; all that is asked of him is that he should be a good citizen. False zeal is a tyrant that depopulates provinces: tolerance is a tender mother who takes care of them and makes them flourish.[105]

Frederick's tolerance did not extend to Jews, for whom he retained an inexplicable antipathy. Even in Enlightenment Berlin Jews still suffered under many civil restrictions. Their numbers were legally limited, and they had to pay heavy dues in return for permission to carry on business.[106] The Jewish factory owner and philosopher Moses Mendelssohn wrote to a Swiss colleague in 1762: 'Under Frederick's rule freedom of thought does indeed flourish in almost republican splendour; but you know how small is the share in the freedoms of this country enjoyed by my co-religionists.'[107]

In the 1780s Frederick's policy of toleration found an unexpected imitator in Joseph II of Austria, who improved on his model by also extending toleration to Jews. Since 1765 Joseph had been joint ruler alongside his mother, Maria Theresa, who severely limited his freedom of action. Maria Theresa was firmly opposed to toleration. The Habsburg Monarchy was a conglomerate of provinces extending from the Russian frontier to Trieste, from the Swiss frontier to Transylvania, and including also the Austrian Netherlands (present-day Belgium). Protestantism, Greek Orthodoxy and other religions were permitted in some outlying regions, but in the Austrian and Bohemian heartlands of the Monarchy only Catholic worship was allowed. In Vienna, Protestant services could be held only in the Dutch, Danish and Swedish embassies. Any Protestants found in the central provinces were deported to Transylvania.[108]

As early as 1765 Joseph contemplated introducing toleration when he got the chance. His motives were religious, since toleration was part of the reforms desired by enlightened Catholics, but also pragmatic. In the Memorandum of 1765, in which he set out his long-term plans, Joseph wrote frankly that if people were obstinate in their errors, they must be left to God's compassion, and should meanwhile be put to use in the service of the state:

> In matters of faith and morals, correction cannot be achieved by execution or violence, personal conviction is necessary; nevertheless I would never wish to suffer any scandal, publicity, or an evil that could damage the good and innocent, but with the incorrigible the best course is to employ them where they can do no harm, and close one's eyes and ears to their shortcomings. For the service of God is inseparable from that of the State, and He wants us to employ those to whom He has given talents and the ability for business, leaving it to His divine pity to reward the good and to punish wicked souls.[109]

On his mother's death in 1780, Joseph as sole ruler began putting into practice the enlightened principles he had been meditating for many years. From October 1781 he issued a series of Patents of Toleration. He allowed

Lutherans, Calvinists and Greek Orthodox believers to worship: in any community where their numbers exceeded a hundred families or five hundred individuals they could build a church and appoint a clergyman. They were also permitted to buy property, join guilds, take part in local government, graduate at universities and enter the civil service. Another series of decrees allowed Jews to attend Christian schools and universities, practise trades, open factories, rent houses, employ Christian servants and attend the theatre.[110] Joseph's legislation on behalf of the Jews was too advanced to find imitators, but his toleration of different Christian groups excited interest throughout the Empire.[111]

## WILLIAM PENN'S HOLY EXPERIMENT

The shining example of toleration in practice is generally agreed to be Pennsylvania, the North American colony for which William Penn obtained a charter from Charles II in 1681. We have already met Penn as a close adviser to Charles's successor James. He occupied an extraordinary position, and a very fortunate one for the cause of toleration, as both an influential political player and a spokesman for the rights of Nonconformists in general and Quakers in particular. The son of a distinguished admiral, Penn, having studied at Oxford, entered local politics as a charity commissioner in Buckinghamshire. When he went to Ireland to look after his family's estates there, several momentous events happened. He drew attention to his abilities by helping to suppress a mutiny among the English troops at Carrickfergus, and he attended a Quaker meeting at Cork which led to his conversion. It seems that at the meeting Penn forcibly ejected a soldier who was creating a disturbance; the soldier returned with reinforcements, and the Quakers, along with Penn, were brought before the magistrate, charged with holding a 'riotous and tumultuary assembly'.[112] The privileged young man thus found himself on the wrong side of the law. This experience must have been decisive in gaining Penn's sympathy for the victims of persecution.

The well-educated Penn with his courtly manners was an incongruous ally for a group that contemporaries found not only distinctive but also outlandish and shocking. Until the early 1660s, Quakers often disrupted church services, insulted clergymen in the streets, and performed public 'signs and wonders'. A powerful Quaker preacher, James Nayler, on 24 October 1656 rode into Bristol in pouring rain with seven companions strewing garments before him and crying 'Holy, holy, holy, Lord God of Sabbath', in a re-enactment of Christ's entry into Jerusalem.[113] For this

apparent blasphemy Nayler was tried by Parliament and sentenced to brutal punishments, including three hundred lashes and an indefinite term of solitary confinement. Despite their sober and peaceable behaviour during the Restoration period, Quakers deliberately marked themselves out by refusing to attend the rites of passage (baptisms, weddings, funerals) that held local communities together; by their ostentatiously plain clothing; and by their peculiar language, with 'thee' and 'thou' instead of the respectful 'you', and avoiding names of days and months that were derived from false gods. They gained a reputation for rudeness by refraining not only from salutations like 'Good day', on the grounds that a day could not be good when so many people were under the power of darkness, but from greeting people altogether.[114] Their refusal to take oaths or to pay tithes often led to harsh punishment. George Fox was imprisoned for six years, William Dewsbury for nineteen years between 1663 and 1686. Many Quaker prisoners died in their insanitary and freezing confinement.[115]

From 1667, the date of his conversion, onwards, Penn developed his political influence and tried to use it on behalf of the Quakers and other persecuted groups. Being considered able to deliver the Nonconformist vote for Parliament, he was cultivated by political managers. Thanks to his education, his social position and, no doubt, the confidence it gave him, he not only sided with the Quakers but argued repeatedly that the restrictions on them were unjust. He maintained that no authority could force people to accept religious propositions that their consciences denied, and that even the attempt to do so overstepped the limits of secular government and denied the liberty of conscience which he claimed was part of England's ancient constitution.[116] His activity earned him several spells in prison. Such a prominent figure could not be ignored, as someone of lower social origins could; when he was first imprisoned in the Tower, in 1668, charged with the heinous offence of denying the Trinity, he received a visit from no less a person than the royal chaplain, Edward Stillingfleet.

By the early 1680s Penn was a leading Court politician. His close co-operation with James II has often puzzled historians. Assuming that James did intend to establish Catholicism in Britain, was Penn too gullible to perceive his intentions? In fact, the co-operation between the Catholic and the Quaker is not so surprising. Both, though themselves privileged, belonged to minorities who were persecuted in England. The general toleration James aimed at could only benefit Quakers. Besides, James confirmed his good intentions in 1686 by having some 1,500 Quakers released from prison. Both James and Penn had an interest in weakening the position of the Church of England as the established Church. If James thought that toleration would bring about many conversions to

Catholicism, Penn had equal reason to expect the Nonconformists to be strengthened. His biographer suspects that he was somewhat uneasy about James, and detects in his pamphlets signs of discomfort with the prospect of complete toleration for Catholics; Penn argues that they are too few in number, and too divided among themselves, to be a danger to the state.[117] The Glorious Revolution, however, brought Penn's political career to a sudden end. He was repeatedly arrested on suspicions of plotting on behalf of the exiled James, and these suspicions may be justified.[118] He was several times imprisoned, and he had a struggle to clear his name and convince the new regime of his loyalty.

Long before then, however, Penn had set up his 'Holy Experiment' across the Atlantic. He was assigned the territory of Pennsylvania as repayment for a debt that the Crown owed his father, but a whole American province was still a remarkably generous grant, and it may well be that Charles II wanted to be rid not only of a substantial number of Nonconformists but also of their most troublesome spokesman.[119] It enabled Penn to emulate such legislators of ancient times as Lycurgus and Solon by setting up a new society. His charter famously specifies very broad toleration:

> That all persons living in this province who confess and acknowledge the one almighty and eternal God to be the creator, upholder and ruler of the world, and that hold themselves obliged in conscience to live peaceably and justly in civil society, shall in no ways be molested or prejudiced for their religious persuasion or practice in matters of faith and worship, nor shall they be compelled at any time to frequent or maintain any religious worship, place or ministry whatever.[120]

By implication, this includes Catholics, something highly unusual at that time; but it excludes atheists, and the charter also debars non-Christians from taking any part in government.[121]

Alongside his religious policies, Penn also promoted an enlightened treatment of the indigenous people, the Lenni Lenape or Delaware Indians. Fortunately, the Lenni Lenape, unlike their Iroquois allies further north, were unwarlike and not very numerous. Penn hoped, in the words of his charter, to 'reduce the Savage Natives by Gentle and just manners to the Love of civill Society and Christian Religion', but, unlike the Jesuits in Canada, Penn's colonists appear not to have undertaken any missionary effort.[122] He did his best to deal fairly with the Lenni Lenape, learning their language, explaining all land transfer agreements to them and securing their informed consent, and forbidding the colonists to give them alcohol. While the Jesuits and the Puritans condemned the Indian dances as obscene, Penn commented sympathetically on the combination of 'Earnestness and

Labour' with 'a great appearance of Joy' in their dances.[123] In the long run, however, colonists and natives could not coexist happily. The influx of colonists gradually squeezed the natives out; and after Penn's death the colonists, in 1742, persuaded the Iroquois to pressure the Lenni Lenape to leave Pennsylvania altogether and migrate to the Ohio River region.[124]

## ARGUMENTS FOR TOLERATION

A crucial argument for toleration was that the conscience could not be forced. People could not be compelled to believe something that their consciences forbade them to believe. Thus, Sir William Temple wrote in his admiring account of the toleration practised in the Dutch Republic:

> Belief is no more in a man's power, than his Stature or his Feature; And he that tells me, I must change my Opinion for his, because 'tis the truer and the better, without other arguments, that have to me the force of conviction, May as well tell me, I must change my gray eyes for others like his that are black, because these are lovelier, or more in esteem.[125]

Therefore, a clergyman or magistrate, however good his intentions, could not save anyone's soul by force. 'No way whatsoever that I shall walk in against the dictates of my conscience will ever bring me to the mansions of the blessed', wrote John Locke.[126] In any case, whatever St Augustine might have said, the use of force was contrary to Christian love. Erasmus had already urged his contemporaries to treat the erring and the offending in keeping with God's loving-kindness.[127] The claims of Inquisitors to be torturing people's bodies for the good of their souls seemed repulsive and incredible. 'That any man should think fit to cause another man, whose salvation he heartily desires, to expire in torments, and that even in an unconverted estate, would, I confess, seem very strange to me, and I think, to any other also,' wrote Locke. 'But nobody, surely, will ever believe that such a carriage can proceed from charity, love, or goodwill.'[128]

Arguments such as Locke's, however, still assume that toleration is something undesirable in principle. It would be better if all Christians could agree. But since they do not, the only permissible way of changing their minds is gentle persuasion. This is an argument against persecution on the grounds that it does not work. It is not yet an argument against interfering with the sanctity of the individual conscience.[129] Nor is it necessarily an argument for allowing people to worship as they please. Liberty of conscience is one thing, but to advertise the diversity of faiths by allowing diverse forms of public worship was often considered undesirable. The

Treaty of Westphalia distinguished public worship, including baptism, marriage and funeral services, from private worship by congregations, and that in turn from domestic devotion, i.e. the holding of religious ceremonies in one's own home. The territorial authority was given the right to forbid the last and require subjects to emigrate. In the Dutch Republic, as we have seen, Catholics and Anabaptists were allowed to worship in inconspicuous buildings that could not be recognized as churches.

Again, members of minority faiths might be allowed to practise their religion but be considered politically suspect. Here the relations between Church and state enter the argument. In the confessional states that emerged in response to the Reformation, the ideal was a single Church which was, so far as possible, directed by the state.[130] Henry VIII gave a drastic example of this policy by declaring himself head of the Church in England. In the late seventeenth century, however, we find Locke arguing forcefully for the separation of religion from the state. He maintains that the civil magistrate has no right to intervene in religious matters. Religion is a matter for each individual; nobody will assign responsibility for his salvation to a public official. Locke also defends religious dissenters against the charge of subversive intentions. They are not banned because they are a danger to the state, but they may become a danger to the state because they are banned and their members driven into disloyalty. The answer is to tolerate them, and they will be harmless – just as assemblies for other purposes are. 'Some enter into company for trade and profit: others, for want of business, have their clubs for claret. Neighbourhood joins some, and religion others. But there is one thing only which gathers people into seditious commotions, and that is oppression.'[131] Besides applauding the good sense Locke shows here, we might note how he demystifies religion by treating a religious assembly as, for legal purposes, the same kind of body as a commercial company or a drinking-club. A secular society seems to be just round the corner.

However, even toleration such as Locke's is still limited. He is reluctant to tolerate Catholics because they owe allegiance to a 'foreign prince', namely the pope, who can enforce obedience by threatening them with 'eternal fire'.[132] And he draws the line very firmly at atheists, because, since they disbelieve in God, they have no inducement to keep their promises.[133] We shall see soon how Pierre Bayle refuted this argument, but it is worth remarking that the same charge of habitual promise-breaking was commonly levelled against Jesuits, who, whatever faults might be imputed to them, undoubtedly did believe in God.

In discussions of toleration, it is rather rare to argue for the sanctity of the individual conscience. A modern commentator on Locke regrets that

'what one misses above all in Locke's argument is a sense that there is anything *morally* wrong with intolerance, or a sense of any deep concern for the *victims* of persecution or the moral insult that is involved in the attempt to manipulate their faith'.[134] For the rights of the conscience, and of the individual mind in intellectual matters generally, we must look to a complete outsider, Spinoza. His *Tractatus theologico-politicus*, a work whose huge importance for the interpretation of the Bible will be explored in a later chapter, proclaims that nobody can surrender his power of reasoning to another, and therefore

> government which attempts to control minds is accounted tyranny, and it is considered an abuse of sovereignty and a usurpation of the rights of subjects, to seek to prescribe what shall be accepted as true, or rejected as false, or what opinions should actuate men in their worship of God.[135]

The argument that conscience is inviolable is put forward, no less forcefully, by Bayle in his commentary on Augustine's 'Compel them to enter'. Compulsion is ineffectual, for somebody terrified by the threat of punishment is in no mood to think calmly about religious or any other matters. But besides being ineffectual, compulsion is wrong, because it denies the integrity of the individual conscience. When the orthodox complain that their opponents are obdurate, they ought instead to respect a firm conviction founded in the conscience:

> as long as a man who has been instructed the best way possible shall say he is still persuaded in his conscience that his own religion is the only right one, the Convertist has no ground to say he has convinced him inwardly and evidently of his errors and accordingly, the man will not be an opiniator, nor worthy of the punishments stubbornness deserves.[136]

Peaceable people, starting with Erasmus and others during the Reformation, tried to reduce confessional strife by arguing that many religious matters were *adiaphora* or 'things indifferent'.[137] Provided one held fast to the spiritual and moral core of Christianity, what did it really matter, for example, whether one was baptized in infancy or adulthood? Locke asked:

> [I]f I be marching on with my utmost vigour, in that way which, according to the sacred geography, leads straight to Jerusalem; why am I beaten and ill used by others, because, perhaps, I wear not buskins; because my hair is not of the right cut; because, perhaps, I have not been dipt in the right fashion; because I eat flesh upon the road, or some other food which agrees with my stomach . . .?[138]

But the common core was gradually whittled down. Early Enlighteners suggested that even some of the central dogmas of Christianity might be treated as *adiaphora*, leaving what the eighteenth century called 'natural religion', which Matthew Tindal in 1730 offered as a basis for toleration:

> By *Natural Religion*, I understand the Belief of the Existence of a God, and the Sense and Practice of those Duties, which result from the Knowledge, we, by our Reason, have of him, and his Perfections; and of ourselves, and our own Imperfections; and of the Relation we stand in to him, and to our Fellow-Creatures; so that the *Religion of Nature* takes in every Thing that is founded on the Reason and Nature of Things.[139]

This could extend to non-Christians. In the notorious fifteenth chapter of Jean-François Marmontel's moral tale *Bélisaire* (1767), which attracted the severe censure of the Church, the hero, a nominal Christian, affirms that the virtuous pagan emperors Titus, Trajan and the Antonines will be encountered in heaven. God has given us two guides, faith and sentiment, but Marmontel repeatedly suggests that the latter trumps the former. Public order depends on innate moral sentiments which do not come from revelation, while the mysterious truths that we would not have known without revelation have nothing to do with morality: 'God has detached them from the chain of our duties, so that, without Revelation, there should be decent people [*d'honnêtes gens*] everywhere.'[140]

Another increasingly popular argument was that in religious matters no one can be certain of the truth, and therefore no one has the right to attack anyone else for their opinion. This argument has been traced back to the Calvinist Sebastian Castellio, who in 1554 attacked Calvin for presumption as well as cruelty in burning Michael Servetus for holding opinions that no one could be absolutely sure about.[141] 'In the vast spaces of error', says Marmontel's Bélisaire, 'truth is only a point. Who has found this unique point? Everyone claims to have done so, but on what evidence?'[142] Lessing in 1778 maintained that nobody could know, nor should even want to know, the absolute truth, which was reserved for God: 'Let everyone say what he thinks is the truth, and let God take care of the truth itself!'[143] What is proposed here, however, is not exactly a tolerant attitude. For if everyone is uncertain, then everybody's beliefs, though different in substance, are held in the same tentative manner. It is a greater challenge to be *convinced* of one's own beliefs and put up with other people's different but equally strong convictions.

Most often, however, we find pleas for toleration using pragmatic or consequentialist arguments. Rather than claiming that toleration is good in itself, it is claimed that it will bring peace and prosperity. As Voltaire

and many others repeatedly pointed out, the Dutch Republic, the most tolerant state in Western Europe in the seventeenth century, was also among the most prosperous.[144] It had defeated Spain, England and France in war, and it was a flourishing commercial society that offered a striking contrast with the poverty of Catholic Spain. William Penn in 1670 pleaded for 'such a *Liberty of Conscience*, as preserves the Nation in Peace, Trade, and Commerce'.[145] Voltaire, in his *Letters concerning the English Nation*, drew attention to the interplay between trade and civil liberty in Britain and to the practical toleration which meant that not only different varieties of Christian, but also Jews and Muslims, could do business together at the Royal Exchange.[146]

Yet with a very few exceptions, such as Spinoza and Bayle, all who argued for toleration and pursued enlightened policies were still assuming that toleration meant putting up – humanely but more or less reluctantly – with people whose religious views were different, probably erroneous, and who should ideally come round to the majority opinion. They had not yet arrived at the acceptance of religious difference for its own sake on the basis of equal human rights. To see how the eighteenth century came to such acceptance, however, let us look briefly at four important writers famous for their tolerant outlooks: Bayle, Voltaire, Lessing and Goethe.

## BAYLE

Pierre Bayle is not only a spokesman for toleration but one of the most attractive and intriguing figures of the Enlightenment.[147] A Huguenot, he briefly attended the Jesuit college at Toulouse, which took in Protestant day-boys. From the Jesuits Bayle, like Voltaire later, received an excellent education, but he was also induced to convert to Catholicism. After formally returning to Calvinism in 1670, he was subject, as a 'relapsed Protestant', to criminal penalties. He spent some time in Switzerland, and then, relying on the inefficiency of the police, returned under a false name to France, where in 1675 he obtained a highly desirable though poorly paid post as a professor at the Protestant Academy of Sedan. Six years later, however, as part of the official campaign against Huguenots, the French authorities abruptly closed the Academy, and since the laws against emigration were not yet being strictly enforced, Bayle made his way without difficulty to the Netherlands. For the rest of his life he lived in Rotterdam. There he obtained a chair in history and philosophy at the town's École Illustre, where his fellow-exile Pierre Jurieu was appointed to a chair in theology. As the teaching schedule was far lighter than at

Sedan, Bayle was able to immerse himself in study, to write his first trea-
tises on toleration, and to found in 1684 a monthly journal of book
reviews, *Nouvelles de la République des Lettres* (*News from the Republic
of Letters*), which found a wide readership among Huguenot refugees in
many countries. The year 1685, however, saw both the revocation of the
Edict of Nantes and the arrest of Bayle's younger brother Jacob as an act
of official revenge on Bayle for his public advocacy of toleration. Jacob's
death plunged Bayle into a spiritual crisis from which he found solace in
intensive writing.

Bayle's arguments for toleration, however, also made him enemies among
the Huguenot community. The victims of intolerance were not themselves
inclined to be tolerant. After all, theirs was the true Church, driven into
exile by the false Church. Like St Augustine, they did not object to persecu-
tion in principle; it was just that the wrong people were doing the persecuting.
In exile they were even more strongly obliged to uphold true Christianity
and to refuse to tolerate error. Hence Jurieu maintained that, while there
was some room for latitude in understanding how divine grace operated on
the will, there could be no tolerance for doctrines that man could be saved
by his own efforts even without grace. Such doctrines recalled those of
Augustine's antagonist, the British theologian Pelagius, who maintained
that the God-given nature of humanity made it free to choose good; Pel-
agius' followers went further and denied outright the Augustinian doctrine
of Original Sin. For Jurieu, the Arminians, Anabaptists and Socinians who
flourished in the Netherlands were all Pelagians.[148] To defend the toleration
of such heretics, as Bayle did, was itself damnable.

Moreover, Jurieu and Bayle disagreed on political issues. Convinced that
William of Orange's successful invasion of Britain was miraculous, Jurieu
upheld the right of subjects to resist bad rulers by rebellion and, if necessary,
assassination, whereas Bayle thought that such arguments were not only
presumptuous, in implying knowledge of the designs of Providence, but also
imprudent in that they must prompt the French authorities to treat Protes-
tants not only as heretics but as potential traitors and hence persecute them
yet more severely. Although Jurieu had no direct power over Bayle, who
was not a clergyman, his denunciations led to the suppression of Bayle's
post at the École Illustre. Bayle wrote to a friend in 1691: 'God preserve us
from the Protestant Inquisition; in five or six years it would be so terrible
that one would yearn for the Roman one as though for a benefit.'[149]

What heresies had Bayle uttered? Soon after arriving in the Netherlands
he published his first book, *Lettre sur la comète* (*Letter on the Comet*,
1682), soon followed by an enlarged edition, *Pensées diverses sur la
comète* (*Miscellaneous Thoughts on the Comet*, 1683). The comet seen

in Western Europe in December 1680, later called the Great or Newton's
Comet, gave Bayle a pretext to attack at length the idea that comets are
'like heralds who come on God's behalf to declare war on the human
race'.[150] Besides exposing the absurdity of such superstition by this char-
acteristically witty image, he analyses and debunks all the arguments that
could possibly be adduced for the malign influence of comets.

However, the comet was only a pretext. Back in 1654, when an earlier
comet had appeared, the French government had sponsored pamphlets to
discourage belief in its influence; and 'when the comet of 1680 appeared,
educated people no longer expected it could presage anything except,
perhaps, the death of the elephant in the menagerie at Versailles'.[151] Bayle's
attack on superstition, where pagan 'idolaters' are in the foreground, can
be read, and was read, as a thinly veiled attack on the unfounded beliefs
promoted by the Catholic Church. He particularly attacks the theological
claim that God created comets in order to make his providence known to
pagans and save them from atheism. For the pagans were idolaters, and
worshipping false gods is just as bad as worshipping none. Atheists are
commonly supposed to be wicked, because they are not restrained by fear
of future punishment. But there were many wicked pagans who were not
atheists. And – this is the nub of Bayle's arguments – many atheists have
in fact led virtuous lives. For even if they have bad principles, human
beings seldom act in accordance with their principles:

> When one compares the morals of a religious man with the general idea
> one forms of that man's morals, one is astonished to find no conformity
> between the two things. The general idea supposes that a man who believes
> in a God, a paradise and a hell will do everything that he knows to be
> pleasing to God, and do nothing that he knows to be displeasing to Him.
> But that man's life shows us that he does exactly the opposite.[152]

The reason for this inconsistency, according to Bayle, is that principles
give *general* guidance, but people's decisions always apply to *particular*
situations, where the influence of one's principles is counteracted and usu-
ally annulled by passions, desires and habits. And our passions are to be
welcomed, because they ensure social order: the desire for other people's
admiration, and the fear of judicial punishment, do more than reason
could to keep people on the straight and narrow. So, there are no grounds
for thinking that a society composed of atheists would be worse than any
other society.

Certainly, Bayle continues, some people persuade themselves of atheism
because they want to commit crimes without any divine sanction. But
atheism does not make them wicked; rather, their wickedness makes them

into atheists. And virtuous atheists are not just a theoretical possibility but have really existed. Bayle's examples are a Jew, a Muslim and a rebel against Christianity. One is Spinoza, whose supposed atheism caused him to be ostracized by the Jewish community at Amsterdam, yet who was well known for his wholly blameless life. Another is Mahomet Effendi, who in the 1660s was executed at Constantinople for denying the existence of God.[153] The third is the Neapolitan Giulio Cesare Vanini, the materialist philosopher who was burned at the stake in Toulouse in 1619 for atheism and blasphemy.[154] Both Mahomet Effendi and Vanini could have concealed their atheism, but instead they proclaimed it because they wished (rightly or wrongly) to enlighten others, and because their principles forbade them to lie even to save their lives.[155]

The *Thoughts on the Comet* makes a powerful case for toleration by the methods characteristic of Bayle. He dismantles conventional assumptions that were so ingrained as to seem obvious, and he does so by pursuing arguments to their logical extremes, in an amusing conversational style. But it also illustrates the problem that still perplexes Bayle's interpreters. What standpoint is he writing from? He excels at taking apart bad arguments, but what are his own beliefs?

The problem becomes still knottier when we examine Bayle's most famous work, his *Historical and Critical Dictionary*. Although it is based on many years of hard study, Bayle worked on it most intensively after losing his academic post, supported by an annuity from his publisher, and it first appeared in three volumes in December 1696. Subsequent editions were enlarged, so that now one finds four unwieldy volumes, containing articles on figures from the Old Testament and antiquity, theologians, philosophers and miscellaneous historical figures. The articles, mostly potted biographies, are hugely enlarged by footnotes in which Bayle addresses innumerable theological and controversial issues and smuggles in many bizarre anecdotes. When one opens a volume, one sees a few lines of large print at the top of the page; enormous numbers of footnotes in small type, taking up most of the space; and, in the margins, references in even smaller type, sometimes containing further observations.[156]

This vast and shapeless work, a sort of philosophical *Tristram Shandy*, was among the most-praised books of the eighteenth century. The Danish Enlightener Ludvig Holberg, who worked in the Bibliothèque Mazarine in Paris around 1714, recalled that it was 'read with extraordinary avidity', and was 'the object of all the struggling and contention at the door, and of the race which took place after the students were admitted'.[157] Voltaire, Gibbon, Hume, Diderot and Lessing all revelled in it.[158] Even the conservative Samuel Johnson praised it.[159] And in 1849 Herman Melville,

# DICTIONAIRE
## HISTORIQUE
### ET
## CRITIQUE:

Par Monfieur B A Y L E.

*T O M E* *P R E M I E R,*

PREMIERE PARTIE.

A——B.

A ROTTERDAM,

Chez R E I N I E R L E E R S,

M D C X C V I I.

*AVEC PRIVILEGE.*

The prominence given in Bayle's title to the word 'historical' may have been intended to divert attention from its theologically explosive implications. Accordingly, the image may represent Clio, the Muse of History.

a Calvinist like Bayle, bought a copy of the English translation in New York; Bayle's erudition and his preoccupation with the proximity of good to evil in the God of the Old Testament would reappear in the allegory of *Moby Dick*.[160]

The appeal of Bayle's *Dictionary* can be illustrated from the mischievous article on St Augustine, the most lastingly influential of Catholic theologians. Bayle sketches his life, dwelling on his sexual incontinence, and wrapping up the period from his ordination in 391 to his death in 430 in two sentences.[161] Others have surveyed Augustine's career, he says, but we need to know a great man from every side. So two footnotes deal with Augustine's debauchery and his illegitimate son. Then Bayle goes on the theological warpath, pointing out that the Church of Rome condemns Jansenism for its doctrine of predestination, yet upholds Augustine's doctrine of necessity, which is essentially the same; he concludes 'that here the theologians are great comedians': 'que les Docteurs sont ici des grans Comédiens'. To support his argument, Bayle in the next footnote commends the Arminians for abandoning St Augustine to their adversaries and recognizing him as no less a 'predestinator' than Calvin. Then he quotes the adverse criticisms of Augustine's biblical commentaries made by the Catholic Bible scholar Richard Simon.

Having now cut Augustine down to size, Bayle turns to local issues, noting that the Dutch Synod held at Amsterdam in 1690 affirmed Augustine's opinion that the magistrate should punish heretics, and commenting on their inconsistency in failing to see that the king of France was equally justified in punishing *them*. Here Bayle not only highlights the intolerance shown by the victims of intolerance, but adopts his favourite 'sauce for the gander' style of argument. Then comes a ribald footnote on the statement by a Paris physician that Augustine drank heavily without getting drunk; and finally, a learned note on editions of Augustine leads to a critique of the behaviour of anonymous pamphleteers. No wonder this gallimaufry, where bold theological arguments rub shoulders with Rabelaisian humour, found such enthusiastic readers – especially those who, like Diderot and Lessing, shared Bayle's aversion to the restrictions imposed by any intellectual system.

Bayle scholars, however, have puzzled over the question of what Bayle *really* thought. Behind the endless arguments of the *Dictionary* and his other works, is there an atheist, a thorough-going sceptic, or a sceptical fideist whose Christianity rests ultimately on faith instead of reason?[162] It was common in the early modern period to try to use the sceptical doctrines attributed to the ancient Greek philosopher Pyrrho of Elis (*c.* 360–*c.* 270 BCE), and transmitted largely by Sextus Empiricus (*c.* 160–*c.* 210 CE), in

defence of Christianity. Pyrrhonism rested on the principle that every state-
ment can be contradicted by an opposing statement, so that one should
remain suspended between opposed viewpoints and, in matters of religion,
rely on faith instead of argument. Ultimately this principle contradicts
itself: to be consistent, I should suspend judgement about whether to sus-
pend judgement, and so forth.[163] However, scepticism served first and
foremost, in the wake of the Reformation, to undermine the rational claims
of opposed theological camps. But it could be used even more boldly as a
weapon against those whose arguments seemed to point towards atheism.
If all the rational arguments for the existence of God were vulnerable to
scepticism, it was held, that just showed how indispensable it was to rely
on faith.[164] So perhaps he was a sceptical fideist, as some distinguished
Bayle scholars have held. Yet, as one of them admits, any faith that Bayle
shows is singularly lukewarm: 'Bayle suffered, apparently, from no angst,
no fear and trembling.'[165] And the fideist reading would require, as Quentin
Skinner has pointed out, 'the (very remarkable) coincidence that . . . all of
Bayle's contemporary opponents were all equally, and in exactly the same
way, mistaken as to [his] real intentions'.[166] A searching recent study con-
cludes that reading Bayle is a twofold procedure that means seeking out
ambiguities while also 'avoiding presumption and withdrawing judgement
at the last moment – for some ambiguities are better left intact'.[167]

If Bayle really was a fideist, he is hardly a convincing advocate for God.
In some famous articles he worries at the problem of evil. Thus, in the
article 'Rufinus' he discusses a notorious Roman provincial governor who
oppressed the virtuous and enriched himself at their expense. Rufinus'
eventual downfall prompted the poet Claudian to claim that providence
was thus vindicated, since a wicked man had met his just deserts. But,
Bayle rejoins, since God knew in advance that Rufinus would commit so
many crimes and render so many people miserable, what was the point of
letting him flourish for years?

> It therefore would have been better to have prevented the abuse than to
> tolerate his crimes for several years in order to inflict a punishment on him
> that cannot compensate for the evil he did, the oppression of so many inno-
> cent people, the death of so many persons, the ruin of so many families.[168]

Divine providence had permitted harm which it need never have allowed
to happen.

The same argument applies to the history of the world. Why did God
permit Adam to fall into sin, thereby condemning the entire subsequent
human race to misery? The standard answer is that God endowed human-
kind with free will, with the risk that they would misuse it. But since God

must have desired man's good, could he not have created man without an inclination to evil?[169] Or, if God did not foresee the fall of man, he must at least have known that it was possible, and that he might therefore have to abandon his paternal goodness and punish humanity by the infliction of misery:

> Neither his goodness, nor his holiness, nor his wisdom could allow that he risked these events; for our reason convinces us in a most evident manner that a mother, who would allow her daughters to go to a ball when she knew with certainty that they ran a great risk of losing their honor there, would show that she loved neither her daughters nor chastity.[170]

There would seem no way of exonerating God from the charge of wanton cruelty towards humankind. The Manichaean heresy, presented by Bayle in several linked articles, solves this difficulty by supposing that there are two deities or two principles, a good and an evil one, and that the miseries suffered by humanity are the work of the latter. But such a solution is inadmissible for Christians. So, since philosophical argument cannot show that God is good, Bayle recommends making reason subordinate to faith: 'Man's understanding must be made a captive of faith and must submit to it. He must never dispute about certain things.'[171] The questioner should abandon philosophy, remain silent about his doubts, and trust that God, despite appearances to the contrary, is good. Such passages as this have led to the conclusion that Bayle was a fideist. But they can also be read as ironic, especially as Bayle did not take his own advice to fall silent but persisted in probing the most awkward theological arguments. Leibniz thought such arguments for faith were counterproductive: 'many readers, convinced of the irrefutable nature of his objections and believing them to be at least as strong as the proofs for the truth of religion, would draw dangerous conclusions.'[172] Indeed. Perhaps Bayle meant them to?

The revocation of the Edict of Nantes induced Bayle to write a typically digressive commentary on Augustine's infamous use of the Bible words 'Compel them to come in', in which Bayle professes to be guided by the light of reason and by 'natural religion, strengthened and perfected by the Gospel'.[173] Reason, which comes from God, is able to discern the true meaning of Scriptural passages that, like Augustine's quotation, appear at first sight to be morally unacceptable. This was an epoch-making step. Without prejudice to theological doctrines traditionally held to be above reason, Bayle, by applying reason to the ethical content of the Bible, gives philosophy priority over theology: 'the philosopher as guardian of ethics now has jurisdiction over the entire Scripture, and in the domain of his competence, his judgments are seen to outweigh those of the theologian.'[174]

Even with the help of reason, however, it is impossible for the soul to find any distinguishing mark that definitely separates true doctrines from false ones. The soul 'must therefore either mistrust them all, despise them all, and so never perform one act of virtue, or else trust them all after feeling inwardly that they seem true and genuine and after having arrived at a thorough conviction of conscience'.[175] Here Bayle speaks up for the rights of the individual conscience, and appears also to be endorsing the implicitly anti-Christian scepticism that has often been taken as his fundamental standpoint. Hence the anecdote transmitted by Gibbon: 'in a conversation with the ingenious Abbé, (afterwards Cardinal) de Polignac, he freely disclosed his universal Pyrrhonism. "I am most truly (said Bayle) a protestant; for I protest indifferently against all Systems, and all Sects." '[176] If he was a fideist, who intended to encourage blind faith, the effect of his writings was the exact opposite: to undermine faith and to spread scepticism as the basis for toleration.

## VOLTAIRE

Among writers on toleration, Voltaire was unusual in being able actively to campaign for it. His opportunity came in the 1760s. By then, Voltaire, aged nearly seventy, was a national figure as a writer of extraordinary talent, wit and versatility. He had been appointed historiographer of France by Louis XV in 1745 and elected to the French Academy. But he was also unpopular, thanks to his merciless satirical power and, especially, his steady opposition to the Catholic Church. In 1750 he had moved to Berlin to enjoy the patronage of the equally anti-Christian Frederick the Great, but the two men's tense relationship ended after three years in a quarrel which was the talk of Europe. In 1758 Voltaire bought an estate at Ferney, close to the Swiss border, and lived there in seclusion, writing prolifically against clerical tyranny and in favour of enlightened causes.

The chance to use his influence came with the Calas affair, a flagrant case of injustice arising from intolerance. In October 1761 Jean Calas, a Protestant cloth merchant in Toulouse, was charged with the murder of his eldest son, Marc-Antoine, who had been found hanged. Catholics and Protestants in Toulouse lived together in an uneasy peace, but the unclarity surrounding Marc-Antoine's death enabled latent suspicion of Protestants to flare up in hatred. Rumours spread that the young man had been murdered by his parents in order to forestall his intended conversion to Catholicism. No evidence of Marc-Antoine's conversion plan was ever produced, and, motive aside, it looked physically impossible for his frail

sixty-three-year-old father, his mother and a friend to kill him, especially as they would have needed the help of their Catholic maidservant. Nevertheless, the court in Toulouse found Calas guilty. He was tortured on the rack, and compelled to drink twenty jugs of water, in an unsuccessful attempt to extort a confession. On 10 March 1762, still protesting his innocence, he was tortured to death. He was tied face up on a wheel, and his arms and legs were broken with an iron bar; he was left there for two hours, then he was strangled and his body was burned. Meanwhile the Catholic clergy of Toulouse gave the supposed convert Marc-Antoine a martyr's funeral.

Soon after hearing of the incident, Voltaire met Calas's youngest son in Geneva, and became convinced that it was the worst outrage against human nature since the Massacre of St Bartholomew's Night.[177] The trial had been held in secret, so the court was not obliged to justify its actions. Voltaire first tried – unsuccessfully – to obtain the trial records. Eventually, after appealing to the intelligent public by distributing a pamphlet expressing the Calas family's point of view, he succeeded. On 4 June 1764, the verdict on Calas was annulled by the King's Court. A new trial was held, and on 12 March 1765 Calas was posthumously rehabilitated.[178]

Voltaire's practical campaigns against intolerance continued. He obtained the rehabilitation of the Sirven family, Huguenots who were accused of murdering their daughter, a convert to Catholicism, and who fled to Switzerland to escape persecution. And he denounced the torture and execution of the chevalier de La Barre, a young man whose crime was to have kept his hat on when a religious procession was passing, and who was further accused, on no evidence, of defacing a wooden crucifix set up on a bridge. La Barre was tortured to make him reveal his accomplices, then beheaded, and his body was publicly burned. Not only were such punishments atrocious, but, as Voltaire maintained, persecution might well be motivated by an individual's malice or greed, and to make its case the Church authorities encouraged informers and relied on flimsy or imaginary evidence, thereby spreading an atmosphere of terror. Voltaire himself found it advisable to retreat to Switzerland for several weeks after issuing his protest against the La Barre case.

The Calas affair prompted Voltaire to write extensively on tolerance, especially in his *Treatise on Tolerance* (1762) and the article 'Tolerance' in his *Philosophical Dictionary* (1764). These writings are part of Voltaire's energetic campaign against Christianity and the power of the Catholic Church. Their case for tolerance is very simple. We are all human and should treat one another with kindness and forbearance. Tolerance is founded on the natural principle: 'Do unto others as you would have

done unto yourself.' Hence tolerance is the 'hallmark of humanity'.[179] It
is founded on reason, the great enemy of superstition, and dictates respect
for each individual's reason. 'Is each individual citizen, then, to be permit-
ted to believe only in what his reason tells him, to think only what his
reason, be it enlightened or misguided, may dictate? Yes, indeed he should,
provided always that he threatens no disturbance to public order.'[180] No
political danger can result from toleration; on the contrary, if there are
more sects, each one becomes less powerful and less dangerous.

In practical terms, Voltaire's proposals are modest. He wants Protes-
tants to receive basic toleration. They need not be allowed to worship in
public or to hold civil offices, but they should no longer be required to
conduct their marriages according to Catholic rites, a demand that obliged
many Protestants to hold clandestine weddings in the countryside.[181]
Although the *Treatise* did not lead to any changes in the law, it helped to
encourage the government to treat Protestants more mildly.

The *Treatise* is a powerful defence of tolerance and an even more power-
ful attack on Christianity. Voltaire contrasts Christian intolerance with
the tolerance allegedly practised in the rest of the world, from the Ottoman
Empire to Japan. The Japanese expelled the Christians only when the latter
began making war on the twelve sects that already lived there in harmony.
'In the end, tolerance has been responsible for not a single civil war, whereas
intolerance has covered the earth with corpses.'[182] Religious intolerance
was unknown in the ancient world. The Greeks did not practise persecu-
tion; the only exception is the death of Socrates, and though the reasons
why he was required to drink hemlock are obscure, he seems to have been
slanderously accused of inciting young men against religion and govern-
ment. The Romans did not persecute; Christians lived peacefully for most
of the time under the Empire, and their martyrdoms, which in any case
were much rarer than Church historians would have us believe, resulted
not from their religion but from their defiance of the established religion.

Voltaire speaks well of the New Testament, acknowledging the human-
ity shown by Jesus in the Gospels. He discusses the parable with the words
'Compel them to enter' that Augustine had used to justify persecution,
and questions whether it can possibly refer to the Kingdom of Heaven.
Moreover, it is intrinsically absurd: 'it stands to reason that a single man-
servant cannot prevail by force upon everyone he comes across to compel
them to dine with his master; besides which, guests invited on such terms
are unlikely to improve the geniality of the occasion.'[183] The humane spirit
of the Gospels, however, was soon smothered by priestly deceptions, big-
otry and superstition. A long excursus quotes many puerile anecdotes
recounted in medieval saints' lives. Voltaire expresses confidence,

however, in the gradual defeat of superstition by reason, 'the one slow but infallible route towards enlightenment'.[184]

## LESSING

Gotthold Ephraim Lessing is a key figure of the German Enlightenment and one of its most appealing representatives. Like Bayle, he is a witty, unsystematic, enigmatic writer, who makes it difficult for us to know what he really thought. Instead of presenting posterity with a single huge work dwarfing all his others, as Bayle did with the *Dictionary*, Lessing produced an astonishing range of work in many genres. Although he reluctantly studied theology at Leipzig in obedience to his father, a Lutheran minister at Kamenz in Saxony, the young Lessing was far more interested in the theatre and told his parents, doubtless to their horror, that he hoped to become the German Molière. He did in fact write over a dozen comedies, one of which, *Minna von Barnhelm* (1767), is acknowledged as among the finest in German. In addition, he wrote domestic tragedy in *Miss Sara Sampson* (1755), a greater and more problematic tragedy in *Emilia Galotti* (1772) and the unclassifiable *Nathan der Weise* (*Nathan the Wise*, 1779), a serious intellectual comedy, which is generally considered a landmark in the history of toleration. But literature – including also witty poems, epigrams and fables – is only a part of Lessing's oeuvre, which includes also antiquarian and aesthetic studies, polemical essays, and investigations into theological issues and biblical criticism.

Lessing's life was as unsettled as his intellect. He tried to make a living as an independent man of letters, something barely possible in eighteenth-century Germany. After many years as a journalist and playwright in Berlin, he took a job as secretary to a Prussian general in the Seven Years War. Thereafter he wrote theatre reviews for the short-lived National Theatre in Hamburg, smuggling into his reviews an unsystematic but searching theory of modern drama. He at last found security working for the duke of Brunswick, who placed him in charge of the library at Wolfenbüttel, which is still one of Germany's foremost research libraries. Having disputed with classical scholars and antiquarians, he entered into a theological controversy with the notoriously rigid and intolerant Pastor Goeze of Hamburg; the duke obliged him to break off the controversy, whereupon Lessing put his views into the drama *Nathan der Weise*.

Lessing's writings, like Bayle's, do not spring from a single settled belief, but rather from a contrarian refusal to rest content with established

positions. He did not aim at the inert possession of truth, but enjoyed the invigorating search for it:

> If God held fast in his right hand the whole of truth and in his left hand only the ever-active quest for truth, albeit with the proviso that I should constantly and eternally err, and said to me: 'Choose!', I would humbly fall upon his left hand and say: 'Father, give! For pure truth is for you alone!'[185]

His writings show a constant scepticism towards authority and a sympathy with outsiders, both past and present. Looking to the past, Lessing wrote defences of figures with a bad reputation in Church history, such as Adam Neuser, a sixteenth-century Lutheran clergyman who was reviled for converting to Islam, and Simon Lemnius, who wrote a scurrilous attack on Martin Luther. He explicitly followed the example of Bayle in defending the Renaissance physician, astrologer, mathematician and autobiographer Girolamo Cardano, who was reputed to be an atheist. In his *De subtilitate rerum* (*On the Subtlety of Things*, 1550) Cardano had undertaken a comparison of paganism, Judaism, Islam and Christianity. Lessing gives the comparison dramatic form by staging an imaginary conversation among representatives of different faiths. The Jewish speaker attacks the thesis that Christianity had superseded Judaism by pointing out that the Jews have survived in large numbers, still practising their religion, which permits the conclusion that God values them and has a yet undisclosed purpose in mind for them. The Muslim speaker criticizes Christianity for relying on miracles, mysteries and the sword to spread its message. This dramatic technique enables Lessing to smuggle in a damaging critique of Christianity.

While Lessing always showed sympathy with outsiders, he was particularly friendly towards Jews. Lessing was a close friend of Moses Mendelssohn, who made his living by running a silk-weaving factory and had in addition mastered German, French and Latin, published works of philosophy, and become a distinguished representative of the Enlightenment. In 1771 the Berlin Royal Academy decided to propose to Frederick the Great that Mendelssohn should be elected a member; but the king, strongly prejudiced against Jews, did not even acknowledge the proposal. His status exposed him also to more trivial annoyances: Jews had to support Prussian manufactures by buying large quantities of china, even if they had no use for it, and Mendelssohn was obliged to buy twenty life-size china monkeys.[186]

Lessing's early comedy *Die Juden* (*The Jews*, written 1749, published 1754) satirizes antisemitism by showing a Jewish traveller, with nothing to mark him out as a Jew, saving a baron from two highwaymen, who are in fact the baron's own dishonest servants, disguised as Jews with false

beards. When the humane and generous traveller reveals to the other characters that he is a Jew, the absurdity of anti-Jewish prejudice is laid bare. As this is a revelation to the audience as well, however, the message is apparent only with hindsight.

Lessing avoided any such mistake in his last play. *Nathan der Weise* is set in Jerusalem during the Third Crusade, so that Jews, Muslims and Christians can be brought together, as in the dialogue with which Lessing had enlivened his defence of Cardano. The wise and cultivated Jewish merchant Nathan – who, like the traveller in *Die Juden*, has few conventionally Jewish features – learns on returning from a journey that his daughter, Recha, has been saved from a fire by a Templar, a member of the order of military monks established to fight in the Crusades. Although the Templar, thanks to his upbringing in Christian bigotry, at first gruffly rejects gratitude from a Jew, he is soon won over by Nathan's evident uprightness and intelligence, and they resolve to be friends, agreeing that good people can be found among every nation and that what counts is basic humanity:

> Verachtet
> Mein Volk so sehr Ihr wollt. Wir haben beide
> Uns unser Volk nicht auserlesen. Sind
> Wir unser Volk? Was heißt denn Volk?
> Sind Christ und Jude eher Christ und Jude,
> Als Mensch? Ah! wenn ich einen mehr in Euch
> Gefunden hätte, dem es gnügt, ein Mensch
> Zu heißen!

> Despise
> My nation as you please. We did not choose
> Our nations, either you or I. Are *we*
> Our nations? What does 'nation' mean? Are Jews
> And Christians first and foremost Jews and Christians,
> And human only second? Would that I
> Had found in you another person who
> Is happy to be human![187]

The play appeals for a humane outlook across religious and racial boundaries, and rails against Christianity as too often a barrier to humanity. Nathan's daughter Recha is in fact a Christian child whom he adopted. Annoyed by Nathan's evident displeasure at his love for Recha, the Templar, who learns this fact from Recha's garrulous Christian nurse, comes close to revealing it to the patriarch of Jerusalem. Asked hypothetically what would happen if a Jew were found to have adopted a Christian child,

the patriarch promptly replies that the Jew would be burned alive. Sobered, the Templar keeps the secret. Presently we learn that Nathan took charge of the infant Recha soon after his wife and seven sons were burned to death by Christians in a pogrom – the danger of death by fire, accidental or deliberate, recurs throughout the play. Eventually it transpires that the Templar himself is the son of Sultan Saladin's brother, and that Recha is his sister; it was a suspicion of their relationship that made Nathan seem disapproving. The curtain falls on the joyful re-establishment of family relationships, a happy ending from which only Nathan, who is nobody's blood relative, is excluded.[188]

The question of specifically religious toleration arises when Nathan is abruptly summoned by Saladin. Instead of asking for a loan, as Nathan expects, Saladin tests Nathan's reputation for wisdom by asking him which of the three religions – Islam, Judaism, or Christianity – is the true one. After all, someone so wise must have adopted, or retained, his religion for weighty reasons. Nathan replies by telling a story, the famous parable of the rings. Long ago, a man possessed a ring which had the power of making its owner beloved of God and man. It passed down through his descendants and eventually came to the father of three equally meritorious sons. Unable to decide which son to leave his ring to, the father had two identical rings made and gave each son, separately, a ring that the son assumed was the true one. Finding they each had a ring, they took their dispute before a judge, who told them that the criterion for the genuineness of the ring was its owner's behaviour. Each, therefore, must strive to make himself beloved of God and man through virtuous conduct.

This conclusion reinforces a message already illustrated by the Templar's rescue of Recha: that the test of merit is not formal belief, but active benevolence. But it goes further. Practical morality is now the test of religious truth. The beliefs professed by Christians, Jews and Muslims are unimportant; all that really matters is their practical consequences. Lessing thus takes the theory of toleration to an extreme. As we have seen, some Reformation theologians classified non-doctrinal matters, such as the conduct of services, as *adiaphora*, 'things indifferent'. Now, by implication, even the doctrines of different religions are *adiaphora*; what matters is a shared ethical core that, being basic to humanity, is even independent of religion. Since religions are no longer recognized as such, this is not really tolerance, however, because there is nothing left to tolerate.

> The representatives of the three major religions, Judaism, Christianity, and Islam, are not here shown to tolerate one another's differences, for it is only temporary misunderstanding that prevents them from recognizing that they

all think alike: they are shown rather to be agreed in a fourth, secret, religion of agnostic humanism.[189]

Lessing has gone beyond toleration and begun imagining a post-religious future.

## GOETHE

The self-governing Imperial City of Frankfurt am Main, where Johann Wolfgang Goethe was brought up as a member of the patrician elite, was reasonably relaxed in religious matters. Although the city was officially Lutheran, Catholicism was highly visible, with a cathedral, several monasteries and the palaces of three ecclesiastical princes, the archbishop-electors of Trier, Cologne and Mainz. Calvinists had to worship outside the walls. Jews were confined within the crowded ghetto, whose gates were shut every night until 1796.[190] The Protestant religious instruction imparted to the young Goethe was, as he recalls in his autobiography some fifty years later, 'a kind of dry morality', and its presentation was as uninspiring as its content.[191] He enjoyed the highly visual Catholic ceremonies, and was intrigued by the Jews; his early writings include a parody of a Yiddish sermon. He acquired a thorough knowledge of the Bible, even learning some Hebrew, along with early scepticism about God. Aged six at the time, he was aware of the Lisbon earthquake of 1755, in which 60,000 people were thought to have perished. In Goethe's view, the Father in Heaven 'had shown Himself by no means fatherly when he abandoned both the just and the unjust to the same destruction'.[192]

Goethe presents himself, admittedly with hindsight, as inclining even in childhood towards the natural religion, focused on earthly things, that was his basic attitude in adult life. 'Universal, natural religion does not really need faith', he wrote in his autobiography, 'for the belief that a great creative being who orders and directs the world conceals himself, as it were, behind nature, in order to make himself manifest to us, such a belief must impress itself on everybody.'[193] He favoured a kind of pantheism, for which he found inspiration in Spinoza's identification of God with Nature; though Goethe's divine Nature is a dynamic, amoral force, constantly alternating between creation and destruction.

In his late teens, however, Goethe underwent a period of ill health that obliged him to return home from his university studies at Leipzig and helped to prompt a phase of immersion in religious matters. Here he was guided by a friend of his mother's, Susanna von Klettenberg, a kindly,

open-minded person who was also a Pietist. Pietists differed from ortho-
dox Lutherans by cultivating an inward, emotional relationship with God.
Together with a like-minded group, Goethe read eclectically in religious
writers, helped by a book to which he pays a warm tribute, Gottfried
Arnold's *Unparteyische Kirchen- und Ketzer-Historie* (*Non-Partisan His-
tory of the Church and Heretics*, 1699–1700).

A clergyman and theologian, Arnold briefly held a chair of history at
the University of Giessen but resigned after a year because he found uni-
versity study incompatible with his semi-mystical devotion to God. His
death resulted from the brutal intrusion of secular politics into his ordered
life: Prussian recruiting officers burst into a church where Arnold was
preparing young men for confirmation and carried them off to be soldiers,
and the shock killed him. Arnold interprets the history of the Church as
a steady decline from the purity of early Christianity. He laments the
disputes, conflicts and devastation caused by religious zeal, and the ten-
dency of theology to substitute empty words for devout feeling. True
Christians have always been scattered individuals who cultivated a per-
sonal relationship with God, and have been at best marginalized, at worst
persecuted by the official Churches. Written in a direct and punchy style,
with ample quotations, his *History* gives an account of innumerable
unorthodox Christians, from the early Gnostics down to the modern
Quakers. It is sympathetic to the Socinians, with a dreadful account of
the burning of Servetus (apparently the wood, being green, burned so
slowly that Servetus took three hours to die), and even includes a sympa-
thetic account of Muhammad, who is praised for allowing freedom of
conscience.[194] With its more than two thousand double-columned pages,
Arnold's book challenges comparison with Bayle's *Dictionary* in its bulk
and in its encyclopaedic character, though as it is arranged chronologically
instead of alphabetically, one can orient oneself more easily. Among
Arnold's admirers was Goethe's great-uncle Johann Michael von Loen,
himself the author of a treatise on toleration.[195]

Deeply influenced by Arnold, and confirmed in his views by Spinoza,
Goethe was predisposed towards a generous tolerance.[196] Questions of
toleration are at the centre of his historical drama *Egmont*, begun around
1775 and completed in 1787. The setting is the Netherlands in 1566, when
they were under Spanish rule. Calvinism is spreading. Its proponents are
violent iconoclasts who attack and pillage churches and abbeys. All the
political figures – Margaret of Parma, the well-intentioned regent; Count
Egmont, the popular Dutch leader; and the emperor's general, the sinister
duke of Alva – agree that these disturbances arising from religious diver-
sity cannot be tolerated, but none of them has a solution. Margaret is at

a loss; Egmont ineffectually exhorts the people to return to their traditional religion; Alva finally intervenes to repress religious dissension with fire and sword, thereby in the long run strengthening it.

The play's only spokesman for a more tolerant approach is one whom most commentators have neglected, the regent's secretary Machiavell. Based on an actual figure, Machiavell is given a far more prominent role in Goethe's play than he had in its main historical source, Famianus Strada's Latin history of the Revolt of the Netherlands. As his name implies, Machiavell is *politique*. In his view, the progress of the new faith cannot be stopped. The only way to control it is a pragmatic policy of toleration, which should drive a wedge between the moderate Protestants and the extremists. The moderates, instead of listening to incendiary sermons by hedge-preachers, should be allowed their own churches and thus be enclosed within the order of civil society. This will put an end to violence. Any other policy will lead to civil war, because the new faith is not confined to the social fringes but has made headway among the broad mass of the people and the soldiers, and has penetrated as high as the nobility and the mercantile class; therefore an attempt to suppress it will unite the whole nation in opposition. In retrospect, Machiavell appears an entirely plausible spokesman for pragmatic toleration.[197]

Goethe explicitly put the case for tolerance in an attractive short text, *Letter from the Pastor at \*\*\* to the New Pastor at \*\*\** (1773). Purporting to be translated from French, it is evidently inspired by the emotional 'Profession of Faith by a Savoyard Vicar' that forms part of Rousseau's *Émile* (1762). The old clergyman who writes a friendly letter to a newly appointed colleague is a lovable figure; though apparently a simple man, he has read not only the theologians but also Voltaire and Rousseau. He readily admits that parts of the Bible are unintelligible, and other parts boring. He rejects the doctrine of Original Sin. His central belief is in the love of God. God's love is so unfathomable that we cannot set bounds to it: we cannot say, for example, that it is denied to the heathen, though his parishioners unfortunately enjoy imagining that unbelievers will be roasted. The clergyman expects to meet the heathen in heaven: 'What joy it is to think that the Turk who considers me a dog, and the Jew who considers me a pig, will one day be glad to be my brothers.'[198] He therefore advocates tolerance, insisting that tolerance of religion does not mean indifference to religion, as the orthodox claim. Indeed, 'when you look at things in the light, each person has his own religion'.[199] Tolerance could hardly go further. The reluctance that is implied in toleration has here been dropped: toleration has mutated into acceptance.

## BEYOND TOLERATION

By the late eighteenth century, the model of toleration as a concession, granted with some degree of reluctance, was being questioned and attacked. There were two objections to it. One was that it implied indifference, indeed contempt. The politician and philosopher Edmund Burke argued in *Reflections on the Revolution in France* (1790) that the toleration advocated by sympathizers with the Revolution was misguided. There was no merit in tolerating opinions that one despised (he might have given Frederick the Great as an earlier example). True tolerance meant treating other people's opinions with respect:

> There are in England abundance of men who tolerate in the true spirit of toleration. They think the dogmas of religion, though in different degrees, are all of moment; and that amongst them there is, as amongst all things of value, a just ground of preference. They favour, therefore, and they tolerate.[200]

Another opponent of the French Revolution, Goethe, agreed: 'Tolerance should really be only a temporary outlook; it must lead to acknowledgement. To tolerate is to insult.'[201] Tolerating different beliefs as a political necessity, or even out of respect for freedom of conscience, no longer seemed enough: toleration had to grow into a positive acceptance of other religions as being valuable and interesting in their own right.

A second argument against toleration, as hitherto conceived, was that a prince who granted it was arrogating a right that he did not possess. In his essay 'What is Enlightenment?' Kant maintains that an enlightened prince should not even claim to be tolerant, but should allow his people complete religious freedom as a matter of course:

> A prince who does not regard it as beneath him to say that he considers it his duty, in religious matters, not to prescribe anything to his people, but to allow them complete freedom, a prince who thus even declines to accept the presumptuous title of *tolerant*, is himself enlightened.[202]

Burke's antagonist Thomas Paine quoted the French Declaration of the Rights of Man and the Citizen, which laid down that no law-abiding person should be molested because of religious opinions. Since conscience was an inalienable natural right, Paine argued, to grant toleration was really just as tyrannical as denying it.

> Toleration is not the *opposite* of Intolerance, but is the *counterfeit* of it. Both are despotisms. The one assumes to itself the right of with-holding

Liberty of Conscience, and the other of granting it. The one is the pope
armed with fire and faggot, and the other is the pope selling or granting
indulgences.[203]

Moreover, Paine went on, toleration was yet more presumptuous, for in
laying down what religions were allowed, it not only dictated to humans
how they should worship God, it also dictated to God what kind of wor-
ship he should receive.

In the late Enlightenment, therefore, it at last becomes possible to
imagine toleration based not on reluctant acceptance, but on positive
respect. Such toleration 'is fully developed for the first time in Kant'.[204]
But this is not quite what Burke means by respect. Burke wants to accord
respect, in varying degrees, to all religious beliefs. Kant's respect is
accorded first and foremost to human beings. For him, each human being
is in principle autonomous, capable of attaining maturity and thinking
independently, without being subject to an alien ('heteronomous') auth-
ority. Other people's beliefs are to be respected insofar as other people are.

The move from toleration of minority religions to equal respect for all
religions is expressed in the First Amendment to the Constitution of the
United States (1789), which begins: 'Congress shall make no law respect-
ing an establishment of religion, or prohibiting the free exercise thereof.'
All religions have equal status. Very importantly, no religion has a privil-
eged status that lets it claim an influence on government policy. In England,
by contrast, not only is the Church of England established by law, but
twenty-six of its bishops sit in the House of Lords as 'Lords Spiritual'.
Nevertheless, religious freedom in the US is still incomplete. It is generally
agreed that any candidate for President must profess belief in God, so that
a hypocrite is more eligible than an honest atheist. Bayle's arguments about
the morality of atheists have not yet penetrated.

The credit for establishing America's still very considerable religious
freedom belongs especially to Thomas Jefferson. Inspired especially by
Milton, Locke and Shaftesbury, he composed a 'Bill for Establishing Reli-
gious Freedom', which in 1786, after much debate, became law in the State
of Virginia, and set a standard for the national constitution. Jefferson
concluded: 'it is honorable for us to have produced the first legislature who
has had the courage to declare that the reason of man may be trusted with
the formation of his own opinions.'[205] His case for freedom of conscience,
however, deserves a moment's scrutiny:

> The error seems not sufficiently eradicated, that the operations of the mind,
> as well as the acts of the body, are subject to the coercion of the laws. But our
> rulers can have authority over such natural rights only as we have submitted

to them. The rights of conscience we never submitted, we could not submit. We are answerable for them to our God. The legitimate powers of government extend to such acts only as are injurious to others. But it does me no injury for my neighbour to say there are twenty gods, or no god. It neither picks my pocket nor breaks my leg ... Reason and free enquiry are the only effectual agents against error. Give a loose to them, they will support the true religion, by bringing every false one to their tribunal, to the test of their investigation. They are the natural enemies of error, and of error only.[206]

Jefferson does not, however, consider how to react if my neighbour, besides proclaiming his own beliefs, insults mine by publishing hostile caricatures of beings that I revere. Am I not entitled to take offence? The multicultural society that we increasingly inhabit today often argues that my beliefs should have the protection of the law, and even that the caricaturist should be indicted for blasphemy.

Tempting though this may seem, we need to acknowledge Jefferson's distinction between true and false religion. For him, religion is not cordoned off from intellectual life, and its assertions should be tested by the standards of argument and evidence that apply elsewhere. We should treat religious believers with civility, but neither delicacy nor intimidation should restrain us from contesting the factual and historical claims that religions put forward with such assurance. Jefferson was sharply conscious of the tyranny that organized religion had exercised throughout most of history. A central aim of the Enlightenment was to break down religious tyranny – rarely in order to destroy religious belief, but most often in order to replace implausible and unfounded statements with beliefs that survived the test of knowledge and good sense. How it did so is the subject of the next chapter.

# 4

# The Religious Enlightenment

Since Enlightenment thinkers set such store by the toleration of different religions, they could hardly have been hostile to religion as such. They certainly opposed the overweening authority assumed by many religious institutions and applied critical scholarship to the Bible, which was a major support for such authority. Nevertheless, a long-standing view interprets the Enlightenment as a whole as attacking the Churches, the Bible and revealed religion. Voltaire is the iconic figure here, with his gleeful dissection of biblical absurdities and the motto with which he signed off many of his letters: *Écrasez l'infâme!* ('Smash the vile thing!'). By this, however, Voltaire meant not so much religion as such, but the oppressive power of the Churches.[1] Peter Gay, while conceding that Enlighteners were influenced by their Christian background, contended in 1966: 'Christianity made a substantial contribution to the philosophes' education, but of the definition of the Enlightenment it forms no part.'[2]

More recent research, however, has emphasized that the Enlightenment took place not only *against* but also *within* the major Churches. In England and Scotland, there was a growing belief that religion could be reconciled with reason (admittedly with the large exception of David Hume).[3] The rigid orthodoxy of German Lutheranism was tempered by the emergence of Neology, which tried to make religion more acceptable to reason.[4] The Catholic Church saw one enlightened pope, Benedict XIV (1740–58), who accepted the findings of modern science, explained many supposed supernatural phenomena from natural causes, campaigned against superstition, and had the gifted female scientist Laura Bassi appointed to a university chair.[5]

Hence one can describe large areas of the Enlightenment without self-contradiction as 'the religious Enlightenment', 'the Christian Enlightenment' and 'the Catholic Enlightenment'.[6] In one well-known intellectual map of the Enlightenment there is a moderate mainstream, in which liberal Christianity shades into deism (belief in a God who, having created the world,

remains outside it), flanked by a radical Enlightenment that favoured materialism, pantheism and/or atheism.[7] It has also been suggested that there was an opposite flank, 'the religious Enlightenment', sustained by 'theologians, clergy, and religious thinkers who were fully committed partisans and reformers of their own tradition'.[8]

The image of the Enlightenment as assailing the authority of the Bible and the Churches would have been familiar in the nineteenth century to a rationalist such as Lecky. But it is, at most, half the truth. There was also, within the Churches, 'a transnational and multiconfessional religious Enlightenment'.[9] Across various confessions and religions – Anglicanism, Calvinism, Lutheranism, Catholicism and Judaism – forward-looking thinkers, including many clerics, sought to preserve religion by reshaping it so as to accommodate ideas associated with enlightenment. Like Locke in *The Reasonableness of Christianity* (1695), they drew on enlightened thinking in order to preserve the spiritually and ethically valuable parts of religion while downplaying or discarding those elements that were intellectually and/or morally unacceptable. They sought a balance between faith and reason, arguing that there need be no conflict between the two. Revelation offered truths that were above reason but could not be contrary to it. They accepted natural religion, agreeing that the existence of God was manifest in the wise and harmonious construction of the world and confirmed by the ethical intuitions available to every well-disposed human being. For them, however, natural religion was 'a necessary but insufficient foundation for belief': revelation was required to develop humanity's moral awareness and instruct us about the nature of God.[10] Distancing themselves from dogmatic orthodoxy on the one hand and from superstitious 'enthusiasm' on the other, enlightened spokesmen from various creeds all advocated a 'middle way'.[11] In doing so, however, they often faced a hard struggle with clerical authority. This chapter deals with enlightened attempts to reconstruct religion. The next chapter will turn to the more radical wing of the Enlightenment, examining attacks on orthodox religious belief and surveying the various heterodox speculations that arose in its place.

## OPTIMISM

Eighteenth-century thinkers took for granted that all beings were linked to each other in a graduated hierarchy. At one extreme were the archangels, who were closest to the divine perfection; at the other extreme were the tiniest microscopic creatures. As Leibniz put it:

All the different classes of beings which taken together make up the universe are, in the ideas of God who knows distinctly their essential gradations, only so many ordinates of a single curve so closely united that it would be impossible to place others between any two of them, since that would imply disorder and imperfection. Thus men are linked with the animals, these with the plants and these with the fossils, which in turn merge with those bodies which our senses and our imagination represent to us as absolutely inanimate.[12]

The chain was continuous. There were no gaps. Some of the links, however, were hard to identify. George Herbert thought that bats were intermediate between birds and mammals, frogs between reptiles and fish.[13] Leibniz was convinced that plant-like animals, or animal-like plants, must exist and would eventually be discovered.[14] He seemed vindicated when in 1744 the Swiss naturalist Abraham Trembley described the freshwater polyp or hydra. Initially Trembley thought that polyps were parasitic plants; then, when he found that they could move, that they were animals; then, when he found that if a polyp was cut in two each part survived independently, that they were plants after all; finally, 'they appeared to me to be animal-plants, occupying a kind of intermediate place between these two classes of organized bodies'.[15]

The chain was also governed by the principle of plenitude, which said that everything that could exist, must exist, for it would be incompatible with the divine goodness to leave any potential unrealized. So the innumerable micro-organisms revealed by Leeuwenhoek's microscope confirmed that God's universe was swarming with the greatest possible variety of life-forms, those that we cannot see being probably more numerous than those we can:

> Êtres, qui par milliers dans l'univers semés,
> Forment un monde entier d'atomes animés.[16]

[Beings that, strewn in thousands throughout the universe, form a whole world of animated atoms.]

With all their profusion, however, each of God's creatures knew its place in a hierarchical system that has been called 'cosmic Toryism'.[17] Humanity was sometimes thought to be half-way between the angels and the animalculae, but was more often located further down, with an immense range of spiritual beings between ourselves and God.[18] Each creature had the properties appropriate to its destined place.

> Why has not Man a microscopic eye?
> For this plain reason, Man is not a Fly.[19]

Thanks especially to Linnaeus, this hierarchical conception became known as the 'economy of nature', in an image taken ultimately from the management of a household. In 1659 Walter Charleton had undertaken to explain 'the most probable *Oeconomy of Nature* in perfect animals', meaning the interdependent functions and movements within a single organism.[20] In his dissertation *Oeconomia naturae* Linnaeus extended this conception to the natural world as a whole. In this text – which, as was then customary in Sweden, Linnaeus dictated to his student, who then translated it into Latin and defended it at Uppsala in 1749 – nature is a divinely ordained and interconnected system, attesting the wisdom and goodness of the Creator.[21] Every animal finds the habitat and food suitable for it. Providence ensures that no species will become too numerous by creating predators to keep down its numbers. Mutual predation, in a counterpart to the chain of being, forms a food chain:

> Thus the *tree-louse* lives upon plants. The fly called *musca aphidivora* lives upon the *tree-louse*. The *hornet* and *wasp fly* upon the *musca aphidivora*. The *dragon fly* upon the *hornet* and *wasp fly*. The *spider* on the *dragon fly*. The *small birds* on the *spider*. And lastly the *hawk* kind on the *small birds*.[22]

The natural world was an endless cycle of generation, destruction and new life. Humanity was at the apex of this system, but equally subject to its economy. Travelling through Sweden, Linnaeus observed that people used churchyard soil to grow cabbages, and concluded: 'In this way we come to eat our dead, and it is good for us.'[23] In another dissertation, Linnaeus cautiously surmised that when human populations increased, and people congregated in cities, contagious diseases spread and mutual animosities resulted in war, thus keeping numbers down. Hence, without intending any criticism of the divine order, Linnaeus described it as *'a war of all against all!'*[24]

This hierarchical conception seemed to provide an answer to one version of the problem of evil. Tender souls might be distressed to think of lions killing antelopes, or human beings breeding animals in order to eat them. But lions were made to devour antelopes, antelopes were made to be devoured, while grass was made to be eaten by antelopes; and it was surely better to be an antelope, even in constant danger from predators, than not to exist at all.[25] One could not call a spider bad for killing flies, argued Shaftesbury, because one had to see both within a larger system. Each played its part within the largest possible system, the divinely created universe. Each was perfectly designed, the spider to be a predator, the fly to be preyed on. Hence,

if the ill of one private system be the good of others, if it makes still to the good of the general system (as when one creature lives by the destruction of another, one thing is generated from the corruption of another, or one planetary system or vortex may swallow up another), then is the ill of that private system no real ill in itself, more than the pain of breeding teeth is ill in a system or body which is so constituted that, without this occasion of pain, it would suffer worse by being defective.[26]

Anyone still uneasy at the spectacle of a universe in which creatures perpetually devoured one another might be heartened by a treatise in which the émigré Lutheran clergyman John Bruckner, an admirer of Linnaeus, addressed the problem head on. Bruckner undertakes to justify 'the general Devastation and Carnage that reign among the different Classes of Animals', as his subtitle has it. By devouring one another, animals prevent overpopulation. Carcases are promptly devoured by other animals: 'the body quickly becomes a re-animated mass; the different parts of which are afterwards dispersed, and resign in their turn the gift of life to other species.'[27] Contemplating the variety of animals, Bruckner exclaims: 'what an insatiable urge to destroy each other!'[28] Having illustrated their destructiveness and affirmed that it is designed by Providence, he adds: 'Such is the wonderful economy of nature!'[29]

Human beings are part of the food chain. Pointing out that agriculture is laborious, and cannot be practised in all climates, Bruckner argues that 'men are destined to feed upon the flesh of animals, and not meerly upon the produce of the earth'.[30] Bruckner denies that the divine economy is cruel, for most animals are not intelligent enough to understand their situation, and those that are aware of dangers also have ways of avoiding them. Man is subject to the same constraints as other animals. Our numbers are kept down by famine, pestilence and war, of which war, though 'doubtless terrible', is the least unpleasant. When attacked, one can fight back; war promotes heroism and fortitude; and its suffering is mitigated by 'the sentiments of anger and revenge, or a thirst for glory, that danger awakens, and that renders men superior to all the evils wars bring with them'.[31] 'Let us never complain of nature', Bruckner concludes; 'all her laws are formed for our happiness.'[32] Life is a blessing which reveals the goodness of the Creator; if people doubt it, 'let them confront the few unfortunate with the thousands of millions of happy creatures, and then decide whether the measure of happiness does not greatly exceed that of misery.'[33]

It is not altogether surprising, therefore, that the Enlightenment has often been condemned for shallow optimism.[34] Thus Shaftesbury explains away 'those seeming blemishes cast upon nature' by affirming: 'It is good

which is predominant, and every corruptible and mortal nature by its mortality and corruption yields only to some better, and all in common to that best and highest nature which is incorruptible and immortal.'[35] Most famously and incautiously, Pope declares in the *Essay on Man*:

All Nature is but Art, unknown to thee;
All Chance, Direction, which thou canst not see;
All Discord, Harmony, not understood;
All partial Evil, universal Good:
And, spite of Pride, in erring Reason's spite,
One truth is clear, 'Whatever is, is right.'[36]

At times we find declarations of optimism which seem not just implausible, but fatuous. The educational reformer Johann Bernhard Basedow argued in 1774 that there is much more good than evil in the world, and also that much apparent evil is not really as bad as it at first seems. If you lose an eye or a leg, you still have one left, so your situation is not actually bad, just less good than it was before. Similarly, if parents of three children lose two, they still have one left, and so forth.[37] Soame Jenyns relied on the chain of being to show that the widespread existence of evil in the world was compatible with God's goodness. For 'the universe is a system whose very essence consists in subordination';[38] therefore, beings in the lower ranks must, in the nature of things, be less happy than those higher up. Moreover, just as we inflict suffering on animals for food and sport, so our sufferings may be inflicted on us, for good reasons that we cannot know, by beings on the higher ranks:

If we look downwards, we see innumerable species of inferior Beings, whose happiness and lives are dependent on [Man's] will; we see him cloathed by their spoils, and fed by their miseries and destruction, enslaving some, tormenting others, and murdering millions for his luxury or diversion; is it not therefore analogous and highly probable, that the happiness and life of Man should be equally dependent on the wills of his superiors?[39]

Jenyns' speculation recalls a modern philosopher's rejoinder to people who lament the lack of a higher purpose in life: what if it turned out that we were being bred for food by a higher race, our purpose being to provide them with cutlets?[40] It aroused the angry ridicule of Samuel Johnson, who, in his review of Jenyns' thesis, sarcastically imagined the superior beings watching the siege of a city as human sportsmen watch a cockfight.[41]

Shallow optimism was famously satirized by Voltaire in *Candide, or Optimism* (1759), intended as a crushing rejoinder to Leibniz's well-known claim that this is the best of all possible worlds. In *Candide*, this claim is

constantly made by the hero's mentor Dr Pangloss, who is impervious to repeated disproof by experience. Thanks to Voltaire, it is commonly understood as an absurdly Pollyanna-ish view which denies the very existence of suffering. But, although Leibniz's arguments may be unconvincing, they are not ridiculous.

Leibniz made his case in his *Theodicy* (1710), which is an attempt to vindicate divine justice. Similarly, in *Paradise Lost*, Milton had already undertaken 'to justify the ways of God to men'.[42] The search for a theodicy would be a lasting preoccupation of religious thinkers in the Enlightenment.

Leibniz's basic argument is simple and logically compelling. God was able to contemplate an infinite number of possible worlds before deciding which one to actualize. Since he is supremely powerful, wise and good, the world he chose to bring into being must be the best of all possible worlds. We may think that a world devoid of suffering, a world in which Adam and Eve had never fallen but stayed in Paradise, would have been better. 'One may imagine possible worlds without sin and without unhappiness, and one could make some like Utopian or Sevarambian romances: but these same worlds again would be very inferior to ours in goodness.'[43] Leibniz alludes to the well-known paradox of the *felix culpa*, the fortunate Fall. The Fall of Man with the arrival of sin was a fortunate event in that it necessitated a supreme display of goodness, Christ's voluntary sacrifice of himself for the whole of humanity. An unfallen world, where no such event took place, would thus be inferior in goodness. And, as Albrecht von Haller pointed out in his Leibnizian poem 'Über den Ursprung des Übels' ('On the Origin of Evil', 1734), good behaviour in an unfallen world, where it was just doing what came naturally, would be less meritorious than good behaviour in our world, where it is always a victory over our sinful nature:

> Gott, der im Reich der Welt sich selber zeigen wollte,
> Sah, daß, wann alles nur aus Vorschrift handeln sollte,
> Die Welt ein Uhrwerk wird, von fremdem Trieb beseelt,
> Und keine Tugend bleibt, wo Macht zum Laster fehlt.[44]

[God, who wanted to manifest himself in the kingdom of the world, saw that if everyone just acted in accordance with a plan, the world would be a piece of clockwork, animated by an alien impetus, and if the power to do evil were lacking, no virtue would be left.]

To support his claim, Leibniz adduces various analogies. Pleasant experiences need an admixture of the unpleasant. 'A little acid, sharpness or

# ESSAIS

## DE

# THEODICÉE

### SUR LA

## BONTÉ DE DIEU,

### LA

## LIBERTÉ DE L'HOMME

### ET

## L'ORIGINE DU MAL.

A AMSTERDAM,

Chez ISAAC TROYEL, Libraire.

MDCCX.

Leibniz's full title runs: 'Essays of Theodicy on God's goodness, man's freedom and the origin of evil' (1710). The illustration shows a climber ascending a steep cliff, and an eagle bearing a scroll which reads 'The way of virtue is hard'.

bitterness is often more pleasing than sugar; shadows enhance colours; and even a dissonance in the right place gives relief to harmony.'[45] In any case, despite the claims of pessimists from Homer down to Leibniz's contemporary Pierre Bayle, there is more good than evil in the world; it is simply that evil is more conspicuous.[46] And evil must not be blamed on God, who does not will evil, but only permits it to happen. Evil results from the essentially limited nature of humanity, which allows people to yield to their passions.

So Leibniz is not so foolish as to deny the existence of evil and suffering. He just thinks that they do not predominate in human life. Indeed, he thinks most people would be happy in principle to live their lives over again, provided that some circumstances were different for the sake of variety:

> Had we not the knowledge of the life to come, I believe there would be few persons who, being at the point of death, were not content to take up life again, on condition of passing through the same amount of good and evil, provided always that it were not the same kind: one would be content with variety, without requiring a better condition than that wherein one had been.[47]

The hardest challenge to Leibniz's optimism comes from the standard belief, which he fully shared, that the vast majority of human beings were condemned to damnation and everlasting torture. Damnation has to be eternal, because the damned keep on sinning in hell by cursing God. But Leibniz still thinks it possible to vindicate God's goodness. For, unlike the ancients, we know that the universe is infinite in extent, and that it contains an infinite number of globes, a great many of which must be inhabited by rational beings. Perhaps it is only on earth that people sin and suffer damnation. 'It may be that all suns are peopled only by blessed creatures', suggests Leibniz, unwittingly echoing Milton's idea that Satan, on his way through the universe to earth, passes many worlds where unknown people live 'thrice happy'.[48] 'As for the number of the damned, even though it should be incomparably greater among men than the number of the saved, that would not preclude the possibility that in the universe the happy creatures infinitely outnumber those who are unhappy.'[49]

This vision of a mostly happy universe, in which earth is a kind of penal settlement, has an obvious appeal. But would it not be more reasonable to argue from the world we know to the worlds we don't, and to suppose that they resemble ours? In that case, there might be innumerable worlds inhabited by sinful creatures liable to damnation, and many trillions of the damned suffering for eternity. One recoils from the thought (and Leibniz, in his conviction of God's goodness, never suggests it).

It was Voltaire, the central figure of the Enlightenment, who attacked such implausible optimism most vigorously. He did so in the article of his *Philosophical Dictionary* entitled 'Bien (Tout est)', where Leibniz, Shaftesbury, Pope and Pope's philosophical mentor Bolingbroke are all put on the spot. Yes, the universe is a spectacle of order. But this order is manifest in the system whereby all creatures live by killing one another, and equally manifest in the process by which a stone develops in the bladder, causing unspeakable agony to the sufferer. Is such order really admirable?

In *Candide*, the philosopher Pangloss maintains that everything is for the best and necessarily serves the best purpose. Even after being narrowly saved from dying of syphilis, he asserts that this illness, which is supposed to have originated from America and now ravages Europe, is a mere side-effect of the general good: 'For if Columbus, on an island in the Americas, had not caught this disease which poisons the spring of procreation, which often even prevents procreation, and which is plainly the opposite of what nature intended, we would have neither chocolate nor cochineal.'[50] He draws the further absurd conclusion – which is not in Leibniz – that since individual misfortunes contribute to the general good, then the more people suffer misfortunes, the better things are in general.

This illogical and unfalsifiable claim remains proof against all experience. Pangloss sticks to it, not only during the Lisbon earthquake, but even after he has been hanged, cut down, partially dissected, sewn up again, and condemned to be a galley-slave: 'I am a philosopher after all. It wouldn't do for me to go back on what I said before, what with Leibniz not being able to be wrong, and pre-established harmony being the finest thing in the world, not to mention the *plenum* and *materia subtilis*.'[51] Voltaire's irony here extends beyond Leibniz's optimism to philosophical speculation in general. He mentions Leibniz's ingenious attempt to explain how the mind and the body were connected through 'pre-established harmony': that is, the mind does not actually exert any causal influence on the body, or vice versa, but God has established in advance a harmonious relation between the two, such that when I resolve to lift my arm, my arm duly rises. He also associates Leibniz with the cosmology put forward by Descartes, according to which the heavenly bodies existed within a *plenum* and were moved by whirlpools or vortices of ethereal fluid (*materia subtilis*). By the time Voltaire wrote, this speculative cosmology had been superseded by Newtonian physics, which showed that the hitherto puzzling question of how one body could have an effect on another distant from it did not require any such extravagant hypotheses but could be explained by the theory of gravitation. So Pangloss is a representative not only of Leibnizian optimism but of the speculative approach to science

that had been rendered obsolete by modern empirical methods. He relies on high-sounding but empty words, and his philosophy cannot be modified by experience – even by the experience of execution, torture and enslavement. Theodicy is represented as a rigid, antiquated dogma whose proponent resolutely ignores the actual world.

The death blow to theodicy was delivered by Kant in his essay 'On the Failure of all Philosophical Attempts at Theodicy' (1791). Starting from the neutral term 'counterpurposiveness' (das Zweckwidrige), Kant distinguishes three things that seem to require justification: moral evil (sin); physical pain; and the mismatch between crimes and punishments. Together, these put in question God's holiness, his goodness and his justice. One defence of God – the supralapsarian claim that, being supreme, he can make good and evil anything he likes, and therefore can do nothing bad – is dismissed by Kant even more forcefully than it was by Leibniz, as 'an apology in which the vindication is worse than the complaint'.[52] The argument that evil arises from human limitations is little better, because it removes the concept of moral evil and resolves it into an aspect of human nature. And the claim that God simply permits evil, but is not responsible for it, is not only hard to reconcile with God's supposed omnipotence, but ends up, like the previous argument, in locating evil in the nature of things and thus denying its evil character.

As for Leibniz's basically sunny view of human life, Kant does not trouble to argue against it. Just ask any sensible person who has lived long enough and reflected on the value of life whether he would be willing to go through it again, even with variations: Kant has no doubt what the answer would be. He makes equally short work of the argument by Pietro Verri that if pain predominates over pleasure, that is due to our animal nature.[53] For if life is predominantly suffering, why did God bother to create us? The standard Christian claim that our life is a series of trials, for which we shall be rewarded in heaven, is no better. Most people fail these tests, and even those who (presumably) pass them don't enjoy their lives. It may be that life has to be this way for some reason which we cannot grasp; but if so, theodicy fails, since it undertook to explain suffering by giving intelligible reasons.

The evident injustice of life, Kant notes, is the objection to divine goodness that people feel most passionately. It is no good claiming that wicked people who enjoy worldly success are nevertheless tormented by the pains of conscience. Anyone who believes this is just projecting his own tender conscience onto people who are in fact as hard as nails and would greet his moral scruples with cynical laughter. Nor can one claim that suffering, including the painful spectacle of injustice, serves to purify the virtue of

the good so that, ultimately, all apparent dissonance will be resolved into a 'glorious moral melody';[54] for since virtue is plainly not rewarded on earth, suffering is only the result of virtue, not a means of refining or enhancing virtue.

As for the prospect of a future life where virtue *is* rewarded, this must be a vain hope. For, while we know nothing about a future life, we can only imagine it as basically resembling the life we do know about. Hence, we must rationally presume that the future life follows the order of nature. In that case, the future life will show the same disproportion of rewards and punishments as this one.[55] And since the upholder of theodicy maintains that the natural order in this life shows the wisdom of the Creator, he cannot claim that a different order in the next life would also show God's wisdom. Therefore, if you rely on heaven to compensate for the shortcomings of earthly life, all you have achieved is to underline how severe these shortcomings are.

The problem of theodicy can be focused in another way. The philosopher Anthony Kenny points to the difference between doing what is right and doing what is good.[56] Doing what is right, according to Kenny, means seeking to obtain the result that will produce the greatest happiness. If this result is achieved, the means used may be bad, but the action, being judged by its consequences, is still right. It follows that torture is justified if it prevents terrorist murders. Doing what is good, by contrast, means that certain actions are impermissible, no matter what good effects result from them. Torture is never justified, even to prevent terrorist murders. Keeping this distinction in mind, we can see that the God of Leibniz and Pope is a consequentialist. He does evil, or at least tolerates evil, so that the greatest possible good may result. He judges the means by the end. Or as Voltaire put it: 'This system of "all is well" represents the author of all nature merely as a powerful and unscrupulous king, who does not worry if four or five hundred thousand people lose their lives, and the rest drag out their days in starvation and tears, provided he accomplishes his plans.'[57]

## PHYSICO-THEOLOGY

The new scientific understanding of the universe, and the close attention to the world around us that it enjoined, were made palatable to Christians by means of 'natural religion' or physico-theology.[58]

Probably the single most important text in this tradition was *Physico-Theology* (1713) by the Anglican cleric William Derham, a book rapidly translated into French and German. Derham was a Fellow of the Royal

Society, a friend of Newton, the astronomer Edmond Halley and the botanist John Ray, and himself the author of many scientific papers. His book is a systematic survey, first of 'the terraqueous globe', then of animals in general, then man, quadrupeds, birds, insects, reptiles and plants. The text is accompanied by extensive footnotes containing more technical information. Its theological purpose is clear, even before Derham's conclusion: 'I have, I hope, abundantly made out that all the Works of the Lord, from the most regarded, admired, and praised, to the meanest and most slighted, are great and glorious Works, incomparably contrived, and as admirably made, fitted up, and placed in the World.'[59] But it can be, and was, enjoyed as a fascinating exposition of natural history.[60] Similarly, Derham's disciple in New England, the Puritan minister Cotton Mather, likewise a Fellow of the Royal Society, wrote a popular account of the physical world based on the latest scientific authorities (Huygens, Halley, Newton and many others), interspersed with eulogies to its Creator for contriving it perfectly: 'The Distance at which our *Globe* is placed from the *Sun*, and the Contemperation of our Bodies and other Things to this Distance, are evident Works of our Glorious GOD!'[61]

Physico-theology generated a large body of what would now be called popular scientific writing. There was a biblical precedent. One of the ways Solomon showed his wisdom was by lecturing on natural history: 'And he spake of trees, from the cedar tree that is in Lebanon even unto the hyssop that springeth out of the wall; he spake also of beasts, and of fowl, and of creeping things, and of fishes' (1 Kings 4:33). The frontispiece to a much-read French work of physico-theology, the *Spectacle de la nature* (1732–50) by Noël-Antoine Pluche, shows Solomon lecturing with a hyssop plant growing behind him and various creatures before him, including a crocodile which an African, with some difficulty, is holding under his arm.[62] In Germany, physico-theology gave rise to a large number of specialisms praising different aspects of creation, such as ichthyotheology (fish), petinotheology (birds), testaceotheology (snails), melittotheology (bees), chortotheology (grass), brontotheology (thunder) and sismotheology (earthquakes), each of which had at least one book devoted to it.[63] The Netherlands produced also theologies of snow, lightning and grasshoppers.[64]

Besides these works, what we would now consider serious scientific writing was often presented as a celebratory description of God's order. Thus, in Holland the microscopist Leeuwenhoek presented his discovery of infusoria and bacteria in the posthumously published *Biblia naturae* (*Nature's Bible*, 1737). Linnaeus was a physico-theologian in his *Systema naturae* (*System of Nature*, 1735). Since he considered biology to be static, not dynamic, he used binomial classification to reveal the order in which

the Creator had arranged all living beings. Hence he quarrelled with Buffon and other naturalists who did not accept the fixity of species. We are still a long way from *The Origin of Species* (1859), in which Darwin offers a dizzying vision of life-forms in constant flux over unimaginably long periods of time. Later in the century the naturalist and illustrator Thomas Bewick, author of the *General History of Quadrupeds* (1790) and the two-volume *History of British Birds* (1797, 1804), gave a physico-theological justification for his work: natural history affords 'endless pleasures . . . to all who wish to trace nature up to Nature's God'.[65]

It was not only surveys of natural history and theological treatises, but also poetry, that brought physico-theology to a wide readership. Barthold Heinrich Brockes in Germany, James Thomson in Britain, and Paul-Alexandre Dulard in France all celebrated God's creation in poems that moved between the span of the heavens and the tiniest of insects, while the Dutch poet Lucas Trip marvelled at how grains of sand, over innumerable centuries, had coalesced to form a pebble.[66] Brockes, a Hamburg senator and diplomat, published nine volumes of poetry under the title *Irdisches Vergnügen in Gott* (*Earthly Delight in God*, 1721–48), which celebrate the world around us without ever mentioning Christ or his redemptive mission.[67] Thomson, a Scot who arrived in London in 1725, made a reputation as a dramatist, as the patriotic lyricist of 'Rule, Britannia' and as the physico-theologian of the four poems ('Winter', 1726; 'Summer', 1727; 'Spring', 1728; 'Autumn', 1730) published together as *The Seasons* in 1730. Here he praises English contributors to modern knowledge, including Boyle and Shaftesbury among the followers of Bacon who 'from the gloom / Of cloister'd Monks, and Jargon-teaching Schools, / Led forth the true Philosophy'.[68] Thomson was a Newtonian, who brought out an elegy to Newton six weeks after the latter's death in 1727.[69] In 'Summer' he apostrophizes the sun as the central point of gravitation:

> 'Tis by thy secret, strong, attractive Force,
> As with a Chain indissoluble bound,
> Thy System rolls entire.[70]

Dulard, however, in his *La Grandeur de Dieu dans les merveilles de la nature* (*The Greatness of God in the Wonders of Nature*, 1749), having briefly surveyed the systems of Descartes, Pierre Gassendi and Newton, professes to take his stand on the Old Testament, but clearly favours Descartes, as he describes the heavenly bodies moving in *tourbillons* (vortices).[71]

While physico-theology sidestepped most controversies arising from the interpretation of Scripture, it had its own difficulties. The history of

the earth was a history of catastrophes. Thomas Burnet, in *Telluris theoria sacra* (1681, 1689), translated as *The Theory of the Earth* (1684, 1690), tried to reconcile the narrative of Genesis with Cartesian science, with help from Newton.[72] Burnet proposed that before the Flood the earth had had a flat, smooth surface, with its axis so aligned as to permit perpetual spring in paradise. However, the 'fountains of the great deep' (Gen. 7:11) had forced their way out, flooded the world and, on retreating, left its surface a jumble of mountains and seas.[73] Other physico-theologians worried about what Derham called '*Volcano's* and Ignivomous Mountains'. On this subject, Derham almost slips back into an older, emblematic reading of nature, but he recovers his nerve:

> although they are some of the most terrible Shocks of the Globe, and dreadful Scourges of the sinful Inhabitants thereof, and may serve them as Emblems, and Presages of Hell it self; yet even these have their great Uses too, being as Spiracles or Tunnels to the Countries where they are, to vent the Fire and Vapours that would make dismal Havock, and oftentimes actually do so, by dreadful Succussions and Convulsions of the Earth.[74]

Dulard repudiates the claim that the existence of poisonous animals, such as the scorpion and the rattlesnake, tells against the goodness of God; they are a punishment for Adam's primal sin, and hence testimony to God's justice.[75] Physico-theologians defend God's goodness even when he lets people be struck by lightning, suffer agonies from gallstones, or have their crops destroyed by locusts.[76]

It might seem that physico-theology would be severely tested by the Lisbon earthquake, which is often thought to have demolished the optimism of the Enlightenment. On 1 November 1755 an earthquake, estimated at 8.5 to 8.8 on the Richter scale, devastated the city of Lisbon. Combined with the fires that then raged for several days, and a succession of floods, it probably killed between 40,000 and 60,000 people.[77] The most famous reaction to this disaster is by Voltaire. He responded with an arresting poem, his 'Poème sur le désastre de Lisbonne', subtitled 'ou examen de cet axiome: "tout est bien" ' ('Poem on the Disaster of Lisbon, or Examination of the Axiom "All is Well" '). The optimism of Pope and Leibniz was subjected to a scathing attack, soon afterwards repeated in *Candide*. Voltaire described the horror of human suffering. What could explain it? Was it punishment for people's misdeeds?

> Direz-vous, en voyant cet amas de victimes:
> 'Dieu s'est vengé, leur mort est le prix de leurs crimes'?

> Quel crime, quelle faute ont commis ces enfants
> Sur le sein maternel écrasés et sanglants?
> Lisbonne, qui n'est plus, eut-elle plus de vices
> Que Londres, que Paris, plongés dans les délices?
> Lisbonne est abimée, et l'on danse à Paris.[78]

[On seeing this heap of victims, will you say: 'God has taken revenge, their death is the reward for their crimes'? What crime, what fault, was committed by those children crushed and bleeding on the maternal breast? Did Lisbon, which no longer exists, have more vices than London or Paris, plunged in pleasures? Lisbon has been swallowed up, and at Paris they are dancing.]

Was the earthquake the result of necessary laws? But if so, was God so feeble that he had no other means of achieving his ends?

> Borneriez-vous ainsi la suprême puissance?
> Lui défendriez-vous d'exercer sa clémence?
> L'éternel artisan n'a-t-il pas dans ses mains
> Des moyens infinis tout prêts pour ses desseins?[79]

[Would you thus set limits to supreme power? Would you forbid Him to exercise His mercy? Does not the immortal workman have in His hands infinite means all ready for His plans?]

Or was it providential, in that the deaths of the Portuguese would somehow benefit other creatures?

> Quand la mort met le comble aux maux que j'ai soufferts,
> Le beau soulagement d'être mangé des vers!
> Tristes calculateurs des misères humaines,
> Ne me consolez point, vous aigrissez mes peines.[80]

[When death crowns the ills that I have suffered, what a fine consolation to be eaten by worms! Dismal calculators of human miseries, do not console me, you merely sharpen my agonies.]

The poet concludes that optimism is false and evil is all too real. Evil is rampant on earth, and it is painfully hard to avoid concluding that it was God who unleashed it:

> Éléments, animaux, humains, tout est en guerre.
> Il le faut avouer, le mal est sur la terre:
> Son principe secret ne nous est point connu.
> De l'auteur de tout bien le mal est-il venu?[81]

[Elements, animals, humans, all are at war. It must be admitted, evil is at large on earth: we do not know its secret principle. Did evil come from the author of all good?]

Voltaire's perplexity, however, was wholly untypical of contemporary reactions to the earthquake. It elicited an angry response from Rousseau, who thought such a physical disaster should not be blamed on nature or God, but rather on human beings, who had brought it upon themselves by abandoning nature and crowding together in cities; this disagreement paved the way for the violent antipathy that developed between Voltaire and Rousseau.[82] In general, commentators agreed with Pope that 'plagues or earthquakes break not Heav'n's design'.[83] This earthquake did not change their minds. After all, an even more destructive earthquake in Sicily in 1693 had elicited from Cotton Mather, who estimated its victims at 'the best part of two hundred thousand souls', only the reflection that 'Mankind ought herein to tremble before the Justice of God'.[84] By the 1750s, preachers had no difficulty in explaining the earthquake from natural causes. The favoured explanation was that earthquakes were produced by underground explosions that resulted either from contact between subterranean bodies of water and the earth's internal fires, producing steam, or from mixtures of sulphur and saltpetre, or possibly from an electrical discharge.[85] It was not necessary to suppose that God was punishing people for their sins; the earthquake could be interpreted as a reminder of his awe-inspiring power. In any case, observed a Protestant professor, a death toll of thirty thousand or so was tiny compared to the hundreds of thousands massacred by Catholics in the sixteenth-century wars of religion.[86]

Kant in 1756 wrote in some detail about the recent earthquake, first explaining its geological causes, and then commenting on its utility. His view of earthquakes is very similar to Derham's view of volcanoes. Earthquakes are connected with subterranean fires that warm the earth in winter, and which also give rise to hot springs that benefit many people's health. We cannot expect to enjoy the benefits without the disadvantages. If people build cities in well-known earthquake zones, such as southern Italy or the Pacific coast of South America, then they are simply asking for trouble.[87] In his *Allgemeine Naturgeschichte und Theorie des Himmels* (*Universal Natural History and Theory of the Heavens*, 1755), Kant goes into full physico-theological mode. Nature reveals God's greatness precisely through incessant destruction and new creation. Whole planets perish, but that is no loss within the economy of nature, which can afford to be extravagant: 'we must not lament the end of a world structure as a true loss of nature. Nature shows its bounty in a kind of extravagance, which, while some parts

# Allgemeine
# Naturgeschichte

und

## Theorie des Himmels,

oder

### Versuch

von der Verfassung und dem mecha-
nischen Ursprunge

## des ganzen Weltgebäudes

nach

### Newtonischen Grundsätzen

abgehandelt.

\* \* \* \* \* \* \*  \* \* \* \* \* \*

### Königsberg und Leipzig,

bey Johann Friederich Petersen, 1755.

Kant's full title runs: 'Universal Natural History and Theory of the Heavens, or essay on the constitution and mechanical origin of the entire universe, treated on Newtonian principles' (1755).

pay their tribute to transience, maintains itself regardless through countless new creations in the whole extent of its perfection.'[88] Nature is like the phoenix, which consumed itself in fire in order to be born again.

Kant's exposition of physico-theology is a serious and original work of science that examines astronomy in the light of Newton's cosmology. Kant was the first person to argue that the nebulae, visible through telescopes as fuzzy masses of stars, might in fact be counterparts of the Milky Way, similarly organized into systems by gravitational attraction.[89] In following Newton's cosmology, Kant does his best to ward off any suspicions of religious unorthodoxy. The world works according to regular laws laid down by God. There is no need to imagine an additional 'god in the machine' constantly intervening to make events happen.[90]

Kant admits that his world-picture may look like that of classical atomism. A number of ancient thinkers put forward theories about the material universe which did not require divine creative activity, though, perhaps out of prudence, they generally maintained that the gods did exist but had no concern with humanity. However, Kant insists, his theory is quite different. The atomists imagined the world emerging from chaos by chance, whereas Kant imagines the world as embodying the wisdom of a supreme being, who implanted in it necessary laws and then left these laws to operate. 'It is not the accidental accumulation of Lucretius' atoms that formed the world; implanted forces and laws that have the wisest reason as their source, have been an immutable origin of that order that had to flow from them, not by accident, but by necessity.'[91] One may feel, however, that Kant protests too much. It seems that these necessary laws are inherent in matter: 'Matter, which is the original material of all things, is thus bound by certain laws, and if it is left freely to those laws, it must necessarily bring forth beautiful combinations.'[92] In that case, could God have created different laws? Or, once matter existed, was it bound to develop according to these laws, because no others were possible? Kant strongly implies the latter conclusion. If so, God as divine planner becomes superfluous. All we need is matter; once matter exists, the universe is bound to develop as it has done, whether or not there is a God to take the credit. So Kant's cosmology, despite his protestations, can be interpreted as materialist. It is only a step away from the explicitly materialist universe, consisting of matter in motion, imagined by the Paris *philosophe* Baron d'Holbach and angrily rejected by Goethe as 'dismal atheistic semi-darkness'.[93]

Kant's emphasis on nature shows how easy it becomes, in physico-theology, for nature to force God into the background and eventually screen him out altogether. The hero of Goethe's *Die Leiden des jungen Werthers* (*The Sorrows of Young Werther*, 1774) perceives God in nature

when he is happy, and his rhapsody has been called 'sentimentalized physicotheology'.[94] When he is overcome by depression, however, Werther forgets about God and sees nature alone, this time as a destructive force, 'a monster that eternally consumes and digests'.[95] Kant was more consistent: if you want to see God in nature, you must be prepared to find him everywhere.

One of the best-known examples of physico-theology, but also one of the latest and weakest, is William Paley's argument about the watch and the watchmaker.[96] If, walking over a heath, I stumble against a stone, I may suppose that the stone has lain there since the beginning of the world. If, however, I find a watch on the heath, and examine the intricacy of its workings, I must conclude that the watch has been placed there, and that the watch is a product, not of nature, but of an intelligent designer. Paley then takes a curious flight of fancy. Supposing the watch were found to contain an apparatus enabling it to give birth to another watch? Would not the watch's existence be adequately explained by calling it the youngest member of a long dynasty of watches? Not at all, because the watch's remotest ancestor must have been designed by some kind of workman. 'Contrivance must have had a contriver, design, a designer; whether the machine immediately proceeded from another machine or not.'[97] To suppose otherwise, adds Paley intimidatingly, is atheism. And if a watch, even one that cannot reproduce its kind, points to the existence of a maker, then natural objects, being much more complex and intricate (as the eye is more intricate than a telescope), are even more obviously the creations of a supremely intelligent designer. This designer has ensured that all the contrivances of nature are perfectly 'accommodated to their end'.[98] He has not only made the eye a perfect instrument of vision, but ensured its safety by providing a socket for it to sit in.

By the time Paley wrote, however, physico-theology had already received its death blow from Kant's later philosophy. In the *Critique of Pure Reason* (1781) Kant undertakes to show that physico-theology cannot prove the existence of a transcendent God.[99] The physico-theological proof, as Kant summarizes it, runs thus: the world shows ample evidence of an order which can only have been introduced by supreme wisdom; the things in the world cannot have fallen into this order by themselves; there must therefore be a supreme intelligence that ordered the world; and the unity of the world, in which all phenomena are intricately interrelated, demonstrates by analogy that this ordering intelligence must likewise be a unitary, single being.[100] Kant admits that this argument is superficially plausible, and indeed treats it with great respect, since it provides the most persuasive grounds for belief in a supreme being. However, the physico-theological

argument is not sufficient by itself to demonstrate that a supreme being exists. The argument claims that if you start from an effect in the natural world and follow it back to its cause, and that cause in turn back to its cause, you will ultimately arrive at the first cause, the transcendent being who created the world. But this argument does not work, for it depends on the analogy between natural phenomena and man-made objects. The latter presuppose a maker. On this analogy, however, we may arrive at a builder of the world (*Weltbaumeister*), but not at a creator of the world, who must necessarily transcend nature and therefore cannot be the starting-point of any causal chain running through nature. So the physico-theological argument for God's existence breaks down, but it disguises its failure by falling back on the cosmological argument (that as causal chains cannot continue infinitely, there must have been a first cause that started the causal chains), which itself is merely a disguised form of the ontological argument (that God, as the most perfect being we can conceive, must exist, because otherwise he would lack a valuable quality, that of existence, and would be imperfect). And in the preceding chapters Kant has already demolished both the cosmological and the ontological arguments.

Paley, moreover, still relies on the Aristotelian concept of final causes. The final cause of the eye is sight, and therefore the eye has been created as the perfect instrument of sight. Teleology, the explanation of phenomena by reference to the purposes they fulfil, also received a withering analysis from Kant. The third of Kant's Critiques, the *Critique of Judgement* (1790), includes a 'Critique of Teleological Reason', with a section explicitly devoted to physico-theology. According to Kant's critical philosophy, we experience the world in terms of time, space and causality. When we examine the natural world, we are therefore justified in discerning the operation of many causes. But we are not justified in taking a further step and perceiving the fulfilment of purposes, attributed to a supreme being. For a purpose is not something we observe empirically; it is an idea which we project onto nature, and which we may well find helpful in describing nature, but it does not allow us to affirm that the world was purposefully designed by a wise creator. Anyway, even if we want to believe that the world embodies a purpose, how do we know that that purpose is an intelligent one? For all we know, the mysterious supreme cause might have shaped the world in accordance with an unreasoning instinct, analogous to the instinct by which birds make nests and bees construct hives:

> it remains undetermined whether that supreme cause is its original ground
> in accordance with a final end throughout rather than through an intelli-
> gence determined by the mere necessity of its nature to the production of

certain forms (in analogy with that which we call artistic instinct in ani-
mals), without it being necessary to attribute to it any wisdom, let alone
the highest wisdom combined with all the other properties requisite for the
perfection of its product.[101]

## RELIGIOUS MODERATION IN
## ENGLAND AND SCOTLAND

Alongside physico-theology, there were many other approaches to the
increasingly pressing task of reconciling Christianity with reason. In the
Church of England, the late seventeenth century saw the emergence of a
moderate party, whose 'middle way' led between Dissenters on the one
hand and, on the other, the conservative High Church party that believed
in a divinely established order centring on sacramental kingship. Moderate
theologians sought to reconcile faith with reason, discarding unimportant
dogmas and embarrassing superstitions in order to place a purified Chris-
tianity on a firmer footing. In his much-reprinted sermons John Tillotson,
archbishop of Canterbury from 1691, maintained that almost all the essen-
tial truths of Christianity were disclosed by the 'natural light' even without
the aid of supernatural revelation.[102] 'Natural religion' already tells us to
love God and obey his laws through 'universal love and kindness and good
will among men', best expressed in the Sermon on the Mount.[103] Jesus'
main mission was to do good in the world and thus set us an example.

This attractive teaching seemed to some of Tillotson's contemporaries
dangerously close to Socinianism, which denied the divinity of Christ, and
Tillotson was at pains to rebut such suspicions by affirming not only the
centrality of the sacraments but also the Incarnation. God sent his Son to
make 'a general atonement for the sins of mankind'.[104] To those who
objected that God, being omnipotent, could have forgiven and reformed
humanity by less drastic means, Tillotson replied that God must have
wanted to impress on humanity that his laws could not be disregarded,
to inspire horror at sin, and to indulge ancient peoples' belief that sin had
to be expiated through sacrifice. These essentially practical arguments
may be thought to dilute or ignore the overwhelming mystery which, for
many Christian believers, is central to the Incarnation.

In *The Reasonableness of Christianity* (1695), Locke, whom we have
already met as a spokesman for toleration, sought a middle way between
doctrine of Original Sin, which was incompatible with God's goodness,
and mere natural religion, which was incompatible with the Gospels.
Human beings did not need revelation to tell them about morality. Moral

knowledge was available through reason to all peoples at all times. But it was nevertheless necessary for God to send his son, Jesus, to earth to preach the gospel. For the wisdom of virtuous pagans, from Socrates to Confucius, did not form a coherent moral code and could be no substitute for the gospel of Jesus. Anyway, rational morality is slow and ineffective: 'Experience shows, that the knowledge of morality, by mere natural light, (how agreeable soever it be to it) makes but a slow progress, and little advance in the world.'[105] It is also impossible for any mere mortal to observe the moral law perfectly. Besides, power-hungry priests, anxious to 'secure their empire', were everywhere at pains to remove reason from religion.[106] So Jesus was sent to preach a message accessible to the simple and unlearned, requiring them only to believe that he was the Messiah, to repent of their sins, and to lead a moral life. Faith in him, and resulting good works, could compensate for humanity's inevitable weakness, and admit them to eternal life. Locke's arguments, based on a close reading of the Gospels, bring out the attractiveness of Jesus' personality and teaching; but although he accepted that Jesus was born of a virgin, and more than mortal, he still found himself charged by many polemicists with Socinianism and Deism.[107]

Clear echoes of Locke are to be found where we might not expect them, in the writings of John Wesley, the founder of Methodism. After prolonged efforts to model his life on that of Christ, Wesley on 24 May 1738 experienced a sudden conversion in which he felt his 'heart strangely warmed' by the inward assurance that Christ had died to save him.[108] He conveyed his message not only through his famous tours throughout the British Isles, preaching to crowds in the open air, but also in publications where he defended his faith as based on 'the Right of Private Judgment, which is indeed unalienable from Reasonable Creatures'.[109] The injunctions of Christianity were wholly consonant with reason: 'If therefore you allow, that it is reasonable to love God, to love Mankind, and to do Good to all Men, you cannot but allow, that Religion which we preach and live, to be agreeable to the highest Reason.'[110] In practice, Wesley trod a narrow line between a heartfelt religion based on good sense, and what his antagonists labelled 'enthusiasm'. He himself dismissed the exiled Huguenot visionaries known as the French Prophets as 'enthusiasts'.[111] It was somewhat embarrassing therefore that those attending Methodist meetings were often so carried away that they fell into convulsions and talked in unknown tongues.[112] Wesley retained a firm belief in the reality of at least some supernatural phenomena, such as witchcraft; but this, it has been argued, was consonant with Lockean empiricism, for such phenomena were attested by ample evidence.[113]

For Wesley, the truth of Christianity rested on Scripture, reason and experience. Could it also be proved by everyday standards of evidence? Some writers tried to do so. On his death, Joseph Addison left an unfinished treatise in which he claimed that the truth of Christianity was inadvertently confirmed by pagan writers who were impressed by the fortitude of Christian martyrs and by the fulfilment of Christ's prophecies, such as his prediction that the gospel would be preached to all nations (Matt. 24:14). In fact, however, very few pagan writers were convinced, and Christ also prophesied events that did not come to pass, such as the imminent end of the world (Matt. 24:2–51).[114]

All such efforts were vulnerable to the counterarguments advanced, with satirical intent, by the barrister Henry Dodwell in *Christianity Not Founded on Argument* (1741), which its author was prudent enough to publish anonymously.[115] Dodwell notes that not everyone is capable of reasoning. If one insists on having one's reason satisfied before accepting Christianity, one is committed to a long and difficult process with no clear end-point; while it is going on one cannot claim to be a Christian; and even if rational conviction results, that is very different from the ardent faith that can move mountains or motivate martyrdom. Jesus did not convert his hearers by rational persuasion or by offering evidence; Doubting Thomas is rebuked for believing in the Resurrection only after feeling Jesus' wounds. The Scriptures never appeal to their readers' intelligence: 'It is indeed but Justice due to the Glorious and Heaven-concerted Scheme of our Salvation, to shew, that no such absurd and preposterous Project was ever offered to be set on Foot in the Cause,' says Dodwell, his tongue firmly in his cheek.[116] Indeed, Julian the Apostate, the Roman emperor who tried to reverse the triumph of Christianity, would have done his adversaries far more harm if, instead of denying them education, he had compelled them to study philosophy – 'the Cultivation of a Science, that has generally been found to prove so destructive of their Principles'.[117] Thanks to the considerable psychological truth in Dodwell's satire, some devout readers took it seriously and found it edifying. The Presbyterian minister Alexander Carlyle met a naïve elderly colleague who thought it 'the Ablest Defence of our Holy Religion, that had been publish'd in Our Times', but Carlyle himself considered it 'the Shrewdest Attack that ever had been made on Christianity'.[118]

If any theologian took on board the new scientific learning, it was the Newtonian Samuel Clarke. He undertook to confute the atheism attributed to Hobbes and Spinoza by following the methods of mathematical demonstration. Starting from the proposition that something must have existed from eternity, he deduced that this something must be an

immutable, independent, single, necessary being with all the properties ascribed to God, including moral perfection. God was, moreover, an intelligent designer, whose wise construction of the universe was proved by 'the *Modern* Discoveries in Astronomy'.[119] Drawing on Newton, Clarke praised the delicate balance between the orbital motion of the planets and their gravitational attraction towards the sun, and the alternation of light and darkness arising from the daily motion of the earth and other bodies around their own centres. Clarke's message closely resembles that of Addison's famous hymn 'The Spacious Firmament on high', in which, although the music of the spheres has been dismissed as fabulous, the planets nevertheless proclaim their intelligent design to the ear of reason:

> What though, in solemn Silence, all
> Move round the dark terrestrial Ball?
> What tho' nor real Voice or Sound
> Amid their radiant Orbs be found?
> In Reason's Ear they all rejoice,
> And utter forth a glorious Voice,
> For ever singing, as they shine,
> 'The Hand that made us is Divine.'[120]

Clarke might have been wiser to stop there and not tackle the peculiarly difficult doctrine of the Trinity.[121] Newton and Locke disbelieved in the Trinity, but kept their opinions to themselves. Milton, in the manuscript 'On Christian Doctrine', which was published only in 1825, questioned it: if Christ was God, how could he describe himself as a mediator with God, i.e. with himself?[122] Clarke addressed it head on by examining all the passages in the New Testament that referred to any of the three persons of the Trinity, and found that the three were treated in quite different ways. Both the Son and the Holy Spirit derived their being and attributes from the Father, but he derived nothing from them. The Son, like the Father, was called God, but the Holy Spirit was never so described. Clarke played fair – and showed his knowledge of textual criticism – by refusing to lay any stress on the supposed affirmation of the Trinity in 1 John 5:7, since the passage was not found in any Greek manuscript and had not been cited in the fourth-century Arian controversy.[123] He declared that within the Trinity, the Father was supreme; the universe was not governed by a committee: 'there being in the *Monarchy* of the Universe but *One Authority*, original in the *Father*, derivative in the *Son*; therefore the *One God* (absolutely speaking) always signifies *Him* in whom the Power or Authority is *original and underived*'.[124] Hence the true doctrine required one to walk a theological tightrope: if one leaned to one side by

maintaining that there was only a single God, one would fall into Arianism or Unitarianism; but if one leaned to the other by trying to elevate the Son and the Holy Ghost to equal status with the Father, one would '*in reality* take away their *very Existence*; and so fall unawares into *Sabellianism* (which is the same with *Socinianism*)'.[125]

Unfortunately, many of Clarke's contemporaries felt that he had lost his balance. By qualifying the divinity of Christ, he had distanced himself from the Athanasian Creed, which maintained that all three persons of the Trinity were equal, and confirmed the widespread suspicion that Newtonian natural philosophy was inimical to theology.[126] His career progressed no further, though we need not give credence to Voltaire's mischievous story that the suspicion of Arianism kept Clarke out of the archbishopric of Canterbury.[127]

Alongside the versions of enlightened Christianity represented by Wesley, Locke, Tillotson and Clarke, we find prominent Anglican figures putting forward ideas that seem very far from reasonable. One of the leading theologians of the day was William Warburton, bishop of Gloucester, who provided an unusual answer to a vexing problem: why does the Old Testament say nothing about such an important doctrine as the immortality of the soul? The answer Warburton gave in *The Divine Legation of Moses* (1737–41) was that Moses himself, having been educated by Egyptian priests, knew the soul was immortal, but deliberately kept this knowledge from the Jews. He instituted a theocracy, whose laws were laid down by God on Sinai, and in which the human king was only God's viceroy or deputy and therefore not entitled to create further laws. God ensured that the Jews' conduct was appropriately rewarded or punished in their earthly lives:

> in the *Jewish* Republic, both the Rewards and Punishments promised by Heaven, were *temporal only*. Such as Health, long Life, Peace, Plenty, and Dominion, &c. Diseases, immature Death, War, Famine, Want, Subjection, and Captivity, &c. And in no one Place of the *Mosaic* Institutes is there the least Mention, or any intelligible Hint, of the Rewards and Punishments of another Life.[128]

The Jews all got their just deserts in this life, and had no need to think about another. This rule by the divine lawgiver lasted until the coming of Christ, and its purpose was to separate the Jewish people from the rest of humanity and thus preserve the religious truth which had been revealed to them. So the absence of a future life from the revelation made to Moses, which was sometimes adduced to cast doubt on his revelation, actually proved its authenticity. This argument is certainly 'very curious', as Gibbon says drily.[129] Not surprisingly, it found few adherents.[130]

Another writer on religion who might seem impeccably enlightened was William Whiston, Newton's successor as Lucasian Professor at Cambridge. He was a brilliant mathematician who did important work in astronomy, particularly in calculating the orbits of comets, and helped to find a method of determining longitude. He was also a biblical scholar who sought to prove that all the prophecies in the Bible, and even those in apocryphal writings, had been fulfilled. Like Newton, he disbelieved in the Trinity, but unlike Newton he made his views public and was dismissed from his chair. In *Astronomical Principles of Religion, Natural, and Reveal'd* (1717), amid serious studies of comets, he also maintained that the New Testament description of hell

> does in every Circumstance so exactly agree with the Nature of a Comet, ascending from the Hot Regions near the Sun, and going into the Cold Regions beyond *Saturn*, with its long smoking Tail arising up from it, through its several Ages or Periods of revolving, and this in the sight of all the Inhabitants of our Air, and of the rest of the System

that sinners must be condemned to travel perpetually on the surface of a comet, thereby affording 'a terrible but a most useful Spectacle to the rest of God's rational Creatures'.[131] Whiston's speculations, despite their scientific air, recall such literal-minded clerical fantasists as the seventeenth-century Jesuit Jeremias Drexel, who calculated that hell must occupy a square German mile (i.e. just under 55 million square metres), enough to contain 100,000,000,000 souls crammed tightly together.[132] Over thirty years before Whiston, Pierre Bayle, as we saw in the previous chapter, had rejected all attempts to interpret comets as signs of punishments from God. By comparison, Whiston must be considered only a very partial representative of the Enlightenment.

Scotland had a distinct Enlightenment, with a complex and sometimes oppositional relationship to the Church. The Church of Scotland was and is Presbyterian and democratic. Instead of a hierarchy of bishops, it has a moderator who holds office for a year and presides at the annual General Assembly. The clergyman, or minister, in each parish is supported by a number of laymen called elders. In the early modern period the Church governed society through the parish kirk session, comprising the minister and elders, which administered religious education and the spiritual and moral well-being of parishioners, punishing offences that ranged from non-attendance at church to fornication and fighting. Malefactors whose crimes were not grave enough for the civil authorities were compelled to do public penance, dressed in sackcloth, sitting on a stool of repentance before the congregation on several successive Sundays. Sexual offenders

might be whipped through the streets.[133] Elders went round people's houses checking that they were at church. Religious instruction was imparted by teaching children the catechism and by examining adults on their knowledge of doctrine. Thus a high level of religious knowledge was gradually diffused.

The central religious ceremony was communion, taken usually twice a year, at most four times. On the Sunday, as usual, two sermons were delivered, each lasting an hour or more. On the previous day there was a preparatory service, and on the following day a sermon of thanksgiving.[134] James Boswell took the sacrament on Sunday, 27 August 1780. The day before, he went to a preparatory service that lasted four hours; the preacher spoke in the churchyard, with the congregation seated. On Sunday, the service lasted till 7 p.m., leaving Boswell 'quite stupefied and fatigued'. Then on Monday there was another four-hour service, including forty minutes of prayer, a sermon lasting an hour, and another lasting an hour and ten minutes. 'Indecent truly,' Boswell noted. 'How the people like it I cannot conceive.'[135] The latter sermon was preached by William Auld of Mauchline, an ultra-conservative minister who would later punish Robert Burns for fornication and appear in his satirical verse as 'Daddie Auld'.[136]

It would be wrong to imagine Presbyterian spiritual life as dreary. Calvinist theology maintained that a small number of elect persons, chosen by God before the beginning of the world, was predestined to salvation. Salvation depended entirely on faith. Yet the assurance that one was saved could never be quite beyond doubt. Hence the inner life of the believer was an absorbing spiritual drama in which doubt alternated with reassurance. In his autobiography, published only after his death in 1732, Thomas Boston, the devout minister of Ettrick in the Borders, repeatedly laments 'the corruption of my nature' and 'my own vileness', shown when as a boy he played at ninepins on the Sabbath, a sin which had since 'occasioned me many bitter reflections'.[137] For Boston, every event is spiritually significant. Nothing ever just happens. Once when preaching he felt faint, but 'by good Providence' there was a hole in the roof which admitted 'a refreshing gale that supported me, and the Lord carried me through'.[138] When he accidentally wounded his face, which swelled up, 'It sent me to the Lord, confessing my sin, and taking with the punishment of mine iniquity.'[139] The spiritual life was also strenuous. People would often spend two hours a day, or longer, in prayer and Bible-reading. We hear of a saintly person, Mr Hew Fulton, who spent eight or nine hours every day in prayer; this activity was known as 'wrestling' with God.[140]

It was difficult for enlightened thinking to make inroads into such an all-pervasive system of authority. Even when, in the eighteenth century,

church discipline weakened, theology remained strict. John Simson, professor of divinity at Glasgow, was repeatedly censured for heresies that he owed to his training at Leiden. In 1717 the General Assembly reprimanded him for adopting unorthodox and unscriptural 'Hypotheses [that] tend to attribute too much to natural Reason and the power of corrupt Nature . . . to the Disparagement of Revelation and of efficacious free Grace'.[141] These included the Arminian view that people might earn their salvation by good works; further, God, being a 'Loving and Bountiful Father', might have predestined a large number of people to salvation, including virtuous heathen and unbaptized infants who had had no chance to sin.[142] This contradicted the standard view, based on Matthew 22:14 ('For many are called, but few are chosen'), that the elect could only be a small minority; Burns' Holy Willie was perfectly orthodox in maintaining that God 'sends ane to heaven an' ten to hell'.[143] Ten years later Simson was charged with disrespectfully maintaining that the Second Person of the Trinity was not consubstantial with nor equal to the First – an argument put forward and carefully documented, as Simson knew, by Samuel Clarke.[144] Thanks to the influence of the ducal family of Argyll, Simson, though suspended from office, remained a member of the Glasgow faculty until his death. To many clerics, including Thomas Boston, who denounced it at the General Assembly, this treatment seemed far too lenient.

Enlightenment did gradually penetrate. Simson's pupils included the moral philosopher Francis Hutcheson, whom we have seen arguing for the greatest happiness of the greatest number. Robert Wallace, minister of Moffat, maintained in a famous sermon that deists who attacked Scripture by means of reason should in turn be attacked with their own weapons: 'We live in an Age so enlightened, when weak arguments and bad reasonings will not pass so well as formerly.'[145] Presbyterianism in any case was not Scotland's only religion. Episcopalians, strongest in the north-east around Aberdeen, were open to enlightenment. An Episcopalian, David Gregory, professor of mathematics at Edinburgh, was among the first commentators on Newton's *Principia*, and introduced Newtonianism to his students; in 1691 Newton helped him obtain the Savilian chair of mathematics at Oxford.[146]

The Kirk was highly fissiparous. A major cause of schism was the Patronage Act of 1712, which gave lay patrons the right to appoint ministers to charges. Patrons, usually local landowners, preferred well-educated clerics, who were often out of touch with their parishioners. When a new minister was inducted there were often riots.[147] On Sunday, 25 August 1728, at Shotts in Lanarkshire, opponents of the new minister barricaded the church doors, so that he was forced to preach out of the window of

the inn while the mob threatened him with stones.[148] Similarly, in John Galt's *Annals of the Parish* (1821), a wonderful fictional chronicle of eighteenth-century social life, the Rev. Micah Balwhidder, appointed to the parish of Dalmailing in the year 1760, finds the church door barred against him and has to climb in by the window. He concludes: 'And I thought I would have a hard and sore time of it with such an outstrapulous people.'[149] The most determined opponents of the Patronage Act, led by Ebenezer Erskine, the minister of Stirling, seceded from the Church of Scotland in 1740. Eventually the secessionists, unable to agree among themselves, formed separate groups, the Old Lichts and the New Lichts, each group in turn divided into Burghers and Anti-Burghers.[150]

These dissensions placed the remaining Church of Scotland firmly in the hands of the Moderate party, which, emerging in the 1750s, managed to sideline the 'Popular' party or 'High-Flyers'. Its leader, William Robertson, infused enlightened thinking into theology in his much-read sermon *The Situation of the World at the Time of Christ's Appearance* (1755), in which (like Lessing twenty years later) he argued that divine revelation was not a single event but a process that was 'gradual and progressive'.[151] As moderator of the General Assembly in 1763–4, and 'Moderate' leader thereafter, he firmly supported patronage. By skilful and persistent political management, Robertson assisted his like-minded fellow-clerics such as Alexander Carlyle, John Home and Hugh Blair, who sought to combine enlightened divinity with polite letters. The greatest conflict occurred over Home's historical tragedy *Douglas*, premiered in Edinburgh in 1756 and performed in London in 1757. Clerical bodies censured Home for writing it, and Carlyle for attending the theatre; Robertson helped to save them from suffering any penalties.[152] By 1784, when the famous actress Sarah Siddons performed in Edinburgh at the time of the General Assembly, important Assembly business had to be scheduled for days when Siddons was not acting, otherwise the enlightened ministers would have absented themselves in order to see her.[153]

One of the most vocal High-Flyers, John Witherspoon, minister of the Laigh Kirk at Paisley, unreconciled to this liberalism, accepted in 1768 an invitation to emigrate and become president of the College of New Jersey (now Princeton University); later he was the only clergyman to sign the Declaration of Independence.[154] Witherspoon nevertheless thought his evangelical Calvinism compatible with selective enlightenment: he introduced into the curriculum the Scottish 'common-sense' philosophy of Thomas Reid and the study of rhetoric and belles-lettres represented at Edinburgh by Hugh Blair. In using reason to justify religion, he was

following the Genevan Calvinist theologian Benedict Pictet, who believed that reason and revelation could be harmonized.[155]

In New England enlightened thought had already made headway. In 1714 the Yale College library received a donation of some 800 books, including works by Shaftesbury, Locke, Clarke and Tillotson, and even Bayle's *Dictionary*. Many Calvinists blamed this reading matter for the scandal of 1722 when the rector of Yale, a tutor and five ministers all defected to Anglicanism. Jonathan Edwards, later a renowned Calvinist theologian and revivalist preacher, read widely in this collection, besides acquainting himself with Newtonianism. He absorbed the Enlightenment spirit to the extent that, instead of relying only on Scriptural authority, he deployed rational arguments in order to confute what he considered enlightened errors. In his *Freedom of the Will* (1754) he assailed the Arminian doctrine of human autonomy, which he found alarmingly popular, by arguing that since God determines all things, all human actions are necessary; people are still accountable, however, for their bad actions, which God does not cause but merely permits (an argument, as we have seen, already challenged by Bayle). Edwards illustrates the adoption of enlightened means to serve very different ends.[156]

## THEOLOGICAL ENLIGHTENMENT IN GERMANY

In Protestant Germany, official Lutheran orthodoxy was widely seen as intellectually ossified. Goethe recalled the religious instruction to which he was exposed in mid-century Frankfurt am Main as 'a kind of dry morality'.[157] Yet the Church was able to silence or banish its opponents. One who felt its power was the philosopher Christian Wolff.[158] Teaching at the University of Halle, Wolff tried to increase the status of philosophy. Hitherto it had been a preliminary course of study, a preparation for the serious disciplines of theology, law and medicine. Wolff offered philosophy as a comprehensive system of knowledge – hence as a potential threat to theology. Certainly, Wolff sought to forestall criticism by demarcating the respective domains of philosophy and theology. Philosophy dealt with the natural truths revealed by reason, theology with the 'supra-natural' truths revealed in Scripture. But all argument in both domains had to be conducted by rigorous philosophical standards. The theologian could not trump the philosopher by claiming divine authority for a doctrine that made no rational sense.

Such a doctrine was Original Sin, which was incompatible with Wolff's

optimistic conception of human nature and with his cognitive conception of morality. The law of nature, according to Wolff, compels everyone to strive towards the good. Therefore you have to use your reason to know what is good. If anyone directs his will towards evil ends, that is not because he is wicked, but because his intellect is clouded and makes him look for the good in the wrong place. There was therefore no need to be afraid of atheists. If they went astray, that was not because they lacked the fear of God, but because their wills were misdirected – which could also be said of many non-atheists. There was no need, either, to regard non-Christians as reprobates. The Chinese, who reportedly had no conception of God, still sought after 'perfection':

> And because the Chinese stressed so strongly the idea that one must continually advance along the path of virtue and not rest at any degree of perfection less than the very highest degree, which of course no one can attain, it is my opinion that their philosophers, too, subscribed to the view that man cannot achieve happiness unless he seeks to attain more perfections day by day.[159]

Wolff made this bold statement in 1721, in a public speech delivered at the installation of his successor as vice-rector of the university. The following day he was denounced from a pulpit. The university authorities intervened, and the theology faculty undertook a scrutiny of all Wolff's publications. They thought they found there a denial of individual moral responsibility that they equated with 'fatalism' or 'Spinozism'. After two years of wrangling, the king of Prussia, Frederick William I, was approached; he issued an edict requiring Wolff to leave his dominions within forty-eight hours. Fortunately Wolff had already been offered a chair at the University of Marburg, in the principality of Hessen-Kassel, so his academic career was interrupted only for a month. His fame as Germany's leading philosopher continued to grow. Finally, when the enlightened Frederick II succeeded to the throne of Prussia, Wolff accepted an invitation to return to Halle.[160]

The message of Wolff's banishment, however, was not lost on potential dissidents, and it was several decades before orthodox theology was again challenged, this time by the loose network of enlightened clerics who acquired the name Neologians. Like Wolff, though more explicitly, they summoned theology before the bar of reason. But they had a different conception of 'reason' from Wolff's. Where Wolff had tried to deduce all truths from first principles by a logical and mathematical procedure, the Neologians understood 'reason' as a faculty comprehending both intellect and feeling (we might call it 'good sense'). Not many orthodox doctrines could withstand the Neologians' rational inquiries. They regarded Jesus

only as a human teacher and denied that his death could in any way have redeemed humanity from sin. Along with his divinity, the doctrine of the Trinity also crumbled. Original Sin was another bugbear. It was incompatible with human dignity, and testified only to the intolerance of the Church Fathers who had devised it, led by Augustine, 'the violent and hard-hearted Bishop of Hippo, undeservedly called a saint'.[161] Eternal punishment was also rejected: the true purpose of punishment was reform, and once people were dead it was too late to reform them.

Seen positively, Neology was an attempt to preserve Christianity while discarding what by eighteenth-century lights was unreasonable in its content. The Neologians continued to claim that God had revealed truths to humanity, but interpreted these truths as rational beliefs which humanity could not have discovered without divine aid. They transferred their attention from unprovable theological doctrines to practical benevolence. God was good, and so, at heart, was humanity. Jesus came not to convince us of our sinfulness, but to lead us closer to perfection. Traditional Christian doctrines that did not serve this purpose could be disregarded.

The Neologians were put on the spot by David Friedländer, a leading figure in the Berlin Jewish community. Friedländer was frustrated by being unable to obtain rights of citizenship for his family. In 1799, therefore, he and some other Berlin Jews sent an anonymous open letter to Wilhelm Abraham Teller, a leading Neologian, saying that they were willing to adopt Christianity if they did not have to affirm its irrational and inessential dogmas.[162] In this pamphlet Friedländer suggests that Judaism and Protestant Christianity are converging; the superstitions of traditional Judaism, like those of Roman Catholicism, are being discarded, and both religions agree on the eternal truths of natural religion; revelation serves to imprint them more forcibly on people's minds, but adds nothing substantial to them. The supernaturalism of the Old Testament is merely metaphorical, and Friedländer hints that such New Testament expressions as 'Son of God' may likewise be mere poetic imagery. However, Friedländer's request was refused: Teller was not prepared in effect to dismantle Christianity.

One could therefore, more critically, argue that Neology was an unstable compromise, intended to hold the line against deism and natural religion, but able to shore up official Lutheranism only for a short time.[163] It certainly seemed so to Lessing, who was annoyed by the wishy-washy doctrines put forward by the Neologians, and by their dishonesty in maintaining the concept of revelation and thereby disparaging the power of human reason. Lessing agreed, even more strongly, that the point of religion was practical benevolence; that is the message of *Nathan der Weise*, where the unanswerable dispute about which religion is the true one is

turned into a contest to prove one's faith in God by good actions. But he differed from the Neologians in thinking that all the truths contained in the Bible could have been discovered by unaided human reason. All that divine revelation accomplished was to help humanity to find them out a bit more quickly.

Lessing developed this idea in his treatise *Die Erziehung des Menschengeschlechts* (*The Education of the Human Race*, 1777, enlarged in 1780), which argues that revelation comes in stages. The revelation through Moses was intended for humanity at an early, child-like stage. That was why, as William Warburton had noted, the Old Testament did not contain the doctrine of the immortality of the soul: the ancient Israelites were not ready for it. Presently, however, the spelling-book represented by the Old Testament was no longer useful, and humanity needed a more advanced textbook from a better-qualified teacher: 'A better instructor must come and snatch the exhausted primer from the child's grasp. Christ came.'[164] With the New Testament, so to speak, humanity was promoted to secondary school. And what about the tertiary stage? Lessing is intrigued by the 'everlasting gospel' foretold in Revelation 14:6. He surmises that the medieval prophet Joachim of Fiore may have been on to something in speaking of the 'three ages of the world': the ages of the Father, the Son, and the Holy Spirit.[165]

Another way of appreciating the Bible while staying clear of theological disputes was to read it as poetry. The poetic qualities of the Old Testament found appreciation and analysis in the lectures given by Robert Lowth as professor of poetry at Oxford, published in Latin in 1753 and in an English translation in 1787. Lowth recognized three modes in the style of the Old Testament: the sententious, employing the device of parallelism, which he was the first to identify; the figurative, including imagery, allegory, comparison and personification; and the sublime. Following the ancient critic known as 'Longinus', Lowth understands the sublime as 'that force of composition, whatever it be, which strikes and overpowers the mind, which excites the passions, and which expresses ideas at once with perspicuity and elevation'.[166] Again like 'Longinus' (whose knowledge of the Bible suggests that he was a Hellenized Jew), he finds an exceptionally impressive example in the words of Genesis: 'And God said, Let there be light, and there was light.'[167]

Lowth's approach to the Old Testament was adopted in Germany by Johann Gottfried Herder and combined with Herder's intense interest in primitive poetry. At the same time as he was writing enthusiastically about folk poetry, Herder turned his attention also to the early chapters of Genesis. Here he recognized poetry that was primitive, not in the sense of being

rough, crude, or unpolished, but in being natural, expressing the spontan-
eous feelings of people whose emotions had not yet been 'sicklied o'er with
the pale cast of thought' or disturbed by intellectual speculation. Although
Herder accepted the prevailing assumption that the Pentateuch – the first
five books of the Old Testament – was the work of Moses, he thought the
opening of Genesis came from an earlier period, because it showed no signs
of Egyptian or Babylonian cosmology. Herder deplores misreadings of
Genesis, whether historical, theological, or theosophical. If you look for a
connected narrative, you will simply find incoherence; if you seek material
to support theological dogma, you entirely miss the lofty simplicity of the
text; if you look for access to the mind of God, you are asking the impossible;
and if, like the exponents of physico-theology, you try to accommodate Gen-
esis to Newtonian science, you simply look ridiculous.[168] The early books of
Genesis are a series of self-contained episodes and poems, and the creation
narrative itself is a sublime *Episch-Historisches Gedicht* (an epic and histori-
cal poem).[169] To appreciate it, you have to feel your way back into the mind
of the early Orientals (evocatively called *Morgenländer*) in their spacious,
empty landscapes, and imagine what it must have felt like to see the sun
rising over the desert. The beginning of Genesis is a poetic evocation of
dawn – '*Gemälde der Morgenröte, Bild des werdenden Tages* – siehe da!
Der ganze Aufschluß!' ('*A painting of dawn, a picture of day as it begins* –
behold! That explains everything!')[170]

## THE CATHOLIC ENLIGHTENMENT

Enlightenment was also gaining ground within the Catholic Church.[171]
The leading figure among progressive-minded Catholic clerics was the
versatile Lodovico Antonio Muratori. A friend of the enlightened Pope
Benedict XIV, Muratori insisted on an enlightened Christianity in alliance
with philosophical reason and historical knowledge. He was familiar with
the philosophies of Locke, Leibniz and Wolff, and the critical scholarship
of Bayle. He embraced the new historical scholarship on the Bible, urging
readers to distinguish between the immutable core of their faith and the
many accidental accretions it had acquired over the centuries. His greatest
achievement, at least in bulk, was as a historian: here his many publica-
tions included an edition, in twenty-eight volumes, of documents,
chronicles and similar sources for Italian history from 500 to 1500. His
enlightened approach is clear from an essay on good taste in the sciences
and the arts, written in 1703, where by 'good taste' he means something
like sound judgement independent of authority. He mocks scholars who

say that the chameleon lives on air, philosophers who say that a statement must be true because it was taught by Aristotle or by the Renaissance critic Castelvetro, and antiquarians who pursue trivial inquiries; the last he calls *cacciatori di mosche* or fly-catchers.[172] He warns against a half-unconscious adulation of authority and the acceptance of received opinions (*anticipate opinioni*).[173] Eighty years before Kant, Muratori was an eloquent advocate of thinking for oneself.

Prelates and monarchs inspired by the Catholic Enlightenment rejected the popular baroque piety with its cults of saints, shrines, pilgrimages and the like, which had grown up in the wake of the mid-sixteenth-century Council of Trent, and whose remnants still astonished the Berlin Enlightener Friedrich Nicolai when he visited Vienna in 1781.[174] Nicolai describes the huge throngs of pilgrims who flocked to such shrines as Mariazell, where the Virgin was called the Magna Mater Austriae, or Mariataferl near Linz, in order to make confession, eat and drink heartily, and buy religious merchandise.[175] Enlightened pamphleteers criticized the public display of saints' images, the sale of indulgences, and the special Masses at which blessings were bestowed (announced in stentorian tones by collectors, who then distracted the faithful during the service by rattling their collection-boxes).[176] The authorities knew that opponents of Catholicism could and did denounce such practices as superstitious. There were also economic concerns: pilgrimages and feast-days reduced the number of working days in the year. Muratori, in *Della regolata divozione de' Cristiani* (*On the Orderly Devotion of Christians*, 1747), condemned processions, pilgrimages and festivals as leading to disorder and impiety. He estimated that time lost to feast-days amounted to about three months a year, which working people could not afford.[177] He urged that church services should be orderly, with beggars and animals excluded from services, and that devotion should be inward, instead of being focused on saints and supposed miracles. Muratori's influence was extensive; in Germany it especially inspired Johann Michael Sailer, bishop of Regensburg, who reformed pastoral theology and practice in Bavaria.

Opposition to superstition of course antedated Muratori. Voltaire tells how in 1702 the enlightened bishop of Châlons-sur-Marne discarded the supposed navel of Christ that had been preserved for centuries; many prominent churchmen and lay citizens protested, claiming that the navel was just as genuine as Christ's robe kept at Argenteuil, his handkerchief at Laon, and his foreskin both at Rome and at Puy-en-Velay, but the bishop stood his ground.[178] Cardinal Lambertini, the future Benedict XIV, as archbishop of Bologna, burned the phial of the Virgin's milk and the piece of Moses' rod that were on display there.[179] As *Promotor Fidei* or Devil's

Advocate in Rome, he insisted on subjecting miracles to professional examination: hence the inexplicably preserved tongue of the fourteenth-century St John Nepomuk was examined by scientists, who could find no explanation for its preservation other than a miracle.[180] Despite some misgivings, Lambertini was satisfied that there was enough evidence to canonize the Counter-Reformation figure Giuseppe da Copertino, who, according to many reputable witnesses, was so excited by religious services that he used to distract the congregation by levitating, and was even seen to fly round church spires.[181]

Enlightened Catholics denied the existence of magic and witchcraft. In mid-eighteenth-century Italy a controversy took place between two Enlighteners, the cleric Girolamo Tartarotti, who maintained that magicians could exist but not witches, and the historian Scipione Maffei, who argued that neither magicians nor witches existed. As an Enlightener, Maffei appealed to the authority of the ancients, pointing out that the Greeks and Romans had not thought it necessary to institute laws against such practices. As a Catholic, he acknowledged that magic and witchcraft appeared in the Old Testament – Pharaoh's magicians, the Witch of Endor – but insisted that the devilish power that animated such people had been extinguished by the coming of Christ, citing the defeat of 'that old serpent, called the Devil' in Revelation (12:9).[182]

An inward devotion, focusing on the word of Scripture rather than images, under the guidance of well-educated parish priests, became the ideal. Again Muratori was a leading figure, but some important influence came from Jansenism. The severely Augustinian theology of Cornelius Jansen's *Augustinus* (1640), which to Catholic authorities seemed suspiciously close to Protestantism and was implicitly denounced by the papal bull *Unigenitus* (1713), fostered inwardness by encouraging believers to examine themselves for signs of grace. From its stronghold at Louvain in the Austrian Netherlands, Jansenism was diffused to Austria by prominent immigrants such as Gerard van Swieten, personal physician to Maria Theresa.[183]

Enlightened and reform-minded clergy favoured practical and moral theology that could help parish priests to do their work. More emphasis was placed on pastoral care by secular clergy. Regular clergy, especially monks, were accused of self-indulgence and idleness, often with reason. Thus we learn that the abbey of Tepl, when ruled by Count Trauttmansdorff as abbot, accommodated many young noblemen who practised horsemanship, fencing and dancing, were attended by liveried servants, and were entertained by the abbot, an enthusiast for horses and shooting, who never conducted services and appeared in church only on high

festivals.[184] Many convents, especially those reserved for noblewomen, followed the 'relaxed observance'; in the mid-eighteenth century, thirty-seven out of forty-eight Mexican convents did so. Their inmates might have 'cells' consisting of two or three rooms, with a sunroof and patio, and be allowed to keep pets, play musical instruments, hold dances, put on theatrical performances, receive visitors and avoid fasting; the attempt to impose stricter standards sometimes provoked rebellion.[185]

There was a darker side to monastic life, which Enlighteners emphasized. Even for those with a vocation, or those allowed privileges, confinement was difficult. For young women incarcerated simply because their parents could not find them a husband (or could not afford their dowry), or indeed for young men who entered the monastery on an ill-considered decision, it could be unbearable. A deadening routine, shared with a few over-familiar faces, could breed enmities (as in Browning's 'Soliloquy of the Spanish Cloister'): in the 1780s an inspection of the small Pauline monastery (comprising only the prior, four monks and six novices) at Ulimie in Styria found that 'the monks behaved unpleasantly to one another, discipline and housekeeping were in disarray'.[186] There was ample scope for psychological and sexual abuse. Diderot's novel *La Religieuse* (*The Nun*, written about 1780, published 1796) reveals how a convent could inflict psychological torture on a stubborn inmate; it also shows its heroine under pressure to accept the lesbian embraces of an abusive mother superior.[187] Johann Pezzl, in a fictionalized version of his own experiences in a Bavarian monastery, notes that the dormitory where the novices sleep is visited at night by a monk, and wonders whether he is in search of homosexuals: 'surely one cannot suppose that some novices have had a fit that makes them go together at night into the stalls and do what Jupiter did to Ganymede, Socrates to Alcibiades, and what even nowadays the Jesuits have so often done to their young students'.[188]

Monastic life could lead to madness. Diderot's younger sister Angélique had entered a convent voluntarily, become insane, allegedly through over-work, and died there aged twenty-eight.[189] The refractory, often mentally disturbed, might be confined for many years in monastery prisons, called *Vade in Pace* (Go in peace) because there was no release but in death.[190] In 1782, in a Capuchin monastery in Vienna, Ignaz-Aurelius Fessler discovered five prisoners, known as 'lions' and under the care of a lay brother known as the 'lion-keeper'; they had been confined respectively for fifty-two, fifty, forty-two, fifteen and nine years.[191] Fessler managed to smuggle out a message that reached the emperor and prompted a thorough investigation.

Monasticism also attracted the disapproval of enlightened statesmen, who considered it a burden to the state. Monasteries took able-bodied

men out of trades, professions and the army, and hampered the circulation of goods in the economy. For many reasons, therefore, Carlantonio Pilati, a professor in the prince-bishopric of Trent, recommended abolishing all monasteries in his *Di una riforma d'Italia* (*On a Reform of Italy*, 1767); Venice suppressed 306 out of its 421 monasteries between 1768 and 1773; Louis XV in 1765 set up a royal commission that finally closed 458 monasteries (out of 2,966 inspected) which were found to be corrupt or too small to be viable; and in Austria, Joseph II in the 1780s closed the monasteries of the contemplative orders, and used their property partly to endow newly created parishes and pay their priests.[192]

Many enlightened clerics wanted a structural reform of the Church in which national Churches should have autonomy and the pope's role should be reduced. Gallicanism, the doctrine that the Church in France should be free from the authority of the papacy, was preached throughout eighteenth-century France. Under the pseudonym 'Febronius', Johann Nikolaus von Hontheim, suffragan bishop of Trier, who had studied among Jansenists at Louvain, published in 1763 *De statu ecclesiae* (*On the State of the Church*), in which he argued for reducing the power of the pope and having the Church governed by regular general councils of bishops. Such proposals would mean in practice that national Churches would fall increasingly under the control of the state. Thus when the elector of Bavaria persuaded the pope to appoint a nuncio in Munich, it was inevitable that the appointee would work closely with the temporal power. His appointment also prompted four prince-archbishops, meeting at Ems in 1786, to issue the Punctation of Ems (*Emser Punktation*), which demanded that the Church within the Empire should be governed by bishops and archbishops, leaving the pope with an honorary role.[193]

Catholic intellectuals such as Muratori took an increasing interest in the secular philosophy and science of the Enlightenment, first in Descartes and Wolff, then in Newton and Locke. From the 1740s, Wolffianism, as 'a complete and self-sufficient system, proved an ideal substitute for the neo-scholastic Jesuit teaching that had dominated Catholic higher education for over a century'.[194] The study of science in particular could be justified as promoting a better understanding of God's wisdom in planning the orderly universe. The Benedictines were especially open to new ideas; they had their own university at Salzburg, with the physicist Dominikus Beck as its leading light.[195]

The Jesuits were widely, though somewhat unjustly, seen as enemies to the Enlightenment.[196] They were reputed to be the shock troops of the papacy, and compared to the janissaries who protected the Ottoman sultan.[197] They were said to exercise enormous backstairs influence on

European rulers, and even to have assassinated several. The 'reductions' that they set up in Paraguay to protect the indigenes from slave-traders were misrepresented – by Voltaire in *Candide*, among others – as a kind of military dictatorship or system of forced-labour camps.[198] The Jesuits were old-fashioned in their educational methods, teaching an outdated Aristotelianism and using the *Ratio studiorum* (1599) which ignored history and stressed mathematics rather than science. Although they gradually included experimental philosophy in textbooks, they were slow to do actual experiments: the Jesuit University of Ingolstadt acquired an air-pump only in 1729, at the high cost of 150 florins.[199] Even by the mid-century, German Jesuits accepted only Newtonian mechanics, not heliocentrism or the theory of gravity which formed its basis; they were taught better by the independent-minded Jesuit physicist Ruggiero Boscovich, who pursued his studies in Rome with the support of Benedict XIV, and who published his Newtonian *Theoria philosophiae naturalis* in 1758.[200] The Jesuits' other scientific luminary was the astronomer Maximilian Hell, who, at the age of thirty-five, was put in charge of the new observatory at the University of Vienna, travelled to the Arctic tip of Norway to observe the transit of Venus across the sun in 1769, and eventually became a member of the scientific societies of Copenhagen, Göttingen, Stockholm, Trondheim and Bologna, and a corresponding member of that of Paris.

Enlightenment in Catholic countries met with many obstacles. A case that became emblematic for all enlightened Europe was that of the Peruvian-born Don Pablo de Olavide, an enlightened layman who had visited Voltaire in 1761. Olavide, who sympathized with advocates of inner devotion rather than outward ceremonial, used his position as a high-placed administrator in Andalusia to curtail the powers and festivities of religious confraternities. However, having inadvertently allowed some Protestants to settle in Spain, and retrospectively approved their presence, Olavide was denounced to the Inquisition and sentenced to eight years in a monastery prison, after which he recanted his enlightened principles and reverted to traditional faith.[201]

The Catholic Enlightenment was swept away, like so much else, by the French Revolution and the Napoleonic wars. The Catholic landscape of Germany was transformed in 1803, when a delegation of the Imperial Diet, under Napoleon's influence, decreed that the ecclesiastical principalities should be secularized. Secular states, ostensibly serving the cause of enlightenment (but in fact seeking easy riches), took over Church buildings, property and land. The year before, the elector of Bavaria, encouraged by his anti-clerical minister Count Maximilian von Montgelas, had

suppressed seventy-seven male and fourteen female religious houses. By 1812 almost all the south German monasteries had been suppressed. The Benedictines retained only St Jakob in Regensburg.[202] Hundreds of thousands of books perished in this 'cultural disaster'.[203]

Having been dissolved in 1773 by Pope Clement XIV, the Jesuits were restored in 1814 as part of the nineteenth-century policy of strengthening papal power. They were recruited largely from elderly priests whom Catherine the Great had invited to Russia to take charge of education there. As a modern Church historian puts it, 'The "reaction" rises in triumph against the demonic liberalism which the Catholic Enlightenment claimed to baptize.'[204] The Church signalled its opposition to modern ideas, enlightened or otherwise, by issuing the *Syllabus of Errors* (1864) and by proclaiming increasingly rebarbative doctrines: the Immaculate Conception of the Virgin (1854) and Papal Infallibility (1870). When dissident Old Catholics left the Church rather than accept the latter doctrine, their action 'could be seen as the last gasp of the Catholic Enlightenment'.[205] In a longer perspective, however, the reforms introduced in the 1960s by the Second Vatican Council can be seen as a belated resurgence of enlightenment.

## ENLIGHTENMENT IN THE ORTHODOX WORLD

The Enlightenment penetrated also into the worlds of Eastern European Orthodoxy, converging, as in Catholic countries, with internal pressures for religious renewal. Enlightenment in Greek-speaking regions had to contend with two sets of authorities: first, the Ottoman Empire, and secondly the patriarchate based in Constantinople. The Ottomans seem in practice to have taken little interest in what their subjects in the *Rum millet* ('Roman nation') were thinking, until they were faced with political rebellion. The Orthodox Church, on the other hand, had power and authority greater than any Western European counterpart: it had never been split by a Reformation, and it was the main embodiment of cultural continuity with the Byzantine Empire which had fallen to the Ottomans in 1453. The Orthodox Church was conservative: as late as 1804, for example, it condemned the educator Beniamin Lesvios for teaching that the earth went round the sun. It was also widely unpopular because it advocated submission to the Ottomans and was responsible for large areas of civil government, and hence involved in corruption and exploitation. Monks, in particular, were believed to support the Ottoman authorities

by informing them about the movements of *klefts* or social bandits.[206] Hence enlightenment flourished in areas remote from Constantinople, such as the Ionian Islands and the principalities of Wallachia and Moldavia on the lower Danube. The region's leading academies were at Bucharest and Jassy. Not only Greeks, but Romanians and Bulgarians who wanted an education had to study there and become proficient in Greek. The Greek Enlightenment was really 'pan-Balkan'.[207]

However, Greek-speaking intellectuals did not face persecution as their counterparts in much of Western Europe did. There was no Inquisition. The Church occasionally ordered a book to be burned or closed progressive schools, but these things happened on a larger scale in France and Germany. On the other hand, Greek Enlighteners for the most part refrained from attacking Orthodoxy. They tried to keep religious doctrine and enlightened philosophy in separate compartments. The leading figure of their first generation, Eugenios Voulgaris, did not accept that philosophy could ever contradict Orthodoxy, so he assumed 'a complete epistemological separation between the Enlightenment and Orthodoxy'.[208] This discretion did not save the enlightened from many bitter attacks: Voulgaris, having been director of the Academy on Mount Athos, was eventually obliged to emigrate to Prussia and thence to Russia, where he became an honorary member of the St Petersburg Academy of Sciences and, at Catherine the Great's request, was ordained archbishop of Slavyansk and Kherson.

Voulgaris was one of numerous Greek Orthodox clerics who were interested in the new philosophy of Western Europe.[209] Some of them had studied in Italy or Germany. Chrysanthos Notaras, patriarch of Jerusalem, having met with liberal theologians and scientists in Paris, produced in 1716 the first printed book which introduced the new science to the Orthodox world. While Chrysanthos cautiously presented the theories of Copernicus and Descartes, however, he did not yet advocate Newtonianism. That was done by Nikephoros Theotokis, who had studied medicine, mathematics and physics at Padua and Bologna, and published his Newtonian *Elements of Physics* (1766–7) at Leipzig, in which he argued for reason and experience against authority, and widened his readership by using a simple style close to everyday speech. While prudently calling Newtonianism a mere 'hypothesis', he devoted most of his book to it.[210] Iosipos Moisiodax, a cleric who had lived in Venice and studied in Padua and Vienna, boldly maintained in his *Apology* (1780) that Newton was the towering figure of the Enlightenment, and that the practical application of his science had brought immense benefits to Western Europe. Like all Greek Enlighteners, however, Moisiodax had to

struggle with the outdated Aristotelian curriculum taught in Greek universities (and which Adam Smith had encountered, to his scorn, in Oxford in the 1740s). As director of the Academy at Jassy, Moisiodax was persecuted by his conservative opponents, accused of ignorance and twice forced to resign.[211]

Enlightened Orthodox clerics found themselves opposed not only from above but also, even more relentlessly, from below. Ordinary people insisted on sticking to their traditional beliefs and customs. The enlightened found support in the work of Muratori. Moisiodax translated his *Filosofia morale* into Greek, and inveighed against popular superstitions as Muratori had done in *Della regolata divozione*:

> 'Sorceries, vampires, witchcraft, ghosts, magic, enchantments, divination of dreams, omens of future catastrophes or epidemics derived from earthquakes, comets, eclipses' – all these and more formed a universe of 'headless ideas' that could easily be imparted to tender minds and become the cause of paralyzing fears, idleness, and loss of good opportunities in daily life because of the false designation of certain days as inauspicious.[212]

Radical criticism of Christianity is rare, but we find it in Christodoulos Pamplekis. Having studied at the Academy on Mount Athos under Voulgaris, he followed Voulgaris' example by moving to Germany, where he taught philosophy to the Greek community in Leipzig. There he published in 1786 selections from the *Encyclopédie* in Greek, with his commentary, and a resolute affirmation of the existence of God, in which he borrowed Samuel Clarke's arguments against deism. After his death his book *On Theocracy* (1793) appeared anonymously. It was the most radical statement of the Greek Enlightenment, upholding the views of Voltaire and Rousseau, and criticizing the Eastern Church as a violent clerical hegemony that benefited from Ottoman rule. Pamplekis rejects the concept of divine revelation, and, though *On Theocracy* does not mention Spinoza, he argues in a manner strongly reminiscent of Spinoza that the world, humanity and divinity form a unified whole; that matter and mind are coextensive parts of an infinite and necessary essence; and that philosophy should make use of observation, experience and the principle of sufficient reason.[213] He attacks celibacy as unnatural and affirms a kind of pantheistic deism. For these views, Pamplekis was anathematized by the Orthodox Church. But he was also something of an embarrassment to Greek Enlighteners, who felt that an all-out attack on the Church could only hinder their task of diffusing enlightened thought among believers.[214] Although he has attracted little attention, Pamplekis was an isolated and courageous spokesman for the radical Enlightenment.

## THE JEWISH ENLIGHTENMENT

The Jewish Enlightenment or Haskalah was a reform movement internal to Judaism, analogous to Reform Catholicism, seeking to reform religious practice and thought, but it also arose from awareness of the external Enlightenment and sought to introduce secular knowledge and bring Judaism up to date with modern intellectual standards.[215] As enlightened Catholics confronted an outworn scholasticism, and enlightened Lutherans a rigid theological orthodoxy, so the Haskalah opposed Talmudic Judaism, which concentrated on interpreting the Law set down in the Pentateuch and which sharpened intellects by directing them to often unreal and fantastic problems. Its intellectual training, *pilpul*, was condemned by the reformers as encouraging only futile ingenuity and hair-splitting. A sarcastic description comes from Salomon Maimon, born Shelomo ben Yehoshua in a traditional community in what is now Belarus, who found his way, through many tribulations, to Enlightenment Berlin, where he became an early expositor of Kant. He described his upbringing in what George Eliot called 'that wonderful bit of autobiography', his *Lebensgeschichte* (1792).[216] Here he cites absurd-seeming problems such as these:

> How many white hairs can a red heifer have and still remain a red heifer? Did the High Priest put on his shirt before his trousers, or the other way round? If the *yabam* (a man whose brother has died childless and who is obliged by law to marry his widow) falls off the roof and sticks in the mud, is he relieved from his duties or not?[217]

Instead, the reformers advocated studying the Bible with the aid of systematic knowledge of Hebrew grammar in order to establish first and foremost the literal sense of the text; this approach was itself traditional, known as *peshat*.[218] The Haskalah also looked back to traditions of medieval scholarship, notably Maimonides' *Guide for the Perplexed*, which aimed to reconcile Judaism with Aristotle; it was republished in 1742. The agents of the Haskalah were known as *maskilim*, familiar with the study of the Law (Torah) and its commentaries (the Talmud) but also with knowledge of secular culture and languages other than Yiddish and Hebrew. They wanted to reform Jewish education by promoting the serious study of Hebrew and a wider interest in philosophy, mathematics and science. The manifesto of the Haskalah was the pamphlet by Naphtali Herz Wessely, *Words of Peace and Truth* (1782), originally published in Hebrew but soon translated into German, French and Italian, which argued that secular education would pose no danger to Judaism, for the 'teaching of

God' comes through revelation, but the 'teaching of man' (languages, science, history) is necessary for social existence.

Was it really possible, however, for the substance of Judaism to remain undiluted by Enlightenment influences? The great figure of the Haskalah, Moses Mendelssohn, was convinced that it could. Born in 1729 in Dessau, a centre of early Haskalah activity, Mendelssohn earned his contemporaries' admiration by acquiring secular learning and a command of German, French and Latin, and by publishing enlightened philosophical works. Although he made his living by managing a silk factory, Mendelssohn socialized with the leading figures of the Berlin Enlightenment, notably Lessing and Friedrich Nicolai.[219] He is often supposed to have been the inspiration for Nathan in Lessing's play *Nathan der Weise*, but though he strongly advocated religious toleration, he differed from the argumentative Nathan in shunning controversy.[220]

Mendelssohn wanted to present Judaism in a manner that would appeal to the international Enlightenment. For this he had to overcome two stereotypes: that Jews were devoted to hair-splitting argument (*pilpul*), and that their Law was full of trivial and superstitious precepts, such as we shall see Voltaire mocking. His civilized style of argument, in complete contrast to *pilpul*, was shown in his first book, *Phädon* (1767), a Socratic discussion on the immortality of the soul. Here Socrates is made to argue, along lines laid down by Leibniz, that everything in nature takes place by gradual change, hence nothing is annihilated, hence the soul must survive death. Mendelssohn's choice of topic was yet another strategy for making Judaism acceptable, for, as we have seen, the Old Testament notoriously says nothing about immortality, yet Mendelssohn claimed – in a Hebrew work called *The Book of the Soul* that presents the essence of *Phädon* – that the doctrine of immortality was a fundamental tenet of the Torah.[221]

The Law presented different problems. In the twelfth century Maimonides had already codified the Law as 613 precepts, and interpreted them as intended to discourage idolatry and promote reverence, morality and health. Thus the Law classified certain animals as unclean because their meat was unwholesome; that the permitted animals chewed the cud and had cloven hooves was unimportant in itself, but merely a sign by which they could be recognized.[222] So Mendelssohn assumed, following Maimonides, that the 613 precepts were fundamentally rational. In his *Jerusalem* (1783), addressed to non-Jews, Mendelssohn maintained that a Jew must uphold the Law: 'I cannot see how those born into the House of Jacob can in any conscientious manner disencumber themselves of the law.'[223] He had a further, ingenious explanation. The laws were related to the doctrines of Judaism, as the body to the soul, or practice to theory.

Without being practised, the doctrines would be dead letters. The Law told Jews how to live their religion. It was a semiotic system in which the actions of daily life always reminded people of the doctrines which they signified: 'The ceremonial law is itself a living script, stirring mind and heart, full of meaning, stimulating contemplation at all times, and offering constant opportunity for oral instruction.'[224]

Did this work in practice? Socializing with non-Jews required some degree of adjustment to dress and behaviour. Better-off English Jews detached themselves from traditional communities and assimilated thoroughly to polite society. As early as 1729, a Huguenot diplomat in London noted that a Jew wearing a beard was sure to be either a rabbi or a recent immigrant.[225] Jews in England and Germany frequented coffee-houses, despite rabbinical fears that the cups, having previously contained milk, might not be kosher; in Frankfurt, with its large ghetto, there were some coffee-houses run exclusively by and for Jews.[226]

Mendelssohn, though not excessively strict, kept the dietary laws, would not travel on the Sabbath and wore a beard, though a very small one (the subject of a hostile pamphlet).[227] Of his three sons, only the eldest, Joseph, a wealthy banker, remained a Jew throughout his life, and he took no particular interest in the Jewish faith. The other two, Abraham and Nathan, converted to Christianity. Abraham justified his move on the grounds that a devotion to virtue could be practised under various religious forms. In 1829 Abraham wrote to his son Felix, the composer:

> Naturally, when you consider what scant value I placed on any form in particular, I felt no urge to choose the form known as Judaism, the most antiquated, distorted and self-defeating form of all. Therefore I raised you as Christians, Christianity being the more purified form and the most accepted by the majority of civilized people.[228]

Abraham's sister Brendel married and divorced a Jewish banker, changed her forename to Dorothea and married the Romantic philosopher Friedrich Schlegel; in 1808 the two of them were received into the Roman Catholic Church. So Mendelssohn's version of enlightened Judaism looks extremely unstable.

Later generations of Jewish leaders would go further than Mendelssohn. Mendelssohn reinterpreted the ceremonial law; Reform Judaism, consolidated in Germany in the 1840s, affirmed that ceremonial laws were less important than the ethical values of Judaism. The intellectual stronghold of Reform Judaism in America, Hebrew Union College, opened in Cincinnati in 1875. At the banquet marking its first graduation class in 1883, foods that had been expressly forbidden as non-kosher – such as

shellfish – were served. If Reform Judaism, in giving primacy to ethics over ritual, can be seen as continuing one strand of Enlightenment thought, another Enlightenment heritage can be seen in the much-celebrated commitment of innumerable emancipated Jews to intellectual inquiry and progressive politics. Yet the familiar roll call of names from Heinrich Heine and Karl Marx onwards includes many who had formally abandoned Judaism or who regarded themselves as secular Jews, feeling Jewishness to be an indefinable but essential part of their identity.[229]

## THE STUDY OF THE BIBLE

The religious Enlightenment fostered the scholarly study of the Bible. Biblical criticism originated not as an attempt to undermine the Bible's authority, but as an endeavour to establish exactly what it said. In the eighteenth century, as now, most people who read the Bible did so in translation, because only a small minority have ever been able to read the Old Testament in the original Hebrew and the New Testament in the original Greek. Scholars who studied the originals faced the problem that these ancient languages could now be only imperfectly understood. Moreover, the study of Hebrew required the assistance of Jews, whose ungodly influence might corrupt the Christian inquirer.[230] The Hebrew text was particularly obscure because it had initially been written without vowels. The Masoretic text, prepared by Jewish grammarians between the sixth and tenth centuries CE and recognized as standard, added vowels in the form of points above the letters, but in some cases it was unclear which of two possible sets of vowels should be inserted, and the text was amplified, though not necessarily clarified, by marginal comments on difficult passages. In addition, both Testaments had been copied many times, and copying always introduces textual variants. So the text of the Bible turned out to be mutable.

For many Protestants, this was an inadmissible discovery. They maintained that the Bible was the authentic Word of God and contained everything necessary for salvation. The Belgic Confession, adopted in 1619 at the Synod of Dort which condemned Arminianism, declared that God, 'by a special care which he takes for us and our salvation, commanded his Servants, the Prophets, and Apostles, to write down his manifested Word; And he himself wrote with his own finger, the two Tables of the Law' (i.e. the Ten Commandments).[231] An extreme position, adopted by the textual scholar Johannes Buxtorf the Younger, was to claim that the vowel points too were divinely inspired; he found few followers.[232] Catholics on the other

hand could regard textual uncertainties with some equanimity, holding that they could be resolved by the authority of the Church.[233]

Eventually, however, the Reformation replaced 'the Bible' with a variety of Bibles. The Catholic Church continued to rely on the Latin translation of the Bible, known as the Vulgate, made by Jerome in the fourth century, supposedly under divine inspiration. Protestants, however, had somehow to reconcile their doctrine of the sufficiency of Scripture (*sola scriptura*) with the fact that the Scriptures survived in numerous different manuscripts whose provenance was often uncertain. Martin Luther maintained, on stylistic grounds, that the Epistle to the Hebrews was not by its alleged author, Paul; and he argued that the Revelation ascribed to St John the Divine was not an inspired text and should not be part of the biblical canon, finding its tone 'unpleasant and repulsive when it speaks of the extermination of the heathen, and so forth'.[234] New translations – notably Luther's German translation, and the Geneva Bible produced in 1557–60 by English Protestants who had fled to Geneva from the Marian persecutions – were all based on linguistic and historical scholarship. It came to be recognized that as no single, totally reliable text could be established, no translation could claim undisputed authority. Accordingly, the *Biblia pentapla*, edited by Johann Otto Glüsing and published in Wandsbek near Hamburg in 1710, presented five different translations of the New Testament side by side.[235]

The most radical and most influential initiative in the study of the Bible came from outside the Churches. Spinoza, after his expulsion from the Jewish community in Amsterdam in 1656, moved in radical Protestant circles. Observing that the Calvinist clergy of Holland were fully as intolerant as the Jewish authorities, he wrote his great work of Bible criticism, the *Tractatus theologico-politicus* (*Theologico-Political Treatise*, published anonymously in 1670), to dispel misunderstanding and superstition and thereby to undermine the authority of the clergy, which rested on their claims to be the privileged interpreters of the Bible's alleged mysteries. 'I have often wondered,' says Spinoza,

> that persons who make a boast of professing the Christian religion, namely love, joy, peace, temperance, and charity to all men, should quarrel with such rancorous animosity, and display daily towards one another such bitter hatred, that this, rather than the virtues they claim, is the readiest criterion of their faith.[236]

Spinoza writes from a standpoint outside Christian or Jewish theology. In his *Ethics* he speaks of 'that eternal and infinite being we call God, or Nature'.[237] Despite this much quoted and much misunderstood formulation,

# TRACTATUS
# THEOLOGICO-
# POLITICUS

## *Continens*

## Diſſertationes aliquot,

Quibus oſtenditur Libertatem Philoſophandi non tantum
ſalva Pietate, & Reipublicæ Pace poſſe concedi: ſed
eandem niſi cum Pace Reipublicæ, ipſaque
Pietate tolli non poſſe.

Johann: Epiſt: I. Cap: IV. verſ: XIII.

*Per hoc cognoſcimus quod in Deo manemus, & Deus manet*
*in nobis, quod de Spiritu ſuo dedit nobis.*

HAMBURGI,

Apud *Henricum Künraht.* cIɔ Iɔ cLxx.

Spinoza's full title runs: 'A theological and political treatise, containing some
arguments by which it is shown that the freedom of philosophizing can not only
be permitted without damage to piety and civil peace, but cannot be abolished
without destroying civil peace and piety'. The quotation is: 'Hereby know we that
we abide in him, and he in us, because he hath given us of his Spirit.' (1 John 4:13)

God is not identical with the world, but immanent in the world, so that the operation of natural laws is at the same time the operation of God's perfect will.[238] God therefore did not create the world, because that would imply that he was separate from the world and existed before it did, and he does not intervene in the world, because that would again imply his difference from it. Nothing can happen out of the order of nature, which is also the divine order. Hence the so-called miracles reported in the Bible are simply natural events imperfectly understood. The essential content of the Bible is a simple ethical message: one should love one's fellow-humans and treat them with charity and justice.

Spinoza describes his method of interpreting Scripture as very similar to the study of nature:

> For as the interpretation of nature consists in the examination of the history of nature, and therefore deducing definitions of natural phenomena on certain fixed axioms, so Scriptural interpretation proceeds by the examination of Scripture, and inferring the intention of its authors as a legitimate conclusion from its fundamental principles.[239]

By 'history', Spinoza does not mean a chronological narrative, but an analysis that starts from empirical data rather than first principles.[240] Just as Bacon had advocated studying nature by first looking closely at actual phenomena, so Spinoza advocates close study of the biblical text. Bacon, and after him the 'mechanical philosophy' associated with Descartes, rejected the scholastic idea that natural objects were animated by occult forces; Spinoza analogously rejects the idea that Scripture requires the inspiration of the Holy Spirit for its interpretation.[241] He agrees with the Arminians, who were condemned at the Synod of Dort for saying that the Bible could be understood by 'right reason' even without inspiration, but he goes further by rejecting as meaningless the very concept of inspiration. It is, he says, a fantasy that enables people to attribute to the Holy Spirit 'every result of their diseased imagination'.[242]

The method Spinoza advocates and adopts is philological and historical. In the first chapter of the *Tractatus* he examines how the Hebrew word *ruach*, often translated 'spirit', is actually used in the Bible, and shows that it means 'God's mind and thought'.[243] (This implies, though Spinoza does not draw the conclusion explicitly, that the Holy Spirit as the third person of the Trinity is an imaginary entity based on a verbal mistake.) Besides understanding the meanings of words, one must understand the intentions of the biblical authors and the historical context in which they lived and wrote. The prophets' messages are shaped by their individual characters and temperaments. Thus Elisha, when soothed by

harp music, prophesied glad tidings; Ezekiel, when 'impatient with anger', denounced the obstinacy of the Jews; and Jeremiah, when miserable and weary of life, foretold their disasters.[244] The prophets had no special knowledge; indeed, they were often ignorant and uneducated. Moses, for example, did not know that God is omnipresent, so went up Mount Sinai to meet him; thus 'God adapted revelations to the understanding and opinions of the prophets'.[245] Instead, the prophets had vivid imaginations, which enabled them to deliver forcefully an essentially moral message. Historical circumstances, too, explain the authority conferred on the Mosaic Law. Having just escaped from Egypt, the Hebrews were in a lawless condition. Moses gave them law and set up a theocracy administered by priests. But this theocracy could not be a model for any other state. Thus Spinoza struck a blow against the overweening authority assumed by modern ecclesiastics.

An example of Spinoza's method is the well-known problem of the authorship of the Pentateuch. It was traditionally believed that the first five books of the Bible were written by Moses. But how could Moses have written: 'So Moses the servant of the Lord died there in the land of Moab' (Deut. 34:5)? Many commentators, including Luther, said that Moses wrote most of the Pentateuch, but the last eight verses were added by someone else, probably Joshua. Thomas Hobbes, however, pointed out in *Leviathan* (1651) that some other passages in the Pentateuch refer to events that happened after Moses' death.[246] A daring solution, proposed among others by the Socinian scholar Adriaan Koerbagh, was that the Pentateuch was written by Ezra, the scribe who returned with the Jews to Jerusalem from their Babylonian captivity. We are told that Ezra read aloud from 'the book of the law' (Nehemiah 8:3) with helpers who 'gave the sense' (ibid. 8:8), which was often taken to mean that they inserted the vowel points.[247] Spinoza agreed, pointing out further reasons why the Pentateuch could not have been written by Moses: for example, it refers to some places by names which they did not acquire until long after his time.[248] Thus, in Spinoza's hands, the Bible becomes a human book, written by human beings, liable to error, and demanding to be studied by the same methods as other, non-sacred books.

The Catholic priest Richard Simon undertook his *Histoire critique du Vieux Testament* (*Critical History of the Old Testament*, 1678) partly in response to Spinoza's *Treatise*. He acknowledged that the text contained inconsistencies and oddities that were a proper subject for criticism. But these mistakes, which often arose from the scribes incorporating material from other, now lost books, did not affect the substantive religious truths of the Old Testament and could not undermine its authority. It was still

an inspired text. For Simon, however, '[i]nspiration is not the equivalent of a word-for-word dictation, but a form of assistance which prevents error in the choice of words and thoughts'.[249] Inspiration inheres not in the words but in the process whereby a series of scribes composed the Scripture, presenting the truths of faith reliably but diverging in inessential matters. Hence Simon drew attention to the duplicate accounts of various events – for example, the creation of Adam is recounted twice, differently, in Chapters One and Two of Genesis – and to the variations of style which suggested that the Pentateuch was the work of several authors.

Simon intended his work to undermine Protestantism by showing how foolish the Protestants were in basing faith on the letter of Scripture alone, and thereby to vindicate the Catholic reliance on tradition.[250] However, when the table of contents and the preface were leaked to the bishop of Meaux, Jacques-Bénigne Bossuet, who as the leading court preacher and tutor to the dauphin was among the most influential men in France, he decided that 'this book was a mass of impieties and a rampart of freethinking'.[251] He easily arranged for all copies to be confiscated and pulped. A few copies managed to survive, so that the *Histoire critique* was published in the Netherlands, both in French and in a Latin translation. From there it crept back clandestinely to France and circulated throughout Europe, alarming some and pleasing others. The Anglican diarist John Evelyn feared that it would damage the Church of England, which 'acknowledges the Holy Scriptures alone to be the canon and rule of faith', but the poet and Catholic convert John Dryden was pleased that it allowed him to profess a faith without dogma.[252]

Bossuet may have perceived that in professing to uphold tradition, Simon was actually redefining it. For Bossuet, Catholic tradition consisted in the many commentaries on Scripture provided by the Church Fathers. For Simon, the Fathers were just another group of commentators, on the same plane as the Rabbinic, Catholic and even Protestant commentators to whom he turned when they could help to elucidate the text. His work typifies the intellectual shift from reliance on authority to empirical study of what is there, and his boldness in defying authority has been compared to that of Galileo.[253]

Thanks to Simon, we find further contributions to the higher-critical study of the Bible within the Catholic Enlightenment. Jean Astruc, a professor of medicine who also practised textual criticism, argued in 1753 that Moses had written the Pentateuch, but had done so by combining a series of different sources: one could distinguish, for example, those that called God Elohim and those that called him Yahweh. These inquiries made possible such radical criticisms as that of the Scottish Catholic priest

(and supporter of the French Revolution) Alexander Geddes, who had absorbed the approach to the Old-Testament-as-myth pioneered by Johann Gottfried Eichhorn and the Göttingen school.[254] Geddes took it further by arguing that the story of Adam and Eve was symbolic: the couple stood for contrasting human faculties, the two trees for the virtues.[255] Dealing with the more historical parts of the Pentateuch, Geddes insisted that the Jehovah presented there was an image 'adapted to the ideas of a stupid, carnal people'.[256] He thus read the Bible, in a manner recalling Lessing's *Education of the Human Race*, as the story of God's gradual self-revelation to people whose understanding slowly became more spiritual in the course of history.

Other commentators treated the Bible less respectfully than Simon had done.[257] They could not so easily brush aside the many inconsistencies in the Old Testament (to go no further for the moment). How was it possible, asked Voltaire, for God first to create light, but to create the sun only four days later? 'One cannot conceive how there is a morning and an evening before there is a sun.'[258] The creation of Adam and Eve was recounted in two incompatible ways: either humanity was created male and female in God's image (Gen. 1:27), or God first created Adam from the dust of the ground, and then extracted one of his ribs and made it into Eve (Gen. 2:7, 21–2). The chronologies of events were full of discrepancies, besides being impossible to reconcile with the much longer histories recorded by the Egyptians, the Chaldaeans, the Chinese and other ancient nations.[259] The longevity of the patriarchs was incredible, and inconsistently reported.[260] The exodus of the Israelites from Egypt was fraught with oddities: instead of leaving Egypt via Sinai, they took a roundabout route, allegedly to avoid the Philistines (Exod. 13:17), which required them to cross the Red Sea by means of a miracle.

Some of these oddities were addressed by Hermann Samuel Reimarus, who from 1727 till his death in 1768 was professor of Oriental languages at the Akademisches Gymnasium in Hamburg. In his later years he composed, but prudently concealed, an immense manuscript entitled *Apologie oder Schutzschrift für die vernünftigen Verehrer Gottes* (*Apology for the Rational Worshippers of God*). His daughter Elise showed the manuscript to Lessing, who, judging it too radical to be published in book form, printed anonymous fragments from it in his journal *Beiträge zu Literatur und Geschichte* (*Essays on Literature and History*), with prefaces by himself claiming not to know where these fragments came from. Reimarus maintains that Christianity is at heart a 'rational, practical religion', enjoining active benevolence and virtue, which has been corrupted by the Churches into a vast edifice of false history and fanciful theology.[261] Among many

other impossibilities, he discusses in great detail the passage of the Israelites through the Red Sea. According to the Bible, six hundred thousand men of war, besides their families and flocks and herds, all passed through the sea in one night (Exod. 12:37–8). Reimarus calculates that if there were so many fighting men, the entire nation must have numbered 4,200,000. They would have formed a column extending 49 German miles (almost 400 kilometres).[262] Their progress would have been slowed by mothers carrying children, infirm old people, unruly animals and baggage wagons, and the exposed bed of the Red Sea would have been uneven and full of rocks, sand and vegetation. It would have been entirely impossible for such a number to pass over such a terrain in such a short time. The story – over which biblical scholars had long been puzzling – made no sense.[263]

Worse still, although the patriarchs and heroes of the Old Testament were supposed to be exemplary, their conduct, though treated with great indulgence in the text, did not stand up to strict examination. The patriarch Abraham was declared by God to be the 'father of many nations' (Gen. 17:5); it did not matter that previously, when in Egypt, he had prostituted his wife Sarah, reassuring customers by telling them she was his sister.[264] That Jacob cheated his brother Esau (Gen. 27:19) and his employer Laban (Gen. 30:32–42) in no way diminished the peculiar favour shown him by God.[265] Moses seemed less than admirable when, after destroying the Golden Calf, he ordered the slaughter of 23,000 of its worshippers.[266] On overcoming the Midianites, Moses was annoyed with his officers for sparing their women, and commanded them to kill all the male children and all the women except for young girls (Num. 31:17–18). Gideon and his followers killed 42,000 men who could not pronounce the word 'shibboleth' (Judges 12:6). David, supposedly a man after God's own heart, and the distinguished ancestor of Jesus, was a bandit, a rebel, a sexual predator and a mass murderer who not only exterminated his victims, but subjected them to bizarre tortures: 'And he brought out the people that were in it [the city of Rabbah], and cut them with saws, and with harrows of iron, and with axes. Even so dealt David with all the cities of the children of Ammon' (1 Chron. 20:3).[267] Even on his deathbed he instructed his son Solomon to perform two murders, one of the victims being a person whose life David had solemnly sworn to protect (1 Kings 2:5–9). Reimarus, who considered David a tool of the priesthood, concluded: 'David carries out their intentions by the most criminal means: assembling a gang of villains, harassing his countrymen, highway robbery, murder, unjust wars, cruelties, ruses, hypocrisy, dissimulation, wickedness, oath-breaking, spiteful malice, and exterminating Saul's entire family.'[268]

All this uncivilized behaviour had to reflect badly on God, who

approved and often even commanded it. When the Israelites were approaching the Promised Land, the Lord expressly commanded them to exterminate all its current inhabitants (Deut. 7:2). Through the prophet Samuel, the Lord ordered the Israelites under Saul to exterminate the Amalekites (troublesome Bedouin tribes), and to 'slay both man and woman, infant and suckling, ox and sheep, camel and ass' (1 Sam. 15:3). When Saul failed in obedience by sparing Agag, the Amalekite king, and the better-quality cattle, the Lord regretted having made Saul king of Israel, and Samuel 'hewed Agag in pieces before the Lord' (1 Sam. 15:33).

Earlier, God had ordered Abraham to sacrifice his son Isaac, only to let him off at the last moment. This morally rebarbative command was famously discussed by Kierkegaard in *Frygt og bæven* (*Fear and Trembling*, 1843) as an example of the 'teleological suspension of the ethical', or how religious obedience trumps morality. Thinkers of the Enlightenment, however, could not accept such a severance not only of religion from morality, but of religion from natural human attachment. Christoph Martin Wieland, later famous as a sceptical ironist, passed in his youth through a 'seraphic' phase in which he wrote a pious mini-epic (1753) celebrating Abraham's devout obedience. Even here, however, Wieland allowed Abraham's servant Elieser a long speech expressing horror at this incomprehensible command.[269] In the revised version published many years later, Wieland made Elieser, instead of uttering a single long speech, argue persistently with his master, and also express the suspicion (absent from the Bible) that Abraham might have been deceived by an evil spirit.[270]

The story of Abraham was thus a test case for the debate on whether things are right and wrong because God makes them so (as Luther, for example, thought), or whether right and wrong exist independently of God's will (thereby limiting his omnipotence). Kant was in no doubt that since the essence of religion was morality, an order that seemed morally wrong could not come from God. If God really spoke to human beings, he argued, the mere human senses could never be enough to show that the voice was divine. But in some cases one could be certain that the voice was *not* divine: for example, if it issued a command that was contrary to morality. Such a command, however majestic it might appear, must be a delusion. This was the case with Abraham:

> As an example we may take the myth of the sacrifice that Abraham, at a divine command, intended to perform by slaughtering and burning his only son (the poor child even unwittingly carried the wood for this purpose). In reply to this supposedly divine voice, Abraham ought to have said: 'it is quite certain that I should not kill my good son; but I am not certain that

you who appear to me are God, and I cannot be certain of it, even if [your voice] rang down from the (visible) heavens.'²⁷¹

In Kant's view, the authenticity of a divine command could only be tested by its correspondence to 'the pure wellspring of the universal religion of reason that dwells in every ordinary person'.²⁷² To allow a supposedly divine voice or a divine book higher authority than one's own moral intuitions would be contrary to reason and to human dignity.

## THE NEW TESTAMENT

The New Testament could not long remain sacrosanct. Voltaire describes St Paul as an authoritarian figure who was probably not a Roman citizen at all, and derides his supposed vision on the road to Damascus, preferring to believe the Jewish tradition that Paul converted out of pique because Rabbi Gamaliel refused to let him marry his daughter.²⁷³ He condemns the alleged miracles of Jesus as impossible and also, in many cases, absurd (the transformation of water into wine, the punishment of the barren fig tree, the destruction of the Gadarene swine). Some doctrines had been clumsily smuggled into the Gospels, such as the attempt to prove Jesus' divinity by providing him with two incompatible genealogies. Others, such as that of the Trinity, were not present in the New Testament at all.

For a long time, however, an open critique could be undertaken only by a reckless or mentally unstable person, such as the eccentric Christian deist Thomas Woolston, who claimed to have visited heaven and discussed the meaning of Scripture with the prophet Elijah and the Church Fathers. Woolston was convinced that as 'the literal Story of many of *Jesus*'s Miracles, as they are recorded in the *Evangelists*, and commonly believed by Christians, does imply Improbabilities and Incredibilities, and the grossest Absurdities, very dishonourable to the Name of Christ', so these narratives must really be allegories, expressing the spiritual renewal brought by Christ.²⁷⁴ Writing in a colloquial, scurrilous style, Woolston had great fun with such strange incidents as that of the Gadarene swine. Why was the madman living in a cemetery? What was the point of sending the devils who possessed him into a herd of pigs? What were Jews doing with pigs, since it was forbidden to keep or eat them? And why didn't Jesus compensate the owners of the pigs for their loss? Or, in the birth narratives, why did the Three Wise Men bring gold, frankincense and myrrh to a new-born child? 'If with their *Gold*, which could be but little, they had brought their *Dozens* of Sugar, Soap, and Candles, which would have been of Use to

the Child and his poor Mother in the Straw, they had acted like wise as well as good Men.'[275]

In successive *Discourses* (1727–9), Woolston attacked the more important miracles with increasing acerbity. The raising of Lazarus, which occurs only in the last of the Gospels, was clearly invented: '*John*, when no body was alive to contradict and expostulate with him for it, trumps up a long Story of a thumping Miracle, in *Jesus*'s raising of *Lazarus*, who had been not only dead, but buried so long that he stank again.'[276] Finally, the resurrection of Jesus is explained by the disciples having stolen his body, and an imaginary rabbi, whom Woolston uses as interlocutor, is made to call Jesus 'so grand a *Deceiver*, *Impostor* and *Malefactor*, as no Punishment could be too great for him'.[277]

Woolston was excessively literal-minded in his approach to some Gospel stories. It would take more than a century for a more appropriate approach to the Gospels to be put forward in 1835–6 by David Strauss, who read them as myth.[278] But Woolston, even if by accident, does seem to have been right in thinking that the miracles recounted in the fourth Gospel, notably the changing of water into wine and the raising of Lazarus, were composed as edifying allegories.[279] At the very least he had put his finger on many real impossibilities in the Gospels. It is significant that his *Discourses* each sold some five thousand copies.[280] Besides the thrill of seeing the New Testament treated so disrespectfully, Woolston pointed out flaws that readers were already aware of but could not quite admit.

An attack on the resurrection of Jesus was fighting talk. The bishop of London, Thomas Sherlock, replied to Woolston by composing a fictitious conversation in which one speaker supports Woolston and another rejoins that someone like him, trained in law, 'which teaches us to consider the Nature of Evidence, and its proper Weight, can be of that Opinion; I am sure you wou'd be unwilling to determine a Property of Five Shillings upon such Evidence, as you now think material enough to overthrow the Miracles of Christ.'[281] A court is convened, with an advocate for and against Woolston, a judge and a jury. This implies that the arguments for the Resurrection, and for miracles in general, are sound enough to withstand secular reasoning such as that of a law court. But Sherlock allows himself some bad arguments. If one observes an event, such as a stone rolling uphill, supposed impossible, one will believe the testimony of one's own senses even if they contradict the course of nature; for the course of nature is only derived from experience. If a man tells me that he has died and been reborn, I can at least examine the evidence. People in hot countries might well disbelieve that water can freeze, because it is not part of their

experience. With such reasoning as this, the jury finds the apostles not guilty of giving false evidence concerning the Resurrection.

Sherlock's entertaining book satisfied readers for some fourteen years, till the deist Peter Annet demolished his arguments. If I see a stone rolling uphill, says Annet, I will first doubt my own eyesight. Far less will I accept such a claim on the evidence of others, as we are required to do in the case of the Resurrection. The evidence cannot now be examined; we have only a mass of testimonies, delivered moreover by interested parties, which contradict one another in every detail. Such evidence, retorts Annet to Sherlock, would *not* suffice to settle a property of five shillings, let alone a matter so momentous as the Resurrection.[282]

Sherlock's analogies are easily exposed as false. That water freezes can be shown by observation; dwellers in hot countries need only visit cold ones to see it happening. Besides, the 'course of nature' is far more than the experience of an individual; it is based on the collective experience of humanity over many centuries. That experience tells us firmly that a dead body cannot live again: 'To believe it possible, contradicts this Maxim, *That Nature is steady and uniform in her Operations*: For one Miracle or Action done contrary to her Laws, contradicts all her steady uniform Springs and Movements, and all that Mankind call Truth and Reason.'[283]

Annet's arguments are thus founded on Newtonian claims for the regularity of nature. But his relation to Sherlock is not quite antithetical. For Sherlock involuntarily testifies to the progress of secularization. By examining the evidence for the Resurrection, he presupposes that the evidence is adequate by secular standards, without any need for faith. But, as Annet remorselessly demonstrated, the evidence is far from adequate. And in arguing that one's understanding of the course of nature could be overturned by an unprecedented experience, such as the return of a human being from death, Sherlock unwittingly anticipated the scepticism with which David Hume, a few years later, would argue that our belief that the sun will rise tomorrow is based *only* on the knowledge that it has risen on all previous days.

Hume's notorious essay 'Of Miracles', written around 1737 under the influence of Bayle's scepticism, decisively undermined not just the likelihood of particular miracles, but the very possibility of miracles at all.[284] Hume had originally intended to include it in his *Treatise of Human Nature*, but refrained in order to avoid getting involved in unnecessary disputes.[285] The essay appeared ten years later in Hume's *Philosophical Essays* (1748, later retitled *An Enquiry concerning Human Understanding*). To his disappointment, Hume found that the furore over the

arguments against the miracles of the early Church, put forward by Con-
yers Middleton in 1749, caused his own essay to be ignored.[286] However,
Middleton's project is different: by an entertaining examination of the
miracles affirmed by the Church Fathers, he shows that they, 'in the judge-
ment of all the learned and candid Protestants, are manifestly fictitious,
and utterly incredible', devised, whether through ignorant credulity or
conscious deceit, to support the pagan-derived rituals of the Catholic
Church.[287] Hume, on the other hand, inquires into the philosophical
criteria for belief in miracles.

Hume defines a miracle as 'a violation of the laws of nature'.[288] The
course of nature is known from the repeated experience of innumerable
people. A miraculous event must rest on reliable testimony, which can
never be more than probable. If the alleged miracle took place a long time
ago, the chain of testimony, descending from the original eyewitnesses,
must be long, and therefore all the less reliable. If the miracle has a reli-
gious significance, then the enthusiasm of the devout, assisted by 'the
strong propensity of mankind to the extraordinary and marvellous', ren-
ders the testimony even more suspect.[289] Even miracles in recent times,
attested by many people, are not generally believed. Hume instances the
miraculous cures believed to have taken place recently in the cemetery of
Saint-Médard in Paris. Many witnesses of unimpeachable integrity con-
firmed these miracles, yet, Hume says, they are not widely accepted: 'what
have we to oppose to such a cloud of witnesses, but the absolute impos-
sibility or miraculous nature of the events which they relate? And this,
surely, in the eyes of all reasonable people, will alone be regarded as a
sufficient refutation.'[290] Hume is not asserting dogmatically that no mir-
acle can ever take place; he is saying that a departure from the laws of
nature is so improbable that no testimony can ever be strong enough to
establish its veracity.

A particularly searching and learned critique of the New Testament
was undertaken by Reimarus in the second part of his clandestine *Apol-
ogy*. In Reimarus' view, the authentic teaching of Jesus had been obscured
by clumsy fabrications introduced into the Gospels by the apostles and
later writers, who were intent on erecting a theological edifice alien to
Jesus' doctrines. Only the methods of criticism and exegesis could uncover
what Jesus actually taught. Living at a time when Judaism had lost its
moral substance and had declined into the mechanical observance of
external ceremonies, Jesus offered an admirable message of practical mor-
ality. He had no interest in theological arguments. False prophets could
be identified, not by their theoretical errors, but by their actual effects:
'Ye shall know them by their fruits' (Matt. 7:16).[291] Although much of

Jesus' teaching was valuable for all humanity, he intended to address the Jews rather than Samaritans or remoter nations. He told them that the Messianic kingdom or the kingdom of God was at hand, and that he himself was the Messiah. In pursuit of his political ambitions, he rode into Jerusalem and caused disruption by driving the money-changers out of the Temple. The priesthood therefore understandably, and in their own terms quite correctly, identified him as a dangerous trouble-maker and had him executed.

So Christianity, on Reimarus' showing, might have ended before it had begun, but the disciples had no wish to return to their previous obscurity, especially as they had been supported by donations from wealthy women. They removed Jesus' body from its tomb and presently gave out that he had risen from the dead. Reimarus subjects the Resurrection narratives to a severe examination, concluding, like Annet, that they would never stand up in a court of law. He imagines the disciples meeting in secret and concocting a story to the effect that Jesus had never intended to be a political Messiah but had died for a spiritual purpose, as a suffering Redeemer, and would eventually return from heaven in the clouds.[292] Gradually, a huge theological superstructure was erected on this fraudulent basis. The equal communities, with goods shared in common, formed by the early Christians gave way to hierarchical bodies ruled by bishops, to quarrels between groups who each denounced the other as heretics, and to the fateful alliance between the Church and that unscrupulous tyrant the Emperor Constantine.

Albert Schweitzer, in his classic survey of New Testament criticism, described Reimarus' work as 'perhaps the most splendid achievement in the whole course of the historical investigation of the life of Jesus'.[293] This tribute is the more impressive since Schweitzer knew only the fragments of the *Apology* published by Lessing; the entire work has been available only since 1972. Admittedly, Schweitzer rejected Reimarus' thesis about Jesus' political mission, and hijacked Reimarus as a witness to his own favoured theory, that the core message of the Gospels was eschatological, concerned with Jesus' future return. That aside, Reimarus' theory has obvious drawbacks. The formation of Christian theology and the composition of the Gospel narratives must have been a far more complex process than Reimarus allows. Moreover, one might well be reluctant to charge the disciples with base and self-seeking motives (though the Gospels often depict them as quarrelsome, envious and cowardly), or to accept that something so prodigious as the Christian religion could originate from a fraud. Even putting aside these scruples, Reimarus seems psychologically short-sighted in failing to recognize the emotional impact of

Jesus' death on his followers and the part played in Christian origins by collective hysteria such as the glossolalic outburst at Pentecost (Acts 2). Nevertheless, many people will find Reimarus' theory rather more plausible than the claim that Jesus really did rise from the dead.

Gradually, the new discipline of textual criticism had a decisive effect on the understanding of the New Testament. Knockabout polemics like Woolston's could make only a brief sensation. Reimarus' fragments could make a stronger impression on a very small public. But the slow, patient work of textual scholars chipped away at the authority of the New Testament and made it, like the Old Testament, into a book composed by human authors and transmitted by fallible scribes, which could be examined and studied like other books. They did not intend to undermine the Bible. When John Mill, principal of St Edmund Hall, Oxford, produced, just before his death in 1707, an edition of the Greek New Testament with 30,000 variant readings, his aim was to strengthen the text by eliminating errors. But the eye-catching figure of 30,000 suggested rather that the text of the Bible could not be finally determined.[294] Similarly, the Swabian Pietist Johann Albrecht Bengel invented the now-standard method of arranging manuscripts in a stemma or genealogical tree, showing how each manuscript is derived from an earlier one; but this indispensable scholarly tool highlighted the diversity of manuscripts and hence the absence of an authoritative text.[295]

The comparison of manuscripts revealed that several texts on which important doctrines rested had been interpolated. Luther, going behind Jerome's Latin version of the Scriptures to the more accurate texts prepared by Erasmus and others, found that the Greek word *metanoia*, meaning an inward experience of contrition, had been tendentiously mistranslated as *poenitentia* (active penance), which provided a spurious basis for the sacramental system of confession, penance and indulgences.[296] Isaac Newton compared every available printed and manuscript version of 1 John 5:7 – the only biblical testimony to the Trinity, on which Erasmus had already cast doubt – and concluded that Jerome, in composing the Vulgate, had deliberately corrupted the text by inserting the 'Johannine comma'.[297] He also pointed out that the supposed testimony to the Incarnation in 1 Timothy 3:16 – 'great is the mystery of godliness: God was manifest in the flesh' – was a false reading, unknown before the sixth century; earlier texts had not 'God' but 'which'.[298]

Many specific doctrines, especially those of the Catholic Church, proved on examination to be based on faulty translations or perverse readings. Francis de Neville, a Capuchin priest who converted to Protestantism and emigrated to England, pointed out that when Jesus said 'This

is my body' (Luke 22:19), he was speaking figuratively, just as when Joseph, interpreting a dream, said 'The three branches are three days', meaning that they stood for three days (Gen. 40:12).[299] The doctrine of the Virgin Birth resulted from the mistranslation of the Hebrew *almah*, young woman, as 'virgin' (Isa. 7:14).[300] The invocation of saints and the practice of auricular confession had no adequate Scriptural justification.[301] The notorious use of the 'thou art Peter' passage to prove that Jesus had instituted a Church with Peter as its first pope was easily shown to be a misreading, contradicted furthermore by the recorded practice of early Christians.[302]

The critical study of the Bible had another momentous consequence. If it was an assemblage of diverse texts, then not all its contents could be equally essential to salvation. The Neologian Johann Salomo Semler pointed out in the 1770s that the story of the woman taken in adultery (John 8) was missing in many ancient copies. But if the Bible lacked it, the Word of God would in no way be lacking.[303] Lessing similarly noted that the Bible contains many trivial matters that cannot be thought essential to religion: for example, Paul's request to Timothy to bring back the cloak he left at Troas (2 Tim. 4:13).[304] So the Bible and the Word of God were not the same thing. Only those passages that contained religious and moral truths could be considered divine. And who was to decide which these passages were? That, said Semler, was up to the judgement of individual readers:

> It must remain open to many people, then, who have begun to experience the salutary power of truth, to pass judgment in light of their own knowledge both on individual books and on certain parts of many books, with reference to their moral and generally beneficial value, just as it is open to other readers, in accordance with their real or assumed insight, unreservedly to represent and declare all books of the whole Old and New Testament, as they have been written or printed together, to be divine, without such a special distinction of content.[305]

Many Bible readers in eighteenth-century Germany were adherents of Pietism, a strand of Lutheranism that encouraged a personal devotion to God and an inward, emotional faith. For them, not only the Bible, but also its readers, were guided by inspiration. The Holy Spirit, or what Semler called 'the salutary power of truth', would help them to interpret Scripture.[306] That meant that the arbiter of divine truth was no longer the text of the Bible alone, but also the religious and moral sensibility of its readers. Hitherto, the Bible, as the Word of God, had been the prime source of theological knowledge. But now theological knowledge, based on moral

awareness, was needed to judge between varying texts and different pas-
sages of the Bible. So theological knowledge must come from somewhere
else: not, or not only, from the revelations made to Moses and through
Jesus, but from the religious and moral sense natural to humanity.

Not surprisingly, such arguments were fiercely attacked. Semler was
said to have undermined the very basis of faith.[307] Lessing got into trouble
when he defended, on similar grounds, the fragments from Reimarus'
*Apology* that he had published. In response to an attack by the chief pastor
of Hamburg, Johann Melchior Goeze, Lessing claimed that Reimarus'
criticisms of the Bible did not impugn religion because the Bible was not
identical with religion. 'The letter is not the spirit, and the Bible is not
religion.'[308] This controversy attracted such widespread notice that Less-
ing's employer, the duke of Brunswick, eventually ordered him to terminate
it. A still more radical conclusion was drawn by Eichhorn, the leader of
the Göttingen school of Bible scholarship, who asserted in his obituary
for Semler that the New Testament was only 'of local and temporal char-
acter, and neither for all times and peoples, nor an indispensable source
for Christianity'.[309]

The effect of all these controversies around the Bible was not to make
it obsolete, but to change its character by producing what Jonathan Shee-
han calls 'the Enlightenment Bible'. The Bible in its various versions
survives as a central object of culture. Though for some people it may still
be the infallible Word of God, for very many others it is a historical text
giving us access to the remote past, a source (if used selectively) of ethical
advice and wisdom, a collection of fascinating and sometimes profoundly
moving narratives, and an aesthetic object preserving the elegance of the
King James translators and the vernacular vigour of Martin Luther. Just
as the religious Enlightenment did not abolish religion, but transformed
it, so the Enlightenment moved the Bible out of the confines of religious
belief and made it widely accessible as a cultural object.

# 5

# Unbelief and Speculation

The religious Enlightenment transformed religion by reaching various compromises between traditional religious claims and those of reason. It moved the emphasis from supernatural belief to ethical teaching. The Bible ceased to be the inerrant Word of God and became a source of moral instruction and, eventually, a fascinating cultural object. But how stable were these compromises? In transforming religion, did the religious Enlightenment weaken it in a way that must ultimately prove fatal? Can religion really be reconciled with reason? 'As soon as a religion seeks help from philosophy,' wrote Heinrich Heine in 1834, 'its doom is inevitable. Trying to defend itself, it talks its way further and further into its perdition.'[1]

If Heine was right, then the rational religion of the Enlightenment may have represented only a lengthy pause in a long history of religious decline, a plateau in the slow descent from the heights of supernatural faith to the depths of secularism and unbelief. Phases in this controversial narrative have been labelled 'the disenchantment of the world' and 'secularization'. It might be argued that the mainstream Enlightenment, in preserving and transforming religion, merely gave new life to an illusion, and that the radical minority who opposed the claims of religion altogether were aiming to provide humanity with a happiness based on truth. The best-known version of this claim was put forward by Karl Marx in 1844:

> To abolish religion as the illusory happiness of the people is to demand their real happiness. The demand to give up illusions about the existing state of affairs is the demand to give up a state of affairs which needs illusions. The criticism of religion is therefore in embryo the criticism of the vale of tears, the halo of which is religion.[2]

Without prejudging the issue by blindly accepting these post-Enlightenment views, we now need to consider how far the Enlightenment, or important aspects of it, can be interpreted as part of a longer narrative of religious decline.

## THE DISENCHANTMENT OF THE WORLD

It is widely agreed that a great tectonic shift took place in European out-looks between 1500 and 1800. In 1917 the sociologist Max Weber labelled it 'the disenchantment of the world', or the elimination of magic from the operations of nature.[3] He thought that such disenchantment was primarily the work of the Protestant Reformation. However, Weber's phrase, though catchy, is now threadbare and misleading. While his historical thesis may be very broadly true, it is possible to suggest that pre-Reformation Europe was not quite so enchanted, and Europe after the Reformation consider-ably more enchanted, than Weber's slogan implies.[4]

Medieval people lived in the presence of the supernatural, inasmuch as the Church claimed to be able to dispense supernatural power. This was shown above all in the ceremony of the Mass. The priest took a piece of bread, and by saying *Hoc est corpus meum* ('This is my body', Christ's words in Matthew 26:26) was understood to transform it into Christ's flesh. He then held it up so that the laity could be convinced that the bread, though unchanged in appearance, was now Christ's own body. The same ceremony was then performed with wine, which became Christ's blood. The priest ate the bread and drank the wine; the laity were thought to gain blessings by gazing at them and were allowed only to eat the bread.[5] A priest normally took communion daily, a layperson only once a year. The consecrated bread, called the Host, was regarded as a magical object; occasionally communicants would carry it away in their mouths and use it as a charm to inspire love, put out fires, or to bring fertility to the fields.[6]

The Mass was only one of the seven sacraments that marked the crucial stages of a Christian's life, beginning with baptism and ending with extreme unction for the dying. Supernatural power was also mediated by the saints, who could be invoked in the hope of a miracle. The saints were individuals, imagined vividly, each with a legendary biography, a special function – for example as patron of a trade – and often with a local shrine; one could have a relationship with one's favourite saint, combining devo-tion with affection.[7] The Church could also bestow blessings on houses, ships, cattle, crops and the sick.

The Church's power extended even to the afterlife. In 1274 the Second Council of Lyons officially approved the doctrine of purgatory. Since few people were good enough to go straight to heaven, it made sense that the rest, provided they had not committed mortal sins, should spend a long period of purification before they were fit to enter heaven. Theologians began to calculate the length of a soul's term in purgatory, what proportion

it bore to sins committed on earth, and how a sentence could be shortened by prayers and special Masses, known as 'suffrages'.[8] The idea that one could affect the well-being of one's departed relatives strengthened the emotional bond between the living and the dead. But it also exposed the living to emotional blackmail, especially as, in the late Middle Ages, the torments of purgatory were thought to be just as dire as those of hell. In 1517 the Dominican monk Johann Tetzel, inviting people to pay to shorten their relatives' time in purgatory, adjured them:

> Do you not hear the voices of your dead parents and other people, screaming and saying: ' "Have pity on me, have pity on me . . . for the hand of God hath touched me" (Job 19.21)? We are suffering severe punishments and pain, from which you could rescue us with a few alms, if only you would.'[9]

How far did the laity believe all this, and how much did they understand about Christianity? In a way these are the wrong questions to ask. There is a strong argument that over most of the Christian centuries, and before, *religio* was not a set of propositional beliefs, but a way of life. Early Christianity 'disembedded' religion from the cultic settings in which it was practised and made it an inner disposition that could be maintained by anyone anywhere. For Augustine and Aquinas, *religio* meant such an inner piety. Certainly, the early Church formulated its doctrine in creeds such as the Nicene Creed, which is still recited in churches today; but such credal statements were intended as a means to help the faithful lead a godly life. 'Belief' did not yet mean the assertion that something existed: belief in God meant trust in God, whose existence was assumed. Only in the seventeenth century did 'believe in' acquire its present-day meaning: 'believe in the actual existence of some person or thing'.[10]

By contrast, medieval religion was – except for theologians – not intellectual:

> Medieval European religion was 'soteriological' in that it offered an understanding of, and a means toward, human salvation focused on the saving death and resurrection of Christ as revealed in the Bible, and, in particular, redemption from sin and its consequences for humans both individually and collectively. It was 'functional' in that it gave meaning to daily life by marking out religiously the key stages in the human life cycle and in the cyclical rhythms of the seasons, thus providing a form of cosmic order for human existence. Its 'pastoral' role was to offer consolation amid the anxieties of daily life and to provide a means of reconciliation for human frailty.[11]

Evidence of religious knowledge can be found in surviving commonplace books by literate laymen of the middling sort: they show 'a sober and

conformist morality', valuing the sacraments, fearing purgatory and tak-
ing little interest in theological niceties.[12] The Church did try to instruct
the laity in the basics of Christianity by means of catechizing. The twelve
articles of the Apostles' Creed, the Seven Deadly Sins and the Seven Sacra-
ments were represented on painted windows, rood screens and carved
fonts.[13] In some places, laymen staged plays on religious subjects, such as
the Corpus Christi cycle of miracle plays performed at York, Chester,
Wakefield and Coventry. These depictions were not intended as a visual
counterpart to reading the Bible, for, as Émile Mâle notes, it was customary
to represent only a small number of Gospel scenes – those commemorated
in the Church's festivals – while episodes from the apocryphal Gospels
were extremely popular.[14]

As laypeople came to think more about their religion, they inevitably
came to question it. The passive role assigned to the laity in the Mass was
frustrating for those who would have liked active participation. The
emphasis on the sanctity of the priestly office did not match the ignorance
and debauchery of many individual priests, and what the historian Johan
Huizinga calls the 'avowed contempt of the clergy' pervades all of medi-
eval culture 'as an undercurrent alongside reverence for the priestly
office'.[15] The supposed miracle of transubstantiation was an assault on
common sense and was rejected by such groups as the Waldensians and
the Lollards, who were duly persecuted as heretics. During the Reform-
ation, sceptics objected that Christ's body could not be in so many places
at one time, and 'the bones would crush in his teeth'.[16] The doctrine of
purgatory could not be found in Scripture, though Thomas More and
others struggled to do so.[17] Its function as a source of Church income was
noted even before Luther's denunciation of 'indulgences' (remissions from
time in purgatory). The unabashed sale of indulgences by Tetzel prompted
Luther's epoch-making outburst. Tetzel's sales campaign was intended to
fund a 'very sweet deal', as Carlos Eire calls it, in which half the proceeds
would go to the building of St Peter's in Rome, and half to helping Arch-
bishop Albrecht of Mainz out of his complicated financial difficulties.[18] It
is striking how rapidly sixteenth-century Protestants discarded the belief
in purgatory, evidently relieved to be free from it.

Alongside growing scepticism, we must assume considerable ignorance,
especially among the country dwellers who formed the bulk of Europe's
population. Many historians of religion no longer regard the Middle Ages
as an 'age of faith'.[19] While an informed and active Christianity existed in
the towns, the country dwellers adhered to pagan practices which had been
superficially Christianized, and which survived down to the nineteenth
century. Thus, a pre-Christian holy well in Wales was renamed St

Winifred's Well and became a licensed place of devotion.[20] Popular religion was practical and materialistic. People prayed not for spiritual blessings, but for a good harvest, a happy marriage, or recovery from sickness. Saints were imagined as people who had to be conciliated but might also be punished: even from nineteenth-century France we hear of villagers whipping the images of saints who had not granted their requests.[21] God and Christ were often imagined in familiar terms. Many folk-tales, such as those collected by Franz Xaver von Schönwerth in a remote corner of nineteenth-century Bavaria, are humorous anecdotes in which either God or Christ jests with St Peter.[22] A seventeenth-century cleric recounted, as a dreadful warning, how a woman heard thunder and said to her neighbour: 'Our Lord's been eating butter-milk, and it's rumbling in his belly', whereupon lightning struck her dead.[23] The Devil too could be imagined as approachable. From eighteenth-century Sweden there are twenty-nine recorded cases of pacts with the Devil, undertaken usually in the hope of money – either a lump sum or, occasionally, a regular income.[24] Death was often imagined in materialist terms as a transition to another place; food and possessions were sometimes left in graves so that the dead could enjoy them in the next world.[25] The materialist cosmogony revealed in sixteenth-century Italy by the (literate) miller Domenico Scandella, known as Menocchio, who told his inquisitors that living beings had been generated from the world like worms from cheese, may have differed from common beliefs only in its ingenious elaboration.[26] Ordinary people, like Menocchio, could think for themselves, and many instances of scepticism, even outright atheism, survive in the records of Church courts.[27]

After the Reformation, both Protestants and Catholics made a concerted attempt to educate their adherents in the principles of their faith. The literate were expected, at least in Protestant countries, to know the Bible thoroughly, and were likely also to read theological treatises and sermons for their edification. It was not only the Reformers who set great store by educating the laity: similar efforts were undertaken by Catholic clergy in the Counter-Reformation. Bishops conducting inquiries in seventeenth-century rural France found much of the population astonishingly ignorant of the basics of Christianity. Missionary efforts were made to educate country people by teaching them the catechism, requiring them to make a general confession of their sins, and making it compulsory to attend Mass every Sunday. Meanwhile, the standard of education and conduct among the clergy was raised, concubinage and drunkenness were punished and, by the early eighteenth century, it was standard for French clergy to be marked out – and hence further restrained from misbehaviour – by wearing the cassock.[28]

While catechizing, over the long run, no doubt raised the standard of religious knowledge among both Protestant and Catholic laypeople, it was an uphill struggle. Repeated admonitions by bishops to clergy suggest that the duty of catechizing was often neglected. The rote-learning of standard answers to standard questions was, in any case, hardly the way to develop an inward understanding of one's professed faith. Even after decades of catechizing, church visitations in sixteenth-century Germany found that the rural population, and even many of their pastors, lacked basic religious knowledge. Many people knew none of the Ten Commandments; one pastor could not distinguish the three persons of the Trinity; another had read the Book of Genesis but could remember nothing about it; others could not name any books of the Old Testament or the parts of the New Testament.[29]

The Reformation did away with the magic of the Mass, though the Eucharist remained a deeply sacred occasion. It abolished purgatory, thereby not only making the dead inaccessible but providing the living with a stark alternative of everlasting bliss or everlasting torment. The physical environment of Christian worship was drastically changed. Churches were emptied of images and other sacred objects. Some church furnishings were vandalized, but many others were sold for cash, and many items, such as chalices, crosses, monstrances, surplices and altar cloths, were stolen.[30] Formerly sacred objects were put to profane uses: altar stones were turned into paving stones or fireplaces, holy-water stoups were used for salting beef and fish.[31] Iconoclastic riots took place in several cities, beginning in 1523 in Zurich, where the Reformer Huldrych Zwingli encouraged his followers to destroy all 'graven images' because their use was forbidden by the Second Commandment (Exod. 20:4). Iconoclasm was at its most severe in the Netherlands, where much of the population was so estranged from the Church and so well indoctrinated by crypto-Protestants that in the summer of 1566, after an outbreak of mass hedge-preaching in the open air by Calvinists, the *beeldenstorm* or 'iconoclastic fury' took place. At Antwerp, 'all forty-two churches in the city were ransacked, the images, paintings, and other objects hauled out into the streets, smashed, and the plate pilfered'; at Utrecht, 'great heaps of art treasures and vestments, including the entire library of the Friars Minor, were put to the torch'.[32] In Scotland, cathedrals were either converted into parish churches, or abandoned, stripped of their lead, and used as quarries.

These changes, however traumatic they must have been to live through, did not bring about a disenchanted world. They did not destroy the sacred; they changed its character. Unable to appeal to saints, and with the clergy

no longer seen as administrators of supernatural power but rather as teachers, Protestants found themselves directly dependent on God and responsible to him. God spoke to his worshippers in two ways: through the Bible, whose authority erased that of tradition, and through the natural world, which was full of signs from which they could deduce their chances of salvation or damnation. They now inhabited a 'moralized universe', where the slightest detail might have an everlasting significance.[33] The Protestant emphasis on individual piety encouraged a profound sense of unworthiness. The result was extreme anxiety, shown in the scrupulous and self-tormenting examinations of conscience that are characteristic of Protestant life-writing.

So the Protestant Reformation did not banish the supernatural. Some historians would go further and suggest that even in more recent centuries the 'disenchantment of the world' has never quite happened. The idea that monarchs were channels of supernatural power, and could cure illnesses such as scrofula by the 'royal touch', lingered until the eighteenth century. In Britain, it was abandoned only by the Hanoverian dynasty, who came to the throne in 1714; a very few years before, the infant Samuel Johnson had been touched by Queen Anne. In France, Louis XVI, on his accession in 1774, touched 2,400 sufferers from scrofula, though whether he continued the ceremony in later years is not recorded.[34] Belief in the supernatural is at the centre of charismatic religions from Wesleyan Methodism onwards. It found a different expression in the late-Victorian fashion for spiritualism, which gained a new impetus during and after the First World War when charlatans exploited the desire of grieving parents for further contact with their fallen sons. And the Catholic Church has examined and authenticated the visions of the Virgin Mary reported from Lourdes in 1858, from Knock in 1879, and from Fatima in 1917.

On the other hand, much of this evidence suggests that the sacred appears in an increasingly diluted form and under increasing pressure from scepticism. When a vision of the Virgin was reported from Marpingen in Saarland in 1876 – not coincidentally, at the height of Bismarck's campaign against the Church's influence in Germany – an investigation did not pronounce it authentic, much to the disappointment of locals hoping for an expansion of their tourist trade.[35] The visions reported since 1981 from Medjugorje in Bosnia have not yet been authenticated and seem unlikely to be. Standards of evidence have grown stricter. Of course, belief in the supernatural has not vanished – who would expect it to? – but it has ceased to be dominant.

It has been argued too that some modern revolutionary regimes have instituted 'political religions', in which the year is structured by communal

festivals, anniversaries and commemorations of martyrs.[36] The prototype of such 'political religions' is the French Revolution, in which Catholic worship was replaced by the Festival of the Supreme Being and many proposals were put forward for erecting an 'altar of the fatherland', giving the Declaration of the Rights of Man and the Citizen the status of a sacred book, instituting 'constitutional prayers', a civic baptism, and even 'a civic Lent, during which people would fast for the sake of liberty'.[37] Few of these proposals were realized, and few people accepted them as 'a transfer of sacrality' from the Catholic Church to its revolutionary successor.[38] Above all, they did not invoke any supernatural power, so that the term 'political religion' is a somewhat lame metaphor.

In modern life, the supernatural may have moved to the margins, but it has also migrated to another domain – that of art. The Romantics, reacting against their understanding of the Enlightenment, longed for a re-enchantment of the world. But such re-enchantment was not a practical programme: it could only be 'the wistful recreation of magical and supernatural worlds' in art and literature.[39] The supernatural, dwindling in the world of daily experience, led a shadowy afterlife in the aesthetic realm. Similarly, ghost stories continued to be told in the eighteenth century, but moved away 'from awe and edification to curiosity and entertainment'.[40] The Devil and his atmosphere of evil survive in Gothic fiction and horror films. Literature can even give rise to supernatural claims. After the British retreat from Mons in August 1914 it was claimed that angels had appeared in the sky to watch over the withdrawal. But this was elaborated from a story by Arthur Machen, published in September 1914, about the ghosts of English bowmen from Agincourt appearing at Mons to protect their fellow-countrymen.[41] For very many people, the supernatural is now literature: that is, the excitement or awe associated with supernatural phenomena is nowadays generated not by supposedly religious experiences, but by the reading of imaginatively compelling fiction, or by the evocation of the uncanny and the supernatural in the cinema. And much of the labour formerly devoted to the exegesis of sacred texts has now been transferred to the interpretation of the secular literary canon.

## MEDICALIZATION

In the early modern period, it became increasingly common to explain away apparent witchcraft, and other supernatural phenomena, on medical grounds. The Dutch physician Johann Weyer, in *De praestigiis daemonum*

*et incantationibus ac veneficiis (On the Illusions of Demons and on Spells and Poisons*, 1563), argued in great detail that witches were weak-minded, melancholic and deluded. Weyer's book, as Lecky notes, was hardly 'audacious', since, believing fully in the supernatural, he ascribed witches' delusions to the work of demons.[42] He was nevertheless a ground-breaker as the first of numerous physicians who offered natural explanations for apparently supernatural experiences.[43]

Such experiences included demonic possession. This was increasingly attributed to the power of the imagination, with strong suggestions of repressed eroticism. In 1704 Pierre Bayle ascribed immense power to the imagination of nuns confined in their convents, who blamed Satan for their evil thoughts and, when such thoughts became irresistibly powerful, claimed that Satan was taking control of their bodies. To show the sexual component in possession, he instances the mystic St Angela of Foligno. By her own account, the devils who entered her body inflamed her with intolerable sexual desire: 'They excited in her body such a flame of impurity that she could not quell its force except by material fire, a remedy forbidden by her confessor.'[44] Saints' lives were now re-read as pathological cases. In his fictionalized account of his novitiate in a Bavarian monastery, Johann Pezzl ridicules the saints' feats of asceticism. He tells how St Francis rolled in the snow to mortify his body; how St Passidea of Siena knelt on thorns, thistles, red-hot nails, or a large grater when she prayed, and had herself hung upside-down in a chimney, like a ham being smoked; and how St Macarius lay buried in earth up to his throat for three years, eating nothing but the grass that was within reach. The narrator concludes: 'Am I wrong, dear brother, in maintaining that the actions formerly praised as deeds of spiritual heroism, as superhuman virtues worthy of heaven, would now get one put in a madhouse?'[45]

The scandalous and much-discussed case of Marie-Catherine Cadière, in Toulon around 1730, illustrates the spread of scepticism. Her possession was at first thought to be divine, not demonic: by clairvoyance, levitation and displaying stigmata, she acquired the reputation of a saint. But when her brother tried to exorcize her, she fell into convulsions and uttered blasphemies. She blamed her possession on Father Girard, her confessor, who was charged with abusing her sexually. When the case was brought before the *parlement* of Aix, half the judges voted for Girard's execution, but the other half thought that Cadière had faked her symptoms. By the president's casting vote, both were acquitted.[46] We can now see faking as an over-simple rationalization for the phenomena variously called 'possession' or 'hysteria'. Partly at least, such displays are 'theatrical productions' that enable people to express their frustrated desires and rebellious urges

while disclaiming responsibility for such feelings, and allow them to become the centre of attention in settings where their position is normally marginal.[47]

Mystical experience, especially when mystics claimed to have seen visions, was similarly ascribed to disordered imaginations. Meric Casaubon, discussing in 1655 the life of Sister Catherine of Jesus, observes that she had visions of hell when in a cave where St Denys was supposed to have hidden, and adds: 'let the Reader judge, whether that holy Cave alone, with the opinion they had of it, was not enough to put any melancholick maid, devoutly given, into an ecstasie'.[48] The mystical contemplation called Quietism, associated especially with Madame Guyon and declared heretical by the Catholic Church, came in for particular ridicule.[49] In the *Lettres persanes* (*Persian Letters*, 1721) by Charles-Louis de Secondat, baron de Montesquieu, a librarian explains mysticism to his Muslim visitor Rica:

> 'Piety, sir,' he said, 'in those of an emotional disposition, heats the blood. The blood gives off a vapour which rises to the brain, heating it also, and so causing ecstasies and trances. This condition is devoutness in delirium; it often develops, or rather degenerates, into quietism – as you know, a quietist is a man of unsound mind, no less, a pious libertine.'[50]

Gibbon comments sceptically on the visions induced by monks of Mount Athos who contemplated an inner and supposedly divine light: 'This light, the production of a distempered fancy, the creature of an empty stomach and an empty brain, was adored by the Quietists as the pure and perfect essence of God himself.'[51]

Many extraordinary phenomena, previously taken as signs of sanctity, were reclassified as 'superstition', 'enthusiasm', or '*Schwärmerei*'.[52] These labels were applied not only by religious sceptics but also by enlightened clerics who felt that such behaviour had no place in religion.[53] 'Superstition' was the broadest term, defined as 'a religious cult, false, misdirected, full of idle terrors, contrary to reason and to the sound ideas that one ought to have of the supreme being'.[54] 'Enthusiasm' may be, as Ronald Knox argued in a classic study, a recurrent phenomenon in religious history. From their own point of view, 'enthusiasts' (who would not describe themselves by this word) are people who believe they are in direct contact with the divine, without the mediation of sacraments or priests; who demand saintly conduct from themselves and others; who are so full of devout emotion that they despise reason; and who would like to live in a theocracy as the closest earthly approximation to the kingdom of God.[55] To outside observers, their behaviour may appear intolerant, sanctimonious and eccentric, being often accompanied by ecstasy, glossolalia, and defiance of laws and

conventions – as when George Fox, the founder of Quakerism, walked barefoot through Lichfield crying 'Woe to the bloody city.'[56]

British writers traumatized by the memory of the seventeenth-century Civil War put some of the blame on the radical religious sects on the fringe of the Parliamentary side. Their claims to divine inspiration were dismissed as 'enthusiasm' and hence delusion. David Hume adopted medical language in his account of the early Quakers: 'The violent enthusiasm of this sect, like all high passions, being too strong for the weak nerves to sustain, threw the preachers into convulsions, and shakings, and distortions in their limbs; and they thence received the appellation of *quakers*.'[57] Locke warned against 'enthusiasm, which though founded neither on reason nor divine revelation, but rising from the conceits of a warmed or over-weening brain, works yet, where it once gets footing, more powerfully on the persuasions and actions of men, than either of these two, or both together.'[58]

Worse still, 'enthusiasm' would not stay safely in the past. It re-emerged among the extreme Huguenots known as Camisards ('smock-wearers') who, from 1702 to 1704, fought back against persecution by the French government from their hide-outs in the mountainous Cévennes region. They were animated by preachers who foamed at the mouth and fell down speechless with swollen throat and stomach before delivering their discourses to an excited crowd. Some survivors went to England, where they prophesied and promised to perform miracles; but the predicted destruction of London, and the resurrection of various people from the dead, never happened, and few people took the French Prophets seriously. At Manchester, however, they converted the Quaker Ann Lee, who afterwards emigrated to America and founded the Shaker sect (which in 2017 still had one remaining member).[59] Shaftesbury attributed their enthusiasm to 'melancholy' and 'vapours', spread by infectious panic and what would later be called collective hysteria. The best way to treat enthusiasts, he argued, was not persecution, which would only encourage them, but ridicule, and he was pleased that their strange gestures were being parodied in a puppet-show at London's Bartholomew Fair.[60]

A yet stranger case of 'enthusiasm' was that of the Paris convulsionaries. The tomb of a famous Jansenist, François de Pâris, in the cemetery of Saint-Médard on the outskirts of Paris, became the site of miraculous cures. Presently both the sick and the healthy assembled there to take part in convulsive dancing, leaping and hopping, while groaning, shrieking and barking like dogs. They had themselves beaten, poked with swords that never pierced the skin, and even crucified.[61] Parisians flocked to see them. The diarist Barbier notes with surprise that even respectable people

('des personnes comme il faut') joined in, such as the Marquis de Legale, a deaf mute, who fell into fits.[62] Even after the cemetery was closed in 1732 the convulsionaries, as they became known, continued this behaviour in private houses.

Like the Camisards, the convulsionaries were responding to persecution, inasmuch as the severe theology of Jansenism had been condemned by the papal bull *Unigenitus* in 1713, a condemnation renewed in 1730. Their behaviour might be explained as acting out the martyrdom of Jansenism in the inarticulate language of the body.[63] Contemporaries, not yet used to symbolic psychodrama, resorted to perhaps over-simple medical explanations. Voltaire attributed to them a kind of gangrene of the brain, caused by fanaticism.[64] A doctor, Philippe Hecquet, argued that their exhibitions were 'the result of a mental derangement of a sexual origin'.[65] Shaftesbury is in no doubt about the sexual element in enthusiasm: 'The pretended floods of grace, poured into the bosoms of the quietists, pietists and those who favour the ecstatic way of devotion, raise such transports as by their own proselytes are confessed to have something strangely agreeable and in common with what ordinary lovers are used to feel.'[66]

## SECULARIZATION?

It may be argued that the anti-religious Enlightenment deserves more attention than the religious Enlightenment, because it pointed more clearly towards the future. On this argument, the history of Europe since the Middle Ages has been a history of progressive secularization. The intellectual and spiritual unity of medieval Europe was fatally fractured by the Reformation; the authority of the Churches was further undermined by the Scientific Revolution of the seventeenth century; and under the influence of the Enlightenment, people came to see the world as it was, without the veils cast over it by religion, and to disbelieve in miracles, magic and, eventually, in God.[67] Such a view was influentially put forward in the nineteenth century by Lecky, who assigned two main causes:

> One of these is the increasing sense of law, produced by physical sciences, which predisposes men more and more to attribute all the phenomena that meet them in actual life or in history to normal rather than to abnormal agencies; the other is the diminution of the influence of theology, partly from causes that lie within itself, and partly from the great increase of other subjects, which inclines men to judge all matters by a secular rather than by a theological standard.[68]

In France, a similar but even greater influence was exerted by the sociologist Auguste Comte, who argued that there were three intellectual epochs, the theological, the metaphysical, and the positive or scientific, and that the modern world was now in the third age, for which Comte offered a Religion of Humanity.

While Lecky ascribed these changes to the spread of scientific and logical thinking, many sociologists, following Max Weber, would see secularization more as part of the social changes labelled modernization.[69] Modern society is based on science and technology, which seek to solve problems by rational means – that is, those shown by experience as most likely to bring about the desired end. It is based on the individual rather than the collective: the state is a loose association of citizens, not a body of believers. Religion survives, but as a matter for the individual, who chooses whether or not to belong to a Church or faith group. The clergy no longer have authority over all aspects of life, but are a specialized group of professionals, analogous to doctors and lawyers. Public policy is dictated by pragmatic and economic criteria. In the Middle Ages, European nations went to war in the Crusades for primarily religious reasons, but what Lecky calls 'the secularization of politics' means that no European state would now do so (which is not to deny the presence of religious among other motives, for example, when Orthodox Serbs fought Catholic Croats and Bosnian Muslims in the Yugoslav civil war).

However, the secularization of public discourse does not mean that religion is vanishing, or is likely ever to vanish, from people's lives. Religion is not only belief; it is also, perhaps more importantly, a matter of practice.[70] It means participating in regular ritual and ceremonial activities that connect one to a larger religious community and which give symbolic recognition to such crucial life events as marriage, childbirth and death. Religion also implies 'the sense of belonging to a culture and having a history; the sense of the ineffable in the world; the sense that there is value in something beyond the satisfaction of one's desires of the present moment'.[71] The idea that religion is simply a set of false propositions ignores its strength as an emotional resource. One can be sceptical about the history recorded in the Bible, reject it altogether as a source of scientific knowledge, assent to the Creed only in the vaguest way, and still find satisfaction and meaning in the performance of Christian ritual. The liturgy is a drama in which emotions are generated, channelled and contained. Christian practice also provides for many people a basis for associational life and charitable work. Religion can provide a sense of security even in disasters. Belief in God is often a matter less of cognition than of trust. Hence such a practice as petitionary prayer, though logically

absurd – is one asking God to change his mind, or to admit that he was wrong? – can still make emotional sense.

Trouble starts when believers try to make their intimations of immortality into the basis of an intellectual system and claim that they correspond to divine revelations given at certain points in history. Such claims are open to challenges on the grounds that they are philosophically incoherent and cannot be supported by historical evidence. Religious practitioners can afford to ignore such challenges, which miss the point of their practical faith. Hence, as Tim Crane points out, the strident arguments for atheism put forward in recent decades by the 'New Atheists' have no impact on people who try to lead a religious life, for a religious life is quite different from an intellectual system.[72] In identifying religion with theological assertions, the New Atheists are demolishing a straw man.

Within the secularization hypothesis, some distinctions can be drawn. Visiting the United States in the 1830s, Alexis de Tocqueville noted that the expectations of Enlightenment philosophers concerning the disappearance of religion had there been frustrated:

> there is no country in the whole world in which the Christian religion retains a greater influence over the souls of men than in America; and there can be no greater proof of its utility, and of its conformity to human nature, than that its influence is most powerfully felt over the most enlightened and free nation of the earth.[73]

All religious denominations – even Catholicism, to Tocqueville's surprise – were compatible with republican democracy. In the absence of a state Church, religion inculcated respect for law and morality in a general sense, and thus stabilized society. This suggests the conclusion that the secularization of public discourse does not imply the secularization of private experience. Thus it is possible for the United States still to be both a modern and a highly religious society.[74] It is also the starting-point from which, in recent decades, varieties of evangelical Protestantism have spread through Latin America and further, to Nigeria, South Korea and post-Soviet Russia, providing centres of spiritual life and communal solidarity in troubled times.[75] It is not religion that has declined, but belief in supernatural intervention.

Reactions to two earthquakes provide a revealing comparison. Respected preachers explained the Lisbon earthquake of 1755 – along with two minor earthquakes that occurred in London in spring 1750 – as God's judgement on humanity's sinfulness.[76] John Wesley thought God had singled out the Portuguese to punish them for their greed in

conquering overseas territories.[77] In 2004 the Boxing Day tsunami, triggered by the Sumatra-Andaman earthquake, killed at least 180,000 people and injured 125,000, but only a handful of spokesmen from various religions attributed it to divine wrath, and even they could not agree what God was angry about.[78] Such reactions now seem not only mistaken but trivial and insulting to the victims. Or again: it is notorious that some 40 per cent of people in the United States reject the theory of evolution and believe that God created the world, perhaps within the last ten thousand years; but creationist beliefs are not part of a general rejection of science. Creationists still consider medical insurance a good investment and call in IT technicians rather than resorting to prayer when their computers break down. The rejection of science is usually confined to those aspects, like the theory of evolution, that have no bearing on people's day-to-day lives. In practical terms, science – and to that extent, the Enlightenment – has won the day.

It may be that the conflict between 'faith and fact' is ultimately vacuous. Religion as practice does not depend on factual claims about cosmology or history, and need not make them.[79] However, since the time of Paul, the first Christian theologian, it has been felt that religion needs theology to preserve and interpret its insights. Hence religion as an intellectual system was first constructed by the Churches, not by their opponents. Although theology has such a long history, only a minority of Christians have been theologians; the great majority of Christian believers throughout the Middle Ages concentrated on practice rather than belief. Peter Harrison argues that it was above all the Protestant Reformers who sought to consolidate their faith by formulating it in a set of propositions, and by instructing the laity in their religion by the questions and answers set out in the catechism.[80] For Locke, early in the Enlightenment, faith is an intellectual matter: 'the assent to any proposition' that derives ultimately from divine revelation.[81] This redefinition of religion meant that religious and scientific statements were of the same kind, both founded on proof and evidence. Innumerable attempts were made to 'prove' the truth of Christianity. But they were ultimately futile. Lessing noted that all such efforts were 'completely contrary to the spirit of Xtianity ... whose truth is to be sensed rather than recognized, felt rather than grasped intellectually'.[82]

However, Enlightenment thinkers who challenged religious belief were not tilting at windmills. For when intellectual and historical claims about religion were made by powerful institutions that could, in the last resort, compel assent by means of physical force – as was still true in the eighteenth century – then resistance to their claims was regarded by Enlighteners as

an intellectual and moral duty. Apart from the radical fringe, Enlighteners did not campaign against religion as such, but against religious beliefs that rested not on reason and evidence, but on oppressive authority.

It remains of course very difficult to say what religious beliefs anyone actually held in his or her daily life, as distinct from the positions they upheld in the artificial exercise of arguing about religion. Shaftesbury observes: 'There are few who think always consistently or according to one certain hypothesis on any subject so abstruse as the cause of all things and the economy or government of the universe.'[83] Many people must have been as uncertain or confused as Diderot's friend Didier-François de Mon-tamy, steward to the duke of Orleans, of whom Diderot says in a letter to Sophie Volland:

> He is as well informed as any man I know and as sensible and prudent in his actions . . . he goes to mass without placing much faith in it, but laughs up his sleeve at the jokes that are made against it, hopes for the resurrection of the dead, without having any very clear ideas about the nature of the soul, and in general is a bundle of contradictory ideas which make his conversation very entertaining.[84]

Even in the eighteenth century, however, the bulk of Europe's population lived in the countryside, and most of them were illiterate. Did changing attitudes to belief reach such people, or were they a concern solely of the literate and intellectual elite? Many famous Enlighteners, especially in the moderate mainstream, thought that ordinary people had little potential for casting off 'superstition' and acquiring enlightenment. 'Do we not know that in every land the vulgar are stupid, superstitious, senseless?' wrote Voltaire.[85] It was above all the enlightened clergy who tried to correct the beliefs and behaviour of their uneducated parishioners. In German-speaking countries especially they had the support of the civil authorities who wished to preserve public order and hence to discourage, or at least inhibit, popular festivals and pilgrimages, which could easily become riotous. These measures were part of a division that had long been developing between the culture of the elite and the culture of the people. If, around 1500, 'popular culture was everyone's culture: a second culture for the educated, and the only culture for everyone else', by the late eighteenth century popular culture, including popular religion, was widely despised as childish, superstitious and primitive.[86] With the Romantic generation, however, the religion of the people would be rediscovered and praised as authentic, age-old, rooted in the soil, and blessedly free from the shallow intellectualism of the educated middle classes.

## THE FEAR OF HELL

If any feature of pre-Enlightenment Christianity was particularly objection-able, it was the constant effort made by preachers and pastors to terrify their flocks into obedience by warning them about the Devil and hell.[87] The world was portrayed as an arena in which God and the Devil constantly contended for the individual's soul. Luther himself was convinced that the Devil was incessantly active.[88] In theory, the Devil was supposed to be sub-ject to God and to act only by his permission. This was itself problematic: did God employ the Devil, as the modern state employs special forces, to do the inadmissible dirty work? In practice the Devil's powers were imag-ined as so great that he might appear to be an equal contender, and the universe, as has often been remarked, seemed to stage a Manichaean strug-gle between equal and opposite forces of good and evil.[89] The Devil had a vivid visual presence, with horns, tail, wings and saucer eyes. Far less was said about the presence of angels. Evil powers were everywhere; good power was accessible through prayer, but frighteningly remote.

Early modern religious teaching was full of terror. Preachers felt that to make any impression on their congregations, they had to evoke in lurid language the punishments God had in store for sinners. Conversion was not expected to be a happy experience: a preachers' handbook published in 1712 says 'Conversion begins with fear.'[90] They could and did appeal to Hebrews 10:31: 'It is a fearful thing to fall into the hands of the living God.' Even if they privately doubted whether a good God would really inflict eternal agonies on the wicked, theologians agreed that people must be told that he would, or else they would plunge into lives of unrestrained crime.[91]

The terrors of the Last Judgement, and the worldwide and cosmic catastrophes that would precede it, with the moon turning to blood, were a popular subject for preachers in the early modern period.[92] God's justice was retributive and was often described as vengeance. François Hébert, curé of Versailles, warned that Jesus would appear as 'a severe, inflexible, pitiless judge'.[93] The preacher Réguis said God would laugh at sinners, on the authority of Scripture: 'He that sitteth in the heavens shall laugh: the Lord shall have them in derision' (Ps. 2:4).[94]

It was generally assumed that only a few would be saved, as the con-ception of the 'elect' implies, and as the Gospels repeatedly state.[95] Some preachers could not help looking at their flocks and estimating how many would be saved: perhaps only ten out of a village with a population of one hundred.[96] The English Nonconformist Lewis du Moulin, in the title of a

book published in 1680, warned that *'not One in a Hundred Thousand (nay probably not One in a Million) from Adam down to our Times shall be saved'.*[97] In his famous sermon 'On the Small Number of the Elect' (1699), Jean-Baptiste Massillon told his hearers that only a tiny number would be saved, a 'little flock' (Luke 12:32), the 'few' who would find a narrow road leading to life (Matt. 7:14). After all, only Noah and his family had survived the Flood; only Lot and his daughters had been saved out of the entire city of Sodom. To attain salvation one had to repent of one's sins; even one's pleasures should be sorrowful, and one should regard oneself as a criminal unworthy of life; one should hold oneself aloof, as the earliest Christians had done, from the allurements of the world, and not imagine oneself an exception to the rule that most would be damned.[98] Voltaire testifies to the effect of Massillon's eloquence: when the preacher invited his hearers to imagine that the last hour had come, and only ten of them would be saved, almost everyone rose, 'shocked out of their senses', and gave a 'murmur of acclamation and surprise'.[99]

Once in hell, most people would suffer unimaginably agonizing torments for ever. Preachers terrified their hearers with sadistic fantasies modelled on the cruel legal punishments that were customary in early modern Europe.[100] Many children suffered nightmares; some adults were driven into madness or suicide.[101] The eternity of divine punishment was defended on the grounds that, since God is infinite, an offence against him is infinite and demands infinite punishment.[102] But how, it was occasionally asked, can God be offended? For offence implies injury, and if God can be injured, he must be less than perfect. Moreover, God's alleged justice is in practice unjust, for all sins, swearing as much as murder, incur equally prolonged torment.[103] When combined with predestination, eternal punishment made God appear both cruel and deceitful, for he pretended to offer salvation to people whom he had already decided to exclude from it.[104] Attempts were made to save God's reputation by saying that his standard of goodness was not ours, but then God's superiority is reduced to his superior power, and he becomes a cruel tyrant.[105]

When sinners were in hell, the blessed, looking down from heaven, would approve their condemnation, and would enjoy watching them suffer.[106] This belief was based on the Gospel story of the rich man who, in hell, 'he lift up his eyes, being in torments', saw the beggar Lazarus in Abraham's bosom 'afar off', and asked in vain for a drop of water to relieve his burning thirst (Luke 16:19–31). If the rich man could see Lazarus, presumably Lazarus could see him. So the idea that the saved would gloat over the torments of the damned is found already in the Church Fathers Tertullian and Augustine, and is confirmed by Aquinas, who also says that the

sinners burning in hell will form a spectacle even more beautiful and pleasing than the stars in the night sky.[107] Damnation is still often imagined as a spectator sport in the seventeenth century, and even occasionally in the eighteenth. In 1653 the Puritan Christopher Love warned a sinner:

> When thou art scorching in thy flames, when thou art howling in thy torments, then God shall laugh at thy destruction, and then the Saints of God shall sing and rejoyce, that thou art a vessel of his justice, and so his power and wrath made known in thee.[108]

The eighteenth-century American Calvinist Jonathan Edwards said of the saved: 'How joyfully will they sing to God and the Lamb, when they behold this!', even when the damned included those 'who were near and dear to them in this world'.[109]

These examples suggest that fantasies of infernal punishment, like the spectacle of brutal physical punishment, tended to desensitize people and make them hard-hearted. Lecky points out that the effect of a vivid belief in hell must be in most cases 'to indurate the character, to diffuse abroad a callousness and insensibility to the suffering of others that will profoundly debase humanity'.[110] This claim is inadvertently borne out by the twentieth-century Catholic convert and devotional writer Thomas Merton, who tells us that having been 'impressed' by reading the hellfire sermon in Joyce's *Portrait of the Artist*, he was prompted by an actual sermon on hell to change his faith, and that he now cannot understand why the thought of hell should cause distress, since 'it is not compulsory for anyone to go there'.[111]

We may speculate that hell appealed to many people: masochists liked to imagine their own sufferings, sadists those of others; such descriptions provided a lurid or morbid thrill, spiced with terror; and preachers were reluctant to abandon a subject that gave so much scope for eloquence and imagination.[112]

To combat unnecessary religious terror was part of the purpose of Luther's Reformation. Luther sought to reassure people that, although their human nature was irremediably corrupted by Original Sin, grace was freely available to them if they would admit their worthlessness and trust in God's redeeming love. But the doctrine of Original Sin meant that even to feel temptation was a reminder of one's fallen nature, so it encouraged horror at one's own vileness. The doctrine of predestination, foregrounded in various forms of Calvinism and, later, in the Jansenist wing of the Catholic Church, meant that one could only be saved if God had, long before one's birth and for no discoverable reason, decided that one should be. Predestination was announced in Christ's words: 'I pray not for the world, but for those whom thou hast given me; for they are thine' (John 17:9).[113]

Salvation depended entirely on faith. Good works were considered mere 'filthy rags of self-righteousness'.[114] So one had anxiously to examine one's feelings in the hope of detecting evidence of what the Westminster Confession (1646) defined as 'effectual calling'. Yet such assurance that one was saved could never be quite beyond doubt. The Jansenist Louis Racine warned that a saint might be damned for a momentary sin, just as a criminal might be saved by a moment of sincere repentance.[115]

Many eighteenth-century autobiographies record struggles with the fear of hell. The Presbyterian clergyman Thomas Boston recalls how, as a boy in the 1680s, reading Revelation 7, he feared that 'the whole number of the elect . . . was already made up; and therefore there was no room for me'.[116] It is notable that his concern was only for himself, not for his family, who were presumably also crowded out of salvation. In Karl Philipp Moritz's autobiographical novel *Anton Reiser* (1785–90), the protagonist is apprenticed to an evangelical hat-maker who is prone to religious melancholy and who once, while taking a herbal bath in a dark room, exclaims: 'Anton! Anton! beware of hell!' thereby overwhelming Anton with the terror of death and damnation.[117] The young Jean-Jacques Rousseau read Jansenist works whose 'frightening doctrine' made him terrified of hell. He tells in his *Confessions* how he solved the problem by throwing a stone against a tree; if he hit the tree he would be saved, if he missed it, damned, and he took care to aim at the broadest tree he could find.[118]

Preaching before the Queen in 1689, the humane John Tillotson affirmed that the threats of eternal punishment in the New Testament meant what they said, but argued ingeniously that they actually vindicated God's goodness, because God intended punishment not as retribution but as deterrence, and made his threats in the hope that he would *not* have to carry them out: 'and therefore the higher the threatning runs, so much the more mercy and goodness there is in it.'[119] Although this logic may seem strange, Tillotson, by interpreting divine punishment as well-intentioned deterrence instead of retribution by a justly offended deity, was doing much to exonerate God from the charge of cruelty.[120] In 1710, when Henry Sacheverell was tried for having denounced the Toleration Act of 1689 in his inflammatory sermons, his statement that Low Churchmen would burn in hell was described by a lawyer on the opposing side as 'a most dreadful Unchristian Sentence'.[121] Writing in 1731, Alexander Pope (a Roman Catholic) laughs at the cosy Anglican doctrine preached to drowsy ears in Timon's private chapel:

> To rest, the Cushions and soft Dean invite,
> Who never mentions Hell to ears polite.[122]

The staunch Christian Samuel Johnson, resisting the tendency of his time, was still terrified of damnation. When asked in 1784 what he meant by 'damned' (the very question shows the change of outlook), he replied 'passionately and loudly': 'Sent to Hell, Sir, and punished everlastingly.'[123] He readily admitted that, if so, God was not perfectly good, 'for infinite goodness would inflict no punishment whatever'.[124]

By the eighteenth century, even believers often rejected the image of God as sternly punishing sin and imagined him as kindly and indulgent. The doctrine of eternal punishment seemed increasingly implausible, though it was felt that one had to uphold it because only the fear of hell could induce people to behave morally. But this argument from deterrence had several weaknesses. Daily experience showed how ineffectual it was. Even with the prospect of hell before them, intermittently reinforced by hellfire sermons, innumerable people behaved with reckless criminality. Diderot questioned whether people really believed in hell: 'Temptation is too near, and hell is too far away.'[125] David Hume in the 1730s noted 'the universal carelessness and stupidity of men with regard to a future state'.[126]

Moreover, a punishment so wildly disproportionate to the sin was hard to believe in. Arguing against the eternity of punishment, the Genevan theologian Marie Huber pointed out that such doctrines, presupposing 'Cruelty and Revenge in an infinitely merciful and compassionate Being', were counterproductive: 'Thus the more terrible Hell becomes, by supposing it eternal, every one more easily persuades himself, that Divine Mercy will exempt him from it.'[127] Besides, good behaviour induced by the fear of punishment could hardly be called moral. And if punishment were eternal, it would continue after the Last Judgement, when there would be no mortals left to deter.[128]

It also seemed increasingly implausible that hell was an actual place. Daniel Defoe derided the standard pictorial image of hell as a mere garbled version of the classical underworld. Sinners must surely suffer moral, not corporeal, punishment, and hellfire must be a symbol for the pain of exclusion from heaven: 'it has pleased God to let the Horror of those eternal Agonies about *a lost Heaven*, be laid before us by those Similitudes or Allegories, which are most moving to our Senses and to our Understandings.'[129] Uneducated people may have avoided these worries altogether, if we can judge from mid-nineteenth-century Lincolnshire, where 'at least one villager was capable of telling his parson, "What you say be all very true for them that's strange an' good or strange an' bad-like, but i' my opinion best part goes nowhere." '[130]

## NATURAL RELIGION

Enlightened thinkers who rejected the authority of the Bible and its theo-
logical doctrines could resort to 'natural religion' or 'deism'. The English
deists of the early eighteenth century were not a close-knit group, and
their beliefs or principles ranged over a spectrum. Bernard Mandeville
offered this definition in 1720: 'He who believes, in the common Accep-
tation, that there is a God, and that the World is ruled by Providence, but
has no Faith in any thing reveal'd to us, is a Deist.'[131] Some deists described
themselves as Christians, including the best-known one, John Toland, who
writes as a follower of Christ. For Toland, Christianity contains no mys-
teries, i.e. nothing that it is in principle impossible for humans to
understand, though it includes much that humans could not in fact have
known if it had not been imparted by revelation. But revelation is only a
useful source of information. The Bible is just another book: 'Nor is there
any different Rule to be follow'd in the Interpretation of *Scripture* from
what is common to all other Books.'[132]

It is hard to know how far Toland's tongue was in his cheek.[133] For his
principles would make Christianity superfluous, as would the arguments of
the All Souls don Matthew Tindal that 'by living according to the rules
of right Reason, we more and more implant in us the moral perfection of
God'.[134] Like his colleague William Wollaston, Tindal advocated '*Natural
Religion*, [by which] I understand the Belief of the Existence of a God, and
the Sense and Practice of those Duties, which result from the Knowledge,
we, by our Reason, have of him, and his Perfections'.[135] Their hedonistic and
naturalistic view of religion was not very far from the freethinker Charles
Blount, the first English translator of Spinoza, who included a version of
Chapter 6 of the *Theologico-political Treatise* in his *Miracles, No Violation
of the Laws of Nature* (1683).[136] And it was even closer to Shaftesbury, a
friend of Toland and Bayle, whom an orthodox opponent in 1736 described
as 'the subtlest Adversary that ever wrote against Christianity'.[137]

Shaftesbury advocated 'a view of divine providence and bounty
extended to all and expressed in a constant good affection towards the
whole'.[138] About the existence of a divine mind, underpinning the order
of nature, he was agnostic, but reassured his readers: 'If there be really a
mind, we may rest satisfied that it is the best-natured one in the world.'[139]
Actual belief in God, for Shaftesbury, is instrumental. A 'theistical belief'
is the best inducement towards virtue.[140] Atheists can be virtuous (here
Shaftesbury agrees with his friend Bayle), for atheism does not mislead
one into approving of anything intrinsically bad, such as cannibalism,

whereas 'by means of corrupt religion or superstition, many things the most horridly unnatural and inhuman come to be received as excellent, good and laudable in themselves'.[141] Atheism is only corrupting if it blinds one to the order and beauty of the universe. And it is this order, not 'the hypothesis of theism', that is for Shaftesbury the ultimate guarantee of virtue.[142] Our innate knowledge of right and wrong is prior to religious belief. The deist Thomas Morgan likewise pointed out that if Abraham's obedience when commanded to sacrifice his son were to be considered praiseworthy, then right and wrong would become meaningless, because they would depend only on God's fiat: 'God may command the most unfit or unrighteous Things in the World by mere arbitrary Will and Pleasure.'[143] Moreover, argued Shaftesbury, if it were God's arbitrary will that made things right or wrong, absurd consequences would ensue: 'Thus, if one person were decreed to suffer for another's fault, the sentence would be just and equitable.'[144] By indicating, in this unobtrusive sentence, that vicarious suffering would be unjust and inequitable, Shaftesbury has quietly wiped away the Christian doctrine of atonement.

Diderot, who translated some of Shaftesbury's work into French, similarly argued that natural religion – belief in a benevolent creator, and one's innate moral sense – was sufficient for humanity. Mischievously adapting a verse from the New Testament, he called natural religion 'the light that every man brings into the world at his birth'.[145] Revealed religion added nothing except half a dozen unintelligible propositions. In answer to the question why there is suffering in the world, the deist answers frankly that he does not know, whereas the Christian first offers a rigmarole about Original Sin, then admits that he does not understand the mystery either. Diderot compares such a non-explanation to the Chinese answer to the question 'What supports the world?' An elephant. What supports the elephant? A tortoise. And what supports the tortoise? I don't know. Better to confess one's ignorance from the outset.[146]

By Diderot's time, deism seemed to the French religious authorities less dangerous than atheism, and some apologists for Christianity were prepared to meet the *philosophes* half-way. Instead of insisting on the authority of biblical revelation, some apologists based their arguments on physico-theology, maintaining that the wonders of the visible creation were enough to convince one of God's power and goodness. Others relied on unaided reason. Louis-Antoine de Caraccioli argued in *Le Langage de la raison* (1763) that 'one cannot be truly reasonable without being a Christian' and that reason could demonstrate the existence of God, the immortality of the soul, and the dictates of morality.[147] But what then was the use of revelation? Going further, the Huguenot Samuel Formey,

secretary of the Berlin Academy of Sciences, based his case not on certainty but on probability. He argued in *La Logique des vraisemblances* (*The Logic of Probabilities*, 1748) that religious truths could not be demonstrated with metaphysical certainty, but rested on moral conviction and on probability; the existence of God and the afterlife were much more probable than the materialist picture of the universe. Finally, some apologists resorted to the weaker argument that one had to believe in God and in the possibility of eternal punishment because otherwise wicked people would run riot. The Catholic abbé Nicolas-Sylvestre Bergier, an enlightened Churchman, defended Christianity in *Apologie de la religion chrétienne* (*Apology for the Christian Religion*, 1769) as 'the sole source of true morality and healthy politics'.[148] This, however, is a merely instrumental argument, implying that one should believe in Christianity not because it is true, but because it is beneficial.

Deists and other sceptics pointed out that Christianity and other religions had often proved far from beneficial. They argued that the misunderstanding and corruption of religion were the fault of priests, who from early times had exploited religion for their own selfish ends. The concept of 'priestcraft' – the idea that cunning, power-hungry priests corrupted some religions, and invented others, in order to delude the ignorant masses with superstitions and ceremonies – is a favourite topic throughout the Enlightenment, and well beyond it.[149] Locke even argued that God sent Jesus to earth in order to save religion from its priests, at a time when 'in the crowd of wrong notions, and invented rites, the world had almost lost the sight of the one only true God'.[150]

The theory of priestcraft, whatever its merits, has the simple and satisfying appeal of conspiracy theories. In the *History of Oracles* (1687) Bernard de Fontenelle attributed oracles not to demons, as was the orthodox explanation, but to the machinations of 'priestly impostors'.[151] In Voltaire's early play *Œdipe* (1718), Jocaste, protesting against the authority of the High Priest, declares:

> Nos prêtres ne sont pas ce qu'un vain peuple pense,
> Notre crédulité fait toute leur science.[152]

[Our priests are not what deluded people think them; all their knowledge consists in our credulity.]

Helvétius, to explain how priests overawed their flock by exploiting the emotions, tells a funny story by way of analogy:

That was quite clear to a certain woman who, surprised by her lover in the arms of his rival, dared to deny the fact he had witnessed: 'What!' said he,

'you carry your impudence to such a point . . .' 'Oh, you traitor,' cried she,
'I can see you don't love me any more; you believe what you see more than
what I say.'

Similarly, the Egyptian priests, displaying a bull to the awestruck devotees,
compelled them to believe that it was no ordinary bull, but the god Apis.[153]
These writers focused on non-Christian religions as an indirect way of
attacking Christianity.

Deists were prepared to challenge even the Gospels. Matthew Tindal
pointed out that the New Testament writers consistently asserted that the
world would shortly come to an end: they were people 'upon whom the
ends of the world are come' (1 Cor. 10:11), to whom Christ had appeared
'in the end of the world' (Heb. 9:26); Jesus, having prophesied the apoca-
lypse to his disciples, added: 'This generation shall not pass, till all these
things be fulfilled' (Matt. 24:34). Tindal asked the obvious question: 'If
most of the Apostles, upon what motives soever, were mistaken in a matter
of this consequence, how can we be certain, that any one of them may not
be mistaken in any other matter?'[154]

In England, the well-known deists were either a coterie of intellectuals,
or noblemen such as Shaftesbury who could get away with heterodox
opinions. How widespread were such views in the general population? We
know only such opinions as were committed, even privately, to paper.
Martin Clifford, master of Charterhouse, wrote a *Treatise of Humane
Reason* (1674) in which he argued that Christianity was sufficiently vin-
dicated by reason, that every soul could use the light of reason, and that
the Churches had led to 'Blood and Confusion' by forbidding people to
follow their own judgement.[155] James Boevey, a businessman of Dutch and
Huguenot descent working in late seventeenth-century London, left many
manuscript treatises, some of which advocated belief in a good, wise,
providential God who did not need to be worshipped in church; he also
denounced the 'biggottism' of priests who used miracles and prophecies
to delude the ignorant.[156] There was widespread scepticism about spiritual
matters in London coffee-house circles, though little evidence of it was
put on paper: it was reported, for example, that the physician Walter
Charleton 'laughes at the Notion of Spirits'.[157] In his *History of the Royal-
Society* (1667), Thomas Sprat boldly claimed that the Society's researches,
far from being a threat to religion, could help to save the rational core of
Christianity at a time of spiritual decline:

> It is apparent to all, That the influence which *Christianity* once obtain'd
> on mens minds, is prodigiously decay'd. The Generality of *Christendom*
> is now well-nigh arriv'd at that Fatal condition, which did immediatly

precede the destruction of the worships of the Ancient World; when the Face of *Religion* in their public *Assemblies*, was quite different from that apprehension which men had concerning it in privat: In public they observ'd its Rules with much solemnity, but in privat regarded it not at all.[158]

In Georgian England the religious temperature was low. Church-going declined: in 1714, seventy-two London churches held daily services, by 1732 only forty-four; few households held family prayers.[159] Indifference and even unbelief were widely thought to be prevalent. Addison imagined native American visitors to London attending a church service and reporting of the congregation: 'they were most of them bowing and curtsying to one another, and a considerable Number of them fast asleep'.[160] 'Point de religion en Angleterre', 'There is no religion in England', noted Montesquieu, who visited England in 1729–31, and found that religion was inadmissible as a subject of conversation.[161] Tobias Smollett, visiting St Peter's at Rome in 1764, showed irreverence towards the central symbol of Christianity: 'the cross, which is in itself a very mean and disagreeable object, only fit for the prisons of condemned criminals'.[162] Lord Hervey wrote in his memoirs (1727–37): 'the fable of Christianity, as Leo X. called it, was now so exploded in England that any man of fashion or condition would have been almost as much ashamed in company to own himself a Christian as formerly he would have been afraid to profess himself none.'[163] Such claims must qualify any picture of eighteenth-century England as a 'confessional state': certainly the great majority of the population was conventionally loyal to the Church of England, but the rise of Methodism indicates a widespread need for a more heartfelt religion than the official doctrine on offer.[164] In France, after the death of Louis XIV in 1715, irreligion became fashionable among the educated classes, in both Paris and the provinces. Deistic or anti-religious books circulated widely though clandestinely; various salons, such as those kept by Madame de Tencin and Madame du Deffand, attracted outspoken freethinkers; and the police recorded openly irreligious conversations overheard in cafés.[165]

## VOLTAIRE AND THE BIBLE

Where in this conspectus of irreligion are we to place Voltaire? To the nineteenth century he was the arch-enemy of all religion. The poet Alfred de Musset called him 'that monkey of genius, sent by the Devil on a mission to man'.[166] Voltaire read several of the English deists, and is now widely considered to have been himself a deist.[167] Although he lived in

England from 1726 to 1728, he paid relatively little attention to religious controversies at that time; he read the deists mainly in later years. His method of reading was to flick through a book and mark any interesting passages to return to later. This is how he used especially the more scurrilous writers Woolston and Annet.[168] It seems likely that the deists provided him with material to support ideas he had already formed, especially when he was composing his critiques of the Bible, but not that they decisively shaped his ideas. What Voltaire actually *thought* about religion is very difficult, perhaps impossible, to know. We can only be certain of what he wrote and, to a lesser extent, of what he said. His writing was constrained by such forces as wariness of the authorities and his particular polemical purposes, while his words were adjusted to his interlocutor.

Many of Voltaire's recorded utterances commend a 'natural religion' that seems not far from deism.[169] He makes the familiar comparison of God to a mechanic: 'I shall always be persuaded that a clock proves a clock-maker and that the universe proves a God.'[170] He argues that Newtonian science confirms that the universe is minutely ordered and must therefore be the work of a supreme intelligence. When in England, he met the Newtonian theologian Samuel Clarke, who, he later claimed, had shown that the existence of God could be proved.[171] In a letter to Frederick the Great a few years later, however, Voltaire denied that the existence of God could be demonstrated like a geometrical proposition:

> The existence of a creator leaves the human mind with insurmountable difficulties, so this truth cannot be ranked among demonstrations properly so called.
>
> I believe this truth, but I believe it because it is the most probable. It is a light that strikes me through a thousand darknesses.[172]

This discrepancy suggests that Voltaire's utterances were often strategic. Writing to the Jesuit Tournemine, he wanted to show that Newtonianism was not irreligious, and thus win over open-minded Catholics.[173] Writing to the freethinker Frederick, he was under no such constraints. Similarly, in correspondence with Diderot, he could express agnosticism: 'In observing by means of thought infinite interconnections among all things, I would have suspected an infinitely adroit workman. It is very impertinent to claim to guess who he is, and why he has made everything that exists, but it strikes me as very bold to deny his existence.'[174] And, many years later, giving in effect an interview to the lion-hunting tourist James Boswell, Voltaire was no doubt shaping his own image for posterity. Boswell reports in December 1764:

He expressed his veneration – his love – of the Supreme Being, and his entire resignation to the will of Him who is All-wise. He expressed his desire to resemble the Author of Goodness by being good himself. His sentiments go no farther. He does not inflame his mind with grand hopes of the immortality of the soul. He says it may be, but he knows nothing of it.[175]

Although he had limited success in promoting Newtonianism in France, and his own spiritual beliefs were flexible, Voltaire continued his campaign against the Church. A major weapon in his hands was criticism of the Bible. The critique of the Old Testament and its actors was performed by Voltaire with exceptional brilliance, persistence and ruthlessness. He often adopts the methods of textual and historical scholarship pioneered by Richard Simon and Spinoza.[176] He insists on the authority of the literal text, rejecting allegorical and typological interpretations such as the claim that the 'suffering servant' of Isaiah 53 foretold the fate of Jesus.[177] The devil 'Lucifer' was a fabrication resulting from a misunderstanding of Isaiah 14:12, where the prophet gloats over the downfall of a Babylonian king.[178] He not only follows Hobbes and others in arguing that Moses did not write the Pentateuch, which he ascribes to a later period of Jewish history, but adopts Simon's view that the various books of the Old Testament were written by different scribes.[179] Given the late composition of the Pentateuch, Voltaire thinks it likely that the religious history recounted in the Old Testament is back to front. The authors give the impression that the Hebrews had from the outset a belief in a single God but kept lapsing from monotheism into idolatry, and being rebuked, first by Moses, then by the prophets. More likely, however, the Hebrews were originally idolaters and gradually developed monotheism under the influence of neighbouring nations.[180] To support this argument, Voltaire finds evidence in the stories of Abraham being prepared to kill Isaac, and Jephthah killing his daughter, that the Hebrews practised not only idolatry but human sacrifice.[181]

Voltaire particularly deplores the brutality of Jewish history. He provides a table showing how many Jews were killed by other Jews (not counting those who perished in the desert or fell in battle against the Canaanites), making the total 239,020.[182] Voltaire has been called inconsistent in questioning the truth of the narratives while criticizing the behaviour they report;[183] but it is hardly to the credit of the biblical authors to have invented such gruesome stories, and still less creditable to Christians to demand their acceptance as Holy Writ. 'It is far from surprising that the neighbouring peoples united against the Jews, who, in the mind of blinded peoples, could appear only as execrable brigands, and not as the sacred instruments of divine vengeance and the future salvation of the

human race.'[184] He enlarges on the savage and deceitful conduct of the patriarchs, Saul, David, and so on. He laughs at the triviality of the Jewish law, in which God gives his people instructions about hygiene (Deut. 23: 12–14) but says nothing about the immortality of their souls.[185] He makes fun of the strange prohibitions in the Law: you must not eat eels, because they have no scales; you must not eat the hare, because it chews the cud and lacks a cleft foot (whereas in fact it does not chew the cud and does have a cleft foot); you must not eat birds that walk on all fours; you must not touch a dead mouse or mole, because it makes you unclean.[186] The Law provides him, as it did other Enlightenment thinkers, with evidence that Jews were prone to irrational and rigid superstition.

Voltaire's animus against the biblical Jews has sometimes been attributed to childhood traumas and adult humiliations, or to his inability, as a rational Enlightener, to cope with mythic narratives about national origins.[187] However, simpler and more obvious explanations can be found, first, in his campaign against the Christian grand narrative of history; and second, in the fact that he actually read the Old Testament closely. A recent writer on Old Testament ethics has noted that all but two of its books mention warfare; that Yahweh appears as a 'man of war', 'mighty in battle', wielding a sword and wading in blood; and that its prophecies of peace always presuppose the defeat, enslavement and sometimes annihilation of enemy nations.[188] Moreover, the fanaticism of the Old Testament had continued to exert malign influence in recent history. Voltaire mentions that in the French Wars of Religion the preachers supporting the Catholic League called for an Ehud, referring to the divinely appointed deliverer who assassinated Eglon, king of Moab, by driving a dagger into his belly.[189] All this was repellent to Voltaire; his denunciations need no further explanation.

Using the Jews as a stick to beat Christianity, Voltaire also presents the paradoxical claim that the Hebrews of the Old Testament were in fact more tolerant than their Christian successors. To make this case, Voltaire mischievously quotes ample evidence, both from Scripture and from Christian historians, that the ancient Hebrews, far from being monotheists, often worshipped many gods alongside or instead of Jehovah. Besides the golden calf made by Moses' brother Aaron, they worshipped numerous other idols, and even on occasion performed human sacrifices. Voltaire interprets this persistent polytheism as 'liberty of conscience'.[190] He concludes: 'Throughout the history of the Jews you will find not one instance of generosity, magnanimity or charity; and yet, in the fog of this long and frightful barbarism, one may always discern rays of universal tolerance.'[191] This, of course, is said with tongue firmly in cheek.

The question has arisen of Voltaire's attitude to the Jews in general. Voltaire's continual depreciation of the Jews has brought him much condemnation. Léon Poliakov places him at the beginning of modern antisemitism by entitling the relevant volume of his *History* 'From Voltaire to Wagner'.[192] Another commentator says he helped to provide 'the basis for secular racism'.[193] Yet another writes: 'In his own time Voltaire's work encouraged anti-Semitism; it was a major obstacle to the freedom of the Jews. For the next century he provided the fundamentals of the rhetoric of secular anti-Semitism.'[194] We find Voltaire being praised in 1803 by the German antisemitic pamphleteer Karl Grattenauer.[195] However, while Grattenauer is among the founders of racial antisemitism, Voltaire's criticisms of Jews are not racial, but religious and cultural.[196] Zalkind Hourwitz, the Polish Jew who spoke for his people's rights during the French Revolution, wrote in 1789:

> the Jews forgive him all the ill he has done them, in consideration of the good he has done them, although involuntarily, perhaps even unknowingly, because if they are enjoying a little peace for a few years, they owe it to the advance of the Enlightenment, to which Voltaire has certainly contributed more than any other writer, by his numerous works against fanaticism.[197]

Voltaire had few personal contacts with Jews.[198] The main ones were business dealings. When he arrived in London in 1726, he was annoyed to find that the Jewish banker with whom he had lodged his money had gone bankrupt.[199] In Berlin in 1750 he engaged in a shady financial speculation with the Jewish businessman Abraham Hirschel; when he tried to back out, it was too late, for the operation was already known, damaging Voltaire's reputation and his standing with Frederick the Great.[200] Since Voltaire owed his wealth partly to scams and to money-lending, his unpleasant remarks about Jewish businessmen may be understood as projection.[201] He speaks highly of a Jewish physician called Fonseca, who gave him information for his *Histoire de Charles XII*, but strangely calls Fonseca 'perhaps the only philosopher of his nation'[202] (what about Spinoza and Maimonides?). A Jew from Amsterdam, Isaac de Pinto, wrote to him politely criticizing his essay *Des Juifs* (*On the Jews*, 1756): Voltaire's critique, he said, applied to uncivilized Jews in Eastern Europe, but not to refined Sephardic Jews like himself. Acknowledging that the words to which Pinto objected were 'violent and unjust', Voltaire replied: 'As you are a Jew, remain so ... But be a philosopher.'[203] Pinto appears to have been satisfied with this answer, but subsequent commentators have found it unyielding and inadequate.[204]

Voltaire's Jews are for the most part textual Jews. They play a role in

his campaign against organized Christianity.[205] Their principal function is to help Voltaire construct a narrative of world history contrary to that presented by Jacques-Bénigne Bossuet in his *Discours de l'histoire universelle* (*Discourse on Universal History*, 1681).[206] For Bossuet, world history is Christian history, and the Jews of the Old Testament, as the recipients of God's first revelation and the forerunners and ancestors of Christ, are utterly central to the narrative. Voltaire, in his *Essai sur les mœurs* (*Essay on Manners*, 1756), presented a history that attempted a much wider perspective, giving a prominent place to the ancient civilizations of China and India, and to Islam.

To serve as a weapon against Christianity, the Jews had to be sidelined and denigrated, and Voltaire found in the Old Testament ample material that served his purpose. First of all, the Jews were not particularly ancient. The great civilizations of Babylon, Egypt and Persia, not to mention China and India, had chronologies that proved they were far older. The history narrated in the earlier books of the Old Testament was no more to be trusted than the old histories of the French people that derive them from Francus, son of Hector.[207] Moses was a legendary figure like Merlin or Odin.[208] Most likely the Jews were originally a wandering tribe of Arabs, living in the desert between Egypt and Syria, especially as they claim that Jews and Arabs are both descended from Abraham.[209] They settled in Jerusalem under David only some two centuries after the Trojan War.[210] Before that, their nomadic and warlike existence gave them no leisure to learn arts and letters. They acquired these only later, from the neighbouring civilizations. Along similar lines, it has recently been argued that ancient Israelite society originated as what Egyptian sources call *habiru*, dispossessed or runaway peasants who formed groups of bandits in areas beyond the control of states, such as northern and central Palestine, and gradually evolved into settled tribal societies.[211]

In contrast to textual Jews, actual Jews did not interest Voltaire much. He wrote in 1761 a fictitious sermon by a rabbi condemning the Portuguese authorities for having burned twenty-seven Jews along with the Jesuit Malagrida. Yet, he made his rabbi point out, Jesus was a Jew. Can Christians call themselves such, when they practise auricular confession, extreme unction and much else that is not in the Gospels?

> He instituted neither cardinals, nor a pope, nor Dominicans, nor promoters, nor inquisitions; he had nobody burned; he recommends only the observation of the Law, the love of God and one's neighbour, following the example of our prophets. If he were to reappear in the world today, would he recognize himself in a single one of those who call themselves Christians?[212]

# ESSAY

## SUR

# L'HISTOIRE

## GÉNÉRALE,

### ET SUR

## LES MOEURS ET L'ESPRIT

## DES NATIONS,

### DEPUIS CHARLEMAGNE
#### JUSQU'A NOS JOURS.

### *TOME PREMIER.*

### *MDCCLVI.*

Voltaire's full title runs: 'Essay on the general history, and on the manners and spirit of the nations, from Charlemagne to the present day'.

And in 1769 Voltaire looks forward to an ecumenical future, when Jews will be liberated both from Christian maltreatment and from their own superstitions:

> Les enfants de Sara, que nous traitons de chiens,
> Mangeront du jambon fumé par des chrétiens.[213]

[The children of Sarah, whom we abuse as dogs, will eat ham smoked by Christians.]

Voltaire's criticisms of the Bible, his *Philosophical Dictionary* and many other writings were cannonades against '*l'infâme*': against clerical tyranny, fanaticism and superstition. 'The great thing,' he said, 'is to prevent the priests from abusing this doctrine in order to dominate us while fattening themselves at our expense. All good people ought to agree and form an alliance to ensure that religion does the least possible harm.'[214]

Another constraint on Voltaire was that, as we have already seen, he thought it useful for most people to believe in God. Fear of divine vengeance might restrain kings from oppressing their subjects and deter the peasants on his estate from stealing his corn and wine.[215] That is why, if God did not exist, he would have to be invented. Addressing the unknown author of the *Treatise of the Three Impostors* (discussed below) in 1769, Voltaire condemns him for being a bad writer, for denying the natural religion shared by Zoroaster, Socrates and Cicero, and for encouraging the misbehaviour that is restrained by belief in God:

> Si les cieux, dépouillés de son empreinte auguste,
> Pouvaient cesser jamais de le manifester,
> Si Dieu n'existait pas, il faudrait l'inventer.
> Que le sage l'annonce, et que les rois le craignent.
> Rois, si vous m'opprimez, si vos grandeurs dédaignent
> Les pleurs de l'innocent que vous faites couler,
> Mon vengeur est au ciel: apprenez à trembler.
> Tel est au moins le fruit d'une utile croyance.[216]

[If the heavens, stripped of his august imprint, could ever cease to manifest him, if God did not exist, he would have to be invented. Let the sage proclaim him, and let the kings fear him. Kings, if you oppress me, if your greatness disdains the innocent tears that you have caused to flow, my avenger is in Heaven; learn to tremble. Such is at least the fruit of a useful belief.]

Though solemnly expressed, this is really only the instrumental argument for belief in God that we have already seen formulated by Shaftesbury and Bergier. It testifies to the attenuation of religious faith.

## ATHEISM

Deism rests especially on the belief that the visible order of the universe implies an intelligent designer. Cleanthes, one of the speakers in Hume's *Dialogues concerning Natural Religion*, expresses the standard view: 'The Order and Arrangement of Nature, the curious Adjustment of final causes, the plain Use and Intention of every Part and Organ; all these bespeak in the clearest Language an intelligent Cause or Author.'[217] The *Dialogues* as a whole, however, are much more iconoclastic than this quotation implies. Having written them in the early 1750s, Hume kept them in his drawer and directed that they should be published only after his death. No wonder, for all the usual arguments for deism are undermined. We have, for example, a version of the 'divine watchmaker' argument.[218] Just as a piece of machinery implies a human maker, so the order of the universe implies a divine maker. But the most sceptical participant, Philo, shows the weakness of this analogy. A complex work such as a ship is not made by a single workman. To make the universe, which is far more complex, we ought by analogy to imagine a number of deities working together. Again, the world we know has many imperfections. If it was made, perhaps it was made badly,

> only the first rude Essay of some Infant Deity, who afterwards abandon'd it, ashamed of his lame Performance: It is the Work only of some dependant, inferior Deity; and is the Object of Derision to his Superiors; It is the Production of Old-Age and Dotage in some superannuated Deity; and ever since his Death, has run on at Adventures, from the first Impulse and active Force, which it receiv'd from him.[219]

Although these conjectures sound comical, they follow logically from the proposed analogy between a human and a divine workman.

It is noteworthy that the orthodox speaker, Demea, undermines his own belief in a benevolent Creator by dwelling on the misery of human life, and can only defend his position by borrowing from Leibniz the argument that this life is a mere moment compared to eternity, and that 'The present Evil Phænomena, therefore, are rectify'd in other Regions, and in some future Period of Existence'.[220] But since he knows nothing about those other regions and future periods, and since his argument for a benevolent deity was supposed to be based on the world he does know, this reply cannot convince.

Belief in a benevolent deity is in any case vulnerable. Hume, like Bayle and many others, quotes the neat summary by the ancient philosopher

Epicurus: '*Epicurus*'s old Questions are yet unanswer'd. Is he willing to prevent Evil, but not able? then is he impotent. Is he able, but not willing? then is he malevolent. Is he both able and willing? Whence then is Evil?'[221]

If natural religion rests on shaky foundations, so does the logical argument for God's existence, which Demea also trots out. Everything must have a cause. There must therefore be either an infinite regress, or a first cause, 'a necessarily existent Being, who carries the reason of his Existence in himself; and who cannot be suppos'd not to exist without an express Contradiction.'[222] But Demea's interlocutors show, first, that there is no logical contradiction in imagining that God does not exist; second, that if God can be imagined as necessarily existent, we can just as well imagine the world as necessarily existent, and then we have no need for God. Similarly, Diderot in *Le Rêve de d'Alembert* (*D'Alembert's Dream*, 1769) exposes the very idea of God as incoherent. As a spokesman in the dialogue, d'Alembert lists the contradictions in the conception of God as immaterial yet omnipresent:

> I must admit that a being that exists somewhere, but not at any point in space; that lacks extension, yet occupies extension and is present in its entirety in every part of that extension; that differs essentially from matter, yet is united with it; that follows matter and moves it, without itself moving; that acts on matter, and itself suffers all the changes undergone by matter; a being of which I cannot form the slightest idea – a being with such a contradictory nature is difficult to admit.[223]

Instead of trying to resolve these riddles, atheism allows one to walk away from them. It is, however, not at all certain how common atheism has been in Western history. Some historians have argued that, until the eighteenth century, it was very uncommon, or even non-existent. Lucien Febvre, the great historian of the *Annales* school, maintained in his study of Rabelais that in the early modern period religious belief was universal and unquestioned, apart from occasional expressions of anger or despair.[224] Many early modern thinkers maintained that intellectual or speculative atheism was impossible. Certainly the Bible admitted the possibility of denying God – 'The fool hath said in his heart, There is no God' (Ps. 14:1) – but only for those who wanted to delude themselves that their wicked lives could escape divine punishment. The word 'atheist' was liberally applied to people whose behaviour and beliefs one abhorred: to Judas, Calvin, Erasmus, Machiavelli or Muhammad.[225] But many writers found it inconceivable that any intelligent person could seriously deny something so self-evident as the existence of God. The occasional contradictions in the Bible, wrote Sir Thomas Browne in 1642, never had 'such advantage of me, as to incline

me to any point of infidelity or desperate positions of Atheisme; for I have beene these many years of opinion there was never any'.[226]

Some thinkers, however, did report having met intellectual atheists who took care not to publicize their beliefs.[227] And it is hard to accept that laws against atheism, or religious apologias directed against atheists, were all aimed at imaginary opponents.[228] Many intellectuals and aristocrats, whether frivolously or seriously, speculated boldly about such religious doctrines as divine providence, the freedom of the will, and the immortality of the soul, and often verged on atheism.[229] Some published ostensibly orthodox treatises that could also be read as sceptical, and whose meaning, like Bayle's in his *Dictionary*, is often still a matter of scholarly debate. Early modern atheism became known only when its proponents were denounced, tried and punished, like Thomas Aikenhead in Edinburgh in 1697, or Giulio Cesare Vanini in Toulouse in 1619. Paolo Sarpi, famous for his ironic *History of the Council of Trent*, was a materialist who rejected all philosophical arguments for belief in God but concealed his opinions by studied hypocrisy. He kept, and carefully concealed, sceptical notes arguing that religion originated from fear of the unknown, unsatisfied desire and puzzlement at inexplicable natural processes; that some religions are useful because they encourage people to restrain their passions and promote a socially beneficial way of life; and that Christianity is particularly unsuitable as a foundation for social life, because it considers people incapable of virtue and urges them to shun worldly affairs.[230] Even in eighteenth-century Scotland, Hume considered it prudent to conceal the extent of his unbelief. After all, he told a friend, social life demanded some conventional dishonesty:

> I wish it were still in my Power to be a Hypocrite in this particular: The common Duties of Society usually require it; and the ecclesiastical Profession only adds a little more to an innocent Dissimulation or rather Simulation, without which it is impossible to pass thro the World. Am I a Lyar, because I order my Servant to say I am not at home, when I do not desire to see company.[231]

Were the Parisian *philosophes* atheists? We can seldom be certain. Some *philosophes* may themselves have been unsure. People cannot always tell whether their speculative ideas amount to atheism, to deism, or to an agnosticism that hovers between the two; and most statements of belief made in eighteenth-century France were likely to be cautious. An aphorism by Diderot provides a sensible comment: 'Somebody was asked one day whether there were real atheists. Do you believe, he replied, that there are any real Christians?'[232] Hume points out that 'the conviction of the

religionists, in all ages, is more affected than real, and scarce ever approaches, in any degree, to that solid belief and persuasion, which governs us in the common affairs of life.'[233] Hence believers resort to bigotry, fanaticism and persecution in order to suppress their own doubts. Religion also generates endless superstition in the form of self-inflicted discomfort. For since moral duties correspond to natural inclinations, or social obligations, or both, one feels no special merit in performing them. The service of God, on the other hand, demands gratuitous and extravagant actions. Hume instances 'the *Rhamadan* of the *Turks*, during which the poor wretches, for many days, often in the hottest months of the year, and in some of the hottest climates of the world, remain without eating or drinking from the rising to the setting of the sun.'[234]

Diderot certainly inclined towards atheism, though he avoided publicizing his unbelief. He warned the Dutch philosopher Frans Hemsterhuis that in Paris, philosophy was constrained by official intolerance: 'I have protected myself by the most subtly ironic tone that I can find, by generalities, laconism and obscurity.'[235] We can also be sure of baron d'Holbach and Jacques-André Naigeon, because they boldly proclaimed their atheism and tried to persuade others. D'Holbach was the host of the most famous and popular male-dominated salon in mid-century Paris. Naigeon, his secretary, was also a close friend of Diderot, who appointed him executor of his will and the first editor of his posthumously collected works.[236] The abbé Morellet recalled how d'Holbach, Diderot and the doctor Augustin Roux presented a system of atheism, 'with persuasiveness, good faith, and honesty, that edified even those among us who, like me, did not believe in their teaching'.[237]

Their atheism was later spelled out in d'Holbach's *Système de la nature* (*System of Nature*, 1770) and in the introduction by Naigeon that was included in some editions. Nothing exists but matter, which has the power of sensation, motion and thought. Knowledge comes only from the senses. Abstractions are not real: there are beautiful things, but there is no such thing as beauty. Likewise, there are no supra-sensible beings, and hence no God.[238] It was at one of d'Holbach's dinners that, according to a much-quoted anecdote, Hume told the baron that he did not believe in the existence of atheists, and d'Holbach replied that of the eighteen people present, 'I am lucky enough to be able to show you fifteen atheists at one glance. The other three have not yet made up their minds.'[239] Rather than revealing the prevalence of atheism, however, d'Holbach's riposte may well have been a joke.[240]

Although the atheism of d'Holbach and Naigeon might seem a comfortless doctrine, it was in fact part of the Enlightenment search for

happiness. Man is alone in the universe with no divine support, no meta-physical consolation. However, in return for rejecting the delusory solace that the Churches offer in order to reinforce their tyranny, one has access to the real happiness available in earthly life, despite the efforts of the religious to make us miserable: 'Nature called on people in vain to think of their present happiness, the priest ordered them to be miserable in the expectation of future happiness.'[241] D'Holbach's atheism was 'a prerequis-ite of any substantial amelioration of the human condition', though, given how prone people were to delusion, he did not expect such improvement any time soon.[242] However, his system was vulnerable to the objection that its determinism ruled out any efforts to improve the human condition. If all human actions are governed by necessity, argued Frederick the Great, what sense does it make for d'Holbach to rage against priests and tyrants, who cannot help what they do? 'One might just as well preach to an oak and try to persuade it to turn into an orange tree.'[243]

Learned atheism was supported by classical precedents. In the pre-Christian world, there was little interest in defining orthodox religious beliefs, and hence none in hunting out heresy. Atheism, though often considered impious and occasionally repressed, was simply one of several possible beliefs about the gods.[244] A number of thinkers put forward theories about the material universe that did not require divine creative activity, though, perhaps out of prudence, they generally maintained that the gods did exist but had no concern with humanity. On these theories, originating with Democritus in the fifth century BCE, the universe con-sisted of atomic particles in constant motion. The soul or the mind was also material, consisting simply of finer particles. Sometimes atoms swerve randomly from their course and bond with other atoms. When this process is repeated often enough, it creates solid bodies, and even-tually the entire material universe that we know. This worldview, associated especially with Epicurus, was memorably developed by the Latin poet Lucretius in his *De rerum natura* (*On the Nature of the Uni-verse*, first century BCE).

Lucretius celebrates Epicurus as the hero who freed humanity from enslavement to false religious beliefs:

> When human life lay grovelling in all men's sight, crushed to the earth under the dead weight of superstition whose grim features loured menacingly upon mortals from the four quarters of the sky, a man of Greece was first to raise mortal eyes in defiance, first to stand erect and brave the challenge. Fables of the gods did not crush him, nor the lightning flash and the growl-ing menace of the sky.[245]

Religion, according to Lucretius, not only sprang from fear but induced people to commit wicked actions, such as the sacrifice of Iphigenia by her father Agamemnon at the start of the Trojan War. A true understanding of the material universe and the causes of natural phenomena would free people from unnecessary fears and permit them to lead healthy and happy lives, untroubled by anxieties about the gods.[246]

Epicureanism appealed strongly to Enlighteners. The Catholic mathematician Pierre Gassendi tried to combine Epicurean atomism and ethics with Christianity. Voltaire, opposing Christianity in his poem 'Épître à Uranie' ('Epistle to Urania', 1722), presented himself as a 'new Lucretius'.[247] Above all, Hume in his *Natural History of Religion* put forward a Lucretian account of how religion began. The truth of deism, obvious to the philosopher, must have been far above the intellectual capacity of primitive humans. Their starting-point was fear. Motivated by 'the anxious concern for happiness, the dread of future misery, the terror of death, the thirst of revenge, the appetite for food, and other necessities', they imagined a pantheon, each member of which had a different remit (love, war, death) and could be propitiated by sacrifices.[248] Following a very widespread human disposition, they conceived their divinities as having a physical, even material form, along with human passions such as anger and vindictiveness. Such religion does not banish fear. Besides fearing natural misfortunes, people now also fear the capricious wrath of their non-existent divinities. In advanced religions, when polytheism has yielded to monotheism, worshippers praise their god while secretly feeling that he is cruel and unjust:

> And thus it may safely be affirmed, that many popular religions are really, in the conception of their more vulgar votaries, a species of dæmonism; and the higher the deity is exalted in power and knowledge, the lower of course is he frequently deprest in goodness and benevolence; whatever epithets of praise may be bestowed on him by his amazed adorers. Amongst idolaters, the words may be false, and belie the secret opinion: But amongst more exalted religionists, the opinion itself often contracts a kind of falsehood, and belies the inward sentiment. The heart secretly detests such measures of cruel and implacable vengeance; but the judgment dares not but pronounce them perfect and adorable.[249]

So religion not only gives people more to be afraid of; it also leads to habitual dishonesty and self-deception.

The classical materialism of Lucretius and Epicurus offered an alternative to the deist belief that the world had been designed by an intelligent creator. But it was difficult to believe that the world, with all its coherence and complexity, had come about by chance, in what has been called 'the infinite

monkey theorem – the claim that a monkey randomly tapping keys on a typewriter for all eternity would eventually produce the works of Shakespeare'.[250] In the ancient world, Cicero had opposed the atomists by claiming that however many letters of the alphabet you threw about at random, they would never produce the *Annals* of Ennius.[251] In the eighteenth century, Rousseau was similarly dismissive: 'if any one told me that printed characters scattered broadcast had produced the *Æneid* all complete, I would not condescend to take a single step to verify this falsehood.'[252]

Rousseau was right, but for the wrong reason. Returning to the monkey, Richard Dawkins has calculated that if it were told to produce by random typing a twenty-eight-character sentence, the odds against success would be unimaginably huge (one in ten thousand million million million million million million), and even if the task were reassigned to a computer, to run through all the permutations would take longer than the age of the universe.[253] But this is not because the world was intelligently designed. The claim that randomness cannot lead to order – that by scattering letters you can never produce the *Aeneid* – overlooks two important facts. First, random processes soon become non-random. If you shake objects in a sieve, the small ones fall through the holes and the large ones are caught; this is not random, but follows predictably from their varying sizes. Second, the evolution of organisms proceeds not through repeated random throws, but through cumulative selection. Evolution typically has a short-term goal: survival, or reproductive success. Random mutations result in a slightly more successful organism; further random mutations of this organism make its descendants considerably more successful. The mutations are not starting from scratch, but from the accumulated mutations that have already occurred. Although evolutionary arguments were not available in the eighteenth century, we can now see that to explain these processes, there is no need to imagine a designer.[254] Indeed, Dawkins's argument could be used in support of Lucretius, because as soon as his falling particles conglomerate into bodies, these bodies will attract more particles, and the process will become less random.

Atheism included not only disbelief in the existence of God, but a radicalized theory of priestcraft. While deists held that an originally pure religion had been corrupted by power-hungry priests in order to keep the ignorant in subjection, atheists went further and claimed that religion itself had been invented for this purpose. They could find support both in Lucretius and in the ancient anti-Christian writer Celsus, who claimed that monotheism was a delusion that Moses had fraudulently imposed on his followers: 'The goatherds and shepherds who followed Moses as their leader were deluded by clumsy deceits into thinking that there was only one God.'[255]

That Moses was a conjurer or 'juggler' was a commonplace of early modern atheism.[256] Muhammad also was generally reputed to be an impostor. Humphrey Prideaux in 1697 treated him as the archetypal fraud, dwelling especially on how Muhammad bullied his initially sceptical followers into believing that he had been carried by the angel Gabriel up to heaven, where God had entered 'into very familiar Converse with him'.[257] The title figure in Voltaire's play *Mahomet* (1741) is a power-hungry cynic who orders a murder on religious grounds. Frederick the Great repeated the standard view: 'Mahomet, far from being devout, was nothing but a rogue who made use of religion to establish his empire and his dominion.'[258]

The most radical and notorious formulation of this theory was the *Treatise of the Three Impostors*, which was the subject of excited rumours throughout the seventeenth century. It was eagerly sought, but proved so elusive that people often concluded that it did not exist. Eventually, however, two versions came to light: the short Latin treatise *De tribus impostoribus MDIIC* (*On the Three Impostors 1598*), which circulated mainly in German-speaking countries, and the French *Traité des trois imposteurs*, dating from the late seventeenth or early eighteenth century.[259] The Latin treatise says that a supreme being exists, but his existence is evident from nature, so we need no priesthood; any further revelations must be supported by rational evidence; lacking such evidence, the teachings of Moses, Jesus and Muhammad are untrustworthy and their authors are fraudulent. The French treatise denounces Moses, Jesus and Muhammad as impostors in one of its chapters, the rest being a radical attack on religion in general, including natural religion; it professes materialism, with a basis in the philosophy of Spinoza. Moses was a successful impostor because he had force to back up his claims: 'Rogues without arms rarely succeed,' says the pamphleteer, probably echoing Machiavelli's words about the need for a prophet to be armed.[260] Jesus followed Moses' example in claiming to work miracles, but came to a bad end for lack of weapons. His being born of a virgin is the same fable that the Tartars tell about Genghis Khan (surely the only time he and Jesus have ever been compared) and the Chinese about their god Fo.[261] Muhammad, though allegedly a person of mediocre abilities, was more successful than either Moses or Jesus in that he enjoyed power and homage in his lifetime. Absurd though the *Treatise* is, it can still cause a faint thrill by its bluntly disrespectful treatment of people regarded as sacred. The thrill of seeing a taboo broken must have been far greater three hundred years ago.

A secret atheist, sweeping and devastating in his critique of all religion, came to light in 1729, when the priest Jean Meslier died and left to posterity a *Testament* in which he denounced all the beliefs he had professionally

supported. Although, as village priest at Étrépigny near Sedan in north-eastern France, he had acquired a reputation as a malcontent, nobody suspected that, as he asserted in his *Testament*, he had for many years been carrying out his duties with 'extreme loathing for what I was doing', especially for 'the idolatrous and superstitious celebrations of Masses'.[262] Ridiculing what he repeatedly calls 'Déocultes et Christocultes' (God-worshippers and Christ-worshippers), Meslier attributes belief in God to imposture sustained by priestcraft. He cites Numa Pompilius (the legend-ary second king of Rome) and many other ancient kings and legislators who claimed divine support in order to lend authority to their decrees. To them he adds Moses, who claimed that God had appeared to him in a burning bush; Jesus, who assured his disciples that he had been sent by God; the trickster Simon, who 'bewitched the people of Samaria, giving out that himself was some great one' and induced them to say 'This man is the great power of God' (Acts 8:9–10); and 'the much renowned false prophet Mohammed'.[263] All religions are mere human inventions. Chris-tianity is a particularly absurd one. It rests on the logical contradiction of the Trinity, maintaining moreover that two of its members are father and son although they have no sex: 'if these two so-called persons are without any body, form, and figure, how is it that the first person is called "the Father" and not "the Mother"? And how is it that the second is called "the Son" and not "the Daughter"?'[264] Jesus was just a mortal man, and 'a fool, a madman, a wretched fanatic, and a miserable scoundrel'.[265] At least he had the sense to deny that he was God, rebuking his followers when they called him 'good' on the grounds that only God is good.[266] The Gospels are full of contradictions and nonsense, and the visions and fan-tasies they record are far more extravagant than those of Don Quixote.

The tissue of absurdities that Meslier denounces is, he continues, used to justify oppression on earth. All human beings are equal, and although society requires some degree of difference among them, nothing can justify the 'huge, unjust, and detestable disproportion between the states and con-ditions of men'.[267] Not only do nobles live in undeserved ease, but monks live in idleness although perfectly able to work. Meslier also criticizes the indissolubility of marriage, which produces 'countless bad and unhappy households' and renders them still more unhappy by the awareness that they cannot escape from their misery. The kings of France are tyrants, yet they are encouraged in their oppression not only by flatterers but by priests who teach that they are established by God and that 'they that resist shall receive to themselves damnation' (Rom. 13:2).[268]

Meslier was a highly intelligent man with leisure to pore over the Bible and anatomize its incoherencies. He was helped by his reading of

Montaigne, Bayle and a book by Jean-Paul Marana, *Letters Writ by a Turkish Spy* (1684–6), which gives an unflattering account of European politics and religion in the mask of an Oriental.[269] He deposited three copies of his *Testament* with a notary shortly before his death. Its discovery caused a scandal, and Meslier was denied Christian burial. One of the copies was borrowed and was in turn copied, so that the *Testament* was soon circulating in the literary underground.[270]

In 1762 Voltaire published a severely abridged and watered-down version of Meslier's work, in which the aggressive atheist was transformed into a harmless deist. The most likely explanation is given by Meslier's biographer Maurice Dommanget: 'Quite simply because the *Testament*, O horror! is atheistic and communist.'[271] Meslier's political radicalism must have repelled Voltaire, who thought the common people should be kept in their place and that atheism, though acceptable for *philosophes*, would, if it got about, weaken people's deference towards authority. Besides, although the *Testament* may be among the most blistering attacks on religion that even the Enlightenment produced, it is no literary masterpiece; its many repetitions convey how obsessively Meslier brooded over the falsehoods he was obliged to teach. Hence Voltaire's reaction: 'His text is too long, too boring, and even too revolting, but the extract is short and contains everything that is worth reading in the original.'[272] A complete edition of the *Testament* was not published until 1864.

## AN EVIL GOD?

In his poem on the Lisbon earthquake, Voltaire voices the darkest surmise in the Enlightenment's critique of religion: the suspicion that the Christian God, if he exists, is wicked.[273] Gibbon observes that while the Protestant Reformers freed believers from the tyranny of the Church, they not only retained the literal understanding of the Bible and the doctrine of the 'real presence' of Christ in communion, but increased the authority of 'the stupendous doctrines of original sin, redemption, faith, grace, and predestination, which have been strained from the epistles of St. Paul.' In the emotional burdens it placed on humanity, Protestantism may have been worse than its predecessor: 'Hitherto the weight of supernatural belief inclines against the Protestants; and many a sober Christian would rather admit that a wafer is God than that God is a cruel and capricious tyrant.'[274]

The darkest doubts about God's goodness were expressed by Pierre Bayle, not speaking in his own person but in arguments that he places in

the mouths of imaginary Manichaeans – that is, dualists who believe in
both a good and an evil God. This occurs especially in the interrelated
articles which have been called 'the Manichaean web'.[275] In the article
'Manichaeans', Bayle composes a speech delivered by the Manichaean
sage Zoroaster in a debate with a pagan, Melissus, whose arguments
resemble those of orthodox Christianity. Bayle's Zoroaster asks:

> If man is the work of a single, supremely good, supremely holy, supremely
> powerful principle, is it possible that he can be exposed to illnesses, to cold,
> to heat, to hunger, to thirst, to pain, to vexation? Is it possible he should
> have so many bad inclinations and commit so many crimes?[276]

Why, asks Zoroaster, was not man created without an inclination to evil?
Bayle's Manichaeans also argue that since God had complete fore-
knowledge, he knew that man would sin, having made man too weak to
resist temptation. 'No matter how it is explained,' they conclude,

> it obviously follows that God wished that man sin, and that he preferred
> this to the perpetual duration of innocence, which was so easy for him to
> bring about and ordain. Reconcile this, if you can, with the goodness that
> he ought to have for his creatures, and with the infinite love that he ought
> to have for holiness.[277]

The issue of divine evil could be explored with the least inhibition in
drama, with the ancient gods as targets. Racine's *Phèdre* (1677) is the
forerunner of a series of plays, mostly on classical themes, in which
humans protest against the cruel and unnatural demands made on them
by the gods.[278] Two motifs prove particularly suitable for this purpose:
the classical story in which Agamemnon, in order to get a fair wind for
his ships bound for Troy, is required by the gods to sacrifice his daughter
Iphigenia; and the Old Testament story in which God orders Abraham to
sacrifice his son Isaac. In both narratives, the victim is saved at the last
moment: Iphigenia is replaced by a doe, Isaac by 'a ram caught in a thicket
by his horns' (Gen. 22:13); and the reader is left wondering why God
played such cruel games with his devotees. In Racine's *Iphigénie* the gods'
demand for Iphigénie's sacrifice is attributed by her father to their in-
explicable rage (IV, iv) and described by her mother as 'an abominable
murder' (III, v).[279] Ostensibly, the criticism applies to the pagan gods, who
of course are disreputable; but alert spectators may think of the Christian
myth in which a divine father sacrifices his son.

The motif of a parent sacrificing a child is varied in the hugely popular
tragedy *Merope* (1713) by Scipione Maffei. The action is based on a lost
play by Euripides, known only from an allusion in Aristotle's *Poetics* and

from a presumed plot summary in another ancient source.[280] Merope mistakenly believes that her long-lost son has been killed and blames his death on a stranger. Maffei altered the plot so that the stranger, who is in fact Merope's son, does not know his own identity and therefore cannot dispel Merope's suspicion. The central tragic emotion is therefore a mother's grief and her desire for revenge. This so appealed to eighteenth-century audiences, who wanted tragedy to provide emotional involvement rather than a bloodstained spectacle, that the play enjoyed enormous success.[281] Planning to kill the supposed murderer, Merope reproaches the unjust gods for allowing this situation to happen, and her servant Euriso says that the gods have been known to behave with apparent injustice, instancing the case of Iphigenia:

> Oscure, imperscrutabili, profonde
> Son quelle vie per cui, reggendo i Fati,
> Guidar ci suol l'alto consiglio eterno.
> Tu ben sai che il gran re, per cui fu tratta
> La Grecia in armi a Troia, in Auli ei stesso
> La cara figlia a cruda morte offerse.[282]

[Obscure, inscrutable, profound are the ways by which the high eternal wisdom, ruling the Fates, is accustomed to guide us. You well know that the great king, by whom Greece was led in arms to Troy, in Aulis himself offered up his dear daughter to cruel death.]

To this Merope replies that the gods have never issued such a command to a mother, because a man cannot feel or understand the intense affection a mother feels for her children. Both her attempts at murder are averted by the merest chance, so the play ends happily, but without removing the doubts that have been raised about divine justice.[283]

Goethe turned to Greek mythology in his unfinished drama *Prometheus*, in which the Titan Prometheus defies the gods with the exception of Minerva, the goddess of wisdom, who enables him to bring to life the statues he has created. The supreme god, Jupiter, is depicted as a tyrant, flattered by Mercury as infinitely good but determined to exert tyranny over the human 'race of worms', a phrase with biblical resonances.[284] Although Goethe did not publish this fragment, he used several lines from it in his dramatic monologue 'Prometheus' (written between late 1773 and 1775, but published only in 1789). Here we are reminded that Prometheus disobeyed the gods by stealing fire from heaven; he thus easily symbolizes enlightenment. Prometheus openly defies the gods, deriding Zeus as a blusterer who, with his thunderbolts, is no more impressive than a child

knocking the heads off thistles. Far from being independent of humanity, the gods rely for their very existence on the 'hoffnungsvolle Toren' (hopeful fools) who offer them prayers and sacrifices but get nothing in return.[285] Now that Prometheus has outgrown his earlier naïve piety, his humane values centre on the image of the cottage and its glowing hearth, which in turn is linked to the ardour of his heart:

> Hast du nicht alles selbst vollendet,
> Heilig glühend Herz?[286]

[Did you not accomplish all this yourself, oh my holy glowing heart?]

In 1787 Goethe completed the drama *Iphigenie auf Tauris*, an adaptation of Euripides' play on the same subject, in which the descendants of Tantalus are all under a curse imposed by the gods when their ancestor abused the divine favour. The devout Iphigenie admits that the gods expected too much of a mere mortal, and hints at their injustice both to Tantalus and his family. Through successive generations, family members have been compelled to slaughter each other. The gods required Agamemnon, Iphigenie's father, to sacrifice her in order to get a fair wind for his ships; however, the goddess Diana rescued her, substituting a doe, and transported her to the distant land of Tauris (modern Crimea). Her civilizing influence has induced the Taurians to abandon their custom of sacrificing strangers, but their king, Thoas, annoyed by her refusal to marry him, resolves to reinstate the custom. Just then, Iphigenie's brother Orest and his friend Pylades turn up, and it seems as if the curse will continue to operate by compelling Iphigenie to sacrifice them. Thanks largely to Iphigenie's moral courage, this threat is narrowly averted. The oracle that sent Orest to Tauris to bring back 'the sister' turns out to have been referring, not to Apollo's sister Diana, whose statue is kept there, but to Orest's own sister – not to a goddess, but to a human being. The play symbolically represents a new era in which human beings act with autonomy, and the gods (who, unlike in Euripides' work, never appear in person) can be understood and dismissed as mere projections of human emotions.

In letting divinity be superseded by humanity, *Iphigenie* resembles a gentler version of 'Prometheus'. The 'heart', apostrophized by Prometheus, is equally important for Iphigenie, for whom the gods speak to us only through our hearts. To imagine the gods as bloodthirsty is, in her opinion, only to project onto them one's own cruel impulses:

> Der mißversteht die Himmlischen, der sie
> Blutgierig wähnt; er dichtet ihnen nur
> Die eignen grausamen Begierden an.[287]

[He fails to understand the heavenly beings who fancies them to be blood-thirsty; he merely imposes his own cruel desires on them.]

But the play invites the conclusion that Iphigenie's hopeful view of the gods is equally a projection, arising from her own nobility and kindness.

Goethe, at least as much as Voltaire, was a devotee of natural religion. He told his clerical friend Johann Caspar Lavater firmly:

> You consider the Gospel the most divine truth; even a loud voice from heaven wouldn't convince *me* that water burns and fire puts it out, that a woman bears a child without a man, or that a man can rise from the dead; instead, I consider these beliefs to be blasphemies against the great God and his revelation in nature.[288]

Inspired partly by Spinoza, whose *Ethics* he continually dipped into, he thought it self-evident that there was a God who was manifested in the order of nature.[289] Natural religion therefore did not require any effort of faith; it was only particular religions that did so. Natural religion sprang from 'the dialogue in our bosom with nature'; it depended on feeling and could not be implanted by rational argument.[290] Goethe disliked Voltaire's mockery of religion, but admired his tolerant outlook and the civic courage he had shown in the Jean Calas affair. He shared Voltaire's hostility to the Christian God of vengeance and to the dogma of Original Sin.[291] The gods in *Iphigenie* lead humanity into wrongdoing, then punish not only the malefactor but also his remote descendants. They thus recall the God of the Old Testament, who proclaims himself to be 'a jealous God, visiting the iniquity of the fathers upon the children, upon the third and upon the fourth generation of them that hate me' (Exod. 20:5).

## NEW RELIGIOUS SPECULATIONS

As the later Enlightenment emancipated itself from the authority of religious experts, a wide range of speculation became possible. A favourite subject was the nature of immortality. Enlightenment thinkers were deeply attached to the idea that humanity could not only make progress, but even attain perfection. The Bible enjoined us to become perfect: 'Be ye therefore perfect, even as your father which is in heaven is perfect' (Matt. 5:48). Leibniz taught that every created thing has the potential for perfection, and, since God does nothing in vain, must eventually realize its potential. But a single human life is too short even to approach perfection. Hence progress towards perfection must continue in a future existence.[292]

The need for perfection seemed to Addison, as an enlightened Christian, to prove that the soul was immortal:

> To look upon the Soul as going on from Strength to Strength, to consider that she is to shine for ever with new Accessions of Glory, and brighten to all Eternity; that she will still be adding Virtue to Virtue, and Knowledge to Knowledge; carries in it something wonderfully agreeable to that Ambition, which is natural to the Mind of Man.[293]

Leibniz, on the other hand, attributed immortality not to the disembodied soul, but to the individual monad, which he imagined as a physical and spiritual unity. His disciple Christian Wolff similarly argued that man's happiness consisted in progress towards ever greater perfection, which would continue in the life to come. Goethe gave poetic expression to this conception at the end of *Faust II*, where Faust, having entered an idiosyncratically imagined heaven, is described by one of its denizens:

> Vom edlen Geisterchor umgeben,
> Wird sich der Neue kaum gewahr,
> Er ahnet kaum das frische Leben,
> So gleicht er schon der heiligen Schar.
> Sieh, wie er jedem Erdenbande
> Der alten Hülle sich entrafft
> Und aus ätherischem Gewande
> Hervortritt erste Jugendkraft.[294]

> Ringed by that noble spirit-chorus,
> This neophyte of life unknown,
> Scarcely awake, and strange before us,
> Already makes our form his own.
> See, how all earthly bonds discarding
> He casts his outworn husk aside,
> And an ethereal raiment parting
> His youth steps out refortified![295]

Such notions, termed palingenesis, were given widespread popularity by the Swiss naturalist and philosopher Charles Bonnet in his *Philosophical Palingenesis* (1769). Instead of a continuous process of palingenesis, however, other thinkers were more attracted by a discontinuous process of metempsychosis, or reincarnation. After all, Lessing argued in *The Education of the Human Race*, this idea deserved respect as humanity's most ancient hypothesis about immortality. An individual might well pass through various lives, getting wiser and better in each. 'Why should I not

come back as often as I am able to acquire new knowledge and new accomplishments? Do I take away so much on one occasion that it may not be worth the trouble [of] coming back?'[296]

These notions mark a relatively new way of imagining the afterlife. In the Middle Ages, the prevailing conception of the future existence awaiting redeemed souls, underpinned by the authority of Thomas Aquinas, held that they would spend eternity in the rapturous contemplation of God's perfection, enthralled by the beatific vision. In the eighteenth century, however, a radically different conception of the afterlife emerged, owing much to the Swedish visionary Emanuel Swedenborg.[297]

Swedenborg was a distinguished scientist, a member of several academies including the Royal Society of London, who, in the 1740s, underwent a spiritual awakening. Thereafter he claimed to be in constant communication with the denizens of the spiritual world, and to have visited heaven and hell. He recounted his visions in highly circumstantial detail in a large number of books, the principal one being *Arcana coelestia* (*Secrets of Heaven*), published anonymously between 1749 and 1756. According to Swedenborg, the saved will enter heaven immediately after their deaths. Instead of uninterrupted contemplation, which Swedenborg thinks would be boring, they will continue their earthly activities and their human relationships, including marriage. They will develop and perfect themselves, under the guidance of angels, and may eventually progress from the 'natural heaven', which resembles this world, to the 'spiritual heaven' and become angels themselves. Swedenborg's international reception was aided by the fact that, having been condemned by the Lutheran Church in Sweden, he had his books published in London. His influence can be traced in many eighteenth-century thinkers, and may well be present, combined with that of Leibniz, in the final scene of *Faust II*.[298]

A Swedenborgian afterlife may seem attractive, yet living for ever – for infinite millions of years – may not. Some people grow weary of life and wish to die; what if one grew weary of immortality and wished to die, but could not? Again, if I make progress towards perfection, sooner or later – probably sooner rather than later – I shall have changed so much that my present self will be unrecognizable. So whatever attains perfection will not be me. Herder, in a critical commentary on Lessing's speculations, concluded that metempsychosis makes no sense, since if people don't remember their previous lives they cannot know why they are suffering in this life. Besides, in earthly history, progress has increased our mechanical ingenuity but not the nobility of our characters; can we be sure that reincarnated beings would be better beings?[299] Though a clergyman, Herder shows his liberal attitude to Christian doctrine by dismissing all versions of future

survival and maintaining that people can prolong their existence, in a few cases by memorable achievements and in very many cases by benefiting their fellow-humans as parents, teachers or friends. Our immortality does not consist in individual existence beyond the grave, but in the contribution that our slightest action makes to collective humanity: 'This is the invisible, magical bond that links even the gestures of human beings; an everlasting communication of qualities, a palingenesis and metempsychosis of thoughts, feelings and impulses that were once mine and now belong to others, that once belonged to others and are now mine.'[300]

Other speculative thinkers adopted universalism, the hope that all may be saved. The most ancient version of this belief is apocatastasis, or 'the restitution of all things' (Acts 3:21), a doctrine especially associated with the early Church Father Origen (c.185–c.254). Origen argues that every rational being has absolute free will. The exercise of free will leads to differences between human beings. Since these differences start from birth, they must go back to acts of will made in a previous existence. Origen then supposes that this previous existence occurred not in the current age, but before the creation, and that there is a whole innumerable series of such ages, each starting with a creation and ending with a Last Judgement. Sinners go to hell, but hell is temporary and hence curative, and people get another chance in the next age. In an unimaginably long succession of ages, the souls of all rational creatures will cleanse themselves of sin, and the restitution of all things will occur. It follows from this doctrine that salvation must extend even to Satan: otherwise there would be a limit to the power of God's love.[301]

Although Origen found some agreement among Church Fathers, notably Gregory of Nyssa (c.330–c.395), his doctrine was rejected by Augustine and condemned at the Second Council of Constantinople in 553.[302] In the early modern period, universal salvation was upheld only by such rare figures as Erasmus – and that of Satan was considered impossible, because, as Milton says in *Paradise Lost*, the fallen angels are damned 'without redemption, without end'.[303] As God's love came to be imagined more vividly than his wrath, however, universal salvation found supporters. Many laypeople probably thought, like Rousseau's friend Madame de Warens, that the Scriptures were interpreted too literally and too severely, and that eternal torments were only figurative.[304] The Catholic priest Pierre Cuppé, writing around 1740 in the hope of 'dissipating those vain Terrors which are only proper to nourish a servile Fear, and to lead Men to dispair', maintained that, if humanity was justified by Christ's sacrifice, that justification must apply to everyone.[305] The Neologian Johann August Eberhard argued that eternal punishment was a

rationally indefensible doctrine, incompatible with God's love and with Leibniz's principle that the world was constantly advancing towards perfection.[306] The logical conclusion that even Satan would be saved was very bold, but the kindly spirit of the late Enlightenment was prepared to accept it. In Laurence Sterne's *Tristram Shandy* (1759–67), after hearing the terrible curse of Bishop Ernulphus, Uncle Toby has this exchange with the Roman Catholic Dr Slop:

> I declare, quoth my uncle *Toby*, my heart would not let me curse the devil himself with so much bitterness. – He is the father of curses, replied Dr. *Slop*. – So am not I, replied my uncle. – But he is cursed, and damn'd already, to all eternity, – replied Dr. *Slop*.
>     I am sorry for it, quoth my uncle *Toby*.[307]

Burns took a step further in his 'Address to the Deil' (1786). Bidding farewell to 'auld Nickie-ben', he hopes that the Devil may still 'tak a thought an' men'!' Hell is too awful even for the Devil:

> I'm wae to think upo' yon den,
>          Ev'n for your sake.[308]

Here a belief in humanity's basic goodness is extended to Satan, who is imagined as capable of remorse and repentance.

## THE POWER OF FEELING

Thinkers of the late Enlightenment were increasingly convinced that religious doctrine had to conform to their emotional intuitions. From there it was a short step to giving emotional intuition the priority over theological doctrine. This step was taken, most famously and influentially, by a religious thinker who stood outside any of the Churches (though he was nominally a Calvinist, and had briefly been a Catholic in his youth), Jean-Jacques Rousseau.

Rousseau's best-known statement of religious belief is the profession of faith supposed to be voiced by a Savoyard vicar, which forms part of *Émile* (1762). Coming from Geneva, Rousseau had no doubt imbibed something of the liberal Christianity propagated there by Jacob Vernet, the prominent Arminian cleric who taught a 'middle way' between orthodox Christianity and natural religion.[309] His vicar, though a fictitious character, owes something to some tolerant Catholic priests Rousseau had met in his youth. Like one of them, the abbé Gaime (who had fallen in love with an unmarried woman), the vicar is supposed to have offended his bishop by

'some youthful fault' and been transferred to a small mountain parish.[310] The vicar's creed is a kind of emotional deism, which explicitly owes much to Samuel Clarke and something also to the physico-theology that had inspired Rousseau since in his youth he read Pluche's *Spectacle de la nature*.[311] The vicar is convinced that the visible order of the universe proclaims a supreme intelligence, just as a watch reveals the existence of the workman who made it. Seeing is believing, for it is also feeling: 'I believe, therefore, that the world is governed by a wise and powerful will; I see it or rather I feel it, and it is a great thing to know this.'[312] By comparison with the evidence of seeing and feeling, theological speculations are mere arid intellectual exercises. The vicar believes in God but does not claim to understand God's attributes.

His religious conviction also guides his morality. The knowledge of right and wrong comes from his conscience, which is more reliable than reason unsupported by feeling:

> Too often does reason deceive us; we have only too good a right to doubt her; but conscience never deceives us; she is the true guide of man; it is to the soul what instinct is to the body; he who obeys his conscience is following nature and he need not fear that he will go astray.[313]

Rousseau is not here rejecting reason. He opposes the materialism of Diderot's circle by rational arguments, finding it intellectually confused. He disapproves of reason only when it is isolated from humanity's other faculties. 'To be genuinely convincing, the conclusions of reason should evoke man's "inner assent", a deeply affective response of his whole self to the truth perceived by his mind.'[314]

This undogmatic, heartfelt, generous conception of religious belief may seem congenial now, and was so to many of Rousseau's readers, but it horrified the orthodox, for it granted no authority to the divine revelation recorded in Scripture. The *parlement* of Paris, influenced by the theologians of the Sorbonne, formally condemned *Émile* and ordered its author's arrest. Copies of the book 'were to be lacerated and burned at the foot of the great staircase in the courtyard of the Palais de Justice'.[315] Rousseau, then living at Montmorency outside Paris, was warned of his danger and fled to Switzerland – not to his native Geneva, for the authorities there were equally angry about *Émile* and had it burned too, but to a secluded spot near Neuchâtel, where he would live until he was again forced to flee three years later.

The theological bestseller of the German Enlightenment was written by Johann Joachim Spalding, a Lutheran theologian who found himself repelled by dogmatic orthodoxy and by the obvious alternatives: the

quasi-geometrical reasoning offered by Christian Wolff, and the anti-rational enthusiasm offered by the Pietists. Fortunately he discovered Shaftesbury. He translated two of Shaftesbury's works, *An Inquiry concerning Virtue or Merit* (1699) and *The Moralists* (1709). There he found an inspiring conception of an 'end' or 'purpose' in human life: 'There being therefore in every creature a certain interest or good, there must be also a certain end to which everything in his constitution must naturally refer.'[316] On this conception, and on Shaftesbury's belief in man's innate and natural affections, which lead to virtue, sociability and religion, Spalding based his book *Die Bestimmung des Menschen* (*The End of Man*, 1748). This little pamphlet was successively enlarged in the eleven editions that appeared up to 1794.[317] It did much to promote the word *Bestimmung* as a way of talking about the purpose of human life with the minimum of theological baggage.[318]

In *Die Bestimmung des Menschen* Spalding tries to emancipate religion from dogmatic theology, to found it in human nature, and to rebuild Christian belief on the basis of an innate urge towards goodness, without any need to appeal to revelation. His essay is a monologue in which the speaker wonders about the purpose or end of his existence. His starting-point is an inner feeling that directs him first of all to satisfy his physical needs. Having done so, he considers the pleasures of the senses, but he soon finds that sensual pleasure is not enough. His own happiness is incomplete unless he strives to increase the happiness of other people. Now his inner urge towards the good becomes an interior lawgiver that wants him to practise justice, honesty, gratitude, magnanimity and love. Thus, not by revelation or external commands, but by self-examination, he comes to recognize 'the eternal rules of right and order'.[319] The resulting state of inner peace frees him from mental conflicts and enables him to appreciate the beauty of the world around him.

This introduces a tricky stage in Spalding's argument. For such a process might lead only to deism, to an appreciation of the unknown designer of the world, whereas he wants it to lead to a reaffirmation of Christianity. So he proceeds to conceive a perfect being who is the source of beauty and order: not an impersonal principle or a divine watchmaker, but a supreme intelligence that intends all things to be good. Not everything here on earth appears to be good, so it is necessary to look forward after death to the disclosure of the greater harmony that reconciles all apparent discords, and the benevolent plan by which the world is governed.

> I only want never to lose sight of my great purpose, and then to surrender myself with unmoved confidence to the dispositions of Him who directs all

things according to His will, and whose will is always good. Guided by His providence, I shall make my way successfully through the most frightful confusions of this life, and all the obscurities that may now surround and baffle me will at last be transformed into light and joy.[320]

Thus Spalding, albeit by a logic which may not seem compelling, re-established Christianity on the basis of feeling, free from the dubious authority of sacred texts. The orthodox sprang to arms, led by Johann Melchior Goeze, who many years later would attack Lessing. Having somehow obtained a manuscript of Spalding's pamphlet before its publi-cation, Goeze promptly wrote and published a reply in which he insisted that religious knowledge came from revelation and that the human will was too weak for people to attain salvation without the aid of divine grace.[321] But such a message no longer had wide appeal. Spalding offered his many readers a way of holding onto Christianity without the grimness of orthodoxy or wallowing in one's own sinfulness, as Pietists were thought to do.[322]

Spalding's emotional Christianity was developed in one of the key texts of modern theology: Friedrich Schleiermacher's *Über die Religion: Reden an die Gebildeten unter ihren Verächtern (On Religion: Speeches to its Cultured Despisers,* 1799). Schleiermacher, who had studied theology at Halle under the Neologian Eberhard, can fairly be called 'Spalding's heir'.[323] His work marks an unequivocal step out of the Enlightenment. For him, even more than for Spalding, religion is essentially feeling. Along-side speculation and praxis – or thought and action – religion is a third force, which links and reconciles the other two. It gives one a sense of union with the universe. But – and here Schleiermacher bids farewell to the Enlightenment – this union requires 'childlike passivity'.[324] Religion means abandoning claims to autonomy and accepting that one is utterly dependent on something far greater than oneself. The autonomy that Schleiermacher rejects is represented by an archetypal figure of the Enlight-enment, Prometheus:

> To want to have speculation and praxis without religion is rash arrogance.
> It is insolent enmity against the gods; it is the unholy sense of Prometheus,
> who in cowardly fashion stole what in calm certainty he would have been
> able to ask for and to expect. Man has merely stolen the feeling of his
> infinity and godlikeness, and as an unjust possession it cannot thrive for
> him if he is not also conscious of his limitedness, the contingency of his
> whole form, the silent disappearance of his whole existence in the
> immeasurable.[325]

## ENLIGHTENED DYING

The ultimate freedom, it could be argued, is over death. We cannot avoid death, but we can sometimes decide when and how to die. Suicide is not condemned in the Bible: despite Hamlet, there is no 'canon 'gainst self-slaughter'.[326] The commandment 'Thou shalt do no murder' is irrelevant, for, as Montaigne points out, taking my own property is not theft, so taking my own life is not murder.[327] Nevertheless, in early modern times suicide was a heinous crime. As the perpetrator could not be punished, the law tried to deter potential suicides by confiscating the property of actual suicides – thus impoverishing their heirs – and burying them at crossroads instead of in consecrated ground. In France the corpses of suicides were disgraced by being drawn through the streets on a hurdle, but in the more civilized eighteenth century this was no longer usual. In England, the ritual burial of a suicide at a crossroads last occurred in 1823.

Moralists argued that suicide implied despair, which was sinful; that one's life was not one's own to dispose of; that fortitude required more courage than suicide; or that a suicide was abandoning his responsibilities, like a sentry deserting his post. The pious poet Robert Blair maintained that as we did not create ourselves, we should not destroy ourselves, and was sure that suicides would suffer 'unheard-of tortures'.[328] Many Enlightenment thinkers advocated a more forgiving attitude. In Montesquieu's *Persian Letters*, Usbek argues that it is unjust to deprive anyone of an escape from a life that has become intolerable, and finally his slave Roxane commits suicide to escape from his unbearable tyranny.[329] Voltaire defended suicide as better than futile suffering: his story *L'Ingénu*, whose hero commits suicide out of grief, ends with the narratorial reflection: 'Malheur n'est bon à rien!' ('An ill wind blows nobody any good!').[330] Hume, opposing the standard objections, pointed out that if suicide disturbed the order of nature, so did every action, including building houses and cultivating fields.[331] The legal reformer Cesare Beccaria argued in 1764 that suicide should be decriminalized: not only does punishing it make no sense, but a suicide harms society less than an emigrant, since the latter takes his property with him while the suicide leaves his, yet it would be wrong for any state to forbid emigration.[332] Adam Smith, in an addition of 1790 to his *Theory of Moral Sentiments*, opined that suicide usually results from melancholy, and should prompt not censure but commiseration.[333]

Kant, here as in some other respects, turns away from the Enlightenment, condemning suicide severely. After briefly rehearsing the usual

objections, he concentrates on the claim that one has a duty to humanity, and hence towards oneself, and to destroy one's life is to violate that duty and hence to degrade the whole of humanity in one's own person. Kant then considers whether it is wrong to destroy parts of one's own body, and maintains that while it is permissible to have diseased limbs amputated, it would be partial suicide to be castrated in order to sing better, or to have a tooth extracted to give to someone else.[334]

Strong, but not unequivocal, support for suicide came from classical authors. To Epicureans and Stoics, the power to decide when to end one's own life was an aspect of human dignity. Roman history, moreover, celebrated many figures who had killed themselves rather than submit to tyranny. The most popular was Cato the Younger (95–46 BCE), a Stoic and staunch republican who killed himself rather than submit to the dictatorship of Julius Caesar, and who provided a hero for tragedies by Addison (*Cato*, 1713) and Johann Christoph Gottsched (*Der sterbende Cato* (*The Dying Cato*), 1732).[335]

In England especially, suicides became objects of compassion rather than execration. Coroners' juries increasingly often decided that the subject had committed suicide when mentally disturbed, so that no penalties should be exacted. In Norwich (for which unusually full records survive), by the 1720s 90 per cent of suicides were judged insane, and from 1770 Norwich coroners returned *only* verdicts of *non compos mentis*.[336] It was in England, too, that the word 'suicide' (instead of 'self-murder') was coined, by Sir Thomas Browne, and borrowed into other languages.[337] This tolerant attitude persuaded foreigners that the English were peculiarly prone to suicide arising from melancholy. Montesquieu attributed this propensity to the English climate.[338] People in England, as elsewhere, committed suicide for many reasons – poverty, family breakdown, disgrace, unrequited love – but the important point is that suicide was seen as a medical problem rather than as an offence against religion.

What about normal death? Eighteenth-century people usually died in public. Family and friends gathered to comfort the dying, who often gave deathbed advice to their children. They made a public display of repentance, trust in God and submission to his will.[339] Catholics made their last confession and received absolution and the Eucharist, which enabled many to die peacefully. Even young children witnessed death, not always with reverent thoughts. In his fictionalized autobiography, Karl Philipp Moritz remembered how, aged eight at most, he stood at the bedside of his uncle by marriage and, having heard his mother say of a dying man 'death is already sitting on his tongue', peered into his uncle's mouth 'in order to discover death, perhaps as a small black figure, on his tongue'.[340]

Many eighteenth-century clerics, of whatever Church, still used their hold over people's emotions in order to terrify the dying and their relatives. In 1754, the sight of his first wife dying in terror confirmed the *philosophe* d'Holbach in his atheism and turned it into a passionate conviction, as we know from the correspondence of an Italian visitor, Alessandro Verri:

> I am told that the Baron's system and the heat with which he maintains it originate from having watched his first wife die torn by inner conflict and amid the horror of an eternity of torment. This moved him powerfully and marked an epoch in his emotional life.[341]

A funeral sermon preached at Springfield, Massachusetts, in 1782 warned those listening:

> Death is justly stiled the King of Terrors, the most terrible of all terribles. The pains and agonies of a dying hour are very terrifying, the thought of being disembodied and dissolved very disagreeable; the consequences infinitely great and important. Many a good man (some for one reason, and some for another) have [*sic*] stood shuddering on the brink, afraid to launch out into the bottomless ocean of eternity.[342]

This view of death found expression in one of the darkest poems of the eighteenth century, Blair's *The Grave* (1743). Blair apostrophizes 'The Grave, dread Thing!' and summons up 'the gloomy horrors of the tomb', with skulls, coffins, the 'dreary' howling wind, and 'grizly spectres'. He contemplates the transience of all worldly attainments and human qualities; imagines how soul and body will part, the former to face an uncertain judgement, while the latter 'drops into the dark and noisome Grave, / Like a disabled pitcher of no use'. In this perspective, the world itself is nothing but 'a spacious *Burial-field* unwall'd'. Only at the end does Blair offer some consolation by foreseeing that the good man will make a calm exit.[343] Harking back to an earlier version of spirituality, Blair's poem belongs to the religious revival led by John Wesley that combated the irreligion imputed to the Enlightenment. He was helped in revising and publishing it by the prominent evangelical Christians Isaac Watts and Philip Doddridge. Neglected for some forty years, the poem gained great popularity from the 1780s with the growth of the evangelical movement. Its morbid imagery also appealed to the Gothic taste that was so powerful at the end of the century, and in which the terrors of religion were transmuted into aesthetic thrills.

To help people die, Christian writers composed *artes moriendi*, instructing people to prepare for death while still alive and well: for 'the life of a Christian is nothing els but a meditation of death', according to the

sixteenth-century Puritan William Perkins.[344] Hence people often wore
rings with a tiny death's-head, and maxims recalling the brevity of life
were engraved on mantelpieces and sundials.[345] The popular motto
'memento mori', 'remember that you must die', urged people to prepare
for their end. Perkins expected a deathbed to be terrifying:

> it is true that not only wicked and loose persons despaire in death, but also
> repentant sinners, who oftentimes in their sickenesse, testifie of themselues
> that being aliue and lying in their beddes, they feel themselues as it were to
> be in hell, and to apprehend the very pangs and torments thereof.[346]

Feelings of terror need not mean that one was damned, but that God was
reminding people of their dependence on him by taking them to heaven
via the gates of hell. But a quiet death did not mean that one was saved:
'a man may die like a lamb, and yet goe to hell'.[347] By contrast, the Angli-
can Jeremy Taylor, in *Holy Dying* (1651), urges that one should prepare
for death throughout one's life by daily self-examination and the practice
of charity, and that death should be accompanied by prayer and repent-
ance. Unlike Perkins, he tries to dispel the fear of death, urging that it is
not an evil: it simply separates 'two differing substances', sending 'the Soul
to God our Father, the Body to the earth our Mother; and what in all this
is evil?'[348]

Enlightened authors sought to combat unnecessary terror. They had
the example of Lucretius, who argues eloquently against the fear of death.
We do not mind not having existed before we were born, says Lucretius,
so why should we mind ceasing to exist after our deaths? The fear of death
sometimes results from the subconscious fancy that after death we shall
still experience sensation.[349] But that is false, and death is best imagined
as a peaceful and uninterrupted sleep. Following Lucretius, the exiled
Italian materialist Alberto Radicati argued in 1732 that in death one does
not cease to exist; the matter of which one is composed merely enters a
new configuration. Hence 'we ought not to be under Apprehension of
losing our Existence when we die, since we only cease to exist in one sort,
in order to begin to exist in another.'[350] Fear of death is not innate; it is
merely the fear, inculcated by miseducation, of real or imaginary danger.
Having published these sentiments, Radicati was obliged to flee from
Britain to Holland, where, worn down by persecution and faced with the
actual prospect of death, he became a Calvinist Christian.

Other Enlighteners adopted less radical and more durable convictions.
The naturalist Buffon argues at length that we should neither fear nor
avoid death, seeking to 'destroy a prejudice so contrary to human happi-
ness'.[351] The *Encyclopédie* urged its readers not to fear death, arguing

from the experience of physicians and clergymen that painful deaths were a minority and that most people died gently (*doucement*):

> People fear death as children fear the dark, and solely because their imaginations have been frightened with phantoms as empty as they are terrifying. The final leave-taking, the tears of our friends, mourning and the ceremony of funerals, the convulsions of the machine as it breaks down, that is what tends to frighten us.[352]

La Mettrie, who as an army doctor had seen many men die in military hospitals, agrees that for the majority death is gentle (*douce*).[353] Spalding accepts death: 'I think of my departure from this stage of life as something I may be called on to do this very hour, and this idea, otherwise so frightful, does not discompose me.'[354] In Rousseau's *La Nouvelle Héloïse*, the Protestant minister deplores how men of the cloth are regarded as messengers of death, and, still more, how Catholics surround dying people with terrifying memento mori images: 'A dying Catholic is surrounded only by objects that horrify him, and ceremonies that bury him while still alive', adding that the Church induces such terror in order to have access to the dying person's purse.[355] The dying Julie retains her confidence in God; instead of surrendering to misery, she dresses neatly and keeps her sickroom pleasant, with the curtains open and flowers on the mantelpiece. In a similar spirit, Lessing contrasts the Christian iconography of death as a skeleton, which breeds unnecessary fear, with the classical image of death, the half-brother of sleep, represented as a handsome youth holding a torch upside down to show that it is extinguished.[356]

A similarly enlightened view of death appears in one of the century's most famous poems, Thomas Gray's *Elegy written in a Country Churchyard* (1751). Here the act of dying is present only as an implied analogy to the tranquil fading of the day with which the poem opens: 'The Curfew tolls the knell of parting day.'[357] The day's death-knell is followed by 'a solemn stillness' in which the poet contemplates the unrecorded lives of the rural poor and imagines what unrealized talents they may have possessed. The poem forbids us to despise their 'useful toil' and reminds us that, no less than their 'destiny obscure', 'the paths of glory lead but to the grave'. Not that the poem is at all egalitarian: the 'universality and impersonality' of its style, as William Empson noted, 'claim as if by comparison that we ought to accept the injustice of society as we do the inevitability of death'.[358] Even so, Gray's respect for the 'common people', in death as in life, makes a welcome contrast to the contempt for them that was often expressed by Voltaire.

Goethe, like Rousseau, detested the Christian imagery of the suffering

body and the cultivation of morbid feelings. In Verona in 1786, he admired ancient funerary monuments that depicted figures with natural emotions:

> And the grave monuments are warm and touching. You see a man beside his wife looking out of a niche as if from a window, a father and mother stand with their son between them and look at one another with ineffable naturalness, a couple stretch out their hands to each other ... I was so deeply moved in the presence of these stones that I could not hold back my tears. Here is no man in armour on his knees waiting for a joyous resurrection, what the artist has here set down with more or less skill is never anything more than the simple present of human beings, which thereby prolongs their existence and makes it permanent.[359]

Many can talk bravely about death, but sooner or later everyone has to go through with it. How did Enlighteners really die? In France, it was difficult to avoid receiving the sacraments, but a few *esprits forts* rebuffed the priest with jokes or defiance. The famous antiquarian Anne Claude de Caylus, seeing his relatives gathered round his deathbed and concerned about his soul, said: 'I am going to let you into my secret. I haven't got one.'[360] Voltaire planned his death in the opposite spirit to the *artes moriendi*: he wanted to comply minimally with custom, but to avoid recognizing the divinity of Christ or receiving the sacraments. He got away with it, declaring 'I die in the Catholic religion in which I was born', which did not actually imply belief in religion. As John McManners says in his masterly account of Voltaire's deathbed manoeuvrings: 'He was a Catholic, but not a Christian.'[361]

We know accounts of several deathbeds of enlightened Christians and deists. Lessing, after two years of declining health, knew from his increasing difficulty in breathing when his end was near. He died peacefully, his last words being addressed to his stepdaughter: 'Be calm, Malchen.'[362] The eighty-year-old Christoph Martin Wieland, a famous ironist and sceptic, died with composure in 1813. Wieland rejected the false reassurances offered by his doctor, and had people read aloud and play music to him for as long as possible. His last clear utterance was: 'The gods are entitled to be rough, because they are gods, but a rational person must act rationally.'[363] In Scotland, William Robertson at the end of his life was 'calm and collected, and placid, and even gay'.[364] In 1790 the Moderate minister and historian Robert Henry summoned his younger fellow-minister, Sir Henry Moncreiff, with the words: 'I have got something to do this week, I have got to die.' As Henry Grey Graham tells the story: 'So the young Evangelical divine stays with the old Moderate divine till he dies, – chatting, joking, reading, – honest piety blending with venerable fun.'[365]

The most notorious instance of an enlightened death was that of David Hume.[366] It was still widely assumed that an atheist would die in terror, like the hero's wicked brother in Sarah Fielding's *David Simple* (1744).[367] Hume disproved this belief. From 1772 his health was in decline. He suffered from what he called 'a diarrhoea, or disorder in my bowels', with nocturnal fevers and internal haemorrhages.[368] But he continued to enjoy life as best he could. In 1776, when his end was clearly in sight, he read and appreciated two new books, Adam Smith's *Wealth of Nations* and the first volume of Gibbon's *Decline and Fall*. In the account of his own life that he wrote in April 1776, he noted: 'I now reckon upon a speedy dissolution.'[369] Adam Smith tells how the dying Hume read the Greek satirist Lucian (a favourite writer also of Wieland's) and diverted himself with imagining the reasons he might give Charon (the ferryman who in classical mythology transported souls to Hades) for not getting into his boat:

> I thought I might say, Good Charon, I have been endeavouring to open the eyes of people; have a little patience only till I have the pleasure of seeing the churches shut up, and the Clergy sent about their business; but Charon would reply, O you loitering rogue, that wont happen these two hundred years; do you fancy I will give you a lease for so long a time? Get into the boat this instant.[370]

In almost his last letter, on 20 August 1776, Hume wrote to the comtesse de Boufflers: 'I see death approach gradually, without any anxiety or regret.'[371] His stoicism is the more impressive because his death, far from being easy, was preceded by constant pain.

Hume's serenity even survived a visit from James Boswell, who had himself absorbed so much of the terror imparted by Presbyterianism that he could not quite believe in Hume's calm acceptance of annihilation. Listening to Hume's dismissal of immortality, Boswell felt 'a degree of horror', and for months afterwards he was haunted by the contradiction between Hume's unbelieving readiness for death and the religious lessons he himself had gained from his mother's instruction and his friendship with Samuel Johnson.[372]

The contrast between Hume's serenity and Boswell's 'horror' suggests some of the difficulties in the Enlightenment search for happiness. Hume and Boswell were more alike than either realized. As a young man, Hume suffered from a 'Distemper' that for a time made him unable to arrange his thoughts coherently, and in his *Treatise of Human Nature* (1739) he admits that abstruse reflections can lead him into a 'philosophical melancholy and delirium' from which sociability provides an

escape.[373] Hume managed to reach a compromise, at least in writing, 'between the needs of the feeling self and the expository capabilities of the rational self'.[374] Boswell found that 'speculation renders us miserable'.[375] Although he made many overambitious plans to control his melancholy by a sober lifestyle, his preferred escape was into dissipation. Some obscure, self-punishing impulse led him to strengthen the religious terrors of his childhood and even take a perverse pleasure in indulging them. The complexity of the mind, over which Boswell repeatedly brooded in his journals, could frustrate any search for happiness. It was appropriate that Enlighteners, especially Hume, turned, as we will see in the next chapter, to the study of human nature, called 'the science of man'.

# 6

# Science and Sensibility

What kind of creatures are human beings, and what kind of creatures should they try to become? In the seventeenth century, immediately prior to the Enlightenment, many people answered these questions by appealing to reason. Humanity was first and foremost rational, endowed by God with the gift of reason in contrast to the animals. The Enlightenment, however, increasingly sought a more rounded conception of humanity, in which emotion and sensibility could coexist harmoniously with reason.

By the eighteenth century it had become difficult to believe that the emotions could be strictly subordinated to reason. Neo-Stoicism, which claimed that the wise man could make himself indifferent to the blows of fate and fortune, seemed now too remote from the facts of experience. Admittedly, elements of Stoicism survived in many eighteenth-century thinkers. The ideal of self-control, the use of reason to discern what is good, the approbation of one's own conscience, and the effort to practise morality without expecting supernatural rewards or punishments were all recognized as valuable. But Adam Smith, who gives a sympathetic account of Stoicism in *The Theory of Moral Sentiments* (1759), nevertheless adds that this philosophy seems contrary to nature, since it centres on 'sublime contemplation', which nature offers us only as the consolation of our misfortunes.[1] In Rousseau's *Julie ou la nouvelle Héloïse* (1761) the Englishman Lord Bomston affects to be a Stoic, but his friend Saint-Preux suspects that he merely invents quasi-philosophical reasons for what are in fact the impulses of his heart.[2]

Not many people, after all, are philosophers. Most people want, and indeed are forced to have, an active, not a contemplative relationship with their fellow-beings. Another model of humanity places the emphasis on self-love, but draws unexpected consequences. As we have seen, a return to the thought of St Augustine produced the important strand of Catholic thinking known as Jansenism, in which one had to examine oneself for signs of grace. Transferred to a worldly framework, this self-examination

brought forth subtle and unsparing psychological analysis, above all in the hands of François de La Rochefoucauld. In La Rochefoucauld's *Maxims* (1665), it is assumed that the chief motor of human action is self-love. True, disinterested love may exist, but as ghosts do: everyone talks about them, but hardly anyone has actually seen any.[3] Self-love gives rise not only to vices but also to virtues. Apparent generosity is often disguised ambition; fidelity is 'an invention of self-love to attract confidence'.[4] Virtue is strengthened, and made effective, by 'interest', a key moral concept that we will find again in Diderot and the Marquis de Sade. 'The virtues lose themselves in interest, as rivers lose themselves in the sea.'[5] So-called friendship is really a way of regulating our interests in a mutually beneficial interaction, which is the centre of social life: 'What people have called friendship is only a society, a reciprocal management of interests, and an exchange of good offices; finally, it is a species of commerce, where self-love is always looking for something to gain.'[6] In the eighteenth century, the world according to La Rochefoucauld was often felt to be repellently bleak.

## SELF-LOVE AND SYMPATHY

The theory of self-love was developed, in drastic and unexpected ways, by Bernard Mandeville. Born in Rotterdam in 1670, Mandeville studied medicine at Leiden but in the 1690s settled in London, mastered the English language, married an Englishwoman, and remained a successful physician till his death in 1733. His fable 'The Grumbling Hive' attracted little attention when first published as a pamphlet in 1705, but in 1714 Mandeville reissued it as *The Fable of the Bees: or, Private Vices, Publick Benefits*, with a series of 'Remarks' some ten times longer than the poem. Enlarged editions in 1723 and 1724 brought Mandeville notoriety. His book was attacked by many prominent writers, including the moralist Francis Hutcheson, the hymn-writer Isaac Watts and Bishop William Warburton, who called its central thesis 'An unheard of Impiety, wickedly advanced, and impudently avowed, against the universal Voice of Mankind'.[7] It was denounced as a public nuisance by the Grand Jury of Middlesex, and Mandeville acquired the nickname 'Man-devil'.[8]

The core argument that enraged Mandeville's contemporaries is that private vices are beneficial to the public. In his fable, the bees individually are proud, greedy, spendthrift and dishonest, yet their hive is far wealthier than any other. But as the bees are always grumbling about immorality, the gods intervene and suddenly convert them all to honesty. Nobody cheats or gets into debt; commerce declines; arts, crafts and manufactures

are forgotten; depopulated and impoverished, the hive barely manages to fight off invaders, and the surviving bees retreat into a hollow tree. The moral, expounded at length in the subsequent remarks, is that a large-scale prosperous commercial society depends on the gratification of instincts that moralists call vicious. Everyone wants to impress and outdo their neighbours by means of luxury and ostentation. Hence trade and manufactures flourish. Without vice, we would not have our present society minus its drawbacks; rather, we would have a virtuous but poor society like ancient Sparta, which none of us would want to live in.

Simply as an economic argument, Mandeville's thesis is initially persuasive. The demand for luxury goods is necessary to power a large-scale, prosperous society. Mandeville punctures such facile assumptions as the claim that luxury makes people soft: 'clean Linnen weakens a Man no more than Flannel'.[9] Characteristically, however, he also addresses the hardest case. He has an eloquent passage about the evils of the gin trade, which 'charms the Unactive, the desperate and crasy of either Sex', destroys the health and industry of the poor whose labour is necessary for a flourishing economy, and is carried on by dishonest retailers who generally go bankrupt through drinking their own wares. And yet, Mandeville argues, this condemnation is short-sighted. We should reflect that the production of gin employs many people; taxes on it increase the national revenue; and anyway, gin makes the poor happy, strengthens some though it weakens others, and is essential to support the courage of soldiers. The latter arguments are placed in the mouth of a 'sharp-sighted good-humour'd Man', as though Mandeville is too uneasy to present them himself.[10] Nowadays, similar arguments could be put forward in defence of drug-dealing or the tobacco industry. Would we accept them? Or would we not rather agree with Hume, in his reply to Mandeville, that vice (even if we avoid this word) can never be beneficial to society?[11] Or, again, is it possible that we and Hume have fallen into the trap laid by Mandeville the satirist, and that the 'good-humour'd Man' is as artificial as the 'very knowing *American* of my Acquaintance' whom Jonathan Swift in 'A Modest Proposal' (1729) pretends to cite as an advocate of eating children?[12]

Mandeville's defence of vice is founded on a theory of human nature that assigns a key role to the passions and places little reliance on reason. He understands humanity as 'a Compound of various Passions, that all of them, as they are provoked and come uppermost, govern him by turns, whether he will or no'.[13] Among these passions, Mandeville agrees with La Rochefoucauld in assigning the primacy to self-love: 'all Passions center in Self-Love'.[14] He rejects claims that humanity is naturally virtuous. If humanity is sociable, it is not because of virtue, but because of vices. The

vice of self-love generates pride, i.e. the overvaluation of oneself, which is the quality most beneficial to society, for it gives rise to the sentiment of honour and its opposite, shame. 'The Greediness we have after the Esteem of others, and the Raptures we enjoy in the Thoughts of being liked, and perhaps admired, are Equivalents that over-pay the Conquest of the strongest Passions, and consequently keep us at a great Distance from all such Words and Actions that can bring shame upon us.'[15] We are made into social beings by the desire to be respected by others, and compelled to behave well by the fear of public disgrace. Honour is

> the tye of Society, and though we are beholden to our Frailties for the chief Ingredient of it, there is no Virtue at least that I am acquainted with, that has been half so instrumental to the civilizing of Mankind, who in great Societies would soon degenerate into cruel Villains and treacherous Slaves, were Honour to be remov'd from among them.[16]

A sunnier view of human nature was promoted by the earl of Shaftesbury, one of the most influential writers of the eighteenth century, and one who decisively shaped the Enlightenment. Born into the Whig aristocracy, and hence with an inbuilt suspicion of kings and their courts, Shaftesbury divided his time between philosophy and politics. Thanks to John Locke, who lived in the Shaftesbury household and had been his tutor in his boyhood, Shaftesbury was in contact with many intellectuals in both Britain and the Netherlands, including Bayle and other advocates of toleration, along with the deist John Toland and the Scottish republican Andrew Fletcher. From 1695 to 1698 he was MP for Poole, and after his father's death in 1699 he conscientiously attended the House of Lords. Political activity, however, had put him under such psychic strain that in 1698 he left England and lived for a year in Rotterdam. Here he kept a journal, which records his psychological crisis with such entries as this: 'Thus frequently in other Losses of Mind not knowing wch way to turn, when beset, when urg'd, when divided in opinion on Family & Publick – Emergencyes: & in reality Distracted thus. Restless Nights. Throws. Labours. Groans.'[17] The calm and optimistic approach to life that Shaftesbury advocated in his mature philosophy clearly had nothing facile about it; it was an attempt, apparently successful, to conquer his own demons. In the first decade of the eighteenth century, Shaftesbury published a series of philosophical works that he assembled in revised form as *Characteristics of Men, Manners, Opinions, Times*. The book appeared in 1711, two years before Shaftesbury's premature death from respiratory disease.

Shaftesbury's account of human nature is intended to oppose the grim picture given by Hobbes in *Leviathan* (1651).[18] For Hobbes, humanity's

natural condition is war. Every man is naturally hostile to every other man. Hence, to control their natural passions, people must be compelled to obey the authority of a sovereign. The natural sociability of ants and bees cannot be a model for humans, because 'men are continually in competition for honour and dignity, which these creatures are not; and consequently among men there ariseth on that ground, envy and hatred, and finally war.'[19] Shaftesbury replies that humanity is by nature both social and sociable. 'If eating and drinking be natural, herding is so too. If any appetite or sense be natural, the sense of fellowship is the same.'[20] Natural affection draws a couple together and impels them to look after their helpless infants. The family need food and a dwelling-place, which will bring them into contact with other people. The household grows into a tribe, and the tribe into a nation. What is natural for man is what preserves the species. In an ingenious reversal of Hobbes's argument, Shaftesbury maintains that even war is a sociable activity, for it depends on co-operation: 'it is in war that the knot of fellowship is closest drawn. It is in war that mutual succour is most given, mutual danger run, and common affection most exerted and employed. For heroism and philanthropy are almost one and the same.'[21] Finally Shaftesbury rebuts Hobbes by arguing that if he had genuinely believed in his philosophical egoism, he would have kept it to himself instead of sharing it with the world. Hobbes was really a 'good sociable man' who wrote for the good of his fellow-humans, in order to liberate them from tyranny and superstition.[22]

Shaftesbury knows, however, that the claim that human beings are basically selfish is not so easily dismissed. Besides Hobbes's philosophical egoism, he is opposed also to the French moralists and aphorists such as La Rochefoucauld, who have ascribed most or all of human behaviour to self-love. So, Shaftesbury brings up two weapons. First, extending his claim that humanity is naturally sociable, he argues that selfish pleasures are not real pleasures. Even the pleasures of sense only become satisfying when they are shared. Eating and drinking are more fun in company. Sex is not really enjoyable unless accompanied by mutual affection. Sympathy with others, and enjoyment of their evident pleasure, is not just an enhancement to our own pleasure, but altogether essential to it. 'So insinuating are these pleasures of sympathy, and so widely diffused through our whole lives, that there is hardly such a thing as satisfaction or contentment of which they make not an essential part.'[23]

As his second weapon, Shaftesbury, perhaps here indebted to Stoicism, maintains that we have a 'natural moral sense'.[24] When we reflect on our conduct, we know when we have acted well or badly. We have a 'moral or natural conscience', independent of religion.[25] We do not need God's

commandments to tell us what is right, and we do not need the fear of God to make us do it. If there were a person without any conscience (in present-day language, a psychopath), such a person would be incapable of affection towards others, and hence incapable of pleasure. Our moral sense co-operates with our natural affections to guide us in pleasurable coexistence with our fellow-humans.

Although morality is in Shaftesbury's view innate, it still requires reflection and interpretation. So he assigns an important role to reason. Natural affection can be overdone and harmful, as when a mother pampers her child. It may also lead us into moral dilemmas.[26] In either case, 'worth and virtue depend on a knowledge of right and wrong and on a use of reason sufficient to secure a right application of the affections'.[27] Reason therefore is necessary as a means of managing our natural affection in the best way. As in orthodox Christianity reason is subordinate to faith, so in Shaftesbury reason becomes subordinate to feeling.

For Enlighteners, this message about humanity's natural virtue, based on feeling, was highly welcome. It was assisted by Shaftesbury's relaxed style. Instead of the austere concision of Hobbes, or the geometrical arguments in Spinoza, Shaftesbury offered conversational prose implying a constant dialogue with the reader. He maintains that pleasures are 'wholly founded in an easy temper, free of harshness, bitterness or distaste, and in a mind or reason well composed, quiet, easy within itself', and he seeks to promote the same attitude in his readers.[28] His work belongs to the 'polite', sociable culture that received a powerful impetus from Addison and Steele with their *Spectator*. Nowadays, his language seems long-winded and sometimes flowery. Adam Smith, in the lectures on rhetoric he gave at Glasgow in 1751–2, criticized Shaftesbury's style for being too prolix and metaphorical.[29] Montesquieu, however, classed him among the four great poets (meaning, presumably, great thinkers who were also great literary artists), the others being Plato, Montaigne and Malebranche.[30] In Diderot's article 'Génie' in the *Encyclopédie*, Shaftesbury is called 'a genius of the first order' to whom we owe 'brilliant systems, often somewhat superficial, yet full of sublime truths'.[31] Wieland in 1758 calls Shaftesbury 'the subtlest and most ingenious of all modern writers'.[32]

Shaftesbury's philosophy of sociability inspired the Scottish school of moral philosophers who, in different ways, saw the power of sympathy as central to human nature. Their first great representative, Francis Hutcheson, an Irish Presbyterian from County Down, developed his ideas while directing a dissenting academy (an advanced school for Presbyterians and other Nonconformists) in Dublin. His early philosophical works, beginning with *An Inquiry into the Original of our Ideas of Beauty and Virtue* (1725), led

to his election to the chair of moral philosophy at Glasgow, where his inaugural lecture, delivered in Latin, dealt with the natural sociability of mankind. Hutcheson was an inspiring lecturer, who introduced the practice of lecturing in the vernacular instead of Latin (as Christian Thomasius had done in Germany since 1687). A pupil later wrote: 'He was a Good Looking Man of an Engaging Countenance. He Deliver'd his Lectures without Notes walking Backwards and forwards in the Area of his Room – as his Elocution was Good and his Voice and Manner pleasing, he rais'd the attention of his Hearers at all times.'[33] It must be a tribute to his exposition that he also drew large numbers of non-academic hearers to the free lectures he gave on Sunday evenings about Grotius' evidence for the truth of Christianity. His own religion was suspect: the idea that humanity could know and do good without help from God led to a prosecution for heresy, against which, however, Hutcheson managed to defend himself – a sign that the institutional Church was gradually losing its power.[34] By his death in 1746 at the age of fifty-two, Hutcheson had inspired much admiration and some controversy.

Hutcheson's first book makes his standpoint clear by its subtitle, which runs (in part): *In Which the Principles of the late Earl of Shaftesbury are explain'd and defended, against the Author of the Fable of the Bees.* He develops Shaftesbury's concept of the moral sense in order to rebut Mandeville's claim that all action is motivated by self-interest. Our perception of goodness is analogous to our perception of beauty, and is similarly immediate. Moral goodness denotes a quality in actions which makes us approve the action, and love the actor, even though it does not serve our advantage. This distinguishes moral good from natural good. We love honest and generous people, but we do not love people just for being healthy, strong, or rich; we are quite likely to envy and hate them. The perception of moral good gives us pleasure, and we call objects and actions good which excite such pleasure; this feeling is *prior* to any advantage they may give us. Our feelings towards someone who helps us for our own sake are quite different from our feelings towards someone who helps us simply from his own self-interest. Benevolence towards others is a natural impulse and a reliable source of pleasure.

To prove the existence of the moral sense, Hutcheson insists, with many examples, that we know the difference between right and wrong. We may act wrongly for our own advantage, but we know what we are doing:

> Should any one advise us to wrong a Minor, or Orphan, or to do an ungrateful Action toward a Benefactor; we at first View abhor it: Assure us that it will be very advantageous to us, propose even a Reward; our Sense of the

Action is not alter'd. It is true, these Motives may make us undertake it; but they have no more Influence upon us to make us approve it, than a Physician's Advice has to make a nauseous Potion pleasant to the Taste, when we perhaps force our selves to take it for the Recovery of Health.[35]

Even wicked people do not admit that they are acting wrongly, but justify their conduct by claiming that it is in some way virtuous:

Were we freely conversant with Robbers, who shew a moral Sense in the equal or proportionable Division of their Prey, and in Faith to each other, we should find they have their own sublime moral Ideas of their Party, as Generous, Courageous, Trusty, nay Honest too; and that those we call Honest and Industrious, are imagin'd by them to be Meanspirited, Selfish, Churlish, or Luxurious; on whom that Wealth is ill bestow'd, which therefore they would apply to better Uses, to maintain gallanter Men, who have a Right to a Living as well as their Neighbours, who are their profess'd Enemys.[36]

Hutcheson's imagined robbers, by reinterpreting their conduct, anticipate the revaluation of values described by Nietzsche over a century and a half later in *The Genealogy of Morals* (1887). But while Nietzsche's distinction between master morality and slave morality is meant to prove that there is no fixed standard of morality, Hutcheson assumes that there *is* a fixed standard, and that everyone knows it, whether they admit it or not.

Hutcheson's account of human nature may now seem too good to be true. Some contemporaries doubted whether he had seen off Mandevillean self-interest as conclusively as he thought. After all, argued John Clarke, a Hull schoolmaster, if benevolence gives pleasure, then the pursuit of benevolence must itself be motivated by self-interest.[37] One might also wonder, if virtue is so pleasurable, why anyone is wicked. Hutcheson attributes wickedness to 'a mistaken Self-Love, made so violent, as to overcome Benevolence'.[38] But if wickedness leads to misery, as Hutcheson insists, why don't people learn from others' mistakes, just as we have learned not to eat poisonous plants? In speaking of violence, has Hutcheson briefly recognized the relentless drive that would later be called 'aggression', but refrained from pursuing the subject? Self-love seems to be a more powerful passion than Hutcheson admits, and his description of human nature looks one-sided.

Adam Smith, who attended Hutcheson's lectures at Glasgow, and subsequently held the chair of moral philosophy there from 1752 to 1764, dissented from his teacher's 'amiable system'.[39] He thought Hutcheson expected too much of people's benevolence. We may remember the famous sentence from *The Wealth of Nations*: 'It is not from the benevolence of

the butcher, the brewer, or the baker, that we expect our dinner, but from their regard to their own interest.'[40] When Smith set out his own system of moral philosophy in *The Theory of Moral Sentiments* (1759), he placed the emphasis not on benevolence but on sympathy, and described its working in a complex way. Smith uses 'sympathy' to mean not benevolence or compassion, but 'our fellow-feeling with any passion whatever'.[41] Sympathy depends on imagination. It is the ability to put ourselves in another person's shoes, to imagine what we would feel in their situation. We feel pleasure when our feelings correspond to another's – that is, when the feelings he expresses are what we would experience in his situation. But we feel displeasure if his feelings appear to be either more or less than we would feel: if someone complains of a misfortune that would not upset us, or if someone pusillanimously accepts an injury which we would resent.

Smith insists that there is nothing selfish about sympathy. It would be selfish if, condoling with a bereaved father, I were to think about what I would feel if I were to lose a child. Sympathy goes much further: 'I consider what I should suffer if I was really you, and I not only change circumstances with you, but I change persons and characters.'[42] Hence I can feel sympathy with people whose misfortunes I could never possibly experience myself: Smith gives the example of a man sympathizing with the pains of a woman in labour.[43]

We adopt the standpoint of a spectator, not only towards others but also towards ourselves: that is, we ask ourselves what a spectator of our own situation would feel, and adjust our feelings accordingly. We examine our own conduct as it would look to others; we try to see ourselves as others see us. Robert Burns, who owned a copy of *The Theory of Moral Sentiments*, introduces Smith's idea of the impartial spectator into 'To a Louse' with the famous wish:

> O wad some Pow'r the giftie gie us
> To see oursels as others see us![44]

Smith's sympathy presupposes that human beings are first and foremost social. We have a fundamental need for the approval of those around us:

> Nature, when she formed man for society, endowed him with an original desire to please, and an original aversion to offend his brethren. She taught him to feel pleasure in their favourable, and pain in their unfavourable regard. She rendered their approbation most flattering and most agreeable to him for its own sake; and their disapprobation most mortifying and most offensive.[45]

T H E

# THEORY

O F

## MORAL SENTIMENTS.

By ADAM SMITH,
Professor of Moral Philosophy in the
Univerfity of Glasgow.

LONDON:
Printed for A. MILLAR, in the STRAND;
And A. KINCAID and J. BELL, in EDINBURGH.
M DCC LIX.

The *Theory of Moral Sentiments* (1759) was the main product of Adam Smith's
tenure of the chair of moral philosophy at Glasgow (1752–64), but since
academic professionalism was less rigid then than now, he had previously
lectured on literary composition, jurisprudence and logic, and would later
apply himself as a private scholar to the study of economics.

However, we do not only want praise: we also want to deserve praise. We therefore act virtuously so that we can approve of our own actions. This self-approval is not vanity, but rather the internalization of the approval that we want other people to feel towards us. It is 'the love of what is honourable and noble, of the grandeur, and dignity, and superiority of our own characters'.[46] Conversely, if we know we are blameworthy, even if undiscovered, we feel 'natural pangs' of conscience when we imagine what people would think of us if they knew of our guilt.[47] Our conscience is an internalized version of our desire for external praise. It enables us to gain some distance both from the judgement of society and from our own egoism.

Sympathy, as Smith defines it, is a cognitive capacity rather than an emotional one. It is not to be identified with sympathetic feeling. Smith points out how difficult it is to feel concern for people who are remote from us. If we did not have conscience to give us some sense of proportion, then, says Smith, we would care more about a trifling injury to ourselves than about the entire destruction of China in an earthquake:

> If [a man] was to lose his little finger to-morrow, he would not sleep to-night; but, provided he never saw them, he will snore with the most profound security over the ruin of a hundred millions of his brethren, and the destruction of that immense multitude seems plainly an object less interesting to him, than this paltry misfortune of his own.[48]

He dismisses those 'whining and melancholy moralists' who claim that we ought to make ourselves unhappy by imagining the unhappiness of people unknown to us.[49] There is no virtue in merely caring (or professing to care) about unknown persons. Passive emotion is feeble and ineffectual, but active virtue is motivated by a far stronger force – that of conscience, originating in a desire for others' approval and hence for self-approval.

We have, moreover, a 'general fellow-feeling . . . with every man merely because he is our fellow-creature'.[50] Our strong emotions, however, are directed towards individuals, beginning with our friends and relatives. General fellow-feeling underlies our attachment to the principle of justice, without which, Smith insists, society would collapse into anarchy. The importance of justice for the good of society is confirmed by reflection. Humane people may well feel sorry for a condemned criminal, especially as, having been captured, he can do no more harm, and may wish him to be spared the death penalty. On further reflection, however, '[t]hey counterbalance the impulse of this weak and partial humanity by the dictates of a humanity that is more generous and comprehensive', and acquiesce in the criminal's execution.[51] What underlies our love of justice, however,

is not an abstract regard for the good of society, but an ingrained feeling, which makes us detest the idea of a murderer escaping punishment.

Misguided emotions need to be corrected by 'reason, principle, conscience ... the man within, the great judge and arbiter of our conduct', which has itself a foundation in the deep emotions implanted in us by nature.[52] Smith thinks well of the emotional self-control advocated by the Stoics. He even praises the astonishing 'magnanimity and self-command' of native North Americans, who endure torture with 'heroic and unconquerable firmness'.[53] But the Stoic virtues are one-sided. Stoics are wrong to recommend insensibility. Affectionate feeling is itself a source of pleasure: 'The poets and romance writers, who best paint the refinements and delicacies of love and friendship, and of all other private and domestic affections, Racine and Voltaire; Richardson, Maurivaux [sic] and Riccoboni; are, in such cases, much better instructors than Zeno, Chrysippus, or Epictetus.'[54] They teach 'that moderated sensibility to the misfortunes of others, which does not disqualify us for the performance of any duty'.[55]

This passage reflects Smith's stay at Oxford in the 1740s. Finding to his disgust that the university taught an outdated Aristotelianism, he spent his time reading modern philosophy and literature. The two were not so separate then as academic philosophy and fiction are nowadays. Marivaux's novels explore complex emotions with great subtlety and with the aid of moralizing reflections which often sound like La Rochefoucauld. Thus Marianne, who is telling her story long after the events, draws a subtle distinction in saying that her lover Valville was not 'amorous' but 'tender', and when Valville proves inconstant, draws the conclusion that tender souls, when their affection is returned, are too easily satisfied:

> It is hard to believe, but tender and delicate souls are inclined to the fault
> of relaxing in their tenderness when they have completely obtained yours;
> the desire to please supplies them with infinite graces, induces them to make
> efforts which are delightful for them, but once they have pleased, they have
> nothing more to do.[56]

Philosophical writing might easily draw on literature for examples: thus Smith mentions Racine's *Phèdre* – in his view, 'the finest tragedy, perhaps, that is extant in any language'[57] – to illustrate how we can sympathize even with the incestuous love of Phèdre for her stepson.[58]

Since Smith's moral philosophy can accommodate such subtle and complex emotions, it is not difficult for him to distance himself from Mandeville's theory of self-love. Mandeville's theory, in Smith's view, is reductive. It assumes that all actions done with good intentions arise from selfishness, which is in turn equated with vanity. This theory could not have found wide

acceptance if it had not contained some truth. Self-love 'may frequently be a virtuous motive of action'.[59] But Mandeville is wrong to equate self-love with vanity.[60] A vain person wants to be praised for trivial things like smart clothes, but self-love makes us want to be praised for real virtues and real accomplishments. The love of virtue and the love of glory are admirable in themselves; their pursuit cannot be dismissed as vanity. Besides, many more ordinary virtues, especially the unspectacular ones that escaped Hutcheson's attention, are commonly attributed to self-love, and are none the worse for it: 'The habits of oeconomy, industry, discretion, attention, and application of thought, are generally supposed to be cultivated from self-interested motives, and at the same time are apprehended to be very praise-worthy qualities, which deserve the esteem and approbation of every body.'[61] But we shall have to wait seventeen years for Smith to reconcile self-interest with the good of society in *The Wealth of Nations* (1776).

In the meantime, there was now a large body of innovative work on philosophy and psychology, among which contemporaries particularly admired Locke's *Essay concerning Human Understanding* (1689) for persuasively arguing that all knowledge arose from experience. Some of Locke's admirers went so far as to find in his empiricism the possibility of a materialism that ruled out any immaterial mind or soul. Locke had speculated on the possibility that matter might be able to think. He did not advocate such a view: he said that it was 'not much more remote from our comprehension to conceive, that God can, if he pleases, superadd to matter a faculty of thinking, than that he should superadd to it another substance with a faculty of thinking'.[62] That is, it was just as difficult to imagine a thinking mind being added to a material body, as to imagine that the material body itself did the thinking. Locke went on to review the insoluble difficulties posed by the concept of thinking matter. Did all matter think? If so, was it not absurd to imagine every single atom pursuing its own thoughts? Or did only some matter think – for example, when matter was organized in a system such as a human being? But in that case how did organized unthinking matter make the leap to become thinking matter?

This speculation provoked much pious condemnation. Voltaire defended Locke, making clear what he had actually said, and paraphrasing the orthodox viewpoint thus: 'I am absolutely ignorant what Matter is; I guess, but imperfectly, some Properties of it; now, I absolutely cannot tell whether these Properties may be joyn'd to Thought. As I therefore know nothing, I maintain positively that Matter cannot think. In this Manner do the Schools reason.'[63]

David Hume acknowledges Locke's importance in the preface to his *Treatise of Human Nature* (1739), where he speaks of 'Lord Bacon and some

late philosophers in England, who have begun to put the science of man on a new footing, and have engaged the attention, and excited the curiosity of the public'. Among these he specifies 'Mr. Locke, my Lord Shaftesbury, Dr. Mandeville, Mr. Hutchinson [*sic*]', and others.[64] The authorities Hume cites are all on this side of the philosophical chasm separating the rationalism of Descartes from the empiricism of Bacon and Locke.

## THE SCIENCE OF MAN: HUME'S *TREATISE*

In *A Treatise of Human Nature*, written in his mid-twenties, Hume offered nothing less than a new science, 'the science of man', on which every other branch of study, even mathematics, natural philosophy and natural religion, must depend.[65] Its method is to be empirical and experimental, following Newton's inductive method that had been applied to the study of human nature by Locke, Shaftesbury and the other predecessors whom Hume acknowledges. Alongside introspection and thought experiments, Hume relies also on 'cautious observation of human life'.[66] The philosopher is now a social being, gathering his evidence by observing the people he talks with.

The *Treatise*, as Hume admitted, is very much a young man's book.[67] He planned it as early as 1729, but, having damaged his health through excessive study, he found that although he had come up with highly original arguments, he lacked the concentration either to pursue a line of reasoning uninterruptedly or to organize his materials into a coherent and well-written whole.[68] He compared his experience to that of 'the French Mysticks' (meaning Quietists such as Madame Guyon) whose ecstasies alternated with 'a Coldness & Desertion of Spirits, which frequently returns'.[69] Seeking a more active life, he made a brief and unsuccessful attempt to start in business in Bristol, where it seems he could not refrain from correcting the style of his employer's letters. In 1734 he moved to France, where, after staying in Paris and Rheims, he settled for two years in the town of La Flèche in Anjou, where he could not only live cheaply but also use the well-stocked library of the local Jesuit college. His philosophical ambition was apparent to the émigré Scottish Jacobite Andrew Ramsay, who met him in Paris. Ramsay, a devout Catholic, remembered Hume as 'too full of himself', given to 'spiritual Self-Idolatry', and considered 'his Imagination more luminous than profound'.[70] The *Treatise*, written mostly at La Flèche, undertakes to provide a new and comprehensive account of its subject, to disprove many of the most obvious assumptions, and to resolve some of the most intractable problems of philosophy. And

A

# TREATISE

OF

## Human Nature:

BEING

An ATTEMPT to introduce the ex-
perimental Method of Reasoning

INTO

## MORAL SUBJECTS.

*Rara temporum felicitas, ubi sentire, quæ velis; & quæ
sentias, dicere licet.* TACIT.

## VOL. I.

OF THE

## UNDERSTANDING.

*LONDON:*
Printed for JOHN NOON, at the *White-Hart*, near
*Mercer's-Chapel*, in *Cheapside.*

MDCCXXXIX.

The quotation on the title-page of Hume's *Treatise* runs: 'It is the rare happiness
of these days that one may think what one likes and say what one thinks'
(Tacitus, *Histories*, Book 1).

Hume actually delivers on many of his promises, with the air of one casually performing unheard-of feats. If any philosophical work can convey to lay readers some of the excitement of doing philosophy, this surely can.

The first Book, 'Of the Understanding', dealing with what later became known as 'philosophy of mind', is often thought to be an exercise in scepticism. Certainly, Hume asks what grounds we have for our professed knowledge – of the external world, of cause and effect, of personal identity and other vexed topics – and shows that such knowledge cannot be rationally justified. His intention, however, is not to deny our knowledge itself, nor to place it on a more solid foundation, nor to replace it with something more accurate, but to challenge the authority of 'pretended supra-scientific metaphysical knowledge'.[71] Our beliefs about the world and ourselves amount to a perfectly adequate working knowledge. Sceptics who seek to destroy such beliefs are a 'fantastic sect'.[72] Hume does not seek to undermine our beliefs, but to show, by describing the workings of the mind, how we come to have them.

For Hume, as for Locke, there are no Cartesian innate ideas. The contents of the mind are all perceptions derived from experience. Our perceptions are either impressions or ideas. When I look at a house, I have an impression of it; when I close my eyes, I have an idea of the house; and the only difference between impressions and ideas is that the former are more vivid. Our reasoning works by associating ideas. There are three kinds of association: resemblance, contiguity and causation. Of these, the last is the most important: 'there is no relation, which produces a stronger connection in the fancy, and makes one idea more readily recal [sic] another, than the relation of cause and effect betwixt their objects'.[73] So what is a causal relation between two objects? It consists in contiguity and succession. Both objects must be adjacent, and one object must precede the other in time: the cause must come before the effect. I go close to the fire, feel hot, and conclude that the fire caused my sensation of heat. But I can never perceive the causal relation between them. I assume it on the basis of habit. I have noticed many times the relation between fire and heat; it is the constant conjunction between these two phenomena that gives me the idea of a causal relation. Hence Hume arrives at the following definition: 'A cause is an object precedent and contiguous to another, and so united with it, that the idea of the one determines the mind to form the idea of the other, and the impression of the one to form a more lively idea of the other.'[74]

The phrase 'lively idea' indicates what Hume thinks belief is. 'An opinion, therefore, or belief may be most accurately defin'd, A lively idea related to or associated with a present impression.'[75] We believe in our memories, but not in fantasies, because our memories are more vivid. Belief is

essentially a feeling. Hume struggles to define this feeling: 'An idea assented to *feels* different from a fictitious idea, that the fancy alone presents to us: And this different feeling I endeavour to explain by calling it a superior *force*, or *vivacity*, or *solidity*, or *firmness*, or *steadiness*.'[76] And so Hume arrives at one of his breathtaking conclusions: 'Thus, all probable reasoning is nothing but a species of sensation. It is not solely in poetry and music, we must follow our taste and sentiment, but likewise in philosophy.'[77]

But, it may be said, aren't some beliefs so well founded that they amount to knowledge? It seems not. Even in mathematics, Hume argues, people make mistakes; much more so in matters of fact, which often depend on a long chain of evidence (e.g. we are sure that Julius Caesar was assassinated, but as we did not see it happen, we are dependent on distant testimony). So-called knowledge, therefore, can only ever be *probable*. Worse still: I have to make a judgement about the object, and also about the reliability of my own judgement; then I have to judge the reliability of my judgement of my reliability; then I have to judge the reliability of *that* judgement; and so on ad infinitum. This procedure, 'when carry'd farther, and apply'd to every new reflex judgment, must, by continually diminishing the original evidence, at last reduce it to nothing, and utterly subvert all belief and opinion'.[78] So if our beliefs were based on reason, we would end up without any beliefs – another bravura piece of argumentation.

Fortunately, human nature bases belief not on evidence but on custom, and so we can continue to hold our everyday beliefs, untroubled by their lack of foundation. Similarly, we have no adequate grounds for believing in the existence of external objects, or in the continuity of these objects. I can never *know* that an object continues to exist when I am not looking at it. Such scepticism, however, can never be more than theoretical. A sceptic, whatever he may say, cannot help believing in the existence of the external world: 'Nature has not left this to his choice, and has doubtless esteem'd it an affair of too great importance, to be trusted to our uncertain reasonings and speculations.'[79]

Finally, the *Treatise* questions personal identity. Introspection does not reveal any solid self that bestows continuity on the ceaseless flux of our impressions and ideas:

> For my part, when I enter most intimately into what I call *myself*, I always stumble on some particular perception or other, of heat or cold, light or shade, love or hatred, pain or pleasure. I never can catch *myself* at any time without a perception, and never can observe anything but the perception.[80]

Hume ends by defining the self as 'nothing but a bundle or collection of different impressions, which succeed each other with an inconceivable

rapidity, and are in a perpetual flux and movement'.[81] My conviction that I am the same person that I was twenty years ago is based only on memory, which makes us aware of 'that chain of causes and effects, which constitute our self or person'.[82]

In Book II of the *Treatise*, Hume deals with emotions ('the passions'), using the basic toolkit set out in Book I. Impressions include passions, as well as sensations; they may be pleasurable or painful, and they differ from ideas, again, in their greater force and vividness. Hume divides the passions into direct, arising immediately from pleasure or pain, and indirect, among which he includes love, hatred, pride, humility, envy, pity and many more. The mind works by association, both of impressions and ideas; the indirect passions require a double association of impressions and ideas. Ideas are linked by relations of resemblance and contiguity.

The key to understanding emotions is the principle of sympathy, on which Hume lays great weight. 'No quality of human nature is more remarkable, both in itself and in its consequences, than that propensity we have to sympathize with others, and to receive by communication their inclinations and sentiments, however different from, or even contrary to our own.'[83] Sympathy too depends on resemblance and contiguity. We can sympathize with others' feelings because we can always find something similar in ourselves; and we sympathize much more with people close to us than with those distant from us. Sympathy is not compassion, though compassion is one of the forms it can take. Rather, sympathy is the expression of our sociable nature. Company is enjoyable, solitude intolerable: 'A perfect solitude is, perhaps, the greatest punishment we can suffer. Every pleasure languishes when enjoy'd apart from company, and every pain becomes more cruel and intolerable.'[84] Sympathy is a kind of natural gregariousness that human beings share with most animals. This enables Hume to resolve a question left unanswered by Mandeville in *The Fable of the Bees*. Mandeville insisted on the paramount importance of self-love, but also on the 'Greediness we have after the Esteem of others, and the Raptures we enjoy in the Thoughts of being liked, and perhaps admired'.[85] It was not clear why Mandeville's selfish individuals should care whether others liked them. The principle of sympathy provides an explanation.

Having made clear that sympathy is central to the passions, Hume issues his famous challenge to conventional views of the relation between passion and reason. It is commonly said that passion should be guided – and, whenever necessary, suppressed – by reason. The function of reason, however, is to discover abstract relations, whether between our ideas, or among the objects of our experience. Abstract relations between ideas – for example, mathematics – may enable a merchant to balance his books,

but will not in themselves motivate any of his actions; they provide knowledge which may help him to make decisions.[86] He may be wondering whether to sell part of his stock. If so, he is considering the objects of his experience. In doing so, he is weighing up the prospects of pain or pleasure. If he sells his goods, will he have the pleasure of making money, or the pain of losing some? Here emotion, or to continue using Hume's preferred term, passion enters the picture. Reason can show the merchant the likely consequences of his actions, but it is passion, not reason, that motivates him to act one way or the other. Reason by itself is 'incapable of preventing volition, or of disputing the preference with any passion or emotion'.[87] This does not mean that people are constantly driven hither and thither by irrational passions; it means, less dramatically, that to do anything, I must *want* to do it, and *wanting* to do something is the product of the passions, not of reason.

Hume draws the conclusion that it is false to contrast passion with reason. Passions are neither reasonable nor unreasonable (though of course the actions they prompt may be judged, in the light of reason, as more or less suitable to attain the desired goal). A passion can only be called unreasonable if it is founded on false information (e.g. if our merchant has done his sums wrong), or if the means it chooses are insufficient for the purpose to be achieved (e.g. if the merchant has not arranged adequate transport for the goods he wants to sell). Otherwise, no passion can be called unreasonable; passions just have nothing to do with reason. Hence: 'It is not contrary to reason to prefer the destruction of the whole world to the scratching of my finger.'[88] Such a preference is no doubt morally reprehensible, but that again is not a *rational* objection to it.

Passions and sensations provide the material for Book III, which deals with morals. If reason cannot motivate our actions, what connection can there be between reason and morality? Book II has already forewarned us that the basis of morality is pleasure and pain: 'if all morality be founded on the pain or pleasure which arises from the prospect of any loss or advantage that may result from our own characters, or from those of others, all the effects of morality must be derived from the same pain or pleasure'.[89] Hume makes short work of the standard view that virtue is 'a conformity to reason', having especially in his sights the Stoic view that you have first to know what is good and then act on your knowledge.[90] Since he has already shown that reason cannot influence passion, it follows that the rules of morality cannot be derived from our reason. They are the product, instead, of pleasant or painful feelings. 'To have the sense of virtue, is nothing but to *feel* a satisfaction of a particular kind from the contemplation of a character. The very *feeling* constitutes our praise or admiration.'[91]

Besides explaining where our conceptions of virtue and vice come from, Hume takes a cautious stand on the great question whether human beings are naturally benevolent, as Shaftesbury claimed, or naturally selfish, as Hobbes and Mandeville would have it. Hume does not believe in general benevolence. He affirms 'that there is no such passion in human minds, as the love of mankind, merely as such, independent of personal qualities, of services, or of relation to ourself'.[92] We hate quite as much as we love. On the other hand, Hume thinks that people's selfishness has been greatly exaggerated by 'some philosophers', whose picture of human beings is as incredible as 'any accounts of monsters we meet with in fables and romances'.[93] However, self-interest is a powerful force, which needs to be restrained if it is not to destroy society.

In any case, we need one another. A human being on his own cannot feed himself or defend himself against the elements. (Even Robinson Crusoe, it will be remembered, relied on many tools and goods that he had not made himself and which he had salvaged from the wrecked ship.) So, to control our selfishness, and to enable us to share the advantages of society, we need justice, an artificial virtue which reason persuades us to exercise for our mutual benefit.[94] But hasn't Hume shown that reason cannot motivate our actions? Yes indeed. Reason shows us what we should do, but it is our passions, especially those derived from sympathy, that make us do it. Sympathy makes us interested in other people, including those who are remote such as our dead ancestors, our distant relatives and, ultimately, though much more weakly, humanity as a whole. Sympathy makes us approve of virtuous actions, most of which tend to the good of society; but it is our propensity for sympathy, not our concern for utility, that makes us praise them. 'If we compare all these circumstances, we shall not doubt that sympathy is the chief source of moral distinctions.'[95]

Hume has shown, to his own satisfaction at least, that our vaunted reason is subordinate to our emotions, and that our emotions are also the foundation of morality. He reinforces his arguments by repeatedly comparing humans to animals. This is a bold move. Christianity held that there was a great gulf fixed between humanity and the animal creation. Descartes, as we have seen, maintained that animals were a kind of machine. But the proto-feminist and Lockean empiricist Judith Drake, after satirizing Descartes' claim, declared: 'I have been able to observe no Differences between our Knowledge and theirs, but a gradual one; and depend on Revelation alone, that our Souls are immortal, and theirs not.'[96]

Hume, like Drake, thinks it obvious 'that the beasts are endow'd with thought and reason as well as men'.[97] At first he seems to be conferring human dignity on animals. But as his argument proceeds, it turns out that

he is implicitly undermining human superiority by equating us with animals. Animals rely on experience, and base their conclusions on custom, just as we do.[98] A dog learns to know when his master will beat or caress him. People admire the instinct of animals and contrast it with human reason; but 'reason is nothing but a wonderful and unintelligible instinct in our souls'.[99] So instead of granting animals reason, Hume is suggesting that humans rely on instinct. This conclusion may seem implausible at first blush; but it is supported by some present-day psychologists, who argue that we arrive at most of our beliefs not by logical deduction, but by intuitive inference, a procedure that also works for animals. As innumerable psychological tests have shown, people are not naturally good at logical reasoning; it is a specialized ability that requires training.[100]

Animals also show passions such as pride and the desire for praise. Here Hume becomes somewhat anthropomorphic: 'The very port and gait of a swan, or turkey, or peacock show the high idea he has entertain'd of himself, and his contempt of all others.'[101] More convincingly, he points out that dogs like being praised and petted by their owners. Finally, sympathy is evident also in the gregarious character shown by many species of animals. So, almost casually, Hume seems to have deprived man of his lofty place in the great chain of being.

Generally, in the *Treatise* and elsewhere, Hume speaks of reason as a means of reaching if not certain, then at least adequately probable conclusions. He says that in metaphysics and theology, 'Nothing there can correct bad Reasoning than good Reasoning.'[102] Even if reason is the slave of the passions, Hume thinks it capable of correcting inaccurate beliefs. However, the conclusions attained by philosophical reasoning, especially when they depend on a long chain of argument, often feel 'forc'd and unnatural'.[103] They gain assent from philosophers, but not the vivid conviction which is properly called belief, and even Hume, by his own account, easily escapes from unwelcome sceptical conclusions by

> some avocation, and lively impression of my senses, which obliterate all these chimeras. I dine, I play a game of back-gammon, I converse, and am merry with my friends; and when, after three or four hour's amusement, I would return to these speculations, they appear so cold, and strain'd, and ridiculous, that I cannot find it in my heart to enter into them any farther.[104]

So Hume, despite some overdramatic language, relies on reason; but he does not think either that the conclusions it reaches can inspire deep conviction, or that it can attain to absolute certainty.[105]

It was a mistake, therefore, to read Hume as anti-rationalist and to find in his work support for fideism, as the Prussian philosopher Johann Georg

Hamann would do from the 1750s on.[106] Another philosopher, Friedrich Heinrich Jacobi, claimed that by showing that our beliefs are not founded on reason, Hume had made belief prior to reason, and thus shown the necessity of religious faith.[107] Such an argument is fallacious, for the belief that the sun will rise tomorrow, and the belief that Jesus was God, are convictions very different in their strength and significance; Hume's project is 'not so much to dethrone reason as to enlarge our conception of it, to make it social and passionate'.[108] His campaign is directed against deductive reason, which seeks demonstrative certainty – the role Descartes assigned to reason – and against 'a wider-ranging inferential reason that was limited to fact-finding, fact-relating and fact-predicting'.[109] When he asserts that 'men are superior to beasts principally by the superiority of their reason', he means a broad, social concept of reason, in which the power of inference is joined with prudence and good sense to form that capacity for judgement which enables one to function effectively in the social world. One reason why the *Treatise* is a central Enlightenment work is that it plays off these two versions of reason against each other: a narrowly cerebral pursuit of truth, which can lead one into strange deserts of abstraction; and a social conception of reason and judgement that reunites one with ordinary human living.

Hume claimed afterwards that, much to his disappointment, the *Treatise* on publication 'fell *dead-born* from the press, without reaching such distinction as even to excite a murmur among the zealots'.[110] In fact it received six reviews, but the only one that Hume knew of was, as he put it mildly, 'somewhat abusive'; the reviewer berated Hume for his frequent references to himself – 'This work abounds throughout with *Egotisms*.'[111] Knowing about the young Hume's precarious health, we might rather excuse the personal references in the *Treatise* by seeing it not only as a ground-breaking work of philosophy but as a therapeutic text, in which Hume's description of himself as a sociable being who is merry with his friends conceals his actual seclusion in La Flèche and indicates the life he aspires to lead, rather than the one he does. The serenity for which Hume was later famous, and which brought him many friends, was hard won.

## ANTHROPOLOGIES

We have seen that in early eighteenth-century France orthodox Cartesian science was gradually being displaced by Newtonianism, which had Voltaire among its champions. At the same time, the Cartesian doctrine of 'innate ideas' was being superseded by radical versions of Lockean sensationalism,

which was likewise promoted by Voltaire. Locke's French followers were prepared not only to accept his sensationalism but also to pursue its implications. Étienne Bonnot de Condillac agreed with Locke that all knowledge came from outside, through the senses, but he went further by denying that the mind had any prior capacity to process this knowledge. Rather, the capacity to reflect on experience developed along with the experience itself. Condillac tried to demonstrate this thesis by a thought experiment. Imagine a statue that has never received any sense-impression and is gradually endowed with various senses one after the other, beginning with smell. Smell will focus the statue's attention; it will be either pleasant or unpleasant; when the experience has become a memory, the statue will be able to compare it with other smells; and thus from sensation alone is built up the ability to compare, to judge, and hence to think.

Condillac makes 'our statue', as he familiarly calls it, the protagonist of a rudimentary *Bildungsroman*. Once equipped with all the senses, the statue feels desires; when these desires are not readily satisfied, the result is pain; the imagination suggests possible evils, and ways of averting them; fear and hope give rise to a range of passions, and these in turn to the ideas of the good and the beautiful. This, however, is as far as the statue can advance without society. To learn anything more, it would need the example of human beings. Social life does not consist in the unfolding of innate capacities, but in learning by imitation. For lack of human company, the statue would probably imitate animals, and walk on all fours. 'We are so strongly inclined to imitation that a Descartes in his place would not learn to walk on his feet; everything he saw would dissuade him from doing so.'[112] This is a dig at the great proponent of innate ideas: had he been brought up among animals, his innate ideas wouldn't have taught him to walk upright.

Another thorough-going sensationalist is Claude Adrien Helvétius. He thinks, in terms recalling Hume, that our consciousness is formed by external impressions, which leave a fainter after-effect called memories, and by the perception of similarities and differences among these mental contents. Thus, if we want to decide whether a judge should be strict or lenient, we form a mental picture of a judge ordering a criminal to be executed, another of the judge ordering his release, and a third of the criminal, armed with a dagger, hastening to murder fifty citizens.[113] This is an impossibly cartoon-like account of mental functioning: it does not allow for abstraction, nor for tense and modality (that is, the pictures do not show whether the criminal has committed murder, or will, must, or might commit murder). Nevertheless, Helvétius pushed sensationalism to its logical extreme. If the mind was really a blank slate, then everyone was born with equal potential,

which could be shaped by appropriate education. There was no intrinsic difference between a genius and a dullard: education could make anyone into anything. Education could also make model citizens. Once the important truth was admitted that self-love led everyone to seek pleasure and avoid pain, then legislators only needed to frame laws that led everyone to seek a happiness consonant with the common good.

> All the skill of the legislator therefore consists in compelling people, by the sentiment of self-love, always to be just towards one another. Now, to draw up such laws, one must be familiar with the human heart, and know in advance that people, sensitive to their own feelings, indifferent to others, are born neither good nor wicked, but ready to be one or the other, according as a common interest shall unite or divide them.[114]

Helvétius' people, like Mandeville's, can thus serve the common good while remaining entirely selfish individuals. They do not need to acquire virtuous dispositions; they just need to act virtuously. And so Helvétius' political programme anticipates later philosophies, like that of Jeremy Bentham, which assume that human beings can be moulded into whatever shape the legislator thinks best for them.[115]

One could reject Descartes' innate ideas and still uphold the mechanistic principles of Cartesian biology. Thus, the English physician George Cheyne maintained in 1733 that

> the Human Body is a Machine of an infinite Number and Variety of different Channels and Pipes, filled with various and different Liquors and Fluids, perpetually running, glideing [sic], or creeping forward, or returning backward, in a constant *Circle*, and sending out little Branches and Outlets, to moisten, nourish, and repair the Expences of Living.[116]

The machine needed the appropriate fuel. Cheyne blamed high living not only for depression but for fevers, gallstones, gout and rheumatism, all of which he lumped together as nervous disorders. The remedy was temperance and, if possible, a vegetarian diet.

Mechanism became full-blown materialism in the hands of Julien Offray de La Mettrie, whose book *L'Homme machine* (*Machine Man*, 1747) caused such outrage that its author fled to Berlin (having already arranged that Maupertuis, a fellow-townsman who was now president of the Academy of Sciences, should secure him an invitation from Frederick the Great in case of such an emergency). La Mettrie, a medical doctor, takes up the mechanistic biology of Descartes, which had claimed that animals were a kind of machine, and asserts that the same is true of humans. Experience shows that the body and the soul are correlated in

innumerable ways. When the body's movement is calmed, body and soul fall asleep together, but when excitement stirs the blood, the soul cannot sleep, while a nightmare during sleep arouses the body. Drugs impose lethargy on both body and soul; coffee stimulates them both. There is no reason to suppose that the soul is some immaterial entity distinct from the body. 'The human body is a machine which winds itself up, a living picture of perpetual motion.'[117] Food is the body's fuel. But where does the body's motion come from? Must it not be imparted to the body by the soul? No: the body contains its own principle of motion. La Mettrie finds this principle demonstrated in irritability, that is, the propensity of all organisms to respond to stimuli; in the erection of the penis; and in many examples of motion continuing in bodies after death, including the story, told by none other than Bacon, of a man whose heart was torn out and thrown into flames, whereupon it leaped a foot and a half into the air and went on bouncing for seven or eight minutes.[118]

Matter could not only move itself but reproduce itself. La Mettrie, like other eighteenth-century scientists, was impressed by Trembley's discovery that the freshwater polyp, a creature with some plant-like and some animal-like features, could survive if cut transversally into two or more parts: each part continued as a self-sufficient organism.[119] And he had no doubt that, as Locke had speculated, matter could think: 'I believe thought to be so little incompatible with organised matter that it seems to be one of its properties, like electricity, motive power, impenetrability, extension, etc.'[120]

La Mettrie is rather vague about how thinking happens. Sensations are turned into symbols and manipulated by means of the faculty which he calls the imagination. Mental powers have developed through imitation: 'Man was trained like an animal; he became an author in the same way as he became a porter. A mathematician learnt the most difficult proofs and calculations, as a monkey learnt to put on and take off his little hat or to ride his trained dog.'[121] But this does not explain how people can reason. If I learn long division by copying someone else, I learn only to do the same sum, and will be baffled when required to solve a different sum by myself. Although La Mettrie makes much of the imagination, he does not seem able to explain mental creativity.

La Mettrie therefore seems no more successful than Helvétius in imagining a materialist psychology. On the other hand, by examining the principle of motion in organisms, he does suggest a way out of the difficulties that the Cartesian 'mechanical philosophy' encountered in what we now call the life sciences. The eminent Dutch physician Herman Boerhaave, whose work La Mettrie translated into French, treated the body in Cartesian terms as a hydraulic mechanism, composed of pipes and

receptacles, where the correct fluid pressure had to be maintained. But this mechanical approach could say little about such vital phenomena as growth, nutrition and reproduction. Phenomena such as irritability, however, suggested a way forward.

A promising alternative was proposed by Georg Ernst Stahl, who originated the concept of the organism. An organism was a heterogeneous collection of bodies, held together by fatty tissue, and preserved from corruption by an *anima sensitiva* (sensitive soul) that circulated through it.[122] However, the *anima sensitiva*, as an extension of the soul, seemed unsatisfactory and outdated, and Stahl did not quite explain how the organism managed to function as a unity. His ideas were developed by the medical school at Montpellier, where Théophile de Bordeu argued that all living matter possesses sensibility and hence the power to feel and move. He compared the living body to a swarm of bees, which cluster together and act as a unified whole.[123]

Bordeu was a contributor to the *Encyclopédie* and a friend of Denis Diderot. Diderot was familiar with the English-language tradition of 'moral sense', since he had translated Shaftesbury's *Inquiry concerning Virtue and Merit*, supplementing it with quotations from other works by Shaftesbury and from sceptical authors such as Montaigne.[124] He pursued the implications of sense and sensibility in one of the Enlightenment's most astonishing works, *Le Rêve de d'Alembert* (*D'Alembert's Dream*, 1769). This philosophical conversation is in three parts. In the first, Diderot talks with his friend and fellow-Encyclopedist Jean Le Rond d'Alembert, trying to convert d'Alembert to his version of materialism. D'Alembert then goes to bed, but their conversation has so penetrated his unconscious mind that he talks wildly yet coherently in his sleep; his companion Julie de Lespinasse summons a doctor, none other than Bordeu; when she reads to him her notes of d'Alembert's apparent ravings, Dr Bordeu is able to elucidate and extend them. The third and shortest section is a later conversation between Bordeu and Lespinasse about the possibilities for inter-species breeding. Diderot has artfully exploited the potential of the sleeping mind to show that his arguments carry intuitive conviction and that, once the psychic censorship is lifted, the mind can form yet further speculations that the waking mind would reject.

The *Dream* is a dizzying work of the scientific imagination.[125] Diderot presents himself as a thorough-going materialist in the manner of Lucretius (he had corrected a new translation of *De rerum natura* the previous year). He varies Lucretius' theory of falling atoms by supposing that the basic building-block of matter is not the atom but what Buffon had called the 'organic molecule', a minimal unit of life, something like the cell

(which had been discovered by Robert Hooke in 1665, but became the basis of biological theory only in the nineteenth century). This concept enables Diderot to overcome the seemingly impassable gulf that Cartesian philosophy placed between mind and matter. Diderot supposes that all matter is also mind, that is, that all matter is endowed with 'sensibility', the capacity to feel, which may be either latent or active. Hence mental functions are best understood by analogy with material objects. Memory, which secures our identity, is like the twang that lingers in the air after one has touched the strings of a harpsichord. We are ourselves musical instruments, endowed with sentience but not essentially different from harpsichords, and if harpsichords had our reproductive powers, they would breed little harpsichords.

This flight of fancy heralds the wilder speculations of d'Alembert's unconscious mind. Diderot dissolves our conventional distinctions between animate and inanimate objects and between different species. He starts from the generally held assumption that living beings were ordered in a hierarchical chain of being. Different species were thought to be sharply distinguished from one another. Locke, however, had argued in the *Essay concerning Human Understanding* that distinctions between species, like all conceptions of 'essences', were constructions of the mind that it imposed on the external world.[126] Buffon, throughout his *Natural History*, is sceptical about classification: 'nature has neither classes nor kinds; it comprehends only individuals'.[127] For Diderot, species are only 'tendencies towards an appropriate common term'.[128]

Nature's potential to generate new forms is shown by what were at the time called 'monsters' or 'monstrous births', such as conjoined twins, or the child born in 1766 with an eye in the middle of its forehead. The inexhaustible fecundity of nature sets no limit to the life-forms that may have existed in the past, appear in the future, or exist even now on the planet Saturn, whose inhabitants may have senses unknown to us. (Diderot and his contemporaries assumed that the other five known planets – Uranus would not be discovered till 1781 – were habitable and inhabited: Kant in his *Universal Natural History and Theory of the Heavens* (1755) describes the qualities that the inhabitants of the different planets may be expected to have.[129]) Diderot suggests that one could even see males as 'monsters' by comparison with females, or vice versa.

The tidy chain of being has now become fluid. Clear distinctions have been dissolved. As the chain was supposed to be continuous, great efforts were made to find 'missing links'. One such link was the self-dividing freshwater polyp, which appeared to be midway between plants and animals. For Diderot, the polyp illustrates how close the contiguity of different

bodies is to their continuity. If a continuous polyp subdivides into contiguous beings, one can see the separate organs in the human body as distinct beings that have become continuous, or a swarm of bees (an image borrowed from Bordeu) as moving from contiguity to continuity. The closing dialogue between Lespinasse and Bordeu touches on the normally taboo topic of human intercourse with animals and imagines that it might some day produce useful hybrids, such as goat-footmen, who would doubtless be just as rude as human footmen and would relieve us from having to employ humans in menial tasks.[130] (Whether the goat-men would like doing menial tasks is not considered: like H. G. Wells's zoological experimenter in *The Island of Dr Moreau* (1896), Diderot's speakers fail to reflect that artificially produced hybrids might have their own point of view.)

The idea of universal sensibility put forward by Diderot and his colleagues has large implications. Sensibility is not just another faculty, but it underlies all our faculties. It is the fundamental way in which we relate to the world. We do not just contemplate the world, think about it, acquire knowledge of it; we relate to it also through our feelings, our hopes, our fears. As the capacity to feel, sensibility is where all our faculties come together. It makes it possible to understand humanity as a whole being, no longer divided between body and soul, and it provides a basis not only for physiology but for moral, political and aesthetic investigations.[131]

In late eighteenth-century Germany a conception of the human being as a whole was reached via anthropology, the study of human nature, which 'became the chief among philosophical disciplines'.[132] Economics, politics and government depended on establishing what human nature was; philosophy and theology depended on establishing what man's nature permitted him to know. Herder called in 1765 for a Copernican shift in philosophy whereby it should become anthropology: 'All philosophy that concerns the people must place the people at its centre, and if the standpoint of philosophy is changed, as the Ptolemaic system became the Copernican, what new fruitful developments will appear, if our entire philosophy becomes anthropology [*Anthropologie*].'[133]

In practice, anthropology could mean many different things. Since the still influential philosophy of Christian Wolff imagined the soul and body as somehow running parallel, some people asked how they were connected. Often they drew on physiology and medicine, as the young Schiller, a medical student, did in his dissertation, *Versuch über den Zusammenhang der tierischen Natur des Menschen mit seiner geistigen* (*On the Connection between the Animal and the Spiritual Nature of Man*, 1780).[134] Or they might inquire into the non-rational aspects of the mind, as Karl Philipp Moritz did in the many case-histories that fill his

pioneering *Magazin zur Erfahrungsseelenkunde* (*Journal of Empirical Psychology*, 1783–93). Or they might practise pragmatic anthropology by gaining knowledge of the human character and how people behaved under various social circumstances.

These inquiries, especially the last, bore fruit in the genre now called the 'anthropological novel'. An early, pioneering masterpiece in this genre is *Die Geschichte des Agathon* (*The Story of Agathon*, 1766–7) by Christoph Martin Wieland.[135] Wieland is as important, attractive and versatile a writer as his contemporaries Diderot and Lessing. Besides his work as editor of the much-read journal *Der teutsche Merkur* (*The German Mercury*, 1773–1800), his oeuvre includes philosophical poetry, erotic verse narratives, mock epic (especially *Oberon*, 1780), plays (including the first blank-verse tragedy in German, *Lady Johanna Gray* (1758)), translations of Shakespeare, innumerable polished and witty essays, versions of his favourite classical writers, Horace and Lucian, and, above all, a series of novels, often set in a mildly anachronistic ancient Greece. In his preface to *Agathon*, Wieland explains that his characters are not intended to illustrate a philosophical thesis, but to represent the truth of human nature:

> The truth that can and should be required of a work such as we are presenting here consists in this: everything corresponds to the way of the world; the characters are not arbitrary creations of the author's imagination or his didactic intentions, but taken from nature's inexhaustible stores; their development must retain intrinsic and relative plausibility, the constitution of the human heart, and the nature of every passion, with all the particular colours and shades a passion gains from each person's individual character and circumstances; while the specific character of the country, the place, the time, in which the story is set, must never be lost from sight; and everything is composed in such a way that no sufficient reason can be given why it could not have happened, or may yet happen, just as it is recounted.[136]

Wieland's realism here is psychological. If Agathon finally attains virtue and wisdom, it is through a series of mistakes and by a process of character development that we can easily imagine happening. Wieland does not practise the kind of realism that depicts ordinary incidents from everyday life. The story is modelled on the ancient Greek narrative, in which lovers are separated, undergo all manner of adventures, and are finally united.[137] Thus, in the opening pages Agathon, exiled from Athens and wandering on a lonely coast, is found by a party of Maenads and mistaken for their god Dionysus, but the dangers of their disillusionment are averted by a company of pirates who land and carry off the women and Agathon; on their ship he finds his lover Psyche, but he is immediately separated

from her, taken to Smyrna, and sold as a slave to the sophist Hippias – all this in the first twenty pages. Moreover, Wieland's humorous narrator teases the reader by occasionally pretending to be translating an ancient Greek manuscript.

Agathon is what eighteenth-century Germans called a *Schwärmer*. Originally applied to dissenting sects within Protestantism, the term was extended, first to anyone claiming direct inspiration from God, and then to seemingly eccentric, head-in-the-clouds idealists.[138] Thus in Schiller's play *Don Carlos* (1787) King Philip of Spain calls the enlightened Marquis Posa a 'sonderbarer Schwärmer' ('strange enthusiast') for advocating freedom of thought.[139] Agathon's *Schwärmerei* consists in believing in a supreme being and in the importance of virtue. Hippias by contrast is a cynical materialist who, as a sophist, has grown rich from other people's credulity and so mastered the art of attaining comfort and happiness. Their opposed philosophies are recognizable in eighteenth-century terms as a Cartesian belief in innate ideas versus a sensualism and materialism recalling Helvétius. Determined to take Agathon down a peg, Hippias introduces him to the beautiful and charming courtesan Danae. It does not take Agathon long to forget about Psyche and enjoy a rapturous love affair with Danae, who returns his affection. The spiteful Hippias then wrecks this idyll by informing Agathon that he is not, as he naïvely imagines, Danae's first lover, but that she has had a whole series of lovers, including even Hippias – a revelation that causes Agathon disgust as well as consternation. This is not the end of the story, nor of Agathon's *Schwärmerei*, but it shows the fine balance that Wieland maintains. Hippias' materialism is a realistic and feasible creed but coupled with selfishness and cynicism; Agathon's idealism is far more attractive, but unfortunately one can't live by it. By juxtaposing two conceptions of humanity and, at the end, tentatively suggesting how they might be reconciled, *Agathon* qualifies for the description 'anthropological novel'.

Enlightenment anthropology culminates in the major work in which Schiller responded to the French Revolution: *Über die ästhetische Erziehung des Menschen* (*On the Aesthetic Education of Man*, 1795). The outbreak of the Revolution aroused hopes for a new society based on humanity, law and freedom. But these hopes were horribly dashed when the Revolution declined into the Reign of Terror.

> The fabric of the natural State is tottering, its rotting foundations giving way, and there seems to be a *physical* possibility of setting law upon the throne, of honouring man at last as an end in himself, and making true freedom the basis of political associations. Vain hope! The *moral* possibility

is lacking, and a moment so prodigal of opportunity finds a generation unprepared to receive it.[140]

The opportunity was there, but humanity could not rise to it. A major reason, according to Schiller, lies in the nature of modern society. A complex society requires the division of labour and hence the fragmentation of human wholeness. We have thinkers who know nothing of practical life, and practical men, men of affairs, who despise ideas. Up to a point this antagonism is desirable, for society develops through productive internal conflict. But eventually the dispersed faculties will have to be united in a new, integrated humanity.

While waiting for that utopian future, Schiller proposes a provisional means of human integration via the aesthetic education of his title. His argument rests on anthropology. He maintains that in human nature there are three drives or urges, dynamically related to one another, and grounded in physiology, in the underlying unity of body and mind. The *Stofftrieb*, or sensuous drive, springs from our physical nature and enables us to deal with particular objects. A person dominated by the *Stofftrieb* lives from moment to moment. The *Formtrieb*, or formal drive, springs from our rational nature and is concerned with abstractions, with principles, with what is timelessly true. These two principles are not in direct conflict. We need both, but they have to be held in balance. Life should not be dominated either by sensuality or rationality.

To provide such balance, Schiller posits a third drive, the *Spieltrieb* or play-instinct. Play, he insists, is not frivolity. It releases man's fullest humanity: 'man only plays when he is in the fullest sense of the word a human being, and *he is only fully a human being when he plays*'.[141] The Greeks knew this, and they, as the most civilized society, idealized their gods by imagining them as constantly at play, enjoying leisure on Mount Olympus. The experience of beauty, which may take various forms, brings the sensual person closer to abstraction, and brings the abstract thinker closer to the sensory world: 'By means of beauty sensuous man is led to form and thought; by means of beauty spiritual man is brought back to matter and restored to the world of sense.'[142] Schiller then argues that there is an intermediate condition between matter and form, between passivity and activity. In this condition, the mind is active, yet not under constraint; it is a condition of free activity. Schiller calls it the 'aesthetic' condition.[143] In this condition, all our faculties are called into play, but by an object that is not real.

Thus, play is the foundation of art, and art in the widest sense, Schiller argues, is essential to the progress of civilization. Art in turn involves the

appreciation of fiction, of aesthetic semblance. Once nations appreciate aesthetic semblance (*ästhetischen Schein*) they are on the way to 'understanding and taste, and every kindred excellence'.[144] They can form a society that is held together not by the brute power of force, nor by the abstract authority of law, but by good manners, social conventions, codes of honour. Schiller acknowledges that such conventions have been attacked as insincere by 'certain shallow critics of our age' (meaning Rousseau) who would prefer the uncouth but unaffected honesty that they attribute to primitive times.[145] Such critics fail to see that politeness is not a mere superficial luxury; the refinement of manners signals that the substance of social life is being gradually refined by aesthetic form, that matter is coming under the dominance of the realm of ideas. This is Schiller's defence of the sociability that the Enlightenment considered an essential attribute of humanity. Only the aesthetic, only deference to taste and harmony, can give humanity a sociable character.[146] The more the individual has internal harmony – thanks to cultivating the aesthetic condition – the more harmoniously one can interact with others: 'Taste alone brings harmony into society, because it fosters harmony in the individual.'[147]

Schiller's theory has had a mixed reception. It prompted the historian Johan Huizinga to write a cultural history of the play-instinct, *Homo Ludens* (1938), but the Cambridge critic I. A. Richards in 1924 denounced the 'phantom aesthetic state' as chimerical.[148] Schiller's achievement lies partly in rescuing the eighteenth-century anthropological project of understanding the human being as a whole. He acknowledges that wholeness is not attainable *now*, except in moments of aesthetic enjoyment. But these moments are a guarantee that wholeness is a valid ambition, albeit one that can be realized only in the remote future.

In his aesthetics Schiller owes much to Kant, whose philosophical work is inseparable from the Enlightenment. In some respects, however, Kant's work also leads away from the Enlightenment and in new directions, as is the case with his relation to the anthropological project sketched above.[149] While the anthropological thinkers sought to imagine humanity as a whole, Kant sees the human being as divided. The noumenal self, where reason and morality are located, is distinct from the phenomenal self, the embodied person. Reason and morality combine to establish our good will, which must often override the desires of the empirical self. Indeed, an action is only morally good insofar as it conflicts with one's desires. If one's moral duty coincides with one's desires or one's interests, one is not really fulfilling a duty. So it is not actually meritorious to help people because one pities them. It would be more meritorious to help them although one is unaffected by their sufferings, as in the example Kant gives:

[I]f nature had put little sympathy in the heart of this or that man; if (in other respects an honest man) he is by temperament cool and indifferent to the sufferings of others, perhaps because he himself is provided with the special gift of patience and endurance toward his own sufferings and presupposes the same in every other or even requires it; if nature had not properly fashioned such a man (who would in truth not be its worst product) for a philanthropist, would he not still find within himself a source from which to give himself a higher worth than what a mere good-natured temperament might have? By all means! It is just then that the worth of character comes out, which is moral and incomparably the highest, namely that he is beneficent not from inclination but from duty.[150]

It is hard to imagine living by this conception of morality, which is 'a category hermetically sealed from all natural human desires and satisfactions'.[151] Kant's austere virtue is antithetical to the concept of sympathy that we have traced from Shaftesbury through Hume in this chapter. For these thinkers, sympathy was the sign of shared humanity and the most natural inducement to virtue. For Kant, sympathy is at best irrelevant to virtue.

## THE SCIENCE OF WOMAN

St Paul, recalling how Eve misled Adam, prescribed subordination for women:

Let the woman learn in silence with all subjection. But I suffer not a woman to teach, nor to usurp authority over the man, but to be in silence. For Adam was first formed, then Eve. And Adam was not deceived, but the woman being deceived was in the transgression. Notwithstanding she shall be saved in childbearing, if they continue in faith and charity and holiness with sobriety. (1 Tim. 2:11–15)

However, as the Spanish Benedictine Benito Jerónimo Feijóo noted in his essay 'Defence of Women' (1726), the sixteenth-century female theologian Isabella de Josa had pointed out that the New Testament also recorded a woman, Priscilla, teaching the Gospel (Acts 18).[152] But although St Paul retained little authority for the enlightened, women's subordination was firmly entrenched in law and society. Throughout Europe a woman was subject first to her father, then to her husband. For the better-off, marriage was primarily a means of transferring property. 'For pray,' asked Mary Astell in 1700, 'what do Men propose to themselves in Marriage? What

Qualifications do they look after in a Spouse? What will she bring is the first question? How many Acres? Or how much ready Coin?'[153] Newspaper announcements of marriages often specified how much property the bride would bring her husband.[154]

In medicine, doctors had by the eighteenth century discarded the notion, derived from Aristotle, of woman as an imperfect man (though Feijóo found it still popularly believed in Spain), but the theory of humours lingered on. According to this, men's temperaments were hot and dry, women's were cold and moist. A woman's colder humours had insufficient energy to drive matter up towards her head; hence her inferior mental faculties.[155] The philosopher Nicolas Malebranche maintained in *De la recherche de la vérité* (*On the Search for Truth*, 1674–5) that women's brains were composed of more delicate fibres, which made them sensitive to sense-impressions and fine judges of taste, but (albeit with occasional exceptions) incapacitated them for abstract thought: 'Whatever depends on taste is their domain, but in general they are incapable of penetrating into truths that are a little difficult to discover. Whatever is abstract is incomprehensible to them.'[156]

Such views were of course contested. Renaissance Europe had seen a lively *querelle des femmes*, in which hundreds of publications argued for women's merit, often by listing illustrious female rulers and scholars. Such treatises ran the risk, however, of appearing to present a mere list of exceptions, which, if anything, confirmed the low capacities of most women. The seventeenth-century poet Katherine Philips was acclaimed as 'the Matchless Orinda' and thereby seemed a prodigy whose accomplishments said nothing about women's potential in general.[157] Similarly, the physicist Laura Bassi, who was appointed to a chair at the University of Bologna in 1732 and was praised by Voltaire, could easily seem a miraculously gifted freak.[158] It was necessary to find a philosophical basis as well as empirical evidence for women's capacity.

The new philosophy of Descartes made possible a radically different view of women, which was first put forward in 1673 by the young philosopher François Poulain de la Barre. Having studied conventional scholastic theology at the Sorbonne, Poulain adopted the new Cartesianism, which in 1671 was officially banned from French universities. His defiant intellectual stance, and perhaps also lack of patronage, denied him a scholarly career; he became a country priest, converted in 1688 to Calvinism, fled to Geneva, and taught and married there.[159] His book *De l'égalité des deux sexes* (*On the Equality of the Two Sexes*, 1673) is based on Cartesian dualism. The soul, or the rational mind, is lodged only contingently in a material body. The body is gendered, but the soul, being immaterial, is neither male

nor female. Hence all arguments for female inferiority based on their sup-
posed physical constitution are simply irrelevant:

> It is easy to observe that the difference between the sexes concerns only the
> body, having really only this part that serves human reproduction; and since
> the mind does nothing more than lend its consent, and does it in the same
> way in everybody, one may conclude that there is no such thing as sex.[160]

This conclusion follows a long polemic against the widespread view –
accepted even by many women – that women lack intellectual capacity
and are fit only to run households and bring up small children. In every
country women are kept in subjection: at best they are used as servants;
in China they have their feet bound so that they cannot leave the house;
in Turkey they are confined in harems; and in Italy they have little more
freedom.[161] Male authority, originally imposed by force, has since been
consolidated by the state and supported by religion, which talks absurdly
of male and female divinities. Girls speak more fluently and learn more
quickly than boys, but they are denied the education which is wasted on
the majority of males. Even uneducated women speak better and examine
questions from more angles than educated men, who too often get bogged
down in verbal quibbles or absurd controversies. In the many convers-
ations he has held with women, Poulain says, none has ever told him that
God is a venerable old man, that the soul is a subtle flame, or that God
could enable a stone to enjoy the beatific vision (this last was apparently
a favourite topic for scholastic dispute). Women are natural Cartesians:
they express common sense in straightforward language.

Poulain's quotable maxim, 'The mind has no sex', was not original in
substance. Even St Jerome and Thomas Aquinas said that the soul or mind
was independent of sex, and many contributors to the *querelle des femmes*
agreed.[162] But Poulain's formulation became a commonplace. In Thomas
Holcroft's Jacobin novel *Anna St Ives* (1792), the radical Anna challenges
her conservative brother: 'Dare you suppose mind has no sex, and that
woman is not by nature the inferior of man?'[163] Much earlier, Judith Drake
based her claim for men's and women's equal endowments on Lockean
empiricism. There were no innate ideas, 'consequently there is no such
Distinction in Male and Female Souls'.[164] As for the physical differences
between the sexes, men's superior strength suggested that they were
designed for hard labour, women for intellectual occupations: 'the very
Make and Temper of our Bodies shew that we were never design'd for
Fatigue; and the Vivacity of our Wits, and Readiness of Invention, (which
are confess'd even by our Adversaries) demonstrate that we were chiefly
intended for Thought, and the Exercise of our Mind.'[165]

In the heyday of Cartesianism, it was relatively easy to acknowledge the achievements of learned women such as Queen Christina of Sweden, Anna Maria van Schurman (1607–78), who was expert not only in Latin and Greek but in several Oriental languages, and who composed an Ethiopian grammar, and the Venetian Elena Cornaro Piscopia (1646–84), who in 1678 became the first woman to receive a doctorate. It was only in the late eighteenth century that a hardening ideology of separate spheres made a woman's learning seem unnatural and reprehensible.[166] A woman's learning, even her reading of any serious work, became an unfeminine eccentricity. In 1778 Frances Burney recorded being nearly caught reading Cicero in Mrs Thrale's library: 'I had just fixed upon a new Translation of Cicero's Laelius, when the Library Door was opened & Mr Seward Entered. I instantly put away my Book, because I dreaded being thought *studious* & affected.'[167] The female narrator of Goethe's 'Bekenntnisse einer schönen Seele' ('Confessions of a Beautiful Soul', part of his novel *Wilhelm Meister's Apprenticeship*, 1795–6), who is modelled on his mother's friend Susanne von Klettenberg, recalls that her reading had to be kept even more secret than a forbidden love affair: 'learned women had been ridiculed, and even the educated were considered intolerable, probably because it was considered impolite to put so many ignorant men to shame.'[168] Women writers sometimes joined in this mockery: we remember how cruelly Jane Austen in *Pride and Prejudice* satirizes the diligent but talentless Mary ('Mary wished to say something very sensible, but knew not how').[169]

Throughout the eighteenth century a lively debate, conducted by both women and men, promoted the rights of women.[170] It was recognized that women were sometimes complicit in their own subjection, as Feijóo sympathetically noted. A defence of women, he argued, should strengthen their confidence and discourage male bullying: 'Man relying on his superiority in reasoning, speaks boldly; and woman, thinking herself inferior in argument, hears with deference and timidity. Who can deny but that here is a great presage that he will compel his ends, and she fall the victim?'[171] Women admitted that they felt at a disadvantage in male company. 'I am very ignorant,' confessed Louise d'Épinay in 1756. 'My whole education has been limited to agreeable talents and to rendering me skilful in the art of devising plausible fallacies (*sophismes*).'[172] Marie-Jeanne Phlipon, better known to posterity as Madame Roland, complained that women were not taken seriously in discussion, and that a woman who said something sensible merely excited the envy of less forthright women and less intelligent men.[173]

Marriage came under fresh scrutiny. The author of the *Encyclopédie* article on women and natural law argued that marriage should be treated

as a contract that affirmed the reciprocal rights of man and woman.[174] Husbands' abuse of their power excited horror (though not always enough): an egregious example was the behaviour of the Scottish judge Lord Grange, who, after prolonged marital discord, in 1732 had his wife, Rachel, kidnapped and confined on various remote Atlantic islands, including St Kilda, until her death in 1745.[175] Boswell and Johnson, who discussed this story when in the Hebrides, felt astonishment rather than sympathy; Johnson remarked callously that 'if M'Leod [St Kilda's owner] would let it be known that he had such a place for naughty ladies, he might make it a very profitable island'.[176] Fiction that defamiliarized European society from the viewpoint of a foreigner highlighted the disadvantages of conventional marriage. When Roxane, at the end of Montesquieu's *Persian Letters*, revolts against her tyrannical master and declares: 'my mind has always remained independent', the target is not only Eastern but also Western servitude.[177] Zilia, the Inca heroine of Françoise de Graffigny's *Lettres d'une Péruvienne* (*Letters from a Peruvian Lady*, 1747), finally prefers friendship to marriage.[178]

Yet all this discussion produced little institutional change. We often find it assumed that because women in European society were treated with civility, and not confined in harems or compelled to dig the fields, they had as much equality as they needed. Buffon declares: 'it is only among nations civilized to the point of politeness that women have obtained that social equality which is yet so natural and so necessary to make society pleasant.'[179] Histories of society which trace the gradual liberation of women conclude that women in civilized society play a role that, on closer inspection, appears merely decorative. Thus the Glasgow historian John Millar writes in 1771:

> The fair sex are more universally admired and courted upon account of the agreeable qualities which they possess, and upon account of the amusement which their conversation affords . . . As they are introduced more into public life, they are led to cultivate those talents which are adapted to the intercourse of the world; and to distinguish themselves by all those polite accomplishments which tend to heighten their personal attractions, and to excite those peculiar sentiments and passions of which they are the natural objects.[180]

Millar ends his chapter on women, however, with a dark hint that the freedom they have gained in modern society may be lost with the growth of luxury, which promotes polygamy in the East and 'prostitution' in Europe.[181]

Moralists, both male and female, insisted that women should defer

patiently to men and not try to enter their public and intellectual spheres of activity.[182] Yet there was one public role that women in eighteenth-century Europe performed with conspicuous success – that of empress. Maria Theresa, who ruled the Habsburg Empire from 1740 to 1780, and Catherine the Great, who governed Russia and propagated Enlightenment ideals there from 1762 to 1796, were acknowledged to be outstanding rulers. Voltaire admitted that Catherine, and earlier figures such as Elizabeth of England, were better rulers than many men.[183] Yet he did not draw the obvious conclusion – that women could and should be entrusted with more political power. A more progressive attitude appears in the *Encyclopédie* article on women in relation to natural law by the Chevalier de Jaucourt, who draws from the achievements of Elizabeth and Catherine a general conclusion about women's potential: 'if it is no longer against reason and nature for them to rule an empire, it would seem no more contradictory for them to be heads of a household.'[184]

With the rise of philosophies like those of Shaftesbury and Hume, who downplayed rationality in favour of feeling, it was increasingly argued that women's superior sensibility strengthened their claim to respect. Such arguments seemed to have a sound medical basis. The Genevan physician Pierre Roussel, a product (like Diderot's friend Bordeu) of the Montpellier school of vitalists, thought that as woman's main purpose is child-rearing, her entire organism serves this end: her nerves and muscles are finer and more sensitive than men's; hence she is more endowed with sensibility than men, and has an eye for detail and a good practical sense.[185] But this was a treacherous argument: women might be the guardians of civilized life because of their sensibility, but their sensibility was needed only in domestic life, in performing the duties of a wife and mother. Their power to feel denied them any creative power, any capacity for abstract thought, any originality. According to Roussel, 'The softer passions are more congenial to a woman, because they are most closely analogous to her physical constitution.'[186] Voltaire maintains that there have been learned women, warrior women, but no female inventors.[187] Diderot likewise thinks that biology is destiny: women's possession of a womb predisposes them to hysteria and explains the larger number of female visionaries.[188] If women were closer to nature, that only proved that they were out of place in the management of culture – in government, the professions and intellectual life.

It is remarkable how many prominent male Enlighteners enjoyed the company of intelligent women, and appreciated their accomplishments, without drawing the seemingly obvious conclusion that women should be equipped for a larger public role. In 1797 Schiller published in his journal *Die Horen* the epistolary novel *Amanda und Eduard* by Sophie Mereau,

and praised it in terms that, by their grudging tone, show what a prejudice he too had to overcome: 'I am really surprised at how our womenfolk (*Weiber*), by merely dilettante means, manage to acquire a certain dexterity in writing which approaches art.'[189] But Schiller also provided a popular blueprint for domestic harmony in his poem 'Das Lied von der Glocke' ('The Song of the Bell', 1800). The poem contrasts the man, who must contend with the storms of life, with the 'modest housewife' who stays at home minding the children.[190]

Women were caught in a trap. As Mary Wollstonecraft argued with force and passion in *A Vindication of the Rights of Woman* (1792), their upbringing focused on frivolities; any education they received that went beyond domestic duties was superficial and unsystematic. There seemed no point in providing secondary schools for girls, since they could not go on to university studies and professional careers. Adam Smith in fact thought it a good thing that girls could not attend public schools: 'There are no publick schools for the education of women, and there is accordingly nothing useless, absurd, or fantastical in the common course of their education.'[191] He meant that their domestic and social lessons were much more useful than the Latin crammed into public schoolboys, who, as was generally admitted, forgot most of it soon after leaving school.[192] In 1686 Louis XIV's mistress, Françoise de Maintenon, had founded a school at Saint-Cyr for noble girls, where they were to learn not only household tasks but also estate management.[193] The Saint-Cyr school was the model for the Smolny Institute for Noble Girls, established in St Petersburg by Catherine the Great in 1764, where, however, the curriculum was more conventional: foreign languages, music, dancing and good manners.[194]

The few women who did receive an intellectual education were fortunate enough to be brought up by well-educated men who valued their intelligent daughters. Damaris Masham, who published works of philosophy and theology, was the daughter of the Cambridge Platonist Ralph Cudworth, and also received much encouragement from John Locke. The father of the mathematician Laura Bassi provided her with high-level private tuition from an academic. Elizabeth Carter, who translated the works of the Stoic philosopher Epictetus from Greek, owed her classical education to her father, a clergyman, who was also a friend of Edward Cave, editor of the *Gentleman's Magazine*, where she published her first poems and translations. And Dorothea Erxleben (née Leporin), the first woman in Germany to obtain a doctorate, submitted in 1754, had been taught medicine and science by her father, the town physician of Quedlinburg. By being undereducated and disempowered, women seemed unfit for responsible tasks, but this result of their upbringing was interpreted as a

fact of nature and provided a pretext for their continued disempowerment. Women, as Wollstonecraft rather desperately urged, needed to take control of their own lives: 'It is time to effect a revolution in female manners – time to restore to them their lost dignity – and make them, as a part of the human species, labour by reforming themselves to reform the world.'[195]

Very few male revolutionaries agreed with Wollstonecraft. Nicolas de Condorcet stands out by his startling declaration, published posthumously in 1795:

> Among the aspects of the progress of the human mind that are most import-
> ant for the general happiness, we must include the entire destruction of
> those prejudices that established between the two sexes an inequality of
> rights that was fatal even for the beneficiary. A vain search was made for
> reasons to justify it by the differences in their physical organization, by the
> difference that people wished to find in the force of their intellect, in their
> moral sensibility. This inequality had no other origin than the abuse of
> strength, and it was in vain that people have tried since then to excuse it by
> means of plausible fallacies.[196]

Condorcet was not writing about the present, but about a future he believed to be imminent. By the time this was published, however, he had already died in a revolutionary prison. The revolutionaries generally agreed with their favourite *philosophe*, Rousseau, that women should not try to transcend their natural limitations: 'The man should be strong and active; the woman should be weak and passive.'[197] Thus Rousseau defined the complementary sexual characteristics that, by the end of the century, were widely thought to be innate and unchangeable. They were formulated thus by the philosopher, educationalist and diplomat Wilhelm von Humboldt in 1794:

> The entire character of the male sex is directed towards *energy*: that is the
> purpose of his strength, his destructive violence, his efforts to affect the
> world around him, his restlessness. By contrast, the temper of the female
> sex, its power of endurance, its tendency to connect with others and to
> reciprocate their influence, and its gracious constancy aim solely at preser-
> vation and *existence*.[198]

Schiller in 'The Song of the Bell' contrasts the modest housewife with the militant women who appeared in the French Revolution: 'Da werden Weiber zu Hyänen / Und treiben mit Entsetzen Scherz' ('Then women turn into hyenas and make a jest of horror').[199] Schiller need not have worried. Some women demanded the right to vote, founded revolutionary societies and proposed forming companies of armed women.[200] But the Jacobins

did not contemplate allowing women to vote, let alone participate actively in politics. The republican philosopher Gabriel Bonnot de Mably, whose reflections on government helped to shape the Revolution, had already warned in 1776 that women could not be trusted in government: 'I challenge you to name any state where women have held power without destroying morals, laws and government. Bring your girls up in modesty and the love of work. Form their early morals so that they will be ambitious for no other glory than to be excellent mothers.'[201]

The plea put forward in September 1791 by Olympe de Gouges, who tried to extend the Declaration of the Rights of Man with her *Déclaration des droits des femmes et de la citoyenne* (*Declaration of the Rights of Women and of the Citizeness*), was ignored. Yet her principles, outrageous in their day, now seem uncontentious. Women are born free and have equal rights with men; the limits which men's tyranny imposes on women's natural rights should be reformed by the laws of nature and reason; women should have equal access with men to all public offices; women and men are equally subject to the law; women have the right to speak in public, provided they do not disturb public order, and to communicate their opinions freely; they should make an equal contribution to the tasks of administration and receive an equal reward.[202] These proposals, however, were of no interest to the revolutionaries. Olympe de Gouges came under suspicion by her adherence to the moderate revolutionary party, her opposition to the radicals led by Robespierre, and her support for the king and queen; her manifesto of women's rights was even dedicated to Marie-Antoinette. She was guillotined on 3 November 1793.

## SEXUAL RELATIONS WITHOUT SIN

One reason for denying women equality was the long-standing belief that they naturally felt inordinate sexual desire, and so had to be restrained by rational and self-controlled men. Traditionally, therefore, sexual behaviour was a matter of public concern that was regulated by the Church. Part of the story of the Enlightenment is the liberation of sexual behaviour from religious control.[203]

The belief that the Churches needed to police sexual conduct survived the Reformation. However, different Churches adopted different viewpoints:

> Protestants used natural law extensively to justify marriage and heterosexual, marital intercourse. This justification went beyond the minimal position, with which Catholics agreed, that marriage was the only acceptable place

for sex. The Protestant viewpoint claimed a natural, narrowly focussed sexual desire. The Catholic viewpoint tended to imagine sexual desire as protean and apt to flow anywhere.[204]

Hence Protestants invented what would nowadays be called 'heteronormativity': the belief that heterosexual monogamy was natural and any deviation from it unnatural. Catholics saw sexual acts as deriving from humanity's fallen nature, which could lead to a great variety of sexual (mis)behaviour. Such misbehaviour was elaborately codified in the manuals used by confessors, who, at least until the seventeenth century, were thus equipped to interrogate their charges in great detail about sexual conduct. Critics of the Church liked to allege that confessors thereby suggested to people obscene acts which they would otherwise never have thought of committing.[205] By the eighteenth century, according to Foucault, such coarse questioning had yielded to discreet but much more searching emotional inquiries, which generated an extensive and nuanced discourse of sexual desire.[206] Such discourse in turn provided endless material for French erotic and psychological fiction, from *La Princesse de Clèves* (1678) down to *Les Liaisons dangereuses* (1782) and beyond.

In England until the Restoration, it was assumed that the business of the government included the supervision of people's spiritual well-being and hence their sexual conduct. Adultery and fornication were public crimes, tried by Church courts and punished with increasing rigour once Puritans gained power. Those found guilty might be imprisoned or do public penance in church, draped in a white sheet. Puritans in New England passed severe laws against unchastity: offenders might be banished, imprisoned, occasionally even executed, or at least, like Hawthorne's Hester Prynne, compelled to wear a scarlet letter for the rest of their lives. Gradually, however, adultery ceased to be considered a public crime. Societies for the reformation of manners tried to make up for the weakness of the authorities by initiating prosecutions, especially against brothel-keepers, but they had little success, and their use of informers brought them into disrepute. In Calvinist Scotland, the kirk session retained its power to punish sexual misbehaviour throughout the century: Robert Burns, having got a young woman pregnant, was compelled in 1785 to do public penance by sitting on the 'cutty-stool' in church on three successive Sundays.[207]

In France, the regulation of sexual conduct was shared between the Church and the state. Marriage was both a religious sacrament and a civil contract. While the Council of Trent had declared that the validity of marriage depended solely on the mutual consent of the partners, the

French state intervened to forbid marriage without parental agreement. The Church regulated sexuality through its parish priests, who were supposed to forbid premarital sex, and was supported by the secular *police de mœurs*.[208] The norms restraining sexuality were therefore more social and legal than religious. Similarly in Protestant Germany, moral regulation passed from Church courts to marriage courts, which did not always include clerics, and thus became increasingly the business of the state.

Sexual toleration, as its most persuasive modern historian has argued, was linked to religious toleration.[209] If religion is a matter for private judgement, shouldn't morality, including sexual morality, be so as well? If my religion concerns only me and my co-religionists, then why should my sexual conduct concern anyone except the consenting adult or adults with whom I share it? The Enlightenment tried to regulate conduct by appealing, not to fear of divine (or indeed human) punishment, but to people's innate virtue, which was encouraged by codes of politeness. It appealed also to 'nature', but that could mean several things. Some thought that natural law and natural religion dictated chastity; others, that by the standards of 'nature' the Christian concept of chastity was artificial. Cunning lawgivers, according to Mandeville, had told early humans 'how unbecoming it was the Dignity of such sublime Creatures to be sollicitous about gratifying those Appetites, which they had in common with Brutes', although admittedly 'those impulses of Nature were very pressing'.[210] It became common to argue that sexual morality depended on its effects, and that infidelity did not harm the public good. If the goal of life was happiness, sexual pleasure must be an important part of that goal.

The literature describing sexual gratification – pornography or erotica – came out from under the counter.[211] Back in 1668, the secretary to the navy, Samuel Pepys, had secretly read a pornographic work, *L'École des filles* (*The School for Girls*, 1655), in which the experienced Françoise explains sex to her naïve friend Catherine and then arranges a series of encounters between Catherine and an ardent young man.[212] A book that is now a classic, *Memoirs of a Woman of Pleasure* (1748–9), brought its author, John Cleland, prosecution and disgrace, though it still circulated widely. In France, however, pornography could be produced more freely, and a key Enlightener, Diderot, wrote some: his *Les Bijoux indiscrets* (*The Indiscreet Jewels*, 1748), published anonymously, consists of gossip from an Oriental court reported by vaginas to which a magic ring has given the power of speech. To Victorian readers, this was intolerable. Thomas Carlyle, in an otherwise admiring essay on Diderot, called it 'the beastliest of all past, present or future dull Novels', without explaining why.[213] Cleland and Diderot both used pornography to convey the inadmissible truth that

women enjoyed sex as much as men did. In the long run, this aided female emancipation. But more immediately, it harmed the cause of women.[214] Advocates of women's rights used the myth of women's smaller sexual appetites to support their claim to moral superiority, and that status in turn enabled women over the next two centuries to demand respect from men and to take the lead not only in promoting their own emancipation but in furthering causes such as the abolition of slavery. The myth of female chastity had its value in building up civilization.

It was possible to imagine sexual behaviour being regulated in a quite different and far freer way than was normal in eighteenth-century Europe. After reading the mouth-watering (and misleading) account given by the explorer Louis Antoine de Bougainville of the sexual freedom practised on the newly discovered island of Tahiti, Diderot, probably in 1772, composed a 'Supplement to Bougainville's Voyage', which includes an imaginary dialogue between the chaplain of Bougainville's ship and a Tahitian chieftain named Orou.[215] Invited to sleep with his host's youngest daughter, the priest initially protests that his office and his religion forbid him to do so. Orou has little difficulty in exposing the absurdities of Christianity, as the priest lamely expounds it. In particular, its sexual precepts are shown to be contrary to nature and reason. Orou persuades the priest that good manners require him to comply with the customs of the country, so the priest on successive nights sleeps with all three of Orou's daughters and then with their mother. In this sexual utopia, marriage lasts only as long as the partners wish. There is no ban on incest, because sexual relations with one's immediate family do no one any harm. The supreme value is placed on procreation. Like European statesmen, the Tahitians think it good to maximize the population. A Tahitian woman who has already had several children brings them to her prospective husband as a dowry. As children are considered wealth, the Tahitians do not mind where they come from (any more than we care who had our money before we got it).

Here Diderot's utopia seems to reveal a contradiction. For if Tahitian sexual behaviour is in accordance with nature, what has happened to the supposedly natural attachment of parents to their own children? When the priest objects to the absence of marital and parental affection, however, Orou has a reply: 'We have replaced them by another, which is far more general, energetic and durable – interest.'[216] Self-interest ensures that, just as we take good care of our property, Tahitians take good care of their children. This is rather chilling. It recalls both the bleak moral analysis practised by La Rochefoucauld and also a moment in Sade's *Juliette ou les Prospérités du vice* (*Juliette or the Rewards of Vice*, 1797), when the heroine's loathsome protector reassures her that he is attached to her

not by love, but by shared tastes and a common interest – hence by the strong chain of egoism.[217] In any case, life constantly shows us people acting against their own best interests. What guarantee is there – apart from the absence hitherto of the temptations offered by civilization – that the Tahitians will be more sensible?

Like most utopias, this imaginary Tahiti has other shortcomings. Fecundity is a virtue, sterility a fault, so sex with a woman who is past child-bearing age is a crime. Presumably contraception, if it existed, would be a crime too. Women will be continually pregnant and occupied in looking after children. The atheist Diderot has depicted a social system that uncannily resembles conservative Catholic social policy. Besides, in a territory as small as Tahiti the population would soon outgrow the available resources, leading to war and starvation.[218] However, Diderot is really attacking the confused and irrational sexual customs of modern Europe, and, in particular, the contradiction whereby 'the birth of a child, always regarded as an increase in the nation's wealth, is more often and still more surely an addition to the family's poverty.'[219]

When sexual activity was released from religious constraints, the resulting freedom tended to benefit men, especially upper-class men, more than women. It was generally agreed that since a woman was in an important sense the property of her husband, and since men did not wish to be saddled with other men's illegitimate children, women's sexuality had to be strictly confined. Hume considered chastity an artificial but necessary virtue, especially in women: 'The long and helpless infancy of man requires the combination of parents for the subsistence of their young; and that combination requires the virtue of chastity or fidelity to the marriage bed. Without such a utility, it will readily be owned, that such a virtue would never have been thought of.'[220] For women to assert their sexual freedom was rare and scandalous.[221] Even if, like the playwright Aphra Behn, they sympathized with the upper-class culture of sexual libertinism that developed after Charles II's restoration, they found that it worked in favour of men and against women, who might well end up abandoned by their lovers, resorting to prostitution, and dying prematurely in a hospital. One sad case is that of Elizabeth Farley, an actress who in the early 1660s attracted the brief attention of Charles II, then became mistress to a lawyer. Abandoned by him, in debt and pregnant, she briefly resumed her acting career, but is last heard of as a prostitute.[222] Women found too that men operated a double standard, whereby male sexual freedom signified virile boldness, that of women signified depravity.[223]

Sexual equality could be imagined in fiction. In Wieland's serio-comic

verse narrative *Musarion* (1769), set amid the freedoms of the pre-Christian world, the heroine Musarion converts her initially recalcitrant lover Phanias to a 'charming philosophy' in which one is guided by nature, regards the world realistically as neither an Elysium nor a hell, enjoys pleasure wherever one can, and practises virtue instead of talking about it. As a foil to Musarion, Phanias has two philosophical friends, one a Pythagorean, the other a Stoic, who unconvincingly claim to despise the senses; after getting blind drunk, the Pythagorean sleeps with Musarion's maid, while the Stoic is left snoring in a pigsty.[224] But Musarion is not merely a mouthpiece for a view of life that Wieland himself affirmed.[225] She is an intelligent, self-confident, attractive woman, in control of her own sexuality; she rebukes Phanias for striking tragic poses after she has had a fling with another young man, and, when in bed with him, decides just how far he may go.

Tolerance did not extend to homosexuality. In early modern Europe same-sex activity was punishable by death, as prescribed in the Old Testament (Lev. 20:13). By 1800 the death penalty had been abolished by the enlightened despots of Prussia, Austria, Tuscany and Russia, and in France the legal reform of 1791 decriminalized same-sex relations entirely. But in Britain persecution actually intensified from the late eighteenth century: between 1806 and 1836 an average of two men per year were executed for sodomy, and the death penalty was commuted to imprisonment with hard labour only in 1861.[226] Jeremy Bentham responded to this situation in extensive private notes, where he took the enlightened approach to sexuality to its extreme. He challenged the supposed scriptural basis of homophobia. He shared the view that priests and rulers had imposed on society an obsession with chastity and an irrational horror of non-standard sexual practices. The Old Testament clearly described an intimate sexual relationship between David and Jonathan. Jesus himself, Bentham suggested, had sexual relationships with both Mary Magdalen and the apostle John (who coyly describes himself as 'one of his disciples, whom Jesus loved', John 13:23). Homosexual conduct (which Bentham thought was not normally exclusive) did not weaken men, as the history of the Greeks and Romans clearly showed; it was compatible with marriage; and it did not reduce the population. Bentham was equally tolerant towards same-sex relations between women, and indeed to any sexual act between consenting adults. An 'all-comprehensive liberty for all modes of sexual gratification' would produce an incalculable 'aggregate mass of pleasure'.[227]

Kant's views on sexual matters show him, as so often, turning sharply away from the Enlightenment. His views on sexual activity are as different

from Bentham's as possible. He thinks that it is permissible only in marriage, because only there, by virtue of a contract, do two people each give the other equal rights over their bodies. Outside marriage, Kant imagines sexual pleasure as objectification, in which I turn another person's body into an object for my own enjoyment, and thus disobey the categorical imperative which requires us always to treat other persons as ends in themselves. Kant's rejection of pleasure as a motive and his identification of sexual desire with animalism make his position 'almost religious in its dourness'.[228]

In particular, Kant disapproves severely of masturbation. He argues that, since it is wrong to use another person's body to gratify one's sexual desire without a special contract, so it must be much worse to use one's own body to gratify one's desire. In doing so one is diverting one's body from its natural purpose, that of procreation, and thereby harming the human race and defiling the whole of humanity. Masturbation is therefore worse than suicide.[229] The severity of Kant's condemnation contrasts strangely with the difficulty he acknowledges in finding arguments to support it. One suspects that Kant is looking for reasons to justify a moral belief he held anyway, and that he has been affected by the eighteenth century's moral panic about masturbation.

The fear that masturbation caused a variety of illnesses was first spread by the anonymous treatise *Onania*, which appeared probably in 1718; given medical authority by Samuel-Auguste Tissot's *L'Onanisme* (1760); and reinforced by the dire warning that Rousseau issued in *Émile*. If Émile even once practises masturbation, his educator warns, he is lost; his body and mind will be enervated, and the dire effects of this habit will accompany him to the grave.[230] The virulence of this panic probably expresses conservative fears that the rising standard of living and the weakening of social control were creating new appetites and new freedoms to satisfy them. Moralists simultaneously ranted against 'luxury' (as we shall see in a later chapter) and against the indulgence in another solitary activity, namely reading.[231] Both stimulated the imagination, and once people's imaginations were unleashed, who could tell what upheavals might follow?

## CLASSIFYING HUMANITY

The study of human nature required consideration of humanity's place in nature as a whole. Enlightenment thinkers still started from the 'great chain of being'. This conception had been reinforced, as we have seen, by the authority of Leibniz:

All the different classes of beings which taken together make up the universe are, in the ideas of God who knows distinctly their essential gradations, only so many ordinates of a single curve so closely united that it would be impossible to place others between any two of them, since that would imply disorder and imperfection. Thus men are linked with the animals, these with the plants and these with the fossils, which in turn merge with those bodies which our senses and our imagination represent to be absolutely inanimate.[232]

It was disputed whether animals were divided into distinct species. The influence of the Bible, which implied that present-day animals had been created only a few thousand years earlier; that of Platonism, for which earthly beings corresponded to ideal forms; and everyday observation, which saw sheep always producing similar sheep, suggested that species were fixed. But Leibniz's principle of continuity implied innumerable gradations, so that where you drew the line and declared a number of individuals to form a species was an arbitrary decision. The empiricism of Locke led to the same conclusion:

in all the visible corporeal world, we see no chasms, or gaps . . . There are fishes that have wings, and are not strangers to the airy region; and there are some birds that are inhabitants of the water, whose blood is cold as fishes, and their flesh so like in taste, that the scrupulous are allowed them on fish-days.[233]

In the first edition of his *Natural History*, Buffon took the nominalist view that the world consisted of individuals, and that any attempt to sort them into species would be defeated by the great number of intermediate specimens. Later, however, he changed his mind, arguing that the sterility of hybrids (e.g. a mule, the offspring of a donkey and a mare, cannot produce offspring) proved that species were distinct.[234] The great taxonomist Linnaeus went the other way. When he began classifying plants on the basis of their reproductive organs, he assumed that species were distinct and had been so since the Creation. He supposed that for Adam to name the animals, each species of animal, and the plants it fed on, must have been present together, and therefore that paradise must have been an equatorial island with a high mountain, affording habitats for all creatures.[235] He gradually abandoned the concept of fixed species, however, because he came mistakenly to believe that new species could be generated, thanks to his observations of the hybridization of plants.

Borderline cases aroused great interest. It was much discussed whether anthropoid apes, collectively referred to as 'Orang-Outangs', were human. One of the speakers in *D'Alembert's Dream* says that the orang-utan kept

in the Jardin du Roi looks like 'St John [the Baptist] preaching in the desert', and claims that Cardinal de Polignac once said to this ape: 'Speak, and I'll baptize you.'[236] Edward Tyson in 1699 gives a detailed anatomical description of what he calls a 'pygmie', and, as it came from Angola, must have been a chimpanzee; some sailors told him that they had seen similar creatures in Borneo, where they were called orang-utans, hence the confusion between the two species. Tyson concludes: 'our *Pygmie* is no *Man*, nor yet the *Common Ape*, but a sort of *Animal* between both.'[237] Following travellers' reports, Buffon thought that apes were like humans in that they formed a society, built huts from branches and used sticks for weapons, but denied them humanity because they lacked the power of speech, which he considered the defining characteristic of humans. The Scottish jurist and philosopher Lord Monboddo, who believed that language was acquired, not innate, thought the 'Orang-Outang' belonged to a portion of the human race which had got stuck at an early stage of development. He amplified Buffon's account with the information that in Angola some 'Orang-Outangs' were seven feet tall and much dreaded by the natives. He himself had seen in Paris a stuffed ape who 'had exactly the shape and features of a man': 'He lived several years at Versailles, and died by drinking spirits.'[238] He had heard of another ape, belonging to a Frenchman in India, who did his master's shopping, but did not speak. Notoriously, Monboddo also believed that some humans still had tails: a Swedish naval officer visiting the Nicobar Islands in the Bay of Bengal had seen 'men with tails like those of cats, and which they moved in the same manner'; the officer's reliability had been confirmed to Monboddo by no less an authority than Linnaeus.[239] And he could himself produce witnesses to attest to 'a man in Inverness, one *Barber*, a teacher of mathematics, who had a tail, about half a foot long; which he carefully concealed during his life; but was discovered after his death, which happened about twenty years ago.'[240]

Insights into the basic nature of humanity were expected, but not received, from feral children. The eighteenth century saw two famous cases. 'Peter the Wild Boy' was found in a forest near Hameln, in Hanover, in summer 1724, aged about eleven and living on acorns and berries. In February 1726 he was sent to the London court and put in the care of Dr John Arbuthnot, the friend of Pope and Swift, but although he was persuaded to wear clothes, Peter proved unteachable and never learned more than a few words of English. Arbuthnot gave up on him after two months, and he spent the rest of his life with a farmer in Hertfordshire, where his grave may still be seen at Northchurch. Peter was a disappointment; his mutism was variously attributed to extreme stupidity, a deformed throat,

social isolation, or to having been supposedly reared by bears. The wild girl of Champagne, now thought to have been a Sioux somehow transported from North America to France, was found in 1731 in an orchard near Songi. She fled by swinging from branch to branch; she was seen to skin a rabbit and eat it raw; but she was captured, baptized Marie-Angélique Leblanc, taught French and needlework, and placed in a convent. It was evidently thought that, as a wild female, she needed to be drastically tamed, though it might have been kinder to leave her in the woods.[241] Lord Monboddo visited both, and regarded them as evidence for the asocial state of primitive humanity. He thought that Peter was just as human as the Orang-Outang, and though Peter, by the time he was seventy, had only learned to say 'Peter' and 'King George', Monboddo was sure that a gifted teacher such as Thomas Braidwood (a famous Scottish teacher of the deaf) could have taught both Peter and the Orang-Outang to speak.[242]

The Enlightenment had at its disposal a huge and ever-growing collection of travel reports from all round the world, by missionaries, diplomats, scientists and pirates. From these, it was increasingly possible to survey the diversity of humanity, and to try to establish general truths about the human species. Two classic attempts to survey humanity are Buffon's *Natural History of Man* (1749), which includes a long chapter on human varieties, and Herder's *Ideen zur Philosophie der Geschichte der Menschheit* (*Ideas on the Philosophy of Human History*, 1784–91). Both are also histories of the ascent of civilization, but my concern here is with what Buffon and Herder contribute to physical and cultural anthropology. The anthropological vocabulary soon included the word 'race', which was a disputed term in the eighteenth century but in the nineteenth century and later would often provide a pretext for hierarchical divisions, both in imagination and in brutal reality.

The Enlightenment, with few exceptions, asserted the unity of humankind. Although the Bible's claim that all humans were descended from Adam and Eve no longer counted as evidence, the substantive similarities among humans rendered it superfluous. Buffon's survey of 'Varieties in the Human Species' concludes:

> Everything therefore concurs to prove that the human race is not composed of species that are essentially different from one another; that, on the contrary, there was originally only a single species of men, which, having multiplied and spread all over the surface of the earth, underwent different changes by the influence of climate, by difference in food, by that of the way of living, by epidemic diseases, and also by the infinitely varied mixture of individuals more or less resembling one another.[243]

The alternative theory, polygenesis, had been put forward by Isaac La Peyrère in *Prae-Adamitae* (1655). It sought to explain the origin of the native Americans, and the long chronologies of non-biblical civilizations, by arguing that God had created two or more human species, and that Old Testament events such as the Flood were merely local and affected only the Hebrews.[244] Voltaire, who had little interest in the science of man, adopted polygenesis in order to mock the creation narrative in Genesis.[245] The traveller Georg Forster saw no difficulty in supposing that 'the Negroes originated in Africa, the whites in the Caucasus, the Scythians and Indians in the Himalayas'.[246] The Scottish jurist Henry Home, Lord Kames, argued that the diversity among human beings, shown in skin colour, bravery or timidity, and suitability for diverse climates, must be due to 'diversity of race'.[247] However, since polygenesis was incompatible with the account in Genesis, he supposed that after the destruction of the Tower of Babel, when humanity was scattered over the whole earth, God then divided them 'into different kinds, fitted for different climates'.[248] Buffon and most others, however, accepted that America had been populated by migrants from Siberia.

Granted the basic unity of humankind, what was one to make of the conspicuous differences in people's appearances and ways of life? Buffon and Herder felt that the sheer diversity of humankind made it impossible to divide people into racial groups. The obvious explanatory framework was the climate theory, inherited from Aristotle and other ancient writers, which maintained that cold climates produced strong but slow-witted people, hot climates indolent ones, and that the intermediate temperate zone was the best place to be born.[249] One of the best-known modern proponents of climate theory, the abbé Dubos, argued that the composition of the air was far more important than descent in determining people's characters. The present-day Catalans, though descended from Goths, have the same indomitable character as the Iberians described by the Romans, while the Germans, although their forests have been cleared and their marshes drained, are as warlike as in the time of Tacitus.[250]

Climate seemed readily to explain skin colour. Hence Buffon explains that northern Europeans and northern Chinese are pale, southern Europeans and Arabs are swarthy, and so forth, because they live in similar climatic zones; if whites lived in Africa for long enough, they would eventually turn black. The absence of blacks from South America puzzles him, but he concludes that equatorial America is much cooler than equatorial Africa. Since there are so many varieties of pigmentation, Herder denies that there are different races: 'Colours merge into one another . . . and

finally everything becomes mere shading in one and the same great paint-
ing that spreads through all the spaces and ages of the earth.'[251]

For Buffon and his successors, physical anthropology was bound up
with the development of culture:

> A civilized (*policé*) nation, living in a certain degree of comfort, accustomed
> to a regulated, gentle and tranquil life, which, thanks to the care of a good
> government, is sheltered from a certain misery, and cannot lack basic neces-
> sities, will, for that reason alone, be composed of stronger, handsomer and
> better-built people than a savage and independent nation, where every
> individual, drawing no support from society, is obliged to provide for his
> own subsistence, to suffer alternately from hunger or from an excess of food
> which is often bad, to exhaust himself in labour or in lassitude, to undergo
> the rigours of the climate with no means of protecting himself, in a word,
> to act more often like an animal than like a human being.[252]

The link between physical beauty and cultural attainments is particularly
clear when Buffon says of the Bengalis: 'These nations are handsome and
well built, they love commerce and have plenty of gentleness in their
manners.'[253]

As this example shows, the description of human varieties is always
value-laden, for the development towards civilization is also a development
towards full humanity. One can also develop away from it: Buffon uses
the ominous term 'degeneration', as when he says that the Lapps and
peoples of northern Siberia 'appear to have degenerated from the human
species'.[254] The categories used are often aesthetic. Thus the Lapps are 'a
race of men of small stature, with a bizarre appearance, whose physi-
ognomy is as savage as their manners'.[255] The Chinese at least 'have
nothing shocking in their physiognomy', but the Papuans have 'thin and
very disagreeable faces'.[256] It is the inhabitants of the temperate zone, from
northern India and Persia via the Caucasus and Turkey across to Europe,
who are 'the most handsome, the whitest, and the best built men on the
whole earth'.[257] While Herder praises the beauty of the Indians, the mod-
ern Persians, and the Turks and Arabs, he likewise links physical and
spiritual excellence, and finds their finest combination on the coasts of the
Mediterranean – an indirect tribute to the Greeks.[258] He shares the stand-
ard view that the most beautiful people of all live in 'Circassia, the mother
of beauty', i.e. present-day Georgia.[259]

Herder, the most generous of cosmopolitan thinkers, insists that the
student of nature must not impose any hierarchy (*Rangordnung*) on the
peoples being studied.[260] He affirms that all humans have the potential for
reason and justice, though it is not yet equally developed: 'Endowed with

these gifts, and applying them suitably, the Negro can organize his society like the Greek, the Troglodyte like the Chinese.'[261] This does not mean that all peoples are essentially the same. Different peoples have different abilities, and in the long run they will balance each other out. 'The Negro, the American, the Mongol, has gifts, skills, preformed dispositions, which the European does not have. The sum may be the same, but with different proportions and compensations.'[262]

Such openness becomes harder to sustain, however, if one thinks that differences within humanity are not fluid and temporary, but fixed and permanent, and accompanied by equally permanent features of character – in other words, if one adopts the concept of 'race'. Present-day anthropology, based on continual discoveries in genetics, rejects 'race' because interbreeding between human populations has always blurred the boundaries between ethnic groups, and because variations within a 'racial' group can be greater than variation between two such groups.[263] In 1775, however, the Göttingen scientist Johann Friedrich Blumenbach proposed a division of humanity into four distinct groups, found respectively in Europe and northernmost America; in Asia south of Siberia; in Africa south of the Mediterranean coast; and in the remainder of America – to which, as an afterthought, he added a fifth group, the newly discovered Pacific islanders.[264] In the third, heavily revised edition of his treatise he calls them Caucasian, Mongolian, Ethiopian, American and Malay. He explains that the white race, who have 'that kind of appearance which, according to our notion of symmetry, we consider most handsome and becoming', are called 'Caucasian' because of the famous beauty of the Georgians, and because the Caucasus was probably the original home of humanity.[265] This doctrine would give nineteenth- and twentieth-century racists ample licence to assert that the white race was the superior race from which all others had degenerated.

However, it is not widely recognized that Blumenbach was building on an essay by Kant, 'On the Various Races of Humanity' (1775).[266] Here Kant asserts that there are four races: the whites, the Negroes, the 'Hunnish' race (meaning the Lapps and the inhabitants of Siberia), and the Indians.[267] Originating as adaptations to different climates, the respective features of each race had, over the course of time, become hereditary and unchangeable; the key feature defining a race was skin colour, because no other feature could so reliably be transmitted through the generations. Kant later instanced the Gypsies, who had come from India to Europe many centuries earlier but still retained their distinctive colouring.[268]

Kant not only asserts, in sharp contrast to Buffon and Herder, that races are fixed, but gives an explanation for their fixity that would lead

to a dispute with Herder: races are not simply responses to climate and other external influences. Rather, human beings were originally endowed with germs (*Keime*) and natural predispositions (*Anlagen*) which could be realized in various ways, depending on the climatic influences to which people were exposed.[269] Originally, everyone was *potentially* white, black, Hunnish or Indian. Climate determined which possibility was realized. Once formed, the races could not be further changed, because people's predispositions were teleological: they strove towards a purpose, and with the four races listed, that purpose had been fulfilled. The Americans, Kant thought, were a race that was still developing, hence their absence from his fourfold scheme. It was in vain for Herder to object that nobody had ever seen such germs; Kant replied that the 'genetic character' to which Herder appealed instead must either depend on such a mechanism or be simply inexplicable.[270]

All such generalizations now look dubious for many reasons, not least their uncertain empirical basis and the unclear conceptions of colour that underlie them. Theorists from Buffon to Blumenbach depended on second-hand reports by travellers. Buffon says the Chinese are white; their place in Kant's scheme is unclear. Kant thinks the South Sea islanders are white; this earned him a rebuke from Georg Forster, who had accompanied Captain Cook to Tahiti and knew what he was talking about.[271] For the Scottish anatomist John Hunter, writing in 1775, the Tartars, Persians, Arabs and Chinese are 'brown', while southern Europeans, Turks and Laplanders are 'light brown'.[272] Anyone who has sampled the later 'racial science' of the nineteenth and early twentieth centuries will know how heavily, despite its scientific rhetoric, it relies on unfounded data and unacknowledged prejudice.

In contrast to the generosity of Herder, some representatives of the Enlightenment were not above blatant racial prejudice. Hume has long been notorious for his footnote to 'Of National Characters' which runs (in the edition of 1753–4):

> I am apt to suspect the negroes, and in general all the other species of men (for there are four or five different kinds) to be naturally inferior to the whites. There never was a civilized nation of any other complexion than white, nor even any individual, eminent either in action or speculation. No ingenious manufactures among them, no arts, no sciences. On the other hand, the most rude and barbarous of the whites, such as the ancient Germans, the present Tartars, have still something eminent about them, in their valour, form of government, or some other particular. Such a uniform and constant difference could not happen, in so many countries and ages, if nature had not made an original distinction betwixt these breeds of men.[273]

Kant refers to Hume approvingly in his 'Observations on the Feeling of the Beautiful and Sublime' (1764), where he asserts: 'The *Negroes* of Africa have by nature no feeling that goes beyond foolishness.'[274] Two pages later Kant reports the opinion of an African that the whites ought to keep their women in subjection, and says there might be something in it, 'but in short, this fellow was black from top to toe, a clear proof that what he said was stupid'.[275] Even in the later essay on races, Kant denies blacks any potential for improvement, saying that their comfortable environment renders them 'lazy, soft and trifling'.[276]

These assertions now shock us by their ingrained prejudice and their casual vulgarity. Hume's aspersions were rejected by the Scottish philosophers James Beattie and Lord Monboddo.[277] Moreover, there were well-educated Africans already in Europe. Hume even mentions one, but disparages him: 'In Jamaica, indeed, they talk of one negroe as a man of parts and learning; but it is likely he is admired for very slender accomplishments, like a parrot who speaks a few words plainly.'[278] As Hume could easily have found out, this man, Francis Williams, was no parrot: he studied mathematics at Trinity College, Cambridge, under the patronage of the duke of Montagu, wrote Latin verse, and became a schoolteacher in Jamaica.[279] Kant says nothing to qualify his blanket dismissal of blacks' abilities, and is unusual among late-Enlightenment thinkers in failing to condemn black slavery.[280] Thomas Jefferson, who reluctantly kept slaves, disapproved of slavery but, albeit more tentatively than Hume, thought blacks innately less gifted than whites: 'I advance it . . . as a suspicion only, that the blacks, whether originally a distinct race, or made distinct by time and circumstances, are inferior to the whites in the endowments both of body and mind.'[281]

By contrast, Blumenbach, though a theorist of race, shows he is no racist by not only condemning slavery but listing a number of blacks who attained eminence as scholars, musicians, engineers, or writers. He mentions the American poet Phillis Wheatley and the military engineer Abram Petrovich Hannibal, an African bought in Constantinople and presented to Peter the Great in 1704, who trained as an engineer, married into Russian high society and became the great-grandfather of the poet Alexander Pushkin.[282] The list also includes Wilhelm Amo, a native of present-day Ghana, who was given an education by the duke of Brunswick-Wolfenbüttel, studied at the University of Halle, took a doctorate in law and taught at the universities of Halle and Jena.[283] Amo's main work, *Treatise on the Art of Philosophising Soberly and Accurately*, is a handbook of philosophical psychology, along the lines of Leibniz and Wolff, and written to accompany his lectures.[284] Blumenbach's list could have been extended: in Vienna, the

famous Masonic lodge Zur wahren Eintracht ('True Harmony') included Angelo Soliman, an African who had been sold into slavery as a child, given to an Austrian general in Italy, and employed by the prince of Liechtenstein as secretary, interpreter and eventually tutor to the prince's nephew.[285] Similarly, Blumenbach concludes, in a manner diametrically opposed to Hume: 'there is no so-called savage nation known under the sun which has so much distinguished itself by such examples of perfectibility and original capacity for scientific culture, and thereby attached itself so closely to the most civilized nations of the earth, *as the Negro*.'[286]

Eighteenth-century London and Paris contained African populations which are difficult to estimate: contemporary guesses at the number in London ranged from three thousand to a less probable twenty thousand.[287] An edict of 1762 requiring all blacks living in Paris to be registered found 159, but probably there were many more.[288] Some blacks in Britain were legally slaves, brought from overseas by their owners. A black boy, often a slave, was a fashionable accessory, as can be seen in many paintings by William Hogarth.[289] Others were free and lived as servants or tradesmen; Samuel Johnson's servant Francis Barber is perhaps the best-known example.[290] Some, including Barber, are known to have married white women, suggesting that although racial prejudice might be developing in some intellectual circles, it was not widespread in the general population. A few black servants obtained not only their freedom but an education. Ignatius Sancho, born aboard a slave ship in 1729 and brought up in Greenwich, managed, through his own determination and help from some patrons, to become a well-known writer; his correspondence with Laurence Sterne was published after his death, and he had his portrait painted by Sir Joshua Reynolds.[291] In America, Phillis Wheatley, born in West Africa, was taught to read and write by her owners in Boston who perceived her talent and encouraged her love of poetry; in 1773, aged twenty, she published *Poems on Various Subjects Religious and Moral*, which gained wide admiration and brought her an invitation from George Washington.

The prejudice shown by Hume and Kant was therefore indefensible even in its own time. However, their remarks do not warrant all the conclusions that have been drawn from them by critics of the Enlightenment. Hume's use of the word 'species' does not make him a polygenist, for the terms 'species', 'race' and 'breed' were at that time used loosely and sometimes interchangeably.[292] Still less does Hume's footnote justify the claim that his entire theory of human nature was racist.[293] Richard Popkin, magnifying Hume's footnote to 'Hume on the color question', has even asserted that, together with Voltaire's sniping at Judaism, it 'provided the basis for secular racism'.[294] In ascribing such monstrous consequences to

these distasteful passages, recent critics of Hume and Kant invite the criticism that Sankar Muthu has made of unhistorical readings of the Enlightenment's views of empire:

> It is perhaps by reading popular nineteenth-century political views of progress, nationality, and empire back into the eighteenth century that 'the Enlightenment' as a whole has been characterized as a project that ultimately attempted to efface or marginalize difference, a characterization that has hidden from view the anti-imperialist strand of Enlightenment-era political thought.[295]

## DIDEROT AND THE GREY AREAS OF HUMANITY

The still-widespread conception of the Enlightenment as a project to erase difference and arrange reality in neat categories, implied in Weber's term 'the disenchantment of the world', meets its refutation in the work of Diderot. As the founder and editor of the *Encyclopédie*, he was fascinated by the solidity and diversity of concrete facts. As a philosopher, he was interested precisely in those areas of experience that resisted being subsumed under a neat theory. Diderot argued not against the materialism of Helvétius, but against Helvétius' conviction that his theory could explain everything: he 'pleads the case for human complexity against the over-hasty simplification of his philosophical ally'.[296] Diderot is especially curious about the specific experience of people with disabilities, about what we would now call the unconscious, and about the primordial human drives that come into conflict with the civilizing impulse.

Followers of Locke, who believed that all knowledge came through the senses, were intrigued by the experience of people lacking one or more sense and wondered what such people could teach them about human faculties. They were particularly curious about blind people who suddenly acquired the power to see. The key issue was known as Molyneux's problem. The Irish doctor William Molyneux, a friend of Locke and sympathetic to his empiricism, had asked whether a blind person, who could distinguish a sphere from a cube by touch, would, on acquiring sight, be able to distinguish them just by looking. Experiments on people whose cataracts were pierced suggested that they could not at first correlate visual shapes with tactile images, or see in three dimensions, and that perception required the co-operation of the senses, especially of sight with touch. It implied further that empiricism might be insufficient,

because the faculty of judgement was needed to assess the information conveyed by different senses.[297]

Diderot's contribution to this debate, the *Lettre sur les aveugles* (*Letter on the Blind*, 1749), aims to imagine what being blind is like. If all our knowledge is derived from experience, and thus from the senses, what sort of knowledge do the blind possess, deprived of one important sense? To answer this, Diderot conducts an empirical inquiry by interrogating a highly intelligent man from the town of Puiseaux who was born blind. It emerges that blindness is not in all ways a disadvantage. Certainly, the blind man cannot properly understand what a mirror is, but the definition he comes up with – 'a machine that projects things in three dimensions at a distance from themselves if they are correctly placed in front of it' – though wrong, is highly astute. The blind man gathers a vast amount of information by senses other than sight:

> The man-born-blind of Puiseaux works out how close he is to the fire by how hot it is, how full a receptacle is by the sound liquid makes as he decants it, and how near he is to other bodies by the way the air feels on his face. He is so sensitive to the most minor changes in the atmosphere that he can tell a street from a cul-de-sac.[298]

Diderot also discusses the blind mathematician Nicholas Saunderson, who in 1711 became Lucasian Professor of Mathematics at Cambridge, and who invented a kind of calculating machine in which pins of different sizes in different places represented numbers. For Saunderson, touch was more reliable than sight, and he could judge the precision of a mathematical instrument by feeling its markings with his fingertips. Diderot speculates that touch might provide the basis for symbols composing a complete language, as sound does for spoken language and sight for written language. Such a tactile language would indeed come into being in 1829, when Louis Braille published his system permitting the French language to be read in this way.

Diderot's essay becomes seriously controversial when he inquires into the ethical and religious implications of blindness. Morality depends on sympathy, which in turn is generated by external signs. The blind, being affected only by sound, hear no difference between a man urinating and a man bleeding to death. Left to themselves, they might develop a morality that is less humane than that of the sighted. When it comes to religion, Diderot imagines Saunderson, on his deathbed, being visited by a clergyman who talks about the wisdom of God manifested in the creation; Saunderson might reply that this evidence leaves him cold, as he can't see it, and if the clergyman were cleverly to argue from the admirable mechanism of

# LETTRE

## SUR

# LES AVEUGLES,

### A L'USAGE

## DE CEUX QUI VOYENT.

*Possunt, nec posse videntur.*
Virg.

## A LONDRES.

### MDCCXLIX.

The Latin motto means: 'They can do what they seem unable to do.'

Saunderson's own body, Saunderson might object that his blindness is an argument against the excellence of God's creation. It was this theme in the *Letter* that led to Diderot's imprisonment in the fortress of Vincennes for four months, from July to November 1749 (though, thanks to the intervention of Voltaire, whose companion Émilie du Châtelet was a relative of the governor of Vincennes, Diderot was only briefly confined in the fortress itself and was thereafter given the freedom of its grounds).

By crediting the blind with a capacity for abstract thought heightened by social isolation, Diderot encouraged contemporaries to find ways of socializing them. The first school for the blind, the Institut National des Jeunes Aveugles, was founded in Paris in 1784 by Valentin Haüy.[299] As a model for a successfully socialized blind person, Haüy identified the internationally famous concert pianist and composer Maria Theresia von Paradis, who had lost her sight in early childhood, and whom he knew personally. Following her example, his educational programme consisted in socializing the blind by developing their sense of touch. Thus, Diderot's reflections on blindness led indirectly to the humane treatment of the disabled.

Diderot also wrote an essay on the deaf and dumb, which admittedly soon digresses away from deaf-mutes to a variety of other topics; but it contains an odd thought experiment in which Diderot imagines a group of people each of whom possesses only one sense – a man who can see but not hear, feel, taste or smell, a man who can only hear, and so on. They would all be able to do arithmetic and algebra, since these branches of mathematics, unlike geometry, do not require sense experience. But, if they could somehow communicate with one another, they would find that they inhabited mutually unintelligible worlds, and the one with access to the richest array of experience – the sighted man – would be dismissed by the others as a lunatic.[300] Diderot had a kindred spirit in Lessing, who translated his theatrical writings into German, and who also speculated on the senses. In a fragment entitled 'That More than Five Senses are Possible for Human Beings', probably dating from 1780, Lessing argues that the senses developed in an evolutionary process, each sense corresponding to an aspect of the physical world (sight to light, etc.), and that we may in time develop further senses corresponding to aspects of the physical world about which at present we know little, such as electrical and magnetic forces. What these senses will be, we cannot now imagine; but if we could not see, we would be unable to imagine what sight was like.[301]

As one would expect of the author of *D'Alembert's Dream*, Diderot also took an especially lively interest in obscure mental phenomena such as dreams, about which the Enlightenment thinkers otherwise had little to

say. Enlightenment writers *could* enthuse about dreams: Addison in 1712 thinks the creativity of the dream 'intimates to us a Natural Grandeur and Perfection in the Soul, which is rather to be admired than explained'. Dreams are 'the Relaxations and Amusements of the Soul', with 'a Sprightliness and Alacrity' rare in waking life, more intense feelings of joy and sorrow, and an 'innumerable multitude and variety of Ideas'. The soul, though still attached to the body, is less 'intangled and perplexed in her Operations, with such Motions of Blood and Spirits', than in waking; hence 'She converses with numberless Beings of her own Creation, and is transported into ten thousand Scenes of her own raising.'[302]

None of the various philosophies that sustained the Enlightenment, however, could do much with dreams.[303] To the empiricist Locke, as to the rationalist Descartes, dreams were simply the absence of reason – although Descartes owed an intellectual breakthrough to his three symbolic dreams of 10 November 1619, which he took to be reprimanding him for having wasted his earlier life, and pointing him towards the future.[304] Older explanations of dreams as messages from God were now ruled out of court. Muratori dismissed the idea that dreams could foretell future events or reveal the location of buried treasure: 'it is quite certain that dreams are unreal and vain phenomena of our imagination, which, being given free rein while we sleep, forms curious but normally incoherent, unconnected and ridiculous comedies.'[305] Enlightenment philosophers and scientists referred dreams to the circumstances of the individual: to impressions made during the previous day, prompted to reappear by disorders of the nervous system, indigestion, or pressure on the bladder. (Later, Dickens would parody such materialism by making Scrooge try to dismiss Marley's ghost as 'a fragment of an underdone potato'.[306]) Dreams were in any case inaccessible to empirical study, because one had to rely on what might be a confused and incomplete account after the dreamer had woken.

Physiological explanations may seem disappointingly meagre to readers influenced by twentieth-century dream research. Yet only the most devoted Freudians and Jungians can believe that *all* dreams are elaborate coded messages from the unconscious or revelations of universal archetypes. It may be that most dreams are what Owen Flanagan calls 'the spandrels of sleep', in which mental contents just randomly fill up psychic space as architects fill up spandrels on the front of arches with decorative designs.[307] But there is no denying the importance of 'big dreams' in some people's biographies, including that of Descartes, nor the importance of 'culture pattern' dreams in some societies where a significant dream may be part of one's initiation as a shaman.[308] Flanagan himself admits that some dreams have a strong emotional charge and an expressive function. The dream that

Diderot assigns to d'Alembert, however, is not an attempt at psychological realism, but an artificial means of presenting unfamiliar ideas. As Diderot explained to his companion Sophie Volland, the dream enabled him to formulate ideas that would have seemed too wild for a philosophical dialogue: 'It is impossible to be more profound and more mad.'[309]

Diderot was also aware of the turbulent passions that need to be tamed and channelled by civilization. These passions are displayed in the novel *Le Neveu de Rameau* (*Rameau's Nephew*), which Diderot began in 1761 but never published. After his death, the manuscript found its way to Goethe, who read it with such enthusiasm that he promptly translated it into German. The novel is a dialogue between the nephew of the composer Rameau and an unnamed interlocutor, who appears simply as 'Moi'. The interlocutor is a conventionally well-behaved person; the nephew ('Lui') is a shameless social parasite who expounds an amoral philosophy of life. Vice and opportunism are the way of the world. 'Virtue is praised, but hated and avoided; it makes you freeze, and in this world you have to have warm feet.'[310] His interlocutor would like to dismiss him as a madman, but has to admit that the nephew often talks good sense. Against the nephew's professed amorality, the 'Moi' describes himself as one of the rare eccentrics who do not think wealth the supreme good, to which the nephew replies that such a disposition is unnatural and can only be acquired by artificial means. The nature of man is to seek wealth, love and happiness at any cost. Natural man is born a little savage. The 'Moi' not only agrees with this unconventional view, but elaborates it: 'If the little savage were left to himself, if he retained all his imbecility and if he combined with a child's lack of reason the violent passions of a thirty-year-old man, he would twist his father's neck and sleep with his mother.'[311] Freud would later seize on this passage as an expression of the Oedipus complex.[312]

It might be tempting, therefore, to interpret the nephew as the enemy not only of conventional sentiments, but of civilization itself, and as embodying the raging, asocial energies that Freud located in the id. But in the nephew, as Lionel Trilling points out in a brief but brilliant discussion, these passions are transferred from the id to the ego. The nephew does not embody unconscious forces; he channels his energies into the entirely conscious project of self-preservation by conforming, albeit with limited success, to the demands of an essentially false and theatrical society.[313] He does not want to attack civilization, but to profit from it. However, he is too self-contradictory a character to be a successful social climber, for a perverse impulse makes him constantly offend those who might help him. *Rameau's Nephew* can be read as an Enlightenment text which, like Rousseau's *Discourses*, undermines the premises of the

Enlightenment. The nephew's contradictions suggest that humanity is ultimately inexplicable. Even if he is an extreme and extraordinary specimen, a limit case, he represents aspects of humanity which must elude even the Enlightenment's science of man.

## EMPATHETIC FICTION

In the mid- to late eighteenth century, the reading public grew so sharply in Britain, France and Germany that historians speak of a reading revolution.[314] Reading was often a shared activity. Rousseau recounts how he and his father read aloud to each other, often continuing all night until they heard the dawn chorus.[315] But it was also, and increasingly, a solitary practice, especially popular among middle-class women who had leisure, access to artificial light, and enough money to buy books. Paintings often show them reclining in armchairs while reading and wearing a special loose-fitting gown known as a *liseuse*.[316] Moralists warned them against unserious and exciting reading. Hester Chapone advises that 'the greatest care should be taken in the choice of those *fictitious stories*, that so enchant the mind – most of which tend to inflame the passions of youth, while the chief purpose of education should be to moderate and restrain them'.[317] Such anxieties may seem to be confirmed by Pierre-Antoine Baudouin's painting *La Lecture* (*Reading, c.*1760), which shows a woman lying back in a comfortable chair, and not actually reading, but daydreaming; the book in her hand rests on a kennel from which her lapdog is looking out.[318] The presence of the lapdog, a symbol of sensuality, reinforces the implication that she is lost in an erotic reverie inspired by her reading. Still clearer is an engraving after Baudouin by Emmanuel de Ghendt, *Le Midi* (*Noon*, 1765), where a young woman is not asleep but lying back with eyes and mouth half open and one hand inside her dress, evidently masturbating under the influence of the book that has fallen to the ground beside her.[319]

People not only read more: they read differently, becoming more involved in fictional worlds. Many novels of the late seventeenth and early eighteenth centuries engage and fascinate the reader. Madame de Lafayette in *La Princesse de Clèves* (1678) offers a minute exploration of passions which are subtle, complex and, in crucial ways, obscure.[320] The first-person singular becomes increasingly popular as a narrative device, which brings the protagonist close to the reader. Such stories often recount the protagonist's progress through sin and error to an understanding of his faults and the reception of divine grace, as in Grimmelshausen's picaresque novel of the Thirty Years War, *Der abenteuerliche Simplicissimus* (1668).[321] Defoe's

*Robinson Crusoe* (1719) not only describes its hero's ingenious contrivances for living on a desert island, but also shows how a sense of spiritual as well as physical abandonment, intensified by both real and supernatural terrors, leads him to repent of his disobedience towards God and his parents.[322]

First-person stories, however, are typically told from a vantage-point late in the narrator's life, when the experiences recounted have been distanced and mastered by memory. New scope for empathy was offered by the epistolary novel. By presenting a character's experience through letters, the novelist brings us close to that experience as it happens. We follow the character's thoughts and feelings in real time, as uncertain as they are about what will happen next. When a novel offers letters from several different people, we have something further: we understand characters' experience from the inside while appreciating the diversity of characters. We are invited to feel the humanity even of those we dislike, and we are encouraged to feel intensely the sufferings of persecuted victims. Stories told in letters involve their readers far more intimately than stories recounted from the distant perspective of an impersonal narrator.

The epistolary novel provided training not only in sympathy but also in empathy. This word was not used in the eighteenth century. It is first recorded in English in 1909 as an equivalent for the German *Einfühlung*. Although the two words are sometimes used interchangeably, empathy is not the same as sympathy. Sympathy is nowadays understood as an emotional capacity; empathy is a cognitive capacity. Sympathy means reaching out emotionally to other people; empathy means appreciating their perspective as distinct from one's own. Despite William Blake –

> Can I see another's woe
> And not be in sorrow too?[323]

– empathy does not mean immersing oneself in another's feelings, nor (to use a popular, but loose and unhelpful term) does it mean identification with another person. It means understanding another person's point of view, putting oneself imaginatively in their position, acknowledging the other as 'an equivalent centre of self, whence the lights and shadows must always fall with a certain difference'.[324]

Although sympathy is not empathy, sympathy can lead to empathy, and it did so for eighteenth-century novel readers. It has recently been argued that reading novels, especially epistolary novels, helped people in the eighteenth century to put themselves in other people's shoes, and sensitized them to cruelty in everyday life, savage punishments and abuses of human rights: 'In reading, they empathized across traditional social boundaries between nobles and commoners, masters and servants, men and women,

perhaps even adults and children. As a consequence, they came to see others – people they did not know personally – as like them, as having the same kind of inner emotions.'[325] Steven Pinker has developed this argument by assigning fiction, especially the epistolary fiction of the Enlightenment, a key function in widening the circle of empathy and thus promoting the growth of humanitarianism:

> Reading is a technology for perspective-taking. When someone else's thoughts are in your head, you are observing the world from that person's vantage point. Not only are you taking in sights and sounds that you could not experience firsthand, but you have stepped inside that person's mind and are temporarily sharing his or her attitudes and reactions.[326]

Empathy with fictional characters is not the same as empathy with real people; but it can be a major step towards it. When we read the emotions of somebody starving in prison or pursued by a sexual assailant, we may come to feel that nobody should be exposed to such suffering in reality.

Three epistolary novels, in particular, shaped the sensibility of the late Enlightenment: Richardson's *Clarissa* (1748–9), Rousseau's *Julie ou la nouvelle Héloïse* (1761), and Goethe's *Die Leiden des jungen Werthers* (1774; revised edition, 1787).[327] All three, by drawing their readers into the intense emotional experiences of their main characters, provided training in empathy which was enthusiastically welcomed. All three were popular across Europe. They do not, however, invite their readers simply to wallow in emotion. The male protagonists who surrender to their emotions – Lovelace, Saint-Preux and Werther – are contrasted with strong women – Clarissa, Julie and Lotte – who, with at least equally deep emotions, also attend to the requirements of piety, duty and good sense. Although that does not prevent a tragic outcome in at least two out of the three cases, it does mean that the novels invite not only the exercise but also the education of emotion.

The Europe-wide vogue of *Clarissa* may at first sight astonish us. Many potential readers nowadays are put off by its enormous length and by the fear that it may contain little but sentimental reflections. If they take the plunge, they will find that *Clarissa* is an absorbing, fast-paced, highly dramatic novel, which creates its own world and reaches tragic heights rarely attained in prose fiction.

The plot of *Clarissa* is in outline so simple that one may wonder how Richardson could take over a million words to tell it. Clarissa Harlowe is courted by a dashing nobleman with an unsavoury reputation, Robert Lovelace. Because of his libertine past, and because of their personal grudges against him, Clarissa's elder siblings press their worried parents

# CLARISSA.

## OR, THE

# HISTORY

## OF A

# YOUNG LADY:

Comprehending

*The most* Important Concerns *of* Private LIFE.

And particularly shewing,

The DISTRESSES that may attend the Misconduct
Both of PARENTS and CHILDREN,

In Relation to MARRIAGE.

*Published by the* EDITOR *of* PAMELA.

## VOL. I.

*LONDON:*

Printed for S. Richardson:

And Sold by A. MILLAR, over-against *Catharine-street* in the *Strand*:
J. and JA. RIVINGTON, in *St. Paul's Church-yard*:
JOHN OSBORN, in *Pater-noster Row*;
And by J. LEAKE, at *Bath*.

M.DCC.XLVIII.

On the title-page of *Clarissa*, Richardson implies that, as with *Pamela*, he has done no more than edit a collection of previously written letters, and highlights his novel's didactic intention without hinting at its immense emotional force.

to make Clarissa refuse Lovelace, and brother James finds her another suitor in Roger Solmes, an older man, ugly, reputedly a miser and misogynist, but vastly rich. Her family confine the defiant Clarissa to her room and threaten to force her into marriage. Having been in secret correspondence with Lovelace, who is lurking in disguise nearby, she escapes to London with his help. He establishes her in what seem to be reputable lodgings, but eventually she finds out that they are a high-class brothel, and again flees, this time to lodgings in Hampstead, whither Lovelace pursues her. Although he is half-heartedly applying for a marriage licence, he has no wish to be a faithful husband, and thinks marriages and parliaments should each last only a year. Thanks to an elaborate intrigue, Lovelace manages to deceive and drug Clarissa, and rapes her while she is semi-conscious. Soon afterwards Clarissa is arrested for debt at the suit of the brothel-keeper Mrs Sinclair and confined in a debtors' prison. She prepares for her death with increasing resignation, writing devout and dignified letters to all her relatives, another to Lovelace forgiving him, and disposes of her property in a lengthy will. Lovelace goes abroad and is killed in a duel by Clarissa's cousin Colonel Morden.

The novel's nail-biting fascination comes partly from its dramatic construction.[328] It is told in letters, between Clarissa and her bosom friend Anna Howe, and Lovelace and his fellow-rake John Belford, with occasional contributions by a dozen or so others. These letters consist sometimes of reflections, more often of reported action and dialogue, the latter in dramatic form, sometimes even with stage-directions. Richardson's careful control of chronology permits suspense: thus, we know that Clarissa's family intend her to be married forcibly on Wednesday 12 April, so she plans her escape, with Lovelace's help, for Monday, and we wait to see whether she will succeed. The whole narrative takes under a year, with letters from 10 January to 18 December.[329] Letters are sometimes dated not only by the day but also by the hour.

It is, however, especially questions of psychology and morality that make the novel enthralling. The dramatic contest of wills between Clarissa and Lovelace rests both on the opposition of their characters and on their complex mutual attraction. Clarissa's conscientious attempts at self-analysis recall the Puritan practice of keeping a spiritual diary, except that her self-examination is not private but social, conducted in letters to be evaluated by Anna.[330] Lovelace is motivated less by lust than by his intellectual enjoyment of complex intrigues. 'More truly delightful to me the seduction progress than the crowning act – for that's a vapour, a bubble!' he tells Belford.[331] The rape itself, reported by both Lovelace and Clarissa, is hardly an erotic event, especially as it takes place in public, in the

presence of Mrs Sinclair and two prostitutes: it is a brutal conquest in which Clarissa pleads for 'mercy' but receives none.[332] Lovelace stylizes himself as a Restoration rake and casts Clarissa as a proud beauty who must be conquered.[333] His stale language of gallantry ('on the wings of love, I fly to my charmer') contrasts with Clarissa's directness and honesty, her 'plain dealing', which he fails to understand.[334] Immediately after the rape, Clarissa's distress emerges from a series of barely coherent draft letters, while Lovelace appears callously impenitent; but even as a victim Clarissa shows herself the stronger character. Her inner strength enables her to prepare for death, face it calmly, and write letters of forgiveness to all her family and even to Lovelace, while he tries to evade the fact of death by his fantasy of embalming her body and preserving her heart in a golden casket.

Samuel Johnson described *Clarissa* as 'a prodigious Work – formed on the stalest of all empty Stories'.[335] The story of the seducer and his victim, however, deserves more respect; it was practically a governing myth of the eighteenth century, descending via Lessing's *Miss Sara Sampson* (1755) and Laclos' *Les Liaisons dangereuses* (1782) down to Kleist's *Die Marquise von O . . .* (1808).[336] The seducer–victim plot transposes to everyday life the tyrant–martyr plot favoured in the previous century. The tyrant gives his victim the chance to display virtue and fortitude, as when Andreas Gryphius responded to the execution of Charles I with the play *Carolus Stuardus* (1657, revised 1663), featuring Cromwell as villainous tyrant and Charles as saintly martyr. If the victim is female, as in Gryphius' *Catharina von Georgien* (1657), she will resist the tyrant's advances with unpredictable results: the Persian tyrant Chach Abbas, his lust unsatisfied, has Catharina tortured to death, but afterwards suffers torments of penitence when it is too late. Lovelace is steeped in English heroic tragedy of this type; in his very first letter he quotes from John Dryden's *Tyrannick Love* (1670): 'But raging fires tempestuous souls invade'.[337] This baroque heritage helps to give Clarissa the tragic dignity with which she approaches death.

Many readers, responding to each volume of *Clarissa* as it was published, implored Richardson for a happy ending. But although such an ending would have benefited sales, Richardson's didactic intention, of showing 'the Folly of trusting to the pernicious Notion, that a Reformed Rake makes the best Husband', his explicit Christian principles and – one hopes – his artistic integrity made him persist with the tragic outcome he had originally planned.[338] 'I intend more than a Novel or Romance by this piece . . . it is of the Tragic Kind', he told his friend the poet Aaron Hill.[339] Diderot, in an outstanding appreciation of Richardson, responded to the tragic dimension

of *Clarissa* when he praised its author for disclosing the evil concealed behind flattering self-deceptions in the dark recesses of the self:

> It is he who carries the torch into the depths of the cavern; it is he who learns to perceive the subtle and disreputable motives hidden and disguised beneath other motives which are respectable and which are eager to display themselves first. He breathes upon the sublime phantom that presents itself at the entrance to the cavern; and the hideous Moor behind the mask is revealed.[340]

Rousseau's novel *Julie ou la nouvelle Héloïse* was even more successful than *Clarissa*, with at least seventy impressions published within forty years.[341] The reasons were partially similar. With a smaller cast and fewer correspondents exchanging letters, its atmosphere is less dramatic but more intense, and its readers felt deeply involved. Emotions are unfolded at greater length than in Richardson, and the social world of *Clarissa* is absent; most of Rousseau's action takes place on two estates in Switzerland. Lengthy landscape descriptions both exploit and promote the new taste for unspoiled nature, and readers were tolerant of mini-essays on, for example, Italian music, children's education and estate management.

The constellation of characters is significantly different. Again there is a clandestine love relationship, but without the torturing ambivalence of that between Clarissa and Lovelace. Julie is as strong a character as Clarissa, though more volatile: emotional distress brings her several times close to death's door. Mutual love develops between her and her tutor Saint-Preux (as it did between the medieval Héloïse and her tutor Abelard), but Saint-Preux is no Lovelace. His emotions are constantly threatening to elude his control. After their first kiss, he laments: 'My senses are disturbed, all my faculties are upset by this fatal kiss.'[342] Their love is consummated early, not only by mutual consent, but on Julie's initiative. She continues to take control, rebuking Saint-Preux firmly for sexual indiscretions, and sending him away in case their relationship is discovered. Like Clarissa, she has an intimate female friend and confidante in her cousin Claire, who sometimes suggests they should live together; and she is also under the thumb of her family. There are no spiteful siblings, but she has an authoritarian father who, out of excessive gratitude to his friend Wolmar, insists that she should marry him, though Wolmar is a retired merchant approaching fifty. When Julie refuses, her father loses control and slaps her several times; falling, she knocks her head against the table leg and bleeds (and it would seem that this accident also causes a miscarriage, killing the child conceived in her night of love with Saint-Preux). There is a reconciliation, in which she covers his face with kisses and both shed tears.[343]

# LETTRES

## DE DEUX AMANS,

### Habitans d'une petite Ville au pied des Alpes.

*RECUEILLIES ET PUBLIÉES*

### Par J. J. ROUSSEAU.

*PREMIERE PARTIE.*

*Non la conobbe il mondo, mentre l'ebbe:*
*Conobill'io ch' a pianger qui rimasi.*
Petrarc.

### A AMSTERDAM,

#### Chez MARC MICHEL REY.

#### MDCCLXI.

---

The novel generally known, in its day and ours, as *Julie ou la nouvelle Héloïse*, originally appeared under the unwieldy title 'Letters from two lovers, living in a small town at the foot of the Alps. Collected and published by J. J. Rousseau'. The Italian quotation runs: 'The world did not know her while it had her; I knew her and remain here to weep', from Petrarch, Sonnet 294.

However, Julie obediently marries Wolmar. Her father, having failed with force, succeeds with emotional blackmail. Julie's mother has discovered her correspondence with Saint-Preux and soon afterwards died, not apparently from grief but from natural causes; the ultra-sensitive Julie blames herself and is in no mood to withstand her father's charge of ingratitude. Meanwhile, Saint-Preux, having gone to England, is ordered by his friend Lord Bomston to accompany the navigator George Anson on a three-year voyage round the world (which actually lasts four years). With Saint-Preux out of the way, a genuine relationship grows up between Julie and Wolmar, who, though emotionally cold, is a kind and good man, utterly different from Richardson's Solmes. They have two sons; they manage their estate on enlightened principles; Julie has a private orchard which is also a nature reserve; her only regret is that Wolmar, although he accompanies her to church, is really an atheist. When the suntanned and pockmarked Saint-Preux returns from his travels, Wolmar, who knows about his relationship with Julie, invites him to visit, and shows his confidence in their integrity by leaving them alone together. It is a close thing, for Saint-Preux insists on indulging his emotions by showing Julie the places where he languished for her ten years earlier. Crossing Lake Geneva by boat, Saint-Preux is tempted to drown them both. In later novels, a boat trip will provide an occasion and a metaphor for the relaxation of self-control and the surrender to romantic emotion (e.g. in Goethe's *Elective Affinities* and George Eliot's *The Mill on the Floss*), but here the ex-lovers end up behaving with unromantic good sense. Although Saint-Preux's emotional outbursts continue to irritate his friends – Claire astutely notes that his self-reproach keeps providing him with occasions for self-admiration[344] – the triangle of Saint-Preux, Julie and Wolmar seems stable.

Rousseau's narrative, immobile for long stretches, is occasionally jerked forward by unforeseen events (Julie's mother's discovery of the letters, Saint-Preux's departure with Anson), and now we have another. Julie jumps into the lake to save her younger son from drowning. She is pulled out, but soon dies from causes that are not altogether clear but sufficient to motivate a deathbed speech comparable to Clarissa's. Wolmar, who has previously anticipated Marx by describing devotion as 'opium for the soul', has his religious doubts removed. So the saintly Julie, we may think, has not died in vain.

The appeal of *La Nouvelle Héloïse* comes not only from the characters but also from the Swiss setting. Julie lives at Vevey and later at Clarens, both on the north-eastern shore of Lake Geneva. The scenery around the lake and in the mountains of the Haut-Valais is enchantingly described, particularly by Saint-Preux, who, as a non-Swiss, sees things freshly. He

maintains that life in the mountains is not only healthy but morally elevat-
ing, encouraging grand and sublime thoughts. People living in or near such
landscapes retain a simplicity of manners that makes them readily offer
hospitality to strangers, and which connects the Swiss with the ideal of
virtue upheld by ancient writers such as Plutarch (whom the young Rous-
seau read avidly). In Switzerland, 'the men of antiquity are found in modern
times'.[345] The extreme antithesis to the simplicity and sincerity of life at
Vevey is Paris, where Saint-Preux finds social life shallow, unfeeling, con-
ventional and regimented, as though people were marionettes pulled on
the same string. The model estate that Julie and Wolmar establish at Cla-
rens, not far from Vevey, offers a utopian alternative to a vanishing past
and a corrupting present.[346] Landscape, rural simplicity, personal virtue
and the restraint of passion combine to form an enchanting daydream in
which Rousseau expresses 'his desire for a purer sky, more open hearts,
and a world at once more intense and more diaphanous'.[347] Thus Rous-
seau's novel did much to propagate his linked ideals of sincerity, genuineness
and liberty, with the Alps as a poetically compelling backdrop.

Rousseau's novel provided a partial model for *Die Leiden des jungen
Werthers* (*The Sorrows of Young Werther*), which Goethe composed
rapidly – 'like a sleepwalker', he recalled long afterwards – in February
1774.[348] Corresponding to the triangle of Saint-Preux, Julie and Wolmar,
we have that of Werther, Lotte and her eventual husband Albert. But
whereas Richardson and Rousseau let all their main characters write letters,
in Goethe's novel all the letters are written by Werther, to a friend named
Wilhelm; none of Wilhelm's replies are preserved, though we can sometimes
infer their content from Werther's irritated counterarguments. So the novel
is more like a diary. It draws us compellingly into Werther's emotional state.
Some distancing is provided by an unnamed editor who professes to have
collected materials relating to Werther's fate, and who intervenes late in the
narrative to comment on Werther's progress towards suicide, drawing on
interviews with Lotte, Albert, Werther's servant and others.

Werther is as emotional as Saint-Preux.[349] A dilettante artist, he loves
nature and natural behaviour, hates snobbery and affectation, and is
clearly fun to be with. Albert, a conscientious and hard-working civil
servant, comes across as worthy and responsible, but dull. Their differ-
ences emerge sharply from an argument about suicide: the conventional
Albert condemns suicide on clichéd and general grounds, whereas Werther
is quick to imagine individual cases and to enter empathetically into the
psychological state in which suicide could seem the only solution. Lotte,
like Julie, is a strong character with deep emotions. She shares with
Werther a love of reading; at the ball where they get to know each other,

# Die Leiden

## des

# jungen Werthers.

## Erster Theil.

Leipzig,
in der Weygandschen Buchhandlung.
1774.

The illustration is not a comment on the book but an advertisement for the publisher, Weygandsche Buchhandlung (hence W. B.), with standard icons of publishing: book, candle (enlightenment), and mirror (self-knowledge).

she enjoys waltzing, a dance which was considered bold because one embraced one's partner; but she is also practical and motherly, for she looks after her widowed father and six younger siblings. Although Werther attracts her, she is committed to marrying Albert.

Werther's love for Lotte becomes an obsession, 'this wild and ceaseless passion'.[350] Where he formerly rejoiced in nature, he now uses it to torment himself by forcing his way through thorn bushes and scaling dangerous crags. He tries to distract himself by taking a job as secretary to an ambassador, but the pedantry of his employer and, above all, the snobbery of a petty German court make him resign his post and return to Lotte's neighbourhood. Perfectly aware of his emotional self-indulgence, Werther slides deeper into it by reading the melancholy prose-poems attributed to Ossian, drinking too much, brooding on past misfortunes, and surrendering to morbid religious anxieties. He visits Lotte so persistently that her marriage to Albert comes under strain. He resolves on suicide, but first pays a visit to Lotte and reads aloud to her from Ossian. The lengthy passages that Goethe here interpolates in his narrative work by both expressing and heightening the melancholy that torments both Werther and Lotte. After the reading, they embrace for the only time; both are momentarily carried away – 'They were oblivious to the world about them,' says the narrator[351] – but Lotte recovers herself and tells Werther they must never meet again. The next day Werther sends his servant to borrow pistols from Albert, on the pretext that he is going on a journey (and hence needs protection against highwaymen). After completing a long suicide note addressed to Lotte, he shoots himself at midnight; he is found by his servant the following morning, but it is too late to save his life.

This summary is of the first version of the novel. In 1787 Goethe produced a revised version in which Werther's language became more conventional and the narrator assumed a more prominent role in distancing Werther from the reader. But an attentive reading of the first version shows that Werther, however attractive, can be insensitive and self-centred, that he indulges his emotions to his own ruin, and that his suicide is a monstrous act of revenge against the people closest to him. At the end we learn that Albert and Lotte are so distressed that there are fears for Lotte's life (though as she later provides the 'editor' with information, she must have survived). Werther is more unruly than Saint-Preux, Lotte less self-controlled than Julie, while Albert, harassed by his job and his new responsibility for Lotte's numerous younger siblings, lacks the mature wisdom of Wolmar.

These three novels not only explore their protagonists' turbulent emotions, but also penetrate their unconscious minds in a way that goes

beyond the rather arid descriptions of mental functioning by Enlighten-
ment psychologists. Emotional crises in the lives of fictional characters
are often accompanied by dreams. In *Clarissa*, shortly before the heroine's
death, the increasingly obsessed Lovelace dreams that Clarissa, robed in
white, ascends to heaven, while he falls into a bottomless hole. 'I awaked
just now in a cursed fright,' he tells his correspondent. 'How a man may
be affected by dreams!'[352] In *La Nouvelle Héloïse*, Saint-Preux has a ter-
rifying dream about Julie wearing a veil, which proves to be a presentiment
of her death.[353] Werther, ten days before his suicide, has a shockingly vivid
erotic dream about Lotte.[354] And in *The Story of Agathon*, Agathon has
a highly symbolic dream about Psyche, from which he awakes in tears,
and which, Wieland says, ambiguously acknowledging the importance of
dreams, may be counted among 'the small causes which bring forth great
events'.[355] All these dreams are psychologically plausible; the quasi-
allegorical imagery of heaven and hell in Lovelace's dream can be
interpreted as the transformation of Christian concepts into an emotion-
ally charged set of symbols. Thus, novelists were ahead of psychologists
both in identifying the emotional significance of certain dreams and in
using them to present their characters as integrated beings in whom the
body and the soul interact.

These three epistolary novels prompted a new kind of reading, empa-
thetic and enthusiastic, as we can see from their reception. Readers felt that
they knew the characters intimately, shared their experiences, were almost
unbearably moved, and could not stop reading. Richardson's friend Lady
Dorothy Bradshaigh read each volume of *Clarissa* as soon as it was pub-
lished, and declared 'I verily believe I have shed a Pint of Tears.'[356] No less
than an army general, Baron Thiébault, spent whole nights reading *La
Nouvelle Héloïse*: 'from emotions to emotions, from upheavals to upheav-
als, I reached Saint-Preux' last letter no longer weeping, but shouting,
howling like an animal.'[357] Diderot, who read Richardson in English,
acknowledged how absorbing his work was: 'O Richardson! one assumes
a role in your works, one joins in the conversation, approving, blaming,
admiring, getting irritated, becoming indignant.' Reading *Clarissa*, he
found himself calling out, like a child at the theatre, 'Don't believe him, he's
lying! Don't go there, or you're lost!'[358] The young dramatist J. M. R. Lenz
rejected dry discussions of the morality of *Werther*, 'for when I read it, I
was conscious of nothing else; magically transported into his world, I loved
with Werther, suffered with Werther, died with Werther.'[359]

These novels' reception was also international, building on and driving
forward the increasingly cosmopolitan character of literary culture. *Clar-
issa* was reviewed enthusiastically in the *Göttingschen Gelehrten Anzeigen*

by the scientist and poet Albrecht von Haller, rector of the University of Göttingen, who induced his colleague the Orientalist Johann David Michaelis to translate it.[360] It was translated into French by another novelist, the abbé Prévost, though he omitted such crucial episodes as Clarissa's funeral and the reading of her will.[361] A French translation of *Werther* appeared in 1776; the translator was Georges Deyverdun, a friend of Gibbon's from Lausanne. To confirm how much the emotional atmosphere of *Werther* was felt to resemble Rousseau, a version of the novel, based on Deyverdun's translation and with the characters' names changed and the setting transferred to the Neuchâtel area, appeared in 1786 as *Le Nouveau Werther*.[362] The English translation by Daniel Malthus (father of the economist) appeared as *The Sorrows of Werter: A German Story* in 1779. Shelley read *La Nouvelle Héloïse* during a week-long sailing tour with Byron on Lake Geneva in June 1816; they visited, in the spirit of pilgrims, the locations of key episodes of the novel.[363]

Often these novels were felt to transcend national boundaries and be part of world literature. The much-read moralist Christian Fürchtegott Gellert wrote:

> Die Werke, die er schuf, wird keine Zeit verwüsten,
> Sie sind Natur, Geschmack, Religion.
> Unsterblich ist Homer, unsterblicher bei Christen
> Der Britte Richardson.[364]

[The works he created will outlast any length of time; they are nature, taste, religion. Homer is immortal, but more so, among Christians, is the Briton Richardson.]

Diderot likewise placed Richardson among the world's supreme writers. Even if he had to sell all his other books, he said, Richardson would stay on his shelf alongside Moses, Homer, Sophocles and Euripides.[365]

The novels inspired further literary works, as well as fan-fiction, continuations and parodies. Innumerable poems, in German, English and French, celebrated Lotte and Werther. Werther, 'Werter' or 'Verter' appeared on British, German, French and Italian stages.[366] A female Werther, who takes an opium overdose, features in Pierre Perrin's *Werthérie* (1791).[367] *Clarissa* found many imitations, set in Britain, such as Marie-Jeanne de Riccoboni's *Lettres de Mistriss Fanni Butlerd* (*Letters of Mrs Fanni Butlerd*, 1757) and *Geschichte des Fräuleins von Sternheim* (*History of Fräulein von Sternheim*, 1771) by Sophie von La Roche, who had learned English in 1754 and was widely read in English literature.[368] In La Roche's novel, the heroine is seduced by a Lovelace-like English

nobleman, Lord Derby, put through a sham marriage, and imprisoned in the 'Scottish lead mountains' (Leadhills in the Upper Ward of Lanarkshire).[369] La Roche, however, did settle for a happy ending: Lord Derby dies, and Sophie von Sternheim is able to marry his honest rival.

Fan-fiction not only testifies to enthusiasm, but lets writers criticize weaknesses they find in the original works. Lady Elizabeth Echlin (the sister of Richardson's admirer Lady Bradshaigh) produced a reworking of *Clarissa* in which the rape did not happen and Lovelace became a reformed character; she also made Clarissa reproach herself for being so easily taken in by Lovelace's schemes.[370] An English writer supplied Lotte's side of the story in letters to a female friend, which condemn Werther's suicide as impious and as an act of cruelty to her: 'O, Werter! – was it not cruel, for ever thus to wound the peace of Charlotte?'[371] Sharper criticism could be expressed in parodies. The Berlin publisher Friedrich Nicolai, who had made mild fun of *Clarissa* in his novel *Sebaldus Nothanker* (1773–6), published *The Joys of Young Werther* (1775), in which a wiser Albert loads his pistols with chicken blood so that Werther's suicide attempt is messy but harmless, then hands Lotte over to Werther; Werther has to get a job to support his wife, encounters real sorrow (the death of a child), which teaches him not to lament over small matters, survives a marital crisis thanks to Albert's intervention, and ends up living happily with Lotte and eight children.[372]

Imitation did not just happen on paper. The costume that Werther wears when he first meets Lotte – and dons for his suicide – a blue coat and yellow breeches, became fashionable among young men of sensibility in Germany. So, allegedly, did suicide. The author of *The Letters of Charlotte* blamed Goethe for justifying 'the horrible crime of Suicide'.[373] While one cannot prove that reading *Werther* was the cause or catalyst for any suicide, there were suspicious cases, like that of Christel von Lassberg, a young woman known to Goethe who in January 1778 drowned herself in the river Ilm, near his home in Weimar, allegedly with a copy of *Werther* in her pocket.[374]

Enthusiasm for *La Nouvelle Héloïse* includes a different note. People felt that it changed their lives, or at least that it ought to. Julie's purity and integrity, the balance of reason and feeling that she and Wolmar establish at Clarens, offered a new way of living. One fan wrote to Rousseau: 'it is as difficult to know you without loving virtue as it is difficult to read you without having the greatest desire to practise it'.[375] Another wrote that the novel enabled him to do good actions: 'one becomes passionate about good, one sometimes does some, at least one thinks that what one has never accomplished may be possible and true'.[376] Rousseau was being read not only as a novelist but as a guide to life, even a prophet.

Sentimental fiction flourished for the rest of the century. Instead of the massive works of Richardson and Rousseau, which create imaginative worlds partly by their sheer scale, we find a tendency to short novels – Goldsmith's *The Vicar of Wakefield* (1766), Marmontel's *Bélisaire* (1767), Henry Mackenzie's *The Man of Feeling* (1771) – which in turn break down into loosely connected sentimental mini-narratives. These mini-narratives are schematic, presenting antithetical character-types – the virtuous sufferer, the callous aggressor or exploiter – observed by the sentimental onlooker who offers charity. The fragmentary character of these narratives itself gives them an air of authenticity: we are supposed to be in the presence of raw feeling, not yet formed into literature, and mediated only by the editor who, as in *Werther* and *The Man of Feeling*, professes to have assembled them with minimal interference.[377] Instead of the psychological ambivalence found in Richardson or Goethe, we have a narrow emotional range, in which the display of sympathy often appears as sentimental self-indulgence. Tears flow in streams. In Johann Martin Miller's *Siegwart: Eine Klostergeschichte* (*Siegwart: A Monastic Tale*, 1776) the hero weeps continually when separated from his beloved Mariane, and weeps nearly as much in emotional communion with his friend Kronhelm.[378]

Inevitably, sentimental fiction brought forth parodies. The most elaborate are the (in every sense) monstrous erotic novels by the Marquis de Sade, where situations inviting sentiment repeatedly reveal new depths of depravity. The obstinately virtuous heroine of *Justine ou les Malheurs de la vertu* (*Justine or the Misfortunes of Virtue*, 1791) seeks refuge in an idyllic-looking monastery, only to be gang-raped by the monks. A male character in *Juliette ou les Prospérités du vice* (*Juliette or the Rewards of Vice*, 1797) meets his long-lost English lover, with the unlikely name 'Clotilde Tilson' (dimly recalling Clarissa), and responds to her heartfelt greeting by torturing her to death.[379] Sade's novels, with their physically impossible sexual contortions, are best read as prolonged exercises in black humour. If they are taken more seriously, their underlying philosophy reveals its incoherence. There is no such thing as morality; materialism means that human beings are merely objects to be used and dismembered for the pleasure of the strong. Yet Sade's characters are motivated by the urge to transgress the morality that they profess not to believe in. The abbess who seduces the thirteen-year-old Juliette invites her to commit crimes; Juliette later joins a Society for the Friends of Crime and, after participating in orgies of group sex and murder orchestrated by the pope, she condemns him as a scoundrel, though the words 'crime' and 'scoundrel' should have no meaning for her. In their polemic against the Enlightenment, Max Horkheimer and Theodor Adorno describe Sade's materialist egotism as

its logical end point.[380] But in fact, by completely rejecting the concept of sympathy, Sade represents an aberration from the Enlightenment.

More serious writers, Laclos and Schiller, worried that enlightened reason without sympathy would produce Sadean monsters. In *Les Liaisons dangereuses* (1782) Choderlos de Laclos depicts a pair of aristocrats, Valmont and Madame de Merteuil, who deliberately subordinate their emotions to their intellect for the pleasure of manipulating others. But emotions are not so easily suppressed. Valmont takes on the challenge of seducing the virtuous Présidente de Tourvel, and succeeds, but at the cost of falling in love with her, which leads to an ultimately fatal breach with his partner in crime. Laclos, a middle-class army officer, is attacking the corruption of the aristocracy; but the novel also strongly invites us to side with the intellectual superiority of the two central characters, and the resulting ambivalence makes the novel endlessly fascinating.[381] Almost simultaneously, the young Schiller in *Die Räuber* (*The Robbers*, 1781) presented an aristocratic villain, Franz Moor, who, as a convinced materialist, regards other people, including his father and brother, as objects to be manipulated for his own advantage; but finally Franz's repressed conscience fills his dreams with images of damnation and drives him to suicide. Franz, whom commentators have compared to Sade's characters, expresses Schiller's doubts about a narrow conception of enlightenment that would reduce it to rational calculation.[382]

These texts by Laclos and Schiller are already part of a reaction against sensibility. Their villains are brought low not by tears, but by the intrinsic insufficiency of their blinkered rational outlook. A broader reaction was inevitable, as summarized by Janet Todd: 'Its adjectives tell the tale of its rise and fall. It is "exquisite" in Addison, "delicate" in Hume, "sweet" in Cowper, and "dear" in Sterne. But as it declines from fashion, it becomes "acute" in Austen, "trembling" in Hazlitt, "mawkish" in Coleridge, and "sickly" in Byron.'[383] In Jane Austen's *Sense and Sensibility* (first drafted 1797–8, published 1811), when Marianne rhapsodizes about the leaves falling in autumn – 'with what transporting sensations have I formerly seen them fall!' – her sister responds drily: ' "It is not every one," said Elinor, "who has your passion for dead leaves." '[384]

Displays of feeling, however, are not always self-indulgent or self-admiring. In *Tristram Shandy*, Uncle Toby learns that a fellow-officer, Le Fever, who fought alongside him in the Low Countries, is now lying, gravely ill, with his young son in a nearby inn. Toby elicits the circumstances through his servant Trim, with no other sign of emotion than 'a deep sigh'. Trim thinks (rightly) that Le Fever's life cannot be saved; Toby responds not with tears, but with determination:

A-well-o'day – do what we can for him, said *Trim*, maintaining his point, the poor soul will die: — He shall not die, by G—, cried my uncle *Toby*.

—The ACCUSING SPIRIT which flew up to heaven's chancery with the oath, blush'd as he gave it in; — and the RECORDING ANGEL, as he wrote it down, dropp'd a tear upon the word, and blotted it out for ever.[385]

Although Toby's intervention does not save Le Fever's life, he shows his practical humanity by having the officer's son educated at his own expense. 'Unlike many sentimentalist heroes, Toby does not pay Le Fever with fine feelings instead of cash.'[386] The only person to weep is the Recording Angel. But the episode points a way out of sentimentalism in another direction than Jane Austen's irony. For it invites two responses. Eighteenth-century readers could enjoy feeling sentimental pity for Le Fever, whose story was often excerpted as a separate mini-narrative. Uncle Toby does not enjoy Le Fever's story: he is distressed and angry and does all he can to help. The reader cannot help, but also cannot and should not ignore Toby's response. For, as Michael Bell continues, 'sharing Toby's response is central to enjoying the fiction, so that the episode effectively distinguishes between the moral and the aesthetic responses while superimposing them and insisting on their common root in moral feeling.'[387] That is: Sterne opens up aesthetic enjoyment as a form of experience that enhances our moral awareness without issuing *directly* in action, and implies simultaneously that this heightening of aesthetic sensibility must lead *ultimately* to practical beneficence when we are in a position to help someone, as Toby is now.

## SENTIMENT AND SOCIETY

One naturally wonders about sentimentalism and reality. Did people in the late Enlightenment really weep copiously and express sympathy readily? The long-standing convention that men should hide their emotion was still upheld by Adam Smith, who in *The Theory of Moral Sentiments* preferred the steadfastness of the ancient Stoics to 'the desponding, plaintive, and whining tone of some modern systems'.[388] Tears were expected and acceptable on certain occasions. It is not surprising that audiences should weep at Methodist meetings, especially when addressed by the famously eloquent preacher George Whitefield, nor that some condemned criminals should weep on the scaffold.[389] Men who unburdened their personal feelings by weeping still incurred disapproval, but it became more acceptable for them to shed tears out of sympathy for others. After all, St John's Gospel (11:35) reported that 'Jesus wept' from grief at the death of his friend Lazarus. In

1791, when Charles James Fox burst into tears in the House of Commons on being unexpectedly attacked by his old friend Edmund Burke for supporting the French Revolution, his breakdown elicited mixed reactions. Journalists derided Fox for giving way to tears. The gossip Horace Walpole, however, reported that Burke had wept too, producing a display of mutual sympathy that was 'the most affecting scene possible'.[390]

The theatre could provide not just entertainment but models of exemplary behaviour. Shakespeare's men, sharing a widespread early modern ideal of self-control, try not to weep: the soft-hearted Earl of Ross in *Macbeth* tells the hapless Lady Macduff, 'I am so much a fool, should I stay longer, / It would be my disgrace, and your discomfort', and hastens away to avoid tears.[391] But in James Thomson's tragedy *Sophonisba* (1730), the moral centre, the Roman general Scipio, is an Enlightenment exponent of sympathy:

> Thy tears are no reproach.
> Tears oft look graceful on the manly cheek.
> The Cruel cannot weep.[392]

The arrival of a new culture of feeling is confirmed by the mid-century taste for tear-jerking dramas, known in French as *comédies larmoyantes*, pioneered to popular acclaim by Pierre Claude Nivelle de la Chaussée in *La Fausse Antipathie* (1733). In these plays, virtue is equated with sensibility, and, though subjected to trials, eventually guarantees happiness. Voltaire contributed to this genre with *Nanine* (1749), in which the heroine (modelled on Richardson's *Pamela*) is threatened with misfortunes, to which she submits docilely, until a happy ending brings relief to her and the affected audience. The new mixture of comedy and tragedy, allowing audiences both to cry and laugh, filled the theatres and secured La Chaussée's election to the French Academy.[393] German audiences also learned to enjoy a good cry. Lessing's tragedy *Miss Sara Sampson* (1755), heavily influenced by *Clarissa*, is set in a middle-class English milieu; the heroine has been seduced and betrayed by Mellefont, an unimpressive version of Lovelace, and is finally poisoned by Mellefont's spurned and vindictive mistress. The play had immense success throughout Germany and even in France. Lessing's friend Friedrich Nicolai (who later parodied *Werther*) reported that he wept frequently throughout the play and in the fifth act (Sara's death) was so affected that he could not even cry.[394] It is significant too that models of unfeeling masculinity are held up to ridicule. In Oliver Goldsmith's *She Stoops to Conquer* (1773) two old-fashioned male types, the rake (Marlow) and the 'booby squire' (Tony Lumpkin), are derided, while in Miller's *Siegwart* the small country squire (*Krautjunker*) Veit von

Kronhelm is an evil figure who not only spends all his time hunting and drinking, and throws a book out of the window onto a dunghill, but pleasurably recalls raping nuns as a soldier and nearly kills his son for refusing to marry the woman Kronhelm has chosen for him.

The abundant emotions expressed in fiction do not necessarily tell us how people behaved in real life.[395] However, we have a variety of written evidence that suggests a much higher emotional temperature in the later 1700s than earlier in the century. The letters between Marie Phlipon and her future husband, Jean-Marie Roland, provide a revealing example. After receiving a letter from her (now lost), Roland in his first letter (17 September 1777) complained of illness and other difficulties and dwelt on the need for friendship. He got an overwhelming response:

> I am pierced to the heart, delighted, despairing; I pity you, I scold you, I . . . I wish I knew several languages and could use all of them at once. It is possible that you could attach any value to my memory and take so long to try to recall it! Is that forgetfulness or confidence? The first would be heart-breaking, and besides, you prevent me from believing it; I would sooner pardon your presumption for the second, if I could truly say that this confidence was presumptuous. You are lucky to deserve pity! If I esteemed you less, I would fear you more; but I would not tell you so. Your letter made me cry, and yet I am happier since receiving it.[396]

Phlipon goes on to commend Roland, ironically, for having waited several days so as to reply to her in a calm, orderly and reassuring manner. That isn't what she wants from a letter, she insists, and she will observe no such restraint. 'I shall not wait, before replying to you, for calm and reflection; you will get disorder, and that does not worry me; sentiment is not so methodical.'[397] Rather than methodical order, sentiment demands an outpouring of emotion. But that isn't exactly what she has sent him. Her first paragraph, quoted above, begins and ends with a passionate mixture of incompatible emotions, but the middle part analyses various emotional possibilities with a subtlety that had become almost second nature to French writers since the days of La Rochefoucauld. So we can see in this letter not so much a spontaneous outburst of emotion, but rather the spectacle of Marie Phlipon training herself to write with sentiment and encouraging Roland to do the same.

Sentimental letters were exchanged not only between couples but within groups. In 1772 Goethe visited the circle around Franz Michael Leuchsenring, tutor to the crown prince of Hesse-Darmstadt, who saw himself as 'the apostle of sentiment'.[398] Members of the circle exchanged emotional letters. They included three ladies who used the pseudonyms Urania, Lila and Psyche (the last was Caroline Flachsland, who in 1773 married Herder).

'I can't write today', writes Lila (Louise von Ziegler) to Psyche, 'but I can love and think a lot about you; if you see a shadow or hear a wish being uttered, that's sure to be me. I'm not very well, but my soul is as well, as happy, as loving as ever. I shall sacrifice a rosebud to my friends.'[399] Members of a similar coterie in Philadelphia wrote to each other under assumed names such as 'Eugenius' (taken from Sterne) and 'Harriet' (from Harriet Byron in Richardson's *Sir Charles Grandison*).[400]

Sentiment was, by definition, social. When its devotees met, they engaged in conversation that was warm and emotional, in contrast to the cool and polished language of politeness. Writing and reading were shared activities. People showed each other their letters and journals. They read together, looking 'for character, for sympathetic sensation, and for moral sentiment'.[401] In Miller's *Siegwart*, the hero and his friend Kronhelm read Klopstock's religious epic *Der Messias* together. In Moritz's autobiographical novel *Anton Reiser* (1785–90), the protagonist and his friend Neries read *Siegwart* together several times, 'and although they were quite hideously bored, they both made an effort to remain in their original state of emotion through all three volumes.'[402]

Among men, we sometimes find an effusively expressed cult of friendship, notably in the circle around the poet Johann Wilhelm Ludwig Gleim, who installed what he called a 'temple of friendship' in his house in Halberstadt in the southern Harz Mountains. This temple, preserved today for visitors, was a handsome room in which Gleim, a well-to-do bachelor, hung specially commissioned portraits of his male friends, mostly writers, and where he maintained a lively and sometimes stormy correspondence with them all. Emotions were sustained by reading; thus Ramler (a close friend who eventually broke with Gleim because of the latter's unfounded jealousy), having been moved by reading about Clarissa's death, promptly imagined how sad he would feel on receiving a letter from the dying Gleim.[403] Friendship here is no longer an affinity based on shared activities or shared values, as when, in Lessing's *Nathan der Weise*, the Templar, recognizing Nathan's virtue, impulsively declares 'We must, must be friends!'[404] It is rather a cult of friendship for friendship's sake, and though not false – Gleim was deeply grieved when his friend Ewald Christian von Kleist was killed at the Battle of Kunersdorf in 1759 – it degenerated into obsessive petty worries about which friend was the most sincere.[405] The volumes of correspondence that Gleim published, in which he and his friends constantly talk of kissing each other, have excited some modern scholars with the supposed discovery of a gay subculture. But there is ample evidence that in eighteenth-century Germany it was commonplace and unsuspicious for men to kiss

each other, even on the lips.[406] The erotic temperature may have been raised, but not very high.

This example prompts the question: granted that people used far more emotional language than before, was it anything more than language? May it not just have been fashionable to give one's discourse a 'sugar-coating of sensibility'?[407] Shouldn't we assume that emotions were roughly constant from one age to another, and that only their expression differed? The work of historians who have begun to write the history of the emotions suggests that this bald antithesis between feeling and expression is too simple. William Reddy, investigating changes in sensibility during the eighteenth century, has coined the noun 'emotive' in a partial analogy to 'performative'. A performative is something you do by speaking, e.g. 'I name this ship . . .' or 'I agree to your conditions'. An emotive is an expression of feeling that helps to create the feeling it denotes. When you find words for feelings, you make it easier to have those feelings. Emotional expressions therefore should be thought of as 'emotives', which not only name an already existing emotion but also strengthen and heighten it and make it easier for other people to share it. In the Rolands' correspondence, the 'emotives' seem to have provoked a similar response, confirming and strengthening emotions that were already incipient.[408] Contemporaries testified that the great sentimental narratives brought out in them feelings that they scarcely knew they had. The abbé Pernetti wrote to Rousseau: 'How much our hearts owe to you for causing feelings to grow that would have remained barren if you had not warmed them!'[409] The conservative journalist August Wilhelm Rehberg recalled, speaking of *Werther*, which he had read at the age of seventeen: 'It became permissible to utter thoughts aloud which one had previously dared to make clear only to oneself; to express emotions which one could not have acknowledged even to oneself.'[410]

Evidence that sympathetic emotions were really aroused, not just talked about, lies in the enormous amount of charitable activity seen in the late Enlightenment. Early in the century several famous London hospitals, named after their founders, were established by private charity, but later philanthropy was unostentatious, and often co-operative rather than individual.[411] In later eighteenth-century London, charitable foundations were established to assist chimney-sweeps, debtors and impoverished authors, and to teach techniques for resuscitating people apparently drowned.[412] John Howard investigated conditions in prisons and hospitals, not only throughout Britain but even in the Near East and Russia.[413]

Sensibility also motivated people to oppose social evils. It was 'often a contrarian pose: it responded to, even needed, a cold, hostile, indifferent world.'[414] Hence it did much to mobilize opposition to the slave trade. It

is instructive to compare Aphra Behn's short novel *Oroonoko, or the Royal Slave* (1688), written before the rise of sensibility, with late eighteenth-century writings. Oroonoko is an African prince, with European features, royal dignity, courage to kill a 'tiger' in single combat, and a refined sense of honour that contrasts with the duplicity of many Europeans. Sold in Surinam to a humane Englishman, he marries his lover Imoinda and is allowed so much freedom that 'he endured no more of the slave but the name'.[415] Foreseeing, however, that his child will be a slave too, Oroonoko – now renamed Caesar – leads several hundred fellow-slaves to found a new colony, but they are defeated. The treacherous governor breaks his promise to Oroonoko and has him savagely flogged. Oroonoko, in an act of Roman virtue and self-sacrifice, kills his wife and is executed for the deed in a particularly barbarous manner.

All this is a denunciation of European treachery and cruelty, but not of slavery as such. Oroonoko is himself a slave-dealer, who has sold 'abundance of his slaves', and is himself sold into slavery, along with Imoinda, by his grandfather, who is jealous of their relationship.[416] When he arrives at the slaves' dwellings on the Surinam plantation, 'they all came forth to behold him, and found he was that prince who had at several times sold most of 'em to these parts', whereupon, far from resenting this treatment, they prostrate themselves before him, kiss his feet, and pay him 'even divine homage'.[417] *Oroonoko* was translated into French in 1745, and became one of the nine most popular English novels there (alongside novels by Richardson and Henry and Sarah Fielding), inspiring many literary portrayals of noble Africans who, like Oroonoko, claim our sympathy because they are exceptional.[418] Only an anachronistic reading can find in *Oroonoko* a plea, not just for the humane treatment of slaves, but for the abolition of slavery.

Once the campaign against slavery got under way, it relied not only on exposing the miseries of the slave trade, but also on inviting people to imagine themselves in the slaves' situation and thus to sympathize. Quakers were among the first to denounce slavery and appeal to sympathy (in present-day language, for empathy). In 1754 the annual meeting of the Society of Friends in Philadelphia asserted that 'to live in ease and plenty by the toil of those whom violence and cruelty have put in our power' was incompatible with Christianity, and appealed to Quakers to make the Africans' case 'our own and consider what we should think, and what we should feel, were we in their circumstances'.[419] In one of his anti-slavery pamphlets, the Quaker Anthony Benezet quotes from the Scottish lawyer George Wallace: if a European were captured by pirates, he would think himself entitled to freedom: 'Have not these unfortunate *Africans*, who meet with the same

cruel fate, the same right? are they not men as well as we? and have they not the same sensibility?'[420] In 1787 a Committee for Effecting the Abolition of the Slave Trade was founded in London, with the Quaker Thomas Clarkson in the lead. Its emblem, designed by Josiah Wedgwood, showed a chained African kneeling with the legend: 'Am I not a man and a brother?'[421]

Anti-slavery literature appealed to the reader's sympathies not only by describing the torments inflicted on slaves, but by inventing stories about named individuals. The milkmaid poet Ann Yearsley, in her 'Poem on the Inhumanity of the Slave Trade', tells how the couple Incilanda and Luco are separated when Luco is carried into slavery and, for trying to resist and escape his captors, is tortured to death.[422] A particularly popular narrative concerns Yarico, a native American, who saves the life of the young British merchant Thomas Inkle; they become lovers and he promises to take her to England and marry her, but on reaching Barbados he reflects that, being pregnant, she is a doubly valuable property, and he sells her into slavery.[423] Olympe de Gouges, who campaigned on behalf of slaves as well as women, wrote a play originally entitled *Zamore et Mirza ou l'Heureux naufrage* (*The Fortunate Shipwreck*); under a title that transferred the emphasis from individual fates to the general issue – *L'Esclavage des nègres, ou l'Heureux naufrage* (*Negro Slavery, or the Fortunate Shipwreck*) – it was performed at the Théâtre de la Nation in December 1789.[424]

Sensibility helped to bring about the gradual end of public executions. An increasingly sensitive public did not necessarily want executions to cease, but could no longer bear to watch these painful spectacles.[425] This was squeamishness rather than empathy. A novel degree of identification with the victim, however, appears in Boswell's responses to executions, which he watched compulsively although he knew they would distress him. In London in 1763 he witnessed the execution of a 'genteel, spirited young fellow', Paul Lewis, who clearly resembled Boswell (or Boswell's idealized self-image) himself: 'I was most terribly shocked,' he recorded, 'and thrown into a very deep melancholy.'[426] In 1774 in Edinburgh, Boswell was deeply upset by the impending execution of the sheep-stealer John Reid, a former client whose acquittal from a previous charge he had secured. He visited Reid in the condemned cell, petitioned the king for Reid's release, and concocted a desperate plan to steal Reid's body after the hanging and try to resuscitate it.[427] Boswell was not distressed by execution as such, but by its infliction on people with a close connection (imaginary or real) to himself. Nevertheless, Boswell's experience 'affirms a sea change in the history of feeling'.[428]

Sensibility also invited people to understand criminals by imaginatively entering their thoughts and feelings. We have already seen (p. 268) Francis

Hutcheson imagining the moral outlook of brigands, as Schiller would later do in *Die Räuber*. The Italian legal theorist Cesare Beccaria, in 1764, justifies his humane proposals by composing the soliloquy that an articulate criminal might utter to explain his disregard for the death penalty. Since the laws that currently exist are made by the rich for their own advantage, the criminal might reason, then in breaking the law one is attacking injustice and gaining goods and freedom which may last for many years; if one is finally caught and hanged, one will at least have gained years of freedom in return for one day of pain.[429] Schiller's short story 'Der Verbrecher aus verlorener Ehre' ('The Criminal from Lost Honour') explores in detail how a criminal is led into bad ways by what would nowadays be called low self-esteem.[430]

In particular, publicists and dramatists called attention to the problem of infanticide. Young women left pregnant by their lovers often killed their children out of desperation. 'How could one who finds herself caught between disgrace and the death of a being unable to feel what harms it, not prefer the latter to the certain misery to which she and her unhappy fruit would be exposed?' asked Beccaria.[431] Goethe, who as a young lawyer may have attended the interrogation of the infanticide Susanna Margaretha Brandt, executed in Frankfurt in 1772, made her story into the tragedy of Gretchen which forms the core of his *Faust* drama and was copied by other young dramatists of the 1770s.[432]

Sentimentalism enjoins sympathy not only for our fellow-humans but for animals. Many writers of the late eighteenth century invited such sympathy, including Sterne and Burns, but in doing so, they were going against the grain of their times.[433] What we would consider appalling cruelty to animals was commonplace, though sometimes it resulted from indifference rather than malice. Unwanted dogs were routinely drowned or hanged – the latter mode of disposal may reflect the frequency of criminal executions.[434] Cats were burned alive at festivals to entertain the public with their caterwauling; the atheist priest Jean Meslier reports with horror how peasants attach live cats to the top of an upright pole and light a fire at its base, 'to have the pleasure of seeing the violent movements and hearing the frightful cries that these poor unfortunate beasts are forced to make because of the savagery of the tortures'.[435] Songbirds were blinded to make them sing better. All kinds of wanton cruelty towards animals form the first of William Hogarth's *Four Stages of Cruelty* (1751), by which he hoped to reduce 'that cruel treatment of poor Animals which makes the streets of London more disagreable [*sic*] to the human mind than anything what ever'.[436] We see young Tom Nero torturing a dog while other boys hang fighting cats from a rope, throw a cat from a top-floor

window, and blind a dove with a hot wire. 'The English are noted for their cruelty', according to Rousseau.[437] Certainly the English had long been notorious for such sports as fox-hunting, bear-baiting, cock-fighting and cock-throwing (in which a cock was tied to a stake and pelted with specially weighted sticks).[438] But Spain and southern France had bull-fighting, while in Saxony a favourite amusement for courtiers was fox-tossing, in which a fox was tossed in a blanket until it died, usually in the palace courtyard with the prince, ladies and gentlemen looking on.[439] Goose-pulling was a popular sport in the Netherlands, and passed from there to North America: a goose was hung from a horizontal bar, with its neck greased; a horseman, riding rapidly past, tried to seize the goose's neck and pull its head off.[440] Friedrich Nicolai, visiting Vienna in 1781, witnessed the animal combats (called *Tierhetze* or *Hatz*) which were held on Sunday afternoons in a wooden amphitheatre. He saw a bull attacked by eight dogs, one of which gripped it by the testicles while another tore off an ear, and a pig eaten alive by two wolves. The latter spectacle was too much even for some of the spectators, who had previously shown no pity for the tormented animals.[441] The Spanish bullfight too attracted criticism, even from Spaniards. In 1774 the Spanish Enlightener José Cadalso, who deplored many aspects of his country, made a fictitious Muslim visitor describe it as 'consisting in seeing men put their lives at risk, trusting only in what with more reason deserves the name of barbarity than of skill in playing with fellow-creatures'.[442]

More usual forms of hunting were practised, sometimes obsessively. On 13 September 1738, Louis XV and his entourage shot 1,700 partridges; Louis XVI, who hunted on average every other day, and kept an account of the game he killed, recorded 1,564 items killed in December 1775.[443] German princely courts spent several months of each year moving from one hunting lodge to another in order to maintain the supplies of game. On special occasions, hunts were organized in which a hundred stags, or even larger numbers of other animals, might be killed. Frederick the Great was highly unusual in denouncing hunting, which he called mindless, cruel and unsuitable for princes: 'it is to be feared that they will become as inhuman toward men as they are toward beasts'.[444] Rousseau recalled the tearful distress he had felt the one time he witnessed the death of a hunted stag.[445] It was common, and long remained so, for men to go out with a gun and shoot at any unprotected live creatures they saw. In *La Nouvelle Héloïse* Saint-Preux takes a gun along on a boat trip to shoot passing birds, until dissuaded by Julie; but later she does not even try to discourage her father from shooting thrushes. Addison, praising field sports as healthy exercise, tells us approvingly that his fictional Sir Roger de Coverley 'has

destroyed many thousands of Pheasants, Partridges and Wood-Cocks', and has secretly imported large numbers of foxes from other counties 'that he might the better signalize himself in their Destruction'.[446] However, Sir Roger shows early compassion by saving the life of a hunted hare.

Robert Burns, who was familiar with sentimental literature (Sterne, Marmontel, Mackenzie), was consistently opposed to shooting animals.[447] His poem, 'On seeing a Wounded Hare limp by me, which a Fellow had just shot at', was inspired by an incident in spring 1789 when a young man wantonly wounded a mother hare. The angry Burns threatened to throw the perpetrator into the river Nith. He recounts the incident in a letter:

> As I was in my fields early one morning in this last spring, I heard the report of a gun from a neighbouring wood, and presently a poor little hare, dragging its wounded limbs, limped piteously by me.—I have always had an abhorrence at this way of assasinating [sic] God's creatures without first allowing them those means of defence with which he has variously endowed them; but at this season when the object of our treacherous murder is most probably a Parent, perhaps the mother, and of consequence to leave two little helpless nurslings to perish with hunger amid the pitiless wilds, such an action is not only a sin against the letter of the law, but likewise a deep crime against the *morality of the heart*.[448]

There were economic reasons for letting a mother hare rear her brood instead of killing her; instead of mentioning these, however, Burns invokes the language of family affection and humanity.

Similar humanity finds expression in 'To a Mouse' (1785). Here Burns extends his sympathies to a humble specimen of the animal creation, and deplores the lordship over animals that the Book of Genesis assigns to humanity:

> I'm truly sorry Man's dominion
> Has broken Nature's social union,
> An' justifies that ill opinion
> Which makes thee startle
> At me, thy poor earth-born companion,
> An' *fellow-mortal*![449]

These lines may be overfamiliar now, but they are not commonplaces. They express a difficult moral insight, which needed a century of sentimental reflection and emotion in order to be formed. In their context, however, they raise further questions. The poet has himself destroyed the mouse's home. The transformation of the field into ploughland results from agricultural improvement which sets the interests of humans and

animals at odds. The poet recalls an earlier charitable ethic in which the poor were allowed to glean grain from a cornfield at harvest time, as is explicitly enjoined in the Bible (Deut. 24:19). He would gladly extend this indulgence to the mouse, for 'A daimen-icker in a thrave / 'S a sma' request' (i.e. the occasional ear of corn in a measure of cut grain); but it is now too late, for December is approaching, and the mouse will no longer be able to find food or materials to build another nest. Thus, the poem lets us trace the evil effects of 'man's dominion' in painful detail.[450]

Sympathy with animals was taken yet further by the Edinburgh-born John Oswald, a poet, journalist, soldier, revolutionary, atheist and vegetarian.[451] He moved to Paris in 1790, edited a monthly journal, spoke in the Jacobin Club, and was made an honorary French citizen and a commander in the revolutionary army; he was killed in 1793 fighting the anti-revolutionary insurgents in Vendée. Before that, he had spent two years as an officer in India. There, probably unlike most British soldiers, he talked with Hindus and acquired a great respect for their religion, especially for its humanity and its fellow-feeling towards animals. In his plea for persecuted animals, *The Cry of Nature* (1791), Oswald says he practises 'a system of life that is more the result of sentiment than of reason', but one practised by the Hindus, who, believing in reincarnation, and animated by natural feelings of pity, protect animals, whereas in Europe our 'callous insensibility, foreign to the native texture of the heart', lets us exercise 'foul oppression . . . over inferior but fellow-creatures'.[452] Besides sentiment, there are reasons to think humanity was intended to be vegetarian. Hunting makes people savage, and a diet of meat is unhealthy: 'Animal food overpowers the faculties of the stomach, clogs the functions of the soul, and renders the animal material and gross.'[453] But Oswald's main argument for vegetarianism comes from the language of sentiment and the heart, the language developed over the previous century.

# 7

# Sociability

Enlightenment thinkers agreed that humanity was naturally sociable. In 1780 Diderot wrote in his novel *The Nun*, directed against the unsocial character of monasticism:

> Man is born to live in society. Separate him, isolate him, and his way of thinking will become incoherent, his character will change, a thousand foolish fancies will spring up in his heart, bizarre ideas will take root in his mind like brambles in the wilderness. Put a man in a forest and he will become wild; put him in a cloister, where the idea of coercion joins forces with that of servitude, and it is even worse.[1]

Sociability could be explained in two ways. Shaftesbury, as we have seen, thought it was a basic human instinct. But this might seem a too-hopeful, even Pollyanna-ish view of human nature. So others ascribed it to rational self-interest. The natural law theorist Samuel Pufendorf in *De jure naturae et gentium* (*On the Law of Nature and Nations*, 1672) spoke of human *socialitas*, that is, the predisposition of man to society: this was 'not an instinct for companionship but a rational choice flowing from practical necessity'.[2] That is, human beings' innate sociability is not sufficient for them to live harmoniously in society. For that, they have to enter the political state, in which the need for self-preservation persuades them to agree on a form of government and submit to their ruler's authority. D'Holbach similarly argues from utility. To say that sociability is a natural sentiment is to say that man, seeking self-preservation and happiness, finds by experience that these goals can be attained within social life, whereas solitude makes individuals unhappy and deprives them of help when they need it. 'Everything proves to man that social life is to his advantage; he becomes attached to it by habit, and finds himself unhappy as soon as he is deprived of the assistance of people like himself. That is the true principle of sociability.'[3] Since we are all mutually dependent, people should treat one

another with the respect due to equals, not in order to create an egalitarian society – which, in d'Holbach's view, must lead to anarchy – but as 'a form of polite theatre'.[4] Adam Smith takes a similar view, describing modern commercial society as a society of strangers held together by a temperate friendship based on shared interests and 'the necessity or conveniency of mutual accommodation'.[5]

Sociability required language as the medium of people's interaction. Hence the Cartesian account of language had to be firmly rejected. For Descartes, language was a means of expressing ideas that had been previously conceived in the mind. The typical language-user was therefore the rational individual seeking first to formulate and then to communicate his ideas. In the Enlightenment account, however, language was communication first and foremost, and hence sociable. One could not invent language on one's own. Here the feral children discussed in the previous chapter provided useful evidence. Condillac in 1746 mentions a boy discovered in Russia in 1694 who had been brought up by bears; he had no language, and when he had painfully acquired it, could say nothing about his life among the bears, because language was necessary for the formation of memory.[6] Language, Condillac says, is a system of signs, including natural signs (spontaneous cries of joy or pain) and 'instituted' or arbitrary signs which derive their meaning from social convention.[7] Systems of meaning require constantly to be interpreted by their users. Hence the use of language is an active, creative process. It is cognitive, but also, and even more importantly, expressive. It is linked to forms of expression such as gesture, song and dance. As ancient poetry shows, language in early times relied on poetic devices such as simile and metaphor, and on rhetorical devices such as repetition. Only gradually did it sober down into something like modern prose:

> At its origin, style was poetic because it began by painting ideas in the most sensible images and in addition was marked by its strongly rhythmic quality. But as languages became more copious, the language of action gradually dissolved, variation of voice became more moderate, and, for reasons that I will explain, a taste for figures and metaphors imperceptibly declined as the style began to resemble our prose.[8]

So what was language *for*? The exact, unambiguous communication of philosophical ideas was a derivative and rather rare linguistic function. Language was ideally suited to mingle emotion with reflection and to communicate the mix of feelings and thoughts that make up the bulk of social interaction.

## POLITENESS

Within its ever-changing linguistic framework, social interaction needed to be regulated by codes of speech and behaviour. To be sociable, says Voltaire, it is not enough to assemble in cities: in addition, 'il faut se communiquer avec politesse', 'one must communicate with politeness'.[9] 'Politeness' and 'civility' provided the necessary codes of social behaviour. Sometimes 'civil' and 'polite' are used interchangeably, but sometimes 'polite' indicates a further and deeper level of refinement. 'Civility' was the opposite of 'barbarity'. It implied not only deference to one's social superiors and courtesy to one's equals, as in the Middle Ages, but was a standard of behaviour increasingly expected of everyone.[10] The key document of 'civility' is Erasmus's treatise on manners, *De civilitate morum puerilium* (*On Civility in Children*, 1530), which 'offered all of learned Europe a unified code of conduct'.[11]

Politeness went further: its object was not just to avoid friction but to give positive pleasure to others through good manners, personal consideration and an attractive aesthetic form.[12] Lord Chesterfield relentlessly orders his son to cultivate a 'graceful manner': 'A thousand little things, not separately to be defined, conspire to form these Graces, this *je ne sais quoi*, that always pleases.'[13] The abbé Trublet, in his essay *Réflexions sur la politesse* (*Reflections on Politeness*, 1731), describes politeness as pleasing manners.[14] Politeness was particularly associated with courts and cities, in contrast to the country. Polite manners were urbane, while those of country-dwellers were thought to be uncouth and boorish, as with the violent Squire Western in Fielding's *Tom Jones*. Politeness was promoted especially by the company of women, and by the cultivation of literary and artistic taste, provided there was no hint of pedantry.[15]

Civility and politeness were best shown in conversation. A vast number of conduct books advised people on how to behave and, especially, how to talk in company. It was all-important to converse properly. Manuals of behaviour enjoined readers to strike a mean between affability and gravity, and to avoid talking about oneself, dominating the conversation, interrupting, making vulgar jokes and puns, and raising topics that were so serious as to verge on pedantry.[16] Above all, one should accommodate oneself to one's company. The Scottish conduct-adviser Adam Petrie, who uses 'civil' and 'polite' interchangeably, says one should never talk above other people's heads: 'It is civil in Converse to accomodate [*sic*] ourselves to the Company, and dextrously lead the Discourse to Subjects proportioned to them; for none should discourse upon a Subject that's above the Reach of the Company.'[17]

Civility and politeness were inclusive ideals. Whoever mastered their rules was qualified to take part in sociability. But they were also exclusive. Despite the *Spectator*'s efforts to spread politeness, it really required leisure for its cultivation. What Hume calls 'a cultivated taste for the polite arts' tends, as he acknowledges, 'to draw off the mind from the hurry of business and interest'.[18]

Moreover, the rules of politeness gave innumerable opportunities for social gaffes. For instance, one had to enunciate properly. In England especially, one was expected to lose a rustic accent and adopt the 'class accent' originally associated with London.[19] Grammar also presented many pitfalls. One had to learn to avoid the double negative or the double superlative ('most handsomest').[20] Jane Austen makes Lucy Steele show her vulgarity by using the simple past tense instead of the past participle ('having took such a liberty'; 'he has never gave me one moment's alarm'), a usage long condemned as ungrammatical and 'barbarous'.[21] Yet a few decades earlier the great authority on gentility, Lord Chesterfield, could say 'he has wrote', and James Woodforde, an Oxford graduate, frequently used such constructions in his diary ('to have rode'; 'to have went').[22] It was also essential to avoid indelicacy. One of the *Spectator*'s correspondents complains of a young woman who 'has no Notion of that which Polite People have agreed to distinguish by the name of *Delicacy*': after a walk she said that she was *'all over in a Sweat'*; she said that 'her *Stomach aked*'; and she had something *'stuck in her Teeth'*.[23] French courtesy books firmly reject some words for parts of the body, such as *poitrine* (implying 'bosom').[24]

Politeness formed, in theory, a code for enlightened discourse. But the widespread demand for manuals of politeness implies considerable social mobility and social anxiety. People wanted to master the manners of the class into which they were trying to ascend. In Britain, members of that large, amorphous, indefinable but unignorable body, the middle class, benefited from increased prosperity (especially in the later eighteenth century). Their class comprehended merchants, bankers, tradesmen and professional men with their families. There were no sharp boundaries separating these groups from the gentry; the titled aristocracy, however, often known as 'the quality', were a distinct and largely inaccessible elite.[25] Although innumerable distinctions were felt to exist within the middle class, its lower boundary was clear: 'On the one side there was a class "composed of Gentlemen of Fortune, Sense, most commonly, of good Understanding" . . . On the other side were "Tradesmen of lower Degree, such as Artificers, Carpenters, Bricklayers, Glasiers, and Painters etc.".'[26] For those above the line, politeness provided a social code that was, in principle, available to all and could establish a virtual equality among them.

In France, the law recognized three estates: the clergy, the nobility, and the rest of the population (the 'third estate'). Nobles were distinguished from non-nobles (*roturiers* or commoners), but real divisions were more complicated. At its upper end, the bourgeoisie was close to the *noblesse de robe*, families ennobled for serving the monarchy in judicial or administrative posts. The latter formed a high proportion of the nobility, and their numbers were growing: between 1715 and 1789 the population of France as a whole increased by 15 per cent, but the numbers of the nobility more than doubled (190,000 in 1715, or 0.9 per cent of the total population of 20 million; 400,000 by 1789, or 1.8 per cent of the total of 23 million).[27] At the lower end, shopkeepers, artisans and other manual workers were felt to fall below the bourgeoisie.

Within the bourgeoisie there were several hierarchies. Professional people, such as lawyers and clerics, considered themselves superior to all but the wealthiest businessmen. Among business people, retailers (*boutiquiers, marchands*) were considered inferior to wholesale merchants (*négociants*). The wealthiest merchants ranked in importance alongside tax-farmers, royal bankers and other financiers. The well-to-do 'old' bourgeoisie considered themselves superior to financiers who had acquired wealth only recently. Wealthy bourgeois aspired to a noble lifestyle: they travelled in sedan chairs and wore swords. They sought, or simply assumed, the particle of nobility ('de') and called themselves 'monsieur' instead of 'maître'.[28] Parvenus betrayed themselves by their lack of taste and their inelegant language. They had been figures of fun at least since Molière's Monsieur Jourdain (in *Le Bourgeois gentilhomme*, 1670; the title is meant to be an oxymoron). Marie Phlipon (the future Madame Roland), visiting the rich son of a farmer-general, noted that

> the caricature of good taste produced here a kind of elegance foreign alike to bourgeois simplicity and to artistic taste ... It was worse with the men: the sword of the master of the house, the efforts of the chef ... could not compensate for the awkwardness of their manners, the deficiencies of language when they wanted to make it seem distinguished, or the commonness of their expressions when they forgot to watch themselves.[29]

Germany was rather different. The middle class defined itself partly through commerce, partly through the university education that qualified large numbers of men to be lawyers, clergymen, doctors and administrators in the many princely states. Deference to the nobility accompanied considerable criticism of court life; confidence in middle-class values of order, honesty, industry and thrift did not assuage the unease which the hero of Goethe's *Wilhelm Meisters Lehrjahre* (*Wilhelm Meister's*

*Apprenticeship*, 1795–6) expresses in a much-discussed letter to his commercial friend Werner. Wilhelm maintains that a nobleman's public, representative role lends an ease and grace to his behaviour which the burgher cannot emulate. By concentrating on becoming a useful citizen, the burgher is inevitably one-sided, unable to reach the harmony which the nobleman displays. Wilhelm concludes that he can only develop a rounded personality by going on the stage and acting the part of a nobleman.[30] Fortunately, since he has already shown his theatrical talent to be very limited, the action of the novel sends him off in a different direction, underlining the real class divisions in Germany by a blatantly utopian ending with three cross-class marriages.

Polite manners were not only sought from below but could also be imposed from above. In Russia, where Peter the Great had softened the outward ruggedness of his boyars, Catherine the Great set to work on their minds. Peter had required the nobility to be loyal and hard-working, and to dress (and shave) like Europeans; Catherine required them also to be refined. The process started with schoolbooks, which not only taught reading but also urged readers to be 'orderly, economical and polite'.[31] Manuals of good manners, mostly translated from French, appeared in large numbers even before Catherine's accession, and in greater numbers afterwards. Catherine herself inculcated refinement by satirizing vulgarity in her plays and stories, and in anonymously published homilies that made fun of ignorant country squires and empty-headed fashionable young ladies.[32]

Not everyone admired politeness. It had long been common, especially – though not only – among Puritans, to decry courtly manners as unnecessary and insincere, but the severity and informality of Puritans and Quakers were themselves often rejected as a form of affectation.[33] Swift satirized polite vacuity in *A Complete Collection of Polite and Ingenious Conversation* (1738), in which Miss Notable, Tom Neverout and their friends discourse fluently in clichés, which, being utterly stale, can never be offensive; in the ironic preface, Swift's persona boasts that 'I . . . have alone, with this Right Hand, subdued Barbarism, Rudeness, and Rusticity; . . . have established, and fixed for ever, the whole System of all true Politeness, and Refinement in Conversation.'[34] The abbé Duclos, writing in 1750, says that politeness is now so generally known to be false that some people go to the other extreme and affect an equally insincere bluntness.[35] In France, the great exemplar of sincerity was Alceste, the protagonist of Molière's *Le Misanthrope* (1666). Rousseau, in an attack on the theatre, held up Alceste as a lover of truth and virtue, whose apparent misanthropy results from his integrity and exposes the shallowness and deceitfulness of the society around him.[36] Alceste thus becomes an example of the 'surly

virtue' or *rauhe Tugend* that we find throughout the century being praised as a countermodel to urbane hypocrisy.[37]

The most famous exponent of refined manners, Lord Chesterfield, unwittingly undermines the value of politeness. In the bullying letters with which he bombarded his illegitimate son Philip Stanhope during the latter's continental Grand Tour, Chesterfield says that he has no affection for his son beyond what the boy must earn through perfectly fulfilling all his father's instructions about study, manners, gentility, diction and so on. Yet he repeatedly says that a graceful manner can enable a wholly ungifted man to succeed in life, instancing 'a man of great quality and station, who has not the parts of a porter, but raised himself to the station he is in singly by having a graceful figure, polite manners, and an engaging address'.[38] He rams the point home: 'Manner is all in everything; it is by manner only that you can please, and consequently rise.'[39] Why, one wonders, was the wretched boy also required to study six hours a day, and acquaint himself with the political constitution of every country he passed through, if a refined manner would suffice for success? It is not surprising that young Stanhope, evidently a studious and shy person, disappointed his father severely. Frances Burney, who met him in London in 1774, compares Stanhope, who with all possible educational advantages had turned out 'a meer *pedantic Booby*', with the natural grace of the Pacific islander Ma'i (known as Omai), who was then making his mark in London drawing-rooms.[40]

How far did politeness aid the growth of enlightenment? It provided a unified social code and common language in which many people could come together. But this language also restricted what could be said. Duclos complained that politeness, the *bon ton*, created an atmosphere in which nothing serious could be uttered:

> Any important question, any connected argument, any rational sentiment, is excluded from smart society and removed from *bon ton* . . . The *bon ton*, among those who have most wit, consists in saying agreeable nothings, and not permitting oneself the slightest sensible remark, unless it can be excused by the conventions of conversation.[41]

The restrictions that politeness imposed on conversation appear in an anecdote told by the abbé Morellet. The hostess Julie de Lespinasse was anxious to meet the great naturalist Buffon. When he came to her salon, she complimented him on his literary style and asked how he achieved it. Buffon, perhaps embarrassed by his gushing hostess, replied: 'Oh, damn it, when it comes to explaining one's style, that's another kettle of fish' (*une autre paire de manches*, literally 'another pair of sleeves'). Lespinasse was so upset by this vulgar comparison (*comparaison des rues*) that she

did not speak to Buffon for the rest of the evening.[42] It is difficult to escape the conclusion that such refinement fatally inhibited the forthright intellectual discussion which was the motor of the Enlightenment.

## THE PUBLIC SPHERE

Enlightenment sociability found expression in a great variety of institutions. Coffee-houses, salons and societies of all kinds permitted face-to-face interaction. Learned journals, newspapers and periodicals created a number of virtual publics. It has famously been argued by the philosopher Jürgen Habermas that all these institutions formed a middle-class civil society, a 'public sphere'; more contentiously, that this public sphere was the venue for rational debate, and that it contributed by its very existence to the growth of enlightenment and emancipation. But as we shall see when we look closely at two institutions that feature prominently in this argument, coffee-houses and salons, it is not clear that either contributed as such to critical and innovatory discussion of social, religious and political issues. They provided venues where such discussion *could* take place, but in no way ensured that it *did*. Similar questions can be asked of academies and other learned societies, or reading groups, clubs and semi-secret societies like the Freemasons. Much enlightened argument did take place there, but not enough to justify identifying them with the process of enlightenment in itself. The virtual public sphere formed by newspapers and journals was, likewise, a potential vehicle of enlightenment, but it was not an actual means of enlightenment unless people chose to use it for that purpose.[43]

Just what contribution to the growth of the Enlightenment should we attribute to the coffee-house?[44] Coffee-houses, where people with leisure could drink fresh roasted coffee in comfortable surroundings, originated in sixteenth-century Istanbul. The first coffee-house in a Christian country opened in London, probably in 1652, at the instigation of a trader who had recently returned from Turkey. Initially a mere shed, it moved into a substantial room in 1656, and found many imitators, first in London, then in provincial towns. An apothecary called Arthur Tillyard opened a coffee-house on the High Street in Oxford around 1655. Others soon opened in Cambridge, Bristol and Yarmouth; in Dublin (1664); in Edinburgh and Glasgow (both 1673); and, around 1670, in Hamburg, Bremen and Amsterdam. Boston had a coffee-house by 1671, New York by 1696, and Philadelphia by 1703. In Paris, a high standard was set by the Café Procope, established in 1686; it was the first café to install mirrors, and also had elegant candelabra and marble-topped tables, and was to become

a favourite meeting-place for *philosophes* such as Voltaire, Diderot and Franklin.[45] It provided a model for the smart Caffè Aurora, established in Venice in 1723. In Rome, the Caffè Greco, a favourite among visiting artists and noblemen doing their Grand Tour, was established around 1750. In Vienna, large quantities of coffee were found among the provisions abandoned by the Ottoman army when it fled after narrowly failing to capture the city in 1683; an entrepreneur sold the coffee, thereby establishing a taste that was properly supplied once an Armenian merchant opened the first coffee-house in 1685.[46] Numbers of coffee-houses are often based on guesswork; Markman Ellis queries the much-repeated assertion that by the beginning of the eighteenth century London had two or even three thousand coffee-houses, and suggests instead a figure of four to five hundred.[47] Dublin at mid-century had eleven, concentrated in an area near the quays and the commercial centre of the city.[48] Paris had 380 cafés by 1723, and at least three times that number by the 1780s.[49]

Coffee-houses provided comfortable spaces for middle- and upper-class men to relax, converse and read the newspapers, escaping from the restrictions of home. The circulation of news was an especially important function.[50] Some coffee-house owners took in manuscript newsletters written by well-placed individuals, and all provided their clientele with the increasing number of newspapers. Some London coffee-houses also supplied newspapers from Paris and the Netherlands. The availability of newspapers, which one customer would often read aloud to others, encouraged discussion of public affairs, and to this extent Macaulay, who gave a well-researched account of coffee-houses in his *History of England* (1849–55), may have been right in saying that 'the coffee houses were the chief organs through which the public opinion of the metropolis vented itself'.[51]

Some coffee-houses were used for political meetings. In 1659 the republican James Harrington founded a political club called the Rota which met in the Turk's Head coffee-house, where the owner had a special table made for its members to sit round (thereby contradicting Habermas's idea that coffee-house discussion was open to all).[52] In eighteenth-century London, some coffee-houses had political colours: Whig politicians met in Button's, Arthur's and St James's coffee-houses, Tories at the Cocoa Tree, which was their London headquarters during the Whig ascendancy from 1715 to 1760. Macaulay tells us about specialized coffee-houses: literary discussion went on first at Will's, where Dryden held court, and later at Button's, dominated by Addison and Steele; medical men gathered at Garraway's; other coffee-houses were mainly frequented by Puritans, Catholics, or Jews.[53] In Paris, the Café de la Régence was the favourite haunt of chess-players.[54] Coffee-houses were also used for transacting business.[55] Previously, taverns had

been used for this purpose, but coffee-houses, besides attracting a more select clientele, had the advantage that the drink dispensed there stimulated the mind instead of clouding it. In all these instances, however, participation was, by definition, exclusive: only members of a club, or parties to a business transaction, would take part.

So the coffee-house was by no means always a forum for the exchange of ideas on any subject. The specimens of coffee-house chat recorded by Boswell in 1762–3 range from the conduct of the Seven Years War to the weather and the impropriety of standing in front of the fire.[56] Nor was it socially inclusive, but appealed primarily to educated middle-class professional men.[57] Women appeared in English coffee-houses only to serve behind the bar, making coffee which was carried to the tables by boys, and were often exposed, as Richard Steele complained in the *Spectator*, to impudence and ribaldry from the customers.[58] The few recorded examples of women mixing with men in coffee-houses are clearly exceptional, as when Hester Pinney, a successful single woman dealing in lace, went to Garraway's and Jonathan's coffee-houses to transact business.[59] We hear of an all-female coffee-house in Bath, but not of mixed ones.[60] Paris cafés were at first frequented by upper-class women, but after the mid-eighteenth century cafés declined and attracted mainly men from a lower social class.[61] In Germany, some cities actually forbade women to enter coffee-houses, on the grounds that they attracted prostitutes. Leipzig issued such an ordinance in 1697 and again in 1704, but ineffectually: in 1734 one of the Leipzig coffee-houses provided the venue for Johann Sebastian Bach's Coffee Cantata, about a young lady who, despite her father's disapproval, refuses to give up drinking coffee.[62]

Great claims have been made for aristocratic salons as venues of Enlightenment sociability, where it is said that 'the nobility and the *grande bourgeoisie* of finance and administration assimilating itself to that nobility met with the "intellectuals" on an equal footing'.[63] With class barriers thus suspended, gender barriers were suspended too. Salons were dominated by (mostly) aristocratic ladies who wished to educate themselves and invited *philosophes* to their homes to engage in intellectual conversation, thereby, according to Habermas, spreading enlightenment.

Certainly, it had been customary since at least the seventeenth century for aristocratic ladies to hold social gatherings in their homes to which they invited writers and thinkers. Thus in seventeenth-century Paris, the marquise de Rambouillet included the dramatist Corneille and the poet Malherbe among her guests. Such occasions provided women with the chance to learn about the new philosophy of Descartes.[64] Women's interest in philosophy and science is evident from the popular treatises directed

explicitly at a female readership, such as Fontenelle's *Conversations on the Plurality of Worlds*. Some hostesses were themselves writers, notably the novelist Madeleine de Scudéry. The company was mixed inasmuch as guests were drawn from both groups of aristocracy – the *noblesse d'épée*, who had earned their titles originally in warfare, and the *noblesse de robe*, ennobled for administrative service – and might include some financiers, administrators, academicians and clerics from the highest rungs of the bourgeoisie.[65]

The most famous hostesses of the eighteenth century, Marie-Thérèse Geoffrin, Julie de Lespinasse and Suzanne Necker, may illustrate the social agency available to women and their active promotion of the Enlightenment.[66] Although they themselves did not publish, in view of the widespread prejudice against intellectual women, it is clear from the many pen-portraits by contemporaries that they were remarkable people. In his memoirs, Marmontel describes Lespinasse – one of the interlocutors in Diderot's *Dream of d'Alembert* – as 'an astonishing compound of decorum, reason, wisdom, with the liveliest mind, the most ardent soul, and the fieriest imagination since Sappho'.[67] At their gatherings, literature was read aloud, and philosophical topics were sometimes discussed: thus the abbé Galiani's *Dialogues on the Corn Trade* originated there, as we learn from Diderot, though in saying 'he preached a great deal against the export of corn' Diderot implies a monologue rather than conversation.[68]

However, the word 'salon' invites misapprehensions. These were not meetings convened for the sake of intellectual discussion. The word 'salon' was not actually applied to social gatherings before the French Revolution.[69] What we retrospectively call 'salons' were not distinct events but extensions of upper-class sociability. They were a form of hospitality, always held in a private home. They were not open to just anyone: one had either to be introduced by a trusted friend of the hostess or provide a letter of recommendation. Edward Gibbon arrived in Paris with fourteen such letters.[70]

Salons were part of an aristocratic culture dedicated to leisure. Their ideal of *aisance*, or effortlessness, forms a sharp contrast to the modern assumption that self-realization and moral dignity come from work.[71] Their main activity was conversation, always governed by the rules of politeness. People gossiped about other people's careers, their social advancement, their love affairs, their scandals. They talked politics, and tried their hand at political intrigue, though cautiously: the eminent hostess Madame de Tencin had been exiled from Paris from June to October 1730 because of her politicking, and allowed back only on condition that she henceforth avoided politics and religion.[72] To escape the boredom that afflicted aristocrats with too little to do, they indulged in all sorts of amusements. Telling stories was a valued skill, at which Geoffrin excelled.

When the future king of Poland, Stanisław August Poniatowski, visited her salon, he was disappointed that Montesquieu sang a 'trivial song' instead of uttering wisdom.[73] People did imitations: the *philosophe* d'Alembert was apparently an excellent mimic. Unexpected talents were displayed: 'One man named Touzet brought delight to the salons by hiding behind a screen and imitating an entire choir of nuns.'[74]

Intellectual and literary discussion was limited by the rules of politeness. At Geoffrin's little supper parties, Marmontel read his stories aloud, and learned how to revise them for publication by noting his hearers' reactions – not explicit comments, but significant silences.[75] More public readings were always received with polite applause. Performances by distinguished men of letters added to the prestige of the household: in this respect, aristocratic gatherings were just as much a form of representation as the ceremonial surrounding the king. In return, authors were rewarded with gifts, recommendations, help in obtaining lucrative posts or election to the French Academy – and, of course, with better dinners than they could normally afford. D'Alembert complains that aristocrats, being badly educated, can seldom appreciate works of literature.[76] Even the most affable aristocrat always regards men of letters as his inferiors. Their patronage is at best insecure; they tend to prefer minor talents to major ones. Some insist on telling their protégés how to write; others publish works themselves which receive absurdly excessive praise. D'Alembert deplores how writers abase themselves before aristocrats; their watchword, he says, should be 'liberty, truth and poverty'.[77]

No doubt some salons had room for serious discussion, in which Lespinasse for one could hold her own, as Marmontel admits; but it seems like an exaggeration to call the salons 'working spaces'.[78] It would seem that salons allowed only limited scope for intellectual discussion, and that *philosophes* were invited mainly as 'chic accessories'.[79] If the conversation at Geoffrin's salon became too argumentative, the hostess would intervene with 'Allons, voilà qui est bien' ('That's enough').[80] Marmontel complains that this set limits to liberty of thought; he felt he was being kept on a leash. Upper-class sociability did not go well with intellectual work: when Voltaire and Émilie du Châtelet were staying with the duchesse de Maine, it was complained that they spent too much time writing and studying instead of taking part in social pursuits like gambling or going for walks.[81] Voltaire, somewhat ungratefully, describes a typical aristocratic supper in *Candide*: 'The supper was like most suppers in Paris. First, silence; then a cacophonous welter of words that no one can make out; and then jokes, which mostly fall flat, false rumours, false arguments, a smattering of politics, and a quantity of slander.'[82]

The contribution of the salons, as part of aristocratic sociability, to the Enlightenment was probably therefore limited, and in any case, being private, they could hardly form part of any 'public sphere'.[83] The small number to which *philosophes* were admitted no doubt furthered the diffusion of ideas, but their principal contribution to the Enlightenment probably consisted in providing its proponents with square meals and salaried jobs.

Gatherings hosted by noble or upper-class women and frequented by authors, musicians, intellectuals and visiting foreigners, were held in many cities. The term 'salon', though unambiguously attested in this sense in English no earlier than 1888, has been retrospectively applied to them all, creating an impression of a distinct and uniform social institution. Some may have had more intellectual and cultural substance than most Paris meetings. Elizabeth Graeme hosted literary discussions at her mansion just outside Philadelphia.[84] Elizabeth Vesey, herself a writer, invited many authors, including Maria Edgeworth, to her house on Usher's Island in Dublin, and gave some of them material support.[85] In Vienna, Mozart was both a guest and a performer at the house of Countess Maria Wilhelmine Thun, and he and Haydn were also frequent visitors to the house of the high-ranking civil servant Franz Sales von Greiner, along with a wide range of statesmen, writers and enlightened clerics.[86] Greiner's wife, née Charlotte Hieronymus, was keenly interested in the natural sciences, comparative religion and feminism, having read Mary Wollstonecraft in French translation.[87] We know from the memoirs of their daughter Caroline, who would later become a distinguished hostess as well as a novelist and dramatist, that the Greiner marriage was troubled, and that Charlotte had an affair with one of the regular guests, Lorenz Leopold Haschka (later famous for writing the text of the Austrian national anthem, 'Gott erhalte Franz den Kaiser' ('God save Emperor Franz'), to music by Haydn). This was not extraordinary: similar gatherings in Paris were often the setting for sexual intrigues.[88] However diverse such gatherings were, they were of considerable importance for cultural life. It does not follow, however, that they contributed equally to the development of Enlightenment thought, and their significance in this respect may have been exaggerated.[89]

Even at their best, Paris salons seem often to have been stuffy, and, still more often, trivial. Quite different, by all accounts, were the dinners held twice weekly by the baron d'Holbach at his Paris house. Apart from the baroness, who said little, the personnel was entirely male, though when d'Holbach moved for the summer to his family estate at Grandval, some miles outside Paris, he often invited female guests, including such prominent hostesses as Madame Geoffrin and Madame d'Épinay. Regulars in

the period 1750–80 included Diderot, Friedrich Melchior Grimm, Marmontel and Raynal, who would later edit the excoriating anti-colonial *Histoire des deux Indes*. Others, including Morellet and Naigeon, attended from about 1760. Many foreign visitors appeared, among them David Hume, John Wilkes, Laurence Sterne (for whom d'Holbach vouched when he arrived in Paris without a passport), Adam Smith, Cesare Beccaria, Alessandro Verri, and many more.[90]

The many surviving accounts of d'Holbach's dinners make clear, first, that their purpose was intellectual conversation, not social chit-chat; second, that they were fun. In both respects they were free from the restraints imposed at the so-called salons. D'Holbach's sociability may have been inspired not by salons, but by his fond recollections of student life in Leiden.[91] At his dinners, according to Morellet's recollections, there was

> lots of argument, but no quarrelling; simple manners, suitable to reasonable and well-educated men, but which never degenerated into coarseness; true gaiety which did not get out of hand; in short, a truly attractive society, as one could tell from this symptom alone – that having arrived at two o'clock, as was the custom then, almost all of us would often still be there at seven or eight in the evening.[92]

Sometimes one person would expound his ideas at length; at other times a verbal duel would take place, with the rest of the company looking on. Thus Morellet heard Marmontel expounding the principles of literature, Raynal talking about the Spanish trade with the Philippines and Mexico, and England's commerce with its colonies; and 'Diderot treating a question of philosophy, arts or literature, and, by his fertility, his fluency, his inspired air, holding our attention for long periods.'[93] Bold, sometimes fantastic arguments were put forward about politics, religion, even cosmology. Diderot describes a conversation beginning with astrology, in which 'I asserted that Saturn had about as much effect on us as an atom of dust has on the face of a great clock', and moving via pre-existent germs to the possible extinction of species, the extinction of suns, and the disappearance and rebirth of humanity after hundreds of millions of years.[94]

The example of d'Holbach draws attention to another shortcoming in Habermas's account of the public sphere. He makes its institutions sound too serious. People went to coffee-houses to relax and enjoy themselves, and to salons to have undemanding conversation with amusing people. In clubs and private gatherings they played cards, performed and listened to music (though in England at least, men often disparaged music as a female accomplishment), and played parlour games such as crambo or bouts-rimés.[95] In crambo, the first player wrote down a line of verse; the next supplied a line

to rhyme with it, and the first line of the next couplet; and so on. In bouts-rimés, a set of unlikely rhyme-words was provided, and the challenge was to compose lines ending with them in the specified order.[96] Amusements like these were an important part of Enlightenment sociability.

## SOCIETIES

Enlightened discussion was to be found less in coffee-houses and salons than in the innumerable societies that sprang up in the Enlightenment. The eighteenth century was indeed 'the sociable century'.[97] In Britain, clubs and societies, though sometimes short-lived, proliferated from 1688 onwards, first in London and then throughout the provinces. Besides simple drinking clubs, there were societies to promote music, the visual arts, politics, natural science and sport. Some provincial societies pursued wide intellectual inter-ests, such as the Gentlemen's Society in the Lincolnshire town of Spalding, founded in 1712, where members studied antiquities and natural history, and sought to make improvements in arts and sciences; they established a library, museum and physic garden, organized concerts, and corresponded with the Royal Society and the Society of Antiquaries.[98] In British America, where most houses were built of wood, there were fire clubs, which com-bined fire-fighting with conviviality.[99] The *Spectator* makes fun of the great variety of clubs, claiming that there are clubs of fat or thin men, and imag-ining a club at Oxford for lovesick young men.[100] We hear also of a society called the Beggar's Benison, founded in 1732 in Anstruther in Fife, which later had branches in Edinburgh, Glasgow and St Petersburg and lasted until 1836. Its members met to drink, talk bawdy, acquire sexual knowledge from lectures and from inspecting naked young women, and, apparently, to engage in communal masturbation. Its activities have been claimed as enlightened, in that they formed a private challenge to the moral panic over the supposed harm done by masturbation.[101]

More serious societies, focused on instruction and self-improvement, established 'proprietary libraries' in provincial English cities.[102] Such a library, administered by the society's members, was founded in Liverpool in 1758; Warrington followed suit in 1760, Manchester in 1765, and Leeds in 1768. A later foundation, the Newcastle Literary and Philosophical Society (1793), set up a magnificent library which is still flourishing. Their membership included many Dissenters, many proponents of enlightened causes, and some radicals. The chemist Joseph Priestley taught at the Dis-senting academy in Warrington in the 1760s and was active on the library committee.[103] William Roscoe of Liverpool, best known for his biography

of Lorenzo de' Medici, supported the anti-slavery movement and showed his radical political sympathies by writing in 1791 a 'Song for the Anniversary of the French Revolution'. There was also a cosmopolitan element: the cleric and naturalist Johann Reinhold Forster, who moved to England after quarrelling with his employers in the Russian government, succeeded Priestley in the school at Warrington and on its committee; soon afterwards (1772–5) he and his son Georg would accompany James Cook on the latter's second voyage round the world.

Most of these clubs and societies combined conviviality with intellectual discussion. William Currie, a doctor and later the biographer of Robert Burns, describes the meetings of an informal society at his house in Liverpool: 'We discuss politics, subjects of taste, science etc. before supper in a regular kind of conversation, and after supper we laugh and talk at large.'[104] Societies could provide a rich social life. To take the case of Adam Smith: as professor of moral philosophy at Glasgow from 1752 to 1764, he belonged to numerous enlightened societies in both Glasgow and Edinburgh. He helped to form the Literary Society of Glasgow, which lasted from 1752 until about 1803 and met on Fridays during the university sessions. He belonged to another club which dined on Saturdays, and on another weekday he attended the Political Economy Club, founded by Provost Andrew Cochrane to discuss commercial improvement. On his frequent visits to Edinburgh he attended meetings of the Philosophical Society, the Select Society and its offshoot, the Edinburgh Society for the Encouragement of Arts, Science, Manufactures and Agriculture in Scotland; he was also among the original members of the Poker Club, founded in 1762 to discuss the question of a Scottish militia.[105] As this list suggests, many societies had definite and practical social aims, which will be discussed in Chapter 8.

In France, men of an intellectual bent might be members of academies. After the foundation of the Paris academies, many groups in provincial towns, such as a circle of friends in Nîmes who had been meeting regularly for thirty years, applied for letters patent and constituted themselves as academies.[106] So Rousseau, when working as a tutor in Lyons in 1739, was able to join an academy, which seems really to have been a glorified book club.[107] Such bodies met for convivial dinners and concerts, but also held essay competitions on politically innocuous social questions such as the advantages of work, or on practical issues such as 'the extinction of begging, wet-nursing techniques and drainage systems'.[108] However, academicians were not numerous: in the 1780s there are estimated to have been only 2,500 of them in all provincial towns.[109] Some of them were local grandees who owed their membership to their social position, not to

intellectual attainments.[110] Societies, providing sociability for people excluded from academies, seem to have become numerous only from 1770 on, first in Paris and then in the provinces. Some societies were relatively informal, consisting of study groups, book clubs and the like; others were more formal, with statutes and rules. They all encouraged the reading of books and, especially, newspapers, and provided refreshments.[111] Many French commercial towns had book clubs with their own premises. Arthur Young describes the one at Nantes, founded in 1759, with 'three rooms, one for reading, another for conversation, and the third is the library; good fires in winter are provided, and wax candles.'[112] Its 125 members paid an initial three *livres*, plus an annual subscription that allowed them to read twenty-four books. The statutes said that the club should buy 'all the newspapers and all the periodical works that are most useful to society' and books about commerce, the navy, history, the arts and literature.[113]

Early modern Italy had a large network of academies that were regarded as centres of sociability and cultivation. By the eighteenth century, however, they were generally thought to be in decay. Oliver Goldsmith opined in 1759: 'There is not, perhaps, a country in Europe, in which learning is so fast upon the decline as in Italy, yet not one in which there are such a number of academies instituted for its support.'[114] Goldsmith maintained that Italy had 550 academies; current research suggests a provisional figure of 585, distributed among 44 cities.[115] According to Goldsmith, these academies, all with whimsical names, produced works of merely local interest, except perhaps for 'the Cicolata Academica (or, as we might express it, the tickling academy) of Florence'. Goldsmith was partly copying the article 'Académies' written for the *Encyclopédie* by d'Alembert, whose criticisms in turn go back to a polemic by the great Italian Enlightener Muratori. Muratori in 1704 condemned the academies as frivolous institutions devoted mainly to love-poetry, which had allowed pre-eminence in the arts and sciences to pass from Italy to the rest of Europe.[116]

The Accademia dei Pugni (Academy of Fisticuffs), founded in Milan in the early 1760s by a group of young men associated with the brothers Pietro and Alessandro Verri, was intended to be a new kind of academy, fluid, flexible, and combining the arts and sciences. It rejected the hierarchy and authority of the old academies, as well as the secrecy and rigidity of Masonic lodges. One of its most distinguished members, the legal reformer Cesare Beccaria, writing in French, described the Accademia as a 'coterie', recalling the friendly informality of the Helvétius circle.[117] Between 1764 and 1766 the Accademia published a journal, *Il caffè*, acknowledging in its title the new culture of coffee-house discussion, and including reflections on law, economics, agriculture, natural science, literature and aesthetics.[118]

The members saw themselves as participating in a Europe-wide network of intellectual exchange: 'At the moment the press is spreading new discoveries and new lights are being diffused in an instant from London to Reggio Calabria', wrote Alessandro Verri in *Il caffè*.[119]

Germany and the Netherlands had numerous reading societies.[120] As elsewhere, books were expensive. Germany's many universities were useless to non-academics: the opening hours were short, and books could seldom be borrowed; at Würzburg the university library would not lend books even to professors. So, from about 1750 onwards people organized their own lending libraries and reading clubs. A town might have several different reading societies with different interests: one reading philosophical and historical works, another theological works, another periodicals. Some prohibited novels, others favoured them; one in Glückstadt in 1798 read only novels. Often they consciously served the goals of practical enlightenment. Thus in 1783 the Koblenz reading society defined its main aim as 'spreading enlightenment and useful knowledge'.[121] People read journals, factual works, novels and narratives of recent voyages, especially in the Pacific, which combined instruction with entertainment. Besides reading, the members often gave lectures to one another. Thus the Dutch society Tot Leerzaam Vermaak ('Instructive Pleasure'), founded in Amsterdam in October 1774, held lectures on such subjects as 'Whether citizens of our country should concern themselves with politics', 'The conversion of the Jews', and 'The character of Machiavelli and the spirit of his writings'.[122]

All these societies were wholly or predominantly male. But women did have their own associational life. The 'Bluestocking Circle', comprising several intelligent, gifted and educated women, included Elizabeth Carter, whom we have already met as a classical scholar (in Chapter 6); Elizabeth Montagu, née Robinson, who published *An Essay on the Writings and Genius of Shakespear* (1769); and Hester Chapone (née Mulso), well known for her correspondence with Richardson and later for her *Letters on the Improvement of the Mind* (1773). But it was a loose network, not a society. Its members lived in different parts of the country. They paid each other many visits, and wrote many letters, but they did not form a unified group, and may never have met all together. They were strongly aware of the dignity due to women. Chapone, in her correspondence with Richardson, declared that '*women*, as rational and accountable beings, are free agents as well as *men*'.[123] Carter read with enthusiasm Feijóo's defence of women. Elizabeth Montagu held evening conversation parties, where guests were encouraged to talk about literary and philosophical subjects; they were attended by Johnson, Burke, David Garrick, Joshua Reynolds and Horace Walpole, and sound more rewarding than most Paris

salons. They had a counterpart in the Dublin gatherings presided over by Elizabeth Vesey, who may have invented the word 'bluestocking'.[124]

In a category of its own was the Berlin Mittwochsgesellschaft (Wednesday Society), composed of eminent officials, professional men and writers. Among people already mentioned in this book, it included the theologians Teller and Spalding, and the publisher Nicolai. The editors of the important journal the *Berlinische Monatsschrift* (*Berlin Monthly*), Friedrich Gedike and Johann Erich Biester, were also members, and Moses Mendelssohn was an honorary member. Hence it was an important forum for enlightened discussion. But we know little of what was discussed, apart from the papers that were published in the *Berlinische Monatsschrift*, for the Society's very existence was kept secret, its members were known by numbers instead of names, and papers read at the Society were on no account to be communicated to non-members. Written papers were circulated in a locked box to members, who were supposed to read them, annotate them with comments, and return the box. The reason for such precautions was presumably that, since some of the members were high officials, they could not have done their jobs effectively if they were known to engage in free discussion, especially during the reactionary reign of Frederick William II of Prussia (1786–97). They discussed philosophy and public affairs, including matters of law and finance, and their discussions are said to have helped shape the Prussian Legal Code issued in 1794. Finally, in 1800, the Society voted to dissolve itself, in accordance with the edict against secret societies issued in 1798.[125]

Another body with a reputation for secretiveness – though everyone knew it existed – was Freemasonry.[126] Originating from stonemasons' guilds in seventeenth-century Scotland, its Grand Lodge opened in London in 1717, and it rapidly spread to the Continent. By 1789 there were an estimated six hundred lodges in France alone, with between fifty thousand and a hundred thousand members, while in Berlin alone forty-three lodges were founded between 1740 and 1781. In France and Austria, though not in Britain, lodges included female Masons. Freemasons performed good works and contributed to the diffusion of culture. For example, Robert Burns became depute master of a Masonic lodge in Ayrshire in 1784, and many Masons subscribed to the Edinburgh edition of his poems in 1787.[127] However, Freemasonry was seldom as egalitarian as it was in Scotland: the entrance fees, the costumes and the banquets were often too expensive for working people, and a high proportion of the German and Austrian Masons – certainly more than half – were of noble status. In France, where Masonry was extremely popular in the second half of the century, the bourgeoisie dominated, with aristocrats providing only 22 per cent of the membership

in Paris, 15 per cent in the provinces. There were a significant number of priests and, in contrast to the academies, businessmen formed a large proportion (36 per cent in the provinces) of the bourgeois contingent. The names that lodges assumed expressed allegiance to broadly defined Enlightenment ideals (e.g. 'Humanité', 'Liberté', 'Préjugés Vaincus': 'Humanity', 'Liberty', 'Prejudices Overcome') but also to the state (e.g. 'Henri IV', 'Gloire', 'Le Dauphin', 'Union des Bons Français'). The authorities had nothing to worry about.[128]

Freemasonry attracted some well-known writers, such as Lessing and Goethe, but only briefly. Many people were as disappointed by it as Pierre Bezukhov is in *War and Peace*, when he finds too many Freemasons either obsessed with abstruse symbolism or concerned with social networking.[129] Goethe concluded in a letter that if you only wanted to be rational and benevolent, there was no need to join a secret society: you could practise these virtues just as well at home in your dressing-gown.[130] Masonry was often suspected of being a cover for subversive and radical ideas. It was banned in the Netherlands in 1735 and condemned by a Papal Bull of 28 April 1738. However, there is not much evidence either for Masons' radical politics or for their more than nominal commitment to enlightened goals.[131] Out of 140 contributors to the *Encyclopédie*, only four at most belonged to Paris lodges.[132] Even in the Netherlands Masonic lodges could 'enforce a profound social conservatism', while in France 'many masonic lodges seem to have been centres of a reactionary rather than a progressive sociability'.[133] The eminent Mason Antoine Court de Gébelin studied the Tarot cards in the belief that they held the secrets of the ancient Egyptians; other Masons sought to recover the esoteric knowledge supposedly possessed by the Knights Templar or encoded in the Old Testament.[134]

In Vienna, however, Freemasonry was associated with enlightened ideals, particularly in the lodge Zur wahren Eintracht ('True Harmony'). Its grand master, Ignaz von Born, was a well-known mineralogist, and sought to make his lodge into a centre of literary and scientific activity. He showed his versatility by also writing an extremely scurrilous anti-clerical satire, *Specimen monachologiae methodo Linnaeana*, which purported to classify the various monastic orders as species in the manner of Linnaeus and defined the monk as 'an anthropoid, cassock-wearing, thirsty animal that howls at night'.[135]

The members of Born's lodge included not only a wide range of talents – the veteran Enlightener Joseph von Sonnenfels, descendant of a Jewish family, who was famous for persuading Maria Theresa to abolish judicial torture; the composer Joseph Haydn; the sculptor Franz Zauner, whose equestrian statue of Joseph II can still be seen on the Josefsplatz in Vienna – it also

included the African Angelo Soliman and several women, such as Born's daughter Maria. Even more surprisingly, it included a Benedictine monk, named Franz Georg Übelacker.[136] Born wanted to make it into a kind of academy: he maintained a library and a cabinet of natural-history speci- mens, and played host to visitors such as Georg Forster. Mozart often visited this lodge, but he belonged to a different and smaller lodge, Zur Wohltätig- keit ('Benevolence'). Whereas Born's lodge was radical and secular, Mozart's lodge had a more Catholic tone and was devoted specifically to advancing the reform of Catholic practice, which was a major theme of the Austrian Enlightenment.[137] There were nevertheless close links between the lodges, and Mozart composed a cantata in honour of Born's scientific achievements, which was performed as 'Die Maurerfreude' ('The Mason's Joy') in Born's lodge in 1785. Yet, despite his enlightened credentials, Born was also an alchemist who thought that the ancient Egyptians had possessed the phil- osopher's stone and concealed the mystery in their hieroglyphs.

An offshoot of Freemasonry that engendered a panic out of all propor- tion to its size or importance was the Illuminati.[138] Founded in 1776 by the Ingolstadt jurist and Mason Adam Weishaupt, they were devoted to radical republicanism and egalitarianism. Weishaupt was unusual in Ger- many in his admiration of the materialist atheism of Helvétius and d'Holbach. He gave the Illuminati a strict hierarchical structure, modelled on that of the Jesuits who had educated him, and intended his order to infiltrate Masonic lodges and thus attain influential positions and even- tually control politics – precisely the strategy attributed to Communist subversives in the twentieth century. Weishaupt had little success, how- ever. His movement peaked in 1784 with about 650 members, mostly in Bavaria. He quarrelled with his main associates. The secrets of the move- ment leaked out, and on 2 March 1785 an edict by the elector of Bavaria banned both Freemasons and Illuminati there. The resulting public panic, however, stirred up fantasies of a great conspiracy against the entire Chris- tian religion and all European governments. The fall of the Bastille in 1789 and the subsequent events seemed to confirm such notions, and theories about subversion by Masons and Illuminati merged with long- standing hostility to the Enlightenment to generate wild theories, tracing the conspiracy back to the ancient Manichaeans and naming the leading *philosophes*, along with Frederick the Great, as its secret directors. 'Vol- taire was the chief, D'Alembert the most subtle agent, Frederick the protector and often the adviser, and Diderot the forlorn hope', claimed the abbé Barruel.[139] Barruel, along with the Scot John Robison, was the most obsessive upholder of the *philosophe* conspiracy theory, and while in England in the 1790s he won the support of Edmund Burke.[140] All that

the Illuminati achieved was to damage the Enlightenment by providing ammunition for its enemies.

A more substantial achievement of Freemasonry was *The Magic Flute* (1791), the joint work of Mozart and his librettist Emanuel Schikaneder, which has been celebrated as 'the most consistent and comprehensive dramatic expression of the political hopes, humanitarian ideals and educational aspirations of Illuminist Freemasonry'.[141] Its debt to Freemasonry is well established. Schikaneder's membership of a Vienna lodge cannot be documented, but he had earlier attended lodge meetings in Regensburg. Mozart, having been initiated on 14 December 1784, rose rapidly through the Masonic degrees, becoming a 'master' in April 1785. The opera derives much of its intellectual substance from Ignaz von Born's essay 'On the Mysteries of the Egyptians', published in the *Journal für Freymaurer* in 1784, and from the novel *Sethos* (1731) by the abbé Jean Terrasson, popular both in the French original and in German translation.[142] These sources inspired the story of how the prince, Tamino, progresses from delusion (belief in the deceitful Queen of the Night) to truth (acknowledgement of the wisdom of the priest of the sun, Sarastro), learning humanity, friendship and wisdom and passing through trials by fire and water to be united with Sarastro and his bride Pamina.

The lasting appeal of this story probably owes less to the elaborate Masonic allusions which scholars have detected than to its archetypal resonances.[143] Despite the appeal of this story, much in the drama is problematic. Initially the Queen of the Night appears as a bereaved mother who commissions Tamino to rescue her daughter from the clutches of the evil demon Sarastro. To explain the change whereby the Queen appears as evil and Sarastro as the benevolent priest-king, it has been conjectured that Schikaneder and Mozart hastily altered their plot when they found that a rival dramatist was about to stage a play based on the legend of the magic flute. But there seems no need for this hypothesis. Rather, Tamino's progress from delusion to wisdom is meant to be shared by the audience. We, along with Tamino, are at first taken in by the Queen and have our eyes gradually opened to the light of truth.[144]

More substantial problems arise from the fact that Mozart and Schikaneder have combined a solemn drama of initiation with elements from Viennese comedy and fairy-tales. Sarastro rules over slaves, whose overseer is the evil Moor Monostatos. Monostatos tyrannizes the subordinate slaves, who hope soon to see him hanged or impaled; Sarastro appears as a Turkish-style despot likely to inflict such punishments. Monostatos, who recaptures Pamina after her escape, not only lusts after her but tries to rape her at knifepoint, being prevented only by the intervention of Sarastro.

When Monostatos delivers Pamina to Sarastro, he is unpleasantly surprised to be rewarded with the bastinado (seventy-seven strokes on the soles of his feet).[145] Why does the wise priest-king have such a being in his service? Moreover, the demonization of the Queen of the Night is liable to arouse discomfort, and the tendency among Freemasons to make women the symbol of animality and amorality may well have disturbed Mozart and Schikaneder, who have tried to compensate by allowing Pamina to go through the initiation process alongside her lover. Altogether, however, *The Magic Flute* seems to present Masonic Enlightenment as imbued with racism, misogyny and patriarchy (to use anachronistic language).

No doubt one just has to accept that Mozart and Schikaneder exploited the prejudices of their time. It may alleviate the impression of misogyny if we accept the conjecture that the Queen of the Night represents the unenlightened Catholic Church (in contrast to the Catholic Enlightenment, with which Mozart sympathized). Support for this interpretation comes from the scene where the Queen of the Night orders Pamina to assassinate Sarastro. This recalls the charge of 'monarchomachy', a standard component of anti-Jesuit polemic; the Jesuits were said to justify the murder of recalcitrant kings, and themselves to have plotted a large number of assassinations.

What, though, are we to make of the discrepancy between Sarastro's principles and his behaviour? He explicitly disavows revenge: 'In diesen heil'gen Hallen / Kennt man die Rache nicht!' ('In these holy halls / Revenge remains unknown!')[146] Yet not only is Monostatos cruelly punished, but, at the end of the opera, he, the Queen and her attendants are all plunged into 'eternal night'. It is tempting to conjecture that, no doubt inadvertently, Mozart and Schikaneder have given the enlightened potentate some of the less attractive features ascribed to the Christian God and imported into their enlightened allegory the ancient problem of evil. If God is omnipotent, why does he permit the Devil to do harm? One – inadmissible but compelling – answer is that in the Christian economy, the Devil is God's secret agent, to whom his dirty and disreputable work is outsourced: 'the Evil One is on God's side. He carries out the garbage.'[147] Monostatos is similarly a useful servant who can be disposed of once he has, overenthusiastically, carried out his task of recapturing Pamina.

## THE REPUBLIC OF LETTERS

Although the coffee-house and the salon were enormously important as spaces of sociability, their effect in promoting the Enlightenment may have been less than writers, under the influence of Habermas, have assumed.

The coffee-house was not a debating society, and aristocratic gatherings were not the setting for intellectual seminars. Societies formed for the specific purpose of intellectual debate, combined with conviviality, contributed much more to the Enlightenment. Face-to-face meetings, however, were only part of the public sphere. An ever-increasing importance was assumed by the virtual public sphere, in which people interacted at a distance via correspondence, journals and newspapers. And this virtual public sphere was made possible by the prior existence of the Republic of Letters.

Research in recent decades has tended to play down the significance of the Republic of Letters, and to see it as only loosely, if at all, connected with the Enlightenment.[148] Yet it was this institution that gave Europe's intellectual culture the infrastructure, and hence the 'impressive cohesion', that Jonathan Israel has recognized in the late seventeenth and eighteenth centuries:

> For it was then that western and central Europe first became, in the sphere
> of ideas, broadly a single arena integrated by mostly newly invented chan-
> nels of communication, ranging from newspapers, magazines, and the salon
> to the coffee-shop and a whole array of fresh cultural devices of which the
> erudite journals (invented in the 1660s) and the 'universal' library were
> particularly crucial.[149]

The Republic of Letters was a virtual community of scholars, which enjoyed its golden age in the period 1650–1750 and was still going strong, with some 30,000 members, on the eve of the French Revolution.[150] It had originated in the humanism of the Renaissance, as Voltaire observed in 1727: 'Since all Europe hath set up the Greek, and Roman Authors for Models of Writing, Homer and Demosthenes, Virgil and Tully, have in some Measure united under their Laws our European Nations, and made of so many and different Countries, a single Commonwealth of Letters.'[151] The first known occurrence of the term is in a letter of 6 July 1417 from the Venetian humanist Francesco Barbaro, thanking Poggio Bracciolini for bringing enrichment to the republic of letters (*huic litterariae Reipublicae*) by rediscovering the works of Lucretius, Quintilian and other Latin authors, and it was current from the early sixteenth century, when Erasmus was called the monarch of the Republic of Letters.[152]

Humanists engaged in restoring ancient texts needed to communicate. They had to consult manuscripts kept in distant monasteries or libraries; if they could not travel there themselves, they had to ask for help from fellow-scholars who were nearer the spot. Communication was essential. Hence, they developed networks of correspondence, which made them aware of themselves not just as scholarly individuals but as a community with shared

values. They exchanged books, announced discoveries, requested information, dealt with publishers, and sought and provided patronage.[153] Erasmus corresponded with Thomas More in London, John Colet in Oxford, Juan Luis Vives in Louvain, Guillaume Budé in Paris, Philipp Melanchthon in Wittenberg.[154] The correspondence network maintained in the early seventeenth century by the antiquary Nicolas-Claude Fabri de Peiresc was at its densest in Paris, followed by London, Aix and Marseilles, but it included isolated correspondents as far north as Hamburg, as far south as Valletta and even Cairo, and as far east as Damascus.[155] The epistolary network of the theologian and scientist Marin Mersenne 'included over seventy widely dispersed scientific correspondents'.[156] That is dwarfed, however, by the network of the polymath Leibniz. A catalogue of Leibniz's letters, compiled in 1889 and based on some 15,300 letters (more have since come to light), identified 1,063 correspondents, some 50 of whom stayed in touch for 20 years; he wrote to some 300 correspondents in German, to the rest in Latin or strikingly elegant French.[157] The scientist and poet Albrecht von Haller, who was a professor at Göttingen from 1736 to 1753 and then returned to his native Bern, had 1,189 individual correspondents (plus 11 institutions); 16,981 of the letters survive.[158] Later in the eighteenth century, Benjamin Franklin is estimated to have sent and received around 15,000 letters during his lifetime, in a network spanning Philadelphia, London and Paris.[159] Such networks were even larger in practice, since letters were often intended to be shared among several readers.

In the seventeenth century, correspondence among scholars was not replaced, but supplemented, by learned journals.[160] Journals evaluated new books, reported scientific advances and scholarly debates, and provided obituaries of deceased scholars. The first genuinely critical journal was the monthly *Nouvelles de la République des Lettres*, which Pierre Bayle edited from March 1684 to February 1687, when illness obliged him to relinquish it, for the enterprising publisher Desbordes, based in Amsterdam. The United Provinces were the ideal base for such an undertaking, since they were not only a commercial centre but also 'the hub of the international book trade'.[161] Anywhere else, access to books was difficult because they were not widely distributed and were in any case prohibitively expensive. Book reviews were therefore indispensable to let journal subscribers know what was happening in the intellectual world. In each issue of the *Nouvelles* Bayle wrote detailed reviews of a dozen recently published books, in the engaging style already familiar from *Thoughts on the Comet*. It enabled him to carry on an extensive correspondence – with the costs paid by the publisher – and to receive 'basketfuls' of new books.[162] Other journals came into being to report on new publications in English

and German, at a time when English was seldom understood on the Continent, or German outside the Empire: the *Bibliothèque angloise* was founded in Amsterdam in 1717, and a *Bibliothèque germanique* in 1720.[163]

Besides the practical value of book reviews, we must remember the sheer intellectual excitement of finding out what was happening in the scattered world of learning.[164] Scholars remote from such centres as London, Paris, or Amsterdam gained the feeling of belonging to a virtual community, with shared interests and values, as subscribers to magazines do nowadays. Leibniz, who contributed thirteen papers to the *Acta Eruditorum* (*Scholarly Papers*) between 1682 and 1686, clearly enjoyed this feeling, especially since he felt isolated in the remote and decidedly non-intellectual court of Hanover, where 'in this country it is not regarded as appropriate for a courtier to speak of learned matters'.[165] By 1718, some fifty intellectual journals existed throughout Europe.

An essential part of the infrastructure of the Republic of Letters, and of the Enlightenment, was the universal public library. Previously, the usual type was the confessional library, which contained only books expounding and defending one particular religious confession. These libraries might be ostensibly public but were in fact difficult of access. Readers of Manzoni's *The Betrothed* will remember his tribute to Federigo Borromeo, founder of the Ambrosian Library at Milan, which opened in 1609:

> In a history of the Ambrosian library, written with the elaborate elegance of the time by one Pierpaolo Bosca, who held the post of librarian there after the death of Federigo Borromeo, there is special mention of the strange fact that the books in this library, which had been built by a private citizen and almost entirely at his expense, were exposed to the view of the public and given out to anyone who asked for them; and that the visitors were actually given somewhere to sit, and writing materials, so that they could make any notes they needed; whereas in every other famous public library of Italy, the books were not even on view, but shut up in cupboards, from which they could only be extracted by special favour of librarians, when they happened to feel like giving someone a glimpse of them for a moment.[166]

The Ambrosian Library, however, was still a confessional library, supporting the Counter-Reformation. The Republic of Letters needed the new type of universal library in which every subject was represented, with books shelved according to discipline. One of the leading advocates of the universal library was Leibniz, who was in charge of the ducal library at Wolfenbüttel. In 1679 he wrote to his employer, Duke Johann Friedrich of Brunswick-Lüneburg: 'My opinion has always been and still is that a Library should be an Encyclopaedia, that is to say, when needed, one could learn in it of

all the matters of consequence and of practice.'[167] By the 1720s even the previously confessional libraries of the Benedictine and Augustinian abbeys of Bavaria and Austria were buying books on science and philosophy; by the 1740s, several of their libraries had over 15,000 volumes.[168] Gradually they were penetrated by the Enlightenment. The abbey library at Melk in Austria, despite its small size, also had Enlightenment journals, including the wide-ranging *Teutscher Merkur*, along with works by Richardson, Herder and Kant, and a second-hand copy of the *Encyclopédie*.[169]

It was no wonder, then, that librarians were key figures in the Republic of Letters. They decided what books libraries should acquire and who might use them. They compiled catalogues, which, in the case of specialized libraries, amounted to important bibliographies and were carefully reviewed in the *Acta Eruditorum*.[170] A late English example is the catalogue of the Harleian Library, a universal library containing some 50,000 books, compiled in 1743–5 by its librarian, William Oldys, and Samuel Johnson, and modelled on the great catalogues of continental libraries produced by seventeenth-century humanists.[171] Scholars, undeterred by the difficulties of early modern travel, undertook tours of libraries, planning their itinerary beforehand and arming themselves with letters of introduction.[172] Thus the ambitious traveller Zacharias Conrad von Uffenbach, after several shorter trips, made in 1709–11 a long-planned journey through north Germany, Holland and southern England, which took him to both Oxford and Cambridge. He called on an array of eminent scholars, including Leibniz in Germany, Herman Boerhaave in Holland and, in England, the astronomers John Flamsteed and William Whiston, the antiquary Thomas Hearne, and the classical scholar Richard Bentley. Like other scholars, he was interested not only in books and manuscripts but in all sorts of curiosities that collectors assembled in their *Wunderkammern* or chambers of marvels. In Oxford (where he had to bribe the sub-librarian with a guinea in order to inspect the manuscripts in the Bodleian) he viewed with considerable scepticism the skeleton of a pygmy, the hand of a siren, and the sword with which King James I was said to have humorously knighted a sirloin of beef.[173]

## THE ETHOS OF SCHOLARSHIP

The first issue of Bayle's journal begins with a preface, addressed to 'the public' and defining an intellectual community, describing its purpose and asking readers to send in obituaries of famous scholars, all of whom will be treated equally without regard to their religion:

It is not a matter of religion, but of science: so one must put down all the terms that divide people into different factions, and consider only the point where they are all united, which is the title of an illustrious man in the Republic of Letters. In this sense all scholars should regard themselves as brothers, or as all coming from equally good families.[174]

The Republic, Bayle says in his *Dictionary*, is a free polity where the state of nature survives, unimpeded by the laws of society, and every individual can take the sword against everyone else.[175]

Bayle here formulates the egalitarian ideal of the Republic of Letters. All its members should regard themselves as brothers. Social divisions, like religious ones, were to be disregarded. The Republic could include artisans and mechanics. After all, early modern scientists, including Galileo, Huygens and Boyle, were also technicians who made their own instruments or worked with artisans to do so.[176] An individual's standing was determined by his scholarly credentials and achievements. In this sense the great late-Renaissance scholars Joseph Justus Scaliger, Justus Lipsius and Isaac Casaubon could be hailed as 'triumvirs'.[177] There was a hierarchy, and the lower members treated the higher with a deference that can now seem dangerously close to grovelling.[178] But the hierarchy was really a meritocracy.

The model of civility was opposed to the image of the uncouth, absent-minded scholar. It became difficult to tolerate such eccentrics as the untidy and unwashed recluse Antonio Magliabechi (1633–1714), librarian to the grand duke of Tuscany, who wore the same clothes summer and winter, and slept in them; his thousands of books were not placed on shelves but formed huge tottering piles on the floor.[179] A more acceptable form of eccentricity was shown by the Vatican librarian, Cardinal Domenico Passionei (1682–1761), who forbade people reading in his private library to take off their hats when he entered, 'to show that all formalities should be banned from the Republic of Scholars'.[180] An eminent French scholar, Charles de Brosses, was disconcerted to find the cardinal reclining on a sofa without his wig; when de Brosses tried to behave formally, the cardinal dragged him down to the sofa beside him.[181]

Worse than eccentricity, however, were the bitter disputes and personal insults that were all too characteristic of scholars. Bayle did his best to discourage such behaviour, insisting that the Republic's freedom did not permit satire and defamation.[182] Similarly, Peiresc deplored harsh comments on other people's works: 'the diligence of study makes this world more austere and more savage than it certainly should be'.[183] Robert Boyle, in his preface to *The Sceptical Chymist* (1661), regretted the tendency even

of scientists to resort to personal vituperation. He explained that his work was composed as a dialogue, 'in a stile more Fashionable than That of meer Scholars is wont to be', for the purpose of

> giving an example how to manage even Disputes with Civility; whence perhaps some Readers will be assisted to discern a Difference between Bluntness of speech and Strength of reason, and find that a man may be a Champion for Truth, without becoming an Enemy to Civility; and may confute an Opinion without railing at Them that hold it.[184]

Nevertheless, scholarly quarrels could not be eradicated.[185] The question of priority in making an important discovery was sure to arouse bitterness, as when Newton and Leibniz both claimed to have been the first to discover the infinitesimal calculus, or when the mathematicians Bernoulli and d'Alembert argued about which of them had first proposed applying mathematics to smallpox inoculation.[186] At a more petty level, the Republic was pervaded by gossip, backbiting, disparagement and potentially dangerous imputations of religious unorthodoxy.[187] The art historian Winckelmann in Rome complains of the swarm of antiquaries who want to attack him; he particularly dislikes one French abbé, whom he has called an ignoramus and a donkey in the presence of Cardinal Passionei.[188] But when he finds himself complaining about his rivals, Winckelmann adds: 'I see I am falling into the language of pedants' – that is, into abusive language.[189] Lessing fiercely attacked Christian Adolph Klotz, who had accused him of making mistakes about Homer in his aesthetic treatise *Laokoon*; but he adds that while criticism should be frank, it must not be *ad hominem*, and even defines five degrees of politeness that one should use against different kinds of opponent: 'Gentle and encouraging towards the beginner; admiringly critical, critically admiring towards the master; firm and forbidding towards the incompetent; scornful towards the braggart; and as bitter as possible towards the intriguer.'[190]

The volume of early modern scholars' correspondence often marks the width of their interests. A common ideal was the 'polyhistor' or polymath, who sought to encompass all knowledge. The Jesuit Athanasius Kircher (1602–80) astonished contemporaries, and sometimes provoked their scepticism, by his erudition, which ranged from mathematics to magnetism, astronomy to geology and volcanology, Roman antiquities to Egyptian hieroglyphics and Chinese history.[191] The supreme polymath, and the last of the breed, was Leibniz. Besides philosophy, theology and mathematics, he spent much of his time, at his employer's behest, in managing mining operations and in composing a history of the Guelf family, during which he made important archival discoveries. His diverse intellectual pursuits

were held together by his early commitment to an encyclopaedic conception of knowledge. He thought it possible to arrive by analysis at a small number of primitive concepts, which formed 'an alphabet of human thoughts', and which, when associated with appropriate signs or characters, could give rise via a set of rules to all other possible concepts.[192] Since Leibniz left many projects unfinished, however, and published only a small proportion of his writings, the universal ambitions that lent coherence to his activities were invisible to later generations. He seemed to have let his wide interests distract him from the mathematics and philosophy in which he excelled, while such figures as Kircher looked in retrospect like industrious dilettantes with few lasting achievements. Research became increasingly specialized and compartmentalized.

The ideal of erudition was now unfashionable. D'Alembert charged that the *érudits* had excavated the past with great labour and no discrimination; '[they] knew everything about the ancients, except their grace and subtlety.'[193] At least, however, they deserved credit for having made it possible for more cultivated people to appreciate ancient authors with taste: 'Erudition was necessary to guide us towards good literature.'[194] The great scholars of the past, with their grotesquely Latinized names and their feats of learning, were now caricatured: 'But you forget the great *Lipsius*, quoth *Yorick*, who composed a work the day he was born: – They should have wiped it up, said my uncle *Toby*, and said no more about it.'[195] In an early comedy, Lessing makes fun of the conceited young scholar Damis, who boasts of his knowledge of languages but is annoyed when his sceptical servant claims to know Wendish (a Slavonic language still spoken in parts of Saxony).[196] The merely erudite scholar was now the 'pedant', dismissed along with the 'antiquary', or collector of ancient objects, and the 'virtuoso' or amateur scientist and art-collector.[197] A whole world of learning was thus occluded, and its achievements were underrated or forgotten; they have been recovered for the present day by the enthusiasm of Anthony Grafton and others.[198] Yet early modern scholarship helped to lay the foundations for the Enlightenment. The study of classical texts developed critical techniques that, in the seventeenth century, were applied by Richard Simon and his successors to the text of the Bible, eventually with devastating results. The collection of antique objects represented an attempt to understand the material culture of antiquity and to transfer attention from words (ancient texts) to things, in the empirical spirit of Bacon and the Royal Society.[199]

While the term 'Republic of Letters' continued to be used loosely, it was also sometimes confined to the *érudits*, and hence some modern scholars have thought that the erudite Republic of Letters was remote from the

Enlightenment. However, a recent study of a provincial *érudit*, Esprit Calvet (1728–1810), reveals him as typical of the Republic of Letters in his wide interests and in his extensive correspondence network, but also as an Enlightener. A physician living in Avignon, he took an interest in the latest medical advances, such as electrotherapy, but also collected mineral specimens, fossils, shells and plants, coins, antiquities and antiques, and was elected, with the help of the comte de Caylus, to the Académie des Inscriptions in 1763. He and his associates aimed through their researches to improve people's health and to combat superstition. Although they had no contact with the Encyclopedists, and only four of them (not including Calvet) had ever met Voltaire, they used the vocabulary of Enlightenment, gaining 'éclaircissements' with the help of 'lumières'.[200]

By 1750, Duclos distinguishes three classes within the Republic of Letters. There are the *savants* or *érudits*, who are now diminishing in number and receiving less esteem. There are other *savants* who concentrate on the natural sciences, and whose studies are recognized as valuable. And there are the men of letters, especially those known as *beaux-esprits*, who are welcome in society, though they are judged less by the quality of their writings than by their witty conversation.[201] Scholarly civility was not enough. The Paris *philosophes* tended to disclaim membership of the Republic of Letters; they aspired to be polite and sociable men of letters (*gens de lettres*).[202] Being imbued with the *esprit philosophique*, according to Voltaire, they applied their criticism not to Greek and Latin words, but to prejudices and superstitions. They could discuss a metaphysical treatise and a play with equal ease and moved comfortably between the study and high society.[203]

How sharp were the divisions in the literary world? A famous article by Robert Darnton draws a sharp distinction between those men of letters who benefited from distinguished patronage, and the many who scraped a living by literary hack-work in the Paris equivalent of Grub Street.[204] Some of the latter would be propelled by their frustration with the established order into the leadership of the French Revolution. Darnton's account has been challenged.[205] Many writers can be found who do not fit into this binary: for example, the future revolutionaries Joseph Fouché and Jean-Paul Marat were not hacks, but a professor and a physician respectively.[206] It has further been objected that Darnton ignores what people actually wrote and treats them solely as careerists, some successful and complacent, others unsuccessful and embittered.

We cannot find a close parallel in England, since it lacked a *parti philosophique* dedicated to spreading enlightenment, but we can find similar divisions in the literary world. Alexander Pope sought to embody polite

learning, as opposed to pedantry, by his translations of Homer into elegant blank verse, and by his edition of Shakespeare (which unfortunately was very inaccurate).[207] In the *Dunciad* he attacked the futile erudition of pedants and the vulgarity of Grub Street hacks. The latter were widely felt to have turned literature into a mere commercial enterprise. However, one should not see Grub Street through Pope's partisan eyes. It was a distinct subculture, comprising around 1725 a hundred or so men and women who lived solely by writing, plus many others who wrote to supplement their income.[208] There were plenty of talented writers among them. It was from this milieu that Samuel Johnson emerged, after precarious years spent translating, writing potted biographies and composing speeches supposed to have been delivered in the House of Commons. In contrast to Pope, Johnson was steeped in humanist learning; he was not a polite man of letters, but a scholar and poet whose talent was immediately clear from his poems *London* and *The Vanity of Human Wishes*. Like many humanists, he wrote poetry also in Latin, and one of the projects that he contemplated, but never realized, was a 'History of the Revival of Learning in Europe'.[209]

## THE VIRTUAL PUBLIC SPHERE

The public sphere was held together by a network of communications.[210] Particularly important were newspapers. Théophraste Renaudot, supported by Cardinal Richelieu, established the Paris *Gazette* in 1631, and the *London Gazette*, modelled on Renaudot's publication, first appeared in 1665.[211] Admittedly these were very much official organs, relaying foreign news but containing little domestic information; the Paris *Gazette* served Richelieu as a vehicle for pro-royal and self-aggrandizing propaganda, while its London counterpart shared the assumption that political information belonged to the arcana of power and should not be widely disclosed.[212] From the later seventeenth century onwards, however, sociable interaction was supplemented and enormously extended by the newspapers and journals that began to proliferate at that time.

In the sixteenth century, many ephemeral pamphlets circulated, but the news they brought was often of prodigies, such as the birth of a two-headed calf or the appearance of a mermaid, like the broadsheets sold by Autolycus in *The Winter's Tale*. Serious political and economic news was collected by professional agents called *novellanti*, whose handwritten newsletters (called *avvisi* – the Danish word for a newspaper is still *avis*) were valuable for political leaders and for international businessmen like the Fuggers of Augsburg, whose large collection of newsletters began

around 1554. In 1620 Abraham Verhoeven of Antwerp had the idea of publishing news reports as a serial. His *Nieuwe Tidinghen* ran for a decade.[213] The sole privilege of publishing similar weekly newsbooks in Britain was awarded in the 1620s to Nicholas Bourne and Nathaniel Butter. Renaudot's Paris *Gazette* followed in 1631, and in 1645 the first newspaper with a title, the *Successi del mondo*, appeared in Turin.[214]

An important turning-point in Britain was Parliament's decision in 1695 not to renew the Licensing Act of 1662, which had placed all periodical publications, apart from the official *London Gazette*, under such close supervision as to stifle their growth. After the Act lapsed, London's first daily paper, the *Daily Courant*, began publishing in 1702. 'In 1746 the city had eighteen newspapers, including six dailies, six tri-weeklies, and six weeklies.'[215] Provincial towns also acquired their own newspapers, beginning with Norwich in 1701; by 1735 some twenty-five provincial newspapers were being published in England, twice that number by 1782. Over the century, 244 provincial papers were produced in 55 different towns, with a circulation in the 1770s of between one and two thousand copies per issue (and each copy was probably read by several people).[216] In 1769, for example, Newcastle upon Tyne acquired its eighth newspaper; the town also had two circulating libraries, three subscription newsrooms, and many book clubs and debating societies, all of which amounted to a flourishing culture with a strong need for information.[217] The papers carried news from the metropolis, local news and advertisements. Samuel Johnson's first periodical essays, now lost, were written for a provincial newspaper, the *Birmingham Journal*.[218] In addition, the manuscript newsletters that originated in the sixteenth century continued to be popular, and much news was also transmitted by cheap, ephemeral pamphlets.

Most of the several hundred papers that existed in Europe by the 1770s were authorized or tolerated by the government, which often controlled what got or didn't get into print. Thus until 1778 the *Gazette de France* held a royal monopoly on the publication of political news.[219] Its Spanish counterpart, the *Gaçeta de Madrid*, is said to have avoided all mention of the French Revolution.[220] The only daily paper in pre-Revolution France, the *Journal de Paris*, largely confined itself to cultural matters. There was more political content in the French newspapers that were published abroad, sometimes in the Huguenot diaspora: the *Gazette de Leyde* and the *Gazette d'Amsterdam* in the Netherlands, the *Courier du Bas-Rhin* in the principality of Cleves in Germany, and Simon-Nicolas-Henri Linguet's *Annales civiles, politiques, et littéraires* in London.[221] These exile papers were a major source of information on domestic politics: Pascal Boyer, the Paris correspondent of the *Gazette de Leyde*,

provided accounts of the major events of the 1780s which Jeremy Popkin, having compared other newspapers, judges 'the best publicly published reporting on French affairs available at the time'.[222] They were not exempt from French government control, since from 1759 their distribution was handled by an official news agency in Paris, which could in theory damage a newspaper's circulation by refusing to distribute it.[223] Even so, however, there were many routes by which foreign journals could slip clandestinely into France.

In England, the freedom of the press, established in 1695, was a source of national pride. 'The liberty of the press', said the great lawyer Sir William Blackstone, 'is indeed essential to the nature of a free state.'[224] Such liberty acquired more substance when, in 1771, the House of Commons conceded the right to publish a record of its proceedings. The absence of censorship, even during the Napoleonic Wars, also impressed foreigners, as did the frequent ferocity of polemics and caricatures.[225] Readers were thus in a position to understand and, when necessary, defend their liberties. 'Every subject not only has the right, but is in duty bound, to enquire into the publick measures pursued,' wrote the *London Magazine* in 1738, 'because by such enquiry he may discover that some of the publick measures tend towards overturning the liberties of the country; and by making such a discovery in time, and acting strenuously . . . he may disappoint their effects.'[226] From the 1740s onwards, readers took to writing large numbers of letters to the press, which were published anonymously or pseudonymously and were not only a form of expression but a means of lobbying. Their expansion coincided with an increase in the political content of the London newspapers.[227]

There were other constraints, however, less visible than censorship. Authors and printers were still liable to prosecution if what they published was deemed by the government to be seditious libel. As seditious libel had no clear definition, authors were kept in constant anxiety that they might unwittingly get themselves into trouble; 'for as the Case now stands,' wrote Daniel Defoe in 1704, ''tis in the Breast of the Courts of Justice to make any Book a Scandalous and Seditious Libel'. Far better, he argued, to make known a list of forbidden subjects, which authors could avoid: ''twould be a wholesome Piece of Justice to all the Nation, to place a *Buoy* on the Rock, and whoever splits on it afterwards would deserve no pity.'[228] Those found guilty might be placed in the pillory* and exposed to the mob. Defoe suffered in this way in 1703 for his pamphlet *The Shortest*

---

* A wooden frame, mounted on a platform, with holes in it through which a person's head and hands were inserted to be pelted with missiles by bystanders.

*Way with the Dissenters* (1702), which ironically pretended to advocate the violent suppression of a religious group to which Defoe himself belonged. The pillory, abolished in England only in 1837, was not only physically dangerous – in the previous year, another libeller had had an eye knocked out – but deeply humiliating. These facts must qualify the familiar self-congratulatory narrative of English press freedom.[229]

Newspapers had to be financed, either by commercial or by political interests. From 1704 Sir Robert Harley, secretary of state and later chancellor of the exchequer, subsidized Defoe's *Review* as a mouthpiece for his ministry.[230] When a Committee of Secrecy examined the conduct of the prime minister, Sir Robert Walpole, in 1742, it found that in the previous ten years of his administration over £50,000 of secret service money had been paid to pamphleteers and newspapers.[231] Government influence was countered, however, by the founding of openly partisan oppositional papers. *The Craftsman* (1726–46) served Lord Bolingbroke and the 'Country' party to attack Walpole's administration. At its height, it printed 10,000–12,000 copies of each issue.[232] John Wilkes founded *The North Briton* in 1762 to pursue his opposition to George III's favourite Lord Bute. His issue number 45, in which he denounced the king, provided a test case for press freedom. The government issued a general warrant for the arrest of everyone – publisher, printer, distributors: forty-nine people altogether – connected with the offending paper. Wilkes challenged this action on the grounds that a general warrant was illegal and that he, as a Member of Parliament, could not be arrested for libel. The challenge succeeded on both counts, and Wilkes became a highly controversial celebrity.[233]

The appetite for news, especially foreign news, was so great that a frequent literary figure of fun was the amateur politician who, having read the newspapers, thinks he knows how Europe should be governed. The best-known example was the *Collegium politicum* in Ludvig Holberg's *Den politiske Kandestøber* (*The Political Tinsmith*, 1722), who, in their ignorance of geography, maintain that the Empire should be defended by building a fleet and keeping it at Vienna or Prague to frighten off the Turks.[234] On a more serious level, it was often argued, by Samuel Johnson among others, that public discussion of politics could easily degenerate into groundless fear and unreasoning frenzy. Johnson used irony to deplore the 'fever of epidemic patriotism' stirred up by the Wilkes affair:

> The sphere of anxiety is now enlarged; he that hitherto cared only for himself, now cares for the public; for he has learned that the happiness of individuals is comprised in the prosperity of the whole, and that his country never suffers but he suffers with it, however it happens that he feels no pain.[235]

In plays written both before and after the French Revolution, Goethe similarly shows the public discussion of events readily being exploited by demagogues, like the scribe and barrack-room lawyer Vansen in *Egmont* (1787) and the village Jacobin Breme (a name borrowed from Holberg) in *Die Aufgeregten* (1793).[236]

It may well be that enlightenment was more effectively promoted by the wide range of journals that discussed cultural and scientific issues. Although the *Acta Eruditorum*, established at Leipzig in 1682, was confined to an academic audience by being in Latin, the *Philosophical Transactions* of the Royal Society and the *Journal des Sçavans*, both dating from the mid-1660s, were published in the vernacular and were, in principle, accessible to the general reader. So were the many serious specialist journals, of which more than eight hundred appeared in France between 1700 and 1789. They included the *Journal économique* (1751–72), the *Observations de la physique* (1752–1823) and the *Journal de médecine* (1754–93).[237]

A broader appeal was exercised by what have been called 'discussion journals', containing book reviews, book extracts and essays on a wide variety of topics.[238] For example, the quarterly *Mercure galant*, founded in 1672, included cultural and literary news alongside court gossip, birth and marriage announcements, and obituaries.[239] Its successor, the *Mercure de France*, likewise an official journal, was edited from August 1758 to January 1760 by Marmontel, who tells us proudly in his memoirs about its varied content. Science was represented by articles on inoculation, the return of Halley's Comet, and new methods of refrigeration, curing snake-bite and resuscitating the almost drowned, while the architect Julien David Le Roy reported on the monuments he had visited in Greece and the engraver Charles Nicolas Cochin on his travels in Italy. Marmontel was also in contact with all the academies in France and published their answers to questions concerning morality, political economy and the useful arts. The intelligent questions posed by his readers impressed him as showing 'the progress of the public mind'.[240]

A German counterpart, the *Teutscher Merkur*, was founded by Wieland in 1773; it was a successful business venture, independent of booksellers, and under Wieland's editorship (from 1773 to 1790) it carried original works of literature, book reviews and essays, affirming but also exploring and sometimes criticizing the principles of the Enlightenment. Since Germany had no cultural centre corresponding to Paris, Wieland's journal had to forge links among readers scattered from Hamburg to Vienna and defined itself as a 'national journal'. Wieland's conception of the nation, however, was entirely compatible with his cosmopolitan outlook – but not with a single-minded elevation of one's own nation over all others:

Whatever political constitution a cosmopolitan may inhabit, whether from necessity or by his own choice, he always lives as a good and peaceful citizen. The principles and convictions that make him a citizen of the world are the basis of his goodwill towards the particular civil society of which he is a member; but they also set bounds to its influence. What among the ancient Greeks and among their proud citizens of that city that thought its purpose was to rule the world [Athens] was called 'love of the fatherland', is a passion incompatible with the basic ideas of cosmopolitanism.[241]

Thus a journal could be used to overcome local and national prejudices and make readers aware of their membership in a virtual international community.

A new kind of publication appeared in 1711 with the *Spectator*. It was inspired by the success of the *Tatler*, written by Richard Steele with assistance from Joseph Addison, which appeared three times a week from April 1709 until January 1711, and contained in each issue an extended essay along with shorter items and many advertisements. The *Spectator* was more ambitious. It appeared every weekday. Each issue consisted of a single essay. It retained the fiction of a personal author, but instead of the *Tatler*'s Isaac Bickerstaff, 'Mr Spectator' was a gentleman with few distinctive qualities other than taciturnity, who reported his observations of everyday life and provided, especially on Saturdays, essays on moral and religious topics. He introduces the reader to a circle of friends, prominent among whom are the lovably eccentric Tory country squire Sir Roger de Coverley, his antithesis the Whig merchant Sir Andrew Freeport, the elderly beau Will Honeycomb, and a small supporting cast. Besides offering these engaging characters, the *Spectator* was interactive: many issues contained letters from correspondents. Its modern editor thinks that most of these letters were genuine; a few originals survive, letting us see how they were tidied up for publication. Some of the correspondents' names are obvious inventions (e.g. 'George Trusty' and 'William Wiseacre' in no. 134), but their letters may still have been genuine. Of the essays, it is calculated that Addison and Steele each wrote 251, their associate Eustace Budgell 29, a certain 'Hughes' 6, leaving 18 that are unidentifiable.[242]

The *Spectator* had an immediate and immense success. There is no reason to disbelieve Addison when he says in no. 10: 'My Publisher tells me, that there are already Three thousand of them distributed every day.' John Gay says that the *Spectator* is 'in every ones Hand, and a constant Topick for our Morning Conversation at Tea-Tables, and Coffee-houses'.[243] Its popularity resulted from the feeling of getting to know literary friends, from its dialogic character, and from its pertinence to everyday life.

Although the *Spectator* disclaims any political standpoint, it is effectively Whiggish in appealing to a broad public and in offering advice on manners that can help people rise in society. People should not complain in public about their aches and pains, talk always on the same subject, pay insincere compliments, or (as lawyers are said to do) constantly pick arguments. Steele describes various types of bore: the one who tells stories with endless irrelevant details; those who start arguments about what is obvious and uncontroversial.[244] Some people insist on singing in public; some speak too loudly, others in a confidential whisper.[245] He complains of 'Wagerers' who constantly bet on silly things, such as whether the Isle of Wight is a peninsula.[246] The *Spectator* offered a training course in politeness, but did not take it to excess. According to Steele, 'an unconstrained Carriage, and a certain Openness of Behaviour are the height of Good Breeding'; elaborate politeness is characteristic of country people who retain the manners of the previous century.[247] He condemns as 'Affectation, not Politeness' the 'false Delicacy' which substitutes genteel euphemism for the forthright language of moral praise and blame.[248] Addison advocates 'Good-nature', which is so necessary that 'Mankind have been forced to invent a kind of Artificial Humanity, which is what we express by the Word *Good-Breeding*'; however, these exterior shows are excellent when founded on real good nature, but repulsive when hypocritical.[249]

Not surprisingly, this model was imitated across the Continent. Pierre de Marivaux, whose fiction shows him to be an acute social observer, issued *Le Spectateur français* (1721–4).[250] In Holland, the Enlightener Justus van Effen first published *Le Misantrope* (1711–12) in French, addressing highly educated people and French refugees, but later issued a Dutch periodical, *De Hollandsche Spectator* (1731–5), aimed at what he called 'the middling ranks'.[251] The *Spectator* found imitators particularly in Germany, in the publications known as 'moral weeklies', of which some 186 (many of them short-lived) appeared between about 1720 and the dissolution of the genre around 1770.[252] They were often known generically as *Zuschauer* ('spectators'), and in Holland as *Spectatoriale Geschriften*.[253] The Danish counterpart, edited by Jens S. Sneedorff, was called *Den patriotiske Tilskuer* (*The Patriotic Spectator*, 1761–3).[254] They rely on the fictive author, who often gives the journal its title (*The Citizen*, *The Patriot*, etc.), and addresses the reader in a friendly, informal and engaging manner.

The moral weeklies were important in inviting people to think about their everyday lives. This is especially visible in later publications that were aimed at readers somewhat lower down the social scale, such as the reflections on manners that the Westphalian administrator Justus Möser issued as *Patriotische Phantasien* (1774–8). Often using the device of fictitious

correspondents, Möser satirizes female fashions, modish Francophilia and excessive coffee-drinking. But he also includes longer essays about the local economy, enabling people to understand the decline of rural commerce and handicrafts as aspects of larger economic developments.[255]

The values propagated in the German moral weeklies are conservative. They accept the social hierarchy and wish social distinctions to be preserved. Their addressee is a member of the middle classes, often employed in commerce, for whom virtue consists in honesty, industry, modesty and contentment with one's station in life. The moral weeklies do not discuss religious topics, but take for granted, in the spirit of physico-theology, that God's goodness and wisdom are apparent in the world. They advocate religious tolerance and oppose such superstitions as the persecution of supposed heretics and witches. They assume that God intends each of us to attain happiness by practising virtue and being a useful citizen. The Hamburg *Bewunderer* declares 'that an honest merchant is in my eyes far more useful to human society than an obscure philosopher or a boastful polymath. A merchant strives to transform the necessity of human society into sources of happiness.'[256] Instead of turning away from the world in the spirit of the baroque, or trying to suppress our emotions, we should enjoy life and channel our passions into socially useful directions. Apparent evil is said, in the spirit of Leibniz's *Theodicy*, to be necessary for the universal good. This eudaemonism comes under considerable strain when the Lisbon earthquake is said to be a useful opportunity for people to display their virtue.[257]

This outlook may seem not only conservative, but philistine and blinkered. The moral weeklies were enlightened, however, not only in focusing on earthly life, but also in asking people to sustain their values through conscious reflection. Virtue could not be based on instinct or habit, but must rest on rational principles: 'Only the enlightened person is truly virtuous, who not only follows the commandments of religion, but arranges his life in accordance with principles that flow from the demands of reason.'[258] Such a person could enjoy happiness on this earth, for a benevolent God had placed it within our grasp: 'God never demands from us anything that exceeds our powers: and he certainly will not have implanted the desire for happiness in us in vain, without giving us the ability to attain it.'[259]

## CENSORSHIP

In most countries, enlightened authors had to struggle with censorship. Britain was a partial exception.[260] When in 1695 the Licensing Act was allowed to lapse, government pre-censorship was abolished. However, in

1737 the Stage Licensing Act required theatrical productions (plays, ope-
ras, farces) to be licensed by the lord chamberlain. This was a response to
thinly veiled attacks on Sir Robert Walpole, notably in John Gay's *The
Beggar's Opera* (1728), where the gangster Macheath was understood to
represent the prime minister, and William Hatchett's *The Fall of Mor-
timer: An Historical Play* (1731), where the over-mighty subject Mortimer
represented his modern counterpart. Authors of published works could
be prosecuted for 'seditious libel' or 'obscene libel', as Defoe was. Thomas
Woolston's anti-religious *Discourses* earned him a prison sentence for
'seditious libel', which was understood to mean attacking the foundations
of Church and state. As we have seen, the radical John Wilkes was charged
with seditious libel for attacking George III's favourite, Lord Bute, in
1763, and also with obscene libel for writing a parody of Pope's *Essay on
Man* entitled *Essay on Woman*. Political attitudes hardened in the 1770s,
when expressions of sympathy with the American rebels led to prosecu-
tion. In the era of the French Revolution, governments were yet more
uneasy: Paine's *The Rights of Man, Part the Second* (1792) brought him
a charge of seditious libel; he escaped arrest by fleeing to France.[261]

In France, censorship was in theory severe and all-embracing.[262] Every
manuscript intended for publication had to be submitted to royal censors,
who wrote reports on it. If they approved, it would be published with
'approbation' and the name of the censor on the title-page. However, the
censors were not at all like the servants of modern repressive regimes who
harass dissident writers. Often they were themselves authors, mixing in
the same circles as the writers whose manuscripts they vetted. They judged
not only works but also authors: did the latter show due deference to
authority, and conformity to social and literary norms? Were they sound,
reliable, a force for stability? Censorship was a subtle means of co-
optation, sustained by such Enlightenment figures as Fontenelle and
Condillac who worked as royal censors. The well-known tragedian and
member of the French Academy Prosper Jolyot de Crébillon was police
censor at the Comédie Française from 1728 to 1762; so, later, was his son,
the novelist usually known as Crébillon *fils*.[263] Their work was normally
unpaid, rewarded only by its prestige. We should imagine them as rather
like modern publishers' readers. They evaluated not only the moral, pol-
itical and religious propriety of manuscripts, but also the accuracy of their
factual information and the merits of their style. Their reports, preserved
in archives, read like short book reviews. They were especially anxious to
avoid anything that might offend the Church, the monarchy, or highly
placed individuals, and thought it best to err on the side of caution. Thus
one clerical censor, reviewing a biography of a thirteenth-century

archbishop of Canterbury, found nothing reprehensible but feared that he might have overlooked some allusion to the present-day authorities, and therefore refused his approval.[264]

In this system, much depended on personalities. Some censors were cautious, others prepared to take risks; some were generous and tolerant, others conservative. For thirteen years the director of censorship was Guillaume-Chrétien de Lamoignon de Malesherbes, a friend and supporter of such leading Enlighteners as Diderot. There were no clear guidelines either for censors or for authors. Well-placed patrons could put in a word for authors and be rewarded with fulsome dedications. A work that seemed meritorious but unsafe might be unofficially approved and published with 'tacit permission'; in that case it would bear no sign of approval, and might, with the censor's connivance, carry a false place of publication, such as London. Enlighteners generally knew better than to submit truly controversial works to the royal censors. Such works would be sent abroad and published in Geneva or Amsterdam. Sometimes the publication details would clearly be humorous: the anti-monastic satire *Le Balai* (*The Broom*, 1761) by Henri-Joseph du Laurens, published in Amsterdam, professed to come from the printing-house of the Mufti at Constantinople.[265]

The system revealed itself as precarious when an attempt to play it went wrong. In 1758 Helvétius let his friend Charles-Georges Leroy, a royal official who had written several articles for the *Encyclopédie*, including one on rabbit warrens, persuade him to submit his materialist treatise *De l'Esprit* (*On the Mind*) for approval. It was read by a particularly tolerant censor, Jean-Pierre Tercier, with no expertise in philosophy. Leroy and the prospective bookseller sent Tercier instalments of the manuscript in reverse order, so that he could not follow the argument, and the bookseller pressed him to approve the page proofs immediately. Thus Tercier was bounced into affirming officially that a work of materialism and atheism contained nothing offensive to religion or morals. Malesherbes, warned of possible trouble, appointed a second censor, who induced Helvétius to remove some anticlerical expressions. When the book was published, the *parlement* of Paris condemned it; the archbishop of Paris, the pope and the Sorbonne added their denunciations; Tercier was made to retract his approval and resign his post as censor; Helvétius had to retract his doctrines publicly and lost his comfortable sinecure; and the book was lacerated and burned by the public hangman at the foot of the *parlement*'s steps. The *parlement* went further and condemned several Enlightenment texts by Voltaire, Diderot and others, including the first seven volumes of the *Encyclopédie*. Malesherbes protected Diderot by ordering the police to raid his premises but first helping him to conceal the voluminous papers

relating to the *Encyclopédie*. The project continued clandestinely, the last ten volumes being issued under the false imprint of Neuchâtel. But the scandal around *De l'Esprit* damaged Malesherbes' authority and made the dissemination of enlightened ideas in France more difficult.[266]

Before then, Malesherbes had done much in particular to support the controversial Jean-Jacques Rousseau. When Rousseau's *Letter to M. d'Alembert on the Theatre* was submitted to him in 1758, he appointed d'Alembert as its well-disposed censor. He enabled *La Nouvelle Héloïse* to be published by requiring small changes, then allowed the original text, published in Holland, to be distributed in France. On receiving the manuscript of *Émile* in 1761, however, Malesherbes ill-advisedly passed it after a superficial reading, but the *parlement* of Paris took umbrage at the liberal 'Profession of Faith by a Savoyard Vicar', complaining that its effect would be 'to produce men preoccupied with scepticism and tolerance'.[267] It condemned the book to be lacerated and burned, and Rousseau to be arrested and imprisoned. Warned by well-placed patrons, Rousseau left Paris just in time. On the way he met the policemen who had been sent to arrest him; they saluted him courteously and let him proceed.[268]

Elsewhere, writers could benefit from political fragmentation. In the Holy Roman Empire, books prohibited in one state might be publishable in another. In Hanover, which was in personal union with the crown of England, there was relative freedom, so that the Göttingen historian August Ludwig von Schlözer was able to attack legal abuses in his periodical, the *Staatsanzeigen*, which appeared about six times a year from 1783 to 1794 and often sold 4,000 copies.[269] On ascending the throne of Prussia in 1740, the enlightened Frederick the Great roused great hopes by granting unlimited freedom to the Berlin newspaper the *Berliner Privilegierte Zeitung*, and declaring: 'if newspapers are to be interesting, they must not be interfered with'.[270] Soon, however, he reintroduced precensorship. His edict of 1749 required all publications first to be vetted by a board of censors. In practice, however, the law was applied tolerantly and flexibly.[271] Yet this very flexibility was a source of uncertainty. Unsure what they could get away with, and unwilling to risk imprisonment, authors and publishers practised self-censorship. Elsewhere in Germany, rulers were intolerant of criticism. In Württemberg, Christian Friedrich Daniel Schubart severely criticized the ducal regime in his *Teutsche Chronik*, demanding equal rights for Jews and the abandonment of the trade in mercenary soldiers; he was arrested in 1777 and confined in prison without trial for ten years.[272]

For Catholic countries the supreme authority was the papal Index of Prohibited Books, which the enlightened pope Benedict XIV reformed by

his bull *Sollicita ac provida* (1753). Complaints about publications were henceforth to be carefully examined. If books were denounced by bishops or universities, the secretary of the Congregation was to inquire into the denouncers' reasons, and to ensure that the book was examined by a panel of competent clergy who were enjoined to read the whole of it, to keep open minds, not to seek reasons for banning the book, and not to lay undue stress on a few statements taken out of context.[273] Since Italy, like Germany, was fragmented, the restrictions imposed by one state could be evaded by publishing in another. Thus in 1762 Pietro Verri had a treatise on economics rejected by the Milanese authorities, but secured its publication in Lucca.[274] The Italian Enlighteners did not object to censorship in principle, provided it was conducted by the right people and not by the Church. They saw it as a means of spreading enlightenment and preventing the publication of superstitious or otherwise pernicious books.[275]

It was in Austria that censorship underwent the greatest changes. The Empress Maria Theresa was anxious to protect her realm against irreligious writings, particularly those emanating from the *philosophes* of Paris. Travellers to the Habsburg Monarchy had their books confiscated at the frontier and often destroyed. However, Maria Theresa was not satisfied with the chaotic system of censorship, nor with its domination by the Jesuits. In 1753 she set up a board of censors chaired by her physician, the enlightened Dutch immigrant Gerard van Swieten.[276] Van Swieten's policy was to permit works now considered safe (by Montesquieu, Leibniz, Wolff, Newton and Locke) while firmly excluding radical works by Machiavelli, Voltaire, Diderot, Hume and Spinoza.[277] This required careful negotiation. Montesquieu's treatise *L'Esprit des lois* was permitted, but to reassure the Empress, his *Lettres persanes* were banned.[278] As in France, the censors were often themselves men of letters whose works were subject to censorship, and who often made things easier for their fellow-writers. Thus Joseph von Sonnenfels, editor of enlightened periodicals including *Der Mann ohne Vorurtheil* (*The Man without Prejudice*, 1765–7), himself joined the board of censors in 1770. Even so, the list of prohibited books was very long. Contemporaries claimed that in 1777 the official catalogue of prohibited books was itself placed on the catalogue of prohibited books, so that people should not know that forbidden fruits existed; but no evidence has been found for this assertion.[279]

The relative severity of Austrian censorship emerges from an anecdote reported by the traveller Friedrich Nicolai. On arriving in Vienna in 1763, his friend Johann Nicolaus Meinhard, author of essays on Italian poetry, had his copies of the works of Machiavelli and Rousseau's *Émile* confiscated. He appealed to van Swieten, hoping at least that the books would

be kept until he left Vienna, but van Swieten told him that they had already been burned, reproached him for reading Machiavelli, and added: 'Don't talk to me about Rousseau, he's a bad lot!' Continuing his journey south, Meinhard found in Klagenfurt another edition of Machiavelli, which he took to Rome. There his books were again confiscated but were returned to him next day by the pope's official theologian, who told him that as a scholar Meinhard could be trusted to be discreet in reading Machiavelli, but that he should obtain a better edition.[280]

Austrian censorship was in any case notoriously leaky. A leading Jansenist in Vienna obtained forbidden books from Holland via a dealer who concealed them among his goods.[281] A Benedictine monk at Krems-münster procured works of rationalist theology through a scythe-dealer who got them at the Leipzig book fair and smuggled them into the mon-astery.[282] In 1778 Ignaz-Aurelius Fessler, reluctantly training for the priesthood, borrowed from friends in Vienna works by Hobbes, Bacon, Machiavelli, Tindal and Reimarus.[283]

Among the enlightened reforms introduced by Joseph II when he became sole ruler on Maria Theresa's death in 1780 was the liberalization of censorship. His decree of 1781 forbade irreligious works but permitted all those that might be conducive to enlightenment:

> Severity is enjoined towards all works containing indecent scenes and smutty jokes, from which no learning, no enlightenment can ever proceed, but indulgence is to be shown to all other works offering learning, know-ledge and sound principles, especially as the former are read only by the masses and by weak intellects, whereas the latter reach minds already prepared for them and souls firmer in their principles.[284]

In addition, Joseph invited serious criticism (as opposed to scurrilous misrepresentations) of himself and all other officials, provided it was signed, since every friend of truth should be grateful for such instruction. This measure prompted a 'flood of pamphlets' (*Broschürenflut*), ranging from amusing trivia such as *Über die Stubenmädchen in Wien* (*On the Parlour-Maids in Vienna*, 1781) to serious historical discussions, notably the critical study of the papacy *Was ist der Pabst?* (*What is the Pope?* 1782) by the Church historian Joseph Valentin Eybel.[285] A number of these pamphlets may well have been secretly commissioned by Joseph's govern-ment in order to win public support for his measures.[286] Joseph was not motivated by the principle of press freedom, but rather by the desire to promote enlightenment from above and to gain useful feedback about his policies. His much-criticized comparison between selling books and sell-ing cheese may suggest also that he regarded the book trade as a useful

branch of the economy and wanted to strengthen it by deregulation. After Joseph's death in 1790, however, his successor, Leopold II, returned to Maria Theresa's principles by forbidding any publication that might 'reduce obedience to the monarch' or encourage 'doubt in spiritual matters'.[287] Under Franz II, who came to the throne in 1792, strict pre-censorship of all manuscripts was introduced, and permission was required to sell in Austria any book that had been published abroad.

Despite the many restrictions, books and journals did permit discussion that promoted enlightenment. The freedom to engage in debate, to make 'public use of one's own reason', was recognized by Kant in 1784 as a basic human right and as indispensable for enlightenment.[288] This debate was to be carried on in the enlarged virtual public sphere of writing: Kant famously asserted that *freedom of the pen* is the only safeguard of the rights of the people'.[289] Voltaire resorted to the public sphere in his campaign to rehabilitate the unjustly executed Jean Calas, by publishing a pamphlet (ghostwritten by himself) in which the surviving members of the Calas family put their own case (see Chapter 3). When, in the mid-1760s, he intervened in the internal struggles of the republic of Geneva, he complained that the Genevan magistrates had forbidden public debate: 'Is there anything more tyrannical, for example, than to remove the freedom of the press? And how can a people say it is free, when it is not permitted to think in writing?'[290] But the freedom to publish could also be used for satire, denunciation, or official propaganda. In 1752 Voltaire wrote in support of a member of the Berlin Academy, Johann Samuel König, whom the president, Maupertuis, had found guilty of forging letters. When Frederick the Great himself took a hand in the controversy, Voltaire wrote: 'I do not have a sceptre; but I do have a pen.'[291] He used his pen, however, not only for public argument but also to ridicule Maupertuis in a satirical pamphlet entitled *History of Dr Akakia*, purporting to be a medical report on the mental derangement that allegedly made Maupertuis think himself greater than Leibniz.[292] Censors were justified in thinking that freedom to publish was a right that would be abused. In retrospect, it seems that in pre-censorship they found the wrong answer to a problem – that of regulating the media – which is still with us.

## UNSOCIABILITY: HUME VS ROUSSEAU

Sociability was essential for the Enlightenment. It was in conversation and debate, especially in focused meetings, that issues both contemporary and timeless were thrashed out. Inevitably, however, sociability came into

conflict with its opposite – the rejection of society as shallow, immoral and time-wasting; the exploration of the solitary self, its hidden depths, its mysteries, its creative potential; and also the dangers it carried of melancholy and even madness. The Enlightenment period can show some famous cases of gifted individuals who became insane, such as the poets Christopher Smart and William Cowper, and the biblical scholar Alexander Cruden, whose *Concordance* (1737) is still in use. Many more people were afflicted with the forms of depression known as '*Vapours, Spleen, Flatus, Nervous, Hysterical*, and *Hypochondriacal* Distempers'.[293] George Cheyne, the physician who gives this list, had himself suffered from a mixture of physical and psychological afflictions, 'a constant violent *Head-ach, Giddiness, Lowness, Anxiety* and *Terror*, so that I went about like a *Malefactor* condemn'd', from which he was freed by a strict diet and by immersion in mystical Christianity.[294] We know of several figures who functioned, sometimes with distinguished success, while fearing the onset of madness: Pitt the Elder, Edmund Burke, Samuel Johnson and James Boswell.[295] For such people, sociability was not only an Enlightenment imperative but also a relief from troubled introspection or sheer misery.

A similar case is Rousseau. Throughout his life he was subject to depression, and, from the 1760s, to paranoia.[296] His scandalous writings also incurred actual persecution: after publishing *Émile* in 1762, he had to flee from Paris to Switzerland to avoid arrest. Fear of real and imagined enemies made him seek isolation. Social life was anyway hampered by a bladder complaint that made him continually need to urinate.[297] The creative power of solitude and of the introspection it makes possible is evident especially from his late masterpiece, the *Rêveries du promeneur solitaire* (*Reveries of the Solitary Walker*, 1782). But so are the dangers. Resenting his isolation, he objected to the line in Diderot's *Le Fils naturel* (*The Natural Son*, 1757): *Il n'y a que le méchant qui soit seul*, 'Only the wicked man is alone.'[298] But Diderot was simply exaggerating a truism of the Enlightenment, expressed pungently by Johnson: 'the solitary mortal is certainly luxurious, probably superstitious, and possibly mad.'[299]

The conflict between sociability and solitude found expression in the notorious quarrel between Rousseau and Hume which fascinated *le tout Paris*, and some of London and Edinburgh, in 1766–7. The details reveal an extraordinary human drama and a clash not only of two temperaments but also of two ways of being.[300]

In 1766 Rousseau was in severe difficulties. He was internationally famous as the author of *La Nouvelle Héloïse, Émile* and *The Social Contract*. But he had quarrelled with several of his former friends among the Paris *philosophes*, especially Diderot and Grimm. By attacking the theatre

as immoral, he had antagonized France's leading dramatist, Voltaire, who in an anonymous pamphlet had revealed the most shocking actions of Rousseau's life: his abandonment of his newborn children (four or five, the number is uncertain), against their mother's protests, to the Foundling Hospital in Paris, where children were unlikely to survive. His books had been burned in Paris and Geneva. He had taken refuge in the remote Swiss village of Môtiers in the province of Neuchâtel (which, thanks to the oddities of eighteenth-century territorial arrangements, actually belonged to Prussia), but had been expelled by villagers who attacked his house with stones. Where could he go next?

Hume, ending a stint as chargé d'affaires at the British Embassy in Paris, promised to find a refuge for Rousseau in England. Initially he not only liked Rousseau, finding him 'mild, and gentle and modest and good-humourd [sic]', he even compared him to Socrates.[301] Once in England, he had difficulty in finding accommodation for Rousseau and the latter's companion, Thérèse Le Vasseur, but eventually Richard Davenport, whom Hume knew through the actor David Garrick, invited Rousseau to stay at his unoccupied mansion, Wootton Hall, at the foot of the Weaver Hills (then in Derbyshire, now in Staffordshire), where Rousseau and Thérèse lived from March 1766 until April 1767.

Rousseau's emotionality was more than Hume could easily handle. When they arrived at Dover, and again before leaving for Wootton, Rousseau embraced Hume and kissed him amid tears. On another occasion, when they were sitting by the fireside, Rousseau was disconcerted by Hume's staring fixedly at him – a bad habit that Hume's friend d'Alembert had warned him against[302] – in a way he thought 'sneering' (moqueur), and then, seized by remorse, embraced Hume so fervently that Hume could only pat him soothingly on the back and exclaim 'Quoi donc, mon cher Monsieur?' ('What's the matter, my dear Sir?')[303]

Greater difficulties soon arose. Hume exerted himself to procure from the king an annual pension of £100; Rousseau at first objected to the pension's being secret (since it might look discreditable when it became known), so Hume went back to work and obtained the offer of a public pension, to which Rousseau replied so ambiguously that everyone assumed he was refusing it. When it turned out that Rousseau did expect to receive the pension, Davenport and Hume again obtained it for him, but understandably felt that Rousseau had messed them about.

Soon after arriving in England, Rousseau saw in the St James's Chronicle a spoof letter, supposedly written to him by Frederick the Great but in fact by the malicious diplomat Horace Walpole, ridiculing him for deliberately seeking persecution.[304] Knowing Walpole to be a friend of

Hume, Rousseau assumed that Hume shared responsibility for the letter; and though this seems unlikely, given Hume's initial admiration for Rousseau, his dismissal of such a hurtful publication as harmless 'raillery' sounds very lame.[305] Rousseau accused Hume of reading his letters; by Hume's account, he opened letters sent to Rousseau to save Rousseau the postage costs (which were paid by the recipient, not the sender) and to see which ones were important enough to send on to him. Hume was wholly unprepared for the letters Rousseau sent him in summer 1766. First came a short letter accusing Hume of luring him to England in order to dishonour him. Then, after Hume remonstrated, there came what Hume called an 'enormous letter', over seven thousand words of small, neat handwriting covering thirty-eight pages, the result of repeated drafts. Here Rousseau charged Hume with conducting a monstrous conspiracy against him; there was no evidence, because of course Hume knew how to cover his tracks, but 'The innate conviction of the heart admits of another kind of proof, which influences the sentiments of honest men.'[306] Vague on detail, but strong on emotional blackmail, the letter leads up to Hume's fatal blow against Rousseau, which consisted in obtaining a pension for him.

Small wonder that Hume was staggered by this ungrateful, self-righteous, paranoid letter. He concluded that he was dealing with a madman. Rousseau was 'such a Composition of Wickedness and Frenzy, that one does not know whether they are to be angry at him for the one or to pity him for the other', he wrote to Davenport, his grammar no doubt weakened by emotion.[307] His judgement also suffered a lapse; it is not unfair to say that he 'acted with the ferocity and frenzy of which he had accused his accuser'.[308] Knowing how gravely his action would damage Rousseau, he resolved to publish his and Rousseau's correspondence in case Rousseau, who was known to be writing an autobiography, should libel him after his death. Adam Smith, d'Alembert and other friends in both Britain and France urged him not to provide a feast for the gossip-hungry public, but Hume went ahead and published a pamphlet, first in French in Paris in October 1766, and then in translation in London a month later. Meanwhile Rousseau, brooding in the Derbyshire wilds, surrounded by country people whose language he did not understand, became convinced that his life was in danger. In April 1767 he fled to Spalding in Lincolnshire, perhaps because a Swiss acquaintance lived nearby. From there he wrote unsuccessfully to the lord chancellor requesting a bodyguard to escort him safe to Dover. He rushed to Dover, without a bodyguard, in two days, and left England on 21 May 1767.

What was at stake here? Partly, it was a clash between the man of reason and the man of feeling, between the sociable and the unsociable

person.[309] The mind, Hume says in the *Treatise of Human Nature*, is 'insufficient, of itself, to its own entertainment . . . Hence company is naturally so rejoicing, as presenting the liveliest of all objects, viz. a rational and thinking being like ourselves.'[310] In Paris, Hume's good nature made *le bon David* the darling of the salons, despite his thickly accented French. Rousseau, however, hated, not society itself, but the constraints it imposed: 'I have to speak when I have nothing to say, stay in one place when I want to walk about, stay seated when I want to stand, cooped up in a room when I long for fresh air . . .'[311] He uses the character of Saint-Preux, his surrogate in *La Nouvelle Heloïse*, to bemoan the shallowness and insincerity of social life in Paris, where even the best conversation serves only to undermine truth and virtue.[312] He was prepared to be the 'strange uncouth monster' that Hume occasionally dreaded becoming.[313]

Instead of accepting social life as an ongoing and often entertaining drama, Rousseau denounced it as a scene of pretence and role-playing. He saw the progress of civilization as corruption, while Hume interpreted it as increasing refinement.[314] Rousseau cultivated sincerity, the truthful expression of the self without adjustment to other people, and his ideal relationship was an intense friendship between two men, such as he felt he had enjoyed with Diderot. He wanted to pour his heart out in an ecstasy of confidence (though it is not clear that he wanted to listen to someone else's outpourings).[315] Being also exceptionally thin-skinned, he felt intensely the discomfort that people usually have in accepting favours, and Hume and Davenport were not as skilful as they might have been in avoiding the appearance of condescension. As Marivaux's heroine Marianne says: 'The benefits people confer are accompanied by a clumsiness that is so humiliating for those who receive them!'[316] In any case, Rousseau considered gratitude incompatible with friendship: 'I have always felt that gratitude and friendship cannot co-exist in my heart.'[317] Altogether, Rousseau made demands on the world and on other people which could not be met; and he lacked the humour, the self-irony and the capacity for compromise that make it possible to survive the disappointments that social life inevitably involves.

But the contrast between Hume and Rousseau must be qualified when we consider that Hume became attached to Rousseau with remarkable speed and intensity. Less than a fortnight after first meeting Rousseau, 'Hume shared [in a letter to Hugh Blair] an enthusiastic description of Rousseau, the wide-eyed wonder of which is unparalleled for the skeptical Scot'.[318] 'I love him much, and hope that I have some share in his affections', he wrote three weeks later.[319] This somewhat extravagant devotion would later swing round into still more extravagant denunciations of

Rousseau as 'the blackest and most atrocious Villain, beyond comparison, that now exists in the World'.[320]

What was it about Rousseau, besides the emotional neediness and the angry ingratitude, that so got under Hume's skin? His initial fascination was connected with Rousseau's resemblance to Socrates. He told Blair that Rousseau acted 'from the Impulse of Genius' and believed himself to receive divine inspiration: 'He falls sometimes into Ecstacies which retain him in the same Posture for Hours together. Does not this Example solve the Difficulty of Socrates's Genius and of his Ecstacies?'[321] Rousseau's eccentricity made him a modern version of Socrates, a philosopher whose oddities could be excused by the innate genius which he attributed to communion with a divine being. Like the Christian visionaries who went into convulsions at Saint-Médard in Paris, Rousseau belonged to a different mental world; but in sharp contrast to the convulsionaries, Rousseau was intellectually respectable, indeed a thinker of genius.[322] Hence perhaps his initial effect on Hume: he was an eccentric, exotic visionary whom one could actually admire. Hume's disillusionment was all the more bitter.

The clash between the two philosophers tells us at least as much about Hume as about Rousseau. For Rousseau's extraordinary mental states corresponded, partially at least, to something Hume was aware of in himself. We remember that, recounting his youthful psychological crisis to a doctor, he compared his condition to the 'Coldness & Desertion of Spirits' reported by mystics. He escaped from it into 'Business & Diversion'.[323] In his solitary philosophical speculations, however, Hume sometimes peeped over the edge into abysses of meaninglessness and solipsism: 'I fancy myself some strange uncouth monster, who not being able to mingle and unite in society, has been expell'd all human commerce, and left utterly abandon'd and disconsolate.'[324] He was saved by his natural sociability. Rousseau, however, seemed not to need sociability, but to find solitude conducive to his 'genius'. Part of Hume admired and even envied Rousseau's ability to survive in such a desolate realm. The *Treatise*, especially Book I, can be read as a defence against the fatal attraction of solitude, showing that no matter where our lonely speculations may lead us, nature can always preserve our sanity by restoring us to the common life which we share with others.[325]

# 8

# Practical Enlightenment

When Jonathan Swift's Gulliver boasts to the king of Brobdingnag that the 'acute wits' of Europe have written several thousand books on the art of government, the king is not impressed. He gives it as his opinion 'that whoever could make two Ears of Corn, or two Blades of Grass, to grow upon a Spot of Ground where only one grew before; would deserve better of Mankind, and do more essential Service to his Country, than the whole Race of Politicians put together.'[1]

Was the king of Brobdingnag an Enlightener? He would not have earned a mention in any study of the Enlightenment, such as the classic work by Ernst Cassirer, that considered it primarily as a philosophical movement. But he might have found a place in a study that related philosophical thought, as Franco Venturi recommended in 1971, to 'the concrete determination to modify this or that aspect of the societies inherited from the past, to bring about practical change'.[2] This chapter, inspired by Venturi, is about the many, often obscure Enlighteners who tried to promote public happiness by reforming the way people lived and by introducing innovations in areas as diverse as industry, agriculture, education, health care and criminal law.

## POLICE

Reformers on the Continent were guided by the concept of *police* or *Polizei*. This did not refer, except incidentally, to 'police' in the English sense – the agencies responsible for catching criminals and enforcing the law. It had a far wider meaning. The verbs *policer* and *civiliser* were often treated as equivalent.[3] *Police* was, so to speak, the external infrastructure of civilization. It implied not only orderly behaviour and the maintenance of law and order, but also good communications and public hygiene. Hence Gibbon says of the ancient Roman magistrates: 'Their

vigilance ensured the three principal objects of a regular police – safety, plenty, and cleanliness.'⁴ Voltaire recalls that under Richelieu 'the *police* of the kingdom was entirely neglected, a certain proof of an unfortunate administration . . . The highways were neither repaired nor guarded; they were infested by brigands; the streets of Paris, narrow, badly paved, and covered with disgusting filth, were filled with robbers.'⁵ In German-speaking countries, 'police ordinances' (*Polizeiordnungen*) were issued to enforce *gute Polizei*; actions contrary to good order, if not legally punishable, were *polizeiwidrig*, 'contrary to *Polizei*', and the goal was a well-ordered *Polizeistaat* – a 'police state', but emphatically not in the brutal sense that became only too familiar in the twentieth century.⁶

The agents of *police* were civil servants. In France, from about 1680 on, *police* was the particular responsibility of the *intendants*. These were administrators, drawn from the *noblesse de robe* or ennobled bureaucracy that had been created in the seventeenth century. Each of the thirty-five or so *généralités* – provinces larger than most English counties – into which France was divided was administered by an *intendant*. His official title was *intendant de justice, de la police et des finances*. His duties were to oversee the administration of justice, to collect taxes, to encourage industry and commerce, to introduce improved agricultural methods, and to look after 'sanitation and public order, morality and poor relief, the recruiting and billeting of soldiers, military equipment, rations and transport, religious processions and the repair of churches, colleges and libraries, parochial and municipal finance'.⁷ He was expected to do all this with a tiny secretarial staff and with assistance from a small number of subdelegates (*subdélégués*), who represented him in each district, and from parish priests – the latter a resource of very varying usefulness. With such a demanding remit, such scanty assistance, and much obstinate resistance from the population, it was a wonder that the *intendants* accomplished anything at all.

Nevertheless, some did. Many *intendants* were devoted to enlightened and progressive aims.⁸ The outstanding figure among these was Anne-Robert-Jacques Turgot, who from 1761 to 1774 was *intendant* of Limoges, a particularly poor province in south-western France with a population of around 580,000, of whom 85 per cent were peasants. Turgot had extraordinary vision and energy. Although he had only thirteen subdelegates to help him, he managed to introduce major reforms. He improved the system of having roads built by forced labour (the *corvée*), which was oppressive and impractical because it took peasants away from their fields, by financing it through taxation and enabling the road-workers to be paid. He introduced a fairer system for recruiting soldiers. He improved

agriculture by encouraging the breeding of Merino sheep and the planting of potatoes (though the peasants used potatoes only as animal fodder until they were forced by famine to eat potatoes themselves). What defeated him was the tax system. Instead of a flat rate of tax, he wanted taxation to be based on each individual's ability to pay. This, however, required the compilation of a comprehensive *cadastre* or property register, and he lacked the resources for the task.[9]

In German-speaking countries administration was much further advanced. It was expected that the economy, social welfare, education and much else should be directed by the state. The many principalities required many civil servants to run them. These were normally university graduates, and in the eighteenth century they were often 'cameralists' who had studied administrative economics or *Cameralwissenschaft*, so named after the 'chamber' which was initially the apartment of the prince, later the place from which his domains were administered.[10] This subject, also called *Polizeiwissenchaft* or 'police science', was understood to contain 'the theory of the happiness of entire states or civil societies'.[11] University chairs in it were established, first at Halle and Frankfurt an der Oder, by King Frederick William I of Prussia. Thus equipped, administrators consciously undertook to increase the happiness of the people.

For this purpose, it was necessary first to collect data about the population, geography, natural resources and industry of a country. Even to know the size of the population was very difficult. Until the introduction of censuses, the best one could do was to extrapolate from the births and deaths recorded in parish registers, or from figures assembled for taxation purposes. There was a widespread belief that the population was declining, and no reliable way of proving otherwise. Montesquieu claimed in the *Persian Letters* that the world's present population was only a tenth of what it had been in ancient times, and that the current rate of decline would make humanity extinct in another thousand years.[12] Few censuses were even attempted. The first was held in Iceland in 1703 by the Danish government, because the country's extreme impoverishment made it necessary to calculate the need for economic assistance.[13] When censuses were undertaken, the result might be treated as a state secret. Thus the results of the Austrian census of 1754 lay hidden in the archives until the twentieth century. In Britain, a bill proposing an annual census was presented to Parliament in 1753 but met with fierce opposition, partly as an attack on English liberty, partly because in the Old Testament David was punished for conducting a census at the prompting of Satan (1 Chr. 21:1). The bill reached the House of Lords but lapsed on procedural grounds, and nobody was interested enough to revive it.[14] Only in 1801 was a national

census held, under the pressures of worries about depopulation and the need to determine Britain's human resources at a time of war.

Administrators had to collect information as best they could. In Fénelon's novel *Télémaque*, a manual for princes cast in fictional form, the wise Mentor, charged with reforming the kingdom of Salente (based on Louis XIV's France), first obtains information about its population, resources, commerce and industry.[15] Such information was called 'statistics', that is, data useful to the state. This is the sense of the adjective in the *Statistical Account of Scotland*, compiled by Sir John Sinclair in the 1790s. Statistical bureaux were set up in various countries: Sweden, worried about depopulation resulting from the Great Northern War of 1700–1721, was far in the lead, establishing its *Tabellverket* in 1748; Prussia followed suit only in 1805. *Statistik* became another academic subject, closely integrated with history, geography and economics, and flourishing especially at Göttingen, which in the late eighteenth century had the most innovative university in Europe.[16]

It was of limited use, however, just to collect vast quantities of discrete facts. Such data had to be interpreted and aggregated to provide statistics in our sense, that is, quantitative information which makes it possible to observe long-term trends and to plan for the future. The initiative came from England, where the London merchant John Graunt had in 1662 published data drawn from the bills of mortality. Graunt presented, partly in tabular form, information about different death rates between men and women, in different parishes, at different times, and from various causes. He was thus able, for example, to provide a plausible estimate of the national population (6 million) and to conclude that it was increasing.[17] His ground-breaking work gained him membership of the Royal Society. It was developed by Sir William Petty in the posthumously published *Political Arithmetic* (1691). Challenging conventional gloom about England's supposed economic decline, Petty undertook to show, on a factual and whenever possible quantitative basis, that the country was at least as well off as Holland and more so than France. He reached the upbeat conclusion 'that it is not impossible, nay a very feasible matter, for the King of England's subjects to gain the universal trade of the whole Commercial World'.[18] Diderot, who summarized Petty's book in his *Encyclopédie* article 'Arithmétique politique', remarked that, since Petty had dedicated his book to the king of England, it was hardly surprising that his calculations should reach such a hopeful result.[19] Petty's example suggests, as has since become familiar, that statistics do not always speak for themselves but can sometimes be induced to say what we want them to say.[20]

Armed with statistical information, though still qualitative rather than

quantitative, the enlightened administrators of the German states set themselves to increase population and productivity and to promote their key idea of public happiness (*Glückseligkeit*). They had the help of alarmingly comprehensive handbooks, such as the *Grundsätze der Policeiwissenschaft* (*Principles of Police Science*) by the leading cameralist Johann Heinrich Gottlob von Justi. In the preface to the second edition, Justi defines his subject as 'the science whose object is the constant maintenance of an exact correspondence and relation between the welfare of individual families and the common good'.[21] The book consists of two bulky volumes with 1,433 pages in total, all of which Justi claims to have proof-read himself. It deals in turn with the physical setting (managing water-courses, draining swamps, forestry and agriculture), population, infrastructure (roads, wells, urban hygiene), manufactures and trade, the orderly practice of religion, printing and censorship, family life, the domestic virtues, crime prevention, fire-fighting, provision for beggars and the poor, law and justice.

Administrators were convinced that states would be best governed if *police* managed almost every aspect of people's lives. 'A people without *police*', says Johann Michael von Loen in 1742, 'is like a well-fed horse that has not been broken in.'[22] To increase the labour force, they opposed the practice of excluding from craft guilds the children of those who practised despised trades, such as grave-diggers and horse-knackers, as well as orphans. To avoid waste, they brought in rules limiting the consumption of food and drink at christenings, betrothals, weddings and funerals. In Catholic territories, enlightened clergy colluded with administrators in cutting down the number of feast-days and encouraging orderly behaviour. Muratori, whose influence extended far beyond Italy into Catholic Germany and Austria, complains about the excessive number of feast-days – twelve in December 1742, closely followed by the Feast of the Circumcision and by Epiphany – which keep people from their work and reduce their income.[23] Traditional festivals were sometimes prohibited on supposedly rational grounds such as danger to health and safety: thus an ordinance issued at Wolfenbüttel in 1745 warned against the dangers arising from horse-races at Pentecost.[24]

Order was strengthened by harsh measures against vagrants. Beggars were expelled across the nearest frontier, but as the next-door state expelled them in turn, they moved in a great circle and ended up back where they started. Justi, who calls beggars 'evil ulcers on the body politic', therefore recommends putting them in workhouses where they may earn not only their own living but a surplus for the state.[25] The French economist Jean-François Melon desired 'the destruction of beggars'.[26] He

thought that 'Idleness' (*l'oisiveté*) should be a capital crime, 'as being the Root of all other Crimes'.[27] Itinerant Jewish pedlars were allowed into German territories only if they obeyed strict passport requirements. Gypsies were regarded with especial disfavour: sometimes they were declared outlaws (*vogelfrei*), so that anyone could kill them, as in a Wolfenbüttel ordinance of 1718.[28]

Instead of expelling vagrants, a concerted attempt was made in France to confine them in closed institutions. Michel Foucault famously, though with some exaggeration, recounts how the French state in 1656 set up the first Hôpital Général to get beggars, paupers and lunatics off the streets, and how a royal edict of 1676 ordered that such an institution should be established in every city in France.[29] By around 1700 over a hundred *hôpitaux généraux* had been established throughout the country; by 1789 there were 176 of them, with about 60,000 inmates.[30] Attempts were made to set the inmates to work, less for economic reasons, it would seem, than from a belief in the punitive or purifying value of hard labour for its own sake. Thus, at Bicêtre in Paris teams of prisoners were set to draw up water from wells, a task normally – and probably more efficiently – performed by horses.[31]

All these bureaucratic regulations, even the milder ones, now make uneasy reading, while the harsher ones tend to bring to mind the twentieth-century associations of 'police state'. Their comprehensiveness has made one historian speak of the administrators' 'rage for regulation' (*Regelwut*).[32] They seem to support Foucault's well-known contention that enlightened institutions were really instruments of discipline and control and the, somewhat older, argument that the early modern state was engaged in 'social discipline'.[33] But if we see all *police* as authoritarian interference with people's freedom, without distinguishing its more punitive from its more philanthropic aspects, we risk being unduly influenced by a liberal individualism which was not yet present in eighteenth-century Europe. The inhabitants of a state were what would now be called its human resources, and had to be tended accordingly: 'If a prince wishes to keep his forests in good condition, he must watch over them attentively and have good care taken of the saplings. It is just the same with the plantation of human beings: it requires protection, attention and care, if it is to thrive and prosper.'[34]

In any case, it is likely that these regulations express aspiration more than achievement. As they were frequently reissued, it was probably difficult to enforce them. Bureaucrats, rather than simply imposing their will, had to negotiate and sometimes compromise: Joseph II's high-handedness was probably exceptional.[35] In practice, moreover, bureaucrats were sometimes incompetent and even corrupt. Justi, whom Frederick the Great placed in

charge of Prussian iron and steel manufacture, ended up in prison charged with grave mismanagement, and was possibly also guilty of fraud.[36]

Claims about social control risk being anachronistic. In implying a kind of bureaucratic conspiracy, they take too little account of the intentions and feelings of the people involved. We can get somewhat closer to eighteenth-century reality by noting that university-educated administrators were at a considerable distance from the people for whose well-being they were concerned. This illustrates the well-established view among historians that the eighteenth century saw an increasing withdrawal of the upper classes from the mass of the populace, something evident also in the growing gulf between high and popular culture.[37] It was thus easy for officials to succumb to a temptation that the use of statistics made more compelling: to regard the administered as an impersonal aggregation of homogeneous units, and to forget about their lived reality.[38] Part of their lived reality consisted in the traditional customs to which they were emotionally attached. Officials tended to discount people's affective relationship to long-established customs, to festivals, to religious ceremonies, to the shape of the Church year.[39] They could easily think – as Joseph II did – that people were merely being perverse in wanting to retain practices, such as burying their dead in expensive coffins, that ran counter to economic rationality. Enlightened administration undoubtedly brought many real benefits, but it also had its shadow side.

We should not envisage *police* simply as an opposition between administrators and the administered. Practical enlightenment was pursued at a local level by many clergymen who were in close contact with their parishioners. One should, for example, give credit to the parish ministers who collected information on their localities for Sinclair's ambitious *Statistical Account of Scotland*. But two figures, locally famous in their time, deserve particular attention: Jean-Frédéric Oberlin in Alsace and Anders Chydenius in Finland (at that time united with Sweden).

Having studied at Strasbourg, Jean-Frédéric or Johann Friedrich Oberlin – he considered himself both French and German – took up an appointment in 1767 as Lutheran pastor in Waldersbach, a parish in the Vosges mountains some twenty miles west of Strasbourg. He ministered there, loyally assisted by his wife, Madeleine-Salomé, until her death in 1783, for fifty-nine years. He found his parishioners poor and ignorant. He saw it as his duty to care not only for their souls but for their material well-being as the precondition for their spiritual improvement. Oberlin encouraged the development of weaving as a cottage industry. He introduced new farming techniques such as enrichment of soil and grafting of fruit trees. He planted orchards on previously unproductive land. He

bought new agricultural implements himself and sold them to his parish-
ioners at or below cost price. One of his first actions was to lead his
parishioners in building roads to bring the parish's five villages within
easy reach of one another and of Strasbourg, and he set an example by
wielding a spade himself; the road to Strasbourg was complete by the
beginning of 1770. He encouraged people to drain marshes, fix the course
of streams, and to plant flax, clover and potatoes. He founded a small
society for the improvement of agriculture. He sent talented young men
to Strasbourg to learn such trades as masonry, carpentry and blacksmith-
ing, and apply them for the benefit of Waldersbach. He was also devoted
to the teaching of young children and set up a system of elementary
schools, the methods being inspired by Rousseau. The children were not
only taught to read and write but also encouraged to collect flowers, to
draw, to go for healthy walks in the open air, and to learn standard French,
in contrast to the local dialect which was unintelligible further afield.
Whenever possible they were taught by means of games, so that learning
was also fun. Teaching was centred on the needs and capacities of the
child. In short, he performed the task of an enlightened monarch in his
small domain, but by persuasion instead of coercion.[40]

Oberlin welcomed the French Revolution, though it deprived him of
his income. He made a profession of republican faith. Nevertheless, he
was forbidden to practise his ministry, and was even imprisoned for sev-
eral days in July 1794 at the height of the Terror. When forced to close his
church, he founded a club and delivered sermons there under the guise of
oratory, and he continued to celebrate Holy Communion clandestinely.

Some 1,200 miles away, Anders Chydenius was ministering to his parish
of Kokkala, on the eastern shore of the Gulf of Bothnia, in an equally
practical spirit. His principle in interpreting the Bible, as he tells us in his
autobiography, was to avoid theological subtleties and to ask: *Quis est usus
huius loci practicus?* ('What is the practical use of this passage?')[41] He
wrote about more efficient methods of cultivation, new cereals, importing
breeds, and improved farm implements. There being no physician in the
area, he studied medicine and became a successful amateur eye surgeon.
He encouraged inoculation. Eventually he got drawn into public affairs,
representing his region at the national Diet (*Riksdag*) in 1765–6. He lived
during the Swedish-Finnish Age of Liberty, which lasted from 1719/20 –
when the new constitution introduced a democratic system dominated by
two parties, the Hats (urban businessmen) and the Caps (rural farmers) –
until 1772, when a *coup d'état* installed the benevolent despotism of Gustav
III. Chydenius sympathized with the Caps but was unusual in his deter-
mined advocacy of free trade and religious toleration. The two causes were

linked. Although the Church opposed the admission of non-Lutherans, Chydenius pointed out that the presence of Jews in Denmark and of Catholics in Prussia had not undermined religion in these countries but had benefited industry and commerce.[42] He was effective in opposing censorship and in establishing the principle of public access to official documents (*offentlighetsprincipen*) that still obtains in Sweden.[43]

One of Chydenius' best-known and most distinctive works is his pamphlet *Thoughts concerning the Natural Rights of Masters and Servants* (1778), which argues for local reforms within an international framework of human rights. When he wrote it, servants in Sweden were obliged to accept annual contracts or else be criminalized as vagrants. Their wages were kept uniform by a national tariff, so that servants had no incentive to work well. Each year they were reassigned to employers by lot, so that even bad employers were sure of finding servants. Such insecure circumstances made it difficult for servants to marry and start families. Chydenius argued that these conditions amounted to slavery and violated the natural, God-given rights that all human beings shared. 'From such heavily oppressed souls', he asserted, 'one cannot expect any civic virtue (*politisk dygd*), when the rod must become almost the sole motive force for their diligence and loyalty, in the same way as the methods applied to the dumb animals.'[44] Here Chydenius is using the language of classical republicanism (whose resonances will be explored in Chapter 13). To become citizens, capable of civic or political virtue, servants had to be free economic agents, able to choose their employers and negotiate the cost of their labour. Such freedom would raise their moral standards, increase the population, and contribute to Sweden's prosperity. Unfortunately, Chydenius' campaign was unsuccessful. He did persuade Gustav III and the government to propose free contracts between masters and servants, but of the four estates represented in the Diet only the Peasants supported it, and it was voted down by the Clergy, the Burghers and the Nobility. Servants remained dependent on their masters, who until 1858 had the right to administer corporal punishment to them.[45]

Whatever doubts one may have about *police* on the Continent, nobody could complain about excessive state regulation in Britain. Initiatives were taken by societies of private citizens. By the 1740s, all large towns (and many smaller ones) had societies concerned with practical improvement. For example, the Honorable Society of Improvers, founded in Scotland around 1723, offered farmers premiums for bringing in new farming methods, lobbied for legislation to advance agriculture and the linen industry, and obtained state funding for a Board of Trustees for encouraging manufactures and fisheries.[46] Particularly distinguished was the Lunar

Society of Birmingham, which met roughly from 1765 to 1800 at a member's house on the Monday nearest the full moon (so that they could afterwards see their way home). The members were united by an enthusiasm for science (especially chemistry and electricity) and its practical applications. They included Matthew Boulton, whose Soho Manufactory in Birmingham produced hardware, silver plate, ormolu and toys, and made him one of the richest manufacturers in England; his business partner James Watt, who developed the steam-engine; Josiah Wedgwood, who established the famous pottery at Etruria near Stoke-on-Trent; Erasmus Darwin, a physician trained at Edinburgh and Cambridge, who published both scientific papers on electricity and didactic poems (e.g. *The Botanic Garden*, 1789–91) with informative notes; and Joseph Priestley, a Dissenting minister, later a sympathizer with the French Revolution, who in his chemical researches discovered not only oxygen but many other gases. No other society for practical improvement, it is safe to say, could show so much talent and originality, or made such an impact on the world.[47] In Germany, though there were many societies devoted to public causes, they had little scope for practical action because of the power of the state, and served primarily to raise the consciousness of their members through discussion.[48]

Projects that in other countries were instituted by the state were in Britain left to private enterprise. This included the building of roads, in which Britain was recognized as far ahead of the Continent. Early in the eighteenth century most roads were little better than cart tracks, many worse.[49] When Wedgwood sent his pots by road, a third of them were often smashed before reaching their destination.[50] In Scotland the roads were even worse, and transport services correspondingly less frequent. Until 1754 a single stagecoach left the Grassmarket in Edinburgh once a month, taking twelve to sixteen days to reach London.[51] It was easier to travel from Aberdeen or Edinburgh to London by sea than by land. Heavy goods sent from Stirling to Glasgow (some twenty miles on land) had to be shipped down the Forth and then right round Scotland, past Cape Wrath and down the west coast.[52] 'In 1720', Henry Grey Graham tells us,

> there were no chariots or chaises to be found north of the Tay; and when the first chaise was seen in 1725 in Inverness drawn by its six horses, the excitement created was immense. As it rumbled along the Highlanders rushed from their huts, and unbonneted with abject reverence before the coachman, whom they took for the principal personage on the equipage.[53]

It became clear that the task of maintaining roads, especially on long-distance routes, could no longer be left to parishes as hitherto. People

therefore set up trusts, with parliamentary approval, to build turnpike roads, which were supposed to be paid for by tolls. There were 25 turnpike Acts in the 1730s, 37 in the 1740s, and 170 in each of the two following decades.[54] Although some trusts got heavily into debt, and the new roads were not always maintained properly, they made travel faster and more comfortable, and enabled locally produced goods to reach a wider market. By 1750, turnpike roads linked London with York, Manchester, Bristol, Dover and other centres.[55] By 1754 it was possible to travel directly from London to Manchester, and by 1773 to Glasgow.

Canals were similarly set up by private enterprise, operating on a large scale. Wedgwood set up a coalition of Midlands landowners and industrialists, including the duke of Bridgewater, to form a joint-stock company and obtain parliamentary approval for the Trent and Mersey Canal, running from Liverpool to Derbyshire. The canal needed a starting capital of £150,000 and took nine years to complete. When opened in 1777, it ran for 94 miles (150 km). Canals carried raw materials to factories, fertilizer to farms, and coal from mines to merchants, and gave industrialists and farmers access to new markets.[56]

In France, infrastructure was the responsibility of the state. The Ponts et Chaussées (Bridges and Highways) service, set up in 1716, employed a corps of engineers and required peasants in every province to devote a fortnight each year to the *corvée*.[57] By the 1780s the Ponts et Chaussées had given France some 18,650 miles (30,000 km) of paved roads; 'between 1765 and the 1780s, the time taken to travel from Paris to Strasbourg, Marseille and Toulouse fell from 11, 12 and 15 days to 4, 8 and 7 days respectively – an astonishing social phenomenon in terms of market integration and the formation of national opinion'.[58] The fragmentation of Germany, on the other hand, made it impossible to establish a system of highways stretching across the country. Some princes, especially in south Germany, ordered the construction of metalled roads, which were first built in Hessen in 1720 and in Baden in 1733. Throughout north Germany, including Prussia, roads remained bad throughout the century. In winter they were deep in mud. When passable, they were deeply rutted; carriage wheels had to be adjustable to the differently sized ruts in different states. Travellers whose carriage did not fit the ruts had to abandon the road and drive over the fields. In 1750 it took Voltaire three weeks to travel from Paris to Berlin.[59] Waterways were all the more important for transporting goods, and the main rivers, such as the Rhine, Danube, Elbe and Main, were supplemented by canals, such as the Plauer Canal between the Elbe and the Oder, built under the direction of Frederick the Great.[60]

Although British private enterprise contrasted with state direction on

the Continent, it regulated people's lives as much as German officialdom did. Britain led the world in the development of manufacturing industry, which demanded strict discipline and timekeeping. The workers' time was the manufacturer's money. In farming or cottage industries, the timing of work had been determined by the task in hand and allowed scope for the rhythm of the body, which does not favour continual concentration from 9 to 5 or longer. The work routine was modified by the common custom of celebrating 'Saint Monday', i.e. taking Mondays off. Industrial production, however, required strict punctuality. The Law-Book of the Crowley Iron Works, composed around 1700, required the Warden of the Mill to keep a daily time-sheet for each employee.[61] At his Etruria pottery, Wedgwood appointed a 'Clerk of the Manufactory' to check when workers arrived and to note any waste or dirt. An early clocking-in system was introduced whereby men handed in tickets on arriving at work. The times of arrival and departure and the length of time spent on meals were recorded on the workers' wage-sheets. Lateness, or such misdeeds as bringing alcohol into the factory, were heavily fined. The division of labour was all-important: where previously potters had moved from one task to another, each of Wedgwood's employees was trained to a high degree of skill in one particular task. Wedgwood announced his intention to 'make such *machines* of the *Men* as cannot err'.[62] In Foucault's language, they became 'docile bodies'.[63]

The life Wedgwood gave his employees sounds dreary. But their submission to his discipline was rewarded with better living conditions; with houses which, though small, were far cleaner and more comfortable than insanitary rural cottages; and with access, for them and their children, to schools, hospitals and libraries. It was not necessarily a bad bargain.

## THE *ENCYCLOPÉDIE*

Encyclopaedias, or compendia of knowledge, were already compiled in the European Middle Ages (and much earlier in China).[64] But the compilation of an encyclopaedia in the Enlightenment faced several new problems. First and foremost, knowledge was exploding. New discoveries, especially in the sciences, created a mass of knowledge too great for any polymath or 'polyhistor' to master, and very hard to squeeze into a book of manageable length. Secondly, a new value was placed on 'useful knowledge', especially the 'mechanical arts' practised by craftsmen of all sorts. In 1675 Louis XIV's long-serving minister Jean-Baptiste Colbert conveyed to the Académie Royale des Sciences his master's instruction to prepare a

book describing 'all the machines in use in the practice of the arts, in France or abroad'; the resulting *Description des arts et des métiers* (*Description of Arts and Trades*) began publication only in the next century, from 1761 on.[65] As we have seen, many societies were founded in the eighteenth century specifically to disseminate useful knowledge. It was thought necessary to make such knowledge public, instead of confining it to secretive craft guilds and to the uncertainty of oral transmission. Consequently, and thirdly, encyclopaedias had to be widely accessible: not only written in the vernacular, but arranged in alphabetical order, an innovation that had gained ground only gradually in the seventeenth century.[66] Yet by providing fragments of factual information, one risked preventing readers from acquiring a coherent understanding of a subject.

Ephraim Chambers tried to overcome these problems in his *Cyclopaedia, or, An Universal Dictionary of the Arts and Sciences*, published by subscription in two folio volumes in 1728. He divided subjects into their component parts so that by reading the separate articles readers could combine them into an overview of the whole. Thus the entry 'Physics' consists of a brief definition followed by a long list of the articles dealing with sub-topics from 'Occasions or means; as Principle, Matter, Form, *&c.*' down to 'Systems or hypotheses hereof; Corpuscular, Epicurean, Aristotelian, Peripatetic, Cartesian, Newtonian, *&c.*', with 'Occult and fictitious qualities, powers, and operations', such as magic and witchcraft, added at the end of the list.[67]

The *Cyclopaedia* was not quite universal. In contrast to Bayle's *Dictionary*, it excluded history and biography. Chambers' overall scheme of knowledge indicates his distance from conventional Christianity (he is variously said to have been a Quaker or a freethinker).[68] Knowledge is classified as either 'Natural and Scientifical' or 'Artificial and Technical'. The former is subdivided into 'sensible' (knowledge of the physical world) and 'rational' (mathematics, ethics, theology, the last having a very inconspicuous place). The latter may be 'internal' (logic) or 'external', which in turn may be 'real' (i.e. concerned with things, *res*), including all practical and technical subjects, or 'symbolical', including heraldry and poetry.[69]

The success of Chambers' *Cyclopaedia* in Britain caught the attention of a French printer and bookseller, André-François Le Breton, who planned to bring out a translation. The new work was to be combined with a translation of John Harris's *Lexicon Technicum: or, an Universal English Dictionary of Arts and Sciences* (1704), which focused mainly on applied mathematical subjects such as navigation, architecture, gunnery and optics.[70] After various conflicts, the project came under the general editorship of Denis Diderot, who was already well known for his

# ENCYCLOPÉDIE,

## OU

## DICTIONNAIRE RAISONNÉ

# DES SCIENCES,

## DES ARTS ET DES MÉTIERS,

### PAR UNE SOCIÉTÉ DE GENS DE LETTRES.

Mis en ordre & publié par M. *DIDEROT*, de l'Académie Royale des Sciences & des Belles-Lettres de Pruffe ; & quant à la Partie Mathématique, par M. *D'ALEMBERT*, de l'Académie Royale des Sciences de Paris, de celle de Pruffe, & de la Société Royale de Londres.

*Tantùm feries junéturaque pollet,*
*Tantùm de medio fumptis accedit honoris !* HORAT.

### TOME PREMIER.

## A PARIS,

Chez
{
BRIASSON, *rue Saint Jacques, à la Science.*
DAVID l'aîné, *rue Saint Jacques, à la Plume d'or.*
LE BRETON, Imprimeur ordinaire du Roy, *rue de la Harpe.*
DURAND, *rue Saint Jacques, à Saint Landry, & au Griffon.*
}

### M. DCC. LI.

*AVEC APPROBATION ET PRIVILEGE DU ROY.*

The full title runs: 'Encyclopaedia, or descriptive dictionary of the sciences, arts and trades, by a society of men of letters. Arranged and published by M. Diderot, of the Prussian Royal Academy of Sciences and Letters; and as regards the mathematical part, by M. d'Alembert, of the Royal Academy of Sciences at Paris, that of Prussia, and of the Royal Society of London'. The editors thus advertise their international academic credentials. The motto comes from Horace's *Art of Poetry*: 'Such power has a just arrangement and connection of the parts; such grace may be added to common subjects.'

translations from English, including (as collaborator) a three-volume medical dictionary and (single-handed) Shaftesbury's *Inquiry concerning Virtue and Merit*. His chief assistant was the mathematician Jean Le Rond d'Alembert.

Diderot's *Encyclopédie* was no mere translation, but a new project, though it took over considerable material from Chambers. Its underlying plan, explained in d'Alembert's 'Preliminary Discourse' and presented visually in an elaborate folding chart, went back to Francis Bacon.[71] D'Alembert explains that the editors have borrowed the genealogical tree of knowledge from Bacon's *De dignitate et augmentis scientiarum* (*On the Dignity and Advancement of Learning*, 1624). Bacon's scheme has the advantage of showing not the subject-matter of knowledge, but the routes by which different areas of knowledge originate from the human mind. However, the editors adapt Bacon considerably. Their visual system of human knowledge has *entendement* ('understanding') at the top, an implicit tribute to Locke, and then three great divisions: memory, reason and imagination. Memory is the domain of history, which may be ecclesiastical, civil, or natural. Ecclesiastical history, prominent in Bacon, is represented here only by the word, whereas natural history is conspicuous and has many subdivisions, including all the mechanical trades that work in various natural products, from gold down to wool. Reason, much the largest area, begins logically with 'general metaphysics, or Ontology, or the Study of Being in general'. It is then divided into the study of God, the study of man and the study of nature. The 'study of God' is disrespectfully short, with three (by implication) equally important parts: natural theology, revealed theology, and the study of evil beings, which is divided into divination and black magic. With religion thus out of the way, a large area is covered by the study of man, and an even larger one by the study of nature, both of which are branches of philosophy. Thus 'theology is effectively dechristianized'.[72] At the very least, theology's claims to intellectual respectability are put in doubt. Revealed theology, moreover, is (in d'Alembert's text, though not in his scheme) reclassified as a form of philosophy because it applies reason to the facts revealed in the Bible ('revealed theology is nothing other than *reason applied to revealed facts*').[73] The third of the great divisions, imagination, is very small, but the amount of space that the arts receive in the discursive part of d'Alembert's introduction shows that this is not meant as disparagement.

Besides explaining the order of knowledge, d'Alembert's 'Discourse' sets out the intellectual ancestry of the *Encyclopédie* project. Its forebears are Bacon, Descartes, Newton and Locke.[74] Descartes is praised, despite such philosophical errors as believing in innate ideas, for his courage in

defying the authority of scholasticism and opening the road to modern philosophy: 'One can regard him as the chief conspirator who had the courage to be the first to rise up against a despotic and arbitrary power, and who, preparing a brilliant revolution, laid the foundations of a fairer and happier government, which he was unable to see established.'[75] The other three are all praised for their empiricism, their refusal to impose a system or merely speculative scheme on the facts of experience. Bacon was the 'Enemy of systems'; Newton, rejecting vague hypotheses, insisted that physics should be 'submitted solely to experience and geometry';[76] while Locke did for philosophy what Newton had done for physics, and, by attending to the operations of his own mind, 'he reduced metaphysics to what it must in effect be, the experimental physics of the soul'.[77] It is thanks to these, and many others, that philosophy has emerged from the contempt in which it was held only recently: 'Philosophy, which forms the dominant taste of our century, seems, by the progress it is making among us, to want to make up for lost time and take vengeance for the kind of contempt with which our fathers treated it.'[78] But there is plenty of catching up to do. D'Alembert maintained that Newton was little known in France, where people were still attached to scholasticism and had not even caught up with Descartes: although Newton was well received in England, 'nevertheless the rest of Europe was far from extending the same welcome to his works. Not only were they unknown in France, but scholastic philosophy was still dominant there when Newton had already overthrown Cartesian physics; and the vortices were destroyed before we dreamed of adopting them.'[79]

The *Encyclopédie* is a vast panorama of knowledge, with some 72,000 articles in seventeen volumes. It also has eleven volumes of beautifully engraved plates, some so large and detailed that they have to be unfolded, illustrating technical processes such as cannon-founding and the making of musical instruments, and skills such as astronomy and navigation, and keyed to detailed explanations. Only history and biography are excluded, and even so the indefatigable contributor Jaucourt provided, at a late stage, about a thousand biographical articles, arranged by the subject's birthplace (so that to find out about Newton's life and achievements, you have to look up 'Wolstrope', i.e. Woolsthorpe). In keeping with the Enlightenment emphasis on useful knowledge, much space is given to 'mechanical arts'. Diderot's article 'Art' deplores the lazy prejudice which ranks the liberal arts far above the mechanical arts, artists above artisans. It is said that Diderot assiduously visited workshops, had the machinery explained to him, tried it out himself, and had machines dismantled and reassembled for his instruction. This is at best an exaggeration; in fact, many of the

technical articles were provided by experts, such as the scientist Jean-Baptiste Le Roy, whose father had been clock-maker to the king, and who described clock-making in detail. The ironmaster Bouchu, an acquaintance from Diderot's home town of Langres (and an occasional visitor to d'Holbach's gatherings), wrote the article on 'Forges (Grosses)'. Diderot recruited his landlord, an ex-engineer, to provide an article on military bridges.[80] His contributors also included thirteen or so actual artisans.[81] However, Diderot himself at least watched a velvet loom and a stocking-frame in action, and his friend Deleyre went to workshops to see how a pin was made in eighteen separate stages; the resulting article ('Épingle') was later used by Adam Smith in *The Wealth of Nations*. It seems that Diderot also had small-scale models of several machines made and used to take them apart and put them together again. The Diderot scholar Jacques Proust says: 'The image of the philosopher playing with an ingenious model in his study, between two editing jobs, is, after all, just as picturesque, and more in keeping with his character.'[82]

Many of the *philosophes* contributed to the *Encyclopédie*: Voltaire, d'Holbach, d'Alembert (especially on mathematics), Rousseau (on music), the economist François Quesnay (later famous as the spokesman for physiocracy), and Turgot (not only on economics, but also on linguistics). Politics and religion were treated with some caution. Jaucourt's article on representative government is distinctly cool about the much-admired English model, which he thinks has no safeguards against politicians who want to line their pockets. The article on God was entrusted to the enlightened Protestant clergyman Samuel Formey, a prominent member of the Berlin Royal Academy, who spent a long time contesting Bayle's arguments that the existence of God could not be proved (and thus giving Bayle more publicity). In the article 'Grâce', Voltaire, having surveyed a range of theological opinions, concluded that theologians had written a great deal about grace and clarified little, and that their discussions were often too futile to deserve a place in any philosophical work. He used his article 'Idole, idolâtre, idolâtrie' to dispute the claim in the Jesuit *Dictionnaire de Trévoux* that all pagans were idolaters; he pointed out that pagans worshipped false gods, not the physical idols that were merely representations of those gods, and worked in some praise for ancient polytheism because it had not given rise to religious wars. Diderot was more skittish, though in inconspicuous places. Tucked away in his ostensibly geographical article on the Caucasus is the claim that Christians should be pleased if their children died, because the children were thus assured of eternal happiness. In his article on the philosophy of the 'Saracens or Arabs', he says that if the history of any nation tells you about a man charged with interpreting

the will of God, and with further powers – here follows a list of powers actually claimed by the papacy – then you must conclude that that man was living in an age of profound ignorance.

From the appearance of the first volume in 1751, the *Encyclopédie* aroused the suspicions of the authorities: 'the book was dangerous'.[83] In 1752 it was declared subversive by the Council of State, but publication was suspended only for a few months. It was religion that eventually got the *Encyclopédie* into serious trouble. In the article on Geneva in volume VII (published 1757), d'Alembert praised the city's clergy for their liberal beliefs. Many disbelieve in hell; a few disbelieve in the divinity of Christ: 'To sum it up in one word, several Genevan pastors have no religion other than a perfect Socinianism, rejecting everything that is called *mysteries*, and imagining that the first principle of a true religion is not to demand belief in anything that clashes with reason.'[84] As we saw in Chapter 3, Socinianism – the denial of Christ's divinity, and hence of the Trinity – was completely beyond the pale. A storm was unleashed. The Genevan clergy issued a protest. In January 1759 the *parlement* of Paris condemned the work and forbade it to be distributed, and in March the Council of State revoked its licence and forbade any further publication, though a later decree permitted it to survive on condition that the seven published volumes should be thoroughly revised by a learned committee.

In 1759, too, the seven published volumes of the *Encyclopédie* were twice examined at Rome, once by the Congregation of the Index and then by the Inquisition. The Congregation recommended only minor corrections. The twenty-seven-page report composed on behalf of the Inquisition, however, identified the *Encyclopédie* as a concerted attack on the Church and religion. The papacy therefore ordered that the *Encyclopédie* should be suppressed as a whole, wherever it was published and in whatever language.[85] This is probably the origin of the idea that the *philosophes* were conspiring against religion and the social order, an idea that would later seem to be confirmed by the outbreak of the French Revolution.[86]

Thanks to powerful protection, the *Encyclopédie* continued to be produced in Paris, though future volumes gave the place of publication as Neuchâtel. Rousseau, angry at the offence to his native city, and numerous other contributors left the enterprise. Voltaire and d'Alembert had already withdrawn. Diderot struggled on, in secret and in fear of arrest, abandoned by associates whose support he might reasonably have expected.[87]

As if this were not enough, Diderot discovered in 1764 that his publisher Le Breton had been quietly exercising censorship, mainly of articles on religious topics. Diderot's praise of Bayle was toned down. The statement

by Jaucourt (a Protestant by background) that in the Middle Ages there was no source of good sense and morality was changed to 'only one source'. An entire article, 'Théologie scholastique', in which Jaucourt made fun of the pointless riddles supposedly debated by scholastics, was omitted. Diderot came close to despair, and claimed, with considerable exaggeration, that the last ten volumes had been hopelessly mutilated.[88] He wrote in the preface to volume VIII (1765): 'Of all the persecutions suffered by those who have yielded to the seductive and dangerous ambition of inscribing their names in the list of benefactors of the human race, there is hardly any which has not been practised against us.'[89]

Despite all these tribulations, Diderot and his collaborators produced a great work that embodies some of the central ideals of the Enlightenment. Above all, it marks a shift in the conception of knowledge. It not only marginalizes theology, but turns decisively away from the often abstruse learning assembled in encyclopaedic works of the early modern era, and also from the humanism that acknowledged the supreme authority of the Greek and Latin classics towards knowledge that is useful and practical, with a focus on trades and manufacturing processes. Many trades were traditionally the preserve of artisans organized in craft guilds, guarding their technical knowledge from outsiders. The *Encyclopédie* made such knowledge generally available and thus contributed to the demise of the guild system (which in France was abolished early in the Revolution).[90] Being partly, in effect, a manual of trades and manufactures, accompanied by informative illustrations, the *Encyclopédie* 'responded to a need for a key, based on the new conception of science, to understanding the material world and its capacity for change'.[91]

It is not clear, however, that the *Encyclopédie* always reached the readers who could benefit most from it. Early editions were luxury items, which most people could consult only in libraries. Between 1777 and 1782, enterprising and sometimes unscrupulous publishers brought out cheaper quarto and octavo editions. According to Robert Darnton, only 40 per cent of the *Encyclopédies* extant before 1789 were the luxurious folio editions; at least 50 per cent were quartos.[92] The purchasers of the quarto edition can be traced from the surviving subscription lists. Not many of them are located in growing industrial centres such as Lille; far more are in old-established cities such as Besançon where academies and administrative offices were situated.[93] Even if it did not always reach its target readership, however, the *Encyclopédie* was both a profitable venture and a landmark in the diffusion and demystification of knowledge.

## AGRICULTURE

In the late eighteenth century most arable land throughout Europe (apart from some areas in northern France and the Low Countries) was still cultivated by the open-field system. The arable territory of each village was divided into two, three, or at most four large fields on which grain crops were rotated to avoid exhausting the soil; one field would always be left fallow in order to recover. Each unenclosed field was divided into separately owned plots, usually long strips to facilitate ploughing; a single peasant-holding might be divided into sixty or more non-adjacent strips. The villagers had to co-operate to ensure that they all carried out sowing, harvesting, gleaning and the pasturing of their cattle on stubble or fallow at the same time.[94] In England, by contrast, it had been common since the Middle Ages to enclose open fields by dividing them into blocks, each managed by an individual farmer. By 1700 only about a third of agricultural land, mainly in the East Midlands, was open-field. Enclosure gave farmers freedom to introduce more productive farming methods, but it was also a move from a communal to an individualistic system of agriculture. It meant overriding long-established customary rights, and called forth considerable protest over the centuries.[95] It worked against the community when uncultivated land, used for pasture, was appropriated by landowners, with the support of successive Acts of Parliament, and turned over to crop-growing. And it created a large class of landless farm labourers who had previously scraped a living by subsistence farming. This appears to be the insoluble dilemma of land distribution: if land is widely distributed, most people make a poor living and cannot afford to introduce more productive farming methods; the alternative, and the present-day norm, is to turn farms into large-scale business ventures that sell most of the food they produce to the urban population.

Despite the human costs, enclosure and the innovation it permitted made England the exemplar for enlightened agriculture. The German cameralist Justi wrote in 1761: 'England is the only country in Europe that can boast of having improved its agriculture and the cultivation of its soil beyond that of any other European nation. The condition of English agriculture, compared with that of our own, is like light contrasted with shade.'[96] Many English innovations were followed abroad. Jethro Tull emphasized the importance of frequent hoeing, not only to remove weeds but also to loosen and refresh the soil; his ideas were transmitted to France by the naval engineer Henri-Louis Duhamel du Monceau in his *Traité de la culture des terres* (1750), which in turn was read enthusiastically by the Neapolitan

economist Antonio Genovesi.[97] Charles Townshend became famous as 'Turnip' Townshend for his advocacy of planting turnips, which can be grown in winter, as fodder for cattle; but his major innovation was the four-course crop-rotation system that he pioneered on his Norfolk estate, superseding the two- or three-course rotation which had previously been in use. Under this system, a field was used in successive years for wheat, clover, oats or barley, and turnips. Thus, all crops were cultivated simultaneously; fields were enabled to regain their nutrient level; and no land was left fallow and unproductive.

New implements were also introduced. Instead of the sickle, it was found that the scythe enabled a labourer to harvest double the amount of crops, and by 1850 the scythe had displaced the sickle in England and in parts of north Germany (it is curious that the Communist symbol of the hammer and sickle, created in 1923, should glorify an implement that was already obsolete outside Russia).[98] The plough, whose design had been constant for a millennium, was altered when in the seventeenth century the Dutch borrowed from the Chinese the use of wheel-less ploughs made partly of iron, which could be adjusted for soils of different depth and pulled by only one or two oxen; in 1730 Joseph Foljambe of Rotherham patented the 'swing plough' made entirely of cast iron, which was lighter, easier to control, and could be manufactured commercially. All these changes contributed to the 'agricultural revolution' that hugely increased the productivity of farming, and thus made it possible to feed the growing population and support an industrial society in which an ever-diminishing proportion of people worked on the land.[99]

The superiority of English agriculture was personified in Arthur Young, whose books recounting his agricultural tours in England and Ireland, and later in France, were widely translated. An American agrarian, John Taylor, said in 1816: 'Arthur Young alone seems to me to occupy the station among agriculturists, which Bacon does among philosophers.'[100] Young's achievement consisted less in exemplary farming than in advocating the enclosure and cultivation of waste land, in disseminating new agricultural methods that he discovered on his tours, and in practical experiments. Some of these led nowhere, as when he examined the effects of electricity on plants, but he had more success with animal fodder, cultivating new types of grass, and trying out new ploughing implements.[101] At his Suffolk farm, Young received visitors from as far away as Hungary and Lithuania, and corresponded with George Washington about the latter's farm at Mount Vernon.[102] Prominent among his continental disciples was Albrecht Daniel Thaer, who experimented with new farming methods on his north German estate, undertook agricultural tours like Young's,

and published books explaining the principles of English agriculture; he gained a reputation as 'Germany's leading advocate of the principles of rational agriculture'.[103]

Among those impressed by English agriculture was Frederick the Great of Prussia. He decided that the best way to introduce it was to import English farmers.[104] An Englishman, Christopher Brown, had already distinguished himself by successfully introducing four-course rotation on the estates of the forward-looking nobleman Count Friedrich Paul von Kameke. Brown was granted a crown estate near Berlin, where he practised English methods, persuading Frederick by his example to set aside 100,000 thalers to help the less wealthy noblemen to introduce English agriculture. However, the disastrous harvest of 1772 got Brown into difficulties and into conflict with Prussian officials, who charged him with insubordination. Although he fled first to Saxony and then to Bohemia, he was fetched back by the Prussian police (in the modern sense of the word) and spent three years in the Berlin city jail. Released impoverished, he ended his days on Count Kameke's estate. There was evidently an insoluble clash of cultures: when in difficulty, the Berlin authorities insisted on imposing direction from above, and Brown persisted in opposing it.

Agricultural innovation was carried out by various bodies: sometimes, as in Germany, by governments; sometimes by individual landowners. Many societies existed to promote agriculture, among other aims, but it is questionable how effective they were. Admittedly, the Scottish Society of Improvers in the Knowledge of Agriculture, founded in Edinburgh in 1723, 'acknowledged the need to reach out and make contact with those who actually tilled the soil'.[105] Most, however, like the Economic Society of Bern, seem not to have included any actual farmers among their membership, but to have circulated information only among themselves. Arthur Young was scathing about the 'society of agriculture' he found at Limoges in 1787: 'This society does like other societies, – they meet, converse, offer premiums, and publish nonsense. This is not of much consequence, for the people, instead of reading their memoirs, are not able to read at all.'[106] How new agricultural knowledge did percolate to actual farmers is a difficult question. The relatively well-educated Robert Burns read books on farming, but, according to a near-contemporary, the typical farmer would 'entrench himself behind a breast-work of old maxims and rustic saws, which he interpreted as oracles delivered against *improvement*'.[107]

The 'agricultural revolution' was often also a social revolution. Reform required the abolition of serfdom, which, in various forms, was still widespread throughout the eighteenth century.[108] In France, there were about a million serfs, called *mainmortables*, who held their land from their lord

and could not sell any of it without obtaining the lord's permission and paying a fee. About 400,000 of them lived in the eastern province of Franche-Comté, which Louis XIV had acquired in 1678; other concentrations were in Burgundy and Savoy.[109] Even nominally free farmers had many unwelcome obligations, such as providing labour for the *corvée*. In Northern and Eastern Europe, servitude was much more onerous. Peasants were required to cultivate their lord's lands as well as their own. This compulsory labour (called *Fron* or *Robot*) not only doubled their work but took precedence over their own needs; thus the lord's harvest had to be brought in before the peasant's, even if the latter was thereby exposed to unsuitable weather. In Denmark, two-thirds of tenant farmers in the islands and between 55 and 60 per cent in Jutland were obliged to work for their lords on at least 200 days a year, and from 1733 onwards all male peasants were subject to *stavnsbåndet* (manorial bondage), which forbade them to leave their place of birth.[110] Often, especially in Russia, serfs were sold, or even exchanged for horses or dogs. In Russia, 'state peasants', living on government-owned land, enjoyed more personal freedom than serfs, but they could be transformed into serfs if the emperor chose to give them away to private individuals.[111] In a remote corner of Europe there were still actual slaves, with no more civil rights than animals: the Danubian principalities of Wallachia and Moldavia still, even in the mid-nineteenth century, contained some 200,000 Gypsies who were held as slaves, mostly by monasteries. Their counterparts in the Austrian province of Bukovina were freed when, in 1785, Joseph II deprived the monasteries of their land.[112]

Enlighteners pilloried such servitude. In his moral weekly *Der Mann ohne Vorurtheil* (*The Man without Prejudice*), the Austrian Joseph von Sonnenfels printed a dialogue with a farmer who describes how, when he returns from a hard day's work in his fields, the judge, supported by soldiers, compels him and his weary horses to do his duty on his lord's land, whatever the weather.[113] In his posthumously published autobiography (1813) the political journalist Johann Gottfried Seume tells how his father, though ill with a painful bladder complaint, was obliged to do extra labour which overtaxed his strength and led, in 1775, to his death at the age of thirty-seven.[114] It was also common for petty German rulers to sell their subjects, whether serfs or nominally free, as mercenary troops. In one of his socially critical pastoral poems (1775) the schoolteacher Johann Heinrich Voss accused north German landlords of selling serfs to the Prussian army.[115]

Empress Maria Theresa sought to regulate the relations between lords and peasants, and soften the latter's obligations, by a code, the *Urbarium*, issued in 1767, despite severe resistance from many landowners. Soon after

assuming sole rule, her son Joseph II gave the peasants significant new freedoms, and later decreed that peasants who held land by their masters' will should henceforth become its hereditary occupants.[116] By contrast, the normally energetic Prussians were slow to introduce reform: servitude was forbidden under the Legal Code (*Allgemeines Landrecht*) of 1794, but not formally abolished until the ascendancy of the Prussian Reform Movement in 1810.

Other reforms required population movement, sometimes on a large scale. Prussia, already enriched by Huguenot refugees expelled from Louis XIV's France, advertised for colonists to settle and cultivate newly reclaimed land, and attracted hundreds of thousands of families – some crowded out of overpopulated districts, some uncomfortable as Protestants in predominantly Catholic regions. During the reign of Frederick the Great, 300,000 immigrants entered Prussia and some 1,200 new rural settlements were established.[117] In Russia, Catherine the Great induced German farmers to move to the virgin soil of the lower Volga region and the southern Ukraine. In Spain, the enlightened administrators Campomanes and Olavide recruited immigrants, especially German Catholic farmers, to colonize the underpopulated districts of Andalusia; by the early 1770s there were forty-four villages and eleven towns inhabited by German and French immigrants.[118]

Some people refused to move. In the Scottish Highlands, after the suppression of the clan system in the wake of the 1745 rebellion, economic restructuring seemed to promise great prosperity. Growing cities further south demanded beef, fish, wool and timber, while kelp (seaweed) was a valuable resource since its ashes were used in glass manufacture and soap-boiling. Landlords increased the scale of cattle-breeding and built new villages where people could take up non-agricultural occupations; that is the origin of the pretty whitewashed towns, such as Ullapool, Beauly and Grantown-on-Spey, that now dot the Highlands. Fields were enclosed and the old strip-farming system (known as runrig) was given up. However, the introduction of sheep, which need a large area to graze in, forced many people off the land. Those who remained were attached to their land and did not want to become landless labourers as happened elsewhere. Farmers divided their property among their children, creating ever-tinier farms which were viable only by increased reliance on potatoes. The population grew rapidly beyond what the land could support. Eventually landlords, fearing bankruptcy, forced tenants off the land, often brutally, while tenants, retaining a residual emotional loyalty to their clan chiefs, felt betrayed when treated as mere economic units. Hence the tragedy of the Highland Clearances. If it had not happened, there would probably have been another

tragedy, involving famine and large-scale emigration as in 1840s Ireland. Either way, economic improvement exacted a heavy human cost.[119]

Enlightenment innovations speeded up the age-old process whereby humanity transforms the landscape.[120] Enclosure replaced large open fields with the familiar chessboard pattern of smaller square fields, surrounded by hedges, sometimes interspersed with trees, and with isolated farmhouses (whereas previously all farmers lived in villages and walked to and between their strips). This new landscape must at first have felt geometrical and dehumanized, and, until trees had grown up, it must also have felt raw and bleak. Meanwhile, large areas of heath were turned into arable land, and birds of prey were shot as pests. Elsewhere in Europe, landscapes were transformed more dramatically. The Oderbruch, a 35-mile (56-km) stretch of wetland along the west bank of the river Oder in Prussia that flooded to a depth of 10 or 12 feet twice a year, was drained and made arable under the command of Frederick the Great, who concluded: 'Here I have conquered a province in peace.'[121] Partly to give his territories firm boundaries that would not be blurred by floods, Frederick initiated many more drainage projects. He encouraged the scientific management of forests. And he issued rewards for the destruction of pests – not only bears, wolves and lynxes, but even sparrows, which damaged crops: between 11 and 12 million sparrows were killed in Brandenburg between 1734 and 1767.[122]

Enlighteners were aware of man-made climate change, though they did not always explain it convincingly. 'When we survey the face of the habitable globe, no small part of that fertility and beauty, which we ascribe to the hand of Nature, is the work of man,' says William Robertson, who then vividly evokes the unimproved landscapes of America when Europeans first discovered them.[123] Gibbon tells how ancient Germany was covered by the great Hercynian forest, which, by keeping off the rays of the sun, made Germany then as cold as Canada was in Gibbon's day (though the extremes of the North American winter are not due to forests, but to a continental climate). 'The climate of ancient Germany has been mollified, and the soil fertilised, by the labour of ten centuries from the time of Charlemagne.'[124] Hume, drawing partly on Dubos, cites a number of ancient writers who affirm that Gaul was bitterly cold, that the Tiber at Rome sometimes froze over, and that the Baltic Sea froze every winter. Like Gibbon, he attributes the change in climate to the felling of forests.[125]

Since deforestation resulted from human action, human action could reverse it. Thanks to this insight, the Enlightenment saw the beginnings of environmentalism.[126] A Newtonian model of the conservation of energy within systems could be applied to the natural world, e.g. to the relation

between plants and the atmosphere. The physician John Woodward explained to the Royal Society in 1697 that plants feed on the mineral substances contained in water and that water passes through them (by the process now called 'transpiration') into the atmosphere. It was for this reason, he argued, that forested countries were damper and had more rainfall. Stephen Hales confirmed in *Vegetable Staticks* (1727) that vegetation affected the quality of the atmosphere; his title, denoting a system of equilibrium, expresses his homage to Newton, 'the great Philosopher of our age'.[127] Although it had previously been thought that forests were unhealthy places and needed to be cut down, it became gradually apparent that they were essential for rainfall and ought to be conserved or restored. The Dutch at the Cape of Good Hope, the French on Mauritius, and the British on St Helena all worked to reforest their colonies.[128]

Improvement consisted also in the transfer between countries of useful plants and animals. The Romans had introduced vines into northern Europe; the American potato began in the eighteenth century to become the staple food of the poor. The Enlightenment accelerated this process of exchange. The Polynesian breadfruit tree was introduced into the West Indies. In keeping with the practical interests of the Enlightenment, former pleasure parks were transformed into botanical gardens where tropical plants could be propagated. In England, two royal estates were merged in 1772 to form the Royal Botanical Gardens at Kew, with Joseph Banks, who had travelled with Cook to Tahiti, as their virtual director. Kew was part of a network of such gardens, including those established (at Banks's urging) by the East India Company at Calcutta, permitting the exchange of botanical specimens around the world.[129]

These interventions in nature, however, created a tension between the view of the natural world as an equilibrium, and the capacity of human action to improve it, damage it, or repair the damage done. Linnaeus and his disciples had seen nature as a static order, in which the cycle of generation and destruction always returned to its starting-point. Although Linnaeus was aware of environmental destruction, as when he visited an area on the Dutch coast that had been overgrazed and now consisted of sand-dunes, he thought such damage would only be temporary.[130] But it was becoming conceivable that humanity could bring about lasting changes, which, it was hoped, would be lasting improvements. An American doctor, Hugh Williamson, proposed in 1760 that forests should be cleared in such a way that the warm air rising from the cleared area would meet the cold air flowing from nearby mountains and thus ensure temperate summers.[131] After all, since human ingenuity had improved the landscape, why should it not also improve the climate?

## MEDICINE

In 1768 Josiah Wedgwood had his leg amputated. As anaesthesia would not be invented until the 1840s, he was mildly sedated with laudanum (liquid opium). He sat upright in a chair, watching his leg being sawn off, without even a groan.[132] He probably knew that one amputation in seven killed the patient. Anyone nowadays who has had a life-saving operation in hospital, under anaesthetics, will be taken aback to find some medical historians rejecting as 'whiggish' any reading of medical history as a success story.[133] Yet modern medicine has, for example, eradicated smallpox, which in the past not only killed many people but often left survivors scarred for life, and it has vastly reduced the rate of infant mortality. Rousseau remarks chillingly in *Émile*: 'One half of the children who are born die before their eighth year', and adds that this is nature's means of eliminating the weak and ensuring that only the strong survive.[134]

However, the sceptical medical historians have a point. Granted, present-day medicine is unprecedentedly successful in eliminating illnesses and deferring death. But to tell the story of medicine teleologically, as an uninterrupted march of progress up to the present, may be seriously misleading. It can instead be argued that medical treatment was so transformed in the nineteenth century that, although (of course) it built on some knowledge acquired earlier, it became something quite different from pre-modern medicine. The decisive revolution in modern medicine has been persuasively dated to 1865, the year in which Louis Pasteur patented the process of destroying bacteria in milk and wine by pasteurization, and Joseph Lister, building on Pasteur's discovery that micro-organisms cause disease, first practised antiseptic surgery in Glasgow.[135]

The Enlightenment scarcely affected medical treatment; the lingering prestige of the mechanical philosophy impeded investigation, and the empiricism that was so powerful in other areas was not applied to medicine.[136] Philosophers had overthrown the authority of Aristotle, but doctors and patients alike still followed the ancient medical writers Hippocrates and Galen in believing that the interior of the body was primarily a collection of fluids, and that health depended on the correct balance between blood, phlegm, choler (yellow bile) and melancholy (black bile). The balance had to be maintained by eliminating excess fluids by emetics, purges and – the favourite method – blood-letting. In his medical casebook, Dr William Brownrigg (1712–1800) of Whitehaven attributed to his patients a 'sanguine temperament', a 'melancholy temperament', or a 'leucophlegmatic disposition'.[137] Doctors attended not to particular

diseases but to the patient as a whole. Thus Dr Johann Storch, a physician in Eisenach who kept a record of his female patients from 1721 to 1750, noted his patients' 'constitution' in a way that slides from physique via temperament to moral character: 'there are women endowed with a "durable nature" and others with a "delicate constitution"; many women have an "angry disposition", a "fiery disposition", or are "self-willed".'[138]

Means of empirical inquiry were available, though some were admittedly unsavoury. William Harvey in the seventeenth century established the circulation of the blood by repeatedly cutting open the bodies of live animals. But there could be no such objection to the use of the microscope. Antonie van Leeuwenhoek, by making microscopes with powerful lenses, had in 1674 discovered huge numbers of tiny creatures, previously unsuspected, which he called infusoria and which are now called micro-organisms. Such creatures, flying in the air, might, Leeuwenhoek speculated, be responsible for the transmission of infectious diseases. An exciting new perspective was opened. Leibniz wrote in the early 1670s: 'I value microscopy far more than telescopy; and if someone were to find a certain and tested cure of any disease whatsoever, he would in my judgement have accomplished something greater than if he had discovered the quadrature of the circle.'[139] Locke, however, maintained in his *Essay concerning Human Understanding* that microscopic research was a waste of time, because God had designed us to live in the world with our unaided senses.[140] Physicians agreed. This lack of curiosity may be attributable to the conservatism of the medical profession. But it may also be that the reigning intellectual paradigm was so powerful that new data were either misunderstood and assimilated into it, or simply rejected.[141] At any rate, the microscope was not exploited until the nineteenth century, when it was at last discovered that micro-organisms are responsible for putrefaction, and hence for much disease.

Instead, medical theorists devoted considerable energy to debates with no bearing on treatment, such as the controversy between mechanism and vitalism, touched on in Chapter 6. Some empirical discoveries were made: René Antoine Ferchault de Réaumur discovered gastric juice and its solvent effect on food, and Bordeu corrected errors about the functioning of the glands.[142] But more attention was paid to ideas that now seem simply weird, such as preformationism. This went back to Aristotle but seemed to be empirically confirmed by Leeuwenhoek's observation of spermatozoa. It was thought that a human being, both body and soul, developed from a tiny blueprint present in either the male sperm or the female egg. But where did this blueprint come from? It must be the product of an even smaller blueprint hidden inside it, and that blueprint in turn must come

from an even tinier blueprint, in a kind of Chinese-box system that went all the way back to Adam and/or Eve. For if the series had started any later, it could not have been created by God, who must be the creator of all life. This theory was popular throughout the eighteenth century but was finally laid to rest when Theodor Schwann formulated cell theory in 1839. The alternative theory was the Hippocratic notion of epigenesis, according to which vital fluids from both parents mixed in the womb and gradually solidified, in a process analogous to cheese-making. The adherence to these theories by supposedly enlightened scientists severely retarded the progress of medical knowledge.

Still, at least two advances in the treatment of disease are familiar, though both seem to have been rather haphazard. Early in the century it became known in Britain that the Turks practised inoculation.[143] A wide cut was made in the arm, a scab and some matter from a smallpox case were inserted and the wound was bound up; the patient would develop a mild case of smallpox with a high chance of recovery. This treatment was reported in the proceedings of the Royal Society in 1714. The report was read by the Boston pastor Cotton Mather, who had inoculations performed with success in the smallpox epidemic of 1721. In Britain, the initiative appears to have been taken by the royal physician Sir Hans Sloane. In August 1721 the treatment was tried out on six prisoners in Newgate Gaol, who all recovered. Inoculation was promoted by Lady Mary Wortley Montagu, herself scarred by smallpox, who had learned about it when in Constantinople with her husband, the ambassador there. Having had both her children inoculated – her five-year-old son in March 1718 and her three-year-old daughter in April 1721 – Montagu helped to persuade the princess of Wales to have two of her daughters inoculated in 1722. Thanks especially to the chapter on inoculation in Voltaire's *Letters concerning the English Nation*, Montagu is generally (though not unanimously) given credit for establishing the method in Britain.[144]

However, inoculation remained controversial. Early enthusiasts for it did not realize that inoculees could infect others. Some clerics objected that trying to prevent illness was an impious attempt to forestall God's purposes (though why then was it permissible for doctors to try to postpone a patient's death?). Doctors often felt that making someone ill, even in order to prevent a worse illness, was contrary to their Hippocratic oath.[145] They were also worried about being held responsible if an inoculee died. Philosophically, Kant briefly discussed inoculation in an essay on suicide, considering it debatable whether the inoculee was entitled to put his life at risk.[146] Still, inoculation caught on, especially after Louis XV's death from smallpox in 1774, but it was eventually superseded by

vaccination. Edward Jenner discovered in the 1790s that inoculation with cowpox gave immunity from smallpox with no risk of infecting others.

The other advance was in curing scurvy. Scurvy results from lack of vitamin C, or ascorbic acid. The gums swell, the teeth fall out, the victim suffers from fatigue and is subject to internal haemorrhages, which are often the immediate cause of death. It especially affected seamen: on long voyages it was common for half the sailors to die of scurvy. It also had a devastating effect on the British troops in Quebec during the Seven Years War: with no access to vegetables during the winter of 1759–60, over a thousand soldiers died, and the remainder, described by an eyewitness as 'starved, scorbutic skeletons', were defeated by a healthy French army.[147] Making his first voyage round the world, beginning in 1769, James Cook gave the crew sauerkraut, and took on fresh vegetables whenever he landed. None of the crew died of scurvy. On his next voyage he took an assortment of remedies, including lemon juice and an infusion of malt called 'wort', but he did not know which were effective and which were not (though he could easily have conducted a test). Back in England, doctors asserted – on no evidence – that it was the wort, not the lemon, that had prevented scurvy. Gilbert Blane, appointed physician to the West Indies Fleet in 1780, did carry out tests, which showed that lemon juice was effective; in 1795 he persuaded the navy to make it part of sailors' daily rations.[148]

Otherwise, Enlightenment physicians tried to improve the environment of disease, rather than treating diseases directly. Quarantine was already in use as a safeguard against the plague, which afflicted Europe intermittently from the Black Death in 1348 to the 1720s. How effective quarantine was is uncertain, since it was not always rigorously enforced and was sometimes criticized for harming trade.[149] People had no idea that the plague was carried by the fleas on black rats which easily jumped to humans (making it an epizootic, or animal disease, rather than an epidemic). Quarantine was, however, clearly effective in 1720 when the plague appeared in Marseilles but was prevented from spreading beyond the south-eastern extremity of France.[150] Plague was soon to vanish from Europe, apart from a recurrence in Moscow in 1771, but nobody is sure why.[151]

Enlightenment medicine can, however, claim credit for advances in surgery, though these consisted in the refinement and diffusion of already existing methods, rather than the invention of new ones.[152] For example, many people suffered agony from stones in the bladder. A means of extracting the stone by incising the perineum, and thus gaining access to the bladder, was devised in the sixteenth century, but was not widely known until it was learned by Georges Mareschal, who became surgeon to Louis XIV in 1706. Lithotomy by this method, known as the *grand*

*appareil*, became frequent and had a high success rate. Another common affliction was cataract. The Marseilles surgeon Jacques Daviel devised a new treatment, which involved cutting the cornea in order to extract the malfunctioning lens. This became the standard technique. It was practised in Germany, often with success but always with great anxiety, by Goethe's friend Johann Heinrich Jung (better known as Jung-Stilling), who had studied medicine in Strasbourg and who describes in his autobiography how he performed the treatment reluctantly and only when patients pleaded with him.[153]

The eighteenth century's great initiative was the building of hospitals. Previously, hospitals – called *hôtels dieu* in France – were more like alms-houses or poorhouses. Places in them could sometimes be bought, as in Edinburgh, or allocated to people on the basis of good connections rather than need.[154] However, nobody chose to enter the *hôpitaux généraux* founded in France from 1656 on, the sites of what Foucault called 'the great confinement'.[155] Their original purpose was not medical care but the control of vagrancy and deviancy by sequestering the sick, the mad and the destitute. During the eighteenth century, their function shifted towards caring for the sick. They were often dreaded, however, as places where diseases were more likely to be shared and exacerbated than cured, and you were unlikely to emerge alive. The notoriously filthy Hôtel Dieu in Paris was described in the *Encyclopédie* as 'the most extensive, the most populous, the richest, and the most terrifying of all our hospitals'.[156] (It has been argued, however, that hospitals in the provinces actually saw an increasing rate of cure and a declining rate of mortality.[157])

In Britain, hospitals were set up by private initiative, beginning with the Westminster Infirmary in 1720. Groups of public-spirited individuals got together to raise funds. Mercer's Hospital in Dublin was funded partly by concerts, including some given by Handel; his *Messiah* was first performed in Dublin in 1742, with singers from the choirs of Dublin's two cathedrals.[158]

In German-speaking countries hospitals were established by the state. The most ambitious was the Allgemeines Krankenhaus in Vienna, founded by the reforming Emperor Joseph II in 1784. It was designed for 2,000 patients, with 15 physicians and 140 nursing attendants, and – something unusual – a single bed for each patient. Nowadays, although the hospital has been moved, its original buildings on the Alserstrasse can still be visited. The long, uniform façade now looks depressingly 'institutional', but in its day it was a remarkable innovation.

The new hospitals were usually spacious and well ventilated, with open areas and gardens for the convalescents. Germs were not yet understood,

but people were afraid of miasmas, sticky and poisonous vapours resulting from 'corruption of the air'.[159] It was difficult to keep hospitals clean: at the Edinburgh Royal Infirmary, the walls and ceilings were whitewashed with lime, and the floors periodically sprinkled with vinegar. However, John Howard, touring hospitals and prisons, noted that the patients there were actually forbidden to use the baths (presumably because they were reserved for paying customers), and that it was easy for dirt to gather in 'interstices'.[160] The Allgemeines Krankenhaus, designed in haste, had no accommodation for nurses, who had to sleep on the floors of the wards. Piles of rubbish accumulated between the buildings. 'Hospital diseases' flourished: typhus and puerperal fever killed almost 20 per cent of the inmates.[161] Even in the London hospitals, Howard noted that windows were sometimes too small or kept shut; that the beds were often too close together, preventing air from circulating; that the wards were often 'offensive' (smelly); and that inadequate means were employed to get rid of bedbugs. The typical diet he describes included bread, mutton and beer, but seldom any vegetables. St George's Hospital at Hyde Park Corner was about average:

> The wards are twenty-two feet and a half wide, and only ten and a half high: they are too close, especially the men's, which were very offensive, all the windows being shut . . . The kitchen and offices are under ground, and were neither neat nor clean. A good cold bath, but not used. A good garden. The staircases here, and in almost all our hospitals, are of wood; the stone staircases in the hospitals *abroad* are more proper.[162]

Howard also observed with displeasure a notice requiring patients at the Middlesex Hospital to buy drugs and medicine 'from tradesmen who are subscribers'.[163] Clearly philanthropists were sometimes motivated by profit as well as charity.

The treatment of the insane in the Enlightenment has attracted particular attention in recent decades. To people still spellbound by the cliché 'the age of reason', it may seem astonishing that the incidence of insanity was as great as at other times. Indeed, insanity was perhaps more conspicuous because it was no longer understood in theological terms, as divine folly or human depravity, but the medical terms to interpret it were not yet available: the science of psychiatry originated only at the end of the eighteenth century.[164] In France, the mad poor often ended up in *hôpitaux généraux*, along with other deviants. In Britain, there was until the 1740s only one public asylum specifically for the insane, the notorious Bethlem or Bedlam at Moorfields in London, where tourists went to gawp at the unfortunate inmates lying on straw with unglazed windows (the mad were supposed not to feel the cold). Institutions intended as more humane were

founded by public subscription, beginning with the Edinburgh Bedlam in 1743, St Luke's in London in 1751, and the Manchester Lunatic Hospital in 1766.[165] Many private madhouses also existed as profit-making enterprises where the inmates were often treated brutally; they had no recourse until the Act for Regulating Private Madhouses was passed in 1774. There was no concerted policy of confinement, as Foucault suggests; many mad people were left to wander about, and it was not until the nineteenth century that they were institutionalized in large numbers.[166]

'Madness' and 'insanity' are of course rough-and-ready terms. What counts as madness differs from one society to another. It is in any case difficult to conduct diagnoses of long-dead people whose symptoms are less than fully recorded. In eighteenth-century England, George III's bouts of madness have been interpreted as resulting from porphyria, a hereditary disease leading to weakness of the limbs, oversensitivity to pain, nausea and giddiness, and hence to irritability, overexcitement, incoherent volubility and delirium.[167] This diagnosis has since been questioned, however, and it has been argued that the king's disorder was primarily psychiatric, due to 'bipolar disorder with recurrent manic episodes'.[168] The case of William Cowper, recorded in his poems and letters, is quite different: a harrowing story involving prolonged spells of suicidal misery and the conviction that God had singled him out as someone uniquely unworthy of the divine love and destined for damnation.[169]

For a long time few attempts were made to cure the mad. Madhouses were intended to keep them safe, not to restore them to sanity. Mad-doctors, such as Francis Willis who attended George III, prided themselves on their ability to subdue their patients through force of will, like lion-tamers. However, Willis also claimed that his methods could actually restore the mad to their senses through salutary fear:

> The emotion of fear is the first and often the only one by which they can be governed. By working on it one removes their attention from the phantasms occupying them and brings them back to reality, even if this entails inflicting pain and suffering. It is fear too which teaches them to judge their actions rightly and learn the consequences.[170]

Willis's claim to have frightened his patients into rationality may sound implausible, but it was accepted by contemporaries.

By the late eighteenth century, physicians across Europe were beginning to talk about 'moral care' as superior to coercion. 'Moral care' meant treating the lunatic as a patient, 'an individual to whom the doctor might relate, rather than an animal to whom he might administer a standard treatment'.[171] When the need to enter into the patient's emotions was

acknowledged, psychiatry was born. The symbolic gesture of striking the chains off the mad was performed in 1788 by Vincenzo Chiarugi at the Hospital Bonifazio in Florence, and by Philippe Pinel in 1793 at the Bicêtre asylum in Paris.[172]

A thoroughly humanitarian method was practised at the York Retreat, a Quaker asylum opened in 1796 by William Tuke. Patients were to be treated kindly in a home-like environment; they lived in a pleasant brick building set in a park and were able to work in the gardens and take supervised walks outside. They were treated as though they were children who needed to be socialized, and were required to be orderly, clean and well-mannered in their behaviour. Their keepers sought to distract patients from their melancholy obsessions by soothing talk. The Retreat succeeded in restoring many of its patients to normal social life.[173]

How far can these methods be described as enlightened? Willis seems to have assumed that his patients had wilfully departed from rationality and could be terrified back into it. Sanity meant a proper empirical under-standing of the world around them. This approach shows no empathy with the mental world of the patient. At the York Retreat, patients were treated with the sympathy that was a major theme of the Enlightenment, and, judging from the emphasis on decency, coaxed back into self-respect. However, the policy of distracting them from their obsessions differs widely from twentieth-century psychiatry with its advocacy of listening to the patient and coming gradually to understand how the world looks to somebody who may be permanently frightened and deeply vulnerable. The kindness of the York Quakers was admirable, but it was only a small advance towards modern psychiatry.

## BRINGING UP CHILDREN

The history of childhood has been much argued over. Historians no longer accept Philippe Ariès' claim that childhood was recognized as a distinct stage of the life only in the seventeenth century, and that previously chil-dren were treated as miniature adults.[174] Nor do they accept the view, put forward with little critical scrutiny of the evidence, that until the mid-twentieth century children were routinely battered and abused.[175] There is ample evidence that parents, at least in early modern England, normally loved their children and punished them, if at all, only reluctantly.[176]

Nevertheless, Enlighteners found a great deal wrong with the rearing and education of children. Immediately after birth, children were swad-dled. The infant was wrapped in long, narrow linen bandages, like 'an

immobile little mummified package about the size and shape of a loaf of bread', unable to stretch its limbs or move its head.[177] Buffon observes that swaddled children, lucky if they are able to breathe, are often left in the charge of uncaring wet-nurses, who let them lie in their own cold urine and excrement.[178] Many babies were sent to live with a wet-nurse till they were weaned, perhaps at eighteen months or later, a practice Buffon also deplores, since wet-nurses might transmit diseases.[179] The young Montesquieu stayed with a nearby miller's family till he was three, and always retained their country accent.[180] This practice cannot have made for much bonding between mothers and children.

These were children with parents. Orphans were liable to starve or freeze in the streets, or, if they survived, to become beggars or worse. In the workhouses established by the English Poor Law of 1722, the death rate among infants was almost 99 per cent. In London, the plight of street children moved a wealthy shipbuilder, Captain Thomas Coram, to campaign for a Foundling Hospital.[181] After George II had given his consent, the Hospital, with a team of governors including William Hogarth, opened its doors to a first batch of thirty babies on 25 March 1741. The children were christened, tended, taught to read (but not to write) and, around the age of nine, became apprentices, cabin-boys, or domestic servants. The death rate was low by contemporary standards: out of 136 children admitted in the Hospital's first year, 80 survived. Coram's humanitarian achievement was acknowledged in Hogarth's full-length portrait of 1740, which shows a vigorous, confident, alert, humorous old man; the portrait now hangs in the Thomas Coram Foundation in London.

Children were treated by their parents sometimes indulgently, sometimes harshly. Locke complains that parents too often coddle their small children, and when the children grow older and become unmanageable, have no recourse but corporal punishment.[182] It is clear that children were often beaten for what we would think small offences. The six-year-old Marie-Jeanne Phlipon was whipped three times by her father when she refused to drink some nasty medicine.[183] Even a supposedly loving mother, Frances Boscawen, a well-known hostess and Bluestocking, beat her four-year-old son for refusing to 'eat milk for breakfast' – 'the rod and I went to breakfast with him'.[184] Lord Chesterfield maintained that a child should be whipped only for serious offences such as 'lying, cheating, making mischief, and meditated malice':

> But either to threaten or whip him for falling down, or not standing still to have his head combed, and his face washed, is a most unjust and absurd severity; and yet all these are the common causes of whipping. This hardens

them to punishment, and confounds them as to the causes of it; for, if a poor child is to be whipped equally for telling a lie, or for a snotty nose, he must of course think them equally criminal.[185]

However, the late eighteenth century was becoming more child-oriented. Although William Caxton in the late fifteenth century was already printing instructional books aimed specifically at girls and boys, it was three hundred years before large numbers of books were written for children.[186] Goethe remarks in his autobiography that in his youth there were no books for children. He read a translation of Fénelon's *Télémaque* and the *Acerra philologica*, a collection of stories from classical mythology.[187] Protestant children could read the Bible, and poorer children also read chapbooks, containing folk-tales that had been passed down since the Middle Ages.[188] The publisher John Newbery published innovative children's books, beginning with *A Little Pretty Pocket Book* (1744), 'intended for the instruction and amusement of little Master Tommy and pretty Miss Polly', designed to teach the alphabet, sold for sixpence and beautifully produced, as well as introductions to science written for children.[189]

At this period, too, clothes and other consumer goods were produced specifically for children whose parents' income was increasing. Children began to wear special clothes. Middle-class English children were often put in semi-fancy dress as sailors, soldiers, Highlanders, or even gardeners.[190] In Catholic cities such as Vienna, according to the traveller Friedrich Nicolai, parents would dress their little boys and girls in miniature versions of the clothes of their favourite religious order: 'You see such little Jesuits, Benedictines or Carmelites being carried in the arms or holding the hands of their nursemaids.'[191] Ignaz Fessler, who as a child was dressed as a Jesuit, tells us that later the fashion changed, and four-year-olds were dressed in little military uniforms.[192] There is evidence too that some games became reserved for children. For example, a Dutch painting by Cornelis Troost in 1745 shows grown-ups playing blind man's buff, later redefined as a children's game.[193]

Philosophers turned their minds to education. Locke's *Some Thoughts concerning Education* (1693) was, for its day, an extraordinarily progressive book, and still has great value. It advocates training children in virtue, fortitude and self-reliance. They should not be cosseted, indulged, or allowed to complain. Early indulgence, which Locke describes vividly, merely sows the seeds of future vices:

> The fondling must be taught to strike and call names, must have what he cries for, and do what he pleases. Thus parents, by humouring and cockering them when little, corrupt the principles of nature in their children, and

wonder afterwards to taste the bitter waters, when they themselves have poison'd the fountain.[194]

Corporal punishment should be kept to a minimum. The child should be taught by observing and guiding its natural inclinations. Thus, children like to be active, so they should always be occupied in study or recreation; and to make them like study, it should be turned into a kind of play. Locke tells of a father who has taught his children to read by inscribing the letters of the alphabet on the sides of four large dice, and letting them compete to see who can make most words by throwing the dice. Gentlemen need to know French and Latin, but should be taught without the customary useless exercises of writing Latin essays and making Latin verses. As for Greek, anyone who really wants to learn it can do so as an adult; most people who are forced to learn Greek at school forget it all in adult life. Young gentlemen should learn a useful trade, such as gardening or carpentry, and they should not be sent on the Grand Tour at the usual age of sixteen to twenty-one, when they are least likely to benefit from foreign travel, but should wait until they are mature.

Locke assumes that the child's mind is more or less a blank slate. The characteristic faults of children result either from simple immaturity, or from the bad examples given by grown-ups. For example, children are cruel to animals: 'they often torment, and treat very roughly, young birds, butterflies, and such other poor animals which fall into their hands, and that with a seeming kind of pleasure.'[195] Such cruelty, however, is the fault of adults who encourage children to think violence amusing or (in the case of soldiers) commendable. Adults, especially foolish servants, also 'awe children, and keep them in subjection, by telling them of raw-head and bloody-bones, and such other names as carry with them the ideas of something terrible and hurtful', with the result that children fear the dark and are prey to superstitious terrors.[196]

Alongside much good sense, Locke has some odd thoughts. He recommends training children to endure discomfort by making them wear thin shoes that let the water in, on the grounds that having wet feet is no worse than having wet hands. And he advises fathers to discourage firmly any inclination for poetry that their children may display, for poets are generally dissolute people who squander money instead of earning it. A more serious problem is that education needs to be entrusted, not to coddling or over-severe parents, but to a sensitive and judicious tutor, who will be hard to find. Nevertheless, the *Thoughts* were not only widely circulated in English but translated into French, German, Italian, Dutch and Swedish.[197]

The most influential book on children's education written in the

eighteenth century, and perhaps ever, was Rousseau's novel *Émile* (1762). It is much more than a pedagogic manual.[198] It follows on from his prize-winning *Discourse on the Arts and Sciences* (1750), where he argues that far from improving humanity, civilization has corrupted us. So-called civilized nations, where the arts and sciences flourish, all fall victim to luxury and vice. Their 'politeness', 'this vaunted urbanity which we owe to the enlightenment of our century', is hollow and insincere, concealing suspicion, hatred and betrayal.[199] People no longer enjoy freedom, no longer love their fatherland; increasingly their only criterion of value is money. Artists compose, not for posterity, but for short-term success, and talent is overestimated at the expense of virtue. Every child born into this corrupt civilization is socialized into its distorted values.

There is an alternative, though, and to describe it Rousseau concentrates on the education of someone who is not to be prepared for any profession or other niche in present-day society, but to have his natural faculties developed in the most rewarding way. The subject of education here is a boy called Émile, but the fiction is perfunctory; we do not learn how he has been entrusted to a tutor, who brings him up apparently in isolation, and often he becomes 'your pupil' or a child in general. He may or may not have parents, but they take no part in his education. The fiction oscillates between observations on education, illustrated by anecdotes, and the narrative of the exemplary education given to Émile.

Rousseau starts with the care of babies. He deplores the habit of swaddling children. He describes how a swaddled child may be hung up on a nail, 'like a bundle of clothes', and left, often in great discomfort, while its nurse goes about her business.[200] He advocates also that women should suckle their own children instead of farming them out to wet-nurses, since 'there is no substitute for a mother's love'.[201] (Here the fiction of Émile is particularly flimsy: presumably he was nursed by his mother; if so, he has been separated from her in what would be an emotionally damaging way.)

Rousseau shows clearly how interesting babies are. Instead of a helpless little bundle, his baby is active in responding to the world, and shows its feelings by the varied play of its facial expressions. If it cries, one must find out what its needs are and supply them, not strike it for making a noise, as Rousseau has seen cruel nurses do. Soon it will learn to walk, and there is no need of go-carts or leading strings to encourage it to do so.[202] Once it is a toddler, it wants to explore its surroundings actively by touching everything. Apart from removing dangerous objects, one should not try too hard to prevent toddlers from hurting themselves: they need to experience pain in order to learn about the hazards of the world around them, and they cannot do themselves serious harm. Once the child is walking

and talking, it should not be made to sit still, but should spend time out of doors: 'Instead of keeping him mewed up in a stuffy room, take him out into a meadow every day; let him run about, let him struggle and fall again and again, the oftener the better; he will learn all the sooner to pick himself up.'[203] Thus two major themes of Rousseauvian education are already introduced: the child learns through direct contact with reality, from which it should not be shielded through mistaken kindness; and its natural faculties need to emerge in their own time, without being artificially induced.

Children should on no account be treated as small adults. 'Childhood has its own ways of seeing, thinking, and feeling; nothing is more foolish than to try and substitute our ways; and I should no more expect judgment in a ten-year-old child than I should expect him to be five feet high.'[204] So one should not impose morality on young children, or expect them to understand concepts such as duty. One would thereby merely be encasing children in an imaginary system of right and wrong, in which the child would receive incomprehensible punishments and be left only with the unhappy sense of its own badness. 'Let us lay it down as an incontrovertible rule that the first impulses of nature are always right; there is no original perversity in the human heart, the how and why of the entrance of every vice can be traced.'[205] Up to the age of twelve, therefore, education should be negative: 'It consists, not in teaching virtue or truth, but in preserving the heart from vice and from the spirit of error.'[206] The child should be given no orders and receive no punishments. If it breaks its toys, it will have to do without them. If it breaks the windows in its room, it will have to lie in a draught. Thus, it will learn from the reality of causes and effects, not from an imaginary and tyrannical system of moral sanctions. *Pace* Locke, there is no point in reasoning with children: as they cannot yet understand reason, the attempt leads at best to futile arguments and at worst risks turning them into barrack-room lawyers. Reason is an acquisition of adulthood; it cannot be expected from children.

Far from idealizing children, Rousseau knows that if they get the chance they will turn into little tyrants. So he insists that one must attend to their real needs but not give in to their importunate demands; 'your child must not get what he asks, but what he needs'.[207] Greedy children, who always get what they ask for, will simply ask for more and more, and will always be dissatisfied. Spoilt children grow into spoilt adults: 'One spoilt child beats the table; another whips the sea.'[208] Here Rousseau is alluding to the story of how the Persian emperor Xerxes, frustrated in his attempt to invade Greece by a storm that destroyed his bridge over the Hellespont, ordered the water itself to be whipped.[209] The emperor was merely a spoilt child who could not understand any restraints on his power.

The child must learn, but present-day education mistakenly tries to train the mind rather than the body, and to teach the child words when he can only learn from things. Just as a cat in a strange room explores her new surroundings by sniffing everywhere, so a child explores his world through his senses, especially by the sense of touch. He learns by using his body. If he tries to pick up a heavy stone and finds he is not strong enough, he may learn to use a lever. Flying a kite teaches him to use his eyes and his hands accurately. But merely verbal lessons are worse than useless. Young children cannot make sense of history, because they do not know what words like 'war', 'king', and 'revolution' denote. If they are taught Latin, they learn mere words without knowing what the words refer to. They will only really learn when their curiosity is excited. So, one should not hurry to teach them reading; they will learn to read much more efficiently once they want to learn. Other subjects should begin from concrete and familiar experience. Geography should begin with one's hometown, not with maps and globes. One should arouse the child's interest in science by inviting him to wonder why the sun sets in one place and rises in another. When Émile asks what is the use of finding one's bearings by the sun, the tutor does not give him a direct answer, which would be too abstract for his understanding; instead, the next day the tutor contrives for him and Émile to get lost in a wood, and they find their way out by the sun. This illustrates the manipulation which is part of Rousseau's educational method, and which some of his English admirers deplored as 'that debasing cunning which Rousseau recommends'.[210]

Since Émile is to learn from things, not words, he will not be encouraged to read books, with a single exception – *Robinson Crusoe*. Defoe's novel shows a solitary man, remote from the corruptions of society, who judges things not by the social prestige they may confer, but solely by their utility. And since Crusoe spends all his time in practical contrivances, the child who follows his experience will get additional training in practical skills. He thus learns to value occupations which in present-day society enjoy low prestige, such as agriculture, metal-working and carpentry, and to hold in low esteem those such as goldsmiths and clockmakers who produce luxury goods. Rousseau thinks everyone should learn a trade, and particularly recommends carpentry. Manual labour is not only practical, but also provides a sense of freedom, since an artisan can be his own master. And since no artisan can be entirely self-sufficient but is dependent on the practitioners of other trades and on people who supply his raw materials, manual labour leads gradually into the understanding of social relations.

By now Émile is about fifteen. Although he has been artificially secluded from society, he now has a much stronger impetus towards social

integration from the development of his passions. Passion comes before reason, and all the passions originate from self-love. Rousseau knows his readers will be surprised to find him harking back to the psychological theories associated with moralists such as La Rochefoucauld. But, he says, 'Our passions are the chief means of self-preservation; to try to destroy them is therefore as absurd as it is useless; this would be to overcome nature, to reshape God's handiwork.'[211] The child's self-love spills over into love for the people around him who are necessary to his well-being. Eventually it leads to sexual love. In the meantime, it can lead to selfishness, but it doesn't have to. If carefully guided, it leads to sympathy for others, which is the basis of social life. It is part of human nature to put ourselves in the place of others who claim our pity; and we do so because we know that their misfortunes could also happen to us. Thus, self-love interacts with fellow-feeling. Further, we pity others in proportion to the feeling we attribute to them. We do not pity sheep that are going to be slaughtered, because they do not foresee their fate; we do pity people whom we know to be suffering as we would if we were in their situation. Thus Rousseau's social theory improves on the theory of sympathy popularized by Shaftesbury. For Shaftesbury, sociability was a primary instinct. For Rousseau, sociability is derived from self-love. Human beings are linked by emotional bonds which acknowledge people's initial and inevitable self-centredness and do not require one to imagine an impossible altruism. Thus, says Rousseau, 'We have reached the moral order at last':

> If this were the place for it, I would try to show how the first impulses of the heart give rise to the first stirrings of conscience, and how from the feelings of love and hatred spring the first notions of good and evil. I would show that justice and kindness are no mere abstract terms, no mere moral conceptions framed by the understanding, but true affections of the heart enlightened by reason, the natural outcome of our primitive affections; that by reason alone, unaided by conscience, we cannot establish any natural law, and that all natural right is a vain dream if it does not rest upon some instinctive need of the human heart.[212]

Émile is now ready to enter society. But two big questions remain unanswered. First, what is his religion to be? Rousseau answers this by inserting the creed of the Savoyard vicar (already examined in Chapter 5), not as a doctrine that Émile must accept, but as illustrating how an honest man of deep and sincere feeling approaches the question of religion. Second, how is Émile to relate to the opposite sex? Rousseau thinks that children should not be encouraged to ask questions about sex, but that, if they do, they should be given plain and unembarrassed answers. Émile

should remain sexually inexperienced until at least the age of twenty (and he should on no account assuage his desires by masturbation). He will then meet a woman who has been trained to be his partner – Sophie.

Sophie's education is very different from Émile's. A woman's physical nature means that the business of her life is to bear and rear children. 'The male is only a male now and again, the female is always a female, or at least all her youth: everything reminds her of her sex.'[213] She should bear as many children as possible, for, as Rousseau has already remarked, half of all children die young.[214] As for the argument that women can do other things than care for children, Rousseau gives the (surely frivolous) reply that a woman cannot be a nursing mother one day and a soldier the next.[215] He has no time for intellectual women, who simply go against nature:

> When women are what they ought to be, they will keep to what they can understand, and their judgment will be right; but since they have set themselves up as judges of literature, since they have begun to criticise books and to make them with might and main, they are altogether astray.[216]

In contrast to the freedom allowed to Émile, girls such as Sophie must be kept under restraint. They must always be busy, to keep them out of mischief, and they must be trained to be gentle and docile, and to submit uncomplainingly to injustice. Their education must always remain practical; men can move from factual observations to abstract generalities, but women never can. As they are first and foremost mothers, they should spend their time at home, as the women of ancient Greece did. Thus, Rousseau imagines women's education as preparing them for subordinate roles in an ideal republic where all public activity is reserved for men.

On its publication, *Émile* caused a scandal. Commentators predictably denounced it as subversive, irreligious, impractical, mad.[217] But the *philosophes* did not like it either. D'Alembert made the obvious criticism that it was absurd to imagine bringing up a child outside society (we might add that Émile has no contact with other children, and therefore misses an essential part of socialization).[218] Voltaire particularly disliked the idea that everyone should learn a handicraft, and condemned the notion of making an upper-class boy into a carpenter.[219] The (non-)education of Sophie understandably annoyed female readers, including Mary Wollstonecraft, who complained that Rousseau imagined women only as slaves to their male masters.[220]

But *Émile* also found both devotees and disciples, especially among readers who had already been swept away by *La Nouvelle Héloïse*. Caroline Flachsland, whom we met in Chapter 6 as 'Psyche', told her fiancé that Rousseau was 'a saint, a prophet, whom I almost worship'.[221] Marie

Phlipon cried while reading *Émile* and was delighted to be given Rousseau's complete works: 'To have the whole of Jean-Jacques in one's possession, to be able to consult it incessantly, to find consolation, to enlighten and elevate oneself with him, is a delight, a felicity, which one can only taste if one adores him as I do.'[222] Thomas Day, a member of the Lunar Society, said that if all the books in the world were to be destroyed, *Émile*, after the Bible, would be most worth saving.[223]

Although the passage of time has sobered our view of Rousseau, we need to empathize with his contemporary admirers. Published in successive years, *La Nouvelle Héloïse* and *Émile* seemed to reveal the civilized world as a huge prison fortified by convention, insincerity and corruption. But they also offered a chink of light, revealing that nature, truth, virtue and hope still existed as human potentiality, and in the bosom of the reader. They were also written, especially *Émile*, in a warm, direct, personal style that made one feel one was in touch with the unique individual Jean-Jacques. Rousseau seemed to embody compassion and morality as 'the advocate of suffering humanity', 'the apostle of virtue, the comforter of the poor'.[224] This may have been a too rose-coloured reading of Rousseau, from whose writings one can also gather a sad doctrine of human depravity.[225] But it was the hopeful, not the pessimistic Rousseau who inspired his contemporaries.

Most readers of *Émile*, however, probably did not know that the individual Jean-Jacques was the last person qualified to advise on the upbringing of children. In his *Confessions*, published posthumously in 1782, he reveals that his companion, Thérèse Le Vasseur, bore him five children, all of whom, much against their mother's wishes, he sent to the Paris foundling hospital (Hôpital des Enfants-Trouvés). This was not an unusual thing to do: five or six thousand infants were placed there every year.[226] Although he admits that it may have been an error, he continues:

> in handing my children over for the State to educate, for lack of means to bring them up myself, by destining them to become workers and peasants instead of adventurers and fortune-hunters, I thought I was acting as a citizen and a father, and looked upon myself as a member of Plato's Republic.[227]

Rousseau does not admit a likely motive that will readily occur to the reader, namely that he shunned the trouble, as well as the expense, of looking after small children; nor does he admit that the foundlings' hospital had a notoriously high mortality rate – 70 per cent of the infants died before they were one year old, many more later – so that in placing his children there he was not providing for their future but sending them to almost certain death.[228] Since nothing more is known about them, they

presumably did die. Tobias Smollett, visiting the institution in 1763, was shocked to see the infants 'so swathed with bandages, that the very sight of them made my eyes water', and as a doctor was able to estimate the lifelong malformation that would be inflicted on the survivors.[229] Rousseau's action consorts badly with his frequent paeans to the beauty of family life, and the nauseating self-justification in the *Confessions* suggests a person with very robust egoism and intense admiration for his own self-image.[230] He tried to keep it secret, but during his bitter quarrel with Voltaire, the latter learned of the fact and publicized it in a polemical pamphlet of 1764.[231]

*Émile* helped to encourage many mothers to give up swaddling their babies and to start breast-feeding them themselves. The author of the *Histoire des deux Indes* noted approvingly that by this development, Europeans were gaining an advantage already possessed by native Americans: 'By feeding their children themselves, our women are beginning to deserve the name of mothers.'[232] Madame de Genlis, as governess to the children of the duc de Chartres from 1777 onwards, followed Rousseau's precepts: she taught them languages through conversation, history by means of anecdotes and pictures, science with experiments.[233] Some parents went further and tried giving their own children a full Émile-type education, with mixed results. Richard Edgeworth (father of the novelist Maria Edgeworth) resolved in 1765 to bring up his son, Richard, born the previous year, by Rousseau's method, and continued until the boy was eight. Young Richard became 'hardy', 'fearless of danger', capable of bearing 'privation of any sort', 'bold, free, fearless, generous', but unruly, with 'an invincible dislike to control'.[234]

The non-education of Sophie provoked criticism. Louise d'Épinay wrote a reply to Rousseau in *Les Conversations d'Émilie* (1774). She had adopted her granddaughter Émilie. Her book consists of twenty imagined conversations between a mother (based on d'Épinay) and Émilie, who is five at the beginning of the book and, by the end, on the eve of her tenth birthday. The conversations are pleasant and natural – more so than the rather stilted conversations with which *Émile* is interspersed – and as Émilie approaches her teens, a life-like tendency to juvenile self-importance is countered by her mother's teasing. D'Épinay believed that girls should receive as good an education as possible, even though it would be of limited use to them in adult life. So Émilie, unlike either Émile or Sophie, can read with great fluency by the age of five, and is encouraged to use her time well for studying. However, she is also encouraged to play and spend time outdoors, and, as in *Émile*, she is discouraged from mere book-learning. When she boasts that she has learned that water is one of the

four elements, her mother mildly chides her for learning things parrot-fashion and shows her some features of water in everyday experience. She is educated in kindness, good manners and concern for others; her mother dissuades her from pulling the wings off flies by telling her that flies feel pain as much as she does. D'Épinay's educational method appeals equally to the girl's intelligence and to her growing power of sympathy. It is assumed that doing good to others is a source of pleasure: 'This is how to make oneself loved, and to procure happiness at every moment; it is by always doing good, and never voluntarily doing harm.'[235]

## SCHOOLS AND UNIVERSITIES

If middle- or upper-class boys were sent to a public school (instead of being taught at home), they could not expect much preparation for the adult world. Their education centred on Latin. French *collèges* taught only Latin and scholastic philosophy. Even towards the end of the seventeenth century, young boys were being taught to read from Latin books that they could not understand.[236] The *Encyclopédie* has an impassioned article, 'Collèges', in which d'Alembert describes how boys are first taught Latin for six years, then learn in Rhetoric to say nothing at great length, then advance to Philosophy, in which one learns scholastic logic and metaphysics, and enough about Descartes and Newton to try to refute them without understanding them.[237] Only at schools run by the Oratorian religious order was there any study of French, history, mathematics, or science. In England, Gibbon observes that 'a finished scholar may emerge from the head of Westminster or Eaton [*sic*] in total ignorance of the business and conversation of English Gentlemen in the latter end of the eighteenth century.'[238] Both he and d'Alembert condemn the usual mixed-ability teaching as inefficient, compared to instruction at home by a private tutor. Diderot agrees, recalling from his schooldays how the teachers concentrated on a small elite of bright boys and left the rest neglected and discouraged.[239]

Rousseau's *Émile* suggested better methods of education. Its practical influence is seen in the educational work of another Swiss, Johann Heinrich Pestalozzi, who called his son Hans Jakob after Jean-Jacques Rousseau, and still more in that of the German Johann Bernhard Basedow. Pestalozzi agreed with Rousseau that education should avoid dry book-learning and acquaint the child with the material world. Education should be about things, not words, and the child should be trained in observation (*Anschauung*). When Hans Jakob was about three and a half, Pestalozzi kept a diary recording two months in the boy's education. The diary describes

him showing the boy how wood floats but a stone sinks, how snow turns to water, and similar natural processes. He tries to make Latin lessons lively by speaking to the boy in that language (but surely Latin, if taught at all, should have been left till later).[240] Unfortunately, like other educational reformers, Pestalozzi had least success with his immediate family. Having a school for poor children to look after, he neglected Hans Jakob, who at the age of twelve still could not read or write.

Basedow, among many books on subjects including teaching methods, produced the four-volume *Elementarwerk* (1774), a systematic compendium of basic knowledge intended for and addressed to children, accompanied by a volume with about a hundred copperplate engravings by the well-known artist Daniel Chodowiecki. Basedow appeals constantly to 'sound reason' and offers an education suitable for families of any religion, from Catholicism to naturalism.[241] Significantly, he begins not with religion but with humanity. Volume I offers a systematic account of anthropology, or human nature, including definitions of the body and the soul, and how the soul survives after death. The keys to eternal life are knowledge and practical benevolence: '*Man's eternal life after the death of the body* is of such a nature that in it we shall eternally be happier, the more we have striven before the death of the body to increase our pleasure through knowledge, and to live with people peaceably and affectionately.'[242] He adds a long note for adult readers justifying this presentation of the subject and saying that one knows instinctively, by feeling, that one has a soul, so that there is no need to offer theological or philosophical proofs. Theology is kept until the second volume, where readers are urged to believe in a loving God who would never inflict eternal torment on anyone and who ensures that there is much more good in the world than evil.[243]

Supported by the duke of Anhalt-Dessau, Basedow opened a school, the Philanthropinum, in Dessau in 1774. Explicitly modelled on Rousseau's principles, the school attracted warm praise from Kant.[244] Rich and poor were to be educated together, the curriculum was practical and lessons were conducted in German (instead of Latin), handicrafts and gardening were taught, there was an emphasis on games and physical exercise, and the school uniform was made simple and more comfortable. Basedow, a rough and combative character, got on badly with the school staff and left his job after four years, but his school provided a model for sixty-odd others.[245]

The Enlighteners showed little interest in extending education to women or the lower classes. In a hierarchical and virtually immobile society, it was pointless, even perhaps dangerous, to educate the labouring poor, who

would thus be unfitted for their work but not enabled to contribute to society in any other way.[246] Voltaire praised the *Essai d'éducation nationale* (*Essay on National Education*, 1763) by Louis-René Caradeuc de La Chalotais for advocating that common people should be taught only their crafts, not reading and writing, and wrote to him: 'I am grateful to you for forbidding study for ploughmen.'[247] 'The poor man has no need of education,' agreed Rousseau.[248] Adam Smith on the other hand argued for universal elementary education, because 'an instructed and intelligent people' will be 'less liable to the delusions of enthusiasm and superstition' and better able to see through 'the interested complaints of faction and sedition'.[249] And Diderot, sketching his ideal of public education for the benefit of Catherine the Great, insisted that it should be open to all, irrespective of social status, for 'it would be equally cruel and absurd to condemn the lower ranks of society to ignorance', and genius, talent and virtue are more likely to emerge from a thatched cottage than from a palace.[250]

An advocate of women's education, however, was the eminent Göttingen historian August Ludwig Schlözer. Opposing the general view that women were naturally incapable of academic learning, Schlözer applied his own pedagogic method to his eldest child, Dorothea, born in 1770.[251] Dorothea learned English, Swedish, Dutch, French and Italian, moving on to Latin at eleven and Greek at fifteen; her main subjects were mathematics, history and mineralogy, and she also acquired the standard 'feminine' skills of sewing, housekeeping, singing, dancing and playing the piano. This may sound like the hothouse education that the rationalist James Mill later imposed on his son John Stuart, and which sent the latter into a nervous breakdown. But Schlözer believed in practical, hands-on learning. Dorothea learned languages so far as possible through conversation. She spent six weeks collecting geological specimens in the Harz Mountains. In her teens, she made a dangerous descent into a 1,200-foot-deep mine. She was a skilful and courageous horsewoman, and an enthusiastic dancer. When she was twelve, her father took her to Rome, where her liveliness, charm and multilingual fluency delighted everyone.

Five years later, Schlözer contrived for Dorothea to take a doctoral examination at Göttingen. She was exempted from the usual Latin disputation, but on 25 August 1787 took a two-and-a-half-hour oral examination in which a panel of leading academics asked her challenging questions on subjects she had prepared: she had to translate an ode by Horace, explain how silver was made into coins, describe the construction of St Peter's at Rome, and solve a difficult problem in geometry.[252] Though this was very unlike a present-day Ph.D. viva, Dorothea certainly earned her degree,

which made her the first woman in Germany to receive a doctorate in the humanities. Her achievement made her a celebrity, though it was belittled by some contemporaries, including Schiller, who shared Rousseau's view about women's inferior intellectual faculties.[253] Unfortunately, there was not much Dorothea could do with her qualification. Having made a seemingly prudent marriage to a wealthy Lübeck patrician, Matthäus Rodde, she became an emotionally frustrated trophy wife.

When a boy proceeded to university, he would normally begin by studying Latin grammar (to improve his command of Latin acquired at school) and philosophy, as a prelude to a professional training in theology, law, or medicine. Until well into the eighteenth century, instruction would normally be in Latin. Christian Thomasius, a law professor at the University of Leipzig, shocked many fellow-academics when on 31 October 1687 he announced a lecture to be delivered in German.[254] Curricula were conservative. In most places, 'philosophy' meant in practice the works of Aristotle. Adam Smith, arriving in 1740 at Balliol College, Oxford, as a Snell Exhibitioner after three years' study under the enlightened Francis Hutcheson at Glasgow, was disappointed to find Aristotle still prominent in the curriculum, with little attention paid to the (no longer very new) philosophy of Locke and Newton.[255] In France, Aristotelian physics was abandoned in favour of the mechanical philosophy in the 1690s; Newton's critique of Descartes was not generally accepted until the 1760s.[256]

England's two universities differed from Scotland's five and all those on the Continent by devoting seven years to the arts: four for the Bachelor of Arts degree, three for the Master's. Students began with Latin, then spent the bulk of their Bachelor studies on logic and ethics, latterly accompanied by Greek and geometry.[257] At Cambridge, perhaps because of Newton's prestige, mathematics came by the 1740s to dominate the curriculum.[258] The Master's degree focused on Greek and higher mathematics. Until 1800, students at both Oxford and Cambridge were still examined by the medieval method of a public disputation. In Germany, much less time was spent on the arts and more on training future clergymen, lawyers, doctors and administrators. Universities were maintained by the state to serve social needs. Between 1600 and 1800, twenty-four new universities were founded in Germany, making a total of nearly fifty, compared to twenty-two in France.[259]

Scotland's universities underwent major reforms early in the eighteenth century. Hitherto their main function had been to train the clergy. To study law or medicine, Scotsmen went abroad, usually to Holland. William Carstares, principal of Edinburgh University from 1703 to 1715, and his brother-in-law William Dunlop, his counterpart at Glasgow from 1690

to 1700, increased their endowment and reformed their teaching methods. Previously a class of students learned all its subjects from a single teacher, called a 'regent' (like children in primary school nowadays). Carstares took the lead in importing from the Netherlands the system of specialist professors. He founded chairs in new subjects, including law and natural science, and in 1726 Edinburgh established the first medical school in Britain.[260] These reforms were an important prerequisite for the Scottish Enlightenment.

Elsewhere, Enlighteners criticized the universities for their antiquated curricula, use of Latin, and ineffective teaching methods. Lectures were poorly attended: when the chair of modern history was founded at Cambridge in 1724, the first holder's inaugural lecture was the last lecture on history delivered before 1773.[261] Examinations were usually perfunctory. German doctoral dissertations were often on trivial, sometimes deliberately comic topics, such as Gottlob Matthaeus' *Dissertatio historico-moralis de malis eruditorum uxoribus, (vulgo) von den bösen Weibern der Gelehrten* ('On the wicked wives of learned men'), presented at Leipzig in 1705.[262] Critics advocated the introduction of modern languages and natural science, and, in the vocational disciplines, a shift from theory to practice: for example, students of divinity should learn less about theological disputes and more about pastoral care.

Actual reform was slow. Curricular innovation was deterred by the separation of universities as teaching institutions from academies as research centres. However, the new University of Göttingen, opened in 1737, encouraged research by means of the publicly funded research seminar, in effect a small institute directed by a professor. The classical scholar Christian Gottlob Heyne ran his Göttingen seminar from 1763 to 1812, besides building up the library into one of the largest in the world and editing a journal of academic reviews, the *Göttingische Anzeigen von gelehrten Sachen* (still in existence as the oldest academic periodical in Germany). The research-based Ph.D. (usually called Dr.Phil. in Germany) was first recognized in Prussia in 1771. By contrast, Cambridge awarded its first doctoral degree in 1882, Oxford its first in 1917.[263] Although Göttingen foreshadowed the modern research university, its key exemplar, postdating the Enlightenment, was the University of Berlin, set up by Wilhelm von Humboldt (an alumnus of Heyne's philological seminar at Göttingen) in 1810.[264] Although the German universities continued to educate young men for the professions, they increasingly assigned central importance to research, and in this respect they formed a model that was exported to the United States, and which is now the dominant paradigm of higher education.[265]

## PUNISHMENT

Punishment may be retributive, utilitarian or reformatory. The retributive principle, upheld by Kant, is that the criminal has committed an offence against society which must be avenged with an equal amount of suffering. The utilitarian principle means that the punishment must be just severe enough to achieve a useful purpose: it should prevent a criminal from repeating his crime and deter others from committing crime in the first place. And the reformatory principle regards punishment as a means to make criminals aware of their wrong-doing and turn them into better citizens.

Punishment in early modern Europe was primarily retributive.[266] The criminal had to suffer for his crimes against God and man, and to display public penitence. Since relatively few criminals were caught, their punishment had to be all the more impressive. Executions formed the climax of a ritual in which a procession, with the condemned man in a white garment of penitence, moved through the town to the scaffold; here the condemned man (or, less often, woman), attended by clergymen, heard his sentence read and was allowed to make his last speech before being hanged.[267] Justice was done before the eyes of a large crowd: in 1755, some six thousand people attended the execution of the French smuggler Mandrin.[268] As hanging was disgraceful, it was rarely inflicted on nobles or women, who were more likely to be decapitated, as Susanna Margaretha Brandt, who had killed her illegitimate child, was in Frankfurt in 1772. Punishment continued after death: the victim's corpse would be exposed on a gibbet outside the town, to warn travellers that the town they were approaching was a law-abiding place. The site of this display was called in German the *Rabenstein* ('ravens' stone') and had sinister and supernatural associations.[269]

Particularly grave crimes met with even harsher penalties. For (supposedly) killing his son, Jean Calas in 1762 was broken on the wheel: he was spread-eagled on a cartwheel and an executioner broke each of his limbs in turn with a heavy iron bar. The diarist Edmond-Jean Barbier describes this treatment being applied in Paris in 1729 to a man of seventy-two who had committed many murders fifty years previously; he spent an hour and a half on the wheel before dying.[270] In the Netherlands, thirty-six people were broken on the wheel in the first half of the eighteenth century (compared to four in the preceding half-century).[271] In Prussia, this penalty was still used in the 1830s, and was removed from the statute books only in 1851.[272] When Robert Damiens attempted the worst of crimes, the assassination of Louis XV, in 1757, he was sentenced to be quartered by

being pulled apart by four horses. Minor offences were often punished by mutilation: the criminal lost some fingers, a hand, or an ear, had his tongue pierced, or was branded on the forehead or shoulder, thereby being marked as unemployable for the rest of his life. Branding was abolished in England in 1779, and in the Netherlands only in 1854.[273]

In England, the law became harsher during the eighteenth century: in 1689 there were fifty capital crimes; by 1800 there were two hundred, mostly offences against property. It was, for example, a capital offence to pick a pocket of goods worth more than a shilling.[274] Public execution ceased to be (if it ever had been) a properly impressive spectacle. Mandeville, writing in 1725, describes vividly how the procession to Tyburn (near the present-day Marble Arch) loses every shred of dignity because it is accompanied by a riotous, howling mob, partly composed of whores and pickpockets looking for business; because the police are beating back the mob with their sticks; and because the malefactors themselves get drunk on gin in order to acquire Dutch courage, and are thus in the worst possible state for the solemnity of death.[275] Until their abolition in 1868, public executions remained popular in England, and not only with the mob: in 1864, excursion trains were laid on to bring spectators from the northern cities to a hanging in Liverpool.[276]

At least England, with its institution of trial by jury, did not practise judicial torture. On the Continent, since the introduction of Roman law in the late Middle Ages, the investigation of a capital crime, where only partial proof was forthcoming, included torture to obtain a confession. The questioning was carefully recorded in documents that have proved invaluable for historians. A defendant who withstood torture without confessing was normally released.

By the eighteenth century this harsh regime was being modified. From 1555 on, when the first 'Bridewell' was established as a 'house of correction' for vagrants and deviants in London, imprisonment, with the inmates compelled to work, became frequent throughout Western Europe. In Amsterdam, for example, the *Tugthuis* (prison) opened in 1595, though it soon became 'a detention centre for petty felons rather than a moral reformatory'.[277] When inmates were set to hard labour, it became known as the *Rasphuis* (Saw-house), and its female counterpart was the *Spinhuis* (Spinning-house). The Dutch workhouses spread in the seventeenth century to Germany, where criminals might also be set to work on military construction projects or building roads. In southern Europe, convicted criminals often had their punishment commuted in rowing in galleys, which was nevertheless so dreaded that some men mutilated themselves to avoid it. When galleys fell out of use in the mid-eighteenth century,

criminals might be compelled to serve in the navy. In Britain, which had no galleys, it became common to transport convicted criminals to work in the American colonies. Later, when the American revolt removed this option, Australia provided a substitute.

Partly because these alternatives were available, in many countries fewer death sentences were passed. In Brussels there were 488 executions in the period 1506–1600, only 40 in 1700–1783. In Florence, fifty-six convicts were executed in 1501–5, four in 1701–5.[278] Courts also practised greater discretion: instead of the full proof demanded by Roman canon law, judges who were convinced of the defendant's guilt increasingly imposed forced labour on the basis of partial evidence.[279]

Great influence has been ascribed to the treatise *Dei delitti e delle pene* (*On Crimes and Punishments*, 1764) by Cesare Beccaria. Beccaria typifies the Enlightenment's combination of reason and sensibility. In his youth, his outstanding mathematical and logical ability earned him the nickname *il newtoncino* ('the little Newton'). He was profoundly influenced by the *philosophes* (Helvétius, Buffon, Diderot) and also by Rousseau: having read *La Nouvelle Héloïse* on its publication in 1761, he named his daughter, born the following year, Giulia after its heroine Julie.[280] He belonged to the Accademia dei Pugni (Academy of Fisticuffs), which met in Milan under the leadership of Pietro Verri. Lombardy was then under Austrian rule. The Austrians, and especially Count Carlo Firmian, who was appointed governor of Lombardy in 1759, wished to reduce the legal privileges of the Church and the local notables. The young intellectuals of the Accademia shared this aim and wanted to go further by reorganizing the economy and the laws in a systematic way that would better promote the happiness of the population. Alongside Verri's *Meditations on Happiness* (1763), Beccaria's *On Crimes and Punishments* is the major expression of their ideals.

Beccaria understands good legislation as 'the art of guiding men to their greatest happiness, or the least unhappiness possible, taking into account all the blessings and evils of life'.[281] Legislators must be realistic, not only in their expectations, but also in their assessment of human beings. Politics is 'the art of guiding and concerting the immutable sentiments of men'.[282] Human beings are neither rational nor benevolent but swayed by their passions and inclined each to exercise a petty despotism of his own. Beccaria is less radical than Kant, who later said that a good political system must work even for a nation of devils.[283] But he thinks laws must be so contrived as to control people's passions and bring out the best in them.

The legislator finds himself confronted with an incoherent array of laws

# DEI DELITTI
## E
# DELLE PENE

—————

EDIZIONE SESTA

Di nuovo corretta ed accresciuta.

—————

*In rebus quibuscumque difficilioribus non expectandum, ut quis simul, & serat, & metat, sed praeparatione opus est, ut per gradus maturescant.* Bacon. Serm. fidel. nu. XLV.

HARLEM,
*Et se vend*
A PARIS,
*Chez Molini Libraire, Quai des Augustins.*

—————

MDCCLXVI.

The motto is taken from Bacon, *Sermones Fideles sive Interiora Rerum* (1638), the Latin version of his *Essays*: 'In all very difficult matters it is not to be expected that anyone should sow and reap at the same time, but a period of waiting is necessary so that they may gradually ripen.'

derived from the past and often unsuitable for present-day circumstances. 'The barbaric notions and fierce ideas of our ancestral northern huntsmen still remain in the popular mind, in our customs and in our laws, which are always a hundred years behind a given nation's stage of goodness and enlightenment.'[284] Criminal justice is savage in its practice of judicial torture and in prescribing the death penalty for crimes of very different gravity.

A reformed legal system must be based on an implicit social contract: a trade-off whereby each person surrenders some of his freedom for the sake of security – but no more freedom than is essential for this purpose. The laws must be clear, allowing no ambiguity or obscurity. Judges must observe the letter of the law, and not deliver arbitrary judgements in accordance with their own preferences, nor be allowed to exercise any discretion. A judgement should be a syllogism ('Murder is a crime with X penalty. The defendant has committed murder. Therefore, he must suffer X penalty'). Princes should not exercise the supposed virtue of clemency by issuing pardons or reducing penalties, because that makes the practice of law inconsistent.

Beccaria's approach to punishment is utilitarian.[285] The purpose of punishment is deterrence. Prevention would be better than punishment, but since there must be punishment, it should be no greater than is required for its deterrent effect. 'One who sees the same punishment of death, for instance, for the killer of a pheasant as for the killer of a man or for the forger of an important document, cannot see any difference among these crimes.'[286] The greatest crimes are those aimed at society or its representative, such as sedition and lese-majesty, followed by those which endanger the security of individuals.

As a means of punishment, Beccaria puts forward several arguments against the death penalty. First, the death penalty fails to deter people from crime. Criminals hope to avoid being caught, and when they are caught and executed, the mass of the population regards their execution merely as a spectacle. Intense punishments such as execution are soon forgotten by the public; to be impressive, a punishment needs to be prolonged, like penal servitude. People who see convicts doing forced labour, or know that they are confined in prison, can easily imagine themselves suffering the same fate if they were to commit the same crimes.

Secondly, the death penalty is excessively savage, and it perpetuates savagery in society. The legislator who prescribes the death penalty, and the judge who orders it, seem as savage as the murderer. Moreover, if executions are to have any effect, they must be frequent; but they can only be frequent if violent crimes are frequent, so executions perpetuate the savage condition which they are supposed to amend.

Thirdly, there is a common and deep-seated feeling that it is wrong: 'because, deep within their souls . . . men have always believed that no-one and nothing should hold the power of life and death over them but necessity, which rules the universe with its iron rod'.[287] This illustrates how Beccaria's utilitarianism is tempered by the need to work with the immovable facts of human nature.

Finally, Beccaria says that although people are supposed, under an implicit social contract, to have surrendered some freedom in return for the protection of the law, no one can give the state the right to kill him. In his brief discussion of Beccaria, Kant seizes on this argument and points out its weakness: I, the individual, do not give the state the specific right to kill *me*, but a *general* right of capital punishment. However, Kant hardly needs to argue against Beccaria, since his principle of retribution, the *lex talionis*, means that the punishment must match the crime; and though many crimes have to be punished not by identical but by roughly equivalent suffering, such as loss of money or honour, there can be no equivalent to death. Killing must be punished by death. In maintaining otherwise, Beccaria was misled, according to Kant, by 'the sympathetic sentimentalism of an affected humanity'.[288] Kant thus falls back on insult and engages no further with Beccaria's arguments.

Having disposed of the myth that harsh punishments deter people from committing crimes, Beccaria punctures several other legal myths. It is foolish to make people swear oaths, because a criminal will have no compunction about breaking an oath. It is not a good idea to forbid people to carry weapons, because only law-abiding people will obey this prohibition, thereby exposing themselves to violence from the criminals who arm themselves illegally. (This does not seem consistent: a society in which everyone carries weapons risks being the kind of savage society that Beccaria wants to relegate to the past.) And judicial torture, as part of an investigative procedure, should be abolished, for it is itself a punishment inflicted on people who have not yet been found guilty; a 'robust ruffian' will withstand torture whereas a weak innocent person will succumb to it; and people, including the innocent, will say anything to make the torture stop.[289]

It is essential, not that punishments should be severe, but that they should be prompt and certain. If a would-be criminal is sure that he will be caught, and if the punishment follows the trial quickly enough to be unmistakably connected with the crime, then deterrence will be achieved. 'The certainty of even a mild punishment will make a bigger impression than the fear of a more awful one which is united to a hope of not being punished at all.'[290]

Beccaria's essay is refreshing in its common sense, its humanity and its

freedom from moralizing. Some arguments, however, fail to convince. First, Beccaria wants every offence to carry a fixed penalty, in a kind of tariff, allowing no scope for judicial discretion. He rightly thinks it unjust that judges should be allowed to increase the severity of a punishment by an arbitrary order. But judicial discretion is often necessary in practice to mitigate the injustice that would arise from a one-size-fits-all application of law, and to take account of contingent circumstances.[291] Secondly, for punishment to have the reliable deterrent effect he wants, criminals would need to be virtually certain of being caught; but this would require a degree of surveillance unimaginable in the eighteenth century, and imaginable but undesirable now.

Thirdly, forced labour might in practice be neither humane nor useful. The use of forced labour by the enlightened Emperor Joseph II is not encouraging. Joseph, a utilitarian, believed that prison could and should be made unpleasant enough to be a more effective deterrent than the death penalty.[292] He usually found conditions in prison too mild. He insisted that prisoners should sleep in chains on straw pallets in unheated rooms and live on bread and water. Those who reported sick had the periods they spent in hospital added to the length of their sentence. In 1783 Joseph proposed that prisoners should make themselves useful by hauling barges up the Danube, sleeping at night in unlit underground bunkers with only air holes along the bank. Over 6 years, 721 out of 1,100 men died while hauling barges. Others did manual labour in chain gangs. Ignaz von Born, the Viennese Freemason and scientist, describes these chain gangs when recounting his mineralogical expedition to what is now Transylvania: 'Soon in the morning I was awakened by a dismal and frightful rattling of chains, which sounded all along the street where I have lodgings. It was occasioned by the malefactors, condemned to the fortifications, who, by couples chained together, went to work.'[293] This policy of forced labour was widely criticized for its inhumanity.[294] It could not be defended even on grounds of cost-effectiveness. For, if criminals are worked to death, they soon cease to be useful. Nor does utilitarianism require that their working conditions should be made gratuitously horrible. It seems more likely that in such cases utility is a mere pretext, and that criminals who receive such treatment are really being subjected, dishonestly and maliciously, to retribution.

Beccaria's treatise was admired by Voltaire, who was energized not only by the executions of Damiens and Jean Calas but also by the torture and execution of the chevalier de La Barre in 1766 for having allegedly defaced a crucifix. In the 1760s Voltaire wrote extensively on criminal law, including an anonymous essay on the La Barre case addressed to

Beccaria, a commentary on Beccaria's treatise, and a satirical dialogue, *André Des Touches à Siam* (1766), in which the absurd legal system of Siam is contrasted with the more humane one of neighbouring Laos (standing respectively for France and Britain).[295] Voltaire did not wholly reject capital punishment, but thought it better to make criminals serve society by doing forced labour, as Empress Elizabeth had ordained in Russia. Besides, he added, this was a good deterrent, since criminals generally feared hard work more than death.[296]

With their arguments, however, Beccaria and Voltaire were pushing at an open door. Beccaria's arguments against judicial torture had been made at intervals ever since the fifteenth century.[297] It was already becoming less frequent.[298] In Bavaria, the Court Council ordered torture in 44 per cent of cases in 1650, but only in 16 per cent in 1690; and in Rome, the highest criminal court ordered twenty-six defendants to be tortured in 1737, but only four in 1786.[299] The abolition of judicial torture (save in exceptional cases) was one of the first decrees made by Frederick the Great when he became king of Prussia in 1740; he abolished it entirely in 1754. It was abolished in Saxony in 1770, in Austria in 1776, in Sweden (where it had already fallen out of use) in 1786, in France in 1789, and in the Dutch Republic in 1795–8.[300] Legend has it that the Austrian Enlightener Sonnenfels went down on one knee before Maria Theresa to beseech her to abolish torture; given the temper of the times, however, he could have been more restrained. The abolition of both judicial torture and capital punishment by Leopold, grand duke of Tuscany from 1765 to 1790, has been plausibly credited to the influence of Beccaria.

While the abolition of torture was a self-evidently enlightened cause, the case against capital punishment was less straightforward. Besides the humane and pragmatic case against it (since a miscarriage of justice could not be remedied), there was an enlightened case *for* capital punishment, based on the conception of the 'moral sense' put forward, as we saw in Chapter 6, by Shaftesbury and Hutcheson. My moral sense tells me that I have done wrong, and exacts punishment by way of retributive justice. And when somebody else does wrong, my moral sense demands their punishment. In extreme cases, my moral sense demands the death penalty. Adam Smith maintains that punishment is 'agreeable to our moral faculties'.[301] This is not because I carry within me an angry Jehovah, demanding vengeance. It is because, first, I intuitively know that certain actions are gravely wrong and need to be punished; and second, because my natural sympathy takes the side of the victim. Smith dismisses utilitarian arguments for punishment: 'It is to be observed that our first approbation of punishment is not founded upon the regard to public utility which is

commonly taken to be the foundation of it. It is our sympathy with the resentment of the sufferer which is the real principle.'[302] The Scottish legal philosopher Lord Kames similarly starts his history of criminal law by arguing that humanity naturally feels that crimes deserve to be punished, and that the perpetrator feels this too:

> Upon certain Actions, hurtful to others, the Stamp of *impropriety* and *wrong* is impressed in legible characters, visible to all, not excepting even the Delinquent. Passing from the action to its Author, we feel that he is *guilty*; and we also feel he ought to be punished for his guilt. He himself, having the same feeling, is filled with remorse.[303]

This view at least acknowledges the moral autonomy of the criminal, whereas the utilitarian view risks treating him merely as material to be used for the benefit of the state.

By the late eighteenth century, however, enlightened opinion favoured reforming and utilitarian approaches to punishment. Both aims, it was increasingly thought, could be achieved by confining convicted criminals in prison. Beccaria and Voltaire were neither original, nor necessarily humane, in advocating forced labour instead of capital punishment. Condemned criminals had long been rowing galleys and building roads. In bridewells and houses of correction, they were supposed both to serve the community by doing useful labour and become reformed characters by discovering the advantages of hard work.

Before prisons could serve these ends, they needed themselves to be drastically reformed.

The greatest credit for prompting prison reform belongs to John Howard. As high sheriff of Bedfordshire, Howard's duties included supervising the county gaol. The abuses he found there induced him to inquire further into prisons. Eventually he made a tour of all the prisons in Britain – and many on the Continent – visiting some more than once to check his facts, and often using persistence and ingenuity to gain admittance. His report, published in 1777 as *The State of the Prisons*, deals both with bridewells or houses of correction, where vagrants and petty criminals were kept, and county gaols, which housed serious offenders and debtors. Debtors in fact made up the majority of prisoners: for the spring of 1776, Howard calculated that there were in all the prisons of England and Wales 4,084 prisoners, of whom 2,437 were debtors.[304] Debtors often increased the prison population yet further by bringing their wives and children with them, as they had nowhere else to go. It was easily forgotten that for debtors, and prisoners awaiting trial, the purpose of confinement was not punishment, merely custody.

Most prisons were hellholes. Few were purpose-built. Men and women, old and young, debtors and felons were all kept indiscriminately together. Young prisoners learned about crimes from old ones; hardened criminals plotted new crimes to be committed on their release; all spread disease; many died of 'gaol fever' (epidemic typhus, transmitted by lice). They were supplied with a pennyworth or, at most, tuppence-worth of bread a day. Water was available only when the gaoler bothered to bring it. There was no medical attention, no fresh air, often no sewers for waste disposal. New arrivals were required to pay 'garnish' to obtain basic necessities, and if they had no money they had to surrender some of their clothing. Even in bridewells, intended as workhouses, little or no work went on, because the prisoners had no tools. The main occupation was gambling. Some inmates were kept in chains, and if their trial was held at a distance from the prison, they might have to walk several miles with heavy irons chafing their legs. The release of prisoners normally took place only on a single appointed day of the year.

When one has read Howard's sober account, one is less surprised by the famous case of Richard and Bridget Smith, who in 1752 killed themselves and their child, leaving a note in which they explained that, being confined for debt with no hope of freedom, 'the Nature and Reason of things' justified their suicide.[305] Their deaths contributed to a moral panic about the evils of deism, though it would have been more justified to worry about the evils of imprisonment for debt.

Howard, inspired by reading Beccaria, campaigned for better prison conditions.[306] He proposed that a county gaol should be in a healthy situation, near running water; it should have a courtyard for exercise with pumps to provide water, a separate small bedroom for each prisoner, and an infirmary. Debtors should be kept separate from felons, and men from women. The gaoler should be adequately paid and should not be able to profit by selling alcohol to prisoners.

Extortion by the gaoler was in fact one of the principal hardships to which prisoners were subjected. Prisoners had to pay for their food, and, if well-to-do, could pay for better food and more secluded accommodation. Debtors were supported, no doubt meagrely, by their creditors. The destitute had to starve or beg. London's Fleet Prison, for example, had a begging grate giving onto Fleet Market, where a prisoner could beg from passers-by; but (in the early nineteenth century) access to the grate itself cost the prisoner one shilling and sixpence.[307]

Late in life Howard witnessed an extensive prison reform. Between 1775 and 1795 at least forty-five reformed prisons were created. But although cleanliness and ventilation were improved, the circumstances of

prison life had not changed significantly by the early nineteenth century. In the chapters of *The Pickwick Papers* (1837) set in the Fleet Prison, Dickens, whose father had been imprisoned for debt, and who often visited prisons, gives a picture little different from Howard's. Moreover, in the 1780s the prison population in Britain grew rapidly, because the end of the American war released large numbers of demobilized soldiers into unemployment and crime, and the loss of colonial markets brought about a trade depression. In 1770 there were 4,084 prisoners in England and Wales; by 1790 there were 7,482.[308]

Other forms of confinement were also adopted. Some criminals were placed in abandoned warships, or 'hulks', moored near naval bases; by 1787 some two thousand convicts were employed in these bases, going ashore in chain gangs to dig sand for ships' ballast or build new dockyard facilities. It was unhealthy work: in the early years when hulks were operating, the death rate was almost one in four.[309] As convicts could no longer be sent to the American plantations, the Transportation Act of 1784 provided for them to be sent anywhere in the world. An experiment with transportation to the Gambia was unsuccessful, as most inmates died. Joseph Banks, who had sailed to Australia with Captain Cook, suggested transportation to New South Wales, and in May 1787 the first shipload of convicts set off, very reluctantly, for Botany Bay, where they arrived in January 1788.[310] Conditions in the Australian settlements, especially in Van Diemen's Land (Tasmania) and Norfolk Island, were a fair anticipation of the Soviet Gulag. But that is another story.[311]

In the planning of new prisons, whenever the aim of reform was uppermost, we can detect two tendencies. One was to treat the prisoner as a responsible moral being who could be led by reflection to repent of his misdeeds and mend his ways. The other was to disempower and manipulate the prisoner in order to make him, willy-nilly, into a useful member of society.

Howard upheld the first tendency. A Nonconformist, he was motivated by intense religious convictions. Believing himself to be a redeemed sinner, he was convinced that prisoners too could be redeemed. As Michael Ignatieff points out, many other campaigners for prison reform were Nonconformists; some were Quakers.[312] The thrust of Ignatieff's argument seems to be that their own commitment to self-discipline, which in Howard's case took the form of extreme asceticism, encouraged them to propose strict disciplinary regimes in prisons.

The disempowering tendency owed much to the materialist *philosophes* such as La Mettrie, and to English empiricists such as Locke and his disciple David Hartley. Humanity had no innate character. People could be

transformed by an external discipline that, working on the body, would gradually acquire the force of habit and imprint itself on the mind. This is what Jeremy Bentham meant when he described his ideal prison as 'a mill for grinding rogues honest, and idle men industrious'.[313]

Both tendencies attached great value to solitary confinement. In contrast to the constant uproar of old-fashioned, crowded gaols, the reformed prisons should leave the prisoner alone with his thoughts, which, reinforced by regular visits from clergymen, were bound to lead him to repentance. 'The idea of being excluded from all human society, to converse with a man's own heart,' opined the philanthropist Jonas Hanway, 'will operate potently on the minds and manners of the people of every class.'[314] To avoid corruption through bad company, communication with other prisoners should be kept to a minimum. However, there were pitfalls. Both Howard and Bentham warned that solitude could lead to paralysing depression.[315] And magistrates were too ready to place minor offenders in solitary confinement, on the grounds that they were more likely to be reformed than hardened criminals. In 1792 a tract entitled *Gloucester Bastille!!!* accused the Gloucestershire justices of sentencing a sixteen-year-old boy to solitary confinement for stealing some clothes.[316]

New prisons tended to separate their inmates not only from each other but also from the rest of society. Old prisons had not been any specific type of building. Prisoners might be confined in old castles, houses modelled on lodging-houses, the gatehouses of city walls, disused chapels, or just strong rooms above a shop or an inn. New prisons were built at a distance from towns. Being provided with necessities, prisoners did not need to beg, and it was harder for their families and friends to visit them. The prison assumed the character of a 'total institution', whose inmates underwent a transformation.[317] On arriving, they were stripped, washed, given a medical check, had their heads shaved and were put in prison uniform. All these measures separated them from their previous lives and weakened their sense of individuality.

Reformed prisons had to be secure and salubrious. For security, prisons were often built with wings radiating from a central hub where the governor lived, thus subordinating everyone symbolically – as well as in reality – to the central authority.[318] For salubrity, they were well ventilated, and were often 'large colanders jacked up on stilts, ventilated by the percolation of air into a uniformly porous container', and hence cold and draughty.[319] Prisoners slept in individual cells, and sometimes worked there during the day on solitary tasks, instead of in communal workrooms.

In independent America, matters were taken even further. The chemist Benjamin Rush led a campaign for solitary confinement with hard labour,

which resulted in 1790 in the building of the solitary block at Walnut Street in Philadelphia, and in 1821 in the establishment of a larger penitentiary in which solitary confinement was the rule. Although the story of the Philadelphia penitentiary lies beyond the temporal scope of this book, it deserves mention here, since an extract from its regulations forms part of the arresting introduction to Foucault's *Discipline and Punish*.[320] It was denounced by Dickens, who wrote: 'I hold this slow and daily tampering with the mysteries of the brain, to be immeasurably worse than any torture of the body', and used by Schopenhauer to illustrate the tortures induced by boredom.[321] It represents an extreme and self-defeating perversion of the reformist approach to punishment.

The most famous utilitarian project is one that was never realized – Jeremy Bentham's Panopticon. He first proposed such a prison in 1791, but his campaign ended in disappointment when Parliament rejected the idea in 1811. Bentham's plans for the Panopticon underwent some changes, but in the scheme drawn up for him in 1791, the governor's house, at the centre, looked out onto a ring of inspection passageways and thence onto a circle of 192 cells, four storeys high; the passageways were patrolled by turnkeys watching the prisoners, and the governor, in his central chamber with apertures on all sides, watched the turnkeys and the prisoners.[322] The whole thing was a self-contained state, even 'an artificial universe, an enclave of reason and order within a larger society still hopelessly irregular and ectopic'.[323] Since the governor saw everything without being seen, it was a fantasy of godlike omniscience and omnipotence.

The Panopticon was also conceived as a commercial enterprise. Bentham proposed to run the prison himself and set the convicts to labour up to fifteen hours a day. As the convicts would not be paid, but would receive only basic subsistence, their labour would be highly profitable. It would thus conform to the demands of Bentham's calculated happiness. The pain inflicted on the prisoners would be outweighed by the pleasure arising from their labour for the governor, who would sell their products, and the public, who would buy them. This plan for private enterprise proved the sticking point for Parliament, who did not think the Panopticon should be operated by a private individual.[324] They heeded the objections raised by the prison reformer George Onesiphorus Paul, who argued that Bentham offered no safeguard against corruption and exploitation. So Parliament rejected the idea of turning prisons into profit-making enterprises, and insisted that the prisoners' well-being should be protected by bureaucratic regulation.[325]

Bentham thought his 'inspection principle' could be adapted to every kind of institution where the inmates had to be supervised.[326] Lunatics in

solitary cells would not need to be restrained by chains, nor annoy others by their raving. If hospital patients were under central observation, doctors could check that their instructions were being followed. This example, adds Bentham, shows 'how far this plan is from any necessary connection with severe and coercive measures'.[327] In factories, workers would be prevented from falling behind schedule or distracting each other from work. Bentham even suggests that the system could be extended to schools, so that pupils could neither copy each other's work nor corrupt each other's morals. In this section, however, Bentham falls into a defiantly flippant tone, as though foreseeing how unpopular such proposals would be. Rousseau, he says, would certainly reject such an educational method for his Émile, but it would be suitable for his Sophie. And if we recall how restrictive an upbringing Rousseau proposes for Émile's destined bride, we must admit that Bentham has here scored a point, albeit against himself.

However, the chapter on schools brings out an essential incoherence in Bentham's project. He formulates many possible objections to his imagined schools, culminating in these: 'Whether the liberal spirit and energy of a free citizen would not be exchanged for the mechanical discipline of a soldier, or the austerity of a monk? And whether the result of the high-wrought contrivance might not be constructing a set of *machines* under the similitude of *men*?'[328] To this entirely valid objection Bentham has only the lame and sanctimonious reply: 'Call them soldiers, call them monks, call them machines, so they were but happy ones, I should not care.'[329] However, happiness has only occasionally been mentioned as a by-product of the inspection principle. The main emphasis has been on efficiency. And it is clear from Bentham's proposals that happiness and efficiency can only be reconciled if the human being undergoes a kind of lobotomy, wholly incompatible with the 'energy of a free citizen'. This strand of the Enlightenment is no longer concerned with the pursuit of happiness, but with adapting human beings to the requirements of an industrial economy. It is salutary to remember that at the same period another wing of the Enlightenment, represented, as we have seen, by Schiller's *Aesthetic Letters*, was trying to maintain an understanding of the human being as an indivisible whole.

# 9

# Aesthetics

Consistent with its emphasis on happiness, the Enlightenment regarded art as a major source of pleasure. In doing so it could appeal to the authority of Aristotle, who speaks of the pleasure arising from imitation (*mimesis*), and elsewhere of the pleasure that arises from having one's curiosity first aroused and then satisfied.[1] Hence the eighteenth-century aesthetician Charles Batteux, having separated off the 'mechanical arts' which serve practical purposes, can say: 'Pleasure is the goal of the other arts. They could originate only in the bosom of joy and other feelings that arise from abundance and tranquillity.'[2]

However, the apparently simple statement 'art gives pleasure' takes a huge amount for granted. First, it presupposes that there is such a thing as art: that literature, painting, sculpture, architecture and music all have something essential in common. Yet such a concept came into being only in the Enlightenment. Batteux, who was highly influential in establishing it, begins his treatise cautiously by speaking only of 'the arts', not yet of 'art'. Only once the concept of art existed could there develop a branch of philosophy concerned with art and called 'aesthetics'.

Secondly, it was not clear that art, or the arts, could or should provide pleasure alone. Another classical authority, Horace, insists that poetry should combine pleasure with truth and thus serve a useful purpose:

> A Poet should instruct, or please, or both: . . .
> But he that joins Instructions with delight,
> Profit with Pleasure[,] carries all the votes.[3]

Instruction could be practical. In Roman times, Lucretius used poetry to explain the nature of the universe. In the eighteenth century it was perfectly acceptable to use verse to describe pleasingly and memorably the brewing of cider, the cultivation of sugar-cane, or the pollination of plants.[4] Often, however, instruction was understood as moral instruction. Works of art with no moral purpose could easily seem frivolous or

immoral. The idea developed only gradually that art could be justified in its own right, with or without a moral purpose; or, alternatively, that there was something moral in the experience of art as such.

Exploring these questions, the Enlightenment is dominated by two broad schools of aesthetic thought. Ernst Cassirer, in his study of Enlightenment philosophy – the only general book on the Enlightenment to devote a major chapter to aesthetics – maintained that the transition from the first to the second corresponded to the change in scientific method between Descartes and Newton.[5] The first, the aesthetics of neoclassicism, appealed to reason to provide timeless standards of beauty and truth. It placed its emphasis on the production of art by means of immutable rules. Although neoclassicism retained considerable authority throughout the eighteenth century, it was modified and eventually displaced by the second school: an aesthetic philosophy that, in the empirical spirit of Newton and his contemporaries, inquired into the actual effect works of art had on their readers, spectators or hearers. This aesthetics was oriented more to the reception of art and drew heavily on psychology.

## ARTS, ART, AESTHETICS

The ancient world had no conception, either of art as such, or of the 'fine arts' in contrast to other activities.[6] The Greek word *techne* and the Latin *ars* meant skill or craft. We still often use 'art' to mean skill or technique (as in the much-parodied book title *The Art of Coarse Fishing*). Poetry, oratory and music were considered wholly distinct from the crafts of painting, sculpture and architecture. The latter were looked down on because they required manual labour, which the ancients held in low esteem. Even in the early Italian Renaissance, many centuries later, artists were considered craftsmen and organized in guilds like other craftsmen; sculptors and architects belonged to the same guild as stonemasons and bricklayers. For the medieval theologian Thomas Aquinas, shoemaking, cooking and juggling are just as much *artes* as poetry and music.[7]

Very gradually, a concept developed, first of the 'liberal arts', then of the 'fine arts'. Martianus Capella, an allegorical poet of the fifth century CE, defined the liberal arts in his poem *De nuptiis Philologiae et Mercurii* (*The Marriage of Philology and Mercury*) as grammar, rhetoric, dialectic, arithmetic, geometry, astronomy and music.[8] This scheme, which remained authoritative for many centuries, omits painting and sculpture, includes poetry only by implied association with rhetoric, and encompasses several subjects that now count among the sciences. In medieval universities, the

liberal arts were divided into the Trivium (grammar, rhetoric, dialectic) and the Quadrivium (arithmetic, geometry, astronomy and music); all these were preliminary to the study of philosophy, medicine, jurisprudence and theology. The 'fine arts' of painting, sculpture and architecture were grouped together by Giorgio Vasari in his biographies of Renaissance artists (1550), under the heading *arti del disegno*. Two of these arts were cultivated by the French Académie Royale de Peinture et de Sculpture, founded in 1648, and all three by the French Academy in Rome, founded in 1666. Other academies were devoted to different arts: the Académie Française to the cultivation of language and literature, others to Architecture, Music and Dance, while the Académie des Sciences and the Académie des Inscriptions et Médailles served non-artistic purposes.[9]

The arts of poetry, music, painting, sculpture and dance were finally discussed together by Batteux in 1746. Having distinguished the merely mechanical arts, and those – notably eloquence and architecture – which were both pleasurable and obviously useful, he argues that the fine arts are linked by a single overriding principle, that of imitation. To add authority to his view, he cites well-known passages from Plato, Aristotle and Horace, although these apply only to some of the arts in his group.

However, in Batteux's view, art does not simply copy nature; it presents an idealized version of it. 'The arts do not imitate slavishly. Rather, they are selective about the objects and properties that they represent and these are represented in the best possible light. In short, the arts present an imitation of reality, not as it is in itself, but as the mind conceives it ought to be.'[10] The arts imitate not just nature but beautiful nature, *la belle nature*:

> So painting imitates *belle nature* by means of colours, sculpture by means of three-dimensional figures, and dancing by movements and attitudes of the body. Music imitates nature by means of inarticulate sounds, and, finally, poetry by means of rhythmic speech. These are the distinctive characteristics of the principal arts.[11]

By placing architecture in a different category, Batteux avoids the difficult question of what (if anything) it imitates.

At the same time as Batteux was constructing a unified theory of the arts, the German philosopher Alexander Gottlieb Baumgarten was composing a philosophical theory of beauty and thus founding the discipline of aesthetics. Baumgarten was a disciple of Leibniz and of Leibniz's German follower Christian Wolff. Leibniz maintained that ideas formed a continuous chain, or hierarchy, from the obscure to the immediately distinct or intuitive. Sensory perceptions came near the bottom of the chain,

abstract concepts near the top. Somewhere in between came the experience of beauty: too intellectual to be merely sensory but falling a long way short of abstraction. Leibniz called this form of knowledge *cognitio clara et confusa*, meaning 'clear and complex [not 'confused'] cognition'. Wolff more disapprovingly spoke of 'obscure' or 'dark ideas' and denied that they had any cognitive content.[12] Baumgarten, building on Leibniz's hint, found a way to reclaim such experiences as a kind of knowledge. He called them 'sensitive representations' and named the study of them 'aesthetics' (a branch of psychology, which would only later develop into the study of art). His Latin lectures, published in 1750 as *Aesthetica*, began (and his exact wording is important): 'Aesthetica (theoria liberalium artium, gnoseologia inferior, ars pulchre cogitandi, ars analogi rationis) est scientia cognitionis sensitivae.' ('Aesthetics (the theory of the liberal arts, the study of the lower faculties of perception, the art of beautiful thinking, the art which is) analogous to reasoning) is the science of sensory knowledge.')[13]

The concept of beauty reappears when Baumgarten defines the purpose of aesthetics as 'the perfection of sensory knowledge as such; and this is beauty'.[14] He thus moves away from the old idea, associated especially with Plato, that beauty may be a property of the object: that things are beautiful in themselves. For Baumgarten, the sense of beauty is something that we bring to objects. It is a matter of the way we perceive them. To understand the beautiful, you have to look first at the person perceiving beauty, only then at the object perceived. Certainly, there has to be a relation between the two: not just anything can be perceived as beautiful. But to understand beauty, you have to look first and foremost at the subjective end of the relation.

Baumgarten not only introduced subjectivity into the discussion of art but added some concepts that would have a long life in aesthetic theory. One is the notion of harmony: 'The universal beauty of sensory knowledge is (since we cannot perceive the signified without signs) the internal harmony of signs, both in their order and in the things themselves.'[15] Another is that of fiction or feigning. He distinguishes between metaphysical truth, which is objectively true, and aesthetic truth, which is 'the representation of objective truths in a given soul', hence subjective truth. He gives the example of advice handed out by a character in a play, which is very different from the advice based on strict reasoning given by an ethical philosopher.[16] (Baumgarten gives no specific instances, but it would follow that the advice given by Polonius to his son in *Hamlet* is not only a set of precepts but also an insight into Polonius' character.)

# CARTESIAN AESTHETICS: NEOCLASSICISM

Batteux and Baumgarten stand on the cusp between the older aesthetics of neoclassicism and a new aesthetics allied to the empirical study of the reader's or spectator's psychology. Batteux is a late representative of an aesthetic doctrine which was formed in Renaissance Italy, fully developed in Louis XIV's France, and lingered in the theories of Goethe and Schiller in 1790s Weimar. Though neoclassical theorists constantly appealed to Aristotle, Horace and other ancient authorities, they often misinterpreted their sources and adapted them, perhaps unwittingly, to the specific circumstances of their own day.

Although Descartes did not write about the arts, and aesthetic theorists were not directly influenced by Descartes, the parallel between their endeavours is striking. As we saw in Chapter 1, Descartes wanted to found knowledge on clear and distinct ideas; the first being the certainty of one's own existence, the second being the certainty that God exists. From this basis Descartes derives the universal truths of logic, mathematics and geometry. In a similar way, neoclassical theorists assume the primacy of reason. Thus Boileau, in his authoritative verse treatise on poetics, enjoins:

> Aimez donc la Raison. Que toûjours vos écrits
> Empruntent d'elle seule et leur lustre et leur prix.[17]

> [Love Reason. Let your writings always borrow their lustre and their value from her alone.]

Boileau's reason, however, is not the logical faculty of Descartes; he equates it with 'good sense'. It is also equated with nature, an omnipresent but multivalent term. Boileau tells his readers never to deviate from nature ('Jamais de la Nature il ne faut s'écarter'),[18] and Pope urges his to follow nature:

> *Unerring Nature*, still divinely bright,
> One *clear, unchang'd*, and *Universal* Light.[19]

Nature is not what we call 'the natural world', nor the empirical world of people, animals and objects. It is rather 'the nature of things', the rational and intelligible character of the world as designed by God.[20] Extended to humanity, 'nature' refers not to the enormous diversity of observable people, but to the deep-seated and permanent features of human nature. These features can be known from our experiences of individuals; but the

business of art is not to portray individuals, but types – even if they bear the name or likeness of an individual. 'Nothing can please many, and please long,' says Samuel Johnson, 'but just representations of general nature.'[21] Thus Molière's Harpagon in *L'Avare* is a typical miser, whereas, two centuries later, George Eliot's Silas Marner is a miserly individual. We learn how Marner's character was formed and we see his better self emerging under the influence of love; but Harpagon does not and cannot change.

In being faithful to nature, in this sense, the poet is also faithful to truth. Truth must always be the aim, even if the form chosen is blatantly fictional:

> Rien n'est beau que le Vrai. Le Vrai seul est aimable.
> Il doit regner partout, et mesme dans la fable:
> De toute fiction l'adroite fausseté
> Ne tend qu'à faire aux yeux briller la Vérité.[22]

[Nothing is beautiful but the True. The True alone is pleasing. It should reign everywhere, even in fables: the skilful falsehood of all fiction only helps the Truth to become more radiant in our eyes.]

However, this is not factual truth, but ideal truth, corresponding to the timeless nature of things. Neoclassical critics constantly repeat the ancient truism that the arts imitate nature, though it was Batteux who applied this principle to the arts most systematically. Batteux agrees with his predecessors in maintaining that the arts do not imitate the empirical world around us but a selective and idealized version of nature. He recounts the ancient anecdote about the painter Zeuxis, who combined the features of several real women to represent an ideally beautiful woman, and adds that Molière, when writing *Le Misanthrope*, combined the features of several gloomy people to create Alceste, who is not an individual but a representation of misanthropy:

> These two examples suffice to give us, in passing, a clear and distinct idea of what is called *belle nature*. This is not the reality that is; rather it is the reality that could be, the truly beautiful, which is represented as if it actually existed, with all of the perfections which it could have.[23]

This principle of idealization reappears in the late-Enlightenment aesthetics of Weimar Classicism. In 1789, reviewing the demotic poems and ballads of Gottfried August Bürger, Schiller complains about their use of vulgar colloquial expressions, asserting: 'One of the first requirements of the poet is idealization, ennoblement, without which he ceases to deserve his name.' Idealization consists in stripping local and particular

circumstances from his subject matter and bringing it closer to the 'internal ideal of perfection that dwells in the poet's soul'.[24]

The neoclassical poet, committed to universal reason and nature, applies their precepts by following objective laws known as 'the rules'. These laws are an unchangeable part of the nature of things.

> Those Rules of old discover'd, not devis'd,
> Are *Nature* still, but *Nature Methodiz'd*.[25]

Not, of course, that anyone could become a great artist simply by following the rules. 'Could we teach taste and genius by rules,' opined the neoclassical painter Sir Joshua Reynolds, 'they would no longer be taste and genius.'[26] The most ardent proponent of the rules, Jean Chapelain, was also the author of an epic poem notorious for its tedium.[27] Pope satirized such mechanical composition in 'A Receit to make an Epick Poem' (1713), which purports to show 'that Epick Poems may be made *without a* Genius, nay without Learning or much Reading'.[28] For someone with the indispensable inspiration, however, the rules determine what can be expressed in each genre. Tragedy, epic, comedy and song each have their own purposes and their range of expression. They are like natural species (which, before Darwin, were likewise thought to be immutable). Generic mixtures are unnatural, like hybrid species.

Hence neoclassical critics disapproved of Shakespeare for mingling comedy with tragedy. Voltaire complains of his 'monstrous Farces, to which the name of Tragedy is given'.[29] Hume agrees, more mildly: 'In his compositions, we regret, that many irregularities, and even absurdities, should so frequently disfigure the animated and passionate scenes intermixed with them.'[30] And Lord Chesterfield deplores Shakespeare's lack of education: 'If Shakespeare's genius had been cultivated, those beauties, which we so justly admire in him, would have been undisgraced by those extravagancies and that nonsense with which they are frequently accompanied.'[31]

In retrospect the neoclassical doctrine of genres, despite its rigidity, shows a sensitivity to the potential of literary forms which it is nowadays hard to recapture.[32] In other ways, however, the rules, far from being timeless, can now be seen to result from particular historical circumstances. The famous doctrine of the three unities, which in its most extreme form held that in order to be credible a play should present a single action, lasting one day, and all set in one place, rests on a sixteenth-century misunderstanding of Aristotle by the literal-minded Italian critic Lodovico Castelvetro.[33] Johnson, despite his sympathy with many neoclassical precepts, treated it with understandable scorn: 'The truth is, that the spectators are always in their senses, and know, from the first act to the last, that the

stage is only a stage, and that the players are only players.'[34] The doctrine of decorum, or *bienséance*, is derived in large part from the manners of seventeenth-century Paris; Boileau advises his readers to be familiar with the court and the city ('Etudiez la Cour, et connoissez la Ville'), as though they represented the whole of humanity.[35] 'Unnoticed,' remarks Cassirer, 'decorum has superseded nature, and convention truth.'[36]

Another problematic neoclassical doctrine was that of *vraisemblance*, probability or verisimilitude. Such resemblance to truth was not at all the same thing as truth. When Corneille's critics objected to the improbability of his play *Héraclius* (1647), they were not satisfied by his affirmation that the events in the play had really happened.[37] A more typical view was that of the abbé d'Aubignac, who thinks that the theatre cannot deal with the true – because many true things cannot be shown – nor with the possible – because many ridiculous or incredible things *could* happen – but with the 'vraisemblable'.[38] In Corneille's most famous tragedy, *Le Cid* (1636), the heroine ends up marrying the hero, although earlier he has killed her father; this gave rise to an immense dispute on the grounds that no decent woman would behave like that and therefore the play's ending was *invraisemblable* and unnatural.[39]

A sketch of neoclassical poetics can easily make them sound artificial, stilted, limiting and even absurd. That would be unjust. Admittedly, one would not want to defend the rigid doctrine of the unities. But, confining ourselves to the theatre, we can see that the five-act structure (inherited from the Roman dramatist Seneca), the compressed action and the homogeneous style enabled Racine to compose masterpieces of tense dramatic concentration, and imposed a salutary discipline on lesser but substantial dramatists such as Voltaire or James Thomson. Thomson's earliest tragedy, *Sophonisba* (1730), is an intensely passionate play, written not in monotonous declamations but in vigorous blank verse with some fiery dramatic confrontations. It is undeservedly notorious for the line 'Oh! *Sophonisba! Sophonisba!* Oh!', which inspired a wag on the first night to call out 'Oh, Jamey Thomson, Jamey Thomson Oh!' and was soon parodied by Fielding in *The Tragedy of Tragedies, or the Life and the Death of Tom Thumb the Great* (1731), as 'Oh! *Huncamunca, Huncamunca,* oh!'[40] Yet Thomson's line, the climax of an impassioned soliloquy, is effective and even powerful in its context. No less a critic than Lessing, in his introduction to a German translation of Thomson's tragedies, praises him for possessing in the utmost perfection 'the magic art of letting every passion develop, grow, and break out before our eyes.'[41] There were good reasons why neoclassical drama proved to be such a durable genre.

In the mid-eighteenth century, neoclassicism received a new lease of life

from the art historian Johann Joachim Winckelmann. A schoolmaster in
Saxony and a self-taught Greek scholar, Winckelmann learned to navigate
the world of patronage – the eighteenth-century equivalent of today's
grant-awarding bodies – with great skill.[42] A stipend from the Saxon court
enabled him to move to Rome in 1755, just after publishing his short but
epoch-making essay, *Gedanken über die Nachahmung der griechischen
Werke in der Malerei und Bildhauerkunst* (*Thoughts on the Imitation of
Greek Works of Painting and Sculpture*, 1755). In Rome he became librar-
ian to Cardinal Alessandro Albani, the city's greatest collector of
antiquities, who enabled him to write a monumental *Geschichte der Kunst
des Alterthums* (*History of Ancient Art*, 1764). While still in Saxony,
Winckelmann studied deeply the literature of the French Enlightenment,
and his aesthetic criteria owe much to French classicism.[43]

As a critic of classical art, Winckelmann held up the Greeks as the
nation who had come closest to a timeless aesthetic ideal. In the manner
commended by Batteux, by selecting and combining the best features from
various bodies, they produced images of the human form that reflected
the ideal. The hallmark of the finest Greek statues is beauty of soul, as
Winckelmann says in a much-quoted and hugely influential passage:

> The general outstanding feature of Greek masterpieces is finally a *noble
> simplicity* and *quiet grandeur*, both in posture and expression. As the
> depths of the sea always remain calm, however much its surface may rage,
> so the expression of Greek figures, despite their passions, reveals a great
> and composed soul.[44]

The great modern artists, among whom Winckelmann counts Raphael
and Michelangelo, followed the Greeks not by imitating their work dir-
ectly, but by going back to the ideal source of beauty. Hence Winckelmann's
paradoxical precept: 'The only way for us to become great, indeed inim-
itable, is the imitation of the ancients, and what someone said about
Homer, that whoever has learnt to understand him also learns to admire
him, applies also to the works of art produced by the ancients, especially
by the Greeks.'[45]

As a historian, Winckelmann broke with the custom of regarding Greek
culture as a homogeneous unit. The *History* places Greek art within a
historical scheme, and distinguishes a historical development within Greek
art itself. Winckelmann's first three chapters describe the art of the Egyp-
tians, Phoenicians, Persians and Etruscans. Turning to Greece, he
elaborates his earlier account of the preconditions of Greek art: the Greeks
had not only a pleasant climate and physical culture which produced
beautiful bodies, but also enjoyed political freedom and gave artists an

Johann Winckelmanns,

Präsidentens der Alterthümer zu Rom, und Scrittore der Vaticanischen Bibliothek,
Mitglieds der Königl. Englischen Societät der Alterthümer zu London, der Maleracademie
von St. Luca zu Rom, und der Hetrurischen zu Cortona,

# Geschichte der Kunst
## des Alterthums.

## Erster Theil.

Mit Königl. Pohlnisch- und Churfürstl. Sächs. allergnädigsten Privilegio.

Dresden, 1764.
In der Waltherischen Hof-Buchhandlung.

Winckelmann's *History of Ancient Art* (1764) was the first study to distinguish periods in ancient art history.

honoured place in their society. Their art passed through four stages: the early style, powerful but hard; the grand or high style, achieved with Phidias; the beautiful style, which softens the high style by adding 'grace' or 'loveliness'; and finally an imitative style, when, as all ways of representing gods and heroes had been exhausted, artists had to fall back on imitating their predecessors and adding trivial elaborations.

The arguments of the *History* were supported by Winckelmann's other writings and, in particular, by the rediscovery of the gigantic Greek temples at Paestum, which Winckelmann was the first German to see and describe. His enthusiastic response to Paestum contrasts with the frosty reactions of other travellers, for whom the temples did not match their narrow conceptions of Greek art. James Adam, visiting Paestum in 1761, found them 'inelegant'.[46] Goethe, reaching them after an arduous journey through marshes frequented by water buffalo, could not at first accommodate them within a view of classical architecture defined by Palladio: 'Our eyes and, through them, our whole sensibility have become so conditioned to a more slender style of architecture that these crowded masses of stumpy conical columns appear offensive and even terrifying.' However, after an hour or so of walking among the temples (free from the restrictions imposed on present-day tourists), Goethe felt reconciled to them and attuned to 'the age with which this architecture was in harmony'.[47]

Winckelmann thus made possible a deeper, more historical appreciation of the ancient world. His 'noble simplicity and quiet grandeur' also set a standard for neoclassical art in various media. The composer Christoph Willibald Gluck argued for 'noble simplicity', free from 'superfluous ornament', in the dedication to his opera *Alceste* (1769).[48] The sculpture of Antonio Canova similarly aims at 'a new style, revolutionary in its severity and uncompromising in its idealistic purity'.[49] And the paintings of Jacques-Louis David, especially *The Oath of the Horatii* (1784–5), show heroic figures in simple, emphatic poses, expressing single-minded patriotic devotion.[50] A few years later David would be active in the French Revolution, whose orators, as we shall see in a later chapter, drew extensively on classical imagery and exemplars from the Roman Republic. David's grand and resolute images helped to furnish their imaginations.

## TASTE

The concept of taste provides a bridge between the Cartesian aesthetics of neoclassicism and the Newtonian aesthetics based on empirical inquiry. To neoclassicists, taste seemed objective and timeless. The canon of great

authors was firmly established. If you did not appreciate Homer, the fault lay not in Homer but in you and your imperfect or depraved taste. The ancients had laid down standards of beauty that, like reason, were valid for all times and all places. Racine stated calmly: 'Good taste and reason were the same in all centuries. The taste of Paris has proved consistent with that of Athens.'[51]

This confident universalism readily provokes the suspicion that its proponents were claiming general validity for standards that were really shared only by a small elite. The aristocrat Charles de Saint-Évremond advocates a refined taste, marked by 'délicatesse' and 'esprit', which can only be acquired by mixing with those who already have it.[52] Thus taste depends on moving in the right social circles. But how is one admitted to these circles if one doesn't already have refined taste? Presumably by virtue of one's social rank. More boldly still, it may be claimed that only Europeans have good taste, and non-European civilizations, with different aesthetic standards, are hopelessly benighted. It was a commonplace that Orientals in all ages had bad taste. Hence Turgot says that among the Greeks, 'taste had succeeded in banishing those piled-up figures of speech, those gigantic metaphors, for which the poetry of the Orientals is criticized'.[53] Voltaire's article on taste in the *Encyclopédie* asserts that there are large territories (clearly meaning the Muslim world) where taste is absent: 'There are vast areas that *taste* has never reached; they are those where society has not been improved, where men and women have nothing in common, where the arts, such as the sculpture and painting of animate beings, are prohibited by religion.'[54]

Many writers, however, concede that taste can be acquired. A few people are wholly without it, like the mathematician who enjoyed nothing about the *Aeneid* except plotting Aeneas' journeys on a map of the Mediterranean.[55] In all those who are capable of it, it needs to be cultivated by assiduously reading and thinking about the best writers. The critic can perform a useful task by teaching people to appreciate the beauties of great works. Hence Addison offers readers of the *Spectator* a detailed examination of *Paradise Lost*. The critic ought also to oppose the bad taste that is often prevalent. Several correspondents are said to have written to the *Spectator* lamenting 'the Depravity or Poverty of Taste the Town is fallen into with relation to Plays and publick Spectacles'.[56] Shaftesbury complains of the fashion for reading exotic travellers' narratives and fictional tales about non-European peoples, and the bad taste 'which makes us prefer a Turkish novel to a Roman, an Ariosto to a Virgil'.[57]

Some people claim that taste can be improved by scholarship. The classical scholar Anne Le Fèvre (better known as Madame Dacier) says that

taste is 'a harmony, an accord between spirit and reason' that enables one to appreciate classical texts despite their superficial differences from one's own day.[58] A commoner view, however, dismisses scholars as pedants whose narrow philological interests have blinded them to the real value of the classics. Thus, Pope caricatures the classical scholar Richard Bentley as delving in worthless authors for linguistic information and ignoring the true classics, by making Bentley say:

> For Attic Phrase in Plato let them seek,
> I poach in Suidas for unlicens'd Greek.[59]

The standard of taste may be founded on consensus. The best authors are those who have pleased the public over a long period. Boileau identifies taste with the judgement of the reading and book-buying public: 'the public is not a judge who can be bribed, nor one who is guided by the passions of other people.'[60] Good authors are admired by the public for a long time. Anyone who does not share this judgement must have deficient, depraved or eccentric taste (*goust bizarre*), irrespective of social rank: Boileau cites the emperor Hadrian, who preferred the writings of an obscure poet to those of Homer.[61]

By appealing to the empirical facts of public preference, however, one may be covertly abandoning the defence of universal, objective standards and substituting standards founded in the contingent facts of human nature. In his essay 'Of the Standard of Taste', Hume uneasily straddles objective and subjective criteria. Literary appreciation is founded on sentiment, and 'all sentiment is right'; aesthetic judgements consist in a relation between the observer and the work of art, and they will not be quite the same for any two observers.[62] At the same time, the principles of taste are 'uniform in human nature'.[63] They are not mysterious, but can be articulated, and enable us to justify our judgement of beauties and blemishes. Systems of philosophy and theology soon fall out of fashion and into oblivion; in the arts, however, 'just expressions of passion and nature are sure, after a little time, to gain public applause, which they maintain for ever'.[64] This sounds plausible, until Hume gives examples. He thinks it unimaginable that Bunyan should ever be considered a better writer than Addison.[65] Yet today, almost three and a half centuries since its first appearance in 1678, there are many editions of *The Pilgrim's Progress* on the market, including a large-print edition and a version in modern English, and it has been published in Everyman's Library, the Penguin Classics, and the Oxford World's Classics, while Addison languishes and the four-volume Everyman edition of the *Spectator* is out of print. In any case, Hume's literary taste may be doubted: he disparaged

*Paradise Lost*, yet he described the *Epigoniad*, an epic poem by William Wilkie, minister of Ratho outside Edinburgh, as 'a Production of great Genius'.[66] The originality of the *Epigoniad* consists in focusing on the siege of Thebes instead of Troy; but it soon reveals itself, even to a reader sympathetic to epic conventions, as clichéd, repetitive and dull.[67]

Moreover, the merits of the classics are not beyond dispute. Voltaire repeatedly insists that, despite the respect conventionally paid to him, Homer is really very boring:

> Notwithstanding the Veneration due, and paid to Homer, it is very strange, yet true, that among the most learn'd, and the greatest Admirers of Antiquity, there is scarce one to be found, who ever read the *Iliad*, with that Eagerness and Rapture, which a Woman feels when she reads the Novel of *Zaïda*, and as to the common Mass of Readers, less conversant with Letters, but not perhaps endow'd with a less Share of Judgment and Wit, few have been able to go through the whole *Iliad*, without strugling against a secret Dislike, and some have thrown it aside after the fourth or the fifth Book. How does it come to pass, that Homer hath so many Admirers, and so few Readers?[68]

Voltaire is here not just disrespectful; he is revolutionary. He is asking about the empirical facts of readers' responses. How does the theoretical standard of taste hold up when compared to reality? In contrast to Shaftesbury, for whom Ariosto's fantasies could only please a depraved taste, Voltaire in his *Philosophical Dictionary* (1764) rates the sixteenth-century Italian poet far above Homer, praising the naturalness of his verse, the wealth of his invention and his success in interesting us in the fates of his characters while retaining a humorous distance.[69] And one could hardly claim that Europe's most brilliant man of letters was unable to judge literature.

The idea of a universal standard of taste, whether founded in objective laws of beauty or the contingent facts of human nature, also looks doubtful when one compares the taste of different nations. Voltaire does this in his *Essay on Epic Poetry*, originally written and published in English. He notes that alongside a general standard, there are tastes peculiar to each nation. The long declamations in Corneille's *Cinna* would bore an English audience; the 'gingling of Words' in Tasso is admired in Italy but nowhere else; and French taste would reject Milton's oxymoron 'darkness visible'. So 'there is such a Thing as a National Taste'.[70]

At other times, however, Voltaire presupposes that the age of Louis XIV set a standard of taste valid for all time. In his Menippean satire*

---

\* A satire that mingles verse and prose.

*Le Temple du Goût* (*The Temple of Taste*, 1733) authors, mostly French, are arranged in a hierarchy. Mere pedants cannot even approach the Temple; certain minor poets are admitted on condition that they burn their inferior works and behave better in future; and the inner sanctuary is occupied by Racine, Molière, Boileau and other giants of the late seventeenth century. Homer and Virgil are not mentioned. Leibniz is admitted and seated beside the philosophical poets Lucretius and Fontenelle (the latter having expounded astronomy in his *Entretiens sur la pluralité des mondes*). Voltaire avoids saying what taste is, though we infer that rather than following the rules, it means a quasi-instinctive sound judgement that keeps one on the right track.[71] At the end he characterizes taste in terms similar to those of Saint-Évremond:

> Vous, noble jeunesse de France,
> Secondez les chants des beaux-arts.
> Tandis que les foudres de Mars
> Se reposent dans le silence,
> Que dans ces fortunés loisirs
> L'esprit et la délicatesse,
> Nouveaux guides de la jeunesse,
> Soient l'âme de tous vos plaisirs.[72]

[Noble youth of France, support the songs of the fine arts. While the thunders of Mars remain silent, let wit and refinement, the new guides of youth, be the soul of all your pleasures in these fortunate intervals.]

The metaphor of taste could suggest that, just as there is no arguing about preferences in food, so tastes in the arts are likewise a matter of individual preference. One reader likes Addison, another prefers Bunyan; one likes Virginia Woolf, another prefers Danielle Steel, for a complex of reasons connected with their individual personalities and their educational and social backgrounds. To leave the matter there might be pleasingly anti-elitist. But Voltaire would not agree. Having alluded to the adage *de gustibus non disputandum*, he continues: 'It is not the same in the arts; as they have real beauties, there is a good *taste* that discerns them, and a bad *taste* which is unaware of them.'[73] In preferring Ariosto to Homer, therefore, he is not being arbitrary; his preference is founded on the authors' real qualities, which conventional judgements fail to acknowledge.

Late in the century, Kant tried to get to the bottom of the matter. In his Third Critique he distinguishes among the agreeable, the beautiful and the good. Physical sensations can be agreeable (*angenehm*). But they are purely subjective. One man's meat is another man's poison. If somebody

says that Canary wine is agreeable, he will not mind being told that he should say 'it is agreeable *to me*'. There is no point in disputing about taste in agreeable or disagreeable things:

> For one person, the color violet is gentle and lovely, for another dead and lifeless. One person loves the tone of wind instruments, another that of stringed instruments. It would be folly to dispute the judgment of another that is different from our own in such a matter, with the aim of condemning it as incorrect, as if it were logically opposed to our own; thus with regard to the agreeable, the principle *Everyone has his own taste* (of the senses) is valid.[74]

On the other hand, there is no point in disputing about the good either. The good may be what is useful, or what is morally good. Any disagreement about the good can be solved by reason. The beautiful comes somewhere between the agreeable and the good. The difference is that both the agreeable and the good appeal to our interests (interest not as the opposite of boredom but as that about which we are practically concerned, self-interested). It is in my interest to eat the food I find agreeable. It is also in my interest to learn what is useful for my purpose and what is morally good, admirable and worthy of imitation. But the beautiful gives me nothing; it does not serve my interests. My appreciation of the beautiful is disinterested. And taste is the ability to judge the beautiful. Hence taste is defined as follows: '*Taste* is the faculty for judging an object or a kind of representation through a satisfaction or dissatisfaction *without any interest*. The object of such a satisfaction is called *beautiful*.'[75]

Then comes the question: what kind of judgement is a judgement of taste? It is subjective, but not in the way that a liking for Canary wine is subjective. Saying 'Shakespeare is a good writer' implies that other people should like him too. So, judgements of taste have some kind of binding force. I can persuade you that the earth is round, or that stealing is wrong, by force of reason. But I cannot persuade you to like Shakespeare by rational argument. Yet when I praise Shakespeare, I mean that the judgement should be valid for you as well, not as the conclusion of a chain of argument, but in a more immediate way.

A judgement of taste, as an aesthetic judgement, concerns a single object. When I say that this rose or this painting is beautiful, I want you to share my judgement. Aesthetic judgements, Kant says, are *allgemeingültig*, 'generally valid'. But their validity does not rest on a concept. There is no abstract principle of the form 'all roses are beautiful, therefore this rose must be'. But, Kant says, there must be something about the feeling of beauty that is shareable, so that it makes sense a priori for me to ask

# Critik

der

# Urtheilskraft

von

## Immanuel Kant.

Berlin und Libau,
bey Lagarde und Friederich
1790.

Kant's *Critique of Judgement* (1790). This is the third of the trilogy, after the *Critique of Pure Reason* (1781) and the *Critique of Practical Reason* (1788), with which Kant revolutionized philosophy and inaugurated the era of philosophical idealism.

you to share my judgement. I can't expect you to share my taste in wine, but I can expect you to share my taste in paintings. There is a *sensus communis*, a 'common sense', which everyone shares. At this point Kant becomes very obscure, as his commentators admit.[76] He proposes that aesthetic taste is a common sense, a *sensus communis*, not something merely private but something public. But he also acknowledges that, empirically, aesthetic tastes differ very widely. Although Kant may wish that rules could be devised for finding which works of art are best, he does not put forward such rules. He does not say that aesthetic judgements will in practice be shared. He only tries to establish that they are in principle shareable.

We may get a little closer to Kant's argument by recalling Baumgarten, whose work Kant greatly admired. It has been argued that Kant's idea of the *sensus communis* revives the long-standing notion of 'internal sensation'. Ever since Aristotle, the 'internal senses' were posited to fill the gap between the external senses and the intellect. They were the means of organizing a sense-experience and presenting it to the mind. The first of the internal senses, according to Aristotle, was the 'common sense' which organized the data provided by the five external senses and was aware of sensation: it 'sees that we see'.[77] It was often linked with *imaginatio*, the process of forming images for the higher mental faculties. The internal senses were often called the 'particular intellect', as opposed to the general or abstract intellect, because they dealt with particular sensations and experiences. They were associated with 'complex' or 'obscure' perception, somewhere between the senses and the intellect. It was on this kind of knowledge, 'sensory knowledge', that Baumgarten founded his new science of aesthetics. 'The internal senses performed the indispensable and literally crucial function of accommodating sensation to intellect, of somehow making the immediately apprehended world also thinkable.'[78]

Kant has the problem of explaining how judgements of taste can be universal: how they can be particular judgements which feel as if they ought to be an example of a universal rule that we cannot state. For this, he invokes the *sensus communis*, making clear that he does not mean ordinary common sense (*der gemeine Menschenverstand*), nor any of our external senses, but rather an internal sense. This common sense is preconceptual. Its work is to organize the material of sensation. It involves both sensation and reflection. It takes the raw material with which our senses provide us, and organizes it, for example, in accordance with the laws of proportion. The judgement of taste is therefore connected, not with raw sensation, but with the basic way in which our minds take the information derived from our senses and structure the world to accommodate

this information. Sensation says merely 'There is a tree in front of me'; the common sense says, 'This tree is attractively proportioned'. The first is a judgement of fact; the latter is a judgement of taste. The judgement of taste depends on the interaction of the faculty of sense-making with the world. While a judgement based on sensation – e.g. of the presence of an object – demands assent, with a judgement of taste 'we do not feel that everyone *must* agree with our judgement, but rather that everyone *should* agree'.[79] It is universally subjective, in that it is grounded in the very structure of subjectivity – in the way in which we shape and interpret our experience. Kant's conception of the *sensus communis* will not solve particular aesthetic disputes. It will not tell us whether Addison is better than Bunyan. But it could offer the basis for a universal standard of judgement.

Although Kant's aesthetics focus on the response of the recipient, not all his ideas have worn well. His concept of 'disinterested pleasure' as the appropriate response to art does have an emancipatory thrust. It implies that art cannot be placed in the service of any didactic purpose and is thus not available to authorities, whether secular or religious, who want to force instruction on us.[80] In that sense it can be seen as the ultimate ancestor of doctrines of 'art for art's sake'. But the idea that art is a self-sufficient realm closed off from the world of practical interests would threaten to evacuate literature, at least, of its intellectual content.

For even more obvious reasons, 'disinterested pleasure' has seldom seemed an adequate account of a response to works of art. Even in a Dutch still-life, may the contemplation of a dish of fruit not arouse my appetite for fruit, while I am perfectly aware of the banal fact that the fruit in the picture is not edible? More sensuous images can arouse much stronger desire. Swinburne, a highly unconventional Victorian, said of Titian's *Venus of Urbino*: 'how any creature can be decently virtuous within thirty square miles of it passes my comprehension'.[81] Kant's phrase scarcely captures the emotional responses often elicited by music or literature. It would hardly fit the enthusiasm with which Diderot devoured the novels of Richardson. Still less would it fit the audience at an exciting drama. At the first night of *Die Räuber* (*The Robbers*), in which the young Schiller aimed to arouse violent passions, an eyewitness report testifies to his success: 'The theatre resembled a madhouse, rolling eyes, clenched fists, stamping feet, hoarse yells in the auditorium! Entire strangers fell sobbing into each other's arms. Women, close to fainting, reeled to the door.'[82] Kant is known to have read novels (including those of Richardson and Fielding) and attended the theatre; but even his aesthetics do not seem to have been shaped by personal experience as was, for example, the moral philosophy of Adam Smith.

## GENIUS

The neoclassical aesthetic, supposedly based on objective standards of beauty, left a few loopholes for subjectivity to creep in. One, as we have just seen, was the concept of taste, which led eventually to empirical attention to the experience of art. Another was the concept of inspiration. Not only were the rules in themselves insufficient to produce great art; certain 'great wits' could on occasion defy the rules and '*snatch* a *Grace* beyond the Reach of Art'.[83] What was this special grace? One seventeenth-century critic, the Jesuit Pierre Mambrun, attributed it to an accession of bile to the brain, which stimulated the rational process of composition.[84] Others ascribed it to divine rapture. But these were not really explanations.

Shaftesbury suggested a new approach by his exalted conception of creativity. He was attracted by the Neoplatonic idea that the beautiful, the true and the good are ultimately identical, forming a supreme reality, with which the artist is in privileged contact. Hence, said Shaftesbury, the artist participates in the creativity whose supreme exemplar is God. The true poet is 'a second maker, a just Prometheus under Jove'.[85] One of the legends about the good Titan Prometheus, reported in Plato's *Protagoras*, says that he created human beings by endowing with diverse qualities the raw material made by the gods.[86] 'Like that sovereign artist or universal plastic nature, he forms a whole, coherent and proportioned in itself, with due subjection and subordinacy of constituent parts.'[87] His creation, that is, is orderly just as the universe itself is. Its order is not imposed from outside by rational calculation but is guaranteed by the creative process itself.

From another direction, Addison offered a new and elevated conception of the poetic imagination. Earlier criticism had assumed that a poem taught a moral lesson by means of the fable. This didactic approach was reduced to absurdity by the neoclassical critic Thomas Rymer, who ironically complained that *Othello* provided only 'a caution to all Maidens of Quality how, without their Parents consent, they run away with Blackamoors', 'a warning to all good Wives that they look well to their Linnen', and 'a lesson to Husbands that before their Jealousie be Tragical the proofs may be Mathematical'.[88] Subsequent critics, instead of looking for moral lessons, asked about the emotions aroused in the reader. Addison, in his appreciation of *Paradise Lost*, constantly appeals to 'the Mind of the Reader'.[89] His method is empirical; a later generation, according to Johnson, dismissed it as 'tentative or experimental, rather than scientifick'.[90] But its tentative character is surely its virtue. His series of essays on 'The Pleasures of the Imagination' examines how the mind is affected by 'the

Sight of what is *Great, Uncommon* or *Beautiful*'.[91] Exceptional experiences, whether of nature or art, call forth an exceptional response: 'Our Imagination loves to be filled with an Object, or to grasp at any thing that is too big for its Capacity. We are flung into a pleasing Astonishment at such unbounded Views, and feel a delightful Stilness [*sic*] and Amazement in the Soul at the Apprehension of them.'[92] Diderot as a critic similarly dwells on the emotional impact of works of art. We have already seen his enthusiastic response to Richardson. In his *Letter on the Deaf and Dumb*, he transfers this enthusiasm to the mind of the creative artist, who communicates an intense experience to the recipient: 'it is he who causes things to be spoken and represented at the same time, so that while the understanding grasps them, the soul is moved by them, the imagination sees them and the ear hears them.'[93]

The artist could now be imagined as motivated by powerful feeling, by 'enthusiasm'. The mere imitator was contrasted with the genius who was inspired directly by nature. For Batteux, the genius only imitated nature by observing it more attentively than others.[94] But according to Diderot, 'Nature impels the man of genius, the man of genius impels the imitator.'[95] The *Encyclopédie* article on genius, generally attributed to Diderot, defines it as 'the extent of the mind [*esprit*], the force of imagination, and the immediacy of the soul – that is genius.'[96] In the genius, memory is enhanced by imagination, so that sensations once experienced remain vividly present to him. In the heat of enthusiasm, he creates imaginary characters and endows them with life by making them an extension of himself.

Genius thus conceived is the opposite of mere taste. 'Genius is a pure gift of nature; what it produces is the work of a moment; taste is the work of study and time; it depends on knowing a multitude of rules, either established or imagined; it gives rise to beauties which are merely conventional.'[97] The genius therefore cannot be confined by rules. 'The rules and the laws of taste would put genius in fetters; it breaks them in order to fly to what is sublime, stirring, great.'[98] Lessing, one of Diderot's foremost admirers and propagators in Germany, agreed, and put forward a conception of genius combining Diderot's enthusiasm and Shaftesbury's coherence:

> the world of a genius, which – permit me, without naming the Creator, to designate him by his noblest creature! – which, I say, to imitate the supreme genius on a small scale, takes the components of the present world, transposes, exchanges, reduces, increases them, in order to make of them a self-contained whole in unison with his own aims.[99]

Thus Lessing develops the crucial aesthetic concept of organic unity foreshadowed in Baumgarten's notion of harmony.[100] The work of art should

be a unity in which everything can be explained from within the work itself. In being coherent and meaningful, the work of art is a tiny model of the world created by God. Our experience may seem fragmentary and meaningless, but the artist takes these fragments as his starting-point:

> From these few fragments he is to make a perfectly shaped whole, where each detail is perfectly explained by the others, where there is no difficulty whose resolution cannot be found in his scheme but needs to be sought elsewhere, in the universal scheme of things; the whole made by this mortal creator must be a blueprint [*Schattenriß*] of the whole made by the eternal creator.[101]

And the integrity of the artistic whole is guaranteed not by rational construction, but by the shaping spirit of the artist's imagination.

The concept of genius went together with that of originality. Neoclassical aesthetics favoured imitation, in which a classical model was adapted to modern circumstances: thus, Donne and Pope wrote imitations of Horace in which his satirical techniques were applied to modern sycophants or spendthrifts. Originality could be sought, as when Milton in *Paradise Lost* undertook 'things unattempted yet in prose or rhyme', and praised, as when Johnson commended the novelty of the mythological apparatus in Pope's *Rape of the Lock*.[102] But it was in no way required. Indeed, the originality of Milton and Pope only appeared such against the background of the epic traditions in which they were writing. Edward Young's highly influential essay *Conjectures on Original Composition*, however, reversed these standards by redefining imitation. '*Imitations* are of two kinds: one of Nature, one of Authors: The first we call *Originals*, and confine the term *Imitation* to the second.'[103] An original such as Homer has a freshness which Young expresses by organic and natural imagery: an original 'rises spontaneously from the vital root of genius', and an original author 'out of a barren waste calls a blooming spring'.[104] An imitator attempts, with the aid of learning, to reproduce the effect made by an original, but always falls short. The effect of genius is inimitable. 'Genius . . . is like a dear Friend in our company under disguise; who, while we are lamenting his absence, drops his mask, striking us, at once, with equal surprize and joy.'[105]

Young is somewhat ambivalent about genius. He does not think that genius, as a native endowment, is all that rare. There may be many people born with genius who never learned to read and write and so never realized their powers. There may also be many educated and gifted people who are so overawed by the achievements of a genius such as Homer that they dare not attempt poetry themselves. Young urges such people to have

confidence in themselves: 'thyself so reverence, as to prefer the native growth of thy own mind to the richest import from abroad'.[106]

The categories of original and imitation reappear in different guises in the essay *Über naive und sentimentalische Dichtung* (*On Naïve and Sentimental Poetry*, 1795) by Schiller, who had read Young as part of his excellent education in modern philosophy and aesthetics. Here the naïve poet, corresponding to Young's original, retains a childlike immediacy in the midst of civilization, whereas the 'sentimental' or reflective poet is necessarily detached from his subject-matter. To clarify this distinction, Schiller contrasts two passages, one from Homer and the other from Ariosto, in which two warriors on opposite sides make common cause. Homer, the naïve poet, recounts the event in a factual manner without narratorial commentary; Ariosto interposes himself as narrator to comment ironically on the nobility of ancient knights.[107] At the present time, the great naïve poet is Goethe, who deals with complex modern subject-matter but, thanks to the power of genius, does so in a simple, direct, plastic way: it is he who 'among modern poets perhaps is least removed from the sensuous truth of things'.[108] Both Young and Schiller are invoking the concept of original genius in response to a modern problem: the felt need to retain contact with nature, with immediate feelings, in an age in which the vast growth of literature risks paralysing creativity and, more generally, in which the expansion of civilization appears to have estranged us from ourselves.

The archetype of original genius was Shakespeare. '*Shakespeare* mingled no water with his wine,' says Young, 'lower'd his Genius by no vapid Imitation.'[109] He seemed to know nothing of the rules. Hence most neoclassical critics regarded his plays as incoherent and tasteless. Their successors, however, increasingly saw in him an untutored genius, a child of nature who, in Milton's words, 'warbled his native wood-notes wild'.[110] His imagination was shown especially in what Addison, borrowing the phrase from Dryden, called 'the Fairie way of writing', in *A Midsummer Night's Dream* and *The Tempest*. Dryden, emancipating himself briefly from neoclassical standards, helped to adapt *The Tempest* as an opera, and the first translator of Shakespeare into German, Christoph Martin Wieland, departed from his usual prose translations to turn *A Midsummer Night's Dream* into verse. Wieland in 1766 urged his readers to admire Shakespeare's heart, 'filled with the extraordinary greatness, sublimity and strength of genius, with the beauty, fire and inexhaustible greatness of imagination'.[111]

Earlier, in 1759, Lessing championed Shakespeare against Germany's foremost spokesman for the rules of drama, the Leipzig professor and

literary dictator Johann Christoph Gottsched. He quotes a contemporary judgement – 'Nobody will deny that the German stage owes its first improvement largely to Professor Gottsched' – and adds: 'I am this Nobody; I deny it outright. It would be better if Herr Gottsched had never meddled with the theatre.'[112] He condemns Gottsched for his exclusively French taste. Gottsched considers Addison's *Cato* the best English tragedy; he has written his own Cato drama with the help of scissors and paste; he knows little or nothing of Shakespeare and the other Elizabethans. But if Shakespeare, instead of Corneille and Racine, had been available in German translation, these plays of genius would have inspired genius in others: 'For a genius can only be set alight by a genius; and most easily by one who seems to owe everything only to nature, and does not put people off by the laboured perfections of art.'[113]

Lessing's reply to Gottsched introduces a further notion: national character. Voltaire, in his *Essay on Epic Poetry*, had already pointed to differences of national taste; Lessing now goes further and argues that deep-seated differences of national character make it much easier for the Germans than for the French to appreciate Shakespeare. It is pointless to try to model German drama on the plays of Corneille and Racine, because such drama runs counter to the national taste of the German people, whereas Shakespeare, a member of a kindred Northern European nation, suits them much better. Corneille was far more familiar with the ancient dramatists than Shakespeare was, but while Corneille might resemble them in the mechanical construction of his plays, Shakespeare approached far more closely to their spirit:

> The Englishman almost always attains the goal of tragedy, whatever strange and individual paths he may choose; and the Frenchman hardly ever attains it, even though he follows in the paths trodden by the ancients. After Sophocles' *Oedipus*, no play in the world can have more power over our passions than *Othello*, *King Lear*, *Hamlet*, etc.[114]

This national theme was developed by Herder in an early essay on Shakespeare. He argues that it is a mistake to try to measure Shakespeare against classical standards. People who do so are failing to think historically. If you consider Greek drama and Northern or Nordic drama as two different kinds of drama, and consider how each came into being, you will see that each type owes its character not to supposed timeless rules but to the circumstances of its origin, and neither can fairly be judged superior to the other. Herder repeats Aristotle's account of the origin of Greek tragedy. First there was the chorus. Then one actor would step out of the chorus to deliver a dithyramb or song telling a story. Aeschylus first brought two

characters onto the stage and thus made the story dramatic. Sophocles and subsequent dramatists enlarged the action. From these circumstances the features of the Greek theatre can be explained: above all, the importance of the unities of time, place and action. A single actor could only recount a simple and coherent action, which could then be brought further to life by two or three players; given its simplicity, it had to cover a short and continuous time-span, hence the unity of time; and the same circumstances account for the unity of place. These unities cannot be universal requirements; they arise from local and particular conditions. It follows that French neoclassical drama by Corneille, Racine and Voltaire (Herder always mentions these as a group), following the unities on theoretical grounds without any need arising from real circumstances, could only be artificial. It was merely imitative. Herder's polemic was directed, like the well-known polemics by Lessing, against the overvaluation of French culture in eighteenth-century Germany, and again like Lessing he was seeking a more appropriate model for Germans to follow.

Herder found this model in Shakespeare, the product of an indigenous tradition that had invented drama anew in accordance with its particular historical circumstances. Shakespeare found, not a chorus or reciter, but a tradition of commemorating national events in the form of plays that already, therefore, had a connected narrative, so he built on that. Hence his plays have a variety of characters, each with his or her own way of speaking, and the setting too requires an appropriate atmosphere. This is Herder's comparison between Shakespeare and Sophocles:

> Allow me to continue as an interpreter and rhapsodist: for I am closer to Shakespeare than to the Greek. If in the latter the unity of an *action* is dominant, so the former deals with the entirety of an *event*, an *incident*. If in the one the characters have a single predominant tone, so the other presents all characters, ranks, and ways of life, as many as are needed to form the prevailing sound of his concert. If in the latter one delicate musical language sounds, as though in a loftier ether, the former speaks the language of all ages, people, and human types, is the interpreter of nature in all her tongues – and both, in such different ways, are the intimates of a single divinity. – And if the one imagines, teaches, moves, and educates *Greeks*, then Shakespeare teaches, moves and educates Northern European *human beings* [*nordische* Menschen]![115]

Thus Shakespeare is from the outset a varied dramatist, attentive to local circumstances, and able to produce a vast variety of settings and characters. He is sensitive to local peculiarities, as Herder wanted. Hence he is closer to nature and, by using the word 'Nature', Herder weighs down the

scales in favour of Shakespeare and invokes a frequent late eighteenth-century motif: by contrast with the artificiality of the French, above all, Shakespeare is natural.

This image of Shakespeare as natural was taken up enthusiastically by the young Goethe, then under Herder's influence, in a speech delivered on Shakespeare's name day in 1771. The French criticize Shakespeare's characters as undignified; but they are simply natural: 'And I cry, nature, nature! Nothing is so much nature as Shakespeare's people.'[116] By contrast, the neoclassical rules of drama are a prison, from which reading Shakespeare has set Goethe free: 'The unity of place seemed so timidly prison-like, the unities of action and time seemed such burdensome fetters on our imagination; I leapt into the open air and felt for the first time that I had hands and feet.'[117] Liberated from neoclassicism, Goethe set to work on his historical drama *Götz von Berlichingen*. Inspired by the history plays in which Shakespeare vividly evoked past epochs, Goethe with considerable success used his dramatic freedom to portray Reformation Germany. His play is a landmark in literary history, for it would presently be translated (very inaccurately) by Walter Scott and would inspire Scott's evocations of past eras in the Waverley Novels.[118]

The concept of genius has thus unfolded into a whole array of aesthetic concepts. The poet of genius is part of nature, and also the spokesman for the spirit of his nation. The poem of genius is an organic product, not the result of labour, and is a self-sufficient whole, like a plant.[119] These concepts were to have a long life, especially in nineteenth- and twentieth-century literary criticism. If we ask what distinguishes the Enlightenment discussion of genius from discussions in Romanticism and after, the answer is probably to be found not in the concept and its implications, but in the quasi-religious reverence attached by the Romantics to the notion of genius and the person thought to embody it.[120] The genius was a particular type of person, in touch with a higher reality. According to Blake in 1788, not only all poetry, but 'all sects of Philosophy' and the 'Religions of all Nations' are derived from 'the Poetic Genius'.[121] 'A Poet participates in the eternal, the infinite, and the one', wrote Shelley.[122] The poet could be imagined as one who had drunk 'the milk of Paradise' and inspired 'holy dread' in mere mortals.[123] The higher reality with which the genius was in touch was best represented by music, as with Beethoven and E. T. A. Hoffmann's fictitious composer Johannes Kreisler.[124] But the genius was close to madness, doomed to suffer in the restrictions of material reality. The Romantic cult of genius is another example of the transfer of emotionally charged images from religion to art, enabling the genius to be imagined and revered as prophet, saint and martyr.

## ART AND MORALITY

Enlightenment critics continued to believe that the beautiful was intrinsically linked to the true and the good. It was hard for them to conceive that art could be morally neutral, that the poet, as Keats said in 1818, could have 'as much delight in conceiving an Iago as an Imogen'.[125] Above all, the theatre, as a public art form, had a particular responsibility to inculcate sound morals. Johnson censured Shakespeare for his failure to provide a clear moral message: 'This fault the barbarity of his age cannot extenuate; for it is always a writer's duty to make the world better, and justice is a virtue independant [sic] on time and place.'[126] Morality, however, might be conveyed in more ways than one. Delivering an explicit message was just one way, and not necessarily the best. One could also address the audience's emotions, rather than their understanding; involve them in the feelings and fates of the characters; make them care about the people on stage; and bring about an emotional transformation, so that the audience would leave the theatre better people than when they entered it. Drama, Diderot claimed, should not just invite us to mock folly and vice, but, above all, strengthen our commitment to our social duties. 'People's duties are as rich a resource for the dramatic poet as their absurdities and their vices.'[127] The presentation of virtue on the stage made not only a different, but also a stronger impression than the display of comic faults. Plays therefore must not be mere sermons in dialogue. The actual events on stage could touch the hearts even of wicked people, 'and the wicked man leaves his box, less inclined to do harm than he would be if he had been reprimanded by a harsh and severe orator'.[128]

In Germany, Diderot found a kindred spirit in Lessing, who translated his two plays and his two main essays on the theatre into German and published them anonymously in 1750.[129] Lessing denies that tragedy improves our character in any straightforward way. It changes us by arousing our emotions. It invites us to sympathize with the unfortunate and to feel pity, not just for the individual on the stage but with sufferers in general, and, by increasing our capacity for pity, it makes us into better people:

> The purpose of tragedy is this: it should enlarge our *ability to feel compassion*. It should not merely teach us to feel compassion for this or that unhappy individual, but should make us so sensitive that the unhappy person at all times and in all guises should move us and appeal to us ... *The most compassionate person is the best person*, the most apt for all

social virtues, all forms of generosity. Whoever makes us compassionate makes us better and more virtuous.[130]

These theories about the improving and uplifting effect of theatre were severely questioned by Goethe and Rousseau. In his novel *Wilhelm Meisters theatralische Sendung* (*Wilhelm Meister's Theatrical Mission*, written in the 1780s but not published until 1910), and in the extended version published as *Wilhelm Meisters Lehrjahre* (*Wilhelm Meister's Apprenticeship*, 1795–6), Goethe's hero imagines himself becoming a great actor and founding a future national theatre. When he mingles with actors, he is disconcerted to find that they never discuss the poetic merit of a play but are only concerned about whether it will draw audiences and how long it is likely to run for. Undeterred, he joins a travelling troupe of actors and, later, an established theatre in an unnamed city suggesting Hamburg. The director, 'Serlo', based on the famous actor-manager Friedrich Ludwig Schröder, only agrees with great reluctance to produce *Hamlet*, with Wilhelm in the title role. When Wilhelm, thanks to a plot twist, leaves the theatre, Serlo and an associate are planning to give up serious drama and to put on only operas, which require lower-paid performers and promise greater profits; they know, but do not care, that by doing so they will be corrupting the public's taste.[131] As manager of the Weimar court theatre from 1791 to 1817, Goethe had to struggle with semi-educated audiences and high-maintenance stars; he was well aware of the gulf separating the visionary hopes of enthusiasts from the commercial realities of the actual theatre.[132]

Some decades earlier, Rousseau, who opposed so many beliefs dear to the Enlightenment, had roundly denied its hopes for the improving influence of theatre. His polemic was prompted by the article on his hometown, Geneva, which d'Alembert had written for the *Encyclopédie*, and in which d'Alembert had recommended that Geneva should acquire a theatre. No, says Rousseau: Geneva is far better off without a theatre, for the theatre cannot improve morals but only corrupt them. It cannot make virtue attractive, for virtue is already attractive. Tragedy cannot sustain the claims made for it from Aristotle onwards. It is said to purge our passions by arousing them; but what is the point of leaving the theatre with one's emotions in a whirl? Passion can be purged only by reason. Again, tragedy is said to arouse pity; but this pity is only a transient emotion, which at most allows us to congratulate ourselves on our fine feelings and does not change our behaviour. Here Rousseau recalls an ancient tyrant who had many people executed every day but wept at the

sufferings of stage heroines – a counterpart to the twentieth-century figure of the concentration-camp commandant who plays Bach.[133]

At least, Rousseau continues, tragic figures are remote from our experience. Comedy is much more dangerous, because it shows us people like ourselves and encourages us to mock honest characters and sympathize with villains. Since Molière is the best comic writer, his theatre above all is 'a school of vices and bad morals'.[134] His acknowledged masterpiece, Le Misanthrope, invites us to mock the central character, Alceste, for rejecting society; yet Alceste has seen through the vices of society and rejects it because it is inimical to the humanity and virtue which he values. As for plays like Racine's Bérénice, which show a character torn between the rival claims of duty and love, they too are corrupting, because for anyone with serious responsibilities – like the emperor Titus in the play – it is clear that his duty to Rome must override his attachment to Bérénice. Finally, theatre wears us out by constantly arousing futile emotions and leaving us unable to respond to the demands of our real lives.

That is only the harm done by the content of plays. Theatre is also corrupting as a social institution. Actors are notoriously immoral, and actresses especially lead scandalous lives. There is a more deep-seated evil: acting is the art of pretending. Actors may not actually deceive anyone, but they cultivate the ability to deceive by assuming a character different from their own. Orators and preachers, on the other hand, play fair with their hearers by taking personal responsibility for the message they deliver. The theatre also encourages people to spend money, to dress up to impress their neighbours, and to neglect the simple and innocent social gatherings with which the Genevans are content at present. With a theatre, the simplicity, order and considerable degree of equality currently found in Geneva would be lost, and the vices of the big city would be imported.

Besides idealizing Geneva, Rousseau shows what may be thought a small-minded prejudice in condemning the moral character of actors. However, his case against acting as pretence forms part of a long-standing anti-theatrical tradition. Impersonating another character is seen, not necessarily as deceit, but as weakening the integrity of the self by rendering its boundaries fluid. This anti-theatrical animus appears a few decades later in Jane Austen's Mansfield Park, where amateur theatricals are represented as a dangerous departure from order; the novel seems to be tinged with the puritanism of the Evangelical Revival.[135]

On the other hand, Rousseau poses a serious challenge to the notion that art automatically makes us better people. Well-known but simplistic claims for the improving effects of literature are notoriously unsupported by empirical evidence. More plausibly, however, it can be argued that

literature benefits us by extending our experience. It introduces us to personalities and circumstances that we have not encountered in our lives. It develops our powers of empathy and makes it possible to imagine what it is like to be another person. It can educate us in conceptions of virtue that are more generous and flexible than Rousseau's rigid notion. Rousseau is surely naïve in saying that virtue is too attractive to need any further recommendation. Often, at least superficially, vice is attractive. Part of Richardson's achievement, for example, is to enable us, through empathy, to explore the outlook of the attractive libertine Lovelace and realize gradually, for ourselves, how hateful his behaviour is. Empathy also makes us understand why Clarissa is attracted to him and how she avoids being morally corrupted by the horrible situation into which he inveigles her. Keats's claim that the poetic imagination is morally neutral might have been less convincing if he had said that it delights equally in a Clarissa and a Lovelace, or indeed if, instead of naming characters from two different plays, he had suggested that Shakespeare's imagination was morally neutral between Iago and his victim Desdemona. There is, then, a connection between the beautiful and the good, between art and morality, but it is more complex than the straightforward causal relationship claimed by Diderot and denied by Rousseau.

## IMITATION

If beauty was related to the good, it must also be related to the true. But the relation between beauty and truth is even more complex. It was always assumed that art imitated nature. Aristotle said that all forms of poetry are imitation.[136] Plato, who favoured the image of a mirror, makes Socrates say that art is the reflection or imitation of reality. But in this account, art is inferior to reality. An actual bed is real insofar as it participates in the ideal form of a bed. A picture of a bed is therefore only a copy, two degrees removed from truth.[137]

A contrary account, however, was given by the Neoplatonists, whose best-known author was Plotinus. For Neoplatonism, the supreme good, truth and beauty coincide in the 'Ideal-Form'. The Ideal-Form is also a principle of order. It arranges diverse parts into a unity and creates harmony and coherence. Beautiful things are orderly, like a house which the craftsman has made into a coherent whole. Thus 'the material thing becomes beautiful – by communicating in the thought (Reason, Logos) that flows from the Divine'.[138] The soul, once it has freed itself from the fetters of the senses, longs for the supreme beauty, which is also the

supreme reality. 'Such vision is for those only who see with the Soul's sight – and at the vision, they will rejoice, and awe will fall upon them and a trouble deeper than all the rest could ever stir, for now they are moving in the realm of Truth.'[139]

This lyrical philosophy had a particular appeal for Shaftesbury. In his dialogue *The Moralists, a Philosophical Rhapsody* (1709), the speaker Theocles distinguishes a hierarchy of beautiful forms. Lowest down are 'dead forms', like metal and stones, which lack the power of shaping other forms. Higher up come the living beings, endowed with mind, which have 'intelligence, action and operation' and are able to form beautiful objects. Far above them is the third and supreme form, which 'fashions even minds themselves' and 'contains in itself all the beauties fashioned by those minds and is consequently the principle, source and fountain of all beauty'.[140] Beauty consists not in material objects but in the forming power that descends from divinity itself.

There were therefore two conceptions of artistic imitation.[141] Art might imitate the creative activity and order that descended from the supreme principle of beauty. Or it might imitate the objects found in the material world. In the former case the artist concentrates on what some Renaissance writers imagined as the radiance streaming from the face of God, and present in the artist's mind, rather than on the visible objects which the last rays of the divine radiance faintly illuminated. Hence the story that a visitor to the Mannerist painter El Greco found him sitting one summer's day with his curtains drawn, absorbed in his inward light.[142] In the latter case the artist concentrates on the visible world around him – but he must not try to represent everything he sees. The object to be imitated was not the actual reality before us, which was too often ugly, messy and misshapen, but, as Batteux and many others said, 'la belle nature', beautiful nature. The artist may follow the Zeuxis method, by selecting the best features from a number of models and combining them into something that is lifelike yet has never actually existed. Or he may actually correct nature, as Sir Joshua Reynolds recommends, by stripping away 'the accidental deficiencies, excrescences, and deformities of things'.[143] He may go further and remove not just ugly details but all incidental details, in order to arrive at 'the idea of that central form . . . from which every deviation is deformity'.[144] The artist thus presents an average figure, guided by 'this idea of the perfect state of nature which the Artist calls the Ideal Beauty'.[145] This procedure may sound like the work of the transcendental artist. The difference, however, is that Reynolds starts from the empirical world and idealizes it, whereas the transcendental artist begins from the higher reality and clothes it in forms taken from the empirical world; though, as El

Greco's elongated figures show, he is free to transform empirical reality in accordance with his inner vision.

Neither approach requires the artist – at least, the artist in words – to represent the empirical world in faithful detail. ' "The business of a poet", said Imlac, "is to examine, not the individual, but the species; to remark general properties and large appearances; he does not number the streaks of the tulip, or describe the different shades in the verdure of the forest." '[146] Dealing with human beings, the artist may represent the generic human type: *the* miser rather than *a* miser. Hence Johnson says that in Shakespeare a character is 'commonly a species' rather than an individual.[147] On the other hand, Johnson does not disavow detailed particulars; he praises Thomson's poetry for its 'enumeration of circumstantial varieties', and values such a unique character as Shakespeare's 'unimitated, unimitable Falstaff'.[148]

The language of representation and portrayal is visual. So it is no wonder that critics constantly quote Horace's tag *ut pictura poesis*, 'poetry is like painting'.[149] It is often coupled with the dictum attributed to the Greek lyric poet Simonides: 'Painting is silent poetry, poetry is speaking painting.'[150] This facile equation, however, was assailed in one of the period's major aesthetic essays, Lessing's *Laocoon: Or on the Boundaries of Poetry and Painting* (1766). Lessing regrets that Simonides' one-liner should have been taken so seriously. Thanks to its influence among credulous critics, poetry is now full of descriptions and painting full of allegories: both art forms are being abused for purposes which they cannot achieve. The test case is the classical sculpture – discovered in 1506 and now in the Vatican Museum – that shows the priest Laocoön and his two sons being strangled by two gigantic snakes. As the same event is recounted by Virgil in Book 2 of the *Aeneid*, it offers a direct comparison between the representational methods of visual and verbal art.

Lessing's unsystematic and often digressive treatise proceeds by arguing with other critics. He begins with Winckelmann. As an example, he takes Winckelmann's statement (in *Thoughts on the Imitation of Greek Works*) that 'the expression in the figures of the Greek artists shows under all passions a great and steadfast soul'. Hence Laocoön does not scream but emits 'an oppressed and weary sigh'.[151] Lessing agrees with Winckelmann's observation, but questions the reason Winckelmann gives for it. It is not true that Greek figures always show steadfastness. In the *Iliad*, heroes – and even gods – scream when wounded. In Sophocles' *Philoctetes*, the hero spends a whole act of the play screaming in agony. Virgil tells how Laocoön's screams rise to the heavens. If the sculptor represents Laocoön only as sighing, the reason lies in the laws of different media. First, the

ancients required visual art to be beautiful, so the expression of emotion is always softened. Zeus, hurling thunderbolts, is shown as looking serious rather than angry. Laocoön could not be depicted as screaming, because an open mouth always looks hideous. If he sighs, we are not forced to contemplate anything ugly, and our imaginations are at liberty to imagine the pain he is feeling. Moreover, the visual artist can only depict a single moment, and that moment has to be carefully chosen if it is to withstand repeated contemplation. La Mettrie had himself painted to look like Democritus, the laughing philosopher, but the second time you look at the painting, the philosopher looks like a grinning idiot.[152]

The poet, on the other hand, can describe Laocoön screaming without requiring us to imagine his open mouth. For the poet, unlike the visual artist, is not bound to a single moment. A narrative unfolds in time. A poet therefore gives us, not a static description, but a sequence of actions. When Homer tells us what Agamemnon is wearing, he does not just list his clothes, as though describing a dressmaker's dummy; he recounts how Agamemnon gets dressed, putting on first his soft undergarment, then his great cloak, then his boots, and girding on his sword. The object of painting is bodies existing alongside one another in space. The object of poetry is actions which succeed one another in time.

Having established this basic contrast, Lessing resorts to semiotics.[153] The visual arts use natural signs: a picture of a tree directly resembles the object it represents. Poetry, on the other hand, uses arbitrary signs, namely words. Except for a few onomatopoeic terms like 'baa', words have no natural relation to the things they represent: 'sheep', 'Schaf' and 'mouton' are equally valid representations of the same animal. Arbitrary signs are much less useful for descriptive purposes than natural signs. If you want to convey what a flower looks like, a picture will enable people to visualize it immediately, whereas, in Lessing's view, the descriptions of Alpine flowers in Haller's poem *Die Alpen* convey only a dim idea of their objects.[154]

Lessing has incisively defined a major difference between painting and poetry. His account, admittedly, has limitations: the distinction applies only to narrative and descriptive poetry, not to lyrical poetry that expresses feelings. Nor is it even-handed: it has been claimed to show a bias in favour of poetry over painting, related to 'the iconophobic and iconoclastic rhetoric' that is said to pervade Western criticism.[155] The nature of this bias becomes clearer when Lessing criticizes religious art. In his view, ancient religion exercised a damaging constraint on the talent of ancient sculptors and painters, inducing them to overload their figures with symbolic attributes.[156] Although Lessing refers explicitly only to ancient religion, he – the

product of a Lutheran parsonage – is here implicitly defending a Protestant culture of the word against a Catholic culture of the image.

Drama, like narrative poetry, moves in time. Hence Aristotle defined tragedy as the imitation of a complete action.[157] A dramatic action is not a visible object but an elaborate mental construct, only prompted by sense-experience. The imitation enacted by a written text, such as a novel, is even more abstract. How then can this mental construct lay any claim to truth? Moreover, in contrast to history, which undertakes to present the truth, literature, whether dramatic or epic, presents only things that *could* have happened but did not. Events in literature must therefore be probable.

Neoclassical critics engaged in detailed discussion of *vraisemblance*, verisimilitude, or probability. They distinguished various categories. Some events were both possible and probable: thus, when Euripides' Medea kills her brother, her action, though atrocious, is probable because it is consistent with her wicked character. When Virgil makes the god of love assume the likeness of Aeneas' son Ascanius in order to persuade Dido to fall in love with Aeneas, this is possible but not probable, because the inflammable Dido would have fallen in love anyway without such a deception. When Aeneas and Dido meet, this is probable but not possible, because they actually lived in different centuries. And when Aeneas' ships are transformed into sea-nymphs, this is both impossible and improbable.[158]

The words 'probability' and *vraisemblance* eventually acquired two meanings, distinct though often conflated. Probable events might be events that resembled the truth because they were familiar from everyday experience. But events might also be subjectively probable, in that they corresponded to the beliefs of a past age even if incredible to us, or because the author described them so convincingly that the audience was persuaded of their truth. We would not believe nowadays that Iphigénie was saved from being sacrificed by a goddess who magically transported her to the remote land of Tauris, but if the Greeks thought such a thing possible, then for them it was also probable.[159] The historical Dido and Aeneas could not have met, but Virgil's vivid description of their encounter removes our disbelief.

New standards of verisimilitude were required by the novel. Courtly romances set in imaginary kingdoms and featuring marvels were displaced by the novels of Richardson, Fielding and Marivaux, set in a recognizable contemporary world. An anonymous essayist in 1751 commends Fielding for offering, instead of the flawless protagonists and impossible adventures of romance, 'a lively Representative of real Life. For chrystal Palaces and winged Horses, we find homely Cots and ambling Nags; and instead of Impossibility, what we experience every Day.'[160] Time and space now

correspond to experience. All the letters in *Pamela* and *Clarissa* are dated, often even by the time of day; Clarissa dies at 6.40 p.m. on Thursday, 7 September.[161] Fielding plots Tom Jones's journey to London in accurate detail. Characters rarely have 'speaking names' like Bunyan's Mr Badman, though Fielding has the benevolent Squire Allworthy. Richardson explains the 'necessity to be very circumstantial and minute, on order to preserve and maintain that air of probability, which is necessary to be maintained in a story designed to represent real life'.[162]

'Probability', a term much used by Enlightenment critics, often means the representation of ordinary and frequent events. However, one may want a story to recount not such events as one is already familiar with, but unusual and striking events, such as the martyrdom of Clarissa, or the survival of Robinson Crusoe on his island. To make such events seem probable, circumstantial detail is required, such as was previously confined for the most part to picaresque and popular fiction about rascally low life.[163] Verisimilitude could be supported by referring to the new science of statistics. Thus Robinson Crusoe repeatedly calculates the probability of events. It was *an hundred thousand to one* that the wrecked ship should have floated to a position in which he was able to recover supplies from it. When he sees the famous single footprint in the sand, he fancies it may have been made by the Devil, who however 'would never have been so simple [as] to leave a mark in a place where 'twas ten thousand to one whether I should ever see it or not'. Back in Europe, after Crusoe and his party have narrowly escaped an attack by wolves in the Pyrenees, the locals tell them 'it was fifty to one but we had been all destroyed'.[164] These astonishing events form 'a chain of wonders' that serve to demonstrate the 'secret hand of Providence'; they are not miraculous departures from the order of Nature, but possible events whose unlikelihood can be computed statistically.[165]

Verisimilitude came also to be demanded in painting. The abbé Dubos rejects allegorical images because they run counter to probability: 'the resemblance of truth cannot be too strictly observed in painting, no more than in poetry. 'Tis in proportion to the exactness of this seeming truth, that we are more or less liable to be seduced by the imitation.'[166] Hence he complains that in Rubens' painting of the arrival of Marie de' Medici at Marseilles, the ship is surrounded by Nereids and Tritons, which 'make, to my mind at least, a very preposterous appearance'. And painting Marie de' Medici in childbed, Rubens should have portrayed midwives and servants, who were actually there, instead of mythological beings.[167] Dubos signals a shift in taste towards realism, seen also in the young Goethe's admiration for the truth to nature he found especially in the paintings of

Dürer and in the Dutch school. In 1781, Goethe places Raphael and Dürer on the highest pinnacle of art, because they both show the supreme qualities which he defines as 'truth, life and power'.[168]

The concept of imitation was dubiously appropriate to arts other than the visual. Narrative and drama could be made to fit, but poetry is difficult because, unlike painting and sculpture, it does not speak directly to our senses:

> Poetry, which comes after painting and sculpture, and employs for imitation only words arranged according to a harmony pleasing to the ear, speaks to the imagination rather than to the senses; it represents in a vivid and touching manner the objects that compose this universe, and seems rather to create them than to paint them by the warmth, movement and life which it is able to give them.[169]

Did poetry represent objects, or did it rather convey the emotions attached to these objects? In 1772 Sir William Jones, in an essay accompanying his translations of Arabic, Persian and Indian poems, resolved the matter by declaring that poetry was not imitative but expressive: 'we may define original and native poetry to be the language of the violent passions, expressed in exact measure, with strong accents and significant words'.[170] At the same time, the aesthetician Johann Georg Sulzer argued that the poet was impelled by his feelings to utter them in rhythmical speech and figurative language. Sulzer initiated a reversal in the relative ranking of poetic genres. Those that could be most easily understood as expressive, such as the ode, now rose to the top of the scale, displacing previously respected forms, notably the epic, that described objects and told stories. And the young Herder was beginning to develop a theory of language, especially poetic language, as first and foremost expressive. In primitive times, he argued, the poet expressed his feelings by combining words with the 'semiotics of the body'.[171] Emotion and expression were not yet separate. That separation happened only when poetry came to be written down and the expressive language of the living body was translated into the dead language of art. It followed that modern poetry should do its best to reverse this process of decline and recapture the vitality of passionate speech.

Music was the most difficult case. D'Alembert maintains that music originated as an imitation of sounds and gradually became 'a species of discourse and even of language by which one can express the different sentiments of the soul, or rather its different passions'.[172] He clings to the idea that music is primarily imitative, only secondarily expressive: music produces the appropriate emotions by imitating agreeable or disagreeable sounds. Similarly, Rousseau in his *Dictionary of Music* calls music an

imitative art, citing the authority of Batteux, and maintaining that music can 'paint' visible objects such as fire, streams, deserts and dungeons; however, 'it will not represent these things directly, but by exciting in the soul the same movements that one feels when seeing them'.[173] The concept of imitation is here being strained to its limit.

An expressive theory, however, would be even less useful, for if music is understood as the expression of emotion, then the emotion and the music are imagined as separate, and value is located in the former rather than the latter; whereas everyone would agree that music is valuable in itself, not as a mere instrument of expression.[174] The Enlightenment, in any case, did not assign to music the lofty aesthetic rank that it would later acquire. Kant, though he enjoyed music and attended concerts, gives music the lowest place among the fine arts, because it 'merely plays with sensations' and therefore 'has, judged by reason, less value than any other of the beautiful arts'.[175] It is a far cry from this to the extraordinary upgrading of music in Romantic aesthetics, culminating in Schopenhauer's contention that music brings us closest to the Will which, in his philosophy, is the essence of reality.[176]

## TRAGEDY

The Enlightenment is often charged with being incapable of tragedy. A basically optimistic outlook, and a faith in the perfectibility of man, are said to render tragedy impossible.[177] The confidence in the orderly universe designed by a benevolent God, which was expressed most influentially by Leibniz, cannot survive – and therefore cannot acknowledge – the presence of irremediable disaster or incurable grief. Nor can it admit, with the prophet Jeremiah, 'The heart is deceitful above all things, and desperately wicked' (Jer. 17:9). Those who think the Enlightenment anti-tragic are likely to consider *King Lear* the most deeply tragic of Shakespeare's plays. Shakespeare denies us any reconciliation or redemption. The good are defeated; Cordelia is hanged, her father too late to rescue her. Lear's extreme grief deprives him of any but the simplest and most moving language: 'Thou'lt come no more, / Never, never, never, never, never!' At the end, the surviving characters are unable to draw any conclusion, let alone comfort, beyond the empty platitudes of the last few lines. The play also confronts us with extreme human wickedness: in the scene where Gloucester is blinded, we can imagine ourselves in the cellars of a modern tyranny. We are denied any metaphysical consolation: the events are set against a cosmic background in which the gods are either indifferent or sadistic.

Whatever the merits of this account of *King Lear*, the play spoke powerfully in such terms to the late twentieth century, and became a touchstone for the attempt of art to express the unbearable truth of existence.[178] The Enlightenment too had difficulties with *Lear*. It was a particularly tough example of the great problem of tragedy. Tragedy, like other art forms, is supposed to instruct and delight. But what can we learn from experiences that are unlikely ever to come our way? Few of us are in danger of finding, like Oedipus, that a stranger we happened to kill at a crossroads was our father, or that the woman we subsequently married is our mother. And how can the presentation of painful and shocking events be enjoyable? 'It seems an unaccountable pleasure,' says Hume, 'which the spectators of a well-written tragedy receive from sorrow, terror, anxiety, and other passions that are in themselves disagreeable and uneasy.'[179]

Tragedy must surely teach a moral lesson. Thomas Rymer thinks that a tragedy should provide 'poetical justice' by showing the villain punished, not just by the law or the prospect of damnation, but by the torments of remorse. It is not enough to know that the malefactor will go to hell: 'the fire must roar in the conscience of the *Criminal*'.[180] Johnson censures Shakespeare for making 'no just distribution of good and evil' and failing to show the good disapproving of the wicked.[181] For this reason he approves of Nahum Tate's revision of *King Lear* (1681), with a happy ending. Here Edgar kills Edmund in a duel; Lear's wicked daughters poison each other; Lear and Cordelia are freed in the nick of time; Lear retires, Cordelia marries Edgar, and the two prepare to rule the kingdom. In the play's closing lines, Edgar says to Cordelia (rounding the action off neatly with a rhyme):

> Thy bright Example shall convince the World
> (Whatever Storms of Fortune are decreed)
> That Truth and Vertue shall at last succeed.[182]

Johnson agreed with the public in preferring this version to Shakespeare's. In his comments on *Lear* he touched on tragedy's dilemma between offering moral satisfaction and approaching the truth of things:

> A play in which the wicked prosper, and the virtuous miscarry, may doubtless be good, because it is a just representation of the common events of human life: but since all reasonable beings naturally love justice, I cannot easily be persuaded, that the observation of justice makes a play worse.[183]

Addison, however, pointed out that if we were sure that the virtuous would triumph, plays would lose their interest: 'as the principal Design of Tragedy is to raise Commiseration and Terror in the Minds of the Audience,

we shall defeat this great End, if we always make Virtue and Innocence happy and successful.' He therefore disapproved of Tate's revised *Lear*: '*King Lear* is an admirable Tragedy of the same Kind, as *Shakespear* wrote it; but as it is reformed according to the chymerical Notion of Poetical Justice, in my humble Opinion it has lost half its Beauty.' The business of tragedy was to leave 'a pleasing Anguish in the mind'.[184]

But how can anguish be pleasing? One answer, with the authority of Aristotle, was that representation in itself is a source of pleasure. According to Aristotle, 'we enjoy looking at the most exact portrayals of things we do not like to see in real life, the lowest animals, for instance, or corpses'.[185] Addison says that even the 'Description of a Dunghill is pleasing to the Imagination'.[186] The artistry of the representation is also a source of pleasure, as Hume says: 'The force of imagination, the energy of expression, the power of numbers, the charms of imitation; all these are naturally, of themselves, delightful to the mind.'[187]

Yet can absolutely anything be made pleasing just by being represented? Edmund Burke takes the hard-headed view that we 'have a degree of delight, and that no small one, in the real misfortunes and pains of others', though he thinks this compatible with the 'bond of sympathy' that unites all human beings. Real calamities cause pleasure, provided they are remote; we would not wish London to be destroyed, but if it were, great crowds would come to survey the ruins. The pleasure in others' misfortunes explains the appeal of tragedy. Burke thinks the enjoyment afforded by representation relatively trivial, because tragedy pleases more the closer it comes to reality. Even so, people would rather witness a real execution than a fictitious tragedy:

> Chuse a day on which to represent the most sublime and affecting tragedy we have; appoint the most favourite actors; spare no cost upon the scenes and decorations; unite the greatest efforts of poetry, painting and music; and when you have collected your audience, just at the moment when their minds are erect with expectation, let it be reported that a state criminal of high rank is on the point of being executed in the adjoining square; in a moment the emptiness of the theatre would demonstrate the comparative weakness of the imitative arts, and proclaim the triumph of the real sympathy.[188]

Most commentators, however, objected to the representation of suffering. Johnson drew the line at the blinding of Gloucester: 'an act too horrid to be endured in dramatick exhibition'.[189] Hume is sure that suffering alone cannot give pleasure: 'The mere suffering of plaintive virtue, under the triumphant tyranny and oppression of vice, forms a disagreeable spectacle, and is carefully avoided by all masters of the drama.'[190] At the end of our

period, Schiller agrees: 'The presentation of suffering, as mere suffering, is never the purpose of art.'[191]

One could argue, as Dubos did, that the agitation of our emotions is pleasurable in itself. People always need something to occupy their thoughts. The enjoyable emotional turmoil produced by tragedy outweighs the unpleasant sensations of pity and fear, provided the spectator remembers that the tragedy is fictitious: 'Poetry and painting raise those artificial passions within us, by presenting us with the imitations of objects capable of exciting real passion.'[192] So we can enjoy the madness of Racine's Phèdre, or the sight of children being murdered in Charles Le Brun's painting of the Massacre of the Innocents, because we know the events are unreal and the emotions they excite will soon wear off. Diderot likewise values the emotional intensity that the theatre can arouse, and advises on how to heighten it by the appropriate use of gestures. For him, however, emotion is not an end in itself but a means of promoting virtue. The spectacle of virtue on the stage has a far greater moral effect than the comic presentation of vices we should avoid: 'So I repeat: decency, decency. It touches us in a sweeter and more intimate manner than what excites our contempt or our laughter.'[193]

An important part of the pleasure of tragedy was often said to be that, although the people on stage are exposed to disaster, we the spectators are safe and untroubled.

> When we look on such hideous objects, we are not a little pleased to think we are in no Danger from them. We consider them at the same time as Dreadful and Harmless; so that the more frightful Appearance they make, the greater is the Pleasure we receive from the Sense of our own Safety. In short, we look upon the Terrors of a Description, with the same Curiosity and Satisfaction that we survey a dead Monster.[194]

Commentators liked to quote the famous passage from Lucretius which says that it is pleasant for someone safe on dry land to watch a sailor battling with a storm.[195]

But this is surely a selfish attitude. Diderot argues instead that tragedy should evoke our sympathy with the characters. Expressive acting, making full use of gesture, should convey natural feelings in which the spectator can share. He opposes the type of melodramatic speech that he calls 'tirades' and that Addison calls 'rants'. 'Nothing is more applauded, nor in worse taste,' Diderot complains.[196] A play full of rants, *Oedipus* by John Dryden and Nathaniel Lee (1679), was immensely popular on the English stage, performed almost every year from 1700 to 1730, and often thereafter.[197] In this play, Oedipus is the virtuous but gullible hero, Creon a

villain even more deformed and malicious than Shakespeare's Richard III, and ghosts provide supernatural horror anticipating the later Gothic mode. It tells us much about the public taste that Addison wanted to reform with his dignified neoclassical *Cato* and, in France, Diderot challenged with his innovatory *drames bourgeoises* set in middle-class surroundings.

In Germany, Diderot's admirer Lessing went further by offering a bold reinterpretation of Aristotle which put the emphasis on sympathy. The only passion tragedy arouses in the spectator is pity or compassion (*Mitleid*). He argues that Aristotle did not mean pity and terror, but pity and fear. The misunderstanding of *phobos* as 'terror' has been abused to justify the presentation of monstrous villains on the stage.

> He speaks of pity and fear, not of pity and terror; and his fear is not at all the fear that the imminent affliction of another person arouses in us for this other person, but the fear arising from our similarity with the suffering person; it is the fear that the misfortunes threatening them may affect us ourselves; it is the fear that we may ourselves become the object of pity. In a word: this fear is pity directed towards ourselves.[198]

In Lessing's view, what people call *Schrecken* or terror is nothing but a sudden outburst of compassion: for example, when the priest declares 'You, Oedipus, are the murderer of Laios', 'I am frightened, for suddenly I see the honest Oedipus unhappy; my pity is suddenly aroused.'[199] This interpretation of Aristotle may not stand much scrutiny. As a later, more tough-minded classicist, Nietzsche, pointed out, Aristotle wants tragedy to purge us by catharsis from both fear and pity. Compassion is a Christian virtue, but the Greeks considered it a feeling that people were better without.[200]

Lessing, however, insists that tragedy arouses compassion and fellow-feeling for the tragic hero, and makes us imagine that his fate could also be our own. If this is the case even with someone so remote from us as Oedipus, king of Thebes, how much more affecting must be the experiences of people more like us. It is therefore mistaken to think, as Hume still did, that a tragedy must present persons of high social standing: 'A tragedy that should represent the adventures of sailors, or porters, or even of private gentlemen, would presently disgust us; but one that introduces kings and princes, acquires in our eyes an air of importance and dignity.'[201] Lessing disagrees:

> The names of princes and heroes can give a play pomp and majesty; but they do nothing to touch our feelings. The misfortune of those whose circumstances are closest to ours must naturally penetrate most deeply into

our souls; and if we have compassion for kings, it is with them as people, not as kings.[202]

Hence Lessing, like Diderot, wrote plays set in middle-class households: *Miss Sara Sampson* (1755) and *Emilia Galotti* (1772). These, like Diderot's *Le Fils naturel* (*The Natural Son*, 1757) and *Le Père de famille* (*The Paterfamilias*, 1758), were inspired by English models such as George Lillo's *The London Merchant* (1731), in which the merchant's apprentice George Barnwell is misled into robbing his employer and murdering his wealthy uncle. Diderot praises the pantomimic display of passion in Lillo, especially in the scene where Barnwell and his lover embrace in prison. However, Lillo could only provide an imperfect model, for he had not yet found a plausible style for his characters to speak. Their stilted prose keeps dropping into blank verse, e.g. 'If still you urge me on this hated Subject, I'll never enter more beneath this Roof, nor see your Face again.'[203]

Diderot and Lessing represent the Enlightenment's great innovation in tragic theory and practice. By making sympathy central to the audience's response, they pioneer a version of tragedy that interests us in the fates of ordinary people. Thus they enormously increase the scope of tragedy. Gradually it becomes possible for any person, however insignificant in the eyes of society, to become a tragic hero. As Terry Eagleton says, 'The Enlightenment, commonly thought to be the enemy of tragedy, is in fact a breeder of it.'[204] The person at the centre of a tragedy can – and indeed must – have faults and weaknesses that we share or can imagine sharing. Flawless heroes, as Lessing argues, belong in epic, not in tragedy, and saints have no place in either. Lessing dislikes the saintly hero of Corneille's martyr-drama *Polyeucte*, because Polyeucte is so keen to be a martyr that he does not inspire pity.[205] The Enlightenment has opened up a literary avenue that will presently lead to Georg Büchner's *Woyzeck* (1837) and Arthur Miller's *Death of a Salesman* (1949).

Not everyone agreed, however, that tragedy rested on sympathy. In 1764 Kant put forward a more restrained conception of tragic feeling. Compassion, he argued, had to be controlled by reason. Otherwise one would dissolve in a flood of tears and become 'a tenderhearted idler'.[206] We may weep over a child but should remain outwardly unmoved at news of a bloody battle. Kant associates tragedy with more demanding emotions: 'magnanimous sacrifice for the well-being of another, bold resolve in the face of danger, and proven fidelity'.[207] Even love in tragedy is not mere romantic sentiment, but 'melancholic, tender, and full of esteem'.[208] Tragedy certainly encourages compassion for others' sufferings, but the generous person also becomes conscious of the dignity of his own nature

(not of his individual personality – that would be too self-congratulatory – but rather of the dignity of *human* nature).

The Enlightenment, it must be admitted, produced no tragic dramas that have stood the test of time. However sympathetic one may be to works popular in the past, it would be difficult now to revive Addison's *Cato* (1713), John Home's *Douglas* (1756) or Voltaire's *Zaïre* (1732), all plays that excited their contemporary audiences. But alongside them, unnoticed by theorists of the tragic, a tragedy was being written, and widely read, that brings a convincingly flawed but essentially virtuous protagonist into situations prompting terror and pity, and evoking extremes of good and evil: Richardson's *Clarissa*. The energies that had once inspired stage tragedy were now being diverted into the novel, producing this masterpiece. It was too much for some readers, who wrote to Richardson wishing that 'poetical justice' might save Clarissa from her fate; but Richardson replied that God had arranged human life differently, and had 'intermingled good and evil' so that only a future life could provide a just distribution of both.[209] His postscript vindicates *Clarissa* as a tragic novel. *Clarissa* proves that the Enlightenment was fully capable of tragedy.

## THE SUBLIME

The Enlightenment defined and analysed a complex pleasure, involving fear and astonishment, under the term 'the sublime'. Sublimity was originally a rhetorical term, denoting a style of writing. In the Enlightenment it came to denote a kind of feeling, a mode of aesthetic experience. And eventually – as often happens with aesthetic discussions – it turned into an ethical concept.

The founding document of the theory of the sublime is a treatise by an unknown author, usually called *On Sublimity*, although *On the High* or *On Height* would be a more exact translation. It is now thought to have been written in the first century CE. It survives in a single, incomplete manuscript, which names the author 'Dionysius or Longinus'; he is conventionally called Longinus. Since he knew the Old Testament, he was probably a Hellenized Jew. His treatise is about grandeur in poetry and oratory, and on the literary devices with which to achieve it. Many of his examples of the sublime come from Homer: for instance, the lines about Poseidon:

> The high hills and the forest trembled,
> and the peaks and the city of Troy and the Achaean ships
> under the immortal feet of Poseidon as he went his way.[210]

And he immediately adds a similar example from the Book of Genesis:

> Similarly, the lawgiver of the Jews, no ordinary man – for he understood and expressed God's power in accordance with its worth – writes at the beginning of his *Laws*: 'God said' – now what? – ' "Let there be light", and there was light; "Let there be earth", and there was earth.'

Longinus' treatise was rediscovered only in 1554, and began to be influential in the late seventeenth century after it had been translated and discussed by Boileau in 1672.

The 'sublime' fulfilled a need. It helped to explain how pleasure could arise from objects to which the word 'beautiful' did not seem appropriate. Thus Addison's discussion of the pleasures of the imagination concentrates on 'great' objects which give pleasure, such as 'huge heaps of mountains, high rocks and precipices, or a wide expanse of water'.[211] Such objects did not fit the long-standing idea, supported by both Plato and the Bible, that beauty consists in proportion and symmetry, the consonance of parts with each other and the whole.[212] Apparently mountains gave pleasure because they were *not* symmetrical but lay in 'huge heaps'. Nor had they any moral content. Their appeal could therefore not be explained by Shaftesbury's Neoplatonic identification of the beautiful, the good and the true.

The concept of the sublime was fully and influentially developed by Edmund Burke in his *Philosophical Enquiry into the Origin of our Ideas of the Sublime and Beautiful*, published in 1757, eight years before the beginning of his parliamentary career. His essay forms part of the Enlightenment attempt to construct a 'science of man' that gives due attention to the emotions alongside reason. Burke, like Hume, is interested in the 'passions' and their non-rational origins. 'I should imagine,' he says, 'that the influence of reason in producing our passions is nothing near so extensive as it is commonly believed.'[213]

Burke contrasts the sublime with the beautiful. The latter is a source of simple pleasure. Beautiful objects are small, delicate, smooth, with mild colours and gentle variation of shapes (nowadays we would call them 'pretty'). Flowers, birds, domestic animals can be beautiful, like 'the fair sex'.[214] The sense of the sublime is a pleasure, but a complex pleasure. It comes from the imminence of pain and terror.

> Whatever is fitted in any sort to excite the ideas of pain, and danger, that is to say, whatever is in any sort terrible, or is conversant about terrible objects, or operates in a manner analogous to terror, is a source of the *sublime*; that is, it is productive of the strongest emotions which the mind is capable of feeling.[215]

The sense of the sublime consists not in pain, but in subsequent relief from pain. This sense of relief Burke calls 'delight', and the sense of the sublime is later called 'not pleasure, but a sort of delightful horror, a sort of tranquillity tinged with terror'.[216]

The sublime is evoked by a wide range of objects, including powerful objects that threaten us with destruction, such as wild animals and deadly natural phenomena. Things that are vast and magnificent are sublime too, such as the starry sky:

> The starry heaven, though it occurs so very frequently to our view, never fails to excite an idea of grandeur. This cannot be owing to any thing in the stars themselves, separately considered. The number is certainly the cause. The apparent disorder augments the grandeur, for the appearance of care is highly contrary to our ideas of magnificence. Besides, the stars lye in such apparent confusion, as makes it impossible on ordinary occasions to reckon them. This gives them the advantage of a sort of infinity.[217]

In the arts, Burke insists that the sublime is aided not only by vastness and terror, but by obscurity and indistinctness. For this reason, the sublime can be conveyed more effectively in words than in visual images. Paintings of hell generally appear ludicrous (Burke gives no examples, but one may think of Breughel or Bosch), while Milton's verbal evocation of hell with its vastness and darkness is deeply impressive. Quoting Milton's description of Satan, Burke commends the confusing variety of images: 'The mind is hurried out of itself, by a croud of great and confused images; which affect because they are crouded and confused.'[218] With the sublime, therefore, the confusion which would normally be an aesthetic flaw becomes an essential part of the artistic effect.

When Burke undertakes to explain why sublime objects cause a pleasure involving pain, he assumes close links between the mind and the body, so that our emotions are not simply mental events but have a physiological basis. The complex sensations of the sublime work as demanding exercise does on the body:

> labour is a surmounting of *difficulties*, an exertion of the contracting power of the muscles; and as such resembles pain, which consists in tension or contraction, in every thing but degree. Labour is not only requisite to preserve the coarser organs in a state fit for their functions, but it is equally necessary to those finer and more delicate organs, on which, and by which, the imagination, and perhaps the other mental powers act.[219]

Burke sees body and mind as closely interrelated, rather than separated by Cartesian dualism. Not only do feelings find physical expression, but

the appropriate physical actions can call forth corresponding feelings. Harmless terror is a kind of working out, a healthy exercise 'of the finer parts of the system'.[220] Thus his theory is as much medical as aesthetic; he seeks 'to observe the physiology of beauty and sublimity'.[221]

Burke's arguments provided the basis for the further development of the theory of the sublime by Kant, who, however, distanced it from aesthetics and physiology and made it a predominantly ethical theory. In the *Critique of Judgement*, Kant draws a firm distinction. The beautiful is found in limited objects, the sublime in those that are unlimited. So – in opposition to the growing fashion for finding sublimity in natural objects such as the Alps – Kant declares that no natural object in itself can be sublime, because every natural object is limited. The stormy ocean is not sublime, only 'horrible'.[222]

Sublimity is conferred on objects by the mind. In doing so, the mind makes a twofold movement. Whereas the beautiful permits a simple appreciation, consisting in a feeling of enhanced life and placing us in a state of restful contemplation, the sublime first imposes on us a blockage or inhibition of the vital energies. In the face of Mont Blanc or the stormy ocean, we may initially feel frightened or diminished. Then, however, reason reasserts itself, reminding us that we are superior to even the hugest material objects:

> Bold, overhanging, as it were threatening cliffs, thunder clouds towering up into the heavens, bringing with them flashes of lightning and crashes of thunder, volcanoes with their all-destroying violence, hurricanes with the devastation they leave behind, the boundless ocean set into a rage, a lofty waterfall on a mighty river, etc., make our capacity to resist into an insignificant trifle in comparison with their power. But the sight of them only becomes all the more attractive the more fearful it is, as long as we find ourselves in safety, and we gladly call their objects sublime because they elevate the strength of our soul above its usual level, and allow us to discover within ourselves a capacity for resistance of quite another kind, which gives us the courage to measure ourselves against the apparent all-powerfulness of nature.[223]

Kant's account of the experience of the sublime can be substantiated from the reports of people who had not read him. Here, for example, is Mary Wollstonecraft recording her complex feelings about a waterfall she saw in Norway in 1795:

> Reaching the cascade, or rather cataract, the roaring of which had a long time announced its vicinity, my soul was hurried by the falls into a new

train of reflections. The impetuous dashing of the rebounding torrent from the dark cavities which mocked the exploring eye, produced an equal activity in my mind: my thoughts darted from earth to heaven, and I asked myself why I was chained to life and its misery? Still the tumultuous emotions this sublime object excited, were pleasurable; and, viewing it, my soul rose, with renewed dignity, above its cares – grasping at immortality – it seemed as impossible to stop the current of my thoughts, as of the always varying, still the same, torrent before me – I stretched out my hand to eternity, bounding over the dark speck of life to come.[224]

Kant also associates the sublime with morality. He applies it to human life in sometimes unexpected ways. War encourages sublime virtues; peace can lead to moral decline.

Even war, if it is conducted with order and reverence for the rights of civilians, has something sublime about it, and at the same time makes the mentality of the people who conduct it in this way all the more sublime, the more dangers it has been exposed to and before which it has been able to assert its courage; whereas a long peace causes the spirit of mere commerce to predominate, along with base selfishness, cowardice and weakness, and usually debases the mentality of the populace.[225]

So a general is a sublime character, but a politician is not. Morality demands obedience to a law, which can mean sublime self-mastery, whereas beauty encourages the free play of the mind and the senses. In art, the moral good must be represented not as beautiful but as sublime, and as arousing respect rather than love.

It may be objected that this is an unattractive concept of morality, and that its aesthetic expression must also be unattractive. But that is not an objection: it is Kant's point. Moral and aesthetic sublimity do not have an immediate appeal. Their appreciation requires a self-mastery which simple goodness and beauty do not. We can perhaps see this more clearly by considering Wordsworth's 'Ode to Duty' (1805), one of his less popular poems today. Here Wordsworth reproaches himself for having been too devoted to the easy pleasures of the beautiful: 'I . . . being to myself a guide, / Too blindly have reposed my trust' and, though aware of ethical imperatives, preferred 'in smoother walks to stray'.[226] Those were the days when every movement in nature 'seemed a thrill of pleasure', when his heart danced with the daffodils, and when he was convinced that 'every flower / Enjoys the air it breathes'.[227] Duty, 'stern daughter of the voice of God', does not fill our hearts with pleasure. She demands 'the spirit of self-sacrifice' and rewards it with 'the confidence of reason'. Duty in fact

requires the twofold movement of the sublime: an initial reluctance, followed by self-overcoming, inner peace and the Stoical conviction that 'Not without hope we suffer and we mourn'.[228]

Wordsworth is thus reviving the Stoicism that the Enlightenment largely rejected; the 'Ode to Duty' has an epigraph from the Stoic philosopher Seneca. Both he and Kant are turning their backs on the Enlightenment hope that the innate dualism of humanity, the conflict between the body and the mind, self-love and social, could somehow be reconciled. And they anticipate a Victorian future lacking in pleasure and ruled by repression, self-mastery and strenuous moral effort.

# 10

# The Science of Society

We have seen how much Newton's model of a self-contained universe provided a template for Enlightenment thought. It was productive also when enlightened thinkers turned their attention to society and history. David Wootton has argued that the 'founding concept of modern social science' is the self-regulating machine that includes its own feedback mechanism. Such a concept underlies, for example, Hume's idea of the balance of trade, Adam Smith's idea of the market, and the checks and balances built into the American constitution.[1] Contemporaries recognized that in providing a comprehensive explanation of the physical universe, based on a few simple principles, Newton had helped students of society to achieve something analogous. If Bacon, by establishing the theoretical bases of empirical science, had made Newton possible, then Montesquieu's broad social analysis in *The Spirit of the Laws* had paved the way for Smith's detailed study of political economy.[2]

In addition, the study of society required the concept of society, which seems to have emerged in the late seventeenth century. The word 'society' is such a basic part of our intellectual equipment that it is hard even to express the idea in other words. Previously, one could talk about the 'body politic', the 'weal' ('this sickly weal', *Macbeth*, V. ii. 27), the 'common weal' or the 'commonwealth', which Locke explains as meaning 'any independent Community which the Latins signified by the word *Civitas*'.[3] These terms referred especially to political existence, whereas the scope of 'society' is much wider. As used by Charles I in 1642 ('the Laws of Society and civill Conversation') or Ralph Cudworth in 1678 ('the good of Humane Society'), it implies 'a social world separable from the world of civic responsibility and larger than the sphere of the household'.[4] Locke made a sharp and influential distinction between the household ('conjugal society') and 'civil or political society', in which a large number of people give up the precarious freedom allowed by the state of nature and unite for 'the mutual preservation of their lives, liberties, and estates, which I

call by the general name property'.[5] In eighteenth-century France, *société* came to mean 'the general field of human existence', detached from dependence on God or the king.[6] It was a network or system with an internal hierarchy, certainly, but not confined to any one political form.

## MONTESQUIEU: *THE SPIRIT OF THE LAWS*

*De l'Esprit des lois* (*The Spirit of the Laws*), published anonymously at Geneva in 1748 by Charles-Louis de Secondat, baron de Montesquieu, is widely regarded as 'the foundational work of modern political sociology'.[7] Its author was a legal expert, having studied law in Bordeaux and Paris, and served from 1716 to 1725 as one of the nine deputy presidents of the *parlement* (appeals court) of Bordeaux, where he was responsible for criminal prosecutions. He was also an active member of the Academy of Bordeaux, which was especially concerned with research in natural science. After resigning from the *Parlement* Montesquieu travelled extensively in Italy, Germany and England. Besides some short essays, he was the author of two brilliant and strikingly dissimilar books: the novel *Persian Letters* (1721) and the historical sketch *Considérations sur les causes de la grandeur des Romains et de leur décadence* (*Considerations on the Greatness and Decline of the Romans*, 1734). Thereafter he devoted himself to an ambitious work that would draw on his legal knowledge, his classical studies, his extensive reading of travel literature, and his experience of foreign states – particularly of the liberty he had found in England.

*The Spirit of the Laws* is not a work of jurisprudence. It deals rather with the political, cultural and geographical constraints which a legislator must take into account when framing laws. 'Many things govern men: climate, religion, laws, the maxims of the government, examples of past things, mores, and manners; a general spirit is formed as a result.'[8] This general spirit, which will be different in each nation, rests in turn on what Montesquieu calls laws of nature and which we might call basic human needs, such as the need to defend oneself, the need to eat, the need for sexual reproduction, and the need to live in society.[9]

The scope of legislation is defined by the form of government. Montesquieu distinguishes three. Where Aristotle had distinguished rule by the many (democracy), the few (aristocracy) and the one (despotism), Montesquieu classifies democracy and aristocracy as subtypes of republican government; adds monarchy, which he says the ancients did not understand; and makes despotism the third form.[10]

In a republic, the people govern: either directly, as in the ancient

# DE L'ESPRIT
## DES
# LOIX,

*Ou du rapport que les Loix doivent avoir avec la Cons-
titution de chaque Gouvernement, les Moeurs,
le Climat, la Religion, le Commerce, &c.*

*à quoi l'Auteur a ajouté*

Des recherches nouvelles fur les Loix Romaines touchant les
Succeffions, fur les Loix Françoifes, & fur les Loix Féodales.

## TOME PREMIER.

## A GENEVE,
Chez BARRILLOT & FILS.

The full title runs: 'Of the Spirit of the Laws, or the relation the laws should have
with the constitution of every government, manners, climate, religion,
commerce, etc.; to which the author has added new researches into the Roman
laws of succession, the French laws, and the feudal laws'.

republics, where all the citizens gathered in the marketplace to vote; or mediately, through an aristocracy. A self-perpetuating aristocracy easily hardens into an oligarchy, and therefore a senate, for example, should be replenished from the ranks of the people. The principle that animates a republic is *virtue*. Its denizens must be public-spirited, willing to put the public interest before their own, free from personal ambition, and inspired by patriotism. A republic can be established by the will and insight of a single legislator, such as Lycurgus in ancient Sparta and William Penn in modern Pennsylvania; on the other hand, when the English sought democracy in the seventeenth century, they ended up under the despotism of a single man, Oliver Cromwell.

A republic, even a democratic one, can still practise commerce (like the Dutch United Provinces), provided that people are frugal in their expenditure and great inequalities of wealth do not arise. To maintain equality, the state must limit the amounts that people can give away or inherit (by imposing death duties and similar taxes) and restrain expenditure by means of sumptuary laws. Luxury is fatal to a republic, because it means putting one's own interests before that of the republic. But extreme equality is also fatal, because egalitarians fail to respect the magistrates, and a general disregard for authority sets in, leading to disorder, anarchy and, eventually, to the despotism of a single strong ruler.

A limitation on republics is that they can only have a small territory. A republic spread over a large area can only be loosely organized and this gives people the opportunity to acquire inordinate wealth and nourish self-centred political ambitions: 'at first a man feels he can be happy, great, and glorious without his homeland; and soon, that he can be great only on the ruins of his homeland.'[11] Moreover, a small republic is vulnerable to a foreign enemy. The solution, and the way to make republics viable in the modern world, is for a number of them to join together in a federal republic. The United Provinces, the league of Swiss cities, and the many states forming the Holy Roman Empire, all provide examples. (This passage was read with particular interest by the American Founding Fathers.[12])

A democratic republic is fragile because political virtue is difficult to sustain. It is best supported by fear of an external enemy, as the Greeks feared the Persians – 'a republic must dread something'.[13] An aristocratic republic always risks turning into a hereditary oligarchy. Aristocrats must therefore practise virtue, or at least self-restraint; their manners should be modest and simple, indistinguishable from those of the people. To avoid their becoming unduly rich, they should not engage in commerce or levy taxes, and on a nobleman's death his estate should be divided among his children, instead of enriching his eldest heir by primogeniture (as happens

in Britain). Nevertheless, it is easy for an aristocracy to harden into a tyranny, as in the republic of Venice.

Montesquieu has more confidence, and more interest, in monarchies. Most of the European states were monarchies, including France, which Montesquieu had helped to administer as a judge. The principle animating a monarchy is *honour*. Everyone wants to distinguish himself in the eyes of the king. That is bad for personal virtue – the vices of courtiers are notorious – but good for the state, in impelling noble and self-sacrificing actions. A monarchy encourages gallantry, courtesy and bold frankness in speech (in contrast to the blunt truthfulness encouraged in republics). Luxury, a danger in republics, is desirable in monarchies. Not only does conspicuous consumption increase the glory of the wealthy, but their extravagance causes wealth to circulate through all levels of society: 'If wealthy men do not spend much, the poor will die of hunger.'[14] The principle of honour makes a monarchy resemble the Newtonian picture of the ordered universe:

> You could say that it is like the system of the universe, where there is a force constantly repelling all bodies from the center and a force of gravitation attracting them to it. Honor makes all the parts of the body politic move; its very action binds them, and each person works for the common good, believing he works for his individual interests.[15]

Since, however, one cannot rely on the virtue either of the prince or of the people, a monarchy must be supported by a firm system of laws, and as there are many distinctions of rank and condition, the laws must be correspondingly elaborate. The criminal law need not be severe, since shame is often an effective punishment. The demands of honour will sometimes lead people to transgress the laws (e.g. by duelling), so the monarch must be able to exercise clemency.

It is essential that in a monarchy there should be intermediate bodies between the monarch and the mass of the population. Such intermediate bodies are the best safeguard against despotism. Montesquieu commends the existence in France of two kinds of nobility, the traditional nobility of the sword, and the service nobility of the robe to which he himself belonged. The latter consists of state servants who have no way to distinguish themselves except through the honest exercise of their duties, and who are rewarded with the honourable conferment of a title. Businessmen too can expect their success to be similarly rewarded, which provides an additional motive for assiduity in their profession.

Dangers threaten a monarchy if the monarch acquires too much power by reducing that of the nobility, or if the nobility become too powerful

and independent. Montesquieu worried about the former danger in France, where the old nobility of the sword had largely lost its intermediate role and become a parasitic class of courtiers. The latter danger applies when a monarchy's territory becomes too extensive and the nobles become in effect petty rulers in their own right.

The third type of government, despotism, is appropriate to large countries with submissive populations, like the Ottoman Empire. Its animating principle is *fear*, often reinforced by the influence of religion. In some despotisms, all land belongs to the prince, so there is no private property. As the prince's will is absolute, subjects have no legal protection. When private property does exist, one cannot expect to bequeath it to one's descendants, because the prince will confiscate some or all of it. Given this continual insecurity, there can be little commerce, and most people live in poverty.

Forms of government can change. Montesquieu had reflected on many examples of political transformation, especially in the history of Rome, where the early kings had been driven out by the founders of the Republic, and where, after many centuries, the Republic had fallen into anarchy and been replaced by the despotism of the emperors. Change can result from external conquest or internal corruption. Democracies can become corrupt when the egalitarian spirit becomes so extreme that nobody wants to acknowledge anyone else's authority: this will lead to anarchy, which will in turn be quelled by the emergence of a tyrant. Monarchies become corrupt if the nobility grow too powerful or too weak. Spain, in Montesquieu's view, had become a despotism, because the vast wealth imported from its American possessions had allowed the nobility to sink into inactivity. Despotism cannot be corrupted because it is already corrupt by definition.

Montesquieu was particularly interested in the unique government of Britain. During his two years' residence there, he had come to know politicians, including Bolingbroke, the outspoken opponent of Sir Robert Walpole, and had attended two debates in the House of Commons. From Bolingbroke, as well as from Locke's *Second Treatise of Civil Government* (1689), Montesquieu developed the doctrine of the separation of powers into three areas: legislative, executive and judicial.[16] The power to frame the laws must belong to one body; the power of executing them, or putting them into practice, must belong to another; and judgement on whether the laws have been executed properly must belong to a third. In a despotism, the same person combined all three powers: this was true of the Ottoman sultan and of the Roman Republic's oppressive provincial governors, who were 'the pashas of the republic'.[17]

Britain did not quite fit into Montesquieu's categories. He considered it a democracy in the form of a monarchy, but one which also found a place for the aristocracy. Whereas the ancient republics, being small, could assemble all the citizens together, a modern democracy needed representative government. There should therefore be one legislature consisting of representatives drawn from various places, who understood the character and needs of their constituencies, and another composed of 'people who are distinguished by birth, wealth, or honors' who can exercise a sensible restraint on the proposals of the first.[18] Here Montesquieu has described the British Parliament, and the respective roles of the Commons and the Lords. It has been remarked that he says nothing about the party system, which admittedly was in flux in his day.[19] But in principle, unlike many theorists who thought 'factions' destructive to a state, Montesquieu agreed with Machiavelli in approving of productive conflict.[20]

Britain was exemplary in other ways. Montesquieu includes many reflections on his own speciality, criminal law, and he commends Britain for doing without judicial torture. He must himself often have administered torture to accused persons, and he remarks elsewhere how often the victims endured torture without confessing anything, thus proving the method to be useless as well as cruel.[21] As for punishments, they can be less severe in societies that have more liberty. Under despotism, harsh penalties are part of the all-pervasive system of terror, but in monarchies and republics one can appeal to people's sense of honour or virtue, and shame them into good behaviour.

Montesquieu's British experience helps also to account for the emphasis he places on commerce. Commerce is a civilizing force. 'Commerce cures destructive prejudices, and it is an almost general rule that everywhere there are gentle mores, there is commerce and that everywhere there is commerce, there are gentle mores.'[22] Here again the English score: Montesquieu calls them 'the people in the world who have best known how to take advantage of each of these three great things at the same time: religion, commerce, and liberty.'[23] By this Montesquieu alludes to the practice of religious toleration which supports commerce. Huguenots banished from intolerant France have enriched other countries, and the invention of bills of exchange, by making wealth invisible, has made it pointless to persecute and plunder Jews, as was customary in the Middle Ages.[24] Spain, on the other hand, having conquered an empire in America, did not use it for commerce but merely as a source of gold and silver, which in due course lost its value and plunged the Spaniards into proud poverty and clerical despotism.

Montesquieu's political sociology rests on – but is fortunately separable from – a kind of historical geography, which attaches great importance

to the supposed effects of climate.[25] People in cold countries are more vigorous, while in hot countries they are lethargic and timid. Northerners are industrious, though given to alcohol abuse; southerners are lazy and voluptuous. Hence northerners have repeatedly conquered southern countries: the Germanic barbarians overcame the Roman Empire, the Tartars invaded China. Hot countries are favourable to passive religions, such as Buddhism, and to the religious idleness of monasticism, which is widespread in Asia as well as Southern Europe. Hence hot Asian countries were bound to be despotisms because the people could not summon up the energy to resist their tyrants. There is a further, more strictly geographical reason why despotism must flourish in Asia. Unlike Europe, it has no temperate zone, and the cold north directly faces the hot south; its mountains are less covered with snow, and its rivers are smaller. This is very inaccurate geography, but in Montesquieu's day Europeans had no idea how high the Himalayas were.[26]

Although the climate theory caught the attention of his contemporaries, it is the most dated part of Montesquieu's work, both empirically ill-founded and internally inconsistent. It rests not only on faulty geography but on national stereotypes reinforced by travellers' reports. Occasionally Montesquieu is simply credulous, as when he affirms that the huge population of China and Japan results from the inhabitants living almost exclusively on fish.[27] He also has a curious physiological explanation for the supposedly different sensibilities of northerners and southerners. He tells us about an experiment in which he froze a sheep's tongue and found that its nerve-endings disappeared, but they reappeared when the tongue was thawed. Hence he concludes that cold climates have a similar effect on human nerves, making their inhabitants relatively insensible to sensations, whether of cold or pleasure, whereas the exposed nerves of southerners make them exquisitely sensitive, and they are enervated by excessive heat.[28] As for the theory's internal contradictions, sometimes Montesquieu implies that the climate has a determining effect on society, so that Asia must always be despotic; elsewhere he shows people working to counteract the effect of climate, as when the emperor of China performs a ploughing ceremony each spring in order to rouse the farmers to activity.[29] In any case, if servitude comes naturally to people in hot countries, then they must be motivated by indolence rather than fear, and their governments then will not correspond to Montesquieu's definition of despotism.[30]

The climate theory was not Montesquieu's invention.[31] It had already been elaborated by Dubos in his *Réflexions critiques sur la poésie et sur la peinture* (1719). Dubos wanted to explain why poetry and painting flourished in certain countries and not others. He thought they were

confined to Europe and even there did not exist north of Holland. Just as plants flourish only in certain soils, so the 'character of our minds and inclinations depends very much on the quality of our blood', which in turn depends on the air one breathes, and the air is affected by emanations from the earth.[32] Dubos' theory is so flexible as to be unfalsifiable. By 'climate' he often just means weather, so that a harsh winter can create a different atmosphere from one year to the next; and to explain the activity of modern northerners, he says that the dulling effect of northern climates has nowadays been counteracted by the introduction of wine.

The obvious objections both to this theory and to Montesquieu's version were made most forcefully by Hume in his essay 'Of National Characters' (1748). How was it that the ancient Greeks had the spirit to resist Persia, while their descendants, living in the same place, submitted tamely to the Ottoman Empire? How was it that the Chinese, according to all travellers, were a homogeneous people, though living in a vast empire with much climatic variation? Hume ascribed national character not to physical but to moral, i.e. cultural and political, causes, notably the diffusion of learning and the effects of different governments.[33] Herder in 1784 mocked the sheep's tongue experiment and pointed out that the putative effects of climate are so complex, and as yet so little known, that we cannot use them to explain the characteristics of entire peoples, especially as adjacent places, with similar populations, often differ widely in climate.[34]

However, Montesquieu deserves great credit for his ambition of putting forward a comprehensive account of human society and providing a typology of political societies that made sense of innumerable social details. *The Spirit of the Laws* is breathtakingly ambitious and innovative in its attempt to integrate law, geography, physiology, economics, social and cultural practices (*mœurs*), and, above all, a sociological approach to politics.

How far does *The Spirit of the Laws* support a belief in progress? It is not a historical narrative, and it says more about how governments are corrupted than about how they are established. Nevertheless, it offers hope in its praise of commerce, in its evocations of a federation of republics and of parliamentary democracy, and in its observation that if we nowadays conquer a nation we do not exterminate its inhabitants, as was customary in the ancient world.[35] But Montesquieu doubts that the 'general spirit' of a nation can be changed. The successful reforms of Peter the Great in Russia may seem a counterexample, but Montesquieu explains that Peter found the Russians living under a despotism that stemmed from the Tartar invaders and was foreign to their cold climate. As 'the empire of climate is the first of all empires', Peter did not even need to introduce

European mores by law; he only needed to let the Russians follow their natural inclination. So, the potential for progress is only what the 'general spirit', resting ultimately on climate, is able to permit.[36]

Leaving aside the question of climate, Montesquieu's argument about the 'general spirit' has significant implications. It suggests that a legislator cannot force people to be free. One can only introduce such political institutions as are in accordance with the 'general spirit', or as we might say, the culture of the people in question. Certainly, in the twentieth and twenty-first centuries, despotism has repeatedly been overthrown by a violent revolution, only to reassert itself in a new guise; and Western governments have attained only patchy success in their attempts to transplant liberal democracy to countries that have newly emerged from colonial rule or internal oppression. More broadly, Montesquieu's insistence on the 'general spirit' anticipates the respect now accorded to cultural difference, although respect for cultural difference can conflict with the universal principles of human rights now officially accepted by most nations and international bodies. So the concept of cultural difference, often represented as incompatible with the universalism attributed to the Enlightenment, actually emerges from a central Enlightenment text, along with the present-day dilemmas to which it gives rise.

## COMMERCE

Montesquieu's contemporaries eagerly agreed that commerce strengthened civilization. It was all the easier to do so because the word 'commerce', in both English and French, also meant 'intercourse', that is, social interaction. La Rochefoucauld combines the social and commercial meanings in his maxim: 'Gratitude is like the good faith of merchants; it supports commerce.'[37] Hume speaks of 'the commerce and society of men, which is so agreeable'; Diderot's unsociable Dorval in *The Natural Son* (1757) says: 'I hate the commerce of men'; and Shaftesbury condemns a misogynist who is 'averse to any commerce with womankind'.[38] Here 'commerce' means social contact, but the narrowly sexual meaning is present when Gibbon talks of the 'vague [i.e. promiscuous] commerce of Theodora' and Gilbert White of the sexual 'commerce' of swallows.[39] So 'commerce', even when it referred primarily to the exchange of goods and money, conjured up a wider network of social relations.

One of the main benefits of commerce was that it freed both individuals and societies from isolation and made them aware that they were part of a chain of relationships encompassing the globe. In George Lillo's popular

play *The London Merchant* (1731), the businessman Thorowgood tells
his assistant

> how it [commerce] is founded in Reason, and the Nature of Things. – How
> it promotes Humanity, as it has opened and yet keeps up an Intercourse
> between Nations, far remote from one another in Situation, Customs and
> Religion; promoting Arts, Industry, Peace and Plenty; by mutual Benefits
> diffusing mutual Love from Pole to Pole.[40]

Voltaire, writing briefly on trade in his *Letters concerning the English
Nation*, ironically pretends to be uncertain whether a French courtier is
more useful than 'a Merchant, who enriches his Country, dispatches
Orders from his Compting-House to *Surat* and *Grand Cairo*, and con-
tributes to the Felicity of the World'.[41] Henry Martin ascribes to Providence
the situation of Britain as an island, which predestines it to excel in nav-
igation and thus import the riches of the world:

> By this we taste the Spices of *Arabia*, yet never feel the scorching Sun which
> brings them forth; we shine in Silks which our Hands have never wrought;
> we drink of Vinyards which we never planted; the Treasures of those Mines
> are ours, in which we have never digg'd; we only plough the Deep, and reap
> the Harvest of every Country in the World.[42]

Countries thus interlinked by commerce, it was thought, could have no
interest in warfare. So international commerce was the surest guarantee
of world peace. 'The natural effect of commerce is to lead to peace,' says
Montesquieu. 'Two nations that trade with each other become reciprocally
dependent; if one has an interest in buying, the other has an interest in
selling, and all unions are founded on mutual needs.'[43] The best guarantee
of eventual peace is trade.[44] For this to happen, however, trade restrictions,
such as those imposed by protectionist economic policies, would have to
be completely abolished, and global free trade established. 'The revolution
will be general; everywhere the clouds will be scattered; a calm day will
shine over the entire globe; nature will resume the reins of the world. Then
or never that universal peace will blossom, which a warlike but humane
king did not think chimerical.'[45]

Looking back over history, Enlighteners celebrated the triumph of the
commercial middle classes over the nobility of feudal Europe. The Middle
Ages looked like an age of anarchy, in which people were fully occupied
in fending off the aggression of their neighbours and in paying servile
homage to their feudal superiors and self-styled protectors. Modern Eur-
ope owed its civilization to the growth of commercial towns: 'through the
greater part of Europe the commerce and manufactures of cities, instead

of being the effect, have been the cause and occasion of the improvement and cultivation of the country.'[46] The perpetual wars of medieval times, and the violent sports favoured by the nobility in intervals of peace, were contrasted with the quiet, sedate and inoffensive occupation of the merchant. It was in this sense that Johnson could say to Boswell: 'There are few ways in which a man can be more innocently employed than in getting money.'[47] The rational interests of the businessman were seen as promoting peace and stability, in contrast to the unbridled passions of the aristocracy.[48] So we find eighteenth-century writers proclaiming that favourite theme of historians, the rise of the middle classes, at the expense of a supposedly improvident and outdated aristocracy. Defoe claims that most of the lower English gentry, and many of the higher, have been impoverished through their own extravagance:

> How are the antient families worn out by time and family misfortunes, and the estates possess'd by a new race of tradesmen, grown up into families of gentry, and establish'd by the immense wealth, gain'd, as I may say, behind the counter; that is, in the shop, the warehouse, and the counting-house?[49]

In fiction, an idealized, progressive merchant often confronts a backward-looking aristocrat: thus Addison's Sir Andrew Freeport argues good-humouredly with the squire Sir Roger de Coverley, and in Steele's play *The Conscious Lovers* (1722) Mr Sealand (a name evoking the global range of commerce) puts the case for trade against Sir John Bevil.

Spokesmen for the middle classes were eloquent about the virtue fostered by their commercial occupations. Adam Ferguson describes how the morality of the merchant develops with the rise of civilization, and even survives its decline:

> The trader, in rude ages, is short-sighted, fraudulent, and mercenary; but in the progress and advanced state of his art, his views are enlarged, his maxims are established: he becomes punctual, liberal, faithful, and enterprising; and in the period of general corruption, he alone has every virtue, except the force to defend his acquisitions.[50]

Defoe advises that a tradesman should be frugal and should defer his gratifications. He should not marry as an apprentice, or until he has been set up in business for some time, for furnishing a house, maintaining a wife and children, and paying servants will cost a great deal. An apprentice who marries secretly 'is frequently driven to wrong his master, and rob his shop, or his TILL for money, if he can come at it; and this, as it begins in madness, generally ends in destruction; for often he is discover'd, expos'd, and perhaps punish'd; and so the man is undone before he

begins.'[51] This is, in a nutshell, the story of George Barnwell, the misguided protagonist of Lillo's *London Merchant*. Defoe also recommends a degree of partnership between husband and wife. A tradesman should 'make his wife so much acquainted with his trade, and so much mistress of the managing part of it, that she might be able to carry it on if she pleased, in case of his death'.[52] Adam Smith maintains that commercial society (a term he was among the first to use) promotes virtue among the lower classes, whereas the presence of a court and its attendant nobility promotes idleness:

> In mercantile and manufacturing towns, where the inferior ranks of people are chiefly maintained by the employment of capital, they are in general industrious, sober, and thriving, as in many English and most Dutch towns. In those towns which are principally supported by the constant or occasional residence of a court, and in which the inferior ranks of people are chiefly maintained by the spending of revenue, they are in general idle, dissolute, and poor; as at Rome, Versailles, Compiegne, and Fontainbleau.[53]

The virtues advocated here are among those that we think of as particularly Protestant: industry, frugality, economy, self-control, strict honesty, a focus on one's home and family. Although Max Weber's argument about the genesis of the 'Protestant ethic' is rarely accepted by present-day historians, the complex of values denoted by the term is still recognizable; the language of the 'Protestant ethic' has come so to shape our thinking that an alternative set of values is hard even to formulate. In the non-commercial, largely agrarian culture of Catholic Europe, however, 'economy' was a virtue with limited application. Provision had to be made against a future bad harvest, but beyond that it made no sense to stockpile perishable goods. In times of prosperity, the best way to use the surplus was to throw a party, contribute to a celebration, or donate to charitable and religious causes. If there was no need to work, there was nothing shameful in inactivity; instead of being condemned as 'idleness', it could be praised as *otium*, leisure for contemplation.[54] There, giving money to beggars was a praiseworthy act of generosity; but not in commercial society, where Addison's Sir Andrew Freeport severely condemns it because it rewards idleness.[55] Defoe similarly argues in 1704 that there is enough work for all able-bodied men and beggars merely take advantage of charity.[56] Eighteenth-century visitors to Switzerland, mostly coming from Northern Europe, comment on the industry of the Protestant cantons and condemn the idleness they see in Lucerne and other Catholic regions.[57] Friedrich Nicolai, a Lutheran from Berlin, was scandalized in 1781 by the hedonism of the Viennese, shown in their eating, drinking, play-going,

and the many secular and religious events that brought crowds onto the streets.[58] Here we see a confrontation between two incompatible value-systems that cannot even be formulated in the same language.

Commerce was therefore not simply a neutral link among different societies, as James Thomson imagined in evoking how 'generous Commerce binds / The Round of Nations in a golden Chain'.[59] In the long run it might remould other societies in the image of Protestant Europe. And in dealing with them it might be far from generous. Jean-François Melon described the basic situation of commerce by asking his readers to suppose several islands, each excelling in a different product, such as corn or woollen goods. Each island would then dispose of its surplus, and supply its own needs, by trade with its differently endowed neighbours. But Melon represented their relations as unstable. Two islands might gang up on the third in a trade war. If that happened, Corn Island (standing for France) might suffer temporarily, but in the long run it was bound to triumph over Wool Island (England), because corn was essential for subsistence as wool was not.[60]

So commerce could easily be competitive. It had clearly been so, in fact, since the late seventeenth century, when Sir William Temple, ambassador to the Netherlands, noted that the United Provinces were under threat not from rivals seeking to undercut their trading services, but from great powers that wanted to put them out of business altogether.[61] 'Trade was never esteemed an affair of state till the last century', wrote Hume in 1752.[62] Now, however, it was war conducted by other means, in an approach that has been called neo-Machiavellianism.[63] Despite the aspirations of legal theorists, international relations were not governed by laws. A 'state of nature' thus prevailed, in which each state sought to strengthen itself at the expense of others. Machiavelli, in his *Discourses on Livy* (1531), had praised the incessant expansionism of the Roman Republic, which had eventually grown into an empire stretching from the Atlantic to the Middle East. Modern statesmen had an analogous ideal in commercial expansionism. So, commerce did not promote peace, as it was supposed to, but gave rise to enmity and frequent war. Adam Smith remarked that commerce 'ought naturally to be, among nations, as among individuals, a bond of union and friendship', but regretted that in recent times it had become 'the most fertile source of discord and animosity'.[64]

It was often argued that instead of playing at beggar-my-neighbour, states ought to abandon their commercial rivalry and give up all restrictions on trade. Hume pointed out in 'Of the Jealousy of Trade' that a state could gain nothing by reducing a neighbour to poverty. The neighbour would then be unable to buy the first state's exports, and poverty would become general. 'I shall therefore venture to acknowledge,' he concluded,

'that, not only as a man, but as a British subject, I pray for the flourishing commerce of Germany, Spain, Italy, and even France itself.'[65] His essay drew an approving letter from Benjamin Franklin, who especially complained that Britain was following a 'selfish' policy towards America instead of pursuing 'the interest of humanity'.[66]

Hume's essay was also quoted in a little treatise by Benjamin Vaughan, a former personal secretary to the earl of Shelburne who in the 1760s and 1770s had tried to shape Britain's commercial policy in accordance with the liberal principles that Smith set out in *The Wealth of Nations*.[67] Vaughan contrasts protectionism ('monopolism') with free trade, and itemizes the shortcomings and errors of the former. He argues for the unimpeded exchange not only of goods, but also of knowledge. The civil power should support free trade not by intervention, but by equal laws, religious freedom and the encouragement of public spirit. He hopes for 'free-trade and pacific systems':

> Nations might then no longer view each other as strangers and as rivals; and individuals learning more and more their real public interests, might consider themselves not merely as the members of separate nations (a sentiment which has hitherto seldom been the companion of general liberality or general justice,) but likewise a member of the Universe, and as the common children of a common Father.[68]

Business should therefore be left to businessmen. In 1774 Franklin wrote:

> When Colbert assembled some wise old merchants ... and desired their advice and opinion, how he could best serve and promote commerce; their answer ... was in three words only, *Laissez nous faire*. Let us alone. It is said, by a very solid writer of the same nation [d'Argenson] that he is well advanced in the science of politics, who knows the full force of that maxim, *Pas trop gouverner*; Not to govern too strictly which, perhaps, would be more use when applied to trade ... It would therefore to be wished that commerce were as free between all the nations of the world, [for] ... those [nations] would not ruin one another by trade.[69]

In wishing to leave commerce to merchants, however, Franklin presupposes that the merchants will conduct trade responsibly, with an eye to the general good, not just to their selfish and short-term interests. How was such responsibility to be guaranteed? Vaughan hopes that their government will have inculcated public spirit in its citizens. The English Dissenter Josiah Tucker, who advocated free trade as being in accordance with God's providential design, thought that merchants had to be Christians and their practices 'under the direction of good morals'.[70] These

hopes sound plaintive in a period when the Christian employees of the East India Company were busy exporting opium to the Chinese. Meanwhile, on the colonial frontier, traders obtained furs from native Americans in exchange for brandy; Baron Louis-Armand de Lahontan, a French officer who travelled extensively in North America, called brandy 'incomparable' in its usefulness for trade.[71] By making their trading partners dependent on alcohol, they disrupted native American society. Far from being provident even with goods, they reduced animal stocks far below replacement level.

Commerce had drawbacks too for the home population. It was inherently unstable. If manufacturers employed too many people, or paid them too much, goods became expensive and uncompetitive. An increase in the money supply would similarly increase consumption and thus raise the price of products and merchandise, making it ultimately cheaper to import goods, damaging domestic manufactures. The Irish economist Richard Cantillon, who made a fortune in France by judicious speculation, therefore argued that there was a cycle of wealth and poverty:

> When a state has reached the highest point of wealth – I am still assuming that the comparative wealth of states consists in the respective quantities of money of which they are the principal possessors – it will not fail to relapse into poverty by the ordinary course of things. The excessive abundance of money, which makes the power of states while it lasts, throws them back insensibly, but naturally, into indigence.[72]

Wealth must pass from one country to another, unless a prince or legislature managed to break the cycle by withdrawing money from circulation at the right moment. Hume too argued that economic prosperity is cyclical (anticipating the present-day concept of globalization). When one nation has gained the advantage in trade, it will eventually lose out to others where the cost of labour is low: 'Manufactures, therefore, gradually shift their places, leaving those countries and provinces which they have already enriched, and flying to others, whither they are allured by the cheapness of provisions and labour, till they have enriched these also, and are again banished by the same causes.'[73]

If the modern world depended on commercial cycles, not all economists approved. Both Hume and Mably noted that ancient writers showed no understanding of commerce.[74] But while Hume thinks this a shortcoming, Mably finds it admirable. What would Plato, Aristotle, Cicero, and all the ancient philosophers think if they heard us saying that a state cannot be happy without extensive trade?[75] Mably cites the notorious case of Spain, where the importation of gold and silver from America simply caused

prices to rise more than incomes and thus led to poverty. Quoting Cantillon's argument about economic cycles, Mably asserts that 'commerce is a kind of monster that destroys itself with its own hands'.[76]

What solutions were there? A low-wage economy was advantageous in the short run, but the goods it produced needed a domestic as well as a foreign market. To enable workers to buy the goods they produced, their earnings must eventually rise, setting the cycle in motion. Labour-saving machinery made it possible to employ fewer people. Why employ individuals to saw logs instead of sending the wood to a sawmill? Melon dismisses anxieties about people being thrown out of work. 'A Proposal was made, for supplying a City with Water by easy, and not expensive Engines. Can it be believed, that the principal Objection, and which, perhaps, hindered its being carried into Execution, was this Question: What will become of the Drawers of Water?'[77] Melon argues that if workers are replaced by machinery, they are then freed to undertake further work. As many people should be employed as possible, including women, who should work alongside men in building roads and digging canals.[78] Melon does not consider, however, that releasing people from one kind of work in order to redeploy them in another, cannot continue indefinitely (it is perhaps approaching its end-point in the twenty-first century with the vast increase in automation).

Clearly a commercial society requires a flexible labour force. Hume, who recommends the diversification of manufactures rather than reliance on a single product, sees no difficulty in re-skilling: 'If the spirit of industry be preserved, it may easily be diverted from one branch to another; and the manufacturers of wool, for instance, be employed in linen, silk, iron, or any other commodities, for which there appears to be a demand.'[79] Henry Martin admits that many people, put out of work by the import of cheaply produced textiles from India, fall back on meagre parish relief or sell themselves to the American plantations, but says they have no need to, since they can always find unskilled labour, such as drawing barges or building roads, and anyway a large labour pool itself brings down wages and thus makes manufactures cheaper and more exportable.[80] Hume, more presciently, insists that the real wealth of a state lies not in money, but in 'men and commodities'.[81] His thinking has been summed up as follows: 'The crucial resource was human capacity. Good education and the willingness for industrial restructuring were more important than the gains offered by labor-saving machinery.'[82] Hume thus begins to envisage an economy in which skills are more important than mere labour.

## POLITICAL ECONOMY

How were the forces of commerce to be used to the best advantage of all? To increase the happiness of society, social thinkers, especially in France, Naples and Scotland, devised the new science of 'political economy', which they regarded as 'the key to what the Enlightenment explicitly thought of as "the progress of society"'.[83] The Neapolitan Antonio Genovesi, who in 1754 became the first holder of a university chair in political economy, said in his inaugural lecture that in a populous nation, the sovereign 'will also have the greatest possible riches and power, and the goods which generate men's natural happiness will be greater, as will the power to repel the evils which commonly afflict the people.'[84] Another such chair was founded in Vienna in 1763, held by the cameralist Joseph von Sonnenfels, and another, held by Cesare Beccaria, at Milan in 1769.[85]

Political economy was not identical with the present-day discipline of economics.[86] It was one aspect of 'the science of a legislator', in Adam Smith's phrase, and intimately connected with social and historical questions.[87] Nor was it the 'dismal science' (contrasted with the 'gay science' of the medieval troubadours) denounced by the backward-looking critic of nineteenth-century industrial society, Thomas Carlyle, who condemned the free market of labour as a subjection to the inhuman 'supply-and-demand principle' and inferior to the relative security offered by medieval serfdom.[88] The word 'economy' implied an analogy with the economy of nature or 'organic economy' admired by eighteenth-century scientists and physico-theologians. Hence Rousseau, in his *Encyclopédie* article on the subject, focuses not on economic activities but on 'the internal organisation and functioning of a political structure' represented as analogous to the human body.[89] The political economists of the Enlightenment saw economic life not as an affair of cold calculations but rather as 'a place of warm and discursive emotions' powered by desire, which had to be properly channelled in order to produce happiness.[90]

Many eighteenth-century legislators were suspicious of commerce and wanted to restrict it. The conduct of the economy in early modern Europe was governed by a set of assumptions and practices that have been labelled mercantilism.[91] Mercantilists advocated a closed, self-sufficient economy, which should – if possible – be extended by colonies providing sources of raw materials and markets for surplus home products. Protectionist policies were favoured even within the home economy: Ireland was forbidden to export wool to England for fear of undercutting the latter's trade in woollen goods, and the American colonies were discouraged from

developing manufactures. British Navigation Acts, passed in the seventeenth century, were intended to ensure trading monopolies with Britain's American, Caribbean and Indian colonies, and it was to preserve these monopolies that Britain fought France in the Seven Years War. Trade with foreign countries should maintain a favourable balance. Imports should be discouraged, and exports encouraged, in order to support home manufactures. When the Habsburg Emperor Leopold I married in 1673, he 'boasted that he wore not a stitch on his person which had not been made in the lands of his inheritance'.[92] A country's wealth should be measured in non-perishable goods, the most durable being gold and silver.

Hume and Smith attacked mercantilism, especially the idea that wealth consists in the accumulation of money, and that a country should aim at a favourable balance of trade by restricting imports and encouraging exports. Hume ridicules the policy of accumulating money by an analogy with nature. Just as water finds its level, unless artificially restrained, so the supply of money tends naturally to become equal. If money is in short supply, labour will be cheap, exports will increase, and thus money will flow back into the country.[93] In Smith's view, it is a basic fallacy to identify wealth with money. Money is merely the means by which wealth circulates. The wealth of a country consists in its land, its material goods, its people and their skills, and money should not be hoarded but used to improve them. Mercantilism confuses the interest of a merchant with the interest of the country. It holds that gold and silver, being durable, should be accumulated 'to the incredible augmentation of the real wealth of the country', instead of being exchanged for perishable commodities; but we might as well accumulate hardware 'to the incredible augmentation of the pots and pans of the country'.[94] Money is worthless if it is not being used productively. Colonies were unprofitable, and the wars fought to acquire and keep them were cripplingly expensive: Hume claims that 'The ENG-LISH fleet, during the late war, required as much money to support it as all the ROMAN legions, which kept the whole world in subjection, during the time of the emperors.'[95]

By contrast with this artificial mercantilist control of the economy, the French physiocrats, the Neapolitan economists and Adam Smith all wanted the economy to correspond to a natural and/or Newtonian order and harmony.

The doctrine of physiocracy was upheld by a group of French thinkers centring on the medical doctor-turned-economist François Quesnay.[96] As Quesnay's patients included Louis XV's lover Madame de Pompadour, and he later became medical adviser to the king, he was able to exert considerable influence. He was an innovator in economic theory through

drawing up an abstract model of the economy, his *Tableau Économique*, of which he brought out three editions in 1758–9. Physiocracy was also supported by the *philosophe* Turgot, whom we have already met as tax collector for Limoges from 1761 to 1774, and who was subsequently Controller-General of Finances from 1774 to 1776. Benjamin Franklin, who met many of the physiocrats in Paris in 1767, adopted their doctrines enthusiastically and did his best to propagate them in America.[97]

The physiocrats maintained that all renewable wealth came from agriculture. Agriculture yielded a 'net product', a surplus beyond the necessary cost of production. Taxation should be levied only on this surplus, not on the farmer's wealth. Manufactures, by contrast, were unproductive, because their products were simply consumed, leaving no net product. The government should increase agricultural productivity by encouraging investment, and should stimulate the demand for agricultural produce. Quesnay advocated freedom of trade because it would benefit agriculture by raising the price of farm products, and high agricultural prices would make it worth farmers' while to improve their land and increase their productivity. These insights, according to the physiocrats, amounted to the recognition of a natural order. The physiocrat Pierre Paul Le Mercier de la Rivière, for example, wrote in 1767 that the social order is part of the physical order:

> Once this truth is recognized, it self-evidently follows that there is nothing arbitrary about the social order; that it is not the work of men; that, on the contrary, it is instituted by the Author of nature . . . consequently, that the immutable laws of this physical order must be regarded as being, in relation to us, the *primitive and essential reason* of all positive legislation and all social institutions.[98]

Thus physiocracy was not just an economic doctrine; it aimed to restore the lost harmony between humanity and nature, and thus to carry out God's intentions. The state remains benevolently in the background, 'rather like the deist conception of God'.[99]

From the belief in a natural order it followed that government should not intervene in the economy but pursue a policy of laissez-faire. Small farms should be replaced by large agricultural enterprises in which former tenant farmers would work as day labourers and economies of scale would make it possible to apply the latest farming techniques. The stumbling-block, however, was the price of corn. Not only was the harvest unpredictable, but bad communications easily produced local shortages. Should the government step in to avert the danger of famine? When Turgot became Controller-General in 1774, he followed the physiocratic line by

deregulating the corn trade and abandoning the traditional policy of stock-piling grain for distribution in times of dearth. Unfortunately for him and for the public, 1774 also saw a bad harvest and a doubling of the price of bread. Peasants rose in revolt, attacked bakers and rich farmers, stopped grain from being transported out of stricken areas and sold it off at what they considered a fair price. Turgot responded to the Flour War with repression and public executions.[100] These measures, combined with the political reforms he rushed through, made Turgot so unpopular that Louis XVI dismissed him from office in May 1776. The Flour War helped to discredit physiocracy in France. However, in the 1770s the doctrine became popular in Germany, where the many absolutist rulers of small states liked an idea that professed to follow and strengthen a natural order.[101]

Physiocracy received some of its sharpest criticisms from the wittiest of all economists, the abbé Ferdinando Galiani.[102] From 1759 to 1769 Galiani lived in Paris as secretary to the Neapolitan Embassy, and was a friend particularly of d'Holbach and Diderot. The *philosophes* were dazzled by his comic talents, his brilliance, and his skill in defending paradoxes, as when he undertook to justify the crimes of the emperors Tiberius and Nero.[103] In 1770 his *Dialogues sur le commerce des bleds* (*Dialogues on the Corn Trade*) appeared under a false London imprint. In these entertaining conversations, the author's mouthpiece, Chevalier Zanobi, attacks the physiocrats' love of abstraction by declaring that the habit of generalizing a particular idea is the greatest source of errors.[104] The physiocrats' generalization concerns the benefits of agriculture. With their one-size-fits-all approach, they overlook the difference between a country such as France, which, thanks to Colbert, has extensive manufactures as well as agriculture, and entirely agricultural countries like Poland or Turkey. A country that relies solely on agriculture is like a gambler. A gambler is dependent on chance; farmers are dependent on the uncertainties of the weather. There are prudent gamblers, and prudent farmers; but not many. An agricultural economy will lead sooner or later to impoverishment, despotism and rebellion. Manufactures are a steady source of income, whereas agriculture is unpredictable and subject to disasters.

The chevalier recommends not only that a nation should encourage large-scale industry, but also, since farming work is irregular and seasonal, that the farmer's wife and children should engage in a cottage industry, such as weaving. Otherwise the physiocrats' policy must lead to catastrophe. Galiani was doubtless influenced by his experience of the Tuscan famine of 1764–5, when he had seen the poor reduced to skeletons starving in the streets; the chevalier in his *Dialogues* has just returned

from Tuscany and Naples, where he has seen thousands of people reduced to nibbling grass and dying of hunger.[105]

Galiani's spokesman further contends that only a manufacturing country makes freedom possible: 'If you except the Roman people which was always an exception to all rules, you will have no example of free countries where manufactures have not flourished.'[106] He concludes:

> A purely agricultural people is the unhappiest of all peoples; delivered over to servitude, superstition, and indigence, it farms all the worse because farming is its sole occupation, and it suffers the horrors of famine all the worse because all its goods are only the productions of the earth. Such are Turkey, Poland, and many other countries in Europe which I need not name. Such was France, and still would be, if the great genius of Colbert had not brought your nation from the idle indigence of the agricultural condition and the ferocious anarchy of chivalry to the tranquillity of submission, the calm of affluence and the luxury of industry.[107]

This passage puts Galiani's arguments in a historical framework. Like many Enlighteners, notably Hume, he regards the Middle Ages as a time of savagery, poverty and superstition. The progress of manufactures has been the crucial agent in reducing superstition and promoting enlightenment and liberty.

Meanwhile, the social thinkers at Naples were trying to place economics on a Newtonian footing.[108] Mid-century Neapolitan intellectual life was divided between the *veteres*, centred on the Accademia degli Oziosi, and the *novatores*, centred on the Accademia delle Scienze, which had been formed in 1732 by Celestino Galiani (the abbé's uncle) and Bartolomeo Intieri. The *novatores* regarded Newton's *Principia* and *Opticks* as models for the study not only of the physical world but also of man and society. They read Mandeville, Bayle and Locke, and admired England and Holland, where there existed a culture and laws favourable to economic development. While the *veteres* thought the development of commerce should be based on 'mutual aid' and be compatible with Christian conceptions of social justice, the *novatores* worked out a model of society based on immutable economic laws reflecting those of the Newtonian universe. This model is expressed in Galiani's early treatise *Della moneta* (*On Money*, 1750), which defends human acquisitiveness: the desire for gain is a basic force in the moral world, corresponding to gravity in the physical world.[109]

Antonio Genovesi tried to reconcile the ethical demands of the *veteres* with the Newtonianism of the *novatores*. Himself the author of a treatise on Newtonian physics, when his interests moved to economics he used the universal forces of attraction and repulsion as a model for the

analogous forces in humanity: self-love and love of the species. Convinced that Mandeville had exaggerated the former, Genovesi called in Shaftesbury to restore the balance. Human happiness required a balance between self-love and concern for society. Self-love drove humanity's acquisitive nature, but to achieve one's ends one had to control one's passions by means of reason and accommodate oneself to society as a whole. The pursuit of one's own interest, thus modified and refined, was equivalent to virtue. It was the best use possible of the physical and cognitive capacities bestowed on us by God.

Genovesi outlined his conception of political economy in his inaugural lecture as professor at Naples, *Ragionamento sul commercio in universale* (*Essay on Commerce in General*, 1757), which he published as a preface to his brother Pietro's three-volume translation of John Cary's *Essay on the State of England* (1695). Like many academic economists since, Genovesi made clear at the outset that his chair of commerce was not intended to teach merchants how to run their businesses. Rather, 'the political science of commerce was concerned with the nation as a whole, with all arts and trades that could further the wealth, power, and happiness of the state.'[110] The aims of political economy (*economia politica*) were two: first, to increase the population as much as possible; and second, on that basis, to maximize goods, wealth and power. Genovesi advocates a balance between agriculture and manufactures, in which about one-sixth of the population are employed in the latter. The numbers of the idle and unproductive must be held in check, and here Genovesi resorts to a familiar natural image, indicating that the economy he wants must correspond to the order of nature: the government must 'follow that law which nature has given to the bees, who drive away the drones which consume honey without helping them'; a law, he continues, laid down by Providence for humanity to imitate.[111] Genovesi's bees are not merely allegorical, like Mandeville's; they are real bees, providing, as so often, a model for human society.

Genovesi draws many lessons from England. To increase productivity, he recommends the adoption of agricultural machinery, citing the treatise on the plough by Jethro Tull (which he had read in a French translation), and mentioning also an improved grinding machine invented by his compatriot Intieri. The example of England shows that a country should export its surplus products; it should import raw materials, not finished products, in order to encourage industry at home; moderate luxury is acceptable, provided that luxury goods are produced at home; and imports should be transported in one's own ships, not in foreign vessels. Finally, Genovesi affirms the principle of competition, and hence a free market without monopolies: he asserts 'that competition is the soul of commerce,

and that all the causes which produce it simultaneously lend spirit and vigour to commerce, and those who oppose it are destroying commerce at its roots.'[112] And this free market is international. Genovesi chides the pessimists who say that Naples, tucked away in a corner of the world, can never be a major economic player. Navigation now extends as far as America and China. Other nations, not only the French, English and Dutch but even the Swedes and the Muscovites, are advancing in commerce and manufactures. Why should not Naples play a part on the world stage?

## ADAM SMITH AND *THE WEALTH OF NATIONS*

People who have not read *The Wealth of Nations*, or have only read the early sections, often imagine Smith as 'the founding father or evil genius of "economic liberalism" '.[113] They may think that it celebrates an actually existing free market. In fact, Smith makes clear that although the free market may be the natural state of the economy, it does not actually exist and is never likely to. 'To expect, indeed, that the freedom of trade should ever be entirely restored in Great Britain, is as absurd as to expect that an Oceana or Utopia should ever be established in it.'[114] Smith's quixotic advocacy of a 'natural' free market ('natural' is a frequent and heavily charged word in *The Wealth of Nations*) recalls his reading of Rousseau.[115] Commentators have noted Rousseauesque moments in his work, as when he supposes that poverty is compensated by freedom from worry, or that disagreeable occupations are adequately compensated by good pay.[116]

Smith's deep disagreement with the actual working of the modern economy may be obscured by his analysis of its components. A complex modern society requires a high degree of specialization. Yet, though all dispersed into different trades and professions, we are all interdependent. Even the making of a pair of shears requires many different kinds of work by different people:

> The miner, the builder of the furnace for smelting the ore, the feller of the timber, the burner of the charcoal to be made use of in the smelting-house, the brick-maker, the brick-layer, the workmen who attend the furnace, the mill-wright, the forger, the smith, must all of them join their different arts in order to produce them.[117]

In his famous example, taken from the article 'Épingle' in the *Encyclopédie*, the making of a pin can be divided into eighteen distinct operations; a single man would be hard put to make one pin in a day, but in a

A N

# I N Q U I R Y

INTO THE

## Nature and Caufes

OF THE

## WEALTH OF NATIONS.

By ADAM SMITH, LL. D. and F. R. S.
Formerly Profeffor of Moral Philofophy in the Univerfity of GLASGOW.

IN TWO VOLUMES.

VOL. I.

LONDON:
PRINTED FOR W. STRAHAN; AND T. CADELL, IN THE STRAND.
MDCCLXXVI.

The original title-page of Smith's *Wealth of Nations* (1776), the landmark text of the discipline known in the eighteenth and nineteenth centuries as 'political economy'.

manufactory where these operations were divided among ten specialized workers, they managed to make forty-eight thousand pins in a day.[118] The division of labour brings about the division of society into different ranks or classes, which exaggerates the superficial differences among people and disguises their common humanity.

Thus, though complex society is increasingly differentiated, and may seem atomized, it is held together by interdependence. The impulse to trade is a basic social impulse, though it rests not on benevolence but on self-love. 'It is not from the benevolence of the butcher, the brewer, or the baker, that we expect our dinner, but from their regard to their own interest. We address ourselves, not to their humanity, but to their self-love, and never talk to them of our own necessities but of their advantages.'[119] 'Self-love' is here to be understood as a basic human instinct, not as an egotistic selfishness, and certainly not as a desire to maximize one's own advantages at the expense of everyone else. It is the foundation of co-operation between people in society: your interest as a seller has to be, and can be, reconciled with my interest as a purchaser.[120] It accords with Pope's account of society in the *Essay on Man*:

> Thus God and Nature link'd the gen'ral frame,
> And bade Self-love and Social be the same.[121]

Smith's analysis of the economy invokes nature, inasmuch as it rests on his conception of the 'natural price' of commodities. The real price of everything 'is the toil and trouble of acquiring it': the toil and trouble which one can save oneself from and can impose on other people. Hence the real price of all commodities is labour; money is only their 'nominal price'.[122] The price for which a commodity is sold consists of three elements. One is labour (the payment to the worker who makes it); another is the profit sought by the seller and needed to replenish his stock; and the third is rent, for when all land is owned, the labourer must pay the landowner for gathering materials from his land (for example, the farmer will normally be a tenant and pay rent to his landlord). The merchant's or manufacturer's stock consists of two parts, one of which he lives on from day to day, while the other, his capital, can either be used for further business dealings, or invested in better machinery and the like. Smith has much to say about the use of capital to increase wealth by productive investment, and of its extension by paper money through the banking system, which he calls 'the great wheel of circulation and distribution'.[123] He warns, however, against 'that excessive multiplication of paper money which ruins the very banks which issue it', aware of some disastrous recent bank failures, notably that of the Ayr Bank on 'Black Monday' (12 June 1772).[124]

In every society or neighbourhood there is 'an ordinary or average rate' of wages, profit and rent.[125] If the price of a commodity is just what is sufficient to pay the rent of the land, the wages of the labour and the profits, it is sold for 'what may be called its natural price'. The actual price for which a commodity is sold is its market price (which may be more or less than, or equal to, its natural price). The market price is regulated by supply and demand. An increase in demand will raise the market price above the natural price; but if supply exceeds demand, the market price falls below the natural price. An equilibrium operates: 'The quantity of every commodity brought to market naturally suits itself to the effectual demand' (the 'effectual demand' is the demand from those who can pay).[126]

> The natural price, therefore, is, as it were, the central price, to which the prices of all commodities are continually gravitating. Different accidents may sometimes keep them suspended a good deal above it, and sometimes force them down even somewhat below it. But whatever may be the obstacles which hinder them from settling in this center [sic] of repose and continuance, they are constantly tending towards it.[127]

Smith's language of 'nature' has various sources. His imagery of gravitation suggests Newtonian mechanics. One reader, Sir Thomas Pownall MP, the former governor of Massachusetts, alluding to Newton, considered *The Wealth of Nations* a fundamental work 'containing the *principia* of those laws of motion, by which the system of the human community is framed and doth act'.[128] Smith's thinking was shaped also by his familiarity with Stoic philosophy, which he studied at Glasgow University, and which conceived nature as a unified and harmonious system.[129] Earlier, in *The Theory of Moral Sentiments*, he speaks not only of 'the oeconomy of nature' but of the 'invisible hand', which ensures that a selfish landlord, by spending his money, effectively distributes his property and, without intending to, supports a large number of people.[130] The 'invisible hand' famously reappears in *The Wealth of Nations*, where Smith argues that a self-interested profit-seeker unwittingly benefits his society by increasing its overall revenue:

> By preferring the support of domestic to that of foreign industry, he intends only his own security; and by directing that industry in such a manner as its produce may be of the greatest value, he intends only his own gain, and he is in this, as in many other cases, led by an invisible hand to promote an end which was no part of his intention. Nor is it always the worse for the society that it was not part of it. By pursuing his own interest he frequently promotes that of the society more effectually than when he really intends to promote it.

I have never known much good done by those who affected to trade for the public good. It is an affectation, indeed, not very common among merchants, and very few words need be employed in dissuading them from it.[131]

If an economy is in its 'natural' state, therefore, self-love and social love are the same; by enriching oneself one enriches society and thus benefits everyone. Before returning to the fact that no such natural economy exists, we may ask how far, on Smith's showing, the natural market really benefits the population as a whole. He argues for another kind of equilibrium that explains why different kinds of work are differently rewarded. High wages are paid to work which is disagreeable, difficult and arduous, such as that of a butcher or a coal-miner; to work which takes a long time to learn; to work which is irregular, so that the worker is often unemployed, as builders are because they cannot work in bad weather; to work which requires a high degree of trust, such as that of goldsmiths, who are entrusted with valuable materials, and doctors and lawyers, to whom we entrust our lives and our reputations; and work in which success is rare, such as the arts. This equilibrium between work and reward invites some scepticism. Smith's ideal-type worker is a man; he ignores the relatively low pay given for work by women. Although he tells us that coal-miners in many parts of Scotland earn three times a common labourer's wage, he does not consider that many miners were legally serfs, excluded from the provisions of the Habeas Corpus Act, and liable to be restored to their masters if they ran away; that does not suggest that high wages were an adequate compensation for the difficulty and danger of the work.[132]

Workers are best off, according to Smith, in a rapidly growing economy, such as that of North America, where labour is in demand. They are less well off in Britain, where expansion is relatively slow, and much worse off in a static economy such as that of China, where the poor eat dead dogs and cats and unwanted children are routinely drowned. In the worst case, how poor can workers become? Smith considers the relation between corn-dealers and the poor who have to buy their corn in order to live. He argues that the corn-dealer should always sell his corn at the highest price. His customers will be able to afford less, but then the supply of corn will last longer. Thus, high prices can be seen as a method of rationing, and the corn-dealer, though intending only his own good, also serves the good of his customers:

> Without intending the interest of the people, he is necessarily led, by a regard to his own interest, to treat them, even in years of scarcity, pretty much in the same manner as the prudent master of a vessel is sometimes obliged to treat his crew. When he foresees that provisions are likely to run

short, he puts them upon short allowance. Though from excess of caution he should sometimes do this without any real necessity, yet all the inconveniencies which his crew can thereby suffer are inconsiderable in comparison of the danger, misery, and ruin, to which they might sometimes be exposed by a less provident conduct.[133]

So although the merchant has stocks of grain in reserve, and could sell more, or sell it at a lower price, he is really benefiting the public by keeping them on short rations. Unwise generosity might turn a shortage (a 'dearth', as Smith calls it) into a famine. Indeed, the corn-dealer is liable to suffer in turn, because when corn becomes more plentiful and prices sink, he will find himself with a stock of corn which he must sell for a lower price.

Here Smith was taking a radical stand on a major economic issue of the later eighteenth century. Mercantilism operated a ' "police" in grain', requiring magistrates to maintain stockpiles of corn in case of famine and to regulate the prices of basic foodstuffs even in prosperous years. French and Italian *philosophes* disagreed on whether governments should intervene to stabilize prices. Some, like Galiani, who advocated free trade in theory, thought the government should nevertheless regulate prices to prevent harm to the poor. Smith, however, maintained that to restrict the farmer from sending his goods to the best market was an interference with the laws of property which could be justified only in a 'case of most urgent necessity' when a large-scale famine was an immediate threat.[134] His recipe for avoiding starvation in bad harvests is to expand the manufacturing sector so that the availability of consumer goods will motivate farmers to produce more food.[135]

Famines result, not from the natural operation of the market, but from real, unavoidable bad harvests and from interference with the market. However, Smith acknowledges that just as an animal population cannot exceed the subsistence available, because surplus members will starve, so also the numbers of the poor will decline: not through famine, however, but through infant mortality, which is highest among the poor. 'It is not uncommon, I have been frequently told, in the Highlands of Scotland for a mother who has borne twenty children not to have two alive.'[136]

Smith shows a somewhat more attractive side when he reflects that both justice and humanity require that workers should be adequately provided for:

No society can surely be flourishing and happy of which the far greater part of the members are poor and miserable. It is but equity, besides, that they who feed, cloath, and lodge the whole body of the people, should have such a share of the produce of their own labour as to be themselves tolerably well fed, cloathed and lodged.[137]

Although he refers repeatedly to labourers being paid at the lowest rate 'which is consistent with common humanity', he leaves it unclear how this 'common humanity' is to show itself in practice. He might mean that private individuals will exercise charity, but since Smith shows remarkably little interest in charity, he more probably means that employers will pay labourers just enough to keep them alive.[138]

However, the free market is an ideal construct. In reality its operation is prevented not only by accidents such as varying harvests, which produce fluctuations in the supply of agricultural products, but by deliberate interference. The rules imposed by guilds and similar corporations artificially raise some workers' wages and restrict access to many trades. The poor law, which makes it almost impossible for a poor person to settle in a parish other than his birthplace, severely hampers the mobility of labour. A monopoly, granted either to an individual or to a trading company, enables the merchant to restrict the supply of his goods and sell them above the natural price. In this context, Smith is sharply critical of colonization. By allowing its American colonies to trade only with the home nation, not internationally, Britain has discouraged investment in manufacturing industry, both in America and at home, in favour of a secure but much smaller source of profit.

Generally, Smith is extremely suspicious of businessmen. They combine to keep wages down, but secretly, so that most people are only aware of the futile efforts of workers to combine to raise their wages. They always want to restrict competition. They pursue their own interest, which is opposite to that of the public. 'People of the same trade seldom meet together, even for merriment and diversion, but the conversation ends in a conspiracy against the publick, or in some contrivance to raise prices.'[139] Smith denounces 'the mean rapacity, the monopolizing spirit of merchants and manufacturers'.[140] Here, evidently, self-love and social interest are *not* the same. For the good of society, monopolies need to be prevented. But the tendency to form monopolies and exclude competition is not only understandable but, surely, as natural as any other human tendency in Smith's system.

Suppose, however, that the removal of monopolies means that a branch of industry loses out to foreign competitors, and large numbers of workers are unemployed? Smith argues that if soldiers, of whom over a hundred thousand were discharged after the Seven Years War, can find employment, skilled workers with industrious habits can do so much more easily. But for that to happen, it will be necessary to remove the restrictions imposed by corporations (guilds) and by the law of settlements, preventing people from moving to a different parish. Restrictions on trade are in any case preserved by the influence of the business community, and anyone who proposes their abolition is exposed to 'the insolent outrage of furious

and disappointed monopolists'.[141] Thus it is hard to see how the restrictions on the free market that Smith finds on every side could be removed piecemeal, as he advocates. A complete transformation would be necessary, and that would be unfeasible.

A major reason why the free market cannot be fully established is the dominance of mercantilism. Book IV of *The Wealth of Nations*, entitled 'Of Systems of Political Oeconomy', is largely devoted to combating this doctrine. Among its other errors, mercantilism advocated the acquisition of colonies which should be allowed to trade only with the home market. Britain imposed this rule on its American colonies, while Spain permitted trade only within its colonial empire; although in the latter case even would-be reformers considered foreign trade 'morally impossible' because it would bring Catholics into contact with heretics.[142]

In one of the most cited passages in *The Wealth of Nations*, Smith formulates the minimal responsibilities of the state. It must defend its population against foreign attacks; defend them against one another by the strict administration of justice; and provide certain public works and institutions which no individual can afford to finance. Smith keeps the last to a minimum, thinking that highways and other infrastructural necessities can be paid for by tolls and local rates, and schools and colleges by the pupils' fees. Two further points about the state, however, are less often noticed; they should deter us from seeing Smith as anticipating the later conception of the 'nightwatchman state' or as an advocate of laissez-faire economics.[143]

First, it emerges from Smith's text as a whole that businessmen are unfit to govern. They seek their own interests at the expense of the public. Government requires 'the science of a legislator, whose deliberations ought to be governed by general principles which are always the same, [rather than] the skill of that insidious and crafty animal, vulgarly called a statesman or politician, whose councils are directed by the momentary fluctuations of affairs.'[144] As Donald Winch has pointed out, 'the fear that runs like a constant refrain through the *Wealth of Nations* is that the merchant interest will always be successful in exerting pressure on the legislature to retain its special, and hence unjust, privileges.'[145] Smith at least implies, therefore, that the sovereign is needed to curb the narrow self-seeking of businessmen, so to that extent the government would need to interfere with the economy. He concedes that the monopolizing spirit of merchants, 'though it cannot perhaps be corrected, may very easily be prevented from disturbing the tranquillity of anyone but themselves'; but he does not specify how.[146]

Second, Smith insists on the importance of elementary education. Without it, the division of labour risks making workers who always perform a

single monotonous task dull-witted and ignorant. Even at the lowest level of society, we need 'an instructed and intelligent people' who will be 'less liable to the delusions of enthusiasm and superstition' and better able to see through 'the interested complaints of faction and sedition'.[147] Smith refers to the parish schools established in Scotland, which have 'taught almost the whole common people to read', and to charity schools in England.[148] His standpoint is much more attractive than that of Mandeville, who opposed charity schools on the grounds that the labouring poor would not work hard if they were not kept in ignorance.[149] At a higher level, Smith is concerned that new religious sects, such as the Methodists, promote narrow-minded ignorance, and to counteract their influence he proposes that access to liberal professions should depend on passing a test in science and philosophy: 'Science is the great antidote to the poison of enthusiasm and superstition; and where all the superior ranks of people were secured from it, the inferior ranks could not be much exposed to it.'[150] Thus Smith thinks the state has a further function, that of counteracting the bad influence of organized religion; and though the state need not pay for this scientific instruction, it should intervene by requiring the test.

## LUXURY

Eulogists of commercial society such as Daniel Defoe were aware of a potential problem. When one's industry and frugality had accumulated a stock of money, one might want to spend some of it on a more comfortable and varied lifestyle. Defoe's ideal of a business managed jointly by a married couple with economy and prudence already seemed outdated by 1725, when, he complains, 'good husbandry and frugality is quite out of fashion'.[151] Tradesmen, and especially their wives, are carried away by snobbery:

> The tradesman is foolishly vain of making his wife a gentlewoman, and forsooth he will have her sit above in the parlour, and receive visits, and drink Tea, and entertain her neighbours, or take a coach and go abroad; But as to the business, she shall not stoop to touch it, he has Apprentices and journeymen, and there is no need of it.[152]

In Holberg's comedy The Political Tinsmith (1722), when Herman, a tradesman obsessed with politics, is deluded into believing that he has been appointed Mayor of Hamburg, his wife Geske receives guests using French phrases, with a lapdog in her arms, and makes their coffee undrinkable by putting syrup in it.[153] This was the problem of luxury – a powerful temptation, but a dangerous one that, in Defoe's view, could ruin an entire nation.

As Western societies in varying degrees increased their populations and expanded their economies in the eighteenth century, material goods became increasingly abundant. This process began in the commercial republic of the United Provinces. Dutch domination of world trade brought prosperity to the middle classes. Pieter de Hooch's domestic interior *Family Making Music* (1663) shows a substantial oak cupboard with Chinese porcelain on top, a handsome tiled floor, a marbled porch visible through the open door, while the family, adults and children alike, are exquisitely dressed.[154] Bernard Mandeville, who was born in Rotterdam, declares in 1714: 'in all *Europe* you shall find no private Buildings so sumptuously Magnificent, as a great many of the Merchant's and other Gentlemen's Houses are in *Amsterdam*, and some other great Cities of that small Province.'[155] But matters soon changed. Intense competition from other nations sharply reduced Dutch international commerce. Luxury trades, which relied mainly on exports, shrank. Amsterdam had some thirty tobacco-processing plants in 1720, only eight in 1751. As Leiden fine cloth lost its export markets, annual production dwindled from 25,000 rolls to 8,000 by the late 1730s.[156] When the populations of all other Western countries increased in the eighteenth century, that of the Dutch Republic declined: Amsterdam's fell from 200,000 in 1688 to 180,000 in 1815; Leiden, over the same period, plunged from 70,000 to 28,500.[157]

The contrast with the growth of population in Britain and France was extreme. London grew from 200,000 inhabitants in 1600 to 900,000 in 1800; Birmingham, Manchester, Liverpool and Leeds each grew fourfold between 1750 and 1800; Glasgow rose from 13,000 in 1700 to 24,000 in 1750 and 77,000 in 1800; smaller urban centres, such as Newcastle, Hull, Nottingham and Aberdeen, doubled their population during the century.[158] The population of France grew from 21.5 million in 1715 to 28.6 million in 1789; in 1700 only 1,850,000 people lived in towns with a population over 10,000, by 1780 2,800,000 did so. Improved communications facilitated the distribution of goods. In England, turnpike roads, built by private enterprise and mostly wide, smooth and well maintained, linked London with York, Manchester, Bristol, Dover and other centres by 1750.[159] By the 1780s France had some 30,000 kilometres of paved roads.[160] In contrast, the relative poverty of early eighteenth-century Scotland was due partly to the extreme difficulty of transport. Until 1754, the single stagecoach a month from Edinburgh to London took twelve to sixteen days to reach its destination, as we have seen.[161]

Mobility within towns was transformed by the spread of street lighting: sometimes lanterns lit by candles, later oil lamps.[162] Paris had 2,736 street lamps in 1697, costing the city some 300,000 *livres*; by 1766 it had at least

7,000.[163] In 1734 the commercial city of Hamburg had 1,734 street lamps; by 1809 there were 3,209.[164] Often the streets were illuminated only on dark nights. Some Catholic cities, notably Rome and Cologne, refrained from lighting the streets on the grounds that it would contravene the divine order. Being able to go out easily at night (not just at full moon like members of the Lunar Society) freed people from dependence on natural light and changed their daily rhythm. Wolfgang Nahrstedt has drawn up charts showing how the daily routine of a Hamburg merchant changed during the century.[165] Around 1700, the merchant would get up at 4.30 or 5 a.m., have breakfast, and either conduct daily prayers with his family, or attend an early-morning sermon. As his house accommodated not only himself and his family but also his apprentices and his office, he would work in his dressing-gown till noon, when he would put on street clothes, go to the Stock Exchange, and then return for a meal. After working till 7 p.m., he would relax over dinner and go to bed about 10 in the evening. His son or grandson in the second half of the century would more likely get up at 7 a.m.; he would seldom go to church, as the main city churches gave up their early-morning sermons between 1778 and 1794. As the day began later, it also ended later. By careful time management and intensive work, the new-style merchant would be able to enjoy his evening, either at a coffee-house (where he might stay till after midnight), at the theatre, or at a social gathering. This new lifestyle struck stern moralists as shockingly luxurious.[166]

Probate inventories enable social historians to trace the growth and differentiation of material possessions. In pre-industrial society poor people owned pitifully few objects – an inventory of 1648 records only an iron pot, a skillet and a skimmer as kitchen equipment – and might get new clothes only a few times in their lives.[167] Increasingly, however, windows were curtained, floors were carpeted, furnishings became more numerous and more varied. People kept their belongings in cupboards, instead of chests that also served as seats; beds became the norm, instead of a sleeping-place on the floor; chairs became differentiated into 'the easy chair (*bergère*), which envelops the body, the duchesse, the gondola chair, the settee, the ottoman, the sofa'.[168] William Cowper at the beginning of *The Task* (1785) recounts the history of seating, summing it up as follows:

> Thus first necessity invented stools,
> Convenience next suggested elbow chairs,
> And luxury th' accomplishd Sofa last.[169]

Tables also became numerous and diverse. Around 1750, a Frankfurt banker's house contained not only several tables with oilcloth covers, but also 'a table covered with a wool carpet, lacquered coffee tables (in addition

to one with oilcloth), a painted bedside table, a lacquered Holland table, a leather-topped walnut card table for playing *L'ombre*, two *guéridons* [one-legged tables to support a candelabrum] and three walnut desks'.[170] By 1725 mirrors were as common a possession in England as chairs and tables. Wallpaper was fashionable by the 1740s. Carpets, produced for the wealthy at Axminster and Kidderminster from the 1760s, became increasingly affordable; by 1800 Kidderminster had a thousand carpet looms turning out commodities for a large public.[171] Such items spread more slowly in Germany, where inventories rarely mention wallpaper. In 1737 the ten mirrors belonging to the notorious court factor Joseph Süss Oppenheimer (known as 'Jud Süss') testified to his would-be courtly ostentation. Only in the second half of the century did people feel a need often to look at themselves, and for that the 'two mirrors with gilded and glass frames' in a Hamburg household of the 1770s were sufficient.[172]

Higher up the social scale, magnificence ceased to be a royal prerogative. Louis XIV had furniture which was supposed to be impossible to imitate, and used porcelain, imported from China, as 'the new gold'.[173] But increased purchasing power brought such goods within the reach of the wealthy middle classes, initiating what historians have called a consumer revolution.[174] Exotic imports, such as porcelain and lacquerware ('japanning'), could be imitated at home. In Saxony, August the Strong compelled the alchemist Johann Böttger to find the recipe for porcelain, and after two years Böttger managed to find the ingredients of the Chinese white clay containing feldspar, quartz and kaolin, and the great porcelain manufactory at Meissen, near Dresden, was started. Porcelain factories were soon established at Berlin, Delft, Paris, Sèvres and Vicenza. Wedgwood, who produced creamware in Staffordshire, lightened its colour so that it might compete with porcelain.[175] Bone china, cheaper than hardpaste porcelain, was patented in 1749, and went into production at Bow. Indian muslins and calicoes provided light and fashionable clothing. At the beginning of the century, sugar, coffee, tea, chocolate and tobacco were luxury goods, but by the 1780s they were becoming standard parts of the middle-class and popular diet: nearly half of Parisian homes had a coffee-pot, and Parisians consumed on average ten pounds of sugar each per year.[176] Even in south German monasteries monks bought coffee or grew coffee-trees in greenhouses; a fire in the abbey of Elchingen in 1751 was caused by a monk brewing coffee in his cell.[177] All these goods not only made life more convenient but added the allure of fashion and a wealth of sensuous pleasure, famously captured by Pope in *The Rape of the Lock* (1714) when he describes Belinda's dressing-table with its perfumes and its tortoiseshell and ivory combs:

This Casket *India*'s glowing Gems unlocks,
And all *Arabia* breathes from yonder box.
The Tortoise here and Elephant unite,
Transform'd to Combs, the speckled and the white.[178]

The transformation of luxury goods into widely affordable commodities called forth indignant diatribes. Thus Reverend Samuel Fawconer deplored the middle classes' expenditure on such household ornaments as 'massy plate, ornamental china, rich tapestry, costly paintings, curious sculpture', and their flocking to the 'temples of pleasure' which, he said, abounded in every corner of the kingdom.[179] But the luxury debate gave expression to further fears. Some lamented that the spread of luxury was dissolving the hierarchical distinctions which had previously structured society. Henry Fielding complained in 1750:

> while the Nobleman will emulate the Grandeur of a Prince; and the Gentleman will aspire to the proper State of the Nobleman; the Tradesman steps from behind his Counter into the vacant Place of the Gentleman. Nor doth the Confusion end here: It reaches the very Dregs of the People, who aspiring still to a Degree beyond that which belongs to them, and not being able by the Fruits of honest Labour to support the State which they affect, they disdain the Wages to which their Industry would intitle them; and abandoning themselves to Idleness, the more simple and poor-spirited betake themselves to a State of Starving and Beggary, while those of more Art and Courage become Thieves, Sharpers and Robbers.[180]

Samuel Cooper in 1764 blamed 'the high wages of some kinds of mechanics and manufactures, which are sufficient to furnish them with some of the conveniences, as well as necessities of life, from little work'. The overpaid and insufficiently industrious mechanics, in his view, took Mondays off work and spent their money on drinking and play-going.[181] Fawconer feared the blurring of gender boundaries, claiming that women were turning into 'female cavaliers', men into 'effeminate fribbles'.[182] Others complained that high living had an especially bad effect on women, rendering them infertile, immoral and disposed for prostitution.[183] Evidently, 'luxury' was most objectionable when enjoyed by those members of society who should be kept under control: the lower orders, and women of all classes.

Complaints about luxury belong to a discourse that stretches back to classical times.[184] Ancient moralists from Plato to Augustine and beyond feared that people would become dissatisfied with the simple, healthy lifestyle enjoined by Nature, and would aspire, as Socrates warns in *The Republic*, to 'sofas, and tables, and other furniture; also dainties, and

perfumes, and incense, and courtesans, and cakes, all these not of one sort only, but of every variety'.[185] The Roman historian Sallust praises the frugality of the early Roman Republic and ascribes its decline to the replacement of civic spirit with selfish ambition and avarice, culminating in the importation of Asiatic luxuries under Sulla and the appearance of a generation of vicious youths from which the evil conspirator Catiline sprang.[186]

In eighteenth-century Britain, the emotive term 'luxury' served to focus a wide range of worries about the viability of commercial society. Tobias Smollett, 'one of the last, most adamant, and most forceful proponents of the classical view',[187] puts an extreme version of the case against commerce into the mouth of a fictional character, the eccentric and crusty but irritatingly well-informed Scottish officer Lismahago in *Humphry Clinker* (1770):

> He observed, that traffick was an enemy to all the liberal passions of the soul, founded on the thirst of lucre, a sordid disposition to take advantage of the necessities of our fellow-creatures. – He affirmed, the nature of commerce was such, that it could not be fixed or perpetuated, but, having flowed to a certain height, would immediately begin to ebb, and so continue till the channels should be left almost dry; but there was no instance of the tide's rising a second time to any considerable influx in the same nation. Mean while the sudden affluence occasioned by trade, forced open all the sluices of luxury and overflowed the land with every species of profligacy and corruption; a total pravity of manners would ensue, and this must be attended with bankruptcy and ruin.[188]

Significantly, Lismahago admires simple societies. He lived for some years in a North American tribe and was elected a chief. He compares Scotland to Sparta, because both are poor and virtuous: 'The Lacedæmonians were poorer than the Scots, when they took the lead among all the free states of Greece, and were esteemed above them all for their valour and their virtue'; he also praises the virtues of the early Roman Republic.[189]

Real-life moralists put a similar case. John Brown, a clergyman with military experience (having been present when Carlisle was recaptured from the Jacobites in 1745), was prompted by Britain's loss of Minorca to the French early in the Seven Years War to denounce his age as one of *'vain, luxurious,* and *selfish* Effeminacy'.[190] With much typographical emphasis, Brown compares corrupt and unwarlike Britain to the declining phase of the Roman Republic, and warns his fellow-countrymen that they may soon see a French army on Salisbury Plain (no doubt recalling that a Dutch army led by William of Orange had crossed that plain in 1688). He blames especially the higher ranks of society, arguing that at the highest stage of commercial society the landed nobility acquire through the vast increase of

their rents a wealth which they squander on material goods, over-spiced foods, gambling and trivial entertainments, at the expense of public spirit. The love of money has fatally weakened religion, honour and 'public Virtue'; 'our Manners are degenerated into those of Women'.[191] Brown's obsessive charge of 'effeminacy' implies an attachment to the ancient republican ideal in which all male citizens fought for their country.

Obscurer fears about degeneracy keep recurring. In France, luxury was blamed for the supposed decline of the population (which was, in fact, increasing).[192] Luxury was vaguely, but incessantly, said to 'enervate' people and make them unwilling or unable to produce children. 'Luxury is the natural parent of indolence, pusillanimity, and effeminacy, which it introduces and diffuses over the whole moral world', writes Fawconer. 'It unnerves the whole system of the human fabric, and breaks the force of our several powers, both of body and mind; enfeebling the strength and hardiness of the one, and enervating the vigour and activity of the other.'[193] As with Brown, this critique presupposes as a norm the virtuous simplicity of the republican ideal. In Germany, it was thought that luxury threatened the proper subordination of youth to age. Rich food, leisure and comfort gave young people more scope for sexual experimentation, while the availability of novels inflamed their imaginations, so that they developed precocious desires without acquiring adult powers of self-control.[194]

Few of the moralists propose any cure for the ills they identify. Their rhetoric tends rather to make 'luxury' seem irremediable, as when Fawconer excitedly calls luxury 'popular madness', a 'national distemper'.[195] Fielding advocates the enforcement of already existing laws against drunkenness and gambling, and the revival of laws requiring the idle poor to be compelled to work, though he admits that houses of correction are ineffectual by bringing criminals together; but prevention, 'by laying some effectual Restraints on the Extravagance of the lower Sort of People', is better than cure.[196] Fawconer calls for a revival of the sumptuary laws, which had formerly served 'to discriminate one from another in point of sex, age and quality'.[197] Such laws had been abandoned in England in the early seventeenth century. In Scotland, such regulations, designed to distinguish nobles from burghers, were last enacted in 1691.[198] An attempt was made to restore them in France in 1759, but without success.[199] In Germany, though still made, they were seldom observed. The last sumptuary edict passed in Frankfurt, in 1731, tried to separate society into five classes, distinguished by clothing, with civic dignitaries in the highest class and servants and labourers in the lowest.[200] The cameralist Justi remarks in 1761 that the desire for fine clothes, far from damaging morality, encourages people to work hard and supports manufactures.[201]

Rousseau denounced luxury, along with all the unnecessary and corrupting refinements of civilization. In *La Nouvelle Héloïse* he imagines a utopia that escapes the danger of luxury by being situated outside the money economy. Julie and her husband Wolmar inhabit an estate at Clarens, overlooking the Lake of Geneva, where, thanks especially to their good taste, luxury, magnificence and splendour are banished in favour of order, symmetry and regularity. The peasants and servants are encouraged in industry and sobriety. 'For my part,' says the appreciative visitor Saint-Preux,

> I find that at least it is a grander and nobler idea to see in a simple and modest house a small number of people enjoying a common happiness, than to see discord and strife dominating in a palace, where each of the occupants is seeking his fortune and his happiness in the ruin of another and in general disorder.[202]

The harmony of Clarens is preserved by its remoteness. Even Geneva, according to another letter-writer, is being corrupted by its reliance on commerce: Genevans who travel abroad imitate the luxury of other nations and despise their traditionally simple way of life: 'they forge irons for themselves from money, not as a chain, but as an ornament.'[203] Clarens is located, significantly, at the other end of the lake from Geneva. There trade is conducted so far as possible in kind, and thus people avoid paying the extra costs imposed by the merchant's need to make a profit. Bread and wine are produced at home; the butcher is supplied with cattle; wool produced on the estate is sent to factories, which in turn send fabrics to be made into clothes; workmen and servants are paid with natural produce. In keeping with Rousseau's ideal of transparency, money is no longer needed as an obstacle mediating between production and consumption: 'Economic success consists in meeting all local needs without producing a surplus that might necessitate recourse to sale and exchange, those twin clouds hovering on the horizon of transparency.'[204] While the Swiss elsewhere send their children to the town, either to study or to support themselves as servants, the inhabitants of Clarens are encouraged to stay there, to accept what is considered their 'natural condition'.[205] This 'fantasy of a stable mini-society, a sort of moral biosphere, in which everyone knows his place and likes it',[206] looks fragile as well as fanciful: its inhabitants are sheltered from the temptations of luxury, instead of learning to resist them.

In the luxury debate, Voltaire was the polar opposite of Rousseau. In 1736 he published a poem, 'Le Mondain' ('The Worldling'), which contrasted the simple life led by Adam and Eve with the manifold pleasures available in a modern city. He imagines the first couple, with dirty fingernails, tousled hair and tanned complexions, making love without

cleanliness, restoring their strength by dining on millet, acorns and water, and then sleeping on the hard ground. Nowadays, on the other hand, one can surround oneself with works of art, travel in a comfortable carriage to the theatre, and then enjoy a lavish dinner enlivened by the popping of champagne corks:

> Chloris, Églé, me versent de leur main
> D'un vin d'Aï dont la mousse pressée,
> De la bouteille avec force élancé,
> Comme un éclair fait voler le bouchon;
> Il part, on rit; il frappe le plafond.[207]

[Chloris, Aglaia, pour me out some wine from Ay; its compressed froth, released forcefully from the bottle, makes the cork fly like a lightning flash; people laugh as it shoots up and strikes the ceiling.]

Voltaire mocks the moralist Fénelon for deploring luxury in the imaginary kingdom of Salente, and concludes that paradise is not in the past but in the present: 'Le paradis terrestre est où je suis' ('The earthly paradise is where I am').[208]

The poem caused a scandal, especially for its impious portrayal of Adam and Eve. Its hedonism met with approval from Frederick the Great, who called it 'a true lesson in morality', and added: 'The enjoyment of a pure pleasure is the most real thing in the world.'[209] Voltaire replied to his detractors with another poem, 'Défense du *Mondain*, ou l'apologie du luxe' ('Defence of the *Worldling*, or apology for luxury'), in which, drawing on Mandeville, he used the familiar argument that when the rich spend money on luxuries, prosperity circulates and eventually reaches everybody.

Many other thinkers contributed to the luxury debate. Adam Ferguson points out that luxury is relative: there were far poorer societies even than Sparta. 'The house-builder and the carpenter at Sparta were limited to the use of the axe and the saw; but a Spartan cottage might have passed for a palace in Thrace.'[210] People often think that luxury begins just above their own level; Ferguson might have added that they readily condemn supposed luxury just below them. Every item once seemed a luxury: Voltaire imagines that when scissors were first invented, people were accused of luxury for using them to pare their nails and cut their hair.[211] Mandeville argues most vehemently against the notion that comfort is harmful: 'clean Linnen weakens a Man no more than Flannel, Tapistry, fine Painting or good Wainscot are no more unwholesome than bare Walls; and a rich Couch, or a gilt Charriot are no more enervating than the cold Floor or a Country Cart.'[212] Hume, though dissenting from Mandeville's more extreme claims, argues

cogently that luxury, provided it is not vicious, neither harms society nor impairs the martial spirit. The Romans were not undone by luxury or Asiatic imports, but by 'an ill-modelled government, and the unlimited extent of conquests'.[213] Pope, after satirizing Timon's hugely expensive and uncomfortable villa, where at dinner-time 'gaping Tritons spew to wash your face', concedes the paradoxical Mandevillean case that such luxury benefits the economy and hence the population at large:

> Yet hence the Poor are cloath'd, the Hungry fed,
> Health to himself, and to his Infants bread
> The Lab'rer bears: What his hard Heart denies,
> His charitable Vanity supplies.[214]

Antonio Genovesi, citing the essay on luxury by 'signor Hum', points out that luxury springs from the ineradicable human desire for distinction, shown already when a young Hottentot who has killed a lion wraps himself in its skin; there is useful and harmful luxury, the latter taking the form of gluttony and overexpenditure which must result in poverty, but even such luxury, while ruining individuals, may benefit society by bringing about the redistribution of wealth.[215] Frederick the Great, ruler of a poor country whose military prowess often evoked comparisons with Sparta, nevertheless accepted the commercial case for the benefits of luxury, and represented it as essential for the health of the body politic:

> The luxury which comes from abundance and makes riches circulate through all the veins of a state makes a great kingdom flourish. It maintains industry and multiplies the needs of the rich and opulent, thus tying them to the poor and indigent. Luxury is to a great empire what the diastolic and systolic movements of the heart are to the human body. It is the spring which sends the blood through the great arteries to our extremities and makes it circulate through the small veins back to the heart for redistribution.[216]

The most comprehensive defence of luxury, however, was put forward by Hume in the essay published in his *Political Discourses* (1752). Originally entitled 'Of Luxury', it was later renamed 'Of Refinement in the Arts'. The renaming was appropriate. Hume starts from 'luxury' in the narrow sense of 'great refinement in the gratification of the senses' and points out that such refinement is in itself innocent. To drink beer is not more virtuous than to drink champagne. But Hume very soon widens out the subject of his essay into a defence of civilization in general: that is, of any society in which 'the mechanical arts' (crafts and technology) and the 'liberal arts' have been brought to a high degree of cultivation. He notes

that two extreme opinions have been expressed: one, that even 'vicious luxury' is beneficial to society (this is Mandeville's view, though Hume does not name him); the other, that luxury and refinement give rise to moral corruption and political disorder and servitude. Hume's main target is the latter view, and to confute it, he undertakes to show that 'the ages of refinement are both the happiest and most virtuous'.[217]

Refinement in the mechanical arts – the production, for example, of complex machinery such as watches or carriages – occupies a large number of people at skilful and satisfying tasks and increases the pleasure of those who use the products. Moreover, progress in the mechanical arts necessarily accompanies progress in the liberal arts: 'The same age which produces great philosophers and politicians, renowned generals and poets, usually abounds with skilful weavers, and ship-carpenters. We cannot reasonably expect, that a piece of woollen cloth will be wrought to perfection in a nation which is ignorant of astronomy, or where ethics are neglected.'[218] Knowledge becomes diffused; people 'cultivate the pleasures of the mind as well as those of the body'.[219] And as the pleasures of the mind cannot be enjoyed to any great degree in solitude, people become more sociable. They gather together in cities, share their knowledge, form clubs and societies, and develop pleasant, relaxed and polished manners. Thus, they become more fully human: 'they must feel an encrease of humanity, from the very habit of conversing together, and contributing to each other's pleasure and entertainment'.

Moralists are wrong to complain that civilization encourages self-indulgence and weakens the warlike spirit. Citing the central cliché of the luxury debate, Hume asserts: 'The arts have no such effect in enervating either the mind or body.'[220] In civilized societies, gluttony and drunkenness are rare; one can imagine by contrast the dinner of a medieval baron, or, in Hume's example, Tartars being 'guilty of beastly gluttony, when they feast on their dead horses'.[221] A civilized society contains a large number of men accustomed to activity who can be called up (for war, for example) when the state needs them. Civilized countries have more soldiers than backward ones, not fewer: Hume instances the huge armies fielded by Louis XIV. They are not lacking in martial spirit, but they conduct war with more intelligence than backward nations. (Hume could have mentioned a very recent example at Culloden, where the Highlanders relied on demoralizing their enemies by a wild charge, but the latter had picked their ground carefully so that the Highlanders were interrupted in their progress and fell victim to superior firepower.) Hume points out that although Rome is always cited as the cardinal example of decline through luxury, and Roman writers themselves held this opinion, the causes of

Roman decline are to be found elsewhere: in their bad form of government, and in their immoderate conquests.

Refinement is not detrimental to political liberty, but actually favours it. In England, the powers of the Crown are restricted by Parliament, which owes its influence to the increase of commerce and the consequent enrichment of private citizens. Hume admits that parliamentary elections are corrupt but maintains that such corruption does not extend to the elected members. No such liberty is to be found in 'rude unpolished nations', where the population is divided into those who own the land and those who cultivate it; the latter are ignorant and the former are petty tyrants, who keep society in disorder by constantly fighting among themselves (very much the picture of medieval England presented, as we shall see, in Hume's *History of England*).[222] Worse still, it is in 'uncivilized ages' that treachery and cruelty particularly flourish. At this point the reader may baulk, thinking of the slaughter of the defeated on the battlefield of Culloden, and recalling that it would be more than a century before the Geneva Convention on the treatment of wounded soldiers would be signed (1864). But Hume's argument can be strengthened by turning to his essay 'Of the Populousness of Ancient Nations', where he evokes graphically the barbarity of the ancient republics, which were 'almost in perpetual war', where battles were fought 'with a degree of fury quite unknown in later ages', and where political revolutions were accompanied by massacres on an enormous scale.[223] Hume's writings offer no support to those moralists who want to extol the virtues of ancient times in order to depreciate modern civilization.

The new science of society, with 'political economy' as its central discipline, made it possible to understand how modern commercial society worked. Sometimes it suggested contradictions, e.g. between unrestricted free trade and the formation of monopolies, which in the following century Karl Marx would use to prise the image of commercial society apart. For the time being, however, the political economists enabled their contemporaries to understand, and potentially to improve, the world they were living in. Their praise of commercial society may sometimes sound complacent. But it was a hard-headed and realistic rejoinder to the many moralists who extolled poor or simple societies, forgetting how disagreeable it would be to live without modern comforts, and indulging in the sentimental illusion that poverty is somehow conducive to virtue. Political economy supported the argument that material and moral progress went hand in hand.

## I I

# Philosophical History

## WRITING SECULAR HISTORY

Until the eighteenth century, the principles underlying history were usually thought by Christians to be sacred. History was 'the grand design of God'. Its end-points were the Creation and the Apocalypse, still usually imagined as being some six thousand years apart.[1] The structure of history was often derived from Daniel's prophecy of four successive Empires (Dan. 7:8), which were taken to be the Assyrian and Persian empires, the Greek empire founded by Alexander, and the Roman Empire of which the Holy Roman Empire was claimed to be a continuation.[2] The crucial turning-point in sacred history was the coming of Christ, and the divinely appointed purpose of the Roman Empire was to facilitate the spread of Christianity. History was first and foremost the history of the Church, or the City of God as St Augustine called it; secular history, that of the earthly city, was of minor importance.[3] This was the scheme put forward by Jacques-Bénigne Bossuet, court preacher to Louis XIV, in his *Discours sur l'histoire universelle* (*Discourse on Universal History*, 1681).

Ironically, sacred history helped the emergence of secular history. The division between the two may have been intended 'to preserve religious history from contamination and from rational investigation';[4] it made possible the study of secular history without needing to demonstrate the workings of Providence. Leaving to the Church historians the study of God's plans, the secular historian could concentrate on the 'secondary causes', the seemingly natural and human events through which God's plans took effect. Moreover, sacred history provided a partial model for world history. It was not confined to the Near East and Europe but comprehended the spread of Christianity to the Americas and parts of Asia. So Voltaire, who found much to admire in Bossuet as well as opposing him, only needed to reverse his perspective. For Voltaire, even if the

Roman Empire fostered Christianity, Christianity destroyed its host: 'Christianity opened Heaven, but it ruined the Empire.'[5]

In writing his own universal history, the *Essai sur les mœurs* (first published in 1756), Voltaire gave a prominent place to the non-Christian cultures of China, India and the Islamic world. He puts Christianity in its place by insisting on the greater antiquity and superior cultivation of non-Christian civilizations. The Chinese annals, confirmed by astronomical observations, go back 2,155 years before the Christian era; Indian civilization is equally ancient, and the doctrines of the Persian Zoroaster are said to be 9,000 years old. China was completely polished (*policée*) when Europeans were still savages.[6] The Indians instructed Pythagoras in geometry and devised a sublime theogony which was transmitted to Jews and Christians as the story of angelic rebellion against God. The Arabs of the Age of Muhammad showed the heroic qualities shared with Homer's Greeks but deplorably lacking among the biblical Hebrews, while the later caliphs practised toleration and encouraged such sciences as astronomy, medicine and chemistry that were barely known in Christian Europe. The history of Islam inverts that of Christianity: Muhammad subdued his antagonists mercilessly, but once his power was secure he was tolerant and indulgent; the founder of Christianity preached forgiveness, but his mild religion had become 'the most intolerant and barbarous of all'.[7]

Turning to Europe, Voltaire debunks the high points of Christian history. Charlemagne, progenitor of the Holy Roman Empire, illustrates the success attained by injustice. His conversion of the Saxons was achieved by massacring the recalcitrant and by the barbarous practice, unknown since Roman times, of transplanting a large number of the conquered population into other countries. Any Saxons who relapsed into their old religion were poisoned by Charlemagne's spies. The Crusades were motivated by the infectious fanaticism of Peter the Hermit and the superstition and greed of feudal nobles: 'The Pope offered the remission of all their sins, and opened Heaven to them by requiring them by way of penance to follow their greatest passion, running after pillage.'[8] Joan of Arc falls victim to cruelty reinforced by fanaticism, though in heroic (i.e. pre-Christian) times her bravery in rescuing her king would have earned her an altar.[9] Calvin's burning of Servetus, and the violent language of Luther's letters, show that the Protestants were as enthusiastic persecutors as their Catholic opponents. If the spirit of philosophy had not gradually prevailed, Europe would now be a vast cemetery.[10]

The *Essai* does not quite live up to its title. It is not principally a history of manners, but a history of events which devotes intermittent attention to social and economic life and to what we would now call cultural

history. Voltaire says that, rather than itemize the horrors of the Middle Ages, he really wants to 'discover what human society was at that time, how people lived at home with their families, what arts were cultivated'.[11] So we learn about the construction of medieval houses, with their low doors and tiny windows; about useful inventions such as spectacles and mirrors; and about the arts, where Voltaire juxtaposes a derisive account of medieval religious drama with a long quotation from the Persian poet Saadi, to illustrate the superiority of Eastern civilization. His overarching narrative recounts the gradual emergence of liberty from the chaos of medieval feudalism. A comfortable life was possible at that time only in the free commercial cities of Italy, which gave rise to the genius and enterprise of the Renaissance: 'Wealth and liberty finally stimulated genius, as they heightened courage.'[12]

The *Essai sur les mœurs* supplied a model for the great sweeping histories that are characteristic of the Enlightenment. Previously, history had most often meant an account of events that the writer himself had witnessed, or about which he had consulted eyewitnesses. The model was Thucydides' *History of the Peloponnesian War*, in which Thucydides drew on his own experience. Among more recent historians, Paolo Sarpi, writing the history of the Council of Trent, had gathered his information from people who had attended the Council. The major source for seventeenth-century British history was the *History of the Rebellion and Civil Wars* (published 1702–4) by Edward Hyde, earl of Clarendon, who had been a Member of Parliament in the early 1640s and was first an opponent, later a supporter and close ally, of Charles I. And even in his early history of Charles XII of Sweden (1731), Voltaire quoted a number of eyewitnesses. Only a few historians, such as Livy on ancient Rome and Machiavelli on the history of Florence, wrote about events that long antedated their own lives.[13]

Voltaire thought that Newtonian physics might provide a model for history, at least in the sense that ancient models would be superseded. Historians should dismiss legends, found in ancient and medieval chronicles, about prodigies, rains of blood, or Bishop Hatto of Mainz being devoured by rats in the year 698. They should instead adopt the inductive methods of the sciences and base their work on the careful collection of empirical data. 'One would wish to know the human race in the interesting details which today form the basis of natural philosophy.'[14] In this spirit, modern historians dismissed the fanciful genealogies on which their early modern predecessors had founded national histories.[15] They no longer believed that Britain and France had first been populated by refugees from Troy. The Swedish *érudit* Olaus Rudbeck, who claimed that Sweden was the site of the lost Atlantis and Swedish the original language

of humanity, was deservedly mocked.[16] The fabulous kings of Scotland, beginning with Fergus I in 300 BCE, whose portraits (all painted around 1680 from the same model) may be seen in Holyrood Palace, were exposed as 'entirely uncertain and groundless' by the sceptical Catholic historian Thomas Innes, whom Hugh Trevor-Roper has described as 'the first and greatest of Scottish antiquaries'.[17]

But how reliable was the knowledge thus acquired? Could we have any certain knowledge of remote events? Even Voltaire toyed with scepticism. Ancient history, he thought, was deeply unreliable. It offered a few truths surrounded by a thousand falsehoods. The conquests of Alexander were probably as fictional as the labours of Hercules.[18]

There was, however, no reason to despair of history. Seventeenth-century thinkers already recognized that absolutely certain knowledge was available only to God. The most certain knowledge available to mortals was that of mathematics. For Descartes, this was the paradigm of knowledge; but a later mathematician, d'Alembert, despite his fondness for geometry, recognized that most knowledge had to be in some measure conjectural.[19] The natural sciences, being dependent on experience and experiment, could at best attain a very high degree of probability or 'moral certainty', which could always be corrected by further experience. Even so, Locke, who discussed probability in his *Essay concerning Human Understanding*, accepted that repeated confirmation, attested by reliable witnesses, did constitute knowledge.[20] Historical knowledge likewise rested on probability. The historian, unable to perform experiments, had to weigh up the intrinsic likelihood or otherwise of an event, and the trustworthiness of witnesses.[21] As Hume argued in his essay on miracles, some events, such as the miraculous cures at Saint-Médard, were so improbable that no testimony could confirm them. Past events had to be recorded in writing, since oral testimony was highly unreliable. Then you had to ask: who provided the testimony? How close were they to the events concerned? What bias might they have had? How had the written record been transmitted? Had it been faithfully copied by scribes? Was an account confirmed by others, or by evidence of a different kind, such as coins and inscriptions? Or was it contradicted by other, incompatible evidence? For example, the chroniclers read by Hume for his *History of England* affirmed that William the Conqueror was enormously wealthy, yet they also revealed that he had difficulty in raising ten thousand marks with which to buy the territory of Normandy from his brother when the latter wanted to go crusading; so William's wealth was clearly exaggerated. If an event was not mentioned in sources where one would expect to find it, was it believable? As Gibbon points out, the darkness said in the Gospels to have covered the whole earth

for three hours during Christ's crucifixion was not noticed even by the elder Pliny, who carefully recorded all astronomical prodigies.[22]

Methods of source criticism were developed alongside new technical skills that historians nowadays take for granted.[23] Monastic historians were among the pioneers: Jean Mabillon, of the Benedictines of St Maur, developed the study of diplomatics, establishing rules for the interpretation of charters and inscriptions, and his work was continued in early eighteenth-century Austria by the brothers Pez of Melk Abbey.[24] In Göttingen, Johann Christoph Gatterer founded in 1766 the Historical Institute, which dealt mainly with auxiliary sciences such as numismatics, palaeography and linguistic studies. Historians began to footnote their sources. Hume apologized to Horace Walpole for not giving source references in the first volume of his *History of England*, and inserted them in the second edition and in subsequent volumes.[25] Gibbon deplores the absence of quotations from sources in the *Histoire des deux Indes* by Raynal and others.[26] William Robertson regrets that Voltaire 'seldom follows the example of modern historians in citing the authors from whom they derived their information'.[27]

There were, then, new and refined methods for establishing facts about the past. But what about the meaning of those facts? A long tradition regarded history as offering *exempla* of good or bad conduct, to be imitated or shunned, and this conception is still found in the eighteenth century. According to Bolingbroke, 'history is philosophy teaching by examples how to conduct ourselves in all the situations of private and public life'.[28] Even in the Renaissance, however, exemplarity came to seem problematic. Machiavelli maintained that human beings were always the same, and therefore ancient history could provide examples for its later readers to follow or avoid.[29] But his fellow-historian Guicciardini warned that past examples might be deceptive, since changing circumstances might mean that they were no longer appropriate for imitation.[30] A conflict was recognized between the typical example and the unique particular.

What general lessons could then be learned from studying history? Among the *philosophes*, D'Alembert thought that history could at most provide useful lessons for children but was insufficiently philosophical to offer anything to adults.[31] The answer was that history was instructive, but not in giving us particular examples to follow. There is no point in resolving to follow the example of Alexander the Great, because one is unlikely ever to be in any situation that Alexander experienced. History did yield general truths, but they were located at a deeper level than that of mere exemplarity. It was necessary to get below specifics and arrive at the underlying general principles. David Womersley identifies this aim as

'part of the ambition of the *philosophes* to do for the study of mankind what Newton had done for natural science'.[32]

The search for general principles in historical development presupposed the existence of a constant and uniform human nature – an idea that has been much criticized and much misunderstood. It may be thought a mask for conservatism, covertly denying that human nature is malleable, suggesting that the present social order is natural and unchangeable, and attempting to rule out such changes as the past century or so has seen, for example, in the social position of women.[33] But Hume and his fellows are not saying that all humans resemble, or should resemble, white male eighteenth-century *literati*. They are sharply conscious of the variety in human customs and cultures. John Millar remarks on 'the amazing diversity in the manners of different countries, and even of the same country at different periods'.[34] Hume illustrates this diversity in a dialogue in which one speaker tells another about the seemingly preposterous customs in a land called Fourli, where one can be an admirable citizen while practising pederasty, marrying one's sister, and killing one's children, and serve the public by conspiring to murder a friend and, finally, committing suicide. 'Fourli' is then revealed as ancient Athens, where older men took young men as lovers, where the law permitted marriage to one's half-sister, where women were kept in seclusion, where unwanted children were exposed to the elements and left to die, and suicide was widely approved; while the conspiracy to murder is modelled on the assassination of Julius Caesar. Modern France, where marriage is a mere formality, sexual relations with other men's wives are normal, parents imprison their daughters in convents, and honour requires constant duelling, is revealed as no less bizarre.

Yet all these variations are outgrowths of the same basic humanity. They can be explained from the basic principles of human nature, modified by local circumstances. Thus Greek practices of male–male love 'arose from a very innocent cause, the frequency of the gymnastic exercises among that people; and were recommended, though absurdly, as the source of friendship, sympathy, mutual attachment, and fidelity; qualities esteemed in all nations and all ages.'[35] As Hume concludes, using a Newtonian analogy, 'The Rhine flows north, the Rhone south; yet both spring from the *same* mountain, and are also actuated, in their opposite directions, by the *same* principle of gravity.'[36] If one denies this, one would seem to be claiming that some human customs and cultures are unintelligible, or somehow not human.

History now ceased to be simply narrative or anecdotal. It analysed events as well as recounting them. A landmark here was Montesquieu's *Considerations on the Greatness and Decline of the Romans* (1734). This

sparkling essay, more a series of snapshots than a continuous narrative like Gibbon's, examined the underlying causes that accounted for the rise of Rome, the expansion and collapse of the Republic, the ascendancy of Augustus, and the eventual decline of the Empire. Unlike Gibbon, Montesquieu largely ignored the effects of Christianity: his history was defiantly secular as well as 'naturalistic'.[37] Nor was history an account only of events. Voltaire said that mere events taught him nothing. He did not want to know anecdotes of court life or the details of a battle. Historians ought to tell us about the growth or decrease of population, the development of trade, arts and sciences, and the virtues or vices that distinguished different nations.[38] That is why his world history was entitled a history of manners.

Now, historians addressed 'the progress of society'. They had to consider whether society really had progressed since ancient times, and for this they had to take a stand in the 'Querelle des Anciens et des Modernes'. A major historical issue in the 'Querelle' was demography. It was widely believed that the ancient world had been much more populous than the present. Isaac Vossius claimed in 1685 that Rome attained the figure of fourteen million inhabitants.[39] In the *Persian Letters*, Montesquieu makes a Persian visitor, Rhédi, assert on the basis of careful calculations that the earth's present population is scarcely one-tenth of what it was in ancient times, and that at this rate the human race will die out in another ten centuries.[40] Rhédi's correspondent Usbek supports the thesis by pointing to the Christian prohibition of divorce, the Muslim practice of polygamy (which tires men out and incapacitates them for siring children), and the vast number of eunuchs required by both religions (a startling and defamiliarizing way of referring to the celibacy of Christian priests).

These arguments aroused great interest and some scepticism. 'Sir William Temple and Montesquieu have indulged, on this subject, the usual liveliness of their fancy,' remarks Gibbon.[41] The controversy was settled in favour of the moderns by Hume, whose essay 'Of the Populousness of Ancient Nations' is a pioneering work of demography. By critical examination of many ancient sources, he showed that claims for a high population were implausible and self-contradictory. The many slaves in the ancient world were seldom encouraged to breed; ancient wars produced far more casualties than modern ones; factional quarrels in the Greek states led to many deaths; and ancient Italy contained extensive areas of uncultivated land, which is incompatible with supporting a large population.[42] Between the lines of Hume's essay it emerges that the ancient world was not only less populous than the modern, but also much more unpleasant to live in.

## TWO CENTRES OF HISTORY:
## GÖTTINGEN AND EDINBURGH

In the late eighteenth century there were two outstanding centres of historical research: Göttingen and Edinburgh. The University of Göttingen was at this period the leading university in Europe. It had been founded in 1737 thanks to the initiative of a shrewd administrator, Gerlach Adolf von Münchhausen, who thought that, since Göttingen was situated in the state of Hanover, which was in personal union with the British crown, a university there would attract young English noblemen who would spend money freely and revivify a decayed town. Of the university's four faculties (theology, medicine, law and philosophy), the first two were relatively weak, law was central, and philosophy (meaning what we would call the arts faculty) soon ceased to provide merely preparatory courses for other subjects and increased its range to include history, politics, languages, psychology, physics, and pure and applied mathematics. Its luminaries included the classical scholar Christian Gottlob Heyne, the Orientalist Johann David Michaelis, the biblical scholar Johann Gottfried Eichhorn, the physicist and satirist Georg Christoph Lichtenberg, and the historian August Ludwig Schlözer, who was appointed to a chair in 1769.[43] Schlözer had previously worked in Sweden, where he published a history of ancient navigation (in Swedish), and in Russia, where his work on Russian history gained him election to the St Petersburg Academy of Sciences. In Göttingen he acquired a high reputation as a teacher and promoted research in many areas of history and beyond: the history of the Slavs, the Germans in Transylvania, Icelandic literature, Finno-Ugric linguistics, even the history of German drinking habits.

Schlözer also edited and published, at his own expense, two periodicals, the *Briefwechsel* and the *Staatsanzeigen*. The latter, which attained a circulation of four thousand, was famous for its political criticism.[44] Taking as his model Voltaire's intervention in the Calas affair, and exploiting an academic's freedom from censorship, Schlözer delivered outspoken attacks on miscarriages of justice throughout Germany and Switzerland.[45] His 1783 article on the trial of Anna Göldi for alleged witchcraft introduced the word *Justizmord* (judicial murder) into the German language.[46] Schlözer was a major public intellectual and a prominent standard-bearer for the cause of enlightenment. His devoted readers included Empress Maria Theresa and her son Joseph II. In his humorous travesty of Virgil's *Aeneid*, the Viennese satirist and Enlightener Aloys Blumauer portrayed an enlightened heaven in which Solon of Athens, Montesquieu, William

Penn, Confucius and Zoroaster drink and smoke together and read Schlözer's *Staatsanzeigen*.[47]

Historical thinking pervaded many academic subjects in Göttingen.[48] Heyne provided historical contexts for the study of ancient authors; Michaelis did the same for the events in the Old Testament; Ludwig Timotheus Spittler, professor of philosophy, absorbed theology into history and wrote ecclesiastical history with minimal reference to Providence; and the study of law became the study of legal history, particularly in the hands of Johann Stephan Pütter, who wrote the history of the Holy Roman Empire. Yet Göttingen scholars did not write straight history for a wider public. Unlike their British counterparts, they did not regard history as a branch of literature. History in their hands remained 'a highly specialized branch of knowledge cultivated by and for a narrowly defined community of scholars'.[49] Schlözer's historical writings were mostly compilations, student textbooks and articles in his journals. It is sometimes alleged that the German reading public was not interested in history.[50] However, the works of Robertson, Hume and other British historians were published in German translation, and there were plenty of readers for the histories written by Schiller at Jena around 1790, and for those produced by the pioneering archival scholar Leopold von Ranke early in the next century.[51] The Göttingen historians' conception of their academic role precluded them from writing narrative histories for a wide public.

This absence was not for lack of ambition. Schlözer dreamed of nothing less than writing 'universal history', the history of the world, but never got beyond publishing a manifesto for such a history. It must not be a mere aggregate of national or local histories but must interpret its materials according to a system. It must be founded on well-authenticated facts – Schlözer took a swipe at Voltaire, saying he made up his facts, or at least coloured them[52] – but it must avoid trivia, like lists of unimportant kings or futile puzzles about chronology. It must concentrate on the nations that had had most influence in the world. It must look beyond Europe to a wider perspective, addressing 'the citizen of the world, humanity in general'.[53] It should make cross-cultural comparisons, showing, for example, what the pope, the caliph and the Dalai Lama had in common. It should discourage a pernicious interest in 'stories of murder' and disclose the surprising history of those everyday objects we take for granted:

> We will awake from the sleep into which our education has lulled us, so that we look with indifference at a loaf of bread, a sheet of printed paper, a pocket-watch, a bill of exchange, a hemispheric map, and a hundred other things, whose present-day perfection has required the unbroken progress of

the human spirit from discovery to discovery over several millennia, forming the basis of the modern civilization of the human race, just because we have seen them ever since our childhood and enjoy their effects every day.[54]

This would have been a wonderful book, if Schlözer had written it. But he produced only the prolegomenon, no doubt because he was busy with so much else, but perhaps also, as Herder surmised in a critical review, because he lacked a guiding idea. Even 'the progress of the human race', Herder complained, was too vague.[55]

Schiller's histories, on the other hand, are guided by the idea of freedom. Schiller was intensely interested in resistance to tyranny. That theme dominates his early dramas, leading up to *Don Carlos*, in which Marquis Posa, an Enlightener born two centuries before his time, attempts to influence King Philip II of Spain to break down the tyranny of the Church and to halt the Spanish oppression of the Netherlands. Posa's demand for intellectual freedom was, of course, anachronistic in a sixteenth-century context, but, as T. J. Reed notes, 'Posa's arguments were for Schiller's day acutely contemporary. It was absolutist rulers who were now the anachronism.'[56] As early modern absolutism might be undermined by conspiracy more easily than by open rebellion, Schiller, who had his living to make, planned to edit a collection of narratives about famous conspiracies. The collection never appeared, but Schiller's contribution, an account of the conspiracy by Dutch nobles that preceded the Spanish invasion under the duke of Alba, grew into the *Geschichte des Abfalls der vereinigten Niederlande von der spanischen Regierung* (*History of the Revolt of the United Netherlands against Spanish Rule*, 1788).

Instead of continuing the story as he once intended, Schiller turned instead to the Thirty Years War. Both this and the earlier history turn on Protestant resistance to the tyrannical power of Catholic monarchs. In the central books of the *Geschichte des Dreißigjährigen Krieges* (*History of the Thirty Years War*, 1791–3), the antagonists are the Swedish king and general Gustav Adolf and the Imperial commander Wallenstein. Gustav Adolf is presented as a great strategist and a devout and humane leader, who prevents his army from devastating the territories it passes through.[57] Wallenstein is a gloomy, frightening character, a megalomaniac who lives in kingly pomp, the instrument of the bigoted Emperor Ferdinand II 'who debases himself to a worm before the Divinity and treads defiantly on the necks of humanity'.[58] Although Gustav Adolf is killed in 1632, his resistance to Imperial pretensions is ultimately shown as worthwhile because the war, despite its horrors, ends with the Treaty of Westphalia, which establishes the modern European state system.

The Scottish historians also had a big idea, the 'four stages theory'. According to this view, society advanced through successive stages, each defined by the dominant mode of subsistence. As Adam Smith explained to his students in 1762, 'There are four distinct states which mankind pass thro:- 1st, the Age of Hunters; 2dly, the Age of Shepherds; 3dly, the Age of Agriculture; and 4thly, the Age of Commerce.'[59] Each state led to different forms of social organization and law. Drawing on Montesquieu for the comparative study of society, the Scottish historians developed a flexible model that made sense of social change and made it possible to write history in a way that was both narrative and analytic.[60]

The four stages theory emerged not only in Scotland but also, and simultaneously, in France, in the early writings of Turgot. He was stimulated in part by corresponding with Françoise de Graffigny, who was preparing a second edition of her novel *Lettres d'une Péruvienne* (*Letters from a Peruvian Lady*), in which an Inca princess is brought to France and comments, in a defamiliarizing manner, on the many differences between France and Peru (e.g. travelling in a carriage; writing with letters instead of *quipu**). Turgot insisted to Graffigny on the superiority of a refined society such as France over a society, like Peru, which was at an earlier stage of development.[61] He worked out the intermediate stages in his notes (published only after his death) for a universal history.[62] He may well also have been prompted to these reflections by observing the immense disparity between the peasants of rural France and the society of the capital. Certainly the Scottish historians had before their eyes the sharp contrast between the commercial society of Edinburgh and Glasgow and the tribal society of the Highlands, whose inhabitants were still in the 'age of shepherds'. And in America, Thomas Jefferson would later confirm the theory by noting that all four stages were simultaneously present on the same continent:

> Let a philosophic observer commence a journey from the savages of the Rocky Mountains, eastwardly towards our sea-coast. These he would observe in the earliest stage of association living under no law but that of nature, subsisting and covering themselves with the flesh and skins of wild beasts. He would next find those on our frontiers in the pastoral state, raising domestic animals to supply the defects of hunting. Then succeed our own semi-barbarous citizens, the pioneers of the advance of civilization, and so in his progress he would meet the gradual shades of improving man until he would reach his, as yet, most improved state in our seaport towns.

---

* Knotted strings of various colours attached to a cord, used to record events.

This, in fact, is equivalent to a survey, in time, of the progress of man from the infancy of creation to the present day.[63]

Several of the sociologically minded Scottish historians who worked out the four stages model were lawyers with an intense interest in legal history. Adam Smith lectured on jurisprudence at Glasgow; one of his pupils, John Millar, became professor of civil law there in 1761; and the prolific author Henry Home became Lord Kames on being appointed a lord of session or senior judge in 1752. Though best known for his work on legal history, Kames also wrote on literary criticism, moral philosophy, farming and education. He argued that law should be studied historically, not taught as a mere collection of facts, and that 'readers of solid judgment' would find 'more entertainment, in studying the constitution of a state, its government, its laws, the manners of its people' than in 'the history of wars and conquests'.[64] Adam Ferguson, a Gaelic-speaking army chaplain who saw action in the War of the Austrian Succession at Fontenoy in 1745, was also versatile, occupying successively the chairs of natural philosophy and moral philosophy at Edinburgh. Of the principal *literati*, only David Hume was not a professor, but he secured in 1752 an enviable post as Keeper of the Advocates' Library in Edinburgh.

William Robertson, the leading historian of this group (alongside Hume), was also one of the most influential shapers of eighteenth-century Scottish culture.[65] As Principal of Edinburgh University from 1762, he led the reconstruction of its buildings, including what is still the Old College, and oversaw many professorial appointments. As Moderator of the General Assembly of the Church of Scotland in 1763–4, and leader of the 'Moderate' Church party thereafter, he skilfully supported patronage whereby well-educated ministers could be appointed to parishes, against those who thought the congregation should elect their ministers. He found time also to research and write four major historical works whose elegant style proved that Scottish writers could fully meet Addisonian standards of 'politeness'. His first great success, the *History of Scotland* (1759), which gained him the position of Historiographer Royal for Scotland, debunked nationalist myths by showing that Scotland before the Act of Union of 1707 was a backward country dominated by turbulent nobles, demolishing the already threadbare legend of the ancient Scottish constitution, and offering a view of Scottish Church history which sidelined its frequent fanaticism and reshaped Presbyterianism as a modern civil religion.[66] His history had a global reach, continuing with *The History of the Reign of Charles V* (1769), *The History of America* (1777), and ending with a surprising new departure, *An Historical Disquisition concerning*

*the Knowledge which the Ancients had of India* (1791). He was recognized in his day, and should be now, as one of the trio of great Enlightenment historians whose other members are Gibbon and Hume.[67]

To reconstruct societies that had left no written record, historians had to rely on informed conjecture. Kames explains that we must fill in the gaps 'by hints from poets and historians, by collateral facts and by cautious conjectures drawn from the nature of the government, of the people, and of the times'.[68] This method acquired from the philosopher Dugald Stewart the label *'Theoretical or Conjectural History'*, meaning, he explained, much the same as Hume's term 'natural history'.[69] It was not speculative, but rather required 'a careful balancing of "empirical" evidence and philosophical conjecture'.[70] Empirical evidence came from travellers' reports about 'primitive' societies surviving in the present, especially about the natives of North America. Particularly rich sources included the account by the Jesuit Pierre de Charlevoix of his travels in the Great Lakes and Mississippi regions in 1720–21, the study of the Iroquois by Joseph-François Lafitau, and the sympathetic description of the 'Hottentots' (the Khoikhoi) by Peter Kolben.[71] Lafitau's work is explicitly comparative, noting similarities between Iroquois groups forming a confederacy for war, and the Greek nations gathering under Agamemnon to attack Troy.[72] Historians drew readily on Homer, for, as Ferguson pointed out, although the Homeric epics were not a record of historical facts they did provide invaluable evidence for 'the conceptions and sentiments of the age in which they were composed'.[73]

In the historians' discussion of the stages of society, there is of course much uncertainty. The stages often overlap. The societies assigned to each stage are not uniform: the Iroquois of North America and the Araucanians of Chile are, as Robertson observes, 'people of cultivated and enlarged understandings' by comparison with the mentally and physically slothful inhabitants of the West Indian islands.[74] The Homeric Greeks are sometimes compared to primitive hunters for their cruelty, to pastoralists for their form of government, and to agriculturalists for their mode of subsistence. The objection will readily occur that at each stage the peoples being compared are in many respects different, but what counts is the broad similarities, and without at least rough comparisons there can be no sociological generalizations. The aim of the sociological historians, seen especially in Robertson's systematic account of the native Americans in Chapter 4 of his *History of America*, is to show how all the institutions and manners of a society result from their mode of subsistence and are interconnected.

Dealing with the 'rude nations' who live by hunting and fishing, the historians try to avoid condescension. Robertson regrets that most visitors to

America were so convinced of their own superiority that they treated the inhabitants with contempt instead of valuing them as fascinating evidence for the primeval state of humanity.[75] Ferguson warns his readers against conceit by pointing out that 'the inhabitants of Britain, at the time of the Roman invasions, resembled, in many things, the present natives of North America; they were ignorant of agriculture; they painted their bodies; and used for clothing, the skins of beasts.'[76] Gibbon achieves a similar defamiliarizing effect by quoting St Jerome's opinion that, in his day, the primitive inhabitants of Scotland were cannibals, and continues:

> If in the neighbourhood of the commercial and literary town of Glasgow a race of cannibals has really existed, we may contemplate in the period of the Scottish history the opposite extremes of savage and civilised life. Such reflections tend to enlarge the circle of ideas, and to encourage the pleasing hope that New Zealand may produce in some future age the Hume of the Southern Hemisphere.[77]

In other words, although the Maoris of New Zealand are savage now (as Captain Cook reported), their savage disposition results only from their primitive mode of subsistence, and in the course of time they can be expected to reveal as great a capacity for cultural and intellectual achievement as any other nation.

However, the historians find the primitive way of life far from attractive. They do not idealize the 'noble savage'. According to the sources drawn on, savages indulge their appetites and resentments without self-control. Their mental horizon is limited: 'The thoughts and attention of a savage are confined within the small circle of objects, immediately connected to his preservation and enjoyment. Every thing beyond that, escapes his observation, or is perfectly indifferent to him.'[78] They do not think abstractly, because they have no occasion to do so. They show 'the hardness of heart, and insensibility, remarkable in all savage nations', with no affection, tenderness, or gratitude, but a 'sullen reserve' even towards their closest dependants.[79] The cruel tortures which native Americans impose and endure are described with horror, but Kames points out: 'No savages are more cruel than the Greeks and Trojans were, as described by Homer; men butchered in cold blood, towns reduced to ashes, sovereigns exposed to the most humbling indignities, no respect paid to age nor to sex.'[80] When they can obtain food without exertion, men are idle. Kolben reports that the Hottentots 'seem to place their whole earthly Happiness in Indolence and Sloth'.[81] Kames, following only the negative side of Kolben's largely sympathetic account, calls them 'of all men the most brutish'.[82]

Above all, savages maltreat their women. 'To despise and to degrade

the female sex, is the characteristic of the savage state in every part of the globe.'[83] Millar, who aims to combine stadial history with the history of the 'passions', says that 'savage nations' show 'extreme insensibility' towards women, not feeling the passion of love but making women 'servants and slaves of the men'.[84] The low status of women is confirmed by the practices of polygamy and the exposure of infants, which shows indifference to the wishes of mothers.[85] Ferguson, like Montesquieu, reports the implausible story that women in Formosa who fall pregnant before the age of thirty-six are compelled to have an abortion.[86]

The institutions of hunter-gatherer society are very simple. Communities can only be small, otherwise the game they depend on would become scarce. There is no government, except for the absolute power of a father over his family. There is no law: injuries are avenged by the sufferers or their families. Leaders are needed only when several households unite to wage war and are chosen for their personal qualities. There is, as yet, no property, no inheritance and no trade, apart from crude barter.

Within this picture, Robertson distinguishes different degrees of savagery. Natives of the American tropics do not need to exert themselves to survive. Some do not even hunt: they live by plucking fruit and by catching fish, which are in places so plentiful as to require no effort. Having nothing to do, they spend their days in indolence; they are physically weak, have small appetites, and are deficient in sexual passion. Others, the natives of North America and Chile, are hunters and warriors, much more robust and intelligent, with extraordinary skill in tracking game. The Aztecs and Incas had become 'polished nations', with laws, distinction of ranks and division of labour, though as they had learned neither to use metal nor to domesticate animals (except for the llama in Peru), Robertson thinks they were only at 'the infancy of civil life'.[87] They posed a problem for stadial history, since the Mexicans seemed to have moved rapidly from primitive independence to outright despotism without shaking off savagery.[88] At all events, the native Americans are not intrinsically inferior, but live under conditions that do not encourage them to develop their abilities.[89]

The second stage, that of herding, begins when people, in Ferguson's language, pass 'from the savage to what may be called the barbarous state'.[90] The change is prompted by increasing population and accompanied by union among a number of families for defence against enemies. Thus we have the beginnings of society, organized by tribes or clans. This stage is not found in America because the Americans have no domestic animals, though Robertson maintains that they could have domesticated the reindeer and the bison.[91] Instead, the Americans are stuck at the hunting stage, supplemented by a limited amount of agriculture. The great

exemplars of the herding stage are the 'Tartars' of Central Asia. They are highly mobile, moving between seasonal grazing-grounds, and preying on more settled peoples as, notoriously, the Huns under Attila and the Mongols under Genghis Khan did. Ferguson assimilates the Homeric Greeks to this stage by citing Achilles as a cattle-rustler, who says airily: 'Cattle . . . may be found in every field.'[92]

At this stage, property begins. Kames tries to reconstruct how the feeling of ownership began: a herdsman who looked after an animal from its birth came to feel a special relationship with it.[93] Property in animals could be passed to one's descendants. Hence inequality, and the distinction of ranks, first appear. However, men retain a sense of independence and treat their chieftain with far less deference than a king would receive in later ages.

Manners become softer. According to Ferguson, who as a military man had a particular sympathy for ancient warriors, warfare creates bonds between warriors, and hostility to an external enemy creates solidarity at home. Barbarians are 'generous and hospitable to strangers, as well as kind, affectionate, and gentle, in their domestic society'; they attack other tribes, but are hospitable to the solitary traveller.[94] We now find men showing personal attachment, even devotion, to women, as in the biblical story of the pastoralist Jacob who served Laban for seven years to win Rachel.[95]

Meanwhile, the population goes on increasing, and new food sources must be found. Hence humanity turns to agriculture. Society becomes differentiated and complex: 'Agriculture requires the aid of many other arts. The carpenter, the blacksmith, the mason, and other artificers, contribute to it. This circumstance connects individuals in an intimate society of mutual support, which again compacts them within a narrow space.'[96] A settled population comes under the stable government of a king, and in an important revolution, the right of punishing offences is transferred from the individual to the magistrate. Stable society makes property increasingly important. Man has a natural affection for property, which 'becomes exceeding strong' in times of peace and stability.[97] It develops in the agricultural stage. A man who has made a field cultivable and then ploughed it feels a close connection with it: 'He contracts, by degrees, a singular affection for a spot, which, in a manner, is the workmanship of his hands. He chuses to live there, and there to deposit his bones.'[98]

For the transition to modern commercial society, the historian at last has a large array of documents and can reconstruct a complex process. Our historians agree in considering the 'feudal age' a crucial part of this development. Millar, recounting the transition from feudal to modern society, makes cross-cultural comparisons. In both ancient Greece and medieval Europe, the need for defence against hostile tribes led people to

gather under the protection of a chief. Alcinous, king of Phaeacia in the *Odyssey*, who says he is one of thirteen chiefs joined in a confederacy, is compared to African and Germanic chieftains and medieval barons.[99] Feudalism, in which vassals held their lands as heritable fiefs received from their overlord, was neither a stable nor a satisfactory system. 'The principles of disorder and corruption are discernable in that constitution under its best and most perfect form,' says Robertson.[100] In early modern Europe, kings gradually asserted their power over barons. Instead of relying on barons for military support, kings relied increasingly on standing armies under their direct control.

But while absolute monarchy destroyed the unruly freedom of feudalism, liberty, as Robertson recounts, grew up in the medieval city republics, initially in Italy. In them, commerce began to flourish; wealth was accompanied by ostentation and luxury, which 'led gradually to greater refinement in manners, and in the habits of life'.[101] Commerce, once established, could not be crushed. If absolutism is the enemy of liberty, commerce is its safeguard. Merchants and craftsmen are dependent not on individual superiors, but on the market. Property is readily transferred from one person to another, and every industrious person can gain a fortune.[102] 'Commercial society' is held together not by force, nor by personal loyalty or affection, but by enlightened self-interest.[103]

Even feudalism had some civilizing influence. The new social institutions created by the Germanic invaders of Western Europe led eventually to the practices of chivalry and courtly love. Here Millar draws on *Mémoires sur l'ancienne chevalerie* (1751) by Jean-Baptiste de La Curne de Sainte-Palaye, a small book which, in spreading a more positive image of the Middle Ages, had an influence out of all proportion to its size.[104] Robertson argues that the Crusades, although 'a singular monument of human folly', had 'beneficial consequences' in introducing Europeans to foreign customs, 'the first gleams of light which tended to dispel barbarity and ignorance'.[105] The real civilizing agent, however, is commerce:

> Commerce tends to wear off those prejudices which maintain distinction and animosity between nations. It softens and polishes the manners of men. It unites them by one of the strongest of all ties, the desire of supplying their actual wants. It disposes them to peace, by establishing in every state an order of citizens bound by their interest to be the guardians of publick tranquillity.[106]

So, has 'the progress of society' brought us close to perfection? Our historians are too cautious to think so. They see dangers in the very freedom that commerce has brought about. Millar warns that commercial

wealth promotes luxury, which leads to 'insolence and dissipation'.[107] Kames thinks it also puts society in danger of disintegrating:

> [W]ealth, acquired whether by conquest or commerce, is productive of luxury and sensuality. As these increase, social affections decline, and at last vanish. This is visible in every opulent city that has long flourished in extensive commerce. Selfishness becomes the ruling passion: friendship is no more; and even blood-relation is little regarded. Every man studies his own interest; and love of gain and of sensual pleasure are idols worshipped by all. And this is the progress of manners, men end as they begun: selfishness is no less eminent in the last and most polished state of society, than in the first and most savage state.[108]

Ferguson is even more vehement in deploring the dissolution of public virtue in a polity given over to the increase of wealth and comfort. Corruption, he warns, will lead to despotism, repeating the story of the downfall of the Roman Republic. And since he agrees with Montesquieu that despotism is intrinsically corrupt, such medicine will create and increase the disease which it professes to cure.[109]

The historians of the Scottish Enlightenment were not concerned only with their own society. They also – Robertson especially – sought to explain how the decay of feudalism had enabled modern Europe to become a system of states arranged in mutual equilibrium. Robertson's *Charles V* was partly intended to explain 'that great secret in modern policy, the preservation of a proper distribution of power among all the members of the system into which the states of Europe are formed'.[110] Hume described in 'Of the Balance of Power' how the nations of Europe had united, first against the excessive power of Spain, and then, after its decline, against the still dangerous pretensions of France to 'universal empire'.[111] The sociologically minded historians were aiming at a narrative analysis of social development that would treat its early stages without condescension and its latest stage without naïve overconfidence.

## TWO HISTORIES OF ENGLAND: DAVID HUME AND CATHARINE MACAULAY

In the later eighteenth century, the many readers of history had the choice between two contrasting accounts of the seventeenth century, by David Hume and Catharine Macaulay. Hume's *The History of England from the Invasion of Julius Caesar to the Revolution of 1688*, though little read nowadays, is among the masterpieces of the Enlightenment. But the

handsome six-volume edition in which it is currently available disguises the process by which Hume wrote it. Appointed Keeper of the Advocates' Library in Edinburgh, the largest library in Scotland, in 1752, and therefore 'master of 30,000 volumes', including extensive historical as well as legal collections, Hume aimed to increase his income by writing history.[112] He began with the relatively recent past, publishing *The History of Great Britain*, from the accession of James I in 1603 to the arrival of William of Orange in 1688, in two volumes (1754 and 1756). The reigns from Henry VII to Elizabeth were then covered in *The History of England under the House of Tudor* (1759). The last volumes to be written, but the first chronologically, ran from the first Roman invasion to the Battle of Bosworth, and appeared in 1761. All six appeared as a single narrative in 1762; Hume made some revisions, especially to the volumes published first, and further revised subsequent editions, down to the last edition which appeared posthumously in 1778.[113]

Catharine Macaulay is read even less today. Yet she was the first female English historian. Her *History of England from the Accession of James I to that of the Brunswick Line*, published in eight volumes between 1763 and 1783, brought her profit and fame, and helped her to become a well-known figure in London society.[114] Her radical political views were notorious, and sometimes ridiculed. Samuel Johnson, as a guest at her house, challenged her, since she believed in equality, to ask her footman to dine with them; but this was unfair, since she believed in political but not economic or social equality.[115] In 1777 she visited Paris, where her acquaintances included Turgot and the salon hostess Madame de Geoffrin. In 1784, with her second husband, she visited America. Her support for the American Revolution, and the powerful theme of liberty in her *History*, had already given her a high reputation there, and she spent ten days staying with George and Martha Washington at Mount Vernon. She and Hume corresponded civilly, but each disapproved of the other's work.[116] Hume's defence of tradition elicited a telling reply from Macaulay: 'Your position, that all governments established by custom and authority carry with them obligations to submission and allegiance, does, I am afraid, involve all reformers in unavoidable guilt, since opposition to established error must needs be opposition to authority.'[117] Macaulay thought Hume a Tory; he objected to her 'Whiggery'. As we shall see, both were mistaken.

Both Hume and Macaulay had, apart from anything else, spotted a gap in the market. By the late eighteenth century, works of history were finding a large readership. Hume urged his 'female readers' to take up history, which they would find more instructive than novels and more entertaining than sermons.[118] Hume thought history the most popular form of writing in his

THE

# HISTORY

OF

# GREAT BRITAIN.

VOL. I.

CONTAINING

*The Reigns of* JAMES I. AND CHARLES I.

By DAVID HUME, Efq;

EDINBURGH:

Printed by HAMILTON, BALFOUR, and NEILL.

M,DCC,LIV.

Hume's *History of Great Britain, containing the Reigns of James I and Charles I* (1754), was followed in 1756 by a second volume on the Commonwealth and Restoration, and later continued under the title *The History of England.* Volumes 3 and 4, *The History of England under the House of Tudor,* appeared in 1759; *The History of England from the Invasion of Julius Caesar to the Accession of Henry VII* followed in 1762.

day: 'I believe this is the historical Age and this [Scotland] the historical Nation.'[119] Histories by Hume and Robertson were among the books borrowed most frequently from circulating libraries.[120] In France, the historical reference book by Nicolas Lenglet Dufresnoy, *La Méthode pour étudier l'histoire* (*How to Study History*, 1715), was so popular that it went through many editions, and by 1772 its original two volumes had been enlarged to fifteen.[121] However, when Hume and Macaulay were writing, histories of Britain were compilations rather than narratives, full of primary sources, and often published as huge unwieldy folios.[122] Readers needed a historical digest, not encumbered by 'original Papers' or 'minute uninteresting Facts'.[123] Hume sought, while remaining intellectually respectable, to compete with the popularity of the novel. He wrote to his close friend William Mure of Caldwell: 'The first Quality of an Historian is to be true and impartial; the next to be interesting. If you do not say, that I have done both Parties Justice; and if Mrs Mure be not sorry for poor King Charles, I shall burn all my Papers and return to Philosophy.'[124]

Contemporaries were anxious to discover the political slant of Hume's *History*. Did it support the Whigs or the Tories? Hume himself wrote: 'My views of *things* are more conformable to Whig principles; my representations of *persons* to Tory prejudices. Nothing can so much prove that men commonly regard more persons than things, as to find that I am commonly numbered among the Tories.'[125] Whigs liked to claim that English liberty had a history extending back to Saxon times, based in a continuous tradition of common law, and that the origins of Parliament lay in the Saxon assembly or Witenagemot.[126] Hume found no evidence for this theory of the 'ancient constitution'. After examining the government of pre-Conquest England, he concluded that the Anglo-Saxon government became 'extremely aristocratical'.[127] Although he agreed that Magna Carta was important, he noted that it concerned only the rights of the barons who extorted it from King John, and that subsequent kings did their best to ignore it. On the other hand, he writes favourably about the efforts of Parliament to resist the authority of Charles I and, later, that of James II, and he concludes that after the Glorious Revolution of 1688, 'we in this island have ever since enjoyed, if not the best system of government, at least the most entire system of liberty that ever was known among mankind.'[128]

'Tory prejudices' may have been flattered by Hume's denunciation of the trial and execution of Charles I as 'the height of all iniquity and fanatical extravagance'.[129] Hume represents Charles as almost saintly in the approach to his death, and may well have drawn some tears from readers who had cried over *Clarissa*.[130] But careful readers will see that Hume is even-handed in showing the conflict between Charles and Parliament as

insoluble, because neither side could understand the other. Charles I genu-
inely thought that his 'monarchical power' was absolute, so when
Parliament denied him the supplies he needed for war with Spain, he did
not understand that they were trying to assert their liberty, and thought
their behaviour was 'highly criminal and traitorous'.[131] Parliament was
motivated in large part by 'bigotry', which made them, for example, anx-
ious to pursue an unrealistic foreign policy by supporting the Huguenots
against the French monarchy.

Moreover, Charles and his father James I simply inherited assumptions
about absolute royal power from the Tudors. It was widely agreed that
Henry VII and Henry VIII had been tyrannical rulers, but Hume
extended this description also to the national heroine Elizabeth.[132] Her
submissive parliaments adulated her in a manner 'more worthy of a Turk-
ish divan than of an English house of commons', and everyone who spoke
to her was obliged to kneel.[133] Tudor government was a despotism, installed
to quell the anarchy of the Wars of the Roses.

While Hume cast doubt on the patriotic glorification of Elizabeth, how-
ever, he also demolished the Jacobite myth of her antagonist Mary Queen
of Scots as a saintly martyr. He examined the evidence for Mary's involve-
ment in Anthony Babington's plot to murder Elizabeth. The case against
Mary depended on the testimony of Mary's two secretaries, which needed
'to be supported by strong probabilities, in order to remove all suspicion
of tyranny and injustice', and Hume concluded that these probabilities did
point to Mary's complicity.[134] Thus he could fairly claim to be impartial in
scrutinizing critically the favourite myths of both parties.

In Hume's historical narrative, English liberty was a recent develop-
ment. It was not to be found in the Middle Ages, which Hume depicts as
chaotic, with unruly barons, futile wars, constant insecurity, frequent
devastation, general superstition and the incessant abuse of clerical (and
especially papal) power. The feudal system led to perpetual war, and
when this war was diverted overseas, on the basis of Edward III's wholly
spurious claim to the throne of France, armies were undisciplined and
campaigns so costly that they could only be sustained for a few months
each summer.

The seventeenth-century Civil War was hardly favourable to liberty
either: Parliament was soon vanquished by its own radicals, the Independ-
ents, who 'expected, by the terror of the sword, to impose a more perfect
system of liberty on the reluctant nation'.[135] The anarchy of the Interreg-
num was quelled by the despotism of Cromwell. English liberty certainly
grew from the conflict between Parliament and the Crown, but its pro-
ponents often used immoral means:

Obliged to court the favour of the populace, they found it necessary to comply with their rage and folly; and have even, on many occasions, by propagating calumnies, and by promoting violence, served to infatuate as well as corrupt that people to whom they made a tender of liberty and justice.[136]

The extreme example of such demagogy was Parliament's encouragement, in 1678, of belief in the Popish Plot, a wholly implausible conspiracy to kill the king, bring Britain under the rule of the pope, and extirpate Protestantism.[137] By supporting and strengthening popular anti-Catholicism, either through cynical dishonesty or sincere zealotry, Parliament asserted its power against the king, and served the ambition of its leaders. Yet, Hume remarks, it was to this demagogic Parliament that Britain owes the freedom from arbitrary imprisonment possessed by no citizens of any other country.[138]

Hume thought the 'mixed government' of Britain a valuable but precarious system. Zeal for liberty needed to be balanced by respect for the traditional order. 'Government is instituted in order to restrain the fury and injustice of the people';[139] the people should therefore be taught the duty of obedience, but not told about any right of resistance, which will arise only in exceptional circumstances. Although Hume did not draw this conclusion, that respect for tradition was already threatened by the accession of William III, which, by ending the Stuarts' hereditary succession, destabilized the whole dynastic principle.[140] He privately thought that the English government was 'probably not calculated for Duration, by reason of its excessive Liberty'.[141]

Religion appears in Hume's *History* mainly as a political force. In the Middle Ages, 'superstition' supports the power of the Church, which seeks to dominate secular rulers. The reign of the Catholic Mary Tudor, when Protestants were burned at the stake, saw 'scenes of horror, which have since rendered the catholic religion the object of general detestation'.[142] Religious reformers, without being insincere, are nevertheless actuated by all-too-human motives: Luther was ambitious for the 'glory of dictating the religious faith and principles of multitudes';[143] the Levellers, 'having experienced the sweets of dominion, would not so easily be deprived of it', but were firmly suppressed by Cromwell.[144] The Puritans and the Civil War sects were motivated by superstition and fanaticism, which Hume often treats with dry irony. Among the Independents, officers claimed to speak by inspiration: 'the officers of the army received inspiration with their commission'.[145] Cromwell, a master of 'refined hypocrisy', maintains his ascendancy by devout language and lengthy prayers.[146] In this

disillusioned treatment of religion, Hume is quietly opposing the tendency to write English history in Providential terms, as divinely guided towards the establishment of the Protestant religion. The persecutions under Mary were sometimes explained as God's punishment for backsliding, sometimes as his method of strengthening people's commitment to Protestantism.[147] Hume would have none of it. The Reformation in England came about through the ambitions of Henry VIII, who had previously received from the pope the title of Defender of the Faith for writing a book against Luther's heresies. This is typical of the irony that Hume displays in his history. A tyrant saved England from the tyranny of Catholicism. Later, the fanatical Puritans saved 'the precious spark of liberty'; 'and it was to this sect, whose principles appear so frivolous and habits so ridiculous, that the English owe the whole freedom of their constitution'.[148]

Hume as a historian has often been criticized for his supposed doctrine of the uniformity of human nature. In fact, Hume is sharply aware both of the complexity of human character, and of the otherness of different cultures. He is astonished, for example, by how the Crusaders, on capturing Jerusalem, first massacred the inhabitants and then thanked God in tears for their success: 'So inconsistent is human nature with itself! And so easily does the most effeminate superstition ally, both with the most heroic courage, and with the fiercest barbarity!'[149] Thus this event serves to deepen the analysis of 'superstition' that proceeds throughout the *History*. His narrative includes characters who are 'singular' because they have intelligible qualities to an extraordinary degree (Joan of Arc, Richard III) or qualities not commonly found together, like the 'singular' Louis IX of France, who combines monkish devotion with a generous and honourable disposition.[150] The faults of Mary Queen of Scots are 'the result of an inexplicable, though not uncommon inconstancy in the human mind'.[151] The character of Charles I has two features that seem 'incompatible': he was 'steady' and 'obstinate' in his purpose, but 'easily governed' by favourites such as Buckingham.[152] Cromwell united 'the most opposite talents', employing 'indefatigable patience' or rapid decisiveness as the occasion required.[153]

Hume gives full attention to the different mental worlds many of his characters inhabited. People went on crusades because of 'the romantic spirit of the age'.[154] He uses the word 'genius' sometimes to denote an individual's gifts (Shakespeare, whom Hume thinks overrated, had 'a great and fertile genius'[155]) but often for the spirit animating a period, a nation, or an institution: 'the genius of the age',[156] 'the warlike genius of the Kentish Saxons',[157] 'the rise and the genius of the Puritans',[158] 'the genius of the English government, and of Charles's administration',[159] 'the genius of a monarchy, strictly limited'.[160] In assessing Thomas Becket, Hume says we

must enter into 'the genius of that age' and appreciate the prevalent 'spirit of superstition', within which Becket was perfectly sincere.[161] So while people may share the same basic emotional equipment, their minds and motives differ widely, being shaped by the 'genius' of the time and society in which they happen to live. Here Hume joins hands with another philosophic historian, Montesquieu, who is equally anxious to acknowledge the diverse 'spirit' animating different societies.

Catharine Macaulay, in contrast to Hume, believed in the 'ancient constitution', but her ideal of liberty also owed much to classical republicanism.[162] The frontispiece to her third volume depicted her as the Roman goddess Libertas, with an allusion to Lucius Junius Brutus, the founder of the Roman Republic.[163] Liberty was for her the will of the people expressed through Parliament, and its ideal manifestation was in a republic. Her heroes are Milton, Locke, the republican theorists Algernon Sidney and James Harrington, and the Levellers. Dealing with Charles I, she acknowledges the dignity with which he faced his imminent death, but she is in no doubt that he had brought it on himself by his obstinate resistance to Parliament and his determination to maintain absolute power:

> The partizans of Liberty applaud his fate; the liberal and humane condemn and pity him: To a mind softened by habits of amusement, and intoxicated with ideas of self-importance, the transition from royal pomp to a prison, from easy, gay, and luxurious life to a premature and violent death by the hands of an executioner, are punishments so sharp and touching, that, in the suffering prince, we are apt to overlook the designing tyrant, to dwell on his hardships, and forget his crimes.[164]

Repeatedly citing Locke, she argues that absolute monarchy is incompatible with civil society. Government was 'instituted for the protection of the people, for the end of securing, not overthrowing, the rights of nature'; this argument 'will meet with little contradiction in a country enlightened by the unobstructed ray of rational learning'.[165] The supreme authority must be the House of Commons, since it is elected by the people.

Macaulay mentions but ignores the objection that sovereignty is vested in Parliament, which comprises the unelected Lords as well as the elected Commons. She does not object to Pride's Purge, the military *coup d'état* by which Colonel Pride, in December 1648, forcibly expelled those members of the Commons who did not support the New Model Army. In Macaulay's view, they were under Charles's influence, and therefore their opinions did not count: 'A parliament under any undue influences or force can do no constitutional act.'[166] One might resist Macaulay's bullying rhetoric, with its suggestion that anyone who disagrees with her is not

THE

# HISTORY

OF

# ENGLAND

FROM THE

## ACCESSION of JAMES I.

TO THAT OF THE

## BRUNSWICK LINE.

VOL. I.

By CATHERINE MACAULAY.

LONDON:

Printed for J. Nourse, Bookseller to his Majesty, in the Strand;
R. and J. Dodsley, in Pall-mall; and W. Johnston, in Ludgate-street.
MDCCLXIII.

Catharine or Catherine Macaulay's *History*, first published in 1763, was widely regarded as a rejoinder to Hume.

'rational'; nevertheless, she rejects facile antitheses. Criticizing Charles, she does not glorify Cromwell. As a republican, she hated Cromwell for dissolving the Rump Parliament in 1653 and replacing it by authoritarian rule. Hence, while Charles wanted to be a tyrant, Cromwell was one. The Commonwealth – the short-lived English Republic – would have been 'the brightest age that ever adorned the page of history', but in practice the people's struggle for liberty 'served to complete the triumph and exalt the power of tyranny'.[167] Cromwell's 'daring tyranny . . . entirely subverted, or rather abolished, every principle of Freedom in the constitution.'[168] Five thousand Levellers make a stand for liberty at Burford, but, 'deceived by a promise from Cromwell of a delay of hostilities', are crushed by an unexpected attack.[169] In Ireland, Cromwell puts not only the garrison of Drogheda but also its civilian population to the sword, except for a few who are sent to slavery in Barbados. Her final sketch of Cromwell's character is even less flattering than Hume's: Cromwell was originally sincere in his religion, but 'the grimace of godliness, when the reality was extinguished by the fumes of ambition, with his signal military talent, at length lifted him to the throne of empire'.[170]

Macaulay's independence of mind is particularly apparent at the end of her *History*, where she refuses to join in the general enthusiasm for the 1688 Revolution. Here she explicitly disagrees with 'Mr. Hume, who is assiduously careful not to offend in any point of popular recommendation'.[171] In Macaulay's opinion, the Whigs welcomed William only out of political expediency, not from any concern about liberty. After his enthronement, it was business as usual: politicians already discredited under the previous reign resumed their seats in the cabinet as if nothing had happened. The Bill of Rights, proclaimed by Parliament in December 1689, could have been 'the best of all possible constitutions', but in failing to provide for annual parliaments, it left the people 'really and truly enslaved to a small part of the community' who had every incentive to yield to corruption.[172]

While Hume relied chiefly on printed sources, Macaulay also made extensive use of state papers, seventeenth-century pamphlets and manuscripts.[173] In criticizing Charles I for obstinacy, for example, she supports her case by quoting three letters from Charles to his wife, which she found in the British Museum. So, by present-day standards, one could call her the more professional historian. Her style is clear and no-nonsense; she puts forward her political arguments forthrightly and in detail. Mary Wollstonecraft paid her a well-deserved tribute: 'she writes with sober energy and argumentative closeness; yet sympathy and benevolence give an interest to her sentiments, and that vital heat to arguments, which

forces the reader to weigh them.'[174] One might call her a contrarian; if so, that is a type of writer that we need more of. In her work, she refused to be patronized for being a woman. When she wanted to see the correspondence between James I and his favourite Buckingham, its custodian tried to deter her by mentioning the indecent content of the letters: ' "Phoo," said she, "a historian is of no sex," and then deliberately read through all.'[175] Catharine Macaulay deserves to be remembered, read, and argued with.

## GIBBON'S *DECLINE AND FALL*

Edward Gibbon stood apart from the mainstream of British intellectual life. His formative years, from the ages of sixteen to twenty-one, were spent in Lausanne. He had impetuously converted to Catholicism; his father sent him abroad so that he might be won back to Protestantism by a Swiss pastor. Young Gibbon flourished, studied the classics, mastered French so thoroughly that he later wrote his first book in French, and learned far more in Lausanne than in the year he had wasted at Oxford. In 1763–4 he stayed in Paris, conversed easily with the leading *philosophes*, and visited Rome, where, according to his much later memoirs, the idea first occurred to him of writing its history: 'In my Journal the place and moment of conception are recorded; the fifteenth of October 1764, in the close of evening, as I sat musing in the Church of the Zoccolanti or Franciscan fryars, while they were singing Vespers in the Temple of Jupiter on the ruins of the Capitol.'[176] Perhaps with poetic licence, Gibbon has here captured a rich symbolic moment, in which the triumph of Christianity is marked by the seemingly humble victors singing in a temple which has been converted into a church. His project, for which he eventually assembled a library of over six thousand books, began in earnest in 1768. Despite the distractions of London society, and of serving as Member of Parliament for Liskeard in Cornwall (which he was not expected to visit, and apparently never did) from 1774 to 1780, Gibbon published *The Decline and Fall of the Roman Empire* in three instalments in 1776, 1781 and 1788. In 1783 he moved back to Lausanne, where he worked on the last volumes in a study overlooking the Lake of Geneva, and completed it, he tells us, in a summer-house between 11 and 12 on the night of 27 June 1787.

The *Decline* was intended to combine narrative with analysis in a manner that Gibbon thought best exemplified by the 'philosophic historian' Tacitus.[177] In his first publication, the *Essai sur l'étude de la littérature* (*Essay on the Study of Literature*, 1761), he adapted from another

THE

# HISTORY

OF THE

DECLINE AND FALL

OF THE

# ROMAN EMPIRE.

By EDWARD GIBBON, Efq;

VOLUME THE FIRST.

Jam provideo animo, velut qui, proximis littori vadis induĉti, mare pedibus ingredi-
untur, quicquid progredior, in vaſtiorem me altitudinem, ac velut profundum invehi ; et
crefcere pene opus, quod prima quæque perficiendo minui videbatur.

LONDON:

PRINTED FOR W. STRAHAN; AND T. CADELL, IN THE STRAND,
MDCCLXXVI.

Gibbon's first volume appeared in 1776, with a quotation from Book 31 of Livy's
*History of Rome*, reading: 'I see that I am like people who are tempted by the
shallow water along the beach to wade out to sea; the further I progress, the
greater the depth, as though it were a bottomless sea, into which I am carried. I
imagined that as I completed one part after another the task before me would
diminish; as it is, it almost becomes greater.'

philosophic historian, Montesquieu, the distinction between 'general causes' and facts. Facts could yield much hidden meaning to a philosophic historian, who would interpret them in the light of 'general causes'. Such causes were principally manifested 'in general events, whose slow but sure influence changes the face of the earth, without the moment of this change being perceptible, and above all in manners, religions, and everything that is subject to the yoke of opinion'.[178] This has been called a 'stratified' conception of history-writing.[179] It requires the superficial stratum of facts to be interpreted through customs, social practices, beliefs, ways of thinking – the 'manners' that Voltaire undertook to describe in his *Essai sur les mœurs*. Montesquieu similarly had spoken of 'manners [*les mœurs*], which reign as imperiously as laws',[180] and had noted that the 'general spirit' of a nation would resist even despotism: a Persian despot could make a son kill his father, but could not make his subjects drink wine.[181]

In being philosophical, Gibbon's history is necessarily also comparative. It identifies patterns of growth and decline that the Greek historian Polybius had found operating in the Roman Republic. Gibbon pays homage to Polybius in the first part of the *Decline* to be written, the 'General Observations on the Fall of the Roman Empire in the West', which dates from 1772 but was inserted at the end of Volume 3 in 1781. He finds similar patterns in the civilization of the Turks and, still more strikingly, among the Arabs, who emerged from the desert and established a caliphate over the conquered territories.

Gibbon's narrative opens in the second century CE, with the age of the Antonine emperors, from the accession of Nerva in 96 to the death of Marcus Aurelius in 180. The Empire was at its zenith – happy, peaceful and prosperous: 'In the second century of the Christian Æra, the Empire of Rome comprehended the fairest part of the earth, and the most civilized portion of mankind.'[182] But Gibbon's description is already philosophical in hinting at the causes of its decline. He continues:

> The frontiers of that extensive monarchy were guarded by ancient renown and disciplined valour. The gentle, but powerful influence of laws and manners had gradually cemented the union of the provinces. Their peaceful inhabitants enjoyed and abused the advantages of wealth and luxury. The image of a free constitution was preserved with decent reverence: the Roman senate appeared to possess the sovereign authority, and devolved on the emperors all the executive powers of government.[183]

In the following pages Gibbon tells us in detail about the discipline of the Roman legions, and takes us on a tour of the Empire's provinces, from Spain, Gaul (France) and Britain to Syria, Egypt and (North) Africa. He

tells us about the Empire's many cities, whose magnificence can be judged by the surviving ruins, and about the infrastructure of public highways that connected them. But the passage just quoted already indicates two sources of the 'slow and secret poison' that would, centuries later, bring down the Empire.[184]

First, Augustus had abolished the political freedom of the Roman Republic. Having put an end to the civil wars which wrecked the republic, he obtained supreme power while pretending to continue republican institutions. The republic had been governed by two consuls, supplemented in emergencies by tribunes. There were safeguards against the abuse of either office. Augustus permitted the senate to confer on him for life the powers of the consuls and the tribunes. He had already allowed the senate to make him supreme ruler of all the provinces and commander of the armies. The 'crafty tyrant' thus possessed unlimited power, while the senate could merely rubber-stamp his decisions.[185]

Augustus and his successors were maintained in power by the supine consent of the people. They no longer possessed 'that public courage which is nourished by the love of independence, the sense of national honour, the presence of danger, and the habit of command'.[186] In the remote days of the republic, 'public virtue' had induced every male citizen to fight for his country when necessary. Now, the legions were still formidable and composed of citizens, but they were already using troops of barbarians as auxiliaries, and in the course of time the Romans would become reluctant to do their own fighting and would rely increasingly on barbarian mercenaries.

Second, Gibbon captures the ambivalence of 'luxury', which Polybius had already identified as a cause of national decline, and which (as we have seen) the eighteenth century worried about.[187] Luxury had real advantages. It made possible high civilization, polite manners, learning and the arts. By causing money to circulate, it adjusted the inequalities of society: 'in the present imperfect condition of society, luxury, though it may proceed from vice or folly, seems to be the only means that can correct the unequal distribution of property'.[188] But its effects were also 'enervating'. Soldiers were 'enervated by luxury' and 'incapable of military fatigue', and unwilling to wear heavy armour or carry burdensome weapons.[189] Similarly, the Vandals, after conquering North Africa, were 'enervated by the luxury of the South';[190] the Isaurians, a bandit nation in Asia Minor, found that 'luxury enervated the hardiness of their minds and bodies';[191] and when the Turks conquered part of China, they were 'enervated by luxury, which is always fatal except to an industrious people'.[192] A cyclical pattern becomes visible, in which a military nation achieves conquests through its solidarity and discipline, enjoys the resulting wealth, but then

succumbs to its own prosperity, grows soft, employs mercenaries to do its fighting, and is finally overcome by those very mercenaries. The same thing happened to the caliphs, the beneficiaries of the Arab conquests: they employed Turkish mercenaries who proved rebellious.[193]

The Roman Empire also illustrates the shortcomings of empires as such. Gibbon offers a cool, almost Machiavellian description of how an empire works:

> an extensive empire must be supported by a refined system of policy and oppression: in the centre an absolute power, prompt in action and rich in resources: a swift and easy communication with the extreme parts: fortifica-tions to check the first effort of rebellion: a regular administration to protect and punish; and a well-disciplined army to inspire fear, without provoking discontent and despair.[194]

But even with all these advantages, empires become too unwieldy and col-lapse under the weight of their own 'immoderate greatness'.[195] The homogeneity of the Roman Empire, which sustained it, also led to its down-fall. Unlike modern Europe, where nations compete with one another, Imperial citizens had no spur for 'emulation'.[196] The Empire was intellec-tually stagnant. Gibbon also had more recent examples in mind: the empire of the Habsburgs, on which the sun never set, and the aspirations of Louis XIV towards 'universal monarchy'.[197] He also notes that the Muslims still 'assert a divine and indefeasible claim of universal empire', though in his day, with the Ottoman Empire in decline, that threat seemed negligible.[198]

Having set the scene, Gibbon embarks on a historical narrative which is initially dominated by the problem of Imperial succession. The virtuous emperor Marcus Aurelius is succeeded by his worthless son Commodus. After Commodus' murder, his successor lasts only eighty-six days before being murdered by the Praetorian Guard. With no hereditary or elective principle, the empire falls to any commander who can muster enough troops, and it is subjected to continual civil wars. Eventually a strong and effective ruler emerges in Diocletian, and another in Constantine. But the empire thus becomes an 'Oriental despotism'.[199] Constantine moves the seat of the empire to his new capital, Constantinople. The empire is divided. Its western half is overrun by the Goths, then by the Huns, and finally – at the end of Gibbon's third volume – the last Roman emperor in the west is overthrown by the Gothic king Odoacer in 476.

Gibbon's readers waited seven years, uncertain what would follow. Having recounted the invasions by the Goths, Vandals, Lombards and other barbarians, he might have continued with the story of the Holy Roman Empire. All we get, however, half-way through Chapter 49, is a

brief and dismissive account of Charlemagne, whom Gibbon does not admire as either a statesman or a legislator. Instead of leaving a stable empire, Charlemagne divided his lands among his sons, ensuring anarchy; and his decrees include such trivia as 'the economy of his farms, the care of his poultry, and even the sale of his eggs'.[200] The Holy Roman Empire appears in an anecdote about Charles IV being arrested for debt by a butcher in Worms, and detained in an inn until he could pay.[201] Otherwise, it forms part of the ascendancy of the papacy to temporal power, since Pope Leo III insisted on crowning Charlemagne and thus asserting the authority of the popes over the empire.

Gibbon might also have followed the example of other Enlightenment historians by recounting the rise of modern commercial society. Some commentators think he did do this. At the beginning of his study of the *Decline and Fall* (which is as long as the *Decline and Fall* itself, and only deals with half of Gibbon's text), John Pocock writes: 'The Enlightened historians – Voltaire, Hume, Robertson – are concerned with the exit from the Christian millennium into a Europe of state power and civil society; the *Decline and Fall* is exceptional in confining itself to the way into that millennium.'[202] Gibbon is said to have contributed to the Enlightenment's grand narrative by applying historical research to understand 'the triumph of barbarism and religion', that is, the obstacles which were overcome in the rise of commercial society. Now Gibbon, as one would expect, and as is clear from many occasional remarks in his text, took this grand narrative for granted. But it is not the story he is telling in the *Decline*. Although he makes many passing references to the modern state of Europe, he does not seek the causes of its emergence. To do so, he would have had to follow Robertson in describing the development from feudalism to absolutism and the modern European state system. However, Gibbon seems, like Hume, interested only in the negative sides of the Middle Ages. For him, early medieval Europe was 'a long subordination of anarchy and discord';[203] the 'feudal system' was a 'tumult' in which 'the still voice of law and reason was seldom heard or obeyed';[204] and the Crusades were a disaster, inspired by 'savage fanaticism', in which Europe learned nothing from the East.[205] He does not pursue the story further.

Instead, Gibbon moves to Constantinople and recounts the history of the Byzantine Empire until the fall of Constantinople in 1453. To him, as to other eighteenth-century historians, this was not a congenial topic: 'the subjects of the Byzantine empire, who assume and dishonour the names both of Greeks and Romans, present a dead uniformity of abject vices, which are neither softened by the weakness of humanity nor animated by the vigour of memorable crimes.'[206] The sterility of Byzantium, which

preserved the Greek classics but added no new works to them, is under-lined by Gibbon's frequent references to the eunuchs who dominated the palace.[207] So, after giving a panorama of the age of Justinian, Gibbon wraps up the subsequent Byzantine emperors in a few hasty chapters, in which the recital of mostly gruesome facts seems to defeat his philosoph-ical approach.[208] Instead, he gives his attention to the foreign nations who successively attacked Constantinople: the Arabs, the Turks, the Crusaders (who conquered and sacked the city in 1204), and the Mongols, whose attacks impelled other nations.[209] Byzantium is central because '*passively* connected with the most splendid and important revolutions which have changed the state of the world'.[210] But narrative continuity is broken. 'A diet of plums forms the substantial basis of the final volumes, representing a most powerful expression of its fragmentary character and abjuration of a master narrative.'[211]

Even if this is indeed a narrative breakdown it is outweighed, however, by the prominence Gibbon gives, in a large number of analytical chapters, to the general causes that underlie the facts he narrates. Since these general causes especially include the 'useful history of human manners',[212] we have what might be called sociological portraits, in which Gibbon examines the ancient Germans, as a society based on hunting (Chapter 9); the 'manners of the pastoral nations', the highly mobile peoples of Central Asia whose migrations drove other peoples before them and incessantly battered at the borders of the Empire (Chapter 26); and the Arabs, whose society was the setting for the new religion proclaimed by Muhammad (Chapter 50).[213] We have a chapter on the law codes of Justinian (Chapter 44), and a briefer account of the much more primitive laws of the Franks.[214] Above all, we have what the reader may by now feel is the elephant in the room – a fam-ous or notorious (at any rate immensely searching) study of the spread of Christianity, the theological controversies that tormented the Christian world, and the effect of Christianity on the decline of the Empire.

In Gibbon's day, as we have seen, Church history was considered a distinct subject. The tree of knowledge in d'Alembert's 'Preliminary Dis-course' to the *Encyclopédie* makes Church history a separate though small branch. Gibbon was inspired partly by Pietro Giannone's *Storia civile del regno di Napoli* (*Civil History of the Kingdom of Naples*, 1723), a history of civil law which subsumes Church institutions into a determinedly secu-lar account, to combine civil and ecclesiastical history.[215] So his first volume ends with two highly controversial chapters. Chapter 15 inquires into the 'secondary causes' of the rapid growth of Christianity (the sup-posed primary cause, its divine truth, being bracketed out); and Chapter 16 asks about the historical reality of the persecutions. Gibbon's approach

is sceptical and ironic, but he does not mock Christianity in the manner of Voltaire (whom he later calls 'an intolerant bigot').[216] As with other controversial writers, we cannot be sure what Gibbon thought, only what he wrote.[217] The standpoint presented in the *Decline* is that of natural religion: 'The God of nature has written his existence on all his works, and his law in the heart of man.'[218] But Gibbon's text also describes the core of Christianity as 'a genuine revelation fitted to inspire the most rational esteem and conviction'.[219] Humanity, however, has an innate propensity to superstition. The 'multitude', incapable of philosophy, wants tangible images of the divine.[220] So when polytheism disappeared, Christians found a substitute in the cult of saints and images, which the Church prudently encouraged.

Hence the valuable core of Christianity has been overlaid with such a huge superstructure of false historical claims, absurd cultic practices, and unintelligible theological controversy – all supported by officially sanctioned hatred and frequent persecution – that the attempt to reconstruct the actual development of Christianity must necessarily be devastating. Yet to understand the history of the later Roman Empire requires some attempt to understand the theological issues under debate, and the mindset of those who fought over them. And so Gibbon devotes later chapters to the Arian heresy (denial of the Trinity, Chapter 21), the worship of saints and relics (Chapter 28), the growth of monasticism (Chapter 37), the disputed doctrine of the Incarnation (Chapter 47), the worship of images (Chapter 49), and the Paulician heresy (Chapter 54), with attention also to the bitterly controversial question of whether the Holy Ghost proceeded from the Father *and* the Son, or from the Father *by* the Son (Chapter 60).

The energies devoted to these religious disputes inevitably distracted people from their civic duty. They were not rarefied debates among intellectuals. In Constantinople, the mass of the people argued about the difference between *homoousion* (the Son being of the same substance with the Father) and *homoiousion* (the Son being of only similar substance to the Father).[221] When the Arabs attacked Syracuse, there were no sailors to defend it, because they were all busy building a church.[222] In contrast to the religious zeal that animated the Arabs, the Greeks of Constantinople were encouraged by their religion only 'to suffer and to yield'.[223] Here Gibbon is repeating an idea – that Christianity makes people unwarlike – most forcibly expressed by Machiavelli, who complains that Christianity disparages worldly honour, courage and ferocity, and commends humility, abnegation and unworldliness.[224]

Religion in the *Decline and Fall* belongs to a distinct narrative, which Gibbon indicates clearly. The persecuted Paulicians anticipate later rebels

against Catholic orthodoxy, such as the Hussites, and they in turn anticipate the Reformation, as does the protest against papal power by Arnold of Brescia.[225] Gibbon regrets only that the Reformers were too timid, that they retained or invented too many absurd doctrines, and that they shared the spirit of persecution, shown most shockingly by Calvin's burning of the Arian Servetus.[226] Fortunately, in his own time, toleration has been introduced in England and Holland; but he ends with a fear that 'the boundless impulse of inquiry and scepticism' may go too far, and that Christianity may be assailed by irreligious and irresponsible people 'who indulge the licence without the temper of philosophy'.[227]

Gibbon's account of early Christianity amounts to a résumé of the Enlightenment charge-sheet.[228] Christians were impressively virtuous, but they were also disagreeably unsocial, showing 'indolent, or even criminal disregard to the public welfare'.[229] They believed that the world would soon come to an end, as Christ had prophesied – 'an opinion which . . . has not been found agreeable to experience'.[230] They expected to enter a material heavenly city, as foretold in the Book of Revelation, while their persecutors would be damned: 'the primitive church . . . delivered over, without hesitation, to eternal torture the far greater part of the human species'.[231] They not only believed in miracles, but thought that resurrection from the dead was quite a common event.[232] Yet none of the miracles attested by early Christians attracted the notice of the wise men of the time.

As for the persecutions of the Christians, Gibbon thinks them much exaggerated. By being themselves intolerant in refusing even nominal homage to the pagan gods, Christians eventually forced long-suffering and humane Roman magistrates to punish them. Moreover, Christians actively sought martyrdom as a way of testifying to their faith.[233] The legends of gruesome tortures inflicted on early saints are most likely projections of the vicious fantasies of intolerant priests.[234] Martyrdoms anyway were comparatively rare. Most of the time the Christians lived without being molested. Even in the ten-year-long persecution under Diocletian, Gibbon estimates the total number of sufferers at about fifteen hundred, which 'will allow an annual consumption of one hundred and fifty martyrs'.[235]

The touch of flippancy in the last-quoted phrase may seem to justify the suspicion that Gibbon treats Christianity with wanton disrespect, and that he is unable to understand it from the inside. The truth is more complex. Certainly, especially in the later stages of the *Decline*, the term 'superstition' is used as a catch-all term to cover every kind of false belief and devotional practice, from the cosmic religion of pre-Islamic Arabs to the ascetic devotion of Emperor Basil II.[236] The Byzantine Empire indulged 'a long dream of superstition' in which 'the Virgin and the saints, their

visions and miracles, their relics and images, were preached by the monks, and worshipped by the people'.[237]

However, Gibbon also shows that the early Christians inhabited a mental world that even professing Christians of his own time would find deeply alien. 'In modern times, a latent and even involuntary scepticism adheres to the most pious dispositions. Their admission of supernatural truth is much less an active consent than a cold and passive acquiescence.'[238] Modern people, whatever they may claim, cannot believe in a future life with the fervour of early Christians. 'The ancient Christians were animated by a contempt for their present existence, and by a just confidence of immortality, of which the doubtful and imperfect faith of modern ages cannot give us any adequate notion.'[239] Here Gibbon is close to Hume, who maintains that assent to religious claims 'is some unaccountable operation of the mind betwixt disbelief and conviction, but approaching much nearer the former than the latter'.[240] But Gibbon is more able than Hume to imagine a time when people thought and felt differently.

Gibbon also offers psychological analysis. The extravagant conduct of early monks, such as the anachorets who ate grass, and Simeon Stylites who spent thirty years on top of a column in 'an aerial penance', is treated with almost open ridicule, but this is in order to argue that ascetic practices make one hard and insensitive not only to oneself but also to others:

> This voluntary martyrdom must have gradually destroyed the sensibility both of the mind and body; nor can it be presumed that the fanatics who torment themselves are susceptible of any lively affection for the rest of mankind. A cruel, unfeeling temper has distinguished the monks of every age and country: their stern indifference, which is seldom mollified by personal friendship, is inflamed by religious hatred; and their merciless zeal has strenuously administered the holy office of the Inquisition.[241]

Earlier, Gibbon has examined the complex and inscrutable character of Constantine, the first Christian emperor, who ruthlessly and treacherously disposed of political rivals and even close relatives. The political analysis applied to Augustus is now combined with psychological assessment. Modern readers, Gibbon says, may suppose that Constantine's adoption of Christianity was tactical, calculated and hypocritical. But that would be over-simple. 'In an age of religious fervour the most artful statesmen are observed to feel some part of the enthusiasm which they inspire; and the most orthodox saints assume the dangerous privilege of defending the cause of truth by the arms of deceit and falsehood.'[242] To understand such figures, we must think our way back into a mental world very different from our own.

The *Decline* is also an innovative achievement in history-writing, and a literary masterpiece. Gibbon combines philosophic history with the critical analysis of sources pioneered by the *érudits* of the Republic of Letters.[243] He drew on the careful compilations of material made by such authors as the Jansenist Tillemont, the Lutheran Mosheim, the Huguenots Basnage and Beausobre, and the Catholics Baronius and Petavius.[244] In his extensive footnotes Gibbon acknowledges these sources and notes their occasional bias. That of Catholic historians, struggling to explain away material that shows their Church in a bad light, is particularly striking and even touching: 'I almost pity the agony of rage and sophistry with which Petavius seems to be agitated in the VIth book of his Dogmata Theologica.'[245] But Gibbon is even-handed, allowing for the contrary prejudices of a Protestant and a Jesuit.[246] He not only drew on written sources, but studied maps and looked at collections of medals.[247] The great difference between Gibbon and modern historians of Rome is, naturally, that they draw on extensive and ever-increasing archaeological findings which were not available to him.[248]

Gibbon is of course famous for his elaborate and ironic style. He uses such literary devices as oxymoron – 'the pious murder of their satraps' (by Christian rebels in Persia); zeugma – 'The restoration of Chosroes was celebrated with feasts and executions'; and offering alternatives – 'the ecclesiastical rulers were relieved from the toil, or deprived of the pleasure, of persecution'.[249] Occasionally the irony is blunt, as when he records a controversy over purgatory: 'whether their souls were purified by elemental fire was a doubtful point, which in a few years might be conveniently settled on the spot by the disputants'.[250] But often it is disconcertingly subtle, as when Gibbon says of the Byzantine emperor and historian John Cantacuzene, 'it is observed that, like Moses and Caesar, he was the principal actor in the scenes which he describes'.[251] Here Gibbon pretends to be accepting the orthodox – but obsolete – idea that Moses was the author of the Pentateuch. But the unwary reader who accepts this attribution with a sigh of relief then finds that he has been misled into equating the inspired Moses with profane historians.

As we approach the end of the *Decline*, we may wonder about the overall shape of the story Gibbon is telling. Those readers for whom it points forward in a celebratory manner to modern Europe regard it as upbeat, 'a story of paradise lost and regained'.[252] Such a reading might seem plausible when one finishes the original Volume 3 and finds Gibbon's 'General Observations'. Here Gibbon argues that civilization cannot again be overrun, because we are almost certain there are no longer any barbarians lurking in Central Asia and, if any did emerge and reached the Atlantic,

Gibbon suggests, in a strange fantasy, 'ten thousand vessels' would transport the surviving Europeans to America.[253] Moreover, the arts of civilization cannot be lost, so civilization cannot seriously regress. 'We may therefore acquiesce in the pleasing conclusion that every age of the world has increased and still increases the real wealth, the happiness, the knowledge, and perhaps the virtue, of the human race.'[254] But this conclusion is not borne out by Gibbon's own narrative, for he has shown that Christianity damaged civilization by demonizing the classics, by preferring saints' legends to the writings of Plato and Cicero, and by distracting people from their civic duties. We can only too easily imagine the rise of another fundamentalism that would preserve our material culture but destroy our cultural heritage.

Still, readers who felt buoyed up by the end of Volume 3 had reason to feel let down seven years later when they got to the end of Volume 6 and found Gibbon contemplating the ruins of Rome. Certainly, Gibbon mentions the renaissance of ancient learning with Petrarch and Poggio. But his focus is on the shapeless fragments of Roman buildings and on the question how they came to be ruined. Although, Gibbon says, he has displayed 'the triumph of barbarism and religion', neither the barbarians nor the Christians can fairly be accused of wrecking Rome's buildings.[255] It was the Romans themselves who, over the centuries, used the remains of antiquity as a quarry. Rome is now largely desolate, 'overspread with vineyards and ruins', and though some magnificent modern buildings have been erected, especially St Peter's, they owe their existence to papal misrule, 'to the abuses of the government, to the influence of superstition'.[256] The end of the *Decline* is downbeat; the book is a narrative of loss, without compensating gains.

Contrary to the widespread view of Gibbon, taken in recent decades, which would see him as joining in the celebration of British progress, the *Decline* invites a different reading. Certainly, as is clear from many asides, Gibbon valued his relatively free and civilized society, the decline of superstition and the defeat of clerical authority. But he offers no guarantee that modern commercial society will not fall victim to the cycle of growth, luxury and corruption that, on his showing, has afflicted so many others. Indeed, his narrative of the decline of the empire founded by Augustus forms a gigantic memento mori, warning his own time, which was often celebrated as a new Augustan age, that civilizations as well as people are mortal. Moreover, the *Decline* is a firmly neoclassical work, presupposing, despite variations of outlook over the centuries, a basically constant human nature always liable to depravation.[257] The peaks of human achievement lie not in the future but in the past, with the classics and – for

Gibbon – especially with the unsurpassable historian Tacitus, and like some other eighteenth-century writers he focuses on the process of decline and the spectacle of ruins.[258]

Gibbon's meditations on the ruins of Rome particularly invite comparison with Volney's reflections on the ruins of Palmyra. Constantin François Chassebœuf, who assumed the name Volney (after *Vol*taire of Fer*ney*), having published an account of his travels through Egypt and Syria (1782–5), followed it with a semi-lyrical work, *Les Ruines* (*The Ruins*, 1791), on the transience of civilizations. There are several voices in the work: that of the melancholy narrator; that of a Genius who informs him in detail about the past and future of humanity; plus the extensive footnotes that support the author's reflections by citing classical sources or bolstering his historical arguments. The Genius recounts the four stages of civilization, culminating in the now-vanished commercial cities of the ancient world. Alongside this narrative runs a political one, in which initial anarchic democracy leads to monarchy and then to despotism, which becomes enfeebled and succumbs to external attacks by barbarians. Fortunately, the forces of ignorance and greed are slowly yielding to enlightenment; the American War of Independence heralds a brighter future; the people, once enlightened, will rise up against the privileged class and demand their rights. A large part of the subsequent text imagines the peoples of the world quarrelling about religion and gradually being reconciled by a legislator who expounds the principles of comparative mythology and religion, followed by those of natural morality.

Volney's rather dry prophecy, however, makes a slighter impression than his meditation on the past. In Mary Shelley's *Frankenstein* (1818), the monster learns history from reading Volney, and is affected not by the prophetic but by the elegiac passages – presumably by such eloquence as this:

> To the tumultuous throng which crowded under these porticos, the solitude of death has succeeded. The silence of the tomb is substituted for the hum of public places. The opulence of a commercial city is changed into hideous poverty. The palaces of kings are become the receptacle of deer, and unclean reptiles inhabit the sanctuary of the Gods. – What glory is here eclipsed, and how many labours are annihilated! – Thus perish the works of men, and thus do nations and empires pass away![259]

Both Gibbon and Volney are aware of the advanced civilization which they inhabit or, in the latter case, anticipate; but what really grips their imagination is the spectacle of decline.

## THE FUTURE

Many Enlightenment thinkers shared the sharp awareness of decline expressed by Gibbon and Volney. They did not question that humanity had made enormous material, scientific and technical progress since antiquity. Modern times could boast the printing-press, the compass, the telescope and Newtonian physics, along with inventions of more controversial value such as gunpowder. But had the moral stature of human beings kept pace with material progress? It was a commonplace among leading Enlighteners that, as Bayle put it, 'History, properly speaking, is nothing but a list of the crimes and misfortunes of the human race.'[260]

Nevertheless, some thinkers, who have mistakenly been identified with the Enlightenment as a whole, confidently proclaimed their conviction that progress, or the march of the human spirit, was underwritten by nature and/or Providence. Despite setbacks, such as the collapse of the Roman Empire and the Muslim conquests, it was bound to continue and could never be reversed. The twenty-three-year-old Turgot affirmed this faith in addresses delivered to the Sorbonne in 1750, and in notes he made about the same time for an essay on world history. The development of humanity, he said, was analogous to that of an individual: 'the human race, considered from its origin onwards, appears in the eyes of a philosopher an immense whole, which itself, like every individual, has its childhood and its progress.'[261] Thus human progress is rooted, by implication, in organic natural processes. Wars and revolutions were mere temporary storms which could not long disturb humanity's movement towards perfection. Indeed, they assisted it. In his notes Turgot maintained that the unruly passions of early conquerors, who united scattered tribes into nations, were essential for progress, just as vigorous fermentation is necessary to produce good wines. War and destruction were necessary, just as, in the primeval forests of America, an old oak must fall and crumble to dust in order to make way for young trees: 'And thus, alternating between agitation and calm, of good and ill, the human race as a whole has advanced unceasingly towards perfection.'[262]

Problems with this argument will come readily to mind. If history is analogous with an individual's lifecycle, it too must end in decrepitude and death. History shows a great deal of war and destruction that does not conduce towards progress in any visible way. Are we being asked to accept the doctrine of progress on faith? If the thousand-year decline analysed by Montesquieu and chronicled by Gibbon does not shake that faith, could *any* catastrophe be bad enough to put it in question?

The landmark assertion of faith in progress, however, is the *Esquisse d'un tableau historique des progrès de l'esprit humain* (*Sketch for a Historical Picture of the Progress of the Human Mind*) written by Nicolas de Condorcet in 1793 at the age of fifty, when in hiding to avoid arrest as a traitor.[263] Ironically, Condorcet was a strong supporter of the French Revolution and an advocate of human rights, especially those of women and blacks. He was internationally famous in his day as a mathematician and is still remembered for the voting system known as the 'Condorcet method'. For his mathematical abilities he was appointed by Turgot as Inspector General of the Paris Mint, and held this office from 1774 to 1791, when he became Secretary to the National Assembly. He fell foul of Revolutionary politics by opposing the execution of Louis XVI, who he thought should instead be sent to the galleys. A warrant was issued for Condorcet's arrest in October 1793. In March 1794 he was betrayed, arrested and imprisoned, and was found dead in his prison cell, probably from exhaustion.

The *Esquisse* is distilled from a much longer history of humanity under the sign of reason that Condorcet never completed. It recounts the history of the human race as a perpetual conflict between superstition and philosophy. The malign power of priesthood is countered, with gradually increasing effectiveness, by the onward march of reason, seen especially in the development of mathematics and physics. Reason will bring about a utopia where the will of the majority determines truth: 'because, since each individual cannot follow his own reason without subjugating others to it, the majority vote is the only character of truth that can be recognized by all', and the resulting unanimity 'makes obligatory all the decisions taken by the majority alone'.[264] It must be clear that this is a utopian projection, anticipating a future in which everyone will have become completely rational.

Condorcet divides human history into ten epochs, in accordance with his favoured method of decimal classification.[265] The early epochs correspond to the four stages theory; the later ones are punctuated by the invention of printing, the Reformation, the Scientific Revolution and the eighteenth-century articulation of human rights. The tenth epoch is that of the future, which Condorcet heralds in lyrical language: 'Yes, it will come, that moment when the sun will illuminate nothing on the earth but free men recognizing no master but their reason.'[266] By adopting this future perspective, Condorcet is able to reveal the meaning of history as 'the picture of the progress of philosophy and of the propagation of enlightenment [*des lumières*]'.[267] This is a dexterous but dubious manoeuvre. The immanent laws of history, revealed in retrospect, serve to guarantee the validity of the backward-looking viewpoint from which Condorcet

discloses them.[268] As interpreter of the past and prophet of the future, Condorcet seems to be pulling himself up by his own bootstraps.

The historical narrative Condorcet offers is strikingly thin and repetitive. It is a war between abstractions. Philosophy and reason fight repeatedly against priesthood and despotism. Condorcet's style, in its abstraction, tends to defamiliarize its subject-matter: barbarian nations had 'a common chief called *king*'; Rome was 'the residence of the chief of religion'.[269] Condorcet appears to be adopting the perspective of future generations who, in their happy ignorance, will need to be told what a king was and will never have heard of a pope.

This rejection of the past is also found in the vision of the future offered by Louis-Sébastien Mercier in *L'An 2440* (*The Year 2440*, 1771), a best-seller in the last decades of the eighteenth century.[270] Mercier's narrator dreams that he wakes up seven centuries in the future. He finds himself in a world which in many ways is attractive. France is now a constitutional monarchy governed by a senate. There is no noble class. Taxpayers surrender one-fiftieth of their income in tax and also make voluntary contributions towards useful public works. Luxury is prohibited; tea, coffee, tobacco and bad wine are banned; peasants no longer need to work long hours to support a useless class. No-fault divorce is allowed, provided both parties agree. Schoolchildren, instead of being bored by Latin and Greek, study languages, sciences and morality, and use the *Encyclopédie* as a textbook. Christianity and Islam have largely faded away; the bishop of Rome (formerly the pope) survives but devotes himself to teaching rational morality. The official religion is worship of the Supreme Being, whose ministers spend most of their time on charitable work among the poor and sick. There is no war because kings have come to understand that conquest is futile. All nations are friendly and enlightened: Montesquieu's *Esprit des lois* has just been translated into Japanese; America, after a slave revolt under a heroic black leader, consists of a northern and a southern empire (Pennsylvania survives, but there is no United States – Mercier was writing before the War of Independence).

Mercier's novel, however, contains a large element of satire. It belongs among those works that have sometimes been read as satires, sometimes taken straight: other examples are Thomas More's *Utopia*, Machiavelli's *The Prince*, and the 'Voyage to the Houyhnhnms' in *Gulliver's Travels*. In Mercier's future, since everyone is rational, and reason is unequivocal, there is nothing to disagree about, and any dissent is therefore criminal. There is no censorship, but if you publish something that the public disapproves of, you must wear a mask to hide your shame, and receive a visit every month from two virtuous citizens, who will reason

you out of your errors. You may disbelieve in the Supreme Being, but if you make your disbelief known, you will receive compulsory lessons in physico-theology, and, if still obdurate, you will be banished – though as the whole world is now enlightened, it is not clear where a dissident could hope to find refuge. Mercier's tongue must surely be in his cheek here.

The past has not just been reduced to abstractions, as by Condorcet, but virtually abolished. History is not taught in schools, because it consists only of crimes and follies. The Royal Library surprises the visitor by its small number of books. It turns out that the books inherited from the past have been sifted, and all those judged worthless have been burned:

> By unanimous consent, we assembled on a vast plain all the books that we judged either frivolous or useless or dangerous; we made them into a pyramid which in height and size resembled a new tower of Babel ... It was composed of five or six hundred thousand commentators, eight hundred thousand volumes of jurisprudence, fifty thousand dictionaries, a hundred thousand poems, sixteen hundred thousand travel books, and a million novels. We set light to this dreadful mass, as an expiatory sacrifice offered to truth, to good sense, to true taste.[271]

This holocaust destroys all immoral and/or erotic works (Catullus, Sappho, 'the vile Aristophanes'), and all those containing falsehoods (the yarn-spinner Herodotus, the atheist Lucretius). Works by religious writers such as Bossuet have perished, but so have Pascal's *Provincial Letters*, because, the Jesuits being now as distant as the Druids, satire on them is no longer needed. This abolition of the past, and hence of the material to support potential dissent, will remind readers of how in Orwell's satire *Nineteen Eighty-Four* past literature is either destroyed or rewritten in Newspeak to conform to the principles of Ingsoc.

A very different, philosophically grounded conception of progress was put forward by Kant in his essay 'Idea for a Universal History with a Cosmopolitan Purpose', published in November 1784 in the *Berlinische Monatsschrift*. The essay starts from the recently established social-scientific discipline of statistics. Marriages, births and, to some extent, deaths result from the free human will. Yet the statistics on them collected annually in large countries show that they follow regular patterns, which are not the result of anyone's will. If there is a plan behind these regularities, it must be that of nature. And if that plan can be discovered, it will disclose a meaning in history – not one imposed from outside by divine Providence, but one that is immanent in history because it follows from human nature.

The natural capacities of every creature are destined to be realized in conformity with their purpose. (Birds are born with voices and wings,

and either instinct or parental instruction will ensure that they will learn to sing and fly.) Human beings, insofar as they possess reason, cannot develop their reason fully within the short span of an individual life. Reason is destined to be fully developed not in the life of any individual, but in the history of the species. And the motor for this development is what Kant calls humanity's 'unsocial sociability': 'their tendency to come together in society, coupled, however, with a continual resistance which constantly threatens to break this society up'.[272] We have two opposed impulses: towards community and towards conflict. The latter, which may take the form of competition for power and achievement, may be unattractive, but without it we would have remained as passive and backward as a flock of sheep. It is this productive conflict that is fatally absent from the unanimous – and therefore boring – utopias of Condorcet and Mercier.

The problem for humanity, Kant explains, is to work out a form of civil society, and an international order, which contains this productive conflict without damaging effects. This is nature's plan: 'The history of the human race as a whole can be regarded as the realisation of a hidden plan of nature to bring about an internally – and for that purpose also externally – perfect political constitution as the only possible state within which all natural capacities of mankind can be developed.'[273] This process, however, is not to be imagined as taking place independently of us, so that we could sit back and watch it happen. Rather, once philosophy has formed and communicated such expectations, what would nowadays be called a 'feedback loop' occurs, so that our knowledge of the plan encourages us to act in ways that will help to realize it: 'We can see that philosophy too may have its *chiliastic* expectations; but they are of such a kind that their fulfilment can be hastened, if only indirectly, by a knowledge of the idea they are based on, so that they are anything but over-fanciful.'[274]

So there is reason to think that progress towards a perfect social order is built into human nature and therefore into human history. Kant does not imagine that such progress will be easy or that the perfect social order will be achieved any time soon. But he sees promising signs in the fact that war is becoming not only risky but unaffordably expensive, and that the states of Europe now have such close commercial ties that they are beginning to assume the outlines of a unified political body: 'And this encourages the hope that, after many revolutions, with all their transforming effects, the highest purpose of nature, a universal *cosmopolitan existence*, will at last be realised as the matrix within which all the original capacities of the human race may develop.'[275]

# 12

# Cosmopolitanism

## CITIZENS OF THE WORLD

An ideal of the Enlightenment was to be a cosmopolitan or 'citizen of the world'. Early in the eighteenth century, the classical scholar Antoine Houdar de la Motte declared that the time had come when 'we are the contemporaries of all mankind and citizens of all places'.[1] Diderot, having deplored how unreal distinctions between nations tend to curb a benevolence that ought to be universal, wrote to Hume: 'My dear David, you belong to all nations, and you will never ask an unfortunate person for an extract from his baptismal register. I pride myself on being, like you, a citizen of that great city, the world.'[2] Boswell received similar praise from John Wilkes, whom he reminded: 'You told me I was "the most liberal man you had ever met with, a citizen of the world, free from the prejudices of any country, who would be liked in France as much as in Britain".'[3] Gibbon wrote to Lord Sheffield in 1787: 'As a Citizen of the World a character to which I am every day rising or sinking I must rejoyce in every agreement that diminishes the separation between neighbouring countries, which softens their prejudices, unites their interests and industry, and renders their future hostilities less frequent and less implacable.'[4] And Georges-Louis de Bär, reputedly the best poet among the numerous eighteenth-century Germans who wrote in French, dissociated himself from his native Westphalia in the poem 'A ma Patrie':

> Je vins, sans mon aveu, dans ce Monde pervers;
> J'y suis, puisque j'y suis, Bourgeois de l'Univers;
> Je suis Cosmopolite, ainsi que Diogène,
> J'embrasse en mon amour toute la Race humaine.
> Tous les Mortels ensemble, & jaunes, noirs & blancs
> Sont par-tout mes prochains, sont par-tout mes parens.[5]

[I came without my consent into this perverse world; since I am here, I am a citizen of the universe; I am a cosmopolitan, like Diogenes, I embrace with my love the entire human race. All mortals together, yellow, black, and white are everywhere my neighbours, are everywhere my relatives.]

Bär's reference to Diogenes indicates that the cosmopolitan ideal derived from ancient philosophy. An anecdote about the Cynic philosopher Diogenes, notorious for living in a tub and performing his natural functions in public, ran: 'Asked where he was from, he said: ["I am] a citizen of the universe." '6 The Stoic philosopher Seneca advocates involvement in public life, not simply to serve one's own relatives or one's own polity, but to benefit all mankind 'in claiming the world as our country'.7 Cicero, in the much-read *De officiis*, imagines our duties as a set of concentric circles, with our duty to our immediate family at the centre, and at the outer rim our duty to humanity as a whole. The first of the 'natural Principles of intercourse and Community among Men', he says, is 'that which is perceiv'd in the Society of the whole human Race, and its Chain is form'd by Speech and Reason, which by teaching, learning, communicating, debating and judging, conciliate Men together, and bind them into a kind of natural Society.'8

The cosmopolitan ideal was especially defended by Christoph Martin Wieland, one of the leading public intellectuals of late eighteenth-century Germany. In the 1780s, the discovery of the Illuminati conspiracy (see Chapter 7) generated a panic about them and about the much more numerous Freemasons. Since such societies professed belief in the brotherhood of humanity, their ideals were labelled cosmopolitan and decried as subversive. Wieland replied that a true cosmopolitan could not be a member of any secret society, because such a person aimed to benefit all humanity and had no reason to shun the light. He defines a cosmopolitan as follows:

> Cosmopolitans bear their name (citizens of the world) in the most genuine and significant sense. They regard all the nations of the earth as so many branches of a single family, and the universe as a state in which they are citizens along with innumerable other rational beings, in order to promote the welfare of the whole under the universal laws of nature by each of them working in his particular manner for his own well-being.9

Another model for the cosmopolitan ideal was the Republic of Letters, which, as we have seen, rested on an international network of contacts and correspondence. Its main creator, Erasmus, when invited to become a citizen of Zurich, replied: 'My own wish is to be a citizen of the world, to be a fellow-citizen to all men.'10 Late in his life Leibniz declared: 'I am not one of those impassioned patriots of one country alone, but I work

for the well-being of the whole of mankind, for I consider heaven as my country and cultivated men as my compatriots.'[11]

The Republic of Letters depended on Latin as an international language of communication. However, even for scholarly purposes, the use of Latin gradually diminished.[12] Christian Thomasius, a young professor at the University of Leipzig, succeeded in provoking a scandal when, on 31 October 1687, he announced a course of lectures to be given in German.[13] Scholarly publication in Latin remained common until the late eighteenth century: not only Newton's *Principia* (1687), but the mathematical works of Jacob Bernoulli the elder (1713), Leonhard Euler (1736), and even Carl Friedrich Gauss in the early nineteenth century, were published in Latin.[14] In 1701, 8.5 per cent of books published at Paris were in Latin; by 1764, only 4.5 per cent of books published throughout France were in ancient or foreign languages.[15] Such figures are somewhat misleading, however, insofar as many vernacular publications were ephemeral pamphlets and the like, while prestigious scholarly works were still often in Latin: in Germany, 55 per cent of the books offered in the Leipzig book fair catalogue for 1701 were in Latin, although by 1740 the figure was only 27 per cent.[16]

Some poetry was still written in Latin, especially on philosophical or scientific subjects. The Jesuit Tommaso Ceva denounced the materialism of Lucretius in his *Philosophia novo-antiqua* (1704), and Benedict Stay wrote an extended poetic exposition of Newtonianism, *Philosophiae recentioris libri decem* (*Modern Philosophy in Ten Books*, 1755–92).[17] Latin was occasionally used even for narrative prose: the Danish Enlightener Holberg used Latin for both his autobiography and his fantastic novel, *Nicolai Klimii iter subterraneum* (*Niels Klim's Underground Journey*, 1741).[18] Vernacular works were sometimes translated into Latin: Addison's play *Cato* was translated by Jesuits and acted by pupils at their seminary in St Omer; and in the 1780s King Stanisław August of Poland read *Paradise Lost* in Latin, presumably in the translation by William Hogg (1690).[19]

Latin was gradually superseded by French as the international language of communication. Often one could get by with French alone. Bayle, who lived in the Netherlands for a quarter of a century, never learned Dutch; he was able to live in a French-speaking bubble. Authors who wanted to reach a wider public used the vernaculars, so it gradually became necessary to know several modern European languages, in addition to French and the classical languages. Lessing was familiar with French, English, Spanish and Italian. Boswell on his travels spoke French, Dutch and Italian, though German was beyond him.

The cachet of English was rising. Voltaire says in his *Encyclopédie*

article 'Gens de Lettres' that a man of letters must know not only the classical languages but Italian, Spanish, 'and above all English'.[20] He himself set a much-needed example: when he arrived in England in May 1726, he did not know the language, but five months later we find him writing letters in excellent English, and even late in life, despite complaining that English was difficult to pronounce, he was able to converse in English with Boswell.[21] Montesquieu prepared for his two-year stay in England (1729–31) by taking English lessons, and though he seems to have conversed in French whenever possible, he could at least read English and understand it when spoken.[22] Diderot never visited Britain, but taught himself to read English by using an Anglo-Latin dictionary, and began his literary career by making translations from English, including Shaftesbury's *Inquiry concerning Virtue and Merit*.[23] The *philosophes* generally talk about 'England', not 'Britain'; they rarely grasped the difference between England and Scotland, and associated the latter mainly with bare-legged Highlanders.[24] Thanks especially to Voltaire's *Letters concerning the English Nation*, England now gained cultural prestige as the homeland of Bacon, Newton and Locke: Voltaire called it 'the land of philosophers'.[25]

England was also widely perceived as a land of aesthetic and political freedom.[26] This freedom could be seen negatively. Shakespeare seemed barbarous in ignoring the neoclassical rules of dramatic composition. The English populace had a reputation for mob violence and brutal sports.[27] English politics seemed alarmingly turbulent, with a successful revolution in 1688 and unsuccessful Jacobite uprisings in 1715 and 1745. But this freedom came to be revalued, especially since Addison and Steele had shown in their *Spectator* that it was compatible with good taste. English culture, even if sometimes unpolished, was closer to nature than the classicism that still officially prevailed in France. Shakespeare, read often in translation, carried readers away by his frank presentation of the passions. English poetry offered both religious sentiment and cultivated wit. Wieland told a correspondent in 1752: 'I shall soon start learning English. I am burning with desire to read *Milton, Pope, Addison, Joung, Thomson* in their own language.'[28] Milton offered a Protestant epic; Pope, witty and morally improving satire; 'Joung' (Edward Young, author of *Night Thoughts*, 1742–5), serious religious reflections; and Thomson, in the hugely popular *Seasons* (1730), combined moral instruction with evocations of landscape as part of the Newtonian world order. Montesquieu in *The Spirit of the Laws* argued that English public life benefited from a happy mixture of parliamentary democracy and constitutional monarchy. Freedom from constraint and happy irregularity were also embodied in English gardens, which were imitated on the Continent. Prince Leopold

of Anhalt-Dessau laid out the first English garden at Wörlitz (today a UNESCO World Heritage site) in 1766; Catherine the Great imitated the English style for her gardens and buildings at Tsarskoe Selo.[29]

Western Europeans were aware, however, that their countries were petty in comparison to the empires of the East. The Ottoman Empire, stretching from the borders of Hungary to those of Persia, and including Egypt and much of the southern coast of the Mediterranean, was still very much a threat. In 1683 the Turks had barely been prevented from capturing Vienna, and only as recently as 1699 they had been compelled to surrender Hungary, by the Treaty of Karlowitz. Much-read books by seventeenth-century travellers attested the extent and power of Europe's eastern neighbours. The jeweller Jean-Baptiste Chardin, who visited Persia in 1666–7 and again in 1672–7, told his readers that it was 750 French leagues in length, from the river Phasis in Georgia to the river Indus, and some 450 leagues in breadth.[30] François Bernier, who spent ten years at the Mughal court as a physician, reported that the distance across India was 'five times as far as from Paris to Lyons'.[31] These accounts were confirmed by another jeweller, Jean-Baptiste Tavernier, who travelled through Turkey, Persia and India, and got as far as the Dutch settlement on Java. And beyond was the dim expanse of China, described in a standard encyclopaedia as 'of a quite appalling magnitude';[32] not to mention Siberia, which the Russians had gradually explored during the seventeenth century.

Montesquieu adopted a non-European perspective in the *Persian Letters*. The *Letters* (1721) are a brilliant, multi-faceted epistolary work of fiction with multiple correspondents, which demands an exceptionally agile reading. Usbek and his younger, more sprightly companion Rica, who are supposed to stay in Paris from 1712 to 1720, correspond with friends; Usbek's wives write to him; his chief eunuch sends reports and receives instructions, mostly bloodthirsty. Most obviously, the letters allow the French, and Europeans more generally, to see themselves as others – in this case, highly cultivated and intelligent visitors from a radically different civilization – might see them. To the foreign observer the Parisians reveal themselves as always in a hurry, rudely inquisitive, trivial-minded, and much more naïve than they imagine themselves to be: when Rica explains to any company where he comes from, he hears people murmuring: 'Oh! oh! is he Persian? What a most extraordinary thing! How can one be Persian?'[33] The letters also allow the reader to consider some values and practices that are forbidden in France, such as suicide (letter 76) and divorce (letter 116).[34] They give a critique of Oriental despotism as it operates in Usbek's harem. Philosophical about foreign customs and human foibles, Usbek is blind to his own tyranny. Outwardly,

all is in order, thanks not least to Usbek's harsh instructions (letters 20, 21). The women write to Usbek telling him how much they love him and miss him, but in reality they are tortured by sexual frustration. The black eunuchs who guard them are outwardly loyal, but they confess to each other that their mutilation makes them miserable (letter 9). They work off some of their frustration by terrorizing the women, while being themselves in terror of Usbek's despotic authority.[35]

Yet the letters discreetly suggest that Persia is in some ways not all that different from France. The women's imprisonment in the harem readily suggests the imprisonment of nuns in convents (letter 62). Catholic priests, often called 'dervishes', are also referred to as 'eunuchs' (letter 117), indicating that celibacy and castration are equally dire in their human and social effects. And in sketching the character of the aged Louis XIV, Usbek reports that Louis explicitly admires the governments of Turkey and Persia. Montesquieu's critique of actual and potential despotism culminates when Usbek learns that his slaves have risen in revolt. Overcome by self-pity, this sentimental tyrant orders them to be harshly and humiliatingly punished. But his favourite wife, Roxane, in the last letter, announces that she has only ever pretended to love him, retaining her independence of mind, and has now taken poison to escape his power and assert her freedom. Her revolt is that of a woman against male oppression and clerical tyranny and, by implication, that of 'a French subject in rebellion against overbearing kingship'.[36]

The *Persian Letters* were much imitated. Oliver Goldsmith wrote 'Chinese Letters', published in book form as *The Citizen of the World* (1762), purporting to be the correspondence of a Chinese philosopher resident in London, and providing humorous comments on English life (as Montesquieu had done for Paris). The freethinking Marquis d'Argens wrote *Lettres juives* (*Jewish Letters*, 1736) and *Lettres chinoises* (*Chinese Letters*, 1739–40). The *Lettres juives*, in which three well-educated Jewish travellers criticize European manners, government and religion (including aspects of Judaism they consider superstitious) by high standards of morality and reason, enjoyed particular success. By 1771, the year their author died, at least ten impressions had appeared, besides two English translations.[37] Others followed Montesquieu in depicting their society from the perspective of intelligent and rational Muslims. Thus José Cadalso wrote *Cartas marruecas* (*Moroccan Letters*, 1773–4, published 1793), in which well-travelled Muslims are guided through Spanish society by a critical native informant, Nuño, who is 'a true cosmopolitan and a citizen of the world [*ciudadano universal*]'.[38] And the Bavarian Johann Pezzl wrote *Marokkanische Briefe* (*Moroccan Letters*, 1784), which is a harsh attack

on Christianity. All these fictitious letters, however, are only partial imit-
ations of Montesquieu, in that they use an outsider's perspective to discuss
or satirize European culture, but do not follow Montesquieu in exploring
in detail the contrast with the observer's own culture.

## TRAVEL AND TRAVEL WRITERS

All this intercultural activity, however, remained focused on the countries
of Western Europe. Could one really call oneself a citizen of the world if
one had travelled no further than France, like Hume, or the German and
Italian courts, like Boswell? Travel between the main towns of Western
Europe had become easier since the introduction of regular mail-coaches
around 1630. One no longer had to arrange each journey separately; time-
tables were published; maps were made showing postal routes. However,
travel was still uncomfortable at best, at worst dangerous. In her memoirs,
Frances, Lady Vane, recalls how in the 1730s she was held up by a high-
wayman on Bagshot Heath, outside London, and, when travelling to
Brussels, she was robbed by highwaymen near Mechlin, and was lucky
not to be raped.[39] When Goethe's Werther asks to borrow a pair of pistols
because he is going on a journey, no further explanation is necessary.[40]

To travel further afield was much more risky and uncertain. When
Leibniz was aboard a ship in the Adriatic in 1689, a storm blew up, and
he overheard the sailors plotting to lighten the load by throwing him over-
board, and to divide his belongings among themselves. Fortunately, having
a rosary with him, Leibniz convinced them that he was a fellow-Catholic
and his life was spared.[41] In 1717, when Lady Mary Wortley Montagu
travelled to Turkey with her ambassador husband, they were accompanied
through Serbia by five hundred Turkish troops, to secure them against the
fifty-strong gangs of robbers who infested the forests.[42]

Beyond Europe, travel was far more hazardous. Tavernier warns that in
Asia 'there are no weekly Coaches or Wagons from Town to Town'; instead,
'there are vast Deserts to cross, and very dangerous, both for want of Water,
and the Robberies that the *Arabs* daily commit therein'.[43] Of the six scien-
tists who set out on the Royal Danish Arabia Expedition (1761–7) only one,
Carsten Niebuhr, survived; the rest died of malaria.[44] The Dane Vitus Ber-
ing, who enrolled in the expanding Russian navy under Peter the Great,
made two expeditions to the North Pacific to find out whether Asia and
America were joined; both had first to cross Siberia, which took two years
because one could not travel in winter, and then the ships had to be built
on the shore of the Pacific. On the second expedition, many of Bering's men,

stranded on a remote island off Kamchatka in 1741, died of scurvy.[45] Until late in the century, scurvy was among the many hazards of long sea voyages. George Anson, who circumnavigated the globe between 1740 and 1744, brought back only one ship out of six, and 145 men out of an original 1,300; storms, cold, scurvy and malnutrition had wiped out the rest.

Nevertheless, the eighteenth century was a great age of travel and exploration. Ambitious voyages generally had a geopolitical as well as a scientific purpose (the Danish Arabia expedition was unusual in having no ulterior motives). The Great Northern Expedition to Kamchatka, led by Bering, was accompanied by a team of scientists assigned by the Imperial Russian Academy of Sciences, but its principal purpose was to investigate the geography of eastern Siberia and assess the economic value of its territories. Between 1760 and 1788 Charles III of Spain sent thirty-three expeditions to Spanish America, in which economic evaluation and scientific discovery were inseparable goals. Thus, the Royal Scientific Expedition to New Spain (1785–1800) was accompanied by scientists and illustrators with instructions 'to examine, draw and describe methodically the natural products of the most fertile dominions of New Spain'.[46]

Expeditions to the Pacific had a particularly pressing motive. It was long believed that there must be a great southern continent to balance the Eurasian land-mass.[47] If so, it was important for Britain to reach and claim it before some other European power – France, or Spain with its dangerously close empire in South America – could do so. Samuel Wallis, the first European to discover Tahiti, and James Cook on his first two voyages, had instructions to search for the southern continent. Cook surveyed and claimed the coasts of New Zealand and the east coast of Australia for Britain, and on his second voyage he got as far south as the pack-ice would let him, some seventy miles from Antarctica, before concluding that there was no southern continent. His third voyage, on which he met his death on Hawaii, had the aim of finding a north-west passage from the Atlantic to the Pacific; having surveyed the north-western coast of America, he was again halted by ice, this time on the north coast of Alaska, and again returned a negative finding. Still, these expeditions added considerably to geographical knowledge, and the second, sponsored by the Royal Society, enabled the transit of Venus across the sun to be observed from Tahiti.

There was a huge appetite for travel narratives among the reading public. Encyclopaedic collections of travel narratives were common; between 1660 and 1800 eight such collections were published in Britain, besides forty-five smaller compilations.[48] Among them there were some fraudulent works, notably the *History of Formosa* by 'George Psalmanazar', whose real name is still unknown. Originating from the south of France, he

passed himself off as an Oriental, even speaking in a made-up 'Formosan' language. His book contains such lurid details – doubtless satisfying to some opponents of 'priestcraft' – as the Formosan practice of burning the hearts of 20,000 young children annually as a sacrifice to their god.[49] But he also tells how, disputing with a Huguenot who criticized the cruelty of the Formosans' god, he retorted that the Calvinist God was yet more cruel in creating millions of people only to damn them eternally.[50] A fictitious travel account can still show us how others see us.

Even less-ambitious journeys increasingly had the purpose of adding to European knowledge of the rest of the world.[51] In the early modern period there developed a type of writing called the apodemic, which contained practical advice for travellers, including what to look out for and how to observe it accurately. Sets of headings called *loci communes* ('common places') helped conscientious travellers to record their observations systematically and prompted them to make more. Scientific academies drew up questionnaires to guide travellers; a famous example was the *Instructio Peregrinatoris* (published under the name of Linnaeus but actually a dissertation by his doctoral student Erik Nordblad), which offered a comprehensive plan for collecting scientific information.[52] A commission of Göttingen scholars directed by the Orientalist Johann David Michaelis prepared a 349-page questionnaire for Carsten Niebuhr to take on his expedition to Arabia. The questionnaire was sent after Niebuhr and reached him only in Bombay, after all his companions had died. However, translated into French and Dutch, it proved useful for many later travellers, down to Jean-François de Galaup, comte de Lapérouse, on the scientific expedition which took him around the Pacific Rim in 1785–9.[53]

These techniques of informed travelling were also useful nearer home. The Berlin Enlightener Friedrich Nicolai prepared carefully for his six-month journey through south Germany and Austria in 1781. Whenever he arrived at a new town, he bought all the maps, plans, guidebooks, newspapers, even mortality statistics that he could find.[54] He travelled in a specially constructed carriage, which could go much faster than the mail-coach and had room for books; he could read, write and even sleep in it. Attached to his carriage was a device that recorded the distance between towns and thus enhanced the geographical accuracy of his report. Volney, during the French Revolution (in which he narrowly escaped the guillotine), worked for the Ministry of the Interior and compiled a set of instructions to be followed in surveying the French provinces. They comprised 135 questions, 44 concerning the physical geography of a region, and 91 dealing with the physique, health and way of life of its population.[55]

Systematic travel produced a different kind of travel book. Relying on

the discipline of statistics which the late Enlightenment so much favoured, books now were strictly factual, orderly and impersonal in their presentation, and based as much as possible on empirical observation. In Europe, Arthur Young's *Travels in France*, carefully describing the state of agriculture in each province, provided an example. Volney's account of his travels in Syria and Egypt rests on an accumulation of details which he builds up into an overall picture by a method that has been called 'demystification': readers can see for themselves what Volney's impressions are based on.[56] William Marsden, in his *History of Sumatra* (1783), insists that philosophical historians must have 'facts to serve as *data* in their reasonings, which are too often rendered nugatory, and not seldom ridiculous, by assuming as truths, the misconceptions, or wilful impositions of travellers'.[57] The factual character of his book is apparent from the full title and from the chapter headings, which begin with 'Situation' and end with 'Brief Account of the Islands lying off the Western Coast of Sumatra'. The author himself, who had lived in Sumatra as an employee of the East India Company from 1771 to 1779, only appears in the preface to reassure us that almost everything he describes comes from his own observation.

In recent decades, however, even the travel accounts that profess the greatest accuracy have been treated with suspicion. It is alleged that European travellers looked on the rest of the world with such contempt that they could not perceive or describe non-European cultures accurately. Some cultures appeared primitive, backward, savage, half-animal; others, though undeniably civilized after a fashion, were unprogressive, stagnant, tyrannical and devoted to religions which were not only false but often absurd and barbarous. These negative views served as a convenient pretext for subjugating other cultures, whether through commercial infiltration or military conquest. What passed for knowledge about other cultures, therefore, is said always to have been distorted by European conceit and imperial self-interest.

These claims have often been put forward with eloquence and passion.[58] In their strongest form, however, they undermine all knowledge, including the knowledge professed by the critic. Stephen Greenblatt maintains that writing about the New World by Europeans reveals only 'the European practice of representation'.[59] Edward Said combines scepticism as to 'whether indeed there can be a true representation of anything' with the comprehensively damning assertion 'that every European, in what he could say about the Orient, was . . . a racist, an imperialist, and almost totally ethnocentric'.[60] But if, instead of disqualifying all travel writers from the outset, we attend to what they have written, we will find that some are better – more observant, more precise, more self-critical, more

sympathetic to their subjects – than others, and have earned corresponding praise from later writers. Gibbon commends Tavernier, 'that rambling jeweller, who had read nothing, but had seen so much and so well'.[61] Judith Still, in her study of hospitality and travel, praises Chardin as 'a good guest (which includes his appreciation of, and praise for, the hospitality of his hosts) with skill in translation in every sense'.[62] Jürgen Osterhammel compliments Niebuhr for his 'differentiated' and 'realistic' account of Arabia.[63] Inevitably these travellers write from a European perspective. All knowledge about human societies is perspectival, including that of the cultural critic; there is no 'view from nowhere'. All have some degree of prejudice. Honest travel writers are not those who profess an impossible objectivity, but those who struggle with their own prejudices and enact that struggle in their writing.

Travellers, first of all, had the problem of language. Niebuhr learned Arabic; Chardin learned Persian; the Jesuit missionaries in China learned Chinese. But how did one cope with a wholly unfamiliar language that had never been written down? Columbus encountered such a language when he first landed on San Salvador, and it is difficult to believe that the information he claimed to get from the islanders corresponded to anything but his own fantasies. Georg Forster believed he had conducted a quite sophisticated conversation about religion with a Tahitian chief, who 'seemed to signify' that the Tahitians shared Forster's deism.[64] However, James Cook, sitting next to Boswell at a London dinner-party in 1776, candidly admitted that he and his men could gain no certain information from Pacific islanders except about material objects: 'their knowledge of the language was so imperfect they required the aid of their senses, and anything which they learned about religion, government, or traditions might be quite erroneous.'[65]

Travellers were often incautious in generalizing about a society on the basis of a brief visit. The Jesuit Joseph-François Lafitau generalized confidently about all native Americans, although the first-hand know-ledge he had acquired as a missionary in 1711–17 was confined to the Iroquois around Sault-Saint-Louis, on the south bank of the St Law-rence River opposite Montreal.[66] From his brief contact with the Tierra del Fuegans (properly, Haush and Selk'nam) Cook concluded that 'they are perhaps as miserable a set of People as are this day upon Earth'.[67] No doubt Cook would have been miserable if he had had to live on Tierra del Fuego, but it did not follow that its inhabitants were. As Nicholas Thomas points out, he was 'wrong to extrapolate from what they were eating at this particular time to the proposition that they subsisted "chiefly" on shellfish. He did not consider that they might

move seasonally, that they might in fact eat a great variety of plants, birds and animals at different times.'[68]

Northern European Protestants were often unduly surprised that other societies did not share their work ethic. The Huguenot Chardin regrets that the Persians, having 'an eager bent to *Voluptuousness, Luxury, Extravagance*, and *Profuseness* ... are ignorant both of Frugality and Trade', though he also makes it clear that there are many Persian merchants.[69] The Persians live for the moment, are fatalistic, do not save money, and, as their religion forbids lending money at interest, do not invest it. They buy property but collect rents from the tenants every day. They are lazy – 'Their Aversion to Labour is the most common Occasion of their Poverty.'[70] Compared to Europeans, Persians have a sedate way of life; they sit still, without fidgeting, and talk without gestures; they see no point in taking exercise, think it absurd to go for a walk without a definite purpose, and the concept of travel for its own sake cannot be expressed in their language. This, however, is only part of Chardin's wide-ranging and differentiated portrait of the Persian character; and although his Protestant bias determines what he chooses to emphasize, it does not falsify his observations. Dutch and British colonists in the East Indies, on the other hand, were very ready to condemn the supposed indolence of the Javanese and the Malays; but that was because their subjects worked at farming and fishing, and shunned the occupations – commerce, domestic service, plantation labour – which were most visible to Europeans.[71]

Good travellers treat their hosts as fellow-human beings, without disparaging them or painting them as exotic. They learn to distance themselves from their own assumptions, and to see their own culture through foreign eyes. Thus Niebuhr, after being hassled by a young drunk Arab in the Sinai, reflects: 'As he heard that we were Europeans and Christians, he tested our patience not a little, by making fun of us just as a young, arrogant and drunk European would do with a Jew', and adds: 'I do not recall on my entire trip, that I ever encountered on the street a drunk and impertinent Arab, other than this one.'[72] He thus avoids the kind of premature generalization of which incautious travellers are often guilty.

Two particularly talented travellers and travel writers deserve attention: Lady Mary Wortley Montagu and Georg Forster. In August 1716, the twenty-seven-year-old Lady Mary set out with her husband, the diplomat Edward Wortley Montagu, and their three-year-old son, on a journey to Constantinople. The purpose of the diplomatic mission was to mediate in the war between the Ottoman and Habsburg Empires. After extensive travels through Germany, prolonged by Edward's having to go to Hanover for further instructions, they reached Belgrade, then in Ottoman territory,

on 5 February 1717, and after three weeks moved on to Sofia and thence to Adrianople (Edirne); they reached Constantinople on 8 June and stayed there for a year until, Edward having been recalled to Britain, they were transported through the Mediterranean on a British ship.

Montagu recorded her travels in the *Turkish Embassy Letters*, published in 1763 after her death. They are not the actual letters she sent at the time, but were written up, probably between 1719 and 1724, from her notes and journals.[73] Thus they are a reconstruction of her experiences, not an immediate report, but there is no reason to think that anything in them is fabricated. When they appeared, they had a preface written, presumably at the same period, by Montagu's friend, the feminist writer Mary Astell.

Montagu writes as an enthusiastic traveller who is determined to see as much as possible for herself and is critical of previous accounts. ''Tis a particular pleasure to me here,' she writes, 'to read the voyages to the Levant, which are generally so far removed from truth, and so full of absurdities.'[74] She particularly dismisses the diplomat Sir Paul Rycaut, whose *The Present State of the Ottoman Empire* (1666) she considers 'commonly' mistaken.[75] Europeans are wrong to assert that Turkish music is discordant, that Turkish houses are 'miserable', or that their Greek subjects are slaves. While at Belgrade, Montagu has many conversations (probably in Italian) with a Turkish scholar whom she calls Achmet Beg, who explains to her the beauties of Oriental poetry, the pure morality of the Koran, and the different sects within Islam, and who corrects Rycaut's claim that some Muslims are really atheists. Achmet Beg is clearly an enlightened and liberal-minded person, who drinks wine, explaining that Muhammad's prohibition on wine-drinking does not apply to those who can use it in moderation, but was only meant to restrain the excesses of the common people.[76]

Thus initiated, Montagu enters still further into Turkish life. At Adrianople she adopts a Turkish costume, comprising 'drawers', a wide-sleeved smock, a 'waistcoat', a *'caftán'* with a girdle round it, a loose robe for colder weather, and a cap with a gold tassel.[77] By adding a muslin veil and hood, or yashmak, and an enveloping outer garment called a *'ferigee'*, she is able later to wander around Constantinople on her own, unrecognized and unmolested, and even to visit mosques, normally off-limits to Christians. She finds many things superior to their European counterparts: the 'drawers' are more modest than petticoats; mosques are not cluttered with pews, like Protestant churches, or disfigured by 'the little tawdry images and pictures, that give the Roman Catholic churches the air of toy-shops'.[78] In particular, she understood the Turkish practice of inoculation against smallpox, applied it to her children, and helped to introduce it into Europe.[79]

Montagu especially distrusts accounts given by male travellers about

# LETTERS

Of the RIGHT HONOURABLE

## Lady M--y W---y M---e:

Written during her TRAVELS in

## EUROPE, ASIA AND AFRICA,

T O

Perſons of Diſtinction, Men of Letters, &c.
in different PARTS of EUROPE.

WHICH CONTAIN,

Among other CURIOUS Relations,

ACCOUNTS of the POLICY and MANNERS
of the TURKS.

Drawn from Sources that have been inacceſſible
to other Travellers.

COMPLETE IN ONE VOLUME.

LONDON:

Printed for M. COOPER, in Pater-noſter-Row.
M DCC LXXV.

The letters recording Montagu's visit to Turkey in 1716–18 were published
posthumously in three volumes in 1763 and reissued in a single volume in 1775.

Turkish women. Since men were never allowed into a harem, such places were surrounded by often prurient fantasies. Harem women were imagined as tortured by sexual frustration and solacing themselves with such expedients as cucumbers and lapdogs.[80] More soberly, Montesquieu used Usbek's harem in the *Persian Letters* to typify his conception of Oriental despotism.

Far from accepting such fantasies, Montagu uses her privileged social position to explore the hidden world of Ottoman women. In Sofia she visits the women's baths. Although she looks out of place in her Western riding-habit, the ladies treat her far more politely than Englishwomen would have:

> I believe in the whole, there were two hundred women, and yet none of those disdainful smiles, or satiric whispers, that never fail in our assemblies when any body appears that is not dressed exactly as in the fashion. They repeated over and over to me, 'Uzelle, pék uzelle', which is nothing but Charming, very charming.[81]

At the same time, the exquisitely mannered Turkish ladies, and their slave attendants, are all stark naked:

> Yet there was not the least wanton smile or immodest gesture among them. They walked and moved with the same majestic grace which Milton describes of our general mother. There were many among them as exactly proportioned as ever any goddess was drawn by the pencil of Guido or Titian – and most of their skins shiningly white, only adorned by their beautiful hair divided into many tresses, hanging on their shoulders, braided either with pearl or ribbon, perfectly representing the figures of the Graces.[82]

Here Montagu's literary and artistic references convey not only the beauty but also the dignity of the Turkish ladies, and, by inviting aesthetic contemplation, discourage the reader from indulging lascivious thoughts.[83] The ladies are not just objects of contemplation, though; they interact with Montagu, inviting her to take her clothes off, and when they see that she is encased in stays, they assume that she has been imprisoned by her husband in a kind of 'machine'. This little anecdote not only reveals the greater freedom of Turkish women but conveys that European women are oppressed by having to squeeze their bodies into uncomfortable contrivances. The sight of the women chatting, drinking coffee or sherbet, persuades Montagu that the baths are 'the women's coffee-house, where all the news of the town is told, scandal invented, &c.'.[84] Since European coffee-houses were normally reserved for men, this is another indication that Turkish women enjoy more freedom.

Here, as in her accounts of the harem, Montagu mingles the unfamiliar and the ordinary.[85] Gossip and coffee-drinking go on in Turkey as in London, only in a different setting, and in a rather more civilized fashion. When Montagu visits Turkish ladies, the harem is not portrayed as the extraordinary forbidden zone of European male fantasies; it is simply the women's domain, and the women who welcome Montagu differ in character just as European women might. The wife of the grand vizier is elderly and devout; Fatima, the wife of his deputy, is not only breathtakingly beautiful, but charming and considerate. Her slaves perform, without any sense of indecency, a dance which Montagu recognizes as highly erotic, and which would later be called 'belly-dancing'.[86] All this is a very different view of the harem from the conventional European one.[87]

Montagu also alleges that Turkish women, since their clothing makes them unidentifiable, carry on love affairs with as much freedom as their European counterparts. This notion – or fantasy? – of erotic libertinism suffers a blow when the corpse of a beautiful young woman is found near Montagu's house, and it is assumed that she was murdered by a jealous husband. Montagu is assured, however, that such events are extremely rare.[88]

However this may be, Montagu has also to acknowledge a restriction on the liberty of Turkish women: they are absolutely required to marry and bear as many children as possible. Contrary to Western belief, Muslims do think that women have souls, but if they do not marry, or die as widows without remarrying, their souls will not go to eternal happiness, but to 'reprobation'. However, Montagu interprets this to the advantage of Islam over Christianity: 'This is a piece of theology very different from that which teaches nothing to be more acceptable to God than a vow of perpetual virginity: which divinity is most rational, I leave you to determine.'[89] Montagu even defends Turkish slavery, arguing that slaves are as well treated as servants in England; and if some are sold for prostitution, that happens in England as well.[90] Admittedly she did not know much about the lives of slaves: one might wonder, for example, what happened when slaves became old – were they left to die, like slaves in ancient Rome?

Moreover, life in Turkey is always overshadowed by the despotism of the government. It prevents the sociability that is characteristic of Europe. Public coffee-houses are haunted by spies, so that one dare not criticize the government for fear of being arrested and tortured to death.[91] 'Veins of wit, elegant conversation, easy commerce, are unknown among the Turks; and yet they seem capable of all these, if the vile spirit of their government did not stifle genius, damp curiosity, and suppress a hundred passions that embellish and render life agreeable.'[92] Even here, however, Montagu is not repeating the familiar cliché of 'Oriental despotism'. She

perceives that the sultan's power is limited by the licence of his troops, or janissaries, and sometimes by popular riots. If the people turn against a minister, they will seize him and tear him to pieces, while 'the most absolute monarch upon earth' is helpless to restrain them.[93] When, in the course of the war, Belgrade is recaptured by the Austrians, the sultan has some officers of state strangled, and the defeated janissaries, straggling back to the capital, are mocked and reviled by the populace. The trouble is not that the sultan has absolute power, but that there is no rule of law.

Georg Forster is a good traveller in two ways. First, he is an exceptionally talented writer, both in German and in English: the English of his narrative is his own. Second, he is honest. Along with his naturalist father, he accompanied James Cook on the latter's second navigation of the globe (1772–5), which included a long stay on Tahiti. Forster brings to Tahiti a full share of prejudices and presuppositions, but he makes them visible, and admits a great deal of empirical evidence that contradicts them. Having absorbed Rousseau, he hopes to find in Tahiti a society free from the vices of civilization. But experience compels him reluctantly to admit that Tahiti has a class hierarchy similar to that which Forster – a radical who would later support the French Revolution and die prematurely in the service of the Jacobin Republic of Mainz – opposed in Europe. Part of the interest of Forster's account lies in the continual conflict between his romantic and egalitarian hopes, and the disillusioning evidence presented by his experience of Tahitian society.

Forster's literary talents are evident in his famous description of his first sight of Tahiti:

> It was one of those beautiful mornings which the poets of all nations have attempted to describe, when we saw the isle of O-Taheitee, within two miles before us. The east-wind which had carried us so far, was entirely vanished, and a faint breeze only wafted a delicious perfume from the land, and curled the surface of the sea. The mountains, clothed with forests, rose majestic in various spiry forms, on which we already perceived the light of the rising sun: nearer to the eye a lower range of hills, easier of ascent, appeared, wooded like the former, and coloured with several pleasing hues of green, soberly mixed with autumnal browns. At their foot lay the plain, crowned with its fertile bread-fruit trees, over which rose innumerable palms, the princes of the grove. Here every thing seemed as yet asleep, the morning scarce dawned, and a peaceful shade still rested on the landscape. We discerned however, a number of houses among the trees, and many canoes hauled up along the sandy beaches.[94]

A

# V O Y A G E

ROUND THE

# W O R L D,

IN

His BRITANNIC MAJESTY's Sloop, RESOLUTION,

commanded by Capt. JAMES COOK, during the Years 1772, 3, 4, and 5.

By G E O R G E   F O R S T E R, F.R.S.

Member of the Royal Academy of MADRID, and of the Society for promoting
Natural Knowledge at BERLIN.

IN   T W O   V O L U M E S.

VOL.  I.

On ne repousse point la vérité sans bruit,
Et de quelque façon qu'on l'arrête au passage.
On verra tôt-ou-tard que c'etoit un outrage,
Dont il falloit qu'au moins la *honte* fut le fruit.      DE MISSY.

L O N D O N,

Printed for B. WHITE, in FLEET-STREET; J. ROBSON, in BOND-STREET;
and P. ELMSLY, in the STRAND,
MDCCLXXVII.

---

The motto is taken from a poem by the Prussian scholar and book collector César de Missy (1703–75), in his *Paraboles ou fables et autres petites narrations* (3rd edn, London, 1769), entitled 'Truth, the Swiss Guard, and the King'; it tells how Truth calls on a king, who rebukes his guard for trying to repel her: 'You cannot drive away Truth without noise, and by whatever means you bar her passage, you will see sooner or later that it was an outrage which must at least result in shame.'

Later he has much to say about the 'romantick scenery', improved still
further by the absence of gnats and mosquitos.[95] The inhabitants seem to
be worthy of their setting. Forster talks repeatedly about their gentleness,
amiability and good humour. The mother of 'Tootahah' (a young man,
now dead, who had made friends with Cook on his previous visit) embraces
Cook and weeps for her son: 'We paid the tribute of admiration due to
such sensibility, which endears our fellow-creatures to us wherever it is
met with, and affords an undeniable proof of the original excellence of
the human heart.'[96] Forster wants to sustain a belief in the Tahitians' hap-
piness. Thus when they meet an old man with a long white beard: 'His
wrinkles, which characterize age with us, were few and not deep; for cares,
trouble and disappointment, which untimely furrow our brows, cannot
be supposed to exist in this happy nation.'[97]

It is a little sobering, however, to observe that as soon as the islanders
have presented the Europeans with a plant as symbol of peace (that, at
least, is how the Europeans interpret it), they start trading on a massive
scale:

> Coco-nuts, and plantanes in great quantity, bread-fruit and several other
> vegetables, besides some fresh fish were offered to us, and eagerly exchanged
> for transparent beads, and small nails. Pieces of cloth, fish-hooks, hatchets
> of stone, and a number of tools, were likewise brought for sale and readily
> disposed of; and many canoes kept plying between us and the shore, exhibit-
> ing a picture of a new kind of fair.[98]

Moreover, the articles in which the Tahitians trade include sex. Women
come aboard ship and having 'yielded without difficulty to the ardent
sollicitations of our sailors', receive the sailors' 'shirts and cloaths' in
return.[99] Some of these 'women' appear to Forster to be only nine or ten
years old. An upper-class woman, who would not normally prostitute
herself, is persuaded to do so because she so much wants some bed-sheets,
but when the copulation is forestalled by an accident, she runs off with
the sheets anyway. Elsewhere, too, the Tahitians can be dishonest. The
crew having bought coconuts, Tahitians aboard ship throw the coconuts
back to their comrades, who then sell them again to the sailors. 'To pre-
vent our being imposed on for the future in this manner, the thieves were
turned out of the vessel, and punished with a whip, which they bore very
patiently.'[100] Forster deplores 'the thievish disposition of the people'.[101] But
it is not entirely clear whether the Tahitians and the Europeans were play-
ing by the same rules.

Forster and his companions hope to find in Tahiti an egalitarian
society:

We had flattered ourselves with the pleasing fancy of having found at least one little spot of the world, where a whole nation, without being lawless barbarians, aimed at a certain frugal equality in their way of living, and whose hours of enjoyment were justly proportioned to those of labour and rest.[102]

It becomes clear, however, that Tahiti has a social hierarchy, which Forster cautiously interprets according to the European model of upper, middle and lower classes: 'Under one general sovereign, the people are distinguished into the classes of are, manahoúna, and towtow, which bear some distant relation to those of the feudal systems of Europe.'[103] At the top is the 'king' or chief of the district, whose solemn air Forster considers 'a mask of hypocrisy'.[104] He promises to send them some pigs, but Forster does not trust 'the specious behaviour of the court and courtiers, who fed our hopes with empty promises'.[105] The upper class live idly, like the 'very fat man' whom Forster finds 'lolling on his wooden pillow' while a woman puts baked fish and breadfruit into his mouth and two servants prepare the next course.[106] Some Tahitians get dead drunk on *kava*, a drink prepared from the pepper-tree, although it produces an unsightly skin rash that reminds Forster of leprosy.

Beneath the idle aristocracy are the Tahitians who show hospitality to the visitors and whom Forster assigns to the 'middle class'. Below them are the 'common sort' or *towtows*, such as the women whom Forster sees making bark into cloth, and who 'were dressed in old and dirty rags of their cloth, and had very hard and callous hands'.[107] The lower classes look after pigs, but are not allowed to eat them, since they are reserved for the chiefs. The women who prostitute themselves to the sailors are 'of the lowest class', and are rewarded not only with beads, nails and shirts, but with fresh pork: 'The quantities of pork which they could consume were astonishing, and their greediness plainly indicated that they were rarely if ever indulged with that delicious food in their own families.'[108] The lower class are distinguished by their small stature. Forster cites Buffon to show that premature sex prevents people from growing tall.[109]

Another disappointing characteristic of the Tahitians, shared with other Pacific islanders, is their habit of waging war on their neighbours. Forster is puzzled to know what motives the islanders can have for fighting. As the islands are equally fertile, they cannot hope for material gain: 'therefore nothing but a spirit of ambition could have stimulated them to contentions. Such a spirit ill agreed with the simplicity and generous character of the people, and it gave us pain to be convinced, that great imperfections cannot be excluded from the best of human societies.'[110] It appears, moreover, that both Tupaia and Ma'i, who had left the islands

aboard Cook's ship on his previous voyage, had been motivated by the desire to obtain firearms with which to make war on their neighbours more effectively.

Forster tries hard to sustain his belief in the happiness of the Tahitians. Their pleasant climate and fertile soil enable them to lead healthy lives without the labour of agriculture. Since everyone can easily get enough to eat, there is no such disparity as in Europe between poverty and luxury. The king is regarded as the father of his people, and everyone can speak familiarly to him. This conclusion palliates the picture Forster has already drawn, in which the lower class live on fruit and the upper class alone eat meat and fish. However, Forster thinks this situation is unstable. He foretells that as the population increases, and the idle class becomes more numerous, the lower class will have to work harder to support them. The classes will even become physically distinct, with the idle aristocrats retaining 'an extraordinary size' and light complexions, while the *towtows* will develop darker skins and 'will dwindle away to dwarfs, by the more frequent prostitution of their infant daughters to the voluptuous pleasures of the great'. The eventual outcome will accord with 'the natural circle of human affairs': 'At last the common people will perceive these grievances, and the causes which produced them; and a proper sense of the general rights of mankind awaking in them, will bring on a revolution.'[111]

So, the balance sheet, much to Forster's regret, is negative. Endowed by nature with abundant food, good health, good humour and a pleasant climate, the Tahitians have formed a class society in which an idle aristocracy enjoys a protein-rich diet, while the lower class does the hard work on a vegetarian regime; hospitality is common, but so are theft and prostitution; and warfare is normal without any material need. But Forster should not have been surprised. The French navigator Louis-Antoine de Bougainville, who had reached Tahiti in 1767 and claimed it for France under the name New Cythera (the mythical island of Venus), was driven to similar conclusions in a text that Forster's father had translated a few years earlier. Having at first thought, like Forster, that the Tahitians were largely equal, Bougainville had to admit: 'I was mistaken; the distinction of ranks is very great at Taiti [*sic*], and the disproportion very tyrannical.'[112] From 'Aotourou', the Tahitian who accompanied him back to France, he learned not only that the Tahitians were constantly at war with the people of neighbouring islands, but also that their priests enjoyed great authority and conducted human sacrifices, taking the victims from the underclass.

Gifted travellers such as Montagu and Forster are open to new experiences. Their writings convey the exotic quality of the countries they visit without falling into the trap of exoticism by imagining that the people

there are radically different from themselves. Montagu perceives how much the Turkish ladies resemble their English counterparts, despite the striking but superficial difference of manners. She reports on the harem without making it an allegory of Oriental despotism, as in Montesquieu's *Persian Letters* or Mozart's *Die Entführung aus dem Serail* (*The Abduction from the Seraglio*), or a scene of erotic fantasy, as in well-known paintings by Ingres and Delacroix.[113] Forster is frank about the prelapsarian fantasies he brought to Tahiti, and also honest about the disillusionment he suffered on finding that the inhabitants had their full share of human shortcomings. The worlds they explore are both excitingly diverse and humanly accessible.

## MYTHS OF CHINA

China, more than any other country, was a blank screen onto which Enlighteners could project their fantasies. Since Marco Polo's visit in the thirteenth century, hardly any Europeans had been there, except for a few traders, ambassadors (from the late seventeenth century) and missionaries.[114] It was Jesuit missionaries, led by the remarkable Matteo Ricci (1552–1610), who supplied eighteenth-century Europe with most of its scanty knowledge of China. Ricci learned Chinese, wrote books in Chinese, made friends with leading Chinese officials, and adopted Chinese dress and customs, wearing the robes of a Confucian scholar. He translated the *Four Books* (the basic canon of Confucianism) into Latin.[115] Other Jesuits followed his example, learning Chinese, becoming integrated into the learned class, and impressing their hosts not only by their knowledge of mathematics and astronomy but, still more, by their command of useful mechanical skills such as making cannon for use (unavailingly) against Manchu invaders.

Deeply impressed by Confucian philosophy, Ricci and some other Jesuits persuaded themselves that the Chinese retained the ancient theology, or *prisca theologia*, which Renaissance theologians had attributed to such ancient sages as Plato, Pythagoras and the shadowy Hermes Trismegistus.[116] They claimed that the Chinese believed in a Supreme Being called Shangdi ('high lord') or Tian ('heaven').[117] Since their hosts seemed already to possess many of the essentials of religion, the Jesuits sought to make converts by accommodating Christianity to Chinese practice. For example, they accepted Chinese ancestor worship, arguing that it was not a religious cult but a civil ceremony. This pleased the Chinese but went down badly in Rome, where the 'Chinese rites controversy', sustained by the Jesuits'

Jansenist rivals, lasted for many years. The Dominicans took a particularly hard line, insisting that the Chinese must abandon even Confucianism and accept Christianity wholesale. In 1739 the 'Chinese rites' were prohibited by Pope Benedict XIV, effectively ending the Jesuit mission in China.[118]

The extensive knowledge of Chinese geography, culture and history collected by learned Jesuits was slow to reach the West. Some classical Confucian texts, slanted towards theism, were published, as *Confucius Sinarum philosophus* (*Confucius, the Philosopher of the Chinese*, 1687), and some basic information appeared periodically as *Lettres édifiantes et curieuses* (*Edifying and Curious Letters*, 1702–73). Jesuits also corresponded with individual scholars back in Europe. Thus, Leibniz learned much from the missionary Joachim Bouvet, who lived in China from 1687 until his death in 1730. In 1697 Leibniz published a selection of Jesuit reports on China, *Novissima Sinica* (*News from China*), to show that Europe had as much to learn from China as China from Europe. He wrote in his preface: 'they surpass us . . . in practical philosophy, that is, in the precepts of ethics and politics adapted to the present life and use of mortals'; and 'we need missionaries from the Chinese who might teach us the use and practice of natural religion, just as we have sent them teachers of revealed theology'.[119] He was particularly taken by Bouvet's study of the ancient divination text known as the *I Ching* or *Book of Changes*, which, according to Bouvet, was created by the semi-legendary emperor 'Fuxi' or 'Fo-hi' who was 'probably the same person as either Zoroaster, Hermes, or Enoch'.[120] Bouvet thought the sixty-four hexagrams on which it was based represented the key ideas underlying all knowledge. Leibniz thought that it anticipated the binary system of numbers which he himself had recently invented, and that it could be combined with his own project of a *characteristica universalis*, 'a universal formal language expressing the principles of all sciences'.[121] Unfortunately Leibniz's generous cosmopolitanism led neither to visits from Chinese missionaries, nor to a universal language based on Chinese characters.

Not all Europeans shared Leibniz's high opinion of Chinese religion. Locke expressed a widespread view when he wrote: 'The missionaries of China, even the Jesuits themselves, the great encomiasts of the Chinese, do all to a man agree and will convince us that the sect of the literati, or learned, keeping to the old religion of China, and the ruling party there, are all of them atheists.'[122] This was an embarrassment for orthodox Christianity, since, given the praise lavished on Chinese morality, it might show that atheists were capable of virtue. For *philosophes* who already held this opinion, notably Pierre Bayle, it was welcome confirmation.[123]

All previous sources on China were superseded by the immense

compendium published in 1735 by the Jesuit Jean-Baptiste du Halde. Although he had never been there himself, du Halde presented in systematic form the information about geography, government, religion and culture collected on the spot by his colleagues. With its fine maps, engraved by the distinguished cartographer d'Anville, du Halde's *Description de la Chine* (*Description of China*) vastly increased Western knowledge of Chinese geography. It presented a vivid picture of Chinese agriculture: every available inch of territory was cultivated, hillsides were shaped into terraces, the country was irrigated by canals, and human excrement was used as manure, leaving the cities much cleaner than their Western counterparts.

On Chinese religion, du Halde conformed to the Jesuit belief that the educated Chinese worshipped a Supreme Being. To get round the problem that their ancient empire was not mentioned in the Bible, du Halde maintained that China had been founded by some of the descendants of Noah, who taught their posterity 'to fear and honour the Sovereign Lord of the Universe, and to live according to the Law of Nature written in their Hearts'.[124] To reinforce this claim, du Halde even doctored his more cautious sources.[125] However, he rather spoiled the picture by admitting that the bulk of the Chinese population followed other and less admirable religions. He could not say much about these, because the Jesuits, hoping to convert China from the top down by infiltrating the educated class, paid little attention to popular belief. But he informed his readers that besides the Confucians, there were two other sects: 'that of the Disciples of *Lao kien*, which is nothing but a Web of Extravagance and Impiety; and that of Idolators, who worship a Divinity called *Fo*, whose Opinions were translated from the *Indies* into *China* about thirty-two Years after the Crucifixion of our Saviour.'[126] In these caricatural descriptions it is difficult to recognize Taoism and Buddhism.

According to du Halde, Chinese government is rational and benevolent. The emperor rules paternally and is regarded with filial piety. The Empire is efficiently administered through a corps of mandarins, who are selected by rigorous examinations and whose conduct is carefully monitored. Justice is slow but scrupulous: a criminal case is often considered by five or six tribunals. As for punishment, 'the Bastinado [beating with a heavy cane] is the common Punishment for slight Faults'.[127] Mostly the Chinese are docile and law-abiding. 'The *Chinese* in general are mild, tractable, and humane; there is a great deal of Affability in their Air and Manner, and nothing harsh, rough, or passionate.'[128] Du Halde concedes, however, that though they are necessarily hard-working, they are also deceitful, vindictive, motivated only by self-interest, and contemptuous of all other nations.

Du Halde's account inspired some eulogies of China as an enlightened paradise. With its mandarins and literati, selected by a rigorous meritocratic system, it seemed to fulfil the dream of a country ruled by rational and moral philosophers who upheld natural religion.[129] Voltaire, in his *Essai sur les mœurs*, and elsewhere, used China as yet another stick with which to beat Christianity. It was far older than Christian civilization: its historical records went back to the king Fo-Hi, who reigned more than twenty-five centuries BCE.[130] Its antiquity proved the wisdom of its fundamental laws, as did the fact that the Mongol and Manchu conquerors had adopted the Chinese imperial system. It was especially superior to Europe in its religious affairs. The elite were deists, untroubled by any priesthood, while the common people were treated tolerantly and allowed to believe whatever nonsense they liked. 'Chinese history is not sullied by any religious strife. There is no prophet to stir up the people, no mystery to play havoc with their souls. Confucius was the first of physicians because he was never a charlatan. And we, wretches! and we!'[131]

Even more enthusiastic was the physiocrat Quesnay. If China was a despotism, he argued, then it was a legitimate one, in which natural law and enlightened deism prevented the Emperor from doing harm and encouraged him to promote his people's happiness, with the help of conscientious and selfless mandarins. China showed the effect of practical philosophy: 'This vast and magnificent empire, preserved for forty centuries against all the efforts of civilized or barbarous passions, by the sheer power of the philosophic spirit, demonstrates the power and efficacy of *moral* and *political* knowledge.'[132]

Given his economic views, Quesnay was particularly pleased by the attention paid in China to agriculture. Much of the population was poor, but the intensive cultivation of the land provided everyone with work and sustenance. Du Halde had underlined the importance of agriculture by describing the annual spring ceremony in which the emperor, after performing sacrifices, would take a plough and drive it for several furrows. This inspired the French dauphin in 1758 to plough some land as a good example to his subjects, and may also have inspired the famous gesture by Joseph II of Austria when, in 1769, he drove a plough for the edification of the Moravian peasants.[133]

These eulogies inevitably provoked scepticism. In the *Histoire des deux Indes* (*History of the East and West Indies*), the abbé Raynal offered a panegyric on China, while Diderot replied with a point-by-point demolition. In fact, Raynal's panegyric is so excessive that one suspects him of writing tongue-in-cheek to provoke Diderot's diatribe.

Diderot and others refused to believe in China's benevolent government.

'The Chinese seem to us to be bowed beneath the yoke of a double tyranny, paternal tyranny in the family, civil tyranny in the Empire', wrote Diderot.[134] Perhaps, suggested the political philosopher Mably in a reply to Quesnay, the Chinese were so peaceful just because they were cowed by prolonged despotism:

> It may be, if you will allow me to say so, that what you take for the work
> of reason and the highest wisdom merely results from spiritual exhaustion
> and from the weariness of a people who have given up all hope of freedom
> and have at last grown accustomed to their slavery.[135]

The lack of a hereditary nobility meant that the authorities were not restrained by any sense of family honour, and mandarins, with families, hangers-on and mistresses to provide for, had ample motives for corruption.[136] It hardly spoke for the humanity of the Chinese that the slightest offences were punished by beating, or that surplus children were habitually exposed.[137] Why didn't the Chinese get rid of their extra population by founding colonies?[138]

It was also noted that although the Chinese had in the past made many technical advances, such as the art of printing, they no longer seemed to progress in the arts and sciences. Educated Chinese needed so long to study their language and learn thousands of characters that they had no time for further inquiries. The examination system required candidates for the mandarinate to rehearse moral truisms, but not to solve problems or to add to knowledge.[139] Even the teaching of Confucius, now available in Western languages, did not seem very startling: 'What is this Confucius who is so much talked of, if one compares him to Sidney or Montesquieu?'[140]

The stereotype developed of China as a completely immobile culture – 'the immense empire of China improgressive for thirty centuries', as Coleridge would later put it.[141] Volney's narrator declares: 'The Chinese, governed by an insolent despotism, by strokes of the bamboo and the cast of lots, and by the radical vices of an ill-constructed language, appear to be in their abortive civilization nothing but a race of automatons.'[142] Herder, after putting the case against China more harshly even than Diderot, concluded: 'The Empire is an embalmed mummy, painted with hieroglyphs and wrapped in silk.'[143] Condorcet put more soberly the view that China had somehow got stuck:

> We must pause for a moment to look at China; at this people who seem to
> have preceded the others in sciences and arts, only to see themselves succes-
> sively eclipsed by them all; this people, whom the knowledge of artillery
> did not save from being conquered by barbarous nations; where the sciences,

of which numerous schools are open to all citizens, are the only road to all dignities, and where, nevertheless, subject to absurd prejudices, these sciences are condemned to an eternal mediocrity; where finally even the invention of printing has remained entirely useless for the progress of the human spirit.[144]

These reflections may not be altogether wide of the mark. Certainly, the Chinese had invented many techniques long before Europeans did: not only the printing-press and gunpowder – which, contrary to common belief, they used for artillery as well as fireworks – but also, even before the Common Era, the seed drill and the blast furnace. They even put up shrines to historic inventors. They learned from abroad by imitating Western clocks, telescopes and microscopes. Training in the Confucian classics probably did not encourage original thought, however (though neither did European training in the Greek and Latin classics), and the absence of nearby competitor nations removed a stimulus to innovation. Above all, the intense agricultural exploitation of the land meant that China was just able to sustain a large population at a low standard of living. It was thus caught in what would now be called a 'high-level equilibrium trap'. Agriculture kept people alive but did not generate any surplus that could be invested in new resources such as labour-saving machinery.[145] The Chinese rulers seem also to have become less interested in Europe. The Kangxi emperor was glad to learn from the Jesuits, but his successor, the Qianlong emperor, was unwelcoming to the diplomatic mission led by Lord Macartney in 1793.[146]

## EMPIRE

As more of the world outside Europe became accessible to armchair travellers, Enlighteners became uncomfortably aware that much of it was coming increasingly under European domination. The conquest and exploitation of overseas territories were anathema to the Enlightenment, which retained the cultural memory of past colonial atrocities. It was notorious that the Spaniards, in conquering Central and South America and looking obsessively for gold and silver, had destroyed two high civilizations and had sharply reduced the population through warfare, intolerable forced labour, and the inadvertent but fatal spread of European diseases. Their depredations in America were considered a supreme atrocity, as we nowadays consider the Holocaust. 'So many cities razed to the ground,' wrote Montaigne, 'so many nations wiped out, so many millions of individuals put to the sword, and the most beautiful and the richest

part of the world shattered, on behalf of the pearls-and-pepper busi-
ness!'[147] The satirist Lichtenberg said pithily: 'The American who first
discovered Columbus made a bad discovery.'[148]

The truth about Spanish destruction is still disputed. Certainly, the
indigenous population of Spanish America declined drastically. In the
century following the conquest, the population of central Mexico was
reduced to one-tenth of its previous size; in Peru, it shrank by 40 per
cent.[149] Early in the twentieth century, however, some Spaniards argued
that to blame the *conquistadores* alone for this decline was a 'black
legend'. They pointed out that the Spanish crown issued many proclama-
tions urging that the 'Indians' should be treated humanely, while
missionaries regarded them as children requiring paternal care. These
arguments were anticipated in the eighteenth century by William Robert-
son, who in his *History of America* argued (plausibly) that the Spaniards
never had a deliberate policy of genocide and that the mass deaths were
due chiefly to European diseases such as smallpox.[150] Robertson certainly
had to be tactful, since he relied on Spanish contacts for access to primary
sources. But he also acknowledged the effects of forced labour and the
barbarity of 'the conquerors and first planters of America, who, by meas-
ures no less inconsiderate and unjust, counteracted the edicts of the
sovereign, and have brought disgrace upon their country'.[151] Once across
the Atlantic, after all, Spanish colonists could easily ignore well-meaning
instructions sent from the mother country. Even Hernán Cortés disobeyed
his orders in conquering Mexico: the governor of Cuba had instructed
him only to take formal possession of the territory; but Cortés, resolved
on conquest, defied the governor and attacked the capital, trusting that
the gold he gained would bring him retrospective approval for his actions.[152]
It has been argued also that although the indigenous way of life survived
unimpaired in many parts of Spanish America, the epidemics were for the
indigenes an incomprehensible catastrophe that left them demoralized.[153]
So perhaps the 'black legend' was no legend, and the Spanish conquest
was for its victims as great a disaster as Montaigne claimed.

Many other countries established settlements overseas, especially in
Asia. The colonization of large tracts of Asia by Britain, France and Hol-
land was not the work of their governments, but of trading companies to
which their governments had granted monopolies. Queen Elizabeth
granted a royal charter to the East India Company in 1600. Its Dutch
counterpart, the Vereenigde Oost-Indische Compagnie, received in 1602
a monopoly on the spice trade with the Moluccas (present-day Indonesia).
France tried to catch up in 1664 when Louis XIV, at the request of his
finance minister Colbert, gave the French East Indies Company

(Compagnie française pour le commerce des Indes orientales) the exclusive right to trade with all territories east of the Cape of Good Hope. They began their operations in Asia at a propitious time. Over the next century and a half, the Mughal Empire, centred on Delhi, would gradually lose control of its outlying provinces, leaving them vulnerable to European influence. In Java, where Jan Pieterszoon Coen in 1619 seized the port of Jayakarta (present-day Jakarta) from the sultan of Bantam and renamed it Batavia, the ruler of Mataram in the interior was trying to assert his hegemony over the whole island; the Dutch helped him to suppress rebellion, in return for territory and commercial privileges, but later they gave their assistance to provinces that were rebelling against Mataram and profited from its disintegration. The French were less successful: having established their company headquarters in Pondicherry and four other trading posts along India's south-eastern coast, they made no further gains in the sub-continent. The French company was always underfunded, and, after its defeat in India by the British, it was dissolved in 1769. Further east, however, the French traded with what is now Vietnam until, in 1787, French troops intervened to help a landowner regain territories. Thereafter they increased their influence until French Indochina (present-day Vietnam, Cambodia and, later, Laos) was set up in 1887.[154]

Other nations tried to get in on the act. The Brandenburg-Africa Company, founded in 1682, set up a fort, Gross-Friedrichsburg, off the West African coast in 1683, but its African presence lasted only to 1721.[155] Austria established an Indian trading company, operating from Ostend in the Austrian Netherlands, in 1722, but dissolved it in return for diplomatic favours from Britain in 1731. The Danish East India Company, set up in 1616, had a string of trading posts in India and West Africa (where the Danish fort of Christiansborg is now the official residence of the president of Ghana), from which it shipped slaves to the three islands it had acquired in the West Indies (and which it retained until it sold them to the USA in 1917). Scotland in 1698 made a short and entirely ill-fated attempt to create a colony at Darien on the Panama isthmus; the territory was ambitiously named Caledonia, and its capital New Edinburgh, but the project proved unsustainable and was abandoned within two years.[156]

The British East India Company established trading posts at Surat, Calcutta, Madras and Bombay. These had to be defended by troops and fortifications. Troops were needed both to overawe Indian rulers and to resist the rival French Compagnie des Indes. The always simmering conflict between Britain and France in India came to the boil when the two nations were at war in Europe, in the 1740s and during the Seven Years War (1756–63); and during the war of American independence, the French,

who were supporting the Americans, sent an expeditionary force to India. French power in India was, however, effectively broken by 1761, but before then, the two states were sometimes drawn into Indian disputes. Thus in 1751 Britain and France each supported a different rival for the throne of the Carnatic (Karnataka). In addition, the decline in the power of the Mughal Empire meant that its nawabs – governors – were largely independent rulers, and sometimes sought British help against their neighbours. The British too were anxious to have friendly, or at least compliant, rulers to deal with, and readily went to war to oust unfriendly ones, such as the nawab of Bengal, Siraj ud-Daula, who was notorious for having confined British soldiers in a space so small (the 'Black Hole of Calcutta') that more than a hundred were suffocated. His defeat by Robert Clive at the battle of Plassey in 1757 increased Clive's personal fortune and consolidated British dominance in Bengal, of which Clive was appointed governor. By the Treaty of Allahabad in 1765, the Mughal emperor granted the East India Company the office of *diwani* or tax collection in the provinces of Bengal, Bihar and Orissa. As taxes passed through many intermediaries, it became necessary to interfere to prevent embezzlement.

The office of *diwani* also meant overseeing the administration of justice. Clive's successor as governor-general, Warren Hastings, told the House of Commons in 1767 that neither the Mughal emperor nor the nawab of Bengal had any real power, and that Bengal was in effect a British province. Despite his good intentions, Hastings would be criticized for raising too little revenue, for oppressing the Indians, and for repeatedly getting involved in wars which, intended to surround the Company's possessions with friendly neighbours, turned into wars of conquest. Wars were expensive and required the acquisition of new territories to defray their expense through increased tax farming. On returning to Britain in 1785, Hastings was charged with corruption and misrule, and denounced by the eloquent Edmund Burke. But after a seven-year trial he was acquitted on all counts.

Hastings' trial was prompted by public concern about the East India Company's chronic mismanagement, or worse. In 1772 the Company was suddenly unable to pay its shareholders' dividends, apparently as a result of mismanagement by its servants. India threatened to become a national liability. The Company's servants in India were thought by Hastings himself to be mostly ignorant and corrupt. A few – led by Clive, the victor of Plassey, who relied partly on insider trading – amassed large fortunes. Since the voyage to India took five or six months, it was impossible for the Company's directors in London, still less the British government, to control what its servants were doing. The extent of their misgovernment was brought home when news arrived of the Bengal famine of 1769–70, in which a drought

was transformed into a catastrophe partly by the Company's prohibition on stockpiling rice, and an estimated ten million people, a third of the population of Bengal and Bihar, died of hunger and the accompanying smallpox epidemic. It was reported too that the Company's excessive tax demands, not abated during the famine, had reduced Bengal, reputedly an exceptionally rich and fertile province, to chronic poverty.[157]

The East India Company provided Adam Smith with his main example of the evils of monopoly. He pointed out that it not only maintained a monopoly on trade with the territories under its control, but it interfered in the internal economy of Bengal. By forbidding merchants to stockpile rice and thus avert possible scarcities, the Company managed to turn a dearth into a famine.[158] Thanks to 'the mercantile company which oppresses and domineers in the East Indies', it is possible for three or four hundred thousand people to die in a single year.[159] Smith comments scathingly on 'the plunderers of India':

> No other sovereigns ever were, or, from the nature of things, ever could be, so perfectly indifferent about the happiness or misery of their subjects, the improvement or waste of their dominions, the glory or disgrace of their administration; as, from irresistible moral causes, the greater part of the proprietors of such a mercantile company are, and necessarily must be.[160]

Since becoming sovereigns, they have even ceased to be competent traders: they have had to appeal to the government to bail them out and avoid bankruptcy.[161]

Enlightenment writers agree in denouncing colonialism and conquest. The Spanish in America were a familiar target. But it was increasingly agreed that Dutch, French and even British colonialism was nearly as bad. Smith described the discovery of America and of a passage to the East Indies via the Cape of Good Hope as 'the two greatest and most important events recorded in the history of mankind', but added: 'To the natives, however, both of the East and West Indies, all the commercial benefits which can have resulted from those events have been sunk and lost in the dreadful misfortunes which they have occasioned.'[162] Kant, having described how relations of mutual hospitality might in theory be established between different continents, remarked what horrifying injustice the European states had instead shown in their dealings with overseas nations, particularly in India:

> In the East Indies (Hindustan), they brought in foreign soldiers under the pretext of merely proposing to set up trading posts, but with them oppression of the inhabitants, incitement of the various Indian states to widespread

wars, famine, rebellions, treachery, and the whole litany of troubles that oppress the human race.[163]

The Chinese had therefore done wisely, after their first encounters with European visitors, to deny them access to the interior of the country, and the Japanese were also wise in dealing only with one European nation, the Dutch, whom they allowed to establish a single trading post but not to mix with the natives.

Colonial empires, however, harmed not only their conquered subjects but also the home metropolis. Two kinds of 'blowback', or unintended consequences, could be envisaged. In one scenario, the military cost of keeping colonies in subjection would overstrain the metropolitan economy, like a tree whose too extensive branches suck the life out of the trunk.[164] Conversely, colonial possessions might enrich the metropolis unduly, generating luxury, corruption and, finally, despotism, as the wealth of the Peruvian mines had left Spain with a stagnant economy and a tyrannical government.[165] Other, more dialectical, consequences were foreseeable. Colonial oppression might go so far as to provoke a previously subservient population to rebel. Or the colonists, by bringing European knowledge to their distant subjects, might eventually enable the latter to attain 'that equality of courage and force which, by inspiring mutual fear, can alone overawe the injustice of independent nations into some sort of respect for the rights of one another'.[166] Kant added that, from a moral viewpoint, it was welcome news that all the European trading companies were on the point of collapse, so that the Europeans' cruelty had brought them no long-term advantage.[167]

## THE *HISTOIRE DES DEUX INDES*

The abbé Raynal, having abandoned the priesthood for journalism, began in the 1760s to plan what would become one of the Enlightenment's underrated masterpieces, the *Histoire philosophique et politique des établissements et du commerce des Européens dans les deux Indes* (*Philosophical and Political History of the Colonies and Commerce of the Europeans in the East and West Indies*), generally known as the *Histoire des deux Indes*.[168] He would write the history of how the European powers, from Spain to Denmark, had colonized North and South America and large tracts of Asia. For this huge project he enlisted the help of many collaborators, including Diderot and d'Holbach. The *Histoire des deux Indes* is in a sense not an original work. It takes information from many

publications, and has often been dismissed as a mere compilation, 'a hotchpotch' full of 'scraps without genius or taste'.[169]

However, now that we understand the extensive role played in its composition by Diderot, the work looks different.[170] It is a vast, encyclopaedic assemblage of information. You can learn about the lifestyle of the Canadian indigenes, the prospects for the Spanish economy, the practice of infibulation among the Arabs, the habits of the beaver, and the cultivation of julep, indigo and cochineal. The information is as accurate as Raynal and his collaborators could make it. Successive editions were thoroughly updated. The first dates from 1770, the second, much expanded edition from 1774, and the third, heavily revised, from 1780.[171] The third edition was brought up to date, for example, by including a section on the then ongoing American War of Independence and a tribute to Captain Cook, who had been killed on Hawaii in 1779.[172]

Diderot's contributions grew with each edition. Working on the *Histoire* was the major project of his later life. His share almost certainly extends far beyond the discrete passages that have so far been identified; it amounts at least to a fifth, perhaps to a third, of the whole work.[173] The factual information supplied by Raynal and his collaborators is interspersed with impassioned reflections by Diderot. He sometimes worked on it for fourteen hours a day, aiming to make it not only an arresting compilation of fact but also a model of eloquence – and in this he succeeded.[174] The result was one of the bestsellers of the late eighteenth century. The book's appeal was no doubt heightened by official disapproval. It was condemned by the *parlement* of Paris as 'an impious, blasphemous, seditious book, tending to rouse nations against sovereign authority, and to uproot the foundations of civil order', and ordered to be burned by the public executioner.[175] Raynal had to leave France to avoid arrest and spent years in Berlin and St Petersburg before returning to France in 1787; a moderate revolutionary, he represented Marseilles in the Estates General. The book was often considered a history in the same league as the works of Hume and Robertson.[176] Its many admirers included Napoleon, who took a copy with him on his expedition to Egypt.[177]

Such popularity may seem surprising, since the *Histoire* covers 4,353 pages. But its reader-friendly division into short chapters means you can dip in and out of it while retaining a sense of its enormous sweep. It has rightly been called 'a kind of epic where he [Raynal] orchestrates all the themes of the Enlightenment'.[178] Denouncing the atrocities of colonization, it presents itself as a work of militant enlightenment: 'The moment is approaching when reason, justice and truth will tear from the hands of ignorance and flattery what they have held only too long. Tremble, you

who feed humanity with lies or make them groan under oppression; you are going to be judged.'[179] Factual data alternate with impassioned tirades, the latter mostly supplied by Diderot. Raynal welcomed Diderot's eloquent digressions; Diderot quotes him as saying: 'It is your lines that will make up for the tedium of my endless calculations.' [180]

Thus the *Histoire* is several books at the same time. It is a great example of the late-Enlightenment genre of statistical writing, that is, the systematic presentation of factual information. The first five books recount European penetration into Asia, dealing successively with the Portuguese, the Dutch, the English, the French and a number of minor colonial nations. From Book VI onwards the spotlight moves to the Americas. We learn about the Spanish conquests of Mexico, Peru, Chile and Paraguay, and the settlement of the Portuguese in Brazil. Just when we think we have supped full with horrors, the focus shifts to Africa and the slave trade that supplied workers for the American plantations. The remaining books deal with the West Indies and North America, finding ultimately signs of hope in the revolt by the Americans against British rule.

The *Histoire* is also, thanks especially to Diderot, an inspiring protest against oppression. A first-person voice appears several times, deploring both the atrocities committed by European conquerors and their insane blindness to their own real interests. At the beginning of Book VII, Diderot writes:

> I am writing history, and I am writing it with my eyes almost always bathed in tears. Grief has sometimes given way to astonishment. I have been surprised that none of these fierce warriors should have preferred the secure path of gentleness and humanity, and that they have all chosen to show themselves as tyrants rather than benefactors.[181]

In places the text is openly dialogical. The excursus on China, where an implausibly rose-tinted account is fiercely challenged, has already been mentioned. In a famous passage on slavery, Diderot argues with its defenders, and later the case against the American rebels is formulated only to be demolished.[182]

Even the factual information is often more than factual. The chapter on the beaver not only tells us how this animal fells trees and dams streams, but treats it as the exemplar of social virtues and as yet another victim of persecution, this time at the hands of fur traders.[183] The beaver 'possesses gifts favourable to society, without being subject, as we are, to vices and misfortunes'; yet 'this gentle, appealing, pitiable animal, whose example and whose fate call forth tears of admiration and compassion from the kind-hearted philosopher who contemplates its life and customs',

has become the prey of remorseless hunters, 'thanks to the insatiable greed of the most civilized nations of Europe'.[184] Thus the *Histoire* is by turns statistical, passionate and sentimental. Its heterogeneity, formerly a reproach, can now be seen as a positive quality, and revalued as polyphony or 'polygraphy'.

The *Histoire* is judicious. It denounces the cruelty, greed and deceitfulness shown by European conquerors. In Mexico, the Spaniards were the real barbarians: 'There was a barbarous competition between the officer and the soldier to see who could immolate the greatest number of victims; and the general himself perhaps surpassed his troops and his lieutenants in ferocity.'[185] The authors note also that men tend to behave badly when freed from the restraints of civilization, and the further they are from home, the worse they behave.[186] Hence the particularly atrocious conduct of the Spaniards in Peru, where they devastated the Inca Empire and enslaved the population. Cortés in Mexico was a mass murderer, but he had heroic qualities which, in different circumstances, would have brought him a glorious reputation; if Julius Caesar had been in his place, Caesar would have been even worse than Cortés.[187]

The conquerors' victims are not idealized. The *Histoire* is sceptical about the alleged glories of Mexican civilization, and thinks the capital can have consisted only of wooden cabins.[188] In the description of the natives of America and West Africa, particular stress is laid on their oppression of their own women.[189] Along the Orinoco women are so badly treated that they often kill their female infants to save them from a miserable life.[190] Yet the native Americans are kind to their widows, orphans and invalids; they never beat or even scold their children; and if they are cruel to Europeans, that is in response to Europeans' treatment of them: 'they have become harsh and cruel to us in reprisal'.[191]

Beginning with its title, the *Histoire* presents itself as a history of commerce. The opening pages sketch the growth of commerce from the Phoenicians onwards. The text affirms the Enlightenment conviction that commerce is a good thing: 'By traversing the earth, by crossing the seas, by removing the obstacles opposed to communication between nations, by extending the sphere of needs and the desire for enjoyment, it multiplies work; it encourages industry; it becomes, in a sense, the motor of the world.'[192] The conquest of the New World resulted in devastation because the Spanish invaders, who were ruffians led by adventurers, did not understand commerce and were carried away by an insensate greed for gold and silver. The sites of Inca cities are now deserts, because of 'the vile and thoughtless greed for silver, to which such more genuine riches and so much of the population were sacrificed'.[193] In an alternative universe, the

Spaniards would have understood their own interests and sought commerce instead of conquest:

> If the Spaniards had known their real interest, then perhaps, on discovering America, they would have been content to form honest ties [*des nœuds honnêtes*] with the Indians, which would have established mutual dependence and profit between the two nations. The products of the Old World's workshops could have been exchanged for those of the New World's mines; and wrought iron would have been paid for by an equal weight of raw silver. A stable union, the necessary consequence of a peaceful commerce, would have been formed, without shedding blood, without devastating empires.[194]

But commerce too has its dark side, illustrated by the activities of the British East India Company in Bengal. Who would have thought that the people of Bengal could ever have wanted their tyrannical nawab back? Yet the British are worse. Under the old regime the taxes were at least fixed, but the British have increased them; they have monopolized the sale of salt, tobacco and betel; they have debased the currency; they have enforced their measures with violence; and they have even brought about an appalling famine in one of the most fertile countries in the world.

> Arbitrary authority has been replaced by a methodical tyranny. Extortions have become general and regular; oppression has been continual and absolute. The destructive art of monopolies has been perfected; new ones have been invented; in a word, all the sources of trust, of public happiness, have been debased and corrupted.[195]

Even more destructive than the Company's rule in Bengal is the African slave trade. The West African rulers were tempted by luxury. Commerce with Europeans offered them swords, guns, gunpowder, brandy, ironmongery, carpets, fabrics.[196] To obtain these goods, Africans broke the laws that had previously controlled slavery. Traditionally, a man could not sell his own slaves, only those whom he had acquired as prisoners of war or in exchange. Now, in their greed for European luxuries, African rulers have made slavery the punishment for all offences; and some chiefs kidnap large numbers of people from outlying villages.[197] After reaching the coast by forced marches, slaves are loaded aboard European ships, where they sometimes lie for a long time before the ship is ready to sail, and are then transported to the New World; one-eighth of them die at sea (a modest estimate), and the survivors lead a miserable life on American and West Indian plantations, treated brutally by 'barbarous' masters.[198]

In the face of these appalling evils, the *Histoire* repeatedly suggests that conquest and exploitation are self-defeating. They ruin the victims, but

they also ruin the masters. This message emerges even from the account of Portuguese voyages in Book I. The Portuguese overstretched themselves by trying to rule a colonial empire that was too scattered; they neglected agriculture, forgetting that it was the only solid basis for prosperity; and their religious intolerance prevented them from admitting Africans and Asians to citizenship. Now their empire is reduced to a few coastal possessions. The fate of the Spanish colonies and of Spain itself is even worse. By desolating America in the search for gold and silver, the Spaniards have ruined their own economy. Spain has sunk into 'inaction and barbarism'.[199] Its nobles, too proud to work, have become *abrutis* (reduced to the level of brutes); this word ironically echoes the term *abrutissement* applied earlier to the inhabitants of Peru, conquerors and conquered alike: 'The Peruvians, all the Peruvians without exception, are an example of the profound brutishness into which tyranny can plunge people: they fell into a stupid and universal apathy.'[200] Even on the American plantations, slavery is counterproductive, because the slaves do as little work as they can, commit sabotage, run away, or, in desperation, resort to suicide.[201]

The picture of the world presented in the *Histoire* is dark and bleak. But there are two sources of hope: commerce and rebellion. Diderot sees signs that in the eighteenth century, sovereigns are at last coming to realize that peaceful commerce serves their own interest:

> Europe, that part of the globe which has most effect on all the others, appears to have assumed a solid and durable situation. Its societies are powerful, enlightened, extensive, jealous in almost equal measure. They will press against one another, and amid this continual ebb and flow, some will grow, others will be compressed, and the balance will swing from one side to the other, without ever being overturned. Religious fanaticism and the spirit of conquest, these two causes of disturbance around the globe, are no longer what they were. The sacred lever, with its tip on the earth and its fulcrum in Heaven, has been broken or gravely weakened. Sovereigns are beginning to notice, not for the sake of their people's happiness, about which they care little, but in their own interests, that the important goal is to combine security and wealth. They support large armies, they fortify their frontiers, and they engage in commerce.[202]

Colonial powers can also be overthrown by rebellion. The text longs for a black leader to arise and lead the American slaves to freedom. This wish was apparently prompted by the prophecy of a black liberator in Mercier's *L'An 2440*, and in turn inspired Toussaint L'Ouverture, who read the *Histoire* avidly, to lead a rebellion in what is now Haiti.[203] But the great example is the revolt of the Americans against British rule. Having

recounted the course of events up to the treaty of 1778 by which France recognized the independence of the United States and strengthened their resolve to continue fighting, the *Histoire* passionately espouses the cause of liberty. The sound of breaking chains, it says, makes ours seem lighter; the world has one tyrant the less; and the remaining tyrants can no longer feel secure on their thrones. Finally the historian, who is not writing only for contemporaries but also for posterity, ventures to prophesy:

> Our imaginations are afire for them; we have felt linked to their victories and their defeats: the spirit of justice, which likes to compensate for past misfortunes by happiness yet to come, is happy to believe that this part of the New World cannot fail to become one of the most flourishing countries of the globe.[204]

## THE DISCOVERY OF ASIA

The European exploration of the globe, though prompted primarily by commercial motives and only secondarily by scientific and cultural curiosity, did spread knowledge about the great historic cultures and religions of Asia. For some open-minded inquirers, it revealed that Europe did not have an exclusive claim to great literature, and Christianity might not have an exclusive claim to truth.

It was admittedly difficult to form a favourable view of Islam, the antagonist of the West since the seventh century. Muhammad was as dubious a character to many Enlighteners as to devout Christians. If not a fraud, he was a fanatic and an enthusiast, who 'deceived himself by deceiving others'.[205] Diderot called him 'the greatest enemy that human reason has had'.[206] A generation of Western Orientalists, however, made it possible to form a more judicious view. They included Barthélemy d'Herbelot (1625–95), who collected copious information about Islamic culture and presented it in the form of an encyclopaedia, the *Bibliothèque orientale* (1697); George Sale (1697–1736), who in 1734 published the first English translation of the Koran; and the historians Simon Ockley (1678–1720) and Johann Jacob Reiske (1716–74).[207]

With their help, a much subtler and more differentiated analysis of Muhammad's career was provided by Gibbon. In his view, Muhammad was a religious 'genius' who offered 'simple and rational piety'.[208] The Koran was 'a glorious testimony to the unity of God', which could satisfy a 'philosophic theist', although Muhammad thought it necessary to dress up his elevated doctrines in 'endless incoherent rhapsody'.[209] Islam was

more impressive than Christianity, both in the time of its origin, when Christian clerics were absorbed in theological hair-splitting, and in Gibbon's own day, when 'in the present decay of religious fervour, our travellers are edified by the profound humility and attention of the Turks and Persians'.[210] Gibbon's account of Muhammad absorbs the various charges against him of enthusiasm, imposture and tyranny, and arranges them in a psychologically plausible narrative. Muhammad was 'endowed with a pious and contemplative disposition' that led him, soon after reaching the age of forty, to oppose idolatry and preach a pure and abstract religion. 'From enthusiasm to imposture, the step is perilous and slippery': Muhammad thought himself entitled to use fraud and force in pursuit of his mission, e.g. recounting legends, and ordering the assassination of his enemies. He became attached to power, thinking that 'he alone was absolved by the Deity from the obligation of positive and moral laws'.[211]

Gibbon was of course partly using Islam as a stick with which to beat Christianity. Nevertheless, such appreciations led to a juster valuation of Islamic culture. The Orientalist Reimarus, who could read the Koran in the original, praised it as the expression of a rational religion: 'I shall meet with the approval of the intelligent and impartial when I say that almost everything essential in Mahomet's doctrine amounts simply to rational precepts.'[212] And the unlettered seaman Joseph Pitts, who was captured by pirates from Algiers, converted to Islam, and lived in North Africa from 1678 to 1693, praised the toleration practised there by contrast with the versions of Christianity he knew about.[213] At the same time, appreciation developed for the high standard of Muslim culture at a time when Christendom was sunk in ignorance. Raynal acknowledges medieval Muslim learning:

> The Arabs, enriched by commerce and sated with conquests, were no longer the same people who had burned the library of the Ptolemies: they cultivated arts and letters, and they are the only conquering nations to have advanced human reason and industry. We owe them algebra, chemistry, insights in astronomy, new machines, remedies unknown to antiquity; but the only one of the fine arts that they have cultivated successfully is poetry.[214]

In the early modern period, at least one Muslim state, the Ottoman Empire, was a formidable enemy. It therefore came readily to Europeans to compose their image of the Ottomans, and by extension of other Muslim states, as the antithesis of a Christian polity. Hence the concept of 'Oriental despotism', first formulated in the late sixteenth century.[215] In *The Spirit of the Laws*, as we have seen, Montesquieu sketched an 'ideal type' of Oriental despotism, in which the arbitrary will of the ruler is not restrained by law, by advisers, or by a hereditary nobility; all land belongs

to him, and private property is never secure from him; commerce therefore cannot flourish, and his subjects are formally or effectively slaves, ruled by terror. For this model, Montesquieu combined the conception of despotism found in Aristotle's *Politics* – and there ascribed to Asia – with the reports of travellers, especially Bernier and Chardin, who had visited the great Muslim empires.[216]

As an 'ideal type', however, Montesquieu's concept was too remote from empirical fact to be useful. It was contradicted by realities on the ground. Montesquieu drew especially on Bernier's letter-chapter to France's finance minister Colbert, in which Bernier maintains that in the domains of the 'Great Mogol' there is no hereditary nobility, no private property, no freedom of trade. Yet Bernier's bleak account, which he applies also to Turkey and Persia, is hard to reconcile with other parts of his travel book where he makes clear that a great deal of international trade passes through India, and that the Mughal emperor, so far from having despotic power, must constantly struggle with unruly rajas and restive tributary kings. As for Chardin, Montesquieu read him selectively. Chardin explained that in Persia there were four kinds of landed property, and the ruler's power applied only to the royal domains. While courtiers paid for their prominence with insecurity and fear, the general population, according to Chardin, far from being slaves or living in terror, were generally well treated by their landlords and led secure lives. It seems likely that both Bernier and Montesquieu were led astray by their desire to warn against the possible excesses of French absolutism. Bernier was warning Colbert where Louis XIV's autocracy and extravagance might lead; Montesquieu was worried about the absolutism of his successors. There seems reason to conclude that ' "Oriental despotism" was not really about the Orient itself, but rather was a rhetorical tool in the arsenal of the opponents of French absolute monarchy.'[217]

The concept of 'Oriental despotism', especially when based on Montesquieu's climatic determinism, implied a 'them and us' contrast between an Asia condemned to systemic misrule and a Europe in which misgovernment was an occasional accident. Yet even Bernier, by calling Asian tax-farmers *fermiers*, undid this contrast by implying how much they resembled their French counterparts. And when Gibbon speaks of 'the system of oriental despotism which Diocletian, Constantine, and the patient habits of fourscore years, had established in the empire', he similarly dismantles the implied contrast with Asia by showing that despotism could flourish in Europe.[218]

Another stroke is added to the portrait when Gibbon says that with Elagabalus 'Rome was at length humbled beneath the effeminate luxury

of oriental despotism'.[219] The Oriental despot was readily imagined as irre-
sponsible, weak, sensual, and surrounded by concubines and eunuchs. An
example is the sultan Mahomet in Samuel Johnson's tragedy *Irene* (1749).
But just as in Roman history debauchees such as Elagabalus and Nero and
sadists such as Tiberius and Caligula were counterbalanced by many cap-
able and vigorous rulers, so Asian history could show many energetic and
effective rulers, such as Aurangzeb in India, Suleiman the Magnificent in
Turkey and Mehmed II, the conqueror of Constantinople.

The image of the Oriental despot was reinforced by Western dramas
featuring bloodstained intrigues at Eastern courts: Racine's *Bajazet* (1672),
Lohenstein's *Ibrahim Sultan* (1673), Dryden's *Aureng-zebe* (1675). But, as
Voltaire pointed out in a critique of Montesquieu, episodes of tyrannical
misbehaviour should not be taken to typify systems of rule; and a govern-
ment in which the entire population were slaves of the ruler would be
unsustainable.[220] William Robertson, after a thorough study of available
Indian sources, showed that in India the power of the monarch was
restrained by the respect due to the priestly caste of Brahmans and by
hereditary governors, who 'came gradually to form an intermediate order
between the sovereign and his subjects', thus providing an equivalent to
the European nobility.[221] Chardin maintained that Persian peasants were
better off than those in France, that the Persian monarchy was based on
a system of civil laws, and that judicial torture (*la question*) was much
commoner in France than in the East.

The Orientalist scholar Abraham-Hyacinthe Anquetil-Duperron, who
knew Persia and India at first hand, contested Montesquieu's account in
great detail in his *Législation orientale* (*Oriental Legislation*, 1778). He
gave ample evidence that property rights did exist in the East, and that
the powers of Muslim rulers were restrained by the code of laws derived
from the Koran and interpreted by the *ulema* (assemblies of Islamic schol-
ars). He also argued that Montesquieu's concept was incoherent:
government by terror alone, without broad popular support, was in the
long run impossible. Commerce flourished in the East, though Eastern
nations had not yet set up a regular trade in slaves: 'in that they are less
advanced than we'.[222] Anquetil-Duperron also commented drily on the
double standard whereby political intrigue was judged villainous when
practised by Orientals but dexterous when done by Europeans.[223] And he
voiced the suspicion that the concept of Oriental despotism provided
Europeans, such as the East India Company, with a convenient pretext
for substituting their own government.[224]

Intellectual attitudes to India changed between the eighteenth century
and the nineteenth, and here, as elsewhere, it is a mistake to project later

imperialist views back onto an earlier period.[225] In the eighteenth century, people who thought seriously about India realized that it was an ancient civilization with high cultural achievements and a distinctive system of law and government. Here the antagonists Burke and Hastings were at one. Burke, having made a thorough study of India, described its inhabitants as 'a people for ages civilized and cultivated; cultivated by all the arts of political life, whilst we were yet in the woods'.[226] In Bengal, he continued:

> There is to be found an antient and venerable priesthood, the depository of their laws, learning, and history, the guides of the people while living, and their consolation in death; a nobility of great antiquity and renown; a multitude of cities, not exceeded in population and trade by those of the first class in Europe; merchants and bankers . . . millions of ingenious manufacturers and mechanicks; millions of the most diligent, and not the least intelligent, tillers of the earth.[227]

Hastings encouraged Charles Wilkins to make the first English translation of the *Bhagavad-Gita*, and described it in his preface as 'almost unequalled in its sublimity of conception, reasoning, and diction'.[228] He shared the liking of Calcutta high society for 'Hindostannie airs', short Indian musical pieces arranged in a European idiom, and performed by professional nautch girls; he could sing such songs himself.[229] Burke insisted that Indians must be governed by 'some mode of justice . . . correspondent with their religion, correspondent with their manners'.[230] Hastings, who learned to conduct negotiations with Indian rulers in Urdu, arranged for a Sanskrit law code, and commentaries on Muslim law, to be translated, as a basis for British administration in Bengal. Europeans also learned from Indians in practical ways, such as adopting loose and light clothing appropriate to the climate. Only in the nineteenth century, to preserve their distance from the Indians, would their rulers insist on retaining European clothing, thereby subjecting themselves to agonies from 'prickly heat'.[231]

The riches of ancient Indian literature gradually became available in the West. Sir William Jones, a judge in Calcutta, founded the Asiatick Society and its periodical *Asiatick Researches*. During his short life – he died in 1794 aged forty-seven – Jones wrote copiously and enthusiastically on many aspects of Indian culture, as well as Persian and Chinese. He learned Sanskrit so well that he not only read its great literature but even wrote his own poetry in Sanskrit. He acknowledged Indian achievements in mathematics and astronomy.[232] He regarded Sanskrit literature as equal in value to ancient Greek literature.[233] He translated the drama *Sakontala*, which was admired throughout Europe; it was turned from English into

German by Georg Forster, and it inspired Goethe to write the 'Prologue in the Theatre' that opens *Faust*.[234] William Robertson, who followed Jones's researches, praised the antiquity of Indian civilization, found its ancient law code far more sophisticated than the contemporaneous Roman Twelve Tables, compared Brahman philosophy with Stoicism, and, having read Wilkins' *Bhagavad-Gita*, was curious about the immense epic, the Mahabharata, of which it was part.[235]

Yet in the nineteenth century, British legislators and administrators disparaged Indian law, religion, and culture. They wanted Indians to read Homer instead of the Mahabharata, Shakespeare instead of *Sakontala*, and, above all, to replace Hinduism with (Protestant) Christianity. The true religion, said the evangelical Charles Grant, a director of the East India Company and staunch defender of its monopoly, would teach Indians 'the use of their reason'.[236] His colleague William Wilberforce said in 1813: 'we find the morals and manners of the natives of India just such as we might have been led to expect from a knowledge of the dark and degrading superstitions, as well as the political bondage, under which they have been so long bowed down.'[237] As a member of the governor-general's Council, Thomas Babington Macaulay in 1835 argued successfully that Indians should be taught English, which would give them access to modern learning and science, whereas to educate them in Arabic and Sanskrit would confine them to texts packed with obsolete and false information. Although English became a lingua franca of India, and remained so even after independence, Macaulay displayed a regrettable lack of sympathy for Eastern literature: 'I have read translations of the most celebrated Arabic and Sanskrit works,' he said, and he had consulted Orientalists who knew the texts in the original, but 'I have never met one of them who could deny that a single shelf of a good European library was worth the whole native literature of India and Arabia.'[238]

## THE PRIMITIVE

Cosmopolitanism was supported by travel, not only in space, but across time. Literature gave educated people access to the past. The analogy between exploring other countries and exploring the past had already been pointed out by Descartes: 'conversing with those of past centuries is much the same as travelling'.[239] It might of course be difficult to appreciate literary depictions of past periods whose manners were markedly different from those of the present. Hume discusses this problem with reference to the *Odyssey*, where Nausicaa, though a king's daughter, goes down to the

seashore with her maids to do the laundry, and Achilles himself roasts pork and goat's meat and serves them to his guest Odysseus: 'It is not without some effort that we reconcile ourselves to the simplicity of ancient manners, and behold princesses carrying water from the spring, and kings and heroes dressing their own victuals.'[240] It was a more serious problem that the Greeks often showed their heroes to be not just warlike, but gratuitously brutal. Even in the ancient world Achilles was considered a repulsive character.[241] To the civilized eighteenth century, he could not inspire sympathy. 'We are not interested', wrote Hume, 'in the fortunes and sentiments of such rough heroes.'[242]

Gradually, however, an appreciation developed for the simple manners to be found among real people at the present day. Primitive peoples were to be found, not only in Africa or Tahiti, but also in the European past – and even on the fringes of the European present. The historians who followed the 'four stages' theory gave, as we have seen, a largely disparaging view of primitive society. But they also noticed similarities with the early heroic society described by Homer. These similarities were double-edged. One might note, as Lord Kames did, that the cruelty of the North American Indians was hardly worse than that of Homer's Greeks and Trojans. But the comparison could be turned around: no less than Homer's Greeks and Trojans, hunter-gathering peoples could display the heroic virtues. Even Adam Smith, the analyst and eulogist of commercial society, praised the 'heroic and unconquerable firmness' with which native Americans were reported to endure torture.[243] Adam Ferguson, who, disagreeing radically with Smith, deplored the low emotional temperature of commercial society, praising the virtues of the ancient Germans, as recounted by Tacitus, and the generous courage shown in clan warfare.[244]

Lafitau, having been a missionary to the Iroquois of Canada, felt the need to relate the native Americans to classical antiquity. He did so by two means. He puts forward a diffusionist theory that the Huron and Iroquois are descended from the peoples of Asiatic Thrace, who spread into the Persian Empire and thence passed through 'Tartary' into America via a land-bridge or narrow strait. But he also adopts a comparative ethnographic method, noting similarities between North American customs and those of the early stages of Greek and Roman civilization. Thus he compares the Americans' councils of war with those of the early Roman Republic, and their wars, in which numerous nations form confederacies, to the war waged against Troy by a confederacy of Greek nations.[245] Kant may be following Lafitau when he compares the American Indians to the Spartans and their warlike expeditions to the voyage of the Argonauts: 'Jason is superior to Attakakullakulla only in the honour of having a Greek name.'[246]

It was now possible to understand Homer, not as the *poeta doctus* imagined by Renaissance commentators, but as a primitive bard. Thomas Blackwell, professor of Greek at Marischal College, Aberdeen, from 1723 to 1757, tried to place Homer in his historical setting, as the product and historian of a Bronze Age warrior culture. Homer was not a learned poet but 'a stroling indigent Bard'.[247] Neoclassical critics had objected to Homer's heroes as undignified; Blackwell replied that they were natural. Homer was thus – in contrast to the oversophisticated Virgil – the poet of natural feeling and emotional truth.[248]

Even more excitingly, remnants of primitive poetry could still be found in modern Europe. Among Blackwell's students at Aberdeen was the Highlander James Macpherson, born near Kingussie in 1736. Macpherson straddled two cultures. At Aberdeen, Edinburgh and, later, London, he moved in modern commercial society. But the society he came from had not yet emerged from the pastoral state. Highlanders lived by herding and raiding cattle. Their clans were held together by family loyalty, not by enlightened self-interest. To the devotees of improvement, the Highlands seemed in need of drastic reform. In 1741, the Society in Scotland for Propagating Christian Knowledge described them as the home of 'Ignorance, Popish and even Heathenish Superstition, Profaneness, Idleness, Theft, and many other Disorders'.[249] Within the 'four stages' scheme of civilization, they were two stages back. Later, several of Walter Scott's novels would gain excitement and poignancy by juxtaposing different stages: thus in *Rob Roy* (1817) Bailie Nicol Jarvie, the arch-representative of Glasgow commerce, is, to his embarrassment, the cousin of the Highland outlaw Rob Roy MacGregor. It has been argued that the hero of *Waverley* (1814) travels back through all the stages of social development, even to the age of hunting.[250]

The need to tame the Highlands became urgent after the unsuccessful but very frightening Jacobite rebellion of 1745. The British government was determined to suppress traditional Gaelic culture by forbidding traditional garb, discouraging the use of the Gaelic language, and sending missionaries to inculcate pure Protestantism. Military roads and fortresses (Fort William, Fort Augustus, Fort George) opened up the Highlands and kept them subdued.

At the other end of Europe, similar attention was being given to the inhabitants of the Balkan mountains, known as Morlaks or Morlacchi. Their territory was part of Dalmatia, the extensive mainland possessions of the Venetian Republic that stretched down the Adriatic coast as far as Montenegro. In Dalmatia, as in the Highlands, society was divided into clans or tribes, owing loyalty to a chief, and always ready to engage

in feuds with other clans. To tidy-minded Venetian administrators, the Morlaks were a nuisance because they would not adjust their way of life to the norms of commercial civilization. 'He does not love working the land,' lamented one administrator of the typical 'Morlacco'; 'he is inclined rather to pillage, and succeeds best at arms.'[251] The people of Dalmatia were said to be 'lazy by nature' and 'incapable of discipline'.[252] We recognize here the 'myth of the lazy native', the solely negative view of peoples whose priorities were simply different from those of visiting Europeans.

Both the Highlanders and the Morlaks found defenders. In the latter case, a favourable view was offered by the abbate Alberto Fortis in his book of travels in Dalmatia, first published in 1774. Fortis sympathizes with many of the Morlaks' customs, defends them against the charge of savagery, and describes enthusiastically the warmth and simplicity of their behaviour, contrasting it implicitly with the coldness of more advanced societies: 'The sincerity, truth, and honesty of these poor people, not only in contracts, but in all the ordinary actions of their life, would be called simplicity and weakness among us.'[253] They are hospitable to strangers and generous to the poor. Again in contrast to commercial society, they are extravagant and improvident, with 'little notion of domestick economy'.[254] Friendship among them is lasting, and solemnized by ceremonies; quarrels are even more durable, being transmitted down the generations as hereditary feuds. Whether Catholic or Orthodox, the Morlaks are superstitious, and believe firmly in witches, fairies, ghosts and vampires. In short, they have the virtues and the shortcomings of a society that is still remote from modern sophistication and corruption.

According to Fortis, the Morlaks are very fond of poetry, which is sung to the *guzla*, a one-stringed instrument, and often sigh and weep at passages that to Fortis seem unremarkable. Fortis has often heard poets perform at some length 'extempore': this must be the technique of oral poetry which was studied in the twentieth century by Albert B. Lord, and provided insights into the composition of the Homeric epics.[255] Fortis translated some of their heroic songs, in which he found 'the simplicity of Homer's times': 'some of them appear to me both well conducted and interesting, but I very readily allow, that they cannot be put in competition with the poems of the celebrated Scotch bard.'[256]

The 'Scotch bard' is of course Ossian, or rather 'Ossian'. James Macpherson defended Gaelic culture by presenting the reading public with what purported to be ancient Gaelic epics, *Fingal* (1762) and *Temora* (1763). It was established as early as 1805, after an investigation by the Highland Society of Scotland, that while Macpherson's epics were

certainly not authentic as entire works, they did include a number of bal-
lads that still circulated in the Highlands. These were placed within a
narrative framework derived from legends that were still current, concern-
ing resistance by the Scots, under Fingal king of Morven, and the Irish
against invaders from Lochlin (Scandinavia).

Although 'Ossian' was not a Scottish Homer, the poems that Mac-
pherson ascribed to him should not be written off as a mere fraud. In the
folk-ballads Macpherson knew, an apparatus of magic and fairy lore
obscured the contours of heroic conflicts. Macpherson wanted to strip
away the superstitious accretions and reveal the heroic narrative that Scot-
land *ought* to have had.[257] It is even likely that, like other inventors of
tradition, he did not feel he was spreading an untruth. Scotland, like other
countries, must have had ancient epics; he was simply helping them from
virtual existence into actual existence. Similarly, Václav Hanka, who pro-
vided enormous support for Czech nationalism by claiming in 1817 to
have discovered a medieval epic, the Queen's Court Manuscript, which
he had in fact written himself, probably did not think of himself as a mere
dishonest forger but as usefully filling an accidental gap in national
tradition.[258]

The Edinburgh literati who were ravished by 'Ossian' in the 1760s did
not get what they thought they were getting. But they got something that
appealed powerfully to contemporary taste: hence the enthusiasm for
'Ossian' that rapidly spread across Europe. In contrast to the measured,
sedate verse characteristic of the early eighteenth century, 'Ossian' offered
the plangent emotions that were thought characteristic of ancient poetry.
Robert Lowth had shown in his Oxford lectures that the poetry of the
Old Testament expressed emotion through devices such as parallelism. In
Greek, the complex syntax of Pindar's odes was thought to be an expres-
sion of overwhelming emotion. Macpherson conveyed intense laments
more accessibly, using simple vocabulary and syntax, and making heavy
use of the parallelism that Lowth had discerned in Hebrew poetry.[259]
Other modern poets aimed for similar effects. Thomas Gray's 'The Bard',
presented as a 'Pindaric Ode' on a Welsh theme, excited contemporaries
with its stirring opening: 'Ruin seize thee, ruthless King!'[260] Friedrich
Gottlieb Klopstock went further and described himself as a bard; besides
his emotional odes, he wrote plays about the ancient Germans which he
called 'Bardiete'.

Macpherson, by reproducing poetic effects in rhythmic prose, created
a form of literature that lent itself to translation; hence its Europe-wide
appeal and the extraordinary testimonies to 'Ossian' with which the later
eighteenth century is filled. Thomas Jefferson wrote in 1773: 'I am not

ashamed to own that I think this rude bard of the North the greatest Poet that has ever existed.'[261] It is a sad irony that a supposed ancient Gaelic poem was celebrated at a time when the government was trying to extirpate the Gaelic culture of the present, and that the Gaelic poets of the eighteenth century – not primitive bards, but educated moderns, such as Duncan MacIntyre and Alexander MacDonald – remained unknown, even to the literati of Edinburgh.[262]

Among the many late-Enlightenment enthusiasts for real or supposed primitive poetry, Goethe stands out by his creative response. The original version of Fortis's book included a transcription and translation of the *Hasanaginica*, or 'Lament of the Noble Wife of Asan Aga'. Goethe, who read the German translation, adapted it in 1774–5 as the poem 'Klaggesang von der edlen Frauen des Asan Aga'. Earlier, having read 'Ossian' in German, Goethe obtained an English edition which contained a 'specimen' of 'Ossian's original' – in fact Macpherson's translation into Gaelic of Book VII of *Temora*. He also got hold of Gaelic dictionaries and attempted his own translation of some passages, though it is unclear whether he was working from the Gaelic or the English.[263] In addition, he included several long extracts from 'Ossian' in his novel *The Sorrows of Young Werther* (1774).

Interest in primitive culture, therefore, did not have to wait for Romanticism, but grew out of the Enlightenment. The 'discovery of the people' was a Europe-wide phenomenon.[264] It showed itself first in a new interest in popular ballads. As early as 1711 Addison in the *Spectator* gave an appreciation of the old ballad 'Chevy Chase', arguing that its popular character testified to its merit: 'for it is impossible that any thing should be universally tasted and approved by a Multitude, tho' they are only the Rabble of a Nation, which hath not in it some peculiar Aptness to please and gratifie the Mind of Man.'[265] The most prominent ballad collector of the mid-eighteenth century, Thomas Percy, is best known for his ballad collection, *Reliques of Ancient English Poetry*, which first appeared in 1765.[266] Herder, in his anthology of folk poetry, published initially as *Volkslieder* (1778–9) and later as *Stimmen der Völker in Liedern* (*Voices of the Nations in Songs*, 1807), includes songs and ballads from many parts of Europe, from Spain to Estonia, and even a song from Peru, addressed to the rain-goddess, which he had found in a book of travels.[267] By the end of the century, the 'people' had been promoted from 'the Rabble of a Nation' to its backbone – the relatively unlettered population which sustained a nation's character and traditions. The way was open for the Romantic cult of the *Volk*.

## CULTURAL COSMOPOLITANISM:
## FORSTER AND HERDER

The immense increase in contacts among different parts of the world is often seen as anticipating what we now call globalization. But there is a danger of anachronism here. Present-day global consciousness has been made possible by the breathtakingly rapid development of communications since the early 1990s. Nothing like the World Wide Web was remotely imaginable in the Enlightenment, and it has remarkably seldom been anticipated even in science fiction. For the Enlightenment, global connections meant first and foremost international trade, which could link diverse regions by supplying each with what it lacked, and thus establishing a beneficial system of exchange. 'The Infusion of a *China* Plant [is] sweetened with the Pith of an *Indian* Cane', wrote Addison in 1711.[268] The benefits appear more uneven, however, when we reflect that the sugar in Addison's tea came from slave labour in West Indian plantations, and when we consider the intense efforts of merchants to turn bilateral exchange into one-sided exploitation by establishing the monopolies that Adam Smith so castigated. Nevertheless, Enlighteners as different in their outlooks as Diderot and Smith went on making the case for global free trade against protectionism – an argument still raging today.

To understand the significance of global links in the Enlightenment, we need to ask what sort of understanding of other people and peoples they made possible. A sympathetic appreciation of other cultures, whether separated in space, or time, or both, has been defined as 'cultural cosmopolitanism'. This outlook neither maintains the supreme value of one's own culture, nor does it claim that all cultures are equally valuable:

> Eighteenth-century cultural cosmopolitans are neither relativists nor ethnocentrists. They want to have it both ways: they wish to preserve open-minded engagement with other cultures in a way that takes their particularity seriously, and yet they reject relativism. They do this by grounding the standard for evaluation in a common humanity that underlies all cultural forms.[269]

The prime spokesman for such an outlook was Johann Gottfried Herder. Among his many achievements as scholar, theologian, literary and cultural critic, and philosopher, Herder put forward, with passionate enthusiasm, a positive conception of cultural cosmopolitanism. He did so most comprehensively in his *Ideen zur Philosophie der Geschichte der Menschheit* (*Ideas on the Philosophy of Human History*, 1784–91), a vast panorama

that first describes the setting for human life, one planet among many in the universe, and then explores humanity's physical, moral and cultural nature. In doing so, Herder is guided by the concepts of *Humanität*, *Bildung*, and *Kultur*, which, as he developed them, would have a lasting impact on the Weimar Classicism centred on Goethe and Schiller.[270] Herder presupposes that the organic world forms a great unity, driven by a single vital energy, with no sharp distinction between spirit and matter, mind and body, humans and animals. All are linked in the great chain of being. The analogy between the growth of a human being from an embryo, and that of a plant from a seed, illustrates this unity.

Herder's philosophy of history is founded on anthropology, the study of human nature. He identifies seven main attributes as fundamental to humanity.[271] The first is peacefulness, for our physical form is not designed for aggression. Then comes the sexual urge, which finds its best expression in marriage based on mutual consent. Thirdly, our ability to hear what other people say grounds our sympathy with others. Fourthly, maternal love, combined with a child's long period of dependence on its parents, is the foundation of social life. Fifthly, our relations with others are kept on an equal footing by our sense of fairness (Herder prefers the tolerant-sounding *Billigkeit* to the severe *Gerechtigkeit*, or justice). Next comes *Wohlanständigkeit* (decency and comeliness of appearance), which emphasizes the beauty and shapeliness of the human body – instead of its being disfigured with the elaborate hairdos of some members of the upper classes or the piercings and mutilations reported by travellers beyond Europe. Finally, true humanity includes religion, which is essentially the hope for immortality. These attributes together constitute our basic *Humanität*, and the purpose of history is their full development. So the word *Humanität* means not only our basic endowment but the goal towards which we are striving. It both describes human nature and provides a yardstick by which to estimate progress or regression.

*Humanität* can only be realized in the individual; otherwise it would be a meaningless abstraction. Each individual is situated in a particular place, connected via the family with a wider people (*Volk*), whose national character is expressed in its language. The individual is further connected with the rest of humanity through the chain of cultural transmission. This cultural chain enables us to be rational. For Herder, reason is not a timeless, quasi-logical faculty; it means refining and applying the sedimented wisdom of previous generations, 'the ongoing work of the *Bildung* of human life'.[272] Chains of tradition and sympathy always converge here and now in the unique individual: 'What each person is and can be, must be the purpose of the human race; and what is this? *Humanität* and

happiness in this place, to this degree, as this particular link in the chain of *Bildung* that stretches through the entire race.'[273]

In history, each people makes its own contribution to *Humanität* through its distinctive culture. No people is wholly without culture. Herder writes about 'primitive' peoples with sympathy and defends them against their detractors. Cultural diversity expresses the richness of *Humanität*; Herder even uses the word 'diversity'.[274] History recounts the progress, even the perfectibility, of our species. Herder is no starry-eyed optimist: he acknowledges atrocities, massacres, long periods of despotism in history, calling them 'errors and failures'.[275] But, like storms in the atmosphere, violent passions and conflicts are necessary in history and spur us on. Even war generates new inventions. The increased deadliness of weapons means that only potentates, not marauding chieftains, can now wage war, and improves the chances of peace. Thus progress is indirect, irregular, like a mountain torrent, or even like humanity's basic action of walking:

> The whole course of culture on our earth, with its broken corners and rough edges, hardly ever resembles a gentle stream, but rather a torrent plunging down the mountains . . . As our gait is a constant falling to right and left, and yet we advance with each step, so also is the progress of culture in human generations and entire peoples.[276]

These ideas, expressed with Herder's infectious enthusiasm, are inspiring, and also liberal and generous. Since he finds some value in every culture, Herder is no nationalist, though his ideas may subsequently have been misused by nineteenth- and twentieth-century upholders of German supremacy. Nor is he a complete relativist for whom different cultures are incommensurable.[277] His conception of *Humanität* offers normative standards by which cultures may be judged. All cultures contribute something, but not all contributions are equally valuable: Herder praises the peaceful Egyptians, the inventive Greeks – or as he also calls them, 'the enlightened Greeks'[278] – and the industrious Phoenicians, but he deplores the Romans' urge for conquest, the tyranny they exercised over conquered peoples, their destruction of alien cultures, and their failure to transmit even much of their own literature to later ages. On Islam he offers a highly differentiated judgement, praising the monotheism and morality of the Koran and the Arabs' preservation and cultivation of the sciences, but regretting the despotic prohibition of free intellectual inquiry and, in particular, the prohibition on historical study of the Koran. His narrative ends with the close of the Middle Ages. He argues that the tyranny of the medieval Church was beneficial in exercising some control over uncouth and warlike nations, but he sees the germs of modern freedom and

enlightenment in the commercial cities. 'Cities carried out what rulers, priests and nobles neither could nor wished to achieve: they created a Europe that worked together for common purposes.'[279]

If the argument concerning cosmopolitanism is pursued through more recent history, it has to address the tension between conquest and cosmopolitanism in the expansion of Europe. In dominating the globe, have Europeans simply subjugated other peoples? Or have they, irrespective of their own intentions, brought different peoples together and thus made possible, at least in the long run, an enlightened cosmopolitanism? These questions are addressed in Georg Forster's essay 'On Local and General Education' (1791). Forster's starting-point is the underlying unity of humanity. Thanks to our geographical dispersion between the Poles and the Equator, humanity's potential has been realized in a great variety of physiques and cultures. Forster considers this diversity valuable in itself. However, he sees a potential conflict between this diversity and the increased dominance of one branch of humanity, the Europeans, who are spreading themselves and their civilization over the entire globe. The Europeans are the bearers of a progressive and inventive culture, as Forster shows by a thumbnail summary of modern history:

> The chivalric spirit, the Crusades, mercantile undertakings, the improvement of navigation, the reawakening sense of human dignity, the first stirrings of the love of liberty against the feudal yoke, as previously against the priestly yoke, the discovery of the Cape of Good Hope and of the route to India and the New World – all were alternately the effect and the cause of new connections among ideas and of the accelerated activity of our mental powers. It was above all the discovery of the East and West Indies that disseminated innumerable new ideas, which in turn, thanks to the invention of printing, brought about an intellectual revolution with incalculable consequences.[280]

Forster does not idealize the process of European expansion. It was powered by such passions as greed, ambition and lust for conquest, and it involved atrocities (*Schandtaten*) which are not to be excused. There may, however, be a higher standpoint than the human, from which the end may have been seen to justify the means. And the consequence is that the Europeans have become more than just another nation: they have acquired a universal quality:

> The specific European character has been replaced by universality, and we are on the way to becoming as it were an idealized people, abstracted from the human race as a whole; such a people, thanks to its knowledge, and,

I should like to add, to its aesthetic and moral perfection, may be called the representation of the entire species.[281]

This is a strong, even staggering claim. Forster seems to mean that, thanks above all to the preliminaries to the Enlightenment – resistance to political and clerical authority; the growth of empirical knowledge – Europeans have emancipated themselves from local traditions and entered into a universal culture, governed by reason, which is open to all humanity. His reference to the moral superiority of Europeans may seem incongruous with his admission of the impure motives and brutal methods present in the expansion of Europe; but his summary of modern history emphasizes the growth of freedom, which may be Europe's gift to the rest of the world.

However, the dominance of reason has its dangers. The intellect, grasping reality in abstract terms, invites us to understand the world in a narrowly mechanical way, and the overarching concept of 'duty' can reduce morality to unemotional, machine-like activity. Yet if we try to discard emotion, we shall be left with an impoverished version even of reason: 'In a human being's personal consciousness, feeling and reason are inseparable.' To save it from withering into dead rationality, European culture needs to be refreshed by the creative forces, the union of 'reason, emotion and imagination', found in every culture, past and present: 'The same basic disposition shines forth from the individuality of Homer and Pindar, Ossian and the Skalds [Scandinavian poets], Moses and David, Saadi and Kalidasa, Shakespeare and Goethe.'[282] Europe needs an aesthetic renewal, made possible especially, in Forster's view, by being open to the rich variety of world literature. He is therefore describing a two-way process. European reason transforms the world; but it is saved from desiccation by being transformed in turn. It is not a question of imposing European norms on the rest of the world, but of coming to appreciate the diversity of human cultures, and thus building up a richer understanding of humanity. As Forster says in his preface to Sakontala: 'Every country has its particular qualities which affect the intellectual powers and the organic structure of the inhabitants. From these diverse individualities, by comparing them and distinguishing the universal from the local, we can develop a more accurate picture of humanity.'[283]

There may be pitfalls, however, in Forster's conception of cosmopolitanism. An aesthetic response to other cultures is not the same thing as humane interaction with the people who compose them. One could imagine a European administrator who appreciated the great Indian epics but advocated harsh treatment of actual Indians. Kant warns against an excessively abstract cosmopolitanism that attends too little to individuals. The friend

of all humanity, practising what Dickens would later call 'telescopic phil-
anthropy', is really no better than the narrow sectarians who, whether
religious or political, are 'destroyers of general good will and philan-
thropy'.[284] Kant advocates 'dutiful global and local patriotism', arguing
that 'both are proper to the cosmopolite, who in fealty to his country must
have an inclination to promote the well-being of the entire world'.[285]

Kant shows no particular interest in cultural diversity. It is not clear
that he ever really disavowed the racism apparent in some early writings.[286]
In the 1790s, however, he puts forward firm and uncompromising theses
about the injustice of colonial conquest. In contrast to his earlier writings,
he does not treat colonial peoples as members of different (and implicitly
inferior) races, but as legal subjects whose shared humanity demands fair
treatment. If the colonists can settle without infringing the rights of the
native inhabitants, then their presence is unobjectionable. But if the inhab-
itants are hunter-gatherers or pastoralists whose way of life requires large
territories, like the Hottentots, the Siberian Tungus, and most native
Americans, then the settlers ought to draw up treaties with them, and
avoid taking advantage of their ignorance.[287] Thus the principles of inter-
national law provide a framework for cosmopolitanism.

Yet neither Herder nor Forster nor Kant can dispel the troubling aware-
ness that cosmopolitanism is made possible by violence. Herder argues
that throughout history, barbarism yields to enlightenment. No modern
European ruler governs his realm as despotically as the ancient king of
Persia, or even as the Romans did; not because modern rulers are neces-
sarily more benevolent, but because reason teaches them that they can
attain their ends better by humane methods than by tyranny. 'The course
of history shows that with the growth of true humanity [*Humanität*] the
destructive demons of the human race have become fewer, in accordance
with the internal natural laws of increasingly enlightened reason and
politics.'[288] However, Herder denies that any providential scheme can pal-
liate violence like that practised by the Romans.[289] Forster speculates that
from a higher perspective, colonial violence may be justified by its end,
but does not think that such a perspective is available to human beings.
Kant acknowledges that such a justification of violence is superficially
plausible, but insists that it cannot wipe away the stain of injustice from
colonial conquests.[290] It may be that human history would never have got
started without violence; but the violence is still deplorable, just as it is
when revolutionaries advocate violent rebellion as a basis for future
justice.

On the other hand, Kant disputes Herder's claim that humanity can
flourish without authority. He quotes Herder's statement from *Ideen*: 'It

would be an *easy* principle, but an *evil* one, to maintain in the philosophy of human history that man is an animal who needs a master, and who expects from this master, or from his association with him, the happiness of his ultimate destiny.'[291] This principle, says Kant, is not evil, and is easy only in the sense that all experience confirms it:

> Does the author really mean that, if the happy inhabitants of Tahiti, never visited by more civilised nations, were destined to live in their peaceful indolence for thousands of centuries, it would be possible to give a satisfactory answer to the question of why they should exist at all, and of whether it would not have been just as good if this island had been occupied by happy sheep and cattle as by happy human beings who merely enjoy themselves?[292]

To leave the Tahitians in their supposedly Arcadian existence would have been a false kindness. They needed to undergo the fortunate fall from animal-like indolence into history and thus into the great project – outlined by Kant in 'Idea for a Universal History with a Cosmopolitan Purpose' – of building a universal free republic. The point of history may be happiness, but a more demanding happiness than comes from lying in the sun and eating breadfruit. It may be the complex happiness that consists in membership of a free, world-wide human community.

> But what if the true end of providence were not this shadowy image of happiness which each individual creates for himself, but the ever continuing and growing activity and culture which are thereby set in motion, and whose highest possible expression can only be the product of a political constitution based on concepts of human right, and consequently of human beings themselves?[293]

# 13

# Forms of Government

*For Forms of Government let fools contest;*
*Whate'er is best administer'd is best.*[1]

Many people in the Enlightenment would have agreed with Alexander
Pope; probably fewer would now. Let us imagine how the cases for and
against an opinion such as Pope's might be put. The following sketches of
ideal-type positions have a bearing on the Enlightenment, and also on our
own day:

'Good administration implies the rule of law under a government that
secures the person and property of every individual, and whose principal
aim is to make its subjects happy. The people who govern, however they
may be chosen, must be taken from the wisest and best men in the state.
Their administration must be efficient, honest, just and impartial. Trade
and industry must be encouraged. Taxation should only be moderate. Pro-
vision must be made for the deserving poor. Crime must be severely punished
so as to deter others. Under such an administration, everyone will have as
much freedom as he can reasonably want. "A good citizen earning his living
by honest work will always enjoy all the liberty he needs."[2] The population
will regard the state, personified by the monarch, with trust, loyalty and
love. Active participation in politics should be left to a minority of people
whose education equips them to understand government and whose own-
ership of property ensures that they will make responsible decisions.'

The reply might run as follows:

'The efficient administration you talk about is the minimum, not the
maximum, that should be expected, and you are naïve if you think that
public spirit is enough to create and maintain it. The educated and prop-
ertied elite has every interest in strengthening its own position at the
expense of those below. The elite will provide for the well-being of the
rest of the population only as much as is necessary to support its own

privileges. Government and its agencies must be regarded with constant distrust; their activities must be rigorously monitored, and their short-comings exposed by a free press. Politicians will only behave responsibly if they have to be re-elected regularly, preferably every year.

'Your sentimental talk of love implies that the state is an extended fam-ily, under the paternal rule of the monarch and his or her ministers. Such a conception is insulting to human dignity. Humanity has now come of age, as Kant said, and a paternalist administration is "the greatest con-ceivable despotism".[3] We insist on our full human rights. All men are equal; as for women, "the tender breasts of ladies were not formed for political convulsions".[4] All men are equally entitled to participate in gov-ernment, preferably by direct democracy, or, if that is not feasible, by representative democracy. The will of the people is sovereign. Active partici-pation in politics is not only the right but also the duty of every citizen.'

Here another voice might interpose:

'Yes, I agree that human beings should be treated as mature and autono-mous, and no government should presume to tell them what will make them happy. We are all individuals, all different. We should each develop our individuality in the richest possible way. But the previous speaker is strangely mistaken in concluding that we should all participate in political activity. Democratic elections may be determined by deceit and corrup-tion. So-called rule by the people can easily become another kind of tyranny. It may impose uniformity and threaten those whose talents raise them above the common level. It is likely to encourage obedience instead of self-reliance. The business of government is only to maintain the rule of law and to secure its citizens against attack. Beyond that, "any State interference in private affairs, where there is no immediate reference to violence done to individual rights, should be absolutely condemned".[5] People should be left to flourish as each one prefers; and life offers many, many more interesting activities than politics.'

## MONARCHY

When thinking about forms of government, or anything else, one has to start from where one is. Enlighteners, looking round eighteenth-century Eur-ope, saw that the prevailing form was monarchy. That comprehended many different types of state, including the constitutional monarchy of Great Britain, the elective monarchy of Poland, the absolute monarchy of France and elsewhere, and the many petty principalities within the Holy Roman Empire. One of the German princes, the elector of Brandenburg, increased

his dignity by having himself crowned in January 1701 as 'king in Prussia'. Further east lay the empire of the tsars, and to the south and east of Russia a number of huge states, from the Ottoman Empire to China and Japan, which were mostly known only to a few travellers, and were classified, as we have seen, under the vague and unsatisfactory term 'Oriental despotism'.

Republics existed, but they were few and relatively small. The most prominent was the United Provinces, or the Netherlands; but there were city-republics also in Italy and Switzerland, including Geneva, which, having Rousseau as its most famous son and Voltaire as a neighbour, played a large part in the Enlightenment's political discussions. The patchwork of the Holy Roman Empire included a number of self-governing Imperial Cities, ruled by patrician elites, among them the great commercial port of Hamburg and Goethe's home town, Frankfurt am Main.

To many thoughtful people, some version of monarchy seemed not only the commonest but the best form of government. 'The obvious definition of a monarchy', writes Gibbon, 'seems to be that of a state, in which a single person, by whatsoever name he may be distinguished, is intrusted with the execution of the laws, the management of the revenue, and the command of the army.'[6] The great advantage of monarchy, but also its glaring weakness, was that succession was (usually) by heredity. Gibbon admitted that it was easy to make fun of the hereditary principle, by which a father transferred the ownership of a kingdom to his perhaps still infant son, 'like a drove of oxen'.[7] But his *History* showed that when there was no legitimate or adoptive son to inherit the Roman Empire, its rule had often been determined by the army, or by a civil war among various claimants; once in fact the Empire was put up for auction, and knocked down to a plutocratic senator, who was deposed and executed after only sixty-six days.[8] Hume added that the stability of a monarchy was based on people's 'passionate regard for the true heir of the royal family', a useful prejudice which one should not try to dispel.[9] Yet it was undeniable that some legitimate heirs had turned out disastrously. Bayle instanced Charles VI of France (r. 1380–1422), who, after a promising start, was incapacitated by frequent bouts of homicidal madness, so that throughout his excessively long reign France was divided by power struggles between the prince's close relatives.[10] By the eighteenth century, it was hard to take seriously the doctrine that kings, irrespective of their human failings, had been installed in office by God and were the agents of his will.[11] The divine right of kings may always have provoked scepticism: Shakespeare's formulation –

> There's such divinity doth hedge a king
> That treason can but peep to what it would,

– is put in the mouth of a usurper who has killed his royal brother.[12] When Louis XIV was crowned in Rheims cathedral in 1654, the bishop of Soissons greeted him as 'the Lord's Anointed, son of the Most High, shepherd of the flock, protector of the Church'.[13] His court preacher Bossuet declared that the king was the image of God, that his grandeur mirrored that of God, and hence that there should be no constitutional restraints on the king's power.[14] But Louis himself, as we can see from the instructions for his son that he compiled in the 1660s, took a more down-to-earth view of his responsibilities. For him, kingship was not about charisma but about statecraft and prudent administration. He qualifies his repeated assertion that 'kings are men' by adding: 'they are this a little less so when they are truly kings because their governing and dominant passion is for their interest, for their greatness, and for their glory'; but he is clear that these attributes are not bestowed by heaven but attained through very hard work, not least by taking control of the state's finances and ploughing doggedly through the accounts.[15]

In England, the execution of Charles I, who believed in his divine right to rule, the expulsion of James II, and the installation of William III as a monarch with strictly limited powers, encouraged a soberly practical attitude towards kingship. Hobbes gave just such a demystifying account in *Leviathan* (1651), defending monarchy by showing how it worked better than aristocracy or democracy.[16] Sir Robert Filmer in *Patriarcha: or The Natural Power of Kings* (1680) maintained that God had given Adam absolute power over all other creatures, and that all subsequent fathers therefore possessed such power over their families, and all kings over their subjects; but these extravagant claims were comprehensively demolished by Locke in the first of his *Two Treatises of Government* (written in the early 1680s). 'Most people, in this island, have divested themselves of all superstitious reverence to names and authority,' noted Hume in 1741. 'The mere name of *king* commands little respect; and to talk of a king as GOD's vicegerent on earth, or to give him any of those magnificent titles which formerly dazzled mankind, would but excite laughter in every one.'[17]

Royal power needed to be limited, or at least restrained. Repudiating the divine right of kings, and arguing for limited monarchy, Lord Bolingbroke daringly pointed out that even God's authority was limited: 'God is a monarch, yet not an arbitrary but a limited monarch, limited by the *rule* which *infinite wisdom* prescribes to *infinite power*.'[18] Kings are sacred, but their sanctity is conditional on their governing well, and must be forfeited if their performance is inadequate. '[U]nless public liberty is protected by intrepid and vigilant guardians,' warned Gibbon, 'the authority of so formidable a magistrate will soon degenerate into despotism.'[19] Bossuet was

sure that a king's sense of equity, or, failing that, of his own self-interest, would suffice to regulate his behaviour. Montesquieu was less sure. In describing 'honour' as the governing principle of monarchy, he assumed that a quasi-Newtonian balance would operate, in which the ambition of the king would, if necessary, be countered by his leading subjects' sense of honour, and his impatience would be restrained by the prudent reflections of his legal officers, which would have no place in a despotism:

> The bodies that are the depository of the laws never obey better than when they drag their feet and bring into the prince's business the reflection that one can hardly expect from the absence of enlightenment in the court concerning the laws of the state and the haste of the prince's councils.[20]

Given these safeguards, Montesquieu was convinced that monarchy, free from the arbitrariness of despotism and the disorder of democracy, was the form of government best suited for the present day.[21]

Enlighteners generally agreed with Montesquieu that intermediate institutions were necessary. 'A martial nobility and stubborn commons, possessed of arms, tenacious of property, and collected into constitutional assemblies, form the only balance capable of preserving a free constitution against the enterprises of an aspiring prince,' argued Gibbon.[22] But here theory was in tension with practice. Absolutist rulers were not keen on having their powers restrained. They had devoted their energies to humbling the nobility, often by creating a 'service nobility'. Thus, in France, Louis XIV built up the *noblesse de robe*, who filled high administrative offices and so counterbalanced the old military aristocracy, the *noblesse d'épée*. Some German states retained effective representative assemblies, which occasionally defied their ruler – as when the Estates in Württemberg, in a long struggle, used economic power against a succession of headstrong dukes.[23] But although most absolutist rulers did not have to face parliaments, their absolutism did not mean untrammelled or despotic power; they still had to negotiate with powerful interest groups in order to enforce their will.

Kings were not short of advice. There was a whole long-lived literary genre, 'mirrors for princes', which instructed them how to govern justly. The model was St Augustine's portrait of the happy emperor who rules justly, avoids pride, pardons his enemies, and tempers justice with mercy.[24] Erasmus contributed to the genre with his *Institutio Christiani Principis* (*The Education of a Christian Prince*, 1516). In the eighteenth century such texts were often cast in fictional form, the best-known example being Fénelon's *Télémaque*, in which the son of Ulysses learns the art of government from his tutor Mentor. Taking leave of Telemachus at the end of the book,

Mentor adjures him: 'Remember always that kings are not promoted to the throne to gratify their own ambition, but for the good of their people.'[25]

More reliance might be placed on the rule of law, supported by intermediary institutions. Ancient political theorists had discussed approvingly the separation of powers in the early Roman Republic. Two consuls, who were elected annually and must previously have held lower offices, filled the place of a king; when, as often, they were away leading armies, the senate governed in their stead; and many aspects of government were in the hands of popular assemblies. All three elements had to co-operate, and a property qualification ensured that the assemblies were dominated by the better-off.

A somewhat similar set of balances seemed to exist in England, where the Crown was supported by the hereditary nobility in the House of Lords and the people were represented in the Commons. Voltaire, having lived in England, praised it for 'that wise Government, where the Prince is all powerful to do good, and at the same time is restrain'd from committing evil; where the Nobles are great without insolence, tho' there are no Vassals; and where the People share in the government without confusion.'[26] Montesquieu, as we have seen, commended the distinction drawn in England between the executive power, which belonged to the king, and the legislative power, which was shared between the two Houses of Parliament.[27]

Unfortunately, the practice of English government could not bear very close examination. The Septennial Act of 1716, which required elections every seven years, was often circumvented. Many parliamentary seats were in the gift of powerful noblemen, and patronage, bribery and corruption were standard, often at great expense: in 1754 the Tories spent an enormous £40,000 on the Oxfordshire election in the vain hope of unseating the Whigs (though we should remember what large sums are spent nowadays in the hope of influencing present-day voters through advertising and media campaigns).[28] There were rotten boroughs, the worst being Old Sarum, which no longer had any inhabitants but still returned two members to the Commons, while new industrial towns such as Birmingham and Manchester were entirely unrepresented. In any case, members of Parliament were not considered responsible for their constituents' interests as their present-day counterparts are, and a long-standing requirement that they should live in their constituencies was commonly ignored. As a system of representation, British government was laughable until 1832, when the Great Reform Bill gave the vote to all male householders whose property had an annual rentable value of £10 or more (roughly one-fifth of the adult male population). The idea of giving the vote to all adults lay far in the future, though Wordsworth, strongly conservative in his later

years, predicted that electoral reform (which he deplored) would end in 'universal Suffrage' – as it eventually did.[29]

Although their use of terms is not always exact, enlightened thinkers made a clear distinction between an absolute ruler restrained by respect for law, and a despotic ruler unrestrained by anything. They were especially suspicious of empires, because such large polities could only be held together, as the Roman Empire had been, by military force, and military rule was bound to promote despotism. Adam Ferguson argues that large empires are bound to become despotic because dictatorial powers and military force are constantly required to keep conquered provinces in subjection.[30] Even worse than physical oppression, however, was the moral corruption of the despot's subjects. Raynal said of the Romans: 'Their despotism, their military government oppressed the nations, extinguished genius, and degraded the human race.'[31] His associate Diderot, writing about the tyrannical Roman emperors Claudius and Nero, warned that tyranny would rapidly degrade the morals of the Roman people, substituting 'the pusillanimous murmur of servitude' for 'the noble and proud accents of liberty':

> This is the inevitable development of degradation: the dangerous tone of frankness is succeeded by secretive subtlety, and that in turn by flattery which worships its object, by duplicity which lies with impudence, by vulgar coarseness which insults without ceremony, or by coded language which disguises indignation.[32]

And yet, could there not be benevolent despots? Suppose there were a virtuous ruler, endowed with supreme power, and determined to use it for his subjects' benefit. Such a ruler could be justified in overriding constitutional restraints, ignoring any intermediary powers, and introducing sweeping reforms. Interest groups might complain that the reforms destroyed their privileges, but their grievances would be trivial in comparison with the enormous benefits such a ruler would bestow on his people. The Franco-German *philosophe* Friedrich Melchior Grimm wrote in 1767: 'It has been said that the rule of an ENLIGHTENED DESPOT, active, vigilant, wise and firm, was of all regimes the most desirable and most perfect, and this is a true saying.'[33] Against the bad Roman emperors, one could cite such benevolent rulers as the regrettably short-lived Titus (r. 79–81 CE) and, in the following century, the sequence of Antonines from Hadrian down to the philosopher-king Marcus Aurelius. Gibbon observed: 'If a man were called to fix the period in the history of the world, during which the condition of the human race was most happy and prosperous, he would, without hesitation, name that which elapsed from the death of

Domitian to the accession of Commodus', i.e. from 96 to 177 CE.[34] Gibbon
starts his history at the end of this period because it was a happy interlude
during which practically nothing happened. Invoking 'the Tituses, the
Antonines and the Trajans', Beccaria rhapsodizes: 'How happy humanity
would be if laws were being decreed for the first time, now that we see
seated on the thrones of Europe benevolent monarchs, inspirers of the
virtues of peace, of the sciences, of the arts, fathers of their peoples,
crowned citizens.'[35] Gibbon is more level-headed, noting that thanks to the
statecraft of Augustus, the Romans paid for their happiness with the sac-
rifice of their liberty; and that, since the Roman Empire covered the known
world, a subject discontented with despotism had nowhere to flee to.

## ENLIGHTENED ABSOLUTISM

The Enlightenment witnessed a series of absolute monarchs who proclaimed
their benevolent intentions while carrying through far-reaching and con-
troversial reforms. This form of government has variously been called
'enlightened despotism' or 'enlightened absolutism'. Both terms have been
much debated.[36] The latter, which is now commoner, was coined in 1874
by the economist Wilhelm Roscher, who offered a neat historical scheme:

> In the development of absolute monarchies among modern nations, three
> stages can regularly be distinguished. First comes confessional absolutism,
> represented, for example, by Philip II and Ferdinand II, with the slogan:
> *cuius regio, eius religio*. Then comes courtly absolutism, reaching its peak
> in Louis XIV, with the slogan: *l'état c'est moi*. Finally comes the enlight-
> ened absolutism of the eighteenth century, with the slogan *le roi c'est le
> premier serviteur de l'état*; it favours the term 'machinery of state' and aims
> to form its subjects into as numerous, prosperous and enlightened instru-
> ments of the ruler's will as possible, in accordance with the most ingenious
> theoretical rules.[37]

Roscher's description of enlightened absolutism as hyper-rational and mech-
anical reflects the anti-Enlightenment reaction characteristic of his time.
The slogan defining it, however, is aptly chosen, being taken from the young
Frederick II of Prussia, who used it in his attempted refutation of Machi-
avelli's *The Prince*: 'The sovereign, far from being the absolute master of
the people under his dominion, is nothing else but their first servant.'[38]

The term 'enlightened absolutism' applies to the policies of many
eighteenth-century rulers and their ministers. Charles III of Spain (r.
1759–88), Gustav III of Sweden (r. 1771–92) and Leopold, grand duke of

Tuscany (r. 1765–90) all exemplify it. So do such powerful and determined ministers as the marquês de Pombal in Portugal, who took advantage of the negligence of King José I (r. 1750–77) to push through drastic reforms; the scandalous Johann Friedrich Struensee in Denmark, who became the queen's lover and ended up being executed in 1772 at the behest of the conservative nobility; and Count Stadion, chief minister of the Electorate of Mainz (1743–68), a warm admirer of Voltaire and the other *philosophes*, an enemy of superstition who forbade the local clergy to encourage belief in witchcraft, and the centre of an intellectual circle that included the novelist and essayist Wieland.[39] But the eyes of Europe were focused especially on Peter I of Russia (r. 1682–1725), Catherine II of Russia (r. 1762–96), Frederick II of Prussia (r. 1740–86) and Joseph II of Austria, who reigned jointly with his mother, Empress Maria Theresa, from 1765 to 1780, and was sole ruler from 1780 to 1790. All four were astonishing individuals who confirm that personalities are crucial to history. The first three were dubbed 'the Great'; the fourth may be seen as a tragic figure, who died believing that all his endeavours had failed.

Peter I attracted the attention of Europe by his prolonged conflict with Sweden, known as the Great Northern War (1700–1721). Russia had no access to the sea except in the ice-bound Arctic. Peter, an enthusiast for sailing and shipbuilding, wanted to obtain a suitable base for his projected navy. Together with Denmark and Poland, Russia invaded Swedish territory, hoping to take advantage of the inexperience of its young king Charles XII. The eighteen-year-old Charles, however, astonished everyone by his unsuspected military talents. With 8,000 soldiers, he defeated 40,000 Russian troops at Narva in 1700. However, Peter recovered from this blow, headed off Charles's attempt to march on Moscow in 1708, and inflicted a crushing defeat on the Swedes at Poltava in Ukraine in 1709. Voltaire, who recounts these events stirringly in his *Histoire de Charles XII* (1731), contrasts Charles, the embodiment of an outdated heroic ideal, with Peter, whose battles were fought in the service of his country. Charles was obsessed with glory, Peter with the project of civilizing Russia.[40] Poltava was a historical turning-point. Charles's defeat just meant that the world had one hero fewer; but 'if the Tsar had perished, immense labours, useful to the entire human race, would have been buried with him, and the largest empire in the world would have fallen back into the chaos from which it had scarcely been drawn.'[41]

Peter was determined to Westernize his country. His resolve was strengthened by his visit in 1697–8 to Holland and England, supposedly incognito (though as he was six feet seven inches tall, most people realized who 'Peter Mikhailov' was). In London he visited the Royal Society and

may have met Isaac Newton, though conclusive evidence is lacking.[42] He perfected his knowledge of shipbuilding by working in Europe's largest shipyard at Amsterdam. Later, the territories he conquered from Sweden on the eastern coast of the Baltic (present-day Estonia and Latvia) and on the southern shore of the Gulf of Finland gave him access to the sea, scope to build a navy, and a site for his new capital, St Petersburg. Founded in 1703, it had acquired its first major buildings, including the Summer and Winter Palaces and the Alexander Nevsky monastery, by 1710, and the avenue later called the Nevsky Prospect was laid down in 1711; by 1714 the city had 50,000 houses. Building a city on a mosquito-infested swamp, where only a few villages and a Swedish fortress had previously stood, required vast expenditure of money and people. Workers were drafted in at the rate of 30,000, later 40,000, for the summer building season each year. Huge numbers died: Voltaire says coolly that the project cost 200,000 lives.[43] As Russians were reluctant to move to this cold, unhealthy and expensive new site, Peter commanded a thousand officers and bureaucrats to move there and build houses at their own (sometimes crippling) expense.[44]

The new capital, displacing Moscow, marked a symbolic break with the past. It helped Peter to reduce the power of the Orthodox Church, whose patriarch had his seat in Moscow. There was comparable symbolism in Peter's reform of the calendar. Traditionally, years were counted from the creation of the world; Peter imposed the Julian Calendar, so that the new year now began on 1 January instead of 1 September, and the year 7207 became 1700. In another form of symbolism, Peter insisted that Russians should shave their beards and replace their long robes with Western clothing. He actually shaved some noblemen himself – an extremely palpable assertion of his power (imagine a giant barber working on your face with a cut-throat razor). Traditional noble titles, such as 'boyar', were allowed to die out – by 1718 there were only six boyars left – and replaced with such European titles as prince, baron and count, listed in Russia's new 'Table of Ranks' of 1722. This reform was both symbolic and substantive: it did not diminish the aristocracy, but converted it from a hereditary into a service nobility expected to undertake a range of military, civil and courtly offices.[45] Peter's further reforms – to education, to bureaucracy, to Church organization – will be discussed below, alongside comparable measures by other enlightened potentates.

Insofar as Peter's reforms were not inspired by enlightened philosophers, he fails to match the standard model of an enlightened despot. He sought the company of foreigners in Russia, and may have joined a Masonic lodge, but practically the only piece of enlightened writing he knew was an essay from the *Spectator*, comparing him with Louis XIV,

which an officer read aloud to him.[46] Voltaire, in his *La Russie sous Pierre le Grand*, does not describe Peter as *éclairé*, but as a great legislator and as an exponent of *police*. Peter is the 'modern Scythian who has civilized (*policé*) so many nations'.[47] Peter's travels in Western Europe had acquainted him with the 'police state' run by administrators, and he aimed to transplant this model to Russia, though perhaps relying more on coercion than consent.[48] His many reforms listed by Voltaire under the heading of *police* included the prohibition of luxury; the establishment of schools teaching basic mathematics, and of orphanages and foundling hospitals; the banishment of beggars from cities; the standardization of weights and measures; regulating the prices of essential goods; and encouraging manufactures. We can therefore count Peter as a representative of the practical Enlightenment discussed earlier in Chapter 8.

Peter's achievement in modernizing Russia was hugely admired by distant observers. He seemed a modern counterpart to those semi-legendary lawgivers of genius, such as Lycurgus in Sparta and Solon in Athens, who had created their countries' constitutions. James Thomson hailed him in *The Seasons* (appropriately in 'Winter') as 'Immortal Peter! First of Monarchs!'[49] More information generated doubts. To reach the throne, Peter had had to suppress persistent rebellions led by his half-sister Sophia, whom he confined in a convent, and by the *streltsy* (armed guards), of whom he had 1,182 executed; some were broken on the wheel and had their corpses hung up outside the windows of Sophia's convent.[50] After learning via Frederick the Great about Peter's violent treatment of his enemies, and even of family members, Voltaire wondered how he could be 'an abominable executioner, and a legislator'.[51] When in 1757 Voltaire accepted a commission from Empress Elizabeth of Russia to write a book on Peter, he stipulated that he should say little about Peter's wars and nothing about his private life, in order not to disclose 'odious truths'.[52] The resulting eulogy, *La Russie sous Pierre le Grand*, struck Voltaire's fellow-*philosophes* as a shameful, even nauseating exercise in flattery.[53] It found an informed critic in Sir Nathaniel Wraxall, a British traveller who toured Northern Europe in 1774–5, and who thought Voltaire had strengthened the 'general delusion' about Peter's excellence.[54] Wraxall admits his own admiration for how the previously barbarous 'Muscovites' were 'forcibly torn from this night of ignorance, and compelled to accept of knowledge, of refinement, and of civilization', but criticizes Peter for the 'unlimited severity, perhaps cruelty' with which he imposed his reforms, and for building his new capital, at immense human cost, in a remote and unhealthy corner of Russia, thus making it harder to control his immense Asian dominions.[55]

Thirty-seven years after Peter's death, an equally remarkable figure ascended the Russian throne. Sophie of Anhalt-Zerbst, a member of the minor German nobility, who took the name Catherine on marrying the future Emperor Peter III in 1745, is one of only two women to earn a sculpture in Walhalla, the German hall of fame established in 1842 near Regensburg (the other is Empress Maria Theresa). As Catherine the Great, she has divided historians. Some see her as an exceptionally intelligent and dedicated ruler, 'probably the most cultured person ever to sit on the Russian throne', who genuinely tried, with great pains and at least partial success, to reform her country's government on enlightened lines.[56] Others disparage her as an autocrat who only read Enlightenment texts because she was bored during the long northern winters, flattered the *philosophes* for their value as propagandists, composed her legislation not to benefit her people but to impress the West, and concentrated on ruthless and amoral power-politics.[57] She has been censured for taking a succession of lovers during and after her marriage to her certainly repulsive and probably impotent husband, and for her possible complicity in her husband's death in the palace coup which placed her on the throne. Being committed both to enlightenment and to *Realpolitik*, it is no wonder if she found Enlighteners sometimes impractical and airy-fairy.[58] She may well have resembled the fascinating and formidable person created by George Bernard Shaw in *Great Catherine* (1913), who controls her rage by admonishing herself: 'Europe is looking on' and 'What would Voltaire say?'[59]

Catherine's enlightened aspirations, which placed her far ahead of her Russian contemporaries, are clear from her summoning a Legislative Commission to draft a new code of laws for Russia. To guide its deliberations, she worked hard on composing the *Nakaz*, or Instruction. This lengthy document, issued in 1767, partly describes the government of Russia, partly indicates how the government should be remodelled on lines taken largely from Montesquieu. Of its 526 articles, 294 are drawn from *The Spirit of the Laws*.[60] Catherine affirms the absolute power of the sovereign, but makes it subject to the fundamental laws of the empire. She envisages intermediary powers such as Montesquieu advocated – not local assemblies or corporations, however, but legal institutions. All citizens are equal under the law, but society should nevertheless be divided into nobility, burghers and agricultural labourers. There is no question of abolishing serfdom, and indeed Catherine warns that it is dangerous to liberate too many at once, but she also suggests that serfs should own some private property – an idea which her alarmed confidants rejected as liable 'to bring down walls'.[61] Turning to legal procedures, Catherine draws extensively on Beccaria in rejecting torture, whether as a means of

investigation or as punishment. Some economic concepts, notably the rules for taxation and the prohibition of monopolies, can be traced back to Adam Smith, having been transmitted by Russian students who attended his Glasgow lectures.[62]

The Instruction attracted attention throughout Europe. The French translation was considered too radical to be published in Paris, and appeared only in Neuchâtel, which had been a Prussian principality in Switzerland since 1707. At home, most of its proposals foundered on the parochial conservatism of the Russian aristocracy. However, Catherine did reorganize the structure of provincial government into smaller, more manageable units, and introduced the rudiments of political represent-ation at local level. On the other hand, her measures increased the number of serfs, who were now forbidden to petition the empress or the govern-ment with grievances against their owners. During her reign, increasing discontent among the serfs was manifested in alarmingly frequent revolts: twenty-seven uprisings in the year 1767 alone.[63]

Besides composing, or compiling, the Instruction, Catherine was a ver-satile author. She translated Marmontel's *Bélisaire* into Russian, including the notorious profession of deism that had caused the novel to be banned in France. She wrote satirical journalism, fairy stories for her grand-children, an account of Russian history and some two dozen plays, besides her memoirs. Her plays, mostly comedies but including a Shakespeare-style historical drama set in pre-Christian Russia, were successfully (and anonymously) performed not only in Russia but also in Germany. Like other Enlighteners, notably Schiller, she thought theatre an excellent way of teaching morals and manners, and once said: 'Theatre is a national school . . . I am the senior teacher in this school.'[64] She was also an adroit, vivid and witty letter-writer.[65]

Catherine was keen to have contact with leading *philosophes*. She initi-ated a correspondence with Voltaire, which lasted until the latter's death in 1778 and has (unkindly) been called a 'mutual congratulation society'.[66] Voltaire loved contact with powerful rulers, while Catherine was no doubt aware that as Europe's most gifted journalist his writings could enhance her reputation.[67] She corresponded also with her fellow-German, the *phil-osophe* Grimm, a friend of Diderot and Rousseau, and had many conversations with him during his stay in St Petersburg in 1773–4. She invited d'Alembert to come to Russia as tutor to her son but was met with a refusal. She showed particular kindness to Diderot, buying his library so that he could provide his daughter with a dowry, and appointing him her librarian. During Diderot's stay in Russia in the winter of 1773–4, they had informal conversations on three afternoons a week, the empress

sitting on a sofa and Diderot opposite her in an armchair.[68] If she was sometimes impatient with Diderot's theorizing, she was probably preoccupied by the rebellion in south-eastern Russia led by the Cossack Yemelyan Pugachev, which began in autumn 1773 and was not finally suppressed until Pugachev's execution in January 1775. Every effort was made to keep the rebellion secret; Diderot may not have known about it.[69]

Voltaire gave her the most unreserved adulation. He interpreted her foreign policy not as a struggle for power, but as a campaign to spread enlightenment. Her intervention in Poland, where she ensured the election of her ex-lover Stanisław Poniatowski to the throne by surrounding Warsaw with Russian troops, was understood by Voltaire as a defence of Polish non-Catholics against harassment by the Catholic nobility. In an essay written to defend Catherine's civilizing mission, he asserted that the Russian troops in Poland were 'ministers of peace'.[70] The first partition of Poland, in 1772, when Russia, Prussia and Austria annexed extensive border regions, initially shocked him, but then gained his approval (whereas Diderot, though unsympathetic to 'those fanatics of Poles', privately called it 'an offence against the human race').[71] He enthusiastically supported Catherine's war against the Ottoman Empire, urging her to drive the benighted and superstitious Turks out of Europe and even to conquer Constantinople: 'it is not enough to humiliate them, they need to be destroyed'.[72] Eventually, however, Voltaire realized that in international power politics he was out of his depth. He wrote to Frederick II of Prussia in 1775:

> I was caught like a fool when I believed in all good faith, before the war with the Turks, that the Empress of Russia had reached an agreement with the King of Poland to ensure just treatment for the dissidents, and to establish liberty of conscience. You kings, you put us on our guard, you are like Homer's gods who make men serve their purposes without these poor people suspecting it.[73]

Voltaire was slow to learn, for his earlier involvement with Frederick had been bruising. Frederick, who ascended the Prussian throne in 1740, liked to be called a philosopher-king and advertised his commitment to the Enlightenment. In extreme contrast to his brutally authoritarian and uncultured father, Frederick William I, who cared only for soldiering, hunting and hard drinking, young Frederick loved the arts, read widely (especially Bayle, Voltaire and Montesquieu), composed poetry and music, and played the flute to a high standard. One of his first acts on taking office was to commission a Palladian opera-house at Berlin. Although officially he supported Protestantism, privately he regarded all forms of Christianity with contempt.[74] He revived the Berlin Academy, which had

been founded by Leibniz in 1700 but neglected by Frederick William I, and invited the distinguished French scientist Maupertuis to become its president. He also provided a refuge for the notorious materialist La Mettrie, who had been expelled from France and even from usually tolerant Holland. Other noted *philosophes* settled in Berlin, including the marquis d'Argens and the popularizer of Newton, Francesco Algarotti (with whom Frederick may have had a homosexual relationship).[75]

Above all, Voltaire, with whom Frederick had corresponded since 1736, and who corrected the grammar and spelling of Frederick's French poetry, arrived in 1750 for an extended stay, supported by a generous salary. Things soon went wrong. Voltaire entered an illegal business transaction with one Abraham Hirschel; it ended in a lawsuit and a public scandal. Even worse, Voltaire got into a feud with Maupertuis and wrote a bogus psychiatric report on him, entitled *History of Doctor Akakia*, which Frederick caused to be publicly burned.[76] When Voltaire left Prussia in 1753, he took with him not only the pamphlet, which he got reprinted in Saxony, but a book of Frederick's poems, which had been privately printed for circulation among the king's intimates. Fearing that Voltaire would publish the poems, including satires against other monarchs, Frederick had him arrested at Frankfurt and detained until the poems were returned.[77] Frederick and Voltaire never met again, but they resumed their correspondence in 1757 and continued it until Voltaire's death in 1778.

In happier times, Voltaire had helped the new king Frederick to publish his political manifesto, the *Anti-Machiavel*.[78] Here Frederick undertook a chapter-by-chapter refutation of the advice given by Machiavelli in *The Prince*. Where Machiavelli encourages a prince in amoral power-seeking and self-aggrandizement, Frederick insists that a prince must be selflessly devoted to his duties: 'The first sentiment of a prince must be the love of country, and his only concern should be to work for the good of the state, to which he must sacrifice his pride and all of his passions.'[79] Where Machiavelli, asking whether it is better to be loved or feared, prefers the latter, Frederick says that even on pragmatic grounds a sovereign should seek to win his people's love: 'a prince who has the gift of being loved will reign over hearts since his subjects find it convenient to have him as a master.'[80] Dealing with other powers, a prince should always keep his word, and should avoid wars of conquest. War is justified in self-defence, to secure one's rights and to forestall a possible attack.[81] Machiavelli's principles are in any case outdated. Nowadays, the virtuous Fénelon is a far better guide for princes: 'if in reading M. de Fénelon's *Telemachus* it seems as if our nature approaches that of the angels, it appears to approach the demons of hell when one reads the *Prince*.'[82]

These edifying maxims, however, seemed to be flatly contradicted by Frederick's actual conduct, which was determined by *Realpolitik*. If his first act as ruler was to commission an opera-house, practically his second was to invade the neighbouring Austrian province of Silesia. Emperor Charles VI, having no male heir, had secretly persuaded several nations, including Prussia, to agree to the Pragmatic Sanction, by which his daughter Maria Theresa should, exceptionally, be acknowledged as Habsburg ruler. No sooner was the emperor's death announced in October 1740 than Frederick planned to break his father's undertaking, and in December Prussian troops entered Silesia, rapidly overran it, and retained it after several years of conflict. This of course was a flagrant breach of faith. But it was not inconsistent with Frederick's principles, which, it has recently been argued, 'constituted a revision rather than a rejection of the idea of reason of state'.[83] The *Anti-Machiavel* allowed for the possibility of a pre-emptive attack. After all, international relations resembled a shark pool. If Frederick had remained inactive, Silesia might well have been seized by another state – probably Saxony, which, being then in personal union with Poland, would have secured a rich territory connecting the two kingdoms and would have partially encircled Prussia. His invasion gave him the chance to enlarge his own kingdom, establish Prussia as a major European power, and gain the military glory which he had disparaged in the *Anti-Machiavel*. In his *Histoire de mon temps* (*History of my own Time*, 1775), Frederick describes how he, in 1740, exhorted his troops to remember their country's past victories, and to make glory their main object; he concluded: 'I shall lead you unremittingly to the appointment with glory that awaits us.'[84]

At war, Frederick revealed a talent for strategy unsuspected in the precious aesthete whom his father had dismissed as an effeminate fool.[85] Since marrying, and gaining some independence from his father, Frederick had applied himself seriously to soldiering. His dedication paid off spectacularly in the Seven Years War, as did the merciless discipline established in Prussia's troops by his father and continued under Frederick. The war began with another pre-emptive attack. Having formed a loose alliance with Britain, Frederick feared a joint assault from a coalition comprising France, Austria and Russia. Rather than wait, Frederick invaded the kingdom of Saxony and used it as a base for operations. Of sixteen battles, Frederick won eight, including the shattering defeat of the French at Rossbach in 1757.[86] But in 1759 the Prussian army was severely defeated at Kunersdorf; Berlin was occupied and plundered. Prussia was saved only by disunity among its opponents and by the death of Empress Elizabeth of Russia, whose short-lived successor, Peter III, an admirer of Frederick,

withdrew from the conflict. The war was concluded by the Peace of Hubertusburg in 1763. Nothing had changed – no power had gained or lost any European territory – except that an estimated 400,000 Prussian subjects had died; Prussia had established itself as a major power, equal to Austria; and Frederick was widely considered 'the greatest man of his century'.[87]

Inevitably, Frederick was also controversial. It was often asserted that he had denounced Machiavelli in theory but followed his precepts in practice. Rousseau condemned his cynicism: 'I can neither esteem nor love a man without principles, who tramples the entire law of nations underfoot, who does not believe in virtue but regards it as a bait with which to delude fools, and who began his Machiavellianism by refuting Machiavelli.'[88] 'He follows Machiavelli, although he has refuted him,' agreed Herder in 1769.[89] German writers were not pleased when Frederick, who always wrote in French, dismissed the German language as an uncouth medium which needed a lot more vowels, and rejected Goethe's pioneering play *Götz von Berlichingen* (1773) as 'an abominable imitation' of the plays of Shakespeare, which themselves 'merit only to be performed in front of savages in Canada'.[90] In his autobiography, however, Goethe praised Frederick for providing poets with great national events to write about, and even argued that he did German writers a service by neglecting them, since they were spurred to redouble their efforts to gain his attention.[91]

These dismissive judgements are characteristic of the older Frederick, an increasingly isolated, crusty and melancholy figure. Having worn himself out by directing all the operations of the Seven Years War himself, he insisted on keeping rigid control of civilian administration, delegating as little as possible. He stayed mostly in Potsdam, communicating only by letter with his ministers 15 miles (24 km) away in Berlin. Hence, when he died childless, not only was his nephew, Frederick William II, unable to assume the enormous administrative burden, but government was divided between the Potsdam secretaries and the Berlin ministries. Frederick thus illustrates the cardinal weakness of enlightened absolutism as a form of government: 'because all freedoms under absolutism depended on the will or whim of a single all-powerful individual, any gains made could not be institutionalized, and certainly not entrenched'.[92]

The fourth great enlightened absolutist, Joseph II of Austria, assumed sole power in 1780. For the previous fifteen years he had shared the rule of the Habsburg Empire with his mother, Empress Maria Theresa – a friction-laden and frustrating partnership.[93] The benevolent and much-loved 'mother of her peoples' could accept some enlightened measures, provided nothing was done to weaken the Catholic Church or acknowledge the rights of heretics. Joseph's aspirations, however, were of a

different order. Successive wars with Prussia had diminished the Monarchy's territory and emptied its coffers, leaving it hard pressed to deal with the Ottoman Empire, its enemy on the other side. The empire needed to be made into a modern, efficient state on the Prussian model. When his mother's death freed him from her apron-strings, Joseph was already thirty-nine, an early middle-aged man in a hurry.

Joseph's main difficulty was that the Habsburg Empire was not a state, but a patchwork of ethnically and culturally diverse territories, acquired by inheritance or conquest over several centuries. Its core, the Hereditary Lands, corresponded largely to the present-day Austrian Republic, plus parts of what is now Slovenia and north-eastern Italy down to the seaport of Trieste. It also included the Lands of the Hungarian Crown (Hungary, Croatia, Transylvania and the Military Frontier against the Turks), Bohemia and Moravia (now the Czech Republic), the duchies of Milan and Mantua, the Breisgau (around Freiburg in south-western Germany), the Austrian Netherlands (now Belgium), the Bukovina (now in Romania), and Galicia, the province seized from Poland in 1772.[94] Five groups of languages were spoken: German, Hungarian, Italian, Romanian, and Slavonic languages. Each province had its own government, usually by nobles in the form of Estates. There was no national bureaucracy such as imposed *police* or *Polizei* in more unified countries. The power of the Church was enhanced by the status of its bishops as princes of the Holy Roman Empire in their own right.[95] No wonder that a French diplomat once reported: 'It is a tough job, said the Emperor Joseph II to me one day, to have to manage nations so remote from the centre and so contrary in character; one can only control or move them with an iron chain.'[96]

It was clear to Joseph that to reform this polity in line with reason, and to maximize the happiness of its inhabitants, required the determined will of a single man, supported by a slavishly obedient civil service. Soon after taking office he told his senior ministers that every head of department 'must come to share as nearly as possible my political aims and the way in which I regard the general welfare, and must make my principles entirely his own'.[97] Drastic reforms came in rapid succession. Joseph's Patents of Toleration, which, beginning in October 1781, granted freedom of worship to communities of Lutherans, Calvinists and Greek Orthodox, also removed the restrictions on their buying property, joining guilds and attending university. Similar measures removed the much more extensive restrictions on Jews. In dealing with the Church, Joseph ordained that all ecclesiastical appointments required the approval of the state; he dissolved the contemplative monastic orders and transferred their property to charitable use; and he reorganized the training of the clergy into twelve

seminaries following a rigorous and uniform curriculum. All these measures caused such alarm in Rome that in the spring of 1782 Pope Pius VI visited Vienna in person to remonstrate with the emperor. To many contemporaries this seemed the greatest event of the century: a reversal of the events at Canossa several hundred years before, when Emperor Henry IV had done humiliating penance before the pope in 1077.[98] A series of decrees concerning the relations between lords and peasants did not quite abolish serfdom but did give former serfs freedom to move about and choose a trade or profession, though still owing dues and services to their masters. The powers of lords to punish peasants were regulated. Even fox-hunting (of which Frederick II also disapproved) was considered: Joseph tried to set an example by closing down his own hunt and retraining the huntsmen as foresters or footmen.[99]

Joseph's concern for his people was shown in his accessibility. His subjects would wait with petitions outside his office in the Hofburg in the centre of Vienna; he would emerge several times a day (not at fixed times) and hear them; some petitioners were taken into a small room for private discussions.[100] He often walked alone in Vienna, speaking affably to ordinary people. But his reforms, especially those affecting the Church, were not always popular. He showed particular insensitivity when he ordained that, because of the timber shortage in Vienna, corpses should be buried sewn into linen sacks instead of being buried in coffins – an edict which aroused such fury that it had to be withdrawn. Joseph's resentment is clear from his written instructions to his chancellor:

> Since I see and hear every day that the attitudes of the living are unfortunately still so materialistic that they attach immense importance to their bodies rotting slowly after death and remaining stinking carcases for longer, and since it is of no great consequence to me how people wish to be buried, if they emphatically make their attitude clear, even after I have shown them the reasonable basis, utility and feasibility of the current method of burial, I do not wish to compel anyone who is not rationally persuaded, and so anyone may do what he likes about his coffin and make whatever arrangements he thinks most acceptable for his dead body.[101]

Joseph can also be criticized for micro-management and excessive tidy-mindedness. In his obsessive devotion to the service of his state, he spent time on such trifling matters that Tim Blanning has called him 'a terrible busy-body who could not mind his own business'.[102] He issued a resolution against making a noise in public: 'Wilful shouting and clapping of hands in the street is forbidden to everyone without exception, on pain of appropriate punishment.'[103] He ordered that street lights should use brass lamps,

not copper ones. A Jewish woman named Neuhauser having acquired a bar of silver of dubious origin, Joseph himself organized a search for the bar, and told his chief of police, Count Pergen, to round up the woman's accomplices. Pergen himself, not to be outdone, held four hearings to establish that one Elisabeth Eberlein had offered for sale some overripe beans, and Joseph commended his zeal.[104]

As for tidy-mindedness, Joseph's toleration required all Christians to register with one of the tolerated Churches. The peasant deists of Bohemia professed belief in one God, and the immortality of the soul, but denied the Trinity and had no visible church but worshipped in their own homes. Unlike the more submissive Hussites, they refused to register as Lutherans. So in 1783 Joseph ordered the young men to be conscripted into the army, the other adults transported to Hungary and Transylvania, and the children under fifteen placed with Catholic guardians.[105] The deists were persecuted essentially because they did not fit into neat categories. (Since persecution only increased their numbers, Joseph had later to abate his severity.)

Joseph eventually wearied of his uphill struggle. His treatment of censorship provides an example. In 1781 he liberalized the censorship, declaring: 'every lover of truth must rejoice to be told the truth, even if it is conveyed to him via the uncomfortable route of criticism'.[106] This measure prompted a 'flood of pamphlets' (*Broschürenflut*), ranging from amusing trivia such as *Über die Stubenmädchen in Wien* (*On the Parlour-Maids in Vienna*, 1781) to serious historical discussions, notably the critical study of the papacy, *Was ist der Pabst?* (*What is the Pope?* 1782) by Church historian Joseph Valentin Eybel (1741–1805).[107] By 1785, however, Joseph felt that public discussion had gone far enough. Worried, like other rulers, about Freemasonry, he brought the lodges under strict control, permitting only one in each provincial capital and requiring meetings and membership to be reported to the police. In 1789, partly to obtain revenue for war, he imposed a stamp duty on all pamphlets, newspapers and plays.[108]

Perhaps Joseph's problem was that, being convinced that truth and reason spoke for themselves, he did not see that he had also to be a politician. He alienated all his potential supporters. Although he demanded total and dedicated support from his civil servants, he often treated them rudely, and he ended their right to cheap accommodation in the city centre.[109] Popular religious ceremonies, however irrational they might seem, could not be abruptly abolished without causing regret and discontentment. He infuriated the Hungarian nobility by reorganizing their local government and requiring them to use German as the language of administration. Finding the government of the Austrian Netherlands in a confused, inefficient and corrupt state, he began in 1787 to impose fundamental reforms that led

first to tax strikes and then to a full-blown revolt, culminating in 1790 in the proclamation of the United States of Belgium. By that time, Joseph had been at war with Turkey for two years. The war was successful, notably when the Austrians captured Belgrade in October 1789, but at the front Joseph contracted tuberculosis, and he died on 20 February 1790, convinced that his project had ended in failure.[110]

Joseph's struggles form a sharp contrast with the relatively smooth reforms introduced by his younger brother Leopold as grand duke of Tuscany.[111] Admittedly, as ruler of a small and homogeneous polity, Leopold had a far simpler task. But he also addressed it in the opposite way from Joseph. While Joseph concentrated power in himself and micromanaged his administration, Leopold sought to delegate powers to local communities. Joseph's ideal of reform was abrupt and transformative, Leopold's was gradual. And while Joseph nagged and bullied his civil servants, Leopold was supported by a cadre of loyal and dependable, though not blindly subservient, administrators and intellectuals.

Leopold was an exemplary enlightened ruler. Although, like his brother, he took little interest in the Paris *philosophes*, he had read Locke, Montesquieu and the physiocrats. His enlightenment was practical. After the Tuscan famine of 1764–5, he and his advisers adopted a physiocratic policy of instituting a free trade in grain subject only to market forces. The Church was kept under control with the help of Jansenists opposed to the authority of Rome. Leopold managed to exert his authority over the bishops, close a number of monasteries, and improve the training of priests. Public discussion of enlightened policies was promoted by publishers and the press. Giuseppe Aubert in Livorno published the works of Beccaria, the Verri brothers and Rousseau, and brought out an edition of the *Encyclopédie* with notes updating its information.[112] Newspapers reported in detail on the progress of the American Revolution. Leopold hoped to introduce a new constitution that would have limited his own powers – he would no longer be able to declare war, make foreign alliances, alter the judicial system, or interfere in any judicial proceedings – and have given the elected deputies positive powers to oversee state expenditure and the judicial system and propose new legislation. Opposition from within, and also from his brother Joseph, prevented these plans from being realized, and on Joseph's death in 1790 Leopold moved to Vienna as his successor on the Imperial throne. He maintained some of Joseph's innovations and repealed others (sharply reducing the number of secret police) but had achieved little by the time of his own unexpected death in 1792.[113]

Major reforming projects were often undertaken by powerful ministers as well. Their position was highly precarious. The favour of their

monarchs allowed them untrammelled power, but if they fell from favour, or if their patron died, they had no powerbase to fall back on. Their reforms generally made them unpopular and, on losing power, they might feel the resentment displaced onto them from an unloved monarch. The Portuguese marquês de Pombal, Sebastião José de Carvalho e Melo, was recalled from Vienna, where he was ambassador, to join the ministry in Lisbon in 1749; his power coincided exactly with the reign of the king, José I, who neglected government and left it to Pombal. Pombal established a system of state education, reformed the University of Coimbra and introduced modern science there, abolished slavery in Portugal (though not in its colonies), and modernized the army. Although he managed to reduce the power of the Inquisition, he did not weaken the Church: it is said that in 1750 Portugal had 200,000 clergy in a population of 3 million.[114] Above all, he took charge of the reconstruction of Lisbon after the catastrophic 1755 earthquake and carried through a major achievement in town planning, comparable to the contemporary construction of the New Town of Edinburgh.[115] On the king's death, the new ruler, Queen Maria I, a devout woman who hated the sceptic Pombal, dismissed him, and he spent the last five years of his life in rural retirement.

More dramatic was the fate of Johann Friedrich Struensee, the German physician to the mentally deranged King Christian VII of Denmark and lover of the teenage Queen Caroline Mathilde. Struensee was an enthusiastic Enlightener who had met d'Alembert and other *philosophes* in Paris. When the king became wholly incapable of government, Struensee managed to assume supreme power, from December 1770 to January 1772. He introduced a whirlwind of reforms, reducing noble privileges, attacking bribery, abolishing judicial torture, improving the well-being of the peasants, and doing away with press censorship. These measures made him many enemies, and the abolition of censorship rebounded on him, for many of the political pamphlets that now appeared were attacks on Struensee.[116] His assumption of the title of Count in December 1771 proved the last straw. In January 1772 he and the queen were arrested; Struensee was charged with usurping the royal authority, and, on 28 April 1772, publicly executed. Caroline Mathilde was divorced and exiled to Germany, where she died in 1775 at the age of twenty-three.

From this account of enlightened absolutist rulers, some common features must already be apparent. Peter, Catherine, Frederick and Joseph were exceptional personalities: dedicated, energetic, single-minded and determined. All worked tirelessly on behalf of their countries. Joseph worked at least ten hours, sometimes eighteen hours, a day, always with three or four secretaries in attendance; in summer he rose at five o'clock,

in winter at six. Frederick got up between three and four o'clock (an hour later in winter) to work through dispatches sent by his ambassadors and dictate replies to his secretaries, who had to be available at all hours of the day and night.[117] In keeping with this humble role, all cultivated a modest and accessible personal style, in contrast to the intimidating grandeur of baroque courts. Peter ordered his subjects not to kneel before him and not to take off their hats when passing his palace.[118] Frederick went further by taking off his own hat to his subjects, though what he did with his hat – whether he raised it only slightly, held it beside his head, or lowered it as far as his elbow – was carefully calibrated according to the ranks and merits of those he was saluting.[119] Of Joseph, the British ambassador reported in 1771: 'He often runs about with a single Servant behind Him; likes to converse with men of all Ranks, puts those he talks to, quite at their Ease; loves easy, familiar Conversations, as much as He hates to talk in a circle.'[120] On his many travels, Joseph stayed at inns instead of noble mansions, ate simply, and slept not in a bed but on straw-filled sacks, covered with a deerskin.[121] The enlightened Charles III of Spain was also noted for his simple lifestyle; 'he was relaxed and friendly with servants and workmen whom he often got to know well'.[122]

However, as the other side of the coin, all four great absolutists were driven and, in some respects, damaged personalities. Peter had reached the throne via a civil war against his sister. He developed an antipathy to his son Alexis, who was an invalid and averse to soldiering. When Alexis tried to flee abroad, Peter induced him to return, disinherited him, accused him of conspiracy, had various alleged accomplices tortured to death, and subjected him to what Lindsey Hughes calls 'the first Russian show trial'.[123] Like many of his twentieth-century counterparts, Alexis was interrogated under torture so severe that he died. Catherine, in many ways the most recognizably human of these figures, suffered an unhappy early life. Her memoirs often emphasize her mother's unkindness and anger, and her unconcern when young Catherine seemed likely to die of pleurisy.[124] As for Frederick, he had a relationship with his authoritarian father nearly as disastrous as that of Alexis with Peter. His father treated him with violence and humiliation, and tried to make a man of his son by forcing him into a guards regiment at the age of fourteen. In 1730 Frederick ran away with a fellow-officer (and perhaps lover), Hans Hermann von Katte; they were arrested and brought back to Berlin, where Frederick was made to witness the beheading of Katte from his prison window. His marriage to Elizabeth of Brunswick-Bevern was enforced, unhappy (for both), and childless. Joseph not only had a difficult relationship with his mother, but both his marriages were unhappy. His first wife, Isabella of Parma, died after three

years; their daughter died in infancy. After Isabella's death, Joseph's sister
Christina thought fit to reveal to him that Isabella had never loved him.[125]
Joseph then made a loveless marriage in 1765 with Princess Maria Josepha
of Bavaria, who died two years later. This sheds a sad light on his declar-
ation to his brother Leopold in 1768: 'The love of my country, the well-being
of the Monarchy, that is in truth, my dear brother, the only passion that I
feel and that will make me undertake anything whatever.'[126]

These driven workaholics faced massive tasks that required intense
commitment, and, despite obvious differences, their tasks had much in
common.

In several countries the monarch had to confront the Church: first,
because it claimed a spiritual authority that trumped secular political
authority; secondly, because the ruler wanted some of its wealth for his
or her own projects; thirdly, because the Catholic and Orthodox institu-
tion of monasticism diverted able-bodied men from useful work and
prevented the population from increasing; and fourthly, because the
Church promoted superstitions which ran counter to enlightenment. In
Russia, the Orthodox Church claimed absolute authority over Russians'
souls. Its primate, Patriarch Adrian, firmly opposed all contact with for-
eigners and all foreign customs, such as shaving. On his death in 1700,
Peter appointed only an interim successor, and in 1721 replaced the patri-
archate with a Holy Synod, a council of ten clerics, modelled on his secular
'colleges' or ministries; he himself appointed all bishops. The tsar placed
Church lands under the control of a Monastery Department, which
ensured that part of the Church's income came to the state. He threatened
idle monks, saying: 'I'll clear them a path to heaven with bread and water,
not with sturgeon and wine.'[127] Monks were required to perform useful
services such as caring for the sick and teaching poor children. To keep
their numbers down, men could only enter a monastery when they were
thirty, women when they were fifty. Frederick likewise disapproved of
monks, though there were none in his solidly Protestant dominions, calling
them 'that multitude of cenobites who, stifling natural instinct, contribute
all they can to the decline of the human species'.[128] Finding the clergy often
ignorant, Peter obliged all priests to learn Latin, or, if they failed, to serve
in the army. He also urged the clergy to eradicate superstition – an inven-
tion of hypocrites – and to enlighten the 'simple people'.[129]

The Catholic Church was a still more dangerous antagonist. Joseph II
shared his mother's devout Catholic faith, but not her deference to the
Church. His famous stand-off with the pope turned on Joseph's successful
claim to appoint all bishops in his territories. Although Maria Theresa had
taken steps to limit the numbers of monks, they were seen, inaccurately,

as excessively numerous: in 1782 the Habsburg Monarchy contained some 25,000 regular clergy (members of monastic orders), though contemporaries estimated 63,000.[130] Joseph took drastic measures, ordaining an inspection of all monasteries and dissolving those of the contemplative orders; those remaining were enjoined to provide pastoral care for local people. Some clerics, aware of the abuses practised in monasteries, welcomed his intervention.[131] The emperor did his best to oppose practices such as pilgrimages to shrines and to promote the enlightened Catholicism advocated especially by Muratori. In Portugal, Pombal was even more high-handed: he expelled the papal nuncio in 1760 and used the resulting breach with Rome to bring the Church under state control, himself appointing bishops and requiring them to promote enlightenment.[132]

To implement their reforms, enlightened rulers needed efficient and loyal bureaucracies. There were never enough educated and trained administrators. German states, where the universities taught *Kameralwissenschaft* or management, were best off. Austria had to import Germans or Dutchmen, such as Gerard van Swieten; initially Maria Theresa's physician, van Swieten later headed her censorship board, reformed medical provision, and conducted an inquiry into the Transylvanian superstitions concerning vampires. Germans made careers in Russia; Huguenot exiles in Prussia. Charles III of Spain initially relied on Italians – the marchese di Squillace (called Esquilache in Spain), whom he made secretary of state for war and finances, and the marqués di Grimaldi, whom he made secretary of state for foreign affairs. However, the revival of a law forbidding men in Madrid to wear slouch hats and long capes, which made it easy for criminals to hide their faces, provoked a violent riot in which the houses of Esquilache and Grimaldi were respectively sacked and stoned, and both had to be dismissed in order to calm the populace – an example of how the interference with trivial but treasured customs could unleash more deeply rooted discontents.[133]

The obvious answer was to create a home-grown professional class by improving education. Peter founded the Moscow School of Mathematics and Navigation, modelled on the Royal Mathematical School at Christ's Hospital, which he knew from his English visit. Teachers were hired from England and Scotland.[134] By 1702 the school had two hundred students. Its alumni were intended to move into the provinces and teach in 'cipher schools' (which concentrated on arithmetic and geometry); all (male) children of the nobility were required to learn basic mathematics between the ages of ten and fifteen in 'cipher schools'. But there were never enough teachers, and pupils were reluctant to attend.[135] Maria Theresa and Joseph planned in 1774 to introduce universal primary education, though at a

higher level van Swieten's educational reforms were hampered by Maria Theresa's prohibition on the teaching of English, which she considered 'a dangerous language, pernicious for religion and morality'.[136] Joseph II established compulsory state education throughout his dominions, though he did not think it necessary for the masses to acquire more than basic literacy and numeracy, and he closed many secondary schools.[137] Higher education similarly should be confined to the practical training of state officials, with no money wasted on what Joseph considered useless subjects such as foreign languages: Joseph accordingly halved the number of universities, converting five into grammar-schools.[138] Frederick of Prussia was even less keen on education for its own sake: his general school regulation of 1763 confirmed existing practice by requiring all children to be educated up to the age of fourteen, but its main purpose was social control. Since, in Frederick's view, the masses were incapable of enlightenment, they should at least learn self-discipline and hard work. They would never abandon prejudices and superstition, but they could be confirmed in useful prejudices: 'Prejudices are the people's reason, and they have an irresistible liking for the marvellous.'[139]

Enlightened monarchs were not, on the whole, interested in encouraging public discussion. How free discussion was in Frederick's Berlin is disputed, but the balance of evidence seems to support Kant's assertion that Frederick in effect told his people: 'Argue as much as you like and about whatever you like, but obey!'[140] Joseph virtually abolished censorship, not for the sake of intellectual freedom, but so that his subjects could respond to his measures with constructive criticisms. Like Struensee in Denmark, however, he found that criticism was often hostile.

The absolutist rulers were mainly interested in practical rather than intellectual enlightenment. It has therefore been argued that they do not deserve the sobriquet 'enlightened'. Robert Darnton has claimed that ' "enlightened absolutism" . . . had little relation to the Enlightenment', and that rulers carried out reforms merely in order to maximize their power.[141] Andreas Pečar has recently argued that, despite posing as a philosopher, Frederick merely repeated enlightened truisms, especially in the *Anti-Machiavel*, in order to gain credit with the *philosophes*. But this argument makes a false dichotomy between sincerity and the desire for prestige.[142] Thomas Carlyle's more plausible judgement of the *Anti-Machiavel* was that 'it leaves us, if we sufficiently force our attention, with the comfortable sense that his Royal Highness is speaking with conviction, and honestly from the heart'.[143] More broadly, it has been argued in response to Darnton that the oppositional stance of the *philosophes* towards the French state was not characteristic of the Enlightenment as a

whole. German Enlighteners in particular subscribed to the natural law tradition that affirmed the absolute power of the prince and, while supporting civil rights, had no interest in constitutional safeguards; they encouraged princes to use their power in order to maximize their subjects' happiness in all the areas that came under the heading of *Polizei*.[144]

Frederick and Catherine were deeply familiar with the *philosophes* as writers, and with some as individuals; both Peter and Joseph, however, were severely practical. Joseph never said, as often alleged, 'I have made philosophy the legislator of my empire.'[145] He did write in 1765: 'I have learned nothing more firmly than to fear intelligence [*esprit*] and all its subtleties. I recognize no argument which comes from the ancient Greeks or the modern French.'[146] He took little interest in the *philosophes*.[147] Although the emperor met many of them, including Buffon, d'Alembert, Grimm and Turgot, in Paris in 1777, it was well known that on his return journey through Switzerland, he passed the gates of Ferney without calling on Voltaire, even though the latter was expecting him, had arranged a dinner-party in his honour, and had placed peasants in the trees to provide an ovation.[148] The absolutists were not the philosopher-kings of whom Enlighteners dreamed. Writing to the philosopher Christian Wolff, Frederick demarcated philosophy from kingship very clearly: 'It is for philosophers to be teachers of the world and the masters of princes. They must think logically, and it is for us to perform logical actions. They must instruct the world by reasoning, and we by examples. They must make discoveries, we must perform practical deeds.'[149]

All the absolutists professed to be the first servants of their people. In her Instruction, Catherine says that flatterers tell sovereigns that the people exist for them, but: 'We think and esteem it a Glory to ourselves to say that We are created for our People.'[150] Joseph II's brother and eventual successor, Grand Duke Leopold, declared: 'I believe that even a hereditary sovereign is only a delegate and employee of the people.'[151] To many thinkers, this ideal showed that monarchy had at last become enlightened. Wearing themselves out on behalf of their people, these monarchs acknowledged the 'common good'. Peter the Great first formulated this concept in a decree of 1702 about inviting foreign specialists into Russian service: 'since our accession to this throne all our efforts and intentions have been aimed at ruling this State in such a manner that as a result of our concern for the common good [*vseobshchee blago*] all our subjects should attain an ever greater degree of well-being.'[152] Joseph's decrees never began 'It is Our will', but always, 'The common good . . .' ('Das allgemeine Beste . . .'), as though he were only the mouthpiece for the indisputable demands of reason.[153]

By 'the common good', absolutists did not mean the sum of the well-being of individuals. Their people were important not as individuals, but as part of the resources of their states. They always placed the common good above the good of the individual. The liberty they offered was a version of what Isaiah Berlin, two hundred years later, called 'positive freedom'; that is, the freedom to become what I *ought* to be, with the tacit condition that somebody else knows better than I can what I ought to be (e.g. a happy and useful citizen).[154] But is this really freedom? Might I not find more real freedom in offering resistance, however perversely, to the assurances of benevolent autocrats that they alone know what is good for me? A passage early in Catherine's Instruction gives one pause:

§15. The Intention and End of Absolute Government is the Glory of its Citizens, of the State, and of the Sovereign.

§16. This Glory in a People under monarchical Government creates a Sense of Liberty, which in such States, is capable of producing as many great Actions, and of contributing as much to the happiness of the Subjects, as Liberty itself.[155]

It was possible to feel, on the other hand, that people treated as the state's human resources were debarred from becoming fully human, and that a sense of liberty was inferior to real liberty. Helvétius annoyed Diderot by quoting with apparent admiration Frederick's defence of absolutism: 'There is nothing better, says the King of Prussia in a speech delivered in the Berlin Academy, than arbitrary government under princes who are just, humane and virtuous.'[156] Not so, Diderot replied: unless they were free to oppose the prince, these happy subjects were no better than a flock of contented sheep:

The arbitrary government of a just and enlightened prince is always bad. His virtues are the surest and most dangerous of seductions: they insensibly accustom a people to love, to respect, to serve his successor, even if the latter is wicked and stupid. He deprives the people of the right to deliberate, to consent or not consent, to oppose even his will when he ordains what is good; but this right of opposition, absurd though it is, is sacred: without it his subjects resemble a herd whose complaints are despised on the pretext of leading them through rich pastures.[157]

A series of beneficent despots, Diderot added, would be enough to ruin a nation by accustoming its people to slavery. Three Queen Elizabeths in succession would have turned the English into the lowest slaves in Europe.[158] So, despite his cosy chats with Catherine, his brief experience of Russia did not persuade him that it represented the way forward for humanity.

Diderot had put his finger on an essential shortcoming of enlightened absolutism: it required unanimity. It assumed that once the clouds of prejudice and superstition had been dispelled, the common good was obvious and undisputable. It did not take account of what Kant identified as humanity's 'unsociable sociability': the inevitable frictions and disagreements among people, which mean that society can only progress through conflict, argument and debate.

## REPUBLICS

In mid-eighteenth-century Europe, monarchy was still the prevailing form of government. Republics were few and small and seemed to be anomalous survivals from the past (rather like the principalities of Monaco and Liechtenstein today). Even around 1760 an impartial observer would have predicted that the form of government most likely to dominate the future was a gradually liberalizing monarchy. There was good reason for Hume's judgement: 'though all kinds of government be improved in modern times, yet monarchical government seems to have made the greatest advances towards perfection.'[159] The American and French Revolutions were still as unimagined as, say, the end of Communism was around 1970.

Although there were few contemporary examples of republics, the idea of republicanism carried considerable weight in political discourse, and the 'virtuous republic' was a compelling ideal. Classical authors provided ample information on the workings of the Greek and Roman republics. They depicted polities where all citizens were prepared to defend their state in war, and where it was thought that one could lead a fully human life only as an active member of the republic.[160] Thucydides reports Pericles as telling the Athenians:

> Here each individual is interested not only in his own affairs but in the affairs of the state as well . . . we do not say that a man who takes no interest in politics is a man who minds his own business; we say that he has no business here at all.[161]

Machiavelli analysed the strengths and weaknesses of the Roman Republic and of the medieval Italian city-republics which had fallen victim to autocrats. The trouble was that not only the medieval but also the ancient republics had all ended badly. They suffered either from internal factional conflict, or imperial overreach, or both. Athens had stood alone against the power of Persia, and seen a flowering of the arts, but it had developed imperial ambitions, fallen prey to demagogues and had eventually been

defeated by Sparta. Sparta might exemplify civic virtue, but it was a militarized and unattractive state. The Roman Republic had steadily conquered one territory after another, and had succumbed to civil conflict between rival factions, before being extinguished and replaced by the imperial rule of Montesquieu's 'crafty tyrant' Augustus.

The lessons to be drawn from the few modern republics were not wholly encouraging either. According to some political theorists, a free state can still be technically a monarchy, provided the monarch's powers are strictly limited.[162] That applied to Sweden, which for much of the eighteenth century had imposed such limitations on the king's powers that it had parliamentary government with republican freedom. Voltaire called Sweden 'the freest country in the world'.[163] Mably described its constitution of 1720, which inaugurated the 'Age of Liberty', as the 'masterpiece of modern legislation'.[164] Under this constitution, Sweden was governed by a Diet (*Riksdag*) comprising four Estates: the Nobility (much the largest), the Clergy, the Burghers and the Peasants; if the king refused to sign a decree of the Diet, he could be overruled and his signature replaced by a stamp with a facsimile.[165] The Nobility included one representative of every noble family, whereas the other three Estates were elective. Elections were considerably more open than in England: there was no patronage, and members were required to live in the constituency they represented (whereas we remember that Gibbon, when an MP, had no contact with the people of Liskeard). The Diet was the legislative power, the executive power being vested in the Council of State. The detail of government was managed by committees, of which the most powerful was the Secret Committee of a hundred members (fifty Nobles, twenty-five Burghers, twenty-five Clergy, no Peasants).

This system soon revealed its shortcomings. The Council, which could not determine policy, became increasingly ineffectual, and power passed to the Secret Committee. The Estates structure was too rigid to respond to social changes, so many social groups, such as professional people, merchants, manufacturers, and non-noble landowners and army officers, were not represented. Civil liberties were not protected: criticism of the Estates was a capital crime; the Diet often intervened in judicial proceedings and persecuted people who voiced unpopular opinions, sometimes subjecting them to torture. Two parties, known as the Hats and the Caps, vied furiously for power. Finally, in 1772, when the Diet had rejected all proposals for constitutional reform, the new king, Gustav III, mounted a bloodless *coup d'état* and instituted an absolute monarchy. He began by forbidding torture and instituting security before the law. Enlighteners such as Anders Chydenius, who were in despair over Swedish misrule, welcomed

his revolution. Outside Sweden, the *philosophes* who had previously praised Swedish 'liberty' (except Mably) hailed the new regime 'as a victory for Enlightenment, for progress, for humanity'.[166] Beccaria declared: 'Torture has been abolished in Sweden and by one of the wisest monarchs in Europe who, bringing philosophy to the throne and legislating as the friend of his subjects, has set them equal and free under the law.'[167]

The long-established republic of Venice was even less attractive as a model. In the early seventeenth century it was widely thought that Venice had an admirable constitution that ensured its stability. It balanced the monarchical power of the doge with the aristocratic power of the Senate and the popular power of the Great Council, consisting of some two thousand members of the patriciate (though some 95 per cent of the population was not represented at all).[168] Later in the century, however, it came to be seen as a tyranny, in which any citizen might suffer anonymous denunciation followed by imprisonment and execution without trial, at the whim of the unchallengeable Council of Ten. Amelot de la Houssaie, who had lived in Venice as a French diplomat, gave a chilling account of how the Council prosecuted alleged criminals without mercy, on the principle that even the appearance of guilt deserved punishment; how it disposed of its victims by having them secretly drowned in the Canal Orfano; and how it maintained an atmosphere of terror by supporting large numbers of informers, who themselves would be quietly disposed of when they ceased to be useful.[169]

The Dutch Republic had also declined from its seventeenth-century 'Golden Age' greatness.[170] Its population was shrinking. As its towns contracted, the market for agricultural products dwindled too, and the countryside became impoverished. The seven provinces were controlled by an oligarchy of regents, chosen from an increasingly restricted group of families. Public offices were up for sale. William V of Orange, who was to be the Republic's last stadholder, was disliked for his reactionary inclinations. The Patriot Revolution that broke out in 1781 obliged him to leave his palace in The Hague and take refuge in his castle at Loo. When his Prussian wife Wilhelmina, niece of Frederick the Great, ventured to return, she was arrested and imprisoned. This act prompted a Prussian invasion that ended the revolution and restored the stadholder to power, which he retained until the French invasion in 1795 forced him into exile in Britain and set up the puppet Batavian Republic.

The republican ideal attracted many people 'as a form of life, not as a political force'.[171] Selfless devotion to the common good was obviously admirable. But had the ancient republics embodied this ideal as polities? Under scrutiny, they showed a number of features that made them dubious models for the present. First – although this objection counted for much

less in the eighteenth century than it would in the twenty-first – they gave power only to a small proportion of the people. Hume points out that under Athenian democracy, women, slaves and strangers were excluded, so no law was voted on by more than a tenth of those who had to obey it.[172] Manual labour was done by slaves, leaving male citizens free to engage in politics, and women remained in the domestic sphere, encouraging civic virtues in their sons (like the redoubtable Volumnia in Shakespeare's *Coriolanus*). Mercier reassured the readers of *L'An 2440* that women would confine themselves to this role in the future, and, if they had any intelligence (*esprit*), would take care to hide it.[173] The men of the French Revolution would take much the same view.

Ancient republics were small. Athenian democracy applied, at most, to 5,000 adult males. Montesquieu and many others thought a republic could only be small. For one thing, direct democracy would be impossible with larger numbers. For another, if a republic were larger, inequalities and disparities of wealth would soon lead citizens to put their own interests before those of the state.[174]

Direct democracy was itself regarded with suspicion. Large assemblies were liable to be turbulent and to be swayed by demagogues. 'Under a democratical government,' says Gibbon, 'the citizens exercise the powers of sovereignty; and those powers will be first abused, and afterwards lost, if they are committed to an unwieldy multitude.'[175] A contemporary example of equal democracy was the Polish Diet, where each member had equal status and any proposal could be vetoed by anyone; this principle of the *liberum veto* helped to make Poland ungovernable and exposed it to the rapacity of neighbouring states.[176]

Accordingly, we find that Enlightenment thinkers, even those whom posterity has labelled 'radical', have little good to say about democracy. Democracy, or rule by the people, is taken to imply constant turbulence, disorder, anarchy and partisan strife, with no larger understanding of the common good. The people are bound to succumb to demagogues, who will either turn into authoritarian rulers, or be swept away by a more determined dictator. It may not be surprising to find Gibbon declaring: 'My own contempt for the wild & mischievous system of Democracy will not suffer me to believe without positive proof that it can be adopted by any man of a sound understanding and historical experience.'[177] But here is the notorious freethinker Baron d'Holbach: 'Democracy, prey to cabals, to licence, to anarchy, does not give its citizens any happiness, and often makes them more anxious about their fate than the subjects of a despot or a tyrant.'[178] And Kant agrees: democracy is *necessarily* despotic, because those who assume leadership claim to be doing the will of the people, yet

the people are in reality never unanimous, so that dissenting opinions are crushed. Democratic government should therefore never be confused with republican government, which can only be representative.[179]

D'Holbach held highly progressive opinions. He denounced the nobility as a class of parasites who abused their unearned privileges. He asserted that society should be governed in the interests of the working people, who were far the most numerous class, and the class on whom everyone's well-being depended. But society should not be governed *by* the people. They lack the education necessary to understand the issues. Their liberty would quickly degenerate into licence:

> Let the people be restrained and protected against its own folly or inexperi-ence, let its voice, too unruly when it speaks for itself, be softened by prudent authorities who speak for it. Representatives, honest magistrates, will watch more reliably over its interests, which it often does not know, exaggerates or fails to formulate.[180]

D'Holbach thinks that the people will probably make a wise choice of representatives, since the latter will be prominent and well-known members of the local community; but the people should not aspire to share in government themselves.

Who then should represent the people? Here again there is a consensus: it must be men of property. Whether they hold property as an inherited responsibility, or have acquired it through their own abilities, such men have a strong interest in, and hence a strong commitment to, the prudent conduct of government. In present-day jargon, they are stakeholders, and powerfully motivated by their own interest. 'Such is the Frailty of the human Heart', wrote John Adams, the second US President, 'that very few Men, who have no Property, have any judgment of their own.'[181] Writ-ing about representation in the *Encyclopédie*, d'Holbach agrees: there must be assemblies where every order of the populace is represented.

> To be useful and just, these assemblies should be composed of those whom their possessions qualify to be citizens, and who are placed by their rank and their enlightenment [*leurs lumières*] in a position to know the interests of the nation and the needs of the people; in a word, it is property that makes the citizen.[182]

Gibbon regretted that the wisest of the Roman emperors had not intro-duced representative government, which might have preserved the Empire against the barbarians. He noted with pleasure that in 418 CE Emperor Honorius set up an assembly of the seven provinces of Gaul, which was to meet annually, for about a month, and consisted of the prefect of Gaul,

seven provincial governors, the magistrates, and perhaps the bishops, of about sixty towns and cities, 'and of a competent, though indefinite, number of the most honourable and opulent *possessors* of land, who might justly be considered as the representatives of their country'.[183] It was not yet thought that citizenship itself entitled one to a vote, far less that any adult member of the population might have a right to a say, however small, in how the nation was governed.

Enlighteners were not sympathetic towards arguments for equality. Admittedly, most agreed with the opening proposition of the American Declaration of Independence that 'all men are created equal'.[184] They could concede that the innate differences between human beings (at least, Europeans) were not great. Adam Smith observes that the division of labour, by causing the division of society into different ranks or classes, exaggerates the superficial differences among people and disguises their common humanity: the difference between 'a philosopher and a common street porter, for example, seems to arise not so much from nature, as from habit, custom, and education'.[185] To claim that there were *no* innate differences, however, one had, like Helvétius, to adopt an extreme form of Lockean sensationalism and argue that everyone's mind, at birth, was an equally blank slate, so that all differences resulted from education. Few agreed. 'I believe that none but Helvetius will affirm that all children are born with equal genius,' observed John Adams, going on to show how unequally people were endowed with strength and beauty.[186] An attempt to institute political equality, whether corresponding to a fancied natural equality or to compensate for natural inequality, could only be pernicious. 'In a civilized society, the chimera of equality is the most dangerous of all,' wrote Diderot. 'To preach this system to the people is to invite them to murder and pillage; it is to unleash domestic animals and change them into savage beasts.'[187] In the ancient republics, argued d'Holbach, the most powerful motive was not virtue, as usually alleged, but equality, so that outstanding talents, and even conspicuous virtue, excited envy and hostility: he instanced Aristides, who was exiled from Athens for an excess of civic virtue.[188]

While it was false to suppose that people were *substantively* equal, however, it was necessary that they should be *formally* equal. Enlighteners insisted on equality before the law: 'there is in nature only a legal equality, never a factual equality [*égalité de fait*]'.[189] John Adams spelled it out:

> That all men are born to equal rights is true. Every being has a right to his own, as clear, as moral, as sacred, as any other being has. This is as indubitable as a moral government in the universe. But to teach that all men are born with equal powers and faculties, to equal influence in society, to equal

property and advantages through life, is as gross a fraud, as glaring an imposition on the credulity of the people, as ever was practiced by monks, by Druids, by Brahmins, by priests of the immortal Lama, or by the self-styled philosophers of the French Revolution.[190]

Formal equality was compatible with the preservation of social hierarchy. Gibbon may sound complacent when he declares:

> The distinction of ranks and *persons,* is the firmest basis of a mixed and limited government. In France, the remains of liberty are kept alive by the spirit, the honours, and even the prejudices, of fifty thousand nobles. Two hundred families supply, in lineal descent, the second branch of the English legislature, which maintains, between the king and commons, the balance of the constitution.[191]

But he is only restating Montesquieu's principle that in a monarchy there have to be intermediate and subordinate powers in order to prevent the government from degenerating into despotism.[192]

Those who wrote about the workings of a republic expressed particular concern about factions. Factions might be based on absurd preferences, as with the supporters of the Blue and Green charioteers in Byzantium, or on theological differences that nobody understood.[193] Or they might reflect real interests, as with the Town and Country parties that originated in late seventeenth-century England and presently acquired the labels Whigs and Tories. In every case, factions stirred up hatreds that led people to place their sectional interest before the good of the country. Addison deplores the evils of 'Party-Spirit', the antagonism which raged with especial violence in the early years of the eighteenth century.[194] Adam Smith observes: 'The animosity of hostile factions, whether civil or ecclesiastical, is often still more furious than that of hostile nations; and their conduct towards one another is often still more atrocious.'[195]

There was, however, a minority view which held that factions were preferable to consensus. Machiavelli argued that the continual quarrels between the nobles and the people in the Roman Republic were 'the primary cause of Rome's retaining her freedom', because they resulted from the intense interest in politics that classical republicanism demanded of all citizens.[196] Montesquieu admitted that these divisions were necessary, because a free state could hardly expect its bold warriors suddenly to become timid in peacetime, and in general a republic would be peaceful only once it had lost its freedom: 'as a general rule, whenever one sees everyone tranquil in a state that calls itself a republic, one can be sure that freedom is absent.'[197] Nowadays the minority view has triumphed. In most

democracies, 'factions' are organized as parties, representing distinct interest groups and/or political philosophies; a one-party state is considered tyrannical, but a state with no parties is hard to imagine.

In the eighteenth century, however, it was commonly thought that republics encouraged factions, which were detrimental to civil liberty. A republican government, having both legislative and executive power, was bound to be oppressive, as Jaucourt pointed out in the *Encyclopédie*: 'It can play havoc with the state through its general wills; and as it retains the power to judge, it can ruin every citizen by its particular wills. All power there is one, and though there may be no external pomp revealing a despotic prince, one constantly senses his presence.'[198] This had happened in Sweden's 'Age of Liberty', when unpopular citizens were subject to arbitrary arrest and show trials, and it had happened on a grand scale in ancient Athens, as everyone knew who had read Thucydides. Under the rule of demagogues, Thucydides reported, discourse was corrupted, words changed their meaning, and moderation itself invited persecution: 'Anyone who held violent opinions could always be trusted, and anyone who objected to them became a suspect.'[199]

Defenders of classical republican ideals insisted that republics worked so long as their citizens were virtuous. Virtue would be promoted by material equality, so that nobody could afford luxury and the moral corruption that went with it. Sparta, where the citizens lived on black broth, which foreigners found uneatable, and where money consisted of heavy pieces of iron to minimize commerce by making it inconvenient, was at least virtuous. Farming was thought to be a particularly virtuous activity. The Roman general Cincinnatus was celebrated because after gaining his military victories he quietly returned to his farm. Commerce, on the other hand, was denigrated as corrupting. 'Commerce diminishes the spirit, both of patriotism and military defence' – so Thomas Paine warned the Americans, a few months before the Declaration of Independence.[200]

Accordingly, the most elaborate proposal for a republican polity, James Harrington's *Oceana* (1656), assumes a society consisting mainly of independent landowners, all prepared to hold public office and to bear arms for their country. Writing in the conviction that the British monarchy had vanished for ever, Harrington based his Oceana on England, and imagined a future lawgiver, the archon, constructing a polity in which an all-important agrarian law, by abolishing primogeniture, would prevent landed property from being concentrated in a few hands. He quotes Aristotle in support of his view that a commonwealth based on 'the country way of life' is 'the most obstinate assertress of her liberty and the least subject unto innovation or turbulency'.[201] Disliking cities and commerce,

he thinks it would be a good idea to replace the degenerate inhabitants of the neighbouring island of Panopea (Ireland) with Jews, who would give up commerce and return to the agriculture that they practised in Old Testament times.[202] Although Harrington refers constantly to classical writers and Machiavelli, his republic is modelled on Venice. It should have a parliament composed of two chambers: a large one comprising representatives of the people, and a small elected senate, imitating the Venetian Council of Ten, able to act promptly in national emergencies. All offices will rotate, forestalling the development of an oligarchy and the growth of factions.

Great claims have been made for Harrington's importance in the history of republican thought.[203] Certainly his vision of an agrarian republic appealed to some of the American Founding Fathers.[204] And he cannot be accused of vagueness: his scheme of the government of Oceana is obsessive in its detail. But in most respects *Oceana* was a dead end. Hume, while praising it as 'the only valuable model of a commonwealth that has yet been offered to the public', pointed out that its key ideas were unworkable: the system of constantly rotating offices would prevent any individual from gathering much political experience; and the agrarian law's limitations on landholding could easily be circumvented.[205] In addition, Harrington's disapproval of mobile property makes his system unsuitable for modern commercial society. Above all, he wants a balanced constitution that will not only prevent tyranny from above or below but will ensure that nothing can ever change. He admires the Venetian Republic because 'there never happened unto any other commonwealth, so undisturbed and constant a tranquillity and peace in herself, as in that of Venice'.[206] Oceana, learning from Venice's example, will be 'a perfect and (for ought that in human prudence can be foreseen) an immortal commonwealth'.[207]

Many republicans besides Harrington thought that the citizens of a republic, or at least the leading citizens, should be prepared to fight for it. Machiavelli insists that mercenary armies are worse than useless, because they only fight for gain, not from patriotism, and do as little fighting as they can get away with.[208] A republic should 'send its own citizens as generals' (as opposed to the commanders of hired troops).[209] Disapproval was expressed not only for foreign troops, but also for the standing armies maintained by early modern absolutists, which kept their people in subjection. After the Peace of Ryswick in 1697, which settled nine years of war between France and a coalition of states including England, it was widely expected that William III would dissolve, or at least sharply reduce, his army; his failure to do so provoked passionate discussions, in which the existence of an army was declared incompatible with liberty.[210]

It was not only republicans who worried about the power at the disposal

of monarchs, but republicans at least offered a solution: the establishment
of a militia, in which every able-bodied man should receive regular train-
ing. The Scottish patriot Andrew Fletcher, who drew up an elaborate
scheme for this purpose, opined: 'A good militia is of such importance to
a nation, that it is the chief part of the constitution of any free govern-
ment.'[211] He pointed out that the armies of the Roman Republic were a
militia, composed of citizens who returned to civilian life after their term
of service, whereas the Empire had a standing army that maintained the
emperor's autocracy. It was possible to feel, however, that in Britain at
least, republicans' panic about a standing army was overdone and hyster-
ical. Adam Smith argued that an army was only dangerous when its
leaders, like Julius Caesar and Oliver Cromwell, did not support the state,
but in modern Britain, when the sovereign is the supreme commander,
and the officers are part of the civil authority, 'a standing army can never
be dangerous to liberty'.[212]

By citing the Roman Republic as a model, Fletcher touched on several
sore points. The surest way of limiting factions in a republic, it could be
argued, was for the republic to be constantly on guard against its enemies.
'A republic must dread something,' states Montesquieu.[213] The authors of
the *Histoire des deux Indes* agree that whereas monarchies need peace
and security, republics thrive on constant anxiety and the fear of an enemy.
Thus Rome needed Carthage, and the real bane of republican liberty was
the elder Cato with his insistence that Carthage must be destroyed.[214]
Solidarity among the Romans, as Machiavelli argued, was preserved by
constant wars – wars of aggression, not defence. War promotes unity in
a republic: 'For discord in a republic is usually due to idleness and peace,
and unity to fear and war.'[215] But this principle is deeply worrying. For if
the health of a republic depends on aggressive warfare and hence on ter-
ritorial expansion, it must eventually turn into an empire – in reality, even
if not in name. And Machiavelli is so taken by Rome's success that he fails
to consider when aggression becomes self-defeating.[216]

## ROUSSEAU AND THE SOCIAL CONTRACT

Jean-Jacques Rousseau emerged from within the Enlightenment to become
its major antagonist. A deep gulf came to separate him from the propo-
nents of the Enlightenment, whose friendship he eventually rejected. He
became famous through what may be called countercultural writings, in
which he argued that modern civilization, far from being an advance on
savagery, marked a state of decline which could only get worse. In this

sense Rousseau is the ancestor of all those subsequent thinkers who have analysed the irremediable discontents underlying our purported civilization.[217] After his countercultural *Discourses*, Rousseau described in *Émile* how a boy might be brought up free from the corrupting influence of civilization; evoked in *Julie ou la Nouvelle Héloïse* how even modern life might be purified by sentiment; and in *The Social Contract* put forward a vision of a possible modern polity based on virtue.

In the 1740s Rousseau was living obscurely in Paris, scraping a living as a tutor and music copyist, when he decided to enter for the prize offered by the Academy of Dijon for an essay on the question 'Has the progress of the sciences and the arts contributed to the corruption or the purification of morals?' By his later account, he saw the announcement in a newspaper while walking from Paris to Vincennes to visit Diderot, who was in prison there, and the title unleashed such a torrent of ideas that he reached Vincennes 'in a state of agitation bordering on delirium'.[218]

Rousseau's prize-winning entry, *Discourse on the Arts and Sciences*, answered the Academy's question with an emphatic assertion that such progress had led to moral corruption. His positive standard throughout is a simple, unsophisticated state in which the arts and sciences are still unknown, virtue is unimpaired, and everyone is devoted to the fatherland and prepared to fight in its defence. His examples include the ancient Persians (of whom Herodotus tells us that they taught boys to ride, to use the bow, and to tell the truth); the Scythians, who in ancient times inhabited what is now southern Russia; the ancient Germans (whose virtues are described by Tacitus); the Romans in the early days of their republic; and the modern Swiss, referred to obliquely as 'that rustic nation so vaunted for its courage which adversity could not subdue, and for its faithfulness which example could not corrupt'.[219] So-called civilized nations, where the arts and sciences flourish, all fall victim to luxury and vice. Their 'politeness', 'this vaunted urbanity which we owe to the enlightenment of our century', is hollow and insincere, concealing suspicion, hatred, and betrayal.[220] People no longer enjoy freedom and no longer love their fatherland; increasingly their only criterion of value is money; artists compose not for posterity, but for short-term success; and talent is overestimated at the expense of virtue. All civilizations have gone through this process of decline and fallen easy prey to simple, virtuous nations that valued liberty and military prowess. Hence Athens was defeated by Sparta, Rome by the nations that it foolishly despised as barbarians, and the Holy Roman Empire at various times by the Swiss and the Dutch.

The arts and sciences do not merely accompany this process of decline but help to promote it. Prometheus, often considered the archetype of

enlightenment in bringing fire to humanity, was not a benefactor, but 'a God inimical to man's repose'.[221] The arts and sciences spring from vices – astronomy from superstition, physics from idle curiosity, eloquence from ambition – and in turn strengthen vice. Printing is a 'terrible art' which has already caused 'frightful disorders'; sovereigns may be expected soon to prohibit it.[222] It makes possible the diffusion of bad books in which philosophers teach pernicious lessons, and scientists answer trivial questions about the geometry of curves and the reproduction of insects. 'While the conveniences of life increase, the arts improve, and luxury spreads; true courage is enervated, the military virtues vanish, and this too is the work of the sciences and of all the arts that are practiced in the closeness of the study.'[223]

For this state of affairs, Rousseau naturally has no solution. He ends the essay by advising the individual to practise virtue in private life. Throughout the essay, however, he has evoked an alternative that, since he finds an approach to it in modern Switzerland, may not be wholly utopian: a society living in virtuous poverty, where everyone is conscious of being a citizen and wishes to serve the polity. Alluding to the classical view that one can only realize one's humanity fully as an active member of a polity, Rousseau declares: 'In politics, as in ethics, not to do good is a great evil, and every useless citizen may be looked upon as a pernicious man.'[224]

Rousseau's essay radically assailed the belief that material and moral progress went together. In 1750, as the Academicians at Dijon were reading his polemic, their colleagues at the Sorbonne were being assured by Turgot that 'the human race as a whole, alternating between calm and agitation, good and ill, is continually marching, though by slow steps, towards a greater perfection.'[225] As we have seen, Turgot's view was too extreme to be representative of Enlighteners in general. Rousseau's arguments were extreme in the opposite direction, and being unexpected and original, aroused widespread attention and controversy.

Still more controversial was Rousseau's second submission to the Dijon Academy. In answer to the question 'What is the origin of inequality among men, and is it authorized by natural law?' Rousseau gave a pessimistic summary of the whole course of history. The *Discourse on the Origin and the Foundations of Inequality among Men* takes its readers back to the very beginnings of history, to the putative state of nature. Natural man was not warlike, as in Hobbes, nor sociable, as in Shaftesbury, but solitary. Natural man was not miserable, whatever the civilized may think, because his body was healthy and his heart at peace. Nor, *pace* Hobbes, was he wicked. He was animated by two basic principles, which Rousseau professes to have discovered by examining his own character.

One was self-preservation (as in *Émile*, where self-love is the primary impulse and can later develop into the love of others).[226] The other was pity, 'a natural repugnance to seeing any sentient being, and especially any being like ourselves, perish or suffer', which in Rousseau's opinion is the natural source of all other virtues.[227] Even animals, he points out, are disturbed by seeing dead members of their own species; and even the cynical Mandeville admits that a man would feel agony on seeing a child suffering and being unable to help it.[228]

Although the *Discourse on Inequality* has always been rightly understood as a defence of primitivism, the primitivism it advocates is not the (imaginary and implausible) lifestyle attributed to humanity before history, but a later condition, when humanity had begun to form a society.[229] Rousseau admits that he can only speculate about 'the various contingencies that can have perfected human reason while deteriorating the species, made a being wicked by making it sociable'.[230] The population may have grown and spread into new environments that made it necessary to find new sources of food by hunting and fishing, which in turn required co-operation. Instead of living in caves, people learned to make huts. Males and females settled there together, and family life developed: 'Each family became a small society, all the better united as mutual attachment and freedom were its only bonds'; it enjoyed 'the sweetest sentiments known to man, conjugal love, and paternal love'.[231] The sweetness of family ties spread to cordial relations with neighbours; but the more society developed, the more scope there also was for jealousy, enmity and bloodshed. People used their leisure for communal dancing and singing; but this too came at a price, for it brought out the innate inequality among people's gifts, and gave rise to 'vanity and contempt on the one hand, shame and envy on the other'.[232] So the formation of society meant a fall from humanity's primeval innocence and happiness. Nevertheless, this early society is a form of primitivism that Rousseau positively commends, lamenting that 'all subsequent progress has been so many steps in appearance toward the perfection of the individual, and in effect toward the decrepitude of the species'.[233]

The remainder of the *Discourse* is a mournful summary of humanity's material progress and moral decline. When people wanted to plan for the future and increase their possessions, they developed metallurgy and agriculture. 'For the philosopher, it is iron and wheat that civilized men, and ruined mankind.'[234] The manufacture of metal goods increased the need for the division of labour and social inequality. When land was cultivated, it had to be divided and transformed into property. The innate differences in people's intelligence and strength reinforced social divisions and confirmed inequality. Relations of domination and servitude appeared, and

had to be regulated and strengthened by laws, which 'contain men without changing them'.[235]

A still more insidious moral corruption appeared when social life became governed by insincerity: 'To be and to appear became two entirely different things, and from this distinction arose ostentatious display, deceitful cunning, and all the vices that follow in their wake.'[236]

The last stage of inequality is that of despotism, when all become slaves, subject to the despot. But in modern life, even if we are not subject to physical tyranny, we are enslaved to the opinion of others: 'everything being reduced to appearances, everything becomes factitious and play-acting: [we are] forever asking of others what we are, without daring to ask it of ourselves.'[237]

By 1762, when Rousseau published *The Social Contract*, the concept that forms its title was a well-established, though controversial, component of political theory. It grows out of the tradition of natural law, whose history goes back to the Stoic ethics developed and popularized by Cicero: 'True law is right reason, consonant with nature, spread through all people. It is constant and eternal; it summons to duty by its orders, it deters from crime by its prohibitions.'[238] The eighteenth-century translator of Cicero's *De officiis* says: 'If we except the Holy Scriptures, the following Work has been, perhaps, of more Service to Mankind, than any that ever was publish'd', and calls it the 'Ground-Work' of all that Grotius, Pufendorf, and other natural law theorists have written.[239] The Dutch theorist Hugo Grotius maintained that natural law was founded on the Ciceronian 'right reason' that man shared with God, and on man's natural sociability. The German lawyer and historian Samuel Pufendorf disagreed with Grotius on both counts. He based his arguments not on theology, but on anthropology: on empirical observation of what human beings were actually like. Observation showed that human nature was not particularly rational or sociable:

> It is quite clear that man is an animal extremely desirous of his own preservation, in himself exposed to want, unable to exist without the help of his fellow creatures, fitted in a remarkable way to contribute to the common good, and yet at all times malicious, petulant, and easily irritated, as well as quick and powerful to do injury. For such an animal to live and enjoy the good things that in this world attend his condition, it is necessary that he be sociable, that is, be willing to join himself with others like him, and conduct himself towards them in such a way that, far from having any cause to do him harm, they may feel that there is reason to preserve and increase his good fortune.[240]

To enjoy the advantages of society, man has to leave the state of nature and enter the political state. This is done by a series of contractual agreements: first a contract of association, then an agreement on the type of government, and then a contract of subjection. The first stage produces a union of wills, and hence a state; in the second, people agree on a particular kind of state (monarchical, aristocratic, or democratic); and in the third they agree to obey its ruler.[241] It is not clear how we are to imagine these agreements as historical events, but at any rate Pufendorf, writing in Germany soon after the devastating Thirty Years War, imagines not a sequence of rational treaties but 'a series of fear-driven decisions that results in the creation and imposition of a new status or moral person', i.e. brings the state into being.[242]

A partially similar explanation of the contractual origins of society was put forward by John Locke in his *Two Treatises of Government*. The theory of political right offered here is still sometimes thought to be a retrospective justification of the Glorious Revolution. In fact, although they were published in 1690, the *Treatises* were written early in the 1680s in response to the Exclusion Crisis, during which nobles led by Locke's employer, the earl of Shaftesbury, tried unsuccessfully to debar Charles II's Catholic brother James from succeeding to the English throne. As Locke developed his ideas about the foundations of government, however, they acquired implications far beyond their immediate occasion.

To explain the origins of political power, Locke imagines a 'state of nature' in which all human beings are equal, without subordination. This state is very different from the barbarous primeval 'war of all against all' deplored by Hobbes in *Leviathan*. It is a state governed by a 'law of nature' that is synonymous with 'reason', and 'teaches all mankind, who will but consult it, that being all equal and independent, no one ought to harm another in his life, health, liberty or possessions'.[243] People in this state combine to form 'civil society', which provides security of property and protection against those malefactors who ignore the voice of reason and harm their fellows. In so doing, people give up their right to take revenge on those who injure them, and resign that right to society, which thenceforth has both the executive power to punish wrongdoing, and the legislative power to make laws. Society thus originates as a contract, in which the individual cedes some freedom in return for security. If at a later stage that contract is broken – if the government invades the property and liberty of the subject – then the subject is entitled to offer resistance, and, in extreme cases, people are entitled to join together and carry out a revolution.

Is the just-so story about the state of nature meant as fact or fiction? To the obvious objection that no such state of nature is known, Locke

# TWO
# TREATISES

OF

# Government:

In the former,

The *false Principles*, and *Foundation*

OF

Sir *ROBERT FILMER*,

And his FOLLOWERS,

ARE

**Detected** and **Overthrown.**

The latter is an

# ESSAY

CONCERNING THE

True Original, Extent, and End

OF

# Civil Government.

---

*LONDON,*

Printed for *Awnsham Churchill*, at the *Black Swan* in *Ave-Mary-Lane*, by *Amen-Corner*, 1690.

Locke's original title-page highlights his disagreement with Sir Robert Filmer's *Patriarcha: or The Natural Power of Kings* (1680).

replies by pointing to the indigenous societies of Florida and Brazil (II §14, §102). Another objection, made by Hume – that the earliest societies we know about are monarchies founded on superior force – Locke forestalls by the rather desperate conjecture that some people in the state of nature made the unwise decision to set up monarchies (II §106).[244] A distinguished expositor of Locke has maintained that 'in practice the inferential resourcefulness of natural theology always proves to exceed that of descriptive anthropology'; in plain English, that the state of nature is merely a fictive expression of the understanding of human nature that Locke derived from his Christian belief.[245]

Whatever its status, Locke's 'state of nature' put into circulation a number of ideas that would eventually permeate and reshape political thinking. Like Pufendorf, Locke detaches politics from theology. The first of his *Two Treatises* is a lengthy attack on the theory of kingship by divine right put forward in Filmer's *Patriarcha*. According to Locke, government depends for its legitimacy on the *consent* of the governed – not on anyone's right to rule over them, nor on the absolute ruler's ability to make them happy.

Admittedly, the concept of consent is problematic. Locke is convinced that every political society rests on an original act of consent, whether this took place before recorded history, or is historically attested (he instances the founding of Rome and Venice, II §102). Now, some people may take part in the founding of a new polity; and some may give their consent to an existing polity in a ceremony, as when American schoolchildren recite the Pledge of Allegiance.[246] These are examples of what Locke calls 'express consent'. But supposing I do not have the chance to do either, how do I signify my consent to the polity I am born into? Here Locke deploys the concept of 'tacit consent'. Birth in a particular country implies no allegiance to that country: one is 'a freeman, at liberty what government he will put himself under, what body politic he will unite himself to' (II §118). I consent tacitly to the laws of a country by living in it; Locke 'was willing to count the ongoing process of continued, voluntary residence as giving consent'.[247] If I travel abroad, I consent to the laws of a foreign government by lodging there, or even just by 'travelling freely on the highway' (II §119). This, however, has often been thought a weak conception of consent. As Adam Smith pointed out, you might as well say that, having been carried aboard a ship while asleep, I consent to being there, though with the ocean all round me I have nowhere else to go.[248] On the other hand, any particular law depends on popular consent, since the people have delegated the power of making laws to the legislative part of government. Hence, among other implications, the government 'must

not raise taxes on the property of the people, without the consent of the people, given by them or their deputies'.[249] It was to this principle that the Americans would later appeal when required to pay taxes to which, not being represented in Parliament, they had no means of consenting.

Rousseau's *Social Contract*, despite its links with Locke, is a highly original work. Its author, not surprisingly, complained that it had been gravely misunderstood. He told a fellow-Genevan living in Parisian exile that it was based on two main principles: 'The first is that legitimately the sovereignty always belongs to the people; the second, that aristocratic government is the best of all.'[250] Although much in *The Social Contract* is strange, and perhaps repellent, it is not a head-in-the-clouds utopian scheme. It is an attempt to imagine a form of government somewhat resembling the Genevan republic in which Rousseau had been brought up, and to educe the underlying principles of government.

In *The Social Contract* Rousseau, like Locke, starts from the fiction of an original contract that men (the heads of families) made for the sake of their common self-preservation. However, the contract is not imagined as being made between some individuals, who agree to be ruled, and others who undertake to rule them. The contract is rather a change in how one understands oneself. Previously one was an isolated being, nominally 'free' to do whatever one wanted but constrained by natural forces (harsh weather, dangerous animals and the like). Under the social contract, one now understands oneself as a member of the sovereign people. Each individual submits himself to the general will and then forms a body politic which can be called State or Sovereign. The freedom he thus gains is the positive freedom of a citizen whose membership of a community sets him free from many physical constraints and enables him to become his best self – 'out of a stupid and bounded animal [to become] an intelligent being and a man'.[251]

However, the individual is not thereby absorbed into the collective. His will as a man may be quite different from the general will in which he participates as a citizen. He may imagine that his contribution to the common cause is voluntary, and that he can withdraw it while continuing to enjoy the rights of a citizen; but if so, he is wrong, and will discover that the social contract includes the tacit condition 'that whoever refuses to obey the general will shall be constrained to do so by the entire body: which means nothing other than that he shall be forced to be free'.[252] This may sound repellent, but it means that the individual is required to continue in his status as a citizen, and not to revert to anarchic, pre-social, insecure 'freedom'. Membership of the sovereign body gives many advantages – for example, the law protects him against violence – and also

DU

# CONTRACT SOCIAL;

OU

# *PRINCIPES*

## DU DROIT POLITIQUE.

PAR J. J. ROUSSEAU,
*CITOTEN DE GENEVE.*

—— *fœderis æquas.*
*Dicamus leges.*
Æneid. XI.

*Suivant la Copie Imprimée*

*A AMSTERDAM,*
Chez MARC MICHEL REY,
M. DCC. LXII.

Rousseau's motto comes from Virgil, *Aeneid*, Book 11, lines 321–2: 'let us name just terms of treaty'.

confers obligations: it is only fair that in return one should be prepared to defend the fatherland when it is in danger.

The people, collectively, is sovereign, and thus expresses the general will. The general will, by definition, cannot be mistaken; it always wills what is best for the community as a whole. The general will is, so to speak, the collective best self of the community; just as positive freedom enables each person to realize his best self, so the general will is 'the rational will everyone *ought* to have', and ultimately the will of God – a concept that has been traced back to Rousseau's Calvinist upbringing.[253] Rousseau thus answers the common objection to classical republicanism – that it was unrealistic in requiring its citizens to be virtuous. Participation in political life is a constant process of civic education, which will encourage virtue, responsibility and public spirit. The general will is expressed through laws which the sovereign people, as the legislative part of the state, give themselves. Obedience to the laws, therefore, is obedience to a rule that one has given oneself. It is self-discipline, and hence freedom.

It is essential, however, that individuals should not combine to form factions. For the wishes of the individuals would be submerged into the policy of a faction that does not correspond to the wish of any individual, and therefore distorts the general will. 'It is important, then,' concludes Rousseau, 'that in order to have the general will expressed well, there be no partial society in the state, and every citizen state only his own opinion.'[254]

By distinguishing sovereignty from government, Rousseau means that the sovereignty of the people does not mean that the people directly govern themselves. He surveys, in the manner of Montesquieu, the pros and cons of three forms of government – democracy, aristocracy and monarchy – and, despite an evident hankering after democracy, decides that aristocracy is the best. By aristocracy he emphatically does not mean a hereditary nobility. He means, rather, rule by *aristoi*, the best: citizens will elect as magistrates those fellow-citizens whom they consider the wisest and most upright. Democracy may work in a very small state, where each citizen knows all the others, and where there is simplicity of morals, equality of ranks, and little or no luxury. Even so, democracy is extremely subject to intestine quarrels and civil wars, but the citizen of a democracy must console himself by saying: 'I prefer a perilous freedom to quiet servitude.'[255] In a larger state, 'the best and most natural order is to have the wisest govern the multitude, so long as it is certain that they will govern it for its advantage and not for their own.'[256]

It is important to note that Rousseau is not advocating government by representation. Since sovereignty is indivisible, it cannot be divided into representatives and the represented. The magistrates are elected for a

limited term to carry out administrative tasks. Rousseau is still keen on popular assemblies, though a little vague about when and where they should meet. It is not practical for such assemblies to do the work of government. They serve, however, to keep the magistrates under scrutiny, to forestall any attempt by the magistrates to seize additional power, and to make the people visible to itself. They also enable the people to reaffirm their acceptance of the contract: 'by returning to its foundations the people reinvigorates a present and immediate commitment to justice, to a single virtue.'[257]

It would be wrong, therefore, to see Rousseau as trying to recreate ancient Athenian democracy for the modern world. However, he does want to retain the ancient ideal of participatory citizenship. Public service ought to be 'the citizens' principal business'.[258] They ought to spend more time attending the assemblies and discussing public affairs than on their private concerns, such as 'the hustle and bustle of commerce and the arts'.[259] Rousseau disapproves of taxes as much as a modern neo-conservative might, but on entirely opposite grounds. Instead of wanting to shrink the state, Rousseau wants to expand it. Rousseau's objection is that the taxpayer is using his money to pay other people to perform tasks that, as a citizen, he ought to do himself. 'I believe corvées to be less at odds with freedom than taxes', he writes, referring to the forced labour by which public highways were built in eighteenth-century France, and implying that a citizen ought himself to help build the roads from which he will benefit.[260]

Some of Rousseau's ideas can be placed in sharper focus, and perhaps made to seem a little less strange, if they are juxtaposed with the political doctrines held by the patricians of his native city. Since the mid-sixteenth century, Geneva had been an independent republic governed supposedly by the entire citizenry in a General Council. Gradually a subordinate body, the Little Council, had taken over so many responsibilities that it had become dominant. In the early eighteenth century, Geneva was rocked by disputes between the patricians, who wanted to retain their oligarchy, and the bourgeoisie who wanted to regain their share in government. The patricians, appealing to natural law, argued that their rule was based on a contract whereby the people gave up their unlimited natural liberty and agreed to submit to rule in return for civil liberty, understood as 'the freedom to lead essentially private lives without arbitrary interference, rather than as the freedom to participate in law-making'.[261] Their councils were bodies representing the people, who had ceded to them the right to rule. Rousseau would have none of this. In his eyes, submission to particular magistrates was mere slavery, and representation a mask for arbitrary rule.

Freedom could only consist in obedience to laws that one had given oneself.

It would be a mistake to read *The Social Contract* in too close conjunction with the *Discourses*. The three texts were written at intervals of several years and argue different cases. *The Social Contract* has even been described as 'an almost inconceivable reversal' of the attacks on society put forward in the *Discourses*.[262] It does not advocate the primitivism of the First *Discourse*. Nor is it an attempt to arrest the decline of civilization, sketched in the Second, by reconstructing an ancient virtuous republic. The combination of participatory democracy and elective aristocracy bears some relation to Rousseau's Geneva, or to what Geneva might have been if it had not been corrupted by illegitimate power and the growth of luxury. Rousseau is not offering a one-size-fits-all model for every society. Like Montesquieu, he contrasts democracy, aristocracy and monarchy, and concludes that an aristocracy only works in a state of moderate size.

The society imagined in *The Social Contract* has aroused contradictory, intense, often visceral reactions. In the Cold War period it was common to denounce Rousseau as a deplorable prophet of modern totalitarianism.[263] It has been pointed out, however, that Rousseau did not imagine the sovereign people as having complete power over individuals. Its sovereignty should never be allowed to infringe the moral imperatives of natural law.[264] Far from envisaging anything like a socialist planned economy, his state would be compatible with modern commercial society – though economic growth would be monitored to forestall the development of imbalances between rich and poor.[265]

Nevertheless, Rousseau's social thinking, even on the most sympathetic reading, poses a number of problems. To take just one example, how does the sovereign people set about making laws for itself? Here Rousseau resorts to the myth of the great legislator. His favourite example is Lycurgus, the lawgiver of Sparta. Plutarch's *Life* of Lycurgus tells how this great man intervened in Sparta, which was in a condition of anarchy, by assigning everyone an equal amount of land, practically abolishing money, doing away with all luxuries, making people eat simple food in public refectories, and instituting a bizarre training system designed to create a population of invincible warriors. Taking Lycurgus as his model, Rousseau declares that the Lawgiver must be 'an extraordinary man', 'a superior intelligence' who understands the temperament of his nation and therefore knows what kinds of laws are suitable for it, and by his wise and far-sighted legal code reshapes the people's character and enables them to flourish in the 'solid and lasting institution' that he has devised.[266]

It is instructive to glance at the judgement on Lycurgus reached by Schiller in his essay 'Die Gesetzgebung des Lykurgus und Solon' ('The Legislation of Lycurgus and Solon', 1790). Schiller points out that Lycurgus' laws promoted one virtue, patriotism, at the expense of all others. Spartans were discouraged from pursuing arts and learning and were forbidden to visit other countries or even to trade with them. In order not to distract the Spartans from their goal of perfect military readiness, nothing new was permitted. Spartan society was not supposed to change or develop. In Athens, on the other hand, the lawgiver Solon, instead of trying to foreclose all change, left the Athenians free to develop, so that the future was open. In Sparta the state was an end in itself; in Athens it was the vehicle for human betterment. 'The state itself is never the purpose, it is only important as a precondition under which the purpose of humanity can be fulfilled, and this purpose is nothing other than the development of all human powers – progress.'[267]

People develop, as Schiller and Kant maintain, through argument, debate and conflict arising from the 'unsocial sociability' that is characteristic of human beings and which makes our lives uncomfortable but also creative. In Rousseau's social model, people will not always agree, but differences of opinion will cancel one another out and be subsumed under the general will. There are to be no factions. The assemblies will not debate social issues, but ceremonially celebrate the people's solidarity. If there is any doubt about what the general will is, magistrates will interpret it for the benefit of the people, whom Rousseau calls 'a blind multitude, which often does not know what it wills because it rarely knows what is good for it'.[268] The aim of the state is 'unity and unanimity'.[269] And in its unanimity Rousseau's free republic becomes a strange mirror-image of absolutist monarchy. As we have seen, the monarch knows what is best for his subjects. In Rousseau's state, the general will knows best, though as it cannot speak for itself, wise and upright magistrates will give it voice. Within a few years, Rousseau's social model would be tested in practice by the French Revolution.

# 14

# Revolutions

The American and French Revolutions might be seen as the climax of this book. Both, after all, famously invoked the ideal of human happiness. The American Declaration of Independence affirmed on 4 July 1776: 'We hold these truths to be self-evident, that all men are created equal, that they are endowed by their Creator with certain unalienable Rights, that among these are Life, Liberty and the pursuit of Happiness.'[1] The first article of the French Constitution promulgated on 24 June 1793 declared: 'The goal of society is common happiness.'[2]

Some distinguished historians have argued that the American and French Revolutions need to be understood as linked and similar events.[3] Taken together, they form the centre of an age of democratic revolutions, along with the Patriot Revolution in the Netherlands, the United Irishmen's unsuccessful revolt against British rule, the revolt of ex-slaves in Haiti under Toussaint L'Ouverture, and liberation movements in Spanish America. All these revolutions, it has been claimed, represent the translation into action of Enlightenment radicalism.

Yet the blanket term 'revolution' denotes a different kind of event in America and in France, and it is far from clear that events in the former were a necessary precondition for events in the latter. Actors in both were imbued with ideals associated with the Enlightenment, but not always those one might expect. The French revolutionaries largely admired Rousseau but rejected the ideas of the Paris *philosophes*, who in turn mostly deplored the course taken by the Revolution; the main exception, Condorcet, became prominent in revolutionary politics, only to fall victim to the Reign of Terror.

The relation between ideas and political events is in any case not straightforward. Ideas can seldom be translated directly into political action. Political events need to be explained first and foremost in political, rather than intellectual, terms. As the history of the French Revolution makes especially clear, they have a dynamism of their own, irrespective

of the ideas that may inspire some of their actors. In examining the American and French Revolutions, therefore, it is necessary both to trace the history of ideas as accurately as possible, and to bear in mind that political power is a force in its own right.

## THE AMERICAN REVOLUTION

American resistance to rule from London took shape among a population that had absorbed much of Enlightenment thought. Society in the American colonies was dominated by an elite of highly educated lawyers and landowners.

> The ruling philosophy of the generation that established the independence of the United States was the very quintessence of the Enlightenment, with its belief in the rights and perfectibility of man and his capacity for peaceful self-government once the artificial barriers to his freedom – monarchy, aristocracy and established church – had been destroyed.[4]

Many members of the ruling elite were familiar with the political theories of Locke, Hume and Montesquieu, and the natural law tradition. Some North American colonists owned extensive private libraries containing works not only by these thinkers but by Newton, Rousseau, Voltaire, Condorcet, Raynal, Burke, Kames and the Aberdonian philosopher Thomas Reid.[5]

The American Revolution was not only an enlightened undertaking, but also a very British affair. First, it was not a revolution in the sense which the term acquired from the French Revolution onwards. It was certainly felt to be 'a mighty revolution', as John Adams wrote to his wife, Abigail, just before the Declaration of Independence.[6] It aimed to throw off a government felt to be oppressive, but not to remodel society. It was not a 'revolt' or a 'rebellion'. Like the Glorious Revolution of 1688, it aimed to restore an order which, it said, had been violated by the government's encroachment on the rights of citizens.[7]

Secondly, as the majority of the American colonists were of British descent, they preserved historical memories of earlier British struggles for liberty. They recalled how John Hampden had stood trial in 1637 for refusing to pay ship money, a tax to build up the navy that Charles I levied without the sanction of Parliament, and how in 1642 Parliament had taken up arms in order to resist the king's attempts to impose high Anglican religious practices on a reluctant people. In the 1770s, as in the 1640s, they took up arms for the initially conservative purpose of defending their

traditional liberties. Edmund Burke, in his great 'Speech on Conciliation with America', reminded the House of Commons that the Americans were 'descendants of Englishmen' and 'therefore not only devoted to Liberty, but to Liberty according to English ideas, and on English principles'.[8]

Ancient wounds were reopened by the government's high-handed imposition of new taxes on America. Since the colonists were not represented in Parliament, they had to pay taxes that they had had no say in establishing. Colonists protested with what commentators, depending on their sympathies, call 'mobbing and rioting' or 'organized crowd action'.[9] The Tea Act (1773) imposed a tax on tea in order to help the struggling British East India Company, thus making tea an expensive luxury. Americans responded with the so-called 'Boston Tea Party', in which colonists disguised as Mohawks boarded three ships and threw huge quantities of tea into Boston Harbour (a complicated technical operation, requiring blocks and tackle to lift up heavy tea chests).[10] Protesting against the earlier Stamp Act (1765), which required stamp duties to be paid on many items and activities, such as buying or selling land, engaging in trade, getting married, reading newspapers or pamphlets, taking public office, or appearing in court, mobs in Boston plundered and destroyed the houses of Thomas Hutchinson, the governor of Massachusetts Bay, and Benjamin Hallowell, the comptroller of customs.[11] In March 1766 Parliament repealed the Stamp Act but simultaneously passed the Declaratory Act, affirming its absolute power to make laws and statutes binding on the people of America.

Religious liberty also seemed under threat. The many Nonconformists who had emigrated and settled in America to practise their particular brands of religion were suspicious of the English missionary Society for the Propagation of the Gospel in Foreign Parts, fearing that it might be a stalking-horse for the introduction of an Anglican episcopate (especially as the Society's American headquarters were in Cambridge, Massachusetts, where there were not many heathen to convert). Moreover, fear of a standing army, as a potential instrument of oppression, was aroused when Parliament sent two British regiments to quieten the Boston area protesting against the Stamp Act. It felt like a replay of the struggle between Charles I and Parliament.

Historians have wished to place the founding of the American republic within one of two historical and intellectual narratives.[12] One is a liberal narrative, which attributes great influence to Locke. In this account, the Founding Fathers were animated by a belief in individual natural rights; they regarded government as simply an instrument to secure legal and property rights; and they thought that a well-planned government could

channel self-interest and acquisitiveness and make these passions work to the advantage of society as a whole. The other narrative insists on the lasting importance of classical republican theories, whereby the republic depends on civic virtue and demands the participation of all its citizens. This tradition, under the name of 'civic humanism', is said to have been transmitted via Machiavelli and seventeenth-century republicanism, especially that of James Harrington, to the Founding Fathers.[13] Its proponents stress the English tradition of radical and republican thought going back to Parliament's struggle against Charles I, often referred to as 'the good old cause'.[14] This tradition, hostile not only to the absolutist pretensions of the Stuart monarchy but also to the dictatorship of Cromwell, was sustained by a small number of 'Commonwealthmen' throughout the eighteenth century. Locke's *Two Treatises of Government*, it is argued, attracted little interest for most of the eighteenth century; in America Locke was regarded as a minor contributor to the natural law tradition, whose leading representatives were Grotius and Pufendorf.[15] A stronger inspiration was the republican Algernon Sidney, whose trial for treason under the notorious Judge Jeffreys, and his subsequent execution in 1683 on the flimsiest grounds, gave him the aura of a martyr. Recently, however, Locke has made a comeback, and claims have again been made for the importance of his thought in early America, though perhaps in a more diffuse way than the earlier generation argued.[16]

Among the intellectual sources of the colonists' resistance, classical republicanism seems to have played only a minor, rhetorical role. Classical sources were 'illustrative, not determinative, of thought'.[17] Nobody proposed to set up a new Athens or Sparta. Addressing the Pennsylvania Convention in 1787, James Wilson, a Scottish-born lawyer who was later appointed to the Supreme Court, observed that the ancients were 'very uninformed' about systems of government; they had no conception of political representation.[18] The 'radical Whig' tradition was clearly important. Sidney's posthumously published *Discourses concerning Government* (1698), affirming a people's positive duty to disobey bad laws and depose a tyrant, were particularly admired by John Adams.[19] But we also find among the Founding Fathers both an insistence on the importance of civic virtue and an awareness that government cannot depend on such a rare quality. Hence the importance they attached to devising a constitution that made constructive use of self-interest by encouraging people to work both for their own good and for the ultimate good of the whole community.

While the colonists saw their conflict as a continuation of the English struggle between royal oppression and parliamentary or republican freedom, contemporaries who ignored this dimension of historical memory

could easily find their resentment disproportionate.[20] The colonists suf-
fered nothing comparable, for example, to the oppression of the Dutch by
the Spain of Philip II, or of the Huguenots under Louis XIV. Their taxes
were not very onerous. As for not being represented, politicians such as
Hans Stanley argued that as the House of Commons represented all the
commons, the Americans were represented by default.[21] If they were to be
represented directly, worried Stanley, it might be necessary to broaden the
domestic franchise, with dreadful consequences. The restrictions on their
commerce, though irritating, might be thought hardly to justify rebellion:
raw materials obtained in America, such as iron, had to be sent to Britain,
and the goods manufactured there had then to be imported to America.
'By an act passed in the 5th Year of the reign of his late majesty king
George the second,' complained Thomas Jefferson, 'an American subject
is forbidden to make a hat for himself of the fur which he has taken per-
haps on his own soil; an instance of despotism to which no parrallel [sic]
can be produced in the most arbitrary ages of British history.'[22]

The point was, however, that the Americans were a politically mature
people, capable of governing themselves and increasingly anxious to do
so. As Jefferson observed, America had been settled not as a government-
sponsored project, but by individuals. They governed themselves,
recognizing the king as 'no more than the chief officer of the people,
appointed by the laws, and circumscribed with definite powers', and
rejecting the authority of a Parliament in which they were not repre-
sented.[23] Similarly, Edmund Burke, deploring the unwisdom of British
policy, acknowledged that the Americans had attained a political maturity
that enabled them to run their affairs peacefully even when their local
assemblies had been prorogued by British intervention.[24] 'In New Eng-
land', he noted in 1775, 'you [the British government] have turned a mean
shifty peddling Nation into a people of heroes.'[25]

Writing in 1774, Jefferson still hoped for a continued union between
America and Great Britain, under the king, on terms which acknowledged
America's substantive independence. British military intervention, how-
ever, prompted Thomas Paine's inflammatory pamphlet *Common Sense*,
which called for complete independence. Paine's pragmatic arguments –
for example, that the sheer distance between them made it impractical for
America to be governed from Britain – combined with his invective against
'the Royal Brute of Britain' to convince a majority of Americans that the
time had come to separate themselves from the mother country.[26]

The upshot was the Declaration of Independence, drafted by Jefferson,
worked over by a congressional committee, and published under the title
*A Declaration by the Representatives of the United States of America, in*

*General Congress Assembled.*[27] Few texts have received such close scrutiny, and of course ambiguities have come to light. Much of the text lists the 'repeated injuries and usurpations' by George III, as reasons for the states' independence. But when it says 'That these United Colonies are, and of Right ought to be Free and Independent States', is it saying that the colonies already *are* independent, or that they will henceforth be independent? In other words, is it descriptive, formulating the present status of the colonies, or is it performative, making them independent by declaring them to be so?

It seems likely that contemporaries looked on the Declaration as a charter of sovereignty, and that its fame as a charter of human rights developed only later. The unforgettable sentence – 'We hold these truths to be self-evident, that all men are created equal, that they are endowed by their Creator with certain unalienable Rights, that among these are Life, Liberty and the pursuit of Happiness' – also requires interpretation. One might ask: if these truths are self-evident, why bother to state them? It is probable that Jefferson is indebted to the 'common sense philosophy' of Thomas Reid, who held that the basic perceptions of the ordinary person were equal in validity to those of the philosopher. This applies not only to simple perception but also to the wider area, which he calls that of common sense: 'Common sense deals with self-evident propositions (e.g., man should help, not hurt, himself and others) and the immediate consequences of those propositions (which are certain though not infallible).'[28] The Declaration therefore rests on the kind of good sense that the Enlightenment called 'right reason' and considered generally accessible to humanity.

The innocent phrase 'all men' was, of course, intensely problematic. Does it mean 'males' (*viri*) or 'human beings' (*homines*)? And what about slaves? Although some of them practised slavery, the colonists' assertion of their liberties repeatedly and injudiciously used the rhetoric of enslavement, denouncing the British government for making 'a regular plan to enslave America'.[29] Paine, writing pseudonymously in the *Pennsylvania Journal* in 1775, argued that slavery was not only contrary to humanity but particularly unacceptable in Christians who professed to love their neighbour as themselves.[30] Many colonists denounced slavery, and several northern states prohibited it. Others were deeply uneasy. Patrick Henry of Virginia deplored 'this lamentable evil' but felt slaves could not be freed because of 'the general inconvenience of living here without them'.[31] Jefferson, who was always too much in debt to free his own slaves, admitted that slavery was indefensible and hoped for 'a total emancipation'.[32] Readers of the Declaration were drawing this conclusion as early as 1776. Probably in that year, Lemuel Haynes, a mixed-race private in the

Continental army who afterwards became a clergyman, composed a denunciation of slavery in which he cited the Declaration and maintained: 'Even an affrican, has Equally as good a right to his Liberty in common with Englishmen.'[33]

The course of the American War of Independence is too familiar to need retelling. It may be said to have begun with the encounter between American militiamen and British troops at Lexington around sunrise on 19 April 1775, and with the skirmish later that day at Concord, where an American fired 'the shot heard round the world'.[34] The Americans benefited from French support; the British forces included large numbers of German soldiers, mercenaries obtained from the princes of Hesse-Cassel and Württemberg, most of whom were not sure where America was, let alone why they were there, and fought without enthusiasm.[35] It ended in October 1781 at Yorktown, where the British army under Cornwallis, trapped between American and French forces approaching by land and a French fleet cutting off its retreat by sea, surrendered. In September 1783 Britain acknowledged the independence of America by signing the Treaty of Paris.

The new nation had now to find a way of governing itself. For that purpose it had to draw up a constitution. This was to be something quite different from the unwritten British constitution. Instead of a set of institutions, laws and customs that had grown up almost haphazardly, the new nation required a set of principles, based on reasoned arguments, which could be formulated in a written charter.[36] Alexander Hamilton wrote in 1787:

> it seems to have been reserved to the people of this country, by their conduct and example, to decide the important question, whether societies of men are really capable or not of establishing good government from reflection and choice, or whether they are forever destined to depend for their political constitutions on accident and force.[37]

Could the power of reason liberate people from the accidents of history?

In addressing this question, the framers of the American constitution confronted a perennial and perhaps insoluble tension within democracy. If, following the principle of popular sovereignty, one grants popular assemblies the power to determine directly the policy of the government, one also runs the risk of encouraging unwise, short-sighted and perhaps malicious decisions. A popular assembly, calling its decisions the will of the people, may exercise what John Adams called 'the tyranny of the majority'.[38] And there have been occasions in several countries during the last two and a half centuries when the democratic majority has supported an illiberal party which, on attaining power, has even put an end to democracy. So, there is a case for having democratic decisions reviewed and

perhaps amended by another assembly, elected by different means or from a different group of citizens – that is, for a bicameral instead of a unicameral legislature. But a restraint on popular power invites the danger that the government may form an elite, out of touch with the mass of the people and perhaps serving its own interests rather than theirs. There is a risk of creating a self-perpetuating political class.

These problems raised strong feelings in the eighteenth century, and still do. In his recent account of the American Revolution and its worldwide impact, Jonathan Israel frankly takes the side of the 'radical democrats', contrasting them with the 'aristocratic' view that the power of the people should be restrained.[39] But one might, with more detachment, regard this tension – between the voters at large, who may abuse their power, and the governing class who may equally well abuse theirs – as endemic to democracy.[40]

During the war, the states were governed by Articles of Confederation, which did not provide a satisfactory basis for a permanent constitution. The Confederation had a rotating presidency and hence a weak executive; it did not have the power to raise taxes, so that the war was funded by the states, which were so reluctant to pay up that in 1780 and 1781 the army mutinied. Meanwhile the various states drew up their own constitutions. Reacting against what they considered the despotic power of the former British governments, they favoured single-chamber assemblies whose members were kept in check by annual elections and hence were responsive to the poorest and least educated electors. Discussing the constitution of Virginia, Jefferson complained that though it had two assemblies, both were chosen from the same body of candidates, so that the state lacked the advantages of bicameral government. He criticized also the concentration of executive, legislative and judicial powers in the same body: this amounted to a despotism, like that of the republic of Venice. 'An *elective despotism* was not the government we fought for.'[41] Instead, he advocated the separation of powers already recommended by Montesquieu. The executive power should be separate from the legislative power, and both separate from the judiciary. One body should make the laws, a second should put them into practice, and a third, in the event of a challenge, pronounce on their legality.

Between May and September 1787, the Constitutional Convention, meeting in Philadelphia, drew up a constitution for the new country. Its model was the Massachusetts constitution of 1780, largely drafted by Adams, which, in contrast to the unicameral assembly deplored by Jefferson, provided for 'a declaration of rights; the separation of powers; a bicameral legislature; an independent judiciary; and a powerful executive

directly elected by the people.'[42] The Convention proposed a constitution which kept the executive power (the presidency) and the judiciary (the Supreme Court) separate from the legislature, in contrast to the British arrangement whereby the prime minister, representing the executive, sat in the House of Commons and the supreme judicial authority was assigned to the House of Lords. Congress should comprise two chambers, the lower one, the House of Representatives, being chosen by the popular vote in each state, while the upper one, the Senate, would be chosen by the state's legislature. The president should not be elected by Congress, but by an electoral college, whose members should be chosen by the state legislatures. This measure was intended to prevent the accession to power of irresponsible populist demagogues.

A further safeguard against the abuse of democratic power was the separation of powers. Paine in *Common Sense* railed against the separation of powers in the British constitution, arguing that it was absurd for the monarchy to provide a check on Parliament and for Parliament to provide a check on the monarchy, as though neither could be trusted.[43] He did not see that powers need to be separate because neither the executive nor the legislature can be expected invariably to show wisdom. Instead, he thought government should be by a single representative assembly combining all three functions. Adams considered Paine 'very ignorant of the Science of Government'.[44] He pointed out that a single assembly can easily be swayed by caprices (especially if encouraged by an eloquent demagogue); it may want to make itself permanent, like the Long Parliament in England; its members cannot be restrained from making arbitrary laws in their own interests; and it is too inefficient, and too public, to exercise executive power in any emergency. Instead of the unicameral government advocated by Paine, Adams argued for a bicameral legislature in which the upper chamber would be a 'mediator between the two extreme branches of the legislature, that which represents the people, and that which is vested with the executive power'.[45]

Once drafted, the constitution was sent to the various states for ratification. Opposition came from those, especially in rural areas, who feared that the executive and the Senate would be too remote from the electorate and would form a hierarchical elite. The case for the federal constitution was made especially in a series of essays by Alexander Hamilton, James Madison and John Jay, published in the New York press between October 1787 and April 1788, and collected under the title *The Federalist*. By June 1788 nine states out of thirteen had ratified the constitution, a sufficient majority for it to become operative. On 30 April 1789, George Washington was inaugurated as the first president of the United States. The

anti-Federalists were defeated, but they did succeed in demanding a Bill of Rights, which was incorporated into the federal constitution in 1791.

In these discussions, the familiar problems of republican government were negotiated, and solutions arrived at. It was agreed on all sides that in the republic, with no monarch and no hereditary aristocracy, the people must be sovereign. But if, as Montesquieu maintained, the principle of a republic was virtue, how were virtuous men to be secured to govern it? In *Common Sense*, Paine argued that in a society of equals nobody would be tempted to depart from virtue by seeking superiority over others: 'Where there are no distinctions there can be no superiority; perfect equality affords no temptation.'[46] The authors of the *Federalist Papers* were less sanguine. 'To presume a want of motives for such contests as an argument against their existence would be to forget that men are ambitious, vindictive, and rapacious,' warned Hamilton.[47] They did not go so far as Hume, who quotes the political maxim *'that every man must be supposed a knave'*.[48] Hamilton wrote: 'The supposition of universal venality in human nature is little less an error in political reasoning than the supposition of universal rectitude.'[49] But it was widely agreed that any republic must fail if it made unrealistic demands on the virtue of its citizens:

> Mankind have been still more injured by insinuations, that a certain celestial virtue, more than human, has been necessary to preserve liberty. Happiness, whether in despotism or democracy, whether in slavery or liberty, can never be found without virtue. The best republics will be virtuous, and have been so; but we may hazard a conjecture, that the virtues have been the effect of the well ordered constitution, rather than the cause.[50]

Everything depended, therefore, on framing a constitution that would encourage and reward virtue, rather than taking its presence for granted. Since a modern republic could not be a direct democracy, like the ancient Greek city-states, but must rely on the election of representatives, a mechanism must be found to select the best: 'to depute power from the many to a few of the most wise and good'.[51] At the same time, the representatives should share the values and wishes of the people they represented. The representative assembly 'should be in miniature the portrait of the people at large. It should think, feel, reason, and act like them.'[52] Some people feared that the representatives would become an out-of-touch elite that put its own interests before those of the people. But with elected representatives, argued Madison, such fears were needless, for the representatives would already be well known to the voters, who could judge their abilities; they would be kept under control by frequent re-elections; and the laws they passed would apply also to themselves.[53]

Even so, the representatives, being human, would not be the egalitarian angels imagined by Paine. They would have their own ambitions and their own interests. The solution, according to Madison, was not to look for impossibly disinterested politicians but to acknowledge and neutralize their interests. One man's ambition must be simultaneously satisfied and made into the safeguard against another man's:

> Ambition must be made to counteract ambition . . . This policy of supplying, by opposite and rival interests, the defect of better motives, [is] particularly displayed in all the subordinate distributions of power, where the constant aim is to divide and arrange the several offices in such a manner as that each may be a check on the other – that the private interest of every individual may be a sentinel over the public rights.[54]

The problem, though, was not just individual interests. Individuals might combine to promote their joint interests, thus creating factions, which had long formed an insoluble problem for republican theory. The Founding Fathers joined those, such as Machiavelli and Montesquieu, who thought that factions or parties were at best a guarantee of liberty, at worst something that had to be lived with. Madison says: 'an extinction of parties necessarily implies either a universal alarm for the public safety, or an absolute extinction of liberty'.[55]

A representative democracy, however, faced the further danger that if a faction obtained majority support, it might tyrannize the minority. 'It is of great importance in a republic not only to guard the society against the oppression of its rulers, but to guard one part of the society against the oppression of the other part.'[56] But here a large republic had a great advantage over small ones. Small political bodies, like the ancient democracies, easily fell under the control of demagogues – as the history of Athens testified. In a republic extending over a continent, no faction could become very large, and factions could neutralize one another. A large republic, too, could avoid the dangers of the representatives becoming too remote from their electors, or else remaining so close to their base as to be incapable of a wider perspective. The representatives of each state would be familiar with the electors; the representatives in Congress would be able to look more broadly at the national interest. 'The federal Constitution forms a happy combination in this respect; the great and aggregate interests being referred to the national, the local and particular to the State legislatures.'[57]

The founding of the United States was celebrated as a triumph of reason and humanity, key values of the Enlightenment. James Wilson, persuading the Pennsylvania Convention to adopt the Constitution in November 1787,

spoke of 'the scene, hitherto unparalleled, which America now exhibits to the world – a gentle, a peaceful, a voluntary, and a deliberate transition from one constitution of government to another.' Elsewhere, revolutions were associated with war and violence; but here they could be considered 'only as progressive steps in improving the knowledge of government, and increasing the happiness of society and mankind'.[58] 'From 1775,' says Jonathan Israel persuasively, 'America became the first albeit highly imperfect model of a new kind of society, laying the path by which the modern world stumbled more generally toward republicanism, human rights, equality, and democracy.'[59] Later generations would of course find much to amend. Property qualifications would come to seem insufficiently democratic; by the 1830s, most states allowed all (non-slave) adult males to vote. Women's suffrage would not be built into the Constitution until the Nineteenth Amendment was added in 1920. Most worryingly for the founders, the Constitution permitted slavery. Southern States were allowed to count a slave as three-fifths of a citizen to establish their population and hence the number of their representatives. Without some such compromise, the Constitution could not have been agreed. But the evil effects that the 'peculiar institution' would have on subsequent American history are only too well known.

Many foreign observers warmly supported the American struggle for independence. 'I am an American in my principles,' wrote Hume, 'and wish we would let them alone to govern or misgovern themselves as they think proper.'[60] Turgot gathered around him a group of *américanistes* who made friends with Benjamin Franklin, the American minister in Paris from 1776 to 1785, and with his successor Jefferson. Schiller sympathized with the Americans' goals of establishing humanity's rights to life, liberty and the pursuit of happiness.[61] He even contemplated emigrating to the United States himself if the revolution there proved successful.[62] In Schiller's view, the American Revolution was a special revolution. It succeeded because the populace that carried it out was already politically mature. In this it differed from most revolutions, including the French Revolution, which, he believed, degenerated into rule by terror because the people were not prepared for their historic opportunity.[63]

## THE FRENCH REVOLUTION

When one immerses oneself in the history of the French Revolution, it is hard not to share the feelings of Georg Büchner, author of the drama *Danton's Death*, who wrote to his fiancée in 1834:

I've been studying the history of the French Revolution. I felt as though utterly crushed by the hideous fatalism of history. I find in human nature a terrible sameness, in human circumstances an ineluctable violence vouchsafed to all and none. Individuals but froth on the waves, greatness a mere coincidence, the mastery of geniuses a dance of puppets, a ridiculous struggle against an iron law that can at best be recognized, but never mastered.[64]

On reflection, however, certain large, perhaps unanswerable questions pose themselves. Why did events that began so promisingly go so horribly wrong, culminating in the Reign of Terror? How far does the French Revolution resemble the American Revolution, which had such a different outcome, and how do they differ? And how far is the French Revolution and, in particular, the Terror, a result of the Enlightenment?[65]

Among the most striking features of the French Revolution is the sheer headlong pace of events. It is as though an explosion, long prepared, suddenly ignited and set off an unstoppable chain reaction. For some years the economic crisis in France had been impossible either to ignore or to resolve. Expensive wars, financed by loans, brought the country close to bankruptcy. The economic crisis highlighted the extreme social disparities of French society. The nobility and clergy were largely exempt from taxation, and taxes weighed most heavily on those who had most difficulty in paying them. Endemic poverty was exacerbated in 1788 by catastrophic weather. The harvest was almost completely lost, and the winter of 1788–9 may have been the coldest of the entire eighteenth century. The price of bread rose steeply. Since poverty reduced the demand for consumer goods, many industrial workers were thrown out of work and threatened with starvation. Real hardships were magnified by imaginary terrors, which, in a largely illiterate society, were spread by rumours. Parisians feared that the bread supply might run out; country people feared not only famine but the depredations of brigands, who were supposed often to be secret agents of aristocratic repression. In Paris, the fear of military repression prompted a crowd, searching for hidden weapons, to attack the Bastille, with the help of some experienced soldiers, on 14 July 1789.

French institutions were also wilfully obstructive. In 1788 the *parlement* of Paris refused to authorize new taxes, arguing that only the Estates General, which had not met since 1614, was entitled to do so. When the king eventually summoned the Estates General the following year, its division into Nobles, Clergy and Commons proved antiquated and unacceptable. It was agreed to double the size of the Third Estate, so that each of 234 constituencies was represented by two clerics, two nobles, and four third-estate deputies. The Third Estate, later enlarged by some of the

clergy, renamed itself the National Assembly on 17 June 1789 and declared itself the only body that could legitimately represent the nation. Continuing to challenge the king's weakening authority, the Assembly, in the session of 4 August that lasted until 2 a.m., enacted sweeping reforms. Its decrees begin: 'The National Assembly abolishes the feudal regime entirely.'[66] Feudal dues and personal serfdom (*mainmorte*) were swept away, along with such long-standing and oppressive privileges as nobles' right to hunt over peasants' land and let pigeons damage their crops. The sale of public offices was ended: 'All citizens may be admitted, without distinction of birth, to all ecclesiastical, civil, and military employments and offices.'[67] The clergy too had their wings clipped, being no longer allowed to collect tithes or to hold more than one lucrative benefice. Even through the dry paragraphs of the decree, one senses the euphoria of the deputies in enacting what was previously unthinkable.[68]

There followed in rapid succession the Declaration of the Rights of Man and the Citizen (27 August 1789), beginning: 'Men are born and remain free and equal in rights; social distinctions may be based only upon general usefulness';[69] and the Decree on the Fundamental Principles of Government, which affirmed that the king was subject to the law. The deepening financial crisis was met in November 1789 by nationalizing the landed property of the Church. The complicated administrative divisions of France were swept away; an initial plan to divide the country into 81 departments, each measuring 324 square leagues and divided into 9 districts, and each district into 9 communes, had a pleasing mathematical precision, being based on multiples of 3, but was impracticable and replaced by 83 departments defined by population.[70] Citizens' militias were all made part of the National Guard, the only body allowed to preserve public order as the army was suspected of undue loyalty to the king. The Assembly went still further. By a decree of 19 June 1790 it ended the French nobility: 'Hereditary nobility is abolished forever; accordingly, the titles of prince, duke, count, marquis, viscount, *vidame*, baron, knight, *messire*, squire, noble, and all similar titles shall neither be accepted by nor bestowed upon anyone whomsoever.'[71] And, having already dissolved monasteries and convents in February 1790, the Assembly on 12 July introduced the Civil Constitution of the Clergy, which removed priests from the authority of the Church, transforming them into elected officials and requiring them to take an oath of loyalty to the state.[72]

All these drastic reforms were still, in principle, compatible with the transformation of France into a constitutional monarchy. But one can see, as one follows the legislation, how each reform made possible another that was yet more sweeping and made the dynamic of reform ever more

difficult to arrest. So, if we ask the counterfactual question – 'Could France have become a constitutional monarchy, like Britain?' – one obstacle is the instability generated by reforms tumbling over each other in such haste. A government that tries to halt such a process is liable to be caught between disappointed radicals on the left and aggrieved conservatives on the right. The legislators of the National Assembly had to reckon with both these groups – with the resentful aristocrats and clergy, and with the newly active people – and, of course, with the king himself.

Louis XVI was well-intentioned but indecisive.[73] He agreed to limitations on his powers, but at some point he began planning counter-revolution. He forfeited his people's trust on being found in June 1791 fleeing with his family in disguise, probably hoping to return with troops supplied by his brother-in-law, Leopold II of Austria. Suspicions of him seemed confirmed when Austrian and Prussian troops invaded France under the command of the duke of Brunswick, who on 25 July 1792 declared the intention of restoring the king's legitimate authority and warned that any threat to the royal family would incur 'exemplary and forever memorable vengeance'.[74] Popular panic led crowds to storm the Tuileries palace and massacre the king's Swiss Guards; the royal family took refuge with the National Assembly, watching from behind a grille as the Assembly declared the monarchy suspended. Secret documents were discovered that revealed that Louis had been corresponding with his emigrant brothers and subsidizing counter-revolutionary publications.[75] From there it was a short path to his trial and execution. It was hardly likely, therefore, that Louis could ever have settled down into constitutional monarchy.

Might France have become a modern democratic republic without passing through the Terror and the subsequent dictatorships of the Directory and then of Napoleon? The events of the late 1780s certainly spread political consciousness. Of the many political clubs and societies that sprang up, some, like the Jacobin Club, charged dues which only middle-class professionals and the like could afford, but others, such as the more radical Cordeliers, charged much less and had a broader membership. Their meetings were open to the general public, who listened to discussions from the galleries. Meanwhile a host of newspapers and pamphlets appeared, some written by such skilful publicists as Jacques-René Hébert and Jean-Paul Marat; they were read eagerly by the literate and read aloud to the illiterate. A class of urban militants emerged, who were active in the forty-eight *sections* into which the municipal government of Paris was divided and who took part in 'crowd activities'. They were called *sans-culottes* because they wore working-men's trousers instead of upper-class breeches. They comprised craftsmen, shopkeepers, and often also labourers, and

amounted to some 10 per cent of urban adult men, with an average age of forty (since younger men were generally serving in the army).[76] Women were increasingly active too: those who marched to Versailles on 5 October 1789 to confront the king included not only stallholders and fishwives but some well-dressed *bourgeoises*; and women, along with domestic servants, also took a large part in food riots.[77]

Are the *sans-culottes* to be seen as the politically conscious people, or as dangerous urban mobs? In French working-class culture violence was common and revenge a frequent motive for it. Gruesome public executions, common in the eighteenth century, tended to brutalize their spectators and desensitize them to violence. Belief in conspiracies which had to be unmasked and their perpetrators destroyed was endemic at all levels of society, not surprisingly in an age when government was secretive and transparency unknown.[78] The populace were ready to believe the most far-fetched rumours of plots by aristocrats, emigrants, speculators and bandits. Given these predispositions to violence and credulity, crowd attacks on royal palaces, and even the notorious prison massacres of September 1792, were to be expected once an angry and hungry people had been mobilized, especially when, as in autumn 1792, Paris was threatened by the approach of foreign armies. Violence was further encouraged by inflammatory journalists, particularly Marat. At the same time, the September Massacres, though the result of collective panic, were not an indiscriminate slaughter. The crowds who invaded the prisons set up impromptu tribunals to examine the prisoners, about half of whom were allowed to live while the rest were hacked to death.[79] Popular violence was motivated not only by political fears, but by hunger: food shortages persisted throughout the Revolution, and a cap on bread prices was complemented by an unpopular cap on wages.

The governing National Convention seems sometimes to have exploited popular protest as a pretext for creating political instruments to use against their enemies, such as the Law of Suspects (17 September 1793), which gave neighbourhood watch committees the power to arrest any suspicious-looking person. Even such an extremist as Robespierre insisted that democracy did not mean that the people, in a continual assembly, should regulate all affairs of state. Rather, while the people was sovereign, it should accept the guidance of its representatives: 'Democracy is a state where the sovereign people, guided by laws which are its own work, does by itself all that it can do well, and by delegates all that it cannot do for itself.'[80] On balance, therefore, it would seem unwise to celebrate the Revolution as a triumph of the popular will. But one cannot accept without some qualification the views of nineteenth-century historians and

psychologists who saw the Revolution as a deplorable example of the raw energies of the mob: the crowd's violence was often manipulated.[81]

The 'people' that Robespierre and others talked about were in any case not the people of France as a whole, but the people of Paris and, to a lesser extent, that of such urban centres as Marseilles and Lyons. The population of France was overwhelmingly rural. Across the countryside, large areas broke into revolt against the revolutionary government, the fiercest conflict being in the Vendée area in the west. Resistance was inspired especially by the Convention's measures against the Church: not only the imposition of the Civil Constitution of the Clergy, but also its interference with a popular religious culture that found expression in pilgrimages and processions. The execution of the king and queen prompted further resistance, as did the decree of February 1793 calling for 300,000 new recruits to the army. For some years, large tracts of France were in a state of civil war. It was against provincial insurrectionaries that the new leaders of France committed some of their most notorious atrocities, especially the *noyades* (drownings) of Nantes, in which, in November 1793, some 1,800 priests and other insurgents were tied up in leaky barges which were then sunk in the Loire.

It was not only identifiable political bodies that shaped the course of the Revolution, but also an impalpable yet inescapable atmosphere of fear, shading into paranoia. Few things inspire such well-founded fear as war, and France was at war for much of the revolutionary period. It was the drive to war that decisively 'blew the Revolution off course'.[82] But war was also welcome to some revolutionary leaders, notably Condorcet and Jacques-Pierre Brissot, who from autumn 1791 pressed for a pre-emptive strike. It met with prudent opposition from Robespierre, who in an impressive speech issued a warning that retains its relevance in the twenty-first century: 'The most extravagant idea that can be born in a politician's head is the belief that a people need only enter with military force among a foreign nation, in order to make it adopt their laws and their constitution. Nobody likes armed missionaries.'[83] The idealist Brissot, who, according to his acquaintance Madame Roland, saw in the Revolution 'a means of regenerating the species', believed that war would have an ennobling effect on the French and, eventually, on humanity.[84] War offered a means of unifying the Jacobins, creating national solidarity, strengthening the Revolution, and carrying its benefits to other nations. The decision to wage aggressive as well as defensive war was a turning-point in the development of the Revolution. Wars, as their instigators usually forget, have to be lost by one side; and even their success is precarious. Either way, they give rise to economic uncertainty, anxiety and unrest at home.

The French in fact achieved remarkable military success. Austrian and

Prussian forces invaded France in autumn 1792, only to be defeated by the French forces at the battle of Valmy. This success emboldened the war party. On 1 February 1793, France declared war on Great Britain and the Dutch Republic. Revolutionaries talked of liberating Poland, Naples and Spain, and of expelling the British from India and the Portuguese from Brazil.[85] John Oswald, whom we have already met in Chapter 6 as a pioneer of vegetarianism, proposed that 600,000 *sans-culottes* should march on London, join with their English brothers, and bring about the execution of George III and the union of Britain and France.[86] French forces set out to conquer the Low Countries. Since it was believed that the natural frontiers of France should extend to the Rhine, they also occupied the German territory west of the river, plundering and maltreating the inhabitants so mercilessly that the latter were soon disgusted with their self-styled liberators.[87]

Setbacks soon followed, and were readily blamed on a monstrous conspiracy, stirred up by emigrants, priests who would not swear loyalty to the state, and agitators in the pay of the British, the Austrians and/or the Prussians. In fact, declared the radical journalist Camille Desmoulins, it showed a lack of good faith to ask for proofs of a conspiracy, for conspirators naturally concealed their intentions; nevertheless, anyone who could read the clues would consider it an established fact, for example, that the moderates around Brissot were agents of the British prime minister.[88]

By spring 1793 the Convention was divided between the radical Montagnards ('Mountaineers', so called because they sat on upper benches) and the relatively moderate Girondins, with the former in the ascendant. The institutions of the Terror were rapidly created. On 6 April 1793 the Committee of Public Safety was set up; it met in secret, was dominated by Georges Danton and acquired almost absolute power. The Law of Suspects, passed in September 1793, mandated the arrest of any suspicious person, and encouraged denunciations. Suspicious behaviour might include addressing someone politely as *vous* instead of *tu*, or as 'Monsieur' instead of 'Citizen'. Less conspicuous deviations were often revealed by secret denunciation. In this atmosphere of furious distrust, political opponents were demonized as traitors, and the verb 'exterminate' came into common use – 'Let us all unite, friends and brothers, and fight and exterminate all our enemies,' said the Girondin sympathizer Corbel; the Committee of Public Safety, concerned by the rebellion in the Vendée, urged the army to 'exterminate this rebel race'.[89] Denunciation became a means of survival: you had to denounce your enemies before they could denounce you. Revolutionary virtue was no protection, for conspicuous revolutionary zeal was suspect as the 'mask of patriotism'.[90] François Chabot, denounced in the Jacobin Club as a crypto-counter-revolutionary,

responded: 'I call on all good citizens to help me to unmask the calumni-ators', whereupon another Jacobin said: 'That is the kind of thing conspirators always say.'[91]

Political groups fell victim to the Terror in rapid succession. Twenty-one leaders of the moderate Girondins were tried and executed in October 1793; the ultra-radical group led by Hébert followed in March 1794. The factional divide within the Montagnards between Robespierre and Danton led to the execution of the latter, along with his associates, in April 1794. The Terror reached its climax in the Law of 22 Prairial (10 June 1794), which imposed the death penalty for innumerable vaguely defined offences against the Revolution, such as 'calumniating patriotism', 'disseminat[ing] false news', and seeking 'to impair the energy and the purity of revol-utionary and republican principles'.[92] The Law accelerated trials and executions, in order to 'exterminate the implacable satellites of tyranny'.[93] The number of executions shot up:

> Of the 2,639 people guillotined in the place de la Révolution between March 1793 and August 1794, over half, 1,515, died during June and July 1794. A far higher proportion of them, too, were from the upper ranks of society than in the Terror as a whole: 38 per cent of its noble victims and 26 per cent of its clerical ones were dispatched during this short phase, and almost half of those from the richer bourgeoisie. Never was the Terror closer to being an instrument of social discrimination rather than one punishing specific counter-revolutionary acts than in these months.[94]

The Terror was brought to an abrupt end by the events of 27 July 1794, famous as 9 Thermidor in the revolutionary calendar. In a speech the previous day, Robespierre had overstepped the mark by denouncing a vast, vague 'conspiracy against public liberty' involving many deputies and even members of the Committee of Public Safety. Each of his hearers feared becoming a target. The Convention decreed the arrest of Robespierre and his closest collaborators, declaring them outlaws as so many previous victims of the Terror had been. After their execution, the Convention ordered the closure of the Jacobin Club. Many suspects were released. Instead of reconciliation, however, there were numerous acts of revenge, amounting often to counterterror.

When one tries to make sense of the Terror, one feels that, although there have been many bloodthirsty regimes throughout history, the Terror was something unprecedented. The sober language of the historian seems inadequate compared to the literary images of natural and cosmic cata-clysm deployed by Anatole France in *Les Dieux ont soif* (*The Gods are Thirsty*, 1912) and Büchner in *Danton's Death* (1834).[95] It is not just the

number of victims that makes the Terror feel so atrocious: far more were killed in the suppression of the Paris Commune in 1871.[96] The Terror also infused the lives of survivors with such incessant anxiety, indeed terror, as to reduce them almost to the primitive state evoked by Hobbes, with 'which is worst of all, continual fear, and danger of violent death'.[97] Between March 1793 and August 1794, at least half a million people suffered imprisonment. Crowded cells and bad sanitation caused many further deaths: in the prisons of Saumur, for example, 1,699 people died between 3 July 1793 and 1 January 1794.[98] Many insurgents, besides those drowned in the Loire, were executed out of hand. Thousands more died fighting on France's frontiers. Human life became disposable.

It may be that the judicial murder of Louis XVI was a traumatic shock that breached a crucial taboo.[99] Even after Louis' humiliating return from Varennes, the Constitution of 3 September 1791 declared: 'The person of the King is inviolable and sacred.'[100] Now his sanctity had vanished. By putting him on trial not as king of the French but as the mere man, Louis Capet, the Revolution desacralized the monarchy and then confirmed its sacrilege by an act of public violence. After this, other deaths became trivial. Since 1790 the journalist Marat had been calling for increasing numbers of executions, even for massacres. After his assassination on 13 July 1793 had made him into a saint of the Revolution, activists told the Convention that November: 'Never forget the sublime words of the prophet Marat: *Sacrifice 200,000 heads, and you will save a million.*'[101] Hence the ratchet effect of the Terror: each death made the next easier, while the growing atmosphere of paranoia made it seem more necessary. At the same time, in contrast to the notorious purges of twentieth-century tyrannies, one has the impression that no one was in charge. Terror campaigns in Soviet Russia and Communist China were orchestrated by Stalin and Mao, but in revolutionary France not even Danton or Robespierre was in control. Political survival depended on fast and ruthless reactions, and in the end nobody was fast enough.

To return now to the question of the relation between the Revolution and the Enlightenment: the Revolution as a *political* event had an energy of its own, sustained by such crucial turning-points as the decision to wage war and the execution of Louis XVI. It was not the creation of Enlightenment intellectuals. The Enlightenment mainstream wished to 'revolutionize ideas, education and attitudes by means of philosophy but in such a way as to preserve and safeguard what were judged essential elements of the older structures, effecting a viable synthesis of old and new, and of reason and faith'.[102] That applies not only to Montesquieu and Voltaire, but also to such an irreligious radical as d'Holbach, who

maintained that revolutions never make the people happier, that the execution of Charles I just led to the tyranny of Cromwell, and that the only way to reform politics is the gradual spread of reason, until people understand that the ills of humanity can only be cured by liberty.

> No, it is not by dangerous convulsions, it is not by struggles, regicides, and useless crimes that the wounds of the nations will be healed ... It is by correcting opinion, combating prejudice, by acquainting princes and peoples with the value of justice, that reason can promise to cure the ills of the human race, and to establish firmly the reign of liberty.[103]

D'Holbach died on 21 January 1789, too early to witness the Revolution. Members of his circle took part in its early stages as electors to the Estates General, but were 'alarmed, when not horrified, by the upheavals that turned their familiar world upside down'.[104] Raynal, in an address sent to the National Assembly in May 1791, denounced 'a government that is the slave of popular tyranny'.[105] Only the Encyclopedist Naigeon supported the assault on noble and ecclesiastical privileges. He and the others survived the Revolution by retiring into obscurity.

On the other hand, the measures proposed by the revolutionaries, and the ideas animating them, were often inspired by Enlightenment debates. It was a commonplace of Enlightenment thought that the purpose of government was the public happiness. To this end, Voltaire, Mably and other leading *philosophes* wanted the government of France to be reformed and the privileges of the nobility to be curtailed. Voltaire, accepting the Crown's claim to sovereignty (the *thèse royale*), supported Louis XV in his struggle against the nobility and the *parlements*. It was no less a commonplace that everyone should be equal before the law, as the Declaration of the Rights of Man insisted in its sixth article.[106] The revolutionaries paid at least lip service to Montesquieu, who could be read as 'the advocate of a new kind of representative constitutional monarchy'.[107]

The mainstream Enlightenment, however, had much less appeal to the revolutionaries than the teachings and personal example of Rousseau, a figure, as we have seen, at odds with the *philosophes*. Brissot was an ardent Rousseauvian: 'If all the libraries perished in a fire or from the decay of ages,' he declared, 'our descendants would have nothing to complain about if they still had the good Rousseau.'[108] When the Revolution came under the ascendancy of Robespierre and the Jacobins, the mainstream Enlightenment was often denounced. Robespierre criticized the 'sect' of Encyclopedists as consisting predominantly of 'ambitious charlatans' who declaimed against despotism while receiving pensions from despots. Their philosophy was materialist, atheist and egotist, and far from respecting

the rights of the people, they were misguided enough to admire the constitution of England.[109] He encouraged the Jacobins to smash a bust of Helvétius, who had persecuted Rousseau.[110]

Robespierre's condemnation of the Encyclopedists precedes an extended tribute to Rousseau as 'a man who, by the loftiness of his soul and the greatness of his character, shows himself worthy to be the teacher of the human race'.[111] Robespierre set store by certain of Rousseau's political ideas, above all the exaltation of the general will, which could never be wrong whatever errors the empirical populace might fall into, and the patriotic festivals, celebrating and consolidating the unity of the nation, which Rousseau recommended to the Poles in his sketch for a reform of their government.[112] In 1793–4, a government dominated by Robespierre fully justified the misgivings that the concept of the general will might inspire. The general will could not be divided. Different opinions showed, at best, that empirical persons did not know what was good for them; at worst – as Robespierre became increasingly certain – they sprang from treacherous enemies of the people, who must be extirpated at all costs. 'From the revolutionary government good citizens deserve the full protection of the nation; enemies of the people deserve only death.'[113]

Above all, however, Robespierre valued Rousseau as an embodiment of virtue who had fallen victim to a corrupt society. Robespierre's speeches, it has been said, show him as 'a figure engaged in an intense, heroic effort to render real and concrete an exaltation of virtue which he had found in Rousseau'.[114] He and his intimate colleague Saint-Just sought to suppress their own human foibles and lead lives of unalloyed patriotic devotion. Though they have often been accused of hypocrisy, it is probable that they were perfectly sincere in sending innumerable 'enemies of the Republic' to the guillotine.

Certain extreme measures taken in the Revolution have often been held up for reprehension and ridicule as expressing the bureaucratic tidy-mindedness, intolerance and authoritarianism attributed to the Enlightenment. That applies especially to the policy of 'dechristianization'. In attacking the power of the Church, seizing its property, and placing the clergy under state control, the revolutionaries were following – in a more thorough-going way – the assault on the Churches that had been necessary also for such enlightened absolutists as Joseph II and Catherine II. Dechristianization was something more. Its leading proponent, Joseph Fouché, had defended the 'necessity' of religious feelings, but after helping to suppress the uprising in the Vendée, which had strong support from priests, he denounced the clergy and called for an education system free from 'the odious influence of religion'.[115]

A concerted attack on religion now included not only the closing and spoliation of churches but also the proclamation of a new, non-Christian reckoning of time. The new era was dated from the establishment of the Republic on 22 September 1792. The months were each of thirty days (with five 'complementary days' to complete the year) and received new names.[116] Each month was divided into three ten-day units called *décades*, every tenth day being the *décadi* (which meant that only one day in ten, instead of one in seven, was free from work). The day was divided into ten equal 'hours', each 'hour' into ten smaller units, and so on.[117] Decimal time proved impractical, since all clocks would have had to be redesigned, but the revolutionary calendar remained in use till 1805 (the year XIV).

Dechristianization was hardly an enlightened policy. It expressed the radical atheism that was present, but marginal, in the Enlightenment, alongside an intolerance that flew in the face of the Enlightenment's struggles for toleration. Even among revolutionaries it conflicted with deism. The dechristianizers held their Festival of Reason in the cathedral of Notre Dame on 10 November 1793, but the deist Robespierre, who deeply disapproved of atheism, countered by introducing the cult of the Supreme Being, whose festival was solemnly celebrated on 8 June 1794.[118]

Policies like these have sometimes led posterity to think that the Revolutionaries were single-minded devotees of reason. Decimal time, the neat division of France into eighty-three *départements*, and the rapid and painless elimination of enemies by the guillotine, all seem evidence of cold, hyper-rational calculation. Certainly, Condorcet aspired to place political decision-making on a fully rational basis by means of 'social mathematics'.[119] We have seen, however, that a quasi-mathematical conception of reason was untypical of the Enlightenment. For the most part, the Revolutionaries favoured the language of sentiment over that of reason. Brissot declared in 1782: 'Reason shows me only shadows, where the moral sense enlightens and directs me. I leave reason behind, therefore, and follow only my moral instinct, the voice of happiness.'[120] Robespierre not only praised reason, but also appealed to the heart: 'patriotism is not a party affair, but an affair of the heart'.[121] 'The more a man is endowed with sensibility and genius, the more attached he is to ideas that enlarge his being and elevate his heart,' he affirmed.[122]

The officers sent to consolidate the Revolution in the provinces often performed their mission with the help of bloodshed, but they reported back in sentimental terms. Thus, Fouché writes to the Committee of Public Safety on 17 August 1793 that he has imposed revolutionary solidarity on the town of Clamecy, but how he has done so is concealed behind sentimental euphemisms:

Light-hearted songs, dances, patriotic sounds of a warlike music, artillery salvos, prolonged cries of 'Long live the Mountain! Long live the Constitution!' announced to all the neighbouring communes the happy festival of a general and fraternal reunion around the tree of liberty. All monuments that might recall hatred, re-ignite vile passions, divorces, hideous litigation, have been destroyed, trampled under foot, reduced to ashes, and everyone has drunk from the cup of equality the water of regeneration. Such sweet tears ran from every eye, because the love of the fatherland lives in every heart.[123]

The regenerated community was held together by tearful sentiment, as here, but also by resistance to its enemies. These, omnipresent yet impalpable, were outside the community and outside the law; they were classed as enemies to the human race who had to be exterminated.[124]

Finally, the revolutionaries made generous use of the language of classical republicanism. Having been immersed in the Latin classics at school, they constantly cited examples of political virtue and vice from the Roman Republic and early Empire, from Cicero, Sallust, Livy, Tacitus and Plutarch.[125] Favourites included Cicero, who disclosed the villainous conspiracy of Catiline, the unbendingly virtuous Cato, and Brutus, who assassinated the would-be tyrant Caesar. Saint-Just regretted that the eighteenth century was less advanced than ancient Rome, when, instead of bothering with legal processes, twenty-three loyal republicans had simply stabbed Caesar in the Senate 'with no other law than the liberty of Rome'.[126] The revolutionaries were also familiar with discussions of ancient polities by Montesquieu, Mably and Rousseau. They felt able to ignore Montesquieu's warning that only a small state could be a republic, for, said Desmoulins, 'even if it were true that a republic and democracy could never have taken root in a state as extensive as France, the eighteenth century, thanks to enlightenment, is beyond all comparison with past centuries.'[127]

As this implies, although the revolutionaries admired ancient Rome, Athens and, to a lesser extent, Sparta, they did not think such polities could be recreated in the present.[128] Classical republicanism provided them not with political blueprints but with a political vocabulary, expressing opposition to monarchy and 'a discourse of political will'.[129] Classical references were meant to be inspiring and uplifting, as when Robespierre urged: 'Let us raise our souls to the height of republican virtues and ancient peoples' and sang the praises of Themistocles and Scipio.[130] In the same spirit, some towns were renamed after republican heroes, as when Saint-Pierre-le-Moutier was renamed Brutus-le-Magnanime, and unfortunate children were given such names as Brutus, Socrates, Scaevola and Phytogynéantrope ('she who bears only warrior sons').[131]

To blame the course of the Revolution on the *philosophes*, let alone on the Enlightenment more broadly, is therefore to fall victim to a historical myth, albeit one upheld by many of the Revolution's contemporary opponents.[132] As early as the 1770s, French conservatives had charged the *philosophes* with conspiring against throne and altar. The Revolution seemed to confirm these suspicions. In a much-read multi-volume polemic, the abbé Augustin Barruel not only described the Enlightenment as a conspiracy in which 'Voltaire was the chief, D'Alembert the most subtle agent, Frederick the protector and often the adviser, and Diderot the forlorn hope';[133] he located their efforts within a vast international plot against Christianity, stretching back to early heretics and continued by the Knights Templar and the Freemasons. Having fled from the Revolution to England, Barruel became a friend of Edmund Burke, who in his *Reflections on the Revolution in France* (1790) blamed it on the 'political Men of Letters' who organized 'the vast undertaking of the Encyclopaedia' and 'formed something like a regular plan for the destruction of the Christian religion'.[134]

There is an ironic resemblance between this theory and the arguments of some modern historians that the *philosophes* were indeed responsible for the Revolution, though the *philosophes* now receive credit rather than blame. This does not imply that the *philosophes*, or anyone else, deliberately planned the Revolution, as Lenin and Trotsky later consciously worked towards revolution in Russia.[135] Instead, 'few events have been so unanticipated as the French Revolution'.[136] Nor need it imply that the writings of the *philosophes* had any kind of direct impact: enlightened ideas were diffused through many written sources, including ephemeral pamphlets, and through discussions in Masonic and other societies.[137] Some weight must no doubt be given to scurrilous pamphlets and caricatures, especially those directed against Marie-Antoinette, which reduced respect for the monarchy.[138] Even with these qualifications, the ideas of the *philosophes* seem to have had less impact on the revolutionaries than those of Rousseau, and in turn Rousseau's strictly political thinking seems to have been less influential than the emotional atmosphere generated especially by *La Nouvelle Héloïse*.[139]

The importance of ideas in the French Revolution may have been exaggerated. Jonathan Israel has recently argued that, since economic explanations for the French Revolution do not account for an event of such magnitude, it must instead be ascribed to the ideas of the radical Enlightenment.[140] The choice between an intellectual and an economic explanation may, however, be a false one. It leaves out politics, a force in its own right, which, according to a well-known theory, rests on the binary of friend versus enemy.[141] The French Revolution was a political event,

with its own dynamism, no matter what intellectual theories may have inspired some of its actors. People did not need the Enlightenment to imbue them with a desire for freedom from the often crushing injustices of the old regime. And as events speeded up, they seem in retrospect to have been shaped increasingly by the friend–enemy dichotomy.

Indeed, many Enlightenment thinkers would not have been at all surprised by the course the Revolution took. As we have seen, it was common to warn against republics because they were liable to descend into factional conflicts, as the Roman Republic had, and to be succeeded by the rule of an absolute monarch such as Augustus Caesar. Thus Hume argued that if Britain became a republic, ruled by the House of Commons, either every election would be accompanied by a civil war, or the House would perpetuate itself and hold no more elections:

> If it continue itself, we shall suffer all the tyranny of a faction, subdivided into new factions. And, as such a violent government cannot long subsist, we shall, at last, after many convulsions, and civil wars, find repose in absolute monarchy, which it would have been happier for us to have established peaceably from the beginning.[142]

D'Holbach agreed: 'The sudden and often cruel and prolonged ferments of republics are commonly seen to be succeeded by the languor and deadly torpor produced by despotism, in whose bosom the people seek repose from the excitement caused by their follies.'[143] The course of events in France, where power passed from the National Convention to the Committee of Public Safety, and, after murderous factional strife, to the Directory and, finally, to the dictator Napoleon Bonaparte, may serve as a textbook illustration of this process.

Observers of the French Revolution naturally saw it as closely linked with the revolution in America.[144] But it is questionable how far the French revolutionaries were inspired by their American counterparts, except in the broad sense that the American example showed a republic to be a viable form of government at the present day. Certainly intellectuals in France, as in other European countries, followed the American struggle for independence with close interest. The Declaration of Independence served as a model for the Declaration of the Rights of Man and the Citizen.[145] Brissot, who visited the United States in 1788, held it up as a model of liberty sustained by good morals (*les bonnes mœurs*): 'you will see there ... to what degree prosperity and liberty can elevate human industry, make men better, incline them towards universal brotherhood.'[146] The deputy Rabaut Saint-Étienne said on 18 August 1789 in the Estates General: 'like the Americans, we want to regenerate ourselves'.[147]

Three individuals in particular mediated between America and France. Benjamin Franklin, famous as an experimental scientist, a diplomat who had brought about the repeal of the Stamp Act, and a statesman who had helped to draft the Declaration of Independence, was already an international celebrity. In London, where he had spent most of his time between 1757 and 1775, he got to know many prominent scientists and philosophers, including David Hume, who wrote to him: 'you are the first philosopher, and indeed the first great man of letters, for whom we are beholden to [America].'[148] Franklin became the American minister in France in 1776. Besides his diplomatic activity, he spent his time with *philosophes* such as Turgot, Voltaire and Helvétius. He was the object of a veritable cult; his death in 1790 was commemorated with a banquet in the Café Procope and by the erection of funerary busts.[149]

Another mediator was the Englishman Thomas Paine. Having prompted American resistance to Britain with his pamphlet *Common Sense*, Paine took up the cause of the French Revolution in *The Rights of Man*, defended it in an extended public argument with Edmund Burke, and turned words into deeds by moving to France and being elected to the National Convention as a representative for the Pas de Calais, despite his very limited knowledge of French. However, Paine's moderate stance, which included opposing the execution of Louis XVI, involved him in the fall of the Girondins. He spent almost a year in prison, allegedly escaping execution only because, when his death was due, the turnkey failed to notice the fatal number chalked on his cell door.[150] Having lost faith in the Revolution, he offered first the Directory, and later Napoleon, a detailed scheme for a French invasion of Britain.[151] Unhappy in a France that was increasingly suspicious of foreigners, and accused even of intriguing with British agents, he returned to America in 1802.

Finally, Gilbert du Motier, marquis de Lafayette, was an early enthusiast for the American cause who fought in the War of Independence. In 1789 he became a member of the Estates General. He helped to draft the Declaration of the Rights of Man, with advice from Thomas Jefferson, who by then was American minister in Paris. Appointed commander-in-chief of the National Guard, and later a military commander, Lafayette, like Paine, adopted a moderate stance that earned him the enmity of the Jacobins. He fled to the Austrian Netherlands, where he was taken prisoner and kept in captivity for five years, returning to France only in 1799. Refusing to support either the autocrat Napoleon or the restored Bourbon monarchy, Lafayette survived long enough to lead the revolution of 1830 which installed the 'citizen king' Louis-Philippe.

The examples of Paine and Lafayette illustrate sharply an obvious

difference between the American and the French Revolutions: the former did not lead to a Terror. Why not? R. R. Palmer lists a number of pre-conditions present in America which might have produced a Terror:

> Revolutionary government as a step toward constitutional government, committees of public safety, representatives on mission to carry revolution to the local authorities, paper money, false paper money, price controls, oaths, detention, confiscation, aversion to 'moderatism', and Jacobins who wind up as sober guardians of the law – how much it all suggests what was to happen in France a few years later![152]

But the differences also leap to the eye. The most obvious is geographical. America was separated from the seat of power by three thousand miles of ocean. It was therefore possible to throw off their antagonists perman-ently; and, unlike Louis XVI, George III was safely remote and physically unavailable as a hate-figure. Moreover, America had no capital. None of the thirteen colonies had a city remotely resembling Paris in which a politicized urban crowd could sway the course of events and encourage a revolutionary administration to impose its will on reluctant provinces.

Other differences were social. America had wealthy landowners, espe-cially in the slave-owning southern colonies, but no hereditary aristocracy and no powerful established Church as in France. Its people were used to participating in the government of their respective colonies, whereas in France the political experience of those elected as deputies could not stretch far beyond the parish pump. According to the French immigrant Hector St John de Crèvecoeur, the farmers who composed the majority of the American population, being free citizens, were much more intelli-gent and politically aware than their European counterparts: 'the simple cultivation of the earth purifies them, but the indulgences of the govern-ment, the soft remonstrances of religion, the rank of independent freeholders, must necessarily inspire them with sentiments, very little known in Europe among people of the same class.'[153]

The two revolutions also had different purposes. The Americans sought the restoration of what they believed to be their ancient liberties; the French aimed at a transformation and regeneration of society. They hoped to spread the Revolution to other countries, and even to rejuvenate the human race, whereas in America such visionary ambitions were expressed only in Paine's assertion: 'We have it in our power to begin the world over again.'[154] Admittedly, this distinction between the aims of the two revolu-tions must be qualified. Simon Schama, discussing the Dutch Patriot Revolution of the 1780s, remarks on the 'shift, not uncommon in revolu-tionary declarations, away from historical justifications of liberty towards

the more confident affirmation of self-evident natural rights'.[155] One can see this shift even within the American Declaration of Independence: the bulk of the text lists the colonists' specific grievances, whereas the preamble states the underlying principles. Nevertheless, the French National Assembly, by abolishing hereditary aristocracy and expropriating the Church and its property, began restructuring society more radically than the Americans ever attempted.

It has been argued that the American Revolution did transform society radically by spreading the idea of equality.[156] Certainly Alexis de Tocqueville, after touring the United States in 1831–2, recorded his conviction that its equality made America unique:

> America, then, exhibits in her social state a most extraordinary phenomenon. Men are there seen on a greater equality in point of fortune and intellect, or, in other words, more equal in their strength, than in any other country of the world, or in any age of which history has preserved the remembrance.[157]

A high degree of equality, however, existed before the Revolution, and while its diffusion was no doubt promoted by the Revolution, it was not among the goals that the revolutionaries set themselves. Nor did they think (except for Paine) that the principle of popular sovereignty required that a governing assembly should be able to turn its decisions into law without careful scrutiny by a second chamber. Hence the United States' constitution provided for a bicameral legislature, consisting of the House of Representatives and the Senate, whereas in France a second chamber seemed like a proposal to reinvent aristocratic rule. The National Assembly rejected bicameralism by 490 votes to 89.[158] At stake were two different conceptions of government. The French assumed that a democratic assembly must reflect the united will of the people, whereas the Americans accepted that the people would rarely be unanimous and that a system of checks and balances was required to reconcile conflicting interests.

In view of the fears induced by war, there perhaps could have been a Terror in America. There were, after all, as many as half a million loyalists, contemptuously dubbed 'Tories' by the revolutionaries. Some 80,000 loyalists emigrated to Britain, Canada or the West Indies. Many lost their property. Some were charged under emergency legislation with treason and imprisoned or executed. Yet they were not remotely as ill-treated as their French counterparts; the Americans never adopted the practice of political execution.[159] At least two significant preconditions of Terror were lacking in America: the possibility of waging an aggressive war on neighbouring countries; and the pressure from a concentrated mass of politicized and panicky city-dwellers.

Yet it is hardly encouraging to think that the American Revolution was saved from degenerating into Terror by an accident of geography, and that the decline of the French Revolution into Terror looks, in retrospect, overdetermined by multiple factors. Far from heralding an age of growing liberty, the French Revolution seems rather to anticipate the twentieth-century revolutions that started with high, even apocalyptic hopes and turned into tyrannies even worse than the regimes they replaced: the Russian Revolution is only the most obvious example.

Some hope, however, is offered by Kant in his treatise *The Contest of Faculties*, published in 1798 but written a few years earlier. In the section entitled 'A renewed attempt to answer the question: "Is the human race continually improving?"', Kant considers and rejects three contrasting conceptions of human history: the 'terroristic' view that everything is getting worse; the 'eudaimonistic' view that everything is getting better (refuted, not by pointing to historical events, but by the argument that if man has $x$ quantity of goodness, he cannot increase it by the exercise of his will); and the 'abderitic' view that the relative quantities of good and evil are always much the same.[160] He finds hope, however, in the fact that the outbreak of the French Revolution called forth widespread enthusiasm; that its supporters acknowledged the right of the French people to choose their own civil constitution; and that they thus fixed their sights on an ideal to be realized in the future. For 'true enthusiasm is always directed exclusively towards the *ideal*, particularly towards that which is purely moral (such as the concept of right), and it cannot be coupled with selfish interests.'[161] The actual course of the French Revolution may dismay us, therefore, but we should take heart from the sympathy it called forth. For that sympathy was not just here and now, but was directed towards an ideal, which the Revolution was an early and inevitably flawed attempt to realize. Thus, Kant gives a theoretical justification for the belief in humanity's progress, whereby, as he says, 'a view opens up into the unbounded future'.[162]

## AT LONG LAST, AN ENGLISH ENLIGHTENMENT

Earlier in this study it was suggested that, while in eighteenth-century England there was plenty of enlightened thinking, there was – in contrast to Scotland – no Enlightenment in the sense of a coherent group of thinkers who systematically investigated such topics as the science of man, history and political economy. Late in the century, however, there was a change:

If there was an English contribution to the Enlightenment, it may be found among the radical and unitarian minority who doubted whether liberty and the gains of commerce were quite what they seemed. These came to the fore between the 1770s and 1790s, and included Richard Price, Joseph Priestley, Jeremy Bentham, Mary Wollstonecraft, and William Godwin.[163]

A number of features link these English Enlighteners. The first is Dissent. Many of them belonged to, or had been brought up in, religious groups outside the Church of England, and were thereby debarred from holding public office or studying at Oxford or Cambridge. A network of Dissenting academies, providing secondary and tertiary education, grew up: at Northampton, where Priestley was educated; at Warrington, where he taught classical and modern languages; and at Moorfields and Hoxton, near London, where Price and Godwin respectively studied. Priestley and Price helped their friend Theophilus Lindsey, an Anglican clergyman who left the Church of England, to found a new denomination, Unitarianism, whose doctrines included disbelief in the divinity of Christ and in the Trinity. The first Unitarian service was held on 17 April 1774. Price became a Unitarian minister at Newington Green, then a village north of London. Mary Wollstonecraft attended his sermons. The young Samuel Taylor Coleridge, though brought up in the Church of England, which he would later embrace once more, was for a time a Unitarian lay preacher.

Although the best-known English Enlighteners were active in London, they had strong roots in the provinces. Some, like Priestley, belonged to the Lunar Society, based in Birmingham. Coleridge found in Bristol an eager audience for the lectures on politics he delivered there in February 1795.

The Enlighteners had wide interests which included science and technology. As we have seen, the Lunar Society included the manufacturer Matthew Boulton and the inventor James Watt. Both Priestley and Erasmus Darwin published research on electricity. Priestley's work on different kinds of air was recognized with a medal by the Royal Society, and Price was elected to the Society for his work on demography. Darwin (grandfather of Charles) was best known for his verse treatise, *The Botanic Garden* (1791), with its humorous description of plant reproduction under the title 'The Loves of the Plants'.[164] It was consistent therefore that Godwin's son-in-law Percy Bysshe Shelley, who is in important ways a radical representative of the late Enlightenment, should incorporate scientific knowledge into such poems as 'The Cloud' (1820).

These groups were united in their desire for reforms: notably the abolition of the slave trade, of the restrictions on Dissenters and on press freedom, and, above all, of the unrepresentative parliamentary system

which, along with the associated network of governmental patronage, nepotism and venality, was later dubbed 'Old Corruption'. The goal of parliamentary reform was widely shared, for example by the Yorkshire County Association, chaired from 1780 by the Reverend Christopher Wyvill. Conservative resistance, however, was enormously strengthened by alarm at the French Revolution, and it was not until 1832, after furious controversy, that the Reform Act would redraw constituencies, remove rotten boroughs, and significantly extend the franchise.

Reformist and radical thinkers found a London focus in the house of the publisher and Unitarian Joseph Johnson, who had helped establish the first Unitarian chapel by obtaining the building and getting it licensed. Johnson's friends and guests included Priestley, Paine, Godwin, Mary Wollstonecraft (who married Godwin in March 1797, and died tragically that September), the American Joel Barlow (author of an epic poem on American history, *The Columbiad*), and Wordsworth, whose *Poems* Johnson published in 1793. His well-attended dinners sound like a later London counterpart to those held by d'Holbach in Paris. His extensive publishing output was not solely radical, but it included theological works concerned with Unitarianism, treatises in support of the American Revolution, feminist texts by Wollstonecraft and the Quaker Priscilla Wakefield, anti-slavery literature, and the remarkable autobiography by the ex-slave Olaudah Equiano.[165] He also published a journal, the *Analytical Review*, intended to review especially books on theology and science; Wollstonecraft worked as reviewer and assistant editor, and its chief theological reviewer was the Scottish Catholic priest Alexander Geddes, an authority on the historical study and literature of the Bible (what came to be known as 'Higher Criticism') and author of a Latin poem, the *Carmen Saeculare*, celebrating the French Revolution.

Joseph Johnson, like many of his friends, actively supported parliamentary reform. He was a member of the Society for Constitutional Information, founded in 1780 to promote this aim. The French Revolution, however, set the cause back by encouraging fears that even mild reform might lead down the slippery slope to revolution. The London Corresponding Society, formed in January 1792 by the shoemaker Thomas Hardy with a subscription of a penny a week, was a particular object of the authorities' suspicion. In 1794 Hardy and two other radicals, John Horne Tooke and John Thelwall, were tried on trumped-up charges of treason, but were acquitted by the jury thanks in part to anonymous articles and pamphlets by Godwin, which showed that the concept of 'constructive treason' was baseless.[166] Their five Scottish counterparts were not so lucky: they were transported to Botany Bay by the sentence of the

notorious 'hanging judge' Lord Braxfield. In Birmingham, on 14 July 1791, Priestley's house was burned down, and his library and laboratory destroyed, by a mob who were almost certainly incited by local Tories.[167]

The Enlighteners followed with close interest not only the events of the French Revolution but also the dispute around famous texts by Edmund Burke and Thomas Paine. The Burke–Paine controversy was unwittingly prompted by Price, who, on the 101st anniversary of the 1688 Revolution, delivered a sermon (published as *A Discourse on the Love of our Country*) comparing the Glorious Revolution to recent events in France. Burke responded with his *Reflections on the Revolution in France*, published on 1 November 1790. He begins by attacking Price's comparison between the two revolutions, and is appalled at Price's conclusion that the British people are entitled to choose their own rulers and dismiss them if they misconduct themselves. He insists that the Glorious Revolution, when James II was deposed and his son-in-law William of Orange invited to assume the throne, was only a minimal deviation, required by necessity, from the principle of hereditary succession. Moreover, such changes, from Magna Carta onwards, have always been a reassertion of traditional rights; they have never been an 'innovation'.[168] Political wisdom consists in accepting the inherited wisdom of the past as the natural order of things:

> By a constitutional policy, working after the pattern of nature, we receive, we hold, we transmit our government and our privileges, in the same manner in which we enjoy and transmit our property and our lives. The institutions of policy, the goods of fortune, the gifts of Providence, are handed down, to us and from us, in the same course and order.[169]

Inherited wisdom is sedimented in people's minds in the form of collective prejudice, which is a much surer guide than the efforts of individual reason. The purpose of government is not to secure people's rights, but to supply their wants, which include an external restraint on their passions. So to design the constitution of a state is a complicated and delicate matter, requiring a deep knowledge of human nature. Mere theoretical rights are valueless, except to mere theorists, who 'are so taken up with their theories about the rights of man, that they have totally forgot his nature'.[170] Government should be dominated by large property-owners, who are used to responsibility, and in particular by the landed interest, who have managed their property for many generations. Representation should be of ability as well as property; but as ability is active, and property is sluggish, property must be much more heavily represented, to safeguard it from 'the invasions of ability'.[171]

Burke's rhetoric is so beguiling that it can distract one from his serious point. He accepts that government is basically an instrument of convenience, not divinely ordained, but in order to work it must be stable, legitimated by veneration for ancient traditions, and not subject to the whims of the people or the ambition of their self-appointed spokesmen. There is surely wisdom in his insistence that politics requires experience and an understanding of human nature as it is, not as it should be. His valuation of collective prejudice at least acknowledges that politics needs to be based in some measure on principles that are taken for granted and do not need constant justification. Yet one baulks at his claim that people of ability should be held in check by property-owners, who have apparently managed their property successfully though lacking ability. His arguments may receive more credence than they deserve from our knowledge of the subsequent disastrous course of the Revolution. But in November 1790 it was too early to talk of 'the fresh ruins of France, which shock our feelings wherever we can turn our eyes'.[172] While it is important to assess Burke's case on its considerable merits, one must also wonder about the emotional sources of his often violent rhetoric.[173] Behind and sometimes in the text we can see the growing paranoia that led Burke to believe in a world-wide Jacobin conspiracy, of which Dissenters such as Price and Priestley, upstarts with 'a vulgar low bred insolence', were the agents or the dupes.[174]

Among some fifty replies to Burke, the first to appear, in December 1790, was Wollstonecraft's *Vindication of the Rights of Men*. She aims to strip away the 'gorgeous drapery' of Burke's rhetoric and reveal the 'tyrannic principles' and gross injustice that it conceals.[175] Where Burke depicts a dignified Parliament based on time-honoured tradition and composed of wise and virtuous representatives, and a Church which guards morality, Wollstonecraft shows a system of corruption, elections which are 'scenes of drunken riot and beastly gluttony', and a House of Commons which often resembles a 'bear-garden'.[176] Burke wants us to 'reverence the rust of antiquity' and admire institutions that originated in the barbarous Middle Ages described so scathingly by Hume.[177] By speaking grandly of 'the moral constitution of the heart', he wants us to be guided by instinct and passion instead of reason.[178] In an *ad hominem* turn, Wollstonecraft shrewdly observes that Burke himself is carried away by his fiery imagination:

> Reading your Reflections warily over, it has continually and forcibly struck me, that had you been a Frenchman, you would have been, in spite of your respect for rank and antiquity, a violent revolutionist; and deceived, as you now probably are, by the passions that cloud your reason, have termed your

romantic enthusiasm an enlightened love of your country, a benevolent respect for the rights of men.[179]

Wollstonecraft's essay, though hastily written and poorly organized, is more than a polemic. In attacking Burke's reliance on reverence, emotion and instinct, it pleads for the primacy of reason in the discussion of politics. The term 'political knowledge', used occasionally throughout the eighteenth century, makes some five hundred appearances in print in the decade following the French Revolution.[180] It stands for the introduction not of rationalism, but of reasoned discussion, based on principles and experience, into the study of politics. Instead of being an arcane mystery, as rulers in previous centuries had tried to make it, politics is now a matter for reasoned analysis and debate.[181]

Like Paine and other British sympathizers, Wollstonecraft wanted to see revolutionary France at close quarters. She moved there in December 1792 and lived with the writer John Hurford Stone. It has been conjectured that Stone was paid by the French government to report on the activities of the British in Paris, and that Wollstonecraft received money from the British secret service.[182] At all events, Wollstonecraft was soon sobered when her Girondin friends such as the Rolands were guillotined, and other British emigrants, including Paine and the poet Helen Maria Williams, were imprisoned. In 1796 she opined that gradual reform was preferable to revolution:

> An ardent affection for the human race makes enthusiastic characters eager to produce alteration in laws and governments prematurely. To render them useful and permanent, they must be the growth of each particular soil, and the gradual fruit of the ripening understanding of the nation, matured by time, not forced by an unnatural fermentation.[183]

Replying to Burke a few months after Wollstonecraft, Paine pursues political knowledge in *The Rights of Man* (1791), where he makes short work of Burke's 'theatrical exaggerations'.[184] As for their substance, Burke cannot be right in saying that the 1688 Revolution was a one-off which can never be repeated, for no body of legislators can bind its successors in perpetuity. Burke's reverence for the past is thus taken to absurd extremes: 'Mr Burke is contending for the authority of the dead over the rights and freedom of the living.'[185] If the 1688 Revolution was an admissible exception, then in France in 1789, too, an exceptional situation required drastic measures: 'the despotic principles of the government ... were become too deeply rooted to be removed, and the augean stable of parasites and plunderers too abominably filthy to be cleansed by any thing short of a complete and universal revolution.'[186]

Descending to detail, Paine argues, like Wollstonecraft, that in praising the inherited wisdom of the British polity, Burke was defending the indefensible. The electoral system is 'capricious' because there is no uniform qualification for voting.[187] It is full of discrepancies such as that whereby huge Yorkshire, with a population of almost a million, and tiny Rutland each send two members to Parliament.

Paine goes further in assaulting prejudices. Noble titles are mere nicknames. Aristocracy itself is unnecessary. The idea of hereditary legislators, with an inherited right to sit in the House of Lords, is as absurd as that of hereditary mathematicians. A state Church is equally absurd, for it constrains freedom of conscience and implies that legislators can tell God which form of worship he should find acceptable. In these respects, public opinion has, after more than two centuries, largely caught up with Paine.

When he turns to actual politics, Paine pooh-poohs the very idea of counter-revolution, on the grounds that the Revolution proceeds from people's increased enlightenment: 'The revolutions of America and France have thrown a beam of light over the world, which reaches into man', and there is no way 'to make man *unknow* his knowledge, or *unthink* his thoughts'.[188] He does not discuss in any detail how public enlightenment is to be translated into political institutions, or how to solve the problem of reconciling conflicts among people's material interests. His dismissal of monarchy as an outdated absurdity ignores the argument that a constitutional monarchy can serve to legitimize government and preserve its stability. Looking back over history, he denies that there was any need to import William III or George I as kings in 1688 and 1714. Looking ahead, he claims that republics will never go to war, because wars are simply a pretext for despotic governments to raise taxes, whereas in republics the interests of the governors and of the nation will always coincide. The system of 'election and representation' is self-evidently recommended by reason: 'Government in a well-constituted republic, requires no belief from man beyond what his reason can give.'[189] 'I do not believe', Paine declared in February 1792, 'that monarchy and aristocracy will continue seven years longer in any of the enlightened countries in Europe.'[190]

Perhaps the most remarkable work to emerge from England's Enlightenment was Godwin's *Enquiry concerning Political Justice*, published in February 1793. This book made Godwin famous in his day. 'Tom Paine was considered for the time as a Tom Fool to him,' recalled William Hazlitt, 'Edmund Burke a flashy sophist.'[191] For long afterwards it seemed an eccentric, cranky work, in which reason was taken to fantastic extremes. Now, despite its undeniable oddities, it seems fresh and challenging, and the political and ethical questions it poses are not easy to dismiss or to answer.

True to his Dissenting background with its emphasis on private con-
science, Godwin starts from man as an individual, endowed with the
power of private judgement, which is the best guide to right and wrong.
'The universal exercise of private judgment is a doctrine so unspeakably
beautiful, that the true politician will certainly resolve to interfere with it
as sparingly and in as few instances as possible.'[192] But this does not mean
that all judgements are equally valid. Private judgement is regulated by
deference to reason and truth, which admit of no uncertainty. Reason
shows us that all human beings are morally equal. We should therefore
regard other people with impartiality. If we judge between them, we judge
only on their merit, that is, their ability to help the human race.

An example of impartiality is the famous passage where Godwin asks
us to suppose that we have the choice between rescuing from a fire either
Fénelon, the author of *Télémaque*, or his chambermaid. Fénelon is at work
on a book which will benefit thousands; if we save his chambermaid
instead, *Télémaque* will never get written and humanity will be the poorer.
Impartiality goes even further. I ought to judge people strictly on their
merit. So I should not favour my children or my parents simply because
they are my relatives. It may be argued that I ought to favour my parents
out of gratitude to them for bringing me up. But if gratitude is 'a sentiment,
which would lead me to prefer one man to another, from some other con-
sideration that that of his superior usefulness or worth', then gratitude has
no place in morality.[193] My duty towards other people is unaffected by
any particular relation they may have to me.

Since we are all equal, it is unjust that I should have more property than
another man, and it is my duty to use what I do not need to relieve pov-
erty. A mere 'scanty pittance' given to charity is not enough. Anything I
do not actually need is a luxury, and it is unjust that I should have any
luxuries while another person lacks necessities. Similarly, if I have abilities,
it is my duty to use them for the benefit of humanity:

> In the same manner as my property, I hold my person as a trust in behalf
> of mankind. I am bound to employ my talents, my understanding, my
> strength and my time for the production of the greatest quantity of general
> good. Such are the declarations of justice, so great is the extent of my duty.[194]

These are the conclusions of reason. Godwin is confident that truth and
reason will eventually triumph. 'The phalanx of reason is invulnerable; it
advances with deliberate and determined pace; and nothing is able to resist
it.'[195] Reason shows me that the world at present is arranged with flagrant
injustice. Government is 'nothing more than a scheme for enforcing by
brute violence the sense of one man or set of men upon another'.[196] It

produces monstrous inequalities of wealth and poverty, subjects people to continual wars, and supports itself by the pretence that one man, as a king or aristocrat, is intrinsically superior to others.

My duty is to oppose any measure or arrangement of which my private judgement leads me to disapprove. Present-day society offers a great deal for my disapproval. But Godwin warns against the resort to force. Superior force has no moral or intellectual authority. Instead, 'The resistance I am bound to employ is that of uttering the truth, of censuring in the most explicit manner every proceeding that I perceive to be adverse to the true interests of mankind.'[197] The best means of revolution are 'argument and persuasion'.[198] Their effect may be slow, but it is sure. Godwin thus agrees with the gradualism of the *philosophes* whom he often cites.[199] To show that patience can be rewarded, he remarks that Helvétius deplored the condition of France and saw no prospect of its improvement; but now the Revolution has taken place, with remarkably little bloodshed (Godwin must have turned a blind eye to the September Massacres).

What political institutions are compatible with reason? The fewer the better. 'Government can have no more than two legitimate purposes, the suppression of injustice against individuals within the community, and the common defence against external invasion.'[200] Criminal behaviour will dwindle as people come to perceive their true interests, and punishment, which has no other purpose than to restrain the individual from further wrong-doing, will be superseded by the force of public opinion. Dangers from foreign countries will likewise disappear when distributive justice has eliminated inequalities between countries and removed the grounds for conflict. No foreign policy will then be necessary. There will be little left for government to do. These arguments have given Godwin a high place among the forebears of philosophical anarchism.[201]

Godwin nevertheless considers forms of government at some length. He has no difficulty in exposing the shortcomings of monarchy and aristocracy. As for democracy, even the turbulent democracy of ancient Athens is better than the other two forms of government, but its faults resulted from its being a direct democracy, and will not exist if we have representative democracy. A national assembly (or parliament) is undesirable, because majority voting obliges the minority to acquiesce in something they do not believe, so it should be summoned only in emergencies. It should not consist of two chambers, because, since truth is uniform, the two cannot disagree without one being in error, and because two chambers will in effect divide the nation against itself. Even democracy is a second best, however – it is desirable to do without government at all:

Above all we should not forget, that government is an evil, an usurpation upon the private judgment and individual conscience of mankind; and that, however we may be obliged to admit it as a necessary evil for the present, it behoves us, as the friends of reason and the human species, to admit as little of it as possible, and carefully to observe whether, in consequence of the gradual illumination of the human mind, that little may not hereafter be diminished.[202]

Late in his book Godwin becomes yet more utopian. The progress of humanity from savagery to our present civilization allows us to hope for much greater progress when reason shall be unimpeded. The mind will increase its power over the body. We may lengthen our lives through sustained 'chearfulness'.[203] We may improve our reasoning powers. We may gain more time by eliminating sleep. We may ultimately become immortal. We shall become 'indifferent to the gratifications of sense' and feel no desire to increase the population and thereby put at risk the planet's resources.

There will be no war, no crimes, no administration of justice as it is called, and no government. These latter articles are at no great distance; and it is not impossible that some of the present race of men may live to see them in part accomplished. But beside this, there will be no disease, no anguish, no melancholy and no resentment. Every man will seek with ineffable ardour the good of all. Mind will be active and eager, yet never disappointed. Men will see the progressive advancement of virtue and good, and feel that, if things occasionally happen contrary to their hopes, the miscarriage itself was a necessary part of that progress.[204]

These strange prophecies should not distract us from the challenge posed by Godwin's claim that it is my duty to devote my surplus property to help other people. How can I justify spending money on luxuries when other people are in want even of necessities? If everyone gave away what they do not need, world poverty could be abolished. It may seem unfair that I should impoverish myself when other well-off people have no intention of doing so, but neither Godwin nor a modern utilitarian would consider that an objection.[205] On the other hand, individual benevolence would not remove the economic structures that create disparities of wealth, and might even be accused of sustaining them.

Again, Godwin's doctrine of impartiality may be hard to swallow. Readers may feel that a sense of human equality debars them from choosing Fénelon over his chambermaid. But imagine a case involving a less remote figure than Fénelon. It is 1990; you have the choice of saving either

Nelson Mandela or his prison guard. If you save the guard, Mandela's work in leading South Africa from apartheid to a peaceful multicultural society will be nipped in the bud, and the result may well be civil war. Is that decision difficult?

It does seem, however, that Godwin overestimates the persuasive power of reason. Or rather, he underestimates the vices – selfishness, envy, vindictiveness, wanton cruelty – that are rooted in human nature. 'Vice is unquestionably no more than error of judgment,' he tells us repeatedly.[206] One may also baulk at Godwin's lack of interest in human diversity. His colourless utopia anticipates that evoked by his son-in-law Shelley in *Prometheus Unbound* (1820):

> The loathsome mask has fallen, the man remains
> Sceptreless, free, uncircumscribed, but man
> Equal, unclassed, tribeless, and nationless,
> Exempt from awe, worship, degree, the king
> Over himself . . . [207]

However, the liberated humanity of Shelley's future is not 'passionless', whereas it is difficult to sympathize with Godwin's vision of beings in whom the mind so controls the body that they have lost interest in the pleasures of the senses (something the still unmarried Godwin probably knew little about).

## SOME ENLIGHTENMENT LEGACIES

The political issues debated today are of course widely different from those discussed in the Enlightenment. Nevertheless, there are some continuities. The proper role of the state, the nature of patriotism, the prospects for international peace, and the concept of human rights are subjects of intense contemporary interest, and were also the topics of Enlightenment arguments. In some instances, concepts that we now take for granted can be traced to origins in the Enlightenment. The themes examined below could be multiplied, but they will show what power the Enlightenment has still to provoke debate.

### Liberalism

Very schematically, it may be said that we have inherited from the Enlightenment two contrasting forms of liberalism.[208] 'Classical liberalism' insists on the freedom of individuals to pursue their own well-being and take

responsibility for their own lives. It urges that government should be kept to the minimum necessary to maintain the rule of law. Regarding private property as sacrosanct, it disapproves of redistribution through taxation. It does not attach importance to social justice, thinking that the welfare of the disadvantaged should be left to private philanthropic initiatives. More radical present-day versions, often called 'neo-liberalism', regard the payment of taxes as an unjust invasion of private property and a check on private enterprise. Individual responsibility and self-reliance are considered positive values that should be encouraged by a free market allowing consumers to make their own choices.

Another form of liberalism is sympathetic to what we now call the 'welfare state'. It descends in part from the *Polizeistaat* of eighteenth-century Germany, in which the state, via a large administrative bureaucracy, took responsibility not only for the maintenance of public order and the infrastructure but also for the well-being and happiness of its citizens. In modern liberalism, it is the state's duty to provide for its citizens' welfare and to support their aspirations to personal fulfilment. Although modern liberals reject socialist conceptions of the overriding importance of material equality, they consider it the state's duty to promote welfare by redistributive taxation, public services available to all (a signal example is the British National Health Service), and measures to save the disadvantaged not only from destitution but from the humiliation of severe poverty. Only if the state assumes such a role, it may be argued, can its citizens form a community, rather than a mere aggregation of unconnected individuals.

Classical liberalism has a founding father in Locke with his theory of civil society based on a social contract. It has an equally famous representative in Adam Smith as the spokesman of commercial society. Not only Smith but Hume, Montesquieu and Voltaire have recently been presented as upholding a 'pragmatic liberalism'.[209] It is pragmatic in that it does not need the Lockean fiction of a social contract, which both Smith and Hume rejected as mythical.[210] It advocates freedom from state control: Smith criticized Louis XIV's finance minister Colbert for trying to regulate the economy, 'instead of allowing every man to pursue his own interest his own way, upon the liberal plan of equality, liberty and justice'.[211] It understands freedom as security guaranteed by the law. 'In a society where there are laws,' says Montesquieu, 'liberty can consist only in having the power to do what one should want to do and in no way being constrained to do what one should not want to do.'[212] Liberty therefore requires good laws which are effectively and impartially enforced. In a state enjoying liberty, the citizen will have no need to fear either other citizens or the government.

Montesquieu, Hume and their like-minded contemporaries believed that liberty was best secured in a monarchy, preferably a constitutional monarchy such as Britain's. Like Voltaire, they thought that Britain, with its separation of powers and restraints on royal prerogatives, approached closer to freedom than any other country. Voltaire put his faith in the reforming potential of the French monarchy, until he was disillusioned by Louis XVI's refusal to support Turgot's much-needed economic reforms.[213] Hume was satisfied with 'a civilized monarchy', describing it as 'a species of government . . . to which, in a high political rant, we may give the name of *Tyranny*, but which, by a just and prudent administration, may afford tolerable security to the people, and may answer most of the ends of political society.'[214]

Mainstream Enlighteners did not see representative government as an end in itself, but as a means of preserving liberty. Smith told his students that elections were 'a great security for the liberty of the people', though they should not be too frequent, as the representatives could easily become too dependent on their constituents; he thought an election every seven years was enough.[215] Gibbon thought that a benevolent oligarchy was sufficient: 'While the Aristocracy of Bern protects the happiness, it is superfluous to enquire whether it be founded in the rights, of man.'[216] They were impatient with advocates of liberty such as John Wilkes, whose appeal to the people they considered mere demagogy. Hume, referring to Wilkes and his associates, thought the word 'liberty' had 'been so much profand [*sic*] by these polluted Mouths, that men of Sense are sick at the very mention of it'.[217]

It was not only the spokesmen of classical liberalism but also those classified as radicals who wanted to reduce the role of government. Paine thinks government is at most 'a necessary evil'.[218] The need for government diminishes with the advance of civilization. 'The more perfect civilization is, the less occasion has it for government, because the more does it regulate its own affairs, and govern itself.'[219] Both Paine and Priestley shared the widespread disapproval of the system of poor relief. The Elizabethan Poor Law of 1601, setting up parish-based workhouses for the destitute, was supplemented in 1723 by a statute denying poor relief to anyone who refused to enter a workhouse. By 1776 there were almost 2,000 parish workhouses in England and Wales, with capacity for over 90,000 paupers.[220] Workhouses were supposed to make a profit, but hardly ever did; they did, however, keep their inmates on the verge of starvation. Many people thought, like Priestley, that this safety-net ought to be abolished. Besides costing ratepayers dear, it discouraged the poor from finding work, weakened habits of frugality, and destroyed people's self-respect.

'Everyone but an idiot,' said Arthur Young, 'knows that the lower class must be kept poor or they will never be industrious.'[221]

England was seen not only as the world's freest society, but also as the leading commercial society. Enlighteners argued that there should be no barriers to internal commerce or to foreign trade. They opposed the doctrine of economic protectionism that went by the name of mercantilism, and instead advocated the philosophy of 'laissez-faire', which left the regulation of trade to the merchants who conducted it. It was generally agreed that the interests of capital and labour were ultimately in harmony: as the merchant's profits increased, so did the prosperity of the country, and therefore also that of the worker.[222] As we have seen, both Adam Smith and the physiocrats thought that merchants should be left alone even in times of famine: corn-dealers had to make a profit, and it was in their interest not to let the price of grain rise beyond what the poor could afford.[223] This was in accordance also with the natural law tradition, which rejected 'distributive' justice, in which the prices of goods should correspond to the needs or merits of the potential purchaser, in favour of 'commutative' justice, in which prices should be regulated by the laws of trade. Accordingly, Edmund Burke lent strong support to Smith's opposition to interference with the corn trade:

> A greater and more ruinous mistake cannot be fallen into, than that the trades of agriculture and grazing can be conducted upon any other than the common principles of commerce, namely, that the producer should be permitted, and even expected, to look to all possible profits which, without fraud or violence, he can make; to turn plenty or scarcity to the best advantage he can; to keep back or bring forward his commodities, at his pleasure; to account to no one for his stock or his gain.[224]

The trouble with laissez-faire policy, however, was that merchants, left to themselves, tended to form monopolies. Smith repeatedly denounced monopolies in *The Wealth of Nations* but could not suggest how they should be prevented except for a degree of government interference incompatible with his principles.

The most thorough-going attempt to shrink the state, anticipating modern neo-liberalism rather than representing its classical forebear, is the essay by the young Wilhelm von Humboldt, *Ideen zu einem Versuch die Grenzen der Wirksamkeit des Staats zu bestimmen* (literally, *Ideas for an Attempt to Define the Limits of the Effectiveness of the State*). Published only partially at the time, it appeared in full in 1852 and in English translation two years later, and was an important stimulus for John Stuart Mill's essay *On Liberty* (1859). Humboldt, like Kant, is reacting against

the German conception of the paternalist *Polizeistaat*. He attaches supreme importance to the self-development of the individual. 'The true end of Man . . . is the highest and most harmonious development of his powers to a complete and consistent whole.'[225] People should be active, self-reliant, energetic and resourceful. The state has no business to tell them how to direct their energies. It should simply let them do so securely by preventing any infringement of their rights by violence, theft, or foreign invasion. It should not try to make people into citizens or offer them moral instruction. There should be no system of national education, for that would produce uniformity instead of encouraging individuality. The state should have nothing to do with religion (in Humboldt's Prussia, a reaction against the tolerance of Frederick the Great, who had died in 1786, had led Lutheranism to be proclaimed the official religion): for Humboldt, as for his contemporary Friedrich Schleiermacher, the essence of religion is feeling, not dogma or morality, and the state cannot prescribe people's feelings. Nor should the state try to regulate marriage, which should instead be left to the morality of individuals. Not surprisingly, Humboldt also disapproves of poor-laws. He says that beggars who take refuge in workhouses earn our contempt, but if they beg for alms they awaken our sympathy and thus benefit us as well as themselves.[226] The vast administrative apparatus characteristic of all German states should be reduced to a minimum, for in bureaucracy the attention of highly educated men is diverted from matters of substance to trivial formalities. With the residual state left to administer only a reduced legal system and foreign policy, the small expenses required could be raised by direct taxation which citizens would barely notice.

In a Humboldtian utopia, we may imagine, citizens would bring to a modern complex society the energy and resourcefulness usually confined to settlers on a distant frontier, but without the violence characteristic of frontiersmen. They would form their own opinions and live by their own moral standards. They would set up private schools, hospitals and other institutions (no doubt including churches) and run them without reference to the state. The best of all these institutions would set standards for others to emulate. The cloud hanging over this utopia, however, is its economic system, which Humboldt says nothing about, apart from several times confessing his ignorance of financial matters. Presumably, the free market would reign unimpeded. So the quality of institutions might be in conflict with their profitability. There would be no sense of citizenship or civic responsibility. The exaltation of the individual would surely eventually destroy the community.

## Patriotism and Nationalism

Cicero, who was an authoritative voice on so many matters, also gave an exemplary dictum about the love of one's country:

> when we view every Thing in the Eye of Reason, of all Connexions none is more weighty, none is more dear than that between every Individual and his Country. Our Parents are dear to us; our Children, our Kinsmen, our Friends are dear to us, but our Country alone comprehends all the dearest Endearments of Mankind. What good Man would hesitate to die for her to do her Service?[227]

In the early to mid-eighteenth century, the love of one's country acquired the name 'patriotism', *patriotisme*, *Vaterlandsliebe*.[228] It had diverse implications and carried with it considerable ambivalence. When one's own country was contrasted with others, patriotism easily shaded into nationalism: the boastful, aggressive, even downright xenophobic exaltation of the alleged individuality of one's own country over others. Ironically, nationalism – by its myth-making – often largely creates the national individuality that it presents as having existed from time immemorial. Hence the definition of nationalism as 'a political program which has as its goal not merely to praise, or defend, or strengthen a nation, but actively to construct one, casting its human raw material into a fundamentally new form'.[229]

Patriotism in itself was clearly commendable. 'Of all human affections,' says Shaftesbury (following Cicero), 'the noblest and most becoming human nature is that of love to one's country.'[230] Shaftesbury regretted that English had no equivalent to the Latin *patria* (and the French *patrie*). The German-sounding 'fatherland', the phoney-sounding 'motherland', and 'mother country' are only rarely attested in the eighteenth century. Many citizens formed 'patriotic societies' to promote agricultural and industrial improvement for the benefit of their country.[231] Such patriotism was not blind devotion; it acknowledged one's country's shortcomings and sought to improve them. This was the aim, for example, of the Helvetic Society, founded in 1761, which sought not only to promote economic reforms but also to create a common Swiss identity by overcoming cantonal and confessional differences. The enlightened historian Isaak Iselin, its president in 1764, delivered a 'Rede über die Liebe des Vaterlandes' ('Address on the Love of the Fatherland'), distinguishing mere narrow attachment to one's town or province from the true and, when necessary, critical patriotism which is an 'emanation of the purest love for humanity'.[232] A patriot could see beyond selfish, short-term interests and envisage

his country's good in the long term. Thus, in Goethe's novel *Wilhelm Meisters Lehrjahre* (1795–6), the enlightened and far-sighted nobleman Lothario works with the narrow-minded businessman Werner, hoping to turn him into a 'good patriot'.[233]

Above all, 'patriotism' tended to be oppositional. Samuel Johnson, in an attack on censorship written with Swiftian irony in the persona of a censor, associates 'opposition, patriotism, publick spirit, and independency, that spirit which we [the government's censors] have so long endeavoured to suppress'.[234] The English and Scottish patriots celebrated by James Thomson in *The Seasons* were rebels in their day: John Hampden, Algernon Sidney and the 'Great Patriot-Heroe' William Wallace.[235] A 'patriot' is often a citizen who stands outside the governing hierarchy and professes a disinterested view of his country's good. Thus the party in the Dutch Republic opposed to the Orange dynasty called themselves Patriots. One of them, Jan Wagenaar, wrote in 1747: 'A Patriot has such a strong and upright feeling for the welfare of his fatherland that in order to advance its interest, he puts not merely his own interest in the balance, but, if needs be, dares to put it entirely on one side.'[236] In *The Idea of a Patriot King* and *A Letter on the Spirit of Patriotism*, printed privately around 1739 and first published in 1749, Bolingbroke similarly criticized the new Hanoverian dynasty. He argues that the proper object of patriotic loyalty is not the royal dynasty but the state. Many kings have been wrongly educated, as Louis XIV was, to think the kingdom is their personal patrimony. But the reverence due to a king is *'natural*, not *personal'*.[237] The sanctity of a king is conditional on his governing well. A good king must be a patriot, concerned principally for the good of his country, and must be judged by his performance.

However, the motives of self-styled patriots were often open to suspicion. John Wilkes, in his campaign against the supposed malign influence of George III's favourite Lord Bute, was often thought to be a demagogue posing as a patriot. It was presumably his example that made Johnson declare: 'Patriotism is the last refuge of a scoundrel.'[238] Writing to his stepmother in 1779, Gibbon reassures her: 'I have not any claims to the injurious epithet of a Patriot.'[239] In Otto von Gemmingen's play *Der teutsche Hausvater* (1780), the worthy paterfamilias, having obtained an administrative post for his son Karl, warns him: 'Love of one's fatherland means wanting the best for one's fatherland and helping to promote it, no matter by whom. It is only too common nowadays for selfishness and ambition to assume the splendid title of a patriot [*eines Patrioten*].'[240] The Dutch Patriot revolutionaries of the 1780s claimed to be speaking in the name of the people, though many of the actual populace supported the conservative Orange dynasty.[241]

Patriotism could easily be heightened by war. In Germany, the Seven Years War provoked an outburst of fervent patriotism, appealing especially to ancient Roman ideals. Thomas Abbt, a professor of philosophy in Frankfurt an der Oder, maintains in his much-read essay *Vom Tode fürs Vaterland* (*On Death for the Fatherland*, 1761) that patriotism should be based not on rational reflection but on passionate enthusiasm, and that one's country has the right to claim one's life. He compares patriotic death to the self-sacrifice of Christian martyrs. Their ideal of a heavenly home is now replaced by the fatherland. Abbt reinforces his argument by a stirring quotation from the poet Ewald von Kleist, who had not only published patriotic poetry but given his own work a special authority by taking part heroically in combat and dying of wounds received at the battle of Kunersdorf in 1759:

> Der Tod fürs Vaterland ist ewiger
> Verehrung werth. – Wie gern sterb ich ihn auch
> Den edlen Tod, wenn mein Verhängniß ruft![242]

[Death for the fatherland deserves everlasting honour. – How gladly I too shall die the noble death, when my destiny calls!]

This exalted patriotism did not please everyone. Lessing reproached his friend Gleim for celebrating the Prussian victory at Zorndorf (1758) with excessive and bloodthirsty fervour, adding: 'to my way of thinking, the praise for being a zealous patriot is the last thing I would long for, if it teaches me to forget that I should be a citizen of the world'.[243] Nevertheless, this patriotic discourse, favouring especially the phrase 'the altar of the fatherland', was to resurface with renewed power at the end of the century, when Germany and Austria were aligned against France.[244]

In France, the word 'patriot' underwent a significant shift. In the 1750s it came to imply not just a loyal subject, but an active citizen whose view of the national interest might differ from that of the government.[245] After the conflict between the *parlements* and the crown in 1771, 'patriotism' implied a sharper opposition to despotism. When the Estates General were summoned and the Third Estate demanded greater representation, its aspirations were labelled 'patriotism'.[246] During the Revolution, 'patriots' were those who supported its aims, in contrast to counter-revolutionaries. Often the term referred to what would nowadays be called 'activists'. Thus Danton urged in 1793 that every 'patriot' should be equipped with a musket, instead of the pikes previously carried by militants.[247] As the revolutionary leadership broke down into factions, however, membership of the wrong faction,

as we have seen, could bring one the accusation of wearing only the 'mask of patriotism' to conceal one's counter-revolutionary intentions.

The French example also shows how easily a proudly defensive patriotism could develop into an aggressive nationalism. The wars waged to repel France's enemies and to spread the Revolution soon acquired the purpose of enabling France to expand to its supposedly 'natural frontiers'. These, according to Danton and the military strategist Carnot, were the ocean, the Alps, the Pyrenees and the Rhine.[248] So the invasion of the German Rhineland and the large part of the Netherlands situated left of the Rhine was not really a campaign of conquest but a necessary readjustment.

The conception of 'natural frontiers' helped to make the 'nation' seem a natural entity. National and revolutionary allegiances were further identified when, from August 1793 onwards, the French government instituted mass conscription (levée en masse), calling on all able-bodied men to serve the nation. Ironically, this example helped to strengthen the German nationalism that would soon afterwards be inflamed by Napoleon's victory over Prussia at the battles of Jena and Auerstedt (1806), followed by French occupation. After Napoleon's defeat in Russia in 1813, the Prussian reforming minister Freiherr von Stein sought 'to turn the weapons of the revolution against their French inventors' by instigating a popular uprising (Volksaufstand) against the occupiers.[249] The German 'War of Liberation' of 1813 would become one of the most influential nationalist myths of the nineteenth century.

In revolutionary France, foreign sympathizers with the Revolution increasingly came under suspicion. The Prussian nobleman Anacharsis Cloots, calling himself the 'Orator of the Human Race', on 19 June 1790 presented to the Parisian National Assembly a delegation of representatives from the 'oppressed nations of the universe', including people dressed in Indian, Turkish and Persian costume.[250] Yet by 1793 Robespierre was asking: 'Can we regard a German baron as a patriot?'[251] Cloots went to the guillotine in March 1794. We have seen how another foreigner, Thomas Paine, narrowly escaped a similar fate.

Self-styled patriots often whipped up emotions that are best described as nationalistic. Wilkes, railing against the Scot Lord Bute, campaigned explicitly for 'English liberty' and denounced the increased visibility of Scots in England since the union of the Parliaments. Claiming that his 'ruling passion' was 'the love of England', he developed a cult of England and Englishness, even defending public executions 'on the grounds that they accustomed Englishmen to a contempt for death'.[252] In the same period a distinct conception of the English national character was taking shape.[253] The aristocracy, immersed in French culture, were seen as

artificial, spendthrift, insincere and affected, and their use of patronage to provide places for their offspring and obstruct social mobility aroused increasing resentment. In his jeremiad against luxury, John Brown warned that the French had infected their neighbours with 'effeminacy' while retaining a sense of national honour that made them dangerous, perhaps irresistible international competitors: 'while she hath allured her neighbour Nations, by her own Example, to drink largely of her *circæan* and *poisoned Cup* of *Manners*, [France] hath secured her own *Health* by the *secret Antidote* of *Principle*'.[254]

In reaction to this French influence, there grew up an image of the English John Bull as sincere, unaffected, frank, blunt and morally independent. Thus Smollett contrasts the honest Humphry Clinker with the Frenchified valet Dutton, of whom his master says: 'He has got a smattering of French, bows and grins, and shrugs, and takes snuff *a la mode de France*, but values himself chiefly upon his skill and dexterity in hair-dressing.'[255] Historians traced the ancestry of the English back to Saxon and Germanic origins, and maintained that the free institutions of the Saxons had been destroyed by William the Conqueror, who brought the English under the 'Norman yoke'.[256] All this amounts to an early nationalism grounded in historical and even racial myths, fortified by opposition to internal and external others (the Scots, the French). Meanwhile in France, the Seven Years War generated a hostility to Britain that largely superseded the positive view, encouraged by Voltaire and Montesquieu, of Britain as the land of liberty guaranteed by exemplary parliamentary institutions. The French foreign minister Choiseul, who dominated the government between 1758 and 1770, affirmed in 1765 that England was and always would be the declared enemy of France.[257] All this casts doubt on Isaiah Berlin's claim that the Germans were 'the first true nationalists'.[258] The militant, racially based nationalism generated by German resistance to Napoleon's occupation, and seen in the exhortations that the philosopher Johann Gottlieb Fichte delivered to Berlin audiences in the winter of 1807–8,[259] has antecedents in France and Britain.

## World Peace

Enlighteners deplored war and questioned the ideal of military heroism. Their humanist predecessor Erasmus denounced Mars, the god of war, as 'the stupidest of all the poet's gods' and described soldiers as 'thick-headed lords . . . not even human except in appearance'.[260] The article 'Heroism' in the *Encyclopédie* says that a hero, 'reduced to his true value, is the shame and the scourge of the human race'.[261] Wise and benevolent rulers,

such as the emperors Trajan and Marcus Aurelius, deserve far more esteem because of their moral virtues.[262] Voltaire wrote in 1735: 'I call great men all those who have excelled in the useful and the agreeable. Plunderers of provinces are merely heroes.'[263] He adds elsewhere that, regrettably, 'Such is the miserable weakness of men that they regard with admiration those who have done evil in a brilliant manner, and they often talk more readily about the destruction of an empire than about its founders.'[264]

These views required Voltaire to exercise particular tact when corresponding with Frederick the Great. During the Silesian campaign, initiated in 1740 when Frederick illegally seized the province from the young and inexperienced Empress Maria Theresa, he and Voltaire exchanged poems, Voltaire writing from Paris and Frederick from his army camp. Having remarked with affected surprise that the Solomon of the North had now become its Alexander, Voltaire continued:

> J'aime peu les héros, ils font trop de fracas;
> Je hais les conquérants, fiers ennemis d'eux même,
>   Qui dans les horreurs du combats
>   Ont placé le bonheur suprême.

[I do not like heroes, they cause too much turmoil; I hate conquerors, proud enemies of themselves, who have placed supreme happiness in the horrors of warfare.]

Does this mean, Voltaire asks rhetorically, that he ought to hate Frederick? No, for Frederick is a reluctant hero, his real vocation being that of a wise ruler:

> Vous êtes un héros; mais vous êtes un sage.
> Votre raison maudit les exploits inhumains
>   Où vous força votre courage.[265]

[You are a hero; but you are a sage. Your reason curses the inhuman exploits which your courage compelled you to undertake.]

For the eighteenth century, the supreme (and also the most absurd) example of the heroic ideal was Charles XII of Sweden. At the age of eighteen, this seemingly untalented young man suddenly emerged as a skilful, determined and astonishingly successful military leader. In the Great Northern War at the beginning of the century he beat off the combined forces of Denmark, Poland and Russia. Determined to force Russia into submission, he anticipated the hubris of Napoleon and Hitler by attempting an invasion, but was defeated in 1709 by a superior force under Peter the Great. After five years of exile, Charles returned to Scandinavia

but was shot by an unknown assailant while besieging a fortress in the south-eastern corner of Norway. Samuel Johnson took Charles to typify the 'vanity of human wishes':

> His fall was destin'd to a barren strand,
> A petty fortress, and a dubious hand;
> He left the name, at which the world grew pale,
> To point a moral, or adorn a tale.[266]

For Pope, Charles was no less an example of heroic folly than Alexander the Great:

> Heroes are much the same, the point's agreed,
> From Macedonia's madman to the Swede.[267]

Voltaire, in his *History of Charles XII*, describes Charles and his antagonist Peter as 'by the consent of the whole world, the most remarkable personages to have appeared for more than twenty centuries'.[268] While Peter used his power to bring Western civilization to Russia, Charles refused the crown of Poland, thereby losing the chance to become an enlightened monarch, and expended his energies on futile and anachronistic military adventures.

Voltaire's authentic hero, the subject of his epic poem the *Henriade* (1728), was Henri IV of France, who ended the religious wars by instituting tolerance, and who is presented as hating war.[269] The historical Henri IV, having brought internal peace to France, had ambitious plans for pacifying Europe. With his loyal minister Sully, he planned, first, a coalition of states which would surround and overcome the over-powerful Habsburg Empire; and secondly, in the much longer term, a federation of Christian states, governed by a Senate which would be a kind of international tribunal to settle their differences. These far-sighted schemes were frustrated when Henri was assassinated in 1610, and rendered unimaginable by the outbreak of what turned out to be the Thirty Years War in 1618.

Nevertheless, Henri's projects inspired later proposals for an international body which should resolve disputes between states peacefully, and whose power might even extend beyond Europe. Thus William Penn's 'Grand Design' for a permanent European parliament, set out in his *Essay Towards the Present and Future Peace of Europe* (1693), included delegates from Russia and Turkey.[270] The most ambitious, and – as everyone hastened to point out – most impractical scheme was put forward by Abbé Charles-Irénee Castel de Saint-Pierre, secretary to one of the French delegates at the peace negotiations in Utrecht which in 1713 ended the War of the Spanish Succession. His *Projet pour rendre la paix perpétuelle en Europe*

(*Project to Make Peace Perpetual in Europe*, 1713), which he had already been working on for several years, proposed that instead of patching up yet another unstable peace, the European sovereigns should form a perpetual alliance, agreeing to renounce the use of force. Disputes between states should be submitted to mediation by a Senate. If any state persistently refused to accept arbitration, the rest should use force to bring it to heel.[271]

Even from this bald summary one can see problems. If, as Saint-Pierre envisaged, the member nations reduced their armies to a maximum of 6,000, they would be ill equipped to deal with a rogue state. And, as Leibniz delicately pointed out in a letter to the author, nobody would want to be the first to disarm.[272] To the rationalist abbé, however, his scheme seemed impeccably logical and self-evidently desirable. Once such a federation was established, it would draw in nations from Asia and Africa. All the princes needed to do was compose and sign a treaty. However, potentates ignored this scheme, while among *philosophes* Saint-Pierre acquired the reputation of a well-intentioned crank.[273]

The abbé's papers were given by his nephew to Rousseau, who, after reading them thoroughly, published in 1761 an abstract of the peace project, along with his own 'judgement' on the project. Rousseau has sometimes been thought an advocate of Saint-Pierre's scheme.[274] In fact, though he considers the idea of perpetual peace admirable in itself, he is clear that only someone so preternaturally naïve as the abbé could imagine that it had the faintest chance of ever being realized. Saint-Pierre, a selfless devotee of reason, 'an ornament of his century and to his kind', nevertheless 'did nothing but proceed from error to error in every system he proposed, because he tried to make all men like himself, instead of taking them as they are and always will be'.[275] In his counterargument, Rousseau reveals deep scepticism towards Enlightenment hopes for progress. Peace would indeed serve the real interests of sovereigns, but what princes actually want is constantly to extend their power, at the expense both of neighbouring states and of the liberty of their subjects. 'The whole life of kings, or of those on whom they shuffle off their duties, is devoted solely to two objects: to extend their rule beyond their frontiers and to make it more absolute within them.'[276] War enables princes to maintain armies that keep their subjects docile, and to fleece their subjects in order to maintain the armies. Ministers, who are always enemies of the people, and usually also of the princes, will never consent to the abolition of war either, because war makes them appear necessary to the prince and they would rather ruin the state than lose their positions of power. Saint-Pierre may imagine that a federation of peaceful states is such an obviously good idea that princes will immediately sign up to it; but Rousseau recalls that

Henri IV spent fifteen years planning his federation, and dared not let other states know what he was aiming at. In any case, concludes Rousseau, 'which of us would dare to say whether the league of Europe is a thing more to be desired or feared? It would perhaps do more harm in a moment than it would guard against for ages.'[277]

In a short essay drafted, like his 'Judgement', in 1756, Rousseau argued further that, although individuals were naturally well disposed towards one another, matters became quite different once they were organized into states, for the relation between states was intrinsically one of enmity. And while each individual is subject to severe limits on physical strength and the duration of life, states know no such limits: 'The state on the other hand, being an artificial body, has no fixed measure; its proper size is undefined; it can always grow bigger; it feels weak so long as there are others stronger than itself. Its safety and preservation demand that it make itself stronger than its neighbours.'[278] Both these essays are based on the hostility to complex society as such that Rousseau had proclaimed in his *Discourses* in the 1750s. Rejecting society outright, he cannot imagine any way in which it could be improved, however gradually. The subjects of a prince, he says, must always be in the position of Ulysses' companions in the Cyclops' cave, waiting helplessly for the monster to devour them.[279]

One of Rousseau's most creative readers was Kant. But while Rousseau rejects Saint-Pierre's plans as hopelessly unrealistic, Kant's essay *Zum ewigen Frieden* (*On Perpetual Peace*, 1795) is a robust defence of political unrealism. It begins with an ironic reference to the tendency of practical politicians to look down on theorists whose ideas are not founded on experience. The assumptions underlying the essay are explained in two appendices, in the second of which Kant denounces the 'political moralist' who adjusts morality to suit his own purposes. The political moralist prides himself on his knowledge of how the world works and on how people actually behave. His understanding of humanity is based on how people act now, not on a wider, anthropological understanding of human nature and of people's potential for acting differently. Relying on his empirical viewpoint, he regards morality as mere empty words, and derives from his experience various practical maxims which express prudence (*Klugheit*) but not wisdom. The 'moral politician', on the other hand, is aware not only of what people do now but of what they may do in the future when their potential is more fully realized. In politics, he will not rest content with the status quo, but, when he sees that reforms are needed, he will try to introduce or at least encourage them. While the political moralist decides on his purpose and then finds the most effective means (recalling Machiavelli's pragmatism), the moral politician will choose his

means in the light of the principle 'do as you would be done by' or the categorical imperative, here formulated as: 'So act that you can will that your maxim should become a universal law (whatever the end may be).'[280]

*On Perpetual Peace* is addressed to far-sighted moral politicians. Kant takes his title from an inn-sign depicting a graveyard (so the title should really be translated as 'At the Sign of Perpetual Peace'), and leaves it undecided whether the sign's satire was directed against humanity in general, against rulers with their insatiable appetite for war, or against the philosophers who dream of peace.[281] Much of his essay sets out the preliminary and substantive articles that would have to be included in any treaty providing for perpetual peace. The preliminary articles mostly concern the need for trust between states. Hence a treaty must not contain any secret reservations permitting the resumption of war later. States must not threaten one another by maintaining standing armies – hence, in present-day language, Kant is calling for multilateral disarmament. Nor must they accumulate large debts with which to maintain armies; here Kant alludes in passing to the English invention of the national debt.[282] No state may try to overthrow the government of another (in our language, 'regime change'), or else trust will be impossible. And no state may render another insecure by sending in assassins and poisoners or by encouraging citizens to become traitors. A rather different article provides that one state cannot acquire another, whether by dynastic marriage, purchase, or exchange. For a state is not a piece of property, even if eighteenth-century princes liked to regard their domains as their personal possession. A state is a society of human beings, and the people composing it must not be transferred hither and thither as though they were mere inanimate objects.

The major articles of the perpetual peace treaty begin by asserting that the states subscribing to it must be republics. Kant is here thinking especially of ancient polities, like Athens and republican Rome, in which, when war occurred, every adult male citizen was obliged to take part actively. If citizens know that in a war they will have to fight, to finance the war themselves, and to repair the devastation that an invading army will cause, they will be very cautious indeed about undertaking warfare. On the other hand, an eighteenth-century prince who regards his state as his property expects his palaces, his hunts and his banquets to continue, and far from hesitating to send his subjects to fight, will regard a war as a kind of pleasure-party, which can always be justified by his corps of pliant diplomats. In a republic, moreover, the legislative power is separate from the executive power, whereas in a despotism the same person makes decisions and carries them out. An autocrat is, by definition, a despot; but democracy – meaning thereby direct rule by the people, as in some ancient

Greek city-states – is also despotic. For the executive power claims to embody the will of the people, yet the people are unlikely ever in fact to be unanimous, so dissent has to be overridden and has no way of being expressed. The only alternative to despotism, whether of the prince or of the people, is representative government, in which the people elect delegates to represent the range of their opinions and to agree on decisions to be taken in the people's name. Such a government will favour peace.

Perpetual peace must be maintained by a loose federation of free states. As Kant explains later, a single state, or universal monarchy, is neither feasible nor desirable; it would become 'a soulless despotism' and collapse into anarchy, but anyway nature prevents it from arising by the differences of language and religion among nations.[283] The natural condition of humanity, before the establishment of civilization, is anarchy. Although nowadays individuals live in ordered societies under governments, states are still in an anarchic condition – and will be until they acknowledge a supreme authority. The precepts of natural law, put forward by Pufendorf, Grotius and Emer de Vattel, will not help, because they are mere pious sentiments that cannot be enforced.

> In accordance with reason there is only one way that states in relation with one another can leave the lawless condition, which involves nothing but war; it is that, like individual human beings, they give up their savage (lawless) freedom, accommodate themselves to public coercive laws, and form an (always growing) *state of nations* (*civitas gentium*) that would finally encompass all the nations of the earth.

And this ideal remains valid and attainable, even though present-day governments do not want it.[284]

Yet such a federation lies, if anywhere, in the remote future. What guarantee is there that it will ever come about? Kant finds such a guarantee in the underlying logic of history. A decade earlier, in his essay 'Idea for a Universal History with a Cosmopolitan Purpose' (1784), Kant had argued that conflict was productive. Humanity lived in a condition of 'unsocial sociability' in which antagonism and competition brought out abilities that would otherwise have lain dormant. The antagonism between states, as well as between individuals, ultimately served a good purpose:

> Wars, tense and unremitting military preparations, and the resultant distress which every state must eventually feel within itself, even in the midst of peace – these are the means by which nature drives nations to make initially imperfect attempts, but finally, after many devastations, upheavals and even complete inner exhaustion of their powers, to take the step which

reason could have suggested to them even without so many sad experiences – that of abandoning a lawless state of savagery and entering a federation of peoples in which every state, even the smallest, could expect to derive its security and rights not from its own power or its own legal judgement, but solely from this great federation (*Foedus Amphictyonum*), from a united power and the law-governed decision of a united will.[285]

In *On Perpetual Peace*, Kant similarly appeals to the intrinsic logic of human development as the guarantee of ultimate peace. He calls this logic 'nature', as the limits of our knowledge forbid us to call it 'providence'. Nature sustains human life even in the most inhospitable parts of the globe by ensuring, for example, that trees that fall into rivers end up as driftwood on the shores of the Arctic Ocean, for the Samoyeds to build their huts with. War serves the purposes of nature by dispersing people all over the globe, from Siberia to Tierra del Fuego. It compels a nation to come together and submit to laws for its own preservation. Although people are naturally bad, they can live together under a suitable constitution, and the best, though the hardest to establish, is the republican constitution. Far from depending on an implausibly hopeful view of human nature, it does not require people to be good individuals, only to be good citizens. A republic would be viable even for 'a nation of devils', because they would see that obeying the constitution was the only means of self-preservation.[286] So Kant gives grounds for thinking, first, that all states will eventually become republics, and secondly, that republics can eventually form a federation to maintain perpetual peace. This federation will be a *Völkerbund* or league of nations (perhaps something like the present-day European Union).

When Kant published his treatise, early in a phase of European warfare that would last for some twenty-five years, it seemed hopelessly irrelevant. Yet, as Anthony Pagden has recently reminded us, its ideas underlie not only the interwar League of Nations but also the flawed but considerably more successful United Nations; Mikhail Gorbachev quoted from *On Perpetual Peace* when accepting the Nobel Peace Prize in 1990.[287] Moreover, although war shows no sign of vanishing, it has changed its character. There is now widespread agreement that war between states has become illegitimate in theory and rare in practice. Since 1945 the world has experienced an – admittedly tremulous – Long Peace in which the much-prophesied Third World War has not come to pass.[288] In addition, states rarely conquer one another's territories. Between 1816 and 1928, we are told, 'there was, on average, approximately one conquest every ten months (1.21 conquests per year)', especially in the later nineteenth century when European states conquered enormous territories in Africa. Once the United

Nations had become established, 'the average number of conquests per year fell dramatically – to 0.26 per year, or one every four years'.[289] Back in 1740, Frederick the Great's seizure of Silesia was cynical but normal; in 2014, the Russian annexation of Crimea was something unusual. Even the American invasion of Iraq was intended not to annex territory, but to occupy it briefly in order to change the regime.

So war has changed its character, though the reasons are not wholly obvious. Clearly the threat of nuclear annihilation is an important dissuasive, but traditional wars have also become rare between non-nuclear states. The increased interconnections resulting from global trade have removed even the semblance of economic justification for war. Many wars and continuing tensions result from controversial or ambiguous arrangements made by the great powers in the wake of the First World War (Iraq, Palestine) or in the process of decolonization (the conflict between India and Pakistan). Wars are often civil wars, occurring especially within failed states. Terrorism is likely to continue indefinitely, but recent experience, despite the phrase 'war on terror', suggests that it is better dealt with by police and security forces rather than by military means.[290] Wars over dwindling natural resources such as oil are easy to foresee; arguably they have already begun. And nuclear war could still occur all too easily through folly, misunderstanding, or accident. Even so, there are grounds to think that Kant has been vindicated, though the Japanese jurist Nishi Amane, who introduced European theories of international law to Japan, may also have been right to say that Kant's perpetual peace would not arrive until '10,000 years in the future'.[291]

## Human Rights

It is generally agreed that the concept of human rights is among our most valuable debts to the Enlightenment. Famous sentences from the American Declaration of Independence and the French Declaration of the Rights of Man and the Citizen ring in our ears: 'We hold these truths to be self-evident, that all men are created equal, that they are endowed by their Creator with certain unalienable Rights, that among these are Life, Liberty and the pursuit of Happiness.'[292] 'Men are born and remain free and equal in rights . . . The purpose of all political association is the preservation of the natural and imprescriptible rights of man. These rights are liberty, property, security and resistance to oppression.'[293] These and similar texts provide a concept of human rights that Lynn Hunt has summed up as follows: 'Human rights require three interlocking qualities: rights must be

*natural* (inherent in human beings), *equal* (the same for everyone), and *universal* (applicable everywhere).'[294]

The idea of natural rights is founded in the concept of natural law. In being conceived as universal, natural rights differ from the particular rights based in law to which protesters against oppression have often appealed. Thus the Dutch petitioners in 1565 complained that the Spanish Inquisition would 'do away with all ancient privileges, franchises, and immunities'.[295] The English Bill of Rights in 1689 confirmed 'the true, ancient and indubitable rights and liberties of the people of this kingdom'.[296] The American Declaration of Independence protests against the actions of George III in overriding established laws, creating arbitrary new ones, and 'taking away our Charters, abolishing our most valuable Laws, and altering fundamentally the Forms of our Governments'.[297]

Natural rights are a very different matter. Locke affirms that even before entering into society, humanity has a natural right to liberty and self-preservation: 'The natural liberty of man is to be free from any superior power on earth, and not to be under the will or legislative authority of man, but to have only the law of nature for his rule.'[298] Moreover, man has a natural right to property. The earth and its fruits belong to nobody, but as soon as I invest my labour in them – whether by tilling the soil, or merely by gathering fallen acorns – they become mine. This does not mean, however, that I can, for example, lay claim to large tracts of land and keep other people off them, or hoard quantities of acorns that I cannot use. My property is only what I need: 'As much as anyone can make use of to any advantage of life before it spoils, so much he may by his labour fix a property in: whatever is beyond this, is more than his share, and belongs to others.'[299]

In the eighteenth century, another right was claimed – the right to pursue happiness. The presence of this claim in the American Declaration of Independence, and the absence of any reference to property, suggests that Locke was less important for its authors than a less-known figure, the Genevan Jean-Jacques Burlamaqui.[300] In his *Principes du droit naturel* (*Principles of Natural Law*, 1747), Burlamaqui argues that 'right' (*droit*) signifies direction; that 'the ultimate end of man is happiness'; and that reason directs humanity towards this goal. Hence

> reason giving its approbation to itself, when it happens to be properly cultivated, and arrived to that state of perfection in which it knows how to use all its discernment, bears, by way of preference or excellence, the appellation of right reason, as being the first and surest means of direction, whereby man is enabled to acquire felicity.[301]

The English translation of Burlamaqui's book was a prescribed text at Harvard and Princeton universities, and helped to form the minds of many later protagonists of the American Revolution.[302]

The concept of natural right has a powerful appeal. We feel that the right to liberty, for example, has a moral authority that overrides the prescriptions of man-made law. In a country where slavery is legal, the authority of the law that denies people their natural freedom deserves no respect but is mere oppression. At the same time, it is difficult to establish a clear basis for natural rights.[303] They can hardly be based on empirical observation. Are we really born free, for example? Jeremy Bentham denied it: 'All men, on the contrary, are born in subjection, and the most absolute subjection – the subjection of a helpless child to the parents on whom he depends every moment for his existence.'[304] Or it may be said that a right to freedom is inherent in being human. But the statement 'Human beings are naturally free' seems different from 'Human beings naturally have two ears'. It is not obvious or banal. It seems not to say what *is* the case, but what *should be* the case. Again, if we have natural rights, what are they? Hobbes conceded only the right to self-preservation, which seems more restricted than the right to liberty. The right to property can apply only in a relatively advanced state of society. The right to work, which has been used to attack government policies leading to unemployment, is of more recent date. If 'rights' are subject to historical change, can they be 'natural'?

The concept of natural rights, as well as common humanity, stood in flagrant contradiction to the trade in slaves and the institution of slavery. Enlighteners passionately opposed both. Helvétius denounced slavery in a famous footnote in *De l'esprit*: 'not a single cube of sugar arrives in Europe which is not stained with human blood'.[305] In Voltaire's *Candide*, a slave the hero meets in the Dutch colony of Surinam tells how he had his right hand cut off because he caught his finger in the grinding-wheel at the sugar-mill, and how his left leg was cut off because he tried to run away, and adds: 'This is the price paid for the sugar you eat in Europe.'[306] Montesquieu mocked standard justifications of slavery in a parodic passage which has occasionally been misread as serious.[307] Raynal and Diderot, as we have seen, denounced slavery fiercely in the *Histoire des deux Indes*. Condorcet advocated the liberation of slaves in his book *Réflexions sur l'esclavage des nègres* (1781), which was published under the significant pseudonym Joachim Schwartz, and partially translated into English by Jefferson.[308] Rather than abolishing slavery at a stroke, however, Condorcet proposed that it should be phased out gradually, on the grounds that the slave who had been previously dependent on his master would be helpless when suddenly left to fend for himself. This may seem half-hearted, but

one may suspect that Condorcet also had in mind the danger of disrupting the economy by the sudden loss of plantation labour, and the fear that emancipated slaves would take violent revenge on their former masters.

In the practical process of emancipation, most of the running was made not by *philosophes* but by lawyers and Christian abolitionists. The Scottish lawyer George Wallace argued in 1760 that as human beings were naturally free, their status as slaves could have no legal force: 'every one of those unfortunate men, who are pretended to be slaves, has a right to be declared free, for he never lost his liberty; he could not lose it; his prince had no power to dispose of him.'[309] Sir William Blackstone in *Commentaries on the Laws of England* (1765) declared that the law of England 'abhors and will not endure the state of slavery within this nation'.[310] The case of the Jamaican slave James Somerset, who escaped and was recaptured, was settled by Lord Mansfield in 1772 'on the simple ground that slavery was so "odious" that nothing could be suffered to support it even if positive law about the matter did not exist'.[311] It is likely that the title of Jane Austen's *Mansfield Park*, where Sir Thomas Bertram clearly owns slave plantations in Antigua, is a covert comment on this judgement. Three years later Joseph Knight, who was brought as a slave from Jamaica to Scotland, appealed for his freedom, and the Scottish Court of Session affirmed in January 1778 that slavery was not legal in Britain.[312] Samuel Johnson, at Boswell's request, dictated a legal argument on Knight's behalf, centring on the principle that 'No man is by nature the property of another'.[313]

However, Mansfield appeared less enlightened in 1783 when trying the case of the *Zong*, whose captain had thrown 133 slaves overboard, alive and chained, allegedly because of a shortage of water on board, but perhaps in order to defraud the insurers. Mansfield horrified many contemporaries by pointing out that in law the slaves counted simply as property, and that jettisoning them, though shocking, was legally no different from throwing a cargo of horses overboard (which nowadays seems also an atrocious action).[314] British commercial interests had to take precedence over humanitarian scruples.

The abolitionist movement in Britain was initiated by Quakers, who were in contact with like-minded fellow-Quakers in Philadelphia. One of the movement's leading figures, Thomas Clarkson, travelled round seaports inspecting ships' log books and established not only that prisoners were packed intolerably closely on slave ships, but also that the voyages led to mass deaths among seamen as well as slaves.[315] The parliamentary campaign against the slave trade was headed by a convert to evangelical Christianity, the Yorkshire MP William Wilberforce, who in many ways was reacting against the perceived unbelief of the Enlightenment. His dedication led in

1807 to the Slave Trade Act, which ended British participation in the trade, and ultimately, a few days before his death, to the Slavery Abolition Act, which in 1833 outlawed slavery throughout the British Empire.

Finally, some slaves were also in a position to help themselves. Late in 1789, French sailors arriving in the colony of Saint-Domingue, the western portion of the island of Hispaniola, told the locals about the Declaration of the Rights of Man. The eventual result was a large-scale slave uprising in August 1791. It led to many atrocities – a predictable revenge for the prolonged cruelty of the slave-owners – and to the emergence of the gifted leader Toussaint L'Ouverture, an ex-slave inspired by reading the *Histoire des deux Indes*. Toussaint's well-disciplined army fought off not only the French governor's forces but also Spanish troops from the eastern half of the island and British troops who were trying to seize the island for Britain. He sent three delegates – one white, one mixed-race, one black – to Paris, where their presence prompted the National Convention to abolish slavery throughout the French colonies on 4 February 1794. Seeking autonomy for Saint-Domingue, Toussaint was arrested and transported to France, where he died in prison in 1803. It was nevertheless thanks to him that his generals were able in 1804 to establish the new state of Haiti, whose constitution forbade slavery.

It might seem that, in the campaign against slavery, Enlighteners provided moral indignation, but zealous Christians made the long and laborious march through the institutions. More fairly, however, it was Enlighteners who made the case against slavery, something that most Christians, like Boswell, had lived with comfortably for many centuries. After all, slavery is taken for granted in the New Testament. Missionaries working in America often became slave-owners. When in South Carolina, the future Methodist leader George Whitefield considered slavery acceptable so long as masters treated their slaves humanely and sought their conversion.[316] Posterity has taken an interest in the former slave-trader John Newton, author of the hymn 'Amazing Grace'. After several hair's-breadth escapes from death, Newton abjured his sins in 1749 and became an evangelical clergyman and an abolitionist. He repented not of slaving, but of 'a course of most horrid impiety and profaneness', and although he writes in his autobiography that he was 'sometimes shocked with an employment that was perpetually conversant with chains, bolts, and shackles', he also affirms: 'During the time I was engaged in the slave trade, I never had the least scruple as to its lawfulness.'[317] It was the humanitarianism diffused by the Enlightenment that helped to motivate Wilberforce and other abolitionists.

Some Enlighteners considered the concept of natural rights a mistake. William Godwin says in *Political Justice* that we have no rights, only

duties. We have a duty to act for the good of humanity. Any so-called right that conflicts with this duty must be illusory. I have no right to hold on to my property when it is my duty to give the surplus to the poor.[318] Bentham, after a close examination of the French Declaration of the Rights of Man, concludes: '*Natural rights* is simple nonsense: natural and imprescriptible rights, rhetorical nonsense, – nonsense upon stilts.'[319] His argument is that real rights can only be created by law. To assert rights that claim more authority than law, as the Declaration does, is either a futile attempt to bind posterity by making decrees that no future legislator may ever modify; or it is a threat to unsettle all established laws and thus keep society in continual insecurity; or it is vacuous, a kind of '*bawling* upon paper'.[320]

Nevertheless, the concept of human rights has become an essential part of modern political thought. It is enshrined in the Universal Declaration of Human Rights proclaimed by the General Assembly of the United Nations in 1948. The first article runs: 'All human beings are born free and equal in dignity and rights.'[321] What gives this sentence a resonance that brushes aside any philosophical uncertainty is a further component which also stems from the Enlightenment – namely, the concept of 'dignity'.[322] While 'dignity' has a long and varied history, it was made central to the understanding of humanity in a novel way by Kant. Each human being, according to Kant, is an end in himself, not an instrument for accomplishing someone else's purpose. This status, this membership of the 'kingdom of ends', derives from my autonomy as a moral being who can recognize the demands of morality and give myself laws to regulate my own conduct. My moral awareness has an absolute value, which Kant names dignity (*Würde*):

> But this lawgiving itself, which determines all worth, must for that very reason have a dignity, that is, an unconditional, incomparable worth; and the word *respect* alone provides a becoming expression for the estimate of it that a rational being must give. *Autonomy* is therefore the ground of the dignity of human nature and of every rational nature.[323]

This moral awareness is egalitarian; it is shared with all human beings. That is not to say that people ever live up to their moral potential. I always fall short, often far short of it. But to recognize my failure is a valuable source of humility, while to recognize the moral kernel within me, to which my natural self should be subject, is an equally valuable source of self-esteem.[324]

Dignity and universality were not yet part of human rights as understood in those ringing declarations of the late Enlightenment. When Olympe de Gouges demanded rights for women, she was not only executed but vilified as a 'woman-man' who had neglected her domestic duties to

meddle in politics.[325] Very gradually, however, reformers convinced the public of the equal humanity of women, Jews, slaves, non-Europeans and children; the list could be extended.[326] At the present day, a compelling case has been made for the recognition of animal rights, especially in view of the cruelty of factory farming; and the Swiss Federal Ethics Committee on Non-Human Biotechnology advocates recognizing the dignity of plants.[327] Perhaps the vegetarian Shelley should be seen as perceptive, rather than fanciful, in attributing complex emotions to his Sensitive Plant.[328]

Putting aside animals and plants, however, it may be objected that in much of the world human rights exist in name only. Ethnic cleansing, civil war, people trafficking, imprisonment without trial all mock the concept of human rights and compel people to struggle for their mere survival. Since the United Nations' Declaration is so far from being realized, should we not admit, with Burke, that mere theoretical rights are of value to nobody but theorists? The business of government, Burke says, is not to secure people's rights, but to supply their needs.

> Government is not made in virtue of natural rights, which may and do exist in total independence of it; and exist in much greater clearness, and in a much greater degree of abstract perfection: but their abstract perfection is their practical defect. By having a right to every thing they want every thing.[329]

Mere paper rights, it could be argued, are a delusion, and worse than that: the belief that they possess rights gives people a bogus consolation for their actual misery.

In reply to such Burkean despondency, however, one can again adduce Kant. As we saw earlier, Kant argued in 1798 that although the French Revolution had gone wrong in practice, the widespread enthusiasm it called forth testified to the strength of the ideal on which it was based. For 'true enthusiasm is always directed exclusively towards the *ideal*, particularly towards that which is purely moral (such as the concept of right)'.[330] Similarly, human rights are a genuine ideal, and now that the ideal exists, it focuses the efforts of dedicated people to bring it closer to reality. The reality of human rights lies far in the future, and the effort to ensure that human rights are observed in the present is an uphill struggle with no end in sight – but the ideal of human rights gives us a goal towards which we can try to make progress.

# Conclusion: The Battle over the Enlightenment

Although its aim, as this book has argued, was the betterment of human life, the Enlightenment has attracted a remarkable amount of hostility. In the eighteenth century, attacks came from conservative quarters. In the twentieth century, more surprisingly, the Enlightenment came under attack also from the left.

Many polemics charge the Enlightenment with inflicting deep and pervasive harm on humanity. It is said to have instilled a narrow, calculating form of rationality that places ends above means in seeking to achieve its purposes, without reference to morality or compassion. This rationality is sometimes also said to commit the opposite error, that of placing means above ends in seeking efficiency at all costs, without examining the purpose which its efficient methods are supposed to serve. Building on the authority of science, and deploying the ever-increasing powers of technology, the heirs of the Enlightenment have plundered the natural world and done irreparable damage to our environment. The 'Enlightenment project' has led both to liberal individualism, in which – at its most extreme – all aspects of life are regulated by the laws of the market, and to Communism, in which the individual is subordinated to the state and all aspects of life are, or should be, controlled by state planning. In the opinion of its most eloquent present-day denouncers, the Enlightenment has not only led to these mutually contradictory results, but has attacked human diversity, reducing the variety of human cultures to a merely marginal and decorative existence, and insisting that human beings are primarily a homogeneous mass of citizens defined by equal rights which make them interchangeable. Yet at the same time, the racial thinking attributed to the Enlightenment decreed that there were indelible differences among human beings that destined some to an inferior status and made it justifiable to subjugate, enslave, or even annihilate them; on this account, the Enlightenment led to the Holocaust.[1]

In response to these indictments, one might initially point out that 'the

Enlightenment project' is a phrase beloved of philosophers but regarded sceptically by historians. In its blanket condemnation, it is far removed from the sort of fine-grained presentation of the Enlightenment that I have attempted in this book. Indeed, in reducing a rich and complex historical period, and a diverse body of thought, to a single model, it imposes on the Enlightenment just that reductive homogenization which the critique claims that the Enlightenment imposed on the world.[2]

The condemnation is also too broad to be plausible. Invoking so many evils – untrammelled liberalism, Communism, Nazism – it fails to associate the Enlightenment convincingly with any of them. The phenomena it denounces are recognizable, even if seen through a fog; but they are aspects of the all-embracing changes that in the last few centuries have transformed the world, and which are often summed up, rather helplessly, by the catch-all term 'modernity'. Liberal individualism, Communist collectivism and Fascist doctrines of race-based nationalism are distinctively modern phenomena. Even the Holocaust, which one might wish to imagine as an atavistic return to a past that had otherwise been overcome, was made possible by modernity.[3] Modern bureaucratic and technological capacity, separated from any morally worthwhile purpose, enabled the Holocaust to happen, though they certainly did not make it inevitable. In lambasting the Enlightenment, its critics are seizing on a scapegoat which is much easier to name than the vast, inchoate tangle of forces that are actually responsible for these developments.

Turning back to the historical Enlightenment, a major thesis of this book has been that to identify Enlightenment 'reason' with cold, logical calculation, and to think of the period as first and foremost the 'age of reason', is to mistake its character. Enlightenment reason is not calculation but argument; it is pursued not by solitary thinkers armed with slide-rules, but by groups whose members often differ in their views and who meet in the settings of Enlightenment sociability. It is often synonymous with 'good sense'. Even thus understood, reason is only one of the Enlightenment's core attributes, alongside the passions sentiment and sympathy.

Given the diversity of the Enlightenment, one can of course find examples to substantiate the critics' indictment. Jeremy Bentham's Panopticon, a device for the surveillance and subjugation of prison inmates by the authorities, has come to symbolize the intrusive control of subjects by the state; one can easily forget that the Panopticon was never actually built. Bentham's wish to ensure people's happiness at the cost of treating them as machines is a remarkable example of prioritizing ends over means. Some thinkers and poets inspired by the Enlightenment constructed utopias that implied a dehumanizing homogeneity, like Shelley's vision of

'nationless' humanity in *Prometheus Unbound*, or Mercier's prediction that by the year 2440 French culture would be diffused throughout the world; but Mercier at least was only half serious. These are in any case single strands within an enormous and diverse tapestry.

The defamation of the Enlightenment is nothing new. It antedates even the existence of 'the Enlightenment' as a period term. In eighteenth-century France, conservative defenders of the Church attacked the Paris *philosophes* as a tightly knit band of atheists and materialists dedicated to destroying religion and overthrowing all traditional authority. This was an absurd charge, considering that the *philosophes* were as prone to quarrelling as most intellectuals; that Voltaire was a deist; and that the proponents of enlightenment set their hopes on reform from above, to be carried out by enlightened rulers, not on revolutionary subversion from below. Nevertheless, conservatives accused the *philosophes* of conspiring against Church and state, and their fears were strengthened by the prevalence of semi-secret societies, the best known being the Freemasons. Anxiety about conspiracies was widespread in France and Germany. 'Believe me,' wrote Goethe in a letter of 1781, 'our moral and political world is mined by subterranean passages, cellars and sewers, like a great city.'[4] Such fears seemed confirmed when in 1785 an actual conspiracy of Illuminati, an offshoot of Freemasonry, was discovered in Bavaria. The Illuminati caused a panic out of all proportion to their numbers or importance. A few years later, the outbreak of the French Revolution was attributed to an unholy alliance between Illuminati and *philosophes*, whose dreams of destruction were thus realized. Edmund Burke in Britain and the abbé Barruel in France, as we have seen, propagated elaborate conspiracy theories, while in Germany the Lutheran clergyman Johann August Starck explained the Revolution as 'the triumph of philosophy'.[5]

Thinkers of the Romantic period, even when resistant to conspiracy theories, denounced the Enlightenment in retrospect as the apotheosis of hyper-rational calculation. Instead of seeing the world as an organic whole animated by spiritual forces, it had focused only on the operation of mechanical laws. The poet Friedrich von Hardenberg, better known as Novalis, expressed a nostalgic yearning for the Catholic Middle Ages, and saw the Enlightenment as the latest stage in a process of fragmentation and irreligion, initiated by the Reformation, which had leached all spiritual content from the world:

> The hatred of religion was naturally and consistently extended to all objects of enthusiasm; it anathematized imagination and emotion, morality and the love of art, the future and the past, it conceded humanity a place at the

top of the natural hierarchy, and turned the infinite creative music of the universe into the monotonous rattling of a monstrous mill, which, propelled by the stream of chance and floating on its surface, was really a mill in itself, without a builder or a miller, a genuine perpetual-motion machine, a mill that ground itself.[6]

Novalis thus took his place among the many writers lamenting what would later be called the disenchantment of the world. Ironically, having trained as a mining engineer, he was deeply familiar with mathematics and natural science. The process he deplores could also be understood as a demystified understanding of nature which made it possible to appreciate this earthly world as the destined home of humanity, and as itself a rich object for imagination and emotion.

In nineteenth-century England the *philosophes* had nearly as bad a reputation. Wordsworth in *The Excursion* (1814) pours scorn on Voltaire, 'the laughing Sage of France', and decries *Candide* as 'this dull product of a scoffer's pen, / Impure conceits discharging from a heart / Hardened by impious pride!'[7] Thomas Carlyle deplored the French eighteenth century, dominated by the *philosophes*, as an age in which a negative, uncreative scepticism sapped the energies of faith.[8]

What Plough or Printing-press, what Chivalry or Christianity, nay what Steam-engine, or Quakerism, or Trial by Jury, did these Encyclopedists invent for mankind? They invented simply nothing; not one of man's virtues, not one of man's powers, is due to them; in all these respects the age of Louis XV. is among the most barren of recorded ages.[9]

It was more difficult to uphold such views in France, where the Revolution, followed by Napoleon's civil reforms, had a profound effect. The revolutionaries had already appropriated Voltaire for their cause by having his remains buried in the Panthéon. Voltaire and the other *philosophes* were widely, though with little justification, regarded as precursors of the Revolution.[10] The Third Republic, proclaimed in 1871, affirmed the 'principles of 1789' and claimed to be the heir of the revolutionary tradition. It was democratic and secularist while opposing Socialism. It set up a system of free, compulsory primary education in which religious education was forbidden, and sought to remove any clerical influence from state schools (though separate Church schools continued to exist).[11] Voltaire was recruited retrospectively for anti-clericalism, while extreme Catholics considered him an instrument of Satan.

Even so, some prominent thinkers, in addition to those who identified with the Catholic Church, were critical of the *philosophes*. In the 1830s,

Tocqueville, analysing the origins of the Revolution, censured the *philosophes* for trusting blindly to abstract theories of government when they had no knowledge of the practical world.[12] Thirty years later, the historian and philosopher Hippolyte Taine, looking back, likewise deplored over-reliance on reason: 'the independence of reasoning reason, which, discarding the imagination, freeing itself from tradition, relating badly to experience, makes logic its queen, mathematics its model, talk its medium, polite society its audience, commonplace truths its business, man in the abstract its subject and ideology its formula.'[13] In the case of Voltaire, scholars who examined his writings closely showed that, far from anticipating republicanism, he wanted only such liberty as could be conferred by an absolute monarch. At the turn of the century the literary historian Émile Faguet described him as a 'liberal absolutist', distinguishing him from Rousseau by the formula: 'Rousseau is for the despotism of the people and Voltaire is for the despotism of the king.'[14]

In Germany meanwhile it became customary to decry the Enlightenment as over-rational, shallow, out of touch with deep currents of feeling, and as a French growth which could not easily take root in Germany.[15] In his inaugural lecture in Basel in 1867, the philosopher Wilhelm Dilthey defined what he called the 'German movement', which comprehended German intellectual life in the last third of the eighteenth century. In contrast to the rationalism Dilthey deplored in the *philosophes*, this movement, represented by Lessing, Kant, Goethe, Schiller and many others, was active, emotional, vigorous; it rested above all on the concept of genius, which was 'the universal basis for all creative powers whatever', whether in poetry, learning, or moral conduct.[16] From Dilthey's many references to works by the young Goethe and Herder, it is clear that for him this movement centred on the 1770s, the period that subsequently became known as the *Sturm und Drang*. Dilthey certainly uses the word *Aufklärung* ('Enlightenment'), as when he says beautifully of the reunion of the two lovers at the end of Lessing's comedy *Minna von Barnhelm* (1767), 'This mutual recognition is like an embodiment of the Enlightenment's dream of the future';[17] his version of the Enlightenment is associated above all with feeling and morality, implicitly distancing it from the over-rationality and libertinism of its French counterpart.

Modern views of the Enlightenment have been particularly affected by the work of two German philosophers, Max Horkheimer and Theodor W. Adorno. They were leading members of the Institute of Social Research in Frankfurt, dedicated to the investigation of modern society by means of an innovative version of Marxism. After the rise of Nazism, they transferred their activities to New York. In 1944 Horkheimer and Adorno

produced the first version of *Dialektik der Aufklärung* (*Dialectic of Enlightenment*). Initially circulated in mimeographed form among colleagues, the book was published in a revised and expanded version in 1947. It attracted wide attention only in 1969, when its reissue coincided with the West German student movement, and later when it was translated into English in 1972.[18]

The title *Dialektik der Aufklärung* is ambiguous. Grammatically, *Aufklärung* here could denote either the process of enlightenment or the Enlightenment as a movement. The book's third sentence, 'Das Programm der Aufklärung war die Entzauberung der Welt', was first translated as 'The program of the Enlightenment was the disenchantment of the world.'[19] The more recent translation of 2002 begins the sentence with the phrase 'Enlightenment's program'.[20] Since the book is a philosophical essay, in no way a historical study, the obvious meaning would seem to be the process of enlightenment. Thanks in part to the first translator, however, the book has been widely understood as an onslaught on the Enlightenment as a movement. Horkheimer and Adorno argue that the process of enlightenment is inherently self-defeating, in that it leads not only to progress but also to regression. Enlightenment begins with humanity's separation from nature. Humanity seeks to control nature, to exploit it, and to forestall the dangers that it presents. It treats nature as an object to be manipulated and transformed by means of reason, which has no substantive content but is a mere instrument of domination. Nature, however, is not only outside us, but also inside us. The conquest of nature includes the repression of humanity's own instinctual nature. However, what is repressed is not abolished; it survives as an unconscious fear. So, in relying on its own reason, humanity cuts itself off both from external nature, which is seen only in abstract terms, and from its own internal emotional life. In order to secure itself from irrational forces, enlightenment accomplishes the disenchantment of the world by a calculating rationality that translates everything into mathematical terms: 'In the preemptive identification of the thoroughly mathematized world with truth, enlightenment believes itself safe from the return of the mythical. It equates thought with mathematics. The latter is thereby cut loose, as it were, turned into an absolute authority.'[21] Here we can recognize the mathematical conception of the universe which was the foundation for Newton's cosmology and hence of the Enlightenment world picture. For Horkheimer and Adorno, it is an intellectual totalitarianism. In a chapter added in the book version, they affirm that by seeing the world as an external object, unrelated to the subject that perceives it, humanity falls victim to a paranoid delusion that ends in actual totalitarianism, namely

Fascism. However, the evil effects of enlightenment are seen as much in capitalism, in mass production, in the homogeneity of modern industrial society, and in the culture industry. Enlightenment reduces science to mere technical utility and art to entertainment, controlled by the culture industry and deprived of any ability to criticize the actual world in the name of ideals.

Does this philosophical construction have anything to do with the historical Enlightenment? The foreground is occupied by modern thinkers: Marx, Freud, Weber and others. Bacon appears as the prophet of applied science; Hobbes and Machiavelli testify to the power of some people to dominate others by rational calculation; but from the Enlightenment period itself, the main actors are Mandeville, Kant and, curiously, the marquis de Sade. When Sade's heroine Juliette urges that in committing crimes one should be completely unfeeling, Horkheimer and Adorno assert that she provides a parallel to the neutral, objective stance of the scientist. They have in fact taken one strand of the Enlightenment, represented by Mandeville's egotism, identified it with the whole, and completely ignored the sympathy and sensibility which were at least as prominent in the Enlightenment.

Rather than a study of the Enlightenment, Horkheimer and Adorno produced a scattergun assault on many aspects of modernity, which a later philosopher (sympathetic to them in many ways) has called 'astoundingly oversimplified'.[22] It has been said that 'their concept of "enlightenment" is a fanciful, unhistorical hybrid composed of everything they dislike: positivism, logic, deductive and empirical science, capitalism, the money power, mass culture, liberalism, and Fascism'.[23] Insofar as they profess to recount a narrative with a counterpart in history, it is surprising that their narrative terminates both in Nazi totalitarianism and in liberal individualism. A third terminus, Soviet Communism, is conspicuously absent; yet in the Soviet Union a project theoretically aimed at the betterment of humanity was carried out by subordinating ends to means and thus producing terror, famine, slave labour and ecological devastation, all on an enormous scale.

*Dialectic of Enlightenment* made its impact when the West, especially its younger generation, was waking up to the industrial exploitation and environmental damage being done by free-market capitalism. Horkheimer and Adorno may have intended to rescue enlightenment, as they understood it, by criticizing an emancipatory process that in their view had gone off the rails; they apparently intended to write a sequel, setting out a positive programme by which to save enlightenment, but none of the material for this sequel has been found.[24] In the book as we have it, they overplayed

their hand. They suggested that science and technology contained in themselves the seeds of inevitable destruction, whereas it is the misuse of science and technology by irresponsible authorities (whether Communist planners or liberal capitalists) that has brought about the economic insecurity and growing environmental danger in which the world now finds itself. And by implying that this process could not be halted, they denied the power of human agency and invited despair instead of action.

There are some surprising similarities between the image of the Enlightenment presented by Horkheimer and Adorno and that conveyed to the English-speaking world by Isaiah Berlin. At least from 1954, when he delivered a famous lecture on 'Historical Inevitability', to his death in 1997, Berlin had an unsurpassed reputation as a public intellectual. He not only founded the history of ideas (without giving it a label) as an academic subject in Britain, but disseminated his own ideas, based on prodigious reading in many languages, to wide audiences via invited lectures, radio broadcasts and essays. During the Cold War he was a leading spokesman for Western values of liberty and pluralism against the monolithic power of Soviet Russia.

Berlin, a philosopher by training, encountered the Enlightenment in the 1930s when commissioned to write a popular biography of Karl Marx. In seeking to contextualize Marx, he relied especially on a study by the early Russian Marxist Georgi Plekhanov, *The Development of the Monist View of History* (1895), which traces Marxist materialism back to that of Helvétius, d'Holbach and other French Enlightenment figures.[25] In doing so, Plekhanov exaggerated and misconstrued the evidence, and, as has now been shown, contributed to the construction of a theory called 'historical materialism', which became Communist orthodoxy but was no part of Marx's original thought.[26] Berlin can hardly be blamed for accepting this account, but it skewed his understanding of the Enlightenment.

Berlin described the Paris *lumières*, in terms which he would repeat throughout his career, as a group of thinkers dedicated to the attainment of happiness. To liberate humanity's essential goodness from the obstructions created by material poverty, tyrannical power and clerical deceit, it was necessary to obey the infallible authority of reason.

> The central tenet of this semi-empirical rationalism consisted in boundless faith in the power of reason to explain and improve the world, all previous failure to do so being explained as ultimately caused by ignorance of the laws which regulate the behaviour of nature, animate and inanimate. Misery is the complex result of ignorance, not only of nature but of the laws of social behaviour. To abolish it, one measure is both necessary and

sufficient: the employment of reason, and of reason alone, in the conduct of human affairs.[27]

In this picture, the greatest figures of the French Enlightenment, Voltaire and Rousseau, are assimilated to such second-rank figures as d'Holbach, Helvétius and La Mettrie, and all are in turn assimilated to the optimistic utopianism which we have seen earlier in this book represented by Turgot and Condorcet. The scepticism Voltaire shows in *Candide*, and the endlessly inventive imagination of Diderot, are absent. The French Enlightenment becomes the ancestor of utopian schemes to erect an ideally harmonious society, such as Robert Owen's industrial community at New Lanark and, of course, the social blueprints of Marxism.

Berlin was naturally well aware that the Enlightenment extended beyond France. In the 1950s he was asked to compile an anthology of philosophical texts from the Enlightenment. French thinkers get only seven pages – Voltaire being represented by a single paragraph from the *Letters concerning the English Nation* – while British writers take up 235 pages. This is because Berlin is interested chiefly in eighteenth-century theories of knowledge, and therefore gives ample space to Locke and Hume, and some also to the epistemological idealist George Berkeley and the common-sense philosopher Thomas Reid. But in his Introduction, having explained the epistemological issues, Berlin repeats without qualification his view of Enlightenment thinkers as believing

> that all the sciences and all the faiths, the most fanatical superstitions and the most savage customs, when 'cleansed' of their irrational elements by the advance of civilization, can be harmonized in the final true philosophy which could solve all theoretical and practical problems for all men everywhere for all time.[28]

Berlin's homogeneous Enlightenment strangely resembles that of Horkheimer and Adorno. It has recently and justifiably been said that 'his understanding of this movement took on some of the very monism that he had accused the Enlightenment itself of creating'.[29]

Berlin is now remembered less as an authority on the Enlightenment than as an analyst and critic of the Counter-Enlightenment. By this term – which, thanks to him, has figured prominently in subsequent discussions of the Enlightenment – he meant a group of thinkers who denied the supremacy of reason and pleaded for the importance of feeling; who were interested not in universal civilization, but in local and particular cultures; who thought that polished modern culture suppressed the creative energies of primitive ages and of uneducated peoples. His star witnesses are the

pre-Enlightenment Neapolitan philosopher Giambattista Vico (1668–1744), the mystical theologian Johann Georg Hamann (1730–88), and the philosopher, critic and theologian Johann Gottfried Herder, who has figured frequently in this book. Vico's cyclical theory of history was incompatible with any belief in linear progress. Hamann was convinced that 'all truth is particular, never general'[30] (this is itself offered as a general truth); and Herder, fiercely opposing claims for the supreme value of polite French civilization, asserted the distinct and incommensurable value of every culture. Their ideas were taken up by the young rebels of the *Sturm und Drang*, including Schiller, who were themselves inspired by Rousseau's cult of feeling and critique of civilization. They were developed by the Romantics, who saw nature as not just an object of study but as filled with vital and spiritual energy, and, in a sinister but fascinating way, by the post-Revolution reactionary Joseph de Maistre (1753–1821). Although Berlin's conception of the Counter-Enlightenment has been highly influential, it misrepresents some of the figures concerned – particularly Herder, in exaggerating his distance from the Enlightenment.[31] However, it draws attention to a real and important movement of ideas in the nineteenth century that eventually fed into Fascism.[32]

Berlin owes an often overlooked intellectual debt to the great German historian Friedrich Meinecke (1862–1954). In *Die Entstehung des Historismus* (*The Origins of Historicism*, 1936) Meinecke depicted the Anglo-French Enlightenment as abstract, universalizing, in thrall to the abstract authority of timeless reason:

> it was held that the pronouncements of reason, though they could certainly be obscured by passions and by ignorance, did nevertheless, wherever they could free themselves from these hindrances, speak truth with the same voice and utter the same timeless and absolutely valid truths, which were in harmony with those prevailing in the universe as a whole.[33]

Acknowledging in his Introduction a debt to Dilthey's conception of the 'German movement', Meinecke undertook to explore a peculiarly German awareness of the diversity of humanity and a determination to understand all human phenomena as rooted in an ever-changing historical world. Berlin, who wrote a foreword to the English translation of Meinecke's book, reproduced and developed Meinecke's antithesis under the names 'Enlightenment' and 'Counter-Enlightenment'. Thus, Berlin became the channel through which a hostile nineteenth-century German understanding of the Enlightenment was transmitted to anglophone readers in the late twentieth century.[34]

For much of this time, it must be remembered, our concept of the

Enlightenment as a historical period, and as a movement spanning Europe and even beyond, did not yet exist. The word *Aufklärung*, which in Kant's famous essay denoted the process of enlightenment, was first attached to a specific period by Hegel in his *Lectures on the History of Philosophy* (delivered between 1819 and 1831, and first published in 1833). In the English-speaking world, 'Enlightenment' as a period term first occurs only in 1910, acquiring its present scope only after the Second World War.[35] Our present understanding of it owes much to Peter Gay's two-volume survey (1966–9). Subsequent interpretations of the Enlightenment have given it a wider geographical range. A book edited by Roy Porter and Mikuláš Teich, published in 1981, may be regarded as a landmark in Enlightenment studies because it examined manifestations of the Enlightenment in thirteen different countries (counting Catholic and Protestant Germany as two countries).[36] It thus laid the foundations for such a wide-ranging, international view of the Enlightenment as that taken by Jonathan Israel in his encyclopaedic volumes.

There is now wide, though not universal, agreement that, while every historical period is a retrospective construction, the Enlightenment has as good a claim to validity as any. Further, the Enlightenment was a diverse but single phenomenon. Peter Gay began his study by declaring: 'There were many philosophes [*sic*] in the eighteenth century, but there was only one Enlightenment.'[37] Jonathan Israel, with even more material at his disposal, agrees in presenting the Enlightenment as 'a single highly integrated intellectual and cultural movement'.[38]

In the spirit of Kant's 'What is Enlightenment?', I would underline that the goals of enlightenment cannot and must not be defined too narrowly. In seeking happiness, we cannot prescribe in advance *how* people are to be happy. Well-intentioned utopian projects, from the Spartan society constructed by Lycurgus (and devastatingly criticized by Schiller) down to the behaviourist communities imagined by B. F. Skinner in *Walden Two* (1948), are always stifling because they assume that nothing new will ever need to happen. The process of enlightenment should be constant experimentation and self-correction. For, as Susan Neiman puts it: 'The Enlightenment is inherently self-critical, morally bound to examine its own assumptions with the same zeal it examines others.'[39]

Enlightened thinking will reject naïve ideas of inevitable progress, even those that originated in the Enlightenment. But it will also steer clear of the pessimism shown by some of the Enlightenment's harshest critics. When we look around we can see ample evidence that humanity has made material and even moral progress in many areas, from food security to human rights. Although the media constantly bombard us with

eye-catching bad news, if we look beyond the specious present we can see many encouraging long-term trends, even in efforts to manage climate change, which is currently the greatest threat to humanity's prospects. Steven Pinker, who presents this evidence quantitatively, is often accused of being a Pollyanna, but his statistical arguments carry weight.[40] Statistics, as we saw in Chapter 8, were an important instrument for Enlighteners to understand human society and find ways of improving it. Numerical evidence, provided its sources have been checked, is far more powerful than claims based merely on impressions. 'Nothing amuses more harmlessly than computation,' said Samuel Johnson, 'and nothing is oftener applicable to real business or speculative enquiries. A thousand stories which the ignorant tell, and believe, die away at once, when the computist takes them in his gripe [sic].'[41] Moreover, while we rightly condemn facile optimism (as Voltaire himself did), we should remember that there is also facile pessimism. The appeal of pessimism lies not least in the pleasing sense of superiority it confers on its proponents.

Given that the process of enlightenment consists in criticism and self-criticism, such activity requires an open society. As the film-maker and writer Hanif Kureishi has recently said: 'The message of the Enlightenment is that we have some choice over who we want to be, making our own destiny as individuals, without submitting to gods, revelation or ancestors. The basis of this is a liberal education and a democracy of ideas.'[42] A 'democracy of ideas' is implicit in the very language of the great Enlightenment writers. The essays of Voltaire, Hume and Lessing were written for a wide public in an accessible and attractive style.

At the moment of writing, liberal ideals are under threat, and democracy, it has been said, is undergoing a 'mid-life crisis'.[43] The refinement of democratic institutions – a process with no end in sight – illustrates how enlightened ideas are always subject to self-correction. By the same token, even the most treasured ideas of the present day are open to constructive criticism. In this sense, those critics who polemicize against the values ascribed to the Enlightenment perform a valuable function, occasionally by identifying actual flaws, more often by stimulating others to defend the Enlightenment. The critiques made by sceptical philosophers assist the process of enlightenment. Even if not enlightened, by engaging in the process of critical reasoning, they can themselves be enlightening.

# References

## ABBREVIATIONS

CHS    Roy Porter, ed., *The Cambridge History of Science*, vol. 4: *Eighteenth-Century Science* (Cambridge, 2003)

DVjs    *Deutsche Vierteljahresschrift für Literaturwissenschaft und Geistesgeschichte*

ELH    *English Literary History*

JHI    *Journal of the History of Ideas*

MLR    *Modern Language Review*

OCD    Denis Diderot, *Œuvres complètes*, ed. Roger Lewinter and others, 15 vols. (Paris, 1969–73)

OCM    Montesquieu, *Œuvres complètes*, ed. Roger Caillois, 2 vols. (Paris, 1949)

OCR    Jean-Jacques Rousseau, *Œuvres complètes*, ed. Bernard Gagnebin and Marcel Raymond, 5 vols. (Paris, 1959–95)

OCV    *Œuvres complètes de Voltaire*, ed. Nicholas Cronk and others, 135 vols. (Geneva, later Oxford, Voltaire Foundation, 1968– )

ODNB    *Oxford Dictionary of National Biography* (Oxford, 2004)

PMLA    *Publications of the Modern Languages Association of America*

SVEC    *Studies on Voltaire and the Eighteenth Century*

TE    *The Twickenham Edition of the Poems of Alexander Pope*, ed. John Butt, 11 vols. (London, 1939–69)

## A NOTE ON THE REFERENCES

References to multi-volume works use small roman numerals for the volume number followed by arabic numerals for page numbers. The only exception is *Œuvres complètes de Voltaire*, where the volumes are so numerous (200 physical volumes in 135 numbered volumes) that, to save the reader from having to decode long roman numerals, the volume number is given in arabic, e.g. OCV 62, p. 37.

## PREFACE

1. Steven Pinker, *Enlightenment Now: The Case for Reason, Science, Humanism and Progress* (London, 2018), p. 8.   2. Susan Neiman, *Moral Clarity: A Guide for Grown-Up Idealists* (London, 2009), p. 131.   3. Eric Hobsbawm, 'Barbarism: a user's guide', in his *On History* (London, 1998), p. 336.   4. The most influential such critique is Max Horkheimer and Theodor W. Adorno, *Dialectic of Enlightenment: Philosophical Fragments*, tr. Edmund Jephcott (Stanford, 2002), first published in German in 1947. I engage with this book in the 'Conclusion'.   5. Steven Pinker, *The Better Angels of our Nature: The Decline of Violence in History and its Causes* (London, 2011), pp. 129–88.

## 1. HAPPINESS, REASON AND PASSION

1. Maria Rosa Antognazza, *Leibniz: An Intellectual Biography* (Cambridge, 2009), p. 115.   2. Diary entry, 8 Feb. 1677, in *An Early Draft of Locke's 'Essay'*, ed. R. I. Aaron and Jocelyn Gibb (Oxford, 1936), p. 88. See Catherine Wilson, 'Locke's hedonism', in her *Epicureanism at the Origins of Modernity* (Oxford, 2008), pp. 207–16, and more generally Darrin McMahon, *The Pursuit of Happiness: A History from the Greeks to the Present* (London, 2006); Garry Wills, *Inventing America: Jefferson's Declaration of Independence* (New York, 1978), pp. 149–64.   3. *An Essay concerning Human Understanding*, Book II, ch. 21, §62, in *The Works of John Locke*, 9 vols. (1794; repr. London, 1997), i. p. 261.   4. Pope, *Essay on Man*, in *TE* iii/1. p. 128.   5. Quoted in Paschalis M. Kitromilides, *The Enlightenment as Social Criticism: Iosipos Moisiodax and Greek Culture in the Eighteenth Century* (Princeton, 1992), p. 59.   6. John Robertson, *The Case for the Enlightenment: Scotland and Naples 1680–1760* (Cambridge, 2005), p. 28.   7. Cf. Caroline Winterer, *American Enlightenments: Pursuing Happiness in the Age of Reason* (New Haven, 2016), p. 3.   8. St Augustine, *Concerning the City of God against the Pagans*, tr. Henry Bettenson (London, 1984), pp. 589–90 (Bk XIV, ch. 25).   9. Pope Innocent III, *The Mirror of Mans Lyfe*, tr. Henry Kirton (London, 1576), Book I, ch. 5 (unpag.). Cf. *King Lear*, IV, vi, 184–5: 'Thou know'st the first time that we smell the air / We waul and cry.' The popularity of Innocent's treatise is attested by its survival in 700 manuscripts: Eamon Duffy, *Saints and Sinners: A History of the Popes* (New Haven, 1997), p. 111.   10. Allen W. Wood, 'Kant versus eudaimonism', in Predrag Cicovacki, ed., *Kant's Legacy: Essays in Honor of Lewis White Beck* (Rochester, NY, 2001), pp. 261–81 (pp. 261–2).   11. Abraham Cowley's translation, quoted in Maren-Sofie Røstvig, *The Happy Man: Studies in the Metamorphoses of a Classical Ideal*, 2 vols., 2nd edn (Oslo, 1962), i. p. 29.   12. *Epicurus's Morals, collected partly out of his owne Greek text, in Diogenes Laertius, and partly out of the Rhapsodies of Marcus Antoninus, Plutarch, Cicero, & Seneca*, tr. Walter Charleton (London, 1656), p. 8.   13. On the reception of Epicurus, see Peter Gay, *The Enlightenment: An Interpretation*, 2 vols. (New York, 1966–9), vol. 1: *The Rise of Modern Paganism*, esp. pp. 304–8; more nuanced accounts in Wilson, *Epicureanism*, pp. 1–38, and Neven Leddy and Avi S. Lifschitz, eds., *Epicurus in the Enlightenment* (Oxford, 2009).   14. *Spectator*, no. 163, 6 Sept. 1711.   15. David Hume, *The Natural History of Religion*, ed. A. Wayne Colver, and *Dialogues concerning Natural Religion*, ed. John Valdimir Price (Oxford, 1976), p. 93.   16. Soame Jenyns, *A Free Inquiry into the Nature and Origin of Evil* (London, 1757), p. 46.   17. 'Discours sur les avantages que l'établissement du christianisme a procurés au genre humain', *Œuvres de Turgot et documents le concernant*, ed. Gustav Schelle, 5 vols. (Paris, 1913), i. pp. 194–214 (pp. 205–6).   18. McMahon, *Pursuit*, p. 222.   19. George Cheyne, *The English Malady: or, a Treatise of Nervous Diseases of All Kinds* (London, 1733), p. 26. On how damaging Cheyne's prescriptions could prove in practice, see Tristram Stuart, *The Bloodless Revolution: Radical Vegetarians and the Discovery of India* (London, 2006), pp. 181–8.   20. Émilie du Châtelet, *Discours sur le bonheur*, ed. Robert Mauzi (Paris, 1961), p. 30.   21. See Ian Davidson, *Voltaire: A Life*, rev. edn (London, 2012), p. 212.   22. François de Fénelon, *Telemachus, Son of Ulysses*, ed. and tr. Patrick Riley (Cambridge, 1994), p. 167; Fénelon, *Les Aventures de Télémaque*, ed. Jeanne-Lydie Goré (Paris, 1968), p. 284.   23. Edward Gibbon, *The History of the Decline and Fall of the Roman Empire*, ed. David Womersley, 3 vols. (London, 1994), i. p. 174.   24. Frederick of Prussia, *The Refutation of Machiavelli's 'Prince' or Anti-Machiavel*, tr. and ed. Paul Sonnino (Athens, OH, 1981), p. 32.   25. 'Rapport au nom du Comité de salut public sur le mode d'exécution du décret contre les ennemis de la Révolution présenté à la Convention nationale le 13 ventôse an II (3 mars 1794)', in Antoine-Louis de Saint-Just, *Œuvres complètes*, ed. Anne Kupiec and Miguel Abensour (Paris, 2004), pp. 672–4 (p. 673).   26. Christian Wolff, *Vernünftige Gedanken von dem gesellschafftlichen Leben der Menschheit und insonderheit dem gemeinen Wesen* (1721), quoted in Ulrich Engelhardt, 'Zum Begriff der Glückseligkeit in der kameralistischen Staatslehre des 18. Jahrhunderts', *Zeitschrift für historische Forschung*, 8 (1981), pp. 37–79 (p. 42).

**27.** Lessing, *Ernst und Falk*, in his *Werke und Briefe*, ed. Wilfried Barner and others, 12 vols. (Frankfurt a.M., 1987–98), x. p. 24. **28.** Quoted in Engelhardt, 'Zum Begriff', p. 64. **29.** Traced by Robert Shackleton, 'The greatest happiness of the greatest number: the history of Bentham's phrase', in his *Essays on Montesquieu and on the Enlightenment*, ed. David Gilson and Martin Smith (Oxford, 1988), pp. 375–89. **30.** Francis Hutcheson, *Inquiry into the Original of Our Ideas of Beauty and Virtue*, 2 vols., 2nd edn, ed. W. Leidhold ([1725] Indianapolis, 2008), ii. p. 164. **31.** Hutcheson, *Inquiry*, 3rd edn (London, 1729), p. 187. See Wills, *Inventing America*, p. 149. **32.** François-Jean de Chastellux, *De la félicité publique ou considérations sur le sort des hommes dans les différentes époques de l'histoire*, ed. Roger Basoni (Paris, 1989), pp. 149–50. **33.** Pietro Verri, *Discorso sull'indole del piacere e del dolore* (1773), in *Discorsi del Conte Pietro Verri sull' indole del piacere e del dolore; sulla felicità; e sulla economia politica* (Milan, 1781), p. 99. **34.** Verri, *Discorso sulla felicità* (1763), in *Discorsi*, pp. 103, 170. **35.** Ibid., p. 179. **36.** *Groundwork of the Metaphysics of Morals*, in Immanuel Kant, *Practical Philosophy*, tr. Mary J. Gregor, The Cambridge Edition of the Works of Immanuel Kant (Cambridge, 1996), pp. 37–108 (p. 57); cf. Kant, *Werke*, ed. Wilhelm Weischedel, 6 vols. (Darmstadt, 1958), iv. p. 28. **37.** *Groundwork*, p. 51; cf. Kant, *Werke*, iv. p. 21. **38.** See Wood, 'Kant versus eudaimonism', p. 274. On the development of Kant's ideas about happiness, see Susan Meld Shell, 'Kant's "true economy of human nature": Rousseau, Count Verri, and the problem of happiness', in her *Kant and the Limits of Autonomy* (Cambridge, MA, 2009), pp. 85–121. **39.** Quoted in Gordon S. Haight, *George Eliot: A Biography* (New York, 1968), p. 464. **40.** Emma Rothschild, *Economic Sentiments: Adam Smith, Condorcet and the Enlightenment* (Cambridge, MA, 2001), p. 12. **41.** For a vivid glimpse of a family's everyday ailments, see Emma Rothschild, *The Inner Life of Empires: An Eighteenth-Century History* (Princeton, 2011), pp. 97–8. **42.** Adam Smith, *The Theory of Moral Sentiments*, ed. D. D. Raphael and A. L. Macfie (Oxford, 1976), p. 10. Cf. the sores of the giant beggars in Brobdingnag, described in Jonathan Swift, *Gulliver's Travels*, ed. Claude Rawson and Ian Higgins (Oxford, 2005), pp. 101–2. See Tim Hitchcock, *Down and Out in Eighteenth-Century London* (London, 2004), pp. 108–19. **43.** Tobias Smollett, *Travels through France and Italy*, ed. Frank Felsenstein (Oxford, 1979), p. 194. **44.** See Olwen H. Hufton, *The Poor of Eighteenth-Century France 1750–1789* (Oxford, 1974), pp. 44–8; Daniel Roche, *France in the Enlightenment*, tr. Arthur Goldhammer (Cambridge, MA, 1998), pp. 613–18. **45.** Roy Porter, *English Society in the Eighteenth Century*, rev. edn (London, 1991), p. 13; Roche, *France in the Enlightenment*, p. 493. Cf. the sketch of living conditions in early modern England in Keith Thomas, *Religion and the Decline of Magic* (London, 1971), pp. 3–21. **46.** Verri, *Discorsi*, p. 161. **47.** Frances Burney, *Journals and Letters*, ed. Peter Sabor and Lars E. Troide (London, 2001), p. 442. For the agony of having a tooth inexpertly drawn, see *The Memoirs of Catherine the Great*, ed. Dominique Maroger, tr. Moura Budberg (London, 1955), pp. 170–71. **48.** David Kirby, *A Concise History of Finland* (Cambridge, 2006), pp. 42, 47. **49.** Jean Delumeau, *La Peur en Occident: XIVᵉ–XVIIᵉ siècles* (Paris, 1978), p. 166; Colin Jones, *The Great Nation: France from Louis XV to Napoleon* (London, 2002), pp. 296–7. **50.** See M. S. Anderson, *War and Society in Europe of the Old Regime, 1618–1789* (Leicester, 1988), pp. 137–9; Christopher Clark, *Iron Kingdom: The Rise and Downfall of Prussia 1600–1947* (London, 2006), pp. 209–10. **51.** William Robertson, *The Situation of the World at the Time of Christ's Appearance* (Edinburgh, 1755), p. 37. On ancient warfare cf. Hume, 'On the Populousness of Ancient Nations', in his *Essays Moral, Political and Literary*, ed. Eugene F. Miller (Indianapolis, 1987), pp. 377–464 (pp. 404–6). **52.** Hume, 'Of Passive Obedience', in his *Essays*, pp. 488–92 (p. 489). **53.** Voltaire, *Histoire de Charles XII*, in *Œuvres historiques*, ed. René Pomeau (Paris, 1957), pp. 233–4. **54.** On how rumours spread in provincial France, see Georges Lefebvre, *The Great Fear of 1789: Rural Panic in Revolutionary France*, tr. Joan White (London, 1973). **55.** See A. Roger Ekirch, *At Day's Close: A History of Nighttime* (London, 2005), p. 124. Cf. Delumeau, *La Peur en Occident*, pp. 87–97. **56.** Adam Smith, *An Inquiry into the Nature and Causes of the Wealth of Nations*, ed. R. H. Campbell and A. S. Skinner (Oxford, 1976), p. 910. Cf. Rothschild, *Economic Sentiments*, p. 14. **57.** Louis Racine, 'La Grâce' (1720) in his *Œuvres*, 6

vols. (Paris, 1808), i. p. 33. For an introduction to Jansenism, see William Doyle, *Jansenism: Catholic Resistance to Authority from the Reformation to the French Revolution* (Basingstoke, 2000). **58.** Hume, *Dialogues concerning Natural Religion*, p. 259. **59.** Anthony Ashley Cooper, third Earl of Shaftesbury, 'An Inquiry concerning Virtue or Merit', in his *Characteristics of Men, Manners, Opinions, Times*, ed. Lawrence E. Klein (Cambridge, 1999), p. 209. **60.** *Spectator*, no. 7, 8 March 1711. **61.** 'The False Alarm' (1770), in *The Yale Edition of the Works of Samuel Johnson*, ed. Herman W. Liebert and others (New Haven, 1963–2010), vol. x: *Political Writings*, ed. Donald J. Greene (1977), pp. 317–45 (pp. 317–18). **62.** Heiko A. Oberman, *Luther: Man between God and the Devil*, tr. Eileen Walliser-Schwarzbart (New Haven, 1989), p. 92; Lyndal Roper, *Martin Luther: Renegade and Prophet* (London, 2016), p. 47. **63.** Michael Hunter, *Boyle: Between God and Science* (New Haven, 2009), p. 48. **64.** Jean-François Marmontel, *Mémoires*, ed. Jean-Pierre Guicciardi and Gilles Thierriat (Paris, 1999), p. 123. **65.** See Christian Begemann, *Furcht und Angst im Prozeß der Aufklärung: zu Literatur und Bewußtseinsgeschichte des 18. Jahrhunderts* (Frankfurt a.M., 1987), pp. 73, 80–82, 104–5. **66.** Sir William Temple, 'An Essay upon the Ancient and Modern Learning' (1690), in *Critical Essays of the Seventeenth Century*, ed. J. E. Spingarn, 3 vols. (Oxford, 1908–9), iii. pp. 32–72 (p. 61). For further examples, see K. F. Hilliard, *Freethinkers, Libertines and 'Schwärmer': Heterodoxy in German Literature, 1750–1800* (London, 2011), pp. 44–5. **67.** See Engelhard Weigl, 'Entzauberung der Natur durch Wissenschaft, dargestellt am Beispiel der Erfindung des Blitzableiters', *Jahrbuch der Jean-Paul-Gesellschaft*, 22 (1987), pp. 7–39. **68.** Kant, 'Continued observations on the earthquakes that have been experienced for some time' (1756), tr. Olaf Reinhardt, in *Natural Science*, ed. Eric Watkins, The Cambridge Edition of the Works of Immanuel Kant (Cambridge, 2012), pp. 367–73 (p. 373). Franklin had proposed his experiment in 1750 and it had already been carried out by Thomas-François Dalibard at Marly, near Paris, on 10 May 1752. See *The Autobiography of Benjamin Franklin*, ed. Leonard W. Labaree and others, 2nd edn (New Haven, 2003), pp. 244–5; Michael Brian Schiffer, *Draw the Lightning Down: Benjamin Franklin and Electrical Technology in the Age of Enlightenment* (Berkeley, 2003), pp. 162–4. **69.** For surveys, see Wolfgang Behringer, *Witches and Witch-Hunts* (Cambridge, 2004); Brian Levack, *The Witch-Hunt in Early Modern Europe*, 4th edn (London, 2016); Julian Goodare, *The European Witch-Hunt* (London, 2016). On its origins, Robin Briggs, ' "Many reasons why": witchcraft and the problem of multiple explanation', in Jonathan Barry, Marianne Hester and Gareth Roberts, eds., *Witchcraft in Early Modern Europe* (Cambridge, 1996), pp. 49–63. For estimated numbers, see Goodare, *European Witch-Hunt*, pp. 410–13. **70.** W. E. H. Lecky, *History of the Rise and Influence of Rationalism in Europe*, 2 vols., new edn (London, 1897), i. p. 12. **71.** Stuart Clark, *Thinking with Demons: The Idea of Witchcraft in Early Modern Europe* (Oxford, 1999), pp. 14–15. **72.** See for example the account of the persecution in the small German territory of Ellwangen, where some 400 people were executed between 1613 and 1619: H. C. Erik Midelfort, *Witch Hunting in Southwestern Germany: The Social and Intellectual Foundations* (Stanford, 1972), esp. pp. 86–7, 98–112. **73.** See Malcolm Gaskill, *Witchfinders: A Seventeenth-Century English Tragedy* (London, 2005), pp. 89–90. The savagery of the tortures is scarcely believable: see *Soldan's Geschichte der Hexenprozesse*, ed. Heinrich Heppe, 2 vols. (Stuttgart, 1880), i. pp. 355–80. **74.** See Robin Briggs, *Witches and Neighbours: The Social and Cultural Context of European Witchcraft*, 2nd edn (Oxford, 2002), pp. 338–9. **75.** See Norman Cohn, *Europe's Inner Demons: An Enquiry Inspired by the Great Witch-Hunt* (London, 1975); R. I. Moore, *The Formation of a Persecuting Society* (Oxford, 1987). **76.** Clark, *Thinking with Demons*, p. 298. **77.** See Geoffrey Parker, *Global Crisis: War, Climate Change and Catastrophe in the Seventeenth Century* (New Haven, 2013), pp. 9–10. **78.** Wolfgang Behringer, 'Weather, hunger and fear: origins of the European witch hunts in climate, society and mentality', *German History*, 13 (1995), pp. 1–27. **79.** Midelfort, *Witch Hunting*, pp. 88–9. **80.** See Mark Knights, *The Devil in Disguise: Deception, Delusion, and Fanaticism in the Early English Enlightenment* (Oxford, 2011), pp. 220–28. **81.** W. N. Neill, 'The last execution for witchcraft in Scotland, 1722', *Scottish Historical Review*, 20 (1923), pp. 218–21. **82.** Susanne Kord, *Murderesses in German Writing, 1720–1860:*

*Heroines of Horror* (Cambridge, 2009), pp. 21-33. **83.** W. B. Carnochan, 'Witch-hunting and belief in 1751: the case of Thomas Colley and Ruth Osborne', *Journal of Social History*, 4 (1970-71), pp. 389-403. For other eighteenth-century lynchings, see Malcolm Gaskill, *Crime and Mentalities in Early Modern England* (Cambridge, 2000), pp. 82-3. **84.** Judith Devlin, *The Superstitious Mind: French Peasants and the Supernatural in the Nineteenth Century* (New Haven, 1987), pp. 116-17. The death in 1895 in County Tipperary of Bridget Cleary, often claimed as 'the last witch-burning in Ireland', represented a different superstition: when Bridget Cleary was disfigured by illness, her husband thought that the fairies had stolen her and substituted a changeling. As burning a changeling was believed to be a way of restoring the real person, he poured paraffin on her and set her on fire. See Angela Bourke, *The Burning of Bridget Cleary: A True Story* (London, 1999). **85.** Quoted in E. William Monter, *Witchcraft in France and Switzerland: The Borderlands during the Reformation* (Ithaca, NY, 1976), p. 38. **86.** Scholars repeatedly but ineffectually pointed out that the Hebrew original could mean poisoners and fornicators, but not witches in the modern sense: Lecky, *Rationalism*, i. p. 11; Goodare, *European Witch-Hunt*, pp. 17-19; Levack, *Witch-Hunt*, p. 110. **87.** Barbara J. Shapiro, *Probability and Certainty in Seventeenth-Century England: A Study of the Relationships between Natural Science, Religion, History, Law, and Literature* (Princeton, 1983), p. 165. Cf. Levack, *Witch-Hunt*, pp. 237-40. **88.** Christian Thomasius, *Vom Laster der Zauberei; Über die Hexenprozesse (De Crimine Magiae; Processus Inquisitorii contra Sagas)*, ed. Rolf Lieberwirth (Munich, 1986), p. 41. For similar readings of Spee, see Behringer, *Witches*, p. 179; Goodare, *European Witch-Hunt*, p. 353. On Thomasius' 'galant' dress and demeanour, see Steffen Martus, *Aufklärung: Das deutsche 18. Jahrhundert. Ein Epochenbild* (Berlin, 2015), pp. 97-104. **89.** Thomasius, *Vom Laster*, p. 47. **90.** Ibid., p. 95. **91.** Gaskill, *Crime and Mentalities*, p. 93. **92.** Midelfort, *Witch Hunting*, p. 82. **93.** John McManners, *Church and Society in Eighteenth-Century France*, 2 vols. (Oxford, 1998), ii. p. 224. **94.** For the structural similarity between this panic and earlier witchcraft panics, see Anne Somerset, *The Affair of the Poisons: Murder, Infanticide and Satanism at the Court of Louis XIV* (London, 2003), p. 144. **95.** On witchcraft and kingship, see Clark, *Thinking with Demons*, pp. 549-682; on the North Berwick case, Clark, 'King James's *Daemonologie*: witchcraft and kingship', in Sydney Anglo, ed., *The Damned Art: Essays in the Literature of Witchcraft* (London, 1977), pp. 156-81. **96.** Peter Maxwell-Stuart, 'Witchcraft and magic in eighteenth-century Scotland', in Owen Davies and Willem de Blécourt, eds., *Beyond the Witch Trials: Witchcraft and Magic in Enlightenment Europe* (Manchester, 2004), pp. 81-99 (p. 85). **97.** Witchcraft fantasies clearly reflect popular misogyny, directed especially at independent women such as spinsters and widows: see especially Lyndal Roper, *Witch Craze: Terror and Fantasy in Baroque Germany* (New Haven, 2004); Christina Larner, *Enemies of God: The Witch-hunt in Scotland* (London, 1981), pp. 100-102. Such fantasies figure occasionally, but far less, in learned demonology: see Clark, *Thinking with Demons*, pp. 112-18; Behringer, *Witches*, pp. 37-9, 42-3. Their diminution may be part of the increasing separation between popular and high culture that historians have noted in the eighteenth century: see Peter Burke, *Popular Culture in Early Modern Europe* (London, 1978). **98.** See Hugh Trevor-Roper, *The European Witch-Craze of the 16th and 17th Centuries* (Harmondsworth, 1969), p. 109; Thomas, *Religion*, pp. 571-2. **99.** Michael Hunter, 'Witchcraft and the decline of belief', *Eighteenth-Century Life*, 22 (1998), pp. 139-47 (p. 144); cf. Hunter, 'The decline of magic: challenge and response in early Enlightenment England', *Historical Journal*, 55 (2012), pp. 399-425. The intellectualist explanation receives perhaps its sharpest criticism in Ian Bostridge, *Witchcraft and its Transformations, c. 1650-c. 1750* (Oxford, 1997), esp. pp. 242-3. **100.** See now Michael Hunter, *The Decline of Magic: Britain in the Enlightenment* (New Haven, 2020), pp. 71-9. **101.** See Moody E. Prior, 'Joseph Glanvill, witchcraft, and seventeenth-century science', *Modern Philology*, 30 (1932), pp. 167-93; Clark, *Thinking with Demons*, pp. 296-7. **102.** Joseph Glanvill, 'Some Considerations about Witchcraft', in his *Saducismus Triumphatus* (London, 1681), pp. 1-95. (Later editions have the spelling *Sadducismus*.) **103.** Glanvill, *Saducismus*, p. 9. **104.** Glanvill, 'Preface' (unpaginated), *Saducismus*, fo. 3. **105.** Montaigne, 'On the lame', in *The Complete Essays*, tr. M. A. Screech (London, 2003),

p. 1168.   106. Reginald Scot, *Discouerie of Witchcraft* (1584; repr. Amsterdam, 1971), p. 27.   107. Thomas Hobbes, *Leviathan*, ed. J. C. A. Gaskin (Oxford, 1996), pp. 424–41 (ch. 45, 'Of demonology, and other relics of the religion of the gentiles'); Hunter, *Decline of Magic*, pp. 49–62.   108. Quoted in Gaskill, *Witchfinders*, p. 128.   109. Hunter, *Boyle*, pp. 186–7.   110. *Spectator*, no. 117, 14 July 1711.   111. *Satire, Fantasy and Writings on the Supernatural by Daniel Defoe*, ed. W. R. Owens and P. N. Furbank (London, 2003–5), vol. 6: *The Political History of the Devil* (1726), ed. John Mullan, p. 251. Cf. Hunter, *Decline of Magic*, p. 50.   112. See Hunter, *Decline of Magic*, pp. 62–6: Hutchinson's 'approach was cautious – almost timid' (p. 65).   113. Francis Hutchinson, *An Historical Essay concerning Witchcraft* (London, 1718), p. 10.   114. Ibid., p. 50.   115. Ibid., p. 11.   116. 'Tableau philosophique des progrès successifs de l'esprit humain', in *Œuvres de Turgot*, i. pp. 214–35 (p. 233).   117. Gerhard Oestreich, *Neostoicism and the Early Modern State*, tr. David McLintock (Cambridge, 1982; originally published 1969).   118. Justus Lipsius, *On Constancy*, tr. Sir John Stradling, ed. John Sellars (Bristol, 2006), p. 37. See Christopher Brooke, *Philosophic Pride: Stoicism and Political Thought from Lipsius to Rousseau* (Princeton, 2012), and the sympathetic brief account in Peter N. Miller, *Peiresc's Europe: Learning and Virtue in the Seventeenth Century* (New Haven, 2000), pp. 36–40.   119. Ernst Cassirer, *The Philosophy of the Enlightenment*, tr. Fritz C. A. Koelln and James P. Pettegrove (Princeton, 1951), p. 105.   120. *Bussy D'Ambois*, Quarto 2, V, iv, 94–7, in *The Plays of George Chapman: The Tragedies*, ed. Allan Holaday (Woodbridge, 1987), p. 177.   121. *Coriolanus*, V, iii, 35–7.   122. T. S. Eliot, 'Shakespeare and the Stoicism of Seneca' (1927), in his *Selected Essays* (London, 1932), pp. 126–40; Geoffrey Miles, *Shakespeare and the Constant Romans* (Oxford, 1996).   123. William J. Bouwsma, 'The two faces of humanism: Stoicism and Augustinianism in Renaissance thought', in Heiko A. Oberman and Thomas A. Brady, Jr, eds., *Itinerarium Italicum: The Profile of the Italian Renaissance in the Mirror of its European Transformations* (Leiden, 1975), pp. 3–60.   124. *Rasselas*, ch. 18, in *The Yale Edition*, vol. xvi: *Rasselas and Other Tales*, ed. Gwin J. Kolb (1990), pp. 70–76.   125. Henry Fielding, *The History of Tom Jones, a Foundling*, ed. Martin C. Battestin and Fredson Bowers, 2 vols. (Oxford, 1974), i. p. 217.   126. Benedict de Spinoza, *Ethics*, tr. Edwin Curley (London, 1996), p. 155.   127. See Adam Sutcliffe, 'The spirit of Spinoza and the Enlightenment image of the pure philosopher', in Geoffrey Cubitt and Allen Warren, eds., *Heroic Reputations and Exemplary Lives* (Manchester, 2009), pp. 40–56.   128. 'Spinoza', note N, in Bayle, *Historical and Critical Dictionary: Selections*, ed. and tr. Richard H. Popkin (Indianapolis, 1965), p. 312.   129. See Cassirer, *Philosophy*, pp. 69–72; David Bell, *Spinoza in Germany from 1670 to the Age of Goethe* (London, 1984), p. 5 and *passim*.   130. This is the main criticism that has been made of Jonathan Israel's enormously erudite *Radical Enlightenment: Philosophy and the Making of Modernity 1650–1750* (Oxford, 2001) and his subsequent volumes, which argue that the core of the Enlightenment was a politically radical, materialist and atheist philosophy descending from Spinoza. See the critiques by Anthony J. La Vopa, 'A new intellectual history? Jonathan Israel's Enlightenment', *Historical Journal*, 52 (2009), pp. 717–38; Antoine Lilti, 'Comment écrit-on l'histoire intellectuelle des Lumières? Spinozisme, radicalisme et philosophie', *Annales*, 64 (2009), pp. 171–206, developed in Lilti, *L'héritage des Lumières: Ambivalences de la modernité* (Paris, 2019), pp. 223–57; and Dan Edelstein, *The Enlightenment: A Genealogy* (Chicago, 2010), pp. 64–5.   131. Fontenelle, Preface to *De l'utilité des mathématiques et de la physique* (1709), quoted in Cassirer, *Philosophy*, p. 16.   132. [Niccolò] Machiavelli, *The Prince*, ed. Quentin Skinner and Russell Price (Cambridge, 1988), p. 59.   133. See Friedrich Meinecke, *Die Idee der Staatsräson in der neueren Geschichte*, ed. Walther Hofer (Munich, 1957); Peter Burke, 'Tacitism, scepticism, and reason of state', in J. H. Burns, ed., *The Cambridge History of Political Thought, 1450–1700* (Cambridge, 1991), pp. 479–98; Maurizio Viroli, *From Politics to Reason of State: The Acquisition and Transformation of the Language of Politics 1250–1600* (Cambridge, 1992), pp. 238–80; Noel Malcolm, *Useful Enemies: Islam and the Ottoman Empire in Western Political Thought, 1450–1750* (Oxford, 2019), pp. 159–83.   134. On the popularity of Botero's treatise, which was translated into six languages, see 'Introduction', [Giovanni] Botero, *The Reason of State*, ed. and tr. Robert Bireley

(Cambridge, 2017), p. xix. **135.** Botero, *Reason*, p. 41. **136.** Ibid., p. 115. **137.** Baltasar Gracián, *El político*, ed. E. Correa Calderón (Salamanca, 1961), p. 43. **138.** David Hume, *The History of England from the Invasion of Julius Caesar to the Revolution in 1688*, 6 vols. (1778; repr. Indianapolis, 1983), v. p. 101. **139.** Gibbon, *Decline and Fall*, i. p. 139. **140.** *Zum ewigen Frieden*, in *Werke*, vi. p. 237; loosely translated as 'twists and turns of an immoral and opportunistic doctrine', in Kant, *Political Writings*, ed. Hans Reiss, tr. H. B. Nisbet, 2nd edn (Cambridge, 1991), p. 121. **141.** Kant, *Political Writings*, p. 122; *Werke*, vi. p. 239. **142.** Locke, *Essay*, Book II, ch. 1, §1, in *Works*, i. p. 77. Locke later qualified this view by admitting that children brought distinct personality traits into the world: see Jonathan Rée, *Witcraft: The Invention of Philosophy in English* (London, 2019), p. 140. **143.** See Margaret J. Osler, 'John Locke and the changing ideal of scientific knowledge', *JHI*, 31 (1970), pp. 3–16. **144.** Locke, *Essay*, Book IV, ch. 1, §2, in *Works*, ii. p. 59. **145.** See Cassirer, *Philosophy*, pp. 8–9. **146.** D'Alembert, 'Discours préliminaire', p. 18. **147.** Jean-Baptiste Dubos, *Réflexions critiques sur la poésie et sur la peinture*, rev. edn, 3 vols. (Paris, 1733), ii. p. 478; quoted in Edelstein, *The Enlightenment*, p. 24. **148.** Diderot, 'Letter on the Blind for the Use of Those who can see', tr. Kate E. Tunstall, in Tunstall, *Blindness and Enlightenment: An Essay* (London, 2011), p. 179. **149.** See Edelstein, *The Enlightenment*, pp. 70–71, with many more examples. **150.** *Spectator*, no. 10, 12 March 1711. **151.** See Stephen Gaukroger, *The Collapse of Mechanism and the Rise of Sensibility: Science and the Shaping of Modernity 1680–1760* (Oxford, 2010), pp. 267–9. **152.** Diderot, 'Philosophe', *Encyclopédie ou Dictionnaire raisonné des sciences, des arts et des métiers*, 17 vols. (Neuchâtel, 1765), xii. pp. 509–11 (p. 509). **153.** Cicero, *On the Commonwealth and On the Laws*, tr. James E. G. Zetzel (Cambridge, 1999), p. 71. **154.** Diderot, 'Philosophe', *Encyclopédie*, xii. p. 510. **155.** See Annette C. Baier, *A Progress of Sentiments: Reflections on Hume's 'Treatise'* (Cambridge, MA, 1991), pp. 277–85. **156.** Hume, *An Enquiry concerning Human Understanding*, ed. Tom Beauchamp (Oxford, 2000), p. 8; also quoted by Baier, *Progress of Sentiments*, p. 283. **157.** Hume, 'Of the Standard of Taste', *Essays*, p. 240. **158.** Baron d'Holbach, *Le bon-sens ou idées naturelles opposées aux idées surnaturelles* (London, 1772); for these and many more examples, see Sophia Rosenfeld, *Common Sense: A Political History* (Cambridge, MA, 2011). **159.** See Werner Schneiders, *Die wahre Aufklärung: Zum Selbstverständnis der deutschen Aufklärung* (Freiburg, 1974); H. B. Nisbet, ' "Was ist Aufklärung?": the concept of enlightenment in eighteenth-century Germany', *Journal of European Studies*, 12 (1982), pp. 77–95; James Schmidt, ed., *What is Enlightenment? Eighteenth-Century Answers and Twentieth-Century Questions* (Berkeley, 1996), which includes many of the primary texts in translation. On the history of the period term 'the Enlightenment', see James Schmidt, 'Inventing the Enlightenment: Anti-Jacobins, British Hegelians, and the *Oxford English Dictionary*', *JHI*, 64 (2003), pp. 421–43. **160.** Hence it features in the last and culminating chapter of Steffen Martus's massive study of the German Enlightenment, *Aufklärung: Das deutsche 18. Jahrhundert*, pp. 835–81. **161.** Johann Friedrich Zöllner, 'Ist es rathsam, das Ehebündnis nicht ferner durch die Religion zu sanciren?', *Berlinische Monatsschrift*, Dec. 1783, pp. 508–17 (p. 516). **162.** Moses Mendelssohn, 'Über die Frage: was heißt aufklären?' in *Was ist Aufklärung*, ed. Ehrhard Bahr (Stuttgart, 1974), pp. 3–8. Originally published in the *Berlinische Monatsschrift*, Sept. 1784. **163.** 'An Answer to the Question: "What is Enlightenment?"' in Kant, *Political Writings*, pp. 54–60 (p. 54); *Werke*, vi. pp. 53–61. Emphasis in original. Coincidentally, '*Sapere aude!*' was also the motto of the journal *Den nye granskare* (*The New Examiner*), which the Swedish Enlightener Thomas Thorild began publishing earlier the same year: see Ernst Cassirer, *Thorilds Stellung in der Geistesgeschichte des achtzehnten Jahrhunderts* (1941), ed. Claus Rosenkranz, in Cassirer, *Gesammelte Werke*, ed. Birgit Recki, 26 vols. (Hamburg, 1998–2009), xxi. pp. 117–236 (p. 209). **164.** Kant's metaphor is 'Gängelwagen', a kind of square enclosure on wheels, within which a child can stand upright and be supported. It thus implies not only dependency (like 'leading strings') but also confinement. **165.** John Christian Laursen, 'The subversive Kant: the vocabulary of "public" and "publicity"', in Schmidt, *What is Enlightenment?*, pp. 253–69 (p. 257). **166.** Kant, *Political Writings*, p. 58. **167.** Ibid., p. 57. **168.** See the entry 'Vernunft; Verstand' in Joachim Ritter, Karlfried

Gründer and Gottfried Gabriel, eds., *Historisches Wörterbuch der Philosophie*, 13 vols. (Basel, 1971–2007), xi. pp. 747–863 (esp. pp. 821–2). **169.** *Phaedrus*, in *The Dialogues of Plato*, tr. B. Jowett, 4 vols., 4th edn (Oxford, 1953), iii. p. 153. **170.** Charles Taylor, *Sources of the Self: The Making of the Modern Identity* (Cambridge, 1989), p. 148. **171.** *The Complete Poems and Plays of Fulke Greville, Lord Brooke (1554–1628)*, ed. G. A. Wilkes, 2 vols. (Lewiston, NY, 2008), i. p. 297. **172.** René Descartes, *The Passions of the Soul and Other Late Philosophical Writings*, tr. Michael Moriarty (Oxford, 2015), p. 206 (§27). Usefully analysed in Stephen Gaukroger, *Descartes: An Intellectual Biography* (Oxford, 1995), pp. 399–405. **173.** Descartes, *Passions*, p. 216 (§48). **174.** Ibid., p. 279 (§211). **175.** Ibid., p. 280 (§212). **176.** Shaftesbury, *Characteristics*, p. 195. **177.** Ibid., p. 192. **178.** Ibid., p. 177. **179.** Ibid., p. 175. **180.** *Essay on Man*, Epistle II, ll. 97–8, in *TE* iii/1. p. 66. **181.** Ibid., ll. 163–4, *TE* iii/1. **182.** Ibid., ll. 107–8, *TE* iii/1. pp. 67–8. **183.** Hume, *A Treatise of Human Nature: A Critical Edition*, ed. David Fate Norton and Mary J. Norton (Oxford, 2007), p. 265 (II iii 3). **184.** Ibid., p. 266 (II iii 3). **185.** Kant, *Werke*, i. pp. 889–90; 'Essay on the maladies of the head', tr. Holly Wilson, in *Anthropology, History, and Education*, ed. Günter Zöller and Robert B. Louden, The Cambridge Edition of the Works of Immanuel Kant (Cambridge, 2007), pp. 63–77 (p. 67). **186.** 'Passions', *Encyclopédie*, xii. p. 145. The author is the Chevalier de Jaucourt. **187.** Ibid., p. 146. **188.** Verri, *Discorsi*, p. 163. **189.** Friedrich Schiller, *On the Aesthetic Education of Man in a Series of Letters*, ed. and tr. Elizabeth M. Wilkinson and L. A. Willoughby (Oxford, 1967), p. 27 (translation modified); *Über die ästhetische Erziehung des Menschen in einer Reihe vom Briefen*, in Schiller, *Sämtliche Werke*, ed. Gerhard Fricke and Herbert G. Göpfert, 5 vols. (Munich, 1958), v. p. 580. Merely rational enlightenment is represented by his dramatic figures Franz Moor in *Die Räuber* (1781) and Talbot in *Die Jungfrau von Orleans* (1801). **190.** Robertson, *The Case for the Enlightenment*, p. 28. Cf. John Robertson, *The Enlightenment: A Very Short Introduction* (Oxford, 2015), p. 13. **191.** See Peter Burke, 'Strengths and weaknesses of the history of mentalities', in his *Varieties of Cultural History* (Cambridge, 1997), pp. 162–82. **192.** On modern religious pluralism as a legacy of the Enlightenment, see Diarmaid MacCulloch, *Reformation: Europe's House Divided* (London, 2003), pp. 698–701. **193.** Pierre Bayle, *Pensées diverses sur la comète*, ed. A. Prat, 2 vols. (Paris, 1939), i, p. vii. **194.** Lorraine Daston and Katharine Park, *Wonders and the Order of Nature, 1150–1750* (New York, 1998), p. 330. **195.** Raymond Williams, *The Long Revolution* (London, 1961), p. 48. **196.** Edelstein, *The Enlightenment*, p. 20. **197.** Robert Darnton, 'The case for the Enlightenment: George Washington's false teeth', in his *George Washington's False Teeth* (New York, 2003), pp. 3–24 (p. 4). First published in the *New York Review of Books*, 27 March 1997. **198.** Peter Gay, *The Enlightenment: An Interpretation*, 2 vols. (New York, 1966–9). **199.** Israel's studies on the Enlightenment and its aftermath now form a heptalogy: *Radical Enlightenment*; *Enlightenment Contested: Philosophy, Modernity, and the Emancipation of Man 1670–1752* (Oxford, 2006); *A Revolution of the Mind: Radical Enlightenment and the Intellectual Origins of Modern Democracy* (Princeton, 2010); *Democratic Enlightenment: Philosophy, Revolution, and Human Rights 1750–1790* (Oxford, 2011); *Revolutionary Ideas: An Intellectual History of the French Revolution from 'The Rights of Man' to Robespierre* (Princeton, 2014); *The Expanding Blaze: How the American Revolution Ignited the World, 1775–1848* (Princeton, 2017); *The Enlightenment that Failed: Ideas, Revolution, and Democratic Defeat, 1748–1830* (Oxford, 2019). **200.** Cf. Margaret C. Jacob, *The Radical Enlightenment: Pantheists, Freemasons and Republicans* (London, 1981). **201.** Nikolai Karamzin, *Letters from a Russian Traveller*, tr. Andrew Kahn (Oxford, 2003), p. 384. **202.** As argued by Roy Porter, 'The Enlightenment in England', in Roy Porter and Mikuláš Teich, eds., *The Enlightenment in National Context* (Cambridge, 1981), pp. 1–18; Porter, *Enlightenment: Britain and the Creation of the Modern World* (London, 2000). **203.** J. G. A. Pocock, 'Clergy and commerce: the conservative Enlightenment in England', in *L'età dei lumi: studi storici sul settecento europeo in onore di Franco Venturi*, 2 vols. (Naples, 1985), i. pp. 523–61. **204.** Franco Venturi, *Utopia and Reform in the Enlightenment* (Cambridge, 1971), p. 132; followed by Robertson, *The Case for the Enlightenment*, who chides Porter for his 'expansive and inclusive fancy' (p. 27). **205.** See Hugh

Trevor-Roper, 'The Scottish Enlightenment', *SVEC*, 58 (1967), pp. 1635–58; 'The Scottish Enlightenment', in his *History and the Enlightenment*, ed. John Robertson (New Haven, 2010), pp. 17–33. Cf. Paul Wood, 'Introduction: Dugald Stewart and the invention of "the Scottish Enlightenment" ', in Wood, ed., *The Scottish Enlightenment: Essays in Reinterpretation* (Rochester, NY, 2000), pp. 1–35. The term was used by William Robert Scott in his *Francis Hutcheson* (Cambridge, 1900). 206. See Robert E. Norton, 'The myth of the Counter-Enlightenment', *JHI*, 68 (2007), pp. 635–58; Joachim Whaley, ' "Wahre Aufklärung kann erreicht und segensreich werden": The German Enlightenment and its interpretation', *Oxford German Studies*, 44 (2015), pp. 428–48. 207. T. J. Reed, *Light in Germany: Scenes from an Unknown Enlightenment* (Chicago, 2015). 208. On the international character of the Enlightenment, see Richard Butterwick et al., eds., *Peripheries of the Enlightenment* (Oxford, 2008), which includes essays on Ireland, Geneva, Naples, Sweden, Hungary, Poland, Russia, Mexico and, curiously, Liverpool. 209. J. G. A. Pocock, *Barbarism and Religion*, 6 vols. (Cambridge, 1999–2015), i: *The Enlightenments of Edward Gibbon* (1999), p. 9. 210. See the criticism of Wittgenstein by Perry Anderson, *A Zone of Engagement* (London, 1992), p. 212. 211. Porter and Teich, *The Enlightenment in National Context*. 212. Israel, *Radical Enlightenment*, p. v; also p. 22. 213. See Winterer, *American Enlightenments*; Susan Manning and Francis D. Cogliano, eds., *The Atlantic Enlightenment* (Aldershot, 2008); A. Owen Aldridge, ed., *The Ibero-American Enlightenment* (Urbana, IL, 1971); Israel, *Democratic Enlightenment*, esp. pp. 510–34; and especially Israel's *The Expanding Blaze*. 214. See Anthony Pagden, *The Enlightenment and Why It Still Matters* (Oxford, 2013); Susan Neiman, *Moral Clarity: A Guide for Grown-up Idealists* (London, 2009) and *Why Grow Up? Subversive Thoughts for an Infantile Age*, rev. edn (London, 2016); Steven Pinker, *The Better Angels of our Nature: The Decline of Violence in History and its Causes* (London, 2011) and *Enlightenment Now: The Case for Reason, Science, Humanism and Progress* (London, 2018). 215. Israel, *Radical Enlightenment*, p. vi. 216. Cassirer, *Philosophy*, p. 45. Cassirer's original term is 'das naturwissenschaftliche Erkennen', i.e. knowledge as practised in natural science: *Die Philosophie der Aufklärung* (Tübingen, 1932), p. 59.

## 2. THE SCIENTIFIC REVOLUTION

1. David Wootton, *The Invention of Science: A New History of the Scientific Revolution* (London, 2015), pp. 68–71. 2. Molière, *Le Malade imaginaire*, Troisième Intermède. 3. Ian Simpson Ross, *The Life of Adam Smith* (Oxford, 1995), p. 73. 4. See e.g. 'Of the Proficience and Advancement of Learning', in *Collected Works of Francis Bacon*, ed. James Spedding, Robert Leslie Ellis and Douglas Denon Heath, 7 vols. in 12 bks. (1879; repr. London, 1996), iii/1, p. 301; Ernst Robert Curtius, *European Literature and the Latin Middle Ages*, tr. Willard R. Trask (New York, 1953), pp. 319–26; Peter Harrison, *The Bible, Protestantism, and the Rise of Natural Science* (Cambridge, 1998), pp. 44–56. 5. 'Man', in *The Works of George Herbert*, ed. F. E. Hutchinson (Oxford, 1941), pp. 90–92 (p. 91). 6. See Peter Burke, 'The rise of literal-mindedness', in his *Secret History and Historical Consciousness: From the Renaissance to Romanticism* (Brighton, 2016), pp. 163–80. 7. Quoted in Harrison, *The Bible*, p. 108. 8. Lorraine Daston, 'Attention and the values of nature in the Enlightenment', in Lorraine Daston and Fernando Vidal, eds., *The Moral Authority of Nature* (Chicago, 2004), pp. 100–126 (p. 120). 9. [Carl von Linné], 'The œconomy of nature, by Isaac Biberg', in *Miscellaneous Tracts relating to Natural History, Husbandry, and Physick*, tr. Benjamin Stillingfleet, 2nd edn (London, 1762), pp. 37–130 (p. 39). This was a doctoral dissertation which Linnaeus, following the Swedish practice of the time, dictated to his student Biberg, who then translated it into Latin and published it in 1747. On the subsequent history of 'economy of nature' and its transition to the concept of ecology, see R. C. Stauffer, 'Ecology in the long manuscript version of Darwin's *Origin of Species* and Linnaeus' *Oeconomy of Nature*', *Proceedings of the American Philosophical Society*, 104 (1960), pp. 235–41. 10. [Carl von Linné], 'On the Police of Nature, by

Christ. Daniel Wilche', in *Select Dissertations from the Amœnitates Academicæ*, tr. F. J. Brand, 2 vols. (London, 1781), i. pp. 129–66 (pp. 134–5).   11. See the references collected in P. G. Walsh, 'The rights and wrongs of curiosity (Plutarch to Augustine)', *Greece & Rome*, 35 (1988), pp. 73–85 (esp. p. 81).   12. *The Confessions of St Augustine*, tr. E. B. Pusey (London, 1907), pp. 106, 114.   13. Ibid., p. 238.   14. Johan Huizinga, *The Waning of the Middle Ages*, tr. F. Hopman ([1924]; Harmondsworth, 1965), p. 150.   15. *Paradise Lost*, viii. l. 175. All Milton quotations are taken from *The Poems of John Milton*, ed. John Carey and Alastair Fowler (London, 1968).   16. 'The Enquiry', in *The Works of Mary Leapor*, ed. Richard Greene and Anne Messenger (Oxford, 2003), p. 110.   17. 'Of the Proficience and Advancement of Learning', in *Collected Works of Bacon*, iii/1, p. 268.   18. See Lorraine Daston and Katharine Park, *Wonders and the Order of Nature, 1150–1750* (New York, 1998), p. 331. On the various meanings of 'curiosity' and its cognates, see Neil Kenny, *The Uses of Curiosity in Early Modern France and Germany* (Oxford, 2004).   19. See Richard Yeo, 'Classifying the sciences', in *CHS*, pp. 241–66 (pp. 244, 254).   20. *The Virtuoso* (1676), in *The Complete Works of Thomas Shadwell*, ed. Montague Summers, 5 vols. (London, 1927), iii. pp. 95–182 (p. 113). Cf. Pope, *The Dunciad, TE* v. p. 381. See Walter Houghton, 'The English virtuoso in the seventeenth century', *JHI*, 3 (1942), pp. 31–73, 190–219.   21. Quoted in James Delbourgo, *Collecting the World: The Life and Curiosity of Hans Sloane* (London, 2017), p. 259. Cf. Krzysztof Pomian, *Collectionneurs, amateurs et curieux: Paris, Venise, XVI<sup>e</sup>–XVIII<sup>e</sup> siècles* (Paris, 1987), pp. 196–303; Paula Findlen, *Possessing Nature: Museums, Collecting, and Scientific Culture in Early Modern Italy* (Berkeley, 1994).   22. *Collected Works of Bacon*, iii/1, pp. 285–6. See Paolo Rossi, 'Bacon's idea of science', in Markku Peltonen, ed., *The Cambridge Companion to Bacon* (Cambridge, 2006), pp. 25–46.   23. Quoted in Michael Hunter, *Boyle: Between God and Science* (New Haven, 2009), p. 117.   24. For Boyle's use of the term, see ibid. though he preferred the word 'corpuscularian' (ibid., p. 104).   25. Stephen Gaukroger, *Descartes: An Intellectual Biography* (Oxford, 1995), pp. 149–50; expanded in Gaukroger, *The Emergence of a Scientific Culture: Science and the Shaping of Modernity, 1210–1685* (Oxford, 2006), pp. 255–6.   26. See Gaukroger, *Emergence*, pp. 262–76.   27. Peter Dear, 'Method and the study of nature', in Daniel Garber and Michael Ayers, eds., *The Cambridge History of Seventeenth-Century Philosophy* (Cambridge, 2012), pp. 147–77 (p. 159).   28. *Principles of Philosophy*, II, iv, in *The Philosophical Writings of Descartes*, tr. John Cottingham, Robert Stoothoff and Dugald Murdoch, 2 vols. (Cambridge, 1985), i. p. 224.   29. On Beeckman, see Gaukroger, *Emergence*, pp. 276–82; for his influence on Descartes, Gaukroger, *Descartes*, pp. 68–73; on the difference between Beeckman's particles and the atoms of Gassendi and the classical theorists, ibid., p. 72.   30. For this example (taken from Descartes) see Tom Sorell, *Descartes: A Very Short Introduction* (Oxford, 2000), p. 33.   31. See Gaukroger, *Descartes*, pp. 272–4.   32. See Peter A. Schouls, *Descartes and the Enlightenment* (Edinburgh, 1989). Descartes was not only a theorist, but also did empirical work in optics: see Gaukroger, *Descartes*, pp. 296–9.   33. Balthasar Bekker, *De betoverde weereld, zynde een grondig ondersoek van 't gemeen gevoelen aangaande de geesten, derselver aart en vermogen, bewind en bedryf: als ook 't gene de menschen door derselver kraght en gemeenschap doen*, 4 vols. (Amsterdam, 1691–3), ii. p. 2.   34. Bekker, *De betoverde weereld*, iii. pp. 14–15.   35. See Andrew Fix, *Fallen Angels: Balthasar Bekker, Spirit Belief, and Confessionalism in the Seventeenth Century Dutch Republic* (Dordrecht, 1999). For an excellent summary of Bekker's book, see Euan Cameron, *Enchanted Europe: Superstition, Reason, and Religion 1250–1750* (Oxford, 2010), pp. 264–9.   36. Jonathan Israel, *Radical Enlightenment: Philosophy and the Making of Modernity 1650–1750* (Oxford, 2001), p. 382.   37. [Bernard de Fontenelle], *A Discovery of New Worlds*, tr. A[phra]. Behn (London, 1688), pp. 12–13. Cf. Fontenelle, *Entretiens sur la pluralité des mondes* (1688), ed. Robert Shackleton (Oxford, 1955), p. 64.   38. Descartes mentions 'Verulamius' (Bacon, Lord Verulam) approvingly in letters to Mersenne, 23 Dec. 1630 and 10 May 1632: see his *Œuvres*, ed. Charles Adam and Paul Tannery, 11 vols., 2nd edn (Paris 1974–86), i. pp. 195, 251.   39. See Gaukroger, *Descartes*, pp. 237–9; Keith Thomas, *Man and the Natural World: Changing Attitudes in England 1500–1800* (London, 1983), pp. 33–5.   40. Voltaire, *Le philosophe ignorant* (1766), *OCV* 62, p. 37.   41. This

story is told in Stephen Gaukroger, *The Collapse of Mechanism and the Rise of Sensibility: Science and the Shaping of Modernity, 1680–1760* (Oxford, 2010). **42.** Alexandre Koyré, quoted in Steven Shapin, *The Scientific Revolution* (Chicago, 2000), p. 1. **43.** Thomas S. Kuhn, 'Mathematical versus experimental traditions in the development of physical science', in his *The Essential Tension: Selected Studies in Scientific Tradition and Change* (Chicago, 1977), pp. 31–65 (p. 40). **44.** Ibid., p. 43. **45.** Wootton, *Invention of Science*, p. 12; cf. John Robert Christiansen, *On Tycho's Island: Tycho Brahe and his Assistants* (Cambridge, 2000), p. 17. **46.** Wootton, *Invention of Science*, p. 17. **47.** See August Buck, *Die 'Querelle des Anciens et des Modernes' im italienischen Selbstverständnis der Renaissance und des Barocks* (Wiesbaden, 1973); Joseph Levine, *The Battle of the Books: History and Literature in the Augustan Age* (Ithaca, NY, 1991); Marc Fumaroli, 'Les abeilles et les araignées', in Anne-Marie Lecoq, ed., *La Querelle des Anciens et des Modernes* (Paris, 2001), pp. 7–218; Paddy Bullard and Alexis Tadié, eds., *Ancients and Moderns in Europe: Comparative Perspectives* (Oxford, 2016). **48.** Voltaire, *Le Siècle de Louis XIV*, in his *Œuvres historiques*, ed. René Pomeau (Paris, 1957), pp. 1025–6; 'Anciens et modernes', in *Questions sur l'Encyclopédie* (1770), *OCV* 38, p. 338. **49.** Fontenelle, *Entretiens sur la pluralité des mondes*, p. 175. **50.** William Wotton, *Reflections upon Ancient and Modern Learning* (London, 1694), p. 301. **51.** Ibid., p. 300. **52.** Ibid., p. 301. **53.** Barbara J. Shapiro, *Probability and Certainty in Seventeenth-Century England: A Study of the Relationships between Natural Science, Religion, History, Law, and Literature* (Princeton, 1983), p. 10; Wootton, *Invention of Science*, pp. 420–21. **54.** Quoted in Wootton, *Invention of Science*, pp. 367–8. **55.** Thomas Sprat, *The History of the Royal-Society of London* (London, 1667), p. 82. **56.** Ibid., p. 33. **57.** Ibid., p. 68. **58.** Ibid., p. 99. **59.** Ibid., p. 90. Cf. Daston and Park, *Wonders*, p. 351. **60.** Sprat, *History*, p. 113. **61.** See Michael Hunter, *Science and Society in Restoration England* (Cambridge, 1981). **62.** An institution of higher learning, founded by Sir Thomas Gresham in 1597, and still flourishing as a venue for public lectures. Swift's Gulliver, on his return from Brobdingnag, presents Gresham College with the stings of some giant wasps: *Gulliver's Travels*, p. 99. **63.** Sprat, *History*, p. 66. **64.** Hunter, *Science*, p. 71. **65.** Ibid., p. 51. **66.** *Philosophical Transactions*, 1 (1665–6), p. 10; see Hunter, *Boyle*, p. 152. **67.** Sir Robert Moray, 'A Relation concerning Barnacles', *Philosophical Transactions*, 12 (1677–8), pp. 925–7. **68.** Shapin, *Scientific Revolution*, pp. 1–4. **69.** Ludwig Wittgenstein, *Philosophische Untersuchungen / Philosophical Investigations*, tr. G. E. M. Anscombe, P. M. S. Hacker and Joachim Schulte (Oxford, 2009), §§ 19, 7; Steven Shapin and Simon Schaffer, *Leviathan and the Air-Pump: Hobbes, Boyle, and the Experimental Life* (Princeton, 1985), p. 22. **70.** Shapin and Schaffer, *Leviathan*, p. 336. **71.** Ibid., p. 342. **72.** See Jan Golinski, 'Chemistry', *CHS*, pp. 375–96 (pp. 387–8). **73.** Shapin, *Scientific Revolution*, p. 165. Against relativism, see Wootton, *Invention of Science*, esp. pp. 41–50, 511–55, 580–92; Paul R. Gross and Norman Levitt, *Higher Superstition: The Academic Left and its Quarrel with Science* (Baltimore, 1994), pp. 63–9; Paul Boghossian, 'What the Sokal hoax ought to reach us', *Times Literary Supplement*, 13 December 1996, pp. 14–15. **74.** Thomas S. Kuhn, *The Structure of Scientific Revolutions*, 2nd, enlarged edn (Chicago, 1969), pp. 111, 117. **75.** Ibid., p. 171. **76.** Alexander Bird, *Thomas Kuhn* (Chesham, 2000), p. 226. **77.** Richard S. Westfall, *Never at Rest: A Biography of Isaac Newton* (Cambridge, 1980), p. 83. **78.** Ibid., pp. 93–4; Rob Iliffe, *Newton: A Very Short Introduction* (Oxford, 2007), pp. 34, 39. **79.** Quoted in I. Bernard Cohen, *The Newtonian Revolution* (Cambridge, 1980), p. 12. **80.** Wootton, *Invention of Science*, p. 390. **81.** Cohen, *Newtonian Revolution*, p. 16. **82.** Rob Iliffe, *Priest of Nature: The Religious Worlds of Isaac Newton* (Oxford, 2017), p. 91. **83.** Voltaire, *Letters concerning the English Nation*, ed. Nicholas Cronk (Oxford, 1994), p. 61. **84.** See David Kubrin, 'Newton and the cyclical cosmos: providence and the mechanical philosophy', *JHI*, 28 (1967), pp. 325–46. **85.** Maria Rosa Antognazza, *Leibniz: An Intellectual Biography* (Cambridge, 2009), p. 535. **86.** Quoted from the Latin *Optics* (1706) in Kubrin, 'Newton and the cyclical cosmos', p. 337. **87.** Westfall, *Never at Rest*, p. 292. **88.** Frank E. Manuel, *Isaac Newton, Historian* (Cambridge, MA, 1963), pp. 12–16. **89.** See J. E. McGuire and P. M. Rattansi, 'Newton and the "pipes of Pan"', *Notes and Records of the Royal Society*

*of London*, 21 (1966), pp. 108–43; Iliffe, *Priest of Nature*, p. 202 and *passim*.   90. William Newman, 'A preliminary re-assessment of Newton's alchemy', in Rob Iliffe and George E. Smith, eds., *The Cambridge Companion to Newton*, 2nd edn (Cambridge, 2016), pp. 454–84.   91. Frank E. Manuel, *A Portrait of Isaac Newton* (Cambridge, MA, 1968), pp. 179–82; Iliffe, *Newton*, pp. 54–61.   92. Quoted in Westfall, *Never at Rest*, pp. 325–6. See Iliffe, *Priest of Nature*, pp. 385–7.   93. 'Discours préliminaire de l'*Encyclopédie*', in *Œuvres complètes de d'Alembert*, 5 vols. (Paris, 1821), i. pp. 17–99 (p. 36); Edward Gibbon, *Memoirs of my Life*, ed. Georges A. Bonnard (London, 1966), p. 43; Johann Wolfgang Goethe, *Sämtliche Werke: Briefe, Tagebücher und Gespräche*, ed. Friedmar Apel and others, 40 vols. (Frankfurt a.M., 1986–2000), iii. p. 245. See Anthony Grafton, 'Scaliger's chronology: philology, astronomy, world history', in his *Defenders of the Text: The Traditions of Scholarship in an Age of Science, 1450–1800* (Cambridge, MA, 1991), pp. 104–44.   94. See Manuel, *Newton, Historian*, pp. 85–8; Iliffe, *Newton*, p. 129.   95. See D. P. Walker, *The Ancient Theology: Studies in Christian Platonism from the Fifteenth to the Eighteenth Century* (London, 1972); Colin Kidd, *The World of Mr Casaubon: Britain's Wars of Mythography, 1700–1870* (Cambridge, 2016), esp. pp. 81–2 on Newton.   96. Quoted in Westfall, *Never at Rest*, pp. 469–70. On its reception, see also Patricia Fara, *Newton: The Making of a Genius* (New York, 2002).   97. See J. B. Shank, *The Newton Wars and the Beginning of the French Enlightenment* (Chicago, 2008), pp. 52–5.   98. Although, as Voltaire wrote this book in London, he was for some time thought to have written it wholly or partly in English, the evidence suggests that it was originally written in French and translated into English by John Lockman. It appeared in London in 1733 as *Letters concerning the English Nation*. See J. Patrick Lee, 'The unexamined premise: Voltaire, John Lockman, and the myth of the *English letters*', *SVEC*, 10 (2001), pp. 240–70.   99. Shank, *Newton Wars*, p. 292.   100. See L. W. B. Brockliss, *French Higher Education in the Seventeenth and Eighteenth Centuries: A Cultural History* (Oxford, 1987), pp. 362–8.   101. For Leibniz's critical response, see Antognazza, *Leibniz*, pp. 295–7.   102. Mordechai Feingold, *The Newtonian Moment: Isaac Newton and the Making of Modern Culture* (New York, 2004), p. 77.   103. See Paula Findlen, 'Science as a career in Enlightenment Italy: the strategies of Laura Bassi', *Isis*, 84 (1993), pp. 441–69. For other female Newtonians, see Feingold, *Newtonian Moment*, pp. 125–35. The first female graduate was the Venetian noblewoman Elena Cornaro Piscopia, who took a degree in philosophy at Padua in 1678. More generally, see Vincenzo Ferrone, *The Intellectual Roots of the Italian Enlightenment: Newtonian Science, Religion, and Politics in the Early Eighteenth Century*, tr. Sue Brotherton (Atlantic Highlands, NJ, 1995).   104. See Paschalis M. Kitromilides, *Enlightenment and Revolution: The Making of Modern Greece* (Cambridge, MA, 2013), pp. 52–3.   105. Margaret C. Jacob and Larry Stewart, *Practical Matter: Newton's Science in the Service of Industry and Empire, 1687–1851* (Cambridge, MA, 2005), p. 15.   106. Some influential recent historians attribute the acceptance of Newton's cosmology to its compatibility with Whig-dominated broad Churchmanship and constitutional monarchy: see Margaret C. Jacob, *The Newtonians and the English Revolution, 1689–1720* (Ithaca, NY, 1976), esp. pp. 18–109; eadem, *The Radical Enlightenment: Pantheists, Freemasons and Republicans* (London, 1981), pp. 87–108; Roy Porter, *Enlightenment: Britain and the Creation of the Modern World* (London, 2000), pp. 135–8. However, the key reason for the success of Newtonianism was its philosophical and scientific superiority to any other cosmology on offer. Against the excesses of cultural historians' attempts at contextualization, see Brian W. Young, *Religion and Enlightenment in Eighteenth-Century England: Theological Debate from Locke to Burke* (Oxford, 1998), pp. 85–6.   107. Desaguliers, *The Newtonian System of the World, the best Model of Government: An Allegorical Poem* (Westminster, 1728), p. 22. On Desaguliers and his poem, see Fara, *Newton*, pp. 89–97; Jacob, *The Radical Enlightenment*, p. 124.   108. See Karen O'Brien, ' "These nations Newton made his own": poetry, knowledge, and British imperial globalization', in Daniel Carey and Lynn Festa, eds., *Postcolonial Enlightenment: Eighteenth-Century Colonialism and Postcolonial Theory* (Oxford, 2009), pp. 281–303.   109. Text in Lynn Hunt, *Inventing Human Rights: A History* (New York, 2007), p. 215.   110. Garry Wills, *Inventing America: Jefferson's Declaration of Independence* (New York, 1978),

p. 97. **111.** Quoted in Gaukroger, *Collapse of Mechanism*, p. 185. **112.** Ibid., p. 266. **113.** Ernst Cassirer, *The Philosophy of the Enlightenment*, tr. Fritz C. A. Koelln and James P. Pettegrove (Princeton, 1951), p. 55. **114.** Quoted ibid., p. 60. **115.** Quoted ibid., p. 61. **116.** 'Discours préliminaire de l'*Encyclopédie*', in *Œuvres complètes de d'Alembert*, i. p. 30. **117.** D'Alembert, *Éléments de Philosophie*, quoted in Cassirer, *Philosophy*, p. 46. **118.** On terms for science and scientists, see Wootton, *Invention of Science*, pp. 22–32. **119.** 'De l'interprétation de la nature', *OCD* ii. p. 748. **120.** 'Essai sur la nature du feu, et sur sa propagation', *OCV* 17, pp. 29–89. **121.** 'Saggio intorno ai cambiamenti avvenuti su'l globo della terra' / 'Dissertation sur les changements arrivés dans notre globe', *OCV* 30C, pp. 24–51. Voltaire wrote his paper first in Italian and then translated it into French; the edition cited prints both on facing pages. **122.** 'Principes philosophiques sur la matière et le mouvement' (1771), *OCD* ix. pp. 609–15. **123.** Robert Shackleton, *Montesquieu: A Critical Biography* (Oxford, 1961), pp. 24–5. **124.** 'Cours de géographie' and 'Traité de sphère', *OCR* v. pp. 535–44, 585–601. **125.** James Boswell, *Life of Johnson*, ed. R. W. Chapman, corrected by J. D. Fleeman (London, 1970), p. 308. On Johnson's relation to the Enlightenment, see Robert Shackleton, 'Johnson and the Enlightenment', in his *Essays on Montesquieu and on the Enlightenment*, ed. David Gilson and Martin Smith (Oxford, 1988), pp. 243–56. **126.** Adam Smith, 'The Principles which Lead and Direct Philosophical Enquiries: Illustrated by the History of Astronomy', in his *Essays on Philosophical Subjects*, ed. W. P. D. Wightman and J. C. Bryce (Oxford, 1980), pp. 31–105. **127.** 'Allgemeine Naturgeschichte und Theorie des Himmels, oder Versuch von der Verfassung und dem mechanischen Ursprunge des ganzen Weltgebäudes nach Newtonschen Grundsätzen abgehandelt', *Werke*, i. pp. 225–396; 'Universal natural history and theory of the heavens or essay on the constitution and the mechanical origin of the whole universe according to Newtonian principles', in *Natural Science*, ed. Eric Watkins, The Cambridge Edition of the Works of Immanuel Kant (Cambridge, 2012), pp. 182–308. **128.** See Boris N. Menshutkin, *Russia's Lomonosov* (Princeton, 1952). For his response to Newton's *Principia*, see Valentin Boss, *Newton in Russia: The Early Influence, 1698–1796* (Cambridge, MA, 1972), pp. 165–84. **129.** Golinski, 'Chemistry', p. 376; Yeo, 'Classifying the sciences', p. 258. **130.** Yeo, 'Classifying the sciences', p. 244; cf. R. W. Home, 'Mechanics and experimental physics', *CHS*, pp. 354–74 (pp. 354–5). **131.** Golinski, 'Chemistry', p. 379; cf. his *Science as Public Culture: Chemistry and Enlightenment in Britain, 1760–1820* (Cambridge, 1992), pp. 13–15, 52–5. **132.** On Boyle and alchemy, see Hunter, *Boyle*, pp. 179–86. **133.** See Hunter, *Boyle*, p. 124, and the illustration on p. 125. **134.** Kuhn, 'Mathematical versus experimental traditions', p. 46. **135.** See A. L. Donovan, *Philosophical Chemistry in the Scottish Enlightenment: The Doctrines and Discoveries of William Cullen and Joseph Black* (Edinburgh, 1975), pp. 21–5. **136.** Ibid., esp. pp. 190–221. **137.** For an introduction to Cavendish, see Russell K. McCormmach, 'Henry Cavendish: a study of rational empiricism in eighteenth-century natural philosophy', *Isis*, 60 (1969), pp. 293–306. **138.** See Robert E. Schofield, *The Enlightened Joseph Priestley: A Study of his Life and Work from 1773 to 1804* (University Park, PA, 2004), p. 364; Golinski, 'Chemistry', p. 391. **139.** Thomas L. Hankins, *Science and the Enlightenment* (Cambridge, 1985), p. 83. **140.** Menshutkin, *Russia's Lomonosov*, pp. 119–21. **141.** Quoted in Hankins, *Science*, p. 112. On the extent to which Lavoisier revolutionized chemistry, see Golinski, 'Chemistry', pp. 392–6. **142.** Hankins, *Science*, p. 84. **143.** Donovan, *Philosophical Chemistry*, pp. 98–9. **144.** See Home, 'Mechanics', pp. 360–63. **145.** On the mathematization of physics, see ibid., pp. 371–4. **146.** Hankins, *Science*, p. 53. Cf. Home, 'Mechanics', pp. 366–71. **147.** Quoted in John L. Heilbron, *Electricity in the 17th and 18th Centuries: A Study of Early Modern Physics* (Berkeley, 1979), p. 313. **148.** Heilbron, *Electricity*, p. 352. **149.** Michael Brian Schiffer, *Draw the Lightning Down: Benjamin Franklin and Electrical Technology in the Age of Enlightenment* (Berkeley, 2003), p. 28. **150.** Ibid., p. 68. **151.** Heilbron, *Electricity*, p. 318. **152.** Home, 'Mechanics', p. 358. **153.** Giuliano Pancaldi, *Volta: Science and Culture in the Age of Enlightenment* (Princeton, 2003), p. 123. **154.** Heilbron, *Electricity*, pp. 461–4; Pancaldi, *Volta*, pp. 179–207. **155.** See Mary Terrall, *The Man who Flattened the Earth: Maupertuis and the Sciences in the Enlightenment* (Chicago, 2002), p. 89.

156. M. de La Condamine, *Journal du voyage fait par ordre du roi, à l'équateur* (Paris, 1751).   157. For an account of the expedition, see Terrall, *The Man*, pp. 88–129.   158. For an explanation, see Harry Woolf, *The Transits of Venus: A Study of Eighteenth-Century Science* (Princeton, 1959), pp. 18–19.   159. See the diaries of Hell's expedition: *P. Hell's Reise nach Wardoe bei Lappland und seine Beobachtung des Venus-Durchgangs im Jahre 1769*, ed. Carl Ludwig Littrow (Vienna, 1835), and Woolf, *Transits*, pp. 176–9.   160. See Nicholas Thomas, *Discoveries: The Voyages of Captain Cook* (London, 2003), p. 18.   161. Woolf, *Transits*, p. 155.   162. M. Le Gentil, 'Remarques et observations sur l'Astronomie des Indiens et sur l'ancienneté de cette Astronomie', *Histoire de l'Académie Royale des Sciences* (1784), pp. 482–501.   163. Martin J. S. Rudwick, *Earth's Deep History: How it was Discovered and Why it Matters* (Chicago, 2014), pp. 12–17.   164. Martin J. S. Rudwick, *The Meaning of Fossils: Episodes in the History of Palaeontology* (Chicago, 1985), pp. 49–53.   165. Peter J. Bowler, *The Fontana History of the Environmental Sciences* (London, 1992), pp. 115–18.   166. Antognazza, *Leibniz*, pp. 230–31.   167. Quoted ibid., p. 327.   168. Rudwick, *The Meaning of Fossils*, p. 93.   169. Francis C. Haber, *The Age of the World: Moses to Darwin* (Baltimore, 1959), pp. 116–18, 136.   170. Ibid., pp. 123–5.   171. O C V 30C, p. 45.   172. Ibid., p. 27.   173. 'De l'interprétation de la nature', *OCD* ii. pp. 768–9.   174. Thomas Jefferson, *Notes on the State of Virginia*, Query VI, in his *Writings*, ed. Merrill D. Peterson (New York, 1984), p. 176.   175. Rudwick, *The Meaning of Fossils*, p. 101.   176. M. le Baron G. Cuvier, *Discours sur les révolutions de la surface du globe*, 5th edn (Paris, 1828), pp. 17–18.   177. Eric Cochrane, *Florence in the Forgotten Centuries 1527–1800: A History of Florence and the Florentines in the Age of the Grand Dukes* (Chicago, 1973), pp. 232–9.   178. Tore Frängsmyr, ed., *Science in Sweden: The Royal Swedish Academy of Sciences, 1739–1989* (Canton, MA, 1989), p. 4.   179. Heilbron, *Electricity*, pp. 117–18; Gaukroger, *Collapse of Mechanism*, pp. 233–6.   180. Lindsey Hughes, *Russia in the Age of Peter the Great* (New Haven, 1998), pp. 307–8.   181. On the many smaller academies (some still extant) in the French provinces, in the German and Italian states, and in colonial America, see James E. McClellan III, *Science Reorganized: Scientific Societies in the Eighteenth Century* (New York, 1985).   182. The St Petersburg Academy, where academicians were also supposed to teach, was an exception: Hughes, *Russia*, p. 308.   183. Heilbron, *Electricity*, p. 131.   184. Gaukroger, *Collapse of Mechanism*, p. 237.   185. Quoted ibid., p. 236.   186. Quoted in Leonard M. Marsak, *Bernard de Fontenelle: The Idea of Science in the French Enlightenment* (Philadelphia, 1959), p. 6.   187. Larry Stewart, *The Rise of Public Science: Rhetoric, Technology, and Natural Philosophy in Newtonian Britain, 1660–1750* (Cambridge, 1992), p. 145.   188. Ibid., p. 95; Marjorie Hope Nicolson and G. S. Rousseau, *'This Long Disease, my Life': Alexander Pope and the Sciences* (Princeton, 1968), p. 137.   189. Stewart, *Rise of Public Science*, p. 147.   190. Ibid., p. 113.   191. Ibid., pp. 183–202; Dava Sobel, *Longitude* (New York, 1995).   192. Stewart, *Rise of Public Science*, pp. 139, 148.   193. Ibid., pp. 132–3.   194. Gaukroger, *Collapse of Mechanism*, p. 186.   195. Letter to Pierre Robert Le Cornier de Cideville, 16 April 1735, O C V 87, p. 132.   196. Barbara Stafford, *Artful Science: Enlightenment Entertainment and the Eclipse of Visual Education* (Cambridge, MA, 1994), p. 144.   197. Jean Antoine Nollet, *L'Art des expériences*, 3 vols. (Paris, 1770), i., p. xxi.   198. Titia Ram, *Magnitude in Marginality: Edward Cave and 'The Gentleman's Magazine', 1731–1754* (Utrecht, 1999), pp. 25, 38.   199. Mary Terrall, 'Natural philosophy for fashionable readers', in Marina Frasca-Spada and Nick Jardine, eds., *Books and the Sciences in History* (Cambridge, 2000), pp. 239–54 (p. 241).   200. Francesco Algarotti, *Sir Isaac Newton's Philosophy Explain'd for the Use of the Ladies*, 2 vols. (London, 1739), i, p. ii. The anonymous translator was the poet and classical scholar Elizabeth Carter.   201. Terrall, 'Natural philosophy', p. 244.   202. Terrall, *The Man*, pp. 192–5.   203. G. S. Rousseau, 'Science books and their readership in the High Enlightenment', in his *Enlightenment Borders* (Manchester, 1991), pp. 265–324 (p. 280).   204. Quoted in Stafford, *Artful Science*, p. 51.   205. W. Hooper, *Rational Recreations, in which the Principles of Numbers and Natural Philosophy are clearly and copiously elucidated, by a series of easy, entertaining, interesting experiments*, 4 vols. (London, 1774).   206. 'Tom Telescope', *The Newtonian System of Philosophy adapted to the*

*Capacities of young Gentlemen and Ladies* (London, 1761), p. 21.  **207.** Ibid., p. 77.  **208.** 'An den Herrn M**', in Lessing, *Werke und Briefe*, i. p. 117. See Karl S. Guthke, 'Lessing and science', in Ritchie Robertson, ed., *Lessing and the German Enlightenment* (Oxford, 2013), pp. 263–90.  **209.** Herder, *Werke*, iv. pp. 723–4.  **210.** See Boyd Hilton, *A Mad, Bad and Dangerous People? England 1783–1846* (Oxford, 2006), pp. 174–82.  **211.** Quoted in Eamon Duffy, *Saints and Sinners: A History of the Popes* (New Haven, 1997), p. 229.  **212.** Frank M. Turner, 'The late Victorian conflict of science and religion as an event in nineteenth-century intellectual and cultural history', in Thomas Dixon, Geoffrey Cantor and Stephen Pumfrey, eds., *Science and Religion: New Historical Perspectives* (Cambridge, 2010), pp. 87–110 (p. 87).  **213.** Lichtenberg, *Aphorisms*, tr. R. J. Hollingdale (London, 1990), p. 184.  **214.** 'Furchtableiter': letter to C. G. Heyne, quoted in Wolfram Mauser, *Georg Christoph Lichtenberg: Vom Eros des Denkens* (Freiburg i.Br., 2000), p. 51.  **215.** Engelhard Weigl, 'Entzauberung der Natur durch Wissenschaft, dargestellt am Beispiel der Erfindung des Blitzableiters', *Jahrbuch der Jean-Paul-Gesellschaft*, 22 (1987), p. 13.  **216.** Constant von Wurzbach, *Biographisches Lexikon des Kaiserthums Oesterreich* (Vienna, 1857–90), i. pp. 210–11.

## 3. TOLERATION

**1.** See Barbara Donagan, 'Atrocity, war crime, and treason in the English Civil War', *American Historical Review*, 99 (1994), pp. 1137–66 (esp. pp. 1152–61).  **2.** See Judith Pollmann, *Memory in Early Modern Europe 1500–1800* (Oxford, 2017), esp. ch. 7.  **3.** Jonathan Israel, *The Dutch Republic: Its Rise, Greatness, and Fall, 1477–1806* (Oxford, 1995), p. 185.  **4.** Mack P. Holt, *The French Wars of Religion, 1562–1629* (Cambridge, 1995), p. 95.  **5.** Peter H. Wilson, *Europe's Tragedy: A History of the Thirty Years War* (London, 2009), pp. 469–70.  **6.** Roy Foster, *Modern Ireland 1600–1972* (London, 1988), p. 85.  **7.** David Hume, *The History of England from the Invasion of Julius Caesar to the Revolution in 1688*, 6 vols. (1778; repr. Indianapolis, 1983), v. p. 345.  **8.** Friedrich Schiller, *Sämtliche Werke*, ed. Gerhard Fricke and Herbert G. Göpfert, 5 vols. (Munich, 1958), iv. pp. 522, 520.  **9.** Tim Harris, *Revolution: The Great Crisis of the British Monarchy, 1685–1720* (London, 2006), p. 182.  **10.** W. E. H. Lecky, *History of the Rise and Influence of Rationalism in Europe*, 2 vols., new edn (London, 1897), ii. p. 57.  **11.** Leah Lydia Otis, *Prostitution in Medieval Society: The History of an Urban Institution in Languedoc* (Chicago, 1985); Lyndal Roper, *The Holy Household: Women and Morals in Reformation Augsburg* (Oxford, 1989), p. 89.  **12.** John Marshall, *John Locke, Toleration and Early Enlightenment Culture* (Cambridge, 2006), p. 8; Perez Zagorin, *How the Idea of Religious Toleration Came to the West* (Princeton, 2003), p. 12.  **13.** Augustine, Sermon 112, in *Sermons on Selected Lessons of the New Testament, by St Augustine, Bishop of Hippo*, 2 vols. (Oxford, 1844), i. pp. 458–65 (p. 465). On the lasting impact of Augustine's admonition, see Marshall, *Toleration*, pp. 204–12; Mark Goldie, 'The theory of religious intolerance in Restoration England', in Ole Peter Grell, Jonathan I. Israel and Nicholas Tyacke, eds., *From Persecution to Toleration: The Glorious Revolution and Religion in England* (Oxford, 1991), pp. 331–68 (pp. 331–4).  **14.** See Henry Kamen, *Inquisition and Society in Spain* (London, 1985), pp. 174–7; Christopher F. Black, *The Italian Inquisition* (New Haven, 2009), pp. 81–8.  **15.** Thomas Edwards, *Gangraena* ([1647] Exeter, 2008), Part II, p. 197.  **16.** Edward Stillingfleet, *The Mischief of Separation: A Sermon Preach'd at Guild-Hall Chappel, May 11 MDCLXXX, being the Fifth Sunday in Easter-Term, before the Lord Mayor, etc.* (London, 1709), p. 23.  **17.** Ibid. p. 39. See John Marshall, 'The ecclesiology of the Latitude-men, 1660–1689: Stillingfleet, Tillotson and "Hobbism"', *Journal of Ecclesiastical History*, 36 (1985), pp. 407–27 (pp. 416–19).  **18.** Edwards, *Gangraena*, Part I, p. 64.  **19.** Sir Charles Firth, *Oliver Cromwell and the Rule of the Puritans in England* ([1900]; Oxford, 1953), p. 148.  **20.** Blair Worden, 'Toleration and the Cromwellian Protectorate', in W. J. Sheils, ed., *Persecution and Toleration*, Studies in Church History 21 (Oxford, 1984), pp. 199–233.  **21.** Herbert Butterfield, *Historical Development of the Principle of Toleration in British Life*, Robert

Waley Cohen Memorial Lecture 1956 (London, 1957), p. 4.   **22.** *Civilization and its Discontents*, in *The Standard Edition of the Complete Psychological Works of Sigmund Freud*, ed. James Strachey, 24 vols. (London, 1953–74), xxi. p. 114.   **23.** Alexandra Walsham, *Charitable Hatred: Tolerance and Intolerance in England, 1500–1700* (Manchester, 2006), p. 230.   **24.** Byron, *The Vision of Judgment*, st. 14, in *Poetical Works*, ed. Frederick Page, corrected by John Jump (Oxford, 1970), p. 159.   **25.** On modern religious pluralism as a legacy of the Enlightenment, see Diarmaid MacCulloch, *Reformation: Europe's House Divided* (London, 2003), pp. 698–701.   **26.** Adam Smith, *An Inquiry into the Nature and Causes of the Wealth of Nations*, ed. R. H. Campbell and A. S. Skinner (Oxford, 1976), pp. 792–3.   **27.** For the text of the Edict, see Roland Mousnier, *The Assassination of Henri IV*, tr. Joan Spencer (London, 1973), pp. 316–63.   **28.** See Holt, *French Wars*, pp. 171–2.   **29.** Quoted in Henry Kamen, *The Rise of Toleration* (London, 1967), p. 150.   **30.** Quoted ibid., p. 194.   **31.** François Bluche, *Louis XIV*, tr. Mark Greengrass (Oxford, 1990), p. 401.   **32.** *The Pastoral Letters of the Incomparable Jurieu Directed to the Protestants in France Groaning under the Babylonish Tyranny*, translated (London, 1689), p. 181.   **33.** *Pastoral Letters*, p. 182. For a survey of the persecutions, with critical attention to sources, see Marshall, *Toleration*, pp. 18–21, 25–8.   **34.** Bluche, *Louis XIV*, pp. 403–5; Kamen, *Toleration*, p. 197.   **35.** Marisa Linton, 'Citizenship and religious toleration in France', in Ole Peter Grell and Roy Porter, eds., *Toleration in Enlightenment Europe* (Cambridge, 2000), pp. 157–74 (p. 160).   **36.** See Arthur Hertzberg, *The French Enlightenment and the Jews* (New York, 1968), pp. 14–28.   **37.** As quoted in Lynn Hunt, *Inventing Human Rights: A History* (New York, 2007), p. 222.   **38.** Sir William Temple, *Observations upon the United Provinces of the Netherlands* [1673], ed. Sir George Clark (Oxford, 1972), p. 103.   **39.** On payment for religious toleration, see Christine Kooi, 'Paying off the sheriff: strategies of Catholic toleration in Golden Age Holland', in R. Po-chia Hsia and H. F. K. van Nierop, eds., *Calvinism and Religious Toleration in the Dutch Golden Age* (Cambridge, 2002), pp. 87–101 (pp. 91–3). For population figures, see Israel, *Dutch Republic*, p. 641.   **40.** Charles H. Parker, *Faith on the Margins: Catholics and Catholicism in the Dutch Golden Age* (Cambridge, MA, 2008), p. 17.   **41.** Temple, *Observations*, p. 105.   **42.** Israel, *Dutch Republic*, pp. 97–8; MacCulloch, *Reformation*, pp. 208–10; Alastair Hamilton, *The Family of Love* (Cambridge, 1981), pp. 111, 140–41.   **43.** Temple, *Observations*, p. 105.   **44.** MacCulloch, *Reformation*, p. 206.   **45.** Samme Zijlstra, 'Anabaptism and tolerance: possibilities and limitations', in Hsia and van Nierop, *Calvinism*, pp. 112–31. At the present day there are some 1.7 million Mennonites scattered through many countries.   **46.** See Sarah Mortimer, *Reason and Religion in the English Reformation: The Challenge of Socinianism* (Cambridge, 2009), pp. 15–22, 149–57. For Socinianism in Germany, see Karl Aner, *Die Theologie der Lessingzeit* (Halle, 1929), pp. 32–46.   **47.** Roland H. Bainton, *Erasmus of Christendom* (London, 1970), p. 169. See Edward Gibbon, *The History of the Decline and Fall of the Roman Empire*, ed. David Womersley, 3 vols. (London, 1994), ii. pp. 442–3.   **48.** Ian Atherton and David Como, 'The burning of Edward Wightman: puritanism, prelacy and the politics of heresy in early modern England', *English Historical Review*, 120 (2005), pp. 1215–50 (esp. p. 1215).   **49.** See Rob Iliffe, *Priest of Nature: The Religious Worlds of Isaac Newton* (Oxford, 2017), p. 136.   **50.** *Paradise Lost*, i. l. 4; see Stephen P. Dobranski and John P. Rumrich, eds., *Milton and Heresy* (Cambridge, 1998).   **51.** See Hugh Trevor-Roper, 'Toleration and religion after 1688', in Grell, Israel and Tyacke, *From Persecution to Toleration*, pp. 389–410 (p. 401).   **52.** See D. P. Walker, *The Decline of Hell: Seventeenth-Century Discussions of Eternal Torment* (London, 1964), pp. 78–9; Jonathan Israel, *Enlightenment Contested: Philosophy, Modernity, and the Emancipation of Man 1670–1752* (Oxford, 2006), pp. 115–24; Mortimer, *Reason and Religion*, pp. 45–53.   **53.** See Jonathan Israel, *Radical Enlightenment: Philosophy and the Making of Modernity 1650–1750* (Oxford, 2001), pp. 185–96; Steven Nadler, *A Book Forged in Hell: Spinoza's Scandalous Treatise and the Birth of the Secular Age* (Princeton, 2011), pp. 38–43.   **54.** Temple, *Observations*, p. 104.   **55.** Quoted in Marshall, *Toleration*, p. 147. On the hostility of the Reformed Church to Jews, see Israel, *Dutch Republic*, pp. 376–7.   **56.** I follow the summary of the debate in Israel, *Dutch Republic*, pp. 500–505.   **57.** Confusingly,

he was William III both as stadholder and later as king. 58. Israel, *Dutch Republic*, p. 647. 59. Marshall, *Toleration*, pp. 160–61. 60. Gilbert Burnet, *History of his own Time*, 2 vols. (London, 1724–34), i. p. 691. 61. Israel, *Dutch Republic*, p. 676; cf. Parker, *Faith on the Margins*, pp. 12–13. 62. Goldie, 'The theory of religious intolerance', p. 331. 63. Marshall, *Toleration*, p. 104. 64. See Adrian Davies, *The Quakers in English Society, 1655–1725* (Oxford, 2000), p. 171; Marshall, *Toleration*, p. 99. 65. Ann Docwra, *Spiritual Community, vindicated among people of different perswasions in some things* (London, 1687), p. 3. On Docwra (1624–1710), née Waldegrave, a prominent and outspoken pamphleteer, see Sarah Apetrei, *Women, Feminism and Religion in Early Enlightenment England* (Cambridge, 2010), pp. 160–68. 66. Quoted in Steve Pincus, *1688: The First Modern Revolution* (New Haven, 2009), p. 96. 67. A brief survey of opinion in Pincus, *1688*, p. 120. See also Scott Sowerby, *Making Toleration: The Repealers and the Glorious Revolution* (Cambridge, MA, 2013). 68. Quoted in Sowerby, *Making Toleration*, p. 25. 69. Quoted in J. R. Jones, 'James II's Revolution: royal policies, 1686–92', in Jonathan I. Israel, ed., *The Anglo-Dutch Moment: Essays on the Glorious Revolution and its World Impact* (Cambridge, 1991), pp. 47–71 (p. 59). 70. Sowerby, *Making Toleration*, p. 41. 71. Docwra, *Spiritual Community*, p. 2. 72. Harris, *Revolution*, p. 192. 73. The Petres' feud with the Fermor family, which started when a Petre cut off a lock of Arabella Fermor's hair, prompted their fellow-Catholic Alexander Pope to write *The Rape of the Lock* (1714). 74. Pincus, *1688*, esp. pp. 121–2. On James's efforts to propagate Catholicism, see J. R. Jones, *The Revolution of 1688 in England* (London, 1972), pp. 78–97, and Pincus, *1688*, pp. 143–78. 75. See Linda Colley, *Britons: Forging the Nation 1707–1837* (New Haven, 1992), pp. 25–8. 76. Marshall, *Toleration*, p. 29. 77. Colley, *Britons*, p. 23. 78. See Colin Haydon, *Anti-Catholicism in Eighteenth-Century England* (Manchester, 1993). 79. See G. C. Gibbs, 'The reception of the Huguenots in England and the Dutch Republic, 1680–1690', in Grell, Israel and Tyacke, *From Persecution to Toleration*, pp. 275–306. 80. 'On the late Massacre in Piedmont' (1655), in *The Poems of John Milton*, pp. 411–12. 81. Harris, *Revolution*, p. 186; Marshall, *Toleration*, pp. 55–69. 82. Pincus, *1688*, p. 137; cf. Jones, *Revolution*, pp. 112–13. 83. Jones, 'James II's Revolution', pp. 55–6. 84. Quoted in Harris, *Revolution*, p. 263. 85. *History of England*, ch. 9, in *The Works of Lord Macaulay*, 12 vols. (London, 1898), iii. p. 25. 86. On the success of William's propaganda campaign in inducing amnesia, see Lisa Jardine, *Going Dutch: How England Plundered Holland's Glory* (London, 2008), p. 35. 87. See Jonathan I. Israel, 'William III and toleration', in Grell, Israel and Tyacke, *From Persecution to Toleration*, pp. 129–70. 88. Israel, 'William III', p. 143. 89. Macaulay, *History of England*, ch. 11, in *Works*, iii. p. 374. 90. On the shortcomings of the Act, and on the continued marginalization of Dissenters in eighteenth-century England, see Trevor-Roper, 'Toleration'; for a qualified defence of the Act, Israel, 'William III', pp. 152–4. 91. Quoted in Israel, 'William III', p. 155. Cf. Marshall, *Toleration*, p. 135. 92. Harris, *Revolution*, p. 449. 93. Marshall, *Toleration*, p. 136. 94. Hobbes, *Leviathan*, p. 256. On the ascription of the Pentateuch to Ezra, see Noel Malcolm, 'Hobbes, Ezra, and the Bible: the history of a subversive idea', in his *Aspects of Hobbes* (Oxford, 2002), pp. 383–431. 95. Michael F. Graham, *The Blasphemies of Thomas Aikenhead* (Edinburgh, 2008), pp. 108–10. See also Michael Hunter, ' "Aikenhead the Atheist": the context and consequences of articulate irreligion in the late seventeenth century', in Michael Hunter and David Wootton, eds., *Atheism from the Reformation to the Enlightenment* (Oxford, 1992), pp. 221–54. 96. Macaulay, *History of England*, ch. 22, in *Works*, vi. p. 259. 97. Cf. Sowerby, *Making Toleration*, p. 251. 98. See Walter Grossmann, 'Religious toleration in Germany, 1684–1750', *SVEC*, 201 (1982), pp. 115–41; Joachim Whaley, 'A tolerant society? Religious toleration in the Holy Roman Empire, 1648–1806', in Grell and Porter, *Toleration*, pp. 175–95. 99. Joachim Whaley, *Germany and the Holy Roman Empire*, 2 vols. (Oxford, 2012), i. pp. 333–6. 100. On the composition of the Empire, see the overview in W. H. Bruford, *Germany in the Eighteenth Century: The Social Background of the Literary Revival* (Cambridge, 1935), pp. 333–6. 101. Whaley, *Germany*, ii. pp. 325–6. 102. Ibid., ii. p. 328. 103. Friedrich Nicolai, *Beschreibung einer Reise durch Deutschland und die Schweiz im Jahre 1781. Nebst Bemerkungen über Gelehrsamkeit*,

*Industrie, Religion und Sitten*, 12 vols. (Berlin and Stettin, 1783–96), v. p. 17.    **104.** Christopher Clark, *Iron Kingdom: The Rise and Downfall of Prussia, 1600–1947* (London, 2006), p. 122.    **105.** *Mémoires pour servir à l'histoire de la Maison de Brandebourg*, in *Œuvres de Frédéric le Grand*, ed. J. D. E. Preuss, 33 vols. (Berlin, 1846–57), i. p. 204.    **106.** See Tim Blanning, *Frederick the Great, King of Prussia* (London, 2015), pp. 379–87.    **107.** Quoted ibid., p. 383.    **108.** Derek Beales, *Joseph II*, vol. i: *In the Shadow of Maria Theresa, 1741–1780* (Cambridge, 1987), pp. 465–73; Beales, *Joseph II*, vol. ii: *Against the World, 1780–1790* (Cambridge, 2009), pp. 171–7.    **109.** *Maria Theresia und Joseph II. Ihre Correspondenz*, ed. Alfred Ritter von Arneth, 3 vols. (Vienna, 1867), iii. pp. 351–2.    **110.** See T. C. W. Blanning, *Joseph II* (London, 1994), p. 72; for a full account, Beales, *Joseph II*, ii. pp. 170–213.    **111.** See Joachim Whaley, *Religious Toleration and Social Change in Hamburg 1529–1819* (Cambridge, 1985), p. 146. Joseph's spirit of tolerance survived into the nineteenth century, notably in the philosopher Bernard Bolzano (1781–1848): see J. P. Stern, 'Bolzano's Bohemia', in his *The Heart of Europe: Essays on Literature and Ideology* (Oxford, 1992), pp. 29–43 (esp. pp. 39–40).    **112.** Mary K. Geiter, *William Penn* (London, 2000), p. 19.    **113.** On this action and its meaning, see Leo Damrosch, *The Sorrows of the Quaker Jesus: James Nayler and the Puritan Crackdown on the Free Spirit* (Cambridge, MA, 1996), pp. 146–76.    **114.** On Quaker customs, see Davies, *Quakers*, pp. 35–63.    **115.** Marshall, *Toleration*, pp. 101–13.    **116.** See Gary S. de Krey, 'Rethinking the Restoration: dissenting cases for conscience, 1667–1672', *Historical Journal*, 38 (1995), pp. 53–83 (esp. p. 64), where Penn's case for toleration is differentiated from arguments made by other Dissenting groups.    **117.** Mary Maples Dunn, *William Penn: Politics and Conscience* (Princeton, 1967), pp. 138–9.    **118.** See Geiter, *Penn*, pp. 68–9.    **119.** Dunn, *Penn*, p. 77.    **120.** Quoted ibid., p. 99.    **121.** Ibid.    **122.** Quoted in Urs Bitterli, *Cultures in Conflict: Encounters between European and Non-European Cultures, 1492–1800*, tr. Ritchie Robertson (Cambridge, 1989), p. 115.    **123.** Penn, *Account of the Lenni Lenape*, quoted in Bitterli, *Cultures*, p. 121.    **124.** Bitterli, *Cultures*, p. 129.    **125.** Temple, *Observations*, p. 99.    **126.** Locke, *Two Treatises of Government* and *A Letter concerning Toleration*, ed. Ian Shapiro (New Haven, 2003), p. 232; cf. p. 240. For other specimens of this argument, see Walsham, *Charitable Hatred*, pp. 240–41.    **127.** Bainton, *Erasmus*, p. 222.    **128.** Locke, *Letter*, p. 217.    **129.** Sylvana Tomaselli, 'Intolerance, the virtue of princes and radicals', in Grell and Porter, *Toleration*, pp. 86–101 (pp. 89–90).    **130.** See Walsham, *Charitable Hatred*, p. 302.    **131.** Locke, *Letter*, p. 248.    **132.** Ibid., p. 245.    **133.** For other thinkers who refused to tolerate atheists, see Israel, *Enlightenment Contested*, p. 143.    **134.** Jeremy Waldron, *God, Locke, and Equality: Christian Foundations in Locke's Political Thought* (Cambridge, 2002), p. 85.    **135.** Benedict de Spinoza, *A Theologico-Political Treatise; A Political Treatise*, tr. R. H. M. Elwes (New York, 1951), p. 257.    **136.** Bayle, *Commentaire philosophique sur ces paroles de Jésus-Christ: contrains-les d'entrer* ('Cantorbery', 1686), p. 211; translation from *Philosophical Commentary*, tr. Amie Godman Tannenbaum (New York, 1987), p. 91.    **137.** Bainton, *Erasmus*, p. 225; Walsham, *Charitable Hatred*, p. 241.    **138.** Locke, *Letter*, p. 229.    **139.** Tindal, *Christianity as Old as the Creation* (London, 1730; repr. New York and London, 1978), p. 13.    **140.** Jean-François Marmontel, *Bélisaire*, ed. Robert Granderoute (Paris, 1994), p. 188. On the scandal, see Alan Charles Kors, *D'Holbach's Coterie: An Enlightenment in Paris* (Princeton, 1976), pp. 124–9.    **141.** See Walsham, *Charitable Hatred*, p. 244.    **142.** Marmontel, *Bélisaire*, p. 190.    **143.** Letter of 6 Apr. 1778 in Lessing, *Werke und Briefe*, xii. p. 144.    **144.** See Jeroom Vercruysse, *Voltaire et la Hollande* (Geneva, 1966), pp. 134, 162–70.    **145.** William Penn, *The Great Case of Liberty of Conscience Once more Briefly Debated & Defended, by the Authority of Reason, Scripture, and Antiquity* (n.p., 1670), p. 34.    **146.** Voltaire, *Letters concerning the English Nation*, ed. Nicholas Cronk (Oxford, 1994), p. 30.    **147.** For a brief account of Bayle's life, see Elisabeth Labrousse, *Bayle*, tr. Denys Potts (Oxford, 1983); more detail in her *Pierre Bayle*, 2 vols. (The Hague, 1963–4), vol. i.    **148.** See Marshall, *Toleration*, pp. 420–23.    **149.** Letter to Pierre Silvestre, 17 Dec. 1691, in *Correspondance de Pierre Bayle*, ed. Elisabeth Labrousse and others, 11 vols. (Oxford, 1999– ), viii. p. 458.    **150.** Pierre Bayle, *Pensées diverses sur la comète*, ed. A. Prat, 2 vols. (Paris, 1939), i. p. 26.    **151.** John McManners, *Church and Society in*

*Eighteenth-Century France*, 2 vols. (Oxford, 1998), ii. p. 225. **152.** Bayle, *Pensées diverses*, ii. p. 9. **153.** On him, see Israel, *Enlightenment Contested*, p. 631. **154.** For a concise account of Vanini's life and opinions, see Nicholas Davidson, 'Unbelief and atheism in Italy, 1500–1700', in Hunter and Wootton, *Atheism*, pp. 55–85 (pp. 73–4). **155.** Bayle, *Pensées diverses*, ii. pp. 135–8. **156.** On the structure and composition of the *Dictionnaire*, see Mara van der Lugt, *Bayle, Jurieu, and the 'Dictionnaire Historique et Critique'* (Oxford, 2016), pp. 15–69. For Bayle's place in the history of footnoting, see Anthony Grafton, *The Footnote: A Curious History* (London, 1997), pp. 191–200. **157.** *Ludvig Holberg's Memoirs*, ed. Stewart E. Fraser (Leiden, 1970), p. 60. **158.** See H. T. Mason, *Pierre Bayle and Voltaire* (Oxford, 1963); J. G. A. Pocock, *Barbarism and Religion*, vol. i: *The Enlightenments of Edward Gibbon, 1737–1764* (Cambridge, 1999), p. 78; H. B. Nisbet, 'Lessing and Pierre Bayle', in C. P. Magill, Brian A. Rowley and Christopher J. Smith, eds., *Tradition and Creation: Essays in Honour of Elizabeth Mary Wilkinson* (Leeds, 1978), pp. 13–29. **159.** James Boswell, *Life of Johnson*, ed. R. W. Chapman, corrected by J. D. Fleeman (London, 1970), p. 301 (conversation of 6 July 1763). **160.** See Millicent Bell, 'Pierre Bayle and *Moby Dick*', *PMLA*, 66 (1951), pp. 626–48. Van der Lugt suggests (*Bayle*, p. 251) that the hero of Melville's *Pierre, or, the Ambiguities* (1852) is named after Bayle. **161.** Bayle, *Dictionnaire historique et critique*, 4 vols. (Amsterdam, 1730), i. pp. 392–3. **162.** On the diversity of interpretations, see Walker, *Decline of Hell*, pp. 178–201 (esp. p. 187); Thomas Lennon, *Reading Bayle* (Toronto, 1999), p. 15; Israel, *Radical Enlightenment*, pp. 332–8; Adam Sutcliffe, *Judaism and Enlightenment* (Cambridge, 2003), pp. 90–94; van der Lugt, *Bayle*, pp. 3–7. **163.** Tim Whitmarsh, *Battling the Gods: Atheism in the Ancient World* (London, 2016), p. 161. Cf. the objections to Pyrrhonism in Hume, *Dialogues concerning Natural Religion*, ed. John Valdimir Price (Oxford, 1976), pp. 148–55. **164.** On the problems raised by this conception of faith, see Terence Penelhum, 'Skepticism and Fideism', in Myles Burnyeat, ed., *The Skeptical Tradition* (Berkeley, 1983), pp. 287–318 (esp. p. 295). **165.** Richard Popkin, *The History of Scepticism: From Savonarola to Bayle* (New York, 2003), p. 291. **166.** Quentin Skinner, 'Meaning and understanding in the history of ideas', *History and Theory*, 8 (1969), pp. 3–53 (p. 34). For the view, held by some contemporaries, that Bayle's apparent fideism was a mere smokescreen, see Israel, *Enlightenment Contested*, p. 82. **167.** Van der Lugt, *Bayle*, p. 249. **168.** 'Rufinus', in Bayle, *Historical and Critical Dictionary: Selections*, ed. and tr. Richard H. Popkin (Indianapolis, 1965), p. 262. **169.** 'Manichaeans', note D, in *Selections*, ed. Popkin, p. 149. **170.** 'Paulicians', note F, in *Selections*, ed. Popkin, p. 181. **171.** 'Paulicians', note F, in *Selections*, ed. Popkin, p. 186. **172.** G. W. Leibniz, *Theodicy: Essays on the Goodness of God, the Freedom of Man and the Origin of Evil*, tr. E. M. Huggard (London, 1951), p. 58. **173.** Bayle, *Commentaire philosophique*, p. 15; translation from *Philosophical Commentary*, p. 31. **174.** Walter Rex, *Essays on Pierre Bayle and Religious Controversy* (The Hague, 1965), p. 161. **175.** Bayle, *Commentaire philosophique*, pp. 529–30; *Philosophical Commentary*, p. 179. **176.** Edward Gibbon, *Memoirs of my Life*, ed. Georges A. Bonnard (London, 1966), p. 65. **177.** Letter to Étienne Noël Damilaville, 4 April 1762, *OCV* 108, p. 369. **178.** See David D. Bien, *The Calas Affair: Persecution, Toleration, and Heresy in Eighteenth-Century Toulouse* (Princeton, 1960); Ian Davidson, *Voltaire: A Life*, rev. edn (London, 2012), pp. 317–31. **179.** *Dictionnaire philosophique*, *OCV* 36, p. 552. **180.** Voltaire, *Treatise on Tolerance and Other Writings*, tr. Brian Masters and Simon Harvey, ed. Simon Harvey (Cambridge, 2000), p. 49. **181.** See John Renwick, 'Voltaire and the politics of toleration', in Nicholas Cronk, ed., *The Cambridge Companion to Voltaire* (Cambridge, 2009), pp. 179–92 (p. 188). **182.** Voltaire, *Treatise*, p. 22. **183.** Ibid., p. 65. **184.** Ibid., p. 25. **185.** 'A Rejoinder' (1778), in Lessing, *Philosophical and Theological Writings*, ed. and tr. H. B. Nisbet (Cambridge, 2005), pp. 95–109 (p. 98). See Nisbet, 'Lessing and the search for truth', *Publications of the English Goethe Society*, 43 (1972–3), pp. 72–95. **186.** See Alexander Altmann, *Moses Mendelssohn: A Biographical Study* (London, 1973), pp. 264–5; Blanning, *Frederick*, p. 384. **187.** *Nathan der Weise*, I. ii, in Lessing, *Werke und Briefe*, ed. Wilfried Barner and others, 12 vols. (Frankfurt a.M., 1987–98), ix. p. 533. Translation from Ritchie Robertson, *The 'Jewish Question' in German Literature, 1749–1939* (Oxford, 1999), p. 41. **188.** On the play's importance in

German-Jewish culture, and on Jewish criticisms of its implied standpoint, see Ritchie Robertson, ' "Dies hohe Lied der Duldung"? The ambiguities of toleration in Lessing's *Die Juden* and *Nathan der Weise*', *Modern Language Review*, 93 (1998), pp. 105–20; Adam Sutcliffe, 'Lessing and toleration', in Ritchie Robertson, ed., *Lessing and the German Enlightenment* (Oxford, 2013), pp. 205–25.  **189.** Nicholas Boyle, *Goethe: The Poet and the Age*, 2 vols. to date (Oxford, 1991–2000), i. p. 33; cf. p. 273, and Rainer Forst, *Toleration in Conflict: Past and Present* (Cambridge, 2011), p. 307.  **190.** Boyle, *Goethe*, i. pp. 44–5.  **191.** Goethe, *Dichtung und Wahrheit*, in *Sämtliche Werke: Briefe, Tagebücher und Gespräche*, ed. Friedmar Apel and others, 40 vols. (Frankfurt a.M., 1986–2000), xiv. p. 50. On the intellectual bankruptcy of eighteenth-century German Lutheranism, see K. F. Hilliard, *Freethinkers, Libertines and 'Schwärmer': Heterodoxy in German Literature, 1750–1800* (London, 2011), pp. 17–24.  **192.** Goethe, *Sämtliche Werke*, xiv. pp. 36–7.  **193.** Ibid., p. 153.  **194.** *Gottfrid Arnolds Unparteyische Kirchen- und Ketzer-Historie / von Anfang des Neuen Testaments biß auff das Jahr Christi 1688*, 4 vols. in 2 (Frankfurt, 1699 and 1700), i. p. 275; on Servetus, ii. p. 407.  **195.** Erich Seeberg, *Gottfried Arnold: Die Wissenschaft und die Mystik seiner Zeit* (Meerane, 1923; repr. Darmstadt, 1964), pp. 537–8.  **196.** On tolerance in a range of Goethe's works, see Paul E. Kerry, *Enlightenment Thought in the Writings of Goethe: A Contribution to the History of Ideas* (Rochester, NY, 2001).  **197.** For the development of this argument, see Ritchie Robertson, 'Goethe and Machiavelli', in John Walker, ed., *The Present Word: Culture, Society and the Site of Literature. Essays in Honour of Nicholas Boyle* (London, 2013), pp. 126–37.  **198.** Goethe, *Sämtliche Werke*, xviii. p. 123.  **199.** Ibid., p. 125.  **200.** Edmund Burke, *Reflections on the Revolution in France*, ed. L. G. Mitchell (Oxford, 1993), p. 151.  **201.** Goethe, *Sämtliche Werke*, xiii. p. 249.  **202.** Kant, *Political Writings*, ed. Hans Reiss, tr. H. B. Nisbet, 2nd edn (Cambridge, 1991), p. 58.  **203.** Thomas Paine, *Rights of Man, Common Sense, and Other Political Writings*, ed. Mark Philp (Oxford, 1995), p. 137.  **204.** Forst, *Toleration*, p. 327.  **205.** Kevin J. Hayes, *The Road to Monticello: The Life and Mind of Thomas Jefferson* (New York, 2008), p. 205.  **206.** Jefferson, *Notes on the State of Virginia*, in his *Writings*, ed. Merrill D. Peterson (New York, 1984), p. 285.

## 4 THE RELIGIOUS ENLIGHTENMENT

**1.** See Voltaire's letter to Mme d'Épinay, c. 1 June 1759, in *OCV* 104, p. 194. On what Voltaire meant by 'l'infâme', see René Pomeau, *La Religion de Voltaire*, 2nd edn (Paris, 1969), pp. 314–15.  **2.** Peter Gay, *The Enlightenment: An Interpretation*, 2 vols. (New York, 1966–9), vol. 1: *The Rise of Modern Paganism*, p. 323. Cf. Ira O. Wade, *The Clandestine Organization and Diffusion of Philosophic Ideas in France from 1700 to 1750* (Princeton, 1938), esp. p. 271.  **3.** See Roy Porter, *Enlightenment: Britain and the Creation of the Modern World* (London, 2000), esp. p. 99; Jeffrey M. Suderman, 'Religion and philosophy', in Aaron Garrett and James A. Harris, eds., *Scottish Philosophy in the Eighteenth Century*, vol. 1: *Morals, Politics, Art, Religion* (Oxford, 2015), pp. 196–238 (p. 235).  **4.** See K. F. Hilliard, *Freethinkers, Libertines and 'Schwärmer': Heterodoxy in German Literature, 1750–1800* (London, 2011), pp. 22–3.  **5.** See Renée Haynes, *Philosopher King: The Humanist Pope Benedict XIV* (London, 1970); on his support for Bassi, see Paula Findlen, 'Science as a career in Enlightenment Italy: the strategies of Laura Bassi', *Isis*, 84 (1993), pp. 441–69 (pp. 457–64).  **6.** David Sorkin, *The Religious Enlightenment: Protestants, Jews, and Catholics from London to Vienna* (Princeton, 2008); Helena Rosenblatt, 'The Christian Enlightenment', in Stewart J. Brown and Timothy Tackett, eds., *The Cambridge History of Christianity*, vol. 7: *Enlightenment, Reawakening and Revolution* (Cambridge, 2006), pp. 283–301; Ulrich L. Lehner, *The Catholic Enlightenment: The Forgotten History of a Global Movement* (Oxford, 2016).  **7.** Jonathan Israel, *Radical Enlightenment: Philosophy and the Making of Modernity 1650–1750* (Oxford, 2001), p. 11.  **8.** Sorkin, *Religious Enlightenment*, p. 20.  **9.** Ibid., p. 19.  **10.** Ibid., p. 13.  **11.** See the quotations ibid., p. 11.  **12.** Leibniz, letter quoted in Arthur O. Lovejoy, *The Great Chain of Being* (Cambridge, MA, 1936), pp. 144–5.  **13.** George Herbert, 'Providence', quoted in Lovejoy, *Great Chain*,

p. 60. **14.** Lovejoy, *Great Chain*, p. 145. **15.** [Abraham] Trembley, *Mémoires pour servir à l'histoire d'un genre de polypes d'eau douce, à bras en forme de cornes* (Paris, 1744), p. 39. The polyp was celebrated in verse: see Inger Leemans and Gert-Jan Johannes, *Worm en donder: Geschiedenis van de Nederlandse literatuur 1700–1800* (Amsterdam, 2013), p. 463. **16.** Paul-Alexandre Dulard, *La Grandeur de Dieu dans les merveilles de la nature: poëme*, 4th, enlarged edn (Paris, 1758), p. 265. The microscopist Leeuwenhoek himself described animalculae as 'living atoms': see Catherine Wilson, *The Invisible World: Early Modern Philosophy and the Invention of the Microscope* (Princeton, 1995), p. 89. **17.** Basil Willey, *The Eighteenth-Century Background: Studies on the Idea of Nature in the Thought of the Period* (London, 1940), p. 43. **18.** Lovejoy, *Great Chain*, pp. 190, 193. **19.** Pope, *An Essay on Man*, i. ll. 193–4, in *TE* iii/1. pp. 38–9. **20.** Walter Charleton, *Natural History of Nutrition, Life and Voluntary Motion* (London, 1659), 'Epistle Dedicatory', n.p. Published simultaneously in Latin as *Oeconomia animalis*. **21.** On Linnaeus' text as an ancestor of modern ecology, see Donald Worster, *Nature's Economy: A History of Ecological Ideas* (Cambridge, 1977), pp. 33–44. Darwin, who read it in 1841, speaks of 'the economy of nature': see Charles Darwin, *The Origin of Species* (Harmondsworth, 1968), p. 116, and Trevor Pearce, ' "A great complication of circumstances" – Darwin and the economy of nature', *Journal of the History of Biology*, 43 (2010), pp. 493–528 (p. 510). **22.** [Carl von Linné], 'The œconomy of nature, by Isaac Biberg', in *Miscellaneous Tracts relating to Natural History, Husbandry, and Physick*, tr. Benjamin Stillingfleet, 2nd edn (London, 1762), pp. 37–130 (p. 114). **23.** Quoted in Lisbet Koerner, *Linnaeus: Nature and Nation* (Cambridge, MA, 1999), p. 83. **24.** Linnaeus, *Politia Naturae* (1760), quoted in Knut Hagberg, *Carl Linnaeus* (London, 1952), p. 183. **25.** This is a loose paraphrase of the argument put forward by William King in *De origine mali* (1702) and discussed by Lovejoy, *Great Chain*, pp. 212–23. **26.** Anthony Ashley Cooper, third Earl of Shaftesbury, *An Inquiry Concerning Virtue or Merit* (1699), in his *Characteristics of Men, Manners, Opinions, Times*, ed. Lawrence E. Klein (Cambridge, 1999), p. 169. **27.** John Bruckner, *A Philosophical Survey of the Animal Creation* (London, 1768), p. 65. Originally *Théorie du système animal* (1767). **28.** Bruckner, *Philosophical Survey*, p. xiv. **29.** Ibid., p. 66. **30.** Ibid., p. 60. **31.** Ibid., pp. 146–7. **32.** Ibid., p. 157. **33.** Ibid., p. 161. Cf. the end of Darwin's chapter 'Struggle for Existence': 'When we reflect on this struggle, we may console ourselves with the full belief, that the war of nature is not incessant, that no fear is felt, that death is generally prompt, and that the vigorous, the healthy, and the happy survive and multiply.' Darwin, *The Origin of Species*, p. 129. **34.** See Carl L. Becker, *The Heavenly City of the Eighteenth-Century Philosophers* (New Haven, 1932), where Enlightenment philosophers are mocked for having blind faith in a cosmic order that was merely a secularized version of the Christian outlook. Becker underestimates the scepticism and pessimism which are also common in the Enlightenment. **35.** Shaftesbury, *The Moralists: A Philosophical Rhapsody* (1709), in *Characteristics of Men*, pp. 245–6. **36.** Pope, *An Essay on Man*, i. l. 294, in *TE* iii/1. pp. 50–51. **37.** Johann Bernhard Basedow, *Elementarwerk: Ein geordneter Vorrath aller nöthigen Erkenntniß zum Unterricht der Jugend*, 4 vols. (Dessau, 1774), ii. p. 16. **38.** Soame Jenyns, *A Free Inquiry into the Nature and Origin of Evil* (London, 1757), p. 45. **39.** Ibid., pp. 65–6. **40.** Thomas Nagel, 'The absurd', in his *Mortal Questions* (Cambridge, 1979), pp. 11–23 (p. 16). **41.** Samuel Johnson, 'Review of Soame Jenyns, *A Free Inquiry into the Nature and Origin of Evil* ', in *The Yale Edition of the Works of Samuel Johnson*, ed. Herman W. Liebert and others (New Haven, 1963–2010), vol. xvii: *A Commentary on Mr Pope's Principles of Morality, or Essay on Man*, ed. O. M. Brack, Jr (2004), pp. 397–432 (p. 419); see Richard B. Schwartz, *Samuel Johnson and the Problem of Evil* (Madison, WI, 1975), who reprints the review in facsimile. In it, Johnson also sharply criticizes the concept of the chain of being (p. 403). **42.** *Paradise Lost*, i. l. 26. **43.** G. W. Leibniz, *Theodicy: Essays on the Goodness of God, the Freedom of Man and the Origin of Evil*, tr. E. M. Huggard (London, 1951), p. 129. Leibniz is alluding to the *History of the Sevarambians*, a utopian novel by the Huguenot exile Denis Vairasse, first published (in Latin and English versions) in London in 1675. **44.** Albrecht von Haller, *Die Alpen und andere Gedichte*, ed. Adalbert Elschenbroich (Stuttgart, 1965), p. 61. **45.** Leibniz, *Theodicy*, p. 130. **46.** It has been

argued that Leibniz is here responding to Bayle's reflections on evil (see Ch. 3 above): David Wootton, *Power, Pleasure and Profit: Insatiable Appetites from Machiavelli to Madison* (Cambridge, MA, 2018), p. 229.  47. Leibniz, *Theodicy*, p. 130.  48. Milton, *Paradise Lost*, iii. l. 570. Cf. Karl S. Guthke, *The Last Frontier: Imagining Other Worlds, from the Copernican Revolution to Modern Science Fiction*, tr. Helen Atkins (Ithaca, NY, 1990).  49. Leibniz, *Theodicy*, p. 205.  50. Voltaire, *Candide and Other Stories*, tr. Roger Pearson (Oxford, 2006), p. 11.  51. Voltaire, *Candide*, p. 83.  52. 'On the miscarriage of all philosophical trials in theodicy', tr. George di Giovanni, in Kant, *Religion and Rational Theology*, The Cambridge Edition of the Works of Immanuel Kant (Cambridge, 1996), pp. 19–37 (p. 27). This translation of Kant's title seems unnecessarily elaborate. Cf. 'Über das Mißlingen aller philosophischen Versuche in der Theodizee', in Kant, *Werke*, ed. Wilhelm Weischedel, 6 vols. (Darmstadt, 1958), vi. pp. 105–24.  53. Verri, 'Introduzione', in *Discorsi del Conte Pietro Verri sull' indole del piacere e del dolore; sulla felicità; e sulla economia politica* (Milan, 1781), pp. 101–4.  54. Kant, *Religion and Rational Theology*, p. 29.  55. Cf. Diderot: 'I do not know why a being who has managed to make me unhappy for no reason should not play the same game twice', *OCD* xi. p. 139.  56. Anthony Kenny, *The God of the Philosophers* (Oxford, 1979), pp. 115–17.  57. Voltaire, 'Bien Tout est', *Dictionnaire philosophique*, *OCV* 35, p. 427.  58. For introductions, see Daniel Mornet, *Les Sciences de la nature en France au XVIII^e siècle* (Paris, 1911), pp. 31–40; Wolfgang Philipp, 'Physicotheology in the age of Enlightenment: appearance and history', *SVEC*, 67 (1967), pp. 1233–67; and Clarence J. Glacken, *Traces on the Rhodian Shore: Nature and Culture in Western Thought from Ancient Times to the End of the Eighteenth Century* (Berkeley, 1967), pp. 375–550.  59. William Derham, *Physico-Theology: or a Demonstration of the Being and Attributes of God, from his Works of Creation*, 3rd edn (London, 1714), p. 429.  60. On the physico-theology of Derham, Thomas Burnet and John Ray, see Willey, *Eighteenth-Century Background*, pp. 27–42.  61. Cotton Mather, *The Christian Philosopher: A Collection of the Best Discoveries in Nature, with Religious Improvements* (London, 1721), p. 75. On Mather, see Caroline Winterer, *American Enlightenments: Pursuing Happiness in the Age of Reason* (New Haven, 2016), pp. 53–4, 176. Mather nevertheless retained an unenlightened belief in witchcraft and supported the Salem witch trials of 1692–3.  62. [Noël-Antoine Pluche], *Le Spectacle de la nature, ou entretiens sur les particularités de l'histoire naturelle*, new edn, vol. 1 (Paris, 1745).  63. Wolfgang Philipp, *Das Werden der Aufklärung in theologiegeschichtlicher Sicht* (Göttingen, 1957), p. 21; a detailed survey of physico-theological writing, pp. 21–30.  64. Leemans and Johannes, *Worm*, p. 452.  65. Quoted in John Brewer and Stella Tillyard, 'The moral vision of Thomas Bewick', in Eckhart Hellmuth, ed., *The Transformation of Political Culture: England and Germany in the Late Eighteenth Century* (Oxford, 1990), pp. 375–94 (p. 381).  66. Leemans and Johannes, *Worm*, p. 460.  67. Steffen Martus, *Aufklärung: Das deutsche 18. Jahrhundert. Ein Epochenbild* (Berlin, 2015), p. 246.  68. 'Summer', ll. 1542–4, in James Thomson, *The Seasons*, ed. James Sambrook (Oxford, 1981), p. 130. Sambrook prints the revised 1744 text.  69. 'A Poem Sacred to the Memory of Sir Isaac Newton', in James Thomson, *'Liberty', 'The Castle of Indolence', and Other Poems*, ed. James Sambrook (Oxford, 1986), pp. 6–14. On this and further Newtonian poems in English, see Karen O'Brien, ' "These nations Newton made his own": poetry, knowledge, and British imperial globalization', in Daniel Carey and Lynn Festa, eds., *Postcolonial Enlightenment: Eighteenth-Century Colonialism and Postcolonial Theory* (Oxford, 2009), esp. pp. 9–16.  70. 'Summer', ll. 97–9, in *The Seasons*, p. 63. See Philip Connell, 'Newtonian physico-theology and the varieties of Whiggism in James Thomson's *The Seasons*', *Huntington Library Quarterly*, 72 (2009), pp. 1–28.  71. Dulard, *La Grandeur*, pp. 11, 14.  72. See the correspondence between Burnet and Newton at www.newtonproject. ox.ac.uk/view/texts/normalized/THEM00014 (retrieved 21 July 2017); Rob Iliffe, *Priest of Nature: The Religious Worlds of Isaac Newton* (Oxford, 2017), pp. 240–42.  73. Thomas Burnet, *The Theory of the Earth*, 2 vols. (London, 1684), i. pp. 9, 76–7.  74. Derham, *Physico-Theology*, p. 69.  75. Dulard, *La Grandeur*, p. 262.  76. Philipp, *Das Werden der Aufklärung*, pp. 166–7.  77. See Charles D. James and Jan T. Kozak, 'Representations of the 1755 Lisbon earthquake', in Theodore E. D. Braun and John B. Radner, eds., *The Lisbon*

*Earthquake of 1755: Representations and Reactions* (Oxford, 2005), pp. 21–33 (pp. 21–2). 78. OCV 45A, p. 336. 79. OCV 45A, p. 338. 80. OCV 45A, p. 340. 81. OCV 45A, pp. 125–8. 82. See Rousseau, 'Lettre de J.-J. Rousseau à M. de Voltaire', OCR iv. pp. 1059–75 (p. 1061); Leo Damrosch, *Jean-Jacques Rousseau: Restless Genius* (New York, 2005), pp. 296–302. 83. Pope, *An Essay on Man*, i. l. 155, in TE iii/1. p. 35. 84. Mather, *The Christian Philosopher*, p. 101. 85. Gerhard Lauer and Thorsten Unger, 'Angesichts der Katastrophe', in Lauer and Unger, eds., *Das Erdbeben von Lissabon und der Katastrophendiskurs im 18. Jahrhundert* (Göttingen, 2008), pp. 13–43 (p. 16). 86. Johann Gottlob Krüger, *Gedanken von den Ursachen des Erdbebens, nebst einer moralischen Betrachtung* (Halle, 1756), partially reprinted in Wolfgang Breidert, ed., *Die Erschütterung der vollkommenen Welt: Die Wirkung des Erdbebens von Lissabon im Spiegel europäischer Zeitgenossen* (Darmstadt, 1994), pp. 25–50 (see esp. p. 50). For a full analysis of Krüger's elaborate text, see Ulrich Löffler, *Lissabons Fall – Europas Schrecken: Zur Deutung des Erdbebens von Lissabon im deutschsprachigen Protestantismus des 18. Jahrhunderts* (Berlin, 1999), pp. 98–114. 87. See Kant, 'History and natural description of the most noteworthy occurrences of the earthquake that struck a large part of the Earth at the end of the year 1755', tr. Olaf Reinhardt, in *Natural Science*, ed. Eric Watkins, The Cambridge Edition of the Works of Immanuel Kant (Cambridge, 2012), pp. 339–64. 88. Kant, 'Universal natural history and theory of the heavens', tr. Olaf Reinhardt, in *Natural Science*, p. 270; *Werke*, i. p. 339. 89. Kant, 'Universal natural history', p. 216; *Werke*, i. pp. 258–9, and see John Gribbin, *Galaxies: A Very Short Introduction* (Oxford, 2008), p. 3. 90. Kant, 'Universal natural history', p. 281; *Werke*, i. p. 357. 91. Ibid., p. 282; *Werke*, i. p. 358. 92. Ibid., p. 199; *Werke*, i. p. 234. 93. See Paul Henri Thiry, baron d'Holbach, *Système de la nature*, 2 vols. (Paris, 1770), i. p. 10; Goethe, *Dichtung und Wahrheit*, in *Sämtliche Werke: Briefe, Tagebücher und Gespräche*, ed. Friedmar Apel and others, 40 vols. (Frankfurt a.M., 1986–2000), xiv. pp. 535–6. Goethe was really objecting not to materialism but to abstraction, which, however, is necessary for all science. 94. Thomas P. Saine, *The Problem of Being Modern, or The German Pursuit of Enlightenment from Leibniz to the French Revolution* (Detroit, 1997), p. 57. 95. Goethe, *Sämtliche Werke*, viii. p. 108. 96. This image for God as designer was popular throughout the eighteenth century: see e.g. Voltaire, OCV 93, p. 78; Rousseau, *Émile*, tr. Barbara Foxley (London, 1911), p. 237; OCR iv. p. 578. 97. William Paley, *Natural Theology, or, Evidences of the Existence and Attributes of the Deity* (London, 1802), pp. 14–15. 98. Paley, *Natural Theology*, p. 19. 99. Kant, *Werke*, ii. pp. 548–55. 100. Ibid., p. 552. 101. Kant, *Werke*, v. p. 566; *Critique of the Power of Judgment*, tr. Paul Guyer, The Cambridge Edition of the Works of Immanuel Kant (Cambridge, 2000), p. 308. 102. *The Works of the Most Reverend Dr. John Tillotson, Archbishop of Canterbury*, 12 vols. (London, 1757), i. p. 136. 103. Ibid., p. 133. 104. Tillotson, *Works*, iii. p. 333. 105. *The Works of John Locke*, 9 vols. (1794; repr. London, 1997), vi. p. 140. 106. Ibid., p. 135. 107. See John W. Yolton, *John Locke and the Way of Ideas* (Oxford, 1956), pp. 169–81. 108. Quoted in Henry D. Rack, *Reasonable Enthusiast: John Wesley and the Rise of Methodism* (London, 1989), p. 144. 109. John Wesley, *An Earnest Appeal to Men of Reason and Religion*, 3rd edn (London, 1744), p. 9. I thank Dorinda Outram for this reference. 110. Wesley, *Earnest Appeal*, p. 11. 111. Rack, *Reasonable Enthusiast*, p. 187. 112. Ibid., pp. 194–5. 113. Ibid. p. 386. 114. Joseph Addison, *The Evidences of the Christian Religion* (Glasgow, 1753), pp. 47, 53. 115. Not to be confused with his father, Henry Dodwell (1641–1711), who also wrote about Christianity, but put forward eccentric views about the location of the soul between death and the Last Judgement; on him, see Philip C. Almond, *Heaven and Hell in Enlightenment England* (Cambridge, 1994), pp. 60–67. 116. Henry Dodwell, *Christianity Not Founded on Argument* (London, 1741), p. 35. 117. Ibid., p. 74. 118. Alexander Carlyle, *Anecdotes and Characters of the Times*, ed. James Kinsley (London, 1973), p. 47. 119. Samuel Clarke, *A Demonstration of the Being and Attributes of God, More Particularly in Answer to Mr. Hobbs, Spinoza, and their Followers* (London, 1705), p. 229. 120. *Spectator*, no. 465, 23 Aug. 1712. 121. On disputes around the Trinity, see John Redwood, *Reason, Ridicule and Religion: The Age of Enlightenment in England 1660–1750* (London, 1976),

pp. 155–71. **122**. Quoted in Redwood, *Reason*, p. 161. **123**. Samuel Clarke, *The Scripture-Doctrine of the Trinity: Wherein every text in the New Testament relating to that doctrine, is distinctly considered, and the divinity of our Blessed Saviour according to the Scriptures, proved and explained*, 2nd edn ([1712]; London, 1719), pp. 205–6. **124**. Clarke, *Scripture-Doctrine*, p. 300. A Presbyterian writer in 1712 actually envisages the Trinity as functioning like a committee: see Henry Grey Graham, *The Social Life of Scotland in the Eighteenth Century* (London, 1901), p. 396. **125**. Clarke, *Scripture-Doctrine*, p. 260. **126**. See Larry Stewart, 'Samuel Clarke, Newtonianism, and the factions of post-revolutionary England', *JHI*, 42 (1981), pp. 53–73. **127**. Voltaire, *Letters concerning the English Nation*, ed. Nicholas Cronk (Oxford, 1994), p. 32. **128**. William Warburton, *The Divine Legation of Moses Demonstrated, on the Principles of a Religious Deist, from the Omission of the Doctrine of a Future State of Reward and Punishment in the Jewish Dispensation*, 3rd edn, 2 vols. (London, 1742), ii. p. 449. **129**. Edward Gibbon, *The History of the Decline and Fall of the Roman Empire*, ed. David Womersley, 3 vols. (London, 1994), i. p. 465, n. 57. **130**. On Warburton's critics, see Brian W. Young, *Religion and Enlightenment in Eighteenth-Century England: Theological Debate from Locke to Burke* (Oxford, 1998), pp. 180–85. **131**. William Whiston, *Astronomical Principles of Religion, Natural and Reveal'd* (London, 1717), p. 156. **132**. Piero Camporesi, *The Fear of Hell: Images of Damnation and Salvation in Early Modern Europe*, tr. Lucinda Byatt (Cambridge, 1990), p. 62. **133**. See Norah Smith, 'Sexual mores and attitudes in eighteenth-century Scotland', in Paul-Gabriel Boucé, ed., *Sexuality in Eighteenth-Century Britain* (Manchester, 1982), pp. 47–73; and the vivid sketch of Presbyterian discipline in Diarmaid MacCulloch, *Reformation: Europe's House Divided* (London, 2003), pp. 597–600. **134**. See Margo Todd, *The Culture of Protestantism in Early Modern Scotland* (New Haven, 2002), pp. 85–7. Todd's admirable account of church life (strangely omitting theology) focuses on the sixteenth and seventeenth centuries. **135**. *Boswell, Laird of Auchinleck, 1778–1782*, ed. Joseph W. Reed and Frederick A. Pottle (Edinburgh, 1993), p. 235. **136**. See 'The Kirk's Alarm', in *The Poems and Songs of Robert Burns*, ed. James Kinsley, 3 vols. (Oxford, 1968), i. p. 473; Nigel Leask, *Robert Burns and Pastoral: Poetry and Improvement in Late Eighteenth-Century Scotland* (Oxford, 2010), p. 184. **137**. *Memoirs of the Life, Time, and Writings of Thomas Boston, A.M.*, ed. George H. Morrison (Edinburgh, 1899), p. 9; 'vileness', p. 50. **138**. Boston, *Memoirs*, p. 39. **139**. Ibid., p. 153. **140**. Graham, *Social Life*, p. 337. **141**. *The Principal Acts of the General Assembly of the Church of Scotland, conveened* [sic] *at Edinburgh the 2d day of May 1717* (Edinburgh, 1717), p. 17. Simson's heresies are described briefly in Suderman, 'Religion and philosophy', p. 202, and exhaustively in Anne Skoczylas, *Mr Simson's Knotty Case: Divinity, Politics, and Due Process in Early Eighteenth-Century Scotland* (Montreal, 2001). **142**. Simson quoted in Skoczylas, *Mr Simson*, p. 141; on the number of the elect, see ibid., pp. 131–8. **143**. Burns, *Poems and Songs*, i. p. 74. See D. P. Walker, *The Decline of Hell: Seventeenth-Century Discussions of Eternal Torment* (London, 1964), pp. 35–6; Almond, *Heaven and Hell*, p. 73. Cf. Matt. 7:14; Luke 13:24. **144**. For Simson's knowledge of Clarke, see Skoczylas, *Mr Simson*, p. 234; M. A. Stewart, 'Religion and rational theology', in Alexander Broadie, ed., *The Cambridge Companion to the Scottish Enlightenment* (Cambridge, 2003), pp. 31–59 (pp. 36, 56). **145**. Quoted in James Buchan, *Capital of the Mind: How Edinburgh Changed the World* (London, 2003), p. 66. **146**. On enlightenment among Episcopalians, see Hugh Trevor-Roper, 'The Scottish Enlightenment', in his *History and the Enlightenment* (New Haven, 2010), pp. 17–33 (pp. 28–31). **147**. See Graham, *Social Life*, p. 368. **148**. *Wodrow's Analecta, or Materials for a History of Remarkable Providences*, 4 vols. (Edinburgh, 1842–3), iv. p. 10. **149**. John Galt, *Annals of the Parish*, ed. James Kinsley (London, 1967), p. 6. **150**. See T. C. Smout, *A History of the Scottish People 1560–1830* (London, 1969), pp. 233–4; David Daiches, *The Paradox of Scottish Culture: The Eighteenth-Century Experience* (London, 1964), p. 48. **151**. Robertson, *The Situation of the World at the Time of Christ's Appearance* (Edinburgh, 1755), p. 6; see Jeffrey R. Smitten, *The Life of William Robertson: Minister, Historian, and Principal* (Edinburgh, 2017), pp. 101–3. **152**. See Buchan, *Capital of the Mind*, pp. 105–13. **153**. Carlyle, *Anecdotes and Characters*, p. 163. **154**. Buchan,

*Capital of the Mind*, p. 74. **155**. Andrew Hook, *Scotland and America: A Study of Cultural Relations 1750–1835* (Glasgow, 1975), pp. 34–8; Daniel W. Howe, 'John Witherspoon and the Transatlantic Enlightenment', in Susan Manning and Francis D. Cogliano, eds., *The Atlantic Enlightenment* (Aldershot, 2008), pp. 61–79. **156**. MacCulloch, *Reformation*, p. 700; Sang Hyun Lee, ed., *The Princeton Companion to Jonathan Edwards* (Princeton, 2005), esp. Peter J. Thuesen, 'Edwards' intellectual background', pp. 16–33. **157**. *Dichtung und Wahrheit*, in Goethe, *Sämtliche Werke*, xiv. p. 50. **158**. This sketch is heavily indebted to Thomas P. Saine, *The Problem of Being Modern, or The German Pursuit of Enlightenment from Leibniz to the French Revolution* (Detroit, 1997), pp. 120–52. See also Tore Frängsmyr, 'Christian Wolff's mathematical method and its impact on the eighteenth century', *JHI*, 36 (1975), pp. 653–68. **159**. Quoted in Saine, *Problem*, p. 145. **160**. On this controversy, see Israel, *Radical Enlightenment*, pp. 544–52; Martus, *Aufklärung*, pp. 263–83. Israel makes it clear that Wolff was not a Spinozist. **161**. Quoted in Karl Aner, *Die Theologie der Lessingzeit* (Halle, 1929), p. 157. This book is still a standard account of Neology. **162**. *Sendschreiben an Seine Hochwürden, Herrn Oberconsistorialrath und Probst Teller zu Berlin, von einigen Hausvätern jüdischer Religion* (Berlin, 1797). On this publication and the resulting controversy, see Martin L. Davies, *Identity or History? Marcus Herz and the End of the Enlightenment* (Detroit, 1995), pp. 206–15. **163**. Hilliard, *Freethinkers*, p. 23. **164**. Lessing, *Philosophical and Theological Writings*, ed. and tr. H. B. Nisbet (Cambridge, 2005), p. 231. **165**. Ibid., p. 238. **166**. Robert Lowth, *Lectures on the Sacred Poetry of the Hebrews*, tr. G. Gregory, 2 vols. (London, 1787), i. p. 307. **167**. Genesis 1:3; Lowth, *Lectures*, i. p. 350; cf. 'Longinus', *On Sublimity*, tr. D. A. Russell, in D. A. Russell and Michael Winterbottom, eds., *Ancient Literary Criticism* (Oxford, 1972), pp. 460–503 (p. 470). **168**. The writers to whom Herder objects are listed in Johann Gottfried Herder, *Werke*, ed. Günter Arnold and others, 10 vols. (Frankfurt a.M., 1985–2000), v. pp. 185 and 188, and identified in the notes. On this genre, see Peter Harrison, *The Bible, Protestantism, and the Rise of Natural Science* (Cambridge, 1998), pp. 171–6. **169**. *Über die ersten Urkunden des menschlichen Geschlechts: Einige Anmerkungen* (1769), in Herder, *Werke*, v. p. 39. **170**. *Älteste Urkunde des Menschengeschlechts* (1774), in Herder, *Werke*, v. p. 239. **171**. See Ulrich L. Lehner and Michael Printy, eds., *A Companion to the Catholic Enlightenment in Europe* (Leiden, 2010); Lehner, *Enlightened Monks: The German Benedictines 1740–1803* (Oxford, 2011); Jeffrey D. Burson and Lehner, eds., *Enlightenment and Catholicism in Europe: A Transnational History* (Notre Dame, IN, 2014); Lehner, *The Catholic Enlightenment*. **172**. *Riflessioni sopra il buon gusto nelle scienze e nelle arti* (extracts) in *Opere di Lodovico Antonio Muratori*, 2 vols., ed. Giorgio Falco and Fiorenzo Forti (Milan, n.d.), i. pp. 224–85 (p. 228). **173**. Ibid., p. 230. **174**. For a positive account of Baroque Catholicism, see Peter Hersche, *Muße und Verschwendung: Europäische Gesellschaft und Kultur im Barockzeitalter* (Freiburg i.Br., 2006). **175**. Friedrich Nicolai, *Beschreibung einer Reise durch Deutschland und die Schweiz im Jahre 1781. Nebst Bemerkungen über Gelehrsamkeit, Industrie, Religion und Sitten*, 12 vols. (Berlin, 1783–96), ii. 'Beylage', pp. 35–46. **176**. See [Johann Baptist Franz and Joseph Maria Weissegger von Weisseneck], *Beyträge zur Schilderung Wiens. Erstes Bändchen* (Vienna, 1781); [Joseph Richter], *Bildergalerie katholischer Mißbräuche*. Von Obermayr (Frankfurt and Leipzig, 1784). On the rich pamphlet literature of the Austrian Enlightenment, see Leslie Bodi, *Tauwetter in Wien: Zur Prosa der österreichischen Aufklärung, 1781–1795*, 2nd edn (Vienna, 1995). **177**. *Della regolata divozione de' Cristiani* (excerpt), in *Opere di Muratori*, i. p. 944. **178**. Voltaire, *Le Siècle de Louis XIV*, in *Œuvres historiques*, ed. René Pomeau (Paris, 1957), p. 1040. **179**. Haynes, *Philosopher King*, p. 58. **180**. Lehner, *The Catholic Enlightenment*, pp. 159–60. **181**. Haynes, *Philosopher King*, pp. 34–5; Catrien Santing, 'Tirami sù: Pope Benedict XIV and the beatification of the flying saint Giuseppe da Copertino', in Ole Peter Grell and Andrew Cunningham, eds., *Medicine and Religion in Enlightenment Europe* (Aldershot, 2007), pp. 79–99. **182**. See the summary of their debate in Giuseppe Silvestri, *Scipione Maffei: Europeo del settecento* (Verona, 1968), pp. 222–8. **183**. See William Doyle, *Jansenism: Catholic Resistance to Authority from the Reformation to the French Revolution* (Basingstoke, 2000); Peter Hersche, *Der Spätjansenismus in*

*Österreich* (Vienna, 1977).   **184.** Eduard Winter, *Der Josefinismus und seine Geschichte: Beiträge zur Geistesgeschichte Österreichs 1740–1848* (Brünn, 1943), p. 148.   **185.** See Margaret Chowning, *Rebellious Nuns: The Troubled History of a Mexican Convent, 1752–1863* (Oxford, 2006), pp. 33–4. Chowning recounts and analyses the rebellion that paralysed the convent of La Purísima Concepción between 1759 and 1772.   **186.** Adam Wolf, *Die Aufhebung der Klöster in Innerösterreich 1782–1790* (Vienna, 1871), p. 81.   **187.** Denis Diderot, *The Nun*, tr. Russell Goulbourne (Oxford, 2005).   **188.** [Johann Pezzl], *Briefe aus dem Novizziat*, 2 vols. ([Zürich], 1780–81), ii. p. 88. On Pezzl, see Ritchie Robertson, 'Johann Pezzl (1756–1823): Enlightenment in the satirical mode', in Burson and Lehner, *Enlightenment and Catholicism*, pp. 227–45. On the Jesuits' reputation for pederasty, of which Voltaire claimed to be a victim, see David Wootton, 'Unhappy Voltaire, or "I shall never get over it as long as I live"', *History Workshop Journal*, no. 50 (2000), pp. 137–55.   **189.** Arthur M. Wilson, *Diderot* (New York, 1972), p. 14.   **190.** See Jean Mabillon, 'Réflexions sur les prisons des ordres religieux', in Mabillon, *Œuvres posthumes*, 3 vols. (Paris, 1724), ii. pp. 321–36 (p. 324); Ulrich L. Lehner, *Monastic Prisons and Torture Chambers: Crime and Punishment in Central European Monasteries, 1600–1800* (Eugene, OR, 2013).   **191.** *Dr. Fessler's Rückblicke auf seine siebzigjährige Pilgerschaft. Ein Nachlass* [sic] *an seine Freunde und an seine Feinde* (Breslau, 1824), pp. 147–50.   **192.** Derek Beales, *Prosperity and Plunder: European Catholic Monasteries in the Age of Revolution, 1650–1815* (Cambridge, 2003), pp. 187–9; Owen Chadwick, *The Popes and European Revolution* (Oxford, 1981), pp. 435–6; Beales, *Prosperity and Plunder*, pp. 169–78 (on France), pp. 192–204 (on Austria); Derek Beales, *Joseph II*, vol. ii: *Against the World, 1780–1790* (Cambridge, 2009), pp. 271–306.   **193.** On Hontheim and the Ems Punctation, see Michael Printy, *Enlightenment and the Creation of German Catholicism* (Cambridge, 2009), pp. 42–54.   **194.** Joachim Whaley, *Germany and the Holy Roman Empire*, 2 vols. (Oxford, 2012), ii. p. 478.   **195.** See Virgil Redlich, 'Die Salzburger Benediktiner-Universität als Kulturerscheinung', in Hildebert Tausch O.S.B., ed., *Benediktinisches Mönchtum in Österreich* (Vienna, 1949), pp. 79–97 (p. 94).   **196.** All the standard charges against the Jesuits are rehearsed in Jean d'Alembert, *Sur la Destruction des Jésuites en France* ([Paris], 1765), and in his article 'Jésuites' in the *Encyclopédie*, viii. pp. 512–16. See Peter Burke, 'The Black Legend of the Jesuits: an essay in the history of social stereotypes', in his *Secret History and Historical Consciousness: From the Renaissance to Romanticism* (Brighton, 2016), pp. 215–40.   **197.** 'Les Jésuites sont les Janissaires du souverain Pontife': D'Alembert, *Sur la Destruction*, p. 107.   **198.** Voltaire, O C V 48, p. 171; Diderot, 'Supplément au voyage de Bougainville', O C D x. p. 201. Cf. Philip Caraman, *The Lost Paradise: An Account of the Jesuits in Paraguay, 1607–1768* (London, 1975).   **199.** On the value of money in eighteenth-century Germany, see W. H. Bruford, *Germany in the Eighteenth Century: The Social Background of the Literary Revival* (Cambridge, 1935), pp. 329–32. The sum of 150 florins (*Gulden*) corresponded to three months' salary for a relatively ill-paid university professor.   **200.** See Marcus Hellyer, *Catholic Physics: Jesuit Natural Philosophy in Early Modern Germany* (Notre Dame, IN, 2005), p. 229; Jonathan A. Wright, 'Ruggiero Boscovich (1711–1787): Jesuit science in an Enlightenment context', in Lehner and Burson, *Enlightenment and Catholicism*, pp. 353–69.   **201.** Lehner, *The Catholic Enlightenment*, pp. 38–9; Jonathan Israel, *Democratic Enlightenment: Philosophy, Revolution, and Human Rights 1750–1790* (Oxford, 2011), pp. 389–95.   **202.** Beales, *Prosperity and Plunder*, pp. 286–7.   **203.** Lehner, *Enlightened Monks*, p. 227.   **204.** Bernard Plongeron, 'Recherches sur l' "Aufklärung" catholique en Europe occidentale (1770–1830)', *Revue d'histoire moderne et contemporaine*, 16 (1969), pp. 555–605 (p. 587).   **205.** Michael Printy, 'Catholic Enlightenment and Reform Catholicism in the Holy Roman Empire', in Lehner and Printy, *Companion*, pp. 207–8.   **206.** Richard Clogg, 'Anti-clericalism in pre-independence Greece *c.* 1750–1821', in Derek Baker, ed., *The Orthodox Churches and the West* (Oxford, 1976), pp. 257–76.   **207.** Peter Mackridge, 'The Greek intelligentsia 1780–1830: a Balkan perspective', in Richard Clogg, ed., *Balkan Society in the Age of Greek Independence* (London, 1981), pp. 63–84 (p. 63).   **208.** Paschalis M. Kitromilides, *Enlightenment and Revolution: The Making of Modern Greece* (Cambridge, MA, 2013), p. 46. On Voulgaris' reception of Western

philosophy see also Jonathan Israel, *Enlightenment Contested: Philosophy, Modernity, and the Emancipation of Man 1670–1752* (Oxford, 2006), pp. 322–5.    **209.** Vasilios N. Makrides, 'The Enlightenment in the Greek Orthodox East: appropriation, dilemmas, ambiguities', in Paschalis M. Kitromilides, ed., *Enlightenment and Religion in the Orthodox World* (Oxford, 2016), pp. 17–47 (p. 27). Mackridge, 'The Greek intelligentsia', provides a list of 36 Enlighteners, including 13 clerics and 23 laymen (p. 79).    **210.** See Kitromilides, *Enlightenment and Revolution*, p. 52.    **211.** On Moisiodax, see Kitromilides, *Enlightenment and Revolution*, pp. 158–74, and his *The Enlightenment as Social Criticism: Iosipos Moisiodax and Greek Culture in the Eighteenth Century* (Princeton, 1992).    **212.** Kitromilides, *Enlightenment and Revolution*, p. 167: the quotations are from Moisiodax.    **213.** As *On Theocracy* is available only in Greek, I owe this account to information kindly provided by Professor Paschalis Kitromilides and Dr Niketas Siniossoglou (letter of 23 May 2016), supplementing Kitromilides, *Enlightenment and Revolution*, pp. 251–4.    **214.** Makrides, 'The Enlightenment', p. 39.    **215.** On the Haskalah in relation to other religious developments, see David Sorkin, *Moses Mendelssohn and the Religious Enlightenment* (London, 1996); Sorkin, *The Berlin Haskalah and German Religious Thought: Orphans of Knowledge* (London, 2000); and Sorkin, *Religious Enlightenment*, esp. pp. 165–213.    **216.** George Eliot, *Daniel Deronda*, ed. Terence Cave (London, 1995), p. 385.    **217.** Salomon Maimon, *Lebensgeschichte*, ed. Jakob Fromer (Berlin, 1912), p. 93. On Maimon's thought, see Abraham Socher, *The Radical Enlightenment of Solomon Maimon: Judaism, Heresy and Philosophy* (Stanford, 2006).    **218.** Sorkin, *Religious Enlightenment*, p. 168.    **219.** See Alexander Altmann, *Moses Mendelssohn: A Biographical Study* (London, 1973), pp. 195–9.    **220.** For Mendelssohn as Nathan, see M. Kayserling, *Moses Mendelssohn: Sein Leben und seine Werke* (Leipzig, 1862), p. 330; but for his peacefulness, ibid., p. 550.    **221.** Quoted in Altmann, *Mendelssohn*, p. 181.    **222.** Moses Maimonides, *The Guide for the Perplexed*, tr. M. Friedländer (New York, 1956), pp. 330–31.    **223.** Moses Mendelssohn, *Jerusalem, or On Religious Power and Judaism*, tr. Allan Arkush (Hanover, NH, 1983), p. 133.    **224.** Quoted in Altmann, *Mendelssohn*, p. 544.    **225.** Todd M. Endelman, *The Jews of Georgian England: Tradition and Change in a Liberal Society* (Philadelphia, 1979), p. 122.    **226.** Robert Liberles, *Jews Welcome Coffee: Tradition and Innovation in Early Modern Germany* (Waltham, MA, 2012), p. 56.    **227.** Michael A. Meyer, *The Origins of the Modern Jew: Jewish Identity and European Culture in Germany, 1749–1824* (Detroit, 1967), p. 51; for his beard, see Steven M. Lowenstein, *The Berlin Jewish Community: Enlightenment, Family and Crisis, 1770–1830* (New York, 1994), p. 46.    **228.** Quoted in Meyer, *Origins*, p. 89.    **229.** See the conspectus in Jacques Picard and others, eds., *Makers of Jewish Modernity: Thinkers, Artists, Leaders, and the World They Made* (Princeton, 2016).    **230.** On 'Christian Hebraism', see Adam Sutcliffe, *Judaism and Enlightenment* (Cambridge, 2003), pp. 23–41.    **231.** Article III, *The Confession of Faith, of the Reformed Churches in the Netherlands ... Translated out of Dutch into English* (Amsterdam, 1689), p. 3.    **232.** Sutcliffe, *Judaism*, p. 31.    **233.** See Susan James, *Spinoza on Philosophy, Religion, and Politics: The 'Theologico-Political Treatise'* (Oxford, 2012), p. 172.    **234.** Quoted in W. G. Kümmel, *The New Testament: The History of the Investigation of its Problems*, tr. S. McLean Gilmour and Howard C. Kee (London, 1973), p. 63. For Luther, see ibid., p. 26, and Jonathan Sheehan, *The Enlightenment Bible: Translation, Scholarship, Culture* (Princeton, 2005), p. 18.    **235.** Sheehan, *Enlightenment Bible*, pp. 57, 62–3.    **236.** Benedict de Spinoza, *A Theologico-Political Treatise; A Political Treatise*, tr. R. H. M. Elwes (New York, 1951), p. 6. On the originality of the *Tractatus*, 'the first attempt at a philosophical justification and foundation of Biblical criticism', see Ernst Cassirer, *The Philosophy of the Enlightenment*, tr. Fritz C. A. Koelln and James P. Pettegrove (Princeton, 1951), p. 184.    **237.** Spinoza, *Ethics*, tr. Edwin Curley (London, 1996), p. 114.    **238.** See the summary of the argument in Spinoza, *Ethics*, p. 25; Israel, *Radical Enlightenment*, pp. 230–32.    **239.** Spinoza, *Treatise*, p. 99.    **240.** See James, *Spinoza*, p. 145.    **241.** See Steven Nadler, *A Book Forged in Hell: Spinoza's Scandalous Treatise and the Birth of the Secular Age* (Princeton, 2011), p. 77.    **242.** Spinoza, *Treatise*, p. 99; see James, *Spinoza*, p. 141, and for a concise account of his method, Israel, *Enlightenment Contested*, pp. 410–13.    **243.** Spinoza, *Treatise*, p. 24.    **244.** Ibid., pp. 30–31.    **245.** Ibid., p. 40.

246. Thomas Hobbes, *Leviathan*, ed. J. C. A. Gaskin (Oxford, 1996), p. 253, referring to Gen. 12:6 and Num. 21:14. See Noel Malcolm, 'Hobbes, Ezra, and the Bible: the history of a subversive idea', in his *Aspects of Hobbes* (Oxford, 2002), p. 397.    247. Malcolm, 'Hobbes', pp. 398–9.    248. Spinoza, *Treatise*, pp. 121–32.    249. Henry Phillips, *Church and Culture in Seventeenth-Century France* (Cambridge, 1997), p. 128.    250. Richard Simon, 'The Authour's Preface' (unpaginated), in *A Critical History of the Old Testament* (London, 1682); Cassirer, *Philosophy*, p. 184.    251. Letter of 19 May 1702, quoted in Patrick Lambe, 'Biblical criticism and censorship in ancien régime France: the case of Richard Simon', *Harvard Theological Review*, 78 (1985), pp. 149–77 (p. 156). Lambe gives a detailed account of the banning of Simon's book.    252. Evelyn, letter of 19 Mar. 1682 to John Fell, bishop of Oxford, quoted in Justin Champion, 'Père Richard Simon and English biblical criticism, 1680–1700', in James Force and David Katz, eds., *Everything Connects: In Conference with Richard Popkin* (Leiden, 1999), pp. 39–61 (p. 43); for Dryden, see Louis I. Bredvold, *The Intellectual Milieu of John Dryden* (Ann Arbor, MI, 1934), ch. 4: 'Roman Catholic Apologetics in England'.    253. Hans Bots and Françoise Waquet, *La République des Lettres* (Paris, 1997), p. 46.    254. See Elinor Shaffer, '*Kubla Khan' and 'The Fall of Jerusalem': The Mythological School in Biblical Criticism and Secular Literature 1770–1880* (Cambridge, 1975).    255. See Mark Goldie, 'Alexander Geddes at the limits of the Catholic Enlightenment', *Historical Journal*, 53 (2010), pp. 61–86; on the context, Goldie, 'The Scottish Catholic Enlightenment', *Journal of British Studies*, 30 (1991), pp. 20–62. For England, see Joseph P. Chinnici, *The English Catholic Enlightenment: John Lingard and the Cisalpine Movement, 1780–1850* (Shepherdstown, WV, 1980).    256. Quoted in Goldie, 'Alexander Geddes', p. 71.    257. For the iconoclastic Bible criticism of Le Clerc, who likewise drew on Spinoza, see Annie Barnes, *Jean Le Clerc (1657–1736) et la République des Lettres* (Paris, 1938), esp. pp. 103–14.    258. Voltaire, 'Genèse', *Dictionnaire philosophique*, OCV 36, p. 150.    259. Spinoza, *Treatise*, pp. 136–8; Edoardo Tortarolo, 'L'eutanasia della cronologia biblica', in Camilla Hermanin and Luisa Simonutti, eds., *La centralità del dubbio*, 2 vols. (Florence, 2011), i. pp. 339–60. I thank Professor John Robertson for giving me a photocopy of this article.    260. On Abraham's age, see Voltaire, 'Abraham', *Dictionnaire philosophique*, OCV 35, pp. 31, 37.    261. Hermann Samuel Reimarus, *Apologie oder Schutzschrift für die vernünftigen Verehrer Gottes*, ed. Gerhard Alexander, 2 vols. (Frankfurt a.M., 1972), i. p. 99; cf. ii. pp. 28–9.    262. Reimarus, *Apologie*, i. p. 131. 'A German mile (Meile) varied between something over 9 kilometres and something under 7' – Bruford, *Germany*, p. 332.    263. On earlier discussions, and Reimarus' extensive knowledge of them, see Ulrich Groetsch, *Hermann Samuel Reimarus (1694–1768): Classicist, Hebraist, Enlightenment Radical in Disguise* (Leiden, 2015), pp. 285–309.    264. Voltaire, 'Abraham', *Dictionnaire philosophique*, OCV 35, p. 293.    265. Voltaire remarks that in a modern court Jacob and his mother, Rebecca, who devised the plan, would be found guilty of fraud: *La Bible enfin expliquée* (1776), OCV 79A (1), p. 161.    266. Voltaire, *La Philosophie de l'histoire*, OCV 59, p. 224. Exod. 32:27–8 says three thousand (still a considerable number). Voltaire was following the Vulgate instead of the Masoretic text: Bertram Eugène Schwarzbach, 'Voltaire et les Juifs: bilan et plaidoyer', *SVEC*, 358 (1997), pp. 27–91 (p. 81).    267. See the horrified comments by Voltaire, 'David', *Dictionnaire philosophique*, OCV 36, p. 5; Reimarus, *Apologie*, i. p. 611. Modern translators and commentators think this means only that David made people do forced labour with various tools.    268. Reimarus, *Apologie*, i. p. 622. See also Peter Annet, *The History of the Man after God's own Heart* (London, 1761), a severe examination of David's actions, which was translated into French by d'Holbach. Voltaire read it attentively and based his drama *Saul* on it: Norman Torrey, *Voltaire and the English Deists* (New Haven, 1930), p. 188.    269. *Der gepryfte Abraham*, in *Wielands Gesammelte Schriften*, ed. by the Deutsche Kommission der Königlich Preußischen Akademie der Wissenschaften, I: *Werke*, 23 vols. (Berlin, 1909–69), ii: *Poetische Jugendwerke, Zweiter Teil*, ed. Fritz Homeyer (1909), pp. 115–16.    270. C. M. *Wielands sämmtliche Werke*, 39 vols. and 6 supplements (Leipzig, 1794–1811), supplement iii, p. 33.    271. Kant, *Der Streit der Fakultäten*, in *Werke*, vi. p. 333, footnote.    272. Kant, *Werke*, vi. p. 333.    273. 'Paul', *Dictionnaire philosophique*, OCV 36, p. 421.    274. Thomas Woolston, *A Discourse on the*

*Miracles of our Saviour* (London, 1727), p. 19.   275. Woolston, *Discourse*, p. 54. For the influence on Voltaire, not only of Woolston's polemics but of his ribald style, see Torrey, *Voltaire*, pp. 59-103.   276. Woolston, *A Fourth Discourse on the Miracles of our Saviour* (London, 1728), pp. 10-11.   277. Woolston, *A Sixth Discourse on the Miracles of our Saviour* (London, 1729), p. 5.   278. David Friedrich Strauss, *Das Leben Jesu, kritisch bearbeitet*, 2 vols. (Tübingen, 1835-6). The translation by Marian Evans ('George Eliot'), *The Life of Jesus, critically examined* (London, 1846), though a fine achievement, inevitably loses the stylistic brilliance of the original.   279. See Maurice Casey, *Jesus of Nazareth: An Independent Historian's Account of His Life and Teaching* (London, 2010), pp. 511-25.   280. William H. Trapnell, *Thomas Woolston: Madman and Deist?* (Bristol, 1994), pp. 57-8.   281. Thomas Sherlock, *The Tryal of the Witnesses of the Resurrection of Jesus* (London, 1729), p. 4.   282. Peter Annet, *The Resurrection of Jesus Considered; in answer to The Tryal of the Witnesses. By a Moral Philosopher* (London, 1743), p. 48.   283. Annet, *Resurrection*, p. 63.   284. See James A. Harris, *Hume: An Intellectual Biography* (Cambridge, 2015), p. 229.   285. Ernest Campbell Mossner, *The Life of David Hume* (Oxford, 1954), pp. 111-12.   286. Hume, 'The Life of David Hume, Esq., written by himself', in his *Essays Moral, Political, and Literary*, ed. Eugene F. Miller (Indianapolis, 1987), p. xxxv.   287. Conyers Middleton, *A Free Inquiry into the Miraculous Powers, which are Supposed to have Subsisted in the Christian Church* (London, 1749), p. lxxvi. Middleton, whether prudently or sincerely, excludes from his incredulity the miracles ascribed to Christ and the apostles (*Free Inquiry*, p. xciv). On him, see Hugh Trevor-Roper, 'From deism to history: Conyers Middleton', in his *History and the Enlightenment*, pp. 71-119; Brian W. Young, 'Conyers Middleton and the historical consequences of heterodoxy', in Sarah Mortimer and John Robertson, eds., *The Intellectual Consequences of Religious Heterodoxy* (Leiden, 2012), pp. 235-66, who differs from Trevor-Roper in understanding Middleton as a heterodox Christian in the tradition of Erasmus.   288. Hume, 'Of Miracles', in *An Enquiry concerning Human Understanding*, ed. Tom L. Beauchamp (Oxford, 2000), p. 86.   289. Hume, 'Of Miracles', in *Enquiry*, p. 89.   290. Ibid., p. 94. Middleton gives the same example: *Free Inquiry*, p. 226.   291. Reimarus, *Apologie*, ii. p. 29.   292. See ibid., p. 305.   293. Albert Schweitzer, *The Quest of the Historical Jesus: A Critical Study of its Progress from Reimarus to Wrede*, tr. W. Montgomery (London, 1910), p. 23.   294. See Kümmel, *The New Testament*, p. 47; Sheehan, *Enlightenment Bible*, pp. 44-6. On Mill's co-operation with Isaac Newton, see Iliffe, *Priest of Nature*, p. 371.   295. Sheehan, *Enlightenment Bible*, pp. 96-105.   296. Harrison, *The Bible*, p. 98.   297. See Frank E. Manuel, *A Portrait of Isaac Newton* (Cambridge, MA, 1968), p. 372; Iliffe, *Priest of Nature*, pp. 373-5.   298. 'Traduction libre de la Lettre du Chevalier Newton, sur 1 Tim. iii,16', *Journal Britannique*, 15 (Nov.-Dec. 1754), pp. 351-90, noted by Gibbon, *Decline and Fall*, ii. p. 940n. See Iliffe, *Priest of Nature*, pp. 385-7.   299. *The Christian and Catholike Veritie, or the Reasons and Manner of the Conversion of Francis de Neville* (London, 1642), p. 103.   300. Voltaire, *Examen important de milord Bolingbroke*, OCV 62, pp. 243-4.   301. *The Christian and Catholike Veritie*, pp. 113-22.   302. Ibid., pp. 32-40. Cf. Francis Wright Beare, *The Gospel according to Matthew: A Commentary* (Oxford, 1981), pp. 353-6; Gibbon, *Decline and Fall*, i. p. 489, n. 122: the pun on 'Peter' and 'rock' only works properly in French.   303. Kümmel, *The New Testament*, p. 63, quoting Semler's *Abhandlung von freier Untersuchung des Canon* (1771-5).   304. Lessing, *Philosophical and Theological Writings*, p. 124. Similarly Kant, *Werke*, vi. p. 334.   305. Quoted in Kümmel, *The New Testament*, p. 64.   306. See Sheehan, *Enlightenment Bible*, p. 90.   307. Kümmel, *The New Testament*, p. 68.   308. 'Commentary on the Fragments of Reimarus' (1777), in Lessing, *Philosophical and Theological Writings*, pp. 61-82 (p. 63).   309. Quoted in Sheehan, *Enlightenment Bible*, p. 90.

## 5. UNBELIEF AND SPECULATION

1. 'On the History of Religion and Philosophy in Germany', in Heinrich Heine, *Selected Prose*, tr. Ritchie Robertson (London, 1993), p. 255.   2. 'Towards a Critique of Hegel's

*Philosophy of Right*: Introduction', in Karl Marx, *Selected Writings*, ed. David McLellan (Oxford, 1977), p. 64. **3.** 'Science as a Vocation', in *From Max Weber: Essays in Sociology*, tr. H. H. Gerth and C. Wright Mills (New York, 1946), pp. 129–56 (p. 139). Cf. Weber, 'Wissenschaft als Beruf', in *Gesammelte Aufsätze zur Wissenschaftslehre*, ed. Johannes Winckelmann (Tübingen, 1988), pp. 582–613 (p. 594). **4.** On Weber's term and concept, see Robert W. Scribner, 'The Reformation, popular magic and the "disenchantment of the world"', *Journal of Interdisciplinary History*, 23 (1993), pp. 475–94; Robin Briggs, *Witches and Neighbours: The Social and Cultural Context of European Witchcraft*, 2nd edn (Oxford, 2002), p. 327; Alexandra Walsham, 'The Reformation and "the disenchantment of the world" reassessed', *Historical Journal*, 51 (2008), pp. 497–528. **5.** Miri Rubin, *Corpus Christi: The Eucharist in Late Medieval Culture* (Cambridge, 1991), pp. 63–82. **6.** Keith Thomas, *Religion and the Decline of Magic* (London, 1971), p. 34. **7.** See Johan Huizinga, *The Waning of the Middle Ages*, tr. F. Hopman (Harmondsworth, 1965), pp. 165–8. **8.** Jacques Le Goff, *The Birth of Purgatory*, tr. Arthur Goldhammer (London, 1984), pp. 227–9. **9.** Quoted in Heiko A. Oberman, *Luther: Man between God and the Devil*, tr. Eileen Walliser-Schwarzbart (New Haven, 1989), p. 188, from the draft of a sermon probably written by Tetzel. Cf. Stephen Greenblatt, *Hamlet in Purgatory* (Princeton, 2001). **10.** Peter Harrison, *The Territories of Science and Religion* (Cambridge, 2015), p. 49; similarly Thomas, *Religion*, p. 76; Jonathan Sheehan, 'Enlightenment, religion, and the enigma of secularization: a review essay', *American Historical Review*, 108 (2003), pp. 1061–80 (p. 1074). **11.** Scribner, 'The Reformation', p. 477. **12.** Eamon Duffy, *The Stripping of the Altars: Traditional Religion in England, c. 1400–c. 1580* (New Haven, 1992), p. 75. **13.** Ibid., pp. 64–5. **14.** Émile Mâle, *The Gothic Image: Religious Art in France of the Thirteenth Century*, tr. Dora Nussey ([1913]; New York, 1958), pp. 176–81, 206–66. The well-known Oberammergau Passion Play is more recent, dating from 1634. **15.** Huizinga, *Waning*, p. 172. **16.** Quoted in Robert Whiting, *The Blind Devotion of the People: Popular Religion and the English Reformation* (Cambridge, 1989), p. 24. **17.** The main evidence was the injunction to pray for the dead in 2 Maccabees 12:44, a book which Protestants regard as apocryphal. See Peter Marshall, *Beliefs and the Dead in Reformation England* (Oxford, 2002), pp. 53–4. **18.** Carlos M. N. Eire, *Reformations: The Early Modern World, 1450–1650* (New Haven, 2016), pp. 146–8. **19.** This applies especially to the monumental work of Jean Delumeau. Besides *La Peur en Occident: XIVe–XVIIe siècles* (Paris, 1978), see his *Catholicism between Luther and Voltaire: A New View of the Counter-Reformation*, tr. Jeremy Moiser (London, 1977); and *Le Péché et la peur: La culpabilisation en Occident, XIIIe–XVIIIe siècles* (Paris, 1983). For an assessment of his work, see J. K. Powis, 'Repression and autonomy: Christians and Christianity in the historical work of Jean Delumeau', *Journal of Modern History*, 64 (1992), pp. 366–74. **20.** Alexandra Walsham, *The Reformation of the Landscape: Religion, Identity, and Memory in Early Modern Britain and Ireland* (Oxford, 2011), p. 103; cf. Margo Todd, *The Culture of Protestantism in Early Modern Scotland* (New Haven, 2002), pp. 205–7; Delumeau, *Catholicism*, p. 165. **21.** Judith Devlin, *The Superstitious Mind: French Peasants and the Supernatural in the Nineteenth Century* (New Haven, 1987), pp. 17–18. **22.** See Schönwerth, *Aus der Oberpfalz: Sitten und Sagen*, 3 vols. (Augsburg, 1857–9); *Original Bavarian Folktales: A Schönwerth Selection*, tr. M. Charlotte Wolf (Mineola, NY, 2014); Devlin, *Superstitious Mind*, p. 23. **23.** Bonifacius Stölzlin, *Geistliches Donner- und Wetterbüchlein* (1654), quoted in Heinz D. Kittsteiner, *Die Entstehung des modernen Gewissens* (Frankfurt a.M., 1991), p. 68. **24.** Soili-Maria Olli, 'The Devil's pact: a male strategy', in Owen Davies and Willem de Blécourt, eds., *Beyond the Witch Trials: Witchcraft and Magic in Enlightenment Europe* (Manchester, 2004), pp. 100–116. **25.** Devlin, *Superstitious Mind*, p. 90. **26.** Carlo Ginzburg, *The Cheese and the Worms: The Cosmos of a Sixteenth-Century Miller*, tr. John and Anne Tedeschi (London, 1980). **27.** Thomas, *Religion*, pp. 163–6. **28.** Delumeau, *Catholicism*, pp. 192–201. **29.** Gerald Strauss, 'Success and failure in the German Reformation', *Past and Present*, 67 (1975), pp. 30–63 (pp. 51, 46, 52). On the ineffectuality of catechism schools and rural missions in seventeenth-century France, see R. Po-chia Hsia, *The World of Catholic Renewal 1540–1770* (Cambridge, 1998), pp. 72–3. **30.** See Whiting, *Blind Devotion*,

pp. 26–30. 31. Thomas, *Religion*, p. 75. 32. Jonathan Israel, *The Dutch Republic: Its Rise, Greatness, and Fall, 1477–1806* (Oxford, 1995), pp. 148–9. 33. Scribner, 'The Reformation', p. 485. 34. Marc Bloch, *Les Rois thaumaturges: étude sur le caractère surnaturel attribué à la puissance royale, particulièrement en France et en Angleterre*, rev. edn (Paris, 1983; first published 1923), p. 399. 35. See David Blackbourn, *Marpingen: Apparitions of the Virgin Mary in Bismarckian Germany* (Oxford, 1993). 36. See Klaus Vondung, *Magie und Manipulation: Ideologischer Kult und politische Religion des Nationalsozialismus* (Göttingen, 1971); Christel Lane, *The Rites of Rulers: Ritual in Industrial Society – the Soviet Case* (Cambridge, 1981); Michael Burleigh, *The Third Reich: A New History* (London, 2000). 37. Mona Ozouf, *Festivals and the French Revolution*, tr. Alan Sheridan (Cambridge, MA, 1988), p. 268. 38. Ibid., p. 271. 39. Euan Cameron, *Enchanted Europe: Superstition, Reason, and Religion, 1250–1750* (Oxford, 2010), p. 311. 40. Walsham, 'The Reformation', p. 518. Contrast e.g. John Aubrey's story of how the ghost of a former schoolfellow appeared to William Twisse and said, '*I am damn'd*', with Daniel Defoe's account of Mrs Veal's apparition: one is a fearful warning, the other is a news item. Aubrey, *Brief Lives*, ed. Oliver Lawson Dick (Harmondsworth, 1972), p. 460; Defoe, *A True Relation of the Apparition of one Mrs. Veal, the next Day after her Death: to one Mrs. Bargrave at Canterbury, the 8th of September, 1705* (London, 1706). 41. Paul Fussell, *The Great War and Modern Memory* (New York, 1975), pp. 115–16. 42. W. E. H. Lecky, *History of the Rise and Influence of Rationalism in Europe*, 2 vols., new edn (London, 1897), i. p. 87. See George Mora, 'Weyer and Psychiatry' in the Introduction to *Witches, Devils, and Doctors in the Renaissance: Johann Weyer, 'De praestigiis daemonum'*, ed. George Mora, tr. John Shea (Binghamton, NY, 1991), pp. lxiii–lxxix. 43. For examples, see Malcolm Gaskill, *Witchfinders: A Seventeenth-Century English Tragedy* (London, 2005), p. 31. 44. Pierre Bayle, *Réponse aux questions d'un provincial*, 5 vols. (Rotterdam, 1704), i. p. 288. The Latin original, which Bayle prints in the margin, speaks unmistakably of 'ignem concupiscentiae', 'fire of lust'. 45. [Johann Pezzl], *Briefe aus dem Novizziat*, 2 vols. ([Zurich], 1780–81), ii. p. 117. 46. Brian P. Levack, *The Devil Within: Possession and Exorcism in the Christian West* (New Haven, 2013), pp. 218–19. 47. See ibid., p. 30; Devlin, *Superstitious Mind*, pp. 133–6; Briggs, *Witches and Neighbours*, p. 337. 48. Meric Casaubon, *A Treatise concerning Enthusiasme* (1655), ed. Paul J. Korshin (Gainesville, FL, 1970), p. 163. 49. See Ronald Knox, *Enthusiasm: A Chapter in the History of Religion* (Oxford, 1950), pp. 319–55. 50. Montesquieu, *Persian Letters*, tr. C. J. Betts (Harmondsworth, 1973), pp. 238–9 (letter 134); O C M i. p. 333. 51. Edward Gibbon, *The History of the Decline and Fall of the Roman Empire*, ed. David Womersley, 3 vols. (London, 1994), iii. pp. 783–4. Cf. the sceptical account of Quietist contemplation in Karl Philipp Moritz, *Anton Reiser: A Psychological Novel*, tr. Ritchie Robertson (London, 1997), pp. 5–8. 52. On *Schwärmerei*, see Anthony J. La Vopa, 'The philosopher and the *Schwärmer*: on the career of a German epithet from Luther to Kant', in La Vopa and Lawrence E. Klein, eds., *Enthusiasm and Enlightenment in Europe, 1650–1850* (San Marino, CA, 1998), pp. 85–115; K. F. Hilliard, *Freethinkers, Libertines and 'Schwärmer': Heterodoxy in German Literature, 1750–1800* (London, 2011); Johannes D. Kaminski, *Der Schwärmer auf der Bühne: Ausgrenzung und Rehabilitation einer literarischen Figur in Goethes Dramen und Prosa (1775–1786)* (Hanover, 2012). 53. See Lorraine Daston, 'The nature of nature in early modern Europe', *Configurations*, 6 (1998), pp. 149–72 (p. 161). 54. 'Superstition', *Encyclopédie ou Dictionnaire raisonné des sciences, des arts et des métiers* (Neuchâtel, 1765), xv. p. 669. 55. Knox, *Enthusiasm*, pp. 1–4. See Michael Heyd, *'Be Sober and Reasonable': The Critique of Enthusiasm in the Seventeenth and Early Eighteenth Centuries* (Leiden, 1995). 56. Macaulay, *History of England*, ch. 17, in *The Works of Lord Macaulay*, 12 vols. (London, 1898), v. p. 29. 57. David Hume, *The History of England from the Invasion of Julius Caesar to the Revolution in 1688*, 6 vols. (1778; repr. Indianapolis, 1983), vi. pp. 143–4. 58. *An Essay concerning Human Understanding*, Book IV, ch. 19, §7, in *The Works of John Locke*, 9 vols. (1794; repr. London, 1997), ii. p. 274. 59. Knox, *Enthusiasm*, pp. 372–88. For a more sympathetic account, see Jane Shaw, *Miracles in Enlightenment England* (New Haven, 2006), pp. 149–57. 60. Anthony Ashley Cooper, third Earl of Shaftesbury, 'A Letter concerning Enthusiasm', in *Characteristics of Men,*

*Manners, Opinions, Times*, ed. Lawrence E. Klein (Cambridge, 1999), pp. 4–28 (pp. 10, 16, 23).   61. Knox, *Enthusiasm*, pp. 377–88.   62. E. J. F. Barbier, *Journal historique et anecdotique du règne de Louis XV*, ed. A. de la Villegille, 2 vols. (Paris, 1847), i. p. 386 (Jan. 1732).   63. Catherine-Laurence Maire, *Les Convulsionnaires de Saint-Médard: Miracles, convulsions et prophéties à Paris au XVIIIᵉ siècle* (Paris, 1985), p. 16. On the convulsionaries as a challenge to the Church's control of the supernatural, see B. Robert Kreiser, *Miracles, Convulsions, and Ecclesiastical Politics in Early Eighteenth-Century Paris* (Princeton, 1978).   64. 'Fanatisme', *Dictionnaire philosophique*, OCV 36, p. 108.   65. John McManners, *Church and Society in Eighteenth-Century France*, 2 vols. (Oxford, 1998), ii. p. 229, referring to Hecquet, *La Cause des convulsions, le naturalisme des convulsions* (1733).   66. Shaftesbury, 'Miscellany II', in *Characteristics*, pp. 351–94 (p. 355).   67. See 'The Enlightenment and Beyond', in Diarmaid MacCulloch, *Reformation: Europe's House Divided, 1490–1700* (London, 2003), pp. 698–708.   68. Lecky, *Rationalism*, i. p. 189.   69. For a handy summary of this thesis, see Steve Bruce, *God is Dead: Secularization in the West* (Oxford, 2002), ch. 1.   70. Émile Durkheim, *The Elementary Forms of Religious Life*, tr. Carol Cosman (Oxford, 2001), p. 46.   71. Tim Crane, *The Meaning of Belief: Religion from an Atheist's Point of View* (Cambridge, MA, 2017), p. 159.   72. Ibid., p. 33.   73. Alexis de Tocqueville, *Democracy in America* (abridged edn), tr. Henry Reeve (London, 1946), p. 233.   74. Even in the US, religious belief seems to be gradually declining. Commenting on 'American exceptionalism', David Voas notes that America is gradually catching up on the unbelief prevalent in other Western societies: Voas, 'The continuing secular tradition', in Detlef Pollack and Daniel V. A. Olson, eds., *The Role of Religion in Western Societies* (London, 2007), pp. 25–48. The Religious Landscape Study conducted by Pew Research found that the proportion of Americans who say they are 'absolutely certain' that God exists shrank from 71% in 2007 to 63% in 2018. The younger generation is less religious: only 18% of Millennials (adults from their late teens to their early 30s) now say that religion is very important to them, and only 18% are absolutely certain that God exists, while 38% are sure that he does not (see https://www.pewforum.org/religious-landscape-study/, accessed 5 August 2019). I am therefore sceptical about the arguments advanced by John Micklethwait and Adrian Wooldridge, *God is Back: How the Global Revival of Faith is Changing the World* (New York, 2009).   75. See David Martin, *Tongues of Fire: The Explosion of Protestantism in Latin America* (Oxford, 1990).   76. Many examples in T. D. Kendrick, *The Lisbon Earthquake* (London, 1956); Gerhard Lauer and Thorsten Unger, eds., *Das Erdbeben von Lissabon und der Katastrophendiskurs im 18. Jahrhundert* (Göttingen, 2008); Robert G. Ingram, ' "The trembling Earth is God's Herald": earthquakes, religion and public life in Britain during the 1750s', in Theodore E. D. Braun and John B. Radner, eds., *The Lisbon Earthquake of 1755: Representation and Reaction* (Oxford, 2005), pp. 97–115.   77. John Wesley, *Serious Thoughts occasioned by the Earthquake at Lisbon*, 6th edn (London, 1756), p. 4.   78. See www.religioustolerance.org/tsunami04c.htm (accessed 3 July 2016).   79. But cf. Jerry A. Coyne, *Faith versus Fact: Why Science and Religion are Incompatible* (New York, 2015).   80. Harrison, *Territories*, pp. 10–11.   81. Locke, *Essay*, in *Works*, ii. p. 63.   82. Lessing, *Werke und Briefe*, ed. Wilfried Barner and others, 12 vols. (Frankfurt a.M., 1987–98), x. p. 626.   83. Shaftesbury, *Characteristics*, pp. 165–6.   84. Letter of 26 Sept. 1762 in Diderot, *Letters to Sophie Volland*, ed. and tr. Peter France (London, 1972), p. 123; OCD v. p. 764.   85. Voltaire, *Essai sur les mœurs*, ed. René Pomeau, 2 vols. (Paris, 1963), i. p. 96; cf. Jonathan Israel, *Enlightenment Contested: Philosophy, Modernity, and the Emancipation of Man 1670–1752* (Oxford, 2006), p. 547.   86. Peter Burke, *Popular Culture in Early Modern Europe* (London, 1978), p. 270; Christof Dipper, 'Volksreligiosität und Obrigkeit im 18. Jahrhundert', in Wolfgang Schieder, ed., *Volksreligiosität in der modernen Sozialgeschichte* (Göttingen, 1986), pp. 73–96.   87. See Delumeau, *La Peur en Occident*, pp. 232–53, esp. p. 243 on 'la théologie terrorisante des intellectuels'.   88. See Oberman, *Luther*, pp. 154–6. For a handy anthology of Luther's statements about the Devil, see Eire, *Reformations*, pp. 649–50.   89. Thomas, *Religion*, pp. 469, 476; Delumeau, *Catholicism*, p. 173; Brian Levack, *The Witch-Hunt in Early Modern Europe*, 4th edn (London, 2016), p. 117.   90. Quoted in John McManners, *Death and the Enlightenment:*

*Changing Attitudes to Death among Christians and Unbelievers in Eighteenth-Century France* (Oxford, 1981), p. 134. 91. D. P. Walker, *The Decline of Hell: Seventeenth-Century Discussions of Eternal Torment* (London, 1964), pp. 5–6. Voltaire too held this opinion: see Roland Mortier, 'Voltaire et le peuple', in his *Le Cœur et la Raison: Recueil d'études sur le dix-huitième siècle* (Oxford, 1990), pp. 89–103 (p. 100). 92. Delumeau, *Péché*, pp. 448–52. 93. Quoted ibid., p. 453. 94. Ibid., p. 453. Cf. Milton, *Paradise Lost*, v. ll. 735–7. 95. Matt. 7:14; Luke 13:24; Matt. 20:16 and 22:14. Cf. Leibniz, *Theodicy: Essays on the Goodness of God, the Freedom of Man and the Origin of Evil*, tr. E. M. Huggard (London, 1951), p. 134; Hume, *Dialogues concerning Natural Religion*, ed. John Valdimir Price (Oxford, 1976), p. 258. 96. Delumeau, *Péché*, p. 466. 97. Philip C. Almond, *Heaven and Hell in Enlightenment England* (Cambridge, 1994), p. 73. 98. 'Sur le petit nombre des élus', in *Œuvres choisis de Massillon*, ed. Frédéric Godefroy, 2 vols. (Paris, 1848), i. pp. 370–404. 99. Voltaire, 'Éloquence', *OCV* 41, p. 65. 100. The comparison is made by McManners, *Death*, p. 133; Almond, *Heaven and Hell*, p. 84. For many examples of such fantasies, see Piero Camporesi, *The Fear of Hell: Images of Damnation and Salvation in Early Modern Europe*, tr. Lucinda Byatt (Cambridge, 1990). On punishments, see Pieter Spierenburg, *The Spectacle of Suffering: Executions and the Evolution of Repression: from a Preindustrial Metropolis to the European Experience* (Cambridge, 1984), pp. 66–77. 101. Many examples in Bernard Capp, *The Fifth Monarchy Men* (London, 1972), pp. 95–6. 102. See Walker, *Decline of Hell*, p. 43; McManners, *Death*, p. 138; Almond, *Heaven and Hell*, p. 154. 103. See the arguments by the Socinian Ernst Soner, in Walker, *Decline of Hell*, p. 43; Karl Aner, *Die Theologie der Lessingzeit* (Halle, 1929), p. 277. 104. Walker, *Decline of Hell*, p. 50. 105. Ibid., pp. 53–4. Leibniz opposes such arguments: *Theodicy*, pp. 236–7. 106. St François de Sales says the saints will feel 'allégresse' (cheerfulness): Delumeau, *Péché*, p. 457. 107. Delumeau, *Péché*, p. 458. For some of Tertullian's 'affected and unfeeling witticisms', see Gibbon, *Decline and Fall*, i. p. 471. Cf. also Pope Innocent III, *The Mirror of Mans Lyfe*, tr. Henry Kirton (London, 1576), Book III, ch. 5 (unpag.), which quotes Psalm 58, 'The righteous shall rejoice when he seeth the vengeance'. 108. Christopher Love, *Hell's Terror: or, A Treatise of the Torments of the Damned, as a Preservative Against Security* (London, 1653), p. 41. 109. Quoted in Almond, *Heaven and Hell*, p. 98. 110. Lecky, *Rationalism*, i. pp. 322–3. 111. Thomas Merton, *The Seven Storey Mountain* (New York, 1948), pp. 211, 217. 112. See McManners, *Death*, p. 146. 113. See also Eph. 1:4: '[God] chose us in him [Christ] before the foundation of the world'; and St Augustine, *Concerning the City of God against the Pagans*, tr. Henry Bettenson (London, 1984), pp. 591–2 (Bk XIV, ch. 26). Gibbon observes that although 'the church of Rome has canonised Augustin and reprobated Calvin', 'the *real* difference between them is invisible even to a theological microscope' (*Decline and Fall*, ii. p. 286 n. 31). 114. Quoted in Henry Grey Graham, *The Social Life of Scotland in the Eighteenth Century* (London, 1901), p. 369. 115. Louis Racine, 'La Grâce' (1720), in his *Œuvres*, 6 vols. (Paris, 1808), i. p. 73. 116. *Memoirs of the Life, Time, and Writings of Thomas Boston, A.M.*, ed. George H. Morrison (Edinburgh, 1899), p. 10. 117. Moritz, *Anton Reiser*, pp. 63–4. 118. Jean-Jacques Rousseau, *Confessions*, tr. Angela Scholar, ed. Patrick Coleman (Oxford, 2000), p. 237. 119. *The Works of the Most Reverend Dr. John Tillotson, Archbishop of Canterbury*, 12 vols. (London, 1757), iii. p. 17. 120. On Tillotson's sermon and its many critics, see Almond, *Heaven and Hell*, pp. 156–7. 121. Quoted by Mark Knights, *The Devil in Disguise: Deception, Delusion, and Fanaticism in the Early English Enlightenment* (Oxford, 2011), p. 152. 122. Pope, 'Epistle to Burlington', ll. 149–50, in *TE* iii/2, pp. 151–2. 123. James Boswell, *Life of Johnson*, ed. R. W. Chapman, corrected by J. D. Fleeman (London, 1970), p. 1296. 124. Ibid.; see also p. 876, where Johnson hopes that some other means besides punishment may prevent a posthumous 'fall from rectitude' – a strange idea, since it was normally assumed that the blessed could no longer sin: see Walker, *Decline of Hell*, p. 23. 125. Diderot, 'Entretien d'un philosophe avec Mme la maréchale de \*\*\*', *OCD* xi. pp. 131–44 (p. 138). 126. Hume, *A Treatise of Human Nature: A Critical Edition*, ed. David Fate Norton and Mary J. Norton (Oxford, 2007), p. 78 (I iii 9). Cf. Keith Thomas, *The Ends of Life: Roads to Fulfilment in Early Modern England* (Oxford, 2009), pp. 232–5.

**127.** [Anon.], *The World Unmask'd; or, The Philosopher the greatest Cheat [ . . . ]; to which is added, The State of Souls separated from their Bodies* (London, 1736). Originally *Sentiments différents de quelques Théologiens sur l'état des âmes séparées du corps* (1731). **128.** See Walker, *Decline of Hell*, pp. 40–42. **129.** *Satire, Fantasy and Writings on the Supernatural by Daniel Defoe*, ed. W. R. Owens and P. N. Furbank (London, 2003–5), vol. 6: *The Political History of the Devil* (1726), ed. John Mullan, p. 167. On attempts to mitigate hell by reinterpreting its torments in moral and emotional terms, see Walker, *Decline of Hell*, pp. 59–70. **130.** James Obelkevich, *Religion and Rural Society: South Lindsey, 1825–1875* (Oxford, 1976), pp. 298–9. **131.** Bernard Mandeville, *Free Thoughts on Religion, the Church, and National Happiness* (London, 1720), p. 3. **132.** [John Toland], *Christianity not Mysterious, or, a Treatise shewing, that there is nothing in the Gospel contrary to Reason, nor above it: and that no Christian Doctrine can be properly call'd a Mystery* (London, 1696), p. 49. **133.** See Roy Porter, *Enlightenment: Britain and the Creation of the Modern World* (London, 2000), p. 116. **134.** [Matthew Tindal], *Christianity as Old as the Creation; or, the Gospel, a Republication of the Religion of Nature* (London, 1731), p. 20. **135.** [Tindal], *Christianity*, p. 11; cf. William Wollaston, *The Religion of Nature Delineated* (London, 1724), p. 40. **136.** See Jonathan Israel, *Radical Enlightenment: Philosophy and the Making of Modernity 1650–1750* (Oxford, 2001), p. 362. **137.** Elisha Smith, *The Cure of Deism, or, the Mediatorial Scheme by Jesus Christ the only True Religion*, 2 vols. (London, 1736), i. p. x. Shaftesbury and Tindal are called the 'Oracles of Deism' (p. vii). See Mark-Georg Dehrmann, *Das 'Orakel der Deisten': Shaftesbury und die deutsche Aufklärung* (Göttingen, 2008). **138.** Shaftesbury, *Characteristics*, p. 182. **139.** Ibid., p. 21. **140.** Ibid., p. 184. **141.** Ibid., p. 180. **142.** Ibid., p. 191. **143.** Thomas Morgan, *The Moral Philosopher. In a Dialogue between Philalethes a Christian Deist, and Theophanes a Christian Jew* (London, 1737), p. 134. **144.** Shaftesbury, *Characteristics*, p. 181. **145.** 'De la Suffisance de la religion naturelle' (1763), *OCD* v. pp. 225–39 (p. 229). Cf. John 1:9: '[Jesus] was the true Light, which lighteth every man that cometh into the world.' **146.** *OCD* v. p. 236. Cf. Hume, *Dialogues*, p. 185; Locke, *Essay*, II xiii 19, in *Works*, i. p. 156. More recent versions of this story end 'it is turtles all the way down': e.g. Clifford Geertz, *The Interpretation of Cultures* (New York, 1973), p. 29. **147.** Quoted in Anton Matytsin, 'Reason and utility in French religious apologetics', in William J. Bulman and Robert G. Ingram, eds., *God in the Enlightenment* (New York, 2016), pp. 63–82 (p. 69). **148.** Quoted ibid., p. 75. Cf. Jeffrey D. Burson, 'Nicolas-Sylvestre Bergier (1718–1790): an enlightened anti-*philosophe*', in Jeffrey D. Burson and Ulrich L. Lehner, eds., *Enlightenment and Catholicism in Europe: A Transnational History* (Notre Dame, IN, 2014), pp. 63–88 (esp. p. 72). **149.** In *The Song of Los* (1795) William Blake shows his interest in comparative religion by giving a potted history of religious imposture, beginning with 'Brama in the East' and continuing with Egypt, where [Hermes] Trismegistus receives an 'abstract Law', Greece, and a misguided Jesus, followed by Mahomet and Odin. See Blake, *Complete Writings*, ed. Geoffrey Keynes (London, 1976), pp. 245–6; Jon Mee, *Dangerous Enthusiasm: William Blake and the Culture of Radicalism in the 1790s* (Oxford, 1994), pp. 121–40. On the history of 'priestcraft', see S. J. Barnett, *Idol Temples and Crafty Priests: The Origins of Enlightenment Anticlericalism* (Basingstoke, 1999). **150.** Locke, *The Reasonableness of Christianity*, in *Works*, vi. p. 135. **151.** *Œuvres complètes de Fontenelle*, ed. Alain Niderst, 9 vols. (Paris, 1989–2001), ii. p. 154. **152.** *OCV* 1A, p. 224. **153.** *De l'esprit*, in Helvétius, ed. Albert Keim (Paris, 1909), p. 21. **154.** [Tindal], *Christianity*, p. 237. **155.** Knights, *Devil*, pp. 100–101. **156.** Ibid., pp. 103–7. **157.** Letter from Joseph Glanvill to Henry More, 25 Sept. 1668?, quoted in Michael Hunter, 'The decline of magic: challenge and response in early Enlightenment England', *Historical Journal*, 55 (2012), pp. 399–425 (p. 403), with further examples. Charleton was an exponent of natural religion and the new mechanical philosophy. **158.** Thomas Sprat, *The History of the Royal-Society of London* (London, 1667), p. 376. **159.** Roy Porter, *English Society in the Eighteenth Century*, rev. edn (London, 1991), p. 169. **160.** *Spectator*, no. 50, 27 Apr. 1711. **161.** 'Notes sur l'Angleterre', *OCM* i. p. 883. **162.** Tobias Smollett, *Travels through France and Italy*, ed. Frank Felsenstein (Oxford, 1979), p. 268. **163.** John, Lord Hervey, *Some Materials towards Memoirs of the Reign of King George II*, ed. Romney

Sedgwick, 3 vols. (London, 1931), i. p. 92.　164. J. C. D. Clark, *English Society 1688-1832: Ideology, Social Structure and Political Practice during the ancien regime* (Cambridge, 1985), pp. 80, 87.　165. Daniel Mornet, *Les Origines intellectuelles de la Révolution Française* (Paris, 1933), pp. 52-8.　166. Quoted in René Pomeau, *La Religion de Voltaire*, 2nd edn (Paris, 1969), p. 8.　167. See e.g. Graham Gargett, 'Voltaire and the Bible', in Nicholas Cronk, ed., *The Cambridge Companion to Voltaire* (Cambridge, 2009), pp. 193-204. 168. See Norman Torrey, *Voltaire and the English Deists* (New Haven, 1930), p. 10.　169. So Pomeau, *Religion, passim*; but contrast Theodore Besterman, *Voltaire* (London, 1969), pp. 207-23.　170. Letter to Ludwig Martin Kahle, ?March 1744, OCV 93, p. 78.　171. Letter to René Joseph Tournemine, *c.* August 1735, OCV 87, p. 187.　172. Letter, *c.* 25 April 1737, OCV 88, p. 295.　173. On Voltaire's promotion of Newtonianism, see Israel, *Enlightenment Contested*, pp. 751-72.　174. Letter to Diderot, ?10 June 1749, OCV 95, p. 84. 175. Boswell, letter to William Temple from Ferney, 28 Dec. 1764, in *Boswell on the Grand Tour: Germany and Switzerland 1764*, ed. Frederick A. Pottle (London, 1953), p. 286. 176. See Bertram Eugene Schwarzbach, *Voltaire's Old Testament Criticism* (Geneva, 1971), esp. ch. 3.　177. *Dieu et les hommes*, OCV 69, p. 442.　178. *La Philosophie de l'histoire*, OCV 59, p. 256.　179. 'Moïse', *Dictionnaire philosophique*, OCV 36, pp. 386-93. See Schwarzbach's introduction to *La Bible enfin expliquée*, OCV 79A (1), pp. 40 (Pentateuch), 58-9 (Simon).　180. 'Juif', OCV 42A, p. 488.　181. *La Bible enfin expliquée*, OCV 79A, p. 305. Voltaire was probably right: see Francesca Stavrakopoulou, 'Child sacrifice in the ancient world: blessings for the beloved', in Laurence Brockliss and Heather Montgomery, eds., *Childhood and Violence in the Western Tradition* (Oxford, 2010), pp. 22-7.　182. *La Philosophie de l'histoire*, OCV 59, p. 230.　183. Adam Sutcliffe, *Judaism and Enlightenment* (Cambridge, 2003), p. 236.　184. *La Philosophie de l'histoire*, OCV 59, p. 229. Cf. *Essai sur les mœurs*, i. p. 261.　185. *Traité de métaphysique* (1734), OCV 14, p. 455. Here Voltaire is probably following Bayle: see 'Akiba', note F, in Bayle, *Dictionnaire historique et critique*, 4 vols. (Amsterdam, 1730), i. p. 123; H. T. Mason, *Pierre Bayle and Voltaire* (Oxford, 1963), p. 31.　186. For the eel, see Lev. 11:10; the hare, Lev. 11:6; birds that walk on all fours, Lev. 11:20; dead mice and moles, Lev. 11:29-31.　187. Léon Poliakov, *The History of Anti-Semitism*, vol. III: *From Voltaire to Wagner*, tr. Miriam Kochan (London, 1975), pp. 91-6; Sutcliffe, *Judaism*, pp. 239-44.　188. Cyril Rodd, *Glimpses of a Strange Land: Studies in Old Testament Ethics* (Edinburgh, 2001), pp. 185, 193, 197. See Exod. 15:3; Ps. 24:8; Isa. 34; Isa. 63:1-6; Isa. 11:1-9. Cf. Steven Pinker, *The Better Angels of our Nature: The Decline of Violence in History and its Causes* (London, 2011), pp. 6-11.　189. 'Juif', OCV 42A, p. 472n. In his mock-epic poem *La Pucelle* (1755), Voltaire speaks of 'Aod, ce Ravaillac hébreu' (OCV 7, p. 447), alluding to the murderer of Henri IV. See Judges 3:12-30, where the assassination is described graphically.　190. Voltaire, *Treatise on Tolerance and Other Writings*, tr. Brian Masters and Simon Harvey, ed. Simon Harvey (Cambridge, 2000), p. 56.　191. Ibid., p. 57.　192. Poliakov, *The History of Anti-Semitism*, vol. III: *From Voltaire to Wagner*, tr. Miriam Kochan (London, 1975).　193. Richard Popkin, *The Third Force in Seventeenth-Century Thought* (Leiden, 1992), p. 74.　194. Arthur Hertzberg, *The French Enlightenment and the Jews* (New York, 1968), p. 286.　195. Poliakov, *History of Anti-Semitism*, iii p. 90. See [Grattenauer], *Wider die Juden. Ein Wort der Warnung an alle unsere christliche Mitbürger* (Berlin, 1803). Grattenauer's scurrilous pamphlet is, however, mainly indebted to obsessive anti-Jewish writers such as the notorious Johann Andreas Eisenmenger (1654-1704).　196. Bertram Eugène Schwarzbach, 'Voltaire et les Juifs: bilan et plaidoyer', *SVEC*, 358 (1997), p. 58.　197. Quoted in Poliakov, *History of Anti-Semitism*, iii p. 98.　198. See Schwarzbach, 'Voltaire', pp. 48-54.　199. See Ian Davidson, *Voltaire: A Life*, rev. edn (London, 2012), p. 59.　200. Ibid., pp. 250-51.　201. Ibid., pp. 34, 75-7. 202. Voltaire, *Histoire de Charles XII*, in *Œuvres historiques*, ed. René Pomeau (Paris, 1957), p. 172.　203. Letter to Pinto, 21 July 1762, OCV 109, pp. 120-21.　204. Hertzberg, *French Enlightenment*, p. 284; Sutcliffe, *Judaism*, pp. 244-5. For more on Pinto, see Hertzberg, *French Enlightenment*, pp. 142-53, 180-83; Sutcliffe, 'Can a Jew be a *philosophe*? Isaac de Pinto, Voltaire and Jewish participation in the European Enlightenment', *Jewish Social Studies*, 6 (2000), pp. 31-51.　205. See Peter Gay, 'Voltaire's anti-Semitism', in his

*The Party of Humanity: Studies in the French Enlightenment* (London, 1964), pp. 97–108 (p. 103).   **206.** See J. H. Brumfitt, *Voltaire, Historian* (Oxford, 1958), pp. 30–32.   **207.** *Dieu et les hommes* (1769), *OCV* 69, p. 335.   **208.** 'Moyse', *OCV* 42B, p. 277.   **209.** *Dieu et les hommes*, *OCV* 69, p. 335. Cf. 'Abraham', *Dictionnaire philosophique*, *OCV* 35, p. 298. **210.** 'Juif', *OCV* 42A, p. 470.   **211.** See Niels Peter Lemche, *Ancient Israel: A New History of Israel*, 2nd edn (London, 2015), pp. 92–5. Lemche's radically demythologizing study of the Old Testament represents the 'minimalist' approach. For a prominent recent example of the 'maximalist' approach, see K. A. Kitchen, *On the Reliability of the Old Testament* (Grand Rapids, MI, 2003), who argues that the Exodus narrative is historical and that the law code was written on papyrus in the second millennium BCE, and also discusses the probable location of the Garden of Eden.   **212.** 'Sermon du Rabin Akib', *OCV* 52, p. 529. Gay is surely unjust in calling Voltaire's protest 'dutiful cant': 'Voltaire's anti-Semitism', p. 101. Contrast Sutcliffe, who calls it 'one of his most passionate pleas for tolerance': *Judaism*, p. 238; similarly Schwarzbach, *Voltaire's Old Testament Criticism*, p. 18.   **213.** 'A l'auteur du livre des trois imposteurs', *OCV* 70A, p. 244.   **214.** Letter to Charles Augustin Feriol, comte d'Argental, 20 April 1769, *OCV* 118, pp. 413–14.   **215.** *OCV* 118, p. 413. Cf. the even more cynical formulation in a letter to Constant d'Hermenches, 26 Dec. 1760, *OCV* 106, pp. 414–15.   **216.** *OCV* 70A, pp. 241–2.   **217.** Hume, *Dialogues*, p. 187.   **218.** Ibid., p. 202.   **219.** Ibid., p. 194.   **220.** Ibid., p. 228.   **221.** Ibid., pp. 226–7. Cf. Bayle, 'Paulicians', Note E, in *Historical and Critical Dictionary: Selections*, ed. and tr. Richard H. Popkin (Indianapolis, 1965), p. 169.   **222.** Hume, *Dialogues*, p. 215.   **223.** *Le Rêve de d'Alembert*, *OCD* viii. p. 55. Cf. Anthony Kenny, *The God of the Philosophers* (Oxford, 1979), p. 121.   **224.** Lucien Febvre, *The Problem of Unbelief in the Sixteenth Century: The Religion of Rabelais*, tr. Beatrice Gottlieb (Cambridge, MA, 1982), pp. 456–8. For a complex interpretation of Febvre's standpoint, see David Wootton, 'Lucien Febvre and the problem of early modern unbelief', *Journal of Modern History*, 60 (1988), pp. 695–730 (pp. 701–3).   **225.** These and many others were labelled atheists by the Jesuit François Garasse in 1623: see Alan Kors, *Atheism in France, 1650–1729*, vol. 1: *The Orthodox Sources of Disbelief* (Princeton, 1990), pp. 29–30.   **226.** Sir Thomas Browne, *Selected Writings*, ed. Geoffrey Keynes (London, 1968), p. 26.   **227.** Kors, *Atheism*, p. 57.   **228.** Wootton, 'Febvre', pp. 700–701.   **229.** See Don Cameron Allen, *Doubt's Boundless Sea: Skepticism and Faith in the Renaissance* (Baltimore, 1964); René Pintard, *Le Libertinage érudit dans la première moitié du XVIIᵉ siècle*, 2nd edn (Geneva and Paris, 1983). On dissimulation of heterodox views, see Perez Zagorin, *Ways of Lying: Dissimulation, Persecution, and Conformity in Early Modern Europe* (Cambridge, MA, 1990), esp. pp. 289–330.   **230.** David Wootton, *Paolo Sarpi: Between Renaissance and Enlightenment* (Cambridge, 1983), pp. 24–9. **231.** Letter to Colonel James Edmonstoune, April 1764, in *New Letters of David Hume*, ed. Raymond Klibansky and Ernest C. Mossner (Oxford, 1954), p. 83. Cf. Nicholas Davidson, 'Unbelief and atheism in Italy, 1500–1700', in Michael Hunter and David Wootton, eds., *Atheism from the Reformation to the Enlightenment* (Oxford, 1992), pp. 55–85 (pp. 70–71), for dissimulation in early modern Italy.   **232.** Diderot, 'Pensées philosophiques', *OCD* i. p. 279.   **233.** Hume, *The Natural History of Religion*, ed. A. Wayne Colver (Oxford, 1976), p. 74.   **234.** Ibid., p. 88.   **235.** Diderot, 'Réfutation d'Hemsterhuis', *OCD* xi. pp. 7–105 (p. 105).   **236.** Alan Charles Kors, *D'Holbach's Coterie: An Enlightenment in Paris* (Princeton, 1976), pp. 27–8.   **237.** *Mémoires de l'Abbé Morellet*, ed. Jean-Pierre Guicciardi (Paris, 1988), p. 131. For a sketch of the life and character of the physician Augustin Roux (1726–76), see Kors, *D'Holbach's Coterie*, pp. 22–3.   **238.** See the excellent account by Kors, 'The atheism of d'Holbach and Naigeon', in Hunter and Wootton, *Atheism*, pp. 273–300.   **239.** Letter to Sophie Volland, 6 Oct. 1765, *OCD* v. p. 946.   **240.** Kors, *D'Holbach's Coterie*, pp. 41–2.   **241.** Paul Henri Thiry, baron d'Holbach, *Système de la nature*, 2 vols. (Paris, 1770), i. p. 281.   **242.** Kors, *D'Holbach's Coterie*, p. 140.   **243.** Quoted in Ernst Cassirer, *The Philosophy of the Enlightenment*, tr. Fritz C. A. Koelln and James P. Pettegrove (Princeton, 1951), p. 71.   **244.** Tim Whitmarsh, *Battling the Gods: Atheism in the Ancient World* (London, 2016), esp. pp. 26–7.   **245.** Lucretius, *On the Nature of the Universe*, tr. R. E. Latham (Harmondsworth, 1951), p. 29.   **246.** Ibid., p. 208.   **247.** *OCV* 1B, p. 485. Cf. his

'Lettre de Memmius à Cicéron' (1771), O C V 72, p. 216; Peter Gay, *The Enlightenment: An Interpretation*, 2 vols. (New York, 1966–9), i. pp. 98–105.   **248.** Hume, *Natural History*, p. 32.   **249.** Ibid., p. 83.   **250.** David Wootton, *The Invention of Science: A New History of the Scientific Revolution* (London, 2015), pp. 443–4.   **251.** Quoted ibid., p. 444.   **252.** Rousseau, *Émile*, tr. Barbara Foxley (London, 1911), p. 238; O C R iv. p. 579.   **253.** Richard Dawkins, *The Blind Watchmaker* (London, 1986), pp. 46–9.   **254.** Ibid., pp. 43–74; I have no doubt caricatured Dawkins's argument, but I hope I have conveyed the essential point.   **255.** Origen, *Contra Celsum*, tr. Henry Chadwick (Cambridge, 1953), p. 22.   **256.** See e.g. Michael F. Graham, *The Blasphemies of Thomas Aikenhead* (Edinburgh, 2008), p. 103. A century earlier Christopher Marlowe was charged with calling St Paul a 'juggler': Charles Nicholl, *The Reckoning: The Murder of Christopher Marlowe* (London, 1992), p. 45.   **257.** Humphrey Prideaux, *The True Nature of Imposture Fully Display'd in the Life of Mahomet*, 5th edn (London, 1713), p. 65.   **258.** *Histoire de mon temps*, in *Œuvres de Frédéric le Grand*, ed. J. D. E. Preuss, 33 vols. (Berlin, 1846–57), ii. p. 17.   **259.** For a short account of both, see H. B. Nisbet, '*De tribus impostoribus*: on the genesis of Lessing's *Nathan der Weise*', *Euphorion*, 73 (1979), pp. 365–87 (pp. 368–71). For an exhaustive study, see the introduction to *Le 'Traité des trois imposteurs' et 'L'Esprit de Spinosa': Philosophie clandestine entre 1678 et 1768*, ed. Françoise Charles-Daubert (Oxford, 1999).   **260.** *Le 'Traité des trois imposteurs'*, p. 732; cf. Machiavelli, *The Prince*, ed. Quentin Skinner and Russell Price (Cambridge, 1988), p. 21.   **261.** *Le 'Traité des trois imposteurs'*, p. 733. On this text, see Israel, *Radical Enlightenment*, pp. 695–700.   **262.** *Le testament de Jean Meslier*, ed. Rudolf Charles, 3 vols. (Amsterdam, 1864), i. p. 25; translation from *Testament: Memoir of the Thoughts and Sentiments of Jean Meslier*, tr. Michael Shreve (New York, 2009), p. 41. On Meslier's conflicts with the authorities, see Maurice Dommanget, *Le curé Meslier: Athée, communiste et révolutionnaire sous Louis XIV* (Paris, 1965), pp. 76–84.   **263.** Meslier, *Le testament*, i. p. 37; *Testament*, p. 49. Although this suggests that Meslier knew the *Traité des trois imposteurs*, there is no external evidence for such a conjecture.   **264.** Meslier, *Le testament*, ii. p. 31; *Testament*, p. 197.   **265.** Meslier, *Le testament*, ii. p. 41; *Testament*, p. 204.   **266.** Meslier, *Le testament*, ii. p. 95; *Testament*, p. 233. See Luke 18:19.   **267.** Meslier, *Le testament*, ii. p. 181; *Testament*, p. 275.   **268.** Meslier, *Le testament*, ii. p. 284; *Testament*, p. 337.   **269.** See Dommanget, *Meslier*, pp. 163–4, 187–9.   **270.** See Ira O. Wade, *The Clandestine Organization and Diffusion of Philosophic Ideas in France from 1700 to 1750* (Princeton, 1938), pp. 65–93.   **271.** Dommanget, *Meslier*, p. 383.   **272.** Voltaire, letter to Damilaville, 10 Oct. 1762, O C V 109, p. 262. On Voltaire's misrepresentation, see Israel, *Enlightenment Contested*, pp. 726–7.   **273.** See now Michael Bergmann, Michael J. Murray and Michael C. Rea, eds., *Divine Evil? The Moral Character of the God of Abraham* (Oxford, 2011).   **274.** Gibbon, *Decline and Fall*, ii. p. 437.   **275.** Mara van der Lugt, *Bayle, Jurieu, and the 'Dictionnaire Historique et Critique'* (Oxford, 2016), pp. 35–46.   **276.** 'Manichaeans', note D, in *Selections*, ed. Popkin, p. 148.   **277.** 'Paulicians', note F, in *Selections*, ed. Popkin, p. 181.   **278.** See Wolfgang Pross, 'Die Konkurrenz von ästhetischem Wert und zivilem Ethos – Ein Beitrag zur Entstehung des Neoklassizismus', in Roger Bauer, ed., *Der theatralische Neoklassizismus um 1800: Ein europäisches Phänomen?* (Bern, 1986), pp. 64–126.   **279.** Jean Racine, *Œuvres complètes*, ed. Georges Forestier (Paris, 1999), p. 734.   **280.** See Rosmarie Zeller, 'Die Rezeption des antiken Dramas im 18. Jahrhundert: Das Beispiel der Merope (Maffei, Voltaire, Lessing)', in Hellmut Flashar, ed., *Tragödie: Idee und Transformation* (Stuttgart, 1997), pp. 142–60.   **281.** Lessing, *Hamburgische Dramaturgie*, §41, in his *Werke und Briefe*, vi. pp. 383–8.   **282.** Scipione Maffei, *Merope*, Collezione portatile di classici italiani, vol. 17 (Florence, 1826), p. 41.   **283.** For other examples, see Pross, 'Konkurrenz', pp. 79–83. Voltaire's much milder *Mérope* (1743) transfers the centre of interest from Merope's maternal dilemma to the situation in which Polyphonte first pressures, then blackmails her into marriage.   **284.** 'Wurmgeschlecht': Goethe, *Sämtliche Werke: Briefe, Tagebücher und Gespräche*, ed. Friedmar Apel and others, 40 vols. (Frankfurt a.M., 1986–2000), iv. p. 413. Cf. Job 25:6, Ps. 22:6.   **285.** Goethe, *Sämtliche Werke*, i. p. 329. Although Goethe is unlikely to have read Hume's *Natural History of Religion*, he here seems very close to Hume's account of the origin of religion in people's hopes and fears: see Jonas

Jølle, '"Prince poli & savant": Goethe's Prometheus and the Enlightenment', *MLR*, 99 (2004), pp. 394–415 (p. 404).  **286.** Goethe, *Selected Verse*, tr. David Luke (Harmondsworth, 1964), p. 18.  **287.** Goethe, *Sämtliche Werke*, v. p. 569.  **288.** Letter to Lavater, 9 Aug. 1782, *Sämtliche Werke*, xxix. pp. 440–41.  **289.** See letter to Sulpiz Boisserée, Aug. 1815, *Sämtliche Werke*, xxxiv. p. 483, and to K. F. Zelter, 7 Nov. 1816, ibid., xxxv. p. 58; Rüdiger Safranski, *Goethe: Kunstwerk des Lebens* (Munich, 2013), pp. 286–92; Ritchie Robertson, *Goethe: A Very Short Introduction* (Oxford, 2016), pp. 27–8. But cf. Nicholas Boyle, *Goethe: The Poet and the Age*, 2 vols. to date (Oxford, 1991–2000), i. pp. 383–5.  **290.** *Dichtung und Wahrheit*, in Goethe, *Sämtliche Werke*, xiv. p. 245.  **291.** See Wolfdietrich Rasch, *Goethes 'Iphigenie auf Tauris' als Drama der Autonomie* (Munich, 1979). On Goethe's relation to Voltaire, see also Gonthier-Louis Fink, 'Goethe und Voltaire', *Goethe-Jahrbuch*, 101 (1984), pp. 74–111.  **292.** John Passmore, *The Perfectibility of Man* (London, 1970), p. 215.  **293.** *Spectator*, no. 111, 7 July 1711.  **294.** *Faust II*, ll. 12,084–91, in Goethe, *Sämtliche Werke*, vii. p. 463. See Klaudia Hilgers, *Entelechie, Monade und Metamorphose: Formen der Vervollkommnung im Werk Goethes* (Munich, 2002), pp. 271–89.  **295.** Goethe, *Faust Part Two*, tr. David Luke (Oxford, 1994), pp. 238–9.  **296.** Lessing, *Philosophical and Theological Writings*, ed. and tr. H. B. Nisbet (Cambridge, 2005), p. 240. See Rudolf Unger, 'Zur Geschichte des Palingenesiegedankens im 18. Jahrhundert', *DVjs*, 2 (1924), pp. 257–74; Lieselotte E. Kurth-Voigt, *Continued Existence, Reincarnation, and the Power of Sympathy in Classical Weimar* (Rochester, NY, 1999); Hilgers, *Entelechie*, pp. 178–96.  **297.** See Bernhard Lang and Colleen McDannell, *Heaven: A History* (New Haven, 1988), esp. ch. 7: 'Swedenborg and the emergence of a modern heaven', pp. 181–227.  **298.** See Michael Heinrichs, *Emanuel Swedenborg in Deutschland: Eine kritische Darstellung der Rezeption des schwedischen Visionärs im 18. und 19. Jahrhundert* (Frankfurt a.M., 1979); Diethard Sawicki, *Leben mit den Toten: Geisterglauben und die Entstehung des Spiritismus in Deutschland 1770–1900* (Paderborn, 2002).  **299.** Herder, 'Palingenesie' (1797), in *Werke*, ed. Günter Arnold and others, 10 vols. (Frankfurt a.M., 1985–2000), viii. pp. 257–82 (p. 272).  **300.** Herder, 'Über die menschliche Unsterblichkeit' (1791), in *Werke*, viii. pp. 203–19 (p. 209).  **301.** This summary follows Walker, *Decline of Hell*, pp. 12–13; C. A. Patrides, 'The salvation of Satan', *JHI*, 28 (1967), pp. 467–78.  **302.** See Morwenna Ludlow, *Universal Salvation: Eschatology in the Thought of Gregory of Nyssa and Karl Rahner* (Oxford, 2000); St Augustine, *City of God*, p. 995 (Book XXI, ch. 17).  **303.** *Paradise Lost*, v. l. 615.  **304.** Rousseau, *Confessions*, p. 223.  **305.** Pierre Cuppé, *Heaven Open to All Men* (London, 1743), pp. ix, 10. Cuppé's original text, *Le Ciel ouvert à tous les hommes*, circulated widely in manuscript, but was not published till 1768, long after his death in 1748; see Wade, *Clandestine Organization*, pp. 33–44; McManners, *Death*, pp. 177–8.  **306.** Aner, *Theologie*, pp. 276–8.  **307.** Laurence Sterne, *The Life and Opinions of Tristram Shandy, Gentleman*, ed. Ian Campbell Ross, rev. edn (Oxford, 2009), p. 143.  **308.** *The Poems and Songs of Robert Burns*, ed. James Kinsley, 3 vols. (Oxford, 1968), i. p. 172. The similarity to Sterne, whose work Burns knew, is pointed out by Nigel Leask, *Robert Burns and Pastoral: Poetry and Improvement in Late Eighteenth-Century Scotland* (Oxford, 2010), p. 199.  **309.** See David Sorkin, *The Religious Enlightenment: Protestants, Jews, and Catholics from London to Vienna* (Princeton, 2008), pp. 69–111.  **310.** Rousseau, *Émile*, p. 224; OCR iv. p. 560; Ronald Grimsley, *Rousseau and the Religious Quest* (Oxford, 1968), p. 8.  **311.** The vicar praises 'the illustrious Clarke' (*Émile*, p. 231; OCR iv. p. 570).  **312.** Rousseau, *Émile*, p. 239; OCR iv. pp. 580–81.  **313.** Rousseau, *Émile*, pp. 249–50; OCR iv. pp. 594–5.  **314.** Grimsley, *Religious Quest*, p. 50.  **315.** Leo Damrosch, *Jean-Jacques Rousseau: Restless Genius* (New York, 2005), p. 358. On theological objections, see Gilbert Py, *Rousseau et les éducateurs: étude sur la fortune des idées pédagogiques de Jean-Jacques Rousseau en France et en Europe au XVIIIᵉ siècle* (Oxford, 1997), p. 52.  **316.** Shaftesbury, *Characteristics*, p. 167. On Spalding's debt to Shaftesbury, see Dehrmann, *Das 'Orakel der Deisten'*, pp. 130–55.  **317.** On its popularity, see Laura Anna Macor, *Die Bestimmung des Menschen (1748–1800): Eine Begriffsgeschichte* (Stuttgart, 2013), pp. 100–103.  **318.** Between 1747 and 1850 at least 71 books were published with 'Bestimmung' in the title: Dehrmann, *Das 'Orakel der Deisten'*, p. 140n.  **319.** Johann

Joachim Spalding, *Die Bestimmung des Menschen*, ed. Albrecht Beutel, Daniela Kirschkowski and Dennis Prause (Tübingen, 2006), p. 110.   **320.** Spalding, *Bestimmung*, p. 166.   **321.** See Macor, *Bestimmung*, pp. 111–17.   **322.** See the quotation from Spalding's *Gedanken über den Wert der Gefühle im Christentum* (1761) in Aner, *Theologie*, p. 167.   **323.** Hilliard, *Freethinkers*, p. 191.   **324.** Friedrich Schleiermacher, *On Religion: Speeches to its Cultured Despisers*, tr. Richard Crouter (Cambridge, 1988), p. 102 (translation modified).   **325.** Schleiermacher, *On Religion*, pp. 102–3.   **326.** *Hamlet*, I, ii, 132. See Lester G. Crocker, 'The discussion of suicide in the eighteenth century', *JHI*, 13 (1952), pp. 47–72; McManners, *Death*, ch. 12; Michael MacDonald and Terence R. Murphy, *Sleepless Souls: Suicide in Early Modern England* (Oxford, 1990).   **327.** Montaigne, 'A custom of the Isle of Cea', in *The Complete Essays*, tr. M. A. Screech (London, 2003), p. 394.   **328.** Robert Blair, *The Grave. A Poem (1743)*, ed. James A. Means (Los Angeles, 1973), l. 413.   **329.** *OCM* i. pp. 246–7, 372. See the discussion in MacDonald and Murphy, *Sleepless Souls*, pp. 154–6.   **330.** *OCV* 63C, p. 328; *Candide and Other Stories*, tr. Roger Pearson (Oxford, 2006), p. 253.   **331.** Hume, 'Of Suicide', in his *Essays Moral, Political, and Literary*, ed. Eugene F. Miller (Indianapolis, 1987), pp. 577–89 (p. 585). Cf. the tolerant attitude towards suicide shown by Gibbon, *Decline and Fall*, ii. p. 842.   **332.** Cesare Beccaria, *On Crimes and Punishments and Other Writings*, ed. Richard Bellamy (Cambridge, 1995), pp. 83–6.   **333.** Adam Smith, *The Theory of Moral Sentiments*, ed. D. D. Raphael and A. L. Macfie (Oxford, 1976), p. 287.   **334.** Kant, *Werke*, ed. Wilhelm Weischedel, 6 vols. (Darmstadt, 1958), iv. pp. 554–5.   **335.** See Miriam Griffin, 'Philosophy, Cato and Roman suicide', *Greece and Rome*, 22 (1986), pp. 64–77, 192–202; MacDonald and Murphy, *Sleepless Souls*, pp. 179–83.   **336.** MacDonald and Murphy, *Sleepless Souls*, p. 123.   **337.** Browne, *Selected Writings*, p. 50.   **338.** Montesquieu, *The Spirit of the Laws*, ed. and tr. Anne M. Cohler, Basia C. Miller and Harold S. Stone (Cambridge, 1989), p. 242 (Book XIV, ch. 13).   **339.** McManners, *Death*, pp. 234–5.   **340.** Moritz, *Anton Reiser*, p. 25.   **341.** Letter from Alessandro Verri to his brother Pietro, 26 November 1766, quoted in John Lough, 'Le Baron d'Holbach. Quelques documents inédits ou peu connus', *Revue d'histoire littéraire de la France*, 57 (1957), pp. 524–43 (p. 543). Cf. d'Holbach's denunciation of the lie of a future life in *Système de la nature*, i. pp. 257–300.   **342.** Quoted in John Demos, *The Unredeemed Captive: A Family Story from Early America* (London, 1996), p. 239.   **343.** Blair, *The Grave*, ll. 9, 5, 33, 40, 380–81, 484.   **344.** William Perkins, *A Salve for a Sicke Man, or, A Treatise containing the Nature, Differences, and Kindes of Death* (London, 1611), p. 60.   **345.** Philippe Ariès, *The Hour of our Death*, tr. Helen Weaver (New York, 1981), p. 331. See Erwin Panofsky, 'Et in Arcadia ego: Poussin and the elegiac tradition', in his *Meaning in the Visual Arts* (1955; Harmondsworth, 1970), pp. 340–67.   **346.** Perkins, *A Salve*, pp. 13–14.   **347.** Ibid., p. 16.   **348.** Jeremy Taylor, *Holy Dying*, ed. P. G. Stanwood (Oxford, 1989), p. 102.   **349.** Lucretius, *Nature*, p. 122. The same idea finds expression in Philip Larkin's poem 'Aubade' (1977): see his *Collected Poems*, ed. Anthony Thwaite (London, 1988), pp. 208–9.   **350.** Alberto Radicati, conte di Passerano, *A Philosophical Dissertation upon Death* (London, 1732), p. 14. See Franco Venturi, *Settecento riformatore: Da Muratori a Beccaria* (Turin, 1969), pp. 27–8.   **351.** Buffon, *De l'homme*, ed. Michèle Duchet (Paris, 1971), p. 158.   **352.** 'Mort (*Hist. nat. de l'homme*)', *Encyclopédie*, x. p. 717.   **353.** Quoted in Robert Favre, *La Mort dans la littérature et la pensée françaises au siècle des lumières* (Lyons, 1978), p. 205.   **354.** Spalding, *Bestimmung*, pp. 188, 190.   **355.** Rousseau, *OCR* ii. p. 717.   **356.** 'Wie die Alten den Tod gebildet', in Lessing, *Werke und Briefe*, vi. p. 778.   **357.** *The Complete Poems of Thomas Gray*, ed. H. W. Starr and J. R. Hendrickson (Oxford, 1966), pp. 37–43.   **358.** William Empson, *Some Versions of Pastoral* (London, 1935), p. 4.   **359.** Goethe, *Sämtliche Werke*, xv/1. p. 645; *The Flight to Italy*, tr. T. J. Reed (London, 1999), pp. 34–5.   **360.** Quoted in McManners, *Death*, p. 261 (with many more examples).   **361.** McManners, *Death*, p. 268; see also Favre, *La Mort*, pp. 173–5.   **362.** H. B. Nisbet, *Gotthold Ephraim Lessing: His Life, Works and Thought* (Oxford, 2013), pp. 648–9.   **363.** Friedrich Sengle, *Wieland* (Stuttgart, 1949), p. 571.   **364.** Alexander Carlyle, quoted in Richard B. Sher, *Church and University in the Scottish Enlightenment: The Moderate Literati of Edinburgh* (Edinburgh, 1985), pp. 185–6.   **365.** Graham, *Social Life*,

p. 363.    366. See the account in Ernest Campbell Mossner, *The Life of David Hume* (Oxford, 1954), pp. 589–603.    367. Sarah Fielding, *The Adventures of David Simple*, ed. Malcolm Kelsall (London, 1969), pp. 286–91.    368. Letter to the Comtesse de Boufflers, 20 Aug. 1776, *The Letters of David Hume*, ed. J. Y. T. Greig, 2 vols. (Oxford, 1932), ii. p. 335. 369. Hume, *Essays*, p. xl.    370. Adam Smith, letter to Alexander Wedderburn, 14 Aug. 1776, in *The Correspondence of Adam Smith*, ed. Ernest Campbell Mossner and Ian Simpson Ross (Oxford, 1977), p. 204. A milder version is in Smith's letter to William Strahan, 9 Nov. 1776, in *Letters of David Hume*, ii. p. 451; also in Hume, *Essays*, p. xlvi.    371. *Letters of David Hume*, ii. p. 335.    372. *Boswell in Extremes*, ed. Charles McC. Weis and Frederick A. Pottle (London, 1971), p. 12; cf. pp. 21, 25, 27.    373. See Hume's letter to an unidentified physician, in *Letters*, i. pp. 12–18; Hume, *Treatise of Human Nature*, p. 175 (I iv 7). 374. Susan Manning, ' "This philosophical melancholy": style and self in Boswell and Hume', in Greg Clingham, ed., *New Light on Boswell* (Cambridge, 1991), pp. 126–40 (p. 129). 375. *Boswell on the Grand Tour*, p. 32.

## 6. SCIENCE AND SENSIBILITY

1. Adam Smith, *The Theory of Moral Sentiments*, ed. D. D. Raphael and A. L. Macfie (Oxford, 1976), p. 292.    2. OCR, ii. p. 126.    3. La Rochefoucauld, *Maximes*, ed. Jacques Truchet (Paris, 1967), p. 24 (no. 76). See Nannerl O. Keohane, *Philosophy and the State in France: The Renaissance to the Enlightenment* (Princeton, 1980), pp. 289–93.    4. La Rochefoucauld, *Maximes*, p. 64 (no. 247).    5. Ibid., p. 44 (no. 171).    6. Ibid., p. 26 (no. 83). 7. William Warburton, *The Divine Legation of Moses Demonstrated, on the Principles of a Religious Deist, from the Omission of the Doctrine of a Future State of Reward and Punishment in the Jewish Dispensation*, 3rd edn, 2 vols. (London, 1742), i. p. 76.    8. See e.g. Pope, *The Dunciad* (B), ii. l. 414, in *TE* v. p. 317.    9. Bernard Mandeville, *The Fable of the Bees*, ed. Phillip Harth (Harmondsworth, 1970), p. 144.    10. Ibid., *Fable*, p. 124.    11. David Hume, 'Of Refinement in the Arts' (originally 'Of Luxury'), in his *Essays Moral, Political, and Literary*, ed. Eugene F. Miller (Indianapolis, 1987), pp. 268–80 (p. 279).    12. Jonathan Swift, 'A Modest Proposal', in *Irish Tracts 1728–1733*, ed. Herbert Davis (Oxford, 1955), pp. 109–18 (p. 111). On the uncertainty of how to read Mandeville, see Hector Monro, *The Ambivalence of Bernard Mandeville* (Oxford, 1975).    13. Mandeville, *Fable*, p. 77. 14. Ibid., p. 108.    15. Ibid., p. 102.    16. Ibid., p. 230.    17. Quoted in Lawrence E. Klein, *Shaftesbury and the Culture of Politeness: Moral Discourse and Cultural Politics in Early Eighteenth-Century England* (Cambridge, 1994), p. 72.    18. On Shaftesbury and Hobbes, see Robert Voitle, *The Third Earl of Shaftesbury, 1671–1713* (Baton Rouge, LA, 1984), p. 113; Stephen Darwall, *The British Moralists and the Internal 'Ought', 1640–1740* (Cambridge, 1995), p. 177.    19. Thomas Hobbes, *Leviathan*, ed. J. C. A. Gaskin (Oxford, 1996), p. 113.    20. Shaftesbury, *Characteristics of Men, Manners, Opinions, Times*, ed. Lawrence E. Klein (Cambridge, 1999), p. 51.    21. Ibid., p. 52.    22. Ibid., p. 42.    23. Ibid., p. 204. 24. Ibid., p. 180. On Shaftesbury and Stoicism, see Anthony J. La Vopa, *The Labor of the Mind: Intellect and Gender in Enlightenment Cultures* (Philadelphia, 2017), pp. 119–27.    25. Shaftesbury, *Characteristics*, p. 209.    26. The classic example of such a dilemma is the decision of Lucius Junius Brutus, the founder of the Roman Republic, to have his sons executed for conspiring to restore kingship. Machiavelli commends his decision (*The Discourses of Niccolò Machiavelli*, tr. Leslie J. Walker (London, 1950), pp. 465–6 (Book III, ch. 3)), whereas Montesquieu deplores it (*The Spirit of the Laws*, ed. and tr. Anne M. Cohler, Basia C. Miller and Harold S. Stone (Cambridge, 1989), p. 180 (Book XI, ch. 18)).    27. Shaftesbury, *Characteristics*, p. 175.    28. Ibid., p. 206.    29. Ian Simpson Ross, *The Life of Adam Smith* (Oxford, 1995), p. 89.    30. OCM i. p. 1546.    31. *Encyclopédie ou Dictionnaire raisonné des sciences, des arts et des métiers*, 17 vols. (Neuchâtel, 1765), vii. p. 583. 32. 'Plan einer Academie zu Bildung des Verstandes und des Herzens junger Leute' (1758), in *Wielands Gesammelte Schriften*, iv: *Prosaische Jugendwerke*, ed. Fritz Homeyer and Hugo Bieber (1916), pp. 183–206 (p. 188). On Shaftesbury's German reception see Mark-Georg

Dehrmann, *Das 'Orakel der Deisten': Shaftesbury und die deutsche Aufklärung* (Göttingen, 2008). 33. Alexander Carlyle, *Anecdotes and Characters of the Times*, ed. James Kinsley (London, 1973), p. 36. 34. Christopher J. Berry, *The Idea of Commercial Society in the Scottish Enlightenment* (Edinburgh, 2013), p. 9. 35. Francis Hutcheson, *Inquiry into the Original of Our Ideas of Beauty and Virtue*, 2nd edn, ed. W. Leidhold (Indianapolis, 2008), p. 95. 36. Ibid., p. 143. 37. See Daniel Carey, 'Francis Hutcheson's philosophy and the Scottish Enlightenment: reception, reputation and legacy', in Aaron Garrett and James A. Harris, eds., *Scottish Philosophy in the Eighteenth Century*, vol. 1: *Morals, Politics, Art, Religion* (Oxford, 2015), pp. 36–76 (p. 46). 38. Hutcheson, *Inquiry*, p. 121. 39. Smith, *Theory*, p. 303. 40. Adam Smith, *An Inquiry into the Nature and Causes of the Wealth of Nations*, ed. R. H. Campbell and A. S. Skinner (Oxford, 1976), p. 26. 41. Smith, *Theory*, p. 10. 42. Ibid., p. 317. 43. Smith's 'sympathy' might nowadays be called 'empathy': see Susan Lanzoni, *Empathy: A History* (New Haven, 2018), pp. 5–6. 44. Burns, 'To a Louse, On Seeing one on a Lady's Bonnet at Church', in *The Poems and Songs of Robert Burns*, ed. James Kinsley, 3 vols. (Oxford, 1968), i. pp. 193–4; Nigel Leask, *Robert Burns and Pastoral: Poetry and Improvement in Late Eighteenth-Century Scotland* (Oxford, 2010), pp. 174–5. 45. Smith, *Theory*, p. 116. 46. Ibid., p. 137. 47. Ibid., p. 118. 48. Ibid., pp. 136–7. 49. Ibid., p. 139. 50. Ibid., p. 90. 51. Ibid., p. 88. 52. Ibid., p. 137. 53. Ibid., p. 207. 54. Ibid., p. 143. 55. Ibid., p. 143. 56. Marivaux, *La Vie de Marianne, ou les aventures de Madame la Comtesse de \*\*\**, ed. Michel Gilot (Paris, 1978), pp. 100, 318. On Smith's reading of Marivaux, see Nicholas Phillipson, *Adam Smith: An Enlightened Life* (London, 2010), pp. 63–4. 57. Smith, *Theory*, p. 123. 58. Ibid., p. 33. 59. Ibid., p. 309. 60. Ibid., p. 308. 61. Ibid., p. 304. 62. Locke, *An Essay concerning Human Understanding*, Bk IV, ch. 3, §6, in *The Works of John Locke*, 9 vols. (1794; repr. London, 1997), ii. p. 103. See John W. Yolton, *Thinking Matter: Materialism in Eighteenth-Century Britain* (Oxford, 1984), pp. 14–17. 63. Voltaire, *Letters concerning the English Nation*, ed. Nicholas Cronk (Oxford, 1994), p. 58. 64. Hume, *A Treatise of Human Nature: A Critical Edition*, ed. David Fate Norton and Mary J. Norton (Oxford, 2007), p. 5 (Introduction). 65. Ibid., p. 4 (Introduction). 66. Ibid., p. 6 (Introduction). 67. Letter to John Stewart, Feb. 1754, *The Letters of David Hume*, ed. J. Y. T. Greig, 2 vols. (Oxford, 1932), i. p. 187. 68. See the long letter which Hume wrote in March or April 1734 (but perhaps never sent) to an unnamed physician: *Letters of David Hume*, i. pp. 12–18. Hume scholars generally assume the addressee is Dr George Cheyne, though Ernest Campbell Mossner, *The Life of David Hume* (Oxford, 1954), p. 84, suggests the Scottish London-based physician and friend of Pope, John Arbuthnot; La Vopa (*Labor of the Mind*, p. 166) agrees. 69. *Letters of David Hume*, i. p. 17. For a searching account of Hume's crisis, see La Vopa, *Labor of the Mind*, pp. 166–71. 70. Letter, 1742, quoted in Mossner, *Life of Hume*, p. 94. 71. John Biro, 'Hume's New Science of the Mind', in David Fate Norton and Jacqueline Taylor, eds., *The Cambridge Companion to Hume*, 2nd edn (Cambridge, 2009), pp. 40–69 (p. 46). 72. Hume, *Treatise of Human Nature*, p. 123 (I iv 1). 73. Ibid., p. 13 (I i 4). 74. Ibid., p. 114 (I iii 14). This is the passage that later woke Kant from his 'dogmatic slumbers': Kant, 'Prolegomena zu einer jeden künftigen Metaphysik, die als Wissenschaft wird auftreten können', in *Werke*, ed. Wilhelm Weischedel, 6 vols. (Darmstadt, 1958), iii. pp. 109–264 (p. 118). 75. Hume, *Treatise of Human Nature*, p. 67 (I iii 7). 76. Ibid., p. 68 (I iii 7). 77. Ibid., p. 72 (I iii 8). 78. Ibid., p. 123 (I iv 1). 79. Ibid., p. 125 (I iv 2). 80. Ibid., p. 165 (I iv 6). 81. Ibid., p. 165 (I iv 6). 82. Ibid., p. 170 (I iv 6). 83. Ibid., p. 206 (II i 11). 84. Ibid., p. 234 (II ii 5). 85. Mandeville, *Fable*, p. 102. 86. The image of the merchant is Hume's, but I have elaborated it in order to provide clear examples. 87. Hume, *Treatise of Human Nature*, p. 266 (II iii 3). 88. Ibid., p. 267 (II iii 3). 89. Ibid., p. 193 (II i 7). 90. Ibid., p. 294 (III i 1). 91. Ibid., p. 303 (III i 2). 92. Ibid., p. 309 (III ii 1). 93. The 'philosophers' are Hobbes and Mandeville; see John Robertson, *The Case for the Enlightenment: Scotland and Naples 1680–1760* (Cambridge, 2005), p. 297. 94. On Hume's analysis of justice and its gradual development in history, see Robertson, *The Case for the Enlightenment*, pp. 296–302. 95. Hume, *Treatise of Human Nature*, p. 394 (III iii 6). 96. [Judith Drake], *An Essay in Defence of the Female Sex, in a Letter to a Lady* ([1696]; London, 1721), p. 13. 97. Hume, *Treatise of Human Nature*,

p. 118 (I iii 16).    98. See also Hume, 'Of the reason of animals', in *An Enquiry concerning Human Understanding*, ed. Tom Beauchamp (Oxford, 2000), pp. 79–82.    99. Hume, *Treatise of Human Nature*, p. 120 (I iii 16).    100. See Hugo Mercier and Dan Sperber, *The Enigma of Reason: A New Theory of Human Understanding* (London, 2017), esp. pp. 51–7.    101. Hume, *Treatise of Human Nature*, p. 212 (II i 12).    102. Letter to Gilbert Elliot of Minto, 18 February 1751, *Letters of David Hume*, i. p. 151.    103. Hume, *Treatise of Human Nature*, p. 124 (I iv 1).    104. Ibid., p. 175 (I iv 7).    105. See David Fate Norton, *David Hume: Common-Sense Moralist, Sceptical Metaphysician* (Princeton, 1982), ch. 5; Dennis C. Rasmussen, *The Pragmatic Enlightenment: Recovering the Liberalism of Hume, Smith, Montesquieu, and Voltaire* (Cambridge, 2014), p. 142.    106. See Isaiah Berlin, 'Hume and the sources of German anti-rationalism', in his *Against the Current: Essays in the History of Ideas*, ed. Henry Hardy (Oxford, 1981), pp. 162–87; on Hamann's misunderstanding of Hume's irony, Rudolf Lüthe, 'Misunderstanding Hume: remarks on German ways of interpreting his philosophy', in Vincent Hope, ed., *Philosophers of the Scottish Enlightenment* (Edinburgh, 1984), pp. 105–15 (pp. 106–8).    107. F. H. Jacobi, *David Hume über den Glauben oder Idealismus und Realismus. Ein Gespräch* (Breslau, 1787); cf. Julian Baggini, *Atheism: A Very Short Introduction* (Oxford, 2003), pp. 30–32. Jacobi also cheats by exploiting the linguistic fact that *Glaube* translates both 'faith' and 'reason', and *ich glaube*, like *je crois* in French, is often used where in English we would say 'I think'.    108. Annette C. Baier, *A Progress of Sentiments: Reflections on Hume's 'Treatise'* (Cambridge, MA, 1991), p. 278.    109. Ibid., p. 279.    110. 'My Own Life', in *Essays*, pp. xxxi–xli (p. xxxiv).    111. Quoted in Mossner, *Life of Hume*, p. 121. On other reviews, see James A. Harris, *Hume: An Intellectual Biography* (Cambridge, 2015), p. 118.    112. Étienne Bonnot de Condillac, *Traité des sensations*, 2 vols. (Paris, 1754), ii. pp. 274–5.    113. Claude Adrien Helvétius, *De l'esprit*, in *Œuvres complètes*, 4 vols. (London, 1777), ii. pp. 9–10. See Michel Malherbe, 'Hume's reception in France', in Peter Jones, ed., *The Reception of David Hume in Europe* (London, 2005), pp. 43–97 (p. 88).    114. Helvétius, *Œuvres complètes*, ii. pp. 193–4.    115. For Bentham, see the end of Ch. 8 below.    116. George Cheyne, *The English Malady: or, a Treatise of Nervous Diseases of All Kinds* (London, 1733), p. 4.    117. La Mettrie, *Machine Man and Other Writings*, tr. and ed. Ann Thomson (Cambridge, 1996), p. 7.    118. Ibid., p. 27.    119. See [Abraham] Trembley, *Mémoires pour servir à l'histoire d'un genre de polypes d'eau douce, à bras en forme de cornes* (Paris, 1744), pp. 6–7; Aram Vartanian, *La Mettrie's 'L'Homme machine': A Study in the Origins of an Idea* (Princeton, 1960), p. 25.    120. La Mettrie, *Machine Man*, p. 35.    121. Ibid., p. 13.    122. Stephen Gaukroger, *The Collapse of Mechanism and the Rise of Sensibility: Science and the Shaping of Modernity 1680–1760* (Oxford, 2010), p. 394.    123. See the quotation from Bordeu in Gaukroger, *Collapse*, p. 400, whose account I follow in this paragraph.    124. See Franco Venturi, *Jeunesse de Diderot (1713–1753)*, tr. Juliette Bertrand (Paris, 1939), pp. 46–70; Arthur M. Wilson, *Diderot* (New York, 1972), pp. 50–52.    125. On the *Dream* as a 'great feat of synthesis', see Wilson, *Diderot*, p. 568; further information, p. 833.    126. See Locke, *Essay*, Book III, ch. 6, §7, in *Works*, i. p. 478.    127. Buffon, *De l'homme*, ed. Michèle Duchet (Paris, 1971), p. 43. Because there was not yet a concept of fixed races, colonial administrators, inspired by the success of animal breeding, could occasionally make wild proposals for changing native populations: thus Gabriel de Bory, a former governor-general of Saint-Domingue, proposed in 1776 to create a military force composed entirely of specially bred mulattoes. See William Max Nelson, 'Making men: Enlightenment ideas of racial engineering', *American Historical Review*, 115 (2010), pp. 1364–94.    128. *OCD* viii. p. 98.    129. 'Anhang, von den Bewohnern der Gestirne', in Kant, *Werke*, i. pp. 377–96; Karl S. Guthke, *The Last Frontier: Imagining Other Worlds, from the Copernican Revolution to Modern Science Fiction*, tr. Helen Atkins (Ithaca, NY and London, 1990), pp. 259–66.    130. On eighteenth-century fascination with imagined human-animal hybrids, see Julia V. Douthwaite, *The Wild Girl, Natural Man, and the Monster: Dangerous Experiments in the Age of Enlightenment* (Chicago, 2002), p. 19.    131. Jessica Riskin, *Science in the Age of Sensibility: The Sentimental Empiricists of the French Enlightenment* (Chicago, 2002); Gaukroger, *Collapse*, pp. 387–420.    132. Matthew Bell, *Goethe's Naturalistic Anthropology:*

*Man and Other Plants* (Oxford, 1994), p. 24. Bell's opening chapter (pp. 1–67) provides an invaluable and probing survey of Enlightenment anthropology. See also Alexander Košenina, *Literarische Anthropologie: Die Neuentdeckung des Menschen* (Berlin, 2008). **133.** 'Wie die Philosophie zum besten des Volks allgemeiner und nützlicher werden kann' (draft), in Herder, *Werke*, ed. Günter Arnold and others, 10 vols. (Frankfurt a.M., 1985–2000), i. p. 134. **134.** See the translation and commentary in Kenneth Dewhurst and Nigel Reeves, *Friedrich Schiller: Medicine, Psychology, Literature* (Oxford, 1978). **135.** See Hans-Jürgen Schings, 'Agathon, Anton Reiser, Wilhelm Meister: Zur Pathogenese des modernen Subjekts im Bildungsroman', in Wolfgang Wittkowski, ed., *Goethe im Kontext* (Tübingen, 1984), pp. 43–68; for Wieland as pioneer, see also Jutta Heinz, ed., *Wieland Handbuch: Leben – Werk – Wirkung* (Stuttgart and Weimar, 2008), p. 269. **136.** Christoph Martin Wieland, *Werke*, ed. Fritz Martini and Hans Werner Seiffert, 5 vols. (Munich, 1964–8), i. p. 375. **137.** See Margaret Anne Doody, *The True Story of the Novel* (London, 1996); on *Agathon*, p. 256. **138.** See K. F. Hilliard, *Freethinkers, Libertines and 'Schwärmer': Heterodoxy in German Literature, 1750–1800* (London, 2011), pp. 75–8, 185–93; Manfred Engel, 'Die Rehabilitation des Schwärmers. Theorie und Darstellung des Schwärmens in Spätaufklärung und früher Goethezeit', in Hans-Jürgen Schings, ed., *Der ganze Mensch: Anthropologie und Literatur im 18. Jahrhundert* (Stuttgart, 1994), pp. 469–98. **139.** Friedrich Schiller, *Sämtliche Werke*, ed. Gerhard Fricke and Herbert G. Göpfert, 5 vols. (Munich, 1958), ii. p. 126. **140.** Friedrich Schiller, *On the Aesthetic Education of Man in a Series of Letters*, ed. and tr. Elizabeth M. Wilkinson and L. A. Willoughby (Oxford, 1967), p. 25. For guidance through this work, see Lesley Sharpe, *Friedrich Schiller: Drama, Thought and Politics* (Cambridge, 1991), pp. 146–69; Frederick Beiser, *Schiller as Philosopher: A Re-examination* (Oxford, 2005), pp. 119–68, 263–7. **141.** Schiller, *Aesthetic Education*, p. 107. **142.** Ibid., p. 123. **143.** Ibid., p. 141. **144.** Ibid., p. 199. **145.** Ibid., p. 201. **146.** Wilkinson and Willoughby weaken Schiller's argument here by translating *einen geselligen Charakter* as 'a social character' (*Aesthetic Education*, p. 215); 'sociable' would be better. The most recent translation also has 'social': *On the Aesthetic Education of Man*, tr. Keith Tribe, ed. Alexander Schmidt (London, 2016), p. 110. **147.** Schiller, *Aesthetic Education*, p. 215. **148.** I. A. Richards, *Principles of Literary Criticism*, 2nd edn (London, 1926), pp. 11–18. **149.** Cf. Rasmussen, *The Pragmatic Enlightenment*, p. 14. **150.** *Groundwork of the Metaphysics of Morals*, in Immanuel Kant, *Practical Philosophy*, tr. Mary J. Gregor, The Cambridge Edition of the Works of Immanuel Kant (Cambridge, 1996), pp. 37–108 (p. 54). Just such a person is described in Sarah Fielding, *The Adventures of David Simple*, ed. Malcolm Kelsall (London, 1969), p. 71. **151.** John Casey, *Pagan Virtue: An Essay in Ethics* (Oxford, 1990), p. vi. **152.** Cited by Benito Jerónimo Feijóo y Montenegro, *An Essay on Woman, or Physiological and Historical Defence of the Fair Sex* (London, 1768), p. 150. On Feijóo's epoch-making essay and its Spanish context, see Mónica Bolufer Peruga, '"Neither male nor female": rational equality in the early Spanish Enlightenment', in Sarah Knott and Barbara Taylor, eds., *Women, Gender and Enlightenment* (Basingstoke, 2005), pp. 389–409. **153.** Mary Astell, *Some Reflections upon Marriage* (1700), 2nd edn (London, 1703), p. 13. **154.** See the announcements quoted in Roy Porter, *English Society in the Eighteenth Century*, rev. edn (London, 1991), p. 26. **155.** Ian Maclean, *The Renaissance Notion of Woman* (Cambridge, 1980), p. 35. **156.** Nicolas Malebranche, *De la recherche de la vérité*, in his *Œuvres*, ed. Geneviève Rodis-Lewis, 2 vols. (Paris, 1992), i. p. 201. **157.** Germaine Greer, *Slip-Shod Sibyls: Recognition, Rejection and the Woman Poet* (London, 1995), p. 17. **158.** Lorraine Daston, 'The naturalized female intellect', *Science in Context*, 5 (1992), pp. 209–35 (p. 229). On Bassi, see Paula Findlen, 'Science as a career in Enlightenment Italy: the strategies of Laura Bassi', *Isis*, 84 (1993), pp. 441–69, and Voltaire's admiring letters to Bassi, 23 Nov. 1744 and 1 Mar. 1745, OCV 93, pp. 190–91, 214. **159.** See Siep Stuurman, *François Poulain de la Barre and the Invention of Modern Equality* (Cambridge, MA, 2004). **160.** François Poulain de la Barre, *De l'égalité des deux sexes* (Paris, 1984), p. 59. **161.** Ibid., p. 19. **162.** Maclean, *Renaissance Notion*, p. 43; Stuurman, *Poulain*, pp. 59–60. **163.** Thomas Holcroft, *Anna St Ives*, ed. Peter Faulkner (London, 1970), p. 172. See Roy Porter, *Enlightenment: Britain and the Creation of the Modern World* (London, 2000), pp. 320–38. **164.** [Drake], *Essay,*

p. 10. **165.** Ibid., p. 16. **166.** Barbara Becker-Cantarino, *Der lange Weg zur Mündigkeit: Frauen und Literatur in Deutschland von 1500 bis 1800* (Munich, 1989), pp. 184–8. **167.** Frances Burney, *Journals and Letters*, ed. Peter Sabor and Lars E. Troide (London, 2001), pp. 90–91. **168.** Goethe, *Wilhelm Meisters Lehrjahre*, in *Sämtliche Werke: Briefe, Tagebücher und Gespräche*, ed. Friedmar Apel and others, 40 vols. (Frankfurt a.M., 1986–2000), ix. p. 756. **169.** Jane Austen, *Pride and Prejudice*, ed. Tony Tanner (Harmondsworth, 1972), p. 55. **170.** See the well-documented survey in Karen Offen, *European Feminisms, 1700–1950* (Stanford, 2000), pp. 27–49. **171.** Feijóo, *Essay on Woman*, p. 219. **172.** 'Mon portrait', in Madame d'Épinay, *Les Conversations d'Émilie*, ed. Rosena Davison (Oxford, 1996), p. 1. **173.** Letter of 11 June 1772 to Sophie Cannet, in *Lettres inédites de Mlle Phlipon (Mme Roland) adressées aux Demoiselles Cannet, de 1772 à 1780*, ed. Auguste Breuil, 2 vols. (Paris, 1841), i. p. 44. **174.** 'Femme (Droit. Nat.)', *Encyclopédie*, vi. p. 471. **175.** See Margaret Macaulay, *The Prisoner of St Kilda: The True Story of the Unfortunate Lady Grange* (Edinburgh, 2009). For a brief contemporary account of the Granges, see Carlyle, *Anecdotes*, pp. 6–9. **176.** *Boswell's Journal of a Tour to the Hebrides with Samuel Johnson, LL.D.*, ed. R. W. Chapman (London, 1924), p. 312. **177.** Montesquieu, *Persian Letters*, p. 280; *OCM* i. p. 372. **178.** Françoise de Graffigny, *Lettres d'une Péruvienne*, ed. Jonathan Mallinson (Oxford, 2002), p. 221. **179.** Buffon, *De l'homme*, p. 133. **180.** John Millar, *Observations concerning the Distinction of Ranks in Society* (London, 1771), p. 75. **181.** Ibid., p. 78; on the originality of Millar's concern here, see Karen O'Brien, *Women and Enlightenment in Eighteenth-Century Britain* (Cambridge, 2009), p. 96. **182.** See Paul Langford, *A Polite and Commercial People: England 1727–1783* (Oxford, 1989), pp. 606–7. **183.** 'Femme', *Questions sur l'Encyclopédie*, *OCV* 41, p. 348. **184.** 'Femme (Droit. Nat.)', *Encyclopédie*, vi. p. 471. **185.** See Lieselotte Steinbrügge, *The Moral Sex: Women's Nature in the French Enlightenment*, tr. Pamela E. Selwyn (New York. 1995). **186.** Pierre Roussel, *Système physique et moral de la femme* (Paris, 1775), p. 34. **187.** 'Femme', *OCV* 41, p. 348. **188.** 'Sur les femmes', *OCD*, x. pp. 31–53. See Jenny Mander, 'No woman is an island: the female figure in French Enlightenment anthropology', in Knott and Taylor, *Women*, pp. 97–116. **189.** Letter to Goethe, 30 June 1797, in *Der Briefwechsel zwischen Schiller und Goethe*, ed. Emil Staiger (Frankfurt a.M., 1966), p. 412. Schiller is taken to task for this sentence in a critical account of his and Kant's views on femininity by Silvia Bovenschen, *Die imaginierte Weiblichkeit: Exemplarische Untersuchungen zu kulturgeschichtlichen und literarischen Präsentationsformen des Weiblichen* (Frankfurt a.M., 1979), pp. 220–44. **190.** Schiller, *Sämtliche Werke*, i. p. 433. **191.** Smith, *Wealth of Nations*, p. 781. Contrast d'Alembert's denunciation of the worthless education with which women were fobbed off: 'Introduction', in Mme d'Épinay, *Conversations*, p. 8. **192.** This amnesia is amply documented in Françoise Waquet, *Latin, or the Empire of a Sign*, tr. John Howe (London, 2001). Jacob Burckhardt in the nineteenth century says that classical education in the *Gymnasium* makes no lasting impression on most of its graduates: see *The Greeks and Greek Civilization*, tr. Sheila Stern (London, 1998), p. 11. **193.** See Carolyn C. Lougee, *Le Paradis des Femmes: Women, Salons, and Social Stratification in Seventeenth-Century France* (Princeton, 1976), pp. 173–95. **194.** Isabel de Madariaga, *Russia in the Age of Catherine the Great* (London, 1981), p. 493. **195.** Mary Wollstonecraft, *A Vindication of the Rights of Woman*, ed. Janet Todd (Oxford, 1993), p. 113. **196.** Condorcet, *Esquisse d'un tableau historique des progrès de l'esprit humain*, ed. Monique and François Hincker (Paris, 1971), pp. 274–5. **197.** Rousseau, *Émile*, p. 322; *OCR* iv. p. 693. **198.** 'Über den Geschlechtsunterschied und dessen Einfluß auf die organische Natur' (1794), in Wilhelm von Humboldt, *Werke*, ed. Andreas Flitner and Klaus Giel, 5 vols. (Stuttgart, 1960–81), i. pp. 268–95 (p. 294). **199.** Schiller, *Sämtliche Werke*, i. p. 440. **200.** Simon Schama, *Citizens: A Chronicle of the French Revolution* (London, 1989), pp. 529–30. **201.** Mably, *De la législation, ou Principes des lois* (1776), in *Collection complète des œuvres*, 15 vols. (Paris, 1794–5), ix. p. 376. **202.** Olympe de Gouges, 'Les droits de la femme', in her *Ecrits politiques 1788–1791*, ed. Olivier Blanc (Paris, 1993), pp. 207–9. **203.** See Faramerz Dabhoiwala, *The Origins of Sex: A History of the First Sexual Revolution* (London, 2012). **204.** Isabel V. Hull, *Sexuality, State, and Civil Society in Germany,*

*1700–1815* (Ithaca, NY, 1996), p. 23.   205. See Bayle, *Dictionnaire historique et critique*, 4 vols. (Amsterdam, 1730), iv. p. 124: art. 'Sanchez', note B.   206. Michel Foucault, *The History of Sexuality*, vol. 1, tr. Robert Hurley (London, 1979), pp. 18–23.   207. Robert Crawford, *The Bard: Robert Burns, A Biography* (London, 2009), p. 168.   208. Daniel Roche, *France in the Enlightenment*, tr. Arthur Goldhammer (Cambridge, MA, 1998), pp. 522–4.   209. Dabhoiwala, *Origins*, p. 86.   210. Mandeville, *Fable*, p. 82.   211. See Peter Wagner, *Eros Revived: Erotica of the Enlightenment in England and America* (London, 1988); Robert Darnton, *The Forbidden Best-Sellers of Pre-Revolutionary France* (London, 1996), esp. pp. 85–114, 'Philosophical Pornography'; Michel Delon, *Le Savoir-vivre libertin* (Paris, 2000).   212. Pepys' diary, quoted in Dabhoiwala, *Origins*, p. 368.   213. Thomas Carlyle, 'Diderot' (1833), in *Critical and Miscellaneous Essays*, 4 vols. in 2 (London, 1888), iii. p. 207.   214. Dabhoiwala, *Origins*, pp. 232–3.   215. On Tahitian reality, see Anne Salmond, *Aphrodite's Island: The European Discovery of Tahiti* (Berkeley, CA, 2009).   216. 'Supplément au voyage de Bougainville', *OCD* x. p. 234.   217. Sade, *Œuvres*, ed. Michel Delon, 3 vols. (Paris, 1998), iii. p. 383.   218. Diderot avoids mentioning the Tahitian practice of infanticide, reported by Bougainville: see Salmond, *Aphrodite's Island*, p. 112.   219. *OCD* x. p. 245.   220. Hume, *Enquiry*, p. 29.   221. Examples in Dabhoiwala, *Origins*, pp. 120–21.   222. Angeline Goreau, *Reconstructing Aphra: A Social Biography of Aphra Behn* (Oxford, 1980), pp. 173–4.   223. See Dabhoiwala, *Origins*, pp. 14–69; Goreau, *Reconstructing Aphra*, pp. 182–3; Susan Staves, 'Behn, women, and society', in Derek Hughes and Janet Todd, eds., *The Cambridge Companion to Aphra Behn* (Cambridge, 2004), pp. 12–28 (esp. p. 21).   224. Wieland, *Werke*, iv. p. 364.   225. See his preface to *Musarion*, in *Werke*, iv. p. 320.   226. Louis Crompton, *Byron and Greek Love: Homophobia in 19th-Century England* (London, 1985), pp. 14–17. For France, see D. A. Coward, 'Attitudes to homosexuality in eighteenth-century France', *Journal of European Studies*, 10 (1980), pp. 231–55.   227. Quoted in Dabhoiwala, *Origins*, p. 137; I follow his summary of Bentham's MS notes, pp. 134–8. See also the fuller account of Bentham's arguments in Crompton, *Byron*, pp. 19–31, 38–53.   228. Hull, *Sexuality*, p. 306. I follow her interpretation of Kant, pp. 299–313.   229. *Die Metaphysik der Sitten* (1798), in Kant, *Werke*, iv. pp. 556–9.   230. Rousseau, *Émile*, p. 299; *OCR* iv. p. 663. See Hull, *Sexuality*, pp. 258–80; Thomas W. Laqueur, *Solitary Sex: A Cultural History of Masturbation* (New York, 2003) (on Kant, pp. 58–61).   231. See Hull, *Sexuality*, p. 272.   232. Quoted in Arthur O. Lovejoy, *The Great Chain of Being* (Cambridge, MA, 1936), pp. 144–5.   233. Locke, *Essay*, in *Works*, i. pp. 482–3; see Lovejoy, *Great Chain*, pp. 228–9.   234. See Gaukroger, *Collapse*, p. 195; Lovejoy, *Great Chain*, p. 230.   235. James L. Larson, 'The species concept of Linnaeus', *Isis*, 59 (1968), pp. 291–9 (p. 292).   236. *OCD* viii. p. 161.   237. Edward Tyson, *Orang-Outang sive Homo Sylvestris, or, The Anatomy of a Pygmie compared with that of a Monkey, an Ape, and a Man* (London, 1699), p. 91.   238. James Burnet, Lord Monboddo, *Of the Origin and Progress of Language*, 2nd edn, 6 vols. (Edinburgh, 1774–92), i. p. 189.   239. Ibid., i. p. 258.   240. Ibid., i. pp. 262–3. A BBC news report of 7 October 2016 tells how a boy in India started growing a tail just after his fourteenth birthday; when surgically removed four years later, it was 20 cm long: http://www.bbc.co.uk/newsbeat/article/37591115/a-teenager-in-india-has-a-20cm-tail-removed-from-his-back (accessed 15 October 2016).   241. See Douthwaite, *Wild Girl*, pp. 21–34.   242. Monboddo, *Origin and Progress*, i. p. 199.   243. Buffon, *De l'homme*, p. 320.   244. See Richard H. Popkin, *Isaac La Peyrère (1596–1676): His Life, Work and Influence* (Leiden, 1987); on the longer history of polygenetic theories, Dominique Tombal, 'Le polygénisme aux XVII^e et XVIII^e siècles: de la critique biblique à l'idéologie raciste', *Revue belge de philologie et d'histoire*, 71 (1993), pp. 850–74. I thank David Wootton for the latter reference.   245. See Michèle Duchet, *Anthropologie et histoire au siècle des Lumières* (Paris, 1977), p. 234.   246. Georg Forster, 'Noch etwas über die Menschenraßen', *Werke*, ed. by the Akademie der Wissenschaften zu Berlin, 18 vols. (Berlin, 1958–89), viii. pp. 130–56 (p. 153).   247. Lord Kames, *Sketches of the History of Man*, 4 vols. (London, 1775), i. p. 22.   248. Ibid., i. p. 43.   249. See Gonthier-Louis Fink, 'De Bouhours à Herder. La théorie française des climats et sa réception outre-Rhin', *Recherches germaniques*, 15 (1985), pp. 3–62.   250. Jean-Baptiste Dubos,

*Réflexions critiques sur la poésie et sur la peinture*, rev. edn, 3 vols. (Paris, 1733), ii. pp. 261, 266–7. For Montesquieu's version of climate theory, see Ch. 10 below.   **251.** *Ideen zur Philosophie der Geschichte der Menschheit*, in Herder, *Werke*, vi. p. 256.   **252.** Buffon, *De l'homme*, p. 270.   **253.** Ibid., p. 250.   **254.** Ibid., p. 223; see Duchet, *Anthropologie*, p. 202.   **255.** Buffon, *De l'homme*, p. 223.   **256.** Ibid., pp. 233, 246.   **257.** Ibid., p. 262. **258.** Herder, *Werke*, vi. p. 226.   **259.** Ibid., vi. p. 223. Cf. the opinion of the traveller Chardin that the Persians have been improved 'by the mixture of the *Georgian* and *Circassian* Blood, which is certainly the People of the World which Nature favours most, both upon the Account of the Shape and Complexion, and of the *Boldness* and *Courage*' (*Sir John Chardin's Travels in Persia*, 2 vols. (London, 1720), ii. p. 119).   **260.** Herder, *Briefe zur Beförderung der Humanität*, in *Werke*, vii. p. 699.   **261.** Herder, *Werke*, vi. p. 654. Sonia Sikka, in her otherwise excellent discussion of Herder on race (*Herder on Humanity and Cultural Difference: Enlightened Relativism* (Cambridge, 2011), pp. 126–59), implausibly thinks this passage implies that different races have unequal *aptitudes* (pp. 150–51). Contrast H. B. Nisbet, 'Herders anthropologische Anschauungen in den *Ideen zur Philosophie der Geschichte der Menschheit*', in Jürgen Barkhoff and Eda Sagarra, eds., *Anthropologie und Literatur um 1800* (Munich, 1992), pp. 1–23 (p. 12). By 'Troglodyt' Herder means the Lapps: cf. Voltaire, *La Russie sous Pierre le Grand*, in his *Œuvres historiques*, ed. René Pomeau (Paris, 1957), p. 359.   **262.** Herder, *Briefe zur Beförderung der Humanität*, in *Werke*, vii. p. 699.   **263.** See John Hutchinson and Anthony D. Smith, eds., *Ethnicity* (Oxford, 1996), esp. p. 29. **264.** Johann Friedrich Blumenbach, *De generis humani varietate nativa* (Göttingen, 1775), in his *Anthropological Treatises*, tr. Thomas Bendyshe (London, 1865), pp. 69–143 (pp. 99–100).   **265.** Blumenbach, *De generis humani varietate nativa*, 3rd edn (Göttingen, 1795), in *Anthropological Treatises*, pp. 147–276 (pp. 265–9).   **266.** On Blumenbach's relation to Kant, see Robert Bernasconi, 'Who invented the concept of race? Kant's role in the Enlightenment construction of race', in Bernasconi, ed., *Race* (Oxford, 2001), pp. 11–36.   **267.** 'Von den verschiedenen Rassen der Menschen', in Kant, *Werke*, vi. pp. 11–30 (p. 14); 'Of the different races of human beings', tr. Holly Wilson and Günter Zöller, in Kant, *Anthropology, History, and Education*, ed. Günter Zöller and Robert B. Louden (Cambridge, 2007), pp. 82–97 (p. 87).   **268.** 'Bestimmung des Begriffs einer Menschenrasse', in Kant, *Werke*, vi. pp. 65–82 (p. 81).   **269.** 'Von den verschiedenen Rassen der Menschen', in Kant, *Werke*, vi. pp. 11–30 (p. 19).   **270.** Herder, *Werke*, vi. p. 256; Kant, review of Herder, in *Werke*, vi. p. 802.   **271.** Forster, 'Noch etwas über die Menschenraßen', in *Werke*, viii. pp. 134–5. **272.** John Hunter, *Disputatio inauguralis, quædam de hominum varietatibus, et harum causis exponens* (1775), included in Blumenbach, *Anthropological Treatises*, pp. 359–94 (p. 367).   **273.** Given as a variant reading in Hume, *Essays*, pp. 629–30. Hume later revised the footnote, removing the blanket dismissal of non-whites but retaining the disparagement of blacks: see *Essays*, p. 208.   **274.** Kant, 'Beobachtungen über das Gefühl des Schönen und Erhabenen', *Werke*, i. p. 880.   **275.** Ibid., i. p. 882.   **276.** Kant, *Werke*, vi. p. 23.   **277.** Quoted in Aaron Garrett, 'Hume's revised racism revisited', *Hume Studies*, 26 (2000), pp. 171–7 (Beattie at pp. 175–6, Monboddo in n. 11).   **278.** Hume, 'Of National Characters', in *Essays*, pp. 197–215 (p. 208n.).   **279.** See Markman Ellis, *The Politics of Sensibility: Race, Gender, and Commerce in the Sentimental Novel* (Cambridge, 1996), p. 54.   **280.** Sikka, *Herder on Humanity*, pp. 153–4.   **281.** Thomas Jefferson, *Notes on the State of Virginia*, in his *Writings*, ed. Merrill D. Peterson (New York, 1984), p. 270. See the discussions of Jefferson's views in Fawn M. Brodie, *Thomas Jefferson: An Intimate History* ([1974]; New York, 2010), pp. 157–61; Garry Wills, *Inventing America: Jefferson's Declaration of Independence* (New York, 1978), pp. 293–306.   **282.** See Andrew Kahn, 'Introduction', in Alexander Pushkin, *The Queen of Spades and Other Stories*, tr. Alan Myers (Oxford, 1997), pp. xxxiv–xxxv; the collection includes 'Peter the Great's Blackamoor'.   **283.** Blumenbach, in *Anthropological Treatises*, pp. 307–12. On Amo, see Henry Louis Gates, Jr., *Figures in Black: Words, Signs and the 'Racial Self'* (New York, 1989), pp. 11–12; Burchard Brentjes, *Anton Wilhelm Amo: Der schwarze Philosoph in Halle* (Leipzig, 1976).   **284.** Amo's works are available in English in a handsome volume produced by the Martin Luther University Halle-Wittenberg: Antonius Gulielmus Amo Afer of Axim in Ghana, *Translation of his Works*, ed. Dorothea

Siegmund-Schultze, tr. Leonard A. Jones (Halle, 1968). **285.** See Ludwig Abafi, *Geschichte der Freimaurerei in Österreich-Ungarn*, 5 vols. (Budapest, 1890–99), iii. pp. 310–11. After Soliman's death, his body was stuffed and exhibited, suggesting that he was no longer regarded as fully human. **286.** Blumenbach, in *Anthropological Treatises*, p. 312. **287.** David Olusoga, *Black and British: A Forgotten History* (London, 2016), p. 85. **288.** Sue Peabody, *'There are No Slaves in France': The Political Culture of Race and Slavery in the Ancien Regime* (New York, 1996), p. 75. **289.** Olusoga, *Black and British*, pp. 87–90; David Dabydeen, *Hogarth's Blacks: Images of Blacks in Eighteenth Century English Painting* (Kingston upon Thames, 1985). **290.** See Michael Bundock, *The Fortunes of Francis Barber: The True Story of the Jamaican Slave who became Samuel Johnson's Heir* (New Haven, 2015). **291.** Olusoga, *Black and British*, p. 108. See also the autobiographies by ex-slaves, Quobna Ottobah Cugoano, *Thoughts and Sentiments on the Evil and Wicked Traffic of the Slavery and Commerce of the Human Species* (London, 1787); Olaudah Equiano, *The Interesting Narrative*, ed. Vincent Carretta (London, 2003). **292.** On Hume's alleged polygenism, compare the relatively cautious formulation by Richard Popkin, 'Hume's racism' (1980), repr. in his *The High Road to Pyrrhonism*, ed. Richard A. Watson and James E. Force (Indianapolis, 1993), pp. 251–66 (p. 254), with the wilder assertion in 'Hume's racism reconsidered', in Richard Popkin, *The Third Force in Seventeenth-Century Thought* (Leiden, 1992), pp. 64–75 (p. 66). For judicious replies to this and other charges against Hume (without letting Hume off the hook of racialism), see Claudia M. Schmidt, *David Hume: Reason in History* (University Park, PA, 2002), pp. 409–13; Andrew Valls, ' "A lousy empirical scientist": reconsidering Hume's racism', in Valls, ed., *Race and Racism in Modern Philosophy* (Ithaca, NY, 2005), pp. 127–49. **293.** E. C. Eze, *Achieving our Humanity: The Idea of the Postracial Future* (London, 2001), p. 59. Contrast Silvia Sebastiani, *The Scottish Enlightenment: Race, Gender, and the Limits of Progress*, tr. Jeremy Carden (Basingstoke, 2013), who points out that 'Eze is unable to back up his claim with a single passage in which Hume explicitly connects the theory of reason with the inferiority of Blacks' and argues that 'the Humean "Black mind" is a construction of Eze himself' (p. 36). **294.** Popkin, *Third Force*, p. 74; see also his 'The philosophical bases of modern racism', in *The High Road to Pyrrhonism*, pp. 79–102. **295.** Sankar Muthu, *Enlightenment against Empire* (Princeton, 2003), p. 6. **296.** Peter France, *Diderot* (Oxford, 1983), p. 73. **297.** See Riskin, *Science*, p. 37; on the wider implications of Molyneux's problem, Ernst Cassirer, *The Philosophy of the Enlightenment*, tr. Fritz C. A. Koelln and James P. Pettegrove (Princeton, 1951), pp. 108–9. **298.** Diderot, 'Letter on the Blind for the Use of Those who can see', tr. Kate E. Tunstall, in Tunstall, *Blindness and Enlightenment: An Essay* (London, 2011), p. 177. **299.** See Riskin, *Science*, pp. 62–7. **300.** *OCD* ii. pp. 525–6. **301.** 'That more than five senses are possible for human beings', in Lessing, *Philosophical and Theological Writings*, ed. and tr. H. B. Nisbet (Cambridge, 2005), pp. 180–83; for comment, see H. B. Nisbet, *Gotthold Ephraim Lessing: His Life, Works and Thought* (Oxford, 2013), pp. 581–2. **302.** Addison, *Spectator*, 8 September 1712. **303.** See Lester G. Crocker, 'L'analyse des rêves au 18ᵉ siècle', *SVEC*, 23 (1963), pp. 271–310; Peter-André Alt, *Der Schlaf der Vernunft: Literatur und Traum in der Kulturgeschichte der Neuzeit* (Munich, 2002), pp. 127–89; Matthew Bell, *The German Tradition of Psychology in Literature and Thought, 1700–1840* (Cambridge, 2005); Bernard Dieterle and Manfred Engel, eds., *The Dream and the Enlightenment/Le Rêve et les Lumières* (Paris, 2003), with a bibliography of previous studies. **304.** See Stephen Gaukroger, *Descartes: An Intellectual Biography* (Oxford, 1995), pp. 106–11; Marie-Louise von Franz, 'The dream of Descartes', in her *Dreams* (London, 1998), pp. 107–91. **305.** *Della forza della fantasia umana* (extract), in *Opere di Lodovico Antonio Muratori*, 2 vols., ed. Giorgio Falco and Fiorenzo Forti (Milan, n.d.), i. p. 913. **306.** Charles Dickens, *A Christmas Carol*, in *Christmas Books*, The Oxford Illustrated Dickens (London, 1954), p. 18. **307.** Owen Flanagan, *Dreaming Souls: Sleep, Dreams, and the Evolution of the Conscious Mind* (New York, 2000). **308.** See Ritchie Robertson, 'Introduction', in Sigmund Freud, *The Interpretation of Dreams*, tr. Joyce Crick (Oxford, 1999). **309.** Letter to Sophie Volland, 11 Sept. 1769, *OCD* viii. p. 904. **310.** *OCD* x. p. 344. **311.** *OCD* x. pp. 396–7. **312.** *Introductory Lectures on Psycho-Analysis* (part III), in *The Standard Edition of the Complete*

*Psychological Works of Sigmund Freud*, ed. by James Strachey, 24 vols. (London, 1953–74), xvi. p. 338. The editorial note lists Freud's other references to this passage.    **313.** Lionel Trilling, *Sincerity and Authenticity* (London, 1972), pp. 27–33.    **314.** See Reinhard Wittmann, 'Was there a reading revolution at the end of the eighteenth century?', in Guglielmo Cavallo and Roger Chartier, eds., *A History of Reading in the West*, tr. Lydia G. Cochrane (Cambridge, 1999), pp. 284–312 (p. 302). For a survey of the growth of literature and the reading public, see James Van Horn Melton, *The Rise of the Public in Enlightenment Europe* (Cambridge, 2001), pp. 81–122.    **315.** Jean-Jacques Rousseau, *Confessions*, tr. Angela Scholar, ed. Patrick Coleman (Oxford, 2000), p. 8.    **316.** Robert Darnton, 'First steps toward a history of reading', *Australian Journal of French Studies*, 51 (2014), pp. 152–77 (p. 163).    **317.** Hester Chapone, *Letters on the Improvement of the Mind*, 2 vols. (London, 1773), ii. p. 144.    **318.** See Roger Chartier, *The Cultural Uses of Print in Early Modern France*, tr. Lydia G. Cochrane (Princeton, 1987), pp. 219–20.    **319.** See Jean Marie Goulemot, *Ces livres qu'on ne lit que d'une main: Lecture et lecteurs des livres pornographiques au XVIII$^e$ siècle* (Aix-en-Provence, 1993), pp. 43–7. I thank Catriona Seth for this reference.    **320.** See the introduction by Terence Cave to his translation of Madame de Lafayette, *The Princesse de Clèves* (Oxford, 1992), esp. p. xix.    **321.** See A. A. Parker, *Literature and the Delinquent: The Picaresque Novel in Spain and Europe, 1599–1753* (Edinburgh, 1967), pp. 78–94.    **322.** See J. Paul Hunter, *The Reluctant Pilgrim: Defoe's Emblematic Method and Quest for Form in 'Robinson Crusoe'* (Baltimore, 1966).    **323.** 'On Another's Sorrow', in *Songs of Innocence* (1789), in Blake, *Complete Writings*, ed. Geoffrey Keynes (London, 1976), p. 122.    **324.** George Eliot, *Middlemarch* (Harmondsworth, 1965), p. 243.    **325.** Lynn Hunt, *Inventing Human Rights: A History* (New York, 2007), p. 40.    **326.** Steven Pinker, *The Better Angels of our Nature: The Decline of Violence in History and its Causes* (London, 2011), p. 175.    **327.** The relations among all three works are discussed, still usefully, in Erich Schmidt, *Richardson, Rousseau und Goethe: Ein Beitrag zur Geschichte des Romans im 18. Jahrhundert* (Jena, 1875). A poem by Alexander Thomson, *The Paradise of Taste* (London, 1796), includes a visit to 'the Vault of Woe', where the effigy of Richardson, who 'taught the world CLARISSA's fate to wail' (p. 65), reposes on a tomb, and the authors of *Julie* and *Werther* are buried at his feet.    **328.** See Mark Kinkead-Weekes, *Samuel Richardson: Dramatic Novelist* (London, 1973), pp. 395–417.    **329.** T. C. Duncan Eaves and Ben D. Kimpel, *Samuel Richardson: A Biography* (Oxford, 1971), p. 238; Kinkead-Weekes, *Richardson*, p. 415.    **330.** See Kinkead-Weekes, *Richardson*, p. 161.    **331.** Samuel Richardson, *Clarissa, or the History of a Young Lady*, ed. Angus Ross (London, 1985), p. 616. This text reproduces the first edition. Richardson's later revisions made Lovelace even more villainous and Clarissa more angelic: see Mark Kinkead-Weekes, '*Clarissa* restored?', *Review of English Studies*, n.s. 10 (1959), pp. 156–71.    **332.** Richardson, *Clarissa*, p. 1011.    **333.** Kinkead-Weekes, *Richardson*, pp. 156–7.    **334.** Richardson, *Clarissa*, pp. 387, 439. Clarissa's phrase recalls the journal *The Plain Dealer* edited by Richardson's friend Aaron Hill.    **335.** James L. Clifford, *Hester Lynch Piozzi (Mrs. Thrale)*, 2nd edn (Oxford, 1952), p. 437.    **336.** See R. F. Brissenden, *Virtue in Distress: Studies in the Novel of Sentiment from Richardson to Sade* (London, 1974).    **337.** Richardson, *Clarissa*, p. 144. On his debt to heroic tragedy, see Margaret Anne Doody, *A Natural Passion: A Study of the Novels of Samuel Richardson* (Oxford, 1974), pp. 108–13.    **338.** Letter to Solomon Lowe, 21 Jan. 1749, in *Selected Letters of Samuel Richardson*, ed. John Carroll (Oxford, 1964), p. 123.    **339.** Letter of 7 Nov. 1748, Richardson, *Selected Letters*, p. 99.    **340.** 'Éloge de Richardson' (1762), *OCD* v. pp. 127–46 (p. 130).    **341.** Leo Damrosch, *Jean-Jacques Rousseau: Restless Genius* (New York, 2005), p. 325. The two novels were compared, to Richardson's advantage, by Rousseau's acquaintance André Morellet: see his *Mémoires de l'Abbé Morellet*, ed. Jean-Pierre Guicciardi (Paris, 1988), p. 117. Rousseau himself considered *Clarissa* a novel unsurpassed in any language: *OCR* v. p. 75n.    **342.** *OCR* ii. p. 63.    **343.** This scene was developed by Kleist into the yet more emotional reconciliation between father and daughter in *Die Marquise von O . . .* See Heinrich von Kleist, *The Marquise of O— and Other Stories*, tr. David Luke (Harmondsworth, 1978), p. 107.    **344.** *OCR* ii. p. 619.    **345.** *OCR* ii. p. 60.    **346.** On the history implied in the novel, see Lionel Gossman, 'The worlds of *La Nouvelle Héloïse*', *SVEC*, 41

(1966), pp. 235–76.   347. Jean Starobinski, *Jean-Jacques Rousseau: Transparency and Obstruction*, tr. Arthur Goldhammer (Chicago, 1988), p. 83.   348. See the autobiographical account, written around 1813, in *Dichtung und Wahrheit*, in Goethe, *Sämtliche Werke*, xiv. p. 639. On the materials Goethe used from his and others' lives, see Nicholas Boyle, *Goethe: The Poet and the Age*, 2 vols. to date (Oxford, 1991–2000), i. pp. 132–5.   349. The two are compared by Gossman, 'The worlds', pp. 246–7.   350. Johann Wolfgang von Goethe, *The Sorrows of Young Werther*, tr. Michael Hulse (London, 1989), p. 68; Goethe, *Sämtliche Werke*, viii. p. 112. This edition prints the earlier and later versions of *Werther* side by side.   351. Goethe, *Sorrows*, p. 125; *Sämtliche Werke*, viii. p. 246.   352. Richardson, *Clarissa*, p. 1218.   353. OCR ii. p. 616.   354. Goethe, *Sämtliche Werke*, viii. p. 215 (only in the revised edition of 1787).   355. Wieland, *Werke*, i. p. 540.   356. Letter of 6–11 Jan. 1749, quoted in Eaves and Kimpel, *Richardson*, p. 224.   357. Quoted in Daniel Mornet, *La Nouvelle Héloïse de J.-J. Rousseau: étude et analyse* (Paris, 1929), p. 313. Similar testimonies in Anna Attridge, 'The reception of *La Nouvelle Héloïse*', *SVEC*, 120 (1974), pp. 227–67; Claude Labrosse, *Lire au XVIIIᵉ siècle: La Nouvelle Héloïse et ses lecteurs* (Lyon, 1985), esp. the sections 'Le délire' and 'Larmes', pp. 87–90; Robert Darnton, 'Readers respond to Rousseau: the fabrication of Romantic sensitivity', in his *The Great Cat Massacre and Other Episodes in French Cultural History* (London, 1984), pp. 215–69.   358. OCD v. p. 128.   359. Quoted in Stuart Atkins, *The Testament of Werther in Poetry and Drama* (Cambridge, MA, 1949), p. 68.   360. See L. M. Price, 'On the reception of Richardson in Germany', *Journal of English and Germanic Philology*, 25 (1926), pp. 7–33.   361. On French and German translations of *Clarissa*, and the subtle cultural differences they introduce, see Thomas O. Beebee, *'Clarissa' on the Continent: Translation and Seduction* (University Park, PA, 1990).   362. Fernand Baldensperger, *Goethe en France* (Paris, 1904), p. 17.   363. Richard Holmes, *Shelley: The Pursuit* (London, 1974), pp. 334–6. Mary Shelley accompanied Shelley to Switzerland but did not take part in this boat trip.   364. Quoted in Schmidt, *Richardson, Rousseau und Goethe*, p. 19.   365. OCD v. p. 131.   366. Details and bibliography in Atkins, *The Testament of Werther*.   367. Baldensperger, *Goethe en France*, p. 18.   368. See Michael Maurer, *Aufklärung und Anglophilie in Deutschland* (Göttingen, 1987), pp. 146–56.   369. Not 'the Highlands', as stated in Henry and Mary Garland, *The Oxford Companion to German Literature*, 3rd edn (Oxford, 1997), p. 279. See Sophie von La Roche, *Geschichte des Fräuleins von Sternheim*, ed. Barbara Becker-Cantarino (Stuttgart, 1983), p. 303. The sham marriage may have been suggested by the deception practised on Olivia in Goldsmith's *The Vicar of Wakefield*, ch. 21.   370. Lady Elizabeth Echlin, *An Alternative Ending to Richardson's 'Clarissa'*, ed. Dimiter Daphinoff (Bern, 1982).   371. Anon., *The Letters of Charlotte during her Connexion with Werter*, 2 vols. (London, 1786), ii. p. 167.   372. See Friedrich Nicolai, *Das Leben und die Meinungen des Herrn Magister Sebaldus Nothanker*, ed. Bernd Witte (Stuttgart, 1991), pp. 286–7. Nicolai's *Freuden des jungen Werthers* is republished in facsimile in Klaus Scherpe, *Werther und Wertherwirkung: Zum Syndrom bürgerlicher Gesellschaftsordnung im 18. Jahrhundert* (Bad Homburg v.d.H., 1970).   373. *Letters of Charlotte*, i, p. ii.   374. See Boyle, *Goethe*, i. pp. 175, 262. For an English example, see Michael MacDonald and Terence R. Murphy, *Sleepless Souls: Suicide in Early Modern England* (Oxford, 1990), p. 191.   375. Letter from Ange-Laurent Lalive de Jully to Rousseau, 31 Jan. 1761, *Correspondance complète de Jean-Jacques Rousseau*, ed. R. A. Leigh, 52 vols. (Geneva, 1965–98), viii. p. 43.   376. Letter from Alexandre de Leyre, quoted in Labrosse, *Lire au XVIIIᵉ siècle*, p. 96.   377. See Leo Braudy, 'The form of the sentimental novel', *Novel*, 7 (fall 1973), pp. 5–13.   378. On the credit side, it was John Stuart Mill's reading of an affecting scene in Marmontel's *Mémoires* that moved him to tears, thus first awakening the emotion suppressed by his hyper-rational education: see his *Autobiography*, in *The Collected Works of John Stuart Mill*, ed. John Robson, 33 vols. (Toronto, 1981–91), i. p. 145.   379. Sade, *Œuvres*, iii. p. 997.   380. 'Excursus II: Juliette or Enlightenment and Morality', in Max Horkheimer and Theodor Adorno, *Dialectic of Enlightenment: Philosophical Fragments*, tr. Edmund Jephcott (Stanford, 2002), pp. 63–93.   381. On this ambivalence, or 'ambiguity', see Philip Thody, '*Les Liaisons dangereuses*: some problems of interpretation', *MLR*, 63 (1968), pp. 832–9 (esp. p. 837).   382. See

'Vorrede zur ersten Ausgabe', in Schiller, *Sämtliche Werke*, i. pp. 484-8; Harald Steinhagen, 'Der junge Schiller zwischen Marquis de Sade und Kant. Aufklärung und Idealismus', *DVjs*, 56 (1982), pp. 135-57.   383. Janet Todd, *Sensibility: An Introduction* (London, 1986), p. 7. For many examples of this reaction, see Thomas Dixon, *Weeping Britannia: Portrait of a Nation in Tears* (Oxford, 2015), pp. 111-12, 116, 135-9, 149.   384. Jane Austen, *Sense and Sensibility*, ed. Tony Tanner (Harmondsworth, 1969), p. 114 (ch. 16).   385. Laurence Sterne, *The Life and Opinions of Tristram Shandy, Gentleman*, ed. Ian Campbell Ross, rev. edn (Oxford, 2009), p. 341.   386. Michael Bell, 'Laurence Sterne (1713-1768): The fiction of sentiment', in Michael Bell, ed., *The Cambridge Companion to European Novelists* (Cambridge, 2012), pp. 107-23 (p. 115).   387. Bell, 'Sterne', p. 115. Bell develops these arguments more fully in *Sentimentalism, Ethics and the Culture of Feeling* (Basingstoke, 2000), chs 2-3.   388. Smith, *Theory*, p. 283. See Bernard Capp, ' "Jesus wept" but did the Englishman? Masculinity and emotion in early modern England', *Past and Present*, 224 (Aug. 2014), pp. 75-108.   389. Dixon, *Weeping Britannia*, pp. 104-5. Many criminals died with defiance and Dutch courage: V. A. C. Gatrell, *The Hanging Tree: Execution and the English People 1770-1868* (Oxford, 1994), pp. 32-8.   390. Contrast Dixon, *Weeping Britannia*, pp. 114-15, with Philip Carter, 'Tears and the man', in Knott and Taylor, *Women*, pp. 156-73 (pp. 167-8).   391. *Macbeth*, IV, ii, 29.   392. James Thomson, *The Tragedy of Sophonisba* (London, 1730), p. 65.   393. See Gustave Lanson, *Nivelle de la Chaussée et la comédie larmoyante* (Paris, 1903).   394. Nicolai in Lessing, *Werke und Briefe*, ed. Wilfried Barner and others, 12 vols. (Frankfurt a.M., 1987-98), iii. pp. 667-8. See Nisbet, *Lessing*, p. 208.   395. The ample material in G. J. Barker-Benfield, *The Culture of Sensibility* (Chicago, 1992), is mostly literary rather than historical.   396. *Lettres d'amour de Madame Roland*, ed. Philippe Godoy (Paris, 2003), p. 26.   397. Ibid. Cf. the comments on this letter by William Reddy, *The Navigation of Feeling: A Framework for the History of Emotions* (Cambridge, 2001), p. 168, though making a somewhat different point.   398. Boyle, *Goethe*, i. p. 126.   399. Letter from Louise von Ziegler to Caroline and Johann Gottfried Herder, 16 July 1773, quoted in Gerhard Sauder, *Empfindsamkeit: Quellen und Dokumente* (Stuttgart, 1980), p. 218.   400. Sarah Knott, *Sensibility and the American Revolution* (Chapel Hill, NC, 2009), ch. 3.   401. Ibid., p. 58.   402. Johann Martin Miller, *Siegwart: Eine Klostergeschichte*, 3 vols. (Leipzig, 1777); Karl Philipp Moritz, *Anton Reiser: A Psychological Novel*, tr. Ritchie Robertson (London, 1997), p. 333. On reading in the open air, as Reiser and Neries do, see Erich Schön, *Der Verlust der Sinnlichkeit oder die Verwandlungen des Lesers: Mentalitätswandel um 1800* (Stuttgart, 1987), pp. 125-68.   403. Wolfdietrich Rasch, *Freundschaftskult und Freundschaftsdichtung im deutschen Schrifttum des 18. Jahrhunderts* (Halle, 1936), p. 194.   404. 'Wir müssen, müssen Freunde sein!' – *Nathan der Weise*, II, v, in Lessing, *Werke und Briefe*, ix. p. 533.   405. Rasch, *Freundschaftskult*, pp. 189-92, 195.   406. See W. Daniel Wilson, 'But is it gay? Kissing, friendship, and "prehomosexual" discourses in eighteenth-century Germany', *MLR*, 103 (2008), pp. 767-83. Besides the examples given there, cf. the apparently innocuous male–male kisses in Miller's *Siegwart*, i. pp. 27, 98. Cf. the emotional relations between men expressed in the correspondence of Horace Walpole and described in George E. Haggerty, *Horace Walpole's Letters: Masculinity and Friendship in the Eighteenth Century* (Lewisburg, PA, 2011).   407. Vivienne Mylne, *The Eighteenth-Century French Novel: Techniques of Illusion* (Manchester, 1965), p. 177.   408. Reddy, *Navigation of Feeling*, p. 169.   409. Letter to Rousseau, 26 Feb. 1761, in *Correspondance complète*, viii. p. 178; quoted in Damrosch, *Rousseau*, p. 327.   410. 'Einleitung', *Gesammelte Schriften von J. M. R. Lenz*, ed. Ludwig Tieck (Berlin, 1828), i. p. 128.   411. Langford, *A Polite and Commercial People*, p. 482.   412. Listed in Ellis, *Politics of Sensibility*, p. 15.   413. See John Howard, *The State of the Prisons in England and Wales, with Preliminary Observations, and an Account of Some Foreign Prisons and Hospitals*, 3rd edn (Warrington, 1784); *An Account of the Principal Lazarettos in Europe* (Warrington, 1789).   414. Knott, *Sensibility*, p. 22.   415. Aphra Behn, *Oroonoko and Other Writings*, ed. Paul Salzman (Oxford, 1994), p. 40.   416. Ibid., p. 33.   417. Ibid., p. 40.   418. Edward D. Seeber, '*Oroonoko* in France in the XVIIIth century', *PMLA*, 51 (1936), pp. 953-9.   419. Quoted in Hugh Thomas, *The Slave Trade: The History of the*

*Atlantic Slave Trade, 1440–1870* (London, 1997), p. 458. **420.** Anthony Benezet, *A Caution to Great Britain and her Colonies, in a Short Representation of the Calamitous State of the Enslaved Negroes in the British Dominions*, new edn (Philadelphia, 1785), p. 30. **421.** Thomas, *Slave Trade*, p. 492. **422.** Quoted in Wylie Sypher, *Guinea's Captive Kings: British Anti-Slavery Literature of the XVIIIth Century* (Chapel Hill, NC, 1942), pp. 198–9. **423.** Told by Steele in *Spectator*, no. 11, 13 Mar. 1711. On its many versions, see Sypher, *Guinea's Captive Kings*, pp. 122–37; Judith Still, *Enlightenment Hospitality: Cannibals, Harems and Adoption* (Oxford, 2011), pp. 35–40. **424.** See David J. Denby, *Sentimental Narrative and the Social Order in France, 1760–1820* (Cambridge, 1994), p. 144. **425.** Pieter Spierenburg, *The Spectacle of Suffering: Executions and the Evolution of Repression: from a Preindustrial Metropolis to the European Experience* (Cambridge, 1984), pp. 183–5. **426.** *Boswell's London Journal*, ed. Frederick A. Pottle (London, 1950), pp. 251–2. **427.** *Boswell for the Defence 1769–1774*, ed. William K. Wimsatt, Jr and Frederick A. Pottle (London, 1960), *passim*, esp. pp. 38–51; Gordon Turnbull, 'Boswell and sympathy: the trial and execution of John Reid', in Greg Clingham, ed., *New Light on Boswell: Critical and Historical Essays on the Occasion of the Bicentenary of 'The Life of Johnson'* (Cambridge, 1991), pp. 104–15. **428.** Gatrell, *Hanging Tree*, p. 291. **429.** Cesare Beccaria, *On Crimes and Punishments and Other Writings*, ed. Richard Bellamy (Cambridge, 1995), p. 69. **430.** See 'The Criminal of Lost Honor. A True Story', tr. Jeffrey L. High, in High, ed., *Schiller's Literary Prose Works: New Translations and Critical Essays* (Rochester, NY, 2008), pp. 39–55. **431.** Beccaria, *Crimes*, p. 81. **432.** See Goethe, *Sämtliche Werke*, vii/2. p. 193; Richard J. Evans, *Rituals of Retribution: Capital Punishment in Germany, 1600–1987* (Oxford, 1996), pp. 67–70. Goethe complains of plagiarism in *Dichtung und Wahrheit*: *Sämtliche Werke*, xiv. pp. 655–6. **433.** See the caged starling episode in Sterne, *A Sentimental Journey through France and Italy*, ed. Ian Jack (Oxford, 1968), p. 71; 'To a Mouse, On turning her up in her Nest, with the Plough, November, 1785', in Burns, *Poems and Songs*, i. p. 127. **434.** See Steele, *Spectator*, no. 174, 19 Sept. 1711 ('hang'd up all his Dogs'); 'My poor old Spaniel Bitch Mab was hung this Morn she being very old and almost blind' (James Woodforde, *The Diary of a Country Parson*, ed. John Beresford, 5 vols. (London, 1926–31), iii. p. 61 (3 Nov. 1788), cf. v. pp. 5–6 (15 Jan. 1797)). Cf. 'I knocked over Hareton, who was hanging a litter of puppies from a chair-back', Emily Brontë, *Wuthering Heights* (1847), ed. Hilda Marsden and Ian Jack (Oxford, 1976), p. 224; and Gatrell, *Hanging Tree*, p. 283. **435.** Keith Thomas, *Man and the Natural World: Changing Attitudes in England 1500–1800* (London, 1983), pp. 109–10; *Le testament de Jean Meslier*, ed. Rudolf Charles, 3 vols. (Amsterdam, 1864), iii. p. 350; translation from *Testament: Memoir of the Thoughts and Sentiments of Jean Meslier*, tr. Michael Shreve (New York, 2009), p. 563 (translation modified); Darnton, *Great Cat Massacre*, pp. 90–91; Jean Delumeau, *Catholicism between Luther and Voltaire: A New View of the Counter-Reformation*, tr. Jeremy Moiser (London, 1977), p. 167. For a fictional instance, supposed to have happened in the nineteenth century, see T. F. Powys, *Mr Weston's Good Wine* (London, 1927), ch. 17. **436.** Quoted in Jenny Uglow, *Hogarth: A Life and a World* (London, 1997), p. 500. **437.** Rousseau, *Émile*, p. 118; OCR iv. p. 411. **438.** See Thomas, *Man and the Natural World*, pp. 144–8; Barker-Benfield, *Culture of Sensibility*, pp. 231–47. **439.** Tim Blanning, *The Pursuit of Glory: Europe 1648–1815* (London, 2007), p. 403. **440.** See David Hackett Fischer, *Albion's Seed: Four British Folkways in America* (New York, 1989), p. 263; on further blood sports in colonial Virginia, ibid., pp. 362–4. **441.** Friedrich Nicolai, *Beschreibung einer Reise durch Deutschland und die Schweiz im Jahre 1781. Nebst Bemerkungen über Gelehrsamkeit, Industrie, Religion und Sitten*, 12 vols. (Berlin, 1783–96), iv. pp. 630–41. **442.** [José] Cadalso, *Cartas marruecas*, ed. Juan Tamayo y Rubio (Madrid, 1956), p. 179 (Letter LXXII, textual variant in footnote). **443.** Blanning, *Pursuit of Glory*, pp. 394–5. **444.** Frederick of Prussia, *The Refutation of Machiavelli's 'Prince' or Anti-Machiavel*, tr. and ed. Paul Sonnino (Athens, OH, 1981), p. 95. **445.** 'Mon Portrait', OCR i. p. 1129. **446.** *Spectator*, nos. 115, 116 (12 and 13 July 1711). **447.** See Leask, *Burns*, p. 162. **448.** Letter to Patrick Miller, 21 June 1789, *Letters of Robert Burns*, ed. J. De Lancey Ferguson, rev. by G. Ross Roy, 2 vols. (Oxford, 1985), i. pp. 417–18. Emphasis in original. For the poem, see Burns, *Poems and Songs*, i.

pp. 465–6.   **449.** 'To a Mouse, On turning her up in her Nest, with the Plough, November, 1785', in Burns, *Poems and Songs*, i. p. 127. Emphasis in original.   **450.** See the commentary by Leask, *Burns*, esp. pp. 164–6.   **451.** See the biography by David V. Erdman, *Commerce des Lumières: John Oswald and the British in Paris, 1790–1793* (Columbia, MO, 1986), and Tristram Stuart, *The Bloodless Revolution: Radical Vegetarians and the Discovery of India* (London, 2006), pp. 295–312. For other late eighteenth-century advocates of humanity towards animals, see Joanna Bourke, *What it Means to be Human: Reflections from 1791 to the Present* (London, 2011), pp. 72–6.   **452.** John Oswald, *The Cry of Nature: or, an appeal to mercy and to justice, on behalf of the persecuted animals* (London, 1791), pp. i, 5.   **453.** Ibid., p. 17.

## 7. SOCIABILITY

**1.** Diderot, *The Nun*, p. 104; OCD iv. pp. 627–8.   **2.** Daniel Gordon, *Citizens without Sovereignty: Equality and Sociability in French Thought, 1670–1789* (Princeton, 1994), p. 63. Cf. Istvan Hont, *Jealousy of Trade: International Competition and the Nation-State in Historical Perspective* (Cambridge, MA, 2005), pp. 167–82.   **3.** Paul-Henri Thiry d'Holbach, *Politique naturelle*, in *Œuvres philosophiques*, ed. Jean-Pierre Jackson, 3 vols. (Paris, 2001), iii. p. 346.   **4.** Gordon, *Citizens*, p. 68.   **5.** Adam Smith, *The Theory of Moral Sentiments*, ed. D. D. Raphael and A. L. Macfie (Oxford, 1976), p. 223. See Lisa Hill and Peter McCarthy, 'Hume, Smith and Ferguson: friendship in commercial society', *Critical Review of International Social and Political Philosophy*, 2 (1999), pp. 33–49. I thank David Wootton for this reference.   **6.** Étienne Bonnot de Condillac, *Essay on the Origin of Human Knowledge*, tr. and ed. Hans Aarsleff (Cambridge, 2001), p. 88. Condillac also discusses this wild boy in *Traité des sensations*, 2 vols. (Paris, 1754), ii. pp. 225–30.   **7.** Condillac, *Essay*, p. 36.   **8.** Ibid., p. 150. Cf. the similar history of language given by Herder in 'Von den Lebensaltern einer Sprache', in his *Werke*, ed. Günter Arnold and others, 10 vols. (Frankfurt a.M., 1985–2000), i. pp. 181–4. Both Condillac and Herder are placed within the history of language discussion by Avi Lifschitz, *Language and Enlightenment: The Berlin Debates of the Eighteenth Century* (Oxford, 2012).   **9.** Voltaire, *La Russie sous Pierre le Grand*, in his *Œuvres historiques*, ed. René Pomeau (Paris, 1957), p. 431.   **10.** Keith Thomas, *In Pursuit of Civility: Manners and Civilization in Early Modern England* (New Haven, 2018), p. 24.   **11.** Roger Chartier, *The Cultural Uses of Print in Early Modern France*, tr. Lydia G. Cochrane (Princeton, 1987), p. 77.   **12.** See Lawrence E. Klein, *Shaftesbury and the Culture of Politeness: Moral Discourse and Cultural Politics in Early Eighteenth-Century England* (Cambridge, 1994), p. 4; Thomas, *In Pursuit of Civility*, pp. 27–30.   **13.** *The Letters of Philip Dormer Stanhope, 4th Earl of Chesterfield*, ed. Bonamy Dobrée, 6 vols. (London, 1932), iii. p. 1115 (letter of 9 March 1748).   **14.** Often reprinted as 'De la politesse'; quoted in Peter France, 'Polish, police, *polis*', in his *Politeness and its Discontents: Problems in French Classical Culture* (Cambridge, 1992), pp. 53–73 (p. 55).   **15.** On the practice of politeness in middle-class England, and on infringements of its rules, see Amanda Vickery, *The Gentleman's Daughter: Women's Lives in Georgian England* (New Haven, 1998), pp. 195–223.   **16.** See Peter Burke, *The Art of Conversation* (Cambridge, 1993), pp. 98–108.   **17.** Adam Petrie, *Rules of Good Deportment, or of Good Breeding* (Edinburgh, 1720), p. 57.   **18.** Hume, 'Of the Delicacy of Taste and Passion', in his *Essays Moral, Political, and Literary*, ed. Eugene F. Miller (Indianapolis, 1987), pp. 3–8 (p. 7).   **19.** See Paul Langford, *A Polite and Commercial People: England 1727–1783* (Oxford, 1989), pp. 116–17; on the development of London speech into a standard, Lynda Mugglestone, *'Talking Proper': The Rise of Accent as Social Symbol* (Oxford, 1995), esp. pp. 13–18; on 'class accent', Anna Bryson, *From Courtesy to Civility: Changing Codes of Conduct in Early Modern England* (Oxford, 1998), pp. 189–92.   **20.** Mugglestone, *'Talking Proper'*, p. 22.   **21.** Jane Austen, *Sense and Sensibility*, ed. Tony Tanner (Harmondsworth, 1969), pp. 164–5 (ch. 24). See Robert Lowth, *A Short Introduction to English Grammar*, 2nd edn (London, 1763), pp. 90–94.   **22.** Chesterfield, *Letters*, iv. p. 1259 (18 Nov. 1748); James

Woodforde, *The Diary of a Country Parson*, ed. John Beresford, 5 vols. (London, 1926–31), ii. p. 18 (16 Apr. 1782), ii. p. 130 (14 Apr. 1784). 23. *Spectator*, no. 217, 8 Nov. 1711. 24. Burke, *Art of Conversation*, p. 104. 25. See Vickery, *The Gentleman's Daughter*, p. 36. 26. *Commons Journal*, xxii. p. 271, quoted in Langford, *A Polite and Commercial People*, p. 75. 27. Figures from Vivian R. Gruder, *The Royal Provincial Intendants: A Governing Elite in Eighteenth-Century France* (Ithaca, NY, 1968), p. 177. On the diversity of the nobility, see Daniel Roche, *France in the Enlightenment*, tr. Arthur Goldhammer (Cambridge, MA, 1998), pp. 390–419. 28. Elinor G. Barber, *The Bourgeoisie in 18th Century France* (Princeton, 1955), p. 88. 29. Quoted ibid., p. 96. 30. Goethe, *Sämtliche Werke: Briefe, Tagebücher und Gespräche*, ed. Friedmar Apel and others, 40 vols. (Frankfurt a.M., 1986–2000), ix. pp. 657–60. See Dieter Borchmeyer, *Höfische Gesellschaft und französische Revolution bei Goethe* (Kronberg i.Ts., 1977), pp. 23–5. 31. Catriona Kelly, *Refining Russia: Advice Literature, Polite Culture, and Gender from Catherine to Yeltsin* (Oxford, 2001), p. 9. 32. Kelly, ibid., p. 17, translates an excerpt. 33. Bryson, *From Courtesy to Civility*, pp. 203–13, 217. 34. Swift, 'Polite Conversation', in *The Cambridge Edition of the Works of Jonathan Swift*, ed. Claude Rawson and others, 17 vols. (Cambridge, 2010– ), ii: *Parodies, Hoaxes, Mock Treatises*, ed. Valerie Rumbold (2013), p. 299. 35. Duclos, *Considérations sur les mœurs*, ed. F. C. Green (Cambridge, 1939), p. 37. 36. 'Lettre à d'Alembert', *OCR* v. pp. 1–125 (pp. 33–41). 37. See Johnson, 'London', l. 145, in *The Yale Edition of the Works of Samuel Johnson*, ed. Herman W. Liebert and others (New Haven, 1963–2010), vi: *Poems*, ed. E. L. McAdam, Jr (1964), pp. 47–61 (p. 55); Wieland, *Hermann* (1752), in *Wielands Gesammelte Schriften*, ed. by the Deutsche Kommission der Königlich Preußischen Akademie der Wissenschaften, I: *Werke*, 23 vols. (Berlin, 1909–69), i. p. 139; Lessing, *Emilia Galotti*, II, 5, in *Werke und Briefe*, ed. Wilfried Barner and others, 12 vols. (Frankfurt a.M., 1987–98), vii. p. 314; *Nathan*, II, v, ibid., ix. p. 529; Voltaire, *L'Écossaise*, V, iii: 'c'est un bon homme, un homme grossièrement vertueux', *OCV* 50, p. 459. 38. Chesterfield, *Letters*, iv. p. 1450 (letter of 26 Nov. 1749). 39. Chesterfield, *Letters*, iv. p. 1700 (letter of 18 Mar. 1751). 40. Frances Burney, *Journals and Letters*, ed. Peter Sabor and Lars E. Troide (London, 2001), p. 33. On Chesterfield's educational method, see the apt comments by John Cannon in the *ODNB* article 'Philip Dormer Stanhope, Lord Chesterfield'. 41. Duclos, *Considérations*, pp. 102–3. 42. *Mémoires de l'Abbé Morellet*, ed. Jean-Pierre Guicciardi (Paris, 1988), p. 128. 43. Jürgen Habermas, *Strukturwandel der Öffentlichkeit: Untersuchungen zu einer Kategorie der bürgerlichen Gesellschaft*, 2nd edn (Frankfurt a.M., 1990); *The Structural Transformation of the Public Sphere: An Inquiry into a Category of Bourgeois Society*, tr. Thomas Burger and Frederick Lawrence (Cambridge, 1989). For an introductory account, see T. C. W. Blanning, *The Culture of Power and the Power of Culture: Old Regime Europe 1660–1789* (Oxford, 2002), pp. 5–14. For an overview of the enormous debate on Habermas, see John H. Zammito, 'The second life of the "public sphere": on charisma and routinization in the history of a concept', in Christian J. Emden and David Midgley, eds., *Changing Perceptions of the Public Sphere* (New York, 2012), pp. 90–119. 44. For a critique of Habermas on this subject, see Markman Ellis, *The Coffee House: A Cultural History* (London, 2004), pp. 220–24. See Macaulay, *History of England*, ch. 3, in *The Works of Lord Macaulay*, 12 vols. (London, 1898), i. pp. 384–7. 45. James Van Horn Melton, *The Rise of the Public in Enlightenment Europe* (Cambridge, 2001), p. 240; Ellis, *Coffee House*, p. 80. 46. On the spread of coffee-houses, Ellis, *Coffee House*, pp. 75–85. 47. Ellis, *Coffee House*, p. 172. 48. Michael Brown, *The Irish Enlightenment* (Cambridge, MA, 2016), pp. 225–6. For numbers of coffee-houses in other cities, see Melton, *Rise of the Public*, pp. 240–41. 49. Colin Jones, *The Great Nation: France from Louis XV to Napoleon* (London, 2002), pp. 180–81. Daniel Roche gives the less plausible figure of 2,800 cafés but does not say at what date: *France in the Enlightenment*, p. 628. 50. See Brian Cowan, *The Social Life of Coffee: The Emergence of the British Coffeehouse* (New Haven, 2005), pp. 172–5. 51. Macaulay, *Works*, i. p. 384. 52. Ellis, *Coffee House*, pp. 46–51. Habermas misleadingly gives the Rota as an example of free coffee-house discussion: *Structural Transformation*, p. 33. 53. Macaulay, *Works*, i. pp. 386–7. 54. I thank Catriona Seth for this and some other information in this chapter. 55. Melton, *Rise of the Public*, p. 244; Brown,

*Irish Enlightenment*, p. 228.    56. *Boswell's London Journal*, ed. Frederick A. Pottle (London, 1950), pp. 221–2, 144, 74–5 (cf. pp. 94, 105, 115).    57. Habermas (*Structural Transformation*, p. 257) mentions a pamphlet of 1674, *The Women's Petition against Coffee, representing to Public Consideration of the Grand Inconveniences accruing to their Sex from the Excessive Use of that Drying, Enfeebling Liquor*, evidently supposing it to be a genuine protest; but it is clearly a spoof in which women complain that coffee-drinking reduces their menfolk's virility. See the text reproduced in Markman Ellis, ed., *Eighteenth-Century Coffee-House Culture*, 3 vols. (London, 2006), i. pp. 111–18, and Ellis's sceptical introduction, pp. 109–10.    58. *Spectator*, no. 155, 28 Aug. 1711; discussed in E. J. Clery, *The Feminization Debate in Eighteenth-Century England: Literature, Commerce and Luxury* (Basingstoke, 2004), pp. 21–5.    59. Cowan, *Social Life of Coffee*, p. 144.    60. Tobias Smollett, *The Expedition of Humphry Clinker*, ed. O. M. Brack, Jr and Thomas R. Preston (Athens, GA, 1990), p. 40.    61. Paul Cheney, 'Commerce', in Daniel Brewer, ed., *The Cambridge Companion to the French Enlightenment* (Cambridge, 2014), pp. 44–59 (p. 49). 62. John Eliot Gardiner, *Music in the Castle of Heaven: A Portrait of Johann Sebastian Bach* (London, 2013), pp. 259–61.    63. Habermas, *Structural Transformation*, p. 33.    64. See Erica Harth, *Cartesian Women: Versions and Subversions of Rational Discourse in the Old Regime* (Ithaca, NY, 1992).    65. See Barbara Krajewska, *Du Cœur à l'esprit: Mademoiselle de Scudéry et ses samedis* (Paris, 1993), p. 25. On the social profile of seventeenth-century salons, see Carolyn C. Lougee, *Le Paradis des Femmes: Women, Salons, and Social Stratification in Seventeenth-Century France* (Princeton, 1976), esp. p. 125.    66. See Dena Goodman, *The Republic of Letters: A Cultural History of the French Enlightenment* (Ithaca, NY, 1994), pp. 74–5. For portraits of many hostesses and an anthology of contemporary texts, see Jacqueline Hellegouarc'h, *L'Esprit de société: Cercles et 'salons' parisiens au XVIII<sup>e</sup> siècle* (Paris, 2000).    67. Jean-François Marmontel, *Mémoires*, ed. Jean-Pierre Guicciardi and Gilles Thierriat (Paris, 1999), p. 201. 'Sappho' probably refers not to the Greek poet Sappho but to Scudéry, who adopted it as her sobriquet: see Krajewska, *Du Cœur à l'esprit*, p. 20.    68. Letter to Sophie Volland, 12 Nov. 1768, *OCD* vii. p. 814. Habermas gives this example: *Structural Transformation*, p. 34.    69. Antoine Lilti, *The World of the Salons: Sociability and Worldliness in Eighteenth-Century Paris*, tr. Lydia G. Cochrane (New York, 2010), p. 6; cf. p. 28.    70. Ibid., p. 35; Edward Gibbon, *Memoirs of my Life*, ed. Georges A. Bonnard (London, 1966), p. 126.    71. Anthony J. La Vopa, *The Labor of the Mind: Intellect and Gender in Enlightenment Cultures* (Philadelphia, 2017), p. 20.    72. Hellegouarc'h, *L'Esprit de société*, p. 68.    73. Richard Butterwick, *Poland's Last King and English Culture: Stanisław August Poniatowski 1732–1798* (Oxford, 1998), p. 104.    74. Lilti, *The World of the Salons*, pp. 143–4.    75. Marmontel, *Mémoires*, pp. 206–7.    76. 'Essai sur la société des gens de lettres et des grands', in *Œuvres complètes de d'Alembert*, 5 vols. (Paris, 1821), i. pp. 337–73 (p. 343).    77. D'Alembert, 'Essai', *Œuvres*, i. p. 367.    78. Goodman, *Republic of Letters*, p. 74. Current research on the attendees at Lespinasse's salon suggests a higher degree of intellectual activity there than at most salons: I thank Chloe Summers Edmondson (Stanford) for sharing with me her unpublished paper 'Julie de Lespinasse and the "philosophical" salon', now in Edmondson and Dan Edelstein, eds., *Networks of Enlightenment: Digital Approaches to the Republic of Letters* (Liverpool, 2019).    79. Cheney, 'Commerce', p. 50 (summarizing Lilti's thesis).    80. Marmontel, *Mémoires*, p. 196.    81. Quoted in Lilti, *The World of the Salons*, p. 160.    82. *Candide*, ch. 22, in Voltaire, *Candide and Other Stories*, tr. Roger Pearson (Oxford, 2006), p. 59.    83. Lilti, *The World of the Salon*, pp. 174, 238. Cf. Lilti, *Le Monde des salons*, pp. 55–7, part of the historiographical survey omitted from the translation.    84. Sarah Knott, *Sensibility and the American Revolution* (Chapel Hill, NC, 2009), p. 44.    85. Brown, *Irish Enlightenment*, p. 221. More Dublin salons are mentioned in T. C. Barnard, '"Grand metropolis" or "The anus of the world"? The cultural life of eighteenth-century Dublin', in Peter Clark and Raymond Gillespie, eds., *Two Capitals: London and Dublin, 1500–1840* (Oxford, 2001), pp. 185–210.    86. See Volkmar Braunbehrens, *Mozart in Vienna 1781–1791*, tr. Timothy Bell (New York, 1986), pp. 149–58; Roswitha Strommer, 'Wiener literarische Salons zur Zeit Joseph Haydns', in Herbert Zeman, ed., *Joseph Haydn und die Literatur seiner Zeit* (Eisenstadt, 1976), pp. 97–121.

**87.** Caroline Pichler, *Denkwürdigkeiten aus meinem Leben*, ed. Emil Karl Blümml, 2 vols. (Munich, 1914), i. pp. 47–8. **88.** Lilti, *Le Monde des salons*, p. 241. Pichler makes only a veiled allusion to her mother's affair (i. p. 56); the evidence is examined in Gustav Gugitz, 'Lorenz Leopold Haschka', *Jahrbuch der Grillparzer-Gesellschaft*, 17 (1907), pp. 32–127. **89.** The 'Jewish salons' held in Berlin from the 1780s onwards by Jewish hostesses such as Henriette Herz and Rahel Levin (later Rahel Varnhagen) fall largely outside the chronological scope of this book. For a thorough account, see Deborah Hertz, *Jewish High Society in Old Regime Berlin* (New Haven and London, 1988); for a critical review of the sources, see Barbara Hahn, 'The myth of the salon', in her *The Jewess Pallas Athena*, tr. James McFarland (Princeton, 2005), pp. 42–55. Further research is needed. **90.** Alan Charles Kors, *D'Holbach's Coterie: An Enlightenment in Paris* (Princeton, 1976), pp. 106–7 (women), 11 (list of regulars), 102–13 (foreigners), 110–11 (Sterne's passport). **91.** Ibid., pp. 11–12. **92.** *Mémoires de Morellet*, p. 130. **93.** Ibid., p. 131. **94.** Letter to Mme de Maux, summer 1769, OCD viii. p. 873. **95.** See Richard Leppert, *Music and Image: Domesticity, Ideology, and Socio-Cultural Formation in Eighteenth-Century England* (Cambridge, 1988); John Brewer, *The Pleasures of the Imagination: English Culture in the Eighteenth Century* (London, 1997), pp. 531–72. On disparagement of music, see Leppert, *Music and Image*, pp. 17–27; Brewer, *Pleasures*, pp. 532–3. Patrick Piggott points out that in Jane Austen's novels men rarely if ever play: *The Innocent Diversion: A Study of Music in the Life and Writings of Jane Austen* (London, 1979), p. 3. **96.** On social games in America, see David S. Shields, *Civil Tongues and Polite Letters in British America* (Chapel Hill, NC, 1997), including a specimen crambo (pp. 165–8). **97.** Ulrich Im Hof, *Das gesellige Jahrhundert: Gesellschaft und Gesellschaften im Zeitalter der Aufklärung* (Munich, 1982). **98.** Peter Clark, *British Clubs and Societies 1580–1800: The Origins of an Associational World* (Oxford, 2000), pp. 78–9. **99.** Ibid., pp. 87–8. On the clubs of British America more generally, see Shields, *Civil Tongues*, pp. 175–208 and 211–16 (Harvard undergraduate clubs). **100.** Addison, *Spectator*, no. 9, 10 Mar. 1711; Steele, *Spectator*, no. 30, 4 Apr. 1711. **101.** David Stevenson, *The Beggar's Benison: Sex Clubs of Enlightenment Scotland and their Rituals* (East Linton, 2001), pp. 76–7. On this moral panic, see Thomas W. Laqueur, *Solitary Sex: A Cultural History of Masturbation* (New York, 2003). **102.** See M. Kay Flavell, 'The enlightened reader and the new industrial towns: a study of the Liverpool Library, 1758–1790', *British Journal for Eighteenth-Century Studies*, 8 (1985), pp. 17–35. **103.** A glimpse of Priestley's activity in Warrington is given by Jenny Uglow, *The Lunar Men: The Friends who Made the Future* (London, 2002), pp. 72–3. **104.** Quoted in Flavell, 'The enlightened reader', p. 31. **105.** Ian Simpson Ross, *The Life of Adam Smith* (Oxford, 1995), pp. 139–41. On the founding and customs of the Poker Club, see Alexander Carlyle, *Anecdotes and Characters of the Times*, ed. James Kinsley (London, 1973), pp. 213–14. **106.** Daniel Roche, *Le Siècle des Lumières en province: Académies et académiciens provinciaux, 1680–1789*, 2 vols. (Paris, 1978), i. p. 26. These academies are not to be confused with the educational institutions called academies or *maisons particulières*, founded in the eighteenth century, sometimes as boarding-schools, specializing in mathematical and technical subjects: see L. W. B. Brockliss, *French Higher Education in the Seventeenth and Eighteenth Centuries: A Cultural History* (Oxford, 1987), p. 26. **107.** Leo Damrosch, *Jean-Jacques Rousseau: Restless Genius* (New York, 2005), pp. 150–51. **108.** Jones, *The Great Nation*, p. 180; Roche, *Le Siècle*, i. p. 331. **109.** Roche, *Le Siècle*, i. pp. 189–90. **110.** Laurence Brockliss, 'Starting-out, getting-on and becoming famous in the eighteenth-century Republic of Letters', in André Holenstein, Hubert Steinke and Martin Stuber, eds., *Scholars in Action: The Practice of Knowledge and the Figure of the Savant in the 18th Century*, 2 vols. (Leiden, 2013), i. pp. 71–100 (p. 97). **111.** Roche, *France in the Enlightenment*, pp. 441–2. **112.** Arthur Young, *Travels during the Years 1787, 1788, and 1789* (Bury St Edmunds, 1792), p. 90. **113.** Roger Chartier, *Lectures et lecteurs dans la France d'Ancien Régime* (Paris, 1987), p. 192. **114.** 'Some Account of the Academies of Italy', in *Collected Works of Oliver Goldsmith*, ed. Arthur Friedman, 5 vols. (Oxford, 1966), i. pp. 473–5 (p. 473). **115.** Simone Testa, *Italian Academies and their Networks, 1525–1700: From Local to Global* (London, 2015), p. 1. **116.** See ibid., pp. 48–52. **117.** Franco Venturi,

*Settecento riformatore* (Turin, 1969), p. 683.  **118.** See Dino Carpanetto and Giuseppe Ricuperati, *Italy in the Age of Reason 1685–1789*, tr. Caroline Higgitt (London, 1987), pp. 264–6.  **119.** Quoted in Venturi, *Settecento riformatore*, p. 681.  **120.** See Marlies Prüsener, 'Lesegesellschaften im 18. Jahrhundert. Ein Beitrag zur Lesergeschichte', *Archiv für Geschichte des Buchwesens*, 13 (1973), pp. 369–594.  **121.** Quoted ibid., p. 421. **122.** P. J. Buijnsters, 'Lesegesellschaften in den Niederlanden', in Otto Dann, ed., *Lesegesellschaften und bürgerliche Emanzipation: Ein europäischer Vergleich* (Munich, 1981), pp. 143–58 (p. 152).  **123.** Quoted in Sylvia Harcstark Myers, *The Bluestocking Circle: Women, Friendship, and the Life of the Mind in Eighteenth-Century England* (Oxford, 1990), p. 144.  **124.** Ibid., pp. 7, 251.  **125.** See Horst Möller, *Aufklärung in Preußen: Der Verleger, Publizist und Geschichtschreiber Friedrich Nicolai* (Berlin, 1974), esp. pp. 230–38; shorter accounts in Möller, 'Enlightened societies in the metropolis: the case of Berlin', in Eckhart Hellmuth, ed., *The Transformation of Political Culture: England and Germany in the Late Eighteenth Century* (Oxford, 1990), pp. 219–33, and T. J. Reed, *Light in Germany: Scenes from an Unknown Enlightenment* (Chicago, 2015), p. 160.  **126.** See J. M. Roberts, *The Mythology of the Secret Societies* (London, 1972); David Stevenson, *The Origins of Freemasonry: Scotland's Century, 1590–1710* (Cambridge, 1988); Roche, *Le Siècle*, i. pp. 257–80; Ran Halévi, *Les loges maçonniques dans la France d'Ancien Régime* (Paris, 1984); and the difficult but important book by Ralf Klausnitzer, *Poesie und Konspiration: Beziehungssinn und Zeichenökonomie von Verschwörungsszenarien in Publizistik, Literatur und Wissenschaft 1750–1850* (Berlin, 2007).  **127.** Nigel Leask, *Robert Burns and Pastoral: Poetry and Improvement in Late Eighteenth-Century Scotland* (Oxford, 2010), p. 12.  **128.** Roche, *Le Siècle*, i. pp. 265 (social groups), 278 (names).  **129.** Leo Tolstoy, *War and Peace*, tr. Louise and Aylmer Maude, 3 vols. (Oxford, 1933), Book VI, ch. 7. **130.** Letter of 15 March 1783, in Goethe, *Sämtliche Werke*, xxix. p. 473.  **131.** The greatest claims for Masonic radicalism have been made by Margaret C. Jacob, *The Radical Enlightenment: Pantheists, Freemasons and Republicans* (London, 1981). Contrast Stevenson, *Origins of Freemasonry*, p. 227. Jacob has pursued her argument in *Living the Enlightenment: Freemasonry and Politics in Eighteenth-Century Europe* (New York, 1991) and *The Origins of Freemasonry: Facts and Fictions* (Philadelphia, 2006).  **132.** Frank A. Kafker, *The Encyclopedists as a Group: A Collective Biography of the Authors of the 'Encyclopédie'* (Oxford, 1996), pp. 25–6. Robert Shackleton similarly finds only four Masons out of a considerably larger group of contributors: 'The Enlightenment and the artisan', in his *Essays on Montesquieu and on the Enlightenment*, ed. David Gilson and Martin Smith (Oxford, 1988), pp. 461–8.  **133.** Jacob, *The Radical Enlightenment*, p. 243; L. W. B. Brockliss, *Calvet's Web: Enlightenment and the Republic of Letters in Eighteenth-Century France* (Oxford, 2002), p. 53.  **134.** Dan Edelstein, *The Enlightenment: A Genealogy* (Chicago, 2010), p. 10; Anne-Marie Mercier-Faivre, *Un supplément à l'Encyclopédie: Le 'Monde primitif' d'Antoine Court de Gébelin* (Paris, 1999), pp. 103–4.  **135.** [Born], *Johann Physiophilus's Versuch einer Mönchologie nach Linnäischer Methode mit dreien Kupfern geziert* [etc.] (AUGSBURG, auf Kosten P. Aloys Merzens Dompredigers, 1786), p. 21. The place of publication is a joke: Aloys Merz, head preacher at Augsburg cathedral, was an outspoken enemy of the Enlightenment.  **136.** Its members are listed in Ludwig Abafi, *Geschichte der Freimaurerei in Österreich-Ungarn*, 5 vols. (Budapest, 1890–99), iii. pp. 308–18. On Born, see Edwin Zellweker, *Das Urbild des Sarastro: Ignaz v. Born* (Vienna, 1953); Helmut Reinalter, 'Ignaz von Born – Aufklärer, Freimaurer und Illuminat', in Reinalter, ed., *Aufklärung und Geheimgesellschaften: Zur politischen Funktion und Sozialstruktur der Freimaurerlogen im 18. Jahrhundert* (Munich, 1989), pp. 151–71.  **137.** Nicholas Till, *Mozart and the Enlightenment: Truth, Virtue and Beauty in Mozart's Operas* (London, 1992), p. 127.  **138.** See Richard van Dülmen, *Der Geheimbund der Illuminaten: Darstellung, Analyse, Dokumentation* (Stuttgart, 1975).  **139.** Abbé Barruel, *Memoirs Illustrating the History of Jacobinism*, tr. Robert Clifford, 4 vols. (London, 1798), i. p. 2. See Darrin M. McMahon, *Enemies of the Enlightenment: The French Counter-Enlightenment and the Making of Modernity* (New York, 2001).  **140.** See Nigel Aston, 'Burke and the conspiratorial origins of the French Revolution: some Anglo-French resemblances', in Barry Coward and Julian Swann, eds.,

*Conspiracies and Conspiracy Theory in Early Modern Europe* (Aldershot, 2004), pp. 213–33.    **141.** Ernst Wangermann, *The Austrian Achievement 1700–1800* (London, 1973), p. 153. The question of which shade of Freemasonry the opera expresses can be left to specialists. **142.** See Peter Branscombe, *W. A. Mozart: 'Die Zauberflöte'* (Cambridge, 1991), pp. 10–25, 37–44.    **143.** See Till, *Mozart*, pp. 277–313. The most detailed Masonic analysis, adding numerological symbolism, is perhaps Hans-Josef Irmen, *Mozart, Mitglied geheimer Gesell-schaften*, 2nd edn (Zülpich, 1991).    **144.** Jan Assmann, *Die Zauberflöte: Oper und Mysterium* (Munich, 2005), pp. 134–5. Against the thesis of the hurried plot-change, see Otto Rommel, *Die Alt-Wiener Volkskomödie* (Vienna, 1952), pp. 495–9; Branscombe, *'Die Zauberflöte'*, pp. 29–32.    **145.** The Moor's punishment is borrowed from C. M. Wieland's fairy-tale collection *Dschinnistan* (1786–9): Rommel, *Alt-Wiener Volkskomödie*, p. 500.    **146.** W. A. Mozart, *Die Zauberflöte* (Stuttgart, 1991), p. 51 (II, 12).    **147.** Luther Link, *The Devil: A Mask without a Face* (London, 1995), p. 188.    **148.** See the critical survey of research in Brockliss, *Calvet's Web*, pp. 5–8.    **149.** Jonathan Israel, *Radical Enlightenment: Philosophy and the Making of Modernity 1650–1750* (Oxford, 2001), p. vi.    **150.** Hans Bots and Françoise Waquet, *La République des Lettres* (Paris, 1997), p. 34; Lorraine Daston, 'The ideal and reality of the Republic of Letters in the Enlightenment', *Science in Context*, 4 (1991), pp. 367–86 (p. 370). The estimate of 30,000 comes from Brockliss, 'Starting-out', p. 74.    **151.** OCV 3B, p. 308.    **152.** Bots and Waquet, *République*, p. 12.    **153.** See Anne Goldgar, *Impolite Learning: Conduct and Community in the Republic of Letters, 1680–1750* (New Haven, 1995).    **154.** Bots and Waquet, *République*, p. 32.    **155.** See the map ibid., p. 130; also in Peter N. Miller, *Peiresc's Europe: Learning and Virtue in the Seventeenth Century* (New Haven, 2000), opposite p. 1.    **156.** Daston, 'The ideal', p. 371.    **157.** Georg Gerber, 'Leibniz und seine Korrespondenz', in Wilhelm Totok and Carl Haase, eds., *Leibniz: Sein Leben – sein Wirken – seine Welt* (Hanover, 1966), pp. 141–71.    **158.** Martin Stuber, Stefan Hächler and Luc Lienhard, eds., *Hallers Netz: Ein europäischer Gelehrtenbriefwechsel zur Zeit der Aufklärung* (Basel, 2005), p. 3.    **159.** Caroline Winterer, 'Where is America in the Republic of Letters?', *Modern Intellectual History*, 9 (2012), pp. 597–623 (p. 608). Now digitized: see https://franklinpapers.org.    **160.** See Israel, *Radical Enlightenment*, pp. 142–51.    **161.** Jonathan Israel, *The Dutch Republic: Its Rise, Greatness, and Fall, 1477–1806* (Oxford, 1995), p. 1046.    **162.** Elisabeth Labrousse, *Pierre Bayle*, 2 vols. (The Hague, 1963–4), i. p. 190.    **163.** Israel, *Dutch Republic*, p. 1047.    **164.** John Marshall, *John Locke, Toleration and Early Enlightenment Culture* (Cambridge, 2006), pp. 503–4.    **165.** Leibniz, letter to Thomas Burnett of Kemnay, 17 March 1696, quoted in Maria Rosa Antognazza, *Leibniz: An Intellectual Biography* (Cambridge, 2009), p. 196.    **166.** Alessandro Manzoni, *The Betrothed*, tr. Bruce Penman (Harmondsworth, 1972), p. 406.    **167.** Letter of May 1679, quoted in Antognazza, *Leibniz*, pp. 208–9.    **168.** Israel, *Radical Enlightenment*, p. 122.    **169.** Johannes Frimmel, *Literarisches Leben in Melk: Ein Kloster im 18. Jahrhundert im kulturellen Umbruch* (Vienna, 2004), pp. 147–9.    **170.** See Mario Rosa, 'Un "média-teur" dans la République des Lettres: le bibliothécaire', in Hans Bots and Françoise Waquet, eds., *Commercium Litterarium: La communication dans la République des Lettres* (Amsterdam, 1994), pp. 81–99.    **171.** See Robert DeMaria, Jr, *The Life of Samuel Johnson: A Critical Biography* (Oxford, 1993), pp. 94–109.    **172.** See Willem Frijhoff, 'La circulation des hommes de savoir: pôles, institutions, flux, volumes', in Bots and Waquet, *Commercium Litterarium*, pp. 229–57.    **173.** Uffenbach's journey is summarized in the biographical preface to Zacharias Conrad von Uffenbach, *Merkwürdige Reisen durch Niedersachsen Holland und Engelland*, 3 vols. (Ulm, 1753–4), i, pp. cxxii–cxxiv; for the antiquities in Oxford, see iii. pp. 113–15.    **174.** 'Préface' (unpaginated), *Nouvelles de la République des Lettres*, 1 (Mar. 1684).    **175.** 'Catius', in Bayle, *Dictionnaire historique et critique*, 4 vols. (Amsterdam, 1730), ii. p. 109.    **176.** Bots and Waquet, *République*, p. 94.    **177.** Brockliss, *Calvet's Web*, p. 103; Bots and Waquet, *République*, p. 95.    **178.** See the account of the 28-year-old scholar Barbeyrac 'abasing himself' before the great Locke, in Goldgar, *Impolite Learning*, p. 161.    **179.** Bots and Waquet, *République*, p. 113.    **180.** Quoted in Carl Justi, *Winckelmann und seine Zeitgenossen*, 3 vols. (Leipzig, 1923), ii. p. 112.    **181.** Ibid., ii. p. 107. Justi gives a detailed account of Passionei, ii. pp. 106–20.    **182.** 'Catius', in Bayle, *Dictionnaire*,

ii. p. 109. On the scholarly disputes that Bayle deplored, and the defamation that he had himself suffered, see Mara van der Lugt, *Bayle, Jurieu, and the 'Dictionnaire Historique et Critique'* (Oxford, 2016), pp. 83–116. **183.** Letter to Bouchard, 30 Aug. 1635, quoted in Miller, *Peiresc's Europe*, p. 43. **184.** Robert Boyle, 'A Preface Introductory' (unpaginated), in *The Sceptical Chymist, or Chymico-physical Doubts & Paradoxes* (London, 1661). **185.** See Joseph M. Levine, 'Strife in the Republic of Letters', in Bots and Waquet, *Commercium Litterarium*, pp. 301–19. **186.** See A. Rupert Hall, *Philosophers at War: The Quarrel between Newton and Leibniz* (Cambridge, 1980); Catriona Seth, *Les rois aussi en mouraient: Les Lumières en lutte contre la petite vérole* (Paris, 2008), pp. 220–29. **187.** Many vivid examples in Martin Mulsow, *Die unanständige Gelehrtenrepublik: Wissen, Libertinage und Kommunikation in der Frühen Neuzeit* (Stuttgart, 2007), pp. 67–86. **188.** Letters to Stosch, mid-Sept. 1757, and to Berendis, 5 Feb. 1758, in Johann Joachim Winckelmann, *Briefe*, ed. Walther Rehm, 4 vols. (Berlin, 1952–7), i. pp. 301, 329. **189.** Letter to Stosch, beginning of Oct. 1757, in Winckelmann, *Briefe*, i. p. 307. **190.** Lessing, *Werke und Briefe*, v/2, p. 581. See Alexander Košenina and Ritchie Robertson, 'Lessing as journalist and controversialist', in Robertson, ed., *Lessing and the German Enlightenment* (Oxford, 2013), pp. 39–63. **191.** Note, however, the scepticism about Kircher which Henry Oldenburg, secretary to the Royal Society, expressed in a letter to Spinoza, quoted in Paula Findlen, ed., *Athanasius Kircher: The Last Man Who Knew Everything* (London, 2004), p. 37. **192.** Antognazza, *Leibniz*, p. 63, quoting a letter of October 1671. **193.** D'Alembert, 'Discours préliminaire de l'Encyclopédie', in *Œuvres*, i. pp. 17–99 (p. 56). **194.** Ibid., p. 57. **195.** Laurence Sterne, *The Life and Opinions of Tristram Shandy, Gentleman*, ed. Ian Campbell Ross, rev. edn (Oxford, 2009), p. 331. 'Lipsius' is the eminent political theorist Justus Lipsius (1547–1606). **196.** Lessing, *Der junge Gelehrte* (1747), I, i, in *Werke und Briefe*, i. p. 145. **197.** See Walter E. Houghton, 'The English virtuoso in the seventeenth century', *JHI*, 3 (1942), pp. 51–73, 190–219; Rosemary Sweet, *Antiquaries: The Discovery of the Past in Eighteenth-Century Britain* (London, 2004). **198.** See e.g. Anthony Grafton, *Joseph Scaliger: A Study in the History of Classical Scholarship*, 2 vols. (Oxford, 1983–93); idem, *Defenders of the Text: The Traditions of Scholarship in an Age of Science, 1450–1800* (Cambridge, MA, 1991); and 'A sketch map of a lost continent: the Republic of Letters', in his *Worlds Made by Words: Scholarship and Community in the Modern World* (Cambridge, MA, 2009), pp. 9–34. **199.** For Peiresc's empiricism, e.g., see Miller, *Peiresc's Europe*, p. 25. **200.** Brockliss, *Calvet's Web*, p. 399. **201.** Duclos, *Considérations*, pp. 136–7. **202.** Lilti, *World of the Salons*, p. 109. **203.** Voltaire, 'Gens de Lettres', *Encyclopédie*, vii. pp. 599–600. **204.** Robert Darnton, 'The High Enlightenment and the low-life of literature in pre-Revolutionary France', *Past and Present*, 51 (May 1971), pp. 81–115, reprinted without change in his *The Literary Underground of the Old Regime* (Cambridge, MA, 1982). **205.** See especially Elizabeth L. Eisenstein, *Print Culture and Enlightenment Thought*, the Sixth Hanes Lecture (Chapel Hill, NC, 1986), and *Grub Street Abroad: Aspects of the French Cosmopolitan Press from the Age of Louis XIV to the French Revolution* (Oxford, 1992); Daniel Gordon, 'The great Enlightenment massacre', in H. T. Mason, ed., *The Darnton Debate: Books and Revolution in the Eighteenth Century* (Oxford, 1998), pp. 129–56. **206.** Eisenstein, *Grub Street Abroad*, p. 145. **207.** See Ritchie Robertson, *Mock-Epic Poetry from Pope to Heine* (Oxford, 2009), pp. 78–80. **208.** Pat Rogers, *Grub Street: Studies in a Subculture* (London, 1972), p. 277. **209.** DeMaria, *Johnson*, p. 100. **210.** On the development of postal services, beginning in the early sixteenth century in the reign of Charles V, and the consequences for news and travel, see Wolfgang Behringer, 'Communications revolutions: a historiographical concept', *German History*, 24 (2006), pp. 333–74. **211.** Examples given by Habermas, *Structural Transformation*, p. 22. **212.** See Andrew Pettegree, *The Invention of News: How the World Came to Know About Itself* (New Haven, 2014), pp. 201–3, 238–9. **213.** See ibid., pp. 190–94. **214.** Blanning, *Culture of Power*, p. 154. **215.** Melton, *Rise of the Public*, p. 29. **216.** Figures from Kathleen Wilson, *The Sense of the People: Politics, Culture, and Imperialism in England, 1715–1785* (Cambridge, 1995), p. 37. **217.** Ibid., p. 32. **218.** DeMaria, *Johnson*, p. 26. For regional newspapers in Ireland, see Brown, *Irish Enlightenment*, p. 233. **219.** Melton, *Rise of the Public*, p. 65. **220.** Jeremy D. Popkin, *News and*

*Politics in the Age of Revolution: Jean Luzac's 'Gazette de Leyde'* (Ithaca, NY, 1989), p. 47. **221.** See Eisenstein, *Grub Street Abroad*. **222.** Popkin, *News*, p. 73. **223.** Bob Harris, *Politics and the Rise of the Press: Britain and France, 1620–1800* (London, 1996), p. 66. **224.** *Blackstone's Commentaries*, ed. Henry Winthrop Ballantine (Chicago, 1916), p. 465. First published 1765–9. **225.** See M. Dorothy George, *English Political Caricature to 1792: A Study of Opinion and Propaganda* (Oxford, 1959). **226.** Quoted in Wilson, *Sense of the People*, p. 42. **227.** Harris, *Politics*, p. 39. **228.** 'An Essay on the Regulation of the Press' (1704), in *Political and Economic Writings of Daniel Defoe*, ed. W. R. Owens and P. N. Furbank, 8 vols. (London, 2000), viii. pp. 143–59 (pp. 153, 154). **229.** Thomas Keymer, *Poetics of the Pillory: English Literature and Seditious Libel, 1660–1820* (Oxford, 2019), pp. 13–21. **230.** Melton, *Rise of the Public*, p. 33. **231.** A. Aspinall, *Politics and the Press, c. 1780–1850* (London, 1949), p. 67. On political subsidies, see further Jeremy Black, *The English Press in the Eighteenth Century* (London, 1987), pp. 147–51. **232.** Melton, *Rise of the Public*, p. 27. **233.** See Arthur H. Cash, *John Wilkes: The Scandalous Father of Civil Liberty* (New Haven, 2006), pp. 100–105. **234.** In its German translation, *Der politische Kannegießer*, this play (set in Hamburg) was so popular that it gave German the term *Kannegießer* for an alehouse politician and the verb *kannegießern* for talking ignorantly about politics. **235.** Johnson, 'The False Alarm' (1770), in *The Yale Edition*, x: *Political Writings*, ed. Donald J. Greene (1977), pp. 317–45 (p. 335). **236.** Goethe directed Holberg's *Der politische Kannegießer* in the Weimar theatre on 17 March 1793. See Goethe, *Sämtliche Werke*, vi. p. 1012; and on his demagogues, W. Daniel Wilson, 'Hunger/artist: Goethe's revolutionary agitators in *Götz, Satyros, Egmont* and *Der Bürgergeneral*', *Monatshefte*, 86 (1994), pp. 80–94. **237.** Pettegree, *Invention of News*, p. 272. **238.** Jack R. Censer, *The French Press in the Age of Enlightenment* (London, 1994), p. 87. **239.** Pettegree, *Invention of News*, p. 274. **240.** Marmontel, *Mémoires*, p. 194. **241.** 'Das Geheimnis des Kosmopolitenordens', originally published in the *Teutscher Merkur* in 1788; quoted from Wieland, *Werke*, iii. p. 562. See Hans-Peter Nowitzki, 'Der "menschenfreundliche Cosmopolit" und sein "National-Journal": Wielands *Merkur*-Konzeption', in Andrea Heinz, ed., *'Der Teutsche Merkur' – die erste deutsche Kulturzeitschrift?* (Heidelberg, 2003), pp. 68–107. **242.** 'Introduction', Joseph Addison and others, *The Spectator*, ed. Donald Bond, 5 vols. (Oxford, 1965), i, p. xlv. Addison says that he has sometimes adapted the letters or based one on a hint given by an actual correspondent: no. 271, 10 January 1712. **243.** Quoted in 'Introduction', ibid., p. xv. **244.** *Spectator*, no. 138, 8 Aug. 1711. **245.** *Spectator*, no. 148, 20 Aug. 1711. **246.** *Spectator*, no. 145, 16 Aug. 1711. **247.** *Spectator*, no. 119, 17 July 1711. **248.** *Spectator*, no. 286, 28 Jan. 1712. **249.** *Spectator*, no. 169, 13 Sept. 1711. **250.** On this and other French imitations, see Ralph A. Nablow, *The Addisonian Tradition in France: Passion and Objectivity in Social Observation* (Rutherford, NJ, 1990). **251.** See P. J. Buijnsters, *Van 'Misantrope' tot 'Hollandsche Spectator': Over aard en ontwikkeling van het schrijverschap van Justus van Effen (1684–1735)* (Amsterdam, 1991), quotation from p. 14; Inger Leemans and Gert-Jan Johannes, *Worm en donder: Geschiedenis van de Nederlandse literatuur 1700–1800* (Amsterdam, 2013), pp. 184–7. **252.** Wolfgang Martens, *Die Botschaft der Tugend: Die Aufklärung im Spiegel der deutschen Moralischen Wochenschriften* (Stuttgart, 1968), p. 23. **253.** Ibid., p. 26; Simon Schama, *Patriots and Liberators: Revolution in the Netherlands 1780–1813* (London, 1977), pp. 71–3. **254.** P. M. Mitchell, *A History of Danish Literature* (Copenhagen, 1957), p. 88. **255.** See Justus Möser, *Patriotische Phantasien I*, in his *Sämtliche Werke*, ed. Ludwig Schirmeyer, 14 vols. (Oldenburg, 1943), iv. **256.** Quoted in Martens, *Botschaft*, p. 305. **257.** Ibid., p. 276. **258.** Ibid., pp. 383–4. **259.** Quoted ibid., p. 237, from *Der Biedermann* (1727–9). **260.** See Donald Thomas, *A Long Time Burning: The History of Literary Censorship in England* (London, 1969); a useful recent survey is Gabriele Müller-Oberhäuser, ' "The press ought to be open to all." Zensur in England im Zeitalter der Aufklärung', in Hubert Wolf, ed., *Inquisition und Buchzensur im Zeitalter der Aufklärung* (Paderborn, 2011), pp. 111–44. **261.** J. C. D. Clark, *Thomas Paine: Britain, America, and France in the Age of Enlightenment and Revolution* (Oxford, 2018), pp. 306–7. **262.** See Georges Minois, *Censure et culture sous l'Ancien Régime* (Paris, 1995); Gregory S. Brown,

'Reconsidering the censorship of writers in eighteenth-century France: civility, state power, and the public theater in the Enlightenment', *Journal of Modern History*, 75 (2003), pp. 235–68; Raymond Birn, *Royal Censorship of Books in 18th-Century France* (Stanford, 2012); Robert Darnton, *Censors at Work: How States Shaped Literature* (London, 2014), pp. 21–86.  **263.** Brown, 'Reconsidering', pp. 249, 256.  **264.** Birn, *Royal Censorship*, p. 43.  **265.** Henri-Joseph du Laurens, *Le Balai, poëme héroï-comique en XVIII chants* ('Constantinople', 1761).  **266.** The story is told in Birn, *Royal Censorship*, pp. 28–32; Darnton, *Censors at Work*, pp. 56–9.  **267.** Quoted in Minois, *Censure*, p. 193.  **268.** OCR i. p. 584; *Confessions*, tr. Angela Scholar, ed. Patrick Coleman (Oxford, 2000), pp. 571–2.  **269.** W. H. Bruford, *Germany in the Eighteenth Century: The Social Background of the Literary Revival* (Cambridge, 1935), pp. 286–7.  **270.** Quoted in Tim Blanning, *Frederick the Great, King of Prussia* (London, 2015), p. 320.  **271.** Dieter Breuer, *Geschichte der literarischen Zensur in Deutschland* (Heidelberg, 1982), p. 96.  **272.** Joachim Whaley, *Germany and the Holy Roman Empire*, 2 vols. (Oxford, 2012), ii. p. 468.  **273.** Minois, *Censure*, pp. 182–4.  **274.** Edoardo Tortarolo, *L'invenzione della libertà di stampa: Censura e scrittori nel Settecento* (Rome, 2011), p. 153.  **275.** Ibid., p. 154.  **276.** Barbara Stollberg-Rilinger, *Maria Theresia: Die Kaiserin in ihrer Zeit* (Munich, 2017), pp. 623–7.  **277.** Israel, *Radical Enlightenment*, pp. 108–9; Stollberg-Rilinger, *Maria Theresia*, p. 624.  **278.** Joseph von Sonnenfels, 'Die erste Vorlesung in dem akademischen Jahrgange 1782', *Sonnenfels gesammelte Schriften*, 10 vols. (Vienna, 1786), viii. pp. 103–46 (pp. 112–13).  **279.** Friedrich Nicolai, *Beschreibung einer Reise durch Deutschland und die Schweiz im Jahre 1781. Nebst Bemerkungen über Gelehrsamkeit, Industrie, Religion und Sitten*, 12 vols. (Berlin and Stettin, 1783–96), iv. pp. 857–8. Cf. Norbert Bachleitner, *Die literarische Zensur in Österreich von 1751 bis 1848* (Vienna, 2017), pp. 55–6.  **280.** Nicolai, *Beschreibung*, iv. pp. 854–5.  **281.** Peter Hersche, *Der Spätjansenismus in Österreich* (Vienna, 1977), p. 233.  **282.** J. W. Nagl, Jakob Zeidler and Eduard Castle, *Deutsch-Österreichische Literaturgeschichte*, 4 vols. (Vienna, 1914–37), ii. p. 22.  **283.** Dr. Fessler's *Rückblicke auf seine siebzigjährige Pilgerschaft. Ein Nachlass* [sic] *an seine Freunde und an seine Feinde* (Breslau, 1824), p. 58.  **284.** Quoted in Bachleitner, *Die literarische Zensur*, p. 428.  **285.** See Leslie Bodi, *Tauwetter in Wien: Zur Prosa der österreichischen Aufklärung, 1781–1795*, 2nd edn (Vienna, 1995), esp. pp. 117–78.  **286.** Ernst Wangermann, *Die Waffen der Publizität: Zum Funktionswandel der politischen Literatur unter Joseph II.* (Vienna, 2004); but cf. Derek Beales, *Joseph II*, vol. ii: *Against the World, 1780–1790* (Cambridge, 2009), p. 614.  **287.** Quoted in Bachleitner, *Die literarische Zensur*, p. 72.  **288.** Kant, 'An Answer to the Question: "What is Enlightenment?"', in *Political Writings*, ed. Hans Reiss, tr. H. B. Nisbet, 2nd edn (Cambridge, 1991), p. 55.  **289.** Kant, 'On the common saying: "This may be true in theory, but it does not apply in practice"', in *Political Writings*, pp. 61–92 (p. 85).  **290.** Letter to Damilaville, 16 October 1765, OCV 113, p. 346.  **291.** Letter to Madame Denis, 15 November 1752, OCV 97, p. 236.  **292.** *Histoire du Docteur Akakia et du natif de Saint-Malo*, OCV 32c, pp. 121–41. Maupertuis came from Saint-Malo. Akakia, meaning 'guileless' but with scatological undertones, was the name adopted by an actual dynasty of physicians.  **293.** George Cheyne, *The English Malady: or, a Treatise of Nervous Diseases of All Kinds* (London, 1733), p. 60.  **294.** Ibid., p. 327.  **295.** See Brian Tunstall, *William Pitt, Earl of Chatham* (London, 1938), pp. 390–91; Isaac Kramnick, *The Rage of Edmund Burke: Portrait of an Ambivalent Conservative* (New York, 1977); Walter Jackson Bate, *Samuel Johnson* (London, 1975), pp. 371–89; Frederick A. Pottle, *James Boswell: The Earlier Years, 1740–1769* (London, 1966), pp. 20–22. On the young Goethe's frequent depression, see M. Kay Flavell, 'Goethe, Rousseau, and the "Hyp"', *Oxford German Studies*, 7 (1972–3), pp. 5–23.  **296.** For depression, see OCR i. pp. 220–22; *Confessions*, pp. 215–18.  **297.** Damrosch, *Rousseau*, p. 221.  **298.** OCD iii. p. 89; Damrosch, *Rousseau*, p. 292.  **299.** Hester Lynch Piozzi, *Anecdotes of Samuel Johnson*, ed. S. C. Roberts (Cambridge, 1932), p. 70.  **300.** On their quarrel, compare Ernest Campbell Mossner, *The Life of David Hume* (Oxford, 1954), pp. 507–32 (favourable to Hume); Raymond Trousson, *Jean-Jacques Rousseau* (Paris, 2003), pp. 625–8 (good on the many pressures Rousseau felt); Damrosch, *Rousseau*, pp. 406–33 (critical of Hume); David Edmonds and John Eidinow, *Rousseau's*

*Dog: Two Great Thinkers at War in the Age of Enlightenment* (London, 2006) (favourable to Rousseau); Robert Zaretsky and John T. Scott, *The Philosophers' Quarrel: Rousseau, Hume, and the Limits of Human Understanding* (New Haven, 2009).   301. Letter to Hugh Blair, 28 Dec. 1765, in *The Letters of David Hume*, ed. J. Y. T. Greig, 2 vols. (Oxford, 1932), i. p. 530.   302. Letter from d'Alembert to Hume, 4 Aug. 1766, *Letters of David Hume*, ii. p. 430.   303. Rousseau, letter to Hume, 10 July 1766, *Letters of David Hume*, ii. p. 391. An English translation of this enormous letter is in [David Hume], *A Concise and Genuine Account of the Dispute between Mr Hume and Mr Rousseau, translated from French* (London, 1766). See the accounts of this incident in Trousson, *Rousseau*, p. 634; Damrosch, *Rousseau*, pp. 421–2. Rousseau recounted it three times, Hume four (references in Trousson, p. 804).   304. For the text, see Maurice Cranston, *The Solitary Self: Jean-Jacques Rousseau in Exile and Adversity* (London, 1997), p. 158.   305. Hume, *Account*, p. 21.   306. Hume, *Account*, p. 34; original in *Letters of David Hume*, ii. p. 385.   307. Letter, 22 July 1766, *Letters of David Hume*, ii. p. 66.   308. Edmonds and Eidinow, *Rousseau's Dog*, p. 223.   309. See Damrosch, *Rousseau*, p. 408.   310. Hume, *A Treatise of Human Nature: A Critical Edition*, ed. David Fate Norton and Mary J. Norton (Oxford, 2007), p. 228.   311. Rousseau, letter to Victor Riquetti, marquis de Mirabeau, 25 Mar. 1767, *Correspondance complète, de Jean-Jacques Rousseau*, ed. R. A. Leigh, 52 vols. (Geneva, 1965–98) xxxii. 239.   312. *OCR* ii. 233.   313. Hume, *Treatise*, p. 172.   314. See Hume, 'Of Refinement in the Arts', *Essays*, pp. 268–80.   315. See Ronald Grimsley, *Jean-Jacques Rousseau: A Study in Self-Awareness* (Cardiff, 1961), pp. 85–97.   316. Marivaux, *La Vie de Marianne, ou les aventures de Madame la Comtesse de ***, ed. Michel Gilot (Paris, 1978), p. 66.   317. Rousseau, letter to the marquise de Créqui, summer 1752, in *Correspondance complète*, ii. p. 191.   318. Zaretsky and Scott, *The Philosophers' Quarrel*, p. 109; see letter to Hugh Blair, 28 Dec. 1765, *Letters of David Hume*, i. pp. 527–32.   319. To the Comtesse de Boufflers, 19 Jan. 1766, *Letters of David Hume*, ii. p. 2.   320. To Hugh Blair, 1 July 1766, *Letters of David Hume*, ii. p. 57.   321. Letter, 28 Dec. 1765, *Letters of David Hume*, i. p. 530.   322. Hume writes about the convulsionaries in 'Of Miracles', *An Enquiry concerning Human Understanding*, ed. Tom Beauchamp (Oxford, 2000), pp. 180–81.   323. *Letters of David Hume*, i. p. 17.   324. Hume, *Treatise of Human Nature*, p. 172.   325. See La Vopa, *Labor of the Mind*, pp. 172–3.

## 8. PRACTICAL ENLIGHTENMENT

1. Jonathan Swift, *Gulliver's Travels*, ed. Claude Rawson and Ian Higgins (Oxford, 2005), p. 124.   2. Franco Venturi, *Utopia and Reform in the Enlightenment* (Cambridge, 1971), p. 99. For a critique of Cassirer's approach, see pp. 1–3.   3. Voltaire, *La Russie sous Pierre le Grand*, in his *Œuvres historiques*, ed. René Pomeau (Paris, 1957), p. 376.   4. Edward Gibbon, *The History of the Decline and Fall of the Roman Empire*, ed. David Womersley, 3 vols. (London, 1994), i. p. 613.   5. Voltaire, *Le Siècle de Louis XIV*, in *Œuvres historiques*, p. 633.   6. Keith Tribe, *Governing Economy: The Reformation of German Economic Discourse 1750–1840* (Cambridge, 1988), p. 32; Marc Raeff, *The Well-Ordered Police State: Social and Institutional Change through Law in the Germanies and Russia, 1600–1800* (New Haven, 1983).   7. Douglas Dakin, *Turgot and the Ancien Régime in France* (London, 1939), p. 28; an even longer list in Maurice Bordes, *L'Administration provinciale et municipale en France au XVIIIᵉ siècle* (Paris, 1972), pp. 122–5.   8. Bordes, *L'Administration*, pp. 148–55.   9. Dakin, *Turgot*, pp. 60–62; Lars Behrisch, *Die Berechnung der Glückseligkeit: Statistik und Politik in Deutschland und Frankreich im späten Ancien Régime* (Ostfildern, 2016), pp. 383–92.   10. Tribe, *Governing Economy*, p. 6.   11. Johann Georg Sulzer, *Kurzer Begriff aller Wissenschaften*, 2nd edn (Leipzig, 1759), quoted in Tribe, *Governing Economy*, p. 31.   12. Montesquieu, *Persian Letters*, tr. C. J. Betts (Harmondsworth, 1973), p. 204; *OCM* i. pp. 295–314. On the depopulation controversy, see Andrea A. Rusnock, *Vital Accounts: Quantifying Health and Population in Eighteenth-Century England and France* (Cambridge, 2002), pp. 179–82.   13. David V. Glass, *Numbering the People: The*

*Eighteenth-Century Population Controversy and the Development of Census and Vital Statistics in Britain* (Farnborough, 1973), pp. 12–13. For the practical Enlightenment in Iceland, see Kirsten Hastrup, *Nature and Policy in Iceland 1400–1800* (Oxford, 1990), p. 271.  14. Glass, *Numbering the People*, pp. 19–20; Joanna Innes, *Inferior Politics: Social Problems and Social Policies in Eighteenth-Century Britain* (Oxford, 2009), pp. 138–9.  15. Fénelon, *Les Aventures de Télémaque*, ed. Jeanne-Lydie Goré (Paris, 1968), p. 276. On the importance of Fénelon's novel and its many imitators, see Wolfgang Biesterfeld, *Der Fürstenspiegel als Roman: Narrative Texte zur Ethik und Pragmatik von Herrschaft im 18. Jahrhundert* (Baltmannsweiler, 2014).  16. See Behrisch, *Berechnung*, pp. 42–56; Gerhard Lutz, 'Geographie und Statistik im 18. Jahrhundert. Zu Neugliederung und Inhalten von "Fächern" im Bereich der historischen Wissenschaften', in Mohammed Rassem and Justin Stagl, eds., *Statistik und Staatsbeschreibung in der Neuzeit* (Paderborn, 1980), pp. 249–63; Justin Stagl, *A History of Curiosity: The Theory of Travel 1550–1800* (London, 1995), pp. 88–9, 246–8.  17. John Graunt, *Natural and Political Observations, Mentioned in a following Index, and made upon the Bills of Mortality* (London, 1662), p. 44. On his work, see Rusnock, *Vital Accounts*, pp. 24–35.  18. Sir William Petty, *Political Arithmetic* (Glasgow, 1751), p. 59. See Ian Hacking, *The Taming of Chance* (Cambridge, 1990), pp. 16–33.  19. 'Arithmétique politique', *Encyclopédie*, i. pp. 678–80 (p. 678).  20. On the collection of quantitative data in England in the century after Petty, see Innes, *Inferior Politics*, pp. 109–75.  21. Johann Heinrich Gottlob von Justi, 'Vorrede', *Die Grundfeste zu der Macht und Glückseligkeit der Staaten oder ausführliche Vorstellung der gesamten Polizeiwissenschaft*, 2 vols. (Königsberg, 1760–61; repr. Aalen, 1965), i. (unpag.).  22. Johann Michael von Loen, *Der redliche Mann am Hofe* (1742; facsimile repr., Stuttgart, 1966), p. 546.  23. *Della regolata divozione de' Christiani* (extracts), in *Opere di Lodovico Antonio Muratori*, 2 vols., ed. Giorgio Falco and Fiorenzo Forti (Milan, n.d.), pp. 941–4.  24. Raeff, *Police State*, p. 84.  25. Justi, *Grundfeste*, ii. p. 415.  26. Jean-François Melon, *Essai politique sur la commerce* ([Paris], 1734), p. 113: 'la destruction des Mendiants'. The English translation omits this harsh expression: *A Political Essay upon Commerce*, tr. David Bindon (Dublin, 1738), p. 149.  27. Melon, *Essai politique*, p. 121; *Political Essay*, p. 155.  28. Raeff, *Police State*, p. 69.  29. Michel Foucault, *History of Madness*, ed. Jean Khalfa, tr. Jonathan Murphy and Jean Khalfa (London, 2006), pp. 48–50. On Foucault's exaggerated claims, see Laurence Brockliss and Colin Jones, *The Medical World of Early Modern France* (Oxford, 1997), pp. 683–4; Mary Lindemann, *Medicine and Society in Early Modern Europe* (Cambridge, 1999), p. 131.  30. Brockliss and Jones, *Medical World*, p. 681.  31. Foucault, *History of Madness*, p. 68.  32. Steffen Martus, *Aufklärung: Das deutsche 18. Jahrhundert. Ein Epochenbild* (Berlin, 2015), p. 78.  33. Michel Foucault, *Discipline and Punish*, tr. Alan Sheridan (London, 1978); Gerhard Oestreich, *Neostoicism and the Early Modern State*, tr. David McLintock (Cambridge, 1982; originally published 1969); Winfried Schulze, 'Gerhard Oestreichs Begriff "Sozialdisziplinierung in der frühen Neuzeit"', *Zeitschrift für historische Forschung*, 14 (1987), pp. 265–302; Peter Hersche, *Muße und Verschwendung: Europäische Gesellschaft und Kultur im Barockzeitalter* (Freiburg, 2006), pp. 668–74; and for the ideological resonances of this concept, Peter N. Miller, 'Nazis and Neo-Stoics: Otto Brunner and Gerhard Oestreich before and after the Second World War', *Past and Present*, 176 (Aug. 2002), pp. 144–86.  34. [Johann Michael von Loen], *Entwurf einer Staats-Kunst, Worinn die natürlichste Mittel entdecket werden, ein Land mächtig, reich und glücklich zu machen* (Frankfurt a.M., 1747), p. 20.  35. See Mary Lindemann, *Health and Healing in Eighteenth-Century Germany* (Baltimore, 1996), p. 139; Derek Beales, *Joseph II*, vol. ii: *Against the World, 1780–1790* (Cambridge, 2009), p. 325.  36. See Andre Wakefield, *The Disordered Police State: German Cameralism as Science and Practice* (Chicago, 2009), pp. 82–110.  37. Cf. Peter Burke, *Popular Culture in Early Modern Europe* (London, 1978), pp. 270–81.  38. Behrisch, *Berechnung*, p. 37.  39. See Rebekka Habermas, *Wallfahrt und Aufruhr: Zum Wunderglauben im Bayern der frühen Neuzeit* (Frankfurt a.M., 1991), p. 119.  40. See 'Oberlin, Johann Friedrich', in *Neue Deutsche Biographie*, 26 vols. (Berlin, 1953– ), xix. pp. 395–6; anon., *Memoirs of John Frederic Oberlin* (London, 1835). The portrayal of Oberlin in Georg Büchner's story *Lenz* (1836) is closely based on contemporary documents,

including Oberlin's journal.    41. 'Autobiography submitted to the Society of Arts and Sciences in Gothenburg' (1780), in *Anticipating 'The Wealth of Nations': The Selected Works of Anders Chydenius (1729–1803)*, ed. Maren Jonasson and Pertti Hyttinen, tr. Peter C. Hogg (London, 2012), pp. 331–46 (p. 334).    42. 'Memorial regarding Freedom of Religion' (1779), ibid., pp. 317–22.    43. See Lars Magnusson, 'Anders Chydenius's life and work: An introduction', in ibid., pp. 1–59 (p. 25).    44. 'Thoughts concerning the Natural Rights of Masters and Servants', ibid., pp. 281–311 (p. 298); original quoted in Carola Nordbäck, *Lycksalighetens källa: Kontextuella närläsningar av Anders Chydenius budordspredikningar, 1781–82* (Åbo, 2009), p. 367.    45. Lars Magnusson, 'Commentary', in *Anticipating*, pp. 313–16 (pp. 314–15). For short accounts of Chydenius, see Magnusson, 'Anders Chydenius's life and work', emphasizing his economic thought, and Carola Nordbäck, 'In defence of freedom: Christianity and the pursuit of human happiness in Anders Chydenius' world', in Göran Rydén, ed., *Sweden in the Eighteenth-Century World: Provincial Cosmopolitans* (Farnham, 2013), pp. 177–99.    46. Peter Clark, *British Clubs and Societies 1580–1800: The Origins of an Associational World* (Oxford, 2000), pp. 85–6.    47. See Robert E. Schofield, *The Lunar Society of Birmingham: A Social History of Provincial Science and Industry in Eighteenth-Century England* (Oxford, 1963); Jenny Uglow, *The Lunar Men: The Friends who Made the Future* (London, 2002).    48. Rudolf Vierhaus, ed., *Deutsche patriotische und gemeinnützige Gesellschaften* (Munich, 1980), gives very little evidence of societies achieving practical goals.    49. See the eloquent passage in Macaulay, *History of England*, ch. 3, in *The Works of Lord Macaulay*, 12 vols. (London, 1898), i. pp. 390–403.    50. Uglow, *Lunar Men*, p. 91.    51. Henry Grey Graham, *The Social Life of Scotland in the Eighteenth Century* (London, 1901), p. 44.    52. Hugh Trevor-Roper, 'The Scottish Enlightenment', in his *History and the Enlightenment*, ed. John Robertson (New Haven, 2010), p. 28.    53. Graham, *Social Life*, p. 40.    54. Paul Langford, *A Polite and Commercial People: England 1727–1783* (Oxford, 1989), p. 391.    55. Roy Porter, *English Society in the Eighteenth Century*, rev. edn (London, 1991), p. 191.    56. On canal-building, see Langford, *A Polite and Commercial People*, pp. 410–17; on the building of the Trent and Mersey, Uglow, *Lunar Men*, pp. 111–19.    57. Colin Jones, *The Great Nation: France from Louis XV to Napoleon* (London, 2002), p. 115.    58. Ibid., p. 354.    59. Ian Davidson, *Voltaire: A Life*, rev. edn (London, 2012), p. 245.    60. W. H. Bruford, *Germany in the Eighteenth Century: The Social Background of the Literary Revival* (Cambridge, 1935), pp. 161–5; Jeremy Black, *The British Abroad: The Grand Tour in the Eighteenth Century* (Stroud, 1992), pp. 110–21.    61. E. P. Thompson, 'Time, work-discipline and industrial capitalism', in his *Customs in Common* (London, 1991), pp. 352–403 (p. 384).    62. Quoted in Neil McKendrick, 'Josiah Wedgwood and factory discipline', *Historical Journal*, 4 (1961), pp. 30–55 (p. 34).    63. Foucault, *Discipline and Punish*, pp. 135–69.    64. Richard Yeo, *Encyclopaedic Visions: Scientific Dictionaries and Enlightenment Culture* (Cambridge, 2001), pp. 5–16; Wolfgang Bauer, 'The encyclopaedia in China', *Cahiers d'Histoire mondiale*, 9 (1966), pp. 665–91.    65. Quoted in Robin Briggs, 'The Académie Royale des Sciences and the pursuit of utility', *Past and Present*, 131 (May 1991), pp. 38–88 (p. 47).    66. See Peter Burke, *A Social History of Knowledge: From Gutenberg to Diderot* (Cambridge, 2000), p. 185; Yeo, *Encyclopaedic Visions*, pp. 25–7. Gibbon complains: 'I never can digest the alphabetical order' of d'Herbelot's *Bibliothèque Orientale*: *Decline and Fall*, iii. p. 238 n. 15.    67. Reproduced in Yeo, *Encyclopaedic Visions*, p. 138.    68. Ibid., p. 37.    69. The scheme is reproduced ibid., pp. 134–5.    70. Ibid., p. 150.    71. See 'Discours préliminaire de l'*Encyclopédie*', in *Œuvres complètes de d'Alembert*, 5 vols. (Paris, 1821), i. pp. 17–99; the chart follows immediately after the text.    72. Robert Darnton, 'Philosophers trim the tree of knowledge: the epistemological strategy of the *Encyclopédie*', in *The Great Cat Massacre and Other Episodes in French Cultural History* (London, 1984), pp. 191–213 (p. 200).    73. D'Alembert, 'Discours préliminaire', p. 49.    74. See Ronald Grimsley, *Jean d'Alembert (1717–83)* (Oxford, 1963), pp. 276–80.    75. D'Alembert, 'Discours préliminaire', p. 67.    76. 'aux expériences et à la géométrie'. On the ambiguity of 'experience' and cognate words in other languages that were acquiring the sense of 'experiment', see David Wootton, *The Invention of Science: A New History of the Scientific Revolution* (London, 2015), p. 312.    77. D'Alembert, 'Discours préliminaire', pp. 63, 68, 70.

78. Ibid., p. 75.    79. Ibid., p. 73.    80. See Jacques Proust, *Diderot et l'Encyclopédie* (Paris, 1967), pp. 22–3, 191–5; Frank A. Kafker, *The Encyclopedists as a Group: A Collective Biography of the Authors of the 'Encyclopédie'* (Oxford, 1996), pp. 38–40.    81. Listed in Robert Shackleton, 'The Enlightenment and the artisan', in his *Essays on Montesquieu and on the Enlightenment*, ed. David Gilson and Martin Smith (Oxford, 1988), p. 467.    82. Proust, *Diderot*, p. 194.    83. Robert Darnton, *The Business of Enlightenment: A Publishing History of the 'Encyclopédie' 1775–1800* (Cambridge, MA, 1979), pp. 6–7.    84. *Encyclopédie*, vi. p. 578. A cross-reference to 'Socinianism' rubs the allegation in.    85. See Catherine Maire, 'L'entrée des Lumières à l'Index: le tournant de la double censure de l'Encyclopédie en 1759', *Recherches sur Diderot et sur l'Encyclopédie*, 42 (2007), pp. 107–40.    86. Cf. Darrin M. McMahon, *Enemies of the Enlightenment: The French Counter-Enlightenment and the Making of Modernity* (New York, 2001), and Amos Hofman, 'The origins of the theory of the *philosophe* conspiracy', *French History*, 2 (1988), pp. 152–72, who trace the reaction against the *philosophes* only to the 1770s, though Hofman also places it in the framework of a longer-term campaign against Protestant heresy.    87. On the 'war over the *Encyclopédie*', see Jonathan Israel, *Democratic Enlightenment: Philosophy, Revolution, and Human Rights 1750–1790* (Oxford, 2011), pp. 56–92.    88. See Diderot, letter to Le Breton, 12 Nov. 1764, *OCD* v. pp. 851–5. Kafker says that 'he wrote in a frenzy and from insufficient evidence': *The Encyclopedists*, p. 97.    89. 'Avertissement', *Encyclopédie*, viii, p. i.    90. Cf. the criticism of the exclusive privileges of 'incorporated trades' made by Smith, *An Inquiry into the Nature and Causes of the Wealth of Nations*, ed. R. H. Campbell and A. S. Skinner (Oxford, 1976), p. 135.    91. Daniel Roche, *France in the Enlightenment*, tr. Arthur Goldhammer (Cambridge, MA, 1998), p. 575.    92. Darnton, *Business of Enlightenment*, p. 6.    93. Ibid., p. 525.    94. Jerome Blum, *The End of the Old Order in Rural Europe* (Princeton, 1978), pp. 120–25; Peter M. Jones, *Agricultural Enlightenment: Knowledge, Technology, and Nature, 1750–1840* (Oxford, 2016), pp. 92–3.    95. See E. P. Thompson, 'Custom, law and common right', in *Customs in Common*, pp. 97–184.    96. Justi, *Von denen Hinternissen einer blühenden Landwirtschaft* (1761), quoted in Hans H. Müller, 'Christopher Brown – an English farmer in Brandenburg-Prussia in the eighteenth century', *Agricultural History Review*, 17 (1969), pp. 120–35 (p. 120).    97. Jones, *Agricultural Enlightenment*, p. 29; Antonio Genovesi, *Scritti economici*, ed. Maria Luisa Perna, 2 vols. (Naples, 1984), i. pp. 143–4.    98. Jones, *Agricultural Enlightenment*, p. 122.    99. The concept of 'agricultural revolution' has been severely mauled by revisionist historians, but is cautiously rehabilitated by Mark Overton, *Agricultural Revolution in England: The Transformation of the Agrarian Economy 1500–1850* (Cambridge, 1996), with the proviso that the decisive breakthroughs took place after 1750. Cf. Jones, *Agricultural Enlightenment*, pp. 136–8.    100. Quoted in Jones, *Agricultural Enlightenment*, p. 73.    101. Young's slightly elusive achievement is summed up in G. E. Mingay, ed., *Arthur Young and his Times* (London, 1975), p. 22.    102. Jones, *Agricultural Enlightenment*, pp. 66–7; Mingay, *Arthur Young*, pp. 8–9. For Young's European reputation, see also Alison E. Martin, 'Paeans to progress: Arthur Young's travel accounts in German translation', in Stefanie Stockhorst, ed., *Cultural Transfer through Translation: The Circulation of Enlightened Thought in Europe by Means of Translation* (Amsterdam, 2010), pp. 297–313.    103. Jones, *Agricultural Enlightenment*, pp. 73–4.    104. See Müller, 'Christopher Brown'.    105. Jones, *Agricultural Enlightenment*, p. 71.    106. Arthur Young, *Travels during the Years 1787, 1788, and 1789* (Bury St Edmunds, 1792), pp. 15–16.    107. Allan Cunningham, quoted in Nigel Leask, *Robert Burns and Pastoral: Poetry and Improvement in Late Eighteenth-Century Scotland* (Oxford, 2010), p. 21. On Burns' agricultural reading, see ibid., pp. 31–4.    108. Blum, *End of the Old Order*, pp. 29–79.    109. Figures ibid., p. 35. On the diversity and complexity of peasant tenure, see Jones, *Great Nation*, pp. 153–4.    110. Jones, *Agricultural Enlightenment*, p. 148.    111. Blum, *End of the Old Order*, p. 43; cf. Lindsey Hughes, *Russia in the Age of Peter the Great* (New Haven, 1998), pp. 160–69.    112. Blum, *End of the Old Order*, p. 44.    113. Joseph von Sonnenfels, *Der Mann ohne Vorurtheil*, II/1, 1. Stück, dated from '. . . stein den 31 May 1766'. For protests in verse by Voss and others, see Eda Sagarra, 'Literature of peasant life in eighteenth-century Germany', *Modern Language Review*, 78 (1983), pp. 79–90 (pp. 81–2).    114. Johann Gottfried Seume, *Mein Leben*, in his

*Werke*, ed. Jörg Drews, 2 vols. (Frankfurt a.M., 1993), i. p. 29.  **115.** Johann Heinrich Voss, 'Die Pferdeknechte' (1775), in his *Ausgewählte Werke*, ed. Adrian Hummel (Göttingen, 1996), pp. 7–11 (p. 8).  **116.** Blum, *End of the Old Order*, pp. 221–6.  **117.** David Blackbourn, *The Conquest of Nature: Water, Landscape and the Making of Modern Germany* (London, 2006), p. 46.  **118.** Richard Herr, *The Eighteenth-Century Revolution in Spain* (Princeton, 1958), p. 116.  **119.** See T. C. Smout, *A History of the Scottish People 1560–1830* (London, 1969), pp. 351–60; T. M. Devine, *Clearance and Improvement: Land, Power and People in Scotland 1700–1900* (Edinburgh, 2006), pp. 93–112.  **120.** See the classic work by W. G. Hoskins, *The Making of the English Landscape* (London, 1955), esp. ch. 6: 'Parliamentary Enclosure and the Landscape'.  **121.** Theodor Fontane, *Wanderungen durch die Mark Brandenburg*, ed. Walter Keitel, 3 vols. (Munich, 1966–8), i. p. 574.  **122.** Blackbourn, *Conquest of Nature*, p. 42.  **123.** William Robertson, *History of America*, 2 vols. (London, 1777), i. p. 256.  **124.** Gibbon, *Decline and Fall*, i. pp. 238–9.  **125.** David Hume, 'Of the Populousness of Ancient Nations', in his *Essays Moral, Political, and Literary*, ed. Eugene F. Miller (Indianapolis, 1987), p. 451.  **126.** See Clarence J. Glacken, *Traces on the Rhodian Shore: Nature and Culture in Western Thought from Ancient Times to the End of the Eighteenth Century* (Berkeley, 1967), pp. 623–705.  **127.** Stephen Hales, *Vegetable Staticks: or, An Account of some Statical Experiments on the Sap in Vegetables* (London, 1727), p. 2. **128.** See Richard H. Grove, *Green Imperialism: Colonial Expansion, Tropical Island Edens and the Origins of Environmentalism, 1600–1860* (Cambridge, 1995).  **129.** Ibid., pp. 311, 341; John Gascoigne, *Joseph Banks and the English Enlightenment: Useful Knowledge and Polite Culture* (Cambridge, 1994), p. 205.  **130.** Lisbet Koerner, *Linnaeus: Nature and Nation* (Cambridge, MA, 1999), p. 85.  **131.** Glacken, *Traces*, pp. 659–61.  **132.** Uglow, *Lunar Men*, p. 176. On the experience of sickness in the long eighteenth century, see Roy Porter and Dorothy Porter, *In Sickness and in Health: The British Experience 1650–1850* (London, 1988), esp. ch. 6, 'The Phenomenology of Pain'.  **133.** Lindemann, *Medicine and Society*, p. 1. Such arguments help historians to approach the medical experience of past generations, and past mentalities, without presentist assumptions and with due attention to patients as well as doctors, as in Lindemann, *Health and Healing*.  **134.** Rousseau, *Émile*, p. 15; OCR iv. p. 259. Similarly in his 'Discourse on the Origin and the Foundations of Inequality among Men', in *The 'Discourses' and Other Early Political Writings*, ed. and tr. Victor Gourevitch (Cambridge, 1997), p. 135.  **135.** David Wootton, *Bad Medicine: Doctors Doing Harm since Hippocrates* (Oxford, 2006), p. 4.  **136.** Cf. Jacques Roger, *The Life Sciences in Eighteenth-Century French Thought*, tr. Robert Ellrich (Stanford, 1997), p. 138.  **137.** Lindemann, *Medicine and Society*, p. 16.  **138.** Barbara Duden, *Geschichte unter der Haut: Ein Eisenacher Arzt und seine Patientinnen um 1730* (Stuttgart, 1987), p. 98. The terms in quotation marks are those repeatedly used by Storch.  **139.** Quoted in Maria Rosa Antognazza, *Leibniz: An Intellectual Biography* (Cambridge, 2009), p. 99.  **140.** *An Essay concerning Human Understanding*, Book II, ch. 23, §12, in *The Works of John Locke*, 9 vols. (1794; repr. London, 1997), i. p. 297.  **141.** See Carlo Cipolla, *Miasmas and Disease: Public Health and the Environment in the Pre-Industrial Age*, tr. Elizabeth Potter (New Haven, 1992), pp. 5–6.  **142.** Brockliss and Jones, *Medical World*, p. 425.  **143.** See ibid., pp. 470–73; Rusnock, *Vital Accounts*, pp. 43–91; Wootton, *Bad Medicine*, pp. 137–8; Catriona Seth, *Les rois aussi en mouraient: Les Lumières en lutte contre la petite vérole* (Paris, 2008).  **144.** Voltaire, *Letters concerning the English Nation*, ed. Nicholas Cronk (Oxford, 1994), pp. 44–8; Genevieve Miller, 'Putting Lady Mary in her place: a discussion of historical causation', *Bulletin of the History of Medicine*, 55 (1981), pp. 2–16; but cf. Isobel Grundy, *Lady Mary Wortley Montagu* (Oxford, 1999), pp. 209–22.  **145.** See Seth, *Les rois*, pp. 150–60.  **146.** Kant, *Die Metaphysik der Sitten*, in *Werke*, ed. Wilhelm Weischedel, 6 vols. (Darmstadt, 1958), iv. p. 556.  **147.** Erica Charters, *Disease, War and the Imperial State: The Welfare of the British Armed Forces during the Seven Years' War* (Chicago, 2014), p. 32.  **148.** Wootton, *Bad Medicine*, pp. 144–5.  **149.** See Paul Slack, *The Impact of Plague in Tudor and Stuart England* (London, 1985), pp. 313–26.  **150.** Brockliss and Jones, *Medical World*, p. 350.  **151.** See Lindemann, *Medicine and Society*, p. 47.  **152.** Brockliss and Jones, *Medical World*, pp. 553–65. See esp. pp. 560–62 on Caesarean sections.  **153.** J. H. Jung-Stilling, *Heinrich Stillings Jugend, Jünglingsjahre*,

*Wanderschaft und häusliches Leben*, ed. Dieter Cunz (Stuttgart, 1968), pp. 326-58. Goethe recounts in *Dichtung und Wahrheit* how Jung-Stilling failed disastrously in treating a prominent Frankfurt citizen: *Sämtliche Werke: Briefe, Tagebücher und Gespräche*, ed. Friedmar Apel and others, 40 vols. (Frankfurt a.M., 1986-2000), xiv. pp. 740-42; cf. *Stillings Jugend*, pp. 343-57.   **154.** R. A. Houston, *Social Change in the Age of Enlightenment: Edinburgh, 1660-1760* (Oxford, 1994), pp. 246-8.   **155.** See Foucault, *History of Madness*, pp. 44-77; Brockliss and Jones, *Medical World*, pp. 678-88.   **156.** 'Hôtel-Dieu', *Encyclopédie*, viii. pp. 319-20.   **157.** Brockliss and Jones, *Medical World*, pp. 720-21.   **158.** T. C. Barnard, '"Grand metropolis" or "The anus of the world"? The cultural life of eighteenth-century Dublin', in Peter Clark and Raymond Gillespie, eds., *Two Capitals: London and Dublin, 1500-1840* (Oxford, 2001), p. 197.   **159.** Cipolla, *Miasmas*, p. 4.   **160.** John Howard, *An Account of the Principal Lazarettos in Europe* (Warrington, 1789), p. 77.   **161.** For detailed accounts of the Edinburgh Royal Infirmary and the Allgemeines Krankenhaus, see Guenter B. Risse, *Mending Bodies, Saving Souls: A History of Hospitals* (New York, 1999), pp. 231-88.   **162.** Howard, *Account*, p. 136.   **163.** Ibid., p. 133.   **164.** Brockliss and Jones, *Medical World*, p. 443.   **165.** R. A. Houston, *Madness and Society in Eighteenth-Century Scotland* (Oxford, 2000), p. 114; Roy Porter, *Mind-Forg'd Manacles: A History of Madness in England from the Restoration to the Regency* (London, 1987), pp. 130-34.   **166.** Porter, *Mind-Forg'd Manacles*, p. 8; Lindemann, *Medicine and Society*, p. 30.   **167.** Ida Macalpine and Richard Hunter, *George III and the Mad-Business* (London, 1969), pp. 172-5.   **168.** Timothy J. Peters and Allan Beveridge, 'The madness of King George III: a psychiatric reassessment', *History of Psychiatry*, 21 (2010), p. 24, quoted in Janice Hadlow, *The Strangest Family: The Private Lives of George III, Queen Charlotte and the Hanoverians* (London, 2014), p. 374.   **169.** For a short account, see Roy Porter, *A Social History of Madness: Stories of the Insane* (London, 1987), pp. 93-102.   **170.** Quoted in Macalpine and Hunter, *George III*, p. 275.   **171.** Anne Digby, *Madness, Morality and Medicine: A Study of the York Retreat, 1796-1914* (Cambridge, 1985), p. 6.   **172.** See Kathleen M. Grange, 'Pinel or Chiarugi?', *Medical History*, 7 (1963), pp. 371-80.   **173.** See Porter, *Mind-Forg'd Manacles*, pp. 222-8; for recovery statistics, Digby, *Madness*, pp. 226-33.   **174.** Philippe Ariès, *Centuries of Childhood*, tr. Robert Baldick (London, 1962).   **175.** Lloyd deMause, 'The evolution of childhood', in deMause, ed., *The History of Childhood* (New York, 1974), pp. 1-73. Pinker perhaps relies too heavily on deMause in Steven Pinker, *The Better Angels of our Nature: The Decline of Violence in History and its Causes* (London, 2011), pp. 428-30.   **176.** Linda Pollock, *Forgotten Children: Parent-Child Relations from 1500 to 1900* (Cambridge, 1983). For critical surveys of the historiography of childhood, see Pollock, *Forgotten Children*, pp. 1-67; 'Introduction' in Laurence Brockliss and Heather Montgomery, eds., *Childhood and Violence in the Western Tradition* (Oxford, 2010), pp. 1-18 (pp. 9-14).   **177.** Karin Calvert, *Children in the House: The Material Culture of Early Childhood, 1600-1900* (Boston, 1992), p. 21.   **178.** Buffon, *De l'homme*, ed. Michèle Duchet (Paris, 1971), p. 58.   **179.** Ibid., pp. 66-7. Cf. *Spectator*, no. 246, 12 Dec. 1711.   **180.** Robert Shackleton, *Montesquieu: A Critical Biography* (Oxford, 1961), p. 4.   **181.** This paragraph follows Jenny Uglow, *Hogarth: A Life and a World* (London, 1997), pp. 326-38.   **182.** Locke, *Some Thoughts concerning Education*, in *Works*, viii. pp. 27-34.   **183.** *Mémoires de Madame Roland*, ed. Paul de Roux (Paris, 1966), p. 209.   **184.** Quoted in Pollock, *Forgotten Children*, p. 157.   **185.** Letter to Solomon Dayrolles, 18 Oct. 1752, in *The Letters of Philip Dormer Stanhope, 4th Earl of Chesterfield*, ed. Bonamy Dobrée, 6 vols. (London, 1932), v. p. 1958.   **186.** See M. O. Grenby, 'The origin of children's literature', in M. O. Grenby and Andrea Immel, eds., *The Cambridge Companion to Children's Literature* (Cambridge, 2009), pp. 3-18.   **187.** Goethe, *Dichtung und Wahrheit*, in *Sämtliche Werke*, xiv. p. 42.   **188.** See Karl Philipp Moritz, *Anton Reiser: A Psychological Novel*, tr. Ritchie Robertson (London, 1997), pp. 18-20; Jung-Stilling, *Heinrich Stillings Jugend*, p. 70.   **189.** See J. H. Plumb, 'Commercialization and society', in Neil McKendrick, John Brewer and J. H. Plumb, *The Birth of a Consumer Society: The Commercialization of Eighteenth-Century England* (London, 1982), pp. 263-334 (pp. 272-3). See also Plumb, 'The new world of children in eighteenth-century England', *Past and Present*, 67 (May 1975), pp. 64-95 (reprinted in *The Birth of a Consumer*

Society). **190.** Plumb, 'Commercialization', p. 272. **191.** Friedrich Nicolai, *Beschreibung einer Reise durch Deutschland und die Schweiz im Jahre 1781. Nebst Bemerkungen über Gelehrsamkeit, Industrie, Religion und Sitten*, 12 vols. (Berlin and Stettin, 1783–96), v. p. 33. Cf. [Johann Friedel], *Heinrich von Walheim oder Weiberliebe und Schwärmerey*, 2 vols. (Frankfurt a.M., 1785), i. p. 7. **192.** *Dr. Fessler's Rückblicke auf seine siebzigjährige Pilgerschaft. Ein Nachlass* [sic] *an seine Freunde und an seine Feinde* (Breslau, 1824), pp. 6–7. **193.** Rudolf Dekker, *Uit de schaduw in't grote licht: Kinderen in egodocumenten van de Gouden Eeuw tot de Romantiek* (Amsterdam, 1995), p. 118. Adults still play blind man's buff in Act III of Johann Nestroy's *Das Mädl aus der Vorstadt* (1841). **194.** Locke, *Works*, viii. p. 28 (§28). **195.** Ibid., viii. p. 113 (§116). **196.** Ibid., viii. pp. 129–30 (§138). **197.** See Margaret J. M. Ezell, 'John Locke's images of childhood: early eighteenth century response to *Some Thoughts concerning Education*', *Eighteenth-Century Studies*, 17 (1983–4), pp. 139–55. **198.** For a sympathetic and accessible introduction to *Émile* and its significance, see Susan Neiman, *Why Grow Up? Subversive Thoughts for an Infantile Age*, rev. edn (London, 2016), pp. 45–79. **199.** Rousseau, *The 'Discourses'*, p. 8. **200.** Rousseau, *Émile*, p. 11; OCR iv. p. 255. **201.** Ibid., p. 13; OCR iv. p. 257. Others shared these views: Harvey Chisick, *The Limits of Reform in the Enlightenment: Attitudes toward the Education of the Lower Classes in Eighteenth-Century France* (Princeton, 1981), p. 194. **202.** Rousseau, *Émile*, p. 42; OCR iv. p. 300. Go-carts (French *paniers roulants*, German *Gängelwagen*) were little wooden containers on wheels in which a child could stand upright and move about without falling down. Kant uses this as an image of enforced immaturity in 'An Answer to the Question: "What is Enlightenment?"' (translated as 'leading-strings' in *Political Writings*, p. 54; cf. *Werke*, vi. p. 54). **203.** Rousseau, *Émile*, p. 42; OCR iv. p. 301. **204.** Ibid., p. 54; OCR iv. p. 319. **205.** Ibid., p. 56 (translation amended); OCR iv. p. 322. **206.** Ibid., p. 57; OCR iv. p. 323. **207.** Ibid., p. 53; OCR iv. p. 316. **208.** Ibid., p. 52; OCR iv. p. 315. **209.** Herodotus, *The Histories*, tr. Aubrey de Sélincourt, rev. A. R. Burn (Harmondsworth, 1972), p. 457. **210.** Maria and Richard Lovell Edgeworth, *Practical Education*, 2 vols. (London, 1798), i. p. 167. Cf. how the tutor teaches Émile about property by encouraging him to plant beans while arranging with the gardener to dig them up (pp. 62–3; OCR iv. p. 330) and Julie's methods in *La Nouvelle Héloïse*, noted by William Kessen, 'Rousseau's children', *Daedalus*, 107 (1978), pp. 155–66 (p. 160). **211.** Rousseau, *Émile*, p. 173; OCR iv. pp. 490–91. **212.** Ibid., p. 196; OCR iv. pp. 522–3. **213.** Ibid., p. 324; OCR iv. p. 697. **214.** Ibid., p. 15; OCR iv. p. 259. **215.** Ibid., p. 325; OCR iv. p. 699. **216.** Ibid., p. 306; OCR iv. p. 673. **217.** For an anthology of insults, see Gilbert Py, *Rousseau et les éducateurs: étude sur la fortune des idées pédagogiques de Jean-Jacques Rousseau en France et en Europe au XVIIIᵉ siècle* (Oxford, 1997), pp. 36–7. **218.** Py, *Rousseau*, pp. 25–6, referring to d'Alembert, *Œuvres complètes*, iv. pp. 463–4. **219.** Py, *Rousseau*, p. 25: Voltaire, letter to the marquis d'Argence, 22 Apr. 1763, OCV 110, p. 187. **220.** Mary Wollstonecraft, *A Vindication of the Rights of Woman* [and other works], ed. Janet Todd (Oxford, 1993), p. 161. Further references in Py, *Rousseau*, pp. 377–88. For more recent, incisive criticism, see Verena Ehrich-Haefeli, 'Natur und Weiblichkeit: Zur Ausarbeitung der bürgerlichen Geschlechterideologie von Rousseau bis zu Schiller', in Jürgen Söring and Peter Gasser, eds., *Rousseauismus: Naturevangelium und Literatur* (Frankfurt a.M., 1999), pp. 155–97. **221.** Quoted in Ehrich-Haefeli, 'Natur', p. 166n. **222.** Letter of 1 Jan. 1778 in *Lettres inédites de Mlle Phlipon (Mme Roland) adressées aux Demoiselles Cannet, de 1772 à 1780*, ed. Auguste Breuil, 2 vols. (Paris, 1841), ii. p. 227. **223.** Letter to Richard Edgeworth, 1769, in *Memoirs of Richard Lovell Edgeworth, Esq., begun by himself, and concluded by his daughter, Maria Edgeworth*, 2 vols., 2nd edn (London, 1821), i. p. 221. **224.** Letter from the Genevan pastor Antoine-Jacques Roustan, 19 Feb. 1761, *Correspondance complète de Jean-Jacques Rousseau*, ed. R. A. Leigh, 52 vols. (Geneva, 1965–98), viii. p. 138. **225.** Cf. the comparison between Rousseau and Pascal made by Ernst Cassirer, *The Philosophy of the Enlightenment*, tr. Fritz C. A. Koelln and James P. Pettegrove (Princeton, 1951), pp. 155–6. **226.** 'It is computed, that every ninth child born at Paris, is sent to the hospital; though it seems certain, according to the common course of human affairs, that it is not a hundredth child whose parents are altogether incapacitated to rear and educate him': Hume, 'Of the Populousness of Ancient Nations', *Essays*, p. 400. On

numbers of foundlings in Paris, London, Amsterdam and elsewhere, see Jean Delumeau, *Catholicism between Luther and Voltaire: A New View of the Counter-Reformation*, tr. Jeremy Moiser (London, 1977), pp. 221-2. **227.** Rousseau, *Confessions*, p. 333; *OCR* i. p. 357. **228.** The Paris hospice was not uniquely negligent. 'Out of 2,339 children received into London workhouses in the five years after 1750, only 168 were alive in 1755' (Porter, *English Society*, pp. 131-2). **229.** Tobias Smollett, *Travels through France and Italy*, ed. Frank Felsenstein (Oxford, 1979), p. 255. **230.** See Leo Damrosch, *Jean-Jacques Rousseau: Restless Genius* (New York, 2005), pp. 191-5. **231.** For the context, see Davidson, *Voltaire*, pp. 373-6. **232.** Guillaume-Thomas Raynal, *Histoire philosophique et politique des établissements et du commerce des Européens dans les deux Indes*, enlarged edn, 10 vols. (Geneva, 1781), v. p. 20. **233.** Py, *Rousseau*, pp. 146-8. **234.** *Memoirs of Richard Lowell Edgeworth*, i. pp. 173-4. For a detailed account of attempts at Rousseauvian education by Edgeworth and others, see Rachel Hewitt, *A Revolution of Feeling: The Decade that Forged the Modern Mind* (London, 2017), pp. 113-31. **235.** Mme d'Épinay, *Les Conversations d'Émilie*, ed. Rosena Davison (Oxford, 1996), p. 68. **236.** Daniel Mornet, *Les Origines intellectuelles de la Révolution Française* (Paris, 1933), p. 61. In early modern France, children normally learned their letters from the texts of familiar Latin prayers which they had already memorized: see Robert Darnton, 'First steps toward a history of reading', *Australian Journal of French Studies*, 51 (2014), pp. 152-77 (p. 168). **237.** 'Collèges', *Encyclopédie*, iii. pp. 634-7 (esp. p. 635). **238.** Edward Gibbon, *Memoirs of my Life*, ed. Georges A. Bonnard (London, 1966), p. 38. **239.** Diderot, 'Réfutation d'Helvétius' (1783-6), in *OCD* xi. pp. 454-653 (p. 648). **240.** 'Tagebuch Pestalozzis über die Erziehung seines Sohnes', in Johann Heinrich Pestalozzi, *Ausgewählte Werke*, ed. Otto Boldemann, 2 vols. (Berlin, 1962), i. pp. 79-92. See Käte Silber, *Pestalozzi: The Man and his Work*, revised edn (London, 1976). **241.** Johann Bernhard Basedow, 'Vorrede', in *Elementarwerk: Ein geordneter Vorrath aller nöthigen Erkenntniß zum Unterricht der Jugend*, 4 vols. (Dessau, 1774), i. pp. i-xviii (p. iv). **242.** Basedow, *Elementarwerk*, i. p. 198. **243.** For Basedow's version of the felicific calculus, see *Elementarwerk*, ii. pp. 15-18. **244.** Kant, 'Essays regarding the Philanthropinum' (1776-7), tr. Robert B. Louden, in Kant, *Anthropology, History, and Education*, ed. Günter Zöller and Robert B. Louden (Cambridge, 2007), pp. 100-104. **245.** See the sympathetic account in T. J. Reed, *Light in Germany: Scenes from an Unknown Enlightenment* (Chicago, 2015), pp. 137-41. Basedow's methods were also criticized as impractical: see the satirical novel by Johann Gottlieb Schummel, *Spitzbart: Eine komi-tragische Geschichte für unser pädagogisches Jahrhundert* [1779], ed. Eberhard Haufe (Leipzig, 1974), and the quotation from Herder in the editor's afterword (p. 240). **246.** See Chisick, *Limits of Reform*, pp. 89-94. **247.** Letter to La Chalotais, 28 Feb. 1763, *OCV* 110, p. 83. In defence of Voltaire, see Roland Mortier, 'Voltaire et le peuple', in his *Le Cœur et la Raison: Recueil d'études sur le dix-huitième siècle* (Oxford, 1990), pp. 96-9. **248.** Rousseau, *Émile*, p. 20; *OCR* iv. p. 267. **249.** Smith, *Wealth of Nations*, p. 788. **250.** Diderot, 'Plan d'une université ... ou d'une éducation publique dans toutes les sciences' (1775), *OCD* xi. pp. 745-868 (pp. 749-50). For similar views in Helvétius and Condorcet, see Antoine Lilti, *L'héritage des Lumières: Ambivalences de la modernité* (Paris, 2019), p. 275. **251.** Martin Peters, *Altes Reich und Europa: Der Historiker, Statistiker und Publizist August Ludwig (v.) Schlözer (1735-1809)* (Münster, 2003), pp. 151-6; Bärbel Kern and Horst Kern, *Madame Doctorin Schlözer: Ein Frauenleben in den Widersprüchen der Aufklärung* (Munich, 1988). **252.** See William Clark, *Academic Charisma and the Origins of the Research University* (Chicago, 2006), pp. 102-5. **253.** Schiller, letter to Körner, 6 Oct. 1787, *Schillers Werke: Nationalausgabe*, ed. Julius Petersen and others, 41 vols. (Weimar, 1943-2010), xxiv. p. 162; see Kern and Kern, *Madame*, p. 126. Cf. Schiller's long satirical poem 'Die berühmte Frau', in which a husband complains about his wife's obsession with her literary career: *Sämtliche Werke*, ed. Gerhard Fricke and Herbert G. Göpfert, 5 vols. (Munich, 1958), i. pp. 154-8. **254.** Thomas Ahnert, *Religion and the Origins of the German Enlightenment: Faith and the Reform of Learning in the Thought of Christian Thomasius* (Rochester, NY, 2006), p. 10. **255.** Ian Simpson Ross, *The Life of Adam Smith* (Oxford, 1995), p. 73. **256.** L. W. B. Brockliss, *French Higher Education in the Seventeenth and Eighteenth Centuries: A Cultural History* (Oxford, 1987), pp. 350-53.

**257.** L. W. B. Brockliss, *The University of Oxford: A History* (Oxford, 2016), p. 235. **258.** See John Gascoigne, *Cambridge in the Age of the Enlightenment* (Cambridge, 1989), pp. 270–75. **259.** T. C. W. Blanning, *Reform and Revolution in Mainz 1743–1803* (Cambridge, 1974), pp. 11–12. **260.** See James Buchan, *Capital of the Mind: How Edinburgh Changed the World* (London, 2003), p. 15. **261.** Clark, *Academic Charisma*, p. 84. **262.** Ibid., pp. 215–16. Cf. the fictional *Hafen Slawkenbergius de Nasis* ('On noses') fabricated by Sterne in *Tristram Shandy*, ed. Ian Campbell Ross, rev. edn (Oxford, 2009), pp. 196–219. **263.** Clark, *Academic Charisma*, pp. 194, 183. **264.** See Charles E. McClelland, *State, Society, and University in Germany 1700–1914* (Cambridge, 1980), pp. 131–40. Particularly valuable is the chapter 'The University: Model of the Mind' in Theodore Ziolkowski, *German Romanticism and its Institutions* (Princeton, 1990), pp. 218–308 (esp. pp. 290–94 on Berlin). **265.** See Brockliss, *The University of Oxford*, pp. 325–9, who speaks of 'English exceptionalism'. **266.** See Julius R. Ruff, *Violence in Early Modern Europe 1500–1800* (Cambridge, 2001), pp. 92–114. **267.** See Richard van Dülmen, *Theatre of Horror: Crime and Punishment in Early Modern Germany*, tr. Elisabeth Neu (Cambridge, 1990); Richard J. Evans, *Rituals of Retribution: Capital Punishment in Germany, 1600–1987* (Oxford, 1996), pp. 65–108; for France, John McManners, *Death and the Enlightenment: Changing Attitudes to Death among Christians and Unbelievers in Eighteenth-Century France* (Oxford, 1981), pp. 378–91. **268.** Ruff, *Violence*, p. 103; see also McManners, *Death*, p. 391. **269.** Pieter Spierenburg, *The Spectacle of Suffering: Executions and the Evolution of Repression: from a Preindustrial Metropolis to the European Experience* (Cambridge, 1984), pp. 57, 90. Cf. *Faust I*, ll. 4399–404, in Goethe, *Sämtliche Werke*, vii/1. p. 191. **270.** E. J. F. Barbier, *Journal historique et anecdotique du règne de Louis XV*, ed. A. de la Villegille, 2 vols. (Paris, 1847), i. pp. 290–91. **271.** Spierenburg, *Spectacle*, p. 74. **272.** Evans, *Rituals of Retribution*, p. 238. **273.** Spierenburg, *Spectacle*, pp. 69–70, 197–9. **274.** Porter, *English Society*, p. 135. **275.** Bernard Mandeville, *An Enquiry into the Causes of the Frequent Executions at Tyburn* (London, 1725), pp. 21–6. Cf. Dickens's description of the 'ribaldry, debauchery, levity, drunkenness, and flaunting vice' among the forty thousand people who watched the hanging of the murderer François Courvoisier in July 1840: quoted in Philip Collins, *Dickens and Crime* (London, 1962), p. 226; V. A. C. Gatrell, *The Hanging Tree: Execution and the English People 1770–1868* (Oxford, 1994), pp. 56–74. **276.** David D. Cooper, *The Lesson of the Scaffold: The Public Execution Controversy in Victorian England* (London, 1974), p. 20. **277.** Simon Schama, *The Embarrassment of Riches: An Interpretation of Dutch Culture in the Golden Age* (London, 1987), p. 18; on Dutch prisons generally, pp. 16–24. **278.** Ruff, *Violence*, p. 110. **279.** See John H. Langbein, *Torture and the Law of Proof: Europe and England in the Ancien Régime* (Chicago, 1977). **280.** Franco Venturi, *Settecento riformatore* (Turin, 1969), pp. 677–8. **281.** Cesare Beccaria, *On Crimes and Punishments and Other Writings*, ed. Richard Bellamy (Cambridge, 1995), p. 103. **282.** Ibid., p. 55. **283.** Kant, *Zum ewigen Frieden* (1795), in *Werke*, vi. p. 224. **284.** Beccaria, *On Crimes*, p. 74. **285.** David B. Young has argued that Beccaria was 'fundamentally a retributivist' because he thought criminals should be punished for violating the implicit social contract. But this, even if granted, does not outweigh the utilitarian emphasis of Beccaria's thought. See Young, 'Cesare Beccaria: utilitarian or retributivist?', *Journal of Criminal Justice*, 11 (1983), pp. 317–26 (p. 319). **286.** Beccaria, *On Crimes*, p. 87. **287.** Ibid., p. 70. **288.** Kant, *Die Metaphysik der Sitten*, in *Werke*, iv. p. 457. **289.** Beccaria, *On Crimes*, pp. 39–44. **290.** Ibid., p. 63. **291.** For an instance of judicial discretion wisely used to avert a riot at Paisley in 1773, see Michael Ignatieff, *A Just Measure of Pain: The Penitentiary in the Industrial Revolution, 1750–1850* (London, 1978), p. 16. **292.** See Paul P. Bernard, *The Limits of Enlightenment: Joseph II and the Law* (Urbana, IL, 1979), pp. 31–6. **293.** Ignaz Edler von Born, *Travels through the Banat of Temeswar, Transylvania, and Hungary, in the year 1770*, tr. R. E. Raspe (London, 1777), p. 11. **294.** Israel, *Democratic Enlightenment*, pp. 291–2. **295.** OCV 62, pp. 117–26. **296.** Voltaire, *La Russie sous Pierre le Grand*, in his *Œuvres historiques*, p. 413. **297.** Langbein, *Torture*, pp. 65–6. **298.** For protests against it, see Bayle, 'Grevius', *Dictionnaire historique et critique*, 4 vols. (Amsterdam, 1730), ii. 610–11; Jaucourt, 'Question ou Torture', *Encyclopédie*, xiii. pp. 703–5. **299.** Ruff, *Violence*, p. 95. **300.** Spierenburg,

*Spectacle*, p. 190; Langbein, *Torture*, pp. 61–4; Israel, *Democratic Enlightenment*, p. 295.   **301.** Smith, *The Theory of Moral Sentiments*, ed. D. D. Raphael and A. L. Macfie (Oxford, 1976), p. 165.   **302.** Smith, *Lectures on Jurisprudence*, ed. R. L. Meek, D. D. Raphael and P. G. Stein (Oxford, 1978), p. 475.   **303.** Henry Home, Lord Kames, *Historical Law-Tracts*, 2 vols. (Edinburgh, 1758), i. p. 2. For Kames' explicit disagreement with Beccaria, see Ferenc Hörcher, 'Beccaria, Voltaire, and the Scots on capital punishment: a comparative view of the legal Enlightenment', in Deidre Dawson and Pierre Morère, eds., *Scotland and France in the Enlightenment* (Lewisburg, WV, 2007), pp. 305–30 (pp. 320–21).   **304.** John Howard, *The State of the Prisons in England and Wales, with Preliminary Observations, and an Account of Some Foreign Prisons and Hospitals*, 3rd edn (Warrington, 1784), p. 17.   **305.** Michael MacDonald and Terence R. Murphy, *Sleepless Souls: Suicide in Early Modern England* (Oxford, 1990), p. 157. Voltaire says that, although they killed their child, they asked a cousin to take care of their dog and cat: 'De Caton, du suicide', O C V 39, pp. 524–5.   **306.** For Beccaria, see Howard, *State of the Prisons*, p. 15.   **307.** Robin Evans, *The Fabrication of Virtue: English Prison Architecture, 1750–1840* (Cambridge, 1982), p. 27; Ignatieff, *Just Measure*, pp. 36–7.   **308.** See the graph in Evans, *Fabrication*, p. 421.   **309.** Ignatieff, *Just Measure*, pp. 80–81.   **310.** Some of their protests are quoted ibid., pp. 91–2.   **311.** Told in Robert Hughes, *The Fatal Shore: A History of the Transportation of Convicts to Australia, 1787–1868* (London, 1987).   **312.** Ignatieff, *Just Measure*, pp. 57–67.   **313.** Bentham, letter to Brissot de Warville, 1791, quoted in Janet Semple, *Bentham's Prison: A Study of the Panopticon Penitentiary* (Oxford, 1993), p. 107.   **314.** Jonas Hanway, *Solitude in Imprisonment, with Proper Profitable Labour and a Spare Diet, the most Humane and Effectual Means of Bringing Malefactors, who have Forfeited their Lives, or are Subject to Transportation, to a Right Sense of their Condition* (London, 1776), p. 109. The encouragement of repentance had also been an argument for solitary confinement in monastery prisons: see Jean Mabillon, 'Réflexions sur les prisons des ordres religieux', in Mabillon, *Œuvres posthumes*, 3 vols. (Paris, 1724), ii. p. 328.   **315.** Evans, *Fabrication*, p. 74.   **316.** Ibid., p. 189.   **317.** On 'total institutions', see Erving Goffman, *Asylums* ([1961]; Harmondsworth, 1968).   **318.** Some examples in Evans, *Fabrication*, p. 146.   **319.** Ibid., p. 162.   **320.** Foucault, *Discipline and Punish*, pp. 6–7. See pp. 104–31 for a list of supposedly enlightened punishments proposed by reformers, but seldom put into practice. For a critique of Foucault's history of penology, see Richard F. Hamilton, *The Social Misconstruction of Reality: Validity and Verification in the Scholarly Community* (New Haven, 1996), pp. 171–96.   **321.** Charles Dickens, *American Notes* (London, 1957), p. 99; Arthur Schopenhauer, *Die Welt als Wille und Vorstellung*, ed. Julius Frauenstädt, 2 vols. (Leipzig, 1923), i. pp. 369–70.   **322.** Evans, *Fabrication*, pp. 201–2.   **323.** Ibid., p. 220.   **324.** Ibid., pp. 227–8.   **325.** On the importance of this decision, see Ignatieff, *Just Measure*, pp. 112–13.   **326.** Jeremy Bentham, *Panopticon; or, The Inspection-House: Containing the Idea of a New Principle of Construction* (London, 1791), p. 1.   **327.** Ibid., p. 113.   **328.** Ibid., p. 127.   **329.** Ibid., p. 128.

## 9. AESTHETICS

**1.** *Ancient Literary Criticism*, ed. D. A. Russell and M. Winterbottom (Oxford, 1972), pp. 94 (poetry as *mimesis*), 134 (satisfied curiosity).   **2.** Charles Batteux, *The Fine Arts Reduced to a Single Principle*, tr. and ed. James O. Young (Oxford, 2015), p. 3.   **3.** Horace, *Of the Art of Poetry*, tr. Wentworth Dillon, Earl of Roscommon (London, 1709), pp. 12, 13. Cf. *Ancient Literary Criticism*, p. 288.   **4.** John Philips, *Cyder: A Poem in Two Books* (London, 1708); James Grainger, *The Sugar-Cane: A Poem* (London, 1764); Erasmus Darwin, *The Loves of the Plants* (London, 1789). See John Chalker, *The English Georgic: A Study in the Development of a Form* (London, 1969), ch. 2. But note the mockery of georgic poetry in Boswell, *Life of Johnson*, ed. R. W. Chapman, corrected by J. D. Fleeman (London, 1970), pp. 698–700.   **5.** Ernst Cassirer, *The Philosophy of the Enlightenment*, tr. Fritz C. A. Koelln and James P. Pettegrove (Princeton, 1951), p. 297.   **6.** This sketch follows Paul O. Kristeller, 'The modern system of the arts', in his *Renaissance Thought and the Arts*, enlarged edn

(Princeton, 1990), pp. 163–227.    7. Ibid., p. 176.    8. On Capella's poem, see C. S. Lewis, *The Allegory of Love* (Oxford, 1936), pp. 78–82.    9. Kristeller, 'The modern system', pp. 190–91.    10. Batteux, *The Fine Arts*, pp. 11–12 (translation modified). Cf. Batteux, *Les Beaux-Arts réduits à un même principe*, ed. Jean-Rémy Mantion (Paris, 1989), p. 91.    11. Batteux, *The Fine Arts*, p. 19; *Les Beaux-Arts*, p. 99.    12. See Matthew Bell, *The German Tradition of Psychology in Literature and Thought, 1700–1840* (Cambridge, 2005), p. 29.    13. Hans Rudolf Schweizer, *Ästhetik als Philosophie der sinnlichen Erkenntnis: Eine Interpretation der 'Aesthetica' A. G. Baumgartens mit teilweiser Wiedergabe des lateinischen Textes und deutscher Übersetzung* (Basel, 1973), p. 106. Simon Grote, *The Emergence of Modern Aesthetic Theory: Religion and Morality in Enlightenment Germany and Scotland* (Cambridge, 2017), translates *sensitiva* as 'sensate' (p. 106 and *passim*).    14. Schweizer, *Ästhetik*, p. 114.    15. Ibid., p. 116.    16. Ibid., p. 158.    17. *L'Art Poétique*, Book I, ll. 37–8, in Nicolas Boileau-Despréaux, *Épîtres, Art Poétique, Le Lutrin*, ed. Charles-H. Bouhours (Paris, 1952), p. 82.    18. *L'Art Poétique*, Book III, l. 414, in Boileau-Despréaux, *Épîtres*, p. 108.    19. Pope, *An Essay on Criticism*, ll. 70–71, in *TE* i. pp. 246–7.    20. See Cassirer, *Philosophy*, p. 281.    21. Johnson, 'Preface to Shakespeare', *The Yale Edition of the Works of Samuel Johnson*, ed. Herman W. Liebert and others (New Haven, 1963–2010), vii. p. 61.    22. *Épître IX*, ll. 43–6, in Boileau-Despréaux, *Épîtres*, p. 48.    23. Batteux, *The Fine Arts*, p. 13.    24. Schiller, 'Über Bürgers Gedichte', *Sämtliche Werke*, ed. Gerhard Fricke and Herbert G. Göpfert, 5 vols. (Munich, 1958), v. p. 979.    25. Pope, *Essay on Criticism*, ll. 88–9, in *TE* i. p. 249.    26. *Discourses on Art*, in *The Works of Sir Joshua Reynolds*, 2 vols. (London, 1797), i. p. 38.    27. See René Bray, *La Formation de la doctrine classique en France* (Paris, 1951), p. 113; Voltaire, 'Essai sur la poésie épique', in *OCV* 3B, pp. 419–20.    28. *The Prose Works of Alexander Pope*, ed. Norman Ault (Oxford, 1936), p. 115.    29. Voltaire, *Letters concerning the English Nation*, ed. Nicholas Cronk (Oxford, 1994), p. 87. But cf. his more nuanced judgement in 1733: *OCV* 3B, pp. 418–19.    30. Hume, *The History of England from the Invasion of Julius Caesar to the Revolution in 1688*, 6 vols. (1778; repr. Indianapolis, 1983), v. p. 151. Contrast the defence by Johnson, 'Preface to Shakespeare', *Yale Edition*, vii. pp. 68–9.    31. To his son, 1 April O.S. 1748, *The Letters of Philip Dormer Stanhope, 4th Earl of Chesterfield*, ed. Bonamy Dobrée, 6 vols. (London, 1932), iii. pp. 1130–31.    32. See Alastair Fowler, *Kinds of Literature: An Introduction to the Theory of Genres and Modes* (Oxford, 1982).    33. See Thora Burnley Jones and Bernard de Bear Nicol, *Neo-Classical Dramatic Criticism 1560–1770* (Cambridge, 1976), pp. 29–31.    34. Johnson, 'Preface to Shakespeare', p. 77.    35. Boileau-Despréaux, *Art Poétique*, Book III, l. 391, in *Épîtres*, p. 108.    36. Cassirer, *Philosophy*, p. 294.    37. Bray, *Formation*, p. 202.    38. Ibid., p. 200.    39. See Jones and Nicol, *Neo-Classical Dramatic Criticism*, p. 56.    40. James Thomson, *The Tragedy of Sophonisba* (London, 1730), p. 29; James Sambrook, *James Thomson 1700–1748: A Life* (Oxford, 1991), p. 92; Henry Fielding, 'The Tragedy of Tragedies' (1731), in *Plays*, ed. Thomas Lockwood, 3 vols. (Oxford, 2004–11), i. p. 568.    41. Lessing, *Werke und Briefe*, ed. Wilfried Barner and others, 12 vols. (Frankfurt a.M., 1987–98), iii. p. 756. Cf. H. B. Nisbet, *Gotthold Ephraim Lessing: His Life, Works and Thought* (Oxford, 2013), p. 211, who thinks Lessing was using Thomson as a stick to beat French neoclassicism.    42. On Winckelmann's management of his career, see Katherine Harloe, *Winckelmann and the Invention of Antiquity: History and Aesthetics in the Age of 'Altertumswissenschaft'* (Oxford, 2013).    43. Martin Fontius, *Winckelmann und die französische Aufklärung* (Berlin, 1968), p. 7. For Winckelmann's biography, see Alex Potts, 'Introduction', in Johann Joachim Winckelmann, *History of the Art of Antiquity*, tr. Harry Francis Mallgrave (Los Angeles, 2006), pp. 1–53.    44. Johann Winckelmann, *Sämtliche Werke*, ed. Josef Eiselein, 12 vols. ([1825]; Osnabrück, 1965), i. pp. 30–31. Emphasis in the original.    45. Winckelmann, *Werke*, i. p. 8.    46. Quoted in David Constantine, *Early Greek Travellers and the Hellenic Ideal* (Cambridge, 1984), p. 114.    47. J. W. Goethe, *Italian Journey*, tr. W. H. Auden and Elizabeth Mayer (Harmondsworth, 1970), p. 218; *Sämtliche Werke: Briefe, Tagebücher und Gespräche*, ed. Friedmar Apel and others, 40 vols. (Frankfurt a.M., 1986–2000), xv/1. pp. 236–7.    48. Quoted in Hugh Honour, *Neo-classicism* (Harmondsworth, 1968), p. 21.    49. Ibid., p. 37.    50. See Simon Schama, *Citizens: A Chronicle of the French*

*Revolution* (London, 1989), pp. 172–4.   51. Jean Racine, preface to *Iphigénie*, in his *Œuvres complètes*, ed. Georges Forestier (Paris, 1999), p. 699.   52. Quoted in Michael Moriarty, *Taste and Ideology in Seventeenth-Century France* (Cambridge, 1988), p. 109.   53. Turgot, 'Tableau philosophique des progrès successifs de l'esprit humain', *Œuvres de Turgot et documents le concernant*, ed. Gustav Schelle, 5 vols. (Paris, 1913), i. pp. 214–35 (p. 223).   54. 'Goût', *Encyclopédie*, vii. p. 761.   55. Addison, *Spectator*, no. 409, 19 June 1712.   56. Steele, *Spectator*, no. 208, 29 Oct. 1711.   57. Shaftesbury, *Characteristics of Men, Manners, Opinions, Times*, ed. Lawrence E. Klein (Cambridge, 1999), p. 154; he denounces the love of 'tales' at some length, pp. 155–8.   58. Quoted in Moriarty, *Taste and Ideology*, p. 15.   59. Pope, *The Dunciad*, in *TE* v. p. 365.   60. Quoted in Moriarty, *Taste and Ideology*, p. 175.   61. Ibid., pp. 180–81.   62. Hume, 'Of the Standard of Taste', in his *Essays Moral, Political, and Literary*, ed. Eugene F. Miller (Indianapolis, 1987), pp. 226–49 (p. 230). Cf. Cassirer, *Philosophy*, p. 307.   63. Hume, 'Of the Standard of Taste', p. 243.   64. Ibid., p. 242.   65. Ibid., pp. 230–31.   66. Letter to William Strahan, 25 May 1757, *The Letters of David Hume*, ed. J. Y. T. Greig, 2 vols. (Oxford, 1932), i. p. 252. For Hume's assessment of Milton, see *History of England*, vi. pp. 150–51.   67. See William Wilkie, *The Epigoniad* (Edinburgh, 1757); James Buchan, *Capital of the Mind: How Edinburgh Changed the World* (London, 2003), pp. 114–15.   68. 'Essay on Epic Poetry', *OCV* 3B, pp. 315–16.   69. *OCV* 7, pp. 164–76; Eugène Bouvy, *Voltaire et l'Italie* (Paris, 1898), pp. 97–129.   70. *OCV* 3B, pp. 310, 312.   71. See Raymond Naves, *Le Goût de Voltaire* (Paris, 1938), p. 145.   72. *OCV* 7, p. 181.   73. Voltaire, 'Goût', *Encyclopédie*, vii. p. 761.   74. *Critique of the Power of Judgment*, tr. Paul Guyer, ed. Paul Guyer and Eric Matthews, The Cambridge Edition of the Works of Immanuel Kant (Cambridge, 2000), p. 97; Kant, *Werke*, ed. Wilhelm Weischedel, 6 vols. (Darmstadt, 1958), v. p. 289.   75. Kant, *Critique of the Power of Judgment*, p. 96; *Werke*, v. p. 288.   76. See e.g. Paul Guyer, 'Pleasure and society in Kant's theory of taste', in Ted Cohen and Paul Guyer, eds., *Essays in Kant's Aesthetics* (Chicago, 1982), pp. 21–54 (pp. 21–2).   77. David Summers, 'Why did Kant call taste a "common sense"?', in Paul Mattick, Jr, ed., *Eighteenth-Century Aesthetics and the Reconstruction of Art* (Cambridge, 1993), pp. 120–51 (p. 122). See also E. D. Hirsch, 'Evaluation as knowledge', in his *The Aims of Interpretation* (Chicago, 1976), pp. 95–109.   78. Summers, 'Why did Kant', p. 124.   79. Ibid., p. 136.   80. See T. J. Reed, 'Kant and his German literary culture: coincidences and consequences', *British Journal of Aesthetics*, 50 (2010), pp. 343–56.   81. Quoted in David Freedberg, *The Power of Images: Studies in the History and Theory of Response* (Chicago, 1989), p. 345.   82. Quoted in Peter-André Alt, *Schiller: Leben – Werk – Zeit. Eine Biographie*, 2 vols. (Munich, 2000), i. p. 282.   83. Pope, *Essay on Criticism*, ll. 152, 155, in *TE* i. pp. 257–8.   84. Bray, *Formation*, p. 89.   85. Shaftesbury, *Soliloquy, or Advice to an Author*, in his *Characteristics*, p. 93.   86. *Protagoras*, in *The Dialogues of Plato*, tr. B. Jowett, 4 vols., 4th edn (Oxford, 1953), i. pp. 146–7.   87. Shaftesbury, *Characteristics*, p. 93.   88. Thomas Rymer, *A Short View of Tragedy* (London, 1693), p. 89.   89. *Spectator*, nos. 303 (16 Feb. 1712), 309 (23 Feb. 1712), 315 (1 Mar. 1712).   90. Samuel Johnson, *The Lives of the most Eminent English Poets; with Critical Observations on their Works*, ed. Roger Lonsdale, 4 vols. (Oxford, 2006), iii. p. 36. Cf. Leopold Damrosch, Jr, 'The significance of Addison's criticism', *Studies in English Literature*, 19 (1979), pp. 421–30.   91. *Spectator*, no. 412 (23 June 1712).   92. Ibid.   93. *OCD* ii. p. 549. See Yvon Belaval, *L'Esthétique sans paradoxe de Diderot* (Paris, 1950), pp. 150–59.   94. Batteux, *The Fine Arts*, pp. 5–6.   95. *OCD* xi. p. 605.   96. 'Génie', *Encyclopédie*, vii. p. 582.   97. Ibid.   98. Ibid.   99. *Hamburgische Dramaturgie*, §34, in Lessing, *Werke und Briefe*, vi. p. 348.   100. See Nisbet, *Lessing*, p. 262.   101. *Hamburgische Dramaturgie*, §79, in Lessing, *Werke und Briefe*, vi. p. 577.   102. *Paradise Lost*, i. l. 16; Johnson, *Lives of the Poets*, iv. p. 10.   103. Edward Young, *Conjectures on Original Composition* (London, 1759), p. 9.   104. Ibid., pp. 12, 10.   105. Ibid., p. 51.   106. Ibid., pp. 53–4.   107. Schiller, *Sämtliche Werke*, v. pp. 714–15.   108. Ibid., v. p. 738.   109. Young, *Conjectures*, p. 78.   110. 'L'Allegro', in *The Poems of John Milton*, ed. John Carey and Alastair Fowler (London, 1968), p. 138. See Jonathan Bate, 'Shakespeare and original genius', in Penelope Murray, ed., *Genius: The History of an Idea* (Oxford, 1989), pp. 76–97.   111. Quoted in Roger Paulin, *The Critical Reception of*

*Shakespeare in Germany 1682–1914: Native Literature and Foreign Genius* (Hildesheim, 2003), p. 105.   **112.** Lessing, *Werke und Briefe*, iv. p. 499.   **113.** Ibid., iv. p. 500.   **114.** Ibid., iv. p. 501.   **115.** Herder, 'Shakespear', in his *Werke*, ed. Günter Arnold and others, 10 vols. (Frankfurt a.M., 1985–2000), ii. p. 509.   **116.** Goethe, 'Zum Shakespears Tag', *Sämtliche Werke*, xviii. p. 11. The speech was delivered on 14 October, the name-day for people christened William.   **117.** Ibid., xviii. p. 10.   **118.** See G. H. Needler, *Goethe and Scott* (Toronto, 1950).   **119.** See M. H. Abrams, *The Mirror and the Lamp: Romantic Theory and the Critical Tradition* (New York, 1953), esp. pp. 283–4.   **120.** See 'Romantic Genius', in Darrin M. McMahon, *Divine Fury: A History of Genius* (New York, 2013), pp. 113–49.   **121.** 'All Religions are One', in Blake, *Complete Writings*, ed. Geoffrey Keynes (London, 1976), p. 98.   **122.** 'A Defence of Poetry', in *Shelley's Poetry and Prose*, ed. Donald H. Reiman and Neil Fraistat (New York, 2002), pp. 509–35 (p. 513).   **123.** 'Kubla Khan', in Coleridge, *Poetical Works*, ed. Ernest Hartley Coleridge (Oxford, 1912), p. 298.   **124.** See *E. T. A. Hoffmann's Musical Writings*, tr. Martyn Clarke, ed. David Charlton (Cambridge, 1989).   **125.** Letter to Richard Woodhouse, 27 Oct. 1818, in *The Letters of John Keats*, ed. Maurice Buxton Forman, 3rd edn (London, 1947), p. 228.   **126.** Johnson, 'Preface to Shakespeare', *Yale Edition*, vii. p. 71.   **127.** *Discours sur la poésie dramatique*, in OCD iii. p. 414.   **128.** OCD iii. p. 417.   **129.** See Roland Mortier, *Diderot en Allemagne (1750–1850)* (Paris, 1954), pp. 57–64; Romira Worvill, 'Lessing and the French Enlightenment', in Ritchie Robertson, ed., *Lessing and the German Enlightenment* (Oxford, 2013), pp. 15–37 (pp. 31–7).   **130.** Lessing, *Werke und Briefe*, iii. p. 671. Emphasis in original.   **131.** Goethe, *Sämtliche Werke*, ix. pp. 386 (national theatre), 412 (mercenary actors), 721 (operas).   **132.** See W. H. Bruford, *Theatre, Drama and Audience in Goethe's Germany* (London, 1950), pp. 288–319.   **133.** 'Lettre à d'Alembert', OCR v. pp. 1–125 (p. 23). The story of this tyrant, Alexander of Pherae, comes from Plutarch's *Life of Pelopidas*; Rousseau probably found it quoted by Montaigne in 'On Cowardice, the mother of cruelty': see *The Complete Essays*, tr. M. A. Screech (London, 2003), p. 786.   **134.** OCR v. p. 32.   **135.** See Jonas Barish, *The Antitheatrical Prejudice* (Berkeley, 1981), esp. pp. 256–94 (on Rousseau) and 299–307 (on Austen).   **136.** *Ancient Literary Criticism*, p. 90.   **137.** *The Republic*, Book X, §598, in *Dialogues of Plato*, ii. p. 472.   **138.** Plotinus, *The Enneads*, tr. Stephen MacKenna, ed. John Dillon (London, 1991), p. 48.   **139.** Ibid., p. 49.   **140.** Shaftesbury, *Characteristics*, pp. 323–4.   **141.** On conceptions of imitation, see Abrams, *The Mirror and the Lamp*, pp. 30–46.   **142.** Anthony Blunt, *Artistic Theory in Italy 1450–1600* (Oxford, 1940), p. 143.   **143.** Discourse Three, in *Works of Reynolds*, i. pp. 39–40.   **144.** Ibid., i. p. 40.   **145.** Ibid.   **146.** Johnson, *Rasselas*, in *Yale Edition*, xvi. p. 43.   **147.** Johnson, 'Preface to Shakespeare', *Yale Edition*, vii. p. 62.   **148.** Johnson, 'Thomson', *Lives of the Poets*, iv. p. 104; *Yale Edition*, vii. p. 523; see Abrams, *The Mirror and the Lamp*, p. 40.   **149.** *Ancient Literary Criticism*, p. 289.   **150.** See Bray, *Formation*, p. 141; Abrams, *The Mirror and the Lamp*, pp. 13, 33.   **151.** J. M. Bernstein, ed., *Classic and Romantic German Aesthetics* (Cambridge, 2003), p. 28; Lessing, *Werke und Briefe*, v/2. p. 17.   **152.** Lessing, *Werke und Briefe*, v/2. p. 33.   **153.** See David Wellbery, *Lessing's 'Laocoon': Semiotics and Aesthetics in the Age of Reason* (Cambridge, 1984); Avi Lifschitz, 'Naturalizing the arbitrary: Lessing's *Laocoon* and Enlightenment semiotics', in Avi Lifschitz and Michael Squire, eds., *Rethinking Lessing's 'Laocoon': Antiquity, Enlightenment, and the 'Limits' of Painting and Poetry* (Oxford, 2017), pp. 197–219.   **154.** Lessing, *Werke und Briefe*, v/2. pp. 125–6.   **155.** W. J. T. Mitchell, *Iconology: Image, Text, Ideology* (Chicago, 1986), p. 112. On the history and psychology of iconoclasm, see Freedberg, *The Power of Images*.   **156.** Lessing, *Werke und Briefe*, v/2. p. 84.   **157.** *Ancient Literary Criticism*, p. 103.   **158.** These distinctions and examples come from Castelvetro: Bray, *Formation*, p. 195.   **159.** The example is from Racine, preface to *Iphigénie*, in his *Œuvres complètes*, ed. Georges Forestier (Paris, 1999), p. 698. On similar grounds, Johnson defends Lear's division of his kingdom: *Yale Edition*, viii. p. 703.   **160.** 'An Essay upon the New Species of Writing founded by Mr Fielding', in Ioan Williams, ed., *Novel and Romance 1700–1800: A Documentary Record* (London, 1970), p. 152.   **161.** Samuel Richardson, *Clarissa, or the History of a Young Lady*, ed. Angus Ross (London, 1985), p. 1363; Ian Watt, *The Rise of the Novel: Studies in Defoe, Richardson and Fielding* (London, 1957),

pp. 24–5.   162. Richardson, 'Postscript', *Clarissa*, p. 1499.   163. Cf. the distinction between 'realism of content' and 'realism of presentation' in C. S. Lewis, *An Experiment in Criticism* (Cambridge, 1961), pp. 57–67.   164. Daniel Defoe, *Robinson Crusoe*, ed. Angus Ross (Harmondsworth, 1965), pp. 80, 163, 295. See Rüdiger Campe, *Spiel der Wahrscheinlichkeit: Literatur und Berechnung zwischen Pascal und Kleist* (Göttingen, 2002), ch. 7.   165. Defoe, *Robinson Crusoe*, p. 269.   166. Jean-Baptiste Dubos, *Critical Reflections on Poetry, Painting and Music*, tr. Thomas Nugent, 3 vols. (London, 1748), i. p. 155.   167. Ibid., i. p. 156.   168. Letter to Friedrich ('Maler') Müller, 21 June 1781, in Goethe, *Sämtliche Werke*, xxix. p. 352. See W. D. Robson-Scott, *The Younger Goethe and the Visual Arts* (Cambridge, 1981), pp. 96–7.   169. *Œuvres complètes de d'Alembert*, 5 vols. (Paris, 1821), i. p. 38. 170. Quoted in Abrams, *The Mirror and the Lamp*, p. 87.   171. 'Zeichensprache des Körpers': Herder, 'Über die neuere deutsche Literatur, III', in *Werke*, i. p. 402.   172. 'Discours préliminaire de l'*Encyclopédie*', in *Œuvres complètes de d'Alembert*, i. p. 39. 173. 'Imitation', *Dictionnaire de musique*, OCR v. pp. 860–61.   174. See Malcolm Budd, *Music and the Emotions: The Philosophical Theories* (London, 1985), pp. 121–4.   175. Kant, *Critique of the Power of Judgment*, pp. 206, 205.   176. Arthur Schopenhauer, *Die Welt als Wille und Vorstellung*, Book I, §52, in his *Sämmtliche Werke*, ed. Julius Frauenstädt, 6 vols. (Leipzig, 1923), ii. p. 304.   177. See e.g. George Steiner, *The Death of Tragedy* (London, 1961), p. 125.   178. Maynard Mack, *'King Lear' in our Time* (Berkeley, 1965), invokes Auschwitz and Hiroshima (pp. 25, 84).   179. Hume, 'Of Tragedy', *Essays*, p. 216. See Earl R. Wasserman, 'The pleasures of tragedy', *ELH*, 14 (1947), pp. 283–307.   180. Thomas Rymer, *The Tragedies of the last Age Consider'd and Examin'd* (London, 1678), p. 26. 181. Johnson, 'Preface to Shakespeare', *Yale Edition*, vii. p. 71.   182. Nahum Tate, *The History of King Lear* (London, 1681), p. 67. See Mack, *'King Lear'*, pp. 9–13.   183. Johnson, Notes on Shakespeare's Plays, *Yale Edition*, viii. p. 704.   184. Addison, *Spectator*, no. 40, 16 April 1711.   185. *Poetics*, in *Ancient Literary Criticism*, p. 94.   186. Addison, *Spectator*, no. 418, 30 June 1712.   187. Hume, 'Of Tragedy', *Essays*, p. 222.   188. Edmund Burke, *A Philosophical Enquiry into the Origin of our Ideas of the Sublime and Beautiful*, ed. Adam Phillips (Oxford, 1990), p. 43.   189. Johnson, Notes on Shakespeare's Plays, *Yale Edition*, viii. p. 703.   190. Hume, 'Of Tragedy', *Essays*, p. 224.   191. Schiller, 'Über das Pathetische' (1793), *Sämtliche Werke*, v. p. 512.   192. Dubos, *Critical Reflections*, i. p. 22.   193. 'De la poésie dramatique' (1758), OCD iii. p. 417.   194. Addison, *Spectator*, no. 418, 30 June 1712.   195. Lucretius, *On the Nature of the Universe*, tr. R. E. Latham (Harmondsworth, 1951), p. 60 (opening of Book II); on the popularity of this passage, see Wasserman, 'Pleasures of tragedy', p. 293.   196. OCD iii. p. 141; cf. Addison, *Spectator*, no. 40, 16 April 1711.   197. Leopold Damrosch, Jr, *Samuel Johnson and the Tragic Sense* (Princeton, 1973), p. 34.   198. Lessing, *Hamburgische Dramaturgie*, §75, 19 Jan. 1768, *Werke und Briefe*, vi. pp. 556–7.   199. Lessing, *Werke und Briefe*, iii. p. 670.   200. Friedrich Nietzsche, *Der Antichrist*, §7, in his *Werke*, ed. Karl Schlechta, 3 vols. (Munich, 1956), ii. p. 1169. 201. Hume, 'Of the Protestant Succession', *Essays*, pp. 502–11 (p. 504).   202. Lessing, *Hamburgische Dramaturgie*, §14, 16 June 1767, *Werke und Briefe*, vi. p. 251.   203. *The London Merchant*, II, ii, in *The Dramatic Works of George Lillo*, ed. James L. Steffensen (Oxford, 1993), p. 168.   204. Terry Eagleton, *Sweet Violence: The Idea of the Tragic* (Oxford, 2003), p. 95.   205. Lessing, *Werke und Briefe*, iii. p. 696. Cf. Lessing's critique of Christian tragedy in *Hamburgische Dramaturgie*, §1–2, 1 and 5 May 1767, *Werke und Briefe*, vi. pp. 187–96.   206. 'Observations on the Feeling of the Beautiful and Sublime', tr. Paul Guyer, in *Anthropology, History, and Education*, ed. Günter Zöller and Robert B. Louden, The Cambridge Edition of the Works of Immanuel Kant (Cambridge, 2007), p. 30.   207. Ibid., p. 27.   208. Ibid.   209. Richardson, 'Postscript', *Clarissa*, p. 1495, quoting Addison on poetical justice.   210. *Iliad*, xiii. ll. 18–20; *Ancient Literary Criticism*, p. 470.   211. *Spectator*, no. 412, 23 June 1712.   212. See Erwin Panofsky, *Meaning in the Visual Arts* ([1955]; Harmondsworth, 1970), p. 96.   213. Burke, *Philosophical Enquiry*, p. 41.   214. Ibid., p. 106.   215. Ibid., p. 36.   216. Ibid., pp. 67, 123.   217. Ibid., p. 71. 218. Ibid., p. 57.   219. Ibid., p. 122.   220. Ibid., p. 123.   221. Samuel H. Monk, *The Sublime: A Study of Critical Theories in XVIII-Century England* (New York, 1935), p. 96. Kant

praised Burke's physiological insight, *Werke*, v. pp. 368–9; but the Romantics, two generations later, mocked it for shallow materialism: see Carsten Zelle, *'Angenehmes Grauen': Literaturhistorische Beiträge zur Ästhetik des Schrecklichen im achtzehnten Jahrhundert* (Hamburg, 1987), pp. 193–4. **222.** *Critique of the Power of Judgment*, p. 129; 'gräßlich', *Werke*, v. p. 330. **223.** *Critique of the Power of Judgment*, pp. 144–5. **224.** Mary Wollstonecraft, *Letters written in Sweden, Norway, and Denmark*, ed. Tone Brekke and Jon Mee (Oxford, 2009), p. 89. Cf. Goethe, *Briefe aus der Schweiz*, 'Zweite Abteilung' (1780), in *Sämtliche Werke*, xvi. p. 33; Jefferson on the 'sublime' Natural Bridge in Virginia, in *Writings*, ed. Merrill D. Peterson (New York, 1984), p. 148, and the comments by Garry Wills, *Inventing America: Jefferson's Declaration of Independence* (New York, 1978), p. 265. **225.** Kant, *Critique of the Power of Judgment*, p. 146. **226.** William Wordsworth, *The Poetical Works of Wordsworth*, ed. Thomas Hutchinson, rev. Ernest de Selincourt (London, 1936), pp. 385–6. **227.** Ibid., pp. 377, 149. **228.** 'Elegiac Stanzas Suggested by a Picture of Peele Castle in a Storm, Painted by Sir George Beaumont', *Poetical Works*, p. 453.

## 10. THE SCIENCE OF SOCIETY

**1.** David Wootton, *The Invention of Science: A New History of the Scientific Revolution* (London, 2015), p. 441. **2.** For this view, see John Millar, *An Historical View of the English Government* (1787), ed. Mark Salber Phillips and Dale R. Smith (Indianapolis, 2006), p. 404n.; quoted and discussed in Christopher J. Berry, *The Idea of Commercial Society in the Scottish Enlightenment* (Edinburgh, 2013), pp. 17, 21. **3.** Locke, *Two Treatises of Government*, II. x. §133, in *The Works of John Locke*, 9 vols. (1794; repr. London, 1997), iv. p. 416; cited in the *Oxford English Dictionary* s.v. 'commonwealth' 2. **4.** Anna Bryson, *From Courtesy to Civility: Changing Codes of Conduct in Early Modern England* (Oxford, 1998), p. 55; citations from *OED* s.v. 'society' 6a, 7a. **5.** Locke, *Two Treatises of Government*, II. ix. §123, in *Works*, iv. p. 412. On Locke's key position in the history of the word 'society', see John Bossy, 'Some elementary forms of Durkheim', *Past and Present*, 95 (May 1982), pp. 3–18 (pp. 14–15). **6.** Daniel Gordon, *Citizens without Sovereignty: Equality and Sociability in French Thought, 1670–1789* (Princeton, 1994), pp. 51–2. **7.** Alan Ryan, *On Politics: A History of Political Thought from Herodotus to the Present* (London, 2012), p. 519. **8.** Montesquieu, *The Spirit of the Laws*, ed. and tr. Anne M. Cohler, Basia C. Miller and Harold S. Stone (Cambridge, 1989), p. 310 (XIX, 4). Roman and arabic numerals refer to the books and chapters into which all editions of Montesquieu's text are divided. **9.** Montesquieu, *Spirit*, pp. 6–7 (I, 2). For a fuller list, drawn from elsewhere in the book, see Robert Shackleton, *Montesquieu: A Critical Biography* (Oxford, 1961), p. 250. **10.** On the originality of Montesquieu's classification, see Shackleton, *Montesquieu*, pp. 266–7. **11.** Montesquieu, *Spirit*, p. 124 (VIII, 16). **12.** See Judith Shklar, *Montesquieu* (Oxford, 1987), pp. 120–24. **13.** Montesquieu, *Spirit*, p. 116 (VIII, 5). **14.** Ibid., p. 99 (VII, 4). **15.** Ibid., p. 27 (III, 7). **16.** See Shackleton, *Montesquieu*, pp. 286, 298. **17.** Montesquieu, *Spirit*, p. 185 (XI, 19). **18.** Montesquieu, *Spirit*, p. 160 (XI, 6). **19.** Shackleton, *Montesquieu*, p. 292. **20.** See Montesquieu, *Considérations sur les causes de la grandeur des Romains et de leur décadence*, in OCM ii. p. 187; Machiavelli, *The Discourses of Niccolò Machiavelli*, tr. Leslie J. Walker (London, 1950), pp. 218–19 (I, 4); Quentin Skinner, *The Foundations of Modern Political Thought*, 2 vols. (Cambridge, 1978), i. p. 181. **21.** Montesquieu, *Spirit*, p. 92 (VI, 17); OCM i. pp. 1475–6; Shklar, *Montesquieu*, p. 90. **22.** Montesquieu, *Spirit*, p. 338 (XX, 1). 'Mores' translates the difficult word *mœurs*, which comprehends manners, customs and morals. **23.** Ibid., p. 343 (XX, 7). **24.** Ibid., p. 389 (XXI, 20). **25.** See ibid., pp. 231–84 (XIV–XVII). **26.** The great source of European knowledge of China, Jean-Baptiste du Halde's *Description géographique, historique, chronologique, politique et physique de l'empire de la Chine et de la Tartarie chinoise* (1734), is very vague about the mountains in Tibet: see du Halde, *The General History of China*, 4 vols. (London, 1736), iv. p. 163. Their height could not be known until it was calculated by European surveyors using trigonometry in the nineteenth century: see Matthew H. Edney, *Mapping an Empire:*

*The Geographical Construction of British India, 1765–1843* (Chicago, 1997), pp. 262–6; Catherine Moorehead, *The K2 Man (and his Molluscs): The Extraordinary Life of Haversham Godwin-Austen* (Glasgow, 2013). Sir John Chardin, who travelled as far as Bengal, says: 'It is in Persia that there are the highest Mountains in the Universe', specifying Ararat (16,854 ft) and Damavand (18,403 ft): *Travels in Persia*, 2 vols. (London, 1720), ii. p. 9. William Robertson thought the highest point in the Old World was the Peak of Tenerife, at 12,198 ft: *History of America*, 2 vols. (London, 1777), i. p. 249.   **27.** Montesquieu, *Spirit*, p. 435 (XXIII, 13).   **28.** Ibid., pp. 233 (XIV, 2, the sheep's tongue), 236 (XIV, 5, enervation).   **29.** Ibid., pp. 237–8 (XIV, 8).   **30.** See Shklar, *Montesquieu*, p. 98.   **31.** See Shackleton, *Montesquieu*, pp. 302–9; Clarence J. Glacken, *Traces on the Rhodian Shore: Nature and Culture in Western Thought from Ancient Times to the End of the Eighteenth Century* (Berkeley, 1967), pp. 553–81; Gonthier-Louis Fink, 'De Bouhours à Herder. La théorie française des climats et sa réception outre-Rhin', *Recherches germaniques*, 15 (1985), pp. 3–62.   **32.** Jean-Baptiste Dubos, *Réflexions critiques sur la poésie et sur la peinture*, rev. edn, 3 vols. (Paris, 1733), ii. p. 177.   **33.** Hume, 'Of National Characters', in his *Essays Moral, Political, and Literary*, ed. Eugene F. Miller (Indianapolis, 1987), pp. 197–215. See Silvia Sebastiani, 'Hume versus Montesquieu', in *The Scottish Enlightenment: Race, Gender, and the Limits of Progress*, tr. Jeremy Carden (Basingstoke, 2013), pp. 23–43. Similar arguments are put succinctly by Helvétius, *Œuvres complètes*, 4 vols. (London, 1777), ii. p. 376.   **34.** Herder, *Ideen zur Philosophie der Geschichte der Menschheit*, in his *Werke*, ed. Günter Arnold and others, 10 vols. (Frankfurt a.M., 1985–2000), vi. pp. 264–5.   **35.** Montesquieu, *Spirit*, p. 139 (X, 3).   **36.** Ibid., p. 316 (XIX, 14). A distinguished authority reads this – admittedly cryptic – passage differently, as implying that of all the factors composing the 'general spirit', climate is the first in the sense of being the earliest and hence the most remote, so it can easily be overlaid by cultural factors, and Montesquieu is therefore offering a theory of progress: Shackleton, *Montesquieu*, pp. 318–19.   **37.** La Rochefoucauld, *Maximes*, ed. Jacques Truchet (Paris, 1967), p. 57 (no. 223).   **38.** David Hume, *A Treatise of Human Nature: A Critical Edition*, ed. David Fate Norton and Mary J. Norton (Oxford, 2007), I iv 7, p. 175; *OCD* iii. p. 88; Shaftesbury, *Characteristics of Men, Manners, Opinions, Times*, ed. Lawrence E. Klein (Cambridge, 1999), p. 170.   **39.** Edward Gibbon, *The History of the Decline and Fall of the Roman Empire*, ed. David Womersley, 3 vols. (London, 1994), ii. p. 565; Gilbert White, *The Natural History of Selborne*, ed. Anne Secord (Oxford, 2013), p. 113.   **40.** *The London Merchant*, III, i, in *The Dramatic Works of George Lillo*, ed. James L. Steffensen (Oxford, 1993), p. 178.   **41.** Voltaire, *Letters concerning the English Nation*, ed. Nicholas Cronk (Oxford, 1994), p. 43.   **42.** Henry Martin, *Considerations upon the East-India Trade* (London, 1701), p. 59. On Henry Martin or Martyn, see Istvan Hont, *Jealousy of Trade: International Competition and the Nation-State in Historical Perspective* (Cambridge, MA, 2005), p. 246.   **43.** Montesquieu, *Spirit*, p. 338 (XX, 2).   **44.** Kant, *Werke*, ed. Wilhelm Weischedel, 6 vols. (Darmstadt, 1958), vi. p. 226.   **45.** Guillaume-Thomas Raynal, *Histoire philosophique et politique des établissements et du commerce des Européens dans les deux Indes*, enlarged edn, 10 vols. (Geneva, 1781), x. p. 250. The king referred to is Henri IV, who contemplated a plan for European union.   **46.** Adam Smith, *An Inquiry into the Nature and Causes of the Wealth of Nations*, ed. R. H. Campbell and A. S. Skinner (Oxford, 1976), p. 422.   **47.** James Boswell, *Life of Johnson*, ed. R. W. Chapman, corrected by J. D. Fleeman (London, 1970), p. 597.   **48.** See Albert O. Hirschman, *The Passions and the Interests: Political Arguments for Capitalism before its Triumph* (Princeton, 1977), p. 58.   **49.** *Religious and Didactic Writings of Daniel Defoe*, ed. W. R. Owens and P. N. Furbank, 10 vols. (London, 2007), vol. 7: *The Complete English Tradesman*, Volume 1 (1725), ed. John McVeagh, pp. 233–4.   **50.** Adam Ferguson, *An Essay on the History of Civil Society*, ed. Duncan Forbes (Edinburgh, 1966), p. 143.   **51.** Defoe, *Tradesman*, p. 118.   **52.** Ibid., p. 222.   **53.** Smith, *Wealth of Nations*, p. 335. Smith introduces the term at p. 33. On its implications, see Istvan Hont, *Politics in Commercial Society: Jean-Jacques Rousseau and Adam Smith*, ed. Béla Kapossy and Michael Sonenscher (Cambridge, MA, 2015), pp. 3–10.   **54.** See Peter Hersche, *Muße und Verschwendung: Europäische Gesellschaft und Kultur im Barockzeitalter* (Freiburg, 2006),

pp. 601–9.    55. *Spectator*, no. 232, 26 Nov. 1711. The authorship of this essay is uncertain; from its subject-matter, it may be by Henry Martyn (*The Spectator*, ed. Donald Bond, 5 vols. (Oxford, 1965), ii. p. 405).    56. Defoe, 'Giving Alms no Charity' (1704), in *Political and Economic Writings of Daniel Defoe*, ed. W. R. Owens and P. N. Furbank, 8 vols. (London, 2000), viii. pp. 167–91 (p. 177).    57. Hersche, *Muße*, p. 605.    58. Friedrich Nicolai, *Beschreibung einer Reise durch Deutschland und die Schweiz im Jahre 1781. Nebst Bemerkungen über Gelehrsamkeit, Industrie, Religion und Sitten*, 12 vols. (Berlin and Stettin, 1783–96), iii. p. 169. On Protestant disapproval of a Southern European lifestyle, see Hersche, *Muße*, pp. 528–32.    59. 'Summer', ll. 138–9, in James Thomson, *The Seasons*, ed. James Sambrook (Oxford, 1981), p. 66.    60. Jean-François Melon, *Essai politique sur la commerce* ([Paris], 1734), pp. 1–5.    61. Sir William Temple, *Observations upon the United Provinces of the Netherlands* [1673], ed. Sir George Clark (Oxford, 1972), p. 123.    62. Hume, 'Of Civil Liberty', *Essays*, p. 88.    63. See J. G. A. Pocock, *The Machiavellian Moment: Florentine Republican Thought and the Atlantic Republican Tradition* (Princeton, 1975), pp. 423–61; Hont, *Jealousy of Trade*, pp. 51–62.    64. Smith, *Wealth of Nations*, p. 493.    65. Hume, 'Of the Jealousy of Trade', *Essays*, p. 331.    66. Quoted in Laurence Dickey, '*Doux-commerce* and humanitarian values: free trade, sociability and universal benevolence in eighteenth-century thinking', *Grotiana*, 22/23 (2001/2), pp. 271–318 (pp. 293–4).    67. On Vaughan, see Dickey, '*Doux-commerce*', pp. 291–3.    68. Benjamin Vaughan, *New and Old Principles of Trade Compared* (London, 1788), pp. 39–40; Hume is quoted on p. 41.    69. Quoted in Dickey, '*Doux-commerce*', p. 294. See Carla J. Mulford, *Benjamin Franklin and the Ends of Empire* (Oxford, 2015), p. 321.    70. Quoted in Dickey, '*Doux-commerce*', p. 317.    71. Quoted in Judith Still, *Enlightenment Hospitality: Cannibals, Harems and Adoption* (Oxford, 2011), p. 84.    72. Richard Cantillon, *Essai sur la nature du commerce en général* [1755] (Paris, 1952), p. 102. On Cantillon, see Terence Hutchison, *Before Adam Smith: The Emergence of Political Economy, 1662–1776* (Oxford, 1988), pp. 163–78.    73. Hume, 'Of Money', *Essays*, pp. 281–94 (pp. 283–4); discussed by Hont, *Jealousy of Trade*, p. 66.    74. Hume, 'Of Civil Liberty', *Essays*, p. 88; *idem*, 'Of the Populousness of Ancient Nations', *Essays*, pp. 416–19.    75. Mably, *Le Droit public de l'Europe, fondé sur les traités*, in *Collection complète des œuvres*, 15 vols. (Paris, 1794–5), vi. p. 510.    76. Ibid., vi. p. 515.    77. Melon, *Essai politique*, p. 146.    78. Ibid., p. 150.    79. Hume, 'Of the Jealousy of Trade', *Essays*, pp. 327–31 (p. 330).    80. Martin, *Considerations*, pp. 6, 60.    81. Hume, 'Of Money', *Essays*, pp. 281–94 (p. 293).    82. Hont, *Jealousy of Trade*, pp. 69–70.    83. John Robertson, *The Case for the Enlightenment: Scotland and Naples 1680–1760* (Cambridge, 2005), p. 29.    84. Antonio Genovesi, 'Ragionamento sul commercio in universale', in his *Scritti economici*, ed. Maria Luisa Perna, 2 vols. (Naples, 1984), i. pp. 119–63 (p. 128).    85. See Dorinda Outram, *The Enlightenment*, 3rd edn (Cambridge, 2013), p. 43.    86. On the history of the words and concepts 'economy' and 'economics', see Keith Tribe, *The Economy of the Word: Language, History, and Economics* (Oxford, 2015), pp. 21–88.    87. Smith, *Wealth of Nations*, p. 468.    88. *The Works of Thomas Carlyle*, 30 vols. (London, 1899), xxix. pp. 354, 370.    89. Tribe, *Economy*, p. 44, referring to 'Économie', *Encyclopédie*, v. pp. 336–40. For the analogy with natural science, see Lorraine Daston, 'Attention and the values of nature in the Enlightenment', in Lorraine Daston and Fernando Vidal, eds., *The Moral Authority of Nature* (Chicago, 2004), p. 120.    90. Emma Rothschild, *Economic Sentiments: Adam Smith, Condorcet and the Enlightenment* (Cambridge, MA, 2001), p. 27.    91. For a recent critique of this label, stressing the diversity of early modern economic thinking, see Jérôme Blanc and Ludovic Desmedt, 'In search of a "crude fancy of childhood": deconstructing mercantilism', *Cambridge Journal of Economics*, 38 (2014), pp. 585–604.    92. Ingomar Bog, 'Mercantilism in Germany', in D. C. Coleman, ed., *Revisions in Mercantilism* (London, 1969), pp. 162–89 (p. 173). See the summary in Kathryn Sutherland, 'The new economics of the Enlightenment', in Martin Fitzpatrick and others, eds., *The Enlightenment World* (London, 2004), pp. 473–85 (pp. 473–5).    93. Hume, 'Of the Balance of Trade', *Essays*, pp. 308–26 (esp. pp. 312–13).    94. Smith, *Wealth of Nations*, p. 439.    95. Hume, 'Of Money', *Essays*, pp. 281–94 (p. 282), referring to the War of the Austrian Succession (1740–48).    96. See the survey (correcting older misrepresentations): T. J. Hochstrasser,

'Physiocracy and the politics of *laissez-faire*', in Mark Goldie and Robert Wokler, eds., *The Cambridge History of Eighteenth-Century Political Thought* (Cambridge, 2006), pp. 419–42. **97.** Caroline Winterer, *American Enlightenments: Pursuing Happiness in the Age of Reason* (New Haven, 2016), pp. 207–9. The physiocrats were equally impressed by Franklin: Mulford, *Franklin*, pp. 223–4. **98.** Le Mercier de la Rivière, *L'Ordre naturel et essentiel des sociétés politiques* (London, 1767), p. 38. **99.** Hochstrasser, 'Physiocracy', p. 431. **100.** On the Flour War, see Colin Jones, *The Great Nation: France from Louis XV to Napoleon* (London, 2002), pp. 296–7. On physiocracy and the corn trade, see Hont, *Jealousy of Trade*, pp. 403–10. The chapter from which this comes was written jointly with Michael Ignatieff and originally published as 'Needs and justice in the *Wealth of Nations*: an introductory essay', in Hont and Ignatieff, eds., *Wealth and Virtue: The Shaping of Political Economy in the Scottish Enlightenment* (Cambridge, 1983), pp. 1–44. **101.** See Keith Tribe, *Governing Economy: The Reformation of German Economic Discourse 1750–1840* (Cambridge, 1988), p. 120. **102.** For introductions to this figure, see Owen Chadwick, 'The Italian Enlightenment', in Roy Porter and Mikuláš Teich, eds., *The Enlightenment in National Context* (Cambridge, 1981), pp. 90–105; Huguette Cohen, 'Diderot's machiavellian Harlequin: Ferdinando Galiani', *SVEC*, 256 (1988), pp. 129–48. **103.** Diderot, letter to Sophie Volland, 12 Nov. 1768, *OCD* vii. p. 814. **104.** Ferdinando Galiani, *Dialogues sur le commerce des bleds* (London, 1770), p. 98. **105.** Ibid., p. 2; Franco Venturi, 'The position of Galiani between the Encyclopaedists and the Physiocrats', in his *Italy and the Enlightenment: Studies in a Cosmopolitan Century*, tr. Susan Corsi (London, 1972), pp. 180–97. On the Tuscan famine and government attempts to prevent recurrences by liberalizing the corn trade, see Till Wahnbaeck, *Luxury and Public Happiness: Political Economy in the Italian Enlightenment* (Oxford, 2004), pp. 90–91. **106.** Galiani, *Dialogues*, p. 114. **107.** Ibid., p. 115. **108.** This account follows Richard Bellamy, ' "Da metafisico a mercatante" – Antonio Genovesi and the development of a new language of commerce in eighteenth-century Naples', in Anthony Pagden, ed., *The Languages of Political Theory in Early-Modern Europe* (Cambridge, 1987), pp. 277–99. **109.** Wahnbaeck, *Luxury*, p. 66. **110.** Genovesi, 'Ragionamento', pp. 126–7. See the fuller summary in Robertson, *The Case for the Enlightenment*, pp. 355–9. **111.** Genovesi, 'Ragionamento', p. 143. **112.** Ibid., p. 160. **113.** Donald Winch, *Adam Smith's Politics: An Essay in Historiographic Revision* (Cambridge, 1978), p. 70. **114.** Smith, *Wealth of Nations*, p. 471. **115.** See Smith's review of Rousseau's *Discourse on the Origins of Inequality* in 'Letter to the Authors of the *Edinburgh Review*' (1756), in his *Essays on Philosophical Subjects*, ed. W. P. D. Wightman and J. C. Bryce (Oxford, 1980), pp. 242–54. **116.** Adam Smith, *The Theory of Moral Sentiments*, ed. D. D. Raphael and A. L. Macfie (Oxford, 1976), p. 185; *idem*, *Wealth of Nations*, p. 131. See D. D. Raphael, *Adam Smith* (Oxford, 1985), p. 80; Dennis C. Rasmussen, *The Problems and Promise of Commercial Society: Adam Smith's Response to Rousseau* (University Park, PA, 2008), esp. pp. 82–9; Hont, *Politics in Commercial Society*. **117.** Smith, *Wealth of Nations*, p. 23. **118.** Ibid., p. 15. **119.** Ibid., pp. 26–7. **120.** Smith's supposed advocacy of ruthless self-interest is one of the 'myths' deftly corrected in Jesse Norman, *Adam Smith: What He Thought and Why it Matters* (London, 2018), see esp. pp. 163–6. **121.** Pope, *An Essay on Man*, in *TE* iii/1. p. 126. **122.** Smith, *Wealth of Nations*, pp. 47, 51. **123.** Ibid., p. 291. **124.** Ibid., p. 321. See Ian Simpson Ross, *The Life of Adam Smith* (Oxford, 1995), pp. 242–3; Henry Grey Graham, *The Social Life of Scotland in the Eighteenth Century* (London, 1901), pp. 525–6; Berry, *Commercial Society*, p. 4. **125.** Smith, *Wealth of Nations*, p. 72. **126.** Ibid., p. 74. **127.** Ibid., p. 75. **128.** 'A Letter from Governor Pownall to Adam Smith', originally published as a pamphlet (1776), repr. in *The Correspondence of Adam Smith*, ed. Ernest Campbell Mossner and Ian Simpson Ross (Oxford, 1977), pp. 337–76 (p. 375). Cf. Norman, *Adam Smith*, p. 150; David Wootton, *Power, Pleasure and Profit: Insatiable Appetites from Machiavelli to Madison* (Cambridge, MA, 2018), p. 191. **129.** See Ross, *Life of Smith*, p. 167. **130.** Smith, *Theory*, pp. 77, 184. **131.** Smith, *Wealth of Nations*, p. 456. **132.** See T. C. Smout, *A History of the Scottish People 1560–1830* (London, 1969), pp. 430–40. **133.** Smith, *Wealth of Nations*, p. 525. On the various faults in Smith's argument, see Wootton, *Power*, pp. 187–217. **134.** Smith, *Wealth of Nations*, p. 539. **135.** See Hont, *Jealousy of*

*Trade*, p. 414.   **136.** Smith, *Wealth of Nations*, p. 97.   **137.** Ibid., p. 96.   **138.** Ibid., pp. 86, 89; on his unconcern with charity, Wootton, *Power*, pp. 199–203.   **139.** Smith, *Wealth of Nations*, p. 145.   **140.** Ibid., p. 493.   **141.** Ibid., p. 471.   **142.** Anthony Pagden, quoting the reformer Campomanes, in *Lords of All the World: Ideologies of Empire in Spain, Britain and France c. 1500–c. 1800* (New Haven, 1995), p. 118.   **143.** See Rasmussen, *Problems and Promise*, pp. 155–7; Norman, *Adam Smith*, pp. 168–9.   **144.** Smith, *Wealth of Nations*, p. 468.   **145.** Winch, *Smith's Politics*, p. 98.   **146.** Smith, *Wealth of Nations*, p. 493. See Rasmussen, *Problems and Promise*, p. 126.   **147.** Smith, *Wealth of Nations*, p. 788. **148.** Ibid., p. 785. On the likely real extent of Scottish literacy, see R. A. Houston, *Scottish Literacy and the Scottish Identity* (Cambridge, 1985), esp. pp. 256–7.   **149.** Bernard Mandeville, *The Fable of the Bees*, ed. Phillip Harth (Harmondsworth, 1970), p. 294.   **150.** Smith, *Wealth of Nations*, p. 796.   **151.** Defoe, *Tradesman*, p. 108.   **152.** Ibid., p. 223.   **153.** Ludvig Holberg, *Værker*, ed. F. J. Billeskov Jansen, 12 vols. (Copenhagen, 1969–71), iii. pp. 55– 6.   **154.** See the description in Simon Schama, *The Embarrassment of Riches: An Interpretation of Dutch Culture in the Golden Age* (London, 1987), p. 304, with a reproduction of the painting.   **155.** Mandeville, *Fable*, p. 205.   **156.** Figures from Jonathan Israel, *The Dutch Republic: Its Rise, Greatness, and Fall, 1477–1806* (Oxford, 1995), p. 999.   **157.** Ibid., p. 1007.   **158.** Maxine Berg, *Luxury and Pleasure in Eighteenth-Century Britain* (Oxford, 2005), pp. 211–12.   **159.** Roy Porter, *English Society in the Eighteenth Century*, rev. edn (London, 1991), p. 191.   **160.** Jones, *The Great Nation*, p. 354.   **161.** Graham, *Social Life*, p. 44.   **162.** See A. Roger Ekirch, *At Day's Close: A History of Nighttime* (London, 2005), pp. 72–4, 329–37.   **163.** Daniel Roche, *Histoire des choses banales: Naissance de la consommation XVII^e–XIX^e siècle* (Paris, 1997), p. 135.   **164.** Wolfgang Nahrstedt, *Die Entstehung der Freizeit, dargestellt am Beispiel Hamburgs* (Göttingen, 1972), p. 196.   **165.** Ibid., pp. 251– 2.   **166.** See Isabel V. Hull, *Sexuality, State, and Civil Society in Germany, 1700–1815* (Ithaca, NY, 1996), p. 273.   **167.** Neil McKendrick, John Brewer and J. H. Plumb, *The Birth of a Consumer Society: The Commercialization of Eighteenth-century England* (London, 1982), p. 27.   **168.** Roche, *Histoire des choses banales*, p. 190; idem, *A History of Everyday Things: The Birth of Consumption in France, 1600–1800*, tr. Brian Pearce (Cambridge, 2000), p. 173.   **169.** *The Poems of William Cowper*, ed. John D. Baird and Charles Ryskamp, 3 vols. (Oxford, 1980–95), ii. p. 119.   **170.** Michael North, 'Material Delight and the Joy of Living': *Cultural Consumption in the Age of Enlightenment in Germany*, tr. Pamela Selwyn (Aldershot, 2008), p. 67.   **171.** Berg, *Luxury*, p. 115.   **172.** North, 'Material Delight', p. 70.   **173.** Berg, *Luxury*, pp. 87–8.   **174.** See McKendrick and others, *Birth of a Consumer Society*; for disputes over this claim, Berg, *Luxury*, pp. 9–11.   **175.** Berg, *Luxury*, p. 81.   **176.** Jones, *The Great Nation*, p. 355.   **177.** Ulrich Lehner, *Enlightened Monks: The German Benedictines 1740–1803* (Oxford, 2011), p. 33.   **178.** Pope, *The Rape of the Lock*, TE ii. p. 156,   **179.** Samuel Fawconer, *An Essay on Modern Luxury: Or, An Attempt to Delineate its Nature, Causes, and Effects* (London, 1765), pp. 20, 10.   **180.** Henry Fielding, *An Enquiry into the Causes of the Late Increase of Robbers and Related Writings*, ed. Malvin R. Zirker (Oxford, 1988), p. 77.   **181.** Samuel Cooper, *Definitions and Axioms Relative to Charity, Charitable Institutions, and the Poor's Laws* (London, 1764), p. 53.   **182.** Fawconer, *Essay on Modern Luxury*, p. 18. 'Effeminacy', a favourite word in the luxury debate, does not imply homosexuality, but rather moral and physical weakness and self-indulgence: see E. J. Clery, *The Feminization Debate in Eighteenth-Century England: Literature, Commerce and Luxury* (Basingstoke, 2004), p. 10.   **183.** Smith, *Wealth of Nations*, p. 96; John Millar, *Observations concerning the Distinction of Ranks in Society* (London, 1771), p. 78.   **184.** See John Sekora, *Luxury: The Concept in Western Thought, Eden to Smollett* (Baltimore, 1977).   **185.** *The Republic*, Book II, §373, in *The Dialogues of Plato*, tr. B. Jowett, 4 vols., 4th edn (Oxford, 1953), ii. p. 215, quoted in Sekora, *Luxury*, p. 30.   **186.** Sallust, *Catiline's Conspiracy, The Jugurthine War, Histories*, tr. William W. Batstone (Oxford, 2010), pp. 14–16.   **187.** Sekora, *Luxury*, p. 2.   **188.** Tobias Smollett, *The Expedition of Humphry Clinker*, ed. O. M. Brack, Jr and Thomas R. Preston (Athens, GA, 1990), p. 198 (letter from Matthew Bramble, 15 July).   **189.** Ibid., p. 265 (letter from Bramble, 20 Sept.).   **190.** John Brown, *An Estimate of the Manners and Principles of the*

*Times* (London, 1757), p. 29.   191. Ibid., pp. 63, 125.   192. See John Shovlin, *The Political Economy of Virtue: Luxury, Patriotism, and the Origins of the French Revolution* (Ithaca, NY, 2006), p. 55.   193. Fawconer, *Essay on Modern Luxury*, p. 50. See also George Cheyne, *The English Malady: or, a Treatise of Nervous Diseases of All Kinds* (London, 1733), pp. 49–55.   194. Hull, *Sexuality*, pp. 258–80.   195. Fawconer, *Essay on Modern Luxury*, pp. 4, 9.   196. Fielding, *Enquiry*, p. 124.   197. Fawconer, *Essay on Modern Luxury*, pp. 16–17.   198. Alan Hunt, *Governance of the Consuming Passions: A History of Sumptuary Law* (Basingstoke, 1996), pp. 34–5.   199. Jones, *The Great Nation*, p. 357.   200. W. H. Bruford, *Germany in the Eighteenth Century: The Social Background of the Literary Revival* (Cambridge, 1935), p. 193.   201. Justi, *Die Grundfeste zu der Macht und Glückseligkeit der Staaten oder ausführliche Vorstellung der gesamten Polizeiwissenschaft*, 2 vols. (Königsberg, 1760–61; repr. Aalen, 1965), ii. p. 366.   202. OCR ii. p. 546.   203. OCR ii. p. 658.   204. Jean Starobinski, *Jean-Jacques Rousseau: Transparency and Obstruction*, tr. Arthur Goldhammer (Chicago, 1988), p. 108.   205. OCR ii. p. 534.   206. Leo Damrosch, *Jean-Jacques Rousseau: Restless Genius* (New York, 2005), p. 320.   207. OCV 16, p. 302. 'Aï', now Ay-Champagne, is a wine-producing district in north-eastern France. Nicholas Cronk notes that sparkling wine was a new luxury, having been produced only since the end of the seventeenth century: 'The epicurean spirit: champagne and the defence of poetry in Voltaire's *Le Mondain*', *SVEC*, 371 (1999), pp. 53–80 (p. 53).   208. OCV 16, p. 307.   209. Letter to Voltaire, 3 Dec. 1736, OCV 88, p. 145.   210. Ferguson, *Essay*, p. 245.   211. Voltaire, 'Luxe', *Dictionnaire philosophique*, OCV 36, p. 328.   212. Mandeville, *Fable*, p. 144.   213. Hume, 'Of Refinement in the Arts' (originally 'Of Luxury'), *Essays*, pp. 275–88 (p. 282).   214. Pope, *Moral Essays IV*, TE iii/2. pp. 152, 153.   215. Genovesi, *Scritti economici*, i. pp. 376, 372–3. See Wahnbaeck, *Luxury*, pp. 64–5.   216. Frederick of Prussia, *The Refutation of Machiavelli's 'Prince' or Anti-Machiavel*, tr. and ed. Paul Sonnino (Athens, OH, 1981), p. 102.   217. Hume, 'Of Refinement in the Arts', *Essays*, p. 269.   218. Ibid., pp. 270–71.   219. Ibid., p. 271.   220. Ibid.   221. Ibid., p. 272.   222. Ibid., p. 277.   223. Hume, 'Of the Populousness of Ancient Nations', *Essays*, pp. 404, 405.

## 11. PHILOSOPHICAL HISTORY

1. The Vulgate (the Latin translation from Hebrew by St Jerome) placed the Creation about 4004 BCE; the Septuagint, the Greek translation made earlier from different Hebrew sources, put the Creation before 5000 BCE.   2. See Joachim Whaley, *Germany and the Holy Roman Empire*, 2 vols. (Oxford, 2012), i. pp. 17–18; Marie Tanner, *The Last Descendant of Aeneas: The Hapsburgs and the Mythic Image of the Emperor* (New Haven, 1993); and the 'Reyen des Verhängnüsses der vier Monarchien' which ends Lohenstein's play *Sophonisbe* (1680).   3. See Arno Seifert, 'Von der heiligen zur philosophischen Geschichte', *Archiv für Kulturgeschichte*, 68 (1986), pp. 81–117; more broadly, C. A. Patrides, *The Grand Design of God: The Literary Form of the Christian View of History* (London, 1972); Ulrich Muhlack, *Geschichtswissenschaft im Humanismus und in der Aufklärung: Die Vorgeschichte des Historismus* (Munich, 1991). John Robertson has explored the lasting importance of sacred history, and the intellectual stimulus it provided down to the late eighteenth century, in 'The Sacred and the Social: History and Political Thought 1650–1800', the Carlyle Lectures given at Oxford in Hilary Term 2016; I am very grateful to him for allowing me to read his text.   4. Robert Shackleton, *Montesquieu: A Critical Biography* (Oxford, 1961), p. 160.   5. Voltaire, *Essai sur les mœurs*, ed. René Pomeau, 2 vols. (Paris, 1963), i. p. 304.   6. Ibid., i. p. 208.   7. Ibid., i. p. 275.   8. Ibid., i. p. 559.   9. Ibid., i. p. 752.   10. Ibid., ii. p. 248.   11. Ibid., i. p. 757. See J. H. Brumfitt, *Voltaire, Historian* (Oxford, 1958), pp. 68–70.   12. Voltaire, *Essai*, i. p. 761.   13. See David Wootton, 'David Hume, "the historian"', in David Fate Norton and Jacqueline Taylor, eds., *The Cambridge Companion to Hume*, 2nd edn (Cambridge, 2009), pp. 447–79, and Wootton's 'Narrative, irony, and faith in Gibbon's *Decline and Fall*', in David Womersley, ed., *Edward Gibbon: Bicentenary Essays* (Oxford, 1997), pp. 203–33.   14. Voltaire, 'Nouvelles considérations sur l'histoire', in his *Œuvres historiques*, ed. René

Pomeau (Paris, 1957), p. 46.   15. Edward Gibbon, *The History of the Decline and Fall of the Roman Empire*, ed. David Womersley, 3 vols. (London, 1994), i. pp. 996–7; David Hume, *The History of England from the Invasion of Julius Caesar to the Revolution in 1688*, 6 vols. (1778; repr. Indianapolis, 1983), i. pp. 3–4.   16. Gibbon, *Decline and Fall*, i. p. 232 n. 9.   17. Thomas Innes, *A Critical Essay on the Ancient Inhabitants of the Northern Parts of Britain, or Scotland* (London, 1729), p. 758. See also Innes's remarks on the unreliability of oral tradition (p. 185), his detailed critical analysis of the dubious or non-existent sources cited by the Renaissance historians Hector Boece and George Buchanan, and his exposure of Buchanan's politically motivated falsifications. Hugh Trevor-Roper praises him in *The Invention of Scotland* (New Haven, 2009), p. 3. Cf. Colin Kidd, *Subverting Scotland's Past: Scottish Whig Historians and the Creation of an Anglo-British Identity, 1689–c. 1830* (Cambridge, 1993), pp. 101–7, who notes that Innes, having exposed Buchanan, put forward a Pictish genealogy of early Scottish kings that was no better founded but suited his Jacobitism.   18. Voltaire, 'Nouvelles considérations sur l'histoire', *Œuvres historiques*, p. 49.   19. See Judith Shklar, 'Jean d'Alembert and the rehabilitation of history', *JHI*, 42 (1981), pp. 643–64 (p. 657).   20. Locke, *An Essay concerning Human Understanding*, in *The Works of John Locke*, 9 vols. (1794; repr. London, 1997), ii. p. 233, discussed by Barbara J. Shapiro, *Probability and Certainty in Seventeenth-Century England: A Study of the Relationships between Natural Science, Religion, History, Law, and Literature* (Princeton, 1983), p. 42.   21. On the rules worked out by Nicolas Fréret for assessing the probability of recorded events, see Chantal Grell, *L'Histoire entre érudition et philosophie: étude sur la connaissance historique à l'âge des lumières* (Paris, 1993), pp. 84–93.   22. Gibbon, *Decline and Fall*, i. p. 512.   23. See Arnaldo Momigliano, 'Ancient history and the antiquarian', in his *Essays in Historiography* (London, 1966), pp. 1–39; Grell, *L'Histoire*.   24. See Ulrich L. Lehner, *Enlightened Monks: The German Benedictines 1740–1803* (Oxford, 2011), ch. 1.   25. Letter to Horace Walpole, August 1758, in *Letters of David Hume*, ed. J. Y. T. Greig, 2 vols. (Oxford, 1932), i. p. 284.   26. Gibbon, *Decline and Fall*, i. p. 748 n. 74. On Gibbon's footnoting, see Anthony Grafton, *The Footnote: A Curious History* (London, 1997), pp. 97–103.   27. William Robertson, *The History of the Reign of the Emperor Charles V*, 3 vols. (London, 1769), i. p. 392.   28. Lord Bolingbroke, *Letters on the Study and Use of History* (1735–8), in his *Historical Writings*, ed. Isaac Kramnick (Chicago, 1972), p. 25.   29. Niccolò Machiavelli, *The Discourses*, tr. Leslie J. Walker (London, 1950), p. 206 (Preface).   30. François Rigolot, 'The Renaissance crisis of exemplarity', *JHI*, 59 (1998), pp. 557–63 (p. 560).   31. 'Collège', *Encyclopédie*, iii. p. 637.   32. See David Womersley, *The Transformation of the Decline and Fall of the Roman Empire* (Cambridge, 1988), p. 12.   33. On Hume's supposed universalism, see e.g. Alasdair MacIntyre, *After Virtue* (London, 1981), who says that his imagined 'reasonable man' is merely 'a complacent heir of the revolution of 1688' (pp. 48–9). Contrast Duncan Forbes, *Hume's Philosophical Politics* (Cambridge, 1975), pp. 109–21.   34. John Millar, *Observations concerning the Distinction of Ranks in Society* (London, 1771), p. ii.   35. Hume, 'A Dialogue', in *An Enquiry concerning the Principles of Morals*, ed. Tom L. Beauchamp (Oxford, 1998), p. 117.   36. Ibid., p. 116.   37. Judith Shklar, *Montesquieu* (Oxford, 1987), p. 53.   38. Voltaire, 'Nouvelles considérations sur l'histoire', *Œuvres historiques*, p. 48.   39. Vossius, *De antiqua urbis Romae magnitudine*, cited in James A. Harris, *Hume: An Intellectual Biography* (Cambridge, 2015), p. 284.   40. *OCM* i. p. 295–7.   41. Gibbon, *Decline and Fall*, i. p. 239 n. 38. On Gibbon and the 'Querelle', see Joseph P. Levine, *Humanism and History: Origins of Modern English Historiography* (Ithaca, NY, 1987), pp. 178–89. Lord Kames likewise disagrees with Montesquieu: *Sketches of the History of Man*, 4 vols. (London, 1774–5), i. p. 53.   42. Hume, 'Of the Populousness of Ancient Nations', in his *Essays Moral, Political, and Literary*, ed. Eugene F. Miller (Indianapolis, 1987), pp. 377–464.   43. Charles E. McClelland, *State, Society, and University in Germany 1700–1914* (Cambridge, 1980), pp. 34–46. For an amusing view of academic life in late eighteenth-century Göttingen, see the novel by Gert Hofmann, *Die kleine Stechardin* (Munich, 1994), also available as *Lichtenberg and the Little Flower Girl*, tr. Michael Hofmann (New York, 2004).   44. T. C. W. Blanning, *Reform and Revolution in Mainz 1743–1803* (Cambridge, 1974), p. 22.   45. See Martin Peters, *Altes Reich und Europa: Der Historiker, Statistiker und Publizist August Ludwig (v.)*

*Schlözer (1735–1809)* (Münster, 2003), pp. 216–31; Thomas Nicklas, 'Publizität als Machtfaktor: Schlözer und die Pressekampagnen der Spätaufklärung', in Heinz Duchhardt and Martin Espenhorst, eds., *August Ludwig (von) Schlözer in Europa* (Göttingen, 2012), pp. 157–76.   **46.** See Susanne Kord, *Murderesses in German Writing, 1720–1860: Heroines of Horror* (Cambridge, 2009), p. 26.   **47.** *Virgil's Aeneis, travestirt*, in *Aloys Blumauer's gesammelte Werke*, 3 parts (Stuttgart, 1839), pt i, p. 161.   **48.** See Ulrich Muhlack, 'German Enlightenment historiography and the rise of historicism', tr. Fiona Robb, in Sophie Bourgault and Robert Sparling, eds., *A Companion to Enlightenment Historiography* (Leiden, 2013), pp. 249–305; Peter Hanns Reill, *The German Enlightenment and the Rise of Historicism* (Berkeley, 1975).   **49.** László Kontler, *Translations, Histories, Enlightenments: William Robertson in Germany, 1760–1795* (New York, 2014), p. 35.   **50.** George G. Iggers, 'The European context of eighteenth-century German historiography', in Hans Erich Bödeker and others, eds., *Aufklärung und Geschichte: Studien zur deutschen Geschichtswissenschaft im 18. Jahrhundert* (Göttingen, 1986), pp. 222–40 (p. 236).   **51.** German historians have been strangely slow to recognize Schiller as a member of their profession: see T. J. Reed, *Light in Germany: Scenes from an Unknown Enlightenment* (Chicago, 2015), p. 54.   **52.** August Ludwig Schlözer, *Vorstellung seiner Universal-Historie (1772/73)*, ed. Horst Walter Blanke (Hagen, 1990), p. 45. For some reason Schlözer's forenames are given as 'Ludwig August' on the title-page of this book, but as 'August Ludwig' in the body of the book and in all other sources.   **53.** Schlözer, *Vorstellung*, p. 31.   **54.** Ibid., p. 33.   **55.** Herder's review appeared in the *Frankfurter gelehrte Anzeigen*, 1772, pp. 473–8, and is reprinted in Schlözer, *Vorstellung*, pp. 453–6. On their controversy, including Schlözer's 190-page reply to Herder, see Daniel Fulda, *Wissenschaft aus Kunst: Die Entstehung der modernen deutschen Geschichtsschreibung 1760–1860* (Berlin, 1996), pp. 191–208, showing how justified Herder was in his criticism.   **56.** Reed, *Light in Germany*, p. 67.   **57.** This is an idealized portrait: contrast Peter H. Wilson, *Europe's Tragedy: A History of the Thirty Years War* (London, 2009), pp. 460, 462, 511.   **58.** Schiller, *Sämtliche Werke*, ed. Gerhard Fricke and Herbert G. Göpfert, 5 vols. (Munich, 1958), iv. p. 497. His presentation of Wallenstein in his historical drama *Wallenstein* (1798–9) is more complex and more positive: see Ritchie Robertson, 'Wallenstein: Man of Destiny?', in his *Enlightenment and Religion in German and Austrian Literature* (Oxford, 2017), pp. 60–74.   **59.** Smith, *Lectures on Jurisprudence*, ed. R. L. Meek, D. D. Raphael and P. G. Stein (Oxford, 1978), p. 14.   **60.** See Ronald L. Meek, *Social Science and the Ignoble Savage* (Cambridge, 1966); Karen O'Brien, *Narratives of Enlightenment: Cosmopolitan History from Voltaire to Gibbon* (Cambridge, 1997), pp. 132–6; Christopher J. Berry, *The Idea of Commercial Society in the Scottish Enlightenment* (Edinburgh, 2013), pp. 32–65. For anticipations in the natural law theories of Grotius and Pufendorf, see Fania Oz-Salzberger, *Translating the Enlightenment: Scottish Civic Discourse in Eighteenth-Century Germany* (Oxford, 1995), p. 22; Istvan Hont, *Jealousy of Trade: International Competition and the Nation-State in Historical Perspective* (Cambridge, MA, 2005), p. 160. Scottish historians did not all make equal use of stadial theory. Smith draws on it in *The Wealth of Nations*; Kames uses it extensively in *Historical Law-Tracts*, but only briefly in *Sketches of the History of Man*; Ferguson is interested in the first and second stages as a foil for his critique of commercial society; Robertson speaks of humanity's 'progress through the different stages of society' (*History of America*, 2 vols. (London, 1777), i. pp. 281–2), and his account of the native Americans is a wide-ranging sociological study of the 'hunting' stage.   **61.** Meek, *Social Science*, pp. 70–71.   **62.** 'Plan de deux Discours sur l'histoire universelle', in *Œuvres de Turgot et documents le concernant*, ed. Gustav Schelle, 5 vols. (Paris, 1913), i. pp. 275–323 (esp. pp. 278–87).   **63.** Letter to William Ludlow, 6 Sept. 1824, quoted in Kevin J. Hayes, *The Road to Monticello: The Life and Mind of Thomas Jefferson* (New York, 2008), pp. 378–9.   **64.** Lord Kames, *Historical Law-Tracts*, 2 vols. (Edinburgh, 1758), i. pp. vi–vii.   **65.** See the brief account by Stewart J. Brown, 'William Robertson (1721–1793) and the Scottish Enlightenment', in Brown, ed., *William Robertson and the Expansion of Empire* (Cambridge, 1997), pp. 7–35; Richard B. Sher, *Church and University in the Scottish Enlightenment: The Moderate Literati of Edinburgh* (Edinburgh, 1985); Jeffrey R. Smitten, *The Life of William Robertson: Minister,*

*Historian, and Principal* (Edinburgh, 2017). **66.** See Colin Kidd, 'The ideological signifi-cance of Robertson's *History of Scotland*', in Brown, *William Robertson*, pp. 122–44. **67.** For a perceptive appreciation, see David Womersley, 'The historical writings of William Robertson', *JHI*, 47 (1986), pp. 497–506. **68.** Kames, *Historical Law-Tracts*, i. p. 36. **69.** Dugald Stewart, 'Account of the Life and Writings of Adam Smith, LL.D.', in Smith, *Essays on Philosophical Subjects*, ed. W. P. D. Wightman and J. C. Bryce (Oxford, 1980), pp. 269–351 (p. 293). **70.** Oz-Salzberger, *Translating*, p. 112. **71.** See Pierre de Charlevoix, *Histoire et description générale de la Nouvelle France*, 2 vols. (Paris, 1744); Joseph-François Lafitau, *Mœurs des sauvages amériquains, comparées aux mœurs des premiers temps*, 2 vols. (Paris, 1724); Lafitau, *Customs of the American Indians compared with the Customs of Primitive Times*, ed. and tr. William N. Fenton and Elizabeth L. Moore, 2 vols. (Toronto, 1974–7); Peter Kolben, *The Present State of the Cape of Good-Hope*, vol. 1: *Containing a Particular Account of the Several Nations of the Hottentots: Their Religion, Government, Laws, Customs, Ceremonies, and Opinions; Their Art of War, Professions, Language, Genius, &c., together with A Short Account of the Dutch Settlement at the Cape*, tr. G. Med-ley (London, 1738). **72.** Cf. the repeated comparisons with ancient Greeks and Romans made by Cadwallader Colden, *History of the Five Indian Nations of Canada* (London, 1747), pp. xix–xxiii, a source cited by Ferguson. **73.** Adam Ferguson, *An Essay on the History of Civil Society*, ed. Duncan Forbes (Edinburgh, 1966), p. 77. **74.** Robertson, *History of America*, i. p. 313. **75.** Ibid., i. p. 284. **76.** Ferguson, *Essay*, p. 75. **77.** Gibbon, *Decline and Fall*, i. p. 1001. Gibbon alludes to Cook's voyages, ibid., ii. p. 516, at the end of the excursus headed 'General Observations on the Fall of the Roman Empire in the West'. **78.** Robertson, *History of America*, i. p. 309. **79.** Ibid., i. pp. 405, 406. **80.** Kames, *Sketches*, ii. p. 21; similarly, Ferguson, *Essay*, p. 194. **81.** Kolben, *Present State*, p. 46. **82.** Kames, *Historical Law-Tracts*, i. p. 3. **83.** Robertson, *History of America*, i. p. 319. **84.** Millar, *Observations*, pp. 9, 19. Similarly Kames, *Sketches*, i. p. 201. **85.** Kames, *Sketches*, i. pp. 208–9. **86.** Ferguson, *Essay*, p. 139; Montesquieu, *The Spirit of the Laws*, ed. and tr. Anne M. Cohler, Basia C. Miller and Harold S. Stone (Cambridge, 1989), p. 437 (XXIII, 16). **87.** Robertson, *History of America*, ii. pp. 267, 269. His sceptical reading of the Spanish accounts of Mexico (esp. pp. 296–302) is a fine example of critical interrogation of sources. **88.** See Nicholas Phillipson, 'Providence and progress: an introduction to the historical thought of William Robertson', in Brown, *William Robertson*, pp. 55–73 (pp. 67–8), and the subtle literary reading by Neil Hargraves, 'Beyond the savage character: Mexicans, Peruvians, and the "imperfectly civilized" in William Robertson's *History of America*', in Larry Wolff and Marco Cipolloni, eds., *The Anthropology of the Enlightenment* (Stanford, 2007), pp. 103–18. **89.** Robertson's account of the Americans has been much criticized, especially by Bruce P. Lenman, ' "From savage to Scot" via the French and the Spaniards: Principal Robertson's Spanish sources', in Brown, *William Robertson*, pp. 196–209. For a defence of Robertson's method, see Jeffrey R. Smitten, 'Impartiality in Robertson's *History of America*', *Eighteenth-Century Studies*, 19 (1985–6), pp. 56–77. **90.** Ferguson, *Essay*, p. 98. **91.** Robertson, *History of America*, i. pp. 332–3. **92.** Ferguson, *Essay*, p. 98. **93.** Kames, *Historical Law-Tracts*, i. p. 140. **94.** Ferguson, *Essay*, p. 101. **95.** Genesis 29: 18–20, quoted in Millar, *Observations*, pp. 42–3. Millar also draws on the depiction of passions in Ossian, in which 'there is often a degree of tenderness and delicacy of sentiment which can hardly be equalled in the most refined productions of a civilized age' (p. 43): hardly surprising, since 'Ossian' is largely a production of the eighteenth century. Cf. Kames, *Sketches*, ii. p. 61. **96.** Kames, *Historical Law-Tracts*, i. p. 78n. **97.** Ibid., i. p. 144. **98.** Ibid., i. p. 146. **99.** Millar, *Observations*, p. 157. Robertson finds feudalism in pre-Conquest Mexico: the 'Mexican constitution' shows 'feudal policy in its most rigid form' (*History of America*, ii. p. 280). **100.** William Robertson, *The History of the Reign of the Emperor Charles V*, 3 vols. (London, 1769), i. p. 15; similarly Kames, *Historical Law-Tracts*, i. p. 283. Present-day historians severely question this understanding of feudalism, which was derived from sixteenth-century French legal historians who generalized from a small number of sources: see J. G. A. Pocock, *The Ancient Constitution and the Feudal Law* (Cambridge, 1957), p. 70; Susan Reynolds, *Fiefs and Vassals: The Medieval Evidence*

*Reinterpreted* (Oxford, 1994). I owe the last reference to Professor John Blair.   101. Robertson, *Charles V*, i. p. 36.   102. Millar, *Observations*, p. 187.   103. Smith speaks of 'commercial society' in *Wealth of Nations*, ed. R. H. Campbell and A. S. Skinner (Oxford, 1976), p. 37. On the implications of the term, see Istvan Hont, *Politics in Commercial Society: Jean-Jacques Rousseau and Adam Smith*, ed. Béla Kapossy and Michael Sonenscher (Cambridge, MA, 2015), pp. 3–10.   104. Millar, *Observations*, p. 57. See M. de la Curne de Sainte-Palaye, *Mémoires sur l'ancienne chevalerie*, 2 vols. (Paris, 1751); Lionel Gossman, *Medievalism and the Ideologies of the Enlightenment: The World and Work of La Curne de Sainte-Palaye* (Baltimore, 1968).   105. Robertson, *Charles V*, i. pp. 25, 27.   106. Ibid., i. p. 81.   107. Millar, *Observations*, p. 180.   108. Kames, *Sketches*, ii. p. 20.   109. Ferguson, *Essay*, pp. 240–41.   110. Robertson, *Charles V*, i. p. 112. See O'Brien, *Narratives of Enlightenment*, pp. 136–42.   111. Hume, 'Of the Balance of Power', *Essays*, pp. 332–41.   112. Letter to John Clephane, 4 Feb. 1752, *Letters of David Hume*, i. p. 167. In fact the library had closer to 25,000 volumes: Harris, *Hume*, p. 538. Harris, pp. 305–407, is now an indispensable study of Hume's *History*.   113. Hume is quoted here from the reprint of the last edition: *The History of England from the Invasion of Julius Caesar to the Revolution in 1688*, 6 vols. (Indianapolis, 1983). On his revisions, see Graeme Slater, 'Hume's revisions of *The History of England*', *Studies in Bibliography*, 45 (1992), pp. 130–57.   114. For details of her earnings, see Bridget Hill, *The Republican Virago: The Life and Times of Catharine Macaulay, Historian* (Oxford, 1992), pp. 49–50.   115. Boswell, *Life of Johnson*, ed. R. W. Chapman, corrected by J. D. Fleeman (London, 1970), pp. 316–17; for Macaulay's rejoinder, see Hill, *Republican Virago*, p. 176.   116. Letter to Macaulay, 29 Mar. 1764, *New Letters of David Hume*, ed. Raymond Klibansky and Ernest C. Mossner (Oxford, 1954), pp. 80–82. On their relations, see Natalie Zemon Davis, 'History's two bodies', *American Historical Review*, 93 (1988), pp. 1–30.   117. Letter to Hume, undated, in 'Account of the Life and Writings of Mrs. Catherine Macauley Graham' [*sic*], *The European Magazine and London Review*, 4 (Nov. 1783), pp. 330–34 (p. 331).   118. Hume, 'Of the Study of History', *Essays*, pp. 563–8 (p. 563).   119. Letter to William Strahan, August 1770, *Letters of David Hume*, ii. p. 230.   120. Paul Langford, *A Polite and Commercial People: England 1727–1783* (Oxford, 1989), pp. 94–5.   121. Grell, *L'Histoire*, p. 5.   122. Harris, *Hume*, p. 322. 123. Letter to the Abbé Le Blanc, Sept. 1754, *Letters of David Hume*, i. p. 193. See Karen O'Brien, 'The history market in eighteenth-century England', in Isabel Rivers, ed., *Books and their Readers in Eighteenth-Century England: New Essays* (London, 2001), pp. 105–33.   124. Letter of 24 Oct. 1754, *Letters of David Hume*, i. p. 210. By 'interesting' Hume means something like 'emotionally engaging': Harris, *Hume*, p. 325.   125. Letter to John Clephane, ?1756, *Letters of David Hume*, i. p. 237.   126. See Pocock, *Ancient Constitution*; Harris, *Hume*, pp. 387–405.   127. Hume, *History*, i. p. 165.   128. Ibid., vi. p. 531. 129. Ibid., v. p. 532.   130. On the fate of Charles I as 'sentimental tragedy', see O'Brien, *Narratives of Enlightenment*, p. 64.   131. Hume, *History*, v. p. 161.   132. O'Brien notes that eighteenth-century historians such as Bolingbroke were already prone to 'Good Queen Bess-ery' (*Narratives of Enlightenment*, p. 86).   133. Hume, *History*, iv. p. 346.   134. Ibid., iv. p. 233. On Mary's complicity, see John Guy, *My Heart is my Own: The Life of Mary Queen of Scots* (London, 2004), p. 483.   135. Hume, *History*, v. p. 509.   136. Ibid., vi. p. 533. 137. See John Kenyon, *The Popish Plot* (London, 1972).   138. Hume, *History*, vi. p. 366. 139. Ibid., v. p. 544.   140. Ibid., vi. p. 531; Harris, *Hume*, p. 338.   141. Letter to William Strahan, *Letters of David Hume*, ii. p. 261.   142. Hume, *History*, iii. p. 435.   143. Ibid., iii. p. 139.   144. Ibid., v. p. 513.   145. Ibid., v. p. 514.   146. Ibid., v. p. 498.   147. Harris, *Hume*, pp. 380–81.   148. Hume, *History*, iv. pp. 145–6.   149. Ibid., i. p. 250.   150. Ibid., ii. p. 40.   151. Ibid., iv. p. 251.   152. Ibid., v. p. 175.   153. Ibid., v. p. 499. On Hume's view of Cromwell, see Nicholas Phillipson, *Hume* (London, 1989), pp. 98–9.   154. Hume, *History*, i. p. 238.   155. Ibid., v. p. 151.   156. Ibid., i. p. 445; iii. p. 324.   157. Ibid., i. p. 26. 158. Ibid., iv. p. 124.   159. Ibid., vi. p. 296.   160. Ibid., vi. p. 360. Cf. 'the genius of the inhabitants [of ancient Gaul] leading them less to arts than arms': 'Of the Populousness of Ancient Nations', *Essays*, p. 454. The word 'genius' occurs in the *History* 233 times. 161. Hume, *History*, i. p. 333.   162. See Hill, *Republican Virago*, pp. 31, 172.   163. Davis,

'History's two bodies', p. 16: the frontispiece is reproduced on p. 15. **164.** Catharine Macaulay, *The History of England from the Accession of James I to that of the Brunswick Line*, 8 vols. (London, 1763–83), iv. p. 391. **165.** Ibid., iv. p. 404. **166.** Ibid., iv. p. 405. **167.** Ibid., v. p. 382. By quoting the phrase about 'the brightest age' out of its context, Hill misleadingly implies that Macaulay thought the Commonwealth a complete success (*Republican Virago*, p. 35). **168.** Catharine Macaulay, *History*, v. pp. 154–5. **169.** Ibid., v. p. 10. A plaque commemorating Levellers who were shot on Cromwell's orders on 17 May 1649 may be seen in Burford church. **170.** Ibid., v. p. 219. The cult of Cromwell as national hero developed only in the nineteenth century: see Blair Worden, *Roundhead Reputations: The English Civil Wars and the Passions of Posterity* (London, 2001), pp. 243–95. **171.** Catharine Macaulay, *History*, viii. p. 329. **172.** Ibid., viii. p. 330. **173.** See Hill, *Republican Virago*, pp. 47–8. **174.** Mary Wollstonecraft, *A Vindication of the Rights of Woman*, ed. Janet Todd (Oxford, 1993), p. 180. **175.** John Taylor, *Records of my Life*, 2 vols. (London, 1832), i. p. 209. Macaulay must have been recalling Poulain de la Barre's dictum 'The mind has no sex' (see Chapter 6 above). **176.** Gibbon, *Memoirs of my Life*, ed. Georges A. Bonnard (London, 1966), p. 136. **177.** Gibbon, *Decline and Fall*, i. p. 230. **178.** Gibbon, *Essai sur l'étude de la littérature: A Critical Edition*, ed. Robert Mankin (Oxford, 2010), p. 128. **179.** Peter Ghosh, 'The conception of Gibbon's *History*', in Rosamond McKitterick and Roland Quinault, eds., *Edward Gibbon and Empire* (Cambridge, 1997), pp. 271–316 (p. 271). **180.** Montesquieu, *Considérations sur les causes de la grandeur des Romains, et de leur décadence*, in O CM ii. p. 193. **181.** Ibid., O CM ii. pp. 202–3; Montesquieu, *Spirit*, p. 30 (III, 10). **182.** Gibbon, *Decline and Fall*, i. p. 31. **183.** Ibid. **184.** Ibid., i. p. 83. **185.** Ibid., i. p. 87. Cf. Montesquieu's description of Augustus as a 'rusé tyran', *Considérations*, in O CM ii. p. 140. **186.** Gibbon, *Decline and Fall*, i. p. 83. **187.** See Peter Ghosh, 'Gibbon observed', *Journal of Roman Studies*, 81 (1991), pp. 132–56 (p. 137). **188.** Gibbon, *Decline and Fall*, i. p. 80. **189.** Ibid., i. p. 145; ii. p. 70. **190.** Ibid., ii. p. 378. **191.** Ibid., ii. p. 603. **192.** Ibid., ii. p. 697. Gibbon is here indebted to Montesquieu's climate theory, but he is aware of its difficulties, and is still more sceptical about the version presented by Dubos: see *Decline and Fall*, iii. p. 978, n. 1. **193.** Ibid., iii. p. 365. **194.** Ibid., iii. p. 142. **195.** Ibid., ii. p. 509; cf. iii. p. 369, for the empire of the caliphs. **196.** Ibid., i. p. 84. **197.** See John Robertson, 'Gibbon's Roman Empire as a universal monarchy: the *Decline and Fall* and the imperial idea in early modern Europe', in McKitterick and Quinault, *Gibbon*, pp. 247–70. Cf. Montesquieu, *Spirit*, p. 136 (IX, 7); Shackleton, *Montesquieu*, pp. 146–51; Hume, 'Of the Balance of Power', *Essays*, pp. 332–41 (esp. p. 341). **198.** Gibbon, *Decline and Fall*, iii. p. 564. **199.** Ibid., i. p. 859. **200.** Ibid., iii. p. 126. On this unfair account, see Rosamond McKitterick, 'Gibbon and the early Middle Ages in eighteenth-century Europe', in McKitterick and Quinault, *Gibbon*, pp. 162–89. **201.** Gibbon, *Decline and Fall*, iii. p. 148. **202.** J. G. A. Pocock, *Barbarism and Religion*, 6 vols. (Cambridge, 1999–2015), i: *The Enlightenments of Edward Gibbon* (1999), p. 4. See O'Brien, *Narratives of Enlightenment*, pp. 167–203. **203.** Gibbon, *Decline and Fall*, iii. p. 411. **204.** Ibid., iii. p. 983. **205.** Ibid., iii. pp. 726–8. **206.** Ibid., iii. p. 24. On other eighteenth-century views of Byzantium, see Womersley, *Transformation*, p. 197. **207.** O'Brien, *Narratives of Enlightenment*, pp. 185–6. **208.** See Giuseppe Giarrizzo, *Edward Gibbon e la cultura europea del settecento* (Naples, 1954), pp. 413–14. **209.** See Gibbon's explanation at the beginning of Chapter 64 (iii. p. 791), and his letter to Lord Hardwicke, 8 Oct. 1781, which confirms that he wanted to concentrate on the most interesting episodes (*The Letters of Edward Gibbon*, ed. J. E. Norton, 3 vols. (London, 1956), ii. p. 280). **210.** Gibbon, *Decline and Fall*, iii. p. 25. **211.** Ghosh, 'The conception of Gibbon's History', p. 305. **212.** Gibbon, *Decline and Fall*, i. p. 70. **213.** It has been argued, though uncertainly and equivocally, that these chapters reveal Gibbon's adoption of the 'four stages' theory of social development: see J. G. A. Pocock, 'Gibbon and the shepherds: the stages of society in the *Decline and Fall*', *History of European Ideas*, 2 (1981), pp. 193–202; J. W. Burrow, *Gibbon* (Oxford, 1985), pp. 73–4; O'Brien, *Narratives of Enlightenment*, pp. 200–201; cf. also Meek, *Social Science*, p. 175. In fact Gibbon does not treat hunting and herding as separate stages, says virtually nothing about farming, and does not describe either Rome or Constantinople

as a commercial society (see *Decline and Fall*, ii. p. 174; iii. p. 381).   **214.** Gibbon, *Decline and Fall*, ii. pp. 472–8.   **215.** See John Robertson, 'Gibbon and Giannone', in Womersley, *Edward Gibbon*, pp. 3–19.   **216.** Gibbon, *Decline and Fall*, iii. p. 916, n. 13.   **217.** Surprised by the hostile reaction to Chapters 15 and 16, Gibbon revised them for the second edition to remove suggestions of deism, but for the third edition he revised them again to strengthen his critique of the Church: see David Womersley, *Gibbon and the 'Watchmen of the Holy City': The Historian and his Reputation 1776–1815* (Oxford, 2002), pp. 18–42.   **218.** Gibbon, *Decline and Fall*, iii. p. 178.   **219.** Ibid., i. p. 499. Pocock tries to relate Gibbon to Arminianism (*Barbarism*, i. pp. 50–71), but the connection, if any, is remote and tenuous. The one reference to 'Arminians' in the *Decline* appears to be critical: iii. p. 439. Peter Ghosh associates Gibbon with 'sceptical fideism': 'Gibbon's timeless verity: Nature and neo-classicism in the late Enlightenment', in Womersley, *Edward Gibbon*, pp. 121–63 (p. 128). On Gibbon's religious beliefs, see further Paul Turnbull, 'The "supposed infidelity" of Edward Gibbon', *Historical Journal*, 25 (1982), pp. 23–41; B. W. Young, ' "Scepticism in excess": Gibbon and eighteenth-century Christianity', *Historical Journal*, 41 (1998), pp. 179–99.   **220.** Gibbon, *Decline and Fall*, i. pp. 498–9.   **221.** Cf. 'Homoiousion is definitely dated. *Everyone* who really counts is for Homoousion – or is it the other way round?' (Evelyn Waugh, *Helena* (London, 1950), p. 96).   **222.** Gibbon, *Decline and Fall*, iii. p. 358.   **223.** Ibid., iii. p. 409.   **224.** Machiavelli, *Discourses*, p. 364 (II, 2). Other instances of this view are listed in Womersley, *Transformation*, p. 105.   **225.** Gibbon, *Decline and Fall*, iii. pp. 430, 988.   **226.** Ibid., iii. p. 438. Cf. i. p. 470 n. 70, where Gibbon describes Zwingli as the only Reformation leader who advocated tolerance.   **227.** Ibid., iii. p. 439. Gibbon refers in a footnote to Joseph Priestley, from whose unbelief he firmly dissociated himself: see his *Letters*, ii. p. 321, and the correspondence which Priestley published after Gibbon's death in *Discourses relating to the Evidence of Revealed Religion*, 3 vols. (London, 1794–9), i. pp. 412–20.   **228.** David Wootton, 'Narrative, irony, and faith in Gibbon's *Decline and Fall*', in Womersley, *Edward Gibbon*, pp. 203–33 (p. 227).   **229.** Gibbon, *Decline and Fall*, i. p. 482. On the key words 'social' and 'society', see Burrow, *Gibbon*, p. 56.   **230.** Gibbon, *Decline and Fall*, i. p. 467.   **231.** Ibid., i. p. 470.   **232.** Ibid., i. pp. 472–3; ii. pp. 93–4.   **233.** Ibid., i. pp. 546–7. Cf. G. W. Bowersock, *Martyrdom and Rome* (Cambridge, 1995).   **234.** Gibbon, *Decline and Fall*, i. p. 539.   **235.** Ibid., i. p. 579.   **236.** Ibid., iii. pp. 166, 61.   **237.** Ibid., iii. p. 423. Contrast the portrayal of Byzantine achievements in e.g. Judith Herrin, *Byzantium: The Surprising Life of a Medieval Empire* (London, 2007).   **238.** Gibbon, *Decline and Fall*, i. p. 475.   **239.** Ibid., i. p. 466.   **240.** David Hume, *The Natural History of Religion*, ed. A. Wayne Colver, and *Dialogues concerning Natural Religion*, ed. John Valdimir Price (Oxford, 1976), p. 74.   **241.** Gibbon, *Decline and Fall*, ii. pp. 427–8.   **242.** Ibid., i. p. 743.   **243.** See Arnaldo Momigliano, 'Gibbon's contribution to historical method', in his *Essays in Historiography*, pp. 40–55.   **244.** See Wootton, 'Narrative, irony, and faith', pp. 211–12.   **245.** Gibbon, *Decline and Fall*, ii. p. 949 n. 39; cf. iii. p. 120 n. 84.   **246.** Ibid., ii. p. 986 n. 124.   **247.** Gibbon, *Memoirs*, p. 147. On Gibbon's integration of geographical research into his historical narrative, see Guido Abbattista, 'Establishing the "order of time and place": "rational geography", French erudition and the emplacement of history in Gibbon's mind', in Womersley, *Edward Gibbon*, pp. 45–72.   **248.** Contrast e.g. Peter Heather, *The Fall of the Roman Empire: A New History* (London, 2005).   **249.** Gibbon, *Decline and Fall*, ii. p. 881; ii. p. 891; iii. p. 424.   **250.** Ibid., iii. p. 889.   **251.** Ibid., iii. p. 768. Another such example is analysed by Womersley, *Transformation*, p. 56.   **252.** Burrow, *Gibbon*, p. 81.   **253.** Gibbon, *Decline and Fall*, ii. pp. 513–14.   **254.** Ibid., ii. p. 516.   **255.** Ibid., iii. p. 1068.   **256.** Ibid., iii. p. 1083.   **257.** See Ghosh, 'Gibbon's timeless verity', esp. pp. 136–8; Paul Fussell, *The Rhetorical World of Augustan Humanism: Ethics and Imagery from Swift to Burke* (Oxford, 1965), pp. 73–4, 118–19.   **258.** Cf. John Dyer's topographical and reflective poem 'The Ruins of Rome', which ends by surveying Roman history from the virtuous poverty of the early Republic via the corruption of the Empire to the destruction ascribed to Goths and Vandals. Dyer puts the blame on luxury: 'O luxury, / Bane of elated life, of affluent states, / What dreary change, what ruin is not thine?' – 'The Ruins of Rome', in *The Poetical Works of John Dyer* (London, 1765), pp. 125–48 (historical survey,

pp. 142–6; quotation from p. 148). **259.** Volney, *The Ruins, or a Survey of the Revolutions of Empires*, tr. anon. (London, 1795), p. 7. The ruins of Palmyra have additional poignancy now that they have been further ruined by Islamic State. See the reflections by the art historian Horst Bredekamp, *Das Beispiel Palmyra* (Cologne, 2016). **260.** Bayle, *Dictionnaire historique et critique*, 4 vols. (Amsterdam, 1730), iii. p. 305 ('Manichéens', note D). Cf. Voltaire: 'history is but a tableau of every crime and catastrophe' ('The Ingenu', in *Candide and Other Stories*, tr. Roger Pearson (Oxford, 2006), p. 221); Gibbon: '[history] is, indeed, little more than the register of the crimes, follies, and misfortunes of mankind' (*Decline and Fall*, i. p. 102); and Wieland: 'Ist die Geschichte wohl viel besser, als ein ungeheures Sündenregister des menschlichen Geschlechts?' ('Unterredung zwischen W\*\*\* und dem Pfarrer zu \*\*\*', 1775, *Werke*, ed. Fritz Martini and Hans Werner Seiffert, 5 vols. (Munich, 1964–8), iii. p. 323). **261.** 'Tableau philosophique des progrès successifs de l'esprit humain', in *Œuvres de Turgot*, i. pp. 214–35 (p. 215). **262.** 'Plan de deux Discours sur l'histoire universelle', in *Œuvres de Turgot*, i. pp. 275–323 (p. 283). **263.** On its genesis, see Keith Michael Baker, *Condorcet: From Natural Philosophy to Social Mathematics* (Chicago, 1975), pp. 344–52. **264.** Condorcet, *Esquisse d'un tableau historique des progrès de l'esprit humain*, ed. Monique and François Hincker (Paris, 1971), p. 207. **265.** See Baker, *Condorcet*, pp. 122, 351. **266.** Condorcet, *Esquisse*, p. 259. **267.** Ibid., p. 206. **268.** See Bronislaw Baczko, *Lumières de l'utopie* (Paris, 1978), p. 197. **269.** Condorcet, *Esquisse*, pp. 155, 156. **270.** Robert Darnton, *The Forbidden Best-Sellers of Pre-Revolutionary France* (London, 1996), pp. 118–36. **271.** Louis-Sébastien Mercier, *L'An deux mille quatre cent quarante: Rêve s'il en fût jamais*, ed. Raymond Trousson (Paris, 1971), pp. 249–50. **272.** 'Idea for a Universal History with a Cosmopolitan Purpose', in Kant, *Political Writings*, ed. Hans Reiss, tr. H. B. Nisbet, 2nd edn (Cambridge, 1991), pp. 41–53 (p. 44). **273.** Ibid., p. 50. **274.** Ibid. **275.** Ibid., p. 51.

## 12. COSMOPOLITANISM

**1.** Quoted in Roland Mortier, 'Le rêve universaliste de l'"Orateur du Genre humain"', in his *Les Combats des Lumières* (Ferney-Voltaire, 2000), pp. 385–94 (p. 385). **2.** Letter to Hume, 22 Feb. 1768, *OCD* vii. p. 653. **3.** Boswell, letter to Wilkes, 22 April 1765, *Boswell on the Grand Tour: Germany and Switzerland 1764*, ed. Frederick A. Pottle (London, 1953), p. 73. **4.** Gibbon, letter to Lord Sheffield, 20 Jan. 1787, in *The Letters of Edward Gibbon*, ed. J. E. Norton, 3 vols. (London, 1956), iii. p. 61. **5.** Georges-Louis de Bär, *Épîtres diverses sur des sujets différens*, 2nd edn (London, 1745), pp. 209–10. **6.** Reported by Diogenes Laertius; quoted in John Moles, 'The Cynics', in Christopher Rowe and Malcolm Schofield, eds., *The Cambridge History of Greek and Roman Political Thought* (Cambridge, 2000), pp. 415–34 (p. 423). **7.** Seneca, 'On Tranquillity of Mind', in *Moral Essays*, tr. John W. Basore, 3 vols., Loeb Classical Library (London, 1970), ii. p. 229; cf. p. 207. **8.** *M. T. Cicero his Offices, or his Treatise concerning the Moral Duties of Mankind*, tr. William Guthrie (London, 1755), p. 30. **9.** Wieland, *Werke*, ed. Fritz Martini and Hans Werner Seiffert, 5 vols. (Munich, 1964–8), iii. p. 556. On Stoicism, Wieland, and 'moral cosmopolitanism', see Pauline Kleingeld, 'Six varieties of cosmopolitanism in late eighteenth-century Germany', *JHI*, 60 (1999), pp. 505–24 (pp. 507–9). **10.** Letter to Huldrych Zwingli, 3(?) Sept. 1522, in *The Correspondence of Erasmus*, tr. R. A. B. Mynors and others, 17 vols. to date (Toronto, 1974–2016), ix. p. 185. **11.** Quoted in Franklin Perkins, *Leibniz and China: A Commerce of Light* (Cambridge, 2004), p. 110. **12.** See Peter Burke, '"Heu domine, adsunt Turcae": a sketch for a social history of post-medieval Latin', in his *Art of Conversation* (Cambridge, 1993), pp. 34–65. **13.** Steffen Martus, *Aufklärung: Das deutsche 18. Jahrhundert. Ein Epochenbild* (Berlin, 2015), pp. 97–8. **14.** Françoise Waquet, *Latin, or the Empire of a Sign*, tr. John Howe (London, 2001), p. 88. **15.** Ibid., p. 81. **16.** Albert Ward, *Book Production, Fiction, and the German Reading Public, 1740–1800* (Oxford, 1974), p. 30. **17.** Yasmin Haskell, 'Conjuring with the classics: neo-Latin poets and their pagan familiars', in Victoria Moul, ed., *A Guide to Neo-Latin Literature* (Cambridge, 2017), pp. 17–34 (pp. 24, 27–30). **18.** See Stefan Tilg, 'Longer prose fiction', in Moul, *Guide*, pp. 322–39 (pp. 332–4). **19.** Samuel Johnson, 'Addison', in his *Lives*

*of the most Eminent English Poets*, ed. Roger Lonsdale, 4 vols. (Oxford, 2006), iii. p. 12; Richard Butterwick, *Poland's Last King and English Culture: Stanisław August Poniatowski 1732–1798* (Oxford, 1998), p. 176; Georges Ascoli, *La Grande-Bretagne devant l'opinion française au XVII*ᵉ *siècle*, 2 vols. (Paris, 1930), ii. pp. 121–2.    **20.** *Encyclopédie*, vii. p. 599. **21.** René Pomeau, *D'Arouet à Voltaire, 1694–1734* (Oxford, 1985), p. 222; Ian Davidson, *Voltaire: A Life*, rev. edn (London, 2012), pp. 61–9. See Voltaire's letter in English to Nicolas Claude Thieriot, 26 Oct. 1726, *OCV* 85, pp. 308–11; *Boswell on the Grand Tour*, p. 280; cf. p. 273.    **22.** Robert Shackleton, *Montesquieu: A Critical Biography* (Oxford, 1961), p. 120.    **23.** Arthur M. Wilson, *Diderot* (New York, 1972), pp. 49–53.    **24.** See Peter France, 'Diderot et l'Écosse', in Peter France and Anthony Strugnell, eds., *Diderot: les dernières années 1770–84* (Edinburgh, 1985), pp. 3–16.    **25.** Voltaire, letter to René Joseph Tournemine, *c*. August 1735, *OCV* 87, p. 184.    **26.** For an excellent survey of continental Anglophilia, see Butterwick, *Poland's Last King*, pp. 35–64; also Michael Maurer, *Aufklärung und Anglophilie in Deutschland* (Göttingen, 1987).    **27.** See Roy Porter, *English Society in the Eighteenth Century*, rev. edn (London, 1991), pp. 99–105.    **28.** Wieland, letter to Schinz, 26 and 28 Mar. 1752, *Wielands Briefwechsel*, ed. Hans Werner Seiffert, 4 vols. (Berlin, 1963–79), i. p. 54. **29.** Butterwick, *Poland's Last King*, p. 55.    **30.** *Chardin's Travels in Persia*, ii. p. 3. Chardin's account of Persia was first published in French in 1686. At that time a French league was equal to 3.898 kilometres.    **31.** François Bernier, letter to Colbert, in *The History of the Late Revolution of the Empire of the great Mogol*, 4 vols., 2nd edn (London, 1676), ii. p. 127.    **32.** Johann Heinrich Zedler, *Grosses vollständiges Universal-Lexikon aller Wissenschafften und Künste*, 64 vols. (Leipzig, 1743), vol. 37, col. 1557.    **33.** Montesquieu, *Persian Letters* tr. C. J. Betts (Harmondsworth, 1973), p. 83 (letter 30); *OCM* i. pp. 176–7.    **34.** Usbek's tolerant views on suicide markedly resemble those in Hume's 'Of Suicide' (*Essays Moral, Political, and Literary*, ed. Eugene F. Miller (Indianapolis, 1987), pp. 577–89, written possibly in the 1750s, but not published till after his death). Cf. the admiration for Roman suicide that Montesquieu later expressed in *Considérations*, *OCM* ii. p. 135.    **35.** On the critique of despotism here, see Judith Shklar, *Montesquieu* (Oxford, 1987), p. 33. It is tempting also to see the absent master Usbek as suggesting God, his rule being enforced by a corps of asexual males (priests/eunuchs): Judith Still, *Enlightenment Hospitality: Cannibals, Harems and Adoption* (Oxford, 2011), p. 164.    **36.** Michael Mosher, 'Montesquieu on empire and enlightenment', in Sankar Muthu, ed., *Empire and Modern Political Thought* (Cambridge, 2012), pp. 112–54 (p. 122).    **37.** See Julia Gasper, *The Marquis d'Argens: A Philosophical Life* (Lexington, KY, 2013), pp. 88–91; *The Jewish Spy . . . by the Marquis d'Argens*, 5 vols. (London, 1739); *Jewish Letters*, 4 vols. (London, 1739–44).    **38.** Cadalso, *Cartas marruecas*, p. 197 (Letter LXXX).    **39.** Vane's 'Memoirs of a Lady of Quality', anonymous but easily identifiable, form chapter 88 of Tobias Smollett, *The Adventures of Peregrine Pickle* (1751), ed. O. M. Brack and W. H. Keithley (Athens, GA, 2014); see pp. 435, 437–8.    **40.** Goethe, *Sämtliche Werke: Briefe, Tagebücher und Gespräche*, ed. Friedmar Apel and others, 40 vols. (Frankfurt a.M., 1986–2000), viii. p. 256.    **41.** Maria Rosa Antognazza, *Leibniz: An Intellectual Biography* (Cambridge, 2009), pp. 299–300. Descartes reported a similar experience in 1621: Tom Sorell, *Descartes: A Very Short Introduction* (Oxford, 2000), p. 23.    **42.** Mary Wortley Montagu, *Letters*, ed. Clare Brant (London, 1992), pp. 103, 107.    **43.** *The six voyages of John Baptista Tavernier, Baron of Aubonne, through Turky, into Persia and the East–Indies, for the space of forty years*, 2 vols. (London, 1677), i. p. 1.    **44.** See Lawrence J. Baack, *Undying Curiosity: Carsten Niebuhr and The Royal Danish Expedition to Arabia (1761–1767)* (Stuttgart, 2014). **45.** Although Bering too had scurvy, the analysis of his body, exhumed in 1991, suggested that he died of heart failure: Orcutt Frost, *Bering: The Russian Discovery of America* (New Haven, 2003), p. 237. The Kamchatka expedition was not only fatal for humans. The naturalist accompanying it, Georg Wilhelm Steller, discovered the giant sirenian (relative of the manatee and the dugong) *Hydrodamalis gigas*, called 'Steller's sea-cow' after him; by 1768, the species was extinct, hunted to death by Russian sailors.    **46.** Quoted in Iris W. Engstrand, *Spanish Scientists in the New World: The Eighteenth-Century Expeditions* (Seattle, 1981), p. 19.    **47.** See e.g. Voltaire, *La Russie sous Pierre le Grand*, in his *Œuvres historiques*, ed. René Pomeau (Paris, 1957), p. 368.    **48.** Thomas M. Curley, *Samuel Johnson and the Age*

*of Travel* (Athens, GA, 1976), p. 53. Cf. Daniel Roche, *France in the Enlightenment*, tr. Arthur Goldhammer (Cambridge, MA, 1998), p. 510; Ward, *Book Production*, p. 136. **49.** George Psalmanazar, *An Historical and Geographical Description of Formosa* (London, 1704), pp. 171–3. On him, see Justin Stagl, *A History of Curiosity: The Theory of Travel 1550–1800* (London, 1995), pp. 171–207; more generally, Percy G. Adams, *Travelers and Travel Liars 1660–1800* (Berkeley, CA, 1962). **50.** Psalmanazar, *Formosa*, p. 34. **51.** On increasing knowledge of the extra-European world, not simply as 'mirrors of the Self', see Sebastian Conrad, 'Enlightenment in global history: a historiographical critique', *American Historical Review*, 117 (2012), pp. 999–1027 (p. 1010). **52.** Stagl, *History of Curiosity*, p. 85. **53.** Baack, *Undying Curiosity*, pp. 63–8; Stagl, *History of Curiosity*, p. 270; Sergio Moravia, *La scienza dell'uomo nel Settecento* (Bari, 1970), p. 165. On the significance of the Niebuhr expedition for biblical scholarship, see Jonathan Sheehan, *The Enlightenment Bible: Translation, Scholarship, Culture* (Princeton, 2005), pp. 186–211. **54.** Friedrich Nicolai, *Beschreibung einer Reise durch Deutschland und die Schweiz im Jahre 1781*, 12 vols. (Berlin and Stettin, 1783–96), i. pp. 15–16. On the practicalities of Nicolai's journey, see Hans Erich Bödeker, ' "Ich wünschte also eine Reise zu thun, in welcher ich, nebst den veränderten Scenen der Natur, Menschen und ihre Sitten und Industrie kennen lernen könnte." Friedrich Nicolai auf Reise', in Rainer Falk and Alexander Košenina, eds., *Friedrich Nicolai und die Berliner Aufklärung* (Hanover, 2008), pp. 305–37. **55.** Moravia, *La scienza dell'uomo*, pp. 166–7. **56.** Ibid., pp. 174–6. **57.** William Marsden, *The History of Sumatra, containing an account of the government, laws, customs and manners of the native inhabitants, with a description of the natural productions, and a relation of the ancient political state of that island*, 3rd edn (London, 1811), p. vii. **58.** See e.g. Mary Louise Pratt, *Imperial Eyes: Travel Writing and Transculturation* (London, 1992). **59.** Stephen Greenblatt, *Marvelous Possessions: The Wonder of the New World* (Oxford, 1991), p. 7. **60.** Edward Said, *Orientalism* (London, 1978), pp. 272, 204. For critiques of Said's hugely influential book, see e.g. Bart Moore-Gilbert, *Postcolonial Theory: Contexts, Practices, Politics* (London, 1997), pp. 34–73; Robert Irwin, *For Lust of Knowing: The Orientalists and their Enemies* (London, 2006), pp. 277–309. **61.** Edward Gibbon, *The History of the Decline and Fall of the Roman Empire*, ed. David Womersley, 3 vols. (London, 1994), ii. p. 993n. **62.** Still, *Enlightenment Hospitality*, p. 141. **63.** Jürgen Osterhammel, *Die Entzauberung Asiens: Europa und die asiatischen Reiche im 18. Jahrhundert* (Munich, 1998), p. 263. For a qualified defence of the capacity of European travellers for empirical observation, see Joan-Pau Rubiés, *Travel and Ethnology in the Renaissance: South India through European Eyes, 1250–1625* (Cambridge, 2000), esp. pp. 388–98. **64.** George [*sic*] Forster, *A Voyage round the World* (1777), in *Georg Forsters Werke: Sämtliche Schriften, Tagebücher, Briefe*, ed. Gerhard Steiner, vol. 1: *A Voyage round the World*, ed. Robert L. Kahn (Berlin, 1968), p. 185. **65.** *Boswell: The Ominous Years, 1774–1776*, ed. Charles Ryskamp and Frederick A. Pottle (London, 1963), p. 341. **66.** Still, *Enlightenment Hospitality*, p. 32. **67.** James Cook, *The Journals*, ed. Philip Edwards (London, 2003), p. 27. **68.** Nicholas Thomas, *Discoveries: The Voyages of Captain Cook* (London, 2003), p. 52. **69.** *Travels of Chardin*, ii. pp. 120–21. **70.** Ibid., i. p. 124. **71.** See Syed Hussein Alatas, *The Myth of the Lazy Native* (London, 1977), pp. 72–6. **72.** Quoted in Baack, *Undying Curiosity*, p. 309. **73.** See Isobel Grundy, *Lady Mary Wortley Montagu* (Oxford, 1999), pp. 199–200. **74.** Montagu, *Letters*, p. 146. **75.** Ibid., p. 108. The letter is dated at a time when she has been on Turkish territory for only two months, but since it was composed, or revised, a few years later, the judgement presumably reflects impressions gathered throughout her visit. **76.** Ibid., pp. 101–2, 108–9. Grundy thinks they spoke Italian (*Montagu*, p. 135). On houses, see Montagu, *Letters*, p. 127; on music, p. 134; on Greeks, pp. 145–6. **77.** Described in great detail in a letter to her sister: Montagu, *Letters*, pp. 114–15; see also Grundy, *Montagu*, pp. 142–3. **78.** Montagu, *Letters*, p. 138. Cf. her mockery of Catholic relics in Cologne (p. 59) and Regensburg (p. 63). **79.** See ibid., pp. 124–5, 162; Grundy, *Montagu*, pp. 209–22. **80.** See the stories quoted in Elisabeth A. Bohls, 'Aesthetics and Orientalism in Lady Mary Wortley Montagu's letters', *Studies in Eighteenth-Century Culture*, 23 (1994), pp. 179–205 (pp. 186–7). For lapdogs, see Diderot, *Les Bijoux indiscrets*, OCD i. pp. 569–75. **81.** Montagu, *Letters*, p. 105. **82.** Ibid. This episode has occasioned

much critical argument: see Mary Jo Kietzman, 'Montagu's *Turkish Embassy Letters* and cultural dislocation', *Studies in English Literature 1500–1900*, 38 (1998), pp. 537–51; Still, *Enlightenment Hospitality*, pp. 184–200, especially pp. 191–4.    83. See Bohls, 'Aesthetics', pp. 187–92.    84. Montagu, *Letters*, p. 106.    85. On how Montagu 'normalizes' the life of Turkish women, see Still, *Enlightenment Hospitality*, pp. 198–9.    86. See Montagu, *Letters*, pp. 133–4; Grundy, *Montagu*, p. 149.    87. Contrast e.g. Hume, 'Of Polygamy and Divorces', *Essays*, pp. 181–90.    88. Montagu, *Letters*, pp. 169–70.    89. Ibid., p. 142.    90. Ibid., p. 166.    91. Ibid., p. 111.    92. Ibid., p. 149.    93. Ibid., p. 112.    94. Forster, *Voyage*, p. 155.    95. Ibid., p. 174. Cf. p. 176 for absence of gnats.    96. Ibid., p. 199.    97. Ibid., p. 175.    98. Ibid., p. 156.    99. Ibid., p. 161.    100. Ibid., p. 160.    101. Ibid., p. 163. Not long before, Spaniards had visited Tahiti and set the Tahitians against the British, whom they therefore considered fair game: Anne Salmond, *Aphrodite's Island: The European Discovery of Tahiti* (Berkeley, CA, 2009), p. 266.    102. Forster, *Voyage*, p. 178.    103. Ibid., p. 216.    104. Ibid., p. 183.    105. Ibid., p. 184.    106. Ibid., p. 178.    107. Ibid., p. 168.    108. Ibid., p. 201.    109. Ibid., p. 161.    110. Ibid., p. 230.    111. Ibid., p. 217.    112. Lewis de Bougainville, *A Voyage round the World*, tr. John Reinhold Forster (London, 1772), p. 269. Forster senior even politicizes Bougainville's text by substituting 'tyrannical' for 'cruelle': cf. Louis-Antoine de Bougainville, *Voyage autour du monde par la frégate du Roi La Boudeuse et la flûte L'Étoile*, ed. Jacques Proust (Paris, 1982), p. 267.    113. See Ruth Bernard Yeazell, *Harems of the Mind: Passages of Western Art and Literature* (New Haven, 2000).    114. See Jonathan Spence, *The Chan's Great Continent: China in Western Minds* (New York, 1998).    115. On the Jesuit missions, see briefly R. Po-chia Hsia, *The World of Catholic Renewal 1540–1770* (Cambridge, 1998), pp. 186–93; more fully Virgile Pinot, *La Chine et la formation de l'esprit philosophique en France (1640–1740)* (Paris, 1932), pp. 15–39; Liam Matthew Brockey, *Journey to the East: The Jesuit Mission to China, 1579–1724* (Cambridge, MA, 2007); Hsia, *A Jesuit in the Forbidden City: Matteo Ricci, 1552–1610* (Oxford, 2010); Mary Laven, *Mission to China: Matteo Ricci and the Jesuit Encounter with the East* (London, 2011).    116. See D. P. Walker, *The Ancient Theology: Studies in Christian Platonism from the Fifteenth to the Eighteenth Century* (London, 1972), esp. pp. 194–230.    117. On this apparent theism, see Perkins, *Leibniz and China*, pp. 16–17, who discusses the multivalence of the Chinese terms.    118. On the rites controversy, see Pinot, *La Chine*, pp. 71–140.    119. Leibniz, *Writings on China*, ed. Daniel J. Cook and Henry Rosemont, Jr (Chicago, 1994), pp. 46–7.    120. Perkins, *Leibniz and China*, p. 9.    121. Antognazza, *Leibniz*, p. 434; cf. Perkins, *Leibniz and China*, pp. 142–3; Walker, *Ancient Theology*, pp. 220–26. On Leibniz's use of his extensive correspondence to obtain information about China, see Michael C. Carhart, *Leibniz Discovers Asia: Social Networking in the Republic of Letters* (Baltimore, 2019).    122. Locke, *An Essay concerning Human Understanding*, in *The Works of John Locke*, 9 vols. (1794; repr. London, 1997), i. p. 58.    123. Pinot, *La Chine*, p. 325.    124. Jean-Baptiste du Halde, *The General History of China, containing a geographical, historical, chronological, political and physical description of the empire of China, Chinese-Tartary, Corea and Thibet*, tr. Richard Brookes, 4 vols. (London, 1736), iii. p. 16.    125. For a blatant example, see Pinot, *La Chine*, p. 177.    126. Du Halde, *General History*, iii. p. 14.    127. Ibid., ii. p. 224.    128. Ibid., ii. p. 128.    129. See Laven, *Mission*, p. 134.    130. Voltaire, *Essai sur les mœurs*, ed. René Pomeau, 2 vols. (Paris, 1963), i. p. 207.    131. Voltaire, *Dieu et les hommes* (1769), OCV 69, p. 290.    132. François Quesnay, 'Avertissement de l'auteur', *Éphémerides du citoyen* (1767), pp. 3–30 (p. 13). The four-part essay 'Despotisme de la Chine' is in issues 3–6 (March to June 1767).    133. David Allen Harvey, *The French Enlightenment and its Others: The Mandarin, the Savage, and the Invention of the Human Sciences* (Basingstoke, 2012), p. 58; Derek Beales, *Joseph II*, vol. i: *In the Shadow of Maria Theresa, 1741–1780* (Cambridge, 1987), p. 338.    134. Raynal, *Histoire philosophique et politique des établissements et du commerce des Européens dans les deux Indes*, enlarged edn, 10 vols. (Geneva, 1781), i. p. 211. This and some other passages which can confidently be ascribed to Diderot are extracted in OCD xv. pp. 399–580.    135. *Doutes proposés aux philosophes économistes sur l'ordre naturel et essentiel des sociétés politiques*, in Mably, *Collection complète des œuvres*, 15 vols. (Paris, 1794–5), xi. pp. 1–256 (p. 101).    136. Diderot in Raynal,

*Histoire*, i. p. 215.  137. Diderot, ibid., i. p. 209; Mably, *Doutes*, p. 129.  138. Diderot in Raynal, *Histoire*, i. p. 209; cf. Pinot, *La Chine*, p. 415.  139. Mably, *Doutes*, p. 110. 140. Diderot in Raynal, *Histoire*, i. p. 222; cf. Mably, *Doutes*, p. 103. 'Sidney' is the English Republican Algernon Sidney (1623–83).  141. *Biographia Literaria*, in *The Collected Works of Samuel Taylor Coleridge*, ed. Kathleen Coburn, 16 vols. (London, 1971–2001), vii. p. 137. 142. Volney, *The Ruins, or a Survey of the Revolutions of Empires*, tr. anon. (London, 1795), p. 121.  143. Herder, *Werke*, ed. Günter Arnold and others, 10 vols. (Frankfurt a.M., 1985–2000), vi. p. 438.  144. Condorcet, *Esquisse d'un tableau historique des progrès de l'esprit humain*, ed. Monique and François Hincker (Paris, 1971), p. 114.  145. See Niall Ferguson, *Civilization: The Six Killer Apps of Western Power* (London, 2011), pp. 44–9; Mark Elvin, *The Pattern of the Chinese Past* (London, 1973), pp. 298, 314 (inventions), 309 (agriculture).  146. For the Kangxi emperor, see Jonathan Spence, *Emperor of China* (London, 1974); for the Macartney mission, P. J. Marshall and Glyndwr Williams, *The Great Map of Mankind: British Perceptions of the World in the Age of Enlightenment* (London, 1982), pp. 82–3.  147. Montaigne, 'On Coaches', in *The Complete Essays*, tr. M. A. Screech (London, 2003), pp. 1017–37 (p. 1031). Cf. Defoe, *Robinson Crusoe*, ed. Angus Ross (Harmondsworth, 1965), p. 178.  148. Lichtenberg, *Aphorisms*, tr. R. J. Hollingdale (London, 1990), p. 110.  149. Edwin Williamson, *The Penguin History of Latin America*, rev. edn (London, 2009), p. 87.  150. Robertson, *History of America*, 2 vols. (London, 1777), ii. pp. 348–9.  151. Ibid., ii. p. 350.  152. Williamson, *Penguin History*, p. 17.  153. Ibid., pp. 87–8. The 'black legend' is reaffirmed by Benjamin Keen, 'The Black Legend revisited: assumptions and realities', *Hispanic American Historical Review*, 49 (1969), pp. 703–19. 154. See C. R. Boxer, *The Dutch Seaborne Empire 1600–1800* (London, 1965); C. A. Bayly, *Imperial Meridian: The British Empire and the World 1780–1830* (London, 1989). 155. Joachim Whaley, *Germany and the Holy Roman Empire*, 2 vols. (Oxford, 2012), ii. p. 271.  156. See T. M. Devine, *Scotland's Empire 1600–1815* (London, 2003), pp. 44–8.  157. See David Arnold, 'Hunger in the garden of plenty: the Bengal famine of 1770', in Alessa Johns, ed., *Dreadful Visitations: Confronting Natural Catastrophe in the Age of Enlightenment* (New York, 1999), pp. 81–111.  158. Adam Smith, *An Inquiry into the Nature and Causes of the Wealth of Nations*, ed. R. H. Campbell and A. S. Skinner (Oxford, 1976), p. 527.  159. Ibid., p. 91.  160. Ibid., p. 752.  161. Ibid., p. 819.  162. Ibid., p. 626; cf. Smith's *Theory of Moral Sentiments*, ed. D. D. Raphael and A. L. Macfie (Oxford, 1976), pp. 206–7.  163. Kant, 'Toward perpetual peace', tr. Mary J. Gregor, in Immanuel Kant, *Practical Philosophy*, tr. Mary J. Gregor, The Cambridge Edition of the Works of Immanuel Kant (Cambridge, 1996), p. 329; *Werke*, ed. Wilhelm Weischedel, 6 vols. (Darmstadt, 1958), vi. p. 215. Cf. Burke's comprehensive denunciation of the British East India Company in his 'Speech on Fox's India Bill', 1 Dec. 1783, in *The Writings and Speeches of Edmund Burke*, ed. Paul Langford, 9 vols. (Oxford, 1991–2000), v. pp. 378–451 (esp. p. 391), and Jonathan Israel, *Democratic Enlightenment: Philosophy, Revolution, and Human Rights 1750–1790* (Oxford, 2011), pp. 583–608.  164. Montesquieu, *Persian Letters*, p. 218; Mosher, 'Montesquieu', p. 118.  165. Smith, *Wealth of Nations*, p. 562; cf. the many quotations assembled by Emma Rothschild, 'Adam Smith in the British Empire', in Muthu, *Empire and Modern Political Thought*, pp. 184–98 (p. 186).  166. Smith, *Wealth of Nations*, p. 626; see Sankar Muthu, 'Conquest, commerce, and cosmopolitanism in Enlightenment political thought', in Muthu, *Empire and Modern Political Thought*, pp. 199–231 (pp. 210–14).  167. Kant, *Werke*, vi. p. 216.  168. 'The West Indies' here comprehends not only the Caribbean islands, which Raynal calls 'the American archipelago', but the whole of North and South America, as a counterpart to the conventional 'Indies', which in turn refers to all of Asia from India eastwards that was reached by Europeans. Cf. Rameau's ballet *Les Indes galantes* (1735), which is set partly in Turkey, partly in South America.  169. Michèle Duchet, *Anthropologie et histoire au siècle des Lumières* (Paris, 1977), p. 348. On Raynal's methods, see Gianluigi Goggi, 'La méthode de travail de Raynal dans l'*Histoire des deux Indes*', in Hans-Jürgen Lüsebrink and Anthony Strugnell, eds., *L'Histoire des deux Indes: réécriture et polygraphie* (Oxford, 1995), pp. 325–56. Goggi particularly discusses Raynal's use of two major sources, themselves compilations, the abbé Prevost's collection of travel narratives, *Histoire générale*

*des voyages*, and the very popular anonymous English *Universal History*.    170. For Diderot's contributions, see Michèle Duchet, *Diderot et l'Histoire des deux Indes, ou l'écriture fragmentaire* (Paris, 1978).    171. Hans Wolpe, *Raynal et sa machine de guerre: L'Histoire des deux Indes et ses perfectionnements* (Stanford, 1957), p. 13. I have used the edition published at Geneva in 1781, which according to Wolpe is textually identical with that of 1780.    172. Raynal, *Histoire*, viii. pp. 336–7 (on Cook). Some of the revisions and additions are discussed by Wolpe, *Raynal*, pp. 33–57.    173. See Anthony Strugnell, 'Dialogue et désaccord idéologiques entre Raynal et Diderot: les cas des Anglais en Inde', in Lüsebrink and Strugnell, *L'Histoire des deux Indes: réécriture et polygraphie*, pp. 409–22 (p. 412). Strugnell brings out sharply the contrast between Raynal's and Diderot's contributions.    174. Wilson, *Diderot*, pp. 682–3.    175. Text of condemnation quoted by Hans-Jürgen Lüsebrink, ' "Le livre qui fait naître des Brutus . . ." Zur Verhüllung und sukzessiven Aufdeckung der Autorschaft Diderots an der *Histoire des Deux Indes*', in Titus Heydenreich, ed., *Denis Diderot 1713–1784: Zeit – Werk – Wirkung. Zehn Beiträge* (Erlangen, 1984), pp. 107–26 (p. 112). On the book's popularity, see Robert Darnton, *The Forbidden Best-Sellers of Pre-Revolutionary France* (London, 1996), p. 49.    176. C. P. Courtney, 'The art of compilation and the communication of knowledge: the colonial world in Enlightenment histories: the example of Raynal's *Histoire philosophique des deux Indes*', in Hans-Jürgen Lüsebrink, ed., *Das Europa der Aufklärung und die außereuropäische koloniale Welt* (Göttingen, 2006), pp. 39–50 (p. 49).    177. Wolpe, *Raynal*, p. 8. See Israel, *Democratic Enlightenment*, pp. 413–42, for a persuasive appreciation of the *Histoire* as the most important and influential of radical Enlightenment texts.    178. C. P. Courtney, 'L'art de la compilation de l'*Histoire des deux Indes*', in Lüsebrink and Strugnell, *L'Histoire des deux Indes: réécriture et polygraphie*, pp. 307–24 (p. 323).    179. Raynal, *Histoire*, vi. p. 67.    180. Diderot, 'Lettre apologétique de l'Abbé Raynal à Monsieur Grimm' (1781), *OCD* xiii. p. 78.    181. Diderot in Raynal, *Histoire*, iv. pp. 1–2.    182. Diderot, in ibid., vi. pp. 183–94 (against slavery); ix. pp. 221–43.    183. Raynal, *Histoire*, viii. pp. 93–109.    184. Ibid., viii. p. 93. Contrast the much more strictly factual account of the beaver in Pluche, *Le Spectacle de la nature, ou entretiens sur les particularités de l'histoire naturelle*, new edn, vol. 1 (Paris, 1745), pp. 361–70.    185. Raynal, *Histoire*, iii. p. 381.    186. Ibid., v. p. 194; cf. iv. p. 316.    187. Ibid., iii. pp. 381–2.    188. Ibid., iii. pp. 363–4; cf. Robertson's scepticism in his *History of America*, ii. p. 297.    189. Raynal, *Histoire*, viii. p. 32 (Canada), vi. p. 84 (Guinea).    190. Ibid., iv. p. 105. Noting that the Spaniards expected to find Amazons on the Amazon, the text observes that there, if anywhere, one would expect women to free themselves from male tyranny (v. pp. 63–4).    191. Ibid., viii. p. 30.    192. Ibid., x. p. 207.    193. Ibid., iv. p. 159.    194. Ibid., iv. p. 354.    195. Ibid., ii. pp. 209–10.    196. Ibid., vi. p. 126.    197. Ibid., vi. p. 97. Two ex-slaves who wrote their autobiographies, Olaudah Equiano and Ottobah Cugoano, were both kidnapped by fellow-Africans and sold on the coast. See *The Interesting Narrative of the Life of Olaudah Equiano, or Gustavus Vassa, the African, written by himself* (London, 1790); Ottobah Cugoano, *Thoughts and Sentiments on the Evil and Wicked Traffic of the Slavery and Commerce of the Human Species* (London, 1787). Cugoano notes (p. 12) that slaves in Africa are incomparably better treated than plantation slaves in America.    198. Raynal, *Histoire*, vi. p. 148.    199. Ibid., iv. p. 347.    200. Ibid., iv. p. 149.    201. Ibid., vi. pp. 148–50.    202. Diderot, in ibid., iii. pp 290–91.    203. Raynal, *Histoire*, vi. pp. 199–200; Wolpe, *Raynal*, p. 44; C. L. R. James, *The Black Jacobins: Toussaint L'Ouverture and the San Domingo Revolution* ([1938]; London, 2001), pp. 20, 74. Cf. Louis-Sébastien Mercier, *L'An deux mille quatre cent quarante: Rêve s'il en fût jamais*, ed. Raymond Trousson (Paris, 1971), pp. 204–6.    204. Raynal, *Histoire*, ix. p. 335.    205. Voltaire, *Essai*, i. p. 257.    206. Diderot, 'Sarrasins ou Arabes, philosophie de', *Encyclopédie*, xiv. p. 664.    207. See Irwin, *For Lust of Knowing*, pp. 113–22; Alexander Bevilacqua, *The Republic of Arabic Letters: Islam and the European Enlightenment* (Cambridge, MA, 2018).    208. Gibbon, *Decline and Fall*, iii. pp. 176, 184.    209. Ibid., iii. pp. 177, 178, 182.    210. Ibid., iii. p. 185.    211. See the summary of Muhammad's character and career, ibid., iii. pp. 212–14, and the comments by David Womersley, *Gibbon and the 'Watchmen of the Holy City': The Historian and his Reputation 1776–1815* (Oxford, 2002), pp. 169–71.    212. Hermann Samuel

Reimarus, *Apologie oder Schutzschrift für die vernünftigen Verehrer Gottes*, ed. Gerhard Alexander, 2 vols. (Frankfurt a.M., 1972), ii. p. 667.　**213.** Linda Colley, *Captives: Britain, Empire and the World 1600–1850* (London, 2002), p. 122.　**214.** Raynal, *Histoire*, i. p. 17. Even the story that Caliph Omar burned the library of Alexandria is sharply questioned by Gibbon: *Decline and Fall*, iii. p. 285.　**215.** Noel Malcolm, *Useful Enemies: Islam and the Ottoman Empire in Western Political Thought, 1450–1750* (Oxford, 2019), p. 227.　**216.** See Osterhammel, *Entzauberung*, pp. 271–309.　**217.** Harvey, *French Enlightenment*, p. 34. See also Aslı Çırakman, 'From tyranny to despotism: the Enlightenment's unenlightened image of the Turks', *International Journal of Middle East Studies*, 33 (2001), pp. 49–68; and for comparisons of Louis XIV's rule to Turkish 'despotism', R. Koebner, 'Despot and despotism: vicissitudes of a political term', *Journal of the Warburg and Courtauld Institutes*, 15 (1951), pp. 275–302 (pp. 293–302).　**218.** Gibbon, *Decline and Fall*, i. p. 859.　**219.** Ibid., i. p. 166. **220.** Voltaire, 'Commentaire sur L'Esprit des lois' (1777), *OCV* 80B, p. 339; *idem*, *Essai*, i. p. 832. See Malcolm, *Useful Enemies*, pp. 391, 397.　**221.** William Robertson, *An Historical Disquisition concerning the Knowledge which the Ancients had of India* (London, 1791), p. 266.　**222.** Abraham-Hyacinthe Anquetil-Duperron, *Législation orientale* (Amsterdam, 1778), p. 29.　**223.** Ibid., p. 37.　**224.** Ibid., p. 18. Cf. Osterhammel, *Entzauberung*, pp. 293–6. **225.** Conrad, 'Enlightenment in global history', notes that 'the spread of Enlightenment tenets' has often been criticized as 'a process of coerced and oftentimes brutal diffusion', but makes clear that this critique applies primarily to the nineteenth century (p. 1006).　**226.** Burke, 'Speech on Fox's India Bill', 1 Dec. 1783, in *Writings and Speeches*, v. pp. 378–451 (p. 389).　**227.** Ibid., v. pp. 389–90.　**228.** Quoted in Michael J. Franklin, *Orientalist Jones: Sir William Jones, Poet, Lawyer, and Linguist, 1746–1794* (Oxford, 2011), p. 213.　**229.** See Ian Woodfield, '"The Hindostannie air": English attempts to understand Indian music in the late eighteenth century', *Journal of the Royal Musical Association*, 119 (1994), pp. 189–221.　**230.** Quoted in P. J. Marshall, *The Impeachment of Warren Hastings* (Oxford, 1965), p. 181.　**231.** See E. M. Collingham, *Imperial Bodies: The Physical Experience of the Raj, c. 1800–1947* (Cambridge, 2001), pp. 159–61.　**232.** Franklin, *Orientalist Jones*, pp. 206–49.　**233.** Letter to the second Earl Spencer, 4–30 Aug. 1787, in *The Letters of Sir William Jones*, ed. Garland Cannon, 2 vols. (Oxford, 1970), ii. pp. 755–6.　**234.** Franklin, *Orientalist Jones*, pp. 251–86.　**235.** Robertson, *Historical Disquisition*, p. 271; for an appreciation of his work on India, see Geoffrey Carnall, 'Robertson and contemporary images of India', in Stewart J. Brown, ed., *William Robertson and the Expansion of Empire* (Cambridge, 1997), pp. 210–30.　**236.** Quoted in P. J. Marshall, *Problems of Empire: Britain and India 1757–1813* (London, 1968), p. 70.　**237.** Quoted ibid., p. 189.　**238.** Thomas Babington Macaulay, 'Minute on Indian Education', in his *Selected Writings*, ed. John Clive and Thomas Pinney (Chicago, 1972), pp. 237–51 (p. 241). For a sympathetic account of Macaulay's policies, see Zareer Masani, *Macaulay: Pioneer of India's Modernization* (London, 2012).　**239.** *Discourse on the Method*, in *The Philosophical Works of Descartes*, tr. John Cottingham, Robert Stoothoff and Dugald Murdoch, 2 vols. (Cambridge, 1985), i. p. 113. **240.** Hume, 'Of the Standard of Taste', *Essays*, p. 245. This had long been a commonplace in critiques of Homer: see e.g. Alessandro Tassoni, *Pensieri diversi* (1620), in *La secchia rapita: Rime e prose scelte*, ed. Giovanni Ziccardi (Turin, 1952), p. 458; *OCV* 3B, pp. 414–15. **241.** See *The Republic*, 390e–391c, in *The Dialogues of Plato*, tr. B. Jowett, 4 vols. 4th edn (Oxford, 1953), ii. pp. 236–7.　**242.** Hume, 'Of the Standard of Taste', *Essays*, p. 246. **243.** Smith, *Theory*, p. 207.　**244.** Adam Ferguson, *An Essay on the History of Civil Society*, ed. Duncan Forbes (Edinburgh, 1966), p. 101.　**245.** Joseph-François Lafitau, *Mœurs des sauvages amériquains, comparées aux mœurs des premiers temps*, 2 vols. (Paris, 1724); for his place in the history of ethnography, see Moravia, *La scienza dell'uomo*, esp. pp. 155–6.　**246.** 'Über das Gefühl des Schönen und Erhabenen', in Kant, *Werke*, i. p. 881.　**247.** Thomas Blackwell, *An Enquiry into the Life and Writings of Homer* (London, 1735), p. 103. **248.** On the reinterpretation of Homer, see Kirsti Simonsuuri, *Homer's Original Genius* (Cambridge, 1979).　**249.** Quoted in Fiona J. Stafford, *The Sublime Savage: A Study of James Macpherson and the Poems of Ossian* (Edinburgh, 1988), p. 7.　**250.** Franco Moretti, *Atlas of the European Novel, 1800–1900* (London, 1998), p. 38.　**251.** Quoted in Larry Wolff,

*Venice and the Slavs: The Discovery of Dalmatia in the Age of Enlightenment* (Stanford, 2001), p. 131. **252.** Quoted ibid., p. 132. **253.** Alberto Fortis, *Travels into Dalmatia* (London, 1778), p. 53. **254.** Ibid., p. 56. **255.** Ibid., p. 86; Albert B. Lord, *The Singer of Tales* (Cambridge, MA, 1960); Robert Fowler, 'The Homeric question', in Fowler, ed., *The Cambridge Companion to Homer* (Cambridge, 2004), pp. 220-32. **256.** Fortis, *Travels*, p. 84. **257.** See Stafford, *Sublime Savage*, p. 97. **258.** Cf. Prys Morgan, 'From a death to a view: the hunt for the Welsh past in the Romantic period', in Eric Hobsbawm and Terence Ranger, eds., *The Invention of Tradition* (Cambridge, 1983), pp. 43-100 (on Hanka, p. 99). **259.** See Stafford, *Sublime Savage*, pp. 90-91. **260.** *The Complete Poems of Thomas Gray*, ed. H. W. Starr and J. R. Hendrickson (Oxford, 1966), p. 18. **261.** Quoted in Kevin J. Hayes, *The Road to Monticello: The Life and Mind of Thomas Jefferson* (New York, 2008), p. 134. **262.** See Derick S. Thomson, 'Gaelic poetry in the eighteenth century: the breaking of the mould', in Cairns Craig, ed., *The History of Scottish Literature*, 4 vols. (Aberdeen, 1987), ii. pp. 175-90. These poets are more properly called Donnchadh Bàn Mac an t-Saoir and Alasdair Mac Mhaighstir Alasdair. **263.** Goethe's translations are in his letter to Herder, Sept. 1771, *Sämtliche Werke*, xxviii. pp. 240-45; see Caitríona Ó Dochartaigh, 'Goethe's translation from the Gaelic *Ossian*', in Howard Gaskill, ed., *The Reception of Ossian in Europe* (London, 2004), pp. 156-75. **264.** See Peter Burke, *Popular Culture in Early Modern Europe* (London, 1978), ch. 1. **265.** *Spectator*, no. 70, 21 May 1711. **266.** See Bertram H. Davis, *Thomas Percy: A Scholar-Cleric in the Age of Johnson* (Philadelphia, 1989). **267.** Herder, *Werke*, iii. p. 359. **268.** *Spectator*, no. 69, 19 May 1711. **269.** Kleingeld, 'Six varieties', p. 515. **270.** See Hans Adler, 'Herder's concept of *Humanität*', in Hans Adler and Wulf Koepke, eds., *A Companion to the Works of Johann Gottfried Herder* (Rochester, NY, 2009), pp. 93-116. **271.** Herder, *Werke*, vi. pp. 154-64. I have adapted here some sentences from my '*Humanität, Bildung, Kultur*: Germany's civilising values', in Sarah Colvin, ed., *The Routledge Handbook of German Politics and Culture* (London, 2015), pp. 20-33. **272.** Herder, *Werke*, vi. p. 144. On the various implications of *Bildung* (education, cultivation, development) see W. H. Bruford, *The German Tradition of Self-Cultivation: 'Bildung' from Humboldt to Thomas Mann* (Cambridge, 1975). **273.** Herder, *Werke*, vi. p. 342. **274.** 'Diversität der Menschheit', ibid., vi. p. 250; noted by Pauline Kleingeld, *Kant and Cosmopolitanism: The Philosophical Ideal of World Citizenship* (Cambridge, 2012), p. 108n. **275.** Herder, *Werke*, vi. p. 633. **276.** Ibid., vi. p. 655. **277.** This common misunderstanding of Herder is corrected in Isaiah Berlin, *Vico and Herder* (London, 1976), p. 153. **278.** Herder, *Werke*, vi. p. 569. **279.** Ibid., vi. p. 892. **280.** Georg Forster, 'Über lokale und allgemeine Bildung', in his *Werke*, vii. pp. 45-56 (p. 47). **281.** Ibid., vii. p. 48. **282.** Ibid., vii. pp. 55-6. **283.** Forster, 'Vorwort des Übersezers', in his *Werke*, vii. pp. 285-6 (p. 286). **284.** 'Notes on the lectures of Mr. Kant on the metaphysics of morals', taken by Johann Friedrich Vigilantius, in *Lectures on Ethics*, ed. Peter Heath and J. B. Schneewind, tr. Peter Heath, The Cambridge Edition of the Works of Immanuel Kant (Cambridge, 1997), p. 406. **285.** Ibid. **286.** See Kant, *Werke*, i. p. 880, vi. p. 23 (discussed in Chapter 6). For differing views on his possible disavowal of racism, see Kleingeld, *Kant*, pp. 111-17; Robert Bernasconi, 'Kant's third thoughts on race', in Stuart Elden and Eduardo Mendieta, eds., *Reading Kant's Geography* (Albany, NY, 2011), pp. 291-318. **287.** Kant, *Metaphysik der Sitten*, *Werke*, iv. pp. 476-7. **288.** Herder, *Werke*, vi. p. 639. **289.** Ibid., vi. p. 623. **290.** Kant, *Werke*, iv. p. 477. **291.** 'Reviews of Herder's *Ideas on the Philosophy of the History of Mankind*', in Kant, *Political Writings*, ed. Hans Reiss, tr. H. B. Nisbet, 2nd edn (Cambridge, 1991), pp. 219-20 (p. 219). Cf. Herder, *Werke*, vi. pp. 368-9. **292.** Kant, *Political Writings*, pp. 219-20; *Werke*, vi. p. 805. **293.** Kant, *Political Writings*, p. 219; *Werke*, vi. p. 804. Cf. *Political Writings*, p. 45.

## 13. FORMS OF GOVERNMENT

**1.** Alexander Pope, *An Essay on Man*, in *TE* iii/1. pp. 123-4. **2.** Goethe, *Egmont*, in *Sämtliche Werke: Briefe, Tagebücher und Gespräche*, ed. Friedmar Apel and others, 40 vols. (Frankfurt a.M., 1986-2000), v. pp. 486-7. **3.** Kant, 'On the Common Saying: "This May be True

in Theory, but it does not Apply in Practice"', in *Political Writings*, ed. Hans Reiss, tr. H. B. Nisbet, 2nd edn (Cambridge, 1991), p. 74. **4.** Thomas Jefferson, quoted in Fawn M. Brodie, *Thomas Jefferson: An Intimate History* ([1974]; New York, 2010), p. 45. **5.** Wilhelm von Humboldt, *The Limits of State Action* [1791–2], ed. J. W. Burrow (Cambridge, 1969), p. 22. **6.** Gibbon, *The History of the Decline and Fall of the Roman Empire*, ed. David Womersley, 3 vols. (London, 1994), i. p. 85. **7.** Ibid., i. p. 187. **8.** Ibid., i. pp. 129–37. **9.** Hume, 'Of the Protestant Succession', in *Essays Moral, Political, and Literary*, ed. Eugene F. Miller (Indianapolis, 1987), pp. 502–11 (p. 503). **10.** Bayle, 'Bourgogne', remark A, *Dictionnaire historique et critique*, 4 vols. (Amsterdam, 1730), i. p. 636. **11.** On its history, see Anthony Pagden, *The Enlightenment and Why It Still Matters* (Oxford, 2013), pp. 250–53. **12.** Shakespeare, *Hamlet*, IV, v, 123–4. **13.** Quoted in Tim Blanning, *The Pursuit of Glory: Europe 1648–1815* (London, 2007), p. 208. **14.** Nannerl O. Keohane, *Philosophy and the State in France: The Renaissance to the Enlightenment* (Princeton, 1980), pp. 252–5. **15.** Louis XIV, *Mémoires for the Instruction of the Dauphin*, tr. Paul Sonnino (New York, 1970), pp. 42, 63–7. **16.** Hobbes, *Leviathan*, ed. J. C. A. Gaskin (Oxford, 1996), pp. 123–32. **17.** Hume, 'Whether the British Government Inclines More to Absolute Monarchy or to a Republic', *Essays*, pp. 47–53 (p. 51). **18.** Henry St John, Viscount Bolingbroke, *Letters, on the Spirit of Patriotism; on the Idea of a Patriot King; and on the State of Parties, at the Accession of King George the First* (London, 1749), p. 94. **19.** Gibbon, *Decline and Fall*, i. p. 85. **20.** Montesquieu, *The Spirit of the Laws*, ed. and tr. Anne M. Cohler, Basia C. Miller and Harold S. Stone (Cambridge, 1989), p. 56 (V, 10). See Michael Mosher, 'Free trade, free speech, and free love: monarchy from the liberal prospect in mid-eighteenth century France', in Hans Blom, John Christian Laursen and Luisa Simonutti, eds., *Monarchisms in the Age of Enlightenment: Liberty, Patriotism, and the Common Good* (Toronto, 2007), pp. 101–18 (esp. p. 106). **21.** See Montesquieu, *Spirit*, p. 57 (V, 11), 'On the excellence of monarchical government'; Daniel Roche, *France in the Enlightenment*, tr. Arthur Goldhammer (Cambridge, MA, 1998), pp. 252–5. **22.** Gibbon, *Decline and Fall*, i. p. 85. **23.** W. H. Bruford, *Germany in the Eighteenth Century: The Social Background of the Literary Revival* (Cambridge, 1935), pp. 22–3. For debates over 'absolutism', and a qualified rehabilitation of the concept, see Peter H. Wilson, *Absolutism in Central Europe* (New York, 2000). **24.** St Augustine, *Concerning the City of God against the Pagans*, tr. Henry Bettenson (London, 1984), p. 220 (Bk V, ch. 24). On this genre, see Bernard Guénée, *States and Rulers in Later Medieval Europe*, tr. Juliet Vale (Oxford, 1985), pp. 69–74; Wolfgang Biesterfeld, *Der Fürstenspiegel als Roman: Narrative Texte zur Ethik und Pragmatik von Herrschaft im 18. Jahrhundert* (Baltmannsweiler, 2014). **25.** François de Fénelon, *Les Aventures de Télémaque*, ed. Jeanne-Lydie Goré (Paris, 1968), p. 505; Fénelon, *Telemachus, Son of Ulysses*, ed. and tr. Patrick Riley (Cambridge, 1994), p. 332. **26.** Voltaire, *Letters concerning the English Nation*, ed. Nicholas Cronk (Oxford, 1994), p. 34. **27.** Montesquieu, 'On the constitution of England', in *Spirit*, pp. 156–66 (XI, 6). For the distinction between separation of powers and mixed government, see Robert Shackleton, *Montesquieu: A Critical Biography* (Oxford, 1961), pp. 298–9. **28.** Roy Porter, *English Society in the Eighteenth Century*, rev. edn (London, 1991), p. 108. **29.** Quoted in Stephen Gill, *William Wordsworth: A Life* (Oxford, 1989), p. 363. **30.** Adam Ferguson, *An Essay on the History of Civil Society*, ed. Duncan Forbes (Edinburgh, 1966), p. 272. **31.** Raynal, *Histoire philosophique et politique des établissements et du commerce des Européens dans les deux Indes*, enlarged edn, 10 vols. (Geneva, 1781), i. p. 11. **32.** Diderot, 'Essai sur la vie de Sénèque le philosophe, sur ses écrits, et sur les règnes de Claude et de Néron' (1779), OCD xii. pp. 509–744 (p. 524). **33.** Quoted in Derek Beales, *Enlightenment and Reform in Eighteenth-Century Europe* (London, 2005), pp. 49–50. **34.** Gibbon, *Decline and Fall*, i. p. 103. **35.** Cesare Beccaria, *On Crimes and Punishments and Other Writings*, ed. Richard Bellamy (Cambridge, 1995), pp. 71–2. **36.** See H. M. Scott, 'Introduction: the problem of enlightened absolutism', in Scott, ed., *Enlightened Absolutism: Reform and Reformers in Later Eighteenth-Century Europe* (London, 1990), pp. 1–35; Joachim Whaley, *Germany and the Holy Roman Empire*, 2 vols. (Oxford, 2012), ii. pp. 447–52. **37.** Wilhelm Roscher, *Geschichte der National-Ökonomik in Deutschland* (Munich, 1874), pp. 380–81. **38.** Frederick of Prussia, *The*

*Refutation of Machiavelli's 'Prince' or Anti-Machiavel*, tr. and ed. Paul Sonnino (Athens, OH, 1981), p. 34. Frederick originally wrote 'le premier domestique', but Voltaire changed it in the published version to 'magistrat': *L'Anti-Machiavel, par Frédéric II, roi de Prusse*, ed. Charles Fleischauer (Oxford, 1958), p. 175.   39. See T. C. W. Blanning, *Reform and Revolution in Mainz 1743-1803* (Cambridge, 1974), pp. 97-107; Friedrich Sengle, *Wieland* (Stuttgart, 1949), p. 142.   40. See the series of antitheses between the two in Voltaire, *Histoire de Charles XII*, in *Œuvres historiques*, ed. René Pomeau (Paris, 1957), pp. 161-2. 41. Voltaire, *La Russie sous Pierre le Grand*, in *Œuvres historiques*, p. 469.   42. Valentin Boss, *Newton in Russia: The Early Influence, 1698-1796* (Cambridge, MA, 1972), pp. 13-15.   43. Voltaire, *Histoire de Charles XII*, in *Œuvres historiques*, pp. 125-6.   44. Lindsey Hughes, *Russia in the Age of Peter the Great* (New Haven, 1998), pp. 210-24.   45. Ibid., pp. 180-85; Blanning, *Pursuit of Glory*, p. 236.   46. Voltaire, *Œuvres historiques*, p. 576. See Steele, *Spectator*, 9 August 1711. For Peter and foreigners, see Hughes, *Russia*, p. 251; Anthony Cross, *By the Banks of the Neva: Chapters from the Lives and Careers of the British in Eighteenth-Century Russia* (Cambridge, 1997).   47. Voltaire, *Œuvres historiques*, p. 346. 48. Marc Raeff, *The Well-Ordered Police State: Social and Institutional Change through Law in the Germanies and Russia, 1600-1800* (New Haven, 1983), p. 215.   49. James Thomson, *The Seasons*, ed. James Sambrook (Oxford, 1981), p. 248 (added in the edition of 1744). See Anthony Cross, 'Petrus Britannicus: the image of Peter the Great in eighteenth-century Britain', in Maria Di Salvo and Lindsey Hughes, eds., *A Window on Russia: Papers from the V International Conference of the Study Group on Eighteenth-Century Russia, Gargnano 1994* (Rome, 1996), pp. 3-9.   50. Hughes, *Russia*, p. 454.   51. Voltaire, letter to Frederick II, 25 April 1738, OCV 89, p. 95.   52. Voltaire, letter to Ivan Ivanovich Shuvalov, 7 Aug. 1757, OCV 102, p. 121.   53. See quotations from d'Alembert and others in Albert Lortholary, *Le Mirage russe en France au XVIIIᵉ siècle* (Paris, 1951), pp. 50-51.   54. Sir Nathaniel Wraxall, *A Tour through some of the Northern Parts of Europe, particularly Copenhagen, Stockholm, and Petersburgh*, 3rd edn (London, 1776), p. 216.   55. Ibid., pp. 197, 220.   56. Quotation from Isabel de Madariaga, *Russia in the Age of Catherine the Great* (London, 1981), p. 305.   57. See e.g. Lortholary, *Mirage*, esp. pp. 81, 104, 128; Lionel Kochan, *The Making of Modern Russia* (Harmondsworth, 1963), pp. 131-6.   58. This is how de Madariaga interprets her reaction to Diderot: *Russia*, p. 340; cf. Arthur M. Wilson, *Diderot* (New York, 1972), p. 640.   59. *The Works of Bernard Shaw*, 33 vols. (London, 1930-38), xv. pp. 193, 197.   60. De Madariaga, *Russia*, p. 152.   61. Count Nikita Panin, quoted in Simon Dixon, *Catherine the Great* (London, 2009), p. 172.   62. De Madariaga, *Russia*, pp. 152-3; Ian Simpson Ross, *The Life of Adam Smith* (Oxford, 1995), p. 132. They also transmitted the 'four stages' theory to Russia: see the quotation from a lecture given at Moscow University in 1781, in Ronald L. Meek, *Social Science and the Ignoble Savage* (Cambridge, 1966), p. 5.   63. De Madariaga, *Russia*, p. 127.   64. Quoted in Lurana Donnels O'Malley, *The Dramatic Works of Catherine the Great: Theatre and Politics in Eighteenth-Century Russia* (Aldershot, 2006), p. 10. Cf. Schiller, 'Was kann eine gute stehende Schaubühne eigentlich wirken?', in his *Sämtliche Werke*, ed. Gerhard Fricke and Herbert G. Göpfert, 5 vols. (Munich, 1958), v. pp. 818-31.   65. For Catherine's epistolary talents, see Voltaire and Catherine II of Russia, *Correspondance 1763-1778*, ed. Alexandre Stroev (Paris, 2006). I am grateful to Andrew Kahn and Kelsey Rubin-Detlev for allowing me to read in advance their introduction to their selection from Catherine's letters, now available as Catherine the Great, *Selected Letters* (Oxford, 2018).   66. Lortholary, *Mirage*, p. 87: 'partie de louanges'.   67. See Voltaire, letter to the comtesse d'Argental, 13 Aug. 1763, OCV 110, p. 352.   68. On Catherine and the *philosophes*, see de Madariaga, *Russia*, pp. 335-41; Wilson, *Diderot*, pp. 629-45.   69. On Pugachev, see de Madariaga, *Russia*, pp. 239-55; on official secrecy, Wilson, *Diderot*, p. 641.   70. Voltaire, *Essai historique sur les dissensions des églises de Pologne* (1767), OCV 63A, pp. 265-89 (p. 289).   71. Diderot, letter to Falconet, 6 Sept. 1768, OCD vii. p. 739; de Madariaga, *Russia*, p. 231.   72. Voltaire, letter to Catherine II, 26 Feb. 1769, OCV 118, p. 303; also in *Correspondance*, ed. Stroev, pp. 75-7. Cf. his 'Épître à l'Impératrice de Russie' (1771), OCV 73, pp. 444-7.   73. Voltaire, letter to Frederick II, 15 Feb. 1775, OCV 125, p. 334.   74. Tim Blanning, *Frederick the Great,*

*King of Prussia* (London, 2015), pp. 371–2. 75. On the question of Frederick's homosexuality, see ibid., pp. 64–71. 76. *Histoire du Docteur Akakia et du natif de Saint-Malo*, O C V 32C, pp. 121–41. Cf. Chapter 7 above. 77. For an entertaining, circumstantial and mordant narrative of this affair, see Thomas Carlyle, *History of Friedrich II. of Prussia, called Frederick the Great*, 6 vols. in 3 (London, [1896?]), iv. pp. 411–22; more briefly, Ian Davidson, *Voltaire: A Life*, rev. edn (London, 2012), pp. 265–6. 78. On this text as manifesto, see Theodor Schieder, *Frederick the Great*, ed. and tr. Sabina Berkeley and H. M. Scott (London, 2000), pp. 75–83. 79. Frederick of Prussia, *Refutation*, p. 90. 80. Ibid., p. 110. 81. Ibid., pp. 160–61. 82. Ibid., p. 58. 83. Isaac Nakhimovsky, 'The enlightened prince and the future of Europe: Voltaire and Frederick the Great's Anti-Machiavell of 1740', in Béla Kapossy, Isaac Nakhimovsky and Richard Whatmore, eds., *Commerce and Peace in the Enlightenment* (Cambridge, 2017), pp. 44–77 (p. 46). 84. *Histoire de mon temps*, in *Œuvres de Frédéric le Grand*, ed. J. D. E. Preuss, 33 vols. (Berlin, 1846–57), ii. p. 59. On Frederick's likely motives, see David Fraser, *Frederick the Great, King of Prussia* (London, 2000), pp. 69–70; Christopher Clark, *Iron Kingdom: The Rise and Downfall of Prussia 1600–1947* (London, 2006), pp. 190–93. 85. Blanning, *Frederick*, pp. 36–7. 86. Clark, *Iron Kingdom*, p. 204. 87. Schiller, *Sämtliche Werke*, v. p. 925. The estimate of deaths comes from H. M. Scott, '1763–1786: the second reign of Frederick the Great?', in Philip G. Dwyer, ed., *The Rise of Prussia 1700–1830* (Harlow, 2000), pp. 177–200 (p. 193). 88. Rousseau, letter to Toussaint-Pierre Lenieps, 4 Dec. 1758, *Correspondance complète de Jean-Jacques Rousseau*, ed. R. A. Leigh, 52 vols. (Geneva, 1965–98), v. pp. 247–8. 89. Herder, *Journal meiner Reise im Jahre 1769*, in his *Werke*, ed. Günter Arnold and others, 10 vols. (Frankfurt a.M., 1985–2000), ix/2. p. 71. 90. Quoted in Blanning, *Frederick*, pp. 342–3. 91. Goethe, *Dichtung und Wahrheit*, in *Sämtliche Werke*, xiv. pp. 306–7. See Katrin Kohl, 'Hero or villain? The response of German authors to Frederick the Great', *Publications of the English Goethe Society*, 81 (2012), pp. 51–72. 92. T. J. Reed, *Light in Germany: Scenes from an Unknown Enlightenment* (Chicago, 2015), p. 16. 93. See Beales, *Enlightenment and Reform*, pp. 182–5. 94. C. A. Macartney, *The Habsburg Empire 1790–1918* (London, 1969), p. 2. 95. See T. C. W. Blanning, *Joseph II* (London, 1994), pp. 10–21. 96. Jean-François Georgel, *Mémoires pour servir à l'histoire des événemens de la fin du dix-huitième siècle depuis 1760 jusqu'en 1806–1810*, 6 vols. (Paris, 1820), ii. p. 368. 97. Derek Beales, *Joseph II*, vol. ii: *Against the World, 1780–1790* (Cambridge, 2009), p. 41. Cf. Joseph's famous 'pastoral letter' of 1783, discussed with extensive quotations, ibid., pp. 345–52. 98. See Elisabeth Kovács, *Der Pabst in Teutschland: Die Reise Pius VI. im Jahre 1782* (Vienna, 1983); Beales, *Joseph II*, ii. pp. 214–38. 99. See Frederick of Prussia, *Refutation*, pp. 94–7; Blanning, *Pursuit of Glory*, pp. 393–407. 100. [Franz Gräffer], *Josephinische Curiosa*, 3 vols. (Vienna, 1848), i. pp. 333–4. 101. Quoted from Beales, *Joseph II*, ii. p. 325. 102. Blanning, *Joseph II*, p. 62. 103. Decree of 1 August 1781, quoted in Paul von Mitrofanov, *Joseph II: Seine politische und kulturelle Tätigkeit*, tr. V. von Demelic (Vienna, 1910), p. 271. 104. Paul P. Bernard, *From the Enlightenment to the Police State: The Public Life of Johann Anton Pergen* (Urbana, IL, 1991), p. 132. 105. Beales, *Joseph II*, ii. p. 191. 106. Quoted in Blanning, *Joseph II*, p. 161. See Beales, *Joseph II*, ii. pp. 89–99. 107. See Leslie Bodi, *Tauwetter in Wien: Zur Prosa der österreichischen Aufklärung, 1781–1795*, 2nd edn (Vienna, 1995), esp. pp. 117–78; on Eybel, David Sorkin, *The Religious Enlightenment: Protestants, Jews, and Catholics from London to Vienna* (Princeton, 2008), pp. 215–59. 108. Beales, *Joseph II*, ii. pp. 598–9, who however gives evidence that Joseph remained fundamentally liberal. 109. Caroline Pichler, *Denkwürdigkeiten aus meinem Leben*, ed. Emil Karl Blümml, 2 vols. (Munich, 1914), i. p. 63. On Joseph's rudeness, see Beales, *Joseph II*, ii. p. 43. 110. See Joseph's heart-rending letter to his brother Leopold, 21 and 28 Jan. 1790, quoted in Beales, *Joseph II*, ii. p. 628. 111. This account largely follows Dino Carpanetto and Giuseppe Ricuperati, *Italy in the Age of Reason 1685–1789*, tr. Caroline Higgitt (London, 1987), pp. 210–21, and Blanning, *Pursuit of Glory*, pp. 259–60. 112. Carpanetto and Ricuperati, *Italy*, p. 213; Robert Darnton, *The Business of Enlightenment: A Publishing History of the 'Encyclopédie' 1775–1800* (Cambridge, MA, 1979), p. 34. 113. On Leopold as emperor, see Macartney, *Habsburg Empire*,

pp. 134–46.  114. Kenneth Maxwell, *Pombal: Paradox of the Enlightenment* (Cambridge, 1995), p. 17.  115. See ibid., pp. 24–35; cf. A. J. Youngson, *The Making of Classical Edinburgh* (Edinburgh, 1966).  116. Thomas Munck, 'The Danish reformers', in Scott, ed., *Enlightened Absolutism*, pp. 245–63 (p. 251). On Struensee and press freedom, see Jonathan Israel, 'Northern varieties: contrasting the Dano-Norwegian and the Swedish-Finnish Enlightenments', in Ellen Krefting, Aina Nøding and Mona Ringvej, eds., *Eighteenth-Century Periodicals as Agents of Change: Perspectives on Northern Enlightenment* (Leiden, 2015), pp. 17–45 (pp. 32–8); also Israel's *The Enlightenment that Failed: Ideas, Revolution, and Democratic Defeat, 1748–1830* (Oxford, 2019), pp. 229–34. On Struensee's medical reforms, see Egill Snorrason, *Johann Friedrich Struensee: Læge og Geheimestatsminister* (Copenhagen, 1968).  117. Blanning, *Frederick*, pp. 125–6.  118. Nicholas V. Riasanovsky, *The Image of Peter the Great in Russian History and Thought* (New York, 1985), p. 9.  119. Ute Frevert, *Gefühlspolitik: Friedrich II. als Herr über die Herzen?* (Göttingen, 2012), p. 70.  120. Lord Stormont, quoted in Beales, *Joseph II*, vol. i: *In the Shadow of Maria Theresa, 1741–1780* (Cambridge, 1987), p. 308.  121. Johann Pezzl, *Charakteristik Joseph des Zweiten*, 3rd edn (Vienna, 1803), p. 206.  122. Charles C. Noel, 'Charles III of Spain', in Scott, ed., *Enlightened Absolutism*, pp. 119–43 (p. 126).  123. Hughes, *Russia*, p. 409.  124. *The Memoirs of Catherine the Great*, ed. Dominique Maroger, tr. Moura Budberg (London, 1955), pp. 25, 64.  125. Pichler, *Denkwürdigkeiten*, i. pp. 122–5.  126. Letter of 25 July 1768, *Maria Theresia und Joseph II. Ihre Correspondenz sammt Briefen Joseph's an seinen Bruder Leopold*, ed. Alfred Ritter von Arneth, 3 vols. (Vienna, 1867–8), i. p. 225.  127. Quoted in Hughes, *Russia*, p. 341.  128. *Examen de l'essai sur les préjugés*, in *Œuvres de Frédéric le Grand*, ix. pp. 131–52 (p. 138).  129. Elena Smilianskaia, 'The battle against superstition in eighteenth-century Russia: between "rational" and "spiritual" ', in Paschalis M. Kitromilides, ed., *Enlightenment and Religion in the Orthodox World* (Oxford, 2016), pp. 141–55 (p. 144).  130. P. G. M. Dickson, 'Joseph II's reshaping of the Austrian Church', *Historical Journal*, 36 (1993), pp. 89–114 (p. 96); Derek Beales, *Prosperity and Plunder: European Catholic Monasteries in the Age of Revolution, 1650–1815* (Cambridge, 2003), p. 180; Pezzl, *Charakteristik*, p. 72.  131. See the speech by Anselm von Edling, abbot of St Paul in Carinthia, welcoming the dissolution of his own monastery, in Erich Nussbaumer, *Geistiges Kärnten: Literatur- und Geistesgeschichte des Landes* (Klagenfurt, 1956), pp. 244–5.  132. Maxwell, *Pombal*, p. 91.  133. See Richard Herr, *The Eighteenth-Century Revolution in Spain* (Princeton, 1958), p. 21.  134. See Cross, *By the Banks of the Neva*, pp. 174–5.  135. Hughes, *Russia*, pp. 301–4.  136. Quoted in Rudolf Kink, *Geschichte der kaiserlichen Universität in Wien*, 2 vols. (Vienna, 1854), i. p. 516.  137. Blanning, *Joseph II*, pp. 68–9; Beales, *Joseph II*, ii. p. 311.  138. Blanning, *Joseph II*, pp. 69–70; Beales, *Joseph II*, ii. pp. 308–9.  139. *Examen de l'essai sur les préjugés*, in *Œuvres de Frédéric le Grand*, ix. p. 132; Blanning, *Frederick*, pp. 410–11; James van Horn Melton, *Absolutism and the Eighteenth-Century Origins of Compulsory Schooling in Prussia and Austria* (Cambridge, 1988), p. 156.  140. Kant, 'An Answer to the Question: "What is Enlightenment?"', in *Political Writings*, p. 59. See Blanning, *Frederick*, pp. 322–5.  141. Robert Darnton, 'In search of the Enlightenment: recent attempts to create a social history of ideas', *Journal of Modern History*, 43 (1971), pp. 113–32 (p. 122).  142. Andreas Pečar, *Die Masken des Königs: Friedrich II. von Preußen als Schriftsteller* (Frankfurt a.M., 2016).  143. Carlyle, *History of Friedrich II.*, i. p. 435.  144. Blanning, *Reform and Revolution*, pp. 33–7, 16–19.  145. This and other forgeries are detected by Beales, 'The false Joseph II', in his *Enlightenment and Reform*, pp. 117–54.  146. Quoted in Beales, *Enlightenment and Reform*, p. 129.  147. See Beales, 'Christians and *philosophes*: the case of the Austrian Enlightenment', in *Enlightenment and Reform*, pp. 60–89.  148. Beales, *Joseph II*, i. p. 382.  149. Letter to Wolff, 23 May 1740, in *Œuvres de Frédéric le Grand*, xvi. p. 208.  150. *Nakaz*, §520, in Paul Dukes, ed., *Russia under Catherine the Great*, 2 vols. (Newtonville, 1978), ii: *Catherine the Great's Instruction (Nakaz) to the Legislative Commission, 1767*, pp. 107–8.  151. Quoted in Beales, *Enlightenment and Reform*, p. 41.  152. Quoted in Hughes, *Russia*, p. 386.  153. Pezzl, *Charakteristik*, p. 223.  154. Isaiah Berlin, 'Two concepts of liberty', in his *Liberty*, ed. Henry Hardy (Oxford, 2002), pp. 166–217 (pp. 178–81).

155. Dukes, ed., *Russia*, ii. p. 44.   156. Helvétius, *L'Homme*, quoted in Diderot, 'Réfutation d'Helvétius', *OCD* xi. p. 574.   157. *OCD* xi. p. 574.   158. Ibid., xi. p. 575.   159. Hume, 'Of Civil Liberty', *Essays*, p. 94.   160. See Aristotle, *Politics*, tr. Ernest Barker, ed. R. F. Stalley (Oxford, 1995), p. 10.   161. Thucydides, *The Peloponnesian War*, tr. Rex Warner (Harmondsworth, 1954), pp. 118–19.   162. See Quentin Skinner, *Liberty before Liberalism* (Cambridge, 1998), p. 54; Alan Ryan, *On Politics: A History of Political Thought from Herodotus to the Present* (London, 2012), pp. 498–9; but contrast David Wootton, *Power, Pleasure and Profit: Insatiable Appetites from Machiavelli to Madison* (Cambridge, MA, 2018), p. 303. Machiavelli acknowledges the possibility of freedom under a prince, but thinks such freedom likely only to be short-lived: *The Discourses*, tr. Leslie J. Walker (London, 1950), p. 468 (III, 5).   163. Quoted in Michael Roberts, *The Age of Liberty: Sweden 1719–1772* (Cambridge, 1986), p. 59. For other eulogies by *philosophes*, see Israel, 'Northern varieties', p. 26.   164. Mably, 'De la Suède', in *De l'étude de l'histoire*, in *Collection complète des œuvres*, 15 vols. (Paris, 1794–5), xii. pp. 241–73 (p. 257), quoted and discussed in Johnson Kent Wright, *A Classical Republican in Eighteenth-Century France: The Political Thought of Mably* (Stanford, 1997), p. 162.   165. According to Mably, *Collection*, xii. p. 249.   166. Roberts, *Age of Liberty*, p. 206; Israel, *The Enlightenment that Failed*, p. 237.   167. Beccaria, *On Crimes*, p. 42.   168. See Eco O. G. Haitsma Mulier, *The Myth of Venice and Dutch Republican Thought in the Seventeenth Century*, tr. Gerard T. Moran (Assen, 1980), pp. 8–12; David Wootton, 'Ulysses bound? Venice and the idea of liberty from Howell to Hume', in Wootton, ed., *Republicanism, Liberty, and Commercial Society, 1649–1776* (Stanford, 1994), pp. 341–67.   169. Abraham-Nicolas Amelot de la Houssaie, *The History of the Government of Venice* (London, 1677), pp. 154–9.   170. See Simon Schama, *Patriots and Liberators: Revolution in the Netherlands 1780–1813* (London, 1977), pp. 24–58; Jonathan Israel, *The Dutch Republic: Its Rise, Greatness, and Fall, 1477–1806* (Oxford, 1995), pp. 998–1018.   171. Franco Venturi, *Utopia and Reform in the Enlightenment* (Cambridge, 1971), pp. 70–71.   172. Hume, 'Of the Original Contract', *Essays*, pp. 465–87 (p. 473). Cf. Hume, 'Of the Rise and Progress of the Arts and Sciences', *Essays*, pp. 111–37 (p. 134).   173. Louis-Sébastien Mercier, *L'An deux mille quatre cent quarante: Rêve s'il en fût jamais*, ed. Raymond Trousson (Paris, 1971), p. 353.   174. Montesquieu, *Spirit*, p. 124 (VIII, 16).   175. Gibbon, *Decline and Fall*, i. p. 61.   176. Montesquieu, *Spirit*, p. 156 (XI, 5).   177. Gibbon, letter to John Gillies, 24 June 1793, in *The Letters of Edward Gibbon*, ed. J. E. Norton, 3 vols. (London, 1956), iii. p. 337.   178. D'Holbach, *Système social* [1773], ed. Josiane Boulad-Ayoub (Paris, 1994), p. 258. Cf. Montesquieu, *Spirit*, pp. 112–13 (VIII, ii).   179. Kant, *Zum ewigen Frieden*, in *Werke*, ed. Wilhelm Weischedel, 6 vols. (Darmstadt, 1958), vi. pp. 206–7. Cf. Montesquieu, *Spirit*, p. 75 (VI, 2); Gibbon, *Decline and Fall*, ii. p. 806; Schiller, *Sämtliche Werke*, iv. p. 832, and Yvonne Nilges, 'Schiller und die Demokratie', in Jeffrey L. High, Nicholas Martin and Norbert Oellers, eds., *Who is this Schiller Now? Essays on his Reception and Significance* (Rochester, NY, 2011), pp. 205–16.   180. D'Holbach, *Politique naturelle*, in *Œuvres philosophiques*, ed. Jean-Pierre Jackson, 3 vols. (Paris, 2001), iii. pp. 431–2.   181. Quoted in Lynn Hunt, *Inventing Human Rights: A History* (New York, 2007), p. 149.   182. D'Holbach, 'Représentans', *Encyclopédie*, xiv. p. 145.   183. Gibbon, *Decline and Fall*, ii. pp. 235–6.   184. See Harvey Chisick, 'The ambivalence of the idea of equality in the French Enlightenment', *History of European Ideas*, 13 (1991), pp. 215–23.   185. Adam Smith, *An Inquiry into the Nature and Causes of the Wealth of Nations*, ed. R. H. Campbell and A. S. Skinner (Oxford, 1976), pp. 28–9.   186. John Adams, letter to John Taylor, 1814, in Adrienne Koch, ed., *The American Enlightenment: The Shaping of the American Experiment and a Free Society* (New York, 1965), p. 221.   187. Diderot in Raynal, *Histoire des deux Indes*, ix. p. 7 (Bk XVIII, ch. 2).   188. D' Holbach, *Politique naturelle*, in *Œuvres philosophiques*, iii. pp. 378–9.   189. Diderot in Raynal, *Histoire des deux Indes*, ix. p. 7 (Bk XVIII, ch. 2).   190. Adams, letter to Taylor, in *American Enlightenment*, p. 222.   191. Gibbon, *Decline and Fall*, ii. p. 806.   192. Montesquieu, *Spirit*, pp. 17–19 (II, 4).   193. Hume, 'Of Parties in General', *Essays*, pp. 54–63.   194. *Spectator*, no. 125, 24 July 1711.   195. Adam Smith, *The Theory of Moral Sentiments*, ed. D. D. Raphael and A. L. Macfie (Oxford, 1976), p. 155.   196. Machiavelli, *Discourses*, pp. 218–19 (I, 4); discussed by

Quentin Skinner, *The Foundations of Modern Political Thought*, 2 vols. (Cambridge, 1978), i. p. 181.   **197.** *Considérations*, *OCM* ii. p. 119.   **198.** 'République', *Encyclopédie*, xiv. p. 151.   **199.** Thucydides, *Peloponnesian War*, p. 219.   **200.** *Common Sense* (1776), in Thomas Paine, *Rights of Man, Common Sense, and Other Political Writings*, ed. Mark Philp (Oxford, 1995), p. 42.   **201.** James Harrington, *The Commonwealth of Oceana and A System of Politics*, ed. J. G. A. Pocock (Cambridge, 1992), p. 5.   **202.** Ibid., p. 6.   **203.** See J. G. A. Pocock, *The Machiavellian Moment: Florentine Republican Thought and the Atlantic Republican Tradition* (Princeton, 1975), p. viii and *passim*, esp. pp. 383–400.   **204.** On Harrington's (limited) influence in America, see J. R. Pole, *Political Representation in England and the Origins of the American Republic* (London, 1966), pp. 12–13; Kevin J. Hayes, *The Road to Monticello: The Life and Mind of Thomas Jefferson* (New York, 2008), p. 264. **205.** Hume, 'Idea of a Perfect Commonwealth', *Essays*, pp. 512–29 (pp. 514, 515–16). **206.** Harrington, *Oceana*, p. 160.   **207.** Ibid., p. 71.   **208.** Machiavelli, *Discourses*, pp. 418–20 (II, 20); *The Prince*, ed. Quentin Skinner and Russell Price (Cambridge, 1988), pp. 42–7.   **209.** Machiavelli, *The Prince*, p. 44. It is disputed whether Machiavelli advocated a citizen army (he cites the Spartans and Swiss as models), or an army which would consist of citizens, whether conscripts or volunteers, and above all be under the control of the republic: contrast Pocock, *Machiavellian Moment*, pp. 200–204, with Wootton, *Power*, pp. 41, 298.   **210.** See Blair Worden, *Roundhead Reputations: The English Civil Wars and the Passions of Posterity* (London, 2001), p. 70.   **211.** Andrew Fletcher, *A Discourse of Government with relation to Militia's* (1698), in his *Political Works*, ed. John Robertson (Cambridge, 1997), pp. 2–31 (p. 21).   **212.** Smith, *Wealth of Nations*, pp. 706–7.   **213.** Montesquieu, *Spirit*, p. 116 (VIII, 5). Cf. E. J. Hobsbawm's remark prompted by the Cold War: 'Democracies, as experience shows, require demonized enemies' (*On History* (London, 1997), p. 229). **214.** *Histoire des deux Indes*, ix. p. 333.   **215.** Machiavelli, *Discourses*, p. 436 (II 25). **216.** See Mark Hulliung, *Citizen Machiavelli* (Princeton, 1983), p. 59.   **217.** As in the canon of modern literature, including texts by Nietzsche, Freud, Conrad, Thomas Mann and Dostoevsky, proposed by Lionel Trilling in 'On the Teaching of Modern Literature' in his *Beyond Culture* (Harmondsworth, 1967), pp. 19–41.   **218.** Jean-Jacques Rousseau, *Confessions*, tr. Angela Scholar, ed. Patrick Coleman (Oxford, 2000), p. 342.   **219.** Rousseau, *The 'Discourses' and Other Early Political Writings*, ed. and tr. Victor Gourevitch (Cambridge, 1997), p. 11; *OCR* iii. p. 11. In quoting Gourevitch's translation, I have omitted the distracting capital letters which he copies from his source-text. On the Persians, cf. Herodotus, *The Histories*, tr. Aubrey de Sélincourt, rev. A. R. Burn (Harmondsworth, 1972), p. 98.   **220.** Rousseau, *Discourses*, p. 8; *OCR* iii. pp. 8–9.   **221.** Ibid., p. 16; *OCR* iii. p. 17.   **222.** Ibid., p. 25n; *OCR* iii. p. 28n.   **223.** Ibid., p. 20; *OCR* iii. p. 22.   **224.** Ibid., p. 17; *OCR* iii. p. 18. **225.** *Œuvres de Turgot et documents le concernant*, ed. Gustav Schelle, 5 vols. (Paris, 1913), i. p. 216.   **226.** Rousseau, *Émile*, tr. Barbara Foxley (London, 1911), p. 174.   **227.** Rousseau, *Discourses*, p. 127; *OCR* iii. p. 126.   **228.** Ibid., p. 152; *OCR* iii. p. 154. On Rousseau and Mandeville, see John Robertson, *The Case for the Enlightenment: Scotland and Naples 1680–1760* (Cambridge, 2005), pp. 392–4.   **229.** See Arthur O. Lovejoy, 'The supposed primitivism of Rousseau's "Second Discourse"', in his *Essays in the History of Ideas* (Baltimore, 1948), pp. 14–37. It has been argued that Rousseau identified primitive man with the orang-utan: see Robert Wokler, 'Perfectible apes in decadent cultures: Rousseau's anthropology revisited', in his *Rousseau, the Age of Enlightenment, and their Legacies*, ed. Bryan Garsten (Princeton, 2012), pp. 1–28.   **230.** Rousseau, *Discourses*, p. 159; *OCR* iii. p. 164.   **231.** Ibid., p. 164; *OCR* iii. p. 168.   **232.** Ibid., p. 166; *OCR* iii. p. 170.   **233.** Ibid., p. 167; *OCR* iii. p. 171. **234.** Ibid., p. 168; *OCR* iii. p. 171.   **235.** Ibid., p. 182; *OCR* iii. p. 188.   **236.** Ibid., p. 170; *OCR* iii. p. 174. Cf. 'Lettre à d'Alembert', *OCR* v. pp. 72–3.   **237.** Rousseau, *Discourses*, p. 187; *OCR* iii. p. 193.   **238.** Cicero, *On the Commonwealth and On the Laws*, tr. James E. G. Zetzel (Cambridge, 1999), p. 71.   **239.** M. T. Cicero his Offices, or his Treatise concerning the Moral Duties of Mankind*, tr. William Guthrie (London, 1755), pp. 1–2.   **240.** Samuel Pufendorf, *De jure naturae et gentium libri octo* (1672), quoted in Ian Hunter, *Rival Enlightenments: Civil and Metaphysical Philosophy in Early Modern Germany* (Cambridge, 2001), p. 173.   **241.** See Alfred Dufour, 'Pufendorf', in J. H. Burns, ed., *The Cambridge*

*History of Political Thought, 1450–1700* (Cambridge, 1991), pp. 561–88 (p. 573); Hunter, *Rival Enlightenments*, p. 186. **242.** Ibid., p. 185. **243.** John Locke, *Two Treatises of Government* and *A Letter Concerning Toleration*, ed. Ian Shapiro (New Haven, 2003), p. 102 (ii, §6). **244.** See Hume, 'Of the Original Contract', *Essays*, p. 471. **245.** John Dunn, *The Political Thought of John Locke: An Historical Account of the Argument of the 'Two Treatises of Government'* (Cambridge, 1969), pp. 97–8. Cf. Richard Ashcraft, 'Locke's state of nature: historical fact or moral fiction?', *American Political Science Review*, 62 (1968), pp. 898–915. David Wootton, 'Introduction', in John Locke, *Political Writings* (London, 1993), pp. 7–133 (p. 67), criticizes Dunn for maintaining that Locke's assumptions were not only Christian but Calvinist. **246.** This example comes from Ryan, *On Politics*, p. 486. **247.** A. John Simmons, *On the Edge of Anarchy: Locke, Consent, and the Limits of Society* (Princeton, 1993), p. 100. **248.** Smith, *Lectures on Jurisprudence*, ed. R. L. Meek, D. D. Raphael and P. G. Stein (Oxford, 1978), p. 317. Cf. Ryan, *On Politics*, p. 483. **249.** Locke, *Two Treatises*, p. 163 (ii, §142). **250.** Rousseau, letter to Isaac-Ami Marcet de Mézières, 24 July 1762, *Correspondance complète*, xii. p. 98. **251.** Rousseau, *The Social Contract and Other Later Political Writings*, ed. and tr. Victor Gourevitch (Cambridge, 1997), p. 53 (I, 8). **252.** Rousseau, *Social Contract*, p. 53 (I, 7). **253.** Helena Rosenblatt, *Rousseau and Geneva: From the 'First Discourse' to the 'Social Contract', 1749–1762* (Cambridge, 1997), p. 255. **254.** Rousseau, *Social Contract*, p. 60 (II, 3). **255.** Ibid., p. 92 (III, 4). **256.** Ibid., p. 93 (III, 5). **257.** Judith Shklar, *Men and Citizens: A Study of Rousseau's Social Theory* (Cambridge, 1969), p. 181. **258.** Rousseau, *Social Contract*, p. 113 (III, 15). **259.** Ibid. **260.** Ibid. **261.** Rosenblatt, *Rousseau and Geneva*, p. 247. **262.** Ernst Cassirer, *The Question of Jean-Jacques Rousseau*, tr. Peter Gay (New York, 1954), p. 52. **263.** See Jacob Talmon, *The Origins of Totalitarian Democracy* (London, 1952), pp. 38–50; also the impassioned but nuanced letter from Isaiah Berlin to Jakob Huizinga, 21 Nov. 1972, in Berlin, *Building: Letters 1960–1975*, ed. Henry Hardy and Mark Pottle (London, 2013), pp. 511–13, and Christopher Brooke, 'Isaiah Berlin and the origins of the "totalitarian" Rousseau', in Laurence Brockliss and Ritchie Robertson, eds., *Isaiah Berlin and the Enlightenment* (Oxford, 2016), pp. 89–98. **264.** Robert Derathé, *Jean-Jacques Rousseau et la science politique de son temps* (Paris, 1952), p. 158. **265.** See Istvan Hont, *Politics in Commercial Society: Jean-Jacques Rousseau and Adam Smith*, ed. Béla Kapossy and Michael Sonenscher (Cambridge, MA, 2015), pp. 100–123, and the defence of Rousseau in Robert Wokler, 'Rousseau's two concepts of liberty', in his *Rousseau, the Age of Enlightenment, and their Legacies*, pp. 154–84. **266.** Rousseau, *Social Contract*, pp. 68–9 (II, 7). **267.** Schiller, *Sämtliche Werke*, iv. p. 815. **268.** Rousseau, *Social Contract*, p. 68 (II, 6). **269.** Talmon, *Origins*, p. 44.

# 14. REVOLUTIONS

**1.** Lynn Hunt, *Inventing Human Rights: A History* (New York, 2007), p. 216. **2.** Darrin McMahon, *The Pursuit of Happiness: A History from the Greeks to the Present* (London, 2006), pp. 261–2. **3.** R. R. Palmer, *The Age of the Democratic Revolution: A Political History of Europe and America, 1760–1800*, 2 vols. (Princeton, 1959–64); Franco Venturi, *The End of the Old Regime in Europe*, tr. R. Burr Litchfield, 2 vols. (Princeton, 1989–91); Jonathan Israel, *The Expanding Blaze: How the American Revolution Ignited the World, 1775–1848* (Princeton, 2017) and *The Enlightenment that Failed: Ideas, Revolution, and Democratic Defeat, 1748–1830* (Oxford, 2019), pp. 257–8. **4.** Michael Howard, *The Invention of Peace: Reflections on War and International Order* (London, 2000), p. 28. **5.** Caroline Winterer, *American Enlightenments: Pursuing Happiness in the Age of Reason* (New Haven, 2016), p. 33. **6.** John Adams, letter to Abigail Adams, 3 July 1776, in Winterer, *American Enlightenments*, p. 185. **7.** See Garry Wills, *Inventing America: Jefferson's Declaration of Independence* (New York, 1978), pp. 51–4. **8.** 'Speech on Conciliation with America', 22 March 1775, in *The Writings and Speeches of Edmund Burke*, ed. Paul Langford, 9 vols. (Oxford, 1991–2000), iii. pp. 105–68 (p. 120). **9.** Robert Middlekauff, *The Glorious Cause: The American Revolution, 1763–1789*, rev. edn (Oxford, 2005), p. 100;

John Keane, *Tom Paine: A Political Life* (London, 1995), p. 90.   10. See Wills, *Inventing America*, pp. 26–7.   11. See Middlekauff, *Glorious Cause*, pp. 95–6.   12. See Lee Ward, *The Politics of Liberty in England and Revolutionary America* (Cambridge, 2004), pp. 1–6.   13. J. G. A. Pocock, *The Machiavellian Moment: Florentine Republican Thought and the Atlantic Republican Tradition* (Princeton, 1975), esp. pp. 506–7. For critical examinations of the concept of 'civic humanism', see Anthony Grafton, 'Humanism and political theory', in J. H. Burns, ed., *The Cambridge History of Political Thought 1450–1700* (Cambridge, 1991), pp. 9–29 (esp. pp. 15–20); James Hankins, ed., *Renaissance Civic Humanism* (Cambridge, 2000).   14. On this term, see Austin Woolrych, 'The Good Old Cause and the fall of the Protectorate', *Cambridge Historical Journal*, 13, ii (1957), pp. 133–61; on the wider tradition, Caroline Robbins, *The Eighteenth-Century Commonwealthman* (Cambridge, MA, 1959); Bernard Bailyn, *The Ideological Origins of the American Revolution*, 2nd edn (Cambridge, MA, 1992), pp. 22–54.   15. See John Dunn, 'The politics of Locke in England and America in the eighteenth century', in John W. Yolton, ed., *John Locke: Problems and Perspectives* (Cambridge, 1969), pp. 45–80.   16. See the survey of research in Ward, *Politics of Liberty*, p. 5, and his reading of Jefferson's 'Summary View of the Rights of British America' as a text inspired by Locke's conception of natural rights (pp. 351–74).   17. Bailyn, *Ideological Origins*, p. 26.   18. 'Speech of James Wilson before the Pennsylvania Convention', in David Wootton, ed., *The Essential Federalist and Anti-Federalist Papers* (Indianapolis, 2003), pp. 97–110 (pp. 100–101).   19. Blair Worden, *Roundhead Reputations: The English Civil Wars and the Passions of Posterity* (London, 2001), p. 157; see his account of Sidney's work and posthumous reputation, pp. 122–80.   20. For the objections by Adam Ferguson and other Scottish philosophers, see Emma Macleod, 'Revolution', in Aaron Garrett and James A. Harris, eds., *Scottish Philosophy in the Eighteenth Century*, vol. 1: *Morals, Politics, Art, Religion* (Oxford, 2015), pp. 361–403 (pp. 372–3).   21. Bailyn, *Ideological Origins*, p. 166; Richard Bourke, *Empire and Revolution: The Political Life of Edmund Burke* (Princeton, 2015), pp. 295–7.   22. Jefferson, 'A Summary View of the Rights of British America', in his *Writings*, ed. Merrill D. Peterson (New York, 1984), pp. 105–22 (p. 109).   23. Ibid., p. 105.   24. Burke, 'Speech on Conciliation with America', p. 127; analysed in Bourke, *Empire and Revolution*, pp. 476–87.   25. Quoted from Burke's papers in Bourke, *Empire and Revolution*, p. 490.   26. Paine, 'Common Sense', in his *Rights of Man, Common Sense, and Other Political Writings*, ed. Mark Philp (Oxford, 1995), p. 34.   27. On the meanings and reception of the Declaration, see Eric Slauter, 'The Declaration of Independence and the new nation', in Frank Shuffelton, ed., *The Cambridge Companion to Thomas Jefferson* (Cambridge, 2009), pp. 12–34. For the text, see Hunt, *Inventing Human Rights*, pp. 215–20. On the moral assumptions underlying the Declaration, and their source in Scottish 'moral sense' philosophy, see Ann Fairfax Withington, *Toward a More Perfect Union: Virtue and the Formation of American Republics* (New York, 1991), p. 12 and *passim*.   28. Wills, *Inventing America*, p. 185. See Sophia Rosenfeld, *Common Sense: A Political History* (Cambridge, MA, 2011), pp. 56–89; Paul Wood, 'Thomas Reid and the Common Sense School', in Garrett and Harris, eds., *Scottish Philosophy*, i. pp. 404–52.   29. Quoted in Bailyn, *Ideological Origins*, p. 119; more examples at pp. 126, 129, 232–3.   30. Summarized in Keane, *Tom Paine*, p. 99.   31. Quoted in Bailyn, *Ideological Origins*, p. 236.   32. Jefferson, *Notes on the State of Virginia*, in his *Writings*, p. 289. See the analysis of Jefferson's views on race and slavery in Wills, *Inventing America*, pp. 293–306.   33. Published in Ruth Bogin, ' "Liberty Further Extended": a 1776 anti-slavery manuscript by Lemuel Haynes', *William and Mary Quarterly*, 40 (1983), pp. 85–106 (quotation from p. 94); discussed by Slauter, 'The Declaration', pp. 13–14.   34. Middlekauff, *Glorious Cause*, pp. 275–7. The phrase comes from Ralph Waldo Emerson's 'Concord Hymn' (1837).   35. See Horst Dippel, *Germany and the American Revolution 1770–1800*, tr. Bernhard A. Uhlendorf (Wiesbaden, 1978), pp. 11–30, and the famous scene concerning German mercenaries in Schiller's *Kabale und Liebe* (1784), in his *Sämtliche Werke*, ed. Gerhard Fricke and Herbert G. Göpfert, 5 vols. (Munich, 1958), i. pp. 780–82, which is based on a very short-lived mutiny that occurred at Ochsenfurt on the river Main on 10 March 1777 (Dippel, *Germany*, pp. 123–4).   36. Bailyn, *Ideological Origins*, pp. 176–83.   37. Hamilton, *The Federalist*, no. 1, in Alexander Hamilton, James Madison and John Jay,

*The Federalist Papers*, ed. Lawrence Goldman (Oxford, 2008), p. 11. Cf. Jeremy Waldron, 'Isaiah Berlin's neglect of Enlightenment constitutionalism', in Laurence Brockliss and Ritchie Robertson, eds., *Isaiah Berlin and the Enlightenment* (Oxford, 2016), pp. 205–19. **38.** Adams, *A Defence of the Constitutions of the United States of America*, in *The Works of John Adams*, 10 vols. (Boston, 1850–56), vi. p. 63. **39.** Israel, *Expanding Blaze*, pp. 4–5. **40.** Cf. the argument that democracy, by its very nature, has two faces: a 'redemptive' face, which offers 'the promise of a better world through action by the sovereign people'; and a 'pragmatic' face concerned with the efficient workings of institutions. You cannot have government without institutions, dull as they may seem; but the institutions of democracy will lose legitimacy if they are not periodically renewed by popular and even populist enthusiasm. See Margaret Canovan, 'Trust the people! Populism and the two faces of democracy', *Political Studies*, 47 (1999), pp. 2–16 (p. 11). **41.** Jefferson, *Notes on the State of Virginia*, Query XIII, in his *Writings*, p. 245. **42.** Wootton, 'Introduction', in *The Essential Federalist and Anti-Federalist Papers*, p. xv. **43.** Paine, 'Common Sense', in *Rights of Man*, pp. 8–9. **44.** Letter quoted in Keane, *Tom Paine*, p. 125. **45.** John Adams, 'Thoughts on Government', in *Works*, iv. p. 196. **46.** Paine, *Rights of Man*, p. 31. **47.** Hamilton, *The Federalist*, no. 6, p. 29. **48.** Hume, 'Of the Independency of Parliament', *Essays Moral, Political, and Literary*, ed. Eugene F. Miller (Indianapolis, 1987), p. 42 (emphasis in original). **49.** Hamilton, *The Federalist*, no. 76, p. 373. **50.** Adams, *A Defence of the Constitutions*, *Works*, vi. p. 219. **51.** Adams, 'Thoughts on Government', *Works*, iv. p. 194. **52.** Ibid., iv. p. 195. **53.** Madison, *The Federalist*, no. 57, pp. 282–3. **54.** Madison, *The Federalist*, no. 51, p. 257. **55.** Madison, *The Federalist*, no. 50, p. 255. **56.** Madison, *The Federalist*, no. 51, p. 258. **57.** Madison, *The Federalist*, no. 10, p. 53. **58.** 'Speech of James Wilson', in Wootton, *The Essential Federalist and Anti-Federalist Papers*, p. 109. **59.** Israel, *Expanding Blaze*, p. 24. **60.** Letter to Baron Mure of Caldwell, 27 Oct. 1775, in *The Letters of David Hume*, ed. J. Y. T. Greig, 2 vols. (Oxford, 1932), ii. p. 303. Cf. Hume's letter to William Strahan, 26 Oct. 1775, ibid., pp. 300–301. **61.** See Jeffrey L. High, 'Introduction: Why is this Schiller [still] in the United States?', in Jeffrey L. High, Nicholas Martin and Norbert Oellers, eds., *Who is this Schiller Now? Essays on his Reception and Significance* (Rochester, NY, 2011), pp. 1–21 (pp. 4–5). **62.** 'Wenn Nordamerika frei wird, so ist es ausgemacht, daß ich hingehe': letter to Henriette von Wolzogen, 8 January 1783, *Schillers Werke: Nationalausgabe*, ed. Julius Petersen and others, 41 vols. (Weimar, 1943–2010), xxiii. p. 60. Dippel misrepresents Schiller as indifferent to the American Revolution: *Germany and the American Revolution*, pp. 49–50. **63.** Friedrich Schiller, *On the Aesthetic Education of Man in a Series of Letters*, ed. and tr. Elizabeth M. Wilkinson and L. A. Willoughby (Oxford, 1967), p. 25. **64.** Georg Büchner, *Complete Plays, 'Lenz' and Other Writings*, tr. John Reddick (London, 1993), pp. 195–6. **65.** The account that follows is based mainly on William Doyle, *The Oxford History of the French Revolution* (Oxford, 1989); Simon Schama, *Citizens: A Chronicle of the French Revolution* (London, 1989); Timothy Tackett, *The Coming of the Terror in the French Revolution* (Cambridge, MA, 2015); and Peter McPhee, *Liberty or Death: The French Revolution* (New Haven, 2016). **66.** John Hall Stewart, *A Documentary Survey of the French Revolution* (New York, 1951), p. 107. **67.** Ibid., p. 109. **68.** Contrast the perspective of an aristocrat who says her father-in-law, the comte de la Tour du Pin, was 'ruined' by this 'veritable orgy of iniquities': *Memoirs of Madame de la Tour du Pin*, tr. Felice Harcourt (London, 1969), p. 116. **69.** Stewart, *Documentary Survey*, p. 114. **70.** Schama, *Citizens*, pp. 475–7. **71.** Decree of 19 June 1790, in Stewart, *Documentary Survey*, p. 142. **72.** On the dissolution of French monasteries, see Derek Beales, *Prosperity and Plunder: European Catholic Monasteries in the Age of Revolution, 1650–1815* (Cambridge, 2003), pp. 231–69. **73.** For a sympathetic account of his motives, see John Hardman, *The Life of Louis XVI* (New Haven, 2016). **74.** Quoted in Doyle, *Oxford History*, p. 188. **75.** Tackett, *Coming of the Terror*, p. 195. **76.** Michel Vovelle, *La mentalité révolutionnaire: Société et mentalités sous la Révolution française* (Paris, 1985), pp. 111, 117. **77.** George Rudé, *The Crowd in the French Revolution* (Oxford, 1959), pp. 180–83; Tackett, *Coming of the Terror*, pp. 252–4. **78.** See Peter R. Campbell, Thomas E. Kaiser and Marisa Linton, eds., *Conspiracy in the French Revolution* (Manchester, 2007), esp. the chapters by Peter Campbell

and David Andress. **79.** David Andress, *The Terror: Civil War in the French Revolution* (London, 2005), pp. 103–4. **80.** Speech of 5 February 1794, in *Œuvres de Maximilien Robespierre*, ed. Marc Bouloiseau and Albert Soboul, 10 vols. (Paris, 1950–67), x. p. 353; quoted in Doyle, *Oxford History*, p. 272. **81.** On theories of crowd psychology, including those which Taine and others based on the French Revolution, see J. S. McClelland, *The Crowd and the Mob from Plato to Canetti* (London, 1989). **82.** T. C. W. Blanning, *The French Revolutionary Wars 1787–1802* (London, 1996), p. 139. Similarly McPhee, *Liberty or Death*, pp. 150, 153. **83.** Robespierre, speech of 2 January 1792, in *Œuvres*, viii. p. 81. **84.** *Mémoires de Madame Roland*, ed. Paul de Roux (Paris, 1966), p. 127; Norman Hampson, *Will and Circumstance: Montesquieu, Rousseau and the French Revolution* (London, 1983), pp. 189–90. The war policy of Brissot and Condorcet is presented more positively in Jonathan Israel, *Revolutionary Ideas: An Intellectual History of the French Revolution from 'The Rights of Man' to Robespierre* (Princeton, 2014), pp. 233–40. **85.** Tackett, *Coming of the Terror*, pp. 227, 248. **86.** David V. Erdman, *Commerce des Lumières: John Oswald and the British in Paris, 1790–1793* (Columbia, MO, 1986), p. 260. **87.** See T. C. W. Blanning, *The French Revolution in Germany: Occupation and Resistance in the Rhineland 1792–1802* (Oxford, 1983), pp. 83–134. **88.** 'Fragment de l'histoire secrète de la Révolution', in *Œuvres de Camille Desmoulins*, ed. Jules Claretie, 2 vols. (Paris, 1874), i. pp. 304–56 (pp. 305–6). **89.** Quoted in Tackett, *Coming of the Terror*, pp. 278, 293. On denunciation, see ibid., pp. 128–31. **90.** Ibid., p. 133. **91.** Quoted in Colin Lucas, 'The theory and practice of denunciation in the French Revolution', *Journal of Modern History*, 68 (1996), pp. 768–85 (p. 784). **92.** Stewart, *Documentary Survey*, p. 529. On the consistency of this law with previous revolutionary legislation, see Dan Edelstein, *The Terror of Natural Right: Republicanism, the Cult of Nature, and the French Revolution* (Chicago, 2009), pp. 249–53. **93.** Georges Couthon, quoted in Tackett, *Coming of the Terror*, p. 332. **94.** Doyle, *Oxford History*, p. 275. Cf. the table in Schama, *Citizens*, p. 837. **95.** Translated as *The Gods Will Have Blood*, tr. Frederick Davies (Harmondsworth, 1979); *Danton's Death*, in Büchner, *Complete Plays*, pp. 1–73. **96.** Donald Greer, *The Incidence of the Terror during the French Revolution: A Statistical Interpretation* (Cambridge, MA, 1935), pp. 26–7. In 1871, between 15,000 and 17,000 Communards were executed within a week. **97.** Thomas Hobbes, *Leviathan*, ed. J. C. A. Gaskin (Oxford, 1996), p. 84. **98.** Greer, *Incidence of the Terror*, p. 32. **99.** Tackett, *Coming of the Terror*, p. 243. Cf. the Freud-inspired interpretation of the execution as symbolic parricide in Lynn Hunt, *The Family Romance of the French Revolution* (Berkeley, 1992). **100.** Stewart, *Documentary Survey*, p. 240. **101.** Quoted in Keith Baker, 'Transformations of classical republicanism in eighteenth-century France', *Journal of Modern History*, 73 (2001), pp. 32–53 (p. 47). On the quasi-religious cult of Marat, see Ian Germani, *Jean-Paul Marat: Hero and Anti-Hero of the French Revolution* (Lewiston, NY, 1992), esp. pp. 65–97. **102.** Jonathan Israel, *Radical Enlightenment: Philosophy and the Making of Modernity 1650–1750* (Oxford, 2001), p. 11. Cf. Dennis C. Rasmussen, *The Pragmatic Enlightenment: Recovering the Liberalism of Hume, Smith, Montesquieu, and Voltaire* (Cambridge, 2014), pp. 194–211; Marisa Linton, 'The intellectual origins of the French Revolution', in Peter R. Campbell, ed., *The Origins of the French Revolution* (Basingstoke, 2006), pp. 139–59. **103.** D'Holbach, *Système social* [1773], ed. Josiane Boulad-Ayoub (Paris, 1994), p. 261. On the *philosophes*' antipathy to revolution, see Dan Edelstein, *The Enlightenment: A Genealogy* (Chicago, 2010), p. 100. **104.** Edelstein, *The Enlightenment*, p. 100. **105.** Quoted in Alan Charles Kors, *D'Holbach's Coterie: An Enlightenment in Paris* (Princeton, 1976), p. 268. For the fates of Marmontel, Grimm and others, see ibid., pp. 261–87. **106.** Stewart, *Documentary Survey*, p. 114. **107.** Hampson, *Will and Circumstance*, p. 59. **108.** Quoted ibid., p. 89. **109.** Robespierre, 'Sur les rapports des idées religieuses et morales avec les principes républicains, et sur les fêtes nationales', in *Œuvres*, x. pp. 442–65 (pp. 454–5). **110.** Ruth Scurr, *Fatal Purity: Robespierre and the French Revolution* (London, 2006), p. 218. **111.** Robespierre, *Œuvres*, x. p. 455. **112.** Rousseau, 'Considérations sur le gouvernement de Pologne', *OCR* iii. p. 963. **113.** Robespierre, speech on 25 December 1793 (5 Nivôse, year II), in *Œuvres*, x. p. 274. **114.** Carol Blum, *Rousseau and the Republic of Virtue: The Language of Politics in the French Revolution* (Ithaca, NY, 1986), p. 154.

**115.** Quoted in D. M. G. Sutherland, *France 1789-1815: Revolution and Counterrevolution* (London, 1985), pp. 210-11.   **116.** Details in Israel, *Revolutionary Ideas*, p. 496. A useful table of the new months is given in Scurr, *Fatal Purity*, p. 263.   **117.** 'Decree Establishing the French Era', in Stewart, *Documentary Survey*, pp. 508-9. For parodies of these extravagances, see Max Beerbohm, 'Perkins and Mankind', in his *A Christmas Garland* (London, 1912), and David Halliwell's play *Little Malcolm and his Struggle against the Eunuchs* (London, 1967), in which four student revolutionaries resolve to rename the first four months after themselves: January will be Scrawdyke after their leader; each of the next eight people to join their movement will have a month named after him.   **118.** For Robespierre's views on religion, see his speech of 7 May 1794 (18 Floréal, year II), in *Œuvres*, x. pp. 452-4; for his denunciation of atheism as aristocratic, his speech of 21 November 1793 (1 Frimaire, year II), 'Pour la liberté des cultes', in *Œuvres*, x. p. 196.   **119.** Keith Michael Baker, *Condorcet: From Natural Philosophy to Social Mathematics* (Chicago, 1975), p. 333. **120.** Quoted in William Reddy, *The Navigation of Feeling: A Framework for the History of Emotions* (Cambridge, 2001), p. 187.   **121.** Robespierre, speech of 26 July 1794 (8 Thermidor, year II), in *Œuvres*, x. p. 551.   **122.** Robespierre, speech of 7 May 1794 (18 Floréal, year II), in *Œuvres*, x. p. 452.   **123.** Quoted in Reddy, *Navigation of Feeling*, pp. 191-2. **124.** Edelstein, *Terror*, pp. 17-18. For the similarly sentimental and high-minded rhetoric of another revolutionary emissary, Joseph-Marie Lequinio, see McMahon, *Pursuit of Happiness*, pp. 253-64.   **125.** Harold T. Parker, *The Cult of Antiquity and the French Revolutionaries* (Chicago, 1937), p. 21.   **126.** Antoine-Louis de Saint-Just, 'Discours sur le jugement de Louis XVI, prononcé à la Convention nationale le 13 novembre 1792', in *Œuvres complètes*, ed. Anne Kupiec and Miguel Abensour (Paris, 2004), pp. 475-84 (p. 476). **127.** Desmoulins, 'Fragment de l'histoire secrète de la Révolution', in *Œuvres*, i. p. 353. **128.** For the revolutionaries and Sparta, see Elizabeth Rawson, *The Spartan Tradition in European Thought* (Oxford, 1969), pp. 271-84.   **129.** Baker, 'Transformations', p. 36. **130.** Robespierre, speech on 25 December 1793 (5 Nivôse, year II), in *Œuvres*, x. p. 277. **131.** Parker, *Cult of Antiquity*, pp. 142-3; McPhee, *Liberty or Death*, p. 241.   **132.** See Darren M. McMahon, *Enemies of the Enlightenment: The French Counter-Enlightenment and the Making of Modernity* (New York, 2001); Amos Hofman, 'The origins of the theory of the *philosophe* conspiracy', *French History*, 2 (1988), pp. 152-72.   **133.** Abbé Barruel, *Memoirs Illustrating the History of Jacobinism*, tr. Robert Clifford, 4 vols. (London, 1798), i. p. 2.   **134.** Burke, *Reflections on the Revolution in France*, ed. L. G. Mitchell (Oxford, 1993), pp. 110-11.   **135.** Daniel Mornet, *Les Origines intellectuelles de la Révolution française* (Paris, 1933), p. 471.   **136.** Linton, 'The intellectual origins', p. 140.   **137.** This approach was pioneered by Mornet, *Les Origines*.   **138.** Robert Darnton, 'The High Enlightenment and the low-life of literature in pre-Revolutionary France', *Past and Present*, 51 (May 1971), pp. 81-115; Roger Chartier, *The Cultural Origins of the French Revolution*, tr. Lydia G. Cochrane (Durham, NC, 1991), pp. 83-4.   **139.** Mornet, *Les Origines*, pp. 92-6; Joan McDonald, *Rousseau and the French Revolution 1762-1791* (London, 1965), esp. pp. 43-65, 155-73.   **140.** Israel, *Revolutionary Ideas*, esp. pp. 14-19; cf. his *Democratic Enlightenment: Philosophy, Revolution, and Human Rights 1750-1790* (Oxford, 2011), p. 929. **141.** See Carl Schmitt, *Der Begriff des Politischen* ([1927]; Hamburg, 1933).   **142.** Hume, 'Whether the British Government Inclines More to Absolute Monarchy, or to a Republic', *Essays*, pp. 52-3.   **143.** D'Holbach, *Système social*, p. 257.   **144.** E.g. Richard Price and Joseph Priestley, quoted in Marilyn Butler, ed., *Burke, Paine, Godwin, and the Revolution Controversy* (Cambridge, 1984), pp. 32, 87; Paine, *Rights of Man*, pp. 146-7.   **145.** See Hunt, *Inventing Human Rights*, pp. 126-33.   **146.** Jacques-Pierre Brissot de Warville, *Nouveau voyage dans les États-Unis de l'Amérique Septentrionale, fait en 1788*, 3 vols. (Paris, 1791), i. pp. xxi-xxii.   **147.** Quoted in Hunt, *Inventing Human Rights*, p. 130.   **148.** Letter of 10 May 1762, *Letters of David Hume*, i. p. 357.   **149.** Israel, *Revolutionary Ideas*, p. 137; Peter Gay, *The Enlightenment: An Interpretation*, 2 vols. (New York, 1966-9), ii. pp. 555-8; Carla J. Mulford, *Benjamin Franklin and the Ends of Empire* (Oxford, 2015), pp. 288-90.   **150.** This story rests on uncertain foundations: see J. C. D. Clark, *Thomas Paine: Britain, America, and France in the Age of Enlightenment and Revolution* (Oxford, 2018),

p. 322.   **151.** See Keane, *Tom Paine*, pp. 414, 440–41.   **152.** Palmer, *Age of the Democratic Revolution*, i. p. 199.   **153.** Hector St John de Crèvecoeur, *Letters from an American Farmer* (Dublin, 1782), p. 44.   **154.** Paine, 'Common Sense', in *Rights of Man*, p. 53; cf. Edelstein, *The Enlightenment*, p. 103.   **155.** Simon Schama, *Patriots and Liberators: Revolution in the Netherlands 1780–1813* (London, 1977), p. 95.   **156.** Gordon S. Wood, *The Radicalism of the American Revolution* (New York, 1992), p. 232 and *passim*.   **157.** Alexis de Tocqueville, *Democracy in America* (abridged edn), tr. Henry Reeve (London, 1946), p. 48.  **158.** Doyle, *Oxford History*, p. 120. On the debate, see Joyce Appleby, 'America as a model for the radical French reformers of 1789', *William and Mary Quarterly*, 28 (1971), pp. 267– 86.   **159.** See Edelstein, *Terror*, p. 131. Edelstein explores further differences between the two revolutions, notably the presence in France of natural rights theories which made it possible to define political enemies as outside the law.   **160.** Kant's word 'Abderitismus' comes from Wieland's novel *Geschichte der Abderiten* (1774–81) about the notoriously foolish citizens of Abdera in ancient Greece.   **161.** *The Contest of Faculties* (extracts), in Kant, *Political Writings*, ed. Hans Reiss, tr. H. B. Nisbet, 2nd edn (Cambridge, 1991), pp. 177–90 (p. 183).   **162.** Ibid., p. 185.   **163.** John Robertson, *The Case for the Enlightenment: Scotland and Naples 1680–1760* (Cambridge, 2005), p. 42.   **164.** See Desmond King-Hele, *Erasmus Darwin* (London, 1963), pp. 97–119.   **165.** See Helen Braithwaite, *Romanticism, Publishing and Dissent: Joseph Johnson and the Cause of Liberty* (Basingstoke, 2003).  **166.** On the trial, and the fabricated 'Pop-Gun Plot', see John Barrell, *Imagining the King's Death: Figurative Treason, Fantasies of Regicide 1793–1796* (Oxford, 2000), pp. 445–503. For Godwin's contribution, see William St Clair, *The Godwins and the Shelleys: The Biography of a Family* (London, 1989), pp. 125–40.   **167.** See Robert E. Schofield, *The Enlightened Joseph Priestley: A Study of his Life and Work from 1773 to 1804* (University Park, PA, 2004), pp. 284–9. On government repression, see the classic account in E. P. Thompson, *The Making of the English Working Class* (London, 1963), esp. ch. 5: 'Planting the Liberty Tree'; and Albert Goodwin, *The Friends of Liberty: The English Democratic Movement in the Age of the French Revolution* (London, 1979).   **168.** Burke, *Reflections*, p. 33. **169.** Ibid.   **170.** Ibid., p. 64.   **171.** Ibid., p. 51.   **172.** Ibid., p. 39.   **173.** See Bourke, *Empire and Revolution*, esp. pp. 677–700.   **174.** Quoted in Isaac Kramnick, *The Rage of Edmund Burke: Portrait of an Ambivalent Conservative* (New York, 1977), p. 151.   **175.** Mary Wollstonecraft, 'A Vindication of the Rights of Men', in *A Vindication of the Rights of Woman* [and other works], ed. Janet Todd (Oxford, 1993), p. 37.   **176.** Ibid., pp. 35, 43.   **177.** Ibid., p. 8; Hume quoted, pp. 9–10.   **178.** Wollstonecraft, *Vindication*, p. 30.   **179.** Ibid., p. 44. **180.** Timothy Michael, *British Romanticism and the Critique of Political Reason* (Baltimore, 2016), p. 8.   **181.** On the doctrine of political mysteries, or *arcana imperii*, see Peter S. Donaldson, *Machiavelli and Mystery of State* (Cambridge, 1988).   **182.** St Clair, *The Godwins*, p. 158.   **183.** Mary Wollstonecraft, *Letters written in Sweden, Norway, and Denmark*, ed. Tone Brekke and Jon Mee (Oxford, 2009), p. 132.   **184.** Paine, *Rights of Man*, p. 110. **185.** Ibid., p. 92.   **186.** Ibid., p. 97.   **187.** Ibid., p. 124.   **188.** Ibid., p. 169.   **189.** Ibid., p. 190.   **190.** Ibid., p. 206.   **191.** William Hazlitt, 'William Godwin', in his *The Spirit of the Age* ([1825]; London, 1954), pp. 19–38 (p. 20).   **192.** William Godwin, *An Enquiry concerning Political Justice*, ed. Mark Philp (Oxford, 2013), p. 77. This text corresponds to the original edition. On the revised versions Godwin published in 1795 and 1797, see Mark Philp, *Godwin's Political Justice* (London, 1986).   **193.** Godwin, *Enquiry*, p. 54.   **194.** Ibid., p. 56.   **195.** Ibid., p. 113.   **196.** Ibid., p. 107.   **197.** Ibid., p. 110.   **198.** Ibid., p. 112.   **199.** On Godwin's debt to Helvétius and d'Holbach, see Seamus Deane, *The French Revolution and Enlightenment in England 1789–1832* (Cambridge, MA, 1988), pp. 72–94; but contrast Philp, *Godwin's Political Justice*, p. 40.   **200.** Godwin, *Enquiry*, p. 299.   **201.** See George Woodcock, *Anarchism: A History of Libertarian Ideas and Movements* (Harmondsworth, 1963), pp. 56–86.   **202.** Godwin, *Enquiry*, pp. 204–5.   **203.** Ibid., p. 454.   **204.** Ibid., p. 458.   **205.** See Toby Ord, 'Global poverty and the demands of morality', in John Perry, ed., *God, the Good and Utilitarianism: Perspectives on Peter Singer* (Cambridge, 2014), pp. 177–91.   **206.** Godwin, *Enquiry*, p. 199; cf. p. 27.   **207.** *The Complete Poetical Works of Percy Bysshe Shelley*, ed. Thomas Hutchinson (London, 1934), p. 253.   **208.** See Alan

Ryan, *The Making of Modern Liberalism* (Princeton, 2012), pp. 23–6.   **209.** Rasmussen, *Pragmatic Enlightenment*, p. 80 and *passim*.   **210.** Smith, *Lectures on Jurisprudence*, ed. R. L. Meek, D. D. Raphael and P. G. Stein (Oxford, 1978), pp. 316–17; Hume, 'Of the Original Contract', *Essays*, pp. 465–87 (pp. 470–71).   **211.** Smith, *An Inquiry into the Nature and Causes of the Wealth of Nations*, ed. R. H. Campbell and A. S. Skinner (Oxford, 1976), p. 664.   **212.** Montesquieu, *The Spirit of the Laws*, ed. and tr. Anne M. Cohler, Basia C. Miller and Harold S. Stone (Cambridge, 1989), p. 155 (XI, 3).   **213.** See Peter Gay, *Voltaire's Politics: The Poet as Realist*, 2nd edn (New Haven, 1988), pp. 93, 332.   **214.** Hume, 'Of the Rise and Progress of the Arts and Sciences', *Essays*, p. 125.   **215.** Smith, *Lectures on Jurisprudence*, p. 273.   **216.** Edward Gibbon, *Memoirs of my Life*, ed. Georges A. Bonnard (London, 1966), p. 185.   **217.** Hume, letter to William Strahan, 26 Oct. 1772, *New Letters of David Hume*, ed. Raymond Klibansky and Ernest C. Mossner (Oxford, 1954), p. 196; cf. his letter to the Comtesse de Boufflers, 23 Dec. 1768, *Letters of David Hume*, ii. p. 191.   **218.** Paine, 'Common Sense', in *Rights of Man*, p. 5.   **219.** Paine, *Rights of Man*, p. 216.   **220.** Paul Langford, *A Polite and Commercial People: England 1727–1783* (Oxford, 1989), pp. 150–51; Roy Porter, *English Society in the Eighteenth Century*, rev. edn (London, 1991), pp. 127–33.   **221.** Quoted in Porter, *English Society*, p. 130; cf. Schofield, *The Enlightened Joseph Priestley*, p. 266. For examples of the opposite view, that the poor should be allowed to earn more and thus benefit the economy by seeking consumer goods, see Wootton, *Power*, pp. 252–3.   **222.** See Smith, *Wealth*, pp. 86–7.   **223.** For a powerful refutation of Smith's argument, see David Wootton, *Power, Pleasure and Profit: Insatiable Appetites from Machiavelli to Madison* (Cambridge, MA, 2018), ch. 7.   **224.** Edmund Burke, 'Thoughts and Details on Scarcity' (1795), in *The Writings and Speeches of Edmund Burke*, ed. Paul Langford, 9 vols. (Oxford, 1991–2000), ix. pp. 119–45 (p. 130). Burke cites Pufendorf (p. 129), though he thinks the obligation to exercise private charity towards the starving is stronger than Pufendorf allows.   **225.** Wilhelm von Humboldt, *The Limits of State Action*, ed. J. W. Burrow (Cambridge, 1969), p. 16.   **226.** Humboldt, *Limits*, p. 40. Wordsworth expresses a similar argument in 'The Old Cumberland Beggar', composed in 1797 (*The Poetical Works of Wordsworth*, ed. Thomas Hutchinson, rev. Ernest de Selincourt (London, 1936), pp. 443–5).   **227.** *M. T. Cicero his Offices, or his Treatise concerning the Moral Duties of Mankind*, tr. William Guthrie (London, 1755), p. 34. On patriotism in antiquity and the Renaissance, see Maurizio Viroli, *For Love of Country: An Essay on Patriotism and Nationalism* (Oxford, 1995), pp. 18–40.   **228.** 'Patriotism' is attested by the *Oxford English Dictionary* in 1716. In France, *patriotisme* appears in the 1750s: see J. H. Shennan, 'The rise of patriotism in 18th-century Europe', *History of European Ideas*, 13 (1991), pp. 689–710 (p. 698).   **229.** David A. Bell, *The Cult of the Nation in France: Inventing Nationalism, 1680–1800* (Cambridge, MA, 2001), p. 3. Cf. Ernest Gellner, *Nations and Nationalism* (Oxford, 1983).   **230.** Shaftesbury, *Characteristics of Men, Manners, Opinions, Times*, ed. Lawrence E. Klein (Cambridge, 1999), p. 399. See Dustin Griffin, *Patriotism and Poetry in Eighteenth-Century Britain* (Cambridge, 2002), esp. pp. 7–33: 'The eighteenth-century debate about patriotism'.   **231.** See Linda Colley, *Britons: Forging the Nation 1707–1837* (New Haven, 1992), pp. 88–98.   **232.** Quoted in Ulrich Im Hof, *Mythos Schweiz: Identität – Nation – Geschichte, 1291–1991* (Zurich, 1991), p. 89.   **233.** Goethe, *Sämtliche Werke: Briefe, Tagebücher und Gespräche*, ed. Friedmar Apel and others, 40 vols. (Frankfurt a.M., 1986–2000), ix. p. 887.   **234.** Johnson, *A Compleat Vindication of the Licensers of the Stage* (1739), in *The Yale Edition of the Works of Samuel Johnson*, ed. Herman W. Liebert and others (New Haven, 1963–2010), x: *Political Writings*, ed. Donald J. Greene (1977), pp. 55–73 (p. 64).   **235.** James Thomson, 'Summer', in *The Seasons*, ed. James Sambrook (Oxford, 1981), p. 128, and 'Autumn', ibid., l. 901, p. 180.   **236.** *De Patriot of Politike bedenkingen over den Staat der Verenigde Nederlanden*, quoted in Joep Leerssen, *National Thought in Europe: A Cultural History* (Amsterdam, 2006), p. 77 (translation modified).   **237.** Henry St John, Viscount Bolingbroke, *Letters, on the Spirit of Patriotism; on the Idea of a Patriot King; and on the State of Parties, at the Accession of King George the First* (London, 1749), p. 88.   **238.** James Boswell, *Life of Johnson*, ed. R. W. Chapman, corrected by J. D. Fleeman (London, 1970), p. 615.   **239.** Gibbon, letter to Dorothea Gibbon,

7 Jan. 1779, in *The Letters of Edward Gibbon*, ed. J. E. Norton, 3 vols. (London, 1956), ii. p. 202. **240.** Otto Freiherr von Gemmingen, *Der teutsche Hausvater* ([Munich?], 1780), p. 86. **241.** Jonathan Israel, *The Dutch Republic: Its Rise, Greatness, and Fall, 1477–1806* (Oxford, 1995), p. 1107. **242.** Ewald Christian von Kleist, *Sämtliche Werke*, ed. Jürgen Stenzel (Stuttgart, 1971), p. 152. Quoted in Thomas Abbt, *Vom Tode fürs Vaterland* (1761), in his *Vermischte Werke*, 6 vols. (Berlin, 1768–80), ii. p. 102. **243.** Lessing, letter to Gleim, 16 Dec. 1758, *Werke und Briefe*, ed. Wilfried Barner and others, 12 vols. (Frankfurt a.M., 1987–98), xi/1. p. 305. On their respective experiences of war, see Johannes Birgfeld, *Krieg und Aufklärung: Studien zum Kriegsdiskurs in der deutschsprachigen Literatur des 18. Jahrhunderts*, 2 vols. (Hanover, 2012), i. pp. 191–204. **244.** See Ritchie Robertson, 'Cosmopolitanism, patriotism, and nationalism in the German-speaking Enlightenment', in his *Enlightenment and Religion in German and Austrian Literature* (Oxford, 2017), pp. 144–62. **245.** Edmond Dziembowski, *Un nouveau patriotisme français, 1750–1770* (Oxford, 1998), p. 367. **246.** Doyle, *Oxford History*, p. 94. **247.** Ibid., p. 251; cf. Tackett, *Coming of the Terror*, p. 163. **248.** See Jacques Godechot, *La Grande nation: l'expansion révolutionnaire de la France dans le monde, 1789–1799* (Paris, 1983), pp. 72–3. **249.** James J. Sheehan, *German History 1770–1866* (Oxford, 1989), p. 313. **250.** Schama, *Citizens*, pp. 474, 816. On Cloots's conception of a universal republic, see Alexander Bevilacqua, 'Conceiving the republic of mankind: the political thought of Anacharsis Cloots', *History of European Ideas*, 38 (2012), pp. 550–69. **251.** Quoted in Shennan, 'The rise of patriotism', p. 701. **252.** Colley, *Britons*, p. 108. On Scottophobia, see ibid., pp. 105–32; Paul Langford, 'South Britons' reception of North Britons, 1707–1820', in T. C. Smout, ed., *Anglo-Scottish Relations from 1603 to 1900* (Oxford, 2005), pp. 143–69. **253.** See Gerald Newman, *The Rise of English Nationalism: A Cultural History, 1740–1830* (London, 1988), esp. pp. 123–39. **254.** John Brown, *An Estimate of the Manners and Principles of the Times* (London, 1757), p. 140; see Newman, *Rise of English Nationalism*, pp. 80–84. **255.** Tobias Smollett, *The Expedition of Humphry Clinker*, ed. O. M. Brack, Jr and Thomas R. Preston (Athens, GA, 1990), p. 151; cf. ibid., p. 154, and Newman, *Rise of English Nationalism*, p. 135. **256.** See Christopher Hill, 'The Norman Yoke', in his *Puritanism and Revolution: Studies in Interpretation of the English Revolution of the 17th Century* (London, 1958), pp. 50–122. **257.** Quoted in Dziembowski, *Un nouveau patriotisme français*, p. 236. **258.** Isaiah Berlin, 'Nationalism: past neglect and present power', in his *Against the Current: Essays in the History of Ideas*, ed. Henry Hardy (Oxford, 1981), p. 350. **259.** Fichte, *Addresses to the German Nation*, ed. Gregory Moore (Cambridge, 2008). **260.** Erasmus, *Dulce bellum inexpertis* [War is sweet to those who have not experienced it], quoted in Michael Howard, *War and the Liberal Conscience* (Oxford, 1978), p. 14. **261.** 'Héroïsme', *Encyclopédie ou Dictionnaire raisonné des sciences, des arts et des métiers* (Neuchâtel, 1765), viii. p. 181. **262.** 'Héros', *Encyclopédie*, viii. p. 182. **263.** Voltaire, letter to Nicolas Claude Thieriot, 15 July 1735, OCV 87, p. 174. **264.** Voltaire, 'Discours sur l'Histoire de Charles XII', OCV 4, pp. 151–5 (pp. 151–2). **265.** OCV 92, p. 198. **266.** Johnson, 'The Vanity of Human Wishes', in *Yale Edition*, vi: *Poems*, ed. E. L. McAdam, Jr (1964), p. 102. **267.** Pope, *Essay on Man*, iv. ll. 219–20, in TE iii/1. pp. 147–8. **268.** Voltaire, *Œuvres historiques*, ed. René Pomeau (Paris, 1957), p. 55. **269.** See J.-M. Moureaux, 'La mythologie du héros dans les rapports de Voltaire et Frédéric de 1736 à 1741', in Peter Brockmeier, Roland Desné and Jürgen Voss, eds., *Voltaire und Deutschland* (Stuttgart, 1979), pp. 223–39. **270.** See Howard, *War and the Liberal Conscience*, p. 19; John Gittings, *The Glorious Art of Peace: From the 'Iliad' to Iraq* (Oxford, 2012), pp. 125–6. **271.** See Abbé de Saint-Pierre, *Projet pour rendre la paix perpétuelle en Europe*, ed. Simone Goyard-Fabre (Paris, 1981), with a helpful summary at pp. 71–84. **272.** Leibniz's letter of 7 February 1715 is reproduced in Saint-Pierre, *Projet*, pp. 565–6. **273.** For insulting or ironic comments by Voltaire, Montesquieu and others, see Joseph Drouet, *L'Abbé de Saint-Pierre: l'homme et l'œuvre* (Paris, 1912), pp. 334–5; Werner Langer, *Friedrich der Große und die geistige Welt Frankreichs* (Hamburg, 1932), p. 53. His ideas are supported and developed in Johann Michael von Loen, *Der redliche Mann am Hofe* (1742; facsimile repr., Stuttgart, 1966), pp. 572–6. **274.** Examples in *Rousseau on International Relations*, ed. Stanley Hoffmann

and David P. Fidler (Oxford, 1991), p. xxiii.   275. Rousseau, *Confessions*, tr. Angela Scholar, ed. Patrick Coleman (Oxford, 2000), p. 412; *OCR* ii. p. 172.   276. 'Jugement sur le projet de paix perpétuelle', in *OCR* iii. pp. 591–600 (p. 592); translation from *Rousseau on International Relations*, p. 90.   277. 'Jugement', p. 600; *Rousseau on International Relations*, p. 100. Rousseau here conflates two separate plans of Henri's, as do the editors of *Rousseau on International Relations*, p. xxvii.   278. 'Que l'état de guerre nait de l'état social', *OCR* iii. pp. 601–12 (p. 605); 'The State of War', in *Rousseau on International Relations*, pp. 33–47 (pp. 37–8).   279. 'Que l'état . . . ', p. 609; 'The State of War', p. 43.   280. 'Toward perpetual peace', in Kant, *Practical Philosophy*, tr. Mary J. Gregor, The Cambridge Edition of the Works of Immanuel Kant (Cambridge, 1996), p. 345.   281. The grim joke about the churchyard was already made by Leibniz: see Drouet, *L'Abbé de Saint-Pierre*, p. 336.   282. In 1694 William III's government founded the Bank of England to finance war with France. By 1800 the national debt stood at £456 million: Porter, *English Society*, p. 117.   283. 'Toward perpetual peace', p. 336. Kant argues similarly in 'On the Common Saying: "This May be True in Theory, but it does not Apply in Practice"', in Kant, *Political Writings*, pp. 61–92 (p. 90).   284. The last clause has often been read as Kant's concession to pragmatism, but I agree with the interpretation of it as compatible with Kant's idealism put forward by Pauline Kleingeld, *Kant and Cosmopolitanism: The Philosophical Ideal of World Citizenship* (Cambridge, 2012), pp. 51–8.   285. 'Idea for a Universal History with a Cosmopolitan Purpose' in Kant, *Political Writings*, pp. 41–53 (p. 47). The *foedus Amphictyonum* or Amphictyonic league was a league formed in ancient Greece by the polities surrounding a sanctuary in order to protect it.   286. Kant, 'Toward perpetual peace', p. 334.   287. Anthony Pagden, *The Enlightenment and Why It Still Matters* (Oxford, 2013), pp. 313–14. Pagden gives a long and helpful analysis of *On Perpetual Peace*, pp. 293–314. On international arbitration, which made considerable progress in the later nineteenth century, see Howard, *War and the Liberal Conscience*; for a critical history of international bodies, Mark Mazower, *Governing the World: The History of an Idea* (London, 2012).   288. See Steven Pinker, *The Better Angels of our Nature: The Decline of Violence in History and its Causes* (London, 2011); Azar Gat, 'Is war declining and why?', *Journal of Peace Research*, 50 (2013), pp. 149–57.   289. Oona J. Hathaway and Scott J. Shapiro, *The Internationalists and their Plan to Outlaw War* (London, 2017), p. 314.   290. See John Gray, *Black Mass: Apocalyptic Religion and the Death of Utopia* (London, 2007), pp. 246–59.   291. Quoted in Hathaway and Shapiro, *The Internationalists*, p. 148.   292. Quoted in Hunt, *Inventing Human Rights*, p. 216.   293. Quoted ibid., p. 221.   294. Ibid., p. 20.   295. Israel, *Dutch Republic*, p. 146.   296. Quoted in Hunt, *Inventing Human Rights*, p. 114.   297. Quoted ibid., p. 218.   298. John Locke, *Two Treatises of Government* and *A Letter Concerning Toleration*, ed. Ian Shapiro (New Haven, 2003), p. 109 (ii §22).   299. Ibid., p. 113 (ii §31). On the issues this raises, see Alan Ryan, *On Politics: A History of Political Thought from Herodotus to the Present* (London, 2012), pp. 475–82.   300. See Wills, *Inventing America*, p. 229.   301. Jean-Jacques Burlamaqui, *The Principles of Natural and Politic Law*, tr. Thomas Nugent, 2 vols. (London, 1763), i. p. 51.   302. See Vincenzo Ferrone, *Storia dei diritti dell'uomo* (Rome, 2014), pp. 127–30; Knud Haakonssen, *Natural Law and Moral Philosophy: From Grotius to the Scottish Enlightenment* (Cambridge, 1996), pp. 337–40.   303. See Margaret MacDonald, 'Natural rights', in Jeremy Waldron, ed., *Theories of Rights* (Oxford, 1984), pp. 21–40.   304. 'An Examination of the Declaration of the Rights of Man and the Citizen decreed by the Constituent Assembly in France', in *The Works of Jeremy Bentham*, ed. John Bowring, 11 vols. (Edinburgh, 1843), ii. pp. 491–529 (p. 498).   305. Helvétius, *De l'esprit* (Paris, 1758), p. 20n.   306. Voltaire, *Candide and Other Stories*, tr. Roger Pearson (Oxford, 2006), p. 48.   307. Montesquieu, *Spirit*, p. 250 (XV, 5). Cf. the *Encyclopédie* articles 'Nègres (Commerce)' (xi. pp. 79–80), 'Nègres, considérés comme esclaves dans les colonies de l'Amérique' (xi. pp. 80–83), 'Traite de nègres' (xvi. pp. 532–3).   308. David Williams, *Condorcet and Modernity* (Cambridge, 2004), p. 139.   309. Quoted in Robin Blackburn, *American Crucible: Emancipation and Human Rights* (London, 2011), p. 147.   310. Quoted in Hugh Thomas, *The Slave Trade: The History of the Atlantic Slave Trade, 1440–1870* (London, 1997), p. 469.   311. Ibid., p. 474.   312. See Michael Bundock, *The Fortunes of Francis Barber: The True*

*Story of the Jamaican Slave who became Samuel Johnson's Heir* (New Haven, 2015), pp. 140–43.   **313.** Boswell, *Life of Johnson*, p. 878. Boswell himself thought that slavery was sanctioned by God and beneficial to Africans, whom it introduced into 'a much happier state of life' than they could have in Africa (ibid.).   **314.** James Walvin, *The Zong: A Massacre, the Law and the End of Slavery* (New Haven, 2011), p. 153.   **315.** Blackburn, *American Crucible*, pp. 164–5.   **316.** Travis Glasson, *Mastering Christianity: Missionary Anglicanism and Slavery in the Atlantic World* (Oxford, 2011), p. 123.   **317.** John Newton, *An Authentic Narrative of some Remarkable and Interesting Particulars in the Life of* \*\*\*\*\*\*\* (London, 1764), pp. 100, 192.   **318.** Godwin, *Enquiry*, pp. 67–9.   **319.** Bentham, 'An Examination', p. 501.   **320.** Bentham, 'An Examination', p. 494.   **321.** Quoted in Hunt, *Inventing Human Rights*, p. 224.   **322.** See Michael Rosen, *Dignity: Its History and Meaning* (Cambridge, MA, 2012).   **323.** Kant, *Practical Philosophy*, p. 85; *Grundlegung der Metaphysik der Sitten*, in *Werke*, ed. Wilhelm Weischedel, 6 vols. (Darmstadt, 1958), iv. p. 69.   **324.** Kant, *Metaphysik der Sitten*, in *Werke*, iv. p. 534; Rosen, *Dignity*, pp. 19–31.   **325.** Joan Wallach Scott, 'French feminists and the rights of "man": Olympe de Gouges' declarations', *History Workshop Journal*, 28 (1989), pp. 1–21 (pp. 16–17).   **326.** See Joanna Bourke, *What it Means to be Human: Reflections from 1791 to the Present* (London, 2011), esp. ch. 8: 'Human Rights'.   **327.** Noted sympathetically by Rosen, *Dignity*, pp. 4, 18–19. A number of vegetarians are known from around 1800, but they were concerned with the benefits to humans, rather than to plants: see Keith Thomas, *Man and the Natural World: Changing Attitudes in England 1500–1800* (London, 1983), pp. 291–300; Timothy Morton, 'Joseph Ritson, Percy Shelley and the making of Romantic vegetarianism', *Romanticism*, 12 (2006), pp. 52–61.   **328.** 'The Sensitive Plant', in *Complete Poetical Works of Shelley*, pp. 589–96.   **329.** Burke, *Reflections*, p. 60.   **330.** Kant, *Political Writings*, p. 183.

## CONCLUSION

**1.** John Gray, *Black Mass: Apocalyptic Religion and the Death of Utopia* (London, 2007), p. 87. See also his *Enlightenment's Wake: Politics and Culture and the Close of the Modern Age* (London, 1995).   **2.** See James Schmidt, 'What Enlightenment project?', *Political Theory*, 24 (2000), pp. 734–57. The phrase was popularized especially by Alasdair MacIntyre, *After Virtue* (London, 1981), but in the narrow sense of a philosophical project to construct a system of ethics independent of any transcendent authority.   **3.** Zygmunt Bauman, *Modernity and the Holocaust* (Cambridge, 1989).   **4.** Goethe, letter to Johann Caspar Lavater, 22 June 1781, *Sämtliche Werke: Briefe, Tagebücher und Gespräche*, ed. Friedmar Apel and others, 40 vols. (Frankfurt a.M., 1986–2000), xxix. p. 360.   **5.** Johann August Starck, *Der Triumph der Philosophie im 18. Jahrhundert* ('Germantown' [Augsburg], 1803); discussed by Klaus Epstein, *The Genesis of German Conservatism* (Princeton, 1966), pp. 509–17.   **6.** Novalis, 'Die Christenheit oder Europa', in his *Schriften*, ed. Paul Kluckhohn and Richard Samuel, 5 vols. (Stuttgart, 1960–88), iii. pp. 507–24 (p. 515).   **7.** Bk IV, l. 996, in *The Poetical Works of Wordsworth*, ed. Thomas Hutchinson, rev. Ernest de Selincourt (London, 1936), p. 637; Bk III, ll. 484–6, ibid., pp. 608–9.   **8.** See Thomas Carlyle, *The French Revolution: A History* (London, 1900), p. 14 (Bk I, ch. 2); Brian Young, *The Victorian Eighteenth Century* (Oxford, 2007), pp. 22–5.   **9.** Thomas Carlyle, 'Voltaire' (1829), in his *Critical and Miscellaneous Essays*, 4 vols. in 2 (London, 1888), ii. p. 53.   **10.** See Stephen Bird, *Reinventing Voltaire: The Politics of Commemoration in Nineteenth-Century France* (Oxford, 2000).   **11.** Robert Tombs, *France 1814–1914* (London, 1996), pp. 141–2.   **12.** Alexis de Tocqueville, *The Ancien Régime and the Revolution*, tr. Gerald Bevan (London, 2008), pp. 142–3.   **13.** Hippolyte Taine, *Histoire de la littérature anglaise* (1863–9), quoted in Zeev Sternhell, *The Anti-Enlightenment Tradition*, tr. David Maisel (New Haven, 2010), p. 181.   **14.** Émile Faguet, *La Politique comparée de Montesquieu, Rousseau et Voltaire* (Paris, 1902), pp. 83, 75.   **15.** See Joachim Whaley, '"Wahre Aufklärung kann erreicht und segensreich werden": The German Enlightenment and its interpretation', *Oxford German Studies*, 44 (2015), pp. 428–48 (pp. 433–5).   **16.** Wilhelm Dilthey, 'Die dichterische und philosophische Bewegung

in Deutschland 1770–1800', in his *Gesammelte Schriften* (Leipzig, 1924), v. pp. 12–27 (p. 20). **17**. Ibid., p. 17.   **18.** For a dissenting but sympathetic interpretation, see James Schmidt, 'Language, mythology, and enlightenment: historical notes on Horkheimer and Adorno's *Dialectic of Enlightenment*', *Social Research*, 65 (1998), pp. 807–38.   **19.** Theodor W. Adorno and Max Horkheimer, *Dialectic of Enlightenment*, tr. John Cumming (New York, 1972), p. 3. See Horkheimer and Adorno, *Dialektik der Aufklärung: Philosophische Fragmente* (Frankfurt a.M., 1969), p. 9.   **20.** Horkheimer and Adorno, *Dialectic of Enlightenment: Philosophical Fragments*, tr. Edmund Jephcott (Stanford, 2002), p. 1.   **21.** Ibid., p. 18. **22.** Jürgen Habermas, *The Philosophical Discourse of Modernity*, tr. Larry Kert (Cambridge, 1990), p. 89. See also Paul Connerton, *The Tragedy of Enlightenment: An Essay on the Frankfurt School* (Cambridge, 1980), pp. 60–79; Jeffrey Herf, '*Dialectic of Enlightenment* reconsidered', *New German Critique*, no. 117 (Fall 2017), pp. 81–9.   **23.** Leszek Kolakowski, *Main Currents of Marxism*, tr. P. S. Falla, 3 vols. (Oxford, 1978), iii. p. 376.   **24.** Habermas, *Philosophical Discourse*, pp. 92–3; Schmidt, 'Language, mythology, and enlightenment', p. 820.   **25.** See Laurence Brockliss and Ritchie Robertson, 'Berlin's conception of the Enlightenment', in Brockliss and Robertson, eds, *Isaiah Berlin and the Enlightenment* (Oxford, 2016), pp. 35–50 (pp. 41–3).   **26.** Gareth Stedman Jones, *Karl Marx: Greatness and Illusion* (London, 2016), p. 192.   **27.** Isaiah Berlin, *Karl Marx* [1939], 5th edn, ed. Henry Hardy (Princeton, 2013), p. 35.   **28.** 'Introduction', in *The Age of Enlightenment: The Eighteenth-Century Philosophers*, ed. Isaiah Berlin ([1956]; Oxford, 1979), pp. 11–29 (p. 28). **29.** Steven B. Smith, 'Isaiah Berlin on the Enlightenment and Counter-Enlightenment', in Joshua L. Cherniss, ed., *The Cambridge Companion to Isaiah Berlin* (Cambridge, 2018), pp. 132–48 (p. 137).   **30.** Isaiah Berlin, 'The Counter-Enlightenment', in his *Against the Current: Essays in the History of Ideas*, ed. Henry Hardy (Oxford, 1981), pp. 1–24 (p. 7). **31.** See Robert Wokler, 'Isaiah Berlin's Enlightenment and Counter-Enlightenment', in his *Rousseau, the Age of Enlightenment, and their Legacies*, ed. Bryan Garsten (Princeton, 2012), pp. 244–59; Robert E. Norton, 'The myth of the Counter-Enlightenment', *JHI*, 68 (2007), pp. 635–58.   **32.** For a detailed account, see Sternhell, *The Anti-Enlightenment Tradition*.   **33.** Friedrich Meinecke, *Historism: The Rise of a New Historical Outlook*, tr. J. E. Anderson (London, 1972), p. lvi.   **34.** See Avi Lifschitz, 'Between Friedrich Meinecke and Ernst Cassirer: Isaiah Berlin's bifurcated Enlightenment', in Brockliss and Robertson, *Isaiah Berlin and the Enlightenment*, pp. 51–66.   **35.** See James Schmidt, 'Inventing the Enlightenment: Anti-Jacobins, British Hegelians, and the *Oxford English Dictionary*', *JHI*, 64 (2003), pp. 421–43.   **36.** Roy Porter and Mikuláš Teich, eds., *The Enlightenment in National Context* (Cambridge, 1981).   **37.** Peter Gay, *The Enlightenment: An Interpretation*, 2 vols. (New York, 1966–9), i. p. 3.   **38.** Jonathan Israel, *Radical Enlightenment: Philosophy and the Making of Modernity 1650–1750* (Oxford, 2001), p. v.   **39.** Susan Neiman, *Moral Clarity: A Guide for Grown-up Idealists* (London, 2009), p. 136.   **40.** See Steven Pinker, *The Better Angels of our Nature: The Decline of Violence in History and its Causes* (London, 2011) and *Enlightenment Now: The Case for Reason, Science, Humanism and Progress* (London, 2018). Cf. the review of the latter book by David Wootton, *Times Literary Supplement*, 16 Feb. 2018, p. 9.   **41.** Letter to Miss Sophia Thrale, 24 July 1783, in *Selected Letters of Samuel Johnson*, ed. R. W. Chapman (London, 1925), p. 236. **42.** Hanif Kureishi, 'Touching the untouchable: Reflections on a fatwa', *Times Literary Supplement*, 1 March 2019, pp. 15–16 (p. 16).   **43.** David Runciman, *How Democracy Ends* (London, 2018), p. 24. Although Runciman was referring to the United States, his analysis has far wider implications, which are still becoming manifest.

# Select Bibliography

## PRIMARY SOURCES

Addison, Joseph, and others, *The Spectator*, ed. Donald Bond, 5 vols. (Oxford, 1965)

Annet, Peter, *The Resurrection of Jesus Considered; in answer to The Tryal of the Witnesses. By a Moral Philosopher* (London, 1743)

Anquetil-Duperron, Abraham-Hyacinthe, *Législation orientale* (Amsterdam, 1778)

Augustine, St, *The Confessions of St Augustine*, tr. E. B. Pusey (London, 1907)

—— *Concerning the City of God against the Pagans*, tr. Henry Bettenson (London, 1984)

Austen, Jane, *Sense and Sensibility*, ed. Tony Tanner (Harmondsworth, 1968)

Bacon, Francis, *Collected Works of Francis Bacon*, ed. James Spedding, Robert Leslie Ellis and Douglas Denon Heath, 7 vols. in 12 (1879; repr. London, 1996)

Barbier, E. J. F., *Journal historique et anecdotique du règne de Louis XV*, ed. A. de la Villegille, 2 vols. (Paris, 1847)

Basedow, Johann Bernhard, *Elementarwerk: Ein geordneter Vorrath aller nöthigen Erkenntniß zum Unterricht der Jugend*, 4 vols. (Dessau, 1774)

Batteux, Charles, *Les Beaux-Arts réduits à un même principe*, ed. Jean-Rémy Mantion (Paris, 1989)

—— *The Fine Arts Reduced to a Single Principle*, tr. and ed. James O. Young (Oxford, 2015)

Bayle, Pierre, *Commentaire philosophique sur ces paroles de Jesus-Christ: contrains-les d'entrer* ('Cantorbery', 1686)

—— *Dictionnaire historique et critique*, 4 vols. (Amsterdam, 1730)

—— *Pensées diverses sur la comète*, ed. A. Prat, 2 vols. (Paris, 1939)

—— *Historical and Critical Dictionary: Selections*, ed. and tr. Richard H. Popkin (Indianapolis, 1965)

—— *Philosophical Commentary*, tr. Amie Godman Tannenbaum (New York, 1987)

Beccaria, Cesare, *On Crimes and Punishments and Other Writings*, ed. Richard Bellamy (Cambridge, 1995)

Behn, Aphra, *Oroonoko and Other Writings*, ed. Paul Salzman (Oxford, 1994)

Bekker, Balthasar, *De betoverde weereld, zynde een grondig ondersoek van 't gemeen gevoelen aangaande de geesten, derselver aart en vermogen, bewind*

*en bedryf: als ook 't gene de menschen door derselver kraght en gemeenschap doen*, 4 vols. (Amsterdam, 1691–3)

Bentham, Jeremy, *Panopticon; or, The Inspection-House: Containing the Idea of a New Principle of Construction* (London, 1791)

—— *The Works of Jeremy Bentham*, ed. John Bowring, 11 vols. (Edinburgh, 1843)

Blair, Robert, *The Grave. A Poem (1743)*, ed. James A. Means (Los Angeles, 1973)

Blake, William, *Complete Writings*, ed. Geoffrey Keynes (London, 1976)

Blumenbach, Johann Friedrich, *Anthropological Treatises*, tr. Thomas Bendyshe (London, 1865)

Boileau-Despréaux, Nicolas, *Épîtres, Art Poétique, Le Lutrin*, ed. Charles-H. Bouhours (Paris, 1952)

Boston, Thomas, *Memoirs of the Life, Time, and Writings of Thomas Boston, A.M.*, ed. George H. Morrison (Edinburgh, 1899)

Boswell, James, *Boswell's Journal of a Tour to the Hebrides with Samuel Johnson, LL.D.*, ed. R. W. Chapman (London, 1924)

—— *Boswell on the Grand Tour: Germany and Switzerland 1764*, ed. Frederick A. Pottle (London, 1953)

—— *Life of Johnson*, ed. R. W. Chapman, corrected by J. D. Fleeman (London, 1970)

—— *Boswell in Extremes*, ed. Charles McC. Weis and Frederick A. Pottle (London, 1971)

Brown, John, *An Estimate of the Manners and Principles of the Times* (London, 1757)

Browne, Sir Thomas, *Selected Writings*, ed. Sir Geoffrey Keynes (London, 1968)

Bruckner, John, *A Philosophical Survey of the Animal Creation* (London, 1768)

Buffon [Georges-Louis Leclerc, comte de], *De l'homme*, ed. Michèle Duchet (Paris, 1971)

Burke, Edmund, *A Philosophical Enquiry into the Origin of our Ideas of the Sublime and Beautiful*, ed. Adam Phillips (Oxford, 1990)

—— *The Writings and Speeches of Edmund Burke*, ed. Paul Langford, 9 vols. (Oxford, 1991–2000)

—— *Reflections on the Revolution in France*, ed. L. G. Mitchell (Oxford, 1993)

Burney, Frances, *Journals and Letters*, ed. Peter Sabor and Lars E. Troide (London, 2001)

Burns, Robert, *The Poems and Songs of Robert Burns*, ed. James Kinsley, 3 vols. (Oxford, 1968)

—— *Letters of Robert Burns*, ed. J. De Lancey Ferguson, rev. by G. Ross Roy, 2 vols. (Oxford, 1985)

Cadalso [José], *Cartas marruecas*, ed. Juan Tamayo y Rubio (Madrid, 1956)

Carlyle, Alexander, *Anecdotes and Characters of the Times*, ed. James Kinsley (London, 1973)

Catherine II of Russia, *The Memoirs of Catherine the Great*, ed. Dominique Maroger, tr. Moura Budberg (London, 1955)

Chardin, Jean, *Sir John Chardin's Travels in Persia*, 2 vols. (London, 1720)

Chesterfield, Lord, *The Letters of Philip Dormer Stanhope, 4th Earl of Chester-field*, ed. Bonamy Dobrée, 6 vols. (London, 1932)

Cheyne, George, *The English Malady: or, a Treatise of Nervous Diseases of All Kinds* (London, 1733)

Chydenius, Anders, *Anticipating 'The Wealth of Nations': The Selected Works of Anders Chydenius (1729–1803)*, ed. Maren Jonasson and Pertti Hyttinen, tr. Peter C. Hogg (London, 2012)

Cicero, M. T. *Cicero his Offices, or his Treatise concerning the Moral Duties of Mankind*, tr. William Guthrie (London, 1755)

———— *On the Commonwealth and On the Laws*, tr. James E. G. Zetzel (Cambridge, 1999)

Clarke, Samuel, *The Scripture-Doctrine of the Trinity: Wherein every text in the New Testament relating to that doctrine, is distinctly considered, and the divinity of our Blessed Saviour according to the Scriptures, proved and explained*, 2nd edn ([1712]; London, 1719)

Condillac, Étienne Bonnot de, *Traité des sensations*, 2 vols. (Paris, 1754)

———— *Essay on the Origin of Human Knowledge*, tr. and ed. Hans Aarsleff (Cambridge, 2001)

Condorcet [Jean-Antoine-Nicolas, marquis de], *Esquisse d'un tableau historique des progrès de l'esprit humain*, ed. Monique and François Hincker (Paris, 1971)

D'Alembert, Jean le Rond, *Sur la Destruction des Jésuites en France* ([Paris], 1765)

———— *Œuvres complètes de d'Alembert*, 5 vols. (Paris, 1821)

Defoe, Daniel, *Robinson Crusoe*, ed. Angus Ross (Harmondsworth, 1965)

———— *Religious and Didactic Writings of Daniel Defoe*, ed. W. R. Owens and P. N. Furbank, 10 vols. (London, 2007), vol. 7: *The English Tradesman, Volume 1* [1725], ed. John McVeagh

———— *Satire, Fantasy and Writings on the Supernatural by Daniel Defoe*, ed. W. R. Owens and P. N. Furbank (London, 2003–5), vol. 6: *The Political History of the Devil* [1726], ed. John Mullan

Derham, William, *Physico-Theology: or a Demonstration of the Being and Attributes of God, from his Works of Creation* [1713], 3rd edn (London, 1714)

Desmoulins, Camille, *Œuvres de Camille Desmoulins*, ed. Jules Claretie, 2 vols. (Paris, 1874)

Diderot, Denis, *Œuvres complètes*, ed. Roger Lewinter and others, 15 vols. (Paris, 1969–73)

———— *The Nun*, tr. Russell Goulbourne (Oxford, 2005)

Docwra, Ann, *Spiritual Community, vindicated among people of different perswasions in some things* (London, 1687)

Dodwell, Henry, *Christianity not Founded on Argument* (London, 1741)

[Drake, Judith], *An Essay in Defence of the Female Sex, in a Letter to a Lady* ([1696]; London, 1721)

Dubos, Jean-Baptiste, *Critical Reflections on Poetry, Painting and Music*, tr. Thomas Nugent, 3 vols. (London, 1748)

Duclos [Charles Pinot], *Considérations sur les mœurs*, ed. F. C. Green (Cambridge, 1939)

Du Halde, Jean-Baptiste, *The General History of China, containing a geographical, historical, chronological, political and physical description of the empire of China, Chinese-Tartary, Corea and Thibet,* tr. Richard Brookes, 4 vols. (London, 1736)

Dulard [Paul-Alexandre], *La Grandeur de Dieu dans les merveilles de la nature: poëme,* 4th, enlarged edn (Paris, 1758; originally 1749)

Edgeworth, Richard, *Memoirs of Richard Lowell Edgeworth, Esq.,* begun by himself, and concluded by his daughter, Maria Edgeworth, 2 vols., 2nd edn (London, 1821)

Edwards, Thomas, *Gangraena* ([1647]; Exeter, 2008)

*Encyclopédie ou Dictionnaire raisonné des sciences, des arts et des métiers,* 17 vols. (Neuchâtel, 1765)

Épinay, Madame d', *Les Conversations d'Émilie,* ed. Rosena Davison (Oxford, 1996)

Fawconer, Samuel, *An Essay on Modern Luxury: Or, An Attempt to Delineate its Nature, Causes and Effects* (London, 1765)

Feijóo y Montenegro, Benito Jerónimo, *An Essay on Woman, or Physiological and Historical Defence of the Fair Sex* (London, 1768)

Fénelon, *Les Aventures de Télémaque,* ed. Jeanne-Lydie Goré (Paris, 1968)

Ferguson, Adam, *An Essay on the History of Civil Society,* ed. Duncan Forbes (Edinburgh, 1966)

Fielding, Henry, *An Enquiry into the Causes of the Late Increase of Robbers and Related Writings,* ed. Malvin R. Zirker (Oxford, 1988)

Fielding, Sarah, *The Adventures of David Simple,* ed. Malcolm Kelsall (London, 1969)

Forster, Georg, *Werke,* ed. by the Akademie der Wissenschaften zu Berlin, 18 vols. (Berlin, 1958–89)

Fortis, Alberto, *Travels into Dalmatia* (London, 1778)

Frederick II of Prussia, *Œuvres de Frédéric le Grand,* ed. J. D. E. Preuss, 33 vols. (Berlin, 1846–57)

—— *The Refutation of Machiavelli's 'Prince' or Anti-Machiavel,* tr. and ed. Paul Sonnino (Athens, OH, 1981)

Galiani, Ferdinando, *Dialogues sur le commerce des bleds* (London, 1770)

Genovesi, Antonio, *Scritti economici,* ed. Maria Luisa Perna, 2 vols. (Naples, 1984)

Gibbon, Edward, *The Letters of Edward Gibbon,* ed. J. E. Norton, 3 vols. (London, 1956)

—— *Memoirs of my Life,* ed. Georges A. Bonnard (London, 1966)

—— *The History of the Decline and Fall of the Roman Empire,* ed. David Womersley, 3 vols. (London, 1994)

Glanvill, Joseph, *Saducismus Triumphatus, Or, Full and plaine evidence concerning witches and apparitions* (London, 1688)

Godwin, William, *An Enquiry Concerning Political Justice,* ed. Mark Philp (Oxford, 2013)

Goethe, Johann Wolfgang, *Selected Verse,* tr. David Luke (Harmondsworth, 1964)

—— *Sämtliche Werke: Briefe, Tagebücher und Gespräche*, ed. Friedmar Apel and others, 40 vols. (Frankfurt a.M., 1986–2000)

—— *The Sorrows of Young Werther*, tr. Michael Hulse (London, 1989)

—— *Faust Part Two*, tr. David Luke (Oxford, 1994)

Hamilton, Alexander, James Madison and John Jay, *The Federalist Papers*, ed. Lawrence Goldman (Oxford, 2008)

Harrington, James, *The Commonwealth of Oceana and A System of Politics*, ed. J. G. A. Pocock (Cambridge, 1992)

Helvétius, Claude Adrien, *Œuvres complètes*, 4 vols. (London, 1777)

Herder, Johann Gottfried, *Werke*, ed. Günter Arnold and others, 10 vols. (Frankfurt a.M., 1985–2000)

Herodotus, *The Histories*, tr. Aubrey de Sélincourt, rev. A. R. Burn (Harmondsworth, 1972)

Hobbes, Thomas, *Leviathan*, ed. J. C. A. Gaskin (Oxford, 1996)

Holbach, Paul Henri Thiry, baron d', *Système de la nature*, 2 vols. (Paris, 1770)

—— *Œuvres philosophiques*, ed. Jean-Pierre Jackson, 3 vols. (Paris, 2001)

Howard, John, *The State of the Prisons in England and Wales, with Preliminary Observations, and an Account of Some Foreign Prisons and Hospitals*, 3rd edn (Warrington, 1784)

—— *An Account of the Principal Lazarettos in Europe* (Warrington, 1789)

Humboldt, Wilhelm von, *The Limits of State Action*, ed. J. W. Burrow (Cambridge, 1969)

Hume, David, *A Concise and Genuine Account of the Dispute between Mr Hume and Mr Rousseau, translated from French* (London, 1766)

—— *The Letters of David Hume*, ed. J. Y. T. Greig, 2 vols. (Oxford, 1932)

—— *New Letters of David Hume*, ed. Raymond Klibansky and Ernest C. Mossner (Oxford, 1954)

—— *The Natural History of Religion*, ed. A. Wayne Colver, and *Dialogues concerning Natural Religion*, ed. John Valdimir Price (Oxford, 1976)

—— *The History of England from the Invasion of Julius Caesar to the Revolution in 1688*, 6 vols. (1778; repr. Indianapolis, 1983)

—— *Essays Moral, Political, and Literary*, ed. Eugene F. Miller (Indianapolis, 1987)

—— *An Enquiry concerning Human Understanding*, ed. Tom L. Beauchamp (Oxford, 2000)

—— *A Treatise of Human Nature: A Critical Edition*, ed. David Fate Norton and Mary J. Norton (Oxford, 2007)

Hutcheson, Francis, *Inquiry into the Original of Our Ideas of Beauty and Virtue*, 2nd edn, ed. W. Leidhold (Indianapolis, 2008)

Hutchinson, Francis, *An Historical Essay concerning Witchcraft* (London, 1718)

[Innocent III, Pope], *The Mirror of Mans Lyfe*, tr. Henry Kirton (London, 1576)

Jefferson, Thomas, *Writings*, ed. Merrill D. Peterson (New York, 1984)

Jenyns, Soame, *A Free Inquiry into the Nature and Origin of Evil* (London, 1757)

Johnson, Samuel, *The Yale Edition of the Works of Samuel Johnson*, ed. Herman W. Liebert and others (New Haven, 1963–2010)

—— *The Lives of the most Eminent English Poets; with Critical Observations on their Works*, ed. Roger Lonsdale, 4 vols. (Oxford, 2006)

Jung-Stilling, J. H., *Heinrich Stillings Jugend, Jünglingsjahre, Wanderschaft und häusliches Leben*, ed. Dieter Cunz (Stuttgart, 1968)

Jurieu, Pierre, *The Pastoral Letters of the Incomparable Jurieu Directed to the Protestants in France Groaning under the Babylonish Tyranny, translated* (London, 1689)

Justi, Johann Heinrich Gottlob von, *Die Grundfeste zu der Macht und Glückseligkeit der Staaten oder ausführliche Vorstellung der gesamten Polizeiwissenschaft*, 2 vols. (Königsberg, 1760–61; repr. Aalen, 1965)

Kames, Lord, *Historical Law-Tracts*, 2 vols. (Edinburgh, 1758)

—— *Sketches of the History of Man*, 4 vols. (London, 1774–5)

Kant, Immanuel, *Werke*, ed. Wilhelm Weischedel, 6 vols. (Darmstadt, 1958)

—— *Political Writings*, ed. Hans Reiss, tr. H. B. Nisbet, 2nd edn (Cambridge, 1991)

—— *Practical Philosophy*, tr. Mary J. Gregor, The Cambridge Edition of the Works of Immanuel Kant (Cambridge, 1996)

—— *Religion and Rational Theology*, ed. and tr. Allen W. Wood and George di Giovanni, The Cambridge Edition of the Works of Immanuel Kant (Cambridge, 1996)

—— *Lectures on Ethics*, ed. Peter Heath and J. B. Schneewind, tr. Peter Heath, The Cambridge Edition of the Works of Immanuel Kant (Cambridge, 1997)

—— *Critique of the Power of Judgment*, tr. Paul Guyer, ed. Paul Guyer and Eric Matthews, The Cambridge Edition of the Works of Immanuel Kant (Cambridge, 2000)

—— *Anthropology, History, and Education*, ed. Günter Zöller and Robert B. Louden, The Cambridge Edition of the Works of Immanuel Kant (Cambridge, 2007)

—— *Natural Science*, ed. Eric Watkins, The Cambridge Edition of the Works of Immanuel Kant (Cambridge, 2012)

Kolben, Peter, *The Present State of the Cape of Good-Hope*, vol. 1: *Containing a Particular Account of the Several Nations of the Hottentots: Their Religion, Government, Laws, Customs, Ceremonies, and Opinions; Their Art of War, Professions, Language, Genius, &c., together with A Short Account of the Dutch Settlement at the Cape*, tr. G. Medley (London, 1738)

Lafitau, Joseph-François, *Mœurs des sauvages amériquains, comparées aux mœurs des premiers temps*, 2 vols. (Paris, 1724)

La Mettrie, *Machine Man and Other Writings*, tr. and ed. Ann Thomson (Cambridge, 1996)

Leibniz, G. W., *Theodicy: Essays on the Goodness of God, the Freedom of Man and the Origin of Evil*, tr. E. M. Huggard (London, 1951)

Lessing, Gotthold Ephraim, *Werke und Briefe*, ed. Wilfried Barner and others, 12 vols. (Frankfurt a.M., 1987–98)

—— *Philosophical and Theological Writings*, ed. and tr. H. B. Nisbet (Cambridge, 2005)

*The Letters of Charlotte during her Connexion with Werter*, 2 vols. (London, 1786)

Lichtenberg, Georg Christoph, *Aphorisms*, tr. R. J. Hollingdale (London, 1990)

Lillo, George, *The Dramatic Works of George Lillo*, ed. James L. Steffensen (Oxford, 1993)

[Linné, Carl von], 'The œconomy of nature, by Isaac Biberg', in *Miscellaneous Tracts relating to Natural History, Husbandry, and Physick*, tr. Benjamin Stillingfleet, 2nd edn (London, 1762)

Locke, John, *The Works of John Locke*, 9 vols. (1794; repr. London, 1997)

—— *Two Treatises of Government* and *A Letter Concerning Toleration*, ed. Ian Shapiro (New Haven, 2003)

Loen, Johann Michael von, *Der redliche Mann am Hofe* (Frankfurt a.M., 1742; facsimile repr., Stuttgart, 1966)

Lowth, Robert, *Lectures on the Sacred Poetry of the Hebrews*, tr. G. Gregory (London, 1787)

Lucretius, *On the Nature of the Universe*, tr. R. E. Latham (Harmondsworth, 1951)

Mabillon, Jean, *Œuvres posthumes*, 3 vols. (Paris, 1724)

Mably, Gabriel Bonnot de, *Collection complète des œuvres*, 15 vols. (Paris, 1794–5)

Macaulay, Catharine, *The History of England from the Accession of James I to that of the Brunswick Line*, 8 vols. (London, 1763–83)

Machiavelli, Niccolò, *The Discourses*, tr. Leslie J. Walker (London, 1950)

—— *The Prince*, ed. Quentin Skinner and Russell Price (Cambridge, 1988)

Maffei, Scipione, *Merope*, Collezione portatile di classici italiani, vol. 17 (Florence, 1826)

Mandeville, Bernard, *The Fable of the Bees*, ed. Phillip Harth (Harmondsworth, 1970)

Marmontel, Jean-François, *Bélisaire*, ed. Robert Granderoute (Paris, 1994)

—— *Mémoires*, ed. Jean-Pierre Guicciardi and Gilles Thierriat (Paris, 1999)

Mather, Cotton, *The Christian Philosopher: A Collection of the Best Discoveries in Nature, with Religious Improvements* (London, 1721)

Melon, Jean-François, *Essai politique sur la commerce* ([Paris], 1734)

—— *A Political Essay upon Commerce*, tr. David Bindon (Dublin, 1738)

Mercier, Louis-Sébastien, *L'An deux mille quatre cent quarante: Rêve s'il en fût jamais*, ed. Raymond Trousson (Paris, 1971)

Meslier, Jean, *Le testament de Jean Meslier*, ed. Rudolf Charles, 3 vols. (Amsterdam, 1864)

—— *Testament: Memoir of the Thoughts and Sentiments of Jean Meslier*, tr. Michael Shreve (New York, 2009)

Middleton, Conyers, *A Free Inquiry into the Miraculous Powers, which are Supposed to have Subsisted in the Christian Church* (London, 1749)

Millar, John, *Observations concerning the Distinction of Ranks in Society* (London, 1771)

Milton, John, *The Poems of John Milton*, ed. John Carey and Alastair Fowler (London, 1968)

Monboddo, Lord, *Of the Origin and Progress of Language*, 2nd edn, 6 vols. (Edinburgh, 1774–92)

Montagu, Mary Wortley, *Letters*, ed. Clare Brant (London, 1992)

Montaigne, Michel de, *The Complete Essays*, tr. M. A. Screech (London, 2003)

Montesquieu, *Œuvres complètes*, ed. Roger Caillois, 2 vols. (Paris, 1949)

—— *Persian Letters*, tr. C. J. Betts (Harmondsworth, 1973)

—— *The Spirit of the Laws*, ed. and tr. Anne M. Cohler, Basia C. Miller and Harold S. Stone (Cambridge, 1989)

Morellet, André, *Mémoires de l'Abbé Morellet*, ed. Jean-Pierre Guicciardi (Paris, 1988)

Moritz, Karl Philipp, *Anton Reiser: A Psychological Novel*, tr. Ritchie Robertson (London, 1997)

Mozart, W. A., *Die Zauberflöte* (Stuttgart, 1991)

Muratori, Lodovico Antonio, *Opere*, ed. Giorgio Falco and Fiorenzo Forti (Milan, [1965?])

Neville, Francis de, *The Christian and Catholike Veritie, or the Reasons and Manner of the Conversion of Francis de Neville* (London, 1642)

Nicolai, Friedrich, *Beschreibung einer Reise durch Deutschland und die Schweiz im Jahre 1781. Nebst Bemerkungen über Gelehrsamkeit, Industrie, Religion und Sitten*, 12 vols. (Berlin, 1783–96)

Oswald, John, *The Cry of Nature: or, an appeal to mercy and to justice, on behalf of the persecuted animals* (London, 1791)

Paine, Thomas, *Rights of Man, Common Sense, and Other Political Writings*, ed. Mark Philp (Oxford, 1995)

Perkins, William, *A Salve for a Sicke Man, or, A Treatise containing the Nature, Differences, and Kindes of Death* (London, 1611)

Pezzl, Johann, *Charakteristik Joseph des Zweiten*, 3rd edn (Vienna, 1803)

Pichler, Caroline, *Denkwürdigkeiten aus meinem Leben*, ed. Emil Karl Blümml, 2 vols. (Munich, 1914)

Plato, *The Dialogues of Plato*, tr. B. Jowett, 4 vols., 4th edn (Oxford, 1953)

Plotinus, *The Enneads*, tr. Stephen MacKenna, ed. John Dillon (London, 1991)

Pope, Alexander, *The Twickenham Edition of the Poems of Alexander Pope*, ed. John Butt, 11 vols. (London, 1939–69)

Poulain de la Barre, François, *De l'égalité des deux sexes* (Paris, 1984)

Psalmanazar, George, *An Historical and Geographical Description of Formosa* (London, 1704)

Racine, Jean, *Œuvres complètes*, ed. Georges Forestier (Paris, 1999)

Racine, Louis, *Œuvres*, 6 vols. (Paris, 1808)

Raynal, Guillaume-Thomas, *Histoire philosophique et politique des établissements et du commerce des Européens dans les deux Indes*, enlarged edn, 10 vols. (Geneva, 1781)

Reimarus, Hermann Samuel, *Apologie oder Schutzschrift für die vernünftigen Verehrer Gottes*, ed. Gerhard Alexander, 2 vols. (Frankfurt a.M., 1972)

Reynolds, Joshua, *The Works of Sir Joshua Reynolds*, 2 vols. (London, 1797)

Richardson, Samuel, *Selected Letters of Samuel Richardson*, ed. John Carroll (Oxford, 1964)

—— *Clarissa, or the History of a Young Lady*, ed. Angus Ross (London, 1985)

Robertson, William, *The Situation of the World at the Time of Christ's Appearance* (Edinburgh, 1755)

—— *The History of the Reign of the Emperor Charles V*, 3 vols. (London, 1769)

—— *The History of America*, 2 vols. (London, 1777)

—— *An Historical Disquisition concerning the Knowledge which the Ancients had of India* (London, 1791)

Robespierre, Maximilien, *Œuvres de Maximilien Robespierre*, ed. Marc Bouloiseau and Albert Soboul, 10 vols. (Paris, 1950–67)

Rousseau, Jean-Jacques, *Émile*, tr. Barbara Foxley (London, 1911)

—— *Œuvres complètes*, ed. Bernard Gagnebin and Marcel Raymond, 5 vols. (Paris, 1959–95)

—— *Correspondance complète de Jean-Jacques Rousseau*, ed. R. A. Leigh, 52 vols. (Geneva, 1965–98)

—— *Rousseau on International Relations*, ed. Stanley Hoffmann and David P. Fidler (Oxford, 1991)

—— *The 'Discourses' and Other Early Political Writings*, ed. and tr. Victor Gourevitch (Cambridge, 1997)

—— *The Social Contract and Other Later Political Writings*, ed. and tr. Victor Gourevitch (Cambridge, 1997)

—— *Confessions*, tr. Angela Scholar, ed. Patrick Coleman (Oxford, 2000)

Russell, D. A., and M. Winterbottom, eds., *Ancient Literary Criticism* (Oxford, 1972)

Sade, marquis de, *Œuvres*, ed. Michel Delon, 3 vols. (Paris, 1998)

Saint-Just, Antoine-Louis de, *Œuvres complètes*, ed. Anne Kupiec and Miguel Abensour (Paris, 2004)

Saint-Pierre, abbé de, *Projet pour rendre la Paix perpétuelle en Europe*, ed. Simone Goyard-Fabre (Paris, 1981)

Schiller, Friedrich, *Schillers Werke: Nationalausgabe*, ed. Julius Petersen and others, 41 vols. (Weimar, 1943–2010)

—— *Sämtliche Werke*, ed. Gerhard Fricke and Herbert G. Göpfert, 5 vols. (Munich, 1958)

—— *On the Aesthetic Education of Man in a Series of Letters*, ed. and tr. Elizabeth M. Wilkinson and L. A. Willoughby (Oxford, 1967)

Schleiermacher, Friedrich, *On Religion: Speeches to its Cultured Despisers*, tr. Richard Crouter (Cambridge, 1988)

Schlözer, August Ludwig, *Vorstellung seiner Universal-Historie (1772/73)*, ed. Horst Walter Blanke (Hagen, 1990)

Shaftesbury, Anthony Ashley Cooper, third earl of, *Characteristics of Men, Manners, Opinions, Times*, ed. Lawrence E. Klein (Cambridge, 1999)

Shelley, Percy Bysshe, *The Complete Poetical Works of Shelley*, ed. Thomas Hutchinson (London, 1934)

Smith, Adam, *An Inquiry into the Nature and Causes of the Wealth of Nations*, ed. R. H. Campbell and A. S. Skinner (Oxford, 1976)
—— *The Theory of Moral Sentiments*, ed. D. D. Raphael and A. L. Macfie (Oxford, 1976)
—— *Lectures on Jurisprudence*, ed. R. L. Meek, D. D. Raphael and P. G. Stein (Oxford, 1978)
—— *Essays on Philosophical Subjects*, ed. W. P. D. Wightman and J. C. Bryce (Oxford, 1980)
Smollett, Tobias, *Travels through France and Italy*, ed. Frank Felsenstein (Oxford, 1979)
—— *The Expedition of Humphry Clinker*, ed. O. M. Brack, Jr and Thomas R. Preston (Athens, GA, 1990),
Spalding, Johann Joachim, *Die Bestimmung des Menschen*, ed. Albrecht Beutel, Daniela Kirschkowski and Dennis Prause (Tübingen, 2006)
Spinoza, Benedict de, *A Theologico-Political Treatise; A Political Treatise*, tr. R. H. M. Elwes (New York, 1951)
—— *Ethics*, tr. Edwin Curley (London, 1996)
Sprat, Thomas, *The History of the Royal Society of London* (London, 1667)
Sterne, Laurence, *The Life and Opinions of Tristram Shandy, Gentleman*, ed. Ian Campbell Ross, rev. edn (Oxford, 2009)
Stillingfleet, Edward, *The Mischief of Separation: A Sermon Preach'd in Guild-Hall Chappel, May II MDCLXXX, being the Fifth Sunday of Easter-Term, before the Lord Mayor, etc.* (London, 1709)
Swift, Jonathan, *Gulliver's Travels*, ed. Claude Rawson and Ian Higgins (Oxford, 2005)
Temple, Sir William, *Observations upon the United Provinces of the Netherlands* [1673], ed. Sir George Clark (Oxford, 1972)
Thomasius, Christian, *Vom Laster der Zauberei; Über die Hexenprozesse (De Crimine Magiae; Processus Inquisitorii contra Sagas)*, ed. Rolf Lieberwirth (Munich, 1986)
Thomson, James, *The Tragedy of Sophonisba* (London, 1730)
—— *The Seasons*, ed. James Sambrook (Oxford, 1981)
Thucydides, *The Peloponnesian War*, tr. Rex Warner (Harmondsworth, 1954)
Tillotson, John, *The Works of the Most Reverend Dr. John Tillotson, Archbishop of Canterbury*, 12 vols. (London, 1757)
[Tindal, Matthew], *Christianity as Old as the Creation; or, the Gospel, a Republication of the Religion of Nature* (London, 1731)
'Tom Telescope', *The Newtonian System of Philosophy adapted to the Capacities of young Gentlemen and Ladies* (London, 1761)
Le *'Traité des trois imposteurs' et 'L'Esprit de Spinosa': Philosophie clandestine entre 1678 et 1768*, ed. Françoise Charles-Daubert (Oxford, 1999)
Trembley, [Abraham], *Mémoires pour servir à l'histoire d'un genre de polypes d'eau douce, à bras en forme de cornes* (Paris, 1744)
Turgot, Anne-Robert-Jacques, *Œuvres de Turgot et documents le concernant*, ed. Gustav Schelle, 5 vols. (Paris, 1913)

Verri, Pietro, *Discorsi del Conte Pietro Verri sull' indole del piacere e del dolore; sulla felicità; e sulla economia politica* (Milan, 1781)

Volney [Constantin-François], *The Ruins, or a Survey of the Revolutions of Empires*, tr. anon. (London, 1795)

Voltaire, *Œuvres historiques*, ed. René Pomeau (Paris, 1957)

—— *Essai sur les mœurs*, ed. René Pomeau, 2 vols. (Paris, 1963)

—— *Œuvres complètes de Voltaire / The Complete Works of Voltaire*, ed. Nicholas Cronk, 135 vols. (Geneva, later Oxford, 1968– )

—— *Letters concerning the English Nation*, ed. Nicholas Cronk (Oxford, 1994)

—— *Treatise on Tolerance and Other Writings*, tr. Brian Masters and Simon Harvey, ed. Simon Harvey (Cambridge, 2000)

—— *Candide and Other Stories*, tr. Roger Pearson (Oxford, 2006)

and Catherine II of Russia, *Correspondance 1763–1778*, ed. Alexandre Stroev (Paris, 2006)

Warburton, William, *The Divine Legation of Moses Demonstrated, on the Principles of a Religious Deist, from the Omission of the Doctrine of a Future State of Reward and Punishment in the Jewish Dispensation*, 3rd edn., 2 vols. (London, 1742)

Wesley, John, *An Earnest Appeal to Men of Reason and Religion*, 3rd edn (London, 1744)

Wieland, Christoph Martin, *Wielands Gesammelte Schriften*, ed. by the Deutsche Kommission der Königlich Preußischen Akademie der Wissenschaften. 1. *Werke*, 23 vols. (Berlin, 1909–69)

—— *Werke*, ed. Fritz Martini and Hans Werner Seiffert, 5 vols. (Munich, 1964–8)

Winckelmann, Johann, *Sämtliche Werke*, ed. Josef Eiselein, 12 vols. (1825; Osnabrück, 1965)

—— *Briefe*, ed. Walther Rehm, 4 vols. (Berlin, 1952–7)

Wollstonecraft, Mary, *A Vindication of the Rights of Woman* [and other works], ed. Janet Todd (Oxford, 1993)

—— *Letters written in Sweden, Norway, and Denmark*, ed. Tone Brekke and Jon Mee (Oxford, 2009)

Woodforde, James, *The Diary of a Country Parson*, ed. John Beresford, 5 vols. (London, 1926–31)

Woolston, Thomas, *A Discourse on the Miracles of our Saviour* (London, 1727)

Wordsworth, William, *The Poetical Works of Wordsworth*, ed. Thomas Hutchinson, rev. Ernest de Selincourt (London, 1936)

Wotton, William, *Reflections on Ancient and Modern Learning* (London, 1694)

Wraxall, Sir Nathaniel, *A Tour through some of the Northern Parts of Europe, particularly Copenhagen, Stockholm, and Petersburgh*, 3rd edn (London, 1776)

Young, Edward, *Conjectures on Original Composition* (London, 1759)

## SECONDARY WORKS

Abrams, M. H., *The Mirror and the Lamp: Romantic Theory and the Critical Tradition* (New York, 1953)

Almond, Philip C., *Heaven and Hell in Enlightenment England* (Cambridge, 1994)

Altmann, Alexander, *Moses Mendelssohn: A Biographical Study* (London, 1973)

Aner, Karl, *Die Theologie der Lessingzeit* (Halle, 1929)

Antognazza, Maria Rosa, *Leibniz: An Intellectual Biography* (Cambridge, 2009)

Atkins, Stuart, *The Testament of Werther in Poetry and Drama* (Cambridge, MA, 1949)

Baack, Lawrence J., *Undying Curiosity: Carsten Niebuhr and The Royal Danish Expedition to Arabia (1761–1767)* (Stuttgart, 2014)

Bachleitner, Norbert, *Die literarische Zensur in Österreich von 1751 bis 1848* (Vienna, 2017)

Baier, Annette C., *A Progress of Sentiments: Reflections on Hume's 'Treatise'* (Cambridge, MA, 1991)

Bailyn, Bernard, *The Ideological Origins of the American Revolution*, 2nd edn (Cambridge, MA, 1992)

Bainton, Roland H., *Erasmus of Christendom* (London, 1970)

Baker, Keith Michael, *Condorcet: From Natural Philosophy to Social Mathematics* (Chicago, 1975)

—— 'Transformations of classical republicanism in eighteenth-century France', *Journal of Modern History*, 73 (2001), pp. 32–53

Baldensperger, Fernand, *Goethe en France* (Paris, 1904)

Barber, Elinor G., *The Bourgeoisie in 18th Century France* (Princeton, 1955)

Barker-Benfield, G. J., *The Culture of Sensibility* (Chicago, 1992)

Barnard, T. C., ' "Grand Metropolis" or "the anus of the world": the cultural life of eighteenth-century Dublin', in Peter Clark and Raymond Gillespie, eds., *Two Capitals: London and Dublin, 1500–1840* (Oxford, 2001), pp. 185–210

Beales, Derek, *Joseph II*, vol. 1: *In the Shadow of Maria Theresa, 1741–1780* (Cambridge, 1987)

—— *Prosperity and Plunder: European Catholic Monasteries in the Age of Revolution, 1650–1815* (Cambridge, 2003)

—— *Enlightenment and Reform in Eighteenth-Century Europe* (London, 2005)

—— *Joseph II*, vol. 2: *Against the World, 1780–1790* (Cambridge, 2009)

Behringer, Wolfgang, *Witches and Witch-Hunts* (Cambridge, 2004)

Behrisch, Lars, *Die Berechnung der Glückseligkeit: Statistik und Politik in Deutschland und Frankreich im späten Ancien Régime* (Ostfildern, 2016)

Bell, Matthew, *The German Tradition of Psychology in Literature and Thought, 1700–1840* (Cambridge, 2005)

Bell, Michael, 'Laurence Sterne (1713–1768): The fiction of sentiment', in Michael Bell, ed., *The Cambridge Companion to European Novelists* (Cambridge, 2012), pp. 107–23

Berg, Maxine, *Luxury and Pleasure in Eighteenth-Century Britain* (Oxford, 2005)

Berry, Christopher J., *The Idea of Commercial Society in the Scottish Enlightenment* (Edinburgh, 2013)

Birn, Raymond, *Royal Censorship of Books in 18th-Century France* (Stanford, 2012)

Bitterli, Urs, *Cultures in Conflict: Encounters between European and Non-European Cultures, 1492–1800*, tr. Ritchie Robertson (Cambridge, 1989)

Blackbourn, David, *The Conquest of Nature: Water, Landscape and the Making of Modern Germany* (London, 2006)

Blackburn, Robin, *American Crucible: Emancipation and Human Rights* (London, 2011)

Blanning, T. C. W. [Tim], *Reform and Revolution in Mainz 1743–1803* (Cambridge, 1974)

—— *Joseph II* (London, 1994)

—— *The Culture of Power and the Power of Culture: Old Regime Europe 1660–1789* (Oxford, 2002)

—— *The Pursuit of Glory: Europe 1648–1815* (London, 2007)

—— *Frederick the Great, King of Prussia* (London, 2015)

Bluche, François, *Louis XIV*, tr. Mark Greengrass (Oxford, 1990)

Blum, Jerome, *The End of the Old Order in Rural Europe* (Princeton, 1978)

Bohls, Elisabeth A., 'Aesthetics and Orientalism in Lady Mary Wortley Montagu's letters', *Studies in Eighteenth-Century Culture*, 23 (1994), pp. 179–205

Bordes, Maurice, *L'Administration provinciale et municipale en France au XVIII⁵ siècle* (Paris, 1972)

Boss, Valentin, *Newton in Russia: The Early Influence, 1698–1796* (Cambridge, MA, 1972)

Bots, Hans, and Françoise Waquet, eds., *Commercium Litterarium: La communication dans la République des Lettres* (Amsterdam, 1994)

—— *La République des Lettres* (Paris, 1997)

Bourke, Joanna, *What it Means to be Human: Reflections from 1791 to the Present* (London, 2011)

Bourke, Richard, *Empire and Revolution: The Political Life of Edmund Burke* (Princeton, 2015)

Boyle, Nicholas, *Goethe: The Poet and the Age*, 2 vols. to date (Oxford, 1991 and 2000)

Branscombe, Peter, *W. A. Mozart: 'Die Zauberflöte'* (Cambridge, 1991)

Braun, Theodore E. D., and John B. Radner, eds., *The Lisbon Earthquake of 1755: Representation and Reaction* (Oxford, 2005)

Bray, René, *La Formation de la doctrine classique en France* (Paris, 1951)

Briggs, Robin, *Witches and Neighbours: The Social and Cultural Context of European Witchcraft*, 2nd edn (Oxford, 2002)

Brockliss, L. W. B., *French Higher Education in the Seventeenth and Eighteenth Centuries: A Cultural History* (Oxford, 1987)

—— *Calvet's Web: Enlightenment and the Republic of Letters in Eighteenth-Century France* (Oxford, 2002)

—— 'Starting-out, getting-on and becoming famous in the eighteenth-century Republic of Letters', in André Holenstein, Hubert Steinke and Martin Stuber, eds., *Scholars in Action: The Practice of Knowledge and the Figure of the Savant in the 18th Century*, 2 vols. (Leiden, 2013), i. pp. 71–100

—— *The University of Oxford: A History* (Oxford, 2016)

and Colin Jones, *The Medical World of Early Modern France* (Oxford, 1997)

and Heather Montgomery, eds., *Childhood and Violence in the Western Tradition* (Oxford, 2010)

and Ritchie Robertson, eds., *Isaiah Berlin and the Enlightenment* (Oxford, 2016)

Brown, Gregory S., 'Reconsidering the censorship of writers in eighteenth-century France: civility, state power, and the public theater in the Enlightenment', *Journal of Modern History*, 75 (2003), pp. 235–68

Brown, Michael, *The Irish Enlightenment* (Cambridge, MA, 2016)

Brown, Stewart J., ed., *William Robertson and the Expansion of Empire* (Cambridge, 1997)

Bruford, W. H., *Germany in the Eighteenth Century: The Social Background of the Literary Revival* (Cambridge, 1935)

Bryson, Anna, *From Courtesy to Civility: Changing Codes of Conduct in Early Modern England* (Oxford, 1998)

Buchan, James, *Capital of the Mind: How Edinburgh Changed the World* (London, 2003)

Bundock, Michael, *The Fortunes of Francis Barber: The True Story of the Jamaican Slave who became Samuel Johnson's Heir* (New Haven, 2015)

Burke, Peter, *Popular Culture in Early Modern Europe* (London, 1978)

—— *The Art of Conversation* (Cambridge, 1993)

—— *Secret History and Historical Consciousness: From the Renaissance to Romanticism* (Brighton, 2016)

Burrow, John, *Gibbon* (Oxford, 1985)

Butterwick, Richard, *Poland's Last King and English Culture: Stanisław August Poniatowski 1732–1798* (Oxford, 1998)

Cameron, Euan, *Enchanted Europe: Superstition, Reason, and Religion, 1250–1750* (Oxford, 2010)

Camporesi, Piero, *The Fear of Hell: Images of Damnation and Salvation in Early Modern Europe*, tr. Lucinda Byatt (Cambridge, 1990)

Carlyle, Thomas, *History of Friedrich II. of Prussia, called Frederick the Great*, 6 vols. in 3 (London, [1896?])

Carpanetto, Dino, and Giuseppe Ricuperati, *Italy in the Age of Reason 1685–1789*, tr. Caroline Higgitt (London, 1987)

Cassirer, Ernst, *The Philosophy of the Enlightenment*, tr. Fritz C. A. Koelln and James P. Pettegrove (Princeton, 1951)

Cheney, Paul, 'Commerce', in Daniel Brewer, ed., *The Cambridge Companion to the French Enlightenment* (Cambridge, 2014), pp. 44–59

Chisick, Harvey, *The Limits of Reform in the Enlightenment: Attitudes toward the Education of the Lower Classes in Eighteenth-Century France* (Princeton, 1981)

Cipolla, Carlo, *Miasmas and Disease: Public Health and the Environment in the Pre-Industrial Age*, tr. Elizabeth Potter (New Haven, 1992)

Clark, Christopher, *Iron Kingdom: The Rise and Downfall of Prussia 1600–1947* (London, 2006)

Clark, J. C. D., *Thomas Paine: Britain, America, and France in the Age of Enlightenment and Revolution* (Oxford, 2018)

Clark, Peter, *British Clubs and Societies 1580–1800: The Origins of an Associational World* (Oxford, 2000)

Clark, Stuart, *Thinking with Demons: The Idea of Witchcraft in Early Modern Europe* (Oxford, 1999)

Clark, William, *Academic Charisma and the Origins of the Research University* (Chicago, 2006)

Cohen, I. Bernard, *The Newtonian Revolution* (Cambridge, 1980)

Colley, Linda, *Britons: Forging the Nation 1707–1837* (New Haven, 1992)

Conrad, Sebastian, 'Enlightenment in global history: a historiographical critique', *American Historical Review*, 117 (2012), pp. 999–1027

Crane, Tim, *The Meaning of Belief: Religion from an Atheist's Point of View* (Cambridge, MA, 2017)

Crompton, Louis, *Byron and Greek Love: Homophobia in 19th-Century England* (London, 1985)

Cronk, Nicholas, ed., *The Cambridge Companion to Voltaire* (Cambridge, 2009)

Cross, Anthony, *By the Banks of the Neva: Chapters from the Lives and Careers of the British in Eighteenth-Century Russia* (Cambridge, 1997)

Dabhoiwala, Faramerz, *The Origins of Sex: A History of the First Sexual Revolution* (London, 2012)

Dakin, Douglas, *Turgot and the Ancien Régime in France* (London, 1939)

Damrosch, Leo, *Jean-Jacques Rousseau: Restless Genius* (New York, 2005)

Darnton, Robert, 'The High Enlightenment and the low-life of literature in pre-Revolutionary France', *Past and Present*, 51 (May 1971), pp. 81–115

—— *The Great Cat Massacre and Other Episodes in French Cultural History* (London, 1984)

—— *The Forbidden Best-Sellers of Pre-Revolutionary France* (London, 1996)

—— *Censors at Work: How States Shaped Literature* (London, 2014)

—— 'First steps toward a history of reading', *Australian Journal of French Studies*, 51 (2014), pp. 152–77 (orig. ibid., 23 (1986), pp. 5–30)

Daston, Lorraine, 'The ideal and reality of the republic of letters in the Enlightenment', *Science in Context*, 4 (1991), pp. 367–86

—— 'Attention and the values of nature in the Enlightenment', in Lorraine Daston and Fernando Vidal, eds., *The Moral Authority of Nature* (Chicago, 2004), pp. 100–126

and Katharine Park, *Wonders and the Order of Nature, 1150–1750* (New York, 1998)

Davidson, Ian, *Voltaire: A Life*, rev. edn (London, 2012)

Davidson, Nicholas, 'Unbelief and atheism in Italy, 1500–1700', in Michael Hunter and David Wootton, eds., *Atheism from the Reformation to the Enlightenment* (Oxford, 1992), pp. 55–85

Davies, Adrian, *The Quakers in English Society 1655–1725* (Oxford, 2000)

Davis, Natalie Zemon, 'History's two bodies', *American Historical Review*, 93 (1988), pp. 1–30

Dawkins, Richard, *The Blind Watchmaker* (London, 1986)

Dehrmann, Mark-Georg, *Das 'Orakel der Deisten': Shaftesbury und die deutsche Aufklärung* (Göttingen, 2008)

Delumeau, Jean, *Catholicism between Luther and Voltaire: A New View of the Counter-Reformation*, tr. Jeremy Moiser (London, 1977)

—— *La Peur en Occident: XIVᵉ–XVIIᵉ siècles* (Paris, 1978)

—— *Le Péché et la peur: La culpabilisation en Occident, XIIIᵉ–XVIIIᵉ siècles* (Paris, 1983)

DeMaria, Robert, Jr, *The Life of Samuel Johnson: A Critical Biography* (Oxford, 1993)

Devlin, Judith, *The Superstitious Mind: French Peasants and the Supernatural in the Nineteenth Century* (New Haven, 1987)

Dickey, Laurence, '*Doux-commerce* and humanitarian values: free trade, sociability and universal benevolence in eighteenth-century thinking', *Grotiana*, 22/23 (2001/2), pp. 271–318

Digby, Anne, *Madness, Morality and Medicine: A Study of the York Retreat, 1796–1914* (Cambridge, 1985)

Dippel, Horst, *Germany and the American Revolution 1770–1800*, tr. Bernhard A. Uhlendorf (Wiesbaden, 1978)

Dixon, Thomas, *Weeping Britannia: Portrait of a Nation in Tears* (Oxford, 2015)

Dommanget, Maurice, *Le curé Meslier: Athée, communiste et révolutionnaire sous Louis XIV* (Paris, 1965)

Douthwaite, Julia V., *The Wild Girl, Natural Man, and the Monster: Dangerous Experiments in the Age of Enlightenment* (Chicago, 2002)

Doyle, William, *The Oxford History of the French Revolution* (Oxford, 1989)

—— *Jansenism: Catholic Resistance to Authority from the Reformation to the French Revolution* (Basingstoke, 2000)

Drouet, Joseph, *L'Abbé de Saint-Pierre: l'homme et l'œuvre* (Paris, 1912)

Duchet, Michèle, *Anthropologie et histoire au siècle des Lumières* (Paris, 1977)

Duffy, Eamon, *The Stripping of the Altars: Traditional Religion in England, c. 1400–c. 1580* (New Haven, 1992)

—— *Saints and Sinners: A History of the Popes* (New Haven, 1997)

Dukes, Paul, ed., *Russia under Catherine the Great*, 2 vols. (Newtonville, MA, 1978), vol. 2: *Catherine the Great's Instruction (Nakaz) to the Legislative Commission, 1767*

Dunn, Mary Maples, *William Penn: Politics and Conscience* (Princeton, 1967)

Dziembowski, Edmond, *Un nouveau patriotisme français, 1750–1770* (Oxford, 1998)

Eaves, T. C. Duncan, and Ben D. Kimpel, *Samuel Richardson: A Biography* (Oxford, 1971)

Edelstein, Dan, *The Terror of Natural Right: Republicanism, the Cult of Nature, and the French Revolution* (Chicago, 2009)

—— *The Enlightenment: A Genealogy* (Chicago, 2010)

Edmonds, David, and John Eidinow, *Rousseau's Dog: Two Great Thinkers at War in the Age of Enlightenment* (London, 2006)

Ehrich-Haefeli, Verena, 'Natur und Weiblichkeit: Zur Ausarbeitung der bürgerlichen Geschlechterideologie von Rousseau bis zu Schiller', in Jürgen Söring and Peter Gasser, eds., *Rousseauismus: Naturevangelium und Literatur* (Frankfurt a.M., 1999), pp. 155–97

Eire, Carlos M. N., *Reformations: The Early Modern World, 1450–1650* (New Haven, 2016)

Eisenstein, Elizabeth L., *Grub Street Abroad: Aspects of the French Cosmopolitan Press from the Age of Louis XIV to the French Revolution* (Oxford, 1992)

Ellis, Markman, *The Politics of Sensibility: Race, Gender, and Commerce in the Sentimental Novel* (Cambridge, 1996)

—— *The Coffee House: A Cultural History* (London, 2004)

Engelhardt, Ulrich, 'Zum Begriff der Glückseligkeit in der kameralistischen Staatslehre des 18. Jahrhunderts', *Zeitschrift für historische Forschung*, 8 (1981), pp. 37–79

Erdman, David V., *Commerce des Lumières: John Oswald and the British in Paris, 1790–1793* (Columbia, MO, 1986)

Evans, Richard J., *Rituals of Retribution: Capital Punishment in Germany, 1600–1987* (Oxford, 1996)

Evans, Robin, *The Fabrication of Virtue: English Prison Architecture, 1750–1840* (Cambridge, 1982)

Fara, Patricia, *Newton: The Making of a Genius* (New York, 2002)

Favre, Robert, *La Mort dans la littérature et la pensée françaises au siècle des lumières* (Lyons, 1978)

Feingold, Mordechai, *The Newtonian Moment: Isaac Newton and the Making of Modern Culture* (New York, 2004)

Findlen, Paula, 'Science as a career in Enlightenment Italy: the strategies of Laura Bassi', *Isis*, 84 (1993), pp. 441–69

Flavell, M. Kay, 'The enlightened reader and the new industrial towns: a study of the Liverpool Library, 1758–1790', *British Journal for Eighteenth-Century Studies*, 8 (1985), pp. 17–35

Forst, Rainer, *Toleration in Conflict: Past and Present* (Cambridge, 2011)

Foucault, Michel, *Discipline and Punish*, tr. Alan Sheridan (London, 1978)

—— *History of Madness*, ed. Jean Khalfa, tr. Jonathan Murphy and Jean Khalfa (London, 2006)

Franklin, Michael J., *Orientalist Jones: Sir William Jones, Poet, Lawyer, and Linguist, 1746–1794* (Oxford, 2011)

Freedberg, David, *The Power of Images: Studies in the History and Theory of Response* (Chicago, 1989)

Freud, Sigmund, *The Standard Edition of the Complete Psychological Works of Sigmund Freud*, ed. James Strachey, 24 vols. (London, 1953–74)

Garrett, Aaron, and James A. Harris, eds., *Scottish Philosophy in the Eighteenth Century*, vol. 1: *Morals, Politics, Art, Religion* (Oxford, 2015)

Gaskill, Malcolm, *Crime and Mentalities in Early Modern England* (Cambridge, 2000)

—— *Witchfinders: A Seventeenth-Century English Tragedy* (London, 2005)

Gatrell, V. A. C., *The Hanging Tree: Execution and the English People 1770–1868* (Oxford, 1994)

Gaukroger, Stephen, *Descartes: An Intellectual Biography* (Oxford, 1995)

—— *The Emergence of a Scientific Culture: Science and the Shaping of Modernity, 1210–1685* (Oxford, 2006)

—— *The Collapse of Mechanism and the Rise of Sensibility: Science and the Shaping of Modernity, 1680–1760* (Oxford, 2010)

Gay, Peter, *The Party of Humanity: Studies in the French Enlightenment* (London, 1964)

—— *The Enlightenment: An Interpretation*, 2 vols. (New York, 1966–9)

Geiter, Mary K., *William Penn* (London, 2000)

Ghosh, Peter, 'Gibbon's timeless verity: Nature and neo-classicism in the late Enlightenment', in David Womersley, ed., *Edward Gibbon: Bicentenary Essays* (Oxford, 1997), pp. 121–63

Glacken, Clarence J., *Traces on the Rhodian Shore: Nature and Culture in Western Thought from Ancient Times to the End of the Eighteenth Century* (Berkeley, 1967)

Glass, David V., *Numbering the People: The Eighteenth-Century Population Controversy and the Development of Census and Vital Statistics in Britain* (Farnborough, 1973)

Goldgar, Anne, *Impolite Learning: Conduct and Community in the Republic of Letters, 1680–1750* (New Haven, 1995)

Goldie, Mark, 'The theory of religious intolerance in Restoration England', in Ole Peter Grell, Jonathan I. Israel and Nicholas Tyacke, eds., *From Persecution to Toleration: The Glorious Revolution and Religion in England* (Oxford, 1991), pp. 331–68

—— 'Alexander Geddes at the limits of the Catholic Enlightenment', *Historical Journal*, 53 (2010), pp. 61–86

Goodare, Julian, *The European Witch-Hunt* (London, 2016)

Goodman, Dena, *The Republic of Letters: A Cultural History of the French Enlightenment* (Ithaca, NY, 1994)

Gordon, Daniel, *Citizens without Sovereignty: Equality and Sociability in French Thought, 1670–1789* (Princeton, 1994)

Goreau, Angeline, *Reconstructing Aphra: A Social Biography of Aphra Behn* (Oxford, 1980)

Gossman, Lionel, 'The worlds of *La Nouvelle Héloïse*', *SVEC*, 41 (1966), pp. 235–76

Grafton, Anthony, *The Footnote: A Curious History* (London, 1977)

—— *Defenders of the Text: The Traditions of Scholarship in an Age of Science, 1450–1800* (Cambridge, MA, 1991)

Graham, Henry Grey, *The Social Life of Scotland in the Eighteenth Century* (London, 1901)

Graham, Michael F., *The Blasphemies of Thomas Aikenhead: Boundaries of Belief on the Eve of the Enlightenment* (Edinburgh, 2008)

Greer, Donald, *The Incidence of the Terror during the French Revolution: A Statistical Interpretation* (Cambridge, MA, 1935)

Grell, Chantal, *L'Histoire entre érudition et philosophie: étude sur la connaissance historique à l'âge des lumières* (Paris, 1993)

Grell, Ole Peter, and Roy Porter, eds., *Toleration in Enlightenment Europe* (Cambridge, 2000)

Grell, Ole Peter, Jonathan I. Israel and Nicholas Tyacke, eds., *From Persecution to Toleration: The Glorious Revolution and Religion in England* (Oxford, 1991)

Grimsley, Ronald, *Rousseau and the Religious Quest* (Oxford, 1968)

Grove, Richard H., *Green Imperialism: Colonial Expansion, Tropical Island Edens and the Origins of Environmentalism, 1600–1860* (Cambridge, 1995)

Grundy, Isobel, *Lady Mary Wortley Montagu* (Oxford, 1999)

Habermas, Jürgen, *The Structural Transformation of the Public Sphere: An Inquiry into a Category of Bourgeois Society*, tr. Thomas Burger and Frederick Lawrence (Cambridge, 1989)

—— *The Philosophical Discourse of Modernity*, tr. Larry Kert (Cambridge, 1990)

Hampson, Norman, *Will and Circumstance: Montesquieu, Rousseau and the French Revolution* (London, 1983)

Harris, Bob, *Politics and the Rise of the Press: Britain and France, 1620–1800* (London, 1996)

Harris, James A., *Hume: An Intellectual Biography* (Cambridge, 2015)

Harris, Tim, *Revolution: The Great Crisis of the British Monarchy, 1685–1720* (London, 2006)

Harrison, Peter, *The Bible, Protestantism, and the Rise of Natural Science* (Cambridge, 1998)

—— *The Territories of Science and Religion* (Cambridge, 2015)

Harvey, David Allen, *The French Enlightenment and its Others: The Mandarin, the Savage, and the Invention of the Human Sciences* (New York, 2012)

Hathaway, Oona J., and Scott J. Shapiro, *The Internationalists and their Plan to Outlaw War* (London, 2017)

Hayes, Kevin J., *The Road to Monticello: The Life and Mind of Thomas Jefferson* (New York, 2008)

Haynes, Renée, *Philosopher King: The Humanist Pope Benedict XIV* (London, 1970)

Hellegouarc'h, Jacqueline, *L'Esprit de société: Cercles et 'salons' parisiens au XVIII^e siècle* (Paris, 2000)

Herr, Richard, *The Eighteenth-Century Revolution in Spain* (Princeton, 1958)

Hersche, Peter, *Der Spätjansenismus in Österreich* (Vienna, 1977)

—— *Muße und Verschwendung: Europäische Gesellschaft und Kultur im Barockzeitalter* (Freiburg, 2006)

Hertzberg, Arthur, *The French Enlightenment and the Jews* (New York, 1968)

High, Jeffrey L., Nicholas Martin and Norbert Oellers, eds., *Who is this Schiller Now? Essays on his Reception and Significance* (Rochester, NY, 2011)

Hilgers, Klaudia, *Entelechie, Monade und Metamorphose: Formen der Vervollkommnung im Werk Goethes* (Munich, 2002)

Hill, Bridget, *The Republican Virago: The Life and Times of Catharine Macaulay, Historian* (Oxford, 1992)

Hilliard, K. F., *Freethinkers, Libertines and 'Schwärmer': Heterodoxy in German Literature, 1750–1800* (London, 2011)

Hochstrasser, T. J., 'Physiocracy and the politics of *laissez-faire*', in Mark Goldie and Robert Wokler, eds., *The Cambridge History of Eighteenth-Century Political Thought* (Cambridge, 2006), pp. 419–42

Holt, Mack P., *The French Wars of Religion, 1562–1629* (Cambridge, 1995)

Honour, Hugh, *Neo-classicism* (Harmondsworth, 1968)

Hont, Istvan, *Jealousy of Trade: International Competition and the Nation-State in Historical Perspective* (Cambridge, MA, 2005)

—— *Politics in Commercial Society: Jean-Jacques Rousseau and Adam Smith*, ed. Béla Kapossy and Michael Sonenscher (Cambridge, MA, 2015)

Horkheimer, Max, and Theodor W. Adorno, *Dialectic of Enlightenment: Philosophical Fragments*, tr. Edmund Jephcott (Stanford, 2002)

Howard, Michael, *War and the Liberal Conscience* (Oxford, 1978)

Hsia, R. Po-chia, and H. F. K. van Nierop, eds., *Calvinism and Religious Toleration in the Dutch Golden Age* (Cambridge, 2002)

Hughes, Lindsey, *Russia in the Age of Peter the Great* (New Haven, 1998)

Huizinga, Johan, *The Waning of the Middle Ages*, tr. F. Hopman ([1924]; Harmondsworth, 1965)

Hull, Isabel V., *Sexuality, State, and Civil Society in Germany, 1700–1815* (Ithaca, NY, 1996)

Hunt, Lynn, *Inventing Human Rights: A History* (New York, 2007)

Hunter, Ian, *Rival Enlightenments: Civil and Metaphysical Philosophy in Early Modern Germany* (Cambridge, 2001)

Hunter, Michael, *Science and Society in Restoration England* (Cambridge, 1981)

—— *Boyle: Between God and Science* (New Haven, 2009)

—— *The Decline of Magic: Britain in the Enlightenment* (New Haven, 2020)

—— and David Wootton, eds., *Atheism from the Reformation to the Enlightenment* (Oxford, 1992)

Ignatieff, Michael, *A Just Measure of Pain: The Penitentiary in the Industrial Revolution, 1750–1850* (London, 1978)

Iliffe, Rob, *Newton: A Very Short Introduction* (Oxford, 2007)

────── Priest of Nature: The Religious Worlds of Isaac Newton (Oxford, 2017)

Innes, Joanna, Inferior Politics: Social Problems and Social Policies in Eighteenth-Century Britain (Oxford, 2009)

Irwin, Robert, For Lust of Knowing: The Orientalists and their Enemies (London, 2006)

Israel, Jonathan I., 'William III and toleration', in Ole Peter Grell, Jonathan I. Israel and Nicholas Tyacke, eds., From Persecution to Toleration: The Glorious Revolution and Religion in England (Oxford, 1991), pp. 129–70

────── The Dutch Republic: Its Rise, Greatness, and Fall, 1477–1806 (Oxford, 1995)

────── Radical Enlightenment: Philosophy and the Making of Modernity 1650–1750 (Oxford, 2001)

────── Enlightenment Contested: Philosophy, Modernity, and the Emancipation of Man 1670–1752 (Oxford, 2006)

────── Democratic Enlightenment: Philosophy, Revolution, and Human Rights 1750–1790 (Oxford, 2011)

────── Revolutionary Ideas: An Intellectual History of the French Revolution from 'The Rights of Man' to Robespierre (Princeton, 2014)

────── The Expanding Blaze: How the American Revolution Ignited the World, 1775–1848 (Princeton, 2017)

────── The Enlightenment that Failed: Ideas, Revolution, and Democratic Defeat, 1748–1830 (Oxford, 2019)

Jacob, Margaret C., The Radical Enlightenment: Pantheists, Freemasons and Republicans (London, 1981)

James, Susan, Spinoza on Philosophy, Religion, and Politics: The 'Theologico-Political Treatise' (Oxford, 2012)

Jones, Colin, The Great Nation: France from Louis XV to Napoleon (London, 2002)

Jones, J. R., 'James II's Revolution: royal policies, 1686–92', in Jonathan I. Israel, ed., The Anglo-Dutch Moment: Essays on the Glorious Revolution and its World Impact (Cambridge, 1991), pp. 47–71

Jones, Peter M., Agricultural Enlightenment: Knowledge, Technology, and Nature, 1750–1840 (Oxford, 2016)

Jones, Thora Burnley, and Bernard de Bear Nicol, Neo-Classical Dramatic Criticism 1560–1770 (Cambridge, 1976)

Justi, Carl, Winckelmann und seine Zeitgenossen, 3 vols. (Leipzig, 1923)

Kafker, Frank A., The Encyclopedists as a Group: A Collective Biography of the Authors of the 'Encyclopédie' (Oxford, 1996)

Kamen, Henry, The Rise of Toleration (London, 1967)

Keane, John, Tom Paine: A Political Life (London, 1995)

Kelly, Catriona, Refining Russia: Advice Literature, Polite Culture, and Gender from Catherine to Yeltsin (Oxford, 2001)

Kenny, Anthony, The God of the Philosophers (Oxford, 1979)

Keohane, Nannerl O., Philosophy and the State in France: The Renaissance to the Enlightenment (Princeton, 1980)

Kern, Bärbel, and Horst Kern, *Madame Doctor Schlözer: Ein Frauenleben in den Widersprüchen der Aufklärung* (Munich, 1988)

Keymer, Thomas, *Poetics of the Pillory: English Literature and Seditious Libel, 1660–1820* (Oxford, 2019)

Kinkead-Weekes, Mark, *Samuel Richardson: Dramatic Novelist* (London, 1973)

Kitromilides, Paschalis M., *Enlightenment and Revolution: The Making of Modern Greece* (Cambridge, MA, 2013)

—— ed., *Enlightenment and Religion in the Orthodox World* (Oxford, 2016)

Klein, Lawrence E., *Shaftesbury and the Culture of Politeness: Moral Discourse and Cultural Politics in Early Eighteenth-Century England* (Cambridge, 1994)

Kleingeld, Pauline, 'Six varieties of cosmopolitanism in late eighteenth-century Germany', *JHI*, 60 (1999), pp. 505–24

—— *Kant and Cosmopolitanism: The Philosophical Ideal of World Citizenship* (Cambridge, 2012)

Knights, Mark, *The Devil in Disguise: Deception, Delusion, and Fanaticism in the Early English Enlightenment* (Oxford, 2011)

Knott, Sarah, *Sensibility and the American Revolution* (Chapel Hill, NC, 2009)

and Barbara Taylor, eds., *Women, Gender and Enlightenment* (Basingstoke, 2005)

Knox, Ronald, *Enthusiasm: A Chapter in the History of Religion* (Oxford, 1950)

Koch, Adrienne, ed., *The American Enlightenment: The Shaping of the American Experiment and a Free Society* (New York, 1965)

Koerner, Lisbet, *Linnaeus: Nature and Nation* (Cambridge, MA, 1999)

Kontler, László, *Translations, Histories, Enlightenments: William Robertson in Germany, 1760–1795* (New York, 2014)

Kord, Susanne, *Murderesses in German Writing, 1720–1860: Heroines of Horror* (Cambridge, 2009)

Kors, Alan Charles, *D'Holbach's Coterie: An Enlightenment in Paris* (Princeton, 1976)

—— *Atheism in France, 1650–1729*, vol. 1: *The Orthodox Sources of Disbelief* (Princeton, 1990)

Krajewska, Barbara, *Du Cœur à l'esprit: Mademoiselle de Scudéry et ses samedis* (Paris, 1993)

Kramnick, Isaac, *The Rage of Edmund Burke: Portrait of an Ambivalent Conservative* (New York, 1977)

Kristeller, Paul Oskar, *Renaissance Thought and the Arts*, enlarged edn (Princeton, 1990)

Kuhn, Thomas S., *The Structure of Scientific Revolutions*, 2nd, enlarged edn (Chicago, 1969)

—— 'Mathematical versus experimental traditions in the development of physical science', in his *The Essential Tension: Selected Studies in Scientific Tradition and Change* (Chicago, 1977), pp. 31–65

Kümmel, W. G., *The New Testament: The History of the Investigation of its Problems*, tr. S. McLean Gilmour and Howard C. Kee (London, 1973)

Labrosse, Claude, *Lire au XVIIIᵉ siècle: La Nouvelle Héloïse et ses lecteurs* (Lyons, 1985)

Labrousse, Elisabeth, *Pierre Bayle*, 2 vols. (The Hague, 1963–4)

Langbein, John H., *Torture and the Law of Proof: Europe and England in the Ancien Régime* (Chicago, 1977)

Langford, Paul, *A Polite and Commercial People: England 1727–1783* (Oxford, 1989)

Laqueur, Thomas W., *Solitary Sex: A Cultural History of Masturbation* (New York, 2003)

Lauer, Gerhard, and Thorsten Unger, eds., *Das Erdbeben von Lissabon und der Katastrophendiskurs im 18. Jahrhundert* (Göttingen, 2008)

Laven, Mary, *Mission to China: Matteo Ricci and the Jesuit Encounter with the East* (London, 2011)

La Vopa, Anthony J., *The Labor of the Mind: Intellect and Gender in Enlightenment Cultures* (Philadelphia, 2017)

Leask, Nigel, *Robert Burns and Pastoral: Poetry and Improvement in Late Eighteenth-Century Scotland* (Oxford, 2010)

Lecky, W. E. H., *History of the Rise and Influence of Rationalism in Europe*, 2 vols., new edn (London, 1897)

Leemans, Inger, and Gert-Jan Johannes, *Worm en donder: Geschiedenis van de Nederlandse literatuur 1700–1800* (Amsterdam, 2013)

Lehner, Ulrich L., *Enlightened Monks: The German Benedictines 1740–1803* (Oxford, 2011)

——— *The Catholic Enlightenment: The Forgotten History of a Global Movement* (Oxford, 2016)

and Jeffrey D. Burson, eds., *Enlightenment and Catholicism in Europe: A Transnational History* (Notre Dame, IN, 2014)

and Michael Printy, eds., *A Companion to the Catholic Enlightenment in Europe* (Leiden, 2010)

Leppert, Richard, *Music and Image: Domesticity, Ideology, and Socio-Cultural Formation in Eighteenth-Century England* (Cambridge, 1988)

Levack, Brian P., *The Devil Within: Possession and Exorcism in the Christian West* (New Haven, 2013)

——— *The Witch-Hunt in Early Modern Europe*, 4th edn (London, 2016)

Lilti, Antoine, *Le Monde des salons: sociabilité et mondanité à Paris au XVIII^e siècle* (Paris, 2005)

——— 'Comment écrit-on l'histoire intellectuelle des Lumières? Spinozisme, radicalisme et philosophie', *Annales*, 64 (2009), pp. 171–206

——— *The World of the Salons: Sociability and Worldliness in Eighteenth-Century Paris*, tr. Lydia G. Cochrane (New York, 2010)

——— *L'héritage des Lumières: Ambivalences de la modernité* (Paris, 2019)

Lindemann, Mary, *Health and Healing in Eighteenth-Century Germany* (Baltimore, 1996)

——— *Medicine and Society in Early Modern Europe* (Cambridge, 1999)

Linton, Marisa, 'The intellectual origins of the French Revolution', in Peter R. Campbell, ed., *The Origins of the French Revolution* (Basingstoke, 2006), pp. 139–59

Lortholary, Albert, *Le Mirage russe en France au XVIII<sup>e</sup> siècle* (Paris, 1951)

Lovejoy, Arthur O., *The Great Chain of Being* (Cambridge, MA, 1936)

Lüsebrink, Hans-Jürgen, and Anthony Strugnell, eds., *L'Histoire des deux Indes: réécriture et polygraphie* (Oxford, 1995)

Macalpine, Ida, and Richard Hunter, *George III and the Mad-Business* (London, 1969)

Macaulay, Thomas Babington, *The Works of Lord Macaulay*, 12 vols. (London, 1898)

McClelland, Charles E., *State, Society, and University in Germany 1700–1914* (Cambridge, 1980)

MacCulloch, Diarmaid, *Reformation: Europe's House Divided* (London, 2003)

MacDonald, Michael, and Terence R. Murphy, *Sleepless Souls: Suicide in Early Modern England* (Oxford, 1990)

MacIntyre, Alasdair, *After Virtue* (London, 1981)

Mack, Maynard, *'King Lear' in our Time* (Berkeley, 1965)

McKendrick, Neil, John Brewer and J. H. Plumb, *The Birth of a Consumer Society: The Commercialization of Eighteenth-century England* (London, 1982)

McKitterick, Rosamond, and Roland Quinault, eds., *Edward Gibbon and Empire* (Cambridge, 1997)

Mackridge, Peter, 'The Greek intelligentsia 1780–1830: a Balkan perspective', in Richard Clogg, ed., *Balkan Society in the Age of Greek Independence* (London, 1981), pp. 63–84

Maclean, Ian, *The Renaissance Notion of Woman* (Cambridge, 1980)

McMahon, Darrin M., *Enemies of the Enlightenment: The French Counter-Enlightenment and the Making of Modernity* (New York, 2001)

—— *The Pursuit of Happiness: A History from the Greeks to the Present* (London, 2006)

McManners, John, *Death and the Enlightenment: Changing Attitudes to Death among Christians and Unbelievers in Eighteenth-Century France* (Oxford, 1981)

—— *Church and Society in Eighteenth-Century France*, 2 vols. (Oxford, 1998)

Macor, Laura Anna, *Die Bestimmung des Menschen (1748–1800): Eine Begriffsgeschichte* (Stuttgart, 2013)

McPhee, Peter, *Liberty or Death: The French Revolution* (New Haven, 2016)

Madariaga, Isabel de, *Russia in the Age of Catherine the Great* (London, 1981)

Makrides, Vasilios N., 'The Enlightenment in the Greek Orthodox East: appropriation, dilemmas, ambiguities', in Paschalis M. Kitromilides, ed., *Enlightenment and Religion in the Orthodox World* (Oxford, 2016), pp. 17–47

Malcolm, Noel, *Aspects of Hobbes* (Oxford, 2002)

—— *Useful Enemies: Islam and the Ottoman Empire in Western Political Thought, 1450–1750* (Oxford, 2019)

Manning, Susan, and Francis D. Cogliano, eds., *The Atlantic Enlightenment* (Aldershot, 2008)

Manuel, Frank E., *Isaac Newton Historian* (Cambridge, MA, 1963)

—— *A Portrait of Isaac Newton* (Cambridge, MA, 1968)

Marshall, John, *John Locke, Toleration and Early Enlightenment Culture* (Cambridge, 2006)

Marshall, P. J., *Problems of Empire: Britain and India 1757–1813* (London, 1968)

Martens, Wolfgang, *Die Botschaft der Tugend: Die Aufklärung im Spiegel der deutschen Moralischen Wochenschriften* (Stuttgart, 1968)

Martus, Steffen, *Aufklärung: Das deutsche 18. Jahrhundert. Ein Epochenbild* (Berlin, 2015)

Mason, H. T., *Pierre Bayle and Voltaire* (Oxford, 1963)

Matytsin, Antoine, 'Reason and utility in French religious apologetics', in William J. Bulman and Robert G. Ingram, eds., *God in the Enlightenment* (New York, 2016), pp. 63–82

Maxwell, Kenneth, *Pombal: Paradox of the Enlightenment* (Cambridge, 1995)

Meek, Ronald L., *Social Science and the Ignoble Savage* (Cambridge, 1966)

Melton, James Van Horn, *The Rise of the Public in Enlightenment Europe* (Cambridge, 2001)

Menshutkin, Boris N., *Russia's Lomonosov* (Princeton, 1952)

Meyer, Michael A., *The Origins of the Modern Jew: Jewish Identity and European Culture in Germany, 1749–1824* (Detroit, 1967)

Middlekauff, Robert, *The Glorious Cause: The American Revolution, 1763–1789*, rev. edn (Oxford, 2005)

Midelfort, H. C. Erik, *Witch Hunting in Southwestern Germany: The Social and Intellectual Foundations* (Stanford, 1972)

Miller, Peter N., *Peiresc's Europe: Learning and Virtue in the Seventeenth Century* (New Haven, 2000)

Mingay, G. E., ed., *Arthur Young and his Times* (London, 1975)

Minois, Georges, *Censure et culture sous l'Ancien Régime* (Paris, 1995)

Moravia, Sergio, *La scienza dell'uomo nel Settecento* (Bari, 1970)

Moriarty, Michael, *Taste and Ideology in Seventeenth-Century France* (Cambridge, 1988)

Mornet, Daniel, *Les Origines intellectuelles de la Révolution française* (Paris, 1933)

Mortier, Roland, *Le Cœur et la Raison: Recueil d'études sur le dix-huitième siècle* (Oxford, 1990)

Mortimer, Sarah, *Reason and Religion in the English Reformation: The Challenge of Socinianism* (Cambridge, 2009)

Mosher, Michael, 'Montesquieu on empire and enlightenment', in Sankar Muthu, ed., *Empire and Modern Political Thought* (Cambridge, 2012), pp. 112–54

Mossner, Ernest Campbell, *The Life of David Hume* (Oxford, 1954)

Moul, Victoria, ed., *A Guide to Neo-Latin Literature* (Cambridge, 2017)

Mugglestone, Lynda, *'Talking Proper': The Rise of Accent as Social Symbol* (Oxford, 1995)

Mulford, Carla J., *Benjamin Franklin and the Ends of Empire* (Oxford, 2015)

Müller, Hans H., 'Christopher Brown – an English farmer in Brandenburg-Prussia in the eighteenth century', *Agricultural History Review*, 17 (1969), pp. 120–35

Muthu, Sankar, ed., *Empire and Modern Political Thought* (Cambridge, 2012)

Myers, Sylvia Harcstark, *The Bluestocking Circle: Women, Friendship, and the Life of the Mind in Eighteenth-Century England* (Oxford, 1990)

Nahrstedt, Wolfgang, *Die Entstehung der Freizeit, dargestellt am Beispiel Hamburgs* (Göttingen, 1972)

Neiman, Susan, *Moral Clarity: A Guide for Grown-Up Idealists* (London, 2009)

Newman, Gerald, *The Rise of English Nationalism: A Cultural History, 1740–1830* (London, 1988)

Norman, Jesse, *Adam Smith: What He Thought and Why it Matters* (London, 2018)

North, Michael, '*Material Delight and the Joy of Living*': Cultural Consumption in the Age of Enlightenment in Germany, tr. Pamela Selwyn (Aldershot, 2008)

Oberman, Heiko A., *Luther: Man between God and the Devil*, tr. Eileen Walliser-Schwarzbart (New Haven, 1989)

O'Brien, Karen, *Narratives of Enlightenment: Cosmopolitan History from Voltaire to Gibbon* (Cambridge, 1997)

Oestreich, Gerhard, *Neostoicism and the Early Modern State*, tr. David McLintock (Cambridge, 1982)

Olusoga, David, *Black and British: A Forgotten History* (London, 2016)

Osterhammel, Jürgen, *Die Entzauberung Asiens: Europa und die asiatischen Reiche im 18. Jahrhundert* (Munich, 1998)

Ozouf, Mona, *Festivals and the French Revolution*, tr. Alan Sheridan (Cambridge, MA, 1988)

Oz-Salzberger, Fania, *Translating the Enlightenment: Scottish Civic Discourse in Eighteenth-Century Germany* (Oxford, 1995)

Pagden, Anthony, *The Enlightenment and Why it Still Matters* (Oxford, 2013)

Palmer, R. R., *The Age of the Democratic Revolution: A Political History of Europe and America, 1760–1800*, 2 vols. (Princeton, 1959–64)

Panofsky, Erwin, *Meaning in the Visual Arts* (1955; Harmondsworth, 1970)

Parker, Charles H., *Faith on the Margins: Catholics and Catholicism in the Dutch Golden Age* (Cambridge, MA, 2008)

Parker, Harold T., *The Cult of Antiquity and the French Revolutionaries* (Chicago, 1937)

Perkins, Franklin, *Leibniz and China: A Commerce of Light* (Cambridge, 2004)

Peters, Martin, *Altes Reich und Europa: Der Historiker, Statistiker und Publizist August Ludwig (v.) Schlözer (1735–1809)* (Münster, 2003)

Pettegree, Andrew, *The Invention of News: How the World Came to Know About Itself* (New Haven, 2014)

Philipp, Wolfgang, *Das Werden der Aufklärung in theologiegeschichtlicher Sicht* (Göttingen, 1957)

Philp, Mark, *Godwin's Political Justice* (London, 1986)

Pincus, Steve, *1688: The First Modern Revolution* (New Haven, 2009)

Pinker, Steven, *The Better Angels of our Nature: The Decline of Violence in History and its Causes* (London, 2011)

—— *Enlightenment Now: The Case for Reason, Science, Humanism and Progress* (London, 2018)

Pinot, Virgile, *La Chine et la formation de l'esprit philosophique en France (1640–1740)* (Paris, 1932)

Plumb, J. H., 'Commercialization and society', in Neil McKendrick, John Brewer and J. H. Plumb, *The Birth of a Consumer Society: The Commercialization of Eighteenth-Century England* (London, 1982), pp. 263–334

Pocock, J. G. A., *The Ancient Constitution and the Feudal Law: A Study of English Historical Thought in the Seventeenth Century* (Cambridge, 1957)

—— *The Machiavellian Moment: Florentine Republican Thought and the Atlantic Republican Tradition* (Princeton, 1975)

—— *Barbarism and Religion*, 6 vols. (Cambridge, 1999–2015)

Poliakov, Léon, *The History of Anti-Semitism*, vol. 3: *From Voltaire to Wagner*, tr. Miriam Kochan (London, 1975)

Pollock, Linda, *Forgotten Children: Parent–Child Relations from 1500 to 1900* (Cambridge, 1983)

Pomeau, René, *La Religion de Voltaire*, 2nd edn (Paris, 1969)

Popkin, Jeremy D., *News and Politics in the Age of Revolution: Jean Luzac's 'Gazette de Leyde'* (Ithaca, NY, 1989)

Popkin, Richard, *The Third Force in Seventeenth-Century Thought* (Leiden, 1992)

—— *The High Road to Pyrrhonism*, ed. Richard A. Watson and James E. Force (Indianapolis, 1993)

—— *The History of Scepticism: From Savonarola to Bayle* (New York, 2003)

Porter, Roy, *Mind-Forg'd Manacles: A History of Madness in England from the Restoration to the Regency* (London, 1987)

—— *English Society in the Eighteenth Century*, rev. edn (London, 1991)

—— *Enlightenment: Britain and the Creation of the Modern World* (London, 2000)

—— and Mikuláš Teich, eds., *The Enlightenment in National Context* (Cambridge, 1981)

Pross, Wolfgang, 'Die Konkurrenz von ästhetischem Wert und zivilem Ethos – Ein Beitrag zur Entstehung des Neoklassizismus', in Roger Bauer, ed., *Der theatralische Neoklassizismus um 1800: Ein europäisches Phänomen?* (Bern, 1986), pp. 64–126

Proust, Jacques, *Diderot et l'Encyclopédie* (Paris, 1967)

Prüsener, Marlies, 'Lesegesellschaften im 18. Jahrhundert. Ein Beitrag zur Lesergeschichte', *Archiv für Geschichte des Buchwesens*, 13 (1973), pp. 369–594

Py, Gilbert, *Rousseau et les éducateurs: étude sur la fortune des idées pédagogiques de Jean-Jacques Rousseau en France et en Europe au XVIIIᵉ siècle* (Oxford, 1997)

Rack, Henry D., *Reasonable Enthusiast: John Wesley and the Rise of Methodism* (London, 1989)

Raeff, Marc, *The Well-Ordered Police State: Social and Institutional Change through Law in the Germanies and Russia, 1600–1800* (New Haven, 1983)

Rasch, Wolfdietrich, *Freundschaftskult und Freundschaftsdichtung im deutschen Schrifttum des 18. Jahrhunderts* (Halle, 1936)

Rasmussen, Dennis C., *The Problems and Promise of Commercial Society: Adam Smith's Response to Rousseau* (University Park, PA, 2008)

—— The Pragmatic Enlightenment: Recovering the Liberalism of Hume, Smith, Montesquieu, and Voltaire (Cambridge, 2014)

Reddy, William, The Navigation of Feeling: A Framework for the History of Emotions (Cambridge, 2001)

Redwood, John, Reason, Ridicule and Religion: The Age of Enlightenment in England 1660–1750 (London, 1976)

Reed, T. J., Light in Germany: Scenes from an Unknown Enlightenment (Chicago, 2015)

Roberts, Michael, The Age of Liberty: Sweden 1719–1772 (Cambridge, 1986)

Robertson, John, The Case for the Enlightenment: Scotland and Naples 1680–1760 (Cambridge, 2005)

Robertson, Ritchie, ed., Lessing and the German Enlightenment (Oxford, 2013)

Roche, Daniel, Le Siècle des Lumières en province: Académies et académiciens provinciaux, 1680–1789, 2 vols. (Paris, 1978)

—— Histoire des choses banales: Naissance de la consommation X VII$^e$–X IX$^e$ siècle (Paris, 1997)

—— France in the Enlightenment, tr. Arthur Goldhammer (Cambridge, MA, 1998)

—— A History of Everyday Things: The Birth of Consumption in France, 1600–1800, tr. Brian Pearce (Cambridge, 2000)

Roger, Jacques, The Life Sciences in Eighteenth-Century French Thought, tr. Robert Ellrich (Stanford, 1997)

Rommel, Otto, Die Alt-Wiener Volkskomödie (Vienna, 1952)

Rosen, Michael, Dignity: Its History and Meaning (Cambridge, MA, 2012)

Rosenblatt, Helena, Rousseau and Geneva: From the 'First Discourse' to the 'Social Contract', 1749–1762 (Cambridge, 1997)

Rosenfeld, Sophia, Common Sense: A Political History (Cambridge, MA, 2011)

Ross, Ian Simpson, The Life of Adam Smith (Oxford, 1995)

Rothschild, Emma, Economic Sentiments: Adam Smith, Condorcet and the Enlightenment (Cambridge, MA, 2001)

Rudwick, Martin J. S., The Meaning of Fossils: Episodes in the History of Palaeontology (Chicago, 1985)

Ruff, Julius R., Violence in Early Modern Europe 1500–1800 (Cambridge, 2001)

Rusnock, Andrea A., Vital Accounts: Quantifying Health and Population in Eighteenth-Century England and France (Cambridge, 2002)

Ryan, Alan, On Politics: A History of Political Thought from Herodotus to the Present (London, 2012)

Saine, Thomas P., The Problem of Being Modern, or The German Pursuit of Enlightenment from Leibniz to the French Revolution (Detroit, 1997)

St Clair, William, The Godwins and the Shelleys: The Biography of a Family (London, 1989)

Salmond, Anne, Aphrodite's Island: The European Discovery of Tahiti (Berkeley, 2009)

Schama, Simon, Patriots and Liberators: Revolution in the Netherlands 1780–1813 (London, 1977)

—— *Citizens: A Chronicle of the French Revolution* (London, 1989)

Schmidt, Erich, *Richardson, Rousseau und Goethe: Ein Beitrag zur Geschichte des Romans im 18. Jahrhundert* (Jena, 1875)

Schmidt, James, 'Language, mythology, and enlightenment: historical notes on Horkheimer and Adorno's *Dialectic of Enlightenment*', *Social Research*, 65 (1998), pp. 807–38

Schofield, Robert E., *The Enlightened Joseph Priestley: A Study of his Life and Work from 1773 to 1804* (University Park, PA, 2004)

Schwarzbach, Bertram Eugène, *Voltaire's Old Testament Criticism* (Geneva, 1971)

—— 'Voltaire et les Juifs: bilan et plaidoyer', *SVEC*, 358 (1997), pp. 27–91

Schweizer, Hans Rudolf, *Ästhetik als Philosophie der sinnlichen Erkenntnis: Eine Interpretation der 'Aesthetica' A. G. Baumgartens mit teilweiser Wiedergabe des lateinischen Textes und deutscher Übersetzung* (Basel, 1973)

Scott, H. M., ed., *Enlightened Absolutism: Reform and Reformers in Later Eighteenth-Century Europe* (London, 1990)

Scribner, Robert W., 'The Reformation, popular magic and the "disenchantment of the world"', *Journal of Interdisciplinary History*, 23 (1993), pp. 475–94

Scurr, Ruth, *Fatal Purity: Robespierre and the French Revolution* (London, 2006)

Sebastiani, Silvia, *The Scottish Enlightenment: Race, Gender, and the Limits of Progress*, tr. Jeremy Carden (Basingstoke, 2013)

Sekora, John, *Luxury: The Concept in Western Thought, Eden to Smollett* (Baltimore, 1977)

Seth, Catriona, *Les rois aussi en mouraient: Les Lumières en lutte contre la petite vérole* (Paris, 2008)

Shackleton, Robert, *Montesquieu: A Critical Biography* (Oxford, 1961)

—— *Essays on Montesquieu and on the Enlightenment*, ed. David Gilson and Martin Smith (Oxford, 1988)

Shank, J. B., *The Newton Wars and the Beginning of the French Enlightenment* (Chicago, 2008)

Shapin, Steven, *The Scientific Revolution* (Chicago, 2000)

and Simon Schaffer, *Leviathan and the Air-Pump: Hobbes, Boyle, and the Experimental Life* (Princeton, 1985)

Shapiro, Barbara J., *Probability and Certainty in Seventeenth-Century England: A Study of the Relationships between Natural Science, Religion, History, Law, and Literature* (Princeton, 1983)

Sheehan, Jonathan, *The Enlightenment Bible: Translation, Scholarship, Culture* (Princeton, 2005)

Shennan, J. H., 'The rise of patriotism in 18th-century Europe', *History of European Ideas*, 13 (1991), pp. 689–710

Sher, Richard B., *Church and University in the Scottish Enlightenment: The Moderate Literati of Edinburgh* (Edinburgh, 1985)

Shields, David S., *Civil Tongues and Polite Letters in British America* (Chapel Hill, NC, 1997)

Shklar, Judith, *Montesquieu* (Oxford, 1987)

Sikka, Sonia, *Herder on Humanity and Cultural Difference: Enlightened Relativism* (Cambridge, 2011)

Skoczylas, Anne, *Mr Simson's Knotty Case: Divinity, Politics, and Due Process in Early Eighteenth-Century Scotland* (Montreal, 2001)

Slauter, Eric, 'The Declaration of Independence and the new nation', in Frank Shuffelton, ed., *The Cambridge Companion to Thomas Jefferson* (Cambridge, 2009), pp. 12–34

Smitten, Jeffrey R., *The Life of William Robertson: Minister, Historian and Principal* (Edinburgh, 2016)

Smout, T. C., *A History of the Scottish People 1560–1830* (London, 1969)

Sorkin, David, *The Religious Enlightenment: Protestants, Jews, and Catholics from London to Vienna* (Princeton, 2008)

Sowerby, Scott, *Making Toleration: The Repealers and the Glorious Revolution* (Cambridge, MA, 2013)

Spierenburg, Pieter, *The Spectacle of Suffering: Executions and the Evolution of Repression: from a Preindustrial Metropolis to the European Experience* (Cambridge, 1984)

Stafford, Barbara, *Artful Science: Enlightenment Entertainment and the Eclipse of Visual Education* (Cambridge, MA, 1994)

Stafford, Fiona J., *The Sublime Savage: A Study of James Macpherson and the Poems of Ossian* (Edinburgh, 1988)

Stagl, Justin, *A History of Curiosity: The Theory of Travel 1550–1800* (London, 1995)

Starobinski, Jean, *Jean-Jacques Rousseau: Transparency and Obstruction*, tr. Arthur Goldhammer (Chicago, 1988)

Sternhell, Zeev, *The Anti-Enlightenment Tradition*, tr. David Maisel (New Haven, 2010)

Stevenson, David, *The Origins of Freemasonry: Scotland's Century, 1590–1710* (Cambridge, 1988)

Stewart, John Hall, *A Documentary Survey of the French Revolution* (New York, 1951)

Still, Judith, *Enlightenment Hospitality: Cannibals, Harems and Adoption* (Oxford, 2011)

Stollberg-Rilinger, Barbara, *Maria Theresia: Die Kaiserin in ihrer Zeit* (Munich, 2017)

Stuart, Tristram, *The Bloodless Revolution: Radical Vegetarians and the Discovery of India* (London, 2006)

Stuurman, Siep, *François Poulain de la Barre and the Invention of Modern Equality* (Cambridge, MA, 2004)

Suderman, Jeffrey M., 'Religion and philosophy', in Aaron Garrett and James A. Harris, eds., *Scottish Philosophy in the Eighteenth Century*, vol. 1: *Morals, Politics, Art, Religion* (Oxford, 2015), pp. 196–238

Summers, David, 'Why did Kant call taste a "common sense"?', in Paul Mattick, Jr, ed., *Eighteenth-Century Aesthetics and the Reconstruction of Art* (Cambridge, 1993), pp. 120–51

Sutcliffe, Adam, *Judaism and Enlightenment* (Cambridge, 2003)

Sypher, Wylie, *Guinea's Captive Kings: British Anti-Slavery Literature of the XVIIIth Century* (Chapel Hill, NC, 1942)

Tackett, Timothy, *The Coming of the Terror in the French Revolution* (Cambridge, MA, 2015)

Talmon, Jacob, *The Origins of Totalitarian Democracy* (London, 1952)

Terrall, Mary, *The Man who Flattened the Earth: Maupertuis and the Sciences in the Enlightenment* (Chicago, 2002)

Testa, Simone, *Italian Academies and their Networks, 1525–1700: From Local to Global* (London, 2015)

Thomas, Hugh, *The Slave Trade: The History of the Atlantic Slave Trade, 1440–1870* (London, 1997)

Thomas, Keith, *Religion and the Decline of Magic* (London, 1971)

—— *Man and the Natural World: Changing Attitudes in England 1500–1800* (London, 1983)

—— *In Pursuit of Civility: Manners and Civilization in Early Modern England* (New Haven, 2018)

Thompson, E. P., *Customs in Common* (London, 1991)

Till, Nicholas, *Mozart and the Enlightenment: Truth, Virtue and Beauty in Mozart's Operas* (London, 1992)

Tocqueville, Alexis de, *Democracy in America* (abridged edn), tr. Henry Reeve (London, 1946)

Todd, Margo, *The Culture of Protestantism in Early Modern Scotland* (New Haven, 2002)

Torrey, Norman L., *Voltaire and the English Deists* (New Haven, 1930)

Tortarolo, Edoardo, *L'invenzione della libertà di stampa: Censura e scrittori nel Settecento* (Rome, 2011)

Trevor-Roper, Hugh, 'Toleration and religion after 1688', in Ole Peter Grell, Jonathan I. Israel and Nicholas Tyacke, eds., *From Persecution to Toleration: The Glorious Revolution and Religion in England* (Oxford, 1991), pp. 389–410

—— *History and the Enlightenment*, ed. John Robertson (New Haven, 2010)

Tribe, Keith, *Governing Economy: The Reformation of German Economic Discourse 1750–1840* (Cambridge, 1988)

—— *The Economy of the Word: Language, History, and Economics* (Oxford, 2015)

Trousson, Raymond, *Jean-Jacques Rousseau* (Paris, 2003)

Uglow, Jenny, *Hogarth: A Life and a World* (London, 1997)

—— *The Lunar Men: The Friends who Made the Future* (London, 2002)

Van der Lugt, Mara, *Bayle, Jurieu, and the 'Dictionnaire Historique et Critique'* (Oxford, 2016)

Venturi, Franco, *Settecento riformatore* (Turin, 1969)

—— *Utopia and Reform in the Enlightenment* (Cambridge, 1971)

Vickery, Amanda, *The Gentleman's Daughter: Women's Lives in Georgian England* (New Haven, 1998)

Voitle, Robert, *The Third Earl of Shaftesbury, 1671–1713* (Baton Rouge, LA, 1984)

Wade, Ira O., *The Clandestine Organization and Diffusion of Philosophic Ideas in France from 1700 to 1750* (Princeton, 1938)

Wahnbaeck, Till, *Luxury and Public Happiness: Political Economy in the Italian Enlightenment* (Oxford, 2004)

Walker, D. P., *The Decline of Hell: Seventeenth-Century Discussions of Eternal Torment* (London, 1964)

Walsham, Alexandra, *Charitable Hatred: Tolerance and Intolerance in England, 1500–1700* (Manchester, 2006)

——— 'The Reformation and the "disenchantment of the world" reassessed', *Historical Journal*, 51 (2008), pp. 497–528

Waquet, Françoise, *Latin, or the Empire of a Sign*, tr. John Howe (London, 2001)

Ward, Albert, *Book Production, Fiction, and the German Reading Public, 1740–1800* (Oxford, 1974)

Ward, Lee, *The Politics of Liberty in England and Revolutionary America* (Cambridge, 2004)

Wasserman, Earl R., 'The pleasures of tragedy', *ELH*, 14 (1947), pp. 283–307

Weber, Max, 'Science as a Vocation', in *From Max Weber: Essays in Sociology*, tr. H. H. Gerth and C. Wright Mills (New York, 1946), pp. 129–56

——— 'Wissenschaft als Beruf', in *Gesammelte Aufsätze zur Wissenschaftslehre*, ed. Johannes Winckelmann (Tübingen, 1988), pp. 582–613

Weigl, Engelhard, 'Entzauberung der Natur durch Wissenschaft, dargestellt am Beispiel der Erfindung des Blitzableiters', *Jahrbuch der Jean-Paul-Gesellschaft*, 22 (1987), pp. 7–39

Westfall, Richard S., *Never at Rest: A Biography of Isaac Newton* (Cambridge, 1980)

Whaley, Joachim, *Germany and the Holy Roman Empire*, 2 vols. (Oxford, 2012)

Whiting, Robert, *The Blind Devotion of the People: Popular Religion and the English Reformation* (Cambridge, 1989)

Whitmarsh, Tim, *Battling the Gods: Atheism in the Ancient World* (London, 2016)

Willey, Basil, *The Eighteenth-Century Background: Studies on the Idea of Nature in the Thought of the Period* (London, 1940)

Williamson, Edwin, *The Penguin History of Latin America*, rev. edn (London, 2009)

Wills, Garry, *Inventing America: Jefferson's Declaration of Independence* (New York, 1978)

Wilson, Arthur M., *Diderot* (New York, 1972)

Wilson, Catherine, *Epicureanism at the Origins of Modernity* (Oxford, 2008)

Wilson, Kathleen, *The Sense of the People: Politics, Culture, and Imperialism in England, 1715–1785* (Cambridge, 1995)

Winch, Donald, *Adam Smith's Politics: An Essay in Historiographic Revision* (Cambridge, 1978)

Winterer, Caroline, *American Enlightenments: Pursuing Happiness in the Age of Reason* (New Haven, 2016)

Wokler, Robert, *Rousseau, the Age of Enlightenment, and their Legacies*, ed. Bryan Garsten (Princeton, 2012)

Wolff, Larry, *Venice and the Slavs: The Discovery of Dalmatia in the Age of Enlightenment* (Stanford, 2001)

Wolpe, Hans, *Raynal et sa machine de guerre: L'Histoire des deux Indes et ses perfectionnements* (Stanford, 1957)

Womersley, David, *The Transformation of the Decline and Fall of the Roman Empire* (Cambridge, 1988)

—— ed., *Edward Gibbon: Bicentenary Essays* (Oxford, 1997)

—— *Gibbon and the 'Watchmen of the Holy City': The Historian and his Reputation 1776–1815* (Oxford, 2002)

Wood, Allen W., 'Kant versus eudaimonism', in Predrag Cicovacki, ed., *Kant's Legacy: Essays in Honor of Lewis White Beck* (Rochester, NY, 2001), pp. 261–81

Wootton, David, 'Lucien Febvre and the problem of early modern unbelief', *Journal of Modern History*, 60 (1988), pp. 695–730

—— 'Narrative, irony, and faith in Gibbon's *Decline and Fall*', in David Womersley, ed., *Edward Gibbon: Bicentenary Essays* (Oxford, 1997), pp. 203–33

—— ed., *The Essential Federalist and Anti-Federalist Papers* (Indianapolis, 2003)

—— *Bad Medicine: Doctors Doing Harm since Hippocrates* (Oxford, 2006)

—— *The Invention of Science: A New History of the Scientific Revolution* (London, 2015)

—— *Power, Pleasure and Profit: Insatiable Appetites from Machiavelli to Madison* (Cambridge, MA, 2018)

Worden, Blair, *Roundhead Reputations: The English Civil Wars and the Passions of Posterity* (London, 2001)

Yeo, Richard, *Encyclopaedic Visions: Scientific Dictionaries and Enlightenment Culture* (Cambridge, 2001)

Young, Brian W., *Religion and Enlightenment in Eighteenth-Century England: Theological Debate from Locke to Burke* (Oxford, 1998)

Zaretsky, Robert, and John T. Scott, *The Philosophers' Quarrel: Rousseau, Hume, and the Limits of Human Understanding* (New Haven, 2009)

# Index